A HISTORY OF

ART IN AFRICA

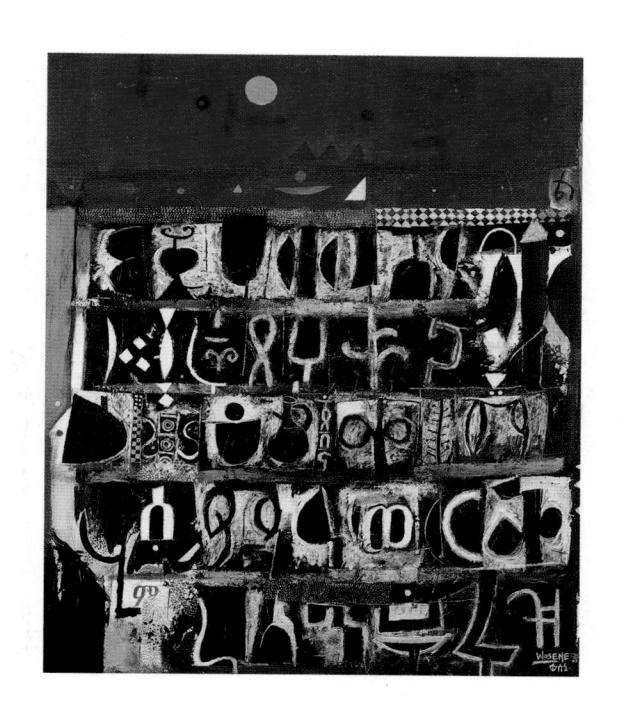

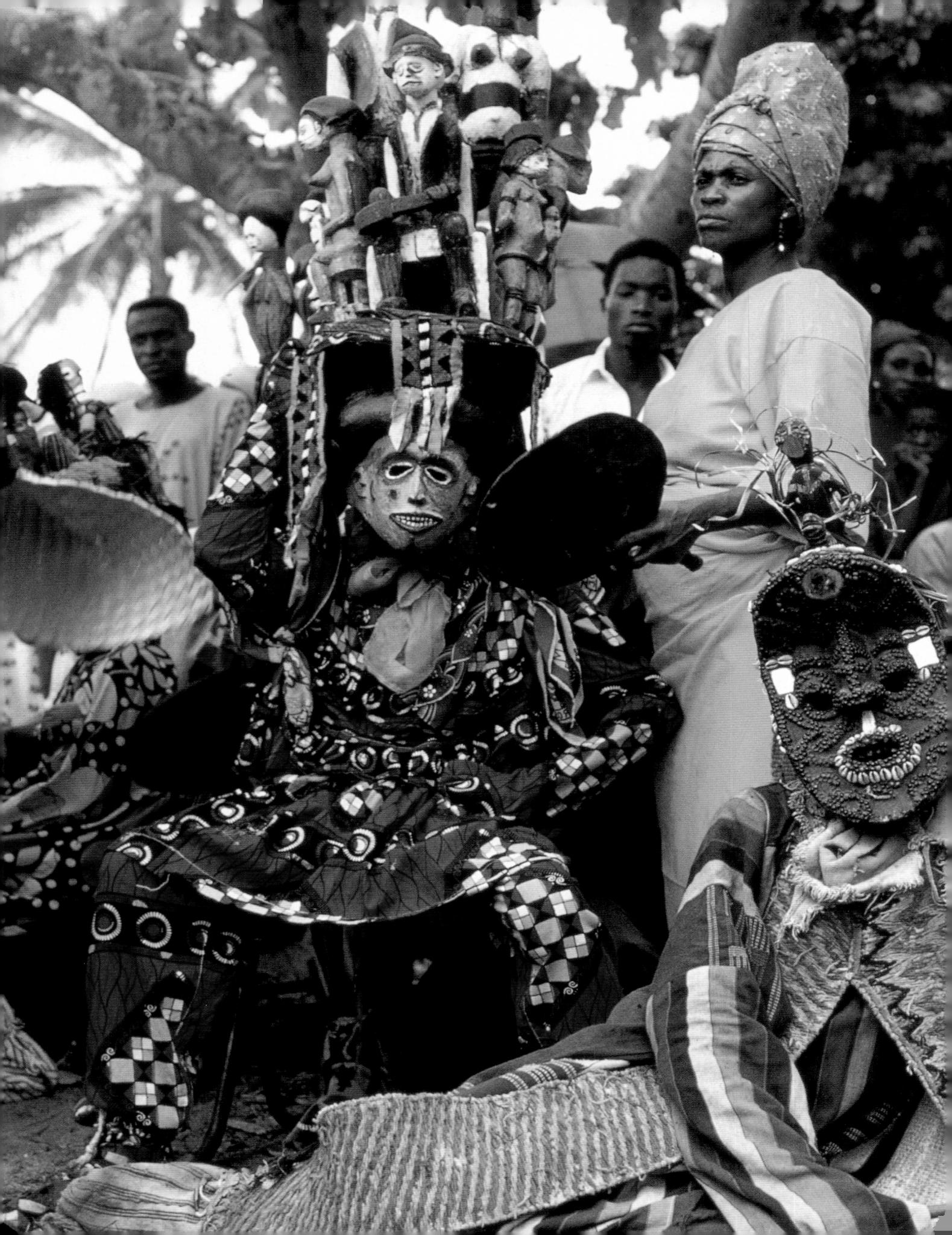

A HISTORY OF

ART IN AFRICA

SECOND EDITION

MONICA BLACKMUN VISONÀ

ROBIN POYNOR

HERBERT M. COLE

With Contributions by

Suzanne Preston Blier (Introduction)

Rowland Abiodun (Preface)

and

Michael D. Harris (Chapter 16)

Upper Saddle River, N.J. 07458

AURORA PUBLIC LIBRARY

Acknowledgments

This book is the result of more than two decades of work by hundreds of people (including those noted in the Annotated Bibliography). We have been assisted by art historians, anthropologists, archaeologists, photographers, photographic researchers, editors, and designers. The initial discussions on the need for this book were held by members of the Textbook Committee of the Arts Council of the African Studies Association (ACASA). These led to discussions with Eve Sinaiko of Abrams, whose vision and commitment were eventually to bring the book to publication. Sinaiko helped shape the first few chapters, then relinquished development to the consummately professional Mark Getlein, who is responsible for making a whole cloth of many strands. After the initial gathering of text and images by Abrams' New York staff, the entire project was moved to London and placed in the capable hands of Kara Hattersley-Smith of Calmann and King. Hattersley-Smith and her colleagues (especially photographic researcher Julia Ruxton) have graciously and effectively managed to coordinate the efforts of contributors on three continents. The book has finally become a reality through the unstinting work of Julia Moore, our editor at Abrams for the duration.

A generous grant from the National Endowment for the Humanities allowed Robin Poynor and Monica Blackmun Visonà to visit photographic archives in London, Cambridge, Oxford, Paris, and Tervuren and to take leaves of absence from teaching in order to write the first drafts. We thank those who offered us advice and hospitality in Europe, especially the staffs of the Photothèque of the Musée de l'Homme, the Musée National des Arts Africains et Oceaniens, the Institut du Monde Arabe and Hoa-Qui in Paris, the Royal Anthropological Society and the Royal Geographical Society in London, and the Afrika Museum in Tervuren. While we do not have space to thank all the scholars, photographers, and photographic researchers who have assisted the four principal authors since that trip, we are especially grateful to the

staff at the Fowler Museum of the University of California Museum and Christraud Geary at the Elisophon Archives of the National Museum of African Art. The four of us would also like to thank our fellow faculty and administrators at Metropolitan State College of Denver, University of Florida, University of California at Santa Barbara, and University of North Carolina at Chapel Hill for allowing us release time from our teaching and administrative duties so that we could produce this book. Our students have suffered through early versions of chapters, yet they have sustained us with their enthusiasm. Most of all, the authors wish to acknowledge the wisdom and generosity of the men and women in Nigeria, Ghana, Côte d'Ivoire, Mali, Kenya, Malawi, and the Republic of Benin who over the years have molded our lives as scholars and as people. We could not have written this book without the support of our spouses (Paolo, Donna, Shelley, Janine, Rudi, and Lea); and we dedicate it to our children: Mark, Marian, Chris, Sarah, Thomas, Peter, Luke, Shani Naima, Dara Ayana, Jocelyn, Adebayo, Aina, and Oluwole.

The second edition was made possible by the support and encouragement of Prentice Hall, and we thank Helen Ronan and her staff for their hard work, as well as those who reviewed the manuscript and made useful suggestions: Lisa Aronson, Skidmore College; Amanda Carlson, University of Hartford; Kathy Curnow, Cleveland State University; Edward DeCarbo, Pratt Institute; Peri M. Klemm, California State University, Northridge; Patrick McNaughton, Indiana University; John Peffer, Northwestern University; and Christopher Roy, University of Iowa. Laurence King provided, once more, an inspired and dedicated team, and we are particularly grateful to Kara Hattersley-Smith, Robert Shore, and the amazing Julia Ruxton. Finally, Monica Blackmun Visonà wishes to thank the art history faculty of the University of Kentucky for giving her the opportunity to complete this challenging project.

Library of Congress Cataloging-in-Publication Data

Visonà, Monica Blackmun.

A history of art in Africa / Monica Blackmun Visonà, Robin Poynor, Herbert M. Cole; with contributions by Suzanne Preston Blier (introduction) Rowland Abiodun (preface) and Michael D. Harris (chapter 16). -- 2nd ed.

p. cm. Includes bibliographical references and index. ISBN 0-13-612872-6 (pbk. : alk. paper) -- ISBN 0-13-612874-2 (case : alk. paper) 1. Art, African. I. Poynor, Robin. II. Cole, Herbert M. III. Title. N7380.H54 2007 709.6--dc22

2007015831

Editor in Chief: Sarah Touborg Senior Sponsoring Editor: Helen Ronan Executive Marketing Manager: Marissa Feliberty Associate Marketing Manager: Sasha Anderson Smith Senior Operations Specialists: Sherry Lewis Senior Managing Editor: Lisa Iarkowski

This book was produced by Laurence King Publishing Ltd., London Copyright © 2008, 2001 Prentice Hall

Published by Pearson Education, Inc., Upper Saddle River, New Jersey, 07458. Pearson Prentice Hall.

All rights reserved. Printed in China. This publication is protected by Copyright and permission should be obtained from the publisher prior to any prohibited reproduction, storage in a retrieval system, or transmission in any form or by any means, electronic, mechanical, photocopying, recording, or likewise. For information regarding permission(s), write to: Rights and Permissions Department.

Pearson Prentice $Hall^{TM}$ is a trademark of Pearson Education, Inc. Pearson $^{\textcircled{a}}$ is a registered trademark of Pearson plc. Prentice $Hall^{\textcircled{B}}$ is a registered trademark of Pearson Education, Inc.

Pearson Education LTD.
Pearson Education, Canada, Ltd
Pearson Education Australia PTY, Limited
Pearson Education Singapore, Pte. Ltd
Pearson Education—Japan
Pearson Educación de Mexico, S.A. de C.V.
Pearson Education North Asia Ltd
Pearson Education Malaysia, Pte. Ltd

This book was designed and produced by Laurence King Publishing Ltd., London www.laurenceking.co.uk

Every effort has been made to contact the copyright holders, but should there be any errors or omissions, Laurence King Publishing Ltd. would be pleased to insert the appropriate acknowledgment in any subsequent printing of this publication.

Page 1: Night of the Red Sky, Wosene Worke Kosrof. 2003, acrylic on linen, Collection of Jolene Tritt and Paul Herzog, New Jersey. Photograph by Black Cat Studio, San Rafael, CA. Courtesy Color of Words Fine Arts Management

Frontispiece: Okpella "dead mother" (left) and *anogiri* (right) masks in performance, Okpella, Nigeria. c. 1973. Photograph by Jean Borgatti

Front cover main image: Crest mask. Cross River region, Nigeria. Wood, stained animal skin, basketry. Fowler Museum of Cultural History, University of California, Los Angeles. Photograph by Don Cole

Front cover inset image: Lion bocio in honor of King Glele. Allode Huntondji. 1858–89. Silver on wood. Musée Dapper, Paris. Photograph by Hughes Dubois.

Spine: Figure in attitude of prayer, Djenne Style. Ancient Mali. Copper alloy. Musée Barbier-Mueller, Geneva. © abm-archives barbier-mueller. Photograph by Studio Ferrazzini-Bouchet, Geneva

Back cover: The Chief; the One who sold Africa to the Colonials (Le chef: celui qui a vendu Afrique aux colons). Samuel Fosso. 1997. C-Print photograph. © the artist and Jean-Marc Patras, Courtesy of Jack Shainman Gallery, New York

Contents

PREFACE 10

ROWLAND ABIODUN

AFRICA, ART, AND HISTORY: AN INTRODUCTION 14

Suzanne Blier

I. From the Nile to the Niger 20

1 THE SAHARA AND THE MAGHREB 22

Monica Blackmun Visonà

Central Saharan Rock Art 23

Large Wild Fauna Style 23

Archaic Style 24

Pastoralist Style 25

Later Styles and Subjects 26

The Maghreb and the Ancient Mediterranean World 27

Carthage 27

Numidia and Mauritania 28

Rome 29

The Coming of Islam 29

The Great Mosque at Qairouan 30

Regional Berber Arts 32

Architecture and Household Arts in the Northern Mountains 32

Architecture and Household Arts in the Sahara 35 Personal Arts of the Shleuh and Tuareg 38

Twentieth- and Twenty-First-Century Arts of North Africa 40

Aspects of African Cultures: Personal Adornment 39

2 LANDS OF THE NILE: EGYPT, NUBIA, AND ETHIOPIA 44

Monica Blackmun Visonà

Early Nile Cultures 45

Kemet 48

Old Kingdom and Middle Kingdom 48

New Kingdom 52

Kush 56

Aksum and Its Time 60

Egypt in the Sphere of Greece, Rome, and

Byzantium 61

Palaces and Tombs of Aksum 62

Ballana 63

Early Christian Arts of Nubia and Ethiopia 64

Faras 64

Lalibala 64

Early Solomonic Period 65

Islamic Art of Egypt 67

Later Christian Art of Ethiopia 68

Lower Nubia Before the Aswan Dam 70

Twentieth-Century Artists from Cairo 72

Artists from Khartoum 73

Artists from Addis Ababa 75

Aspects of African Cultures: Techniques for Dating

African Art 58

3 THE CENTRAL SUDAN 76

Monica Blackmun Visonà

Ancient Art in Fired Clay 77

Nok and Sokoto 77

Bura 80

Sao 81

Living Arts of Small Communities 82

The Dakakari and the Nigerian Plateau 82

The Ga'anda and the Gongola River 82

Musgum and the Logone River 85

The Jukun of the Middle Benue River 86

The Chamba of the Nigeria/Cameroon

Borderlands 87

The Mumuye of the Upper Benue River 88

The Mambila of the Nigeria/Cameroon Borderlands 90

The Imperial Arts of the Kanuri and Hausa 91

Hausa Mosques and Civic Architecture 93 Art, Literacy, and Mystic Faith 95

The Fulani 97

The Futa Diallon 97

The Inland Niger Delta 98

Southern Niger 100

Northeastern Nigeria and the Adamawa 102

Art and Identity in the Modern World 102

Aspects of African Cultures: The Illicit Trade in

Archaeological Artifacts 78

MANDE WORLDS AND THE UPPER NIGER 104

MONICA BLACKMUN VISONÀ

In the Sphere of Ancient Empires 105

Wagadu 105

Mali and the Inland Niger Delta 107

The Architectural Legacy of Jenne 108

Takrur and Jolof 111

Recent Mande Arts: Nyamakalaw and Their Work 112

Gwan and Jo 112

Ntomo and Tyi Wara 115

Bogolanfini 118

Komo and Kono 119

Kore, Secular Masquerades, and Puppetry 121

Arts of the Home 123

Twentieth- and Twenty-First-Century Art in Senegal 125

Artists in Bamako 128

Aspects of African Cultures: Shrines and Altars 58

THE WESTERN SUDAN 130 5

HERBERT M. COLE

The Tellem 131

The Dogon 132

Sculpture 133

Architecture 137

Masks and Masquerades 140

The Senufo 143

Poro 144

Sandogo 146

Masks and Masquerades 148

Celebrations 151

Tourist Arts in Korhogo 151

Related Peoples of Burkina Faso 153

Lobi Sculpture and Metalwork 154

Bwa Masguerades 156

Mossi Sculpture and Masking 159

Bobo Masking 160

Koma Terracottas 161

Nankani Architecture 162

Ouagadugu and Contemporary Art 164

Aspects of African Cultures: Export Arts, Copies,

Fakes, Authenticity, and Connoisseurship 152

II. Western Africa 166

WEST ATLANTIC FORESTS 168

Monica Blackmun Visonà

Early Arts 169

Stone Figures 169

Export Ivories 171

Masking and Related Arts 173

Initiations of the Jola, the Bidjogo, and Their Neighbors 173

Performed Art of the Baga and Their Neighbors 176 Women's and Men's Societies: Sande/Bondo and Poro 179

Masks and Sacred Authority: The Dan and Their Neighbors 183

Women's Arts Among the Dan and the We 186

Masguerades of the Guro 188

Cross-Currents and Hybrid Forms 190

American-African Architecture 190

Festival Arts 191

Contemporary Arts in Abidjan and Other Urban

Centers 192

7 AKAN WORLDS 196

HERBERT M. COLE

The Visual-Verbal Nexus 197

Regalia and Arts of Statecraft 198

Regalia in Ghana 199

Thrones, Stools, and Chairs 200

State Swords 201

Linguist Staffs 202

Baule and Lagoons Regalia 203

Metal Arts: The Culture of Gold 204

Textiles 207

Terracotta Funerary Sculpture 209

Wood Sculpture and Shrines 211

Akua Ma 211

Asante Carvings and Shrines 212

Baule, Anyi, and Lagoon Sculpture in Wood 214

Secular Carvings 216

Royal Festivals in Ghana 217

Baule Masks and Masquerades 218

Portrait Masks 218

Goli 218

Bonu Amwin and Do 220

Age-Grade Arts of Lagoons Peoples 221

Arts of Fante Military Companies 222

Lives Well Lived: Contemporary Funerary Arts 224

Artists and Academies in Ghana 226

Aspects of African Cultures: Art and Leadership 198

8 THE YORUBA AND THE FON 228

Robin Poynor

Early Ife 229

Archaic and Pre-Pavement Periods 229

Pavement Period 230

Early Owo 235

Esie 237

Recent Yoruba Arts 238

Royal Arts 238

The Ogboni Society 243

Art and the Spirit World 244

Orunmila and Eshu 244

Ogun, Osanyin, and Eyinle 248

Altars 249

Shango and Ibeji 250

Masks and Masquerades 252

Dahomey 256

Royal Arts 257

Art and the Spirit World 260

Art and Modernity 264

Brazilian Architecture 264

Pioneers of Nigerian Modernism 265

Mbari Mbayo and Oshogbo 266

The Ona Group and Nigerian Universities 269

Contemporary Artists in Lagos 270

Contemporary Art in the Republic of Cotonou 271

Aspects of African Cultures: Lost-Wax Casting 234

9 THE LOWER NIGER 272

HERBERT M. COLE

Benin: Six Centuries of Royal Arts 273

Art, Ideology, and the Benin World 274

Plaques 277

Royal Altars 279

Portuguese Presence in Benin Arts 282

Masks and Masquerades 283

Igbo Ukwu 284

Recent and Contemporary Igbo Arts 287

Title Arts 287

Shrines and Shrine Figures 291

Mbari 293

Ugonachonma 296

Masks and Masquerades 297

Shared Themes in Lower Niger Arts 302

Personal Altars 302

Light/Dark Masking: Beauties and Beasts 304

Hierarchical Compositions 308

Ibibio Memorial Arts 308

Oron Ancestral Figures 310

Kalabari Ijaw Festivals and Memorial Arts 310

A Contemporary Nigerian Shrine 313

Aspects of African Cultures: Mamy Wata 291

III. Central Africa 316

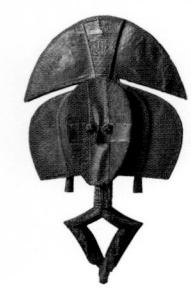

10 CROSS RIVER, CAMEROON GRASSLANDS, AND GABON 318

Robin Poynor

Cross River 319

Early Arts 319

Recent Arts of Secret Societies 320

Cameroon Grasslands 323

Palace Architecture 325

Arts of the Royal Treasuries 326

Royal Spectacle and Masquerade Arts 333

Maritime Arts: The Duala 336

Gabon 339

Reliquary Guardians 339

Masks and Masquerades 344

Contemporary International Arts 348

Aspects of African Cultures:

Masquerades 324

11 THE WESTERN CONGO BASIN 350

ROBIN POYNOR

Early Art 351

The Kongo Kingdom 351

Early Leadership Arts 352

Religious Arts 353

Funerary and Memorial Arts 355

Minkisi 359

In the Sphere of the Lunda Empire 363

Chokwe Leadership and Initiation Arts 364

The Yaka and the Suku 371

The Pende 375

The Salampasu 379

The Kuba 381

Leadership Arts 382

Ndop 383

Architecture 384

Prestige Objects 385

Textile Arts 387

Masks and Masquerades 389

In the Shadow of the Kuba: The Ndengese, the Binji, and the Wongo 392

The Lulua 393

Art in Kinshasa and Brazzaville 395

Aspects of African Cultures: Divination, Diagnosis,

and Healing 366

12 THE EASTERN CONGO BASIN 400

ROBIN POYNOR

Early Art from the Upemba Depression 400

In the Sphere of the Luba Empire 402

The Luba Heartland 402

The Hemba 408

The Tabwa 409

The Songye 411

Societies of the Lega, the Bembe, the Mbole, and the

Azande 413

Bwami 414

Elanda and 'Alunga 416

Lilwa 417

Mani 418

Court Art of the Azande and the Mangbetu 418

The Mbuti 423

Painting from Lumbumbashi 424

Aspects of African Cultures: Rites of Passage 413

IV. Eastern and Southern Africa 428

13 EASTERN AFRICA 430

Monica Blackmun Visonà

The Swahili Coast 430

Islamic Arts 431

Arts of Leadership 434

Domestic Architecture 435

Other Coastal Bantu Cultures 438

Prestige Arts of the Interlacustrine Region 442

The Nyamwezi 442

Royal Treasuries 444

Ceramics and Basketry 445

Masquerades and Other Arts of the Maravi, the Makonde, the Makua, and the Yao 447

Nyau 447

Lipiko 448

Sculpture 450

Export Art 451

Madagascar 452

Memorial Arts 453

Cushitic and Nilo-Saharan Speakers of the

Interior 456

Memorial Figures and Stone Tombs 456

Personal Arts 457

Artists of Uganda, Tanzania, and Kenya 461

Aspects of African Cultures: Cycles and Circles 449

14 SOUTHERN AFRICA 464

Monica Blackmun Visonà

Rock Art of Southern and Eastern Africa 465

Earliest Images 465

Zimbabwe 467

Eastern Africa 468

The Drakensberg Mountains 469

Early Art of Bantu Speakers 471

The Shona and Great Zimbabwe 471

Recent Art of the Shona and Their Neighbors 476

Art and Ancestors 476

Initiations and Related Art 478

Arts of the Sotho and the Nguni 481

Art and Leadership Among the Sotho and the

Tswana 481

Nguni Beadwork 482

Images in Cloth—Women's Workshops 484

Nguni Arts of Daily Life 485

Architecture 486

Art and Contemporary Issues 489

The Beginnings of Modern Art in South Africa 489

Modern Art in Mozambique and Zimbabwe 490 Art Under Apartheid 492

V. The Diaspora 498

15 AFRICAN ARTISTS ABROAD 500

Monica Blackmun Visonà

Artists from the Maghreb 504

Artists from Egypt, Sudan, and Ethiopia 506

Western Africa 509

Nigeria 512

Central, Eastern, and Southern Africa 514

16 ART OF THE AFRICAN DIASPORA IN THE AMERICAS 516

MICHAEL HARRIS

Art in Slave and Folk Settings 517

Speaking Through New Forms 519

Reclaiming Africa 523

Image and Idea 523

Getting Behind the Mask: Transatlantic

Dialogues 528

African Heritage in Popular and Ritual Arts 532

Six Contemporary Artists 537

Aspects of African Cultures: Artists Working Outside

the Frame 520

GLOSSARY 542

ANNOTATED BIBLIOGRAPHY 544

PICTURE CREDITS 552

INDEX 555

Preface

S ince its inception last century, the field of African art studies has been vexed by the problem of cross-cultural translation. How can one, for example, meaningfully present to a Western audience two radically different Yoruba works? The ako is a seated, life-like, life-sized, human-garbed burial effigy carved in wood which is painted to enhance its mimetic qualities—a social and psychological reconstruction of the dead (fig. i). The aale is a hanging, seemingly abstract sculptural construct made from a bit of red rag, a slipper, a metallic soup spoon, and some sticks—a deterrent impregnated with ase, the catalytic life-force, to stop thieves and ward off unauthorized persons from one's property (fig. ii). Both of them could have been created around the same period, possibly even by the same artist. Quite often, our inadequate preparation to grapple with seeming incongruities of this kind has led to many misconceptions, bizarre conclusions, and at other times, brilliantly presented but untenable theories on African art. This simple comparison reveals how, in considering African art, conventional Western arthistorical assumptions of stylistic progression and individual artistic identity are called into question. To make any substantial progress in dealing with the problems of cross-cultural translation as it pertains to the study and presentation of African art, we must consider both perspectives: the indigenous as well as the Western.

While it may have been useful to utilize only Western theoretical paradigms in the study of African art history and aesthetics in the early twentieth century, it has now become imperative to search carefully within the African cultures in which the art forms originate and to use internally derived conceptual frameworks in any critical discourse on African art. There are, however, difficulties in translating this theoretical position into practice. The study of African art, having begun within the discipline of anthropology, inherited some pertinent and vexing questions. Among these is the false assumption that Western scholars can fully understand and interpret the cultures of other peoples only by using their Western cultural notions, values, and standards—a claim that cannot be divorced from a long-standing Western, imperialistic involvement in Africa. In the traditional discipline of art history, the importance of African art has hardly advanced beyond that of catalyst and sanction for the revolutionary goals of European artists such as Pablo Picasso at the beginning of the twentieth century. Thus, Roy Sieber, a leading scholar in African art, has noted that an insufficient understanding of African art has caused it "to fall prey to the taste of the twentieth century."

In a bold and innovative manner, the authors of this textbook have taken a major step toward the goal of fashioning a new "lens"—one which appreciates the methodology of the finest traditions in Western art history but which also recognizes the need to critically examine, modify, and expand. This will enable scholars to deal with the special challenges presented by the

visual art traditions of predominantly non-writing, pre-colonial peoples of Africa. To illustrate my point, let us consider the question of anonymity in African art, a problem exacerbated by the fact that traditional African artists do not sign their works in the way artists in many contemporary Western societies do. Western audiences have become accustomed to appreciating and enjoying African works of art without knowing the names of their creators. Why should there be an interest in the issue of artists' identities now? Have we not read works by many scholars and even some "African art experts"

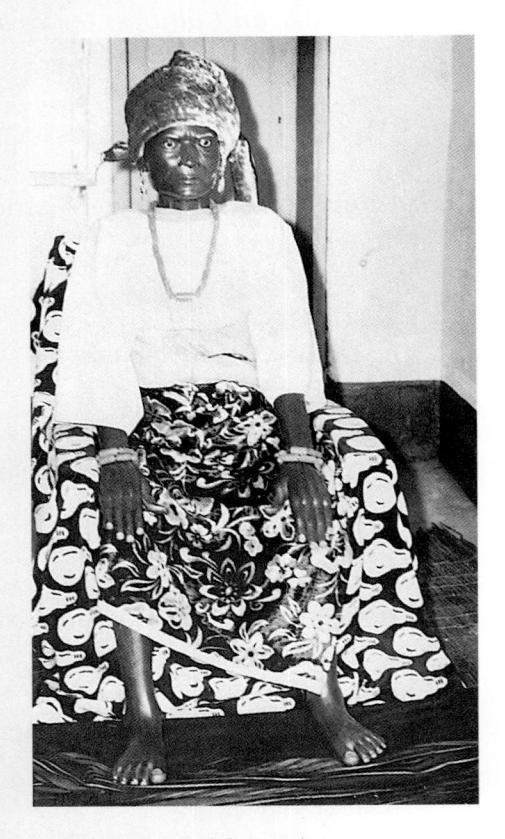

i. Ako effigy for Madam Alade, Yoruba, Ipele-Owo, Nigeria. Painted wood. Photograph 1972

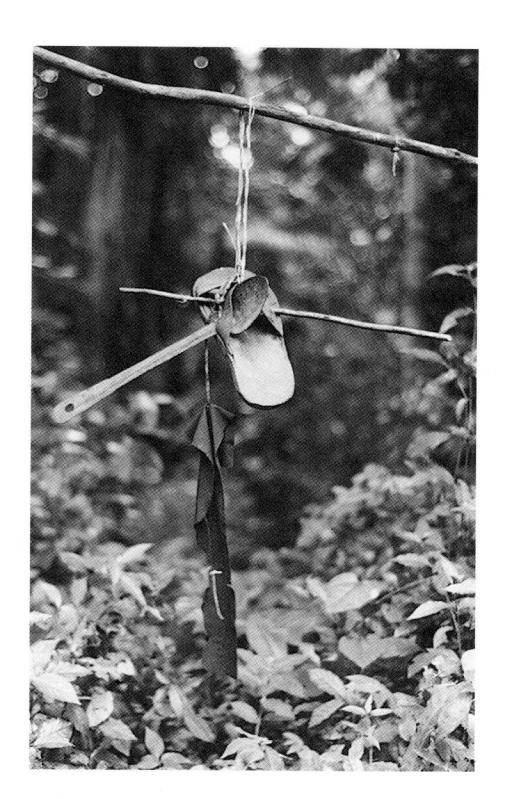

II. Aale (an abstract power-impregnated sculptural construct), Yoruba. Photograph 1982

premised on the notion that supposedly rigid African traditions are oblivious or even hostile to notions of individuality itself? The situation is complicated further when we consider how some art dealers and collectors view the issue of anonymity. A collector has been quoted as saying, "I am completely enchanted by the artist's anonymity. Not knowing the artist is something that gives me enormous pleasure. Once you hear who made it, it ceases to be primitive art."

To continue with the example of the Yoruba of West Africa, research confirms that Yoruba people not only know the value of the authorship of works of art, but that they, in fact, celebrate it through the literary genre known as *oriki* (citation poetry). There are, of course, other appropriate tradi-

tional contexts and occasions in which an artist's name may be heard and used. They include child-naming, installation and burial ceremonies, blessing and healing rituals, and important family gatherings. The myth of anonymity was constructed and reinforced by many early Western researchers who believed that, although the artifacts and the traditional thought systems (their raison d'être) belong to Africans, the interpretation of such works and the theorization of African art would always be a Western prerogative. Many scholars today (including the authors of this volume) are, however, more cautious about not repeating that same old error; i.e., believing that if the definitions of art or artistic procedures in other cultures do not take the forms with which we in the West are familiar, they must be lacking.

In considering the question of anonymity, it is important to note some reasons that the Yoruba may not publicly or openly associate specific art forms with the names of their authors. Often, names given at birth are closely linked to and identified with the essence of one's personality and destiny called ori inu (inner spiritual head), which in Yoruba religious belief, determines a person's success or failure in this world and directs his or her actions. In Yoruba society, the act of calling out a person's given names generally functions to differentiate individuals. In their religious system, naming also is believed to have the ability to arouse or summon a person's spiritual essence and cause him or her to act according to the meaning of those given names or in some other way desired by the caller. This is the basis of the Yoruba saying, oruko a maa ro'ni: "one's name controls one's actions." For example, a

name like Maboogunje is actually a plea, the full sentence being "Ma(se) ba oogun je," the translation of which is "Do not render medication ineffective."

Yoruba naming ceremonies and practices are among the most elaborate and sophisticated known anywhere. In addition to serving as identification, a name also incorporates elements of family history, beliefs, and the physical environment. With every naming, there begins a corresponding oriki (citation poetry), which grows with an individual's accomplishments. Thus, leaders, warriors, diviners, and other important personages, including artists, are easily identified by their oriki, which chronicles intricate oral portraits of all that is notable in their character and history. To illustrate, let me cite a part of the oriki of Olowe, one of the greatest traditional Yoruba sculptors of the twentieth century:

Olowe, oko mi kare o

Olowe, my excellent husband

Aseri Agbaliju

Outstanding in war.

Elemoso

Elemoso (Emissary of the king),

Ajuru Agada

One with a mighty sword

O sun on tegbetegbe

Handsome among his friends.

Elegbe bi oni sa

Outstanding among his peers.

O p'uroko bi oni p'ugba

One who carves the hard wood of the *iroko* tree as though it were as soft as a calabash.

O m'eo roko daun se ...

One who achieves fame with the proceeds of his carving \ldots

Ma a sin Olowe

I shall always adore you, Olowe.

Olowe ke e p'uroko

Olowe, who carves iroko wood.

Olowe ke e sona

The master carver.

O lo ule Ogoga

He went to the palace of Ogoga

Odun merin lo se libe

And spent four years there.

O sono un

He was carving there.

Ku o ba ti de'le Ogoga

If you visit the Ogoga's palace,

Ku o ba ti d'Owo

And the one at Owo,

Use oko mi e e libe

The work of my husband is there.

Ku o ba ti de'kare

If you go to Ikare,

Use oko mi i libe

The work of my husband is there.

Ku o ba ti d'Igede

Pay a visit to Igede,

Use oko mi e e libe

You will find my husband's work there.

Ku o ba ti de Ukiti

The same thing at Ukiti.

Use oko mi i libe

His work is there.

Ku o li Olowe l'Ogbagi

Mention Olowe's name at Ogbagi,

L'Use

In Use too.

Use oko mi i libe

My husband's work can be found

Ule Deji

In Deji's palace.

Oko mi suse libe l'Akure

My husband worked at Akure.

Olowe suse l'Ogotun

My husband worked at Ogotun.

Ikinniun

There was a carved lion

Kon gbelo silu Oyibo

That was taken to England.

Owo e o lo mu se.

With his hands he made it.

The *oriki* of Olowe was collected by John Pemberton III in 1988 from Oluju-ifun, one of Olowe's surviving wives, and has been found to be instrumental in reconstructing his life and work (fig. iii).

Clearly, neither Yoruba culture nor the Yoruba system of storing and retrieving important information about their artists is impoverished. We do know, however, that artists may become vulnerable targets of unknown malevolent forces because of their profession and special position in the traditional community. For this reason, until relatively recent times, artists rarely revealed their full given names to strangers. It is, therefore, not surprising that many outstanding Yoruba artists whose works have been collected and studied by researchers have been identified in scholarly literature only by their nicknames or bynames such as, for example, Olowe Ise (meaning Olowe from the town of Ise); Ologan Uselu (Ologan from Uselu quarters in Owo); and Baba Roti (father of Rotimi). (The status of such personal information is as confidential as modern-day codes such as Personal Identification Numbers for banking purposes or government-issued social security numbers.) Early researchers were clearly ill equipped in their training to grapple with the problems of naming traditions different from those with which they were familiar. This initial lack of understanding may have led them to assume that the authorship of art works was unimportant among the Yoruba. Moreover, the biases of these

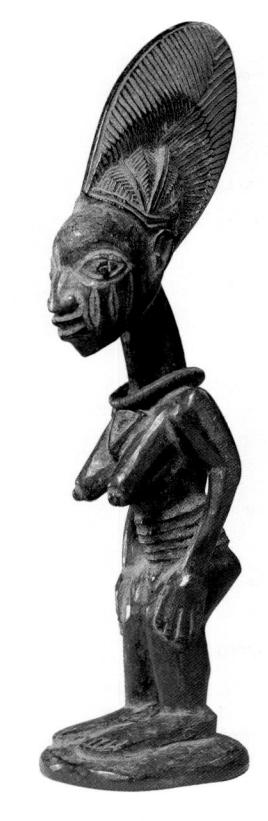

iii. Ibeji (twin figure), Olowe of Ise, Yoruba, before 1938. Wood, beads, iron, pigment. Height 131/16" (33.5 cm). The Collection of Mareidi Singer, Munich

early researchers must have prevented them from carrying out any diligent probing for artists' full given names. It is ironic that such information was so highly valued by art historians in relation to Western art.

Most Yoruba people would, in fact, be surprised about the sensitivity I am attributing to them about the identity or name of a person. When a person's *oriki* is recited, it is assumed that anyone who listens carefully and understands it will know enough about the subject's identity, name, lineage, occupation, achievements, and other qualities so that stating the person's given name becomes superfluous. Hence a Yoruba saying (from the collection of Oyekan Owomoyela):

A n ki

We recite someone's oriki

Ansac

We intone his attributes

O ni oun o mo eni to ku

But one person says he does not know who has died O ngbo "iku meru

He hears, "Death has taken a renowned man.

Opaga,

A titled man,

Abisuutabiododo

Whose yams spread like petals

Alabaoka,

Who possesses a barn of corn

Arokofeyeje"

Whose fields are a bounty for birds"

After this description, which clearly identifies a certain individual, there is a question:

O ni "Agbe lo ku ni tabi onaja?"

This (foolish) person still asks, "Is the dead man a farmer or a trader?"

African societies recognize the contribution of individual artists, but they frame their praises in their own distinctive terms. Thus, according to Gene Blocker, a philosopher of art and aesthetics, the problem of anonymity in African art "has more to do with a tradition of individuality than with the 'fact of individuality.'"

The contributors to this book have critically reflected upon cultural and art historical assumptions and biases similar to the one just described. They have sought to locate meanings within the thoughts and practices of Africans themselves. This assembled volume on the art of the continent

of Africa is also measurably more comprehensive than previous works of its kind. It includes, notably, Africa north of the Sahara and the African diaspora, both of which embody some of the most important developments spatially and temporally in the history of African art. These areas have likewise either been underrepresented or simply ignored by a majority of textbooks on African art. In their detail and sympathetic insight, these chapters are a testament not only to the massive amount of research that the contributors have conducted over the years but equally importantly, to an open-eyed alertness to individual human achievements. This publication, therefore, represents a milestone in the study and future perception of African art.

Preface to the 2nd Edition

The book you are reading is the gift of hundreds of people in Africa and in other continents who have shared their art, their images, and their expertise with the authors. Changes in this edition have been made in response to suggestions and corrections we have been given since *A History of Art in Africa* first appeared, and we are grateful for the help of the many colleagues who continue to read, evaluate, and comment upon this text.

New photographs, many more color photographs, and a new layout allow the art works illustrated in this new edition to be seen more clearly. New maps will assist the student, and the bibliography has been updated. Thematic essays from the first edition have been joined by several new ones.

Yet the most important additions are new discussions of African artists working in varied colonial and post-

colonial worlds. At the end of each chapter, new images introduce talented individuals who were pioneers of African modernism in the years before their nations' independence from colonial powers. These artists include painters, sculptors and architects from Morocco, Egypt, Sudan, Ghana, Nigeria, Congo, Zimbabwe, and Madagascar. Expanded discussions of artists and patronage in southern Africa allow fuller coverage of art both during and after the apartheid era. Furthermore, new examples of recently created twenty-first-century art works have been added throughout the book.

Over the last decade, spectacular exhibitions have showcased the work of African artists who live in Europe and the United States. A new chapter, "African Artists Abroad," presents the art of these expatriates in the context of new "post-modern" art markets, but

also compares their careers to those of artists working on the African continent. In the first edition, the chapter on the "Art of the African Diaspora" by Michael Harris included descriptions of African art forms that took root in New World communities. Its focus was upon the creative response of artists in the United States to their African heritage and to African arts. In this edition, a new essay, "Artists Working Outside the Frame," further underscores some of the issues confronted by the diaspora artists in both chapters.

It is our hope that this book reflects the vitality of African arts of the past, present, and future as they continue to inspire, provoke, delight, and intrigue Africans and non-Africans alike. We invite you to contribute to the study of the visual arts of Africa by sending us your comments and corrections for future editions. MBV

Introduction

FRICA, A CONTINENT OF STRIK-ING cultural richness and ecological diversity, is distinguished by the visual power and creativity of its arts. This book examines the full corpus of these arts. It includes ancient art from Egypt and northern Africa as well as rock art from southern Africa and archaeological artifacts from western Africa. It surveys architecture and arts of daily life, in addition to contemporary works by African artists and artists of African descent. The book's overarching focus is on Africa's many diverse peoples and regions, the artistic developments of each region, the broader cross-cultural traits that link them, and the different local and regional responses to historical concerns. This can be seen, for example, in the blending of Islam and Christianity into existing social and aesthetic structures, the creation of art in the context first of the slave trade and then colonial rule, and the rich, creative impact of recent post-nationalist and international art movements. Accordingly, this volume presents the arts of many different "Africas": not only those of distinct regions, historical periods, and religious beliefs (varied local forms as well as Islamic and Christian) but also arts representing a diversity of social and political situations (dynastic and plebeian, urban and rural, nomadic and settled, outwardly focused and inwardly defined).

At the risk of promoting an inaccurate sense of Africa as a place of unified or monolithic artistic practice, the question of what, if anything, is

distinctively "African" about African art is an intriguing and interesting one to address as a preface to the survey that follows. The answers to this question are subtly different with regard to specific areas of the continent and periods of its history. Among the formal features which stand out across the broad sweep of Africa are the following (not in order of priority):

Innovation of form. The impressive diversity of art traditions across Africa offers evidence of a larger continentwide concern with artistic innovation and creativity. This can be seen not only in the variety of forms within a relatively small area (a single culture, a city or town, an individual artist) but also through history. Innovation has been widely promoted by local art patrons and cultural institutions, as in the imperative that kings coming to the throne must create a new palace and capital for themselves along with a range of new art forms or textile designs that will distinguish their reigns. African artists have long looked outside their own communities for sources of inspiration, not only in other cultural areas of Africa but also in Europe, Asia, and, recently, America.

Visual abstraction. There is a preference in much of Africa for varied forms of visual abstraction or conventionalization: that is to say, art works which in bold and subtle ways lie outside more naturalistic renderings of form. It was indeed these features of near-abstraction and visual boldness that in part led European artists at the beginning of the twentieth century to turn to African art in rethinking form

more generally. The importance placed on abstraction in African art is evidenced across media—sculpture, architectural facade paintings, textile design, and other forms. In some cases, this non-realistic stylization is fairly subtle. In other works, only minimal suggestions tie the forms to the human. Complementing the importance of abstraction is an emphasis on visual boldness. Many African works are particularly forceful in their visual impact while many others are inventive departures from any animal or human form.

Parallel asymmetries. African artists often reveal a fundamental concern with a visual combination of balanced composition and vital asymmetries. This gives even a relatively static form a sense of vitality and movement. Parallel asymmetries are also evidenced in profile and back views of the same figure and in the push/pull of negative and positive spaces. The overall painting of the symmetrical features of the body is frequently distinguished by asymmetry, as in the lines and shapes painted on the human body by the men of a Nuba group in southern Sudan (see fig. 13-48). Similarly, bold asymmetries characterize African architectural design, particularly when one looks at these works alongside the rigidly symmetrical architectural traditions of other parts of the world. In African sculpture and textiles, as in architecture, broken or undulating lines are generally preferred to rigidly straight lines. Varied pattern elements and intentional breaks or shifts in a pattern are also emphasized over exact replication.

Sculptural primacy. Most art in Africa is carved, molded, or constructed into three-dimensional forms, even though important traditions of two-dimensional painted, engraved, or raised designs also exist. In many cases, even two-dimensional art forms are meant to be seen and admired primarily three-dimensionally, as when wall paintings (such as those mentioned above) wrap around building surfaces in ways that enhance their sculptural effects. Flat textiles become three-dimensional when used as tents or enclosures; they become four-dimensional (spanning time as well as height, breadth, and depth) when they move through space on the human body, as in the astounding variety of performed masquerades. Earthen and stone architecture also has a sculptural tradition that distinguishes African Islamic and Christian examples from those of other areas.

Performance. Many of the visual art forms surveyed in this volume were first seen in performance contexts. Indeed, it may well be that for African peoples, performance, which always implies music and dance, is the primary art form. Elaborate personal decoration, for example, nearly always involves public display and very often invokes gesture, dance, and other stylized forms of behavior: in short. performance. Many groups of people both perform with art (such as sculptures, masks, and dance wands) and, in their collectivities, often become art. Statuary that resides in a shrine for most of its "life" may be ceremonially carried to the site in a "festival of images." The ultimate performance

genre is the festival—with events invoking visual, audial, and kinetic forms of great variety and richness. These events are all orchestrated toward a large communal or state purpose, be it a proper funereal "send-off" for a prominent person, an initiation of youths, or a New Year's or First Fruits ceremony. Masquerades—in both prevalence and astonishing variety—are among the most complex and prominent of African arts.

Humanism/Anthropomorphism. Home to the first humans, Africa is remarkable for the emphasis its patrons and artists have historically placed on the adornment, and often transformation, of the human body. This use of the human skin as canvas can be seen in images painted in rock shelters of the Sahara more than seven thousand years ago, which seem to depict humans in elaborate paint and beadwork. African art also focuses on representations of the human body, human spirit, and human society, and most sculptural traditions in Africa incorporate human beings as their primary subjects. Even portrayals of animals in masquerades and other arts often include humanderived elements, such as jewelry or elaborate coiffures. Virtually all art and architecture on the continent (with the exception of ancient Egypt) has been conceived on a human scale. Anthropomorphism also features prominently in African architecture, with the naming of particular construction elements to represent parts of the human anatomy, or the decoration of building facades to suggest textile patterns or body scarification.

Ensemble/Assemblage. An isolated statue or other African work is rare

and exceptional. Varied works are usually assembled together, as in a shrine or multicharacter masquerade. And many individual works are themselves composite, having been made from diverse meaningful materials. Power figures from Mali to Benin and Nigeria and on to the Congo make this point with particular force, as the purposes of these images derive from their varied materials, just as their visual character is dependent upon them. Thus the ensemble—the collection of works or the assembling of composite materials in a single work—is a vital trait of visual arts all over Africa. The idea is driven home by the elaborate assemblages of personal decorations featured for ceremonies nearly everywhere—scarification or tattoo, coiffure, jewelry, cloth, and sometimes body or face painting—and by the combination of varied arts, including music and dance. in festivals. It follows, then, that these art works and ensembles—in part because they comprise many materials and forms—will have many meanings.

Multiplicity of meaning. Like a telephone line that carries multiple messages simultaneously, African art is characterized by its multiplicity of meanings and intellectual complexity. As in the varied rhythms and competing melodies of jazz, these differential meanings exist concurrently and harmoniously within the same work, giving it an even larger (broader) sense of symbolic and intellectual grounding than it otherwise might have. In African art a single form is often intended to mean different things to different members of society, depending on age, level of knowledge, and level of initiation. A Dogon kanaga mask form (see fig.

5-19) signifies at once a variety of beings, such as a bird, a crocodile, or a primordial being. Another example of this multiplicity of meanings is that of an Asante goldweight depicting a bird scratching its back with its beak or looking backwards. "Pick it up if it falls behind" is one common translation. This can refer to the "wisdom of hindsight"—how one can learn from one's mistakes—or it can indicate more literally that one needs to clean up things left behind, such as an incomplete task or a mess. Thus there are many possible meanings for an apparently simple image depending on the circumstances of its occurrence or use, as well as each viewer's experience, knowledge of proverbs, and wisdom. This multi-referential quality in African art makes research into art symbolism both challenging and rewarding; artists and users frequently offer different interpretations to the meanings of a single given form.

CHANGING PERCEPTIONS OF AFRICAN ART

Africa was known to the ancient world for the power, wealth, and artistic magnificence of Egypt and was a place of thriving art production during much of Europe's "dark ages." Great inland art centers, such as Zimbabwe and Ile-Ife, were flourishing at this time and have left behind striking evidence of the aesthetic and cultural complexity of powerful indigenous political systems. Africa has also been host to larger artistic encounters. Christianity thrived in many African regions, and in Ethiopia works of painting, sculpture, and architecture still draw upon one of the world's oldest Christian traditions. Africa also

played a crucial role in the development and expansion of Islam. Mosques in Egypt and Tunisia are over a thousand years old. Timbuktu (in present-day Mali) became the home to one of the world's most important universities, its large library specializing in law. The kings of Mali, who controlled much of the world's gold trade at this time, were wealthy beyond compare. In addition to the gold-ornamented horse trappings and other decorative arts made in Mali, court builders created magnificent multistoried architectural projects using local earth. During this period (eleventh to fifteenth centuries), cities of the East African coast such as Kilwa were said to be among the most handsome in the world, both for their inhabitants' elegant fashions of dress and for their unique traditions of decorative coral architecture. Asian merchants sought out these rich East African ports and interior markets, leaving behind large quantities of export ceramics and other materials that have been important for the dating of sites.

In the sixteenth through eighteenth centuries, Africa continued to be known as a place of powerful kings and lavish courts. In this era of broadbased sea exploration, many European travelers to Africa compared the continent's court architecture and thriving cities favorably with the best of Europe. They also brought home ivories, textiles, and other art works that eventually found their way into the collections of the most distinguished art patrons and artists of Europe, such as the Medici family and Albrecht Dürer. Even during the horrors of the slave trade, which resulted in inconceivable personal suffering,

massive political instability in much of Africa, and the transportation of a significant proportion of Africa's own essential labor force to the Americas to provide for the West's industrialization drive—outside observers continued to hold highly favorable views of Africa and its arts.

These generally positive images of Africa changed dramatically in the nineteenth century. Western desire for greater control over Africa's trade partners, religious beliefs, and political engagements led to an era of widespread colonial expansion. Consistent with the aims of nineteenth-century colonialism, Africa was then frequently described in published accounts as a place of barbaric cultural practices and heinous rulers. If art was mentioned at all, it tended to be in negative terms. Charles Darwin's theories of biological evolution also had a negative impact and were used to support popular parallel theories of social evolution that falsely maintained that African societies (as well as those of other peoples such as American Indians, Indonesians, Irish, and peasants more generally) represented a lower level of humanity, indeed an earlier prototype within the human evolutionary sequence.

Arts and other contributions of these societies were similarly disparaged as lacking in rational foundation, true innovation, and sustained cultural accomplishment. For example, when the great archaeological finds at Ile-Ife (in present-day Nigeria) were discovered at the beginning of the twentieth century, it was wrongly assumed that a group of lost Europeans was responsible for these technically and aesthetically sophisticated sculptures.

With the growth of colonial interests in Africa, writing about the social fabric of its arts also changed. Africa was described primarily as a place of separate (and fixed) "tribal" entities which lacked sophisticated political and economic institutions as well as broad-based authority. This was also the period when many major European collections of African art were started. State treasuries of kingdoms such as Benin, Asante, and Dahomey were taken to Europe as war booty following the defeat of their rulers by European forces and formed the basis for the rich collections of newly founded ethnographic museums. In the literature of the time, the broad regional influences of these kingdoms were often played down in favor of narrow ethnic identities. Regional dialects of larger language groups in turn became erroneously identified as distinct fixed languages, each supposedly unique to a separate "tribe" and artistic "style." "Tribalism" became the predominant framework within which the continent's art production was discussed, and to some extent this model of the distinctive ethnic group ("tribe") survives today. The great dynastic arts of Egypt were an exception that proved the rule, for by that time Egypt had largely been removed from consideration as an African civilization and was instead positioned culturally with the Near East. The Christian arts of Nubia and Ethiopia were rarely, if ever, discussed alongside other African works. Earlier maps highlighting Africa's impressive royal capitals, inland cities, and material resources were largely replaced with new maps showing small-scale, rigidly fixed cultural boundaries (each "unique" to one "tribe" and one art

"style") which were again falsely presumed to have existed for much of history. What was mistakenly called a distinct "tribal style" in the early twentieth century was often the result of the iconographic requirements of a particular image type. Today, we also know that a number of art works were created in one place (and culture) yet used in another. Many "Mangbetu" works were made by Azande artists; a significant number of "Bamun" artists were from other grasslands cultures: some of the most important "Dahomey" artists were of Yoruba or Mahi origin; and many Bushoong/Kuba and Asante art genres also have foreign origins.

The longstanding and problematic label of "tribal art" has had a negative impact on the field African art and meant that until recently little academic interest was shown in the historical dimensions of these arts or the names of individual artists. This in part explains why far fewer dates and artist attributions are available to us than is the case in other comparable art surveys.

Other problematic views by colonial authorities influenced the early classification of African art within the larger context of world art history. In keeping with now long-disproven social evolutionary theories, early social scientists identified African art as a form of "primitive art," indicating that African art works, regardless of age, were necessarily primeval. Textbooks of the early twentieth century presented all African arts as conceptually similar to prehistoric works or to the arts of children. Even early modern artists, such as Picasso, assumed that African art was based upon intuitive, "primal" impulses. They did not

realize that African art is as intellectual and intentional as Western own nor did they appreciate the degree to which African artists were grappling with the art historical traditions of their culture as well as with new. imported ideas and art forms.

Partly as a result of African art's "primitive" label—and even though today most art historians acknowledge its importance to the development of European modernism—too few African artists are credited for their understanding of the unique intellectual and formal possibilities of abstraction or for utilizing the vital aesthetic power of collage and assemblage, both of which were so central to the development of Western Cubism. Thus, whereas many twentieth-century art works in Western museums bear the label "abstract art," the comparable (and much earlier) abstract works made by African artists generally are not so labeled. It is assumed, wrongly, that Western abstract works alone are intellectualized and intentional, while abstract works by African artists are intuitive and/or the result of errors in trying to copy from nature. Comparable misunderstandings have also been frustrating for contemporary African artists seeking to gain wider acceptance for their art because their use of abstraction and similar "modern" idioms is seen by some critics as derivative of the West. African artists who seek to address contemporary issues or subject matter in their works face similar problems.

AFRICAN ART AS ART

Despite European modernism's universally acknowledged debt to African art, some art historians still ask: "Is

African art really 'art'?" If today we tend to see art as something of beauty or visual power, but as something devoid of function, we would need to acknowledge that European religious and political arts—to say nothing of modern architectural works guided by the value that "form should follow function"—would have to be purged from a strict "art for art's sake" canon. In Africa, as in Europe for most of its history, a number of words for "art" and "artist" exist, but they are not those used by contemporary critics; they address questions of skill, know-how, and inherent visual characteristics.

"Something made by hand" (alonuzo) is how the Fon of Benin designate art. The nearby Ewe of Togo use a similar term, adanu (meaning "accomplishment, skill, and value") to refer at once to art, handwriting techniques, and ornamentation. For the Bamana of Mali, the word for sculpture is translated as "things to look at." In linking "art" to "skill," African words for art are similar to those used in late medieval Germany, or in Renaissance Italy. The Latin root for "art," ars, has its source in the word artus (meaning to join or fit together). Both the Italian word arte and the German word for art, Kunst, were linked to the idea of practical activity, trade, and know-how (Kunst has its etymological source in the verb können, "to know"). African words for art not only help us to further pry open the definition of the word "art," but also to reposition African art within its broader historical conceptualization. Recent debates in art history have caused the breakdown of modern categories dividing "high" art from "low" art, and "fine arts" from

"crafts." These discussions have encouraged researchers in African art to study objects of beauty such as ceramics or ornamented gourds, even when these works are made by women, and even when they form part of daily life. Contemporary Western art forms, such as performance projects and installations, also have parallel African conceptualizations—the masquerade (versus the mask) and the altar complex (versus the shrine figure).

As with all art forms, the market, collection history, and museum display also have an impact on whether or not Western observers can understand African art as "art." When works of African art are exhibited on special mounts under bright spotlights and behind the antiseptic barriers of glass vitrines in fine arts museums as "high art," or under fluorescent lights and in large display cases in natural history museums as "artifacts," they take on qualities more accurately attributed to the viewing than to the creating culture. Removed from their local contexts they look very different from how they were seen by local viewers. This is equally true for other arts too, of course, such as ancient Greek and Roman art, or European Renaissance art, suggesting not that African art is "different" from these other arts (and must be displayed in different ways) but rather that museums need to be more creative in thinking about displaying all art forms.

Let us briefly examine one particularly beautiful, refined sculpture, a regal head once worn by a female leader in a masquerade (fig. 6-17). In this photograph, we are able to appreciate the aesthetic qualities of the

carved image. While the artist and the owner of this work would also have been able to view it in such splendid isolation, everyone else in the region would have experienced it as a fleeting part of an exciting performance, one feature in a ceremony such as that illustrated in figure 6-1. Both views of this type of sculpted mask are "true," even though only one may conform to the modern museum or gallery experience of art.

In beautifully produced books such as this one, certain ways of isolating, lighting and photographing, and labeling objects also signal "art" to viewers, the camera lavishing a form of attention on the object that substitutes for the attention we would bestow in person. With works of African art, the tendency at one time was to photograph them using backgrounds, lighting sources, or angles that made them look mysterious or sometimes even sinister. This fortunately has changed. One of the noteworthy features of this book is the significant number of contextual photographs that help to remind us that, like other arts, African art works are (or were) a part of living cultures, and that the study of art history shares a close bond with anthropology-especially so in the case of Africa. How the anthropological study of art in Africa has differed from the art historical is not an easy question to answer. There has been excellent (and less good) research done on African art in both fields. Anthropology, a field within the social sciences, historically has focused on the broader contexts of visual experience; art history, a discipline within the humanities (which also includes literature, foreign languages, philosophy,

music, and theater), has traditionally been interested in the history and symbolism of visual forms. Methodologies used for studying African art necessarily draw on the best features of both disciplines, as is done in the pages that follow.

The importance of including the whole continent of Africa and the long history of its arts (including contemporary forms) within a survey such as this one is in part the result of the specific contexts in which Africa and its arts have been problematized in the past. By including Egypt, the authors of this book seek to bring back this art-rich civilization to the continent of Africa as one of its own. By incorporating African Islamic and Christian art traditions, the importance of Africa in the formulation and creative vibrancy of these religious arts is also emphasized. The inclusion of contemporary art from Africa makes the point that art in Africa is not dead, that African artists are continuing to make important contributions both to Africa and to global contemporary art movements. The addition of works by artists of the diaspora, who were (or are) of African descent but who lived (or live) far from is shores, stresses the ongoing importance of Africa to world art.

PART I

From the Nile to the Niger

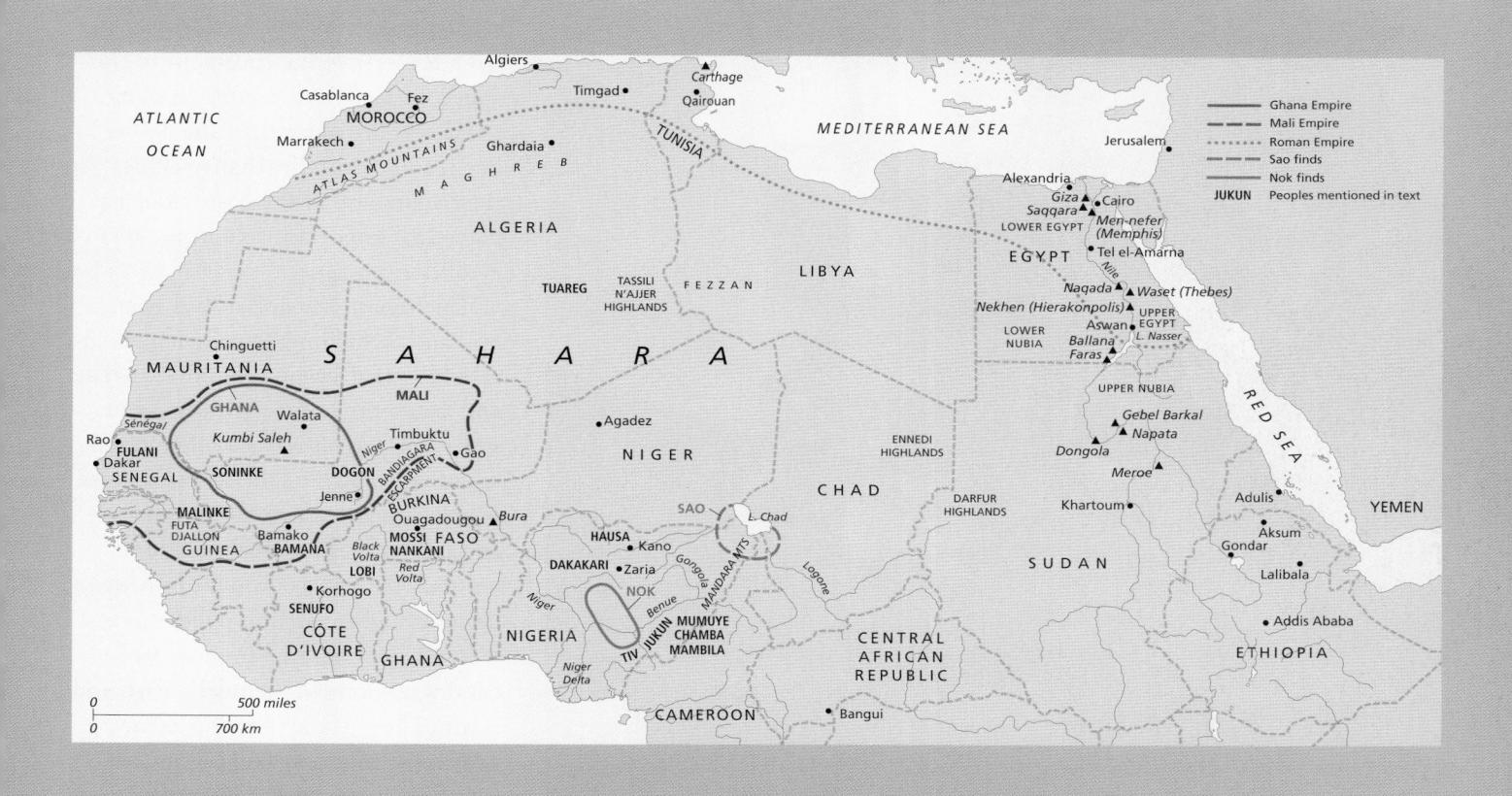

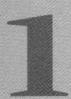

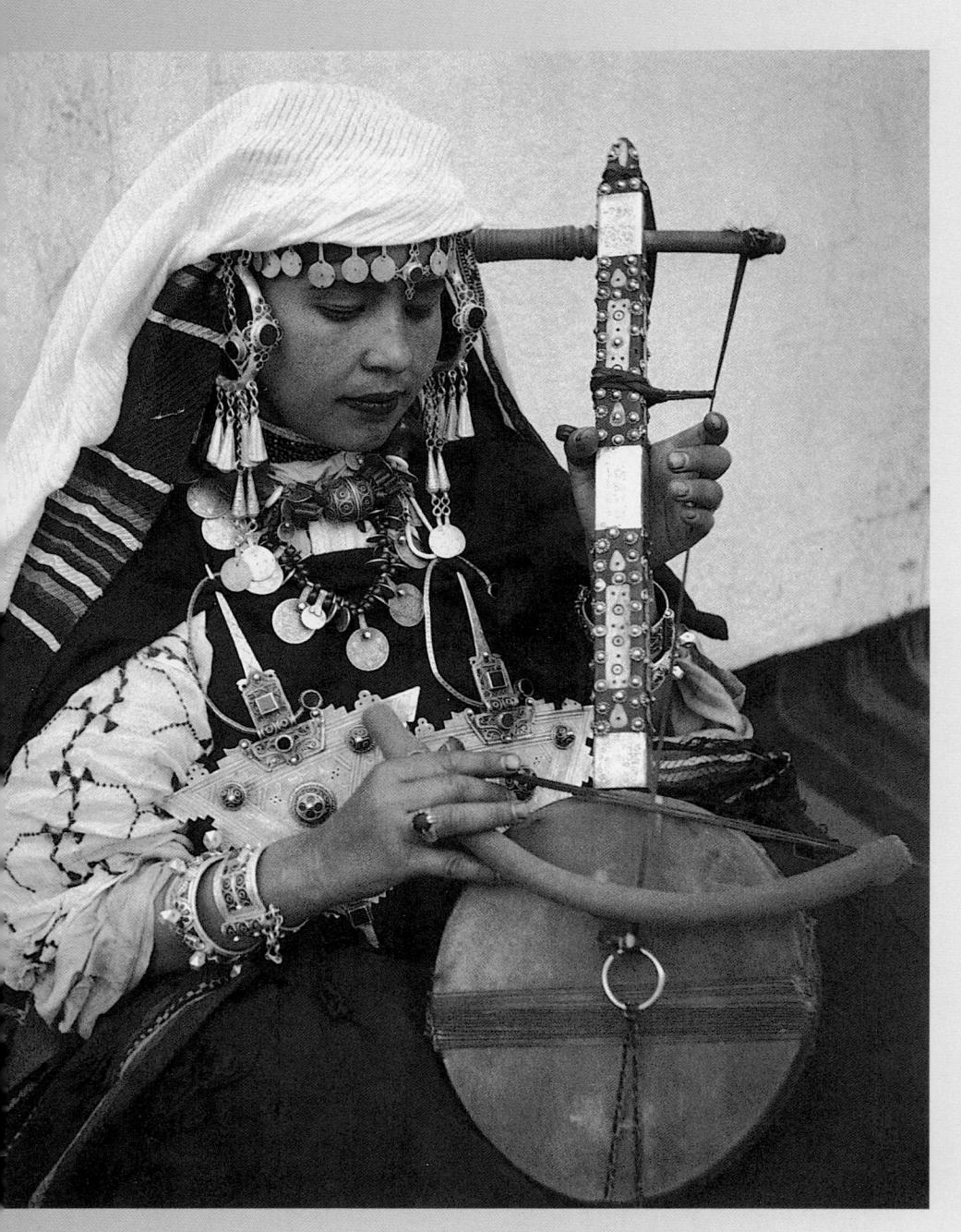

1-1. Woman wearing silver ornaments, Shleuh Berber, Sous, Morocco. 1950s

This Berber woman is playing the one-stringed instrument used to accompany songs of love and war in many desert Berber groups. Tuareg women who compose these long ballads perform for large groups under the desert stars. At these concerts women of distant clans exchange news and young people form romantic attachments.

THE ARABIC NAME AL-SAHRA means simply "the desert," as L though the Sahara were the definitive example of a dry, barren landscape. A vast expanse of stone and sand covering a landmass larger than the continental United States, the Sahara would seem to sever the coastal regions of northern Africa from the rest of the continent to the south. In fact, trade routes crossing the desert are older than the desert itself, and cultural exchange across the Sahara and in the oasis cities has played an important role in the history of African art.

The Sahara has not always been arid and forbidding. During a geological phase that began around 11,000 BC and lasted for some eight thousand years, the region was a well-watered savannah, a fertile land where diverse peoples invented new technologies and created new art forms. After around 3000 BC, as drought followed upon drought, Saharan populations would have migrated to more welcoming regions to the north, east, and south. The early arts of the Sahara thus most probably laid the foundation for artistic traditions in many areas of the African continent.

By about 1000 BC the desert as we know it had emerged. The cool mountains and coastal plains to the northwest, however, remained green and fertile. Divided today between the countries of Morocco, Algeria, and Tunisia, this region is known by its Arabic name, the Maghreb. The Maghreb has a long history of attracting foreign settlers, beginning

with colonies founded by the Phoenicians and ancient Greeks during the first millennium BC and continuing through successive periods of conquest and rule by Romans, Vandals, Byzantines, and Arabs. The Greeks referred to the indigenous peoples of the region (as they referred to all foreigners) as "barbarians," barbaroi. Their term is the origin for the word "Berber," the name still used to refer to these peoples. Inhabitants of the region since at least the second millennium BC, Berbers speak languages related to ancient Egyptian. Their arts, and the art of early Saharan peoples, are the principal focus of this chapter.

CENTRAL SAHARAN ROCK ART

Early arts discovered in North Africa include incised shells from Paleolithic sites in central Tunisia and intriguing semi-abstract stone sculptures from the central Sahara, which may date to the first millennium BC (fig. 1-10). The oldest and most widespread Stone Age art form of the Sahara, however, is rock art. Symbols and images cut into rock have been found from the Canary Islands in the west to the Red Sea in the east, and from the Atlas mountains of northern Morocco to the Ennedi highlands of central Chad. The most fully documented sites are those of the central Sahara.

Large Wild Fauna Style

The Fezzan region of southwestern Libya is marked by rugged plateaus and outcrops of bare stone overlooking windswept plains of gravel and

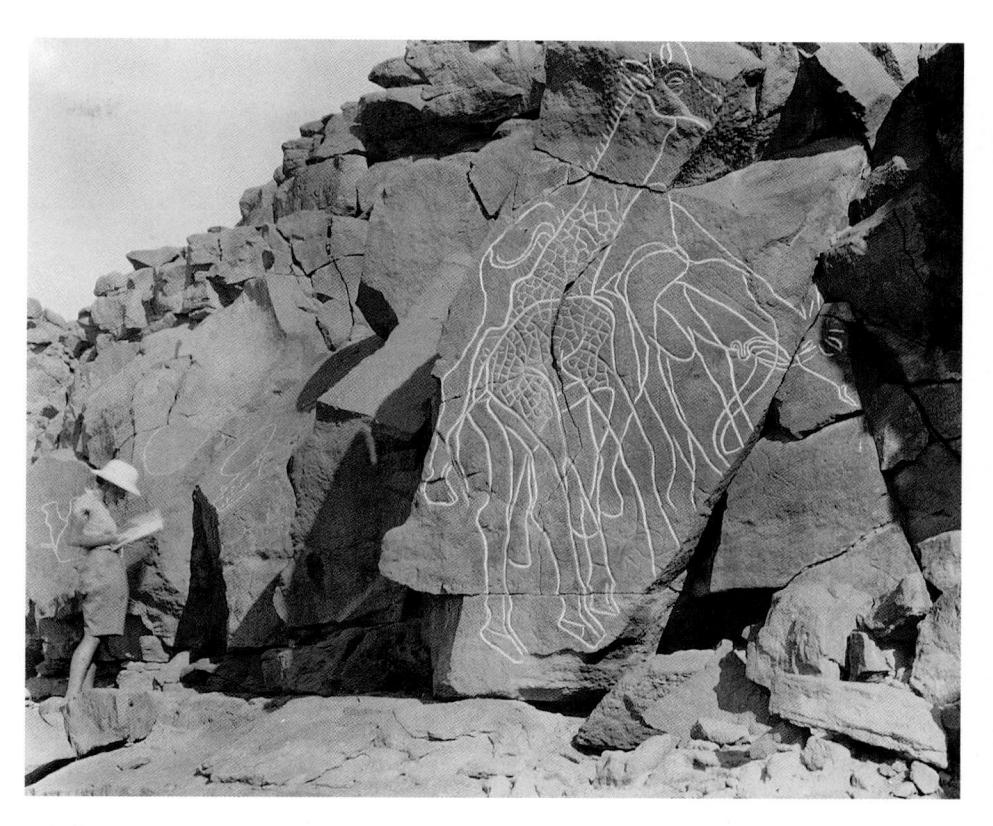

1-2. Superimposed elephant and two giraffes, Large Wild Fauna style, Fezzan region, Libya, after 8000 bc (?). Grooves in stone. Photograph 1932

sand. Only a few brackish pools and two tiny oases provide water for nomads and their camels. Images of giraffes and an elephant incised by Paleolithic artists into the rock walls of a streambed, however, evoke a time when the region was filled with animals now extinct or found only south of the Sahara (fig. 1-2).

This type of rock art is generally known as Large Wild Fauna style, after the impressive scale of the animals depicted. It has also been known as Bubalous style, after *Bubalous anticus*, an extinct species of wild cattle sometimes portrayed. The giraffes in the example here are almost lifesize. Deep, smooth, and continuous, the outlines of the three beasts are so fluid that it is difficult to remember that they were laboriously ground

into the rock with stone tools and abrasives. The portrayal is largely naturalistic and evidently observed from life (note the giraffe that bends down in a characteristic pose to drink). The size of the elephant's head is exaggerated, however, and all three animals bear the outsized, rounded feet typical of Large Wild Fauna images.

Hundreds of such images have been found in the central Sahara, especially in the Fezzan region. Scholars have often assumed that the images were somehow involved in "hunting magic," an attempt by Paleolithic peoples to control the animals they wished to kill. Yet this explanation is probably too simplistic. Large Wild Fauna images were more likely rooted in a conceptual system

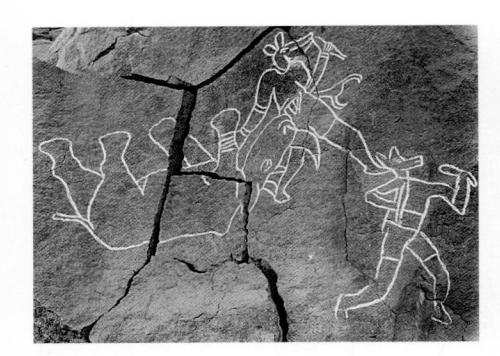

1-3. Jackal (?)-headed figures with rhinoceros, Large Wild Fauna style, Fezzan region, Libya, after 8000 bc (?). Grooves in stone. Photograph 1932

as sophisticated as the world view of the hunters who created the rock art of southern Africa (see chapter 14).

Some images clearly have a supernatural dimension (fig. 1-3). Here, a rhinoceros lies on its back, its broad feet waving in the air. Two humanlike creatures, their legs in running position, their hands grasping unidentified objects, appear to the right of the animal. Instead of human heads, the figures have the heads of jackallike animals. These energetic animalheaded human figures are not unique: depictions of canine- and feline-headed figures have also been found in the region.

The integration of animal heads and human bodies seems remarkably similar to the ways in which ancient Egyptian artists depicted their deities (see fig. 2-15). But until examples of Large Wild Fauna rock art can be securely dated, no firm conclusions can be drawn from such correspondences. Certainly the images were created after 10,000 BC, when humans reentered the newly green Sahara. The spread of new cultures across the region between 7000 and 5000 BC may mark the end of the style, for no references to the pottery, crops, or

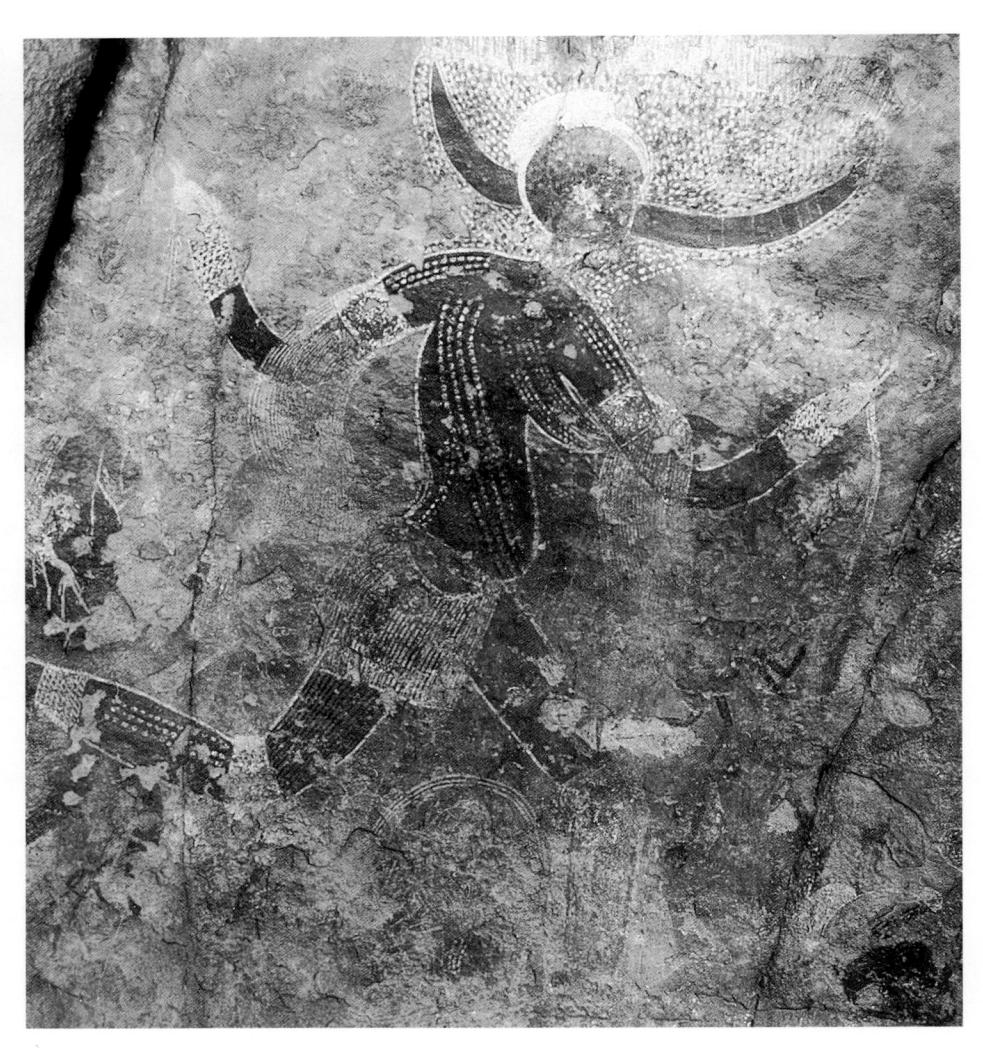

1-4. Horned female figure, Archaic style, Tassili n'Ajjer region, Algeria, 8000–6000 bc. Pigment on stone

By the beginning of the third millennium BC, the Egyptians worshiped a cattle-headed goddess named Hathor, whom they called "the mistress of the western desert." This painting may honor a horned deity of the central Sahara, possibly one of Hathor's predecessors.

herds of these populations have been found in Large Wild Fauna works. On the other hand, the Large Wild Fauna culture may have lived alongside these new cultures until the desiccation of the desert was complete. For the time being, we can only state that animal-headed images from the Sahara preceded those of the Nile Valley. Their presence in both areas suggests that ancient Saharans and

ancient Egyptians shared some cultural features.

Archaic Style

Pigments permit images in the socalled Archaic, or Round Head, style to be much more securely dated. Carbon-14 testing in the Tadrart Acacus region south of Fezzan has yielded dates of 8000 to 6000 BC for works in the same style as this splendid horned female figure from the Tassili n'Ajjer highlands of southeastern Algeria (fig. 1-4). As in other Archaic works, shapes of solid color are outlined in white or black. The round head is featureless. The fine lines streaming from the arms and hips may depict raffia garments, or they may allude to rain and moisture. Rows of dots highlight the legs, shoulders, and pointed breasts. Tiny dark figures surround the figure, emphasizing its majestic scale. Certainly, this rhythmic image is no mere dancing girl; she may instead represent or invoke a sacred horned being.

One of the most intriguing examples of Archaic art seems to depict a human figure whose outsize face is

1-5. Figure with masklike head, Archaic style, Tassili n'Ajjer region, Algeria, 8000–6000 bc. Pigment on stone

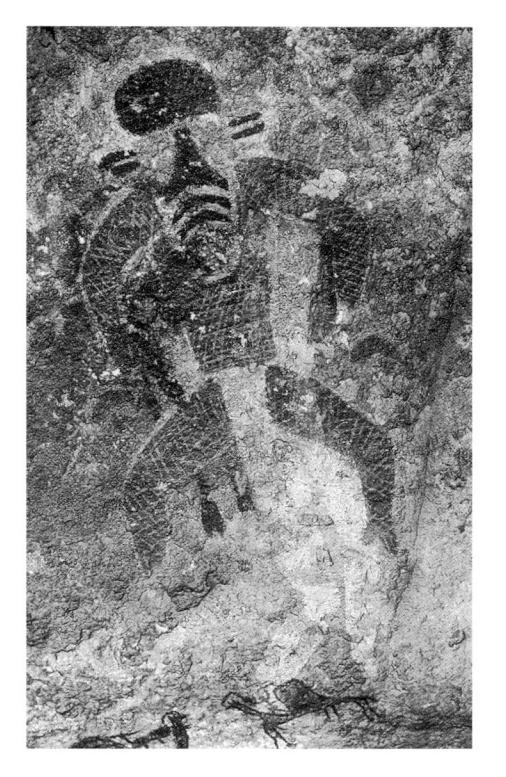

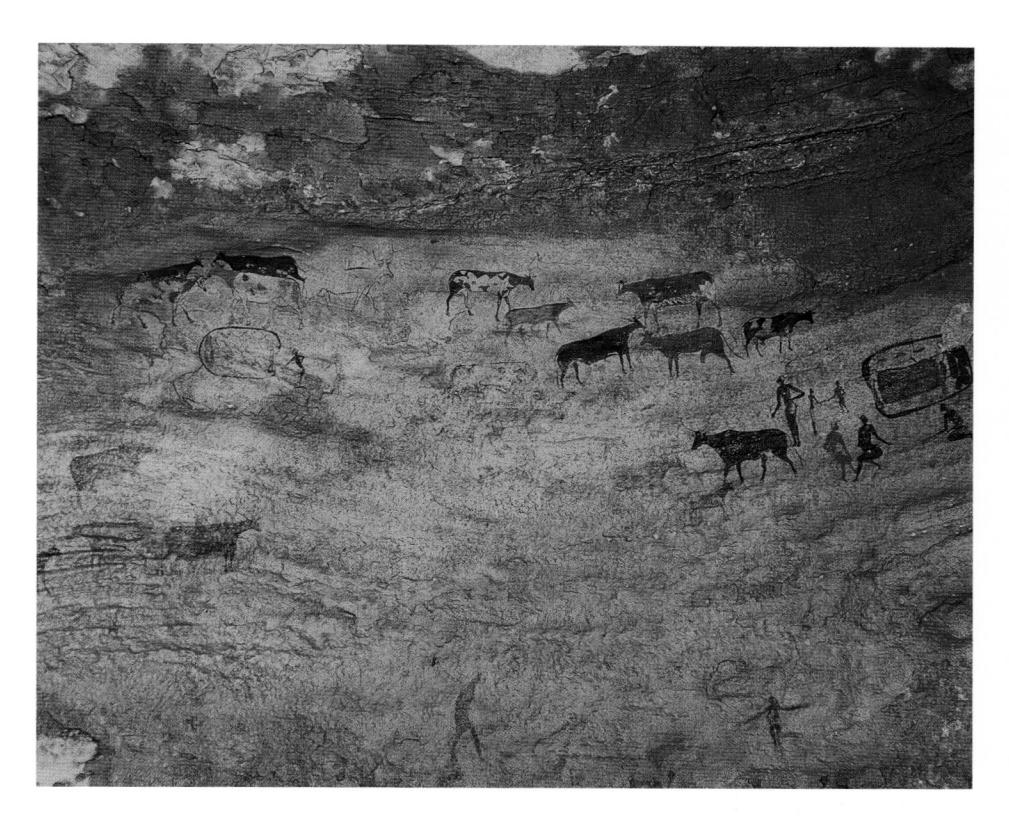

1-6. Scene with cattle and figures, Pastoralist style, Tassili n'Ajjer region, Algeria, 5000-2000 Bc. Pigment on stone

The subtle reds, yellows, and browns in this painting show the wide range of ochers, or colored clays, used by the artist. White chalk and black charcoal may also have been used. Chemical analysis has revealed that the pigments were bound with milk. Thus the medium as well as the subject matter underscores the importance of cattle in the life of the Pastoralist people.

filled with exaggerated features (fig. 1-5). The image may well portray a masquerader, a dancer transformed into a deity or spirit through wearing a costume—here apparently knotted-and a wooden mask. Hands and feet, often carefully hidden in African masquerades, disappear here in the repeated curves of the figure's limbs. Whether this striking image depicts the masked human who temporarily made a superhuman being manifest, or whether it once evoked a spirit who would otherwise have been invisible, a spirit who was visualized in such a guise could easily have been

manifested in a masquerade. We may thus be looking at some of the earliest evidence for one of the most important of all African art forms.

Pastoralist Style

Images in the Archaic style are sometimes found overlaid by paintings in the Pastoralist, or Cattle, style. Pastoralist works were created by herders and agriculturalists, who appeared in the central Sahara during the early fifth millennium BC. The detailed naturalism of Pastoralist works is striking, and their depiction

of everyday life unprecedented. In a typically large and complex scene, cattle are lovingly and individually catalogued (fig. 1-6). A man seems to tend his herd, while women and children carry on a conversation. An oval shape may be a symbol transforming the images into a mythical realm, or it may simply depict an enclosure or a dwelling. In another detail from a painted rock face in Tassili, a woman strides forward with determination, pulling along a dawdling child whose whining protests are almost audible (fig. 1-7).

Most of the Pastoralist art of Tassili n'Ajjer and the surrounding highlands was produced during the middle of the fourth millennium BC. By the second millennium BC the Pastoralists seem to have left the Sahara, which had probably already become too dry to sustain their herds and crops. Scholars have speculated that their descendants now inhabit regions of

northeastern Africa where cattle are the focus of present-day cultures. Yet elders of the cattle-raising Fulani people of West Africa have interpreted some Pastoralist images as references to their own myths and religious initiations, and the influence of the Pastoralist people may have been widespread south of the Sahara.

Later Styles and Subjects

Even after the Sahara became dry and desolate, the practice of rock art continued. Horses and chariots are common later subjects (fig. 1-8). Simply drawn in a variety of stylistic conventions, the images mark locations along trans-Saharan trade routes used by semi-nomadic Berber peoples, who knew of the use of chariots in the Maghreb and Egypt, and who during the first millennium BC had increasing contacts with settled peoples of the western Sudan.

Some of the schematic, economical images of camels found throughout the Sahara share stylistic features with these horses and charioteers, and thus most probably represent a continuation of the same tradition. For example, the rod-shaped heads of the figures in one energetic painting (fig. 1-9) can also be seen in depictions of horses and chariots. Although the image may have been painted almost two thousand years ago, the saddle and canteens resemble those still used by Tuareg Berber nomads today.

The drawing is a delightful arrangement of geometric shapes. The camel itself has been constructed of triangles and parabolas. The solid rectangular rider, probably male, is contrasted with the triangular forms of the figure in the enclosure, probably female. The two figures raise their arms in identical gestures, giving us the impression that they have been seized by some strong emotion.

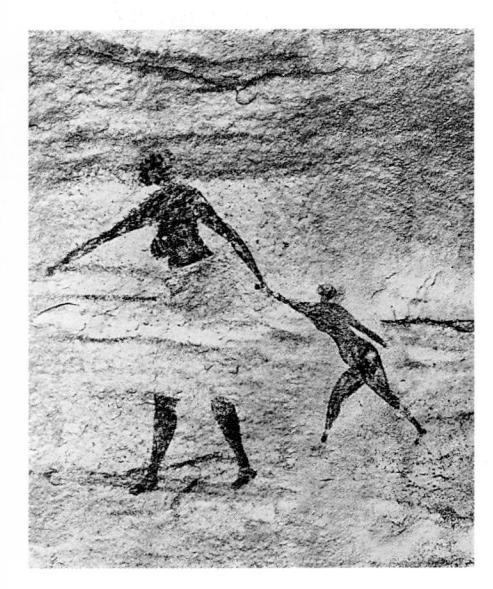

1-7. Figures of Woman and Child, Pastoralist style, Ozanéare, Tassili n'Ajjer region, Algeria, 5000–2000 bc. Pigment on stone

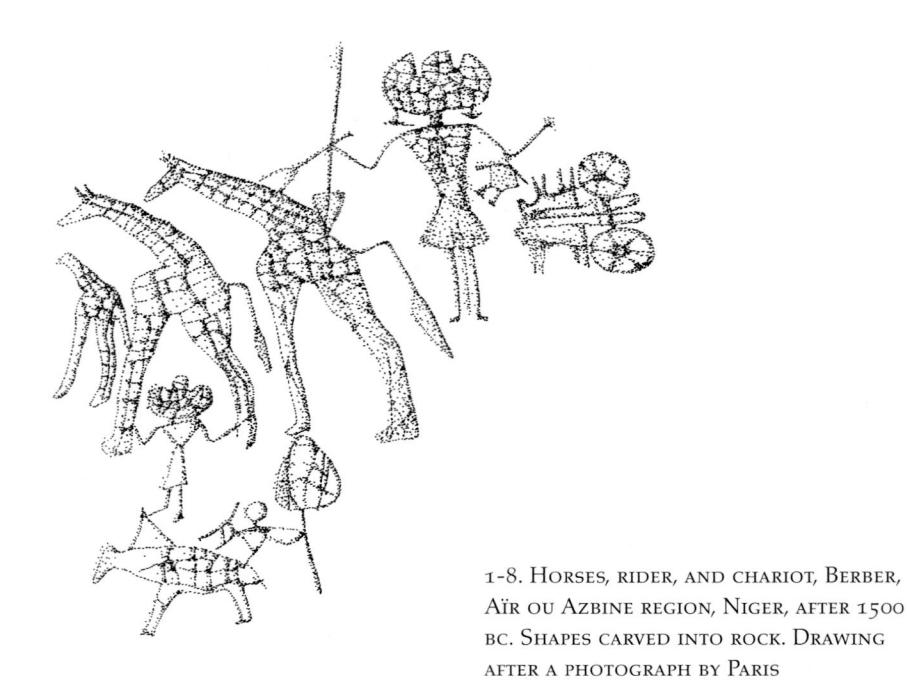

1-9. Figures with camel, Berber, Tassili n'Ajjer region, Algeria, after 700 bc. Pigment on stone

The square around the figure on the left seems equivalent to the home or symbolic space in the Pastoralist painting examined earlier (see fig. 1-6).

Just as the rock art of the Sahara is often difficult to link to specific populations, carved stones found lying in the desert are impossible to place in a cultural context. We may assume that these mysterious, phallic sculptures were left by an ancient Berber group, and on some works the minimal indications of brow and forehead suggest a human face (fig. 1-10). Yet no archaeological data indicates why or when they were left in such isolated locations.

1-10. Sculpture, Berber (?), central Sahara, date unknown. Stone. Musée du Quai Branly, Paris

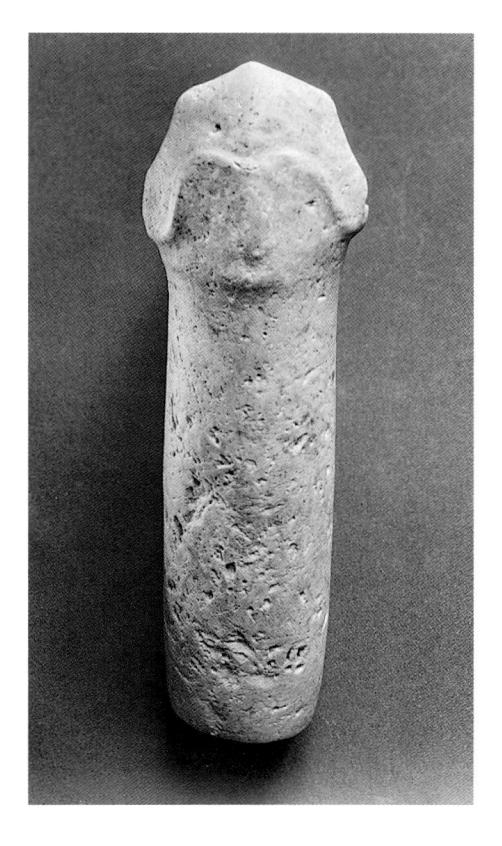

THE MAGHREB AND THE ANCIENT MEDITERRANEAN WORLD

As the Sahara dried out, the Maghreb emerged as a distinct region, an arc of land that remained fertile and green. With the founding of the Phoenician colony of Carthage around 800 BC, the region and its peoples were drawn into a period of history marked by the growth of ever more expansive civilizations around the Mediterranean basin, a period that culminates with the unification of the entire Mediterranean surround under Roman rule.

Carthage

A wealthy commercial city on the northern tip of present-day Tunisia, Carthage soon founded colonies of its own and eventually came to control not only most of the Maghreb but also parts of Spain and the islands of Sardinia, Corsica, and Sicily. In general, the art of Carthage remained closely linked to the eastern Mediterranean world from which it had come. Distinctive stone votive slabs (steles), however, feature motifs also found in Berber arts over the centuries.

The votive slab here (fig. 1-11) comes from a *tophet*, or sacred area, outside Carthage. Dating from the fourth century BC, it honors two of the most important Carthaginian deities, the male god Baal and the female deity Tanit. The upper register is inscribed with a prayer in the Phoenician script. The middle register contains three symbols. At the left, a hand indicates worship or protection, or both. In the center,

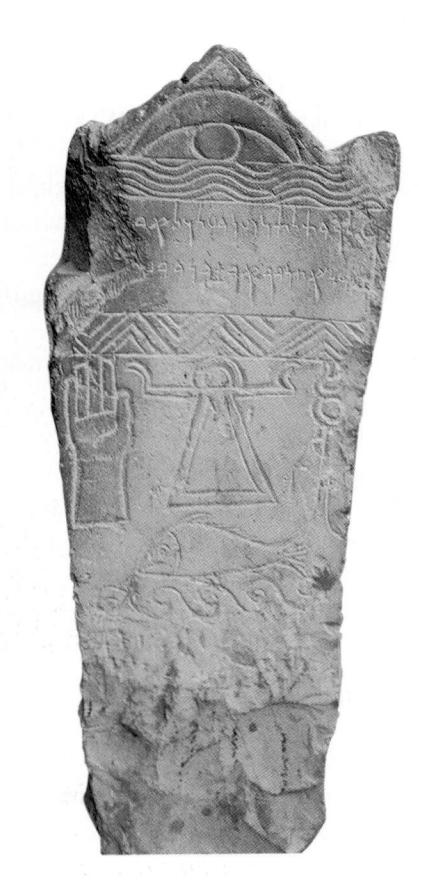

1-11. Stele dedicated to Baal and Tanit, Punic, Carthage, Tunisia, 4th century Bc. Stone. Musée National du Bardo, Tunis

Tanit is represented by a triangle surmounted by a circle and two raised arm-like forms. To the right, Baal is represented as a horned circle upon an upright pole. The fish in the lower register may be an image of male fertility associated with Baal, while the crescent moon and circular star or planet, which form an eye-like image in the triangular projection at the top of the stone, probably refer again to Tanit. Hands, eyes, and fish still figure symbolically in Berber art. Similarities between Tanit's triangular symbol and the triangular figure in the Saharan rock painting examined earlier are especially

intriguing (see fig. 1-9). Triangular shapes occur over and over again in Berber arts as images of female presence and power. We do not know whether one culture influenced the other, or whether the similarities are a coincidence, a straightforward reference by both peoples to the pubic triangle. In any case, the Carthaginian triangle of Tanit must have resonated with local Berber groups.

Numidia and Mauritania

To the south of Carthage, a succession of Berber rulers consolidated a kingdom known as Numidia. Together with rulers from another important Berber kingdom known as Mauritania. Numidian rulers played an active role in the Punic Wars, the three great conflicts in which the upstart civilization of Rome, based in the Italian peninsula, challenged Carthage, then the dominant power of the western Mediterranean. Conspiring with both sides, Berber rulers were partially responsible for Rome's ultimate victory in 143 BC.

Monumental stone tombs of Mauritanian and Numidian rulers still stand from this period of powerful Berber polities. One of the most famous of these monuments marks the grave of a member of the ruling family of Numidia who died in the late third century BC (fig. 1-12). The huge conical structure, almost 116 feet in diameter, is supported on a shallow cylindrical base ornamented with engaged columns. The Numidian tomb resembles descriptions of the tomb of the fourth-century BC Greek king Mausolus, who ruled in Asia Minor. His tomb, which has

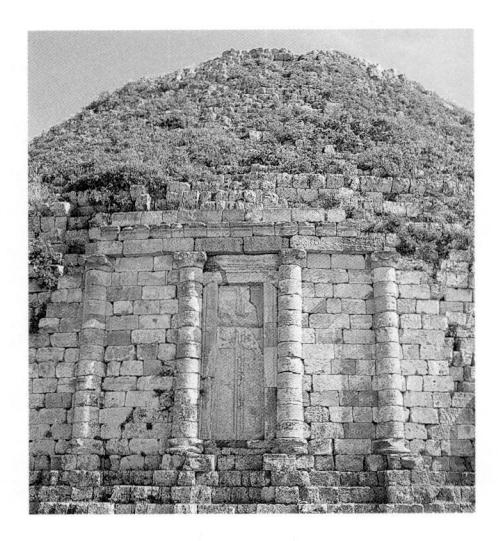

1-12. Detail of tomb, Numidian, Tunisia, 1st-2nd century BC. Stone blocks. Height 115' (54.33 M)

given us the word "mausoleum," was famous throughout the ancient Mediterranean world, and it might well have seemed a suitable model for a powerful Numidian king. The interior of this tomb has chambers similar to those found in Egyptian and Nubian pyramids.

The Numidian tomb illustrates well the cross-cultural currents of the ancient Mediterranean world, but it also takes its place in an indigenous regional tradition of stone funerary architecture. Megalithic funerary structures of natural or dressed boulders were erected in the Maghreb as early as the third millennium BC. In the northern Sahara, chambered tombs of stone with earthen mortar are contemporary with later Berber, Carthaginian, and Roman monuments, while throughout the central Sahara are found numerous stone tumuli, mounds of uncut rocks piled into ovals or concentric circular patterns, which have not yet been dated.

Rome

Unlike earlier settlers, who had confined themselves to the immediate coastal areas, the Romans extended their control over most of the agricultural land north of the Sahara. Administrators, soldiers, and slaves from as far north as Scotland and as far east as Iran were sent to Rome's African provinces, while Berbers were appointed to military and administrative positions throughout the empire. One of the most powerful Roman emperors, Septimius Severus (ruled AD 193–211), was of Berber origin.

Perhaps the most important legacy of Roman presence in Africa is the Roman city. A wonderfully preserved example is Thamugadis, or Timgad (figs. 1-13, 1-14). Built by order of the emperor Trajan in the early second century AD, Timgad was located along a major Roman road in the heart of Numidian Berber territory, less than a day's journey from the Numidian tomb. Typical of the cities Romans built throughout the provinces of their empire, it was constructed on a square plan bisected by the cardo (the central north/south street) and the decumanus (the cen-

1-13. PLAN OF TIMGAD

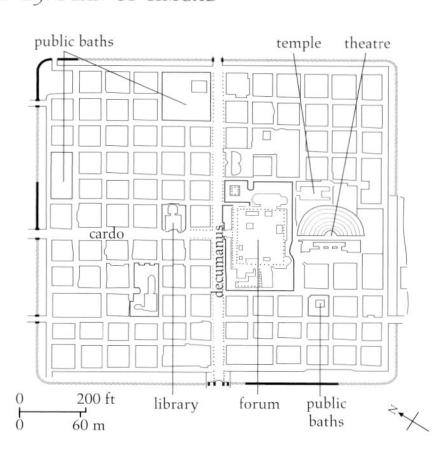

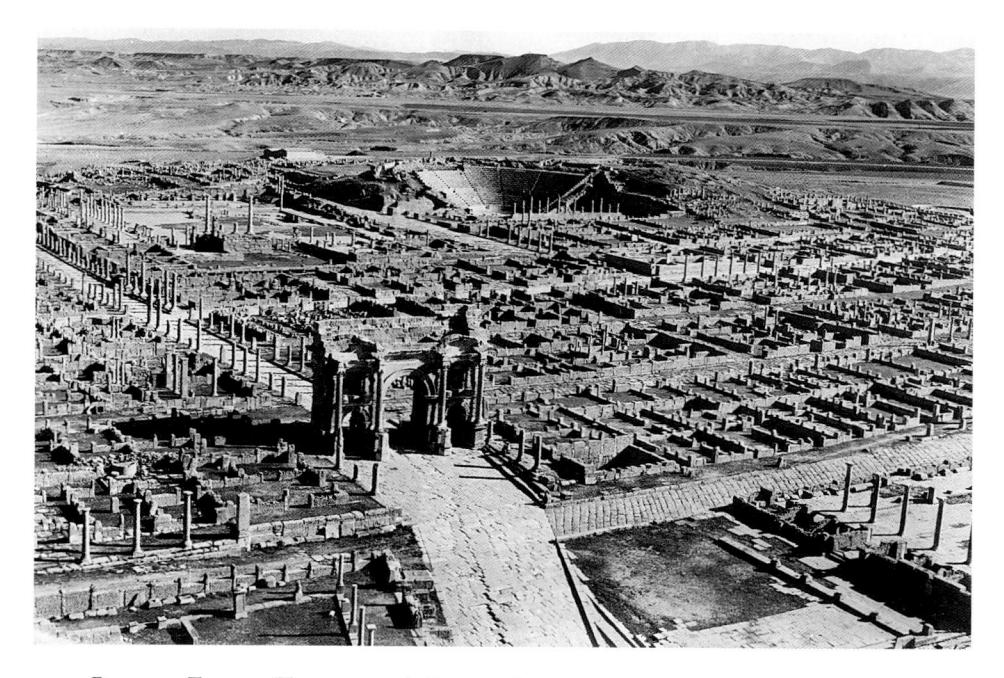

1-14. Ruins of Timgad (Thamugadis), Roman, Algeria, early 2nd century ad. Photograph 1960

tral east/west street). At their intersection was the forum, the central square of the city. A small temple, public toilets, and a public meeting hall called a basilica were all arranged around the forum. Near one end of the *decumanus* were spacious public baths, and at the other was a huge triumphal arch, an imposing gateway to the city.

The public baths of Timgad have their equivalent in Maghreban towns today, for public bathhouses still function in North African Islamic culture as meeting places. Monumental arches in Roman cities such as Timgad were models for Islamic city gateways and mosque entrances. The most influential type of building in Timgad, however, was the basilica. Roman basilicas provided the basic plan for early Christian churches, and together with them served as sources for the prayerhalls of Islamic mosques.

THE COMING OF ISLAM

During the fifth century AD, Timgad was conquered by a Christianized Germanic people known as the Vandals, who entered and took control of Rome's African provinces. A century later, the region was reclaimed by the armies of the Byzantine empire, as the successor state to the eastern Roman empire was later known. Timgad was finally abandoned after the great cultural upheavals of the seventh century AD, when Arab armies, newly united under the banner of Islam, swept across North Africa.

The religious, social, and political order of Islam dates its beginnings to an event called the *hijra*, when the Prophet Muhammad emigrated from the city of Mecca to the city of Yathrib, later called Medina, some two hundred miles to the north on the Arabian peninsula. From Medina,

where he quickly established leadership, Muhammad continued to preach islam, or "submission" to God's will. He also continued to have visions in which the Archangel Gabriel revealed to him God's word, revelations that were later written down and collected into the Our'an, the holy book of Islam. The Prophet reached out through both diplomacy and warfare to bring the divided Arab clans of the peninsula into the single, all-embracing umma, or "community," of Muslims ("those who have submitted"). As the event that signaled the founding of the umma, the hijra marks the starting point for the Islamic calendar. It occurred in AD 622, or 1 AH in Islamic reckoning.

During the century following Muhammad's death in AD 632 (10 AH), the new order expanded dramatically as Arab armies conquered territories north to Persia, east to the Indian subcontinent, and west across northern Africa and up into Spain and France. The Byzantine army was quickly ousted from northern Africa. More significant resistance came from Berber groups led by such rulers as the Zenata Berber queen known to Arab historians as al-Kahina. Nevertheless, within a generation the Maghreb found itself part of a vast new Islamic world. North Africans, including Berbers, gradually converted to Islam, which over the ensuing centuries would spread peacefully into western Africa and along the eastern Africa coast.

The Great Mosque at Qairouan

Taken from the Arabic *mesjid*, "the place where one prostrates oneself," a mosque is the Islamic house of

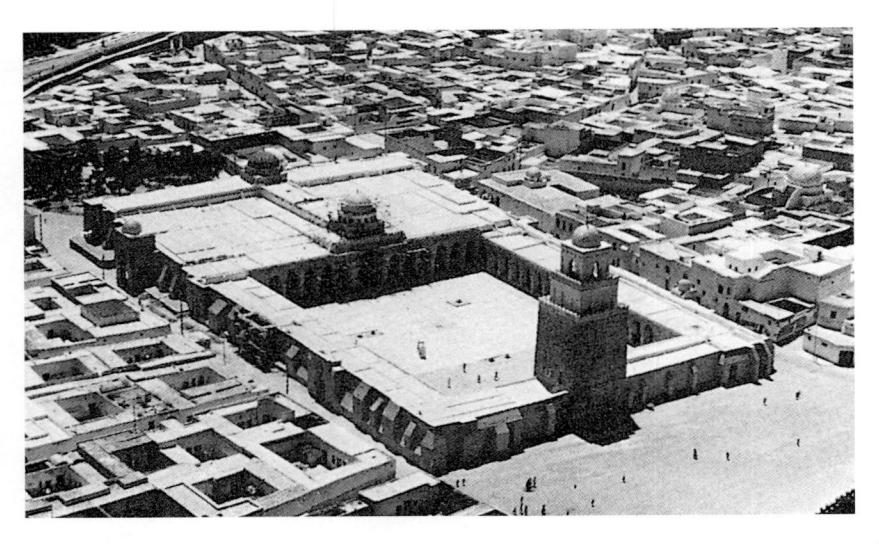

1-15. The Great Mosque, Aghlabid period, Qairouan, Tunisia, 9th century ad. Stone. Aerial view

prayer. The first mosques are said to have been modeled after the place where Muhammad had instructed his followers in Medina. A simple adobe structure, it consisted of shaded walkways surrounding a rectangular courtyard. As Islam expanded, its architects translated this early model into more permanent and monumental form.

One of the first stone mosques was built around AD 670 (48 AH) by the Arab general Uqba ben Nafi at his capital, Qairouan, near the northeastern coast of Tunisia. When that mosque was destroyed by rebellious Berbers, a new mosque was begun on its ruins. Completed in AD 836 (214 AH), the Great Mosque of Qairouan (fig. 1-15) is one of the oldest mosques still in use, and it has served as a prototype for later mosques throughout Islamic Africa.

The massive stone walls of the compound are strengthened by buttressing and embellished with arched gateways. The walls created an imposing stronghold for the local Arab leaders, who were the military as well as the religious rulers of the city. The prayerhall itself is preceded by a large open courtvard, sahn, surrounded by a covered, colonnaded walkway. In the center of the west wall of the courtvard (to the right in the photograph) rises a minaret, a tall platform for the crier, or muezzin, who calls the faithful to prayer. Minarets serve as a visual reminder that a town is under the protection of Islam. The minaret of the Great Mosque at Qairouan is a sturdy watchtower overlooking the city. It has an interior staircase, and is crowned with two square rooms and a small dome. Elsewhere in the Islamic world, minarets developed into slender towers large enough for only a single muezzin, but the minarets of many African mosques have the imposing scale and sloping sides of the minaret at the Great Mosque at Oairouan.

At the opposite end of the courtyard is the prayerhall, a large rectan-

1-16. Plan of Great Mosque, Qairouan, Tunisia, showing *Qibla*, *Mihrab*, prayerhall, courtyard, minaret, and defensive wall. Drawing after K.A.C. Cresswell

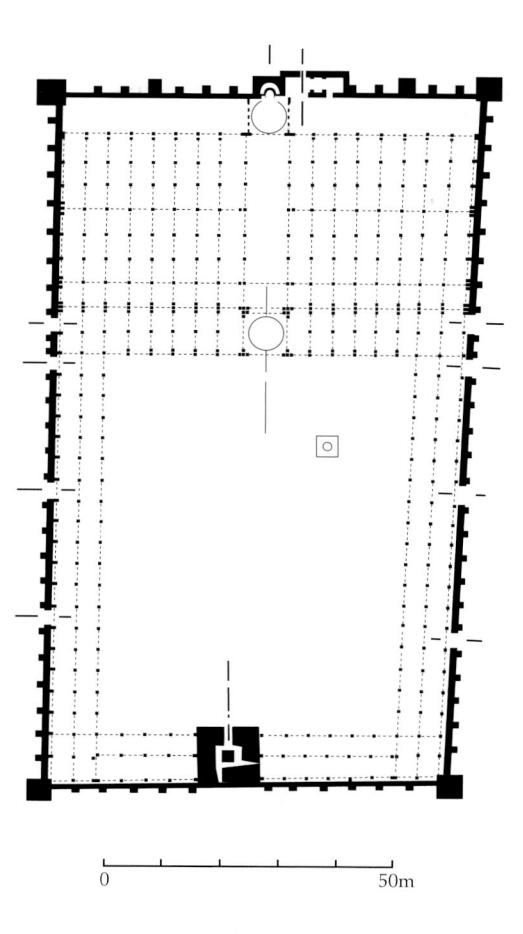

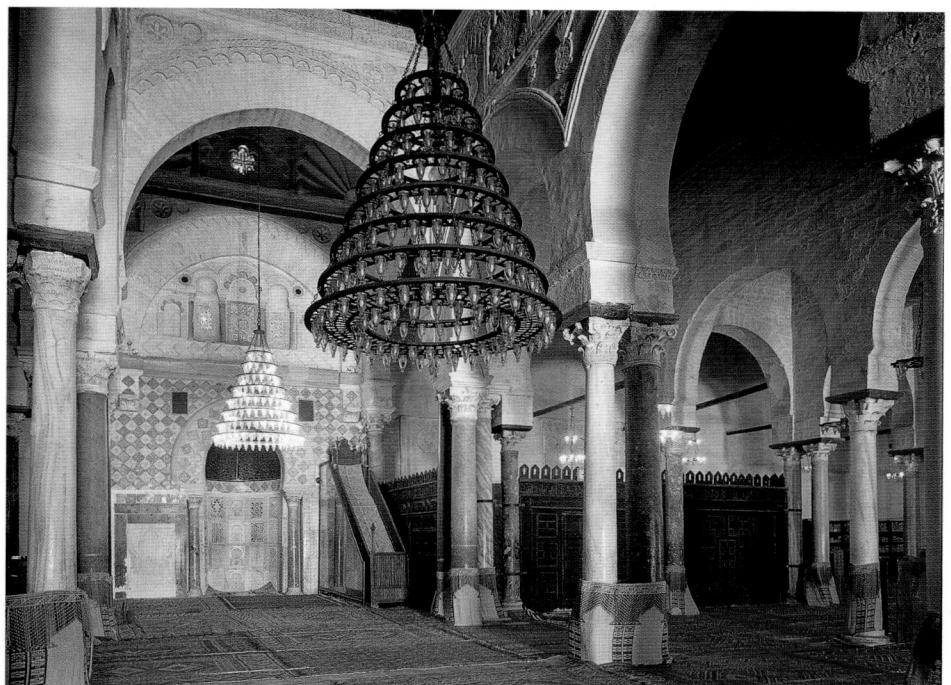

1-17. Interior of the Great Mosque, showing <code>mihrab</code>, pulpit (<code>minbar</code>), and arcades, Fatimid and Aghlabid periods, Qairouan, Tunisia, founded ad 670 (restored)

gular room, its roof supported by sixteen arcades—rows of arches set on columns—running parallel to the wider central aisle. The columns were salvaged from earlier Roman and Byzantine buildings, and their capitals are carved in a variety of styles. The wall opposite the principal entrance is the *qibla* wall, the wall closest to and oriented toward Mecca, the direction in which Muslims bow to pray (fig. 1-16).

The qibla wall is marked by an empty niche called the mihrab (fig. 1-17), which may serve as a mystical reference to the presence of God. In the Great Mosque of Qairouan the mihrab is framed by an arch and two marble columns, and its curved stone surface is pierced through with floral patterns. Inset into parts of the mihrab and the surrounding wall are glazed ceramic tiles imported from Syria. Adjacent to the *mihrab* is a minbar, the pulpit from which the imam (Arabic for "leader") leads the congregation in prayer. Elaborately carved of wood, it is the oldest known *minbar* still in existence.

The central aisle establishes an axis joining the main entrance of the prayerhall to the mihrab. On the exterior, the axis is made evident by two domes, one over the entrance and one before the *mihrab*. The section drawing in figure 1-18 taken along the central aisle, shows the two domes, the *mihrab*, and a supporting arcade. Like the Roman and Byzantine architects from whom they inherited the form, Islamic architects used the dome as a reference to the heavens and as a metaphor for the divine order of the universe. The fluted interiors of domes at Qairouan, with supporting ribs dividing the sur-

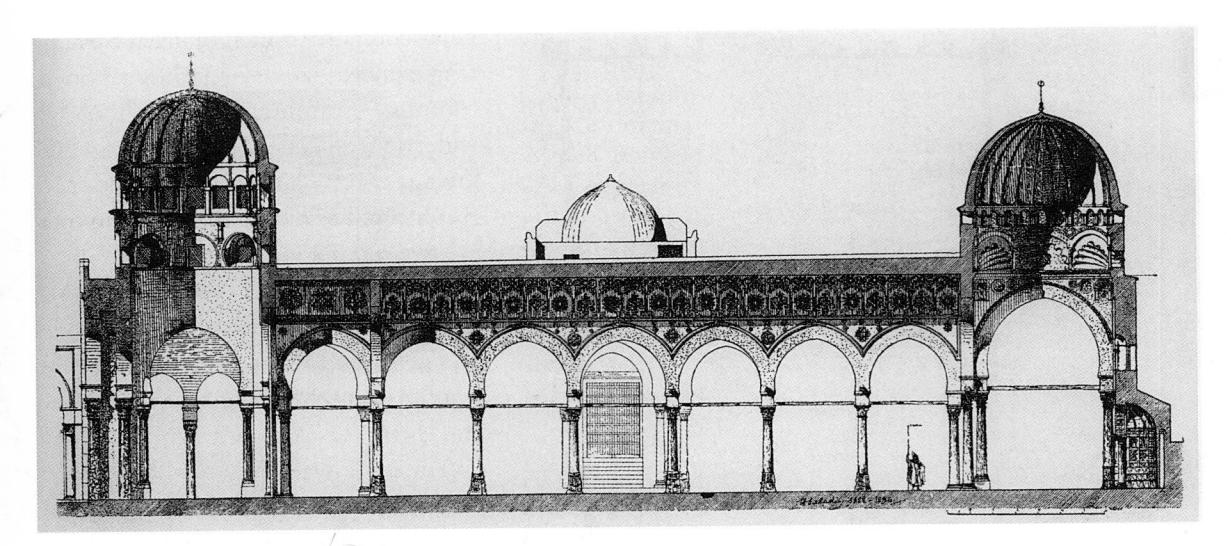

1-18. SECTION TAKEN
ALONG THE CENTER
AISLE OF THE PRAYERHALL OF THE GREAT
MOSQUE AT
QAIROUAN, SHOWING
MIHRAB AT FAR RIGHT.
DRAWING AFTER
H. SALADIN

face into concave sections, are a formal innovation.

Qairouan was to develop a major *madrasa*, or college, and Muslims from many regions of West Africa traveled across the Sahara to study in this Tunisian city. Libraries and schools are joined to mosques throughout the Islamic world, and African mosques have served as centers of literacy and learning for centuries.

REGIONAL BERBER ARTS

Berber groups that inhabited the Maghreban plains have generally been absorbed into the international Arabicized culture that has developed throughout Islamic North Africa. Distinctive Berber languages, cultural practices, and art forms still thrive, however, in the more isolated communities of Tunisia and Algeria, and in Morocco south of the urban Mediterranean shoreline. Art forms created by and for Berber peoples during the twentieth century still bear influences of the many cultures that have flourished in the Maghreb

and in the Saharan oases. Berbers have generally heeded the warnings in the Qur'an against idolatry by avoiding figural representation in their arts; masks and statuary are quite rare. Instead, Berber artists employ a rich vocabulary of abstract, often symbolic motifs and patterns in architecture, ceramics, textiles, and body arts.

Architecture and Household Arts in the Northern Mountains

The architecture of northern Berber groups has intrigued foreign observers for thousands of years. Writing in the fifth century BC, the Greek historian Herodotus noted that a group of Berbers called Troglodytes lived in subterranean dwellings. Underground houses are still used in areas of Tunisia and Libya. Studies have shown that the interiors of these excavated spaces maintain a remarkably even temperature year-round.

Furniture in underground dwellings is carved from the surrounding stone and earth, then covered with whitewash, clay, or paint. Hearths, benches, and shelves of dried mud covered with plaster and paint are also found in Berber homes constructed above ground. In Kabylie homes, which are owned and decorated by women, rows of painted triangles surrounding square or rectangular niches in the interior walls are references to femininity (fig. 1-19). These triangular motifs sometimes bear a striking resemblance to the triangle-bordered enclosure depicted in the rock painting discussed earlier from Tassili n'Ajjer, a thousand miles to the south and perhaps many centuries older (see fig. 1-9). It is tempting to interpret the enclosure as also indicating a female realm, but we have no firm evidence for such links between Berber arts over distance and time.

Diamond-shaped motifs, or lozenges, occur in vertical and horizontal bands in most Berber arts. This shape is seen as an eye of power and protection, capable of counteracting the gaze of evildoers or the "evil eye." Protection from the evil eye is also found in the five fingers, a con-

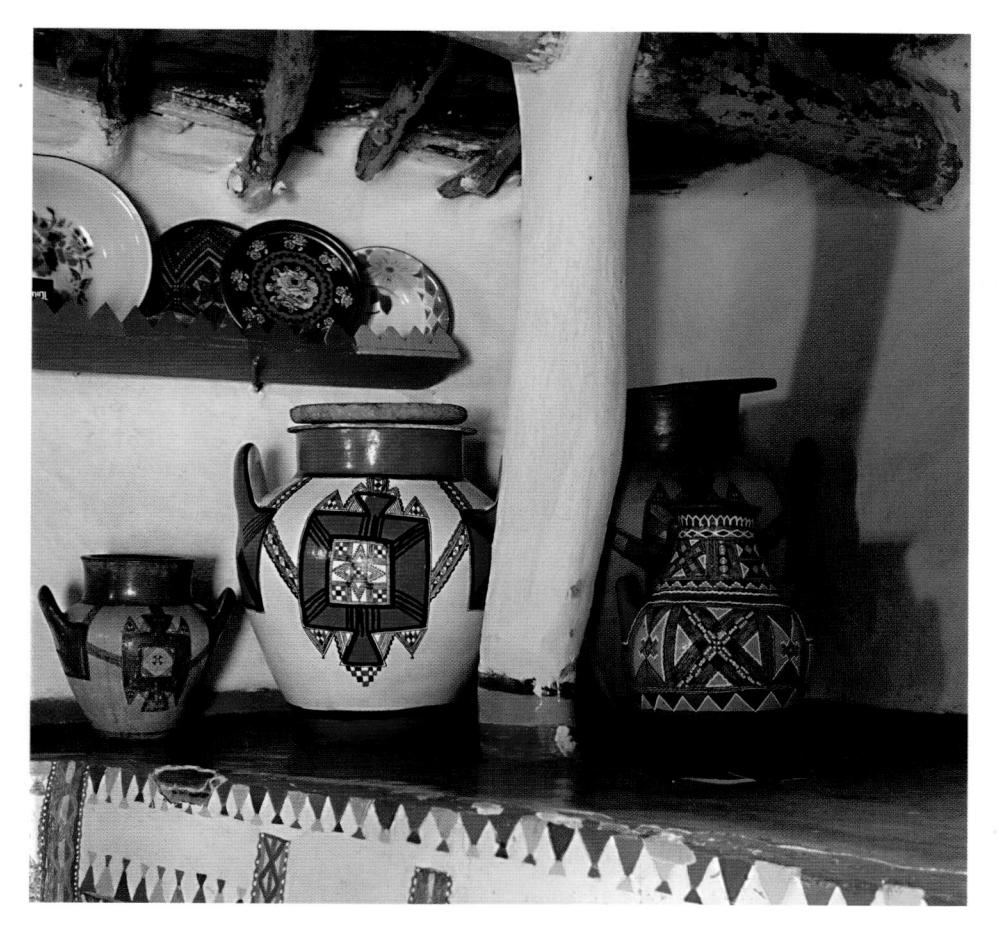

1-19. Interior of House, Kabylie Berber, Aurès Mountains, Algeria, 1980s–1990s

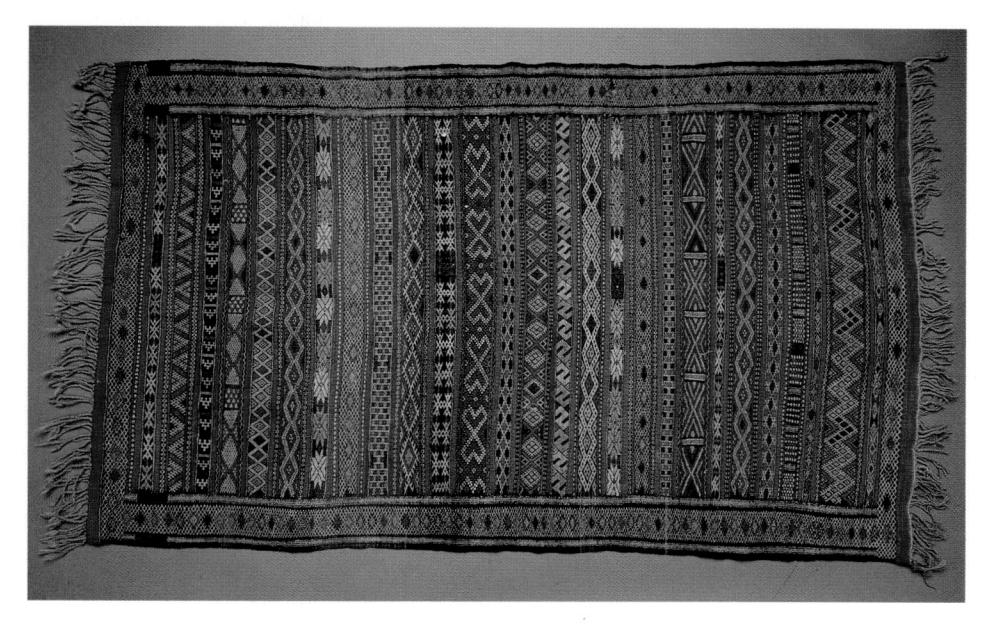

1-20. Rug or saddle blanket, Zemmour Berber, Morocco, 20th century. Wool, 5'2'' x $3'\frac{1}{4}''$ (1.57 x 1 m). The British Museum, London

cept expressed in the gesture of an outstretched hand and in the common expression "five in your eye." The importance of khamsa, the number five, is evident in the way diamond, zigzag, and triangular patterns are often grouped in fives. Protective images such as the eye, the hand, or the symbolism of five allude to spiritual defenses against misfortune and tap into a supernatural power known as baraka. Unleashed by certain substances, people, actions, and experiences, baraka is believed to bring prosperity and blessing to a family that properly conserves and controls this unseen force.

Pottery of the Kabylie and other Berber groups is also marked with rows of triangles. Although little research has been done on Berber ceramics, archaeologists suggest that vessels made by Berbers today appear to be quite similar to those used by their ancestors in the Maghreb over two thousand years ago. Both the overall shapes and the decoration with dark patterns over buff surfaces seem to have changed remarkably little over time. Ceramic vessels may be seen in this photograph of a contemporary Kabylie Berber home, whose murals echo the designs of the pottery (fig. 1-19).

The protective shapes found on the walls of this Kabylie house are also found in Berber textiles. A splendid wool rug or saddle blanket, woven by a Zemmour Berber woman from the hilly region between Fez and the northern Moroccan coast, displays multiple variations of these popular symbols (fig. 1-20). The horizontal bands feature at least eight different types of lozenges, some of which are spiked with five projections on each

side. Five tiny diamonds stacked vertically may be a motif known as the tree of life, and at least one of the zigzag forms may be a reference to a motif called fish tails, an ancient image of blessing and power. Textiles woven in the Maghreb have traveled over trans-Saharan trade routes for over five hundred years. As early as the sixteenth century, Portuguese vessels were carrying Berber weaving to both Europe and West Africa. Textiles in many regions of Africa south of the Sahara thus show the influence of Berber designs.

Perhaps the most visually compelling examples of Berber architecture are the fortress-like walled towns, ksar (sing. ksour), of Morocco. Constructed of pounded adobe bricks, or stone plastered with clay, ksar are found in the river valleys of the southwestern slopes of the Atlas Mountains. One particularly imposing entrance gate to a ksour in southern Morocco is surmounted by triangular projections and flanked by towers (fig. 1-21). Above the arched opening is a paneled relief protected by a shallow roof. Inside a ksour, closely packed three- to fivestory dwellings line narrow streets, creating cool canyons sheltered from the harsh sunlight and fierce winds of the desert.

Fortified farmhouses known as tigermatin (sing. tighremt) are often found near ksar, though isolated tigermatin are also known. A photograph shows a tighremt adjacent to a ksour in central Morocco (fig. 1-22). On the facade of the tighremt the bricks have been placed in layers to form relief patterns around the narrow openings. Sometimes fresh and crisp (as in this example), sometimes

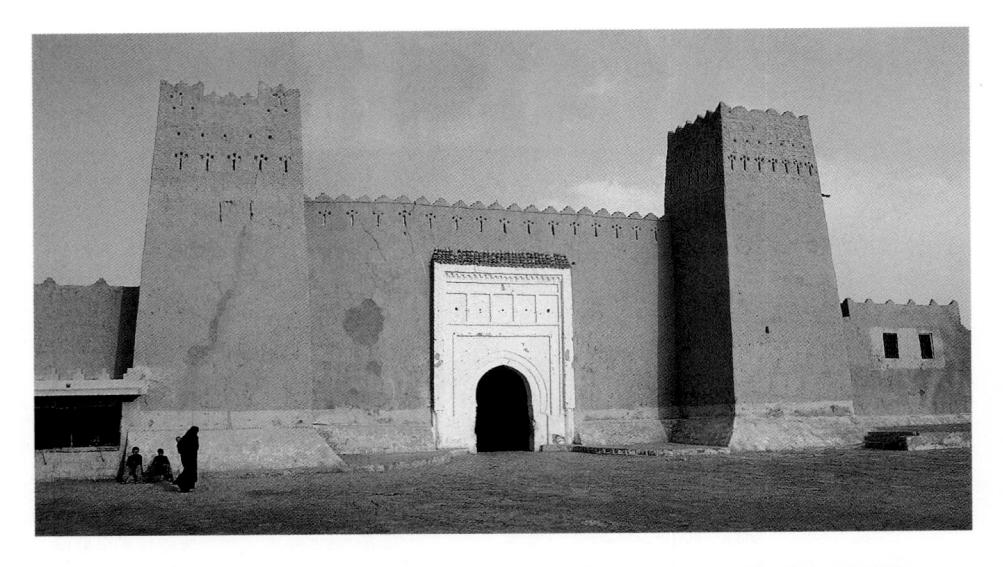

1-21. Gateway to a *ksour*, Berber, south of Atlas Mountains, Morocco, after 12th century (?). Stone and adobe

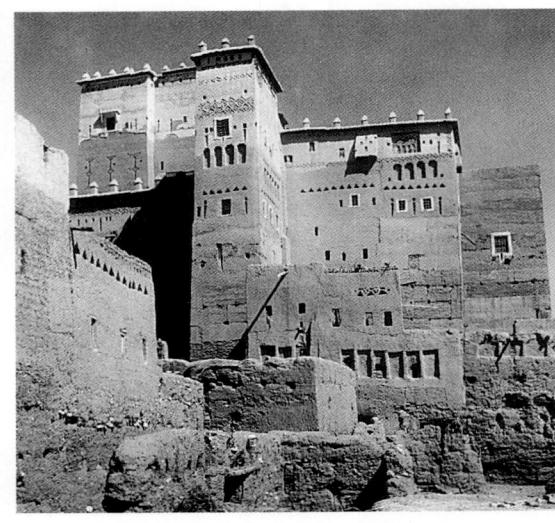

1-22. KSOUR AND TIGHREMT, BERBER, SOUTHWEST OF ATLAS MOUNTAINS, MOROCCO, AFTER 12TH CENTURY (?). STONE AND ADOBE. PHOTOGRAPH C. 1940

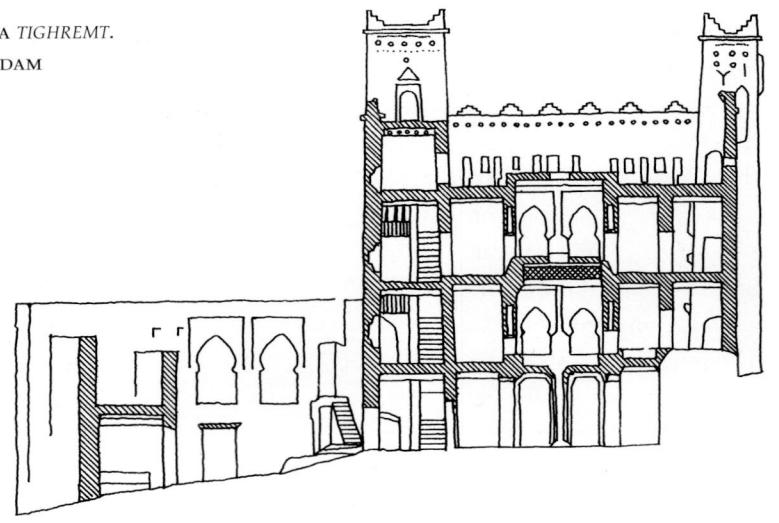

weathered and crumbling, these geometric decorations adorn the exteriors of both ksar and tigermatin.

A section drawing of a similar tighremt (fig. 1-23) reveals the structure of this fortified farmhouse. Animals are stabled in the ground floor, where storerooms and granaries are located. A central courtyard opens to the sky, providing light and ventilation. Arched doorways open from the reception hall and living areas onto interior balconies overlooking the courtyard. The roof serves as a work area, and the towers as observation posts.

We do not know when or how these distinctive architectural forms developed. A fourth-century AD Roman mosaic from Carthage depicts a farmhouse whose fortress-like aspect, ground-floor granary, and corner towers suggest an early version of a tighremt. The names and locations of ksar can be found in Arabic geographies written in the twelfth century. But beyond these isolated clues nothing is known.

Architecture and Household Arts in the Sahara

Oasis cities of the Sahara have also developed distinctive architectural forms, all adapted to the task of sheltering dwellers from the extremes of the desert climate. In the northern Sahara, many oasis communities are administered by religious groups, Islamic congregations of Arab refugees and their Berber followers. They were joined in the past by Jews and Christians fleeing religious persecution. As important centers along the trans-Saharan trade routes, these northern oases have also attracted

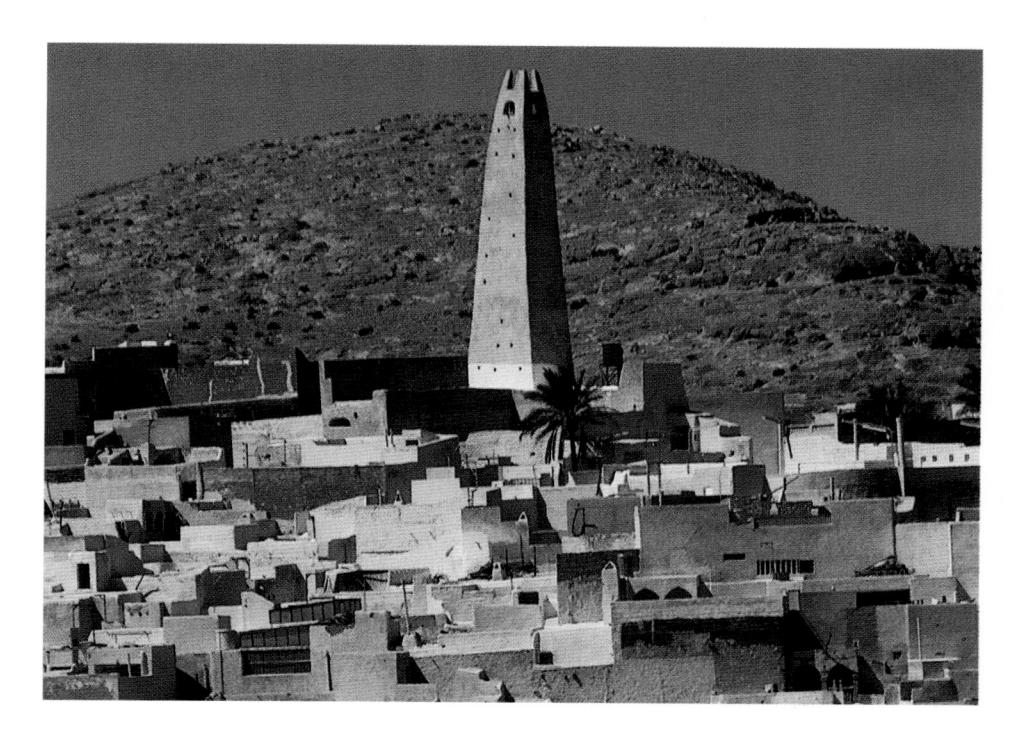

1-24. View of Gardaia showing minaret of mosque, Mzab region, Algeria, after 11th century. Clay over stone. Photograph 1980s

nomadic peoples as well as immigrants from the south. The architectural forms of these towns thus reflect influences from many African regions.

The cities of the Mzab oasis of north-central Algeria were founded by Ibadites, a group of Khajarite Muslims, in the eleventh century AD. The smooth and organic forms of their mosques may be the result of sustained contact between the Mzab and the Inland Niger Delta empire of Mali after the thirteenth century AD. Gardaia, the largest community in the Mzab, is dominated by the tapering cone of its minaret and the curved walls of the mosque flowing over the hillside beside it (fig. 1-24). The Gardaia minaret echoes the square base, sloping sides, and general proportions of the minaret at the Great Mosque of Qairouan to the northeast (see fig. 1-15). But its soft contours

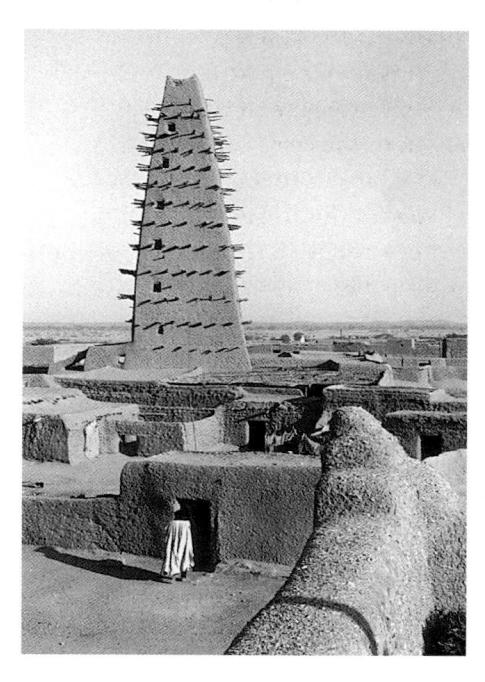

1-25. MINARET OF GREAT MOSQUE, TUAREG AND HAUSA, AGADEZ, NIGER, BY SONGHAI emperor Muhammad Askia, built 1515, REBUILT 1844 IN SAME STYLE. ADOBE AND wood. Photograph 1965

and adobe plastering link it as well to the West African mosques across the desert to the south (fig. 1-25; see fig. 4-9). The four horn-like projections at the top are similar to those found on the gates of the *ksour* illustrated above (see fig. 1-21).

A striking minaret flanks the main mosque of Chinguetti (pronounced "shinget"), an oasis over two thousand miles to the southwest in what is now central Mauritania (fig. 1-26). The stone minaret of Chinguetti shares the geometric outlines of the minaret at Qairouan, but has the four projections of the minaret at Gardaia. Like all the buildings in Chinguetti, the minaret and its mosque are made of narrow slabs of schist fractured from nearby outcrops of rock. The facades of important structures in the town are ornamented with layers of stones in different colors, with triangular openings above doorways, and with decorative courses of slanting rocks.

The history of the mosque at Chinguetti may be deduced from what we know of ethnic relationships in the southwestern Sahara. The dominant populations of Mauritania today are of Berber and Arabic origin, and speak an Arabic dialect known as Hassaniyya. They call themselves the Bidan, in contrast to their vassals, whom they call the Harratin. The Harratin appear to be the descendants of Manding populations such as the Soninke, who founded the ancient empire of Ghana (see chapter 4). Similarities between the stone buildings of Chinguetti and those found to the south at the ruined site of Kumbi Saleh, assumed to have been the capital of ancient Ghana, suggest that stone architecture in Mauritania was

1-26. Minaret of the mosque at Chinguetti, Harratin builders (?) for Arab and Berber patrons, Tagant region, Mauritania, after 13th century (?). Stone

The oasis of Chinguetti may have been settled in Neolithic times, and was perhaps connected to trade routes serving copper and salt mines in the first millennium BC. The mosque and other stone buildings were probably constructed after the thirteenth century AD. Ostrich eggs set atop the four pinnacles of the minaret may share the symbolic meanings of fertility, purity, and adherence to Islam associated with eggs adorning mosques on the Niger River, which were also constructed by Manding architects. In the 1970s prolonged droughts left the region extremely arid, and the city of Chinguetti was virtually abandoned. This photograph, taken in the 1950s, shows the minaret after restoration.

developed by Harratin/Soninke builders. Stone architecture appears in the thirteenth- to fifteenth-century layers of Kumbi Saleh, and the stone buildings of Chinguetti also seem to date from this period.

The oasis city of Walata, in southeastern Mauritania, was also constructed by Harratin masons. The stone buildings of Walata are plastered with reddish clay, and their interior courtyards are ornamented with murals painted by Harratin women. Professional potters, the women are classified as artisans, *ma'allem*, by the Bidan patrons who own the houses. Each window and door of an aristocratic Bidan home in Walata is framed in white, and the whitewashed panels of the doorways leading to a wife's bedroom from the central courtyard are covered with designs.

A photograph taken in Walata shows designs in a courtyard which include most of the motifs recorded by scholars (fig. 1-27). The white linear forms and dark bands closest to the openings are a motif called "chains," and seem to have the form of women's jewelry. The three dark cross-like forms in the surrounding white band were said to refer to people or community. The same symbol occurs in the corners of the white band above. Between the crosses are a series of semi-circular linear forms with the wonderful and suggestive name "mother of thighs." A similar motif isolated in the center of the white band above is a variant of the woman with long hair motif, identifying the owner of the room as a mature married woman. On the same panel, two motifs flanking the door are elaborate versions of the Arabic letter waw, which has associations with male sexuality.

Beds can be seen in the courtyard, and a pair of wooden posts are set on either side of the doorway. Called ashenad in Hassaniyya Arabic, these are supports for calabashes, a type of gourd used as a container. In a Bidan tent, an ashenad is set up on the woman's side of the central partition,
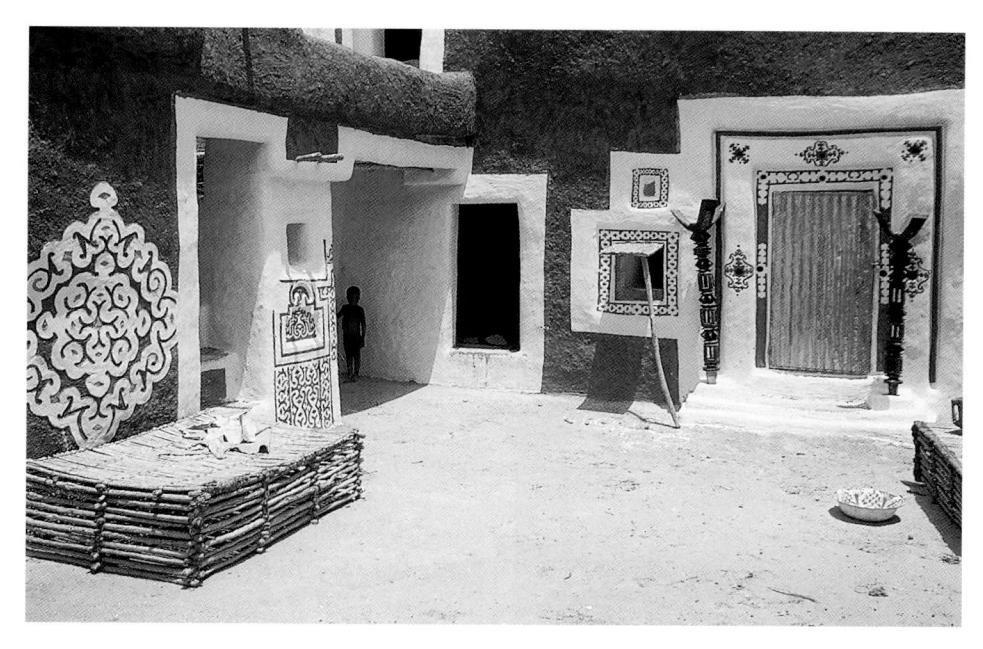

1-27. COURTYARD WITH ENTRANCE TO A WOMAN'S ROOM, HARRATIN ARTISTS FOR ARAB AND Berber patrons, Walata, Mauritania, after 14th century (?). Pigment and adobe over STONE, WOODEN ASHENAD

During the fourteenth century, the Arab traveler and writer Ibn Battuta passed through Walata on his way to Jenne and Timbuktu. He was impressed by the piety of the Muslims of Walata, but he was scandalized to find that both men and women had friends of the opposite sex who were not their spouses. He was particularly shocked to see the wife of one of his hosts talking to a male acquaintance while seated on a canopied bed in a courtyard such as this.

and the calabash it holds is filled with milk. The ashenad is thus an indicator that this space belongs to a woman, and it reinforces the visual messages of fertility and sexuality surrounding the door.

Although the buildings of the Saharan oases are of great beauty, the most important architectural form of the Sahara is the tent. A bewildering variety of tent forms exists, reflecting the multi-ethnic history of Saharan peoples. There are considerable differences from region to region, and from clan to clan. The drawing here illustrates some of the variations of the mat- or leather-covered tents of the nomadic Berbers known as the Tuareg (fig. 1-28). Speakers of a Berber language called Tamacheq, Tuareg aristocrats and their retainers travel through desert territories spanning thousands of miles in the central and southern Sahara. Droughts have driven some Tuareg as far south as Burkina Faso.

A tent of the Kel Ayr Tuareg illustrates the interior furnishings of these structures (fig. 1-29). Made of straw mats upon an armature of bent acacia roots, it resembles tents of the Kel Ferwan (fig. 1-28e). In the center is a bed, easy to disassemble and tie to a camel's back. Each leg and crosspiece is carved from a single piece of wood and ends in a flat ornamented disk. A man's shield and water container are suspended on the wall nearby.

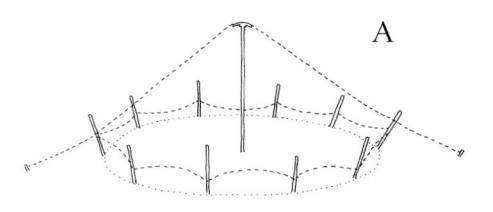

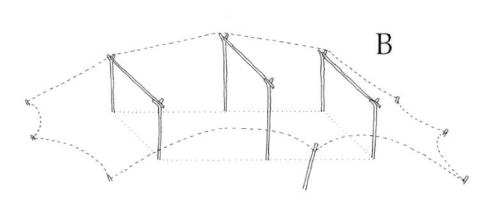

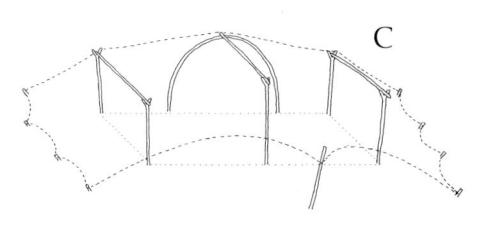

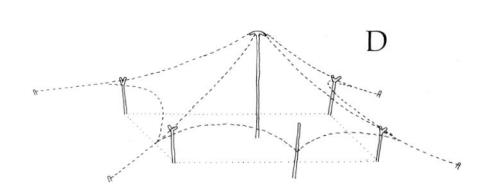

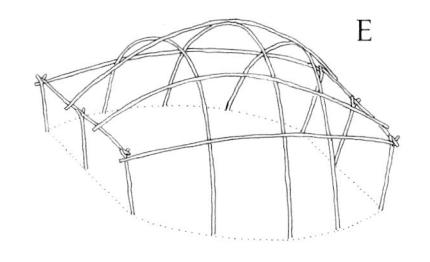

1-28. TENT STRUCTURES, TUAREG BERBER, DRAWINGS AFTER LABELLE PROUSSIN, TAKEN FROM NICOLAS, FOUCAULD, LHOTE, AND Casaius.

A–C KEL AHAGGAR LEATHER TENTS D KEL DENNEK LEATHER TENT E KEL FERWAN MAT-COVERED TENT

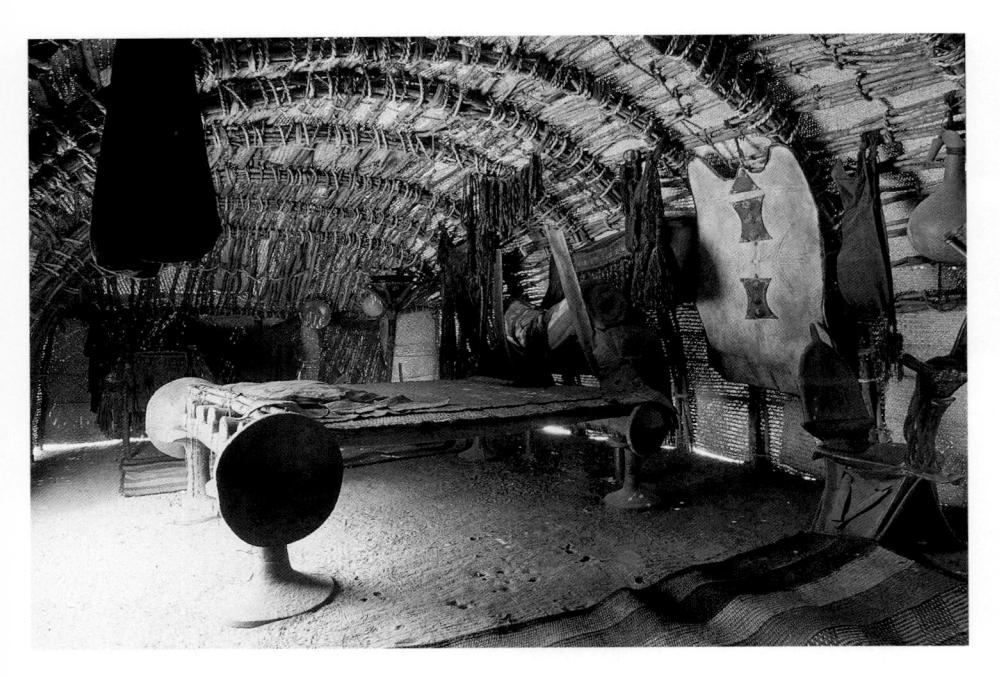

1-29. Interior of a tent, Tuareg, Kel Ayr, 20th century. Leather, wood, and other materials

A Tuareg tent belongs to a woman, who both obtains the materials to build it and supervises its construction. The association between women and their tents is so strong that the same term, ehen, refers to both a wife and a tent.

Elaborately appliquéd multicolored leather pouches and packs suspended from the walls are often used to hold the clothing and other personal articles of Tuareg men and women, though none are visible in this photograph. Their panels are dyed in vibrant contrasts of green, red, and vellow. The rectilinear geometric shapes created through painting and appliqué may be based upon the calligraphic forms of tifinar, the script used to write Tamacheq, just as the more curvilinear forms of the Hassaniyya speaking peoples are based upon Arabic calligraphy.

Most Tuareg leatherwork is fashioned by women known as Temaden. Wooden implements and metal objects, such as a man's saddle and sword, are made by their male rela-

tives, the Inaden. Temaden and Inaden form an endogamous group of artisans within Tuareg culture. Such hereditary occupational groups are often found in African societies.

Personal Arts of the Shleuh and Tuareg

Well into the twentieth century, Berbers, Arabicized Berbers, Arabs, and Jews of the Maghreb wore distinctive styles of dress and jewelry, allowing knowledgeable observers to determine their ethnic identity, status, and even marital situation at a glance (see Aspects of African Cultures: Personal Adornment, page 39). Today these references to identity are less clear, since social and economic hierarchies are more fluid.

The symbolic importance and aesthetic richness of Berber personal adornment can be seen in a photograph taken in the southern Moroccan coastal city of Sous during the 1950s (fig. 1-1). It shows an entertainer of the Shleuh people, who live in the southern Atlas Mountains. Her head is framed by distinctive jewelry and cloth, for Berber peoples believe that the head needs particular protection from the evil eye. The silver coins are believed to contain baraka, as is the pure white color of the headcloth. The deep reds, blues, greens, and yellows of her heavy enameled silver jewelry also increase the protective power of the ornaments.

The woman's huge ear pendants are too heavy to be hung from the ears themselves, and are supported instead by a hidden cord across the top of her head. An egg-shaped symbol of female fertility is suspended at her throat, and a four-pointed pendant lies upon her forehead. It may refer to the protective eye, a talisman in the shape of a jackal's paw, or an abbreviated hand.

The projections forming polyhedrons on one of the enameled silver bracelets may be related to the phallic extensions and pointed spikes on other Moroccan bracelets. Just as an eye form protects against the evil eye, a phallic projection evidently guards against unbridled male aggression, for women are said to have been able to fend off rapists with these heavy ornaments. Bracelets ending in similar geometric knobs are popular throughout the Sahara, and have been photographed as far east as Somalia.

The woman's dress is pinned together by enormous brooches modeled upon the much smaller fibulae

Aspects of African Cultures

Personal Adornment

Kaleidoscopic in its range and beauty, African dress embraces not only clothing and jewelry but also coiffure, scarification, and body painting. Like speech, dress is a primary civilizing phenomenon, a means of symbolic communication. Operating in a matrix of cultural codes and personal preferences, it conveys to informed onlookers a culturally constructed self or identity. Such an identity is rarely one-dimensional, and a person's various roles—family elder, diviner, government official—may each find expression in dress. Dress is thus transformative; its logical end point is the masquerade.

The creation of keloids (raised scars) or incised lines in the skin is a socializing process among many African peoples. Such patterning may be considered necessary not only for acceptance as a fully civilized being, but also for being considered pleasing to the eye, and to the hand as well, since many decorative scars have a tactile and erotic dimension. Against such permanent markings can be set other more or less transient embellishments. Applied in elegant complexes, some skin dyes may be intended to last for weeks; elsewhere body painting may transform the wearer only for the few hours of a ceremony. Hairstyles too may remain in place for several months. Social states that last for months or even years may in fact be marked by distinctive hairstyles, as when Maasai men during their warrior years wear long, intricately braided coiffures (see fig. 13-49). Many peoples wear substantial amounts of jewelry, sometimes constantly for many years, as visible signs of status and wealth.

Virtually all African peoples distinguish in their dress between daily life and exceptional occasions, when elements such as face paint or distinctive textiles are added to the ensemble to differentiate extraordinary from ordinary times. A person's dress ensemble also alters

perceptibly with age or accession to a particular office. Changes in dress often identify age or status: marriageable girl, warrior, titled man, elder, woman past childbearing. Dress thus has a biographical quality. Usually beginning in childhood, too, dress is gender specific, as are social roles and occupations. At times, however, cross-gender attire is sanctioned, as when Yoruba devotees of the god Shango wear brides' hairstyles to indicate their "marriage" to the deity (see chapter 8).

Dress codes depend as well on a culture's way of life. Nomadic pastoralist peoples, unable to carry with them much personal property, tend to wear their ensembles day and night and for long periods. They also tend to focus wealth in what is worn. The daily dress of pastoralist Fulani women, for example, includes heavy gold earrings and rich constellations of jewelry. Many settled farming peoples, in contrast, do not inform everyday dress with such artistry. Able to accumulate and store property, including garments and jewelry, they reserve their most splendid outfits for occasional use. Yet as the Fulani prove so well, pastoralists also amplify their already sumptuous attire for annual festivals of dancing and display (see fig. 3-38).

Motion and change are fundamental qualities of African dress. Kinetic elements such as feathers, raffia, and flowing cloth accentuate activity. Beads and mirrors flash and glitter; metal bracelets, anklets, and bells sound forth, announcing their owners. Skin painting, too, assumes the fundamental mobility of the body, especially in dance contexts. It may well be that dance, the primary African art form, is largely responsible for the prevalence of voluminous clothing and freely moving ornaments. The very opposite effect is also evoked in some instances, as when the oba of Benin is dressed so as to appear heavy and unshakable, aspects of his ritual persona that seem to express the sacred permanence of his office (see fig. 9-4). HMC

once worn by wealthy Romans, while the techniques used to manufacture the enamel and silver may date back to the Vandalic and Byzantine eras. The triangular shapes attached to the pins are a characteristic Berber addition, and are probably related to the triangular pendants worn by the Tuareg.

Until recently, most types of jewelry in the Maghreb were made by Jewish silversmiths, or by endogamous groups of Jewish origin. Most Berber peoples seem to believe that the act of creating supernaturally charged, expensive metal objects is dangerous or polluting. In popular Berber thought, Solomon and other Jewish patriarchs were regarded as powerful magicians, and Solomon's heirs were thus believed to have the occult abilities necessary to manipulate baraka through silversmithing. Large silver jewelry is increasingly rare in the Maghreb today, for most Jews left northern Africa after a series of persecutions in the middle of the twentieth century.

The woolen cloth worn by the entertainer was woven by women in her family. The Shleuh and their neighbors also weave beautiful cloaks called hanif or aknif for their husbands and sons (fig. 1-30). This warm woolen garment is a potent protection against the evil gaze, for the central red area is considered to be a gigantic, hypnotic eye. Geometric projections along the border of the eye, like the geometric projections around the storage areas of a Kabylie home, are often grouped by five, and are thus hand-like in their defensive qualities. Along the center of the red eve are additional protective designs which act as the weavers' signatures and give each *hanif* its individual identity.

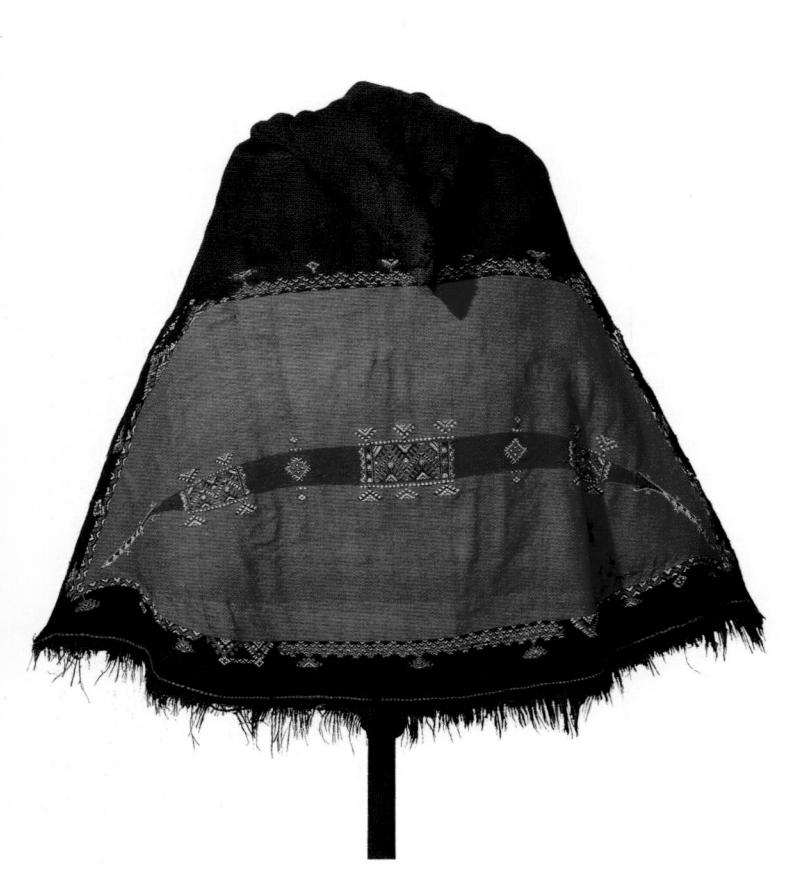

1-30. HANIF (CAPE), BERBER, SOUTHERN ATLAS MOUNTAINS, MOROCCO, 19TH CENTURY. WOOL AND GOAT'S HAIR. THE BRITISH MUSEUM, LONDON

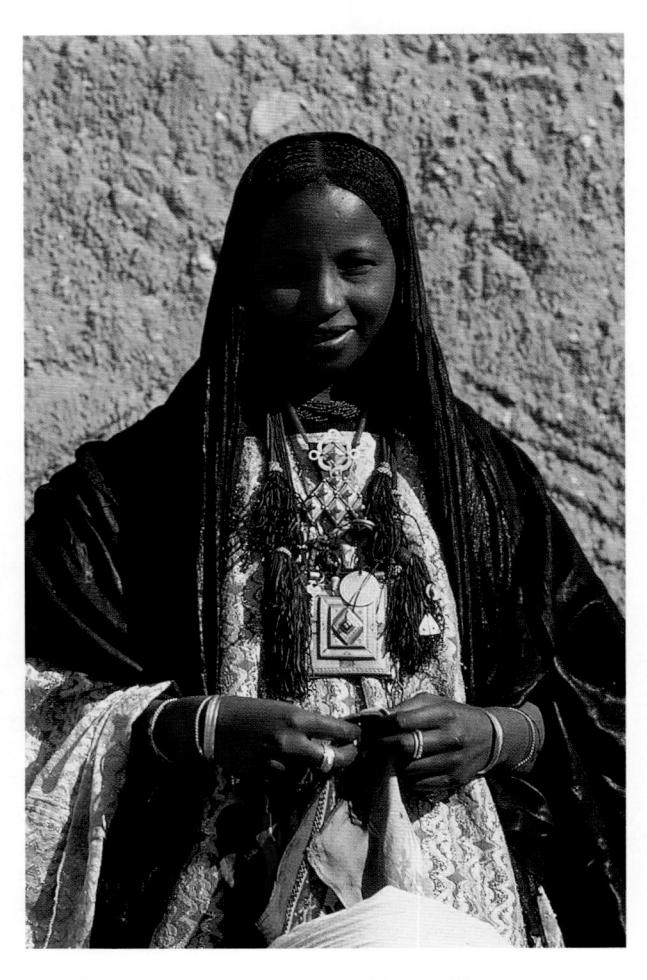

1-31. Woman outside her home, Tuareg, Hoggar region, Algeria

The nomadic Tuareg have the most dramatic of Berber personal arts. Tuareg men wear dark blue robes and shimmering indigo veils, leaving only their eyes, hands, and feet exposed to view. Aristocratic warriors gird themselves with swords and amulets. Tuareg women also wear indigo scarves, although they leave their faces uncovered.

The elegance of Tuareg silverwork can be seen in the profuse ornaments of a wealthy Tuareg woman photographed in the Hoggar highlands of central Algeria (fig. 1-31). All were forged by the Inaden smiths who have a special relationship with her clan. Her large triangular amulets may be filled with sand taken from a tomb or other sacred site, a substance imbued with *baraka*. Or they may contain a bit of paper or parchment inscribed with a verse from the Qur'an. The triangular shape of the amulets is given additional protective power by the fringe of five silver cones.

TWENTIETH- AND TWENTY-FIRST-CENTURY ART OF NORTH AFRICA

French colonial authorities had established an Ecole des Beaux-Arts (School of Fine Arts) in Algiers by 1881, during the period when Morocco, Algeria, and Tunisia were under the control of European powers. By the 1930s, the most influential teacher at the institute was Mohammed Racim (1896–1975), who

1-32. Номабе то *Fatimah,* Анмеd Cherakaoui, Morocco, 1961–62. Oil on canvas. 3′9½″ x 6′2½″ (116 x 189 см)

painted elaborately detailed, brightly colored illustrations of Algerian scenes and historical events. By the middle of the century, however, painters from the Maghreb were studying in Paris, and their styles were shaped by the prevailing trends of European modernism. The Algerian artist known as Issakhem (1928–85), who returned from Paris to teach at the School of Fine Arts, painted figures using loose brushstrokes, but many of the North African artists in this generation preferred pure abstraction. Two of these

artists, Jilali Gharbaoui (1930–71) and Ahmed Cherkaoui (1934–67), are celebrated as the founders of modern art in Morocco, even though both lived in Europe for most of their adult lives. Both artists trained in France, and both embraced materials and techniques (oil paints applied with brushes to primed, stretched canvas) employed by European artists for five centuries.

Cherkaoui claimed that the abstract images in his oil paintings were based upon Arabic calligraphy (and were thus a tribute to Islam) and upon Berber script (and were thus a tribute to his personal heritage). The titles he chose for works such as *Homage to Fatimah* (fig. 1-32) underscore his desire to create distinctly Moroccan art works. Yet Cherkaoui seems to have adopted foreign media, and foreign attitudes toward art, without question. In fact, European definitions of "fine art," which emphasize painting and sculpture to the detriment of all other forms of visual art, were adopted by educated élites throughout the African continent in the twentieth century.

1-33. HAND, FARID
BELKAHIA, MOROCCO,
1980. DYES ON TREATED
CATTLE HIDE AND WOOD.
6' X 4'1" (152 X 124.5
CM). COURTESY
MATISSE ART GALLERY,
MARRAKESH

1-34. Women of Chtouka, Chaibia Tallal, Morocco. Acrylic mural. c. 9 x 16' (2.74 x 4.88 m). Photograph taken at artist's home 1978

The prevalence of these imported ideas makes the work of Farid Belkahia (born 1934) even more extraordinary. Although Belkahia trained in Paris and worked in Prague, he developed a fresh approach to his profession when he returned to Morocco in 1964 in order to teach at the national art institute in Casablanca. There he researched the techniques, materials, and forms of Moroccan art, studying metalwork, textiles, and ceramics. The result of these investigations can be seen in his work from the 1980s, when he created flat forms of treated animal skin using the tanning techniques and traditional dyes of Moroccan leatherworkers. Across the surface of Hand (fig. 1-33) can be seen delicate tracery linked to women's henna painting, and to women's tattoos. The outline of the hand itself is obviously tied to protective images appearing throughout the art history of the region (see fig. 1-11).

Almost all of the artists who studied in North African art institutes during the twentieth century were men, for social pressures and religious attitudes discouraged women from enrollment. Yet even before women joined these art schools in the last decades of the century, it was possible for both men and women who had no formal art background to become successful painters in the Maghreb. The Kabylie Berber painter known as Baya (born 1931) was given her first Paris exhibition when she was only sixteen years old. Chaibia Tallal (born 1929) was encouraged to paint by her foreign employers, and she has shared exhibition space with academically trained artists in Morocco and in Europe since the 1960s. Like many

untrained artists, she paints in a very distinctive way and prefers figurative representation to abstraction. The faces and figures of her painting are barely discernible, for they are almost overwhelmed by vivid color (fig. 1-34).

The constant interchange between the Maghreb and Europe continues, as graduates of art institutes in North Africa and Paris often shuttle between their homeland and Europe. Chapter 15 presents the work of artists who identify themselves as Muslim or North African immigrants, and who therefore engage foreign viewers in a foreign context. However, many artists with international connections draw upon their cultural roots for inspiration, and may be discussed in the context of the arts of their native countries. For example, photographer Jellel Gasteli (born in Tunisia in 1958), explores the whitewashed streets of the Berber towns of Hammamet and Ierba. His subtle images of walls, windows, and pillars emphasize abstract, formal qualities. This photograph of a saint's tomb is taken from a set of images entitled White Series (Série Blanche) (fig. 1-35). Graves of holy men and women are visited by devout Muslims in the Maghreb because of their association with baraka, and Gasteli manages to capture some of the solemnity and purity of a sacred place.

1-35. Untitled from the White Series (Série Blanche), Jellel Gasteli, Tunisia/France, 1987–97. Gelatin silver print on fiber paper base, laminated on aluminum. $4'\frac{1}{4}'' \times 4'\frac{1}{4}''$ (1.3 X 1.3 M). COLLECTION OF THE ARTIST

Lands of the Nile: Egypt, Nubia, and Ethiopia

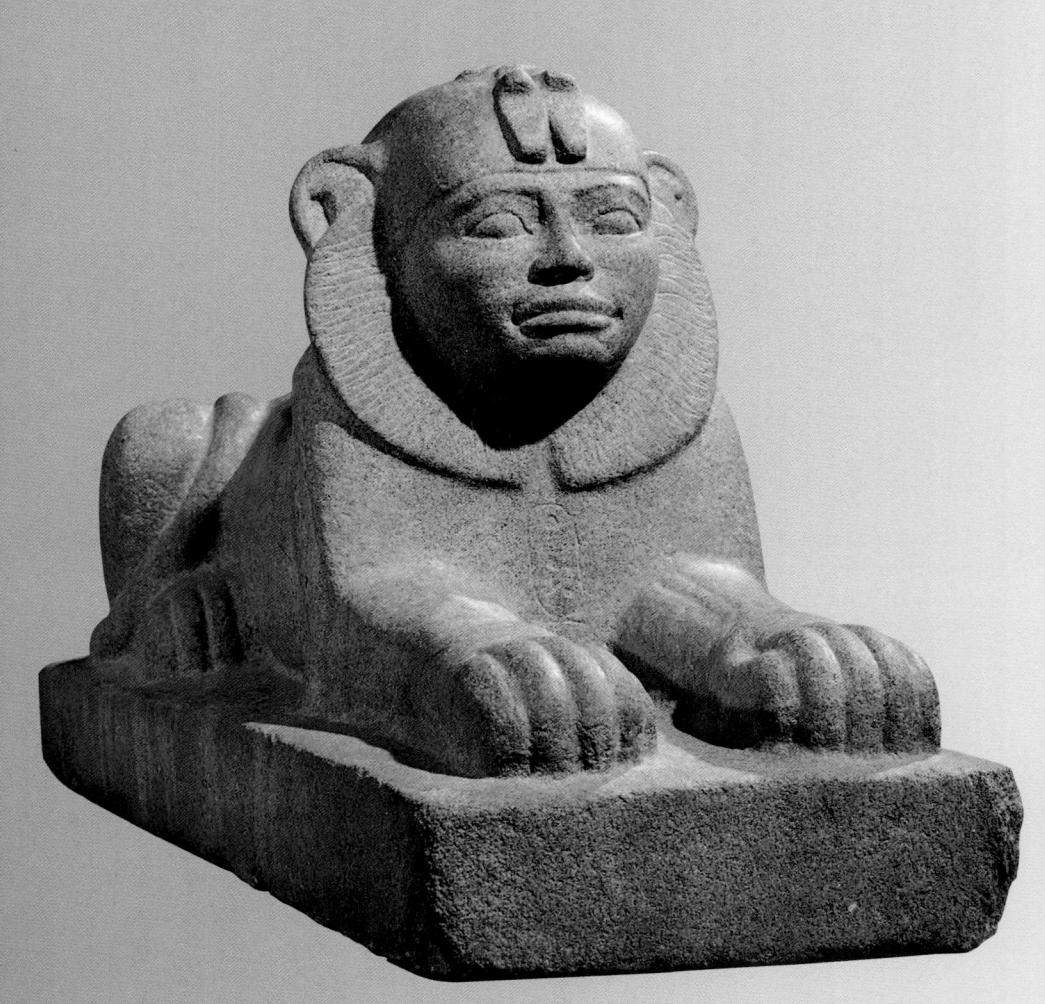

2-1. Sphinx of Taharqo, Kawa, Sudan, Nubian, Egyptian Dynasty 25, c. 690–664 bc. Granite. Height $15\frac{1}{4}$ " (40 cm). The British Museum, London

Art historians have noted that Kushite sculpture such as this portrait shares stylistic features with Middle Kingdom works from Kemet and revives the high standards of workmanship found in Old Kingdom figures. The Nubian kings were clearly interested in promoting the artistic as well as the spiritual values of the past.

I world and older than the flow of human blood in human veins," wrote American poet Langston Hughes in "The Negro Speaks of Rivers." One of the rivers the poet invokes is the Nile, the world's longest river, the nurturing force that sustained numerous African civilizations.

One of its tributaries, the White Nile, originates in the green hills of Uganda; a second, the Blue Nile, originates in the highlands of Ethiopia. In the vast region between these two rivers the ancestors of the human race may have first appeared. Flowing northward, the White Nile and the Blue Nile converge near Khartoum, in the center of Sudan. The Nile then describes a broad S-curve punctuated by a series of six unnavigable rapids known as cataracts. The region along this stretch of the Nile is known to historians as Nubia. After the northernmost, or first, cataract the Nile flows smoothly northward, finally fanning out into a marshy delta before emptying into the Mediterranean Sea. Before the river was dammed at Aswan during the twentieth century, the Nile gently flooded its banks for several months every year and then receded, leaving this stretch of the valley covered with a layer of fertile black silt. Ancient Egyptians called their country Kemet, the Black Land, after the color of this life-giving mud.

While the people of Kemet distinguished between Upper Egypt (the narrow southern floodplains), and

Lower Egypt (the northern marshes of the Delta), the entire region shared a common culture. Their language belonged to the Afro-Asiatic family, and was thus related to Hebrew, Arabic, and the Amharic spoken in the Ethiopian highlands, as well as to forms of Berber and early Cushitic and Chadic languages.

In contrast to the people of Kemet and the peoples of central Ethiopia, most Nubians seem to have spoken languages of the Nilo-Saharan family. Distantly related Nilo-Saharan languages are still spoken today by nomads in the central Sahara, by farmers in southern Sudan and southern Ethiopia, and by cattle-raising pastoralists in Kenya and Tanzania. Unlike Kemet, which was bordered by particularly inhospitable desert, Nubia was linked to lands and peoples to the south, east, and west.

Although little is known of the history of the Ethiopian highlands prior to the first millennium BC, they have been in contact with other regions of the Nile Valley for at least two thousand years. Trade routes joined Ethiopia's ports on the Red Sea to Egypt's desert coastline, while soldiers, pilgrims, and merchants traveled down the Blue Nile from the Ethiopian highlands to Nubia and Egypt.

The tombs of the ancient rulers of Kemet and Nubia provide our most extensive source of information about their cultures. While the tombs of Kemet have been looted for thousands of years, sometimes by the very workers who built them, an astonishing number of funerary objects have survived these thefts. Still more objects have been unearthed by archaeologists during the twentieth

century. The monuments and artifacts illustrated here are thus but a tiny sample of the vast range of objects and monuments available for study today.

Since Kemet was affected by developments in Western Asia, and since the monuments and styles of this African civilization had a great impact upon the ancient cultures of Greece and Rome, to which Europe traces its own cultural roots, Egyptian art has most often been discussed in terms of its relationship to non-African cultures. Furthermore, the study of ancient Egyptian culture long relied on Greek names for rulers, cities, and objects—the word "Egypt" is itself of Greek origin. Even after the writing system of Kemet was deciphered during the nineteenth century, Greek terms largely remained in use. This chapter uses the words of Kemet whenever possible, often giving the better-known Greek equivalent in parentheses. Later art forms of Egypt, Nubia, and Ethiopia were strongly influenced by Greek, Roman, and Byzantine art, while developments in Islamic Egypt affected Islamic arts in the Mediterranean and in Western Asia. Yet despite these many crosscurrents, Egyptians, Nubians, and Ethiopians are all African peoples, nourished by the African past.

This brief survey focuses upon works from the Nile regions that share important features with other African art forms. Some of these similarities are rooted in the movements of peoples and ideas across the Sahara prior to the third millennium BC. Others are due to trade and pilgrimage routes joining the Nile Valley to the central Sudanic region over the past millennium. While in some cases

these shared features may simply be coincidental, they nevertheless provide interesting points of comparison.

Many of the prevalent themes of Egyptian, Nubian, and Ethiopian art discussed here are not unique to the African continent. However, they have been eloquently and effectively expressed in the art of many African cultures, and reappear throughout this book. These include commemoration of ancestors and invocations of their protective power, alignment of the living with primordial beings through images of the creation of the world, rulers who personify divine justice, affirmations of sexuality as the source of life itself, and the layering of multiple images, symbols, and contexts within a single object.

EARLY NILE CULTURES

Between the eighth and fifth millennia BC, before the great savannahs of northern Africa became the desert sands of the Sahara, important cultural innovations spread from Nubia westward to the Atlantic Ocean. Populations began to domesticate cattle, cultivate grains, and fire ceramic vessels. "Wavy line" and "dotted wavy line" pottery dated to the eighth and seventh millennia BC testify to these changes. Found along the southern Nile and as far west as Mali. they represent one of the world's oldest ceramic traditions. By the fourth millennium BC, the Egyptian reaches of the Nile were increasingly influenced by these developments.

Female images in fired clay were some of the most striking objects made in Nubia and Kemet during the fourth and third millennia. A figure from the early Egyptian culture

2-2. Female figure with raised arms, Egypt, Pre-dynastic period (Naqada II culture), c. 3650–3300 bc. Terracotta. Height 11½" (29.3 cm). Brooklyn Museum, New York. Museum Collection Fund

known as Nagada displays the full curves and simplified features of these female forms (fig. 2-2). Breasts are indicated by simple protrusions, as is the bird-like head. The arms curve upward as if in imitation of horns, recalling the gestures of horned female images from the central Sahara (see fig. 1-4). It is also tempting to link this figure to cattle imagery, because music and dance in Kemet were later associated with Hathor, the bovine goddess of female sexuality. Yet we know very little of the function or meaning of this work. It may have been used during the lifetime of the deceased, or it may have been made especially as a

funerary offering.

Similar figures were modeled in the Nubian culture referred to simply as A-Group. Other objects from A-Group burials include an array of ceramic vessels. By the second millennium BC, ceramics of the Nubian state of Kerma were as thin as eggshells, their red and black surfaces burnished to a shine (fig. 2-3). These finely crafted pots and cups demonstrate the mastery that developed from regional pottery traditions that were already over two thousand years old.

Toward the end of the fourth millennium, around 3100 BC, a series of kings strove to unify the separate districts of Egypt into a single realm. A stone object known as the Palette of Narmer refers to these political developments (fig. 2-4). Unearthed in a deposit near a temple at Nekhen (Hierankonpolis), the Upper Egyptian capital of the First Dynasty, it is the most important work to come down

to us from the years prior to the Early Dynastic period of Kemet (2920–2649 BC).

The object is called a palette because the indentation on one side may have held pigment. At the top of each side are early versions of a form of writing the people of Kemet called medu netcher, "the words of the gods." The symbols have become known in English as "hieroglyphs," from the Greek word for "holy carvings." Here the catfish, nar, and broad chisel, mer, combine to spell one of the first recorded names in human history, Narmer. Narmer is the largest figure depicted on the palette, and he towers over the less important human beings who surround him. This use of size to indicate relative status is known as hierarchical scale, or social proportion. Although hierarchical scale is by no means limited to African art, it is a particularly important feature of the art of Kemet and occurs as well in much more recent depictions of kings in other African realms.

2-3 Vessel, Nubian, Classic Kermac, c. 1750–1550 bc. Fired and glazed clay, height 4½" (11.5 cm). The British Museum, London

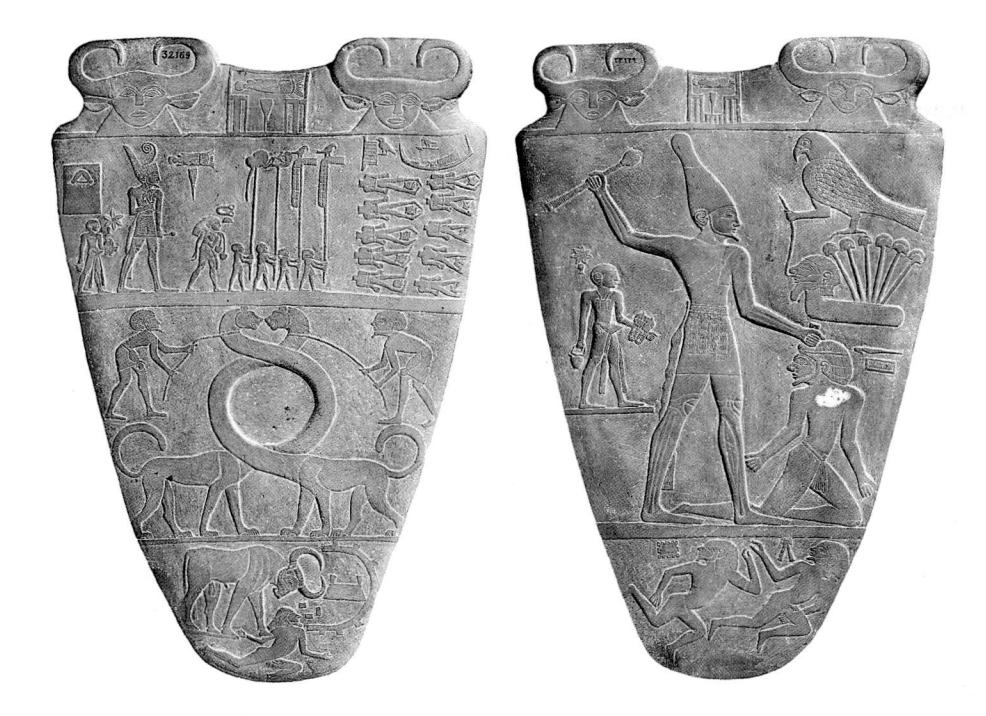

2-4. Palette of Narmer, Egypt, Archaic, Dynasty 1, c. 3000 bc. Slate. Height 25'' (63.5 cm). Egyptian Museum, Cairo

The pictographs forming Narmer's name are suspended over a simple image of the mudbrick towers of the royal palace. The close association between kingship and the dwelling place of the king also occurs in the word "pharaoh." Evidently this Greek (and biblical) term for the kings of Kemet is based upon the ancient Egyptian words per-o, which referred to the house of the king rather than merely to the ruler himself.

On one side of the palette, Narmer is depicted wearing the white crown of Upper Egypt (see fig. 2-4, right); on the other side he is shown wearing the red crown of Lower Egypt (see fig. 2-4, left). Both sides portray him victorious over his enemies as he raises a mace to smite a prisoner he grasps by the hair (right) and surveys a row of decapitated victims (left). Unlike the Pastoralist paintings of the Sahara created during roughly the same period (see figs. 1-6, 1-7), these images do not depict lifelike scenes of human interaction. Rather, they are coded visual proclamations of Narmer's kingly power.

By smiting his enemies and bringing order to chaos, Narmer upholds divine justice. Later kings of Kemet were to refer to this guiding principle as ma'at. The king's victory is supported by divine beings who will reappear in the art of Kemet for the next three thousand years. His aggressive stance is mirrored by the actions of a bull, an emblem of virility and power later linked to the god Ptah, and a falcon, almost certainly representing the solar god Horus. Horus was closely identified with the kings of Kemet, and during this period the king was believed to make manifest the powers of the god. The bovine heads on the

top registers are surely references to a celestial goddess who took the form of a cow or a horned woman.

The presence of so many potent deities suggests that Narmer may not have achieved the unification so boldly proclaimed here. Instead, this object may have functioned as a prayer, a petition to the gods asking that these events come to pass. Later art of Kemet is full of images serving as incantations, as visual spells to bring about a desired state of affairs.

The priestly role of the king, an important aspect of his reign, is also set forth in this work. The small figure behind Narmer holds the sandals of the king and a water container, evidently to wash and purify Narmer so that the king can walk clean and barefoot on holy ground in the presence of the gods. In later periods priests fulfilled their duties on behalf of (or as substitutes for) the sacred ruler.

Narmer and the other humans in this work are composed of disparate elements. Torsos, arms, hands, and eyes are turned toward the viewer and shown frontally, while legs and the rest of the head are seen in profile. Both feet are planted firmly on the ground, even though the knees are straight. Thus every part of the body is easy to read as part of the human form, just as medu netcher are easily identifiable images combined into legible words. Even at this early stage of Kemet, both written words and figurative art are conceived as visual equivalents of verbal statements. This specific combination of frontal and profile features to produce a figure, and the nature of images as elements in a visual language, were to be typical of Egyptian art for the next three thousand years.

Many other African art works, although created thousands of years later and by very different cultures, were also meant to convey a clear message to the viewer. Elsewhere on the continent, figurative images were not joined to a system of writing, and were not visual extensions of a prayer or incantation. Yet African sculptors in many regions emphasized features that depict a ruler's supernatural attributes, or metaphors connected to the reign, rather than his or her physical appearance. An appreciation of the symbolic nature of ancient Egyptian art thus heightens our ability to understand more recent African art as well.

KEMET

The history of Kemet after the Early Dynastic period is marked by three broad periods of unity and stability known to historians as Old Kingdom (c. 2649–2134 BC), Middle Kingdom (c. 2040–1640 BC), and New Kingdom (c. 1550–1070 BC). Each of these kingdoms was succeeded by an Intermediate Period, a time of disunity. After the Third Intermediate Period comes a Late Period (712–332 BC). Marked by intermittent centuries of foreign domination, the Late Period ends with the conquest of Kemet by the Greeks.

Old Kingdom and Middle Kingdom

Perhaps the most influential monument of the Old Kingdom was the funerary complex constructed for the Dynasty 3 king Netjerikhet, or Djoser, at Saqqara around 2620 BC (figs. 2-5, 2-6). A funerary district, Saqqara was located on the west bank of the Nile near the city of Men-nefer (Memphis in Greek), the capital of Kemet during this period.

An inscription in the tomb complex itself suggests that Djoser entrusted the architectural work to his advisor Imhotep; if so, Imhotep is

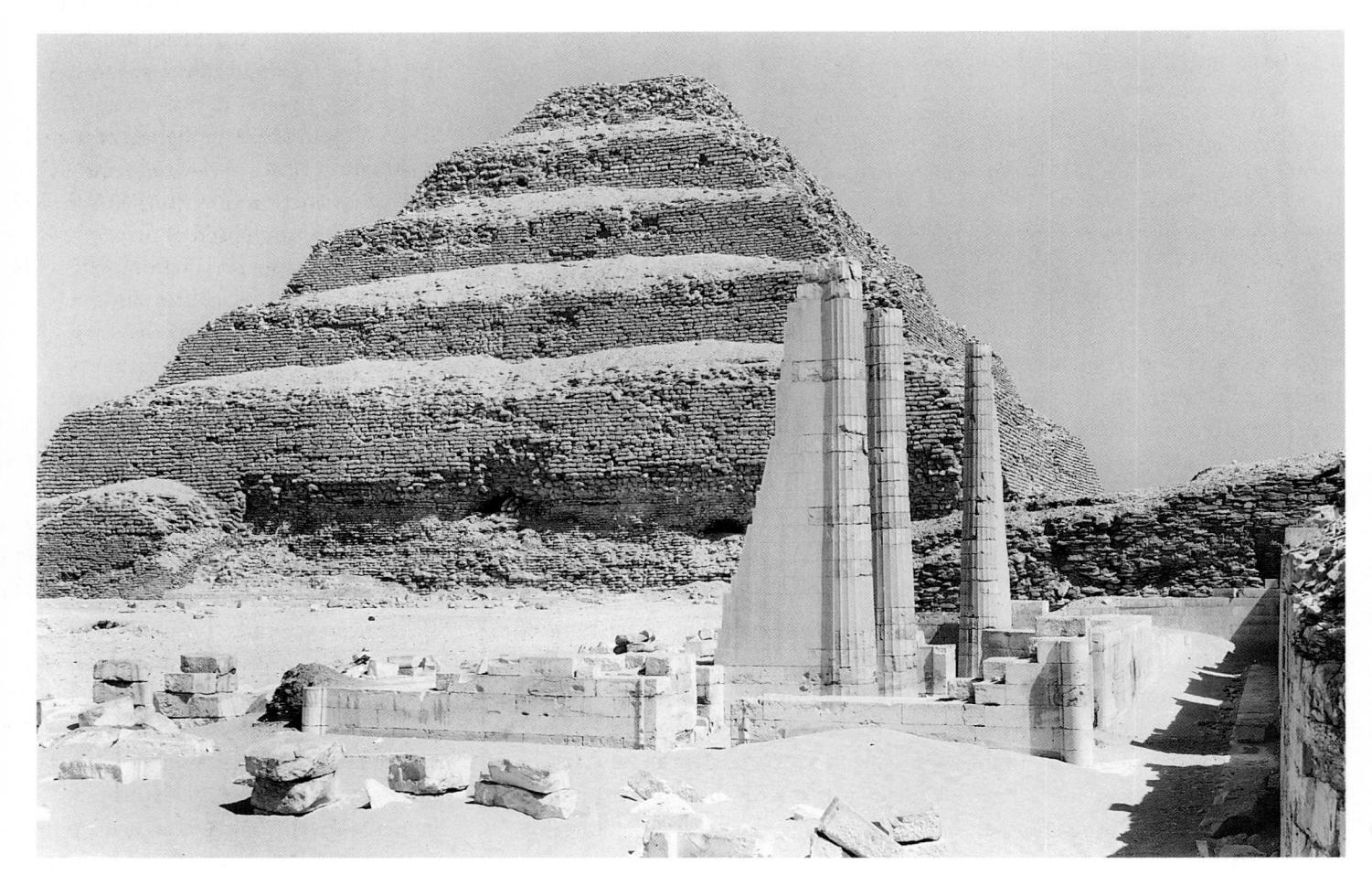

2-5. DJOSER'S FUNERARY COMPLEX, SAQQARA, EGYPT, ATTRIBUTED TO IMHOTEP, DYNASTY 3, C. 2620 BC. STONE (PARTIALLY RECONSTRUCTED)

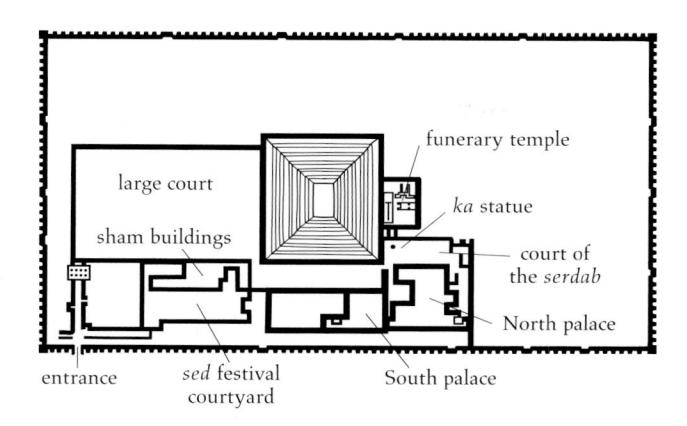

2-6. Plan of the funerary complex of Dioser. Drawing after J. P. Lauer

The west bank of the Nile River, where the sun sinks into the horizon and the dead enter the afterlife, was considered to be an especially suitable site for tombs, just as the east bank (where the sun emerges) was the land of living. The conception of spatial relationships as divisions between east (the place of birth) and west (the place of rebirth) and between north (Lower Egypt) and south (Upper Egypt) was clearly based upon the geography of the Nile Valley. Yet similar emphases upon the cardinal directions appear in art and architecture elsewhere on the African continent, and may be based upon ways of ordering the cosmos which are very old indeed.

the first artist in history whose name is known to us. Djoser's future grave was first marked with a large rectangular platform with sloping sides. The bench-like platform, known by the Arabic word mastaba, was placed over vertical shafts leading to underground chambers where the king would be buried. Previous kings had been buried under similar structures, but theirs were made of adobe, while Djoser's was stone. In a further innovation, five progressively smaller stone platforms were then stacked on top of the mastaba base, giving the finished monument a stepped pyramidal form some 195 feet tall.

The pyramid stood near the center of a walled compound. Next to it was a stone temple for the priests charged with the daily worship of the deceased king and the upkeep of his soul. Near this temple were two non-functional stone replicas of Djoser's

Upper Egyptian and Lower Egyptian adobe-and-reed palaces. At one corner of the compound was a courtyard set up for a royal festival of dominion and rejuvenation known as heb-sed. During the *heb-sed* celebrated by Djoser during his lifetime, tents and reed pavilions served as temporary abodes for the deities. In this vast funerary complex, these temporary structures were reproduced in stone, as if to allow the king's spirit to celebrate his vitality forever before divine onlookers. The entrance to this courtvard was through a corridor ornamented with engaged columns carved to resemble bundles of reeds.

The funerary complex of Djoser had a significant impact upon later architecture. First of all, it inaugurated the use of stone as a suitable material for tombs, especially for the eternal resting place of kings and queens. The task of quarrying stone on such a

scale and of organizing the vast work force needed to build the complex may even have contributed to the development of the Egyptian state. In any case, the effort and expense involved in realizing such a huge project was only possible in a highly organized, centralized society with a large labor pool.

Other influential features were the roof supports and wall ornaments modeled after bundles of reeds or an aquatic plant such as papyrus and lotus. Freestanding columns in the later temples of Kemet continued to evoke these motifs. Supporting the broad roofs of enormous halls, closely spaced rows of such columns symbolized the marshes surrounding the primeval mound, the land that arose from the waters at the world's creation.

Yet the most intriguing innovation of Djoser's complex was undoubtedly the pyramidal shape of the royal tomb. It may have been seen as a version of the stepped podium that a living king mounted during his investiture ceremonies, or as a stairway leading from the earth (the place of mortals) to the sky (the home of the solar god). In any case, the pyramid of Djoser was the first of a great series of pyramidal monuments.

The most famous Old Kingdom pyramids are the three enormous tombs constructed a dozen miles downstream from Saqqara at the west bank site of Giza (fig. 2-7). The oldest and largest of the three pyramids, not visible in this photograph, was built for Khufu (ruled c. 2551–2528 BC). It rises to a height of 481 feet from a perfectly square base oriented to the points of the compass. The smooth white limestone sheath once covering

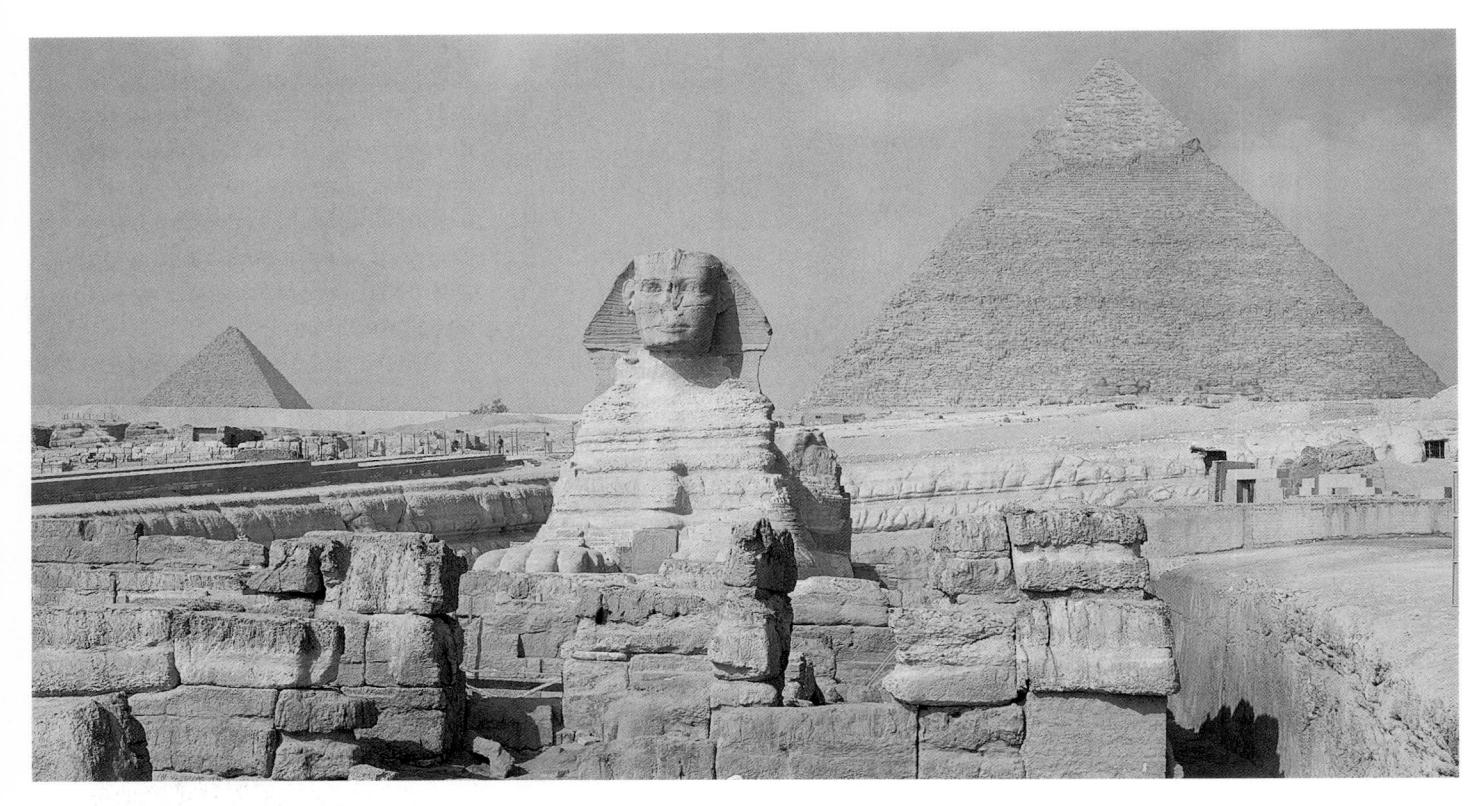

2-7. Sphinx and Pyramid of Khafre, Giza, Egypt, Dynasty 4, 2520–2494 BC. Stone. Height (Pyramid) 450′ (137 m)

it has been stripped away over the centuries. Some of this limestone sheathing still clings to the apex of the pyramid of Khafre (ruled c. 2520–2494 BC), visible on the right of the photograph. The smooth, shining surfaces of all three pyramids must once have reflected the bright sunlight, and the people of Kemet seem to have seen these monuments as channeling or celebrating the sun's sacred, life-giving rays.

Each pyramid has a temple at its base, connected by a long causeway to a second temple on the Nile bank. Smaller pyramids and *mastaba* were built nearby for queens and other members of the royal courts. Near the causeway joining the pyramid of Khafre to the Nile, an outcrop of stone was carved to form an enormous lion with a human head. The

form was extended with stone blocks. This composite beast has become known as a sphinx, a word of Greek origin probably based upon the Egyptian term *shesep ankh* ("living image"). On this example, known simply as the Great Sphinx, the head wears a royal headcloth, and may be identified with Khafre himself. The leonine aspect refers to the power of the divine king, for lions had been emblems of kingship since Early Dynastic times. Similar associations between wild beasts and kingship are common throughout Africa.

Lions roaming the edges of the desert wilderness were also viewed as guardians of the rising and setting sun, and thus this composite creature seems also to have been associated with the horizons, themselves viewed as entrances to the underworld and afterlife. An image of a human figure or a solar disk between recumbent lions was one of the ways to indicate "horizon." In a metaphorical or mystical manner, a king was believed to approach the western horizon to enter into the underworld at sundown and death, and to reappear at the eastern horizon when he returned at dawn and resurrection. As a result of these complex relationships, by New Kingdom times the Great Sphinx was known as Horemakhet, meaning "Horus in the horizon," and was honored as a protective, divine image.

The third and smallest pyramid was constructed for the king Menkaure (ruled c. 2490–2472 BC). The walls of this pyramid's two funerary temples and the causeway that linked them were lined with

fine-grained stone statues, among them an idealized image of Menkaure himself and his Great Royal Wife, probably Queen Khamerernebty II (fig. 2-8). Khamerernebty shares the heavy wig and facial features of nearby sculpture depicting the bovine goddess Hathor. Since the principal queens of the Old Kingdom (both great royal wives and the mothers of kings) seem to have embodied the divinity of Hathor, this resemblance may have been deliberate. Khamerernebty's protective gesture is appropriate for a mother of a future king, who provides her husband with

spiritual support.

The smooth and subtle surfaces of the statue suggest that the king and queen have young, firm bodies. Their slim waists and thick legs provide both solidity and grace, and their joined pose communicates strength and dignity. The artist or artists may have intended to cover the stone surface with a layer of painted plaster, a common practice in the Old Kingdom. If so, the pair would have been even more lifelike. However, their erect posture and their stances (arms at the side, fists clenched, one foot forward) are almost as conventionalized as those of Narmer's palette, and their poses reappear in the art of Kemet until the beginning of the Christian era.

The Middle Kingdom is perhaps best known for art found in the tombs of the non-royal elite. While most human and animal figures placed in Middle Kingdom tombs were quite naturalistic, some images were highly abstracted, such as this flat, paddle-like female form carved in wood and painted with geometric patterns (fig. 2-9). The head and arms 2-8. Menkaure and Khamerernebty, from the funerary complex of Menkaure, Giza, Egypt, Dynasty 4, 2490–2472 bc. Greywacke. Height 56" (1.42 m). Museum of Fine Arts, Boston. Harvard University—Boston Museum of Fine Arts Expedition

The height and facial features of Menkaure and his consort seem very much alike, and we know that they were half-siblings, both children of Khafre. Such royal incest set the king apart from normal mortals, and mirrored the incestuous marriages of gods. However, the union of royal brothers and sisters in Old Kingdom Kemet may have also served to repeat the creation of the world, when primordial twins Shu and Tefnut were the first beings to emerge and procreate. The people of Kemet valued duality in art and thought, and the king and queen form two halves of a single dyad.

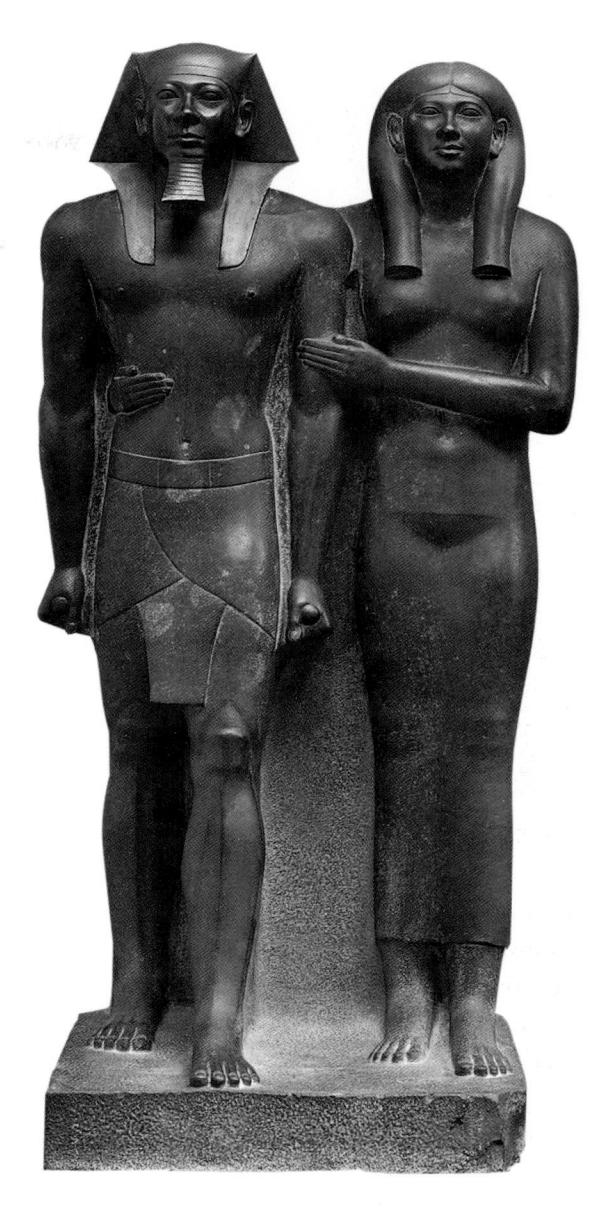

are tiny, while the mass of hair, the pubic triangle, and the contours of the hip region are greatly enlarged. The people of Kemet considered abundant, well-groomed hair to be erotic, and the emphasis on genitalia suggests that the figure is concerned with sexuality. The hair is made of tiny beads formed from the black mud of the Nile floods, and was considered imbued with the mud's life-giving fertility. The wood may be sycamore or one of the other trees sacred to

goddesses of sexuality and mother-hood. Figures such as this have been found in Middle Kingdom houses as well as tombs. Evidently personal possessions of the deceased, they were assuredly not playthings, for they were owned by men and women of all ages.

Female figures in many different forms have been found in tombs of both Kemet and Nubia through the first millennium BC. The clay images of the early Nile cultures discussed

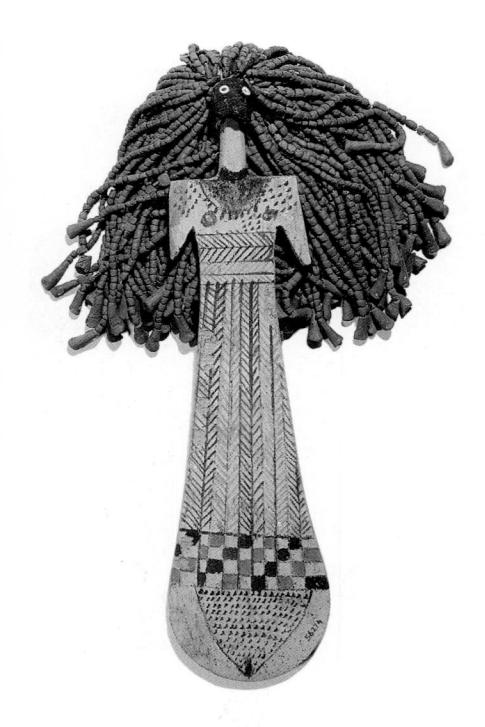

2-9. Female figure, from a grave at Waset (Thebes), Egypt, Dynasty 11, 2050–1991 bc. Wood, pigment, clay. Height 9" (23 cm). Egyptian Museum, Cairo

earlier may well have been their prototypes (see fig. 2-2). Interesting parallels to such female figures may be found in doll-like wax objects given to girls in central Sudan today. In fact, in many African regions similarly abbreviated female figures in wood or wax are given to young people when they are betrothed, or to women who have had problems conceiving a child. Although there is no clear link between the Egyptian and Nubian female figures and these other African works, it seems safe to generalize that all of these images may have had a role in protecting the sexual and reproductive health of their owners. In Kemet, this protective role would have made them quite suitable as grave objects, for by the time of the Middle Kingdom the souls of the dead seem to have been expected to draw upon sexual energy in order to be born again in the afterlife, just as sexual union is necessary for birth into the world of the living.

New Kingdom

The New Kingdom was the era of Kemet's greatest military and political expansion. To the south, Egyptian control reached far into Nubia. To the north, alliances were formed with peoples of the Mediterranean and Western Asia. As in the past, tombs were full of artistic treasures, but now grave goods were particularly lavish. Allusions to sexuality and rebirth were still important in New Kingdom tombs, but there was a new emphasis upon the god of death and rebirth,

Osiris, his consort and redeemer, Isis, and his son and champion, another manifestation of Horus.

Funerary chapels adjacent to the sealed burial chamber served as settings for annual memorial ceremonies. Their walls were adorned with paintings, or with painted images carved in low relief, which often portrayed the feasting, music, dancing, and drinking desirable at a memorial festival. In addition to inspiring the family who gathered to commune with their ancestors, these murals encouraged passersby to visit the chapel, where they might leave a small gift for the deceased.

A particularly beautiful New Kingdom painting (fig. 2-10) was removed from the walls of a chapel

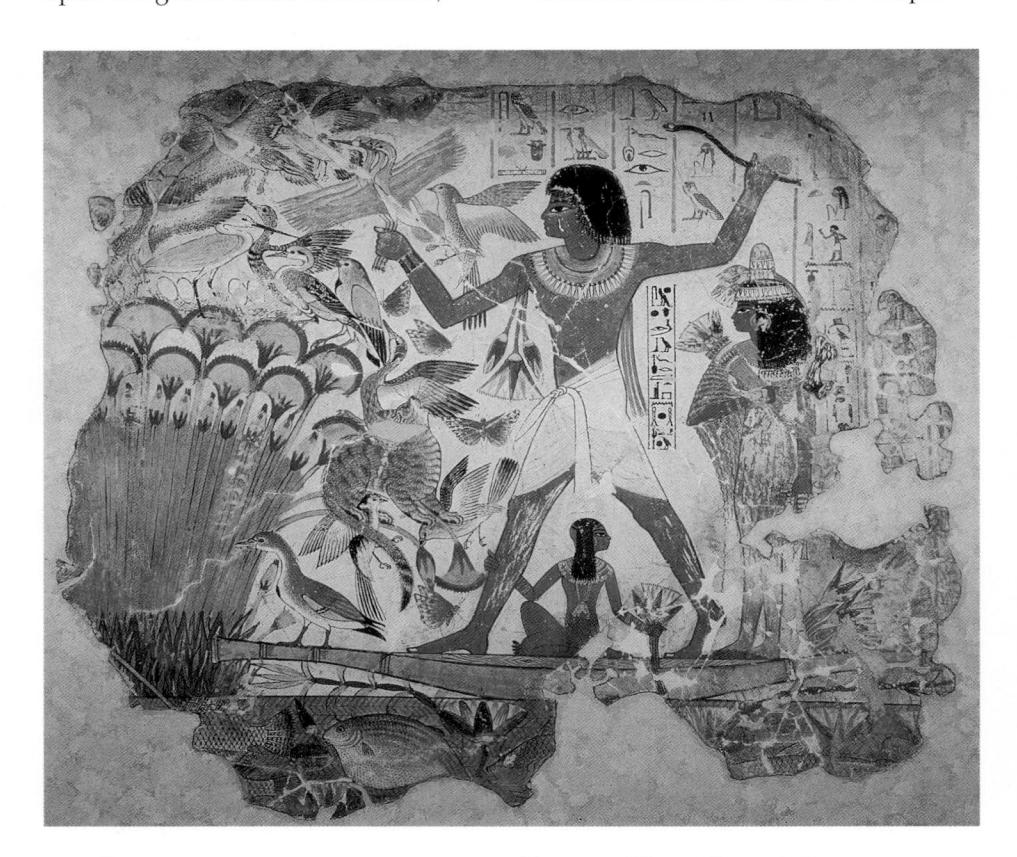

2-10. Fragment of a scene, from the tomb of Nebamun, Waset (Thebes), Egypt, Dynasty 18, c. 1350 BC. Pigment on Plaster. Height $32\frac{1}{2}$ " (83 cm). The British Museum, London

that may have belonged to a man named Nebamun, in the funerary district west of Waset (Thebes). The scene is both visually rich and conceptually dense. On one level, the deceased man is depicted young and alive, enjoying a pleasant family outing on the river. He stands in a reed boat, with his beautiful wife behind him and his young daughter between his feet. Both female figures are much smaller in scale than the man, one of whose hands is raised to throw a stick while the other grasps a clutch of waterfowl.

Yet the man's aggressive gesture recalls that of Narmer, and it proclaims the ability of the deceased. aided by the feral cat, to emerge victorious from the dangers of the transition from death to life. The marsh setting evokes the battle of Horus and his dangerous rival, the crocodile-like Seth, suggesting that the tomb owner's triumph over death replicates Horus's victory over his enemy. Isis, the goddess who prepared her husband Osiris for resurrection, also performed her magical acts of restoration in the marshes of the Nile. Finally, marshes were linked to the creation of the world in Egyptian thought as the place where life and order arose from chaos, just as rebirth and reordering will prevail over the chaos of death.

This fragment from the chapel walls also contains references to the creative power of human sexuality. The verb for "launching a throwing stick" was also the verb for "ejaculate," while the word "throwing stick," *qema*, also meant "to create" or "to beget." The action of the deceased is thus a visual pun. The elegant young wife, holding objects used

in the worship of Hathor, is obviously dressed for a feast or ceremony, not a day in the country. The child is placed in a position to remind us that she is the fruit of the owner's loins. All these layers of meaning are echoed by the *medu netcher* written between husband and wife, which translate as "enjoying oneself, viewing the beautiful . . . at the place of the constant renewal of life."

The interlocking references to sexuality and rebirth are found in objects left in tombs as well as in tomb paintings. A mirror originally made for the bedroom or the tomb consists of a shining disk in the shape of the lifegiving sun, supported on the head of a naked young woman wearing the wig of Hathor (fig. 2-11). The object joining the sun disk to the head of the figure, probably an aquatic plant, meets her outstretched arms so that the enclosed space gives the impression of wings. As Egyptians portrayed the human soul as winged beings, this may be a further allusion to spiritual life as well as physical beauty.

The scene in the tomb of Nebamun was probably painted during the reign of Amenhotep III, father of the extraordinary Dynasty 18 king who began his reign as Amenhotep IV but then changed his name to Akhenaten, "son of Aton." With this change the king proclaimed his devotion to the deity Aton (or Aten), whom he worshiped as a supreme being, and the corresponding suppression of the worship of Amun (also Amen or Amon), the solar deity of Waset. Akhenaten built a new capital. Akhetaton, whose ruins are now known as Tel el-Amarna. The period of his rule is thus called the Amarna Period (c. 1353–1333 BC).

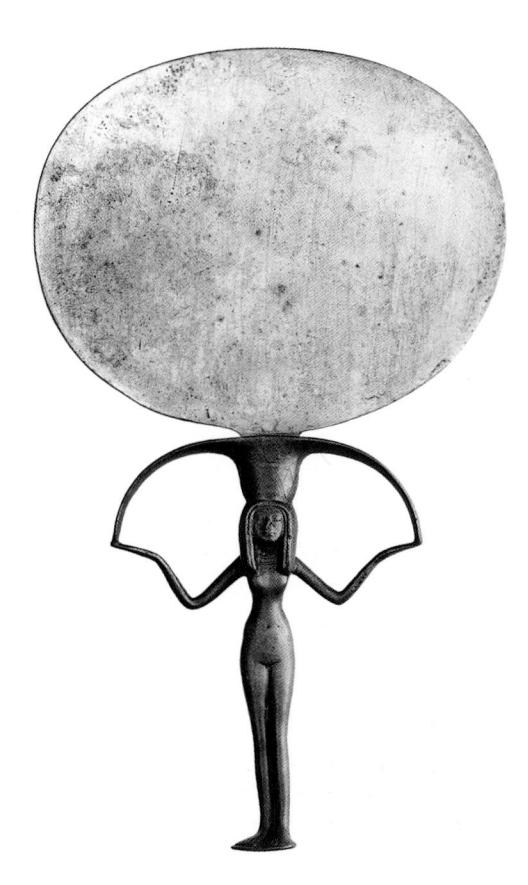

2-11 Mirror with female figure, Egypt, Dynasty 18. Copper alloy. Brooklyn Museum, New York

The varied uses of this African object revolve around its ability to reflect the image of the beholder during life and its presence in the tomb after death. The shape resembles the ankh, the Egyptian symbol for spiritual life. Egyptians portrayed human spirits with wings, and the female figure that forms this mirror's handle is posed so that her outstretched arms connect with the object on her head to give an impression of wings. These references to life and to beauty were enhanced by the reflective surface of the sunlike disk, an image of the life-giving sun. Unclothed young women such as this were depicted on many works destined for the bedroom and the tomb, for they were meant to evoke the sexuality leading to both child-bearing and to rebirth of the soul in the afterlife. The heavy wig may link this figure to the wigged Hathor, the primordial goddess associated with the sun and with female sexuality.

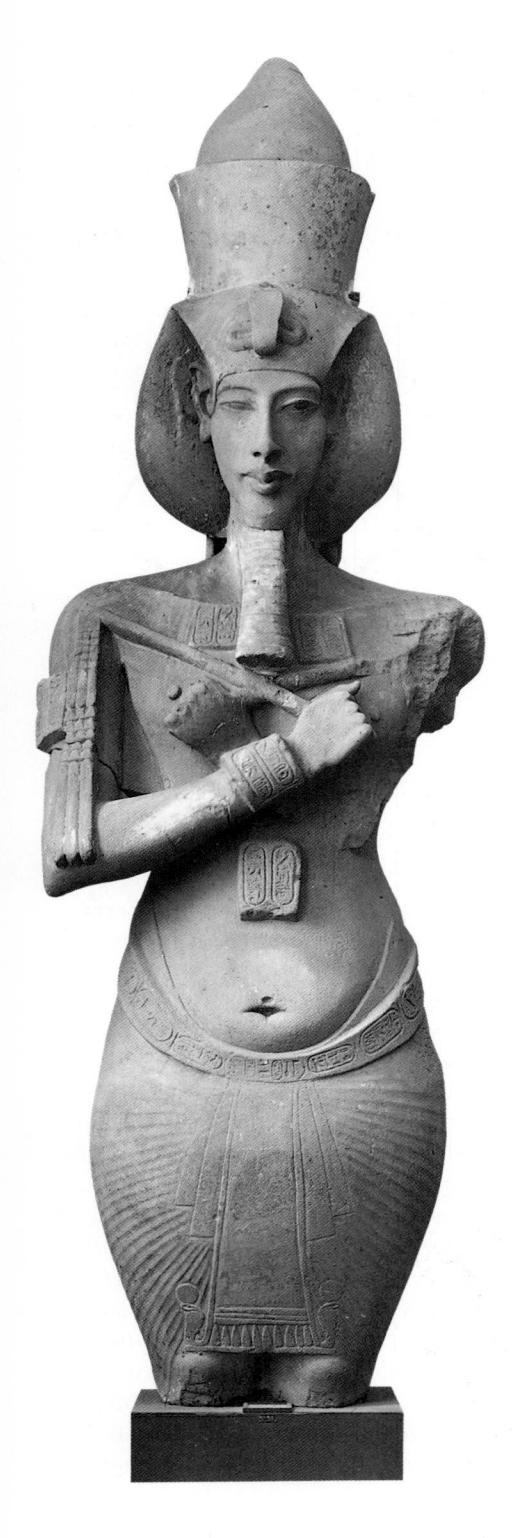

2-12. COLOSSAL STATUE OF AKHENATEN, FROM A TEMPLE OF ATON, KARNAK, EGYPT, DYNASTY 18, AMARNA PERIOD, 1353–1335 BC. SANDSTONE. HEIGHT 13' (3.96 M). EGYPTIAN MUSEUM, CAIRO

Akhenaten has always been a highly controversial figure. He may have been a religious mystic, or he may have been a wily politician who sought to curb the wealth of the powerful priesthood of Amun and the other gods. He composed or commissioned evocative hymns to Aton as Lord of Creation, and his chief sculptor, Bak, wrote that he had been instructed by Akhenaten himself. Thus the king seems to have played an important role in developing a new artistic language to express his radical restructuring of Egyptian cosmology.

An excellent example of the earliest and boldest art commissioned by Akhenaten is a fragment of a colossal sandstone statue representing the king himself (fig. 2-12). Over three times life-size, it is one of several statues of Akhenaten discovered in the ruins of a temple to Aton near Waset. All had been thrown down and desecrated after Akhenaten's death. The headdress and the crossed crook and flail are familiar Egyptian symbols of kingship, but the proportions of the face and figure are completely novel.

Bak and the other artists working for Akhenaten were purposefully rejecting previous Egyptian conventions in favor of a different, equally artificial system of representation. The head is elongated, with sharp planar cheekbones, narrowed eyes, sensuous lips, enormous ears, and a prominent chin. The slim waist, broad hips, full pectorals, and distended abdomen evidently portray Akhenaten as a bisexual being, the embodiment of the creator and omnipresent god Aton. As the son of Aton, Akhenaten no longer worshiped separate male and female

deities, but a single creator who was the source of both male and female sexuality. In the words of one of his hymns, Aton was "all alone and shining."

Figures and reliefs created later in the Amarna Period were somewhat more naturalistic. We would know little about art from the end of Akhenaten's reign, and from the reigns of his successors, if an archaeologist named Howard Carter had not discovered the tomb of Akhenaten's son-in-law, Tutankhamun, in 1922. Compared to the powerful New Kingdom kings who preceded and followed him, Tutankhamun (c. 1333-1323 BC) was a minor ruler indeed. Yet his tomb, unlike theirs, survived almost intact into the modern era. As we contemplate the fabulous treasures buried with this adolescent king, we must remember that most kings of Kemet were given far richer burials.

In one of the underground chambers of Tutankhamun's small tomb, Carter discovered a large rectangular sarcophagus. Inside it were three coffins, including one of solid gold. The mummified body of the young pharaoh still lay within, its head, chest, and arms encased in gold inlaid with semi-precious stones. After the garlands of long-dead flowers were removed, the expedition's photographer recorded the appearance of the body in its golden mask and golden gloves (fig. 2-13). Although only partially cleaned, the lustrous gold of the helmet mask still shines with the radiance of the life-giving sun. The precious metal affirmed the divinity of the king, for the flesh of the gods was gold and it never decayed. The cobra and the vulture, symbols of

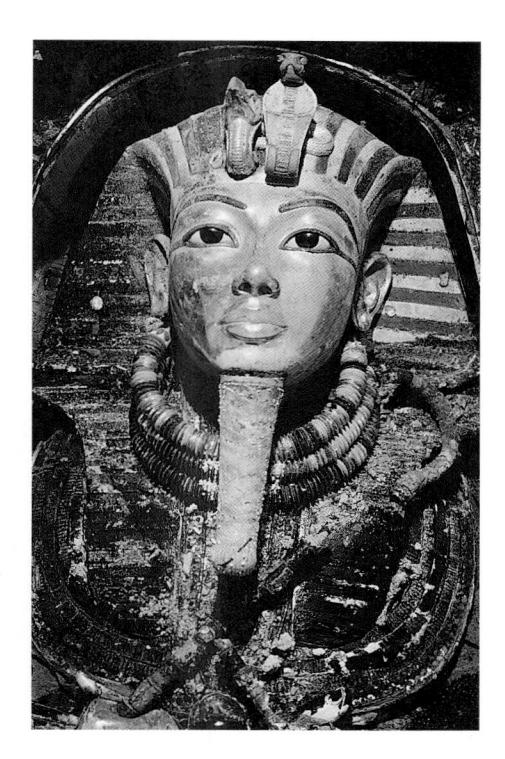

2-13. Funerary mask of Tutankhamun as DISCOVERED IN HIS TOMB, VALLEY OF THE KINGS, EGYPT. PHOTOGRAPH 1922

protective goddesses, are clearly visible on the brow of the mask.

Among the hundreds of art works accompanying the young king was a headrest carved of elephant ivory imported from the south (fig. 2-14). As in other African cultures, headrests supported the heads of sleepers in Kemet, taking the place of a pillow, and were treasured personal possessions. During the New Kingdom, headrests were also placed in tombs to protect the neck and fragile head of the deceased. This example is formed of a kneeling male figure holding the curved neck support. The figure's soft stomach reflects the lingering influence of the Amarna style. A small lion lies on each side of the oval base. The headrest is thus a reference to "horizon," for these are the lions of the desert that flank the hills framing

the rising or setting sun. Here the hills are formed by the curve of the upper surface, and the head of the king would have taken the place of the sun. Falling asleep and rising from sleep were thus linked metaphorically to the journey of the sun as it sets yet rises again. Conceptually, this small ivory object is related to the Great Sphinx, the colossal leonine sculpture near the pyramid of Khafre (see fig. 2-7).

By Dynasty 19 (1307–1196 BC), increasingly elaborate mummification processes were used for royals and non-royals alike, and the ceremonies designed to bring the souls of the dead safely into the afterlife became more codified. Funerary practices in Kemet during this period were similar to those of many other African peoples, in that deceased elders were elevated to ancestral status by the rites performed by their heirs.

Preparations for the afterlife were recorded and illustrated in long papyrus scrolls buried with the dead. Because the prayers, actions, and directives were present in the tomb as word and image, the people of Kemet believed that they were eternally and perfectly recited and re-enacted for the deceased. Such collections of funerary texts are known to Egyptologists as the Book of the Dead; in Kemet they were called Coming Forth by Day.

One of the most important rituals recorded in these collections is the Opening of the Mouth ceremony (fig. 2-15). These rites were performed both on a statue placed in a temple or funerary setting and, as illustrated

2-14. Headrest, from the tomb of TUTANKHAMUN. EGYPT, DYNASTY 18, 1333-1323 BC. IVORY. HEIGHT 6¾" (17.5 CM). EGYPTIAN MUSEUM, CAIRO

2-15. Opening of the Mouth Ceremony, from the Book of the Dead of Hunefer. Egypt. Dynasty 19, c. 1300 BC. Pigment on Papyrus. Height 18'' (45.7 cm). The British Museum, London

here, on a mummy before it was sealed into a tomb. The carver's adze was applied to the inanimate figure's lips during the ceremony, as if the physical act of cutting out the mouth supernaturally allowed the statue or mummy to breathe. The priests depicted in this papyrus carry the adze and other implements in addition to water vessels for purification. They are supervised by a temple official, or possibly by the heir himself, who wears a leopard skin and holds a smoking censer of incense. Both the leopard pelt and the incense would have been imported from the south, either from Nubia or through Nubian intermediaries.

To the far right is a tomb in the shape of a tapering pillar topped with

a small pyramid. Now known as an obelisk, this form was called *tekhen* by the people of Kemet, who used it in several contexts. Enormous monolithic *tekhen* commonly flanked temple entryways. In front of the tomb is a stone slab covered with *medu netcher*.

The two women in attitudes of grief who touch the mummy may be impersonating the goddesses Isis and Nephtys, just as the deceased was believed to become the goddess's brother, Osiris. Behind the mummy stands the jackal-headed god of the dead, Anubis. It is possible that the role of Anubis may have been played by a masked attendant, although we cannot draw such a conclusion from the evidence of illustrations such as

this one alone (just as we cannot be sure that the peoples of the Sahara used masks thousands of years ago on the basis of their art alone; see chapter 1). The papyrus probably places Anubis in the scene as a symbolic, invisible presence. Yet two masks of Anubis are known to exist in museum collections, and their rarity might be due to some type of ceremonial destruction. If masquerades did indeed play a role in the religion of Kemet, religious experiences in this ancient culture would have been more similar to those of the peoples of western and Central Africa, and less similar to those of the peoples of northern and northeastern Africa, than we have previously believed.

KUSH

The A-Group culture of Lower Nubia, discussed earlier, flourished until roughly the beginning of the Old Kingdom in Kemet. Slightly later, around 2300 BC, a new cultural phase called C-Group emerged in northern Nubia, while near the third cataract a wealthy cultural center arose at Kerma (see fig. 2-3).

Kerma and the C-Group culture were overwhelmed around 1500 BC, when Kemet at the beginning of its New Kingdom conquered Nubia as far south as the fourth cataract. With the waning of Egyptian power at the end of the New Kingdom, however, a new Nubian polity arose between the third and the sixth cataracts of the Nile, in the region where the river curves back toward the southwest before resuming its northward course. It is known as the kingdom of Kush.

The culture of Kush synthesized Nubian and Egyptian elements,

2-16. Plan of the temple of Amun at Gebel Barkal, Nubian, Sudan. Drawing by Pierre Hamon

reflecting both the centuries of Egyptian presence in Nubia and the heritage of Kerma. The kings of Kush built pyramidal tombs near their capital, Napata, and placed within them art works of gold, silver, and rock crystal. In the eighth century BC, Kushite kings responded to a period of divided rule in Kemet by marching northward and unifying it. Their reign forms Dynasty 25 of Egypt (770–657 BC), and ushers in the Late Period of Egyptian history.

As rulers of Egypt, the Kushites did not consider themselves to be alien overlords. In fact, they attributed their victories to the divine favor of the gods of Kemet, whose worship had been neglected during the upheavals following the end of the New Kingdom. The rulers of Kush particularly honored Amon or Amun, the solar deity of Waset, for they believed that his true home was a sacred mountain near Napata. New Kingdom kings of Kemet had built a temple to Amun in the shadow of this rocky peak, and the first kings of the Kushite Dynasty restored and expanded it. The site of the temple is known today by its Arabic name, Gebel Barkal, meaning "mountain of holiness."

Only the foundations of the temple of Amun at Gebel Barkal are visible today, but they have enabled archaeologists to reconstruct its plan and general appearance (fig. 2-16). There may have been an encircling wall of adobe or molded clay surrounding the entire structure, for in Kemet temples were identified in this way with the primal, muddy mound of creation. A monumental gateway, or *bekhenet*, marked the southern entrance to the structure. Usually known by the

Greek word "pylon," a bekhenet took the form of two flat, sloping towers linked by a shorter, rectangular portal. Such gateways were a feature of temples in Kemet from at least the Middle Kingdom, and were usually adorned with protective images. In some New Kingdom temples the bekhenet faced east so that the open space above the portal and between the towers framed the rising sun. At Gebel Barkal, however, the bekhenet faces southeast, and the temple as a whole serves as a forecourt to the sacred mountain itself. Two grooves on each tower would have held wooden poles where banners or pennants were attached.

The stone walls of the open courtyard directly behind this first bekhenet were lined with columns in the shape of enormous aquatic plants. Colossal statues of Kushite kings stood in their midst. Beyond a second gateway, adorned with four more flagpoles, a longer and narrower courtyard was lower, darker, and filled with columns that also evoked the tall reeds of the primordial swamp. Only priests and rulers were allowed within the maze of small chambers behind the next gateway. There the image of Amun was kept in the innermost sanctuary, a room that represented the place of creation itself. At annual festivals, processions of priests carried the image from the dark heart of the temple, through the long courtyards, out to the bright sun at the first gateway.

A causeway leading to the entrance of the temple was flanked by stone sculptures of rams, the emblematic animal of Amun. Figures of rams were also found before a temple at the site of Kawa (modern Dongola),

Aspects of African Cultures

Techniques for Dating African Art

When writing was invented in Egypt some five thousand years ago, kings commemorated events (and dated monuments) by assigning them to a certain year of their reign. Gradually this relationship switched, so that an important event (the foundation of Rome, the establishment of the Han Dynasty, the birth of Jesus, Muhammad's hijra to Medina) could determine the number of the year. Thus Christians divided time into the years "before Christ" (BC) and those that were the anno Domini (AD), the "year of the Lord." The English abbreviations of Muslim labels for time are BH (before the hijra) and AH (after the hijra). There is, of course, no cross-cultural way to describe time (the terms cE for "Common Era" and BCE for "Before Common Era" simply attempt to make Christian dates universal), with the exception of the designation preferred by archaeologists, BP (Before Present).

Yet in African cultures which resisted literacy until the modern era, these terms are immaterial; history is fluid, and the ancient objects inherited by the living are never accompanied by written labels. Scholars still seek ways to provide art works with firm dates.

If a work of art has been mentioned by someone in a dated manuscript, that notation serves to fix a *terminus ante quem*, a "point before which" a piece was in existence. For example, a Dutch traveler described seeing clay figures at an Akan funeral in 1602, so we know that this type of funerary object was made before that date. A *terminus post quem*, a "point after which" can also be used to date works; a crucifix from a kingdom of the Congo people can only have been made after the king converted to Christianity in 1491.

Yet since so few outside visitors to Africa in the pre-colonial era recorded detailed information on the figures, masquerades, or architecture they encountered, most archival and published material comes from reports drawn up in the colonial period, and from anthropological research conducted since the 1920s. And these written descriptions mention so little in the way of art that many tentative dates are based upon fragmentary information gathered from African elders, expatriate collectors, and foreign gallery owners who have seen, heard about, sold, or purchased the art work.

In the case of particularly old African objects, archaeologists and art historians resort to scientific analysis. The most accurate dating process is known as radiocarbon dating, or Carbon-14. It relies upon the regular rate at which Carbon-14, a substance found in all living things, begins to decay and turn to Nitrogen-14 after the death of the plant or animal. Organic remains can thus be tested to find what proportion of the Carbon-14 has decayed, and thus how many years ago the organism was alive. Even if an art work is made of stone or metal, organic material buried with it may be used to provide its terminus ante quem. Obviously, the accuracy of the test depends upon the purity of the sample (was it contaminated by a recent campfire, or by a sprinkling of cigarette ash?).

Fired ceramic objects may be subjected to thermoluminescence testing; samples are heated until they release light, and the amount of light emitted demonstrates how much energy has been absorbed by the sample since the clay was last fired. However, this type of analysis is not very reliable, and archaeologists usually subject the earth found in and around the object to separate analyses. The condition in which the object was found also needs to be recorded, so that the humidity and the solar radiation absorbed by the piece may be taken into account. Thus art works separated from their place of origin cannot be securely dated by thermoluminescence dates alone. MBV

about a day's journey upstream from Kerma. Also from Kawa is a sculpture of a composite creature (fig. 2-1). It portrays a Kushite ruler of Kemet, Taharqo (ruled c. 690–664 BC), with the body, ears, and short mane of a lion. Although the headdress of double cobras was given only to Nubian kings, the combination of leonine and human features was well established in representations of the kings of Kemet, such as the Great Sphinx, Khafre's huge protective structure at Giza (see fig. 2-7).

After almost a century of Kushite rule, kings arose in Kemet to form new dynasties. Warriors from Western Asia invaded the Nile Valley on two separate occasions, but were driven back by Egyptian armies. Meanwhile, the Nubians moved their capital to Meroe, far to the south, a move that marks the shift from the Napatan to the Meroitic phase of Kush. By 337 BC, Nubian rulers were also buried at Meroe rather than Napata. Deep in the southern reaches of Upper Nubia, between the fourth and sixth cataracts, the kings and queens of Kush were to reign for seven more centuries.

The pyramids erected at Meroe for the kings and queens of Kush attest to the rich history of this enduring Nubian kingdom (fig. 2-17). Built between 337 BC and AD 339, they are much smaller than the Old Kingdom tombs constructed at Giza more than three thousand years earlier. In contrast to the pyramids of Kemet, each of the four faces of these pyramids is an isosceles triangle, and ridges along each side lead the eye upward. A mortuary temple with a *bekhenet* entrance attached to each tomb marked the last point

of contact between the living and the dead.

From the pyramid of Queen Amanishakheto at Meroe comes a gold ornament made during the first century BC (fig. 2-18). Many of the images depicted on this precious object are familiar from the art of Kemet, including the ram's head of the solar deity Amun and the circular sun above it. Behind the solar disk is a portal, the central portal of a bekhenet, perhaps representing the entrance to a temple or tomb. The erect snakes at the top were associated in Kemet with an ancient protective goddess. Yet while images on this object were also common in the art of Kemet, their combination has no counterpart in the north. A fringe of cowrie shells (or gold replicas of cowries) originally hung along the lower edge of this piece of jewelry. In Kemet, cowrie shells were associated with female genitalia because of their shape, and were worn by women as amulets to safeguard their sexual and reproductive well-being. Nubians probably used these shells in the same context. It is interesting to note that cowries are still worn today by women and babies in northeastern Africa for protection and blessing. This gold object may have been a ring that covered the entire hand, or an ornament worn on the chest or on a belt. As recently as the mid-twentieth century, women from this region of Sudan wore golden disks on their foreheads. Perhaps the ornament here was the centerpiece of Queen Amanishakheto's headdress, a distant prototype of more recent Nubian jewelry.

Many temple forms were used by the Nubians during the Meroitic phase of Kush, including some evi-

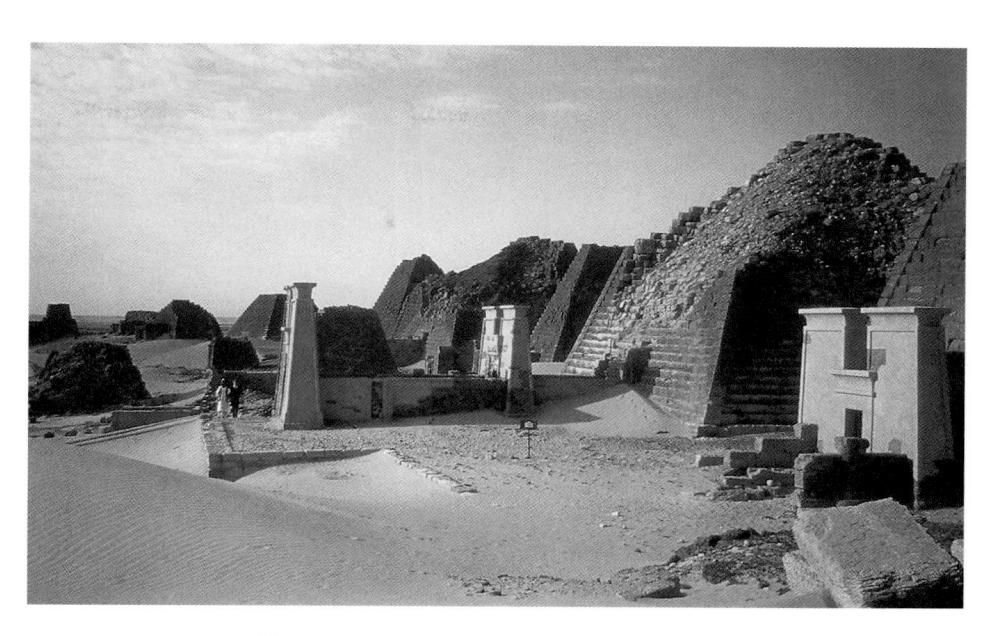

2-17. Royal Pyramids, Nubian, Meroe, Sudan, C. 337 BC-AD 339. Stone

A nineteenth-century Italian adventurer searching for treasure dynamited many of the pyramids at Meroe, causing much of the damage evident in this photo. He took the burial goods of Queen Amanishakheto from the blasted rubble of her tomb.

2-18. Ornament from the tomb of Queen Amanishakheto, Nubian, Meroitic Period, 50–1 bc. Gold with glass inlay. Height 25/6" (5.5 cm). Staatliche Sammlung Ägyptischer Kunst, Munich

dently equipped with enclosures for elephants. An example of the simplest is the temple to the lion-like god Apedemak at the site of Naga, or Naga (fig. 2-19). Commissioned by King Natakamani and Queen Amanitare during the early first century AD, this temple was a smaller and more compact version of the temple of Amun at Gebel Barkal (see fig. 2-16). The facade of the bekhenet, shown here, is carved with monumental reliefs, which were originally highlighted with bright colors. On either side of the entrance, King Natakamani and Oueen Amanitare are depicted smiting their enemies in poses almost identical to that of Narmer on his palette (see fig. 2-4). Instead of Narmer's single prisoner, however, these rulers hold great clusters of captives, and a lion rather than a bull refers to the divine power assisting them. While some three

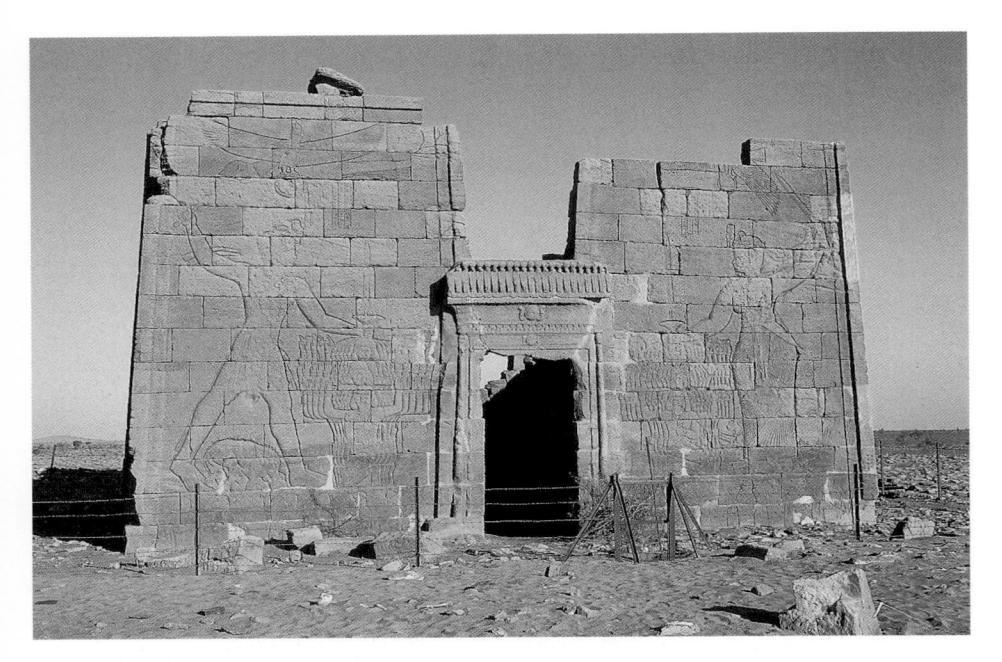

2-19. Bekhenet (Gateway) of the temple of Apedemak, Nubian, Naqa, Sudan, Meroitic Period, 1st century ad

The sloping gateways, or bekhenet, of the temples of Kemet and Nubia marked the rising and setting of the sun, its birth and rebirth. These gateways are often known as pylons, after the Greek word for gate, and the sanctuaries are thus called pylon temples by some art historians.

thousand years separate the Palette of Narmer from this temple, the meaning of the rulers' gestures may have remained fundamentally unchanged: the rulers are manifestations of divine justice, they act on behalf of the gods for their people, they create a secure world for the worship of the gods.

The artists of Meroe often portrayed their queens as large and heavy, as is the case with Queen Amanitare here. According to historical sources, the queen, *kandake*, of Meroe was a powerful figure politically. Since kingship in Meroe was matrilineal, rulers inherited their position from their maternal uncles. A *kandake* was either the partner of the king (as was the case for Amanitare) or a ruler in her own

2-20. Reserve head of a man, Nubian, Meroitic period, 4th century ad. Sandstone. Height 10½" (26.7 cm). Sudan National Museum, Khartoum

right who could have a male consort. The slender proportions used by artists for the royal women of Kemet, where few queens wielded such political power, may have seemed inappropriate in Nubia. Nubian conventions may better have suited a woman of strength and majesty, and perhaps reflect status rather than actual physical appearance.

An intriguing sculpture dating from the early fourth century AD, toward the end of the Kushite civilization, may be an example of what scholars call "reserve heads," after the theory that they functioned as replacements for the mummified body, as places for the soul should the body decay (fig. 2-20). Such heads are also known from Old Kingdom Kemet, some two thousand years earlier. This abstracted Meroitic sculpture is clearly not a detailed portrait of the deceased. In some ways it even appears to share the simplified styles of works from the earliest Nile cultures of the fourth millennium BC (see figs. 2–2, 2–3). The lines across the forehead repeat the grooves marking the eyes and mouth. While these parallel lines across the brow may depict a headband, they may also represent scarification. Today Nuer warriors in southern Sudan incise their brows with identical furrows to celebrate their bravery and strength, their adult status, and their ethnic identity.

AKSUM AND ITS TIME

While Meroe flourished in Upper Nubia, Kemet became increasingly tied to the political events of Western Asia and southern Europe. Conquered and ruled first by the

Assyrians, then by the Persians, the country finally fell in 332 BC to the invading armies of the Macedonian king Alexander, one of whose generals founded the Ptolemaic Dynasty (304-30 BC) of Egypt. Egypt became a possession of the Roman empire in 30 BC when the Ptolemaic queen Cleopatra VII was defeated by the Roman general Octavian (later Augustus). After the Roman empire was split into eastern and western territories during the fourth century AD, Egypt was administered by the eastern Byzantine emperors, who reigned at Constantinople (presentday Istanbul).

The Greeks, Romans, and Byzantines all engaged in trade along the Red Sea, in some cases even traveling by ship to distant India. It was the Red Sea trade, in part, that caused the state of Aksum to flourish in the Ethiopian highlands, and it was Aksum that emerged as the strongest of the three Nile civilizations at the beginning of the Christian era.

Egypt in the Sphere of Greece, Rome, and Byzantium

Egyptian art in the Ptolemaic Period included many conscious revivals of past styles, for the Ptolemies portrayed themselves as heirs to the glories of the New Kingdom. Religion for ordinary Egyptians, meanwhile, came to stress personal ties to specific deities, ties that could be strengthened through pilgrimage to the deity's holy city. There animals sacred to the deity were raised in the temple precinct. Ceremonially killed and mummified by priests, they were sold to pilgrims, who left them in the sanctuary as offerings.

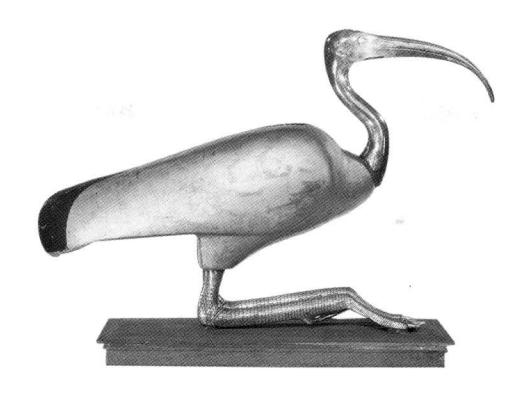

2-21. Coffin for an Ibis, Egypt, Late Period, 332–30 BC. Wood, Gold, Silver, Rock Crystal. 23% x 15'' (58.8 x 38.2 cm). Brooklyn Museum, New York

2-22. Tapestry band, Egypt, Coptic, ad 475–500. Flax and wool. $57\frac{1}{4}$ x $10\frac{1}{4}$ " (147 x 26 cm). Musée du Louvre, Paris

Animal sacrifice was thus an important feature of Egyptian religion during the Ptolemaic Period. Wealthier worshipers often provided the holy animal with a splendid coffin in the shape of the animal itself. One particularly beautiful sarcophagus was built just prior to Ptolemaic rule for a sacred ibis of the god Thoth (fig. 2-21). Manifest as an ibis or a baboon, Thoth was believed to be present at the final judgment of the soul, and his blessing was needed for the afterlife. The ibis, like the hornbill in other African cultures, was viewed as an embodiment of divine wisdom. This precious object served as a reliquary, a container of Thoth's sacred power, as well as a gift linking deity and supplicant.

The ungainly appearance of the living bird has been transformed by the sculptor into an elegant, asymmetrical arrangement of forms. The simultaneous attention to detail (on the head and feet) and overall composition is particularly satisfying. The

expensive and supernaturally potent materials of gold (associated with the sun and the flesh of the gods) and silver (associated with the moon, with the bones of gods, and with the foreign lands where it was mined) indicate that this ibis was offered by someone with unusual wealth, or by a person with a particularly pressing need for Thoth's divine favor.

The worship of ancient Egyptian gods and goddesses gradually faded during the first centuries of the Christian era. Christianity is based upon the teachings of a Jewish preacher and healer named Jesus, whose followers believe him to have been the Christ, or "anointed one," the Messiah spoken of in Hebrew scripture. In Christian belief, Jesus was both fully human and fully divine, both the Son of God and one with God. He is believed to have risen from the dead, and in this act to have triumphed on behalf of all humanity over mortality. Like other religions, including the worship of the Egyptian goddess Isis, Christianity spread through the network of travel and communication made possible by the Roman empire. Christianity flourished in Northern Africa, but one of its most important early centers was in Egypt at Alexandria. Many Egyptians had already converted to Christianity by AD 325, the year the Roman empire legalized Christianity.

During the three centuries that followed, until Egypt's surrender to Islamic Arab armies in the early seventh century, Egyptians produced "Coptic art," the term "Copt" being derived from the Greek word for Egypt. However, "Coptic art" is also used to describe works created as late

as the eleventh or twelfth centuries AD by Christian Egyptians, or by artists working in a conservative, pre-Islamic style.

The Coptic textile shown here is typical of the complicated and colorful tapestry strips that ornamented the white linen garments of Egyptians during the centuries of Byzantine rule (fig. 2-22). It was woven during the late fifth century AD, when Christianity was the dominant religion of Egypt, yet the subject matter is tied to a pre-Christian past. The female nude in one frame and the male wearing an animal skin in the other may refer symbolically to Christian values, but it is more likely that they are simply dancing figures, celebrations of life based upon the poetry of the Greco-Roman world.

Palaces and Tombs of Aksum

The flourishing trade joining the Horn of Africa (present-day Ethiopia, Diibouti, and Somalia) to both Egypt and India stimulated the development of interrelated cultures on both the eastern and western shores of the Red Sea. In southern Arabia and Eritrea, Ethio-Sabaen kingdoms shared similar Afro-Asiatic languages and scripts. By the beginning of the Christian era, an Ethio-Sabaen culture in the Ethiopian highlands had formed the kingdom of Aksum. Aksumite merchants, warriors, and diplomats traveled between the capital (the city of Aksum, now in Ethiopia) and the coastal port of Adulis (now in Eritrea).

During the first two to three centuries AD, the kings of Aksum built a

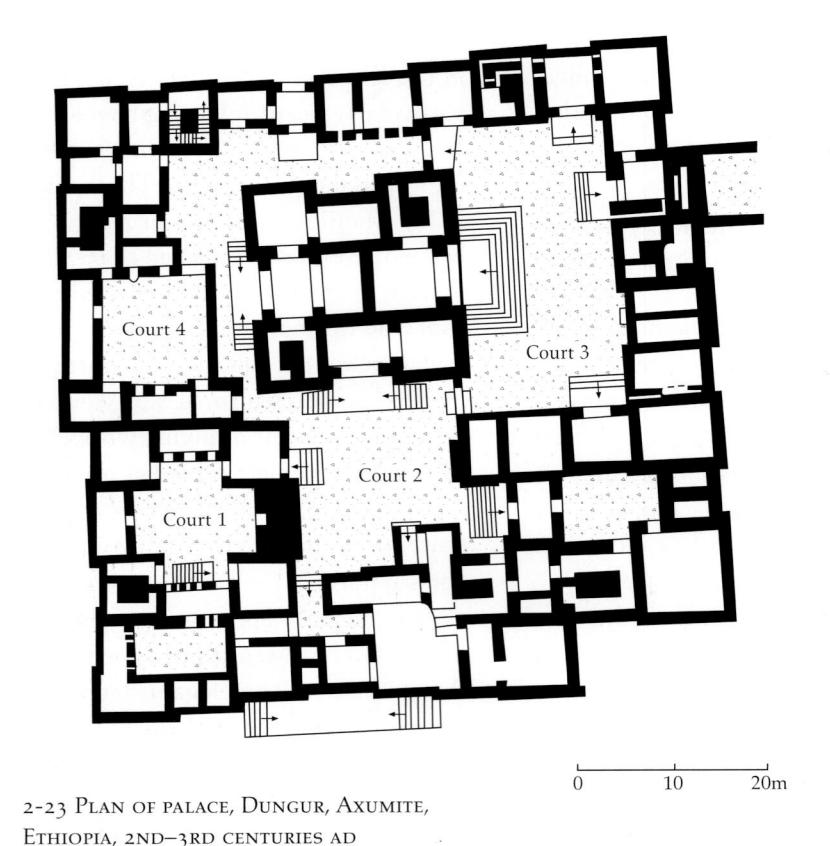

series of spectacular palaces of stone and wood. Unfortunately, these palaces have since fallen into ruin, but their foundations have survived (fig. 2-23). Square in plan, the palaces of Aksum were set upon stepped platforms. Judging from the construction techniques of stone churches built several centuries later in the same region, windows and doors were set into recessed panels in the layered stone and mortar walls. Wooden beams supporting the upper floors protruded slightly from the exterior walls, forming decorative bosses.

Valuable information about these lost palaces also comes from the enormous granite monoliths that marked royal Aksumite burials (fig. 2-24). Erected between the third and fifth

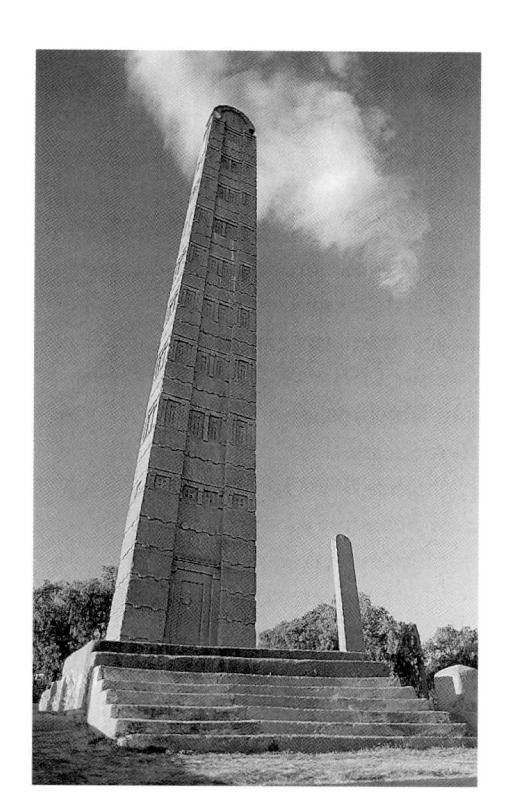

2-24. Funerary monoliths, Aksumite, Aksum, Ethiopia, C. ad 350. Stone. Height of largest standing monolith C. 69′ (21 m)

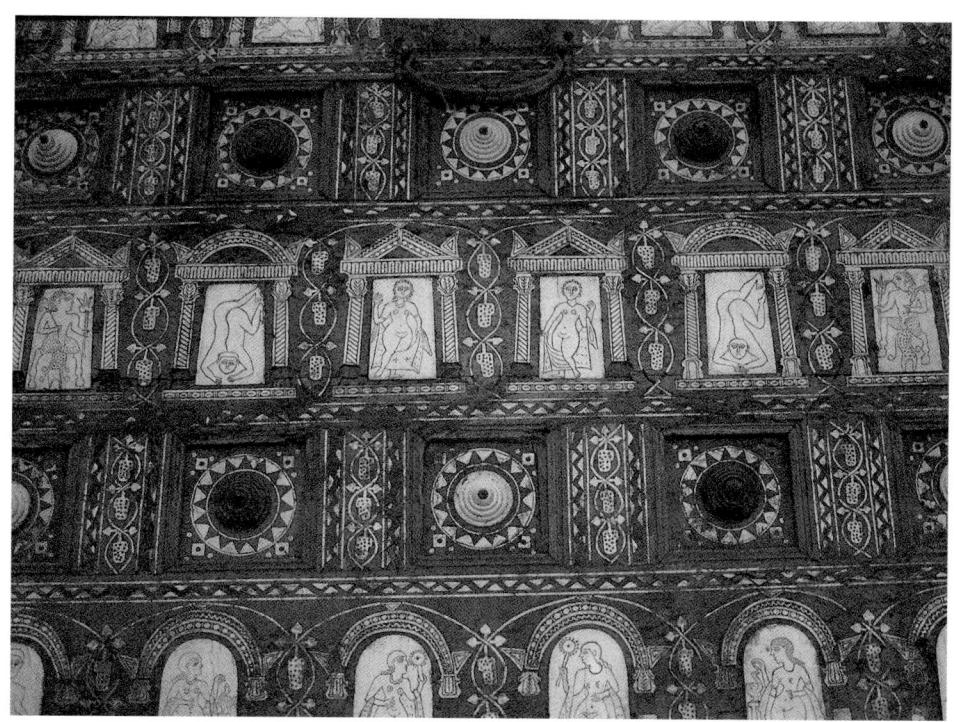

2-25. Detail of Chest, Lower Nubia, Ballana culture, c. ad 375–400. Wood with Ivory Inlay. Aswan Nubia Museum

centuries AD, the ten- to ninety-foottall monoliths are carved in relief to resemble skyscraper versions of the royal residences. Doors, inset windows, and protruding beam-ends are all faithfully copied in stone. Beneath these towering slabs of stone, the dead were buried in underground chambers.

Ballana

Around AD 330 the Aksumite king Exana apparently invaded Meroe, and a thousand years of rule by Kushite kings came to an end. Nubia eventually recovered some of its former prosperity, however, and a royal court was established near the site of Ballana, which flourished from about AD 350 to 700. Rich grave goods, including silver crowns for a king and

queen, were found there by archaeologists in the 1960s.

While some of the Ballana works are quite similar to objects found at Meroe, others such as this large wooden chest show the influence of the late Roman and Byzantine world (fig. 2-25). Small insets of ivory are delicately etched with voluptuous figures in various states of undress. Some evidently portray Roman gods and goddesses, although Bes (the potbellied, large-headed deity) is from Kemet. Each ivory piece is framed in an architectural niche surrounded by organic and geometric ornaments, and the chest may be a miniature version of a many-storied palace. The lightly clad ladies and gentlemen of the Ballana chest may also be linked to the dancing figures of Coptic fabrics (see fig. 2-22).

EARLY CHRISTIAN ARTS OF NUBIA AND ETHIOPIA

References to Ethiopia in Hebrew scripture attest to many centuries of relations between the peoples of Ethiopia and the Israelites. The Jewish faith itself was adopted by various communities in Ethiopia. During the fourth century AD, Judaism was joined in the Ethiopian highlands by Christianity. Exana, the Aksumite king who seems to have crushed Meroe, established Christianity as the religion of Aksum about the time it became legal throughout the Roman empire, and he was one of the first kings in history to strike coins with a cross. Three Christian kingdoms later arose in Nubia, all with close ties to the Byzantine world and to their Egyptian and Aksumite neighbors. One, the kingdom of Makuria, grew out of the culture at Ballana. Its neighbor to the south was the kingdom of Nobatia or Nobotia, while still further south arose the kingdom of Alwa.

Faras

The Christian faith of the Nubians found expression in churches built between the eighth and twelfth centuries AD. Archaeological work undertaken before the Aswan Dam flooded Lower Nubia revealed striking paintings on the walls of the cathedral at Faras. Faras was an administrative center of Makuria during this period, and portraits of the kingdom's religious and secular leaders adorned the church. Biblical scenes such as the birth of Mary, mother of Jesus, and the divine rescue of the three Israelite youths from the fiery furnace were

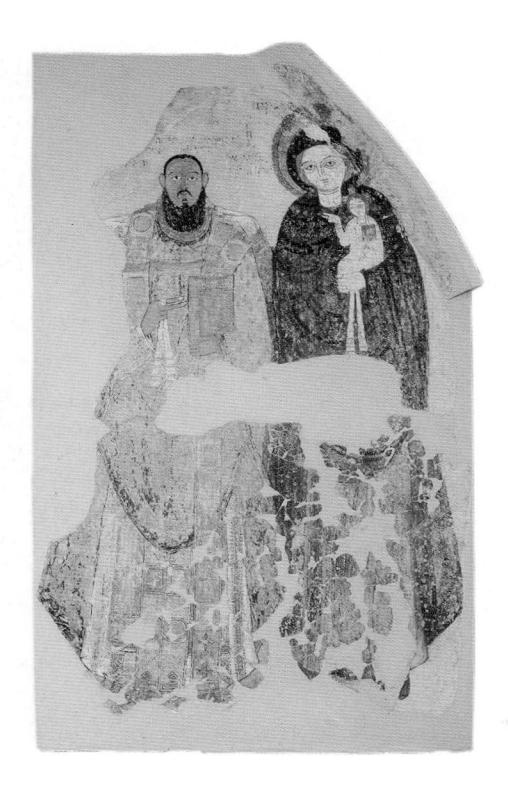

2-26. THE MADONNA AND CHILD WITH BISHOP MARIANOS, DETAIL OF A WALL PAINT-ING FROM THE CATHEDRAL AT FARAS, SUDAN, NUBIAN, C. AD 1030. PIGMENT ON PLASTER. MUSEUM NARODWE, WARSAW

also depicted. In a detail of an eleventh-century mural from the cathedral, Mary and the Christ child give their blessing to Marianos, a local bishop who was buried nearby (fig. 2-26).

The formal, frontal poses of the three figures, and the lack of interest in creating an illusion of depth, are features shared by images produced in lands administered by the rulers of distant Byzantium (Constantinople, modern Istanbul). As in many regions of the Christian world, Nubian and Egyptian Coptic artists employed Byzantine styles even when their rulers had no political ties to the Byzantine empire. The simple dark outlines of these Nubian figures, their

enormous eyes, and the rhythmic parallel folds of their drapery, are particularly close in style to Coptic painting produced during the first three to four centuries of Islamic rule in Egypt. The pallid, greenish complexion of Mary, the Madonna, and the rich brown tones of Marianos may reflect local conventions for showing gender or ethnicity.

Lalibala

Although murals and devotional images were produced for Aksumite churches, none seem to have survived. Evidently many were destroyed during the eleventh century, when Aksum and neighboring kingdoms were overthrown by rulers of the Zagwe Dynasty. Later monarchs considered the Zagwe emperors to be usurpers, with no divine right to rule Ethiopia. However, the thirteenth-century Zagwe emperor Lalibala, or Lalibela, is still revered as a saint, in part because of his desire to create a new Jerusalem on Ethiopian soil. Jerusalem, the principal city of Israel in the time of Jesus, is a holy city for Christians, as it is for Jews and Muslims. The site Lalibala chose to replicate this sacred place, in the highlands 8500 feet above sea level, now bears his name. It is still a place of pilgrimage and retreat.

Stone carvers sculpted eleven churches at Lalibala, each a counterpart of a church in Jerusalem. Unlike earlier Aksumite palaces and churches, they were not constructed of stone blocks and mortar reinforced with timber, but were carved from solid rock. Starting at ground level, the builders chipped away the rock from the roof down to the foundations,

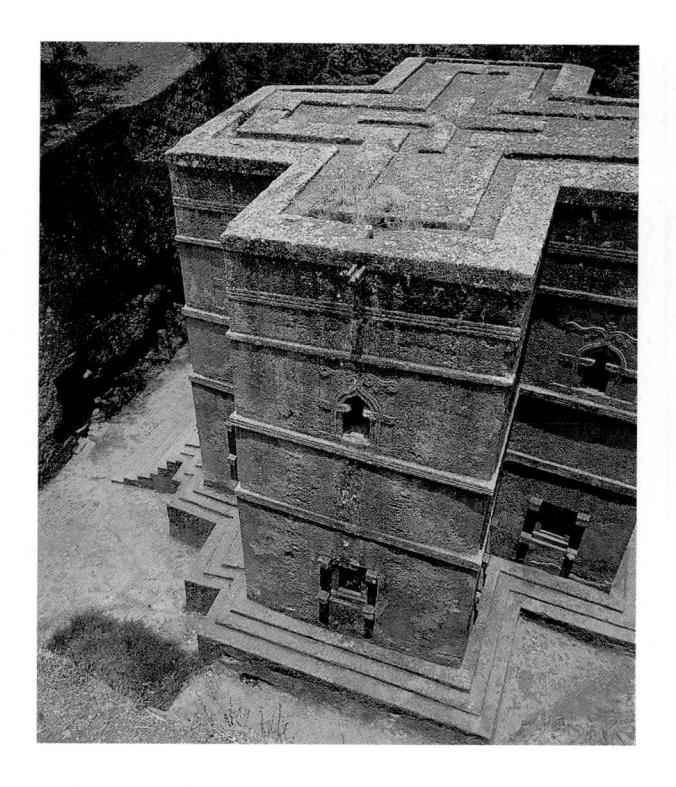

2-27. Beta Giyorgis or Beta Giorghis (Church of St. George), Lalibala, Ethiopia, Zagwe Dynasty, 13th century ad. Cut rock

2-28. Interior view of the Central Dome of Beta Giorghis

and tunneled into the mass of stone to hollow out the interior from the ceiling to the floor. The religious fervor that inspired this extraordinary work is legendary. According to one story, angels took up the tools of the sleeping workers every night to help them complete the churches in a miraculously short period of time. The sound of hammers striking stone is said to have resounded through the hills like the music of a great celebration.

Most of the rock-cut churches are square or rectangular in plan, and have the form of a basilica (see chapter 1, p. 31). However, Beta Giorghis (fig. 2-27), literally the "house of (Saint) George," is in the shape of a modified cross whose arms are equal in length. The carved lines on the roof of the church, partially visible from the rim of the pit encircling the building, emphasize this central plan, quite common in

Byantine architecture. Spectacular church ceremonies take advantage of the forty feet spanning the height of the surrounding earth and the depth of pathway around the church. Processions wind their way downward and upward along narrow passages, tunnels, and stairways, while chanted prayers join worshipers above and below. This pattern of call and response is compared to the ways the praises of people on earth are repeated by the angels in heaven.

Some Lalibala churches have windows set in recessed panels like those carved on Aksumite monoliths (see fig. 2-24), and are thus following the traditions of architecture erected over a thousand years earlier. Beta Giorghis, however, has windows framed with organic linear designs similar to *harag*, the painted tendrils ornamenting the borders of later Ethiopian manuscripts (see fig. 2-29).

Inside, the ceiling of Beta Giorghis

(fig. 2-28) displays a central hemispherical dome similar to those of the Byzantine churches seen by Ethiopian pilgrims in Jerusalem. Its smooth surfaces manipulate the soft light entering from the underground windows, creating a mystical setting for priests entering the sanctuary. Other Lalibala churches evidently reproduce in stone the timber ceilings of early Aksumite buildings.

Early Solomonic Period

The Zagwe Dynasty was brought to an end in AD 1270 by people of Amhara in the central mountains. They were led by an emperor who claimed to be descended from the rulers of Aksum, and who revived an old legend to establish himself as the heir of the biblical king David, who ruled Israel during the tenth century BC. According to this legend, after the Queen of Sheba visited King

Solomon, the son of David, she bore a son named Menelik. Menelik succeeded her as ruler of Ethiopia, and had the wisdom and the divine favor of his father Solomon. The era of rule by Amharic emperors is thus referred to as the Solomonic Period.

The early Solomonic monarchs of the thirteenth to sixteenth centuries were active patrons of the church and of liturgical arts, the art forms used in worship. The royal court of this period was itinerant, moving from town to town. While their parents traveled, princes were left in isolated monasteries to be brought up by priests. Their religious education led to royal involvement in theology, music, literature, and art. The fourteenthcentury Solomonic king Dawit (David) may have commissioned this gadl, an account of the lives of saints (fig. 2-29). Like many Ethiopian manuscripts, it was written and lavishly illustrated in tempera paint on parchment, then bound in wood covered with leather and stored in a box or chest of wood, leather, or quilted cloth.

The gadl is written in Ge'ez, an archaic language still used in Ethiopian churches today. Organic vegetation-like forms known as harag frame the text on the right page. The two religious leaders shown here are visualized almost as mirror images of each other. Each holds a staff topped by a cross. Their robes, indicated through broad areas of geometric patterns enclosed in black lines, cover all of their bodies with the exception of their heads, hands, and tiny triangular feet. While the flat, patterned surfaces and their boldly elongated heads and fingers are unique features of this particular gadl, high degrees of

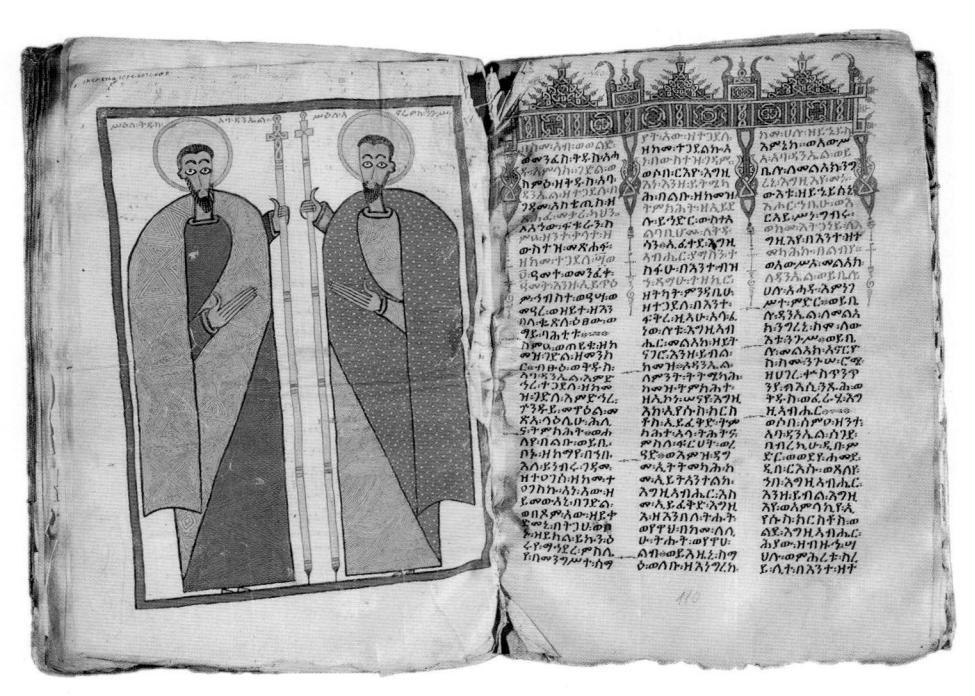

2-29. GADL (ACCOUNT OF THE LIVES OF SAINTS), ETHIOPIA, SOLOMONIC PERIOD, 14TH CENTURY. PIGMENT ON GOATSKIN OR SHEEPSKIN. CHURCH OF MARYAM SEYOU, LAKE ZEWAY, ETHIOPIA

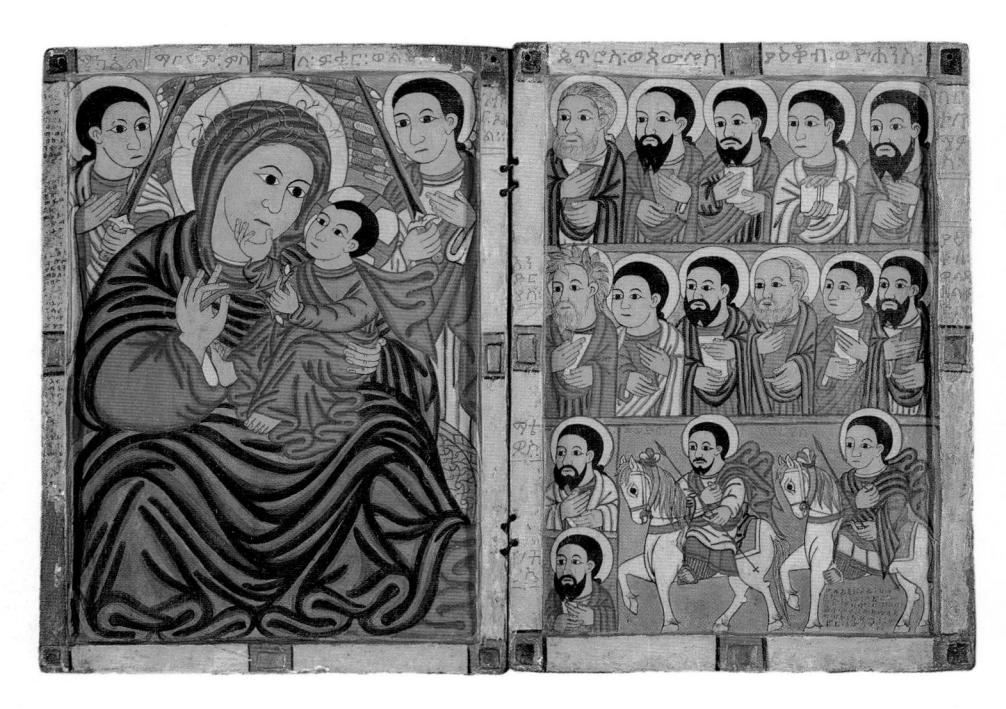

2-30. Diptych, Fre Siyon, 1445–80. Ethiopia, Solomonic period. Tempera on gesso-covered wood. $17\frac{1}{4}$ x $24\frac{1}{2}$ " (44 x 62 cm). Institute of Ethiopian Studies, Addis Ababa

As in medieval Europe, many Ethiopian artists have been priests or church officials. Fre Siyon (or Fere Seyon) was a monk who lived in a monastery near Lake Tana when he was not working on commissions elsewhere.

abstraction can also be found in some other early Solomonic manuscripts. In general this period of Ethiopian art is marked by a rich variety of highly diverse styles.

During the fifteenth century, King Zara Yaeqob (Jacob) established new forms of worship for Mary, the mother of Jesus, encouraging his people to use images of Maryam (Mary) painted on wooden panels in their personal prayers and meditation. He invited foreign painters to work in Ethiopian monasteries, and he imported Christian art works from Jerusalem. The most influential artist of his court was the Ethiopian painter Fre Siyon, or Fere Seyon, who translated Zara Yaeqob's hymns and sacred poetry into visual form.

The portable two-paneled image, or diptych, illustrated here is an elegant example of Fre Siyon's work (fig. 2-30). Painted in tempera on two pieces of wood, it can be closed for transport, then opened like a book and stood upright on a flat surface for use as a devotional image. The left panel shows Maryam with the infant Jesus in the crook of her left arm. As in many African depictions of motherhood, faces show little expression, but gestures are full of meaning; the Christ child rests his foot upon his mother's arm, stroking her chin with one hand while grasping in the other the branch she is extending to him. Two angels fill the corners of the scene. On the right panel, three rows of saints turn to view the mother and child. Slight differences in their hair, beards, and hand gestures give variety to the assembly.

A comparison between the diptych of Fre Siyon and the mural from Faras (see fig. 2-26) shows the

Ethiopian work's affinity with other Byzantine styles. His work displays the rhythmic lines, stylized faces, and simplified shapes of the earlier Nubian painting of the Madonna. Yet Fre Siyon's work is smoother, more delicate, and more intimate, reflecting his patron's desire to interpret Maryam's role as a loving mother and an effective advocate for sinners, one who could petition her son on their behalf

ISLAMIC ART OF EGYPT

Egypt was among the earliest of the Islamic conquests, surrendering to Arab armies around AD 639 (17 AH). Ruled initially as a province of the rapidly expanding Aghlabid empire, it came under the control of Fatimids, a North African dynasty, in AD 969 (357 AH). While Christian art forms continued to flourish in Nubia and Ethiopia under the Zagwe Dynasty and the early Solomonic rulers, Christian Coptic artists worked in a cosmopolitan but predominantly Islamic culture in Egypt. Mosques, schools, tombs, palaces, fountains, lav-

ish private residences, and imposing city gates embellished Fustat, the first Islamic capital, and Cairo, al-Qahira in Arabic, the capital founded by the Fatimids.

The impact of art made in Egypt under Islam can perhaps best be seen in the portable art forms that traveled far from their place of origin. For example, rock crystal mined along the East African coasts and in the Persian Gulf was imported by the Fatimids, and then carved into delicate vessels. Traders and crusaders brought these precious objects from Islamic lands to Europe, where they held Christian relics or communion wine.

Other objects made by Egyptian artisans were cast of brass. Made during the Mamluk period (AD 1250–1517), the shallow brass basin here is inlaid with silver and covered with bands of decoration (fig. 2-31). At the widest part of the bowl, Arabic letters are transformed into several series of vertical strokes. While many Mamluk brass basins displayed inscriptions—often quotations from the Qur'an or a short blessing—the calligraphy here is quite difficult to

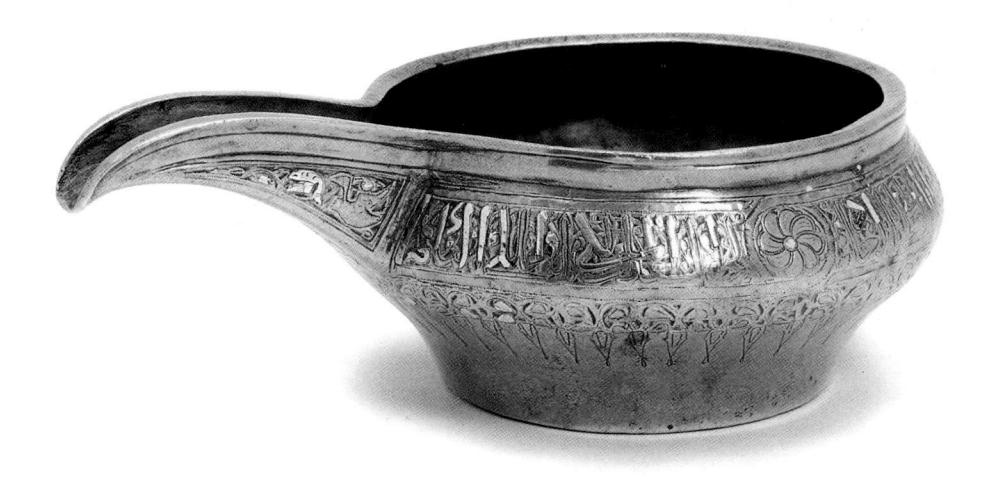

2-31. Bowl, Egypt, Mamluk Period, C. 1300. Brass with silver inlay. Victoria and Albert Museum, London

decipher, and may have served as a visual and verbal puzzle to amuse the owners. Beside the Arabic letters are circular shapes made of interlocking and radiating lines. These are part of the vast repertoire of Islamic designs drawn from geometry, calligraphy, and sacred divisions of space, which fascinated both Muslim and non-Muslim owners.

Metal basins were used for ritual washing before prayers and before entering mosques, and were proudly displayed in Muslim homes. In other cultures, these exotic and expensive objects took on other roles and meanings. In northern European churches, for example, imported Mamluk vessels sometimes served as baptismal fonts. Today Egyptian brass bowls and locally made replicas may still hold sacred substances in the shrines of southern Ghana (see chapter 7).

LATER CHRISTIAN ART OF ETHIOPIA

In AD 1516 the Mamluk rulers of Egypt were defeated by the Ottomans, an imperial Islamic dynasty based in what is present-day Turkey. Nubia came under Ottoman control as well, and Christians in these regions of the Nile were pressured to convert to Islam. Further to the south, the Christian highlands of Ethiopia were overrun in 1527-43 by Islamic forces led by Ahmad ibn Ibrahim. After twenty years, however, the Solomonic kings regained control of the highlands. While these Christian kings of the late Solomonic Period continued to move their courts from place to place, they began to spend the entire rainy season near Lake Tana, in the northwest of their

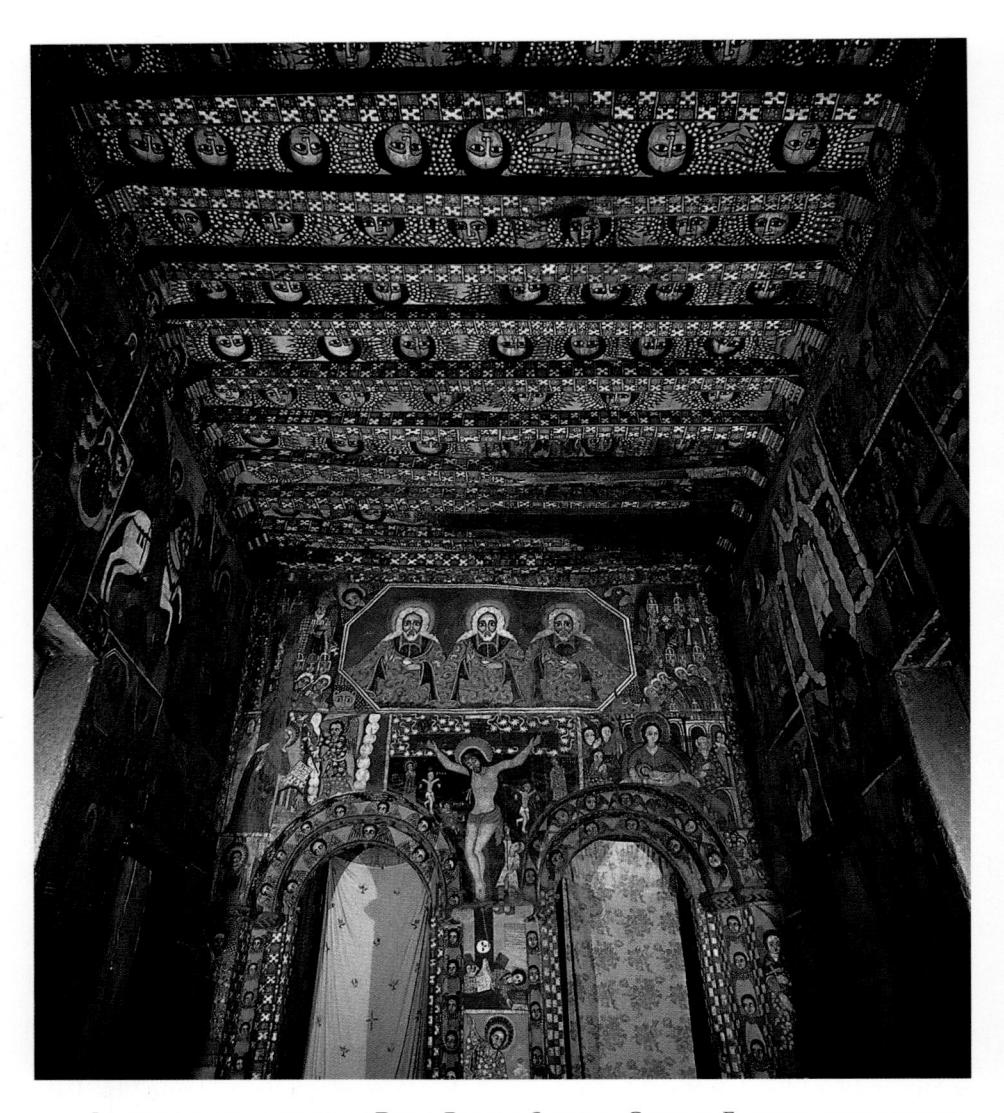

2-32. Interior of the church of Debre Berhan Selassie, Gondar, Ethiopia, 17th century. Pigment on plaster

kingdom. During the seventeenth and eighteenth centuries they built a series of palaces near the site of Gondar. Repeatedly sacked during the nineteenth century, the palaces are still imposing in their ruined and abandoned states.

The churches built in this region by these Solomonic kings have survived relatively intact. Debre Berhan Selassie (or Debra Berhan Sellase), the Church of the Trinity, was founded by King Iassu I toward the end of the seventeenth century. A small, thatched, rectangular church, it stands just outside Gondar. The wall paintings of its interior display the full aesthetic impact of the style known as Gondarene (fig. 2-32), originally developed by artists working for the court in Gondar during the mid-seventeenth century.

At the front of the church are the two arched and veiled entrances to the sanctuary, or "holy of holies," the area where sacred tablets are kept.

Above and between the arches Iesus is depicted crucified upon a cross, the death he suffered as related in Christian scripture. The cross is shown issuing from the grave of Adam, the first man created, thus indicating Christ's role as the fulfillment of human history, the Savior whose death redeemed the human race from the sin committed by Adam. Over the crucifixion is a panel depicting the Holy Trinity, a central mystery of Christian doctrine in which God is understood simultaneously as one and three. Here, the Trinity is envisioned as three identical elders, each with a halo of gold and red light. In the segmented areas around them are depicted various saints and Mary, the mother of Iesus. The beams and ceiling are covered with the heads and wings of eighty angels interspersed with scintillating patterns.

The bright colors, lack of extraneous detail, and direct gaze of most of the figures are also found in the much earlier altar by Fre Siyon (see fig. 2-30). Yet the artists of Debre Berhan Selassie have added shaded areas to the faces of the Trinity and to the body of Christ to suggest rounded surfaces, and have emphasized the eyes of the angels and saints with bold dark lines.

Although there is no longer a royal court in Ethiopia (the last emperor, Haile Selassie, the Ras Tafari, was overthrown by a military coup in 1974), historical paintings in the Gondarene style may still be made for foreigners and local clients today. Despite past invasions and the civil warfare that destroyed much of Ethiopia's artistic heritage in the twentieth century, churches also con-

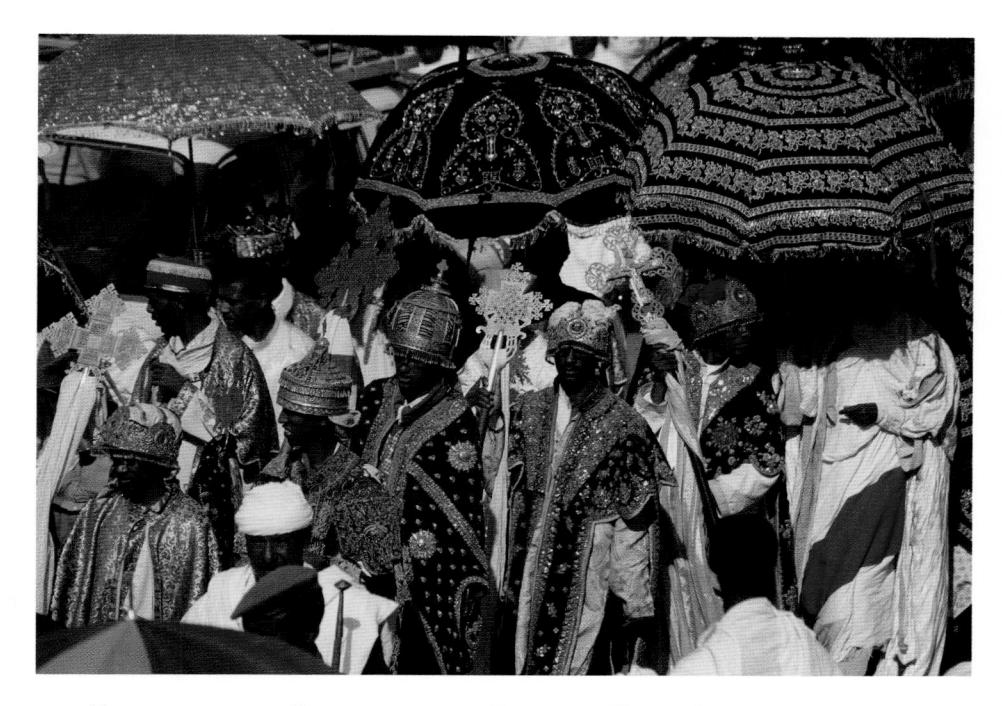

2-33. Procession of the Tabots during the Festival of Timkat (Epiphany), Lalibala, Ethiopia

tinue to use cast, carved, and painted works of art during Christian worship.

During church festivals such as Timkat, art works are carried in great processions (fig. 2-33). Crosses of brass or silver, adorned with streamers, are held aloft. Church officials wear elaborate crowns. Umbrellas of costly brocade symbolize the dome of heaven and honor the sacred presence of holy objects. Ornamented chests (not visible here) contain tabot, tablets replicating the stone tablets of the Ten Commandments that the Bible relates were given to the Hebrew prophet Moses by God on Mount Sinai. Just as the Ark of the Covenant traveled through the wilderness with the people of Israel, these chests spend the night in tents before being returned to the church the next day. Ethiopian Christians believe that they should sing and dance before the tabot just as the

Bible relates that King David once danced for joy before the Ark of the Covenant in ancient Israel. While processions to and from churches may be seen in Christian communities around the world, these striking forms of worship in Ethiopia are also reminiscent of the processions in which the priests of Kush and Kemet brought images of deities out of the dark recesses of their temples for annual festivals.

The processions are often led by lay priests, dabtara or debtera, who are particularly accomplished singers, cantors, and dancers. Debtera themselves also make liturgical art. One who has received considerable attention from foreign collectors is known simply as Gera (born 1941). Like many debtera, Gera works for private individuals as well as for the church. He specializes in talismans, sacred scrolls providing mystical protection

2-34. Mystery, Gera, Ethiopia, 1988. Tempera on Paper. 48 x 345/4" (122 x 88 cm). Collection of Jacques Mercier

for his clients. These are long strips of parchment or goatskin, which can be laid over someone lying ill in bed, or hung in a bedroom. Ideally they are painted upon the skin of a goat that was sacrificed to God by the petitioner (the *debtera*'s client) to invoke blessing and forgiveness.

Based upon the Jewish mystical tradition known as the kaballah or cabbala, these scrolls contain prayers written in Ge'ez, and faces and figures representing both protective beings and monsters to be overcome. In function, the scrolls are quite similar to the ancient Egyptian collection of spells known as the Book of the Dead (see fig. 2-15), for the words and images they contain are believed by their presence alone to offer continual protection to the individual (living or dead) who owns and displays them.

Gera's work for foreign collectors consists of original interpretations of these ancient protective paintings. He still uses the faces and intersecting geometric shapes painted on mystic scrolls, manuscripts, and pleated fans by debtera for centuries. In works such as Mystery (fig. 2-34), the motifs originally painted on long strips expand to fill a rectangular format, and patterns radiate to form stellar, circular designs similar to those on the Mamluk brass bowls (see fig. 2-31). The hues are rich and intense. Paintings such as Mystery are no longer intended to bless and heal, but rather to intrigue and decorate.

LOWER NUBIA BEFORE THE ASWAN DAM

The Aswan High Dam, completed in 1971, blocked the free flow of the

Nile to create Lake Nassar, a huge reservoir that supplies the modern nation of Egypt with electricity and water for irrigation. The waters of Lake Nassar filled the Nile Valley between the first and second cataracts, the core of northern Nubia. Inhabitants were relocated, but nevertheless an old and deeply rooted culture was lost. Before these Nubian communities were submerged, their distinctive architecture was documented by photographers.

In the Kenuzi Nubian region of southern Egypt, domestic architecture was decorated by women, who painted the walls of interior courtyards with delicate polychrome patterns similar to those of their textiles and jewelry (fig. 2-35). In the Mahasi (or Feija) Nubian region of northern Sudan and southernmost Egypt, houses were decorated by itinerant male artists, who modeled and painted low reliefs on the exterior walls. Inside Mahasi homes the marriage hall, diwani, was also frequently painted (fig. 2-36). Reserved for male guests of the groom during the long wedding festivities, a diwani could also serve as the temporary home of the newlyweds. Objects displayed in a diwani were chosen both for their beauty and for their associations with fertility and prosperity.

The tightly woven palm fiber baskets hanging on the wall are trays used for feasts on saints' days or at weddings. Rolls of mats are tied under the ceiling, and wall paintings echo the geometric patterns of the basketry. The large marriage chest recalls the inlaid chest from the Ballana culture (see fig. 2-25), carved in the same region some 1500 years earlier.

2-35. Painted Houses, Nubia (Southern Egypt). Photograph 1960s.

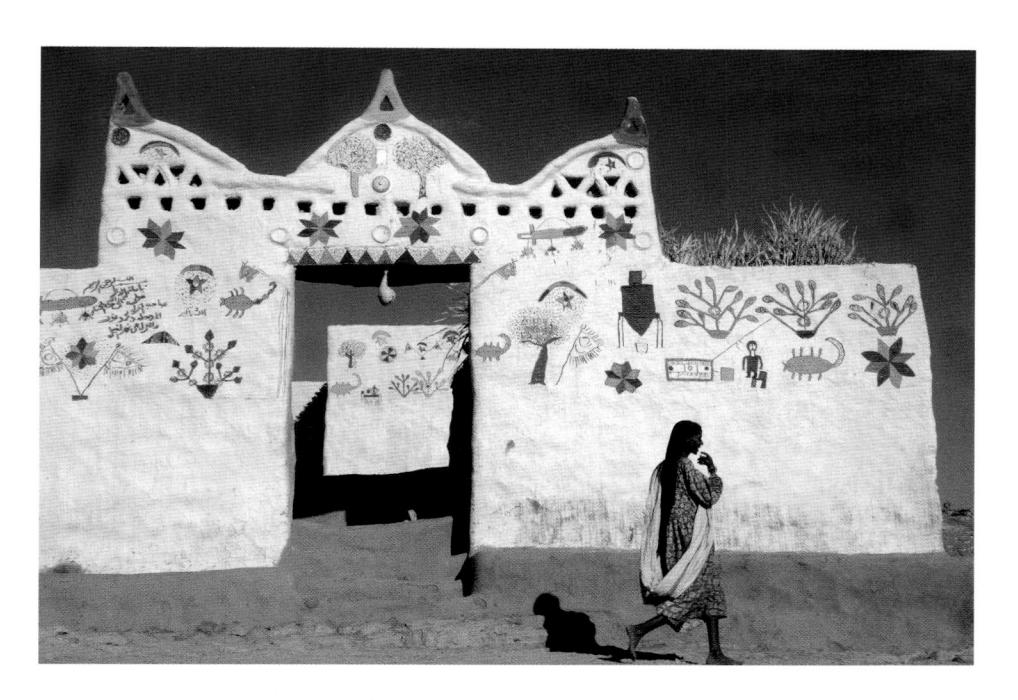

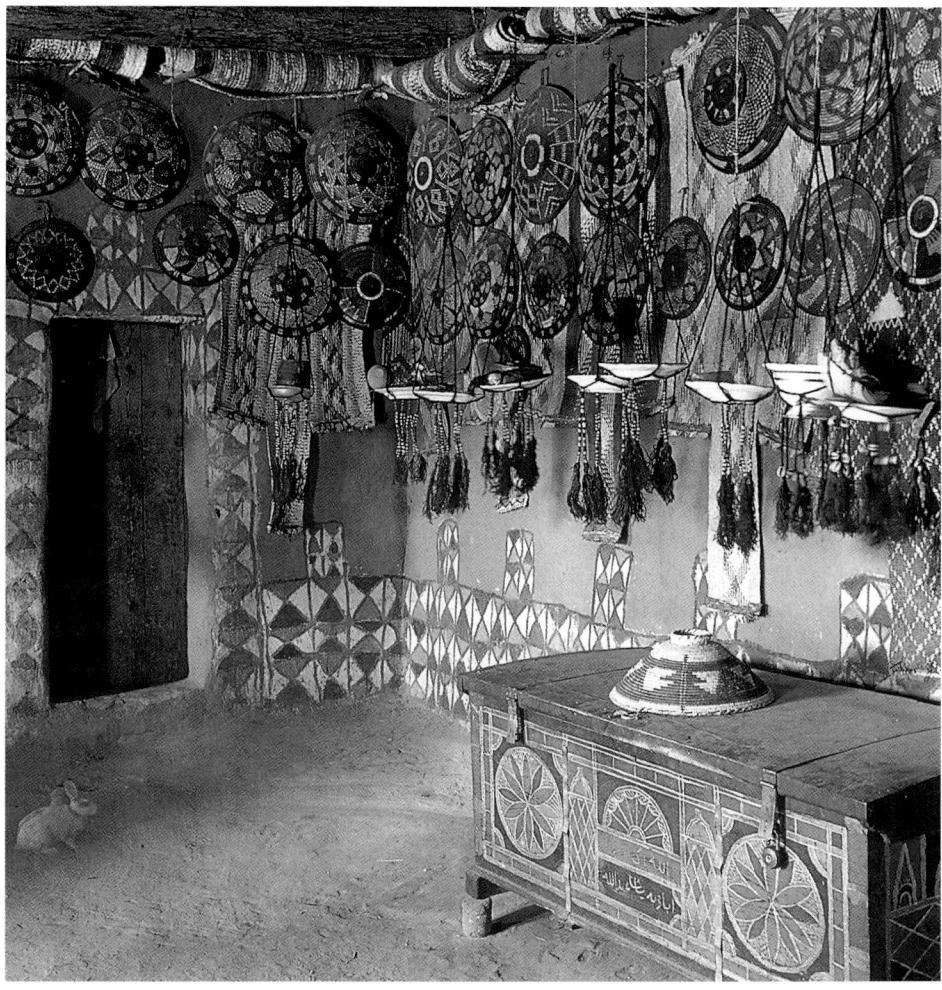

2-36. DIWANI (MARRIAGE HALL), NUBIA (NORTHERN SUDAN). PHOTOGRAPH 1960S

TWENTIETH-CENTURY ARTISTS FROM CAIRO

For the last two thousand years, much Egyptian art has served foreign rulers. Yet in the early years of the twentieth century, when Egyptians sought to form an independent nation, artists began to produce art forms in response to these nationalist movements. The arts of modern Egypt have been closely linked to the political history of the country, beginning with the career of Mahmoud Mukhtar (1891–1934).

Mukhtar is said to have wandered into the School of Fine Arts in Cairo when he was a teenager. The school had been founded only a year or so earlier by Prince Youssef Kamal, an influential Egyptian politician. Mukhtar's training at the school led to a scholarship at the Ecole des Beaux Arts in Paris, where he evidently adopted the dissolute lifestyle of the French avant-garde. Upon his return to Egypt, he carved stone in smooth abstract styles that are based upon European art of the late nineteenth and early twentieth centuries (fig. 2-37). However, he also carved images that seem similar in spirit and form to sculpture made in Egypt during the reign of the Greeks and Romans. These include a sphinx and a personification of Egypt, Cairo landmarks commissioned by the nationalist Wafd party.

While Mukhtar is highly regarded in Egypt, another twentieth-century artist is much more widely known by non-Egyptians. This is architect Hassan Fathy (1899–1989), whose research into the architecture of Nubian villages (see fig. 2-35) nourished the study of vernacular archi-

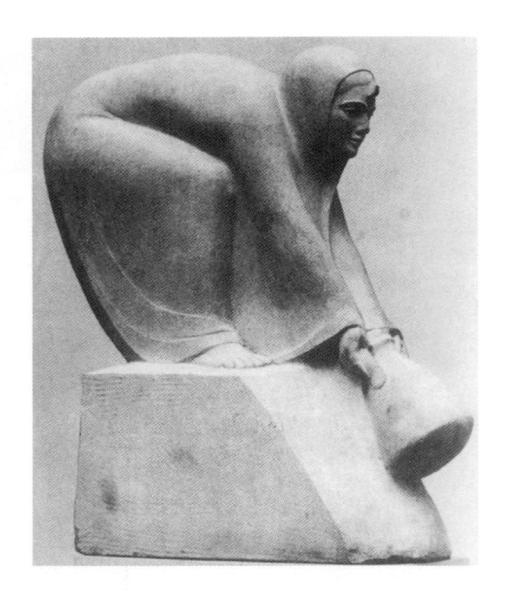

2-37 FELLAHIN, MAHMOUD MUKHTAR, EGYPT. STONE. COLLECTION MUKHTAR Museum, Cairo

2-38 Architectural drawings, plans for village housing, New Gourna, Hassan Fathy, Egypt, c. 1948

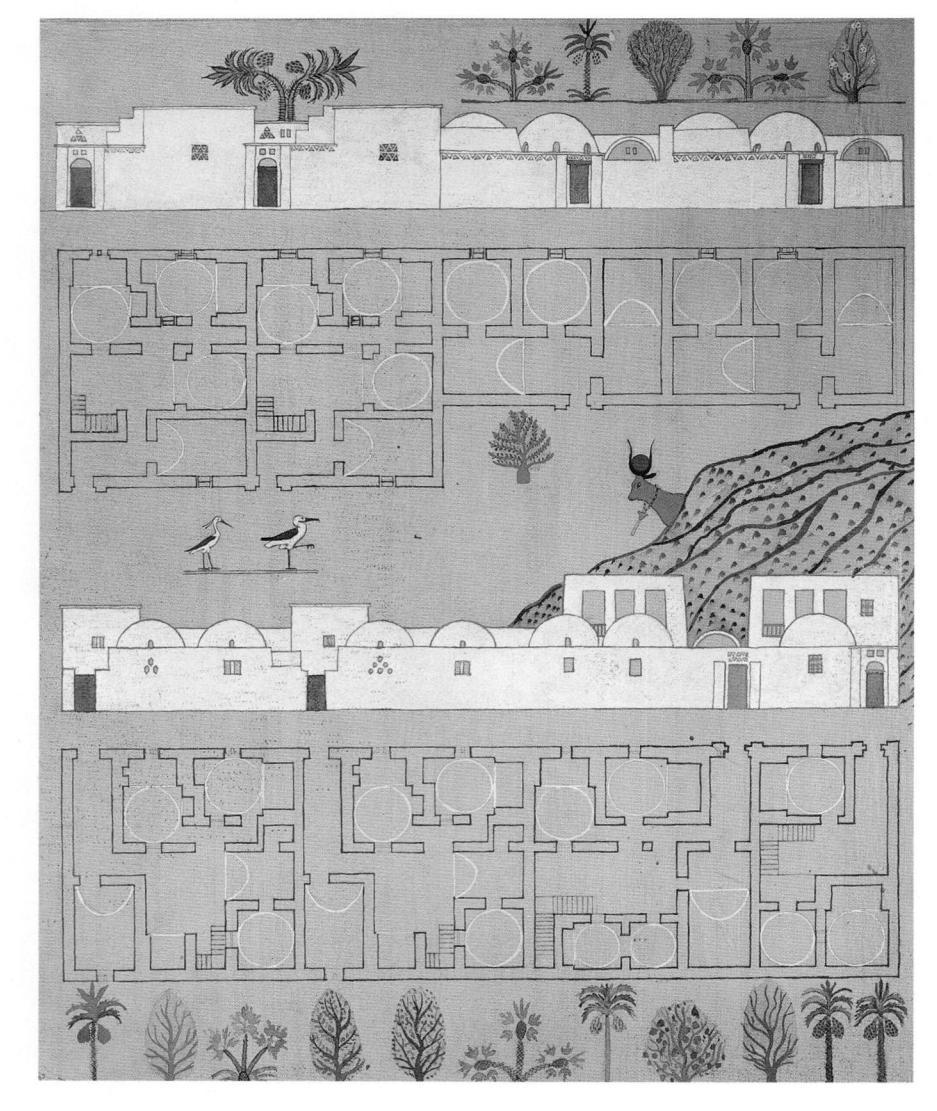
tecture worldwide. For private homes, Fathy borrowed the pierced wooden screens of medieval Egyptian windows, and the "wind-catchers" of Cairo roofs, to create dwellings suited to harsh sunlight and intense heat. He is also known for the planned community of New Gourna, an architectural complex intended to replace the ancient but impoverished village sprawling above the ruins of the tombs of Luxor (ancient Waset) (fig. 2-38). While the project was never completed, and was never fully accepted by the villagers themselves, it has influenced later, more successful communities around the world.

Contemporaries of Hassan Fathy explored European models rather than indigenous traditions. This was particularly true of painters, who tended to work in the new, foreign medium of oil paint on canvas. Like Mahmoud Mukhtar, these pioneers produced representational art rather than purely abstract images. Since most pursued careers as illustrators, designers, and educators, their stylized scenes of urban and village life might have been tied to their professional responsibilities. When Egypt became the United Arab Republic after World War II, artists were seen as cultural ambassadors. and several attended the first Festival of Negro Arts, held in Dakar, Senegal, in 1963.

Two members of the Egyptian delegation to this festival, Effie Afflatoun and Gazbia Sirry (born 1925), were engaged with social movements. Afflatoun's political involvements even led to her imprisonment as a dissident. Gazbia Sirry's evocative *Martyr* (fig. 2-39) is an

2-39 Martyr, Gazbia Sirry, Egypt, 1961. Oil on canvas. $52\frac{1}{4}$ x $19\frac{1}{5}$ " (134 x 50 cm). Collection of the artist. Courtesy Zamalek Art Gallery, Cairo

example of her expressive protests against injustice. Today her works are quite different; they are luminous, saturated with color, and entirely abstract. Other artists of her generation (such as renowned sculptor Adam Heinan) have also experimented with freer and less recognizable forms.

By the end of the twentieth century, a generation of Egyptian artists had emerged who had abandoned both painting and sculpture for video production and other forms of photography, for site specific installations, and for collaborative, multi-media projects.

ARTISTS FROM KHARTOUM

Artists in Sudan first received formal training in easel painting, the European tradition of painting with oils on canvas, at the end of the colonial period. They studied at an institute often known simply as the Khartoum School, which has changed names and affiliations several times since its foundation in 1947 and is now part of Sudan University of Science and Technology. Many had already been influenced by local painters who, with no formal training, were creating landscapes and portraits for wealthy Sudanese patrons by the 1930s.

One of the most renowned members of the Khartoum School is Ibrahim el Salahi (born 1930), who was one of the first Sudanese artists to exhibit his paintings overseas. After advanced art studies in London, el Salahi returned to Sudan, where he taught at the Khartoum School and met with other artists at the studio of Osman Waqialla (1925–2007). During the 1960s he also participated in

2-40. Funeral and Crescent, Ibrahim el Salahi, Sudan/England, 1963. Oil on Board. 37" x 38" (84 x 52 cm). Collection of Mrs. Markisa Marker

2-41 Opening of the Surat Ya Sin, Chapter 36, Osman Waqialla, Sudan, 1982. Inks and gold on paper. 7 x 9'' (18 x 23 cm). Collection of the artist

workshops in Nigeria and in the United States.

In Funeral and Crescent (fig. 2-40) el Salahi remembers the death of his father, a Muslim cleric, and the affirmation of faith surrounding the burial. Heavy dark lines radiate from the mask-like faces and elongated bodies as the corpse is lifted upwards toward the lunar symbol of Islam. The colors are muted, purposefully echoing the hues of earth found in Sudan. The painting also expresses el Salahi's desire to create images through calligraphic strokes, merging the Islamic (and Arabic) heritage of sacred writing with the African heritage of figurative art.

Many Sudanese artists shared el Salahi's goal of combining Arabic calligraphy and "pan-African" styles and themes during the 1960s and 1970s. Yet Osman Waqialla created lush variations on Arabic script, giving splendour to the words of the holy Our'an (fig. 2-41). In 1986, young artists following his example formed a movement known as the School of the One to produce art closely attuned to the values of Islam. Other groups of artists from the Khartoum School formulated other aesthetic programs. For example, Kamala Ibrahim Ishaq, one of the few women artists active in Khartoum, established the Crystalist School in 1978.

El Salahi was imprisoned by the Sudanese government in 1975, and left the country after his release to live in exile in Qatar and England. Political conditions in Sudan have driven many other respected artists to emigrate as well. Sudanese artists now living in the United States include Mohammad Omer Khalil (born 1936), whose New York

printshop has printed the work of American artists such as Romare Bearden and Louise Nevelson, and sculptor Amir Nour (born 1939). The work of Sudanese artists living abroad will be discussed again as African expatriates in chapter 15.

ARTISTS FROM ADDIS ABABA

Other complex responses to local and international cultures may be seen in the work of Ethiopian artists. The first art institute in Ethiopia, the Addis Ababa Fine Arts School, was founded by Ale Felege Selam in 1957. Several Ethiopian artists who had studied and taught in Europe returned to Addis Ababa to teach at the school in the 1960s. One of these influential teachers was Gebre Kristos Desta (1932–81).

Kristos Desta included abstracted yet recognizable figures in oil paintings such as *Crucifix* (fig. 2-42). He was criticized by some Ethiopians for using the styles and themes of European modernism to convey his own twentieth-century sensibility. Yet styles and themes of foreign art have been adapted to an Ethiopian context many times over the centuries, as, for example, in the four-teenth-century painter Fre Siyon's elegant reworking of Byzantine styles (see fig. 2-30).

Kristos Desta was forced to leave Ethiopia after the military takeover of 1974, and he died as a refugee in Oklahoma. Many of his former associates and students have also fled to the United States. Skunder Boghossian (born 1937), who once taught with Gebre Kristos Desta in Addis Ababa, has mentored genera-

2-42 Crucifix (Golgotha), Gebre Kristos Desta, Ethiopia, 1963

tions of students at Howard University, in Washington, D.C. Elizabeth Atnafu, a former student of Gebre Kristos Desta, is an installation artist. Achameyeleh Debela (born 1947) uses computer-generated imagery to create art in cyberspace as well as photographic prints. Their contributions, and those of other Ethiopian artists who have worked closely with American students, will thus be discussed further in chapter 15 of this book.

The Central Sudan

3-1. Head, Nok style, Nigeria, c. 800 bc–ad 200. Terracotta. Height 8%'' (22 cm). National Museum, Lagos

OUTH OF THE SAHARA AND north of the equatorial forest lies a transitional zone where the desert sands give way to fertile grassland. Arab travelers named this semi-arid region the sahel, meaning "port" or "shore"; here caravans rested after crossing the vast "sea" of the desert. It was also known as the Land of the Blacks, bilad al-sudan, where Africans rather than Arabs held political and religious authority. The Arabic term "Sudan" was used by European colonial powers to designate the entire band of savannah south of the Sahara, which stretches from the Atlantic Ocean in the west to the Great Rift Valley of eastern Africa.

For this chapter, we have chosen to focus upon the central portion of the Sudanic region, which would extend roughly from the southward swing of the Niger River through the present-day nations of Niger and Nigeria in the west to the Ennendi and Darfur highlands of Chad and Sudan in the east. These geographic markers do not reflect ethnic boundaries, however, and there are few cultural, artistic, or linguistic features that would clearly mark subdivisions within this enormous area.

A vast array of art forms have been created in the central Sudanic region by diverse populations with varied histories. Researchers have generally categorized these populations by language group, though cultural practices cut across linguistic boundaries as well. One such linguistic group comprises peoples who speak Nilo-Saharan languages and live in the

lands east and south of Lake Chad. the sizeable but shrinking body of water at the heart of the central Sudan. While many are nomadic pastoralists, populations such as the Kanuri have built fortified cities. Little is known of the art history of these Nilo-Saharan-speaking groups, who are mostly Muslim, and who have suffered greatly over the last half century from drought, warfare, and even (in the Darfur region) from genocide. Other central Sudanic peoples speak Chadic languages of the Afro-Asiatic family. Having migrated westward over the millennia, they now live in northern Nigeria and southern Niger. Of these Chadicspeaking groups, the Islamic Hausa have attracted the most attention from art historians, for their mosques, palaces, manuscripts, regalia, and embroidered clothing are spectacular examples of Islamic art. However, other Chadic-speakers are not Muslims. They live interspersed among the earlier inhabitants of this region (who speak either Adamawa or Niger-Benue languages of the Niger-Congo family) and share their art forms. These include body arts, metal and ceramic objects, statuary, and masks. Finally, a West Atlantic language of the Niger-Congo family is spoken by the Fulani people, who have entered the region over the last several centuries, and who are discussed in this chapter even though they are not confined to this part of the African continent. Textiles and gourds made by Fulani artists may be purchased by their neighbors, just as the Fulani themselves patronize artists from other groups.

Despite this linguistic and artistic diversity, the peoples of the central

Sudan do share some important features. Spiritual leaders wear distinctive dress and display sacred regalia. In the complex atmosphere of crosscultural interactions that characterizes the region, personal adornment celebrates ethnicity as well as beauty and social rank. Objects used in daily life are given serious aesthetic attention, and architectural forms are among the most varied and most impressive in all of Africa.

ANCIENT ART IN FIRED CLAY

The ceramic arts of the central Sudan are rooted in regional practices that are thousands of years old. Recent excavations suggest that iron and copper have been smelted, forged, and cast in some areas for at least three thousand years. Metallurgy and ceramic technologies in the central Sudan appear to have been intertwined, for the oldest figurative sculpture in fired clay has been found in sites where iron was produced. Although there are still enormous gaps in our knowledge of the past, archaeologists have thus far categorized major types of ceramic images as Nok, Bura, and Sao.

Nok and Sokoto

The oldest art works from all of western and central Africa were found by chance. During the first half of the twentieth century, Nigerians mining for tin uncovered fragments of fired clay figures. Hundreds of pieces were unearthed near a small town called Nok, which gave its name to these ceramic sculptures. Terracottas in Nok style have subsequently been discovered across central Nigeria, suggesting that Nok figures were made or traded throughout the Plateau region north of the confluence of the Niger and Benue rivers.

While most of these terracottas are human figures, or heads broken from human figures, some animals (including a wonderful head of an elephant) form part of this stylistic group. A head found near the town of Jemaa is a fine example of these ceramic images (fig. 3-1). Like most Nok heads, it is hollow and was once attached to a full or partial figure. Its overall shape is a simplified geometric form; while this example is ovoid, other Nok heads are cylindrical. spherical, or even conical. Smooth round holes pierce the eyes, nostrils, and mouth. The straight line of the upper eyelids joins the recessed space for the eyes to form a triangular shape, and the ears are placed in unusual positions at the side of the head.

We would expect such a work to have been formed by an additive technique, first built up and modeled from pliant clay, then fired to hardness. However, the crisp contours and the patterns of the hair, eyebrows, and lips suggest that the head was carved in a subtractive technique, perhaps from clay air-dried to a leatherhard stage. This unusual procedure suggests that the artist may have been trained as a woodcarver rather than as a potter.

Few complete Nok figures have been documented by archaeologists. One notable exception is a tiny image found along a river near the town of Bwari (fig. 3-2). Unlike most Nok works, it is solid rather than hollow. The opening between

Aspects of African Cultures

The Illicit Trade in Archaeological Artifacts

An object looted from an archaeological site in Africa has a fascinating history, much of which may be quite recent. To look at some of the issues involved in these histories, imagine the hypothetical case study of one ancient terracotta.

TODAY: A collector holds her newly acquired possession. She is sure that this rare and precious piece is approximately two thousand years old because she has submitted it to a laboratory that conducts thermoluminescent dating (see Aspects of African Cultures: Techniques for Dating African Art, p. 58). She needs or wants no more information about this mysterious object, which speaks to her in a universal language. She is convinced of its authenticity by the beauty of its form. Of course, the object was expensive, but she is accustomed to paying large amounts of money for the art she loves. In fact, she would be happy to sponsor an archaeological dig in order to obtain a treasure such as this.

LAST WEEK: A gallery owner wavers before placing the terracotta back on his shelf. He will not donate it to the national museum along with other ancient works because there is something a little "off" about the piece. Instead, he will sell it. He is convinced that the international laws and conventions prohibiting the selling of antiquities are simply foolish—if he doesn't buy the pieces someone else will. He would prefer to purchase the works legally, but there is no provision in the laws to do so. The museum curator who is accepting the gallery owner's donation is too sophisticated to believe that the documents the gallery owner has provided for the pieces are real—everyone knows that the works were obtained illegally—but the curator is also too sophisticated to allow

scruples to stand in the way of such a major acquisition. He too, like the collector, would be more than willing to finance an archaeological excavation in order to obtain a few fabulous pieces. In fact, the Egyptian pieces in his museum were all obtained through the legal digs it sponsored in the early twentieth century.

FIVE MONTHS AGO: A trader packs his suitcase very carefully, making sure that his merchandise is not damaged in transit. A devout Muslim, he considers the clay objects in his luggage to be pagan idols, uncomfortable reminders of his ancestors' lack of faith. He is pleased that he can remove them from his homeland.

SIX MONTHS AGO: An official working for an African government signs a document in exchange for a large sum of money. It will allow a trader to remove twenty objects from an archaeological site. The official knows that the laws of his nation prohibit antiquities from leaving the country, but he also knows that his superiors are taking even larger "commissions" from other merchants. The official sees the archaeological treasures of his land as a resource to be exploited, and he resents attempts by outsiders to meddle in his affairs.

NINE MONTHS AGO: An archaeologist stands at an artificial mound, looking down at the holes dug by local men, women, and children. Without funding, and without the support of local authorities, she will never be able to salvage information from the site. Unless the site can be scientifically excavated, no one will know why these objects were buried, or how they were used, or anything at all about the ancient culture which produced them. An entire heritage is disappearing, and she is powerless to stop the process. She wishes that private or public funds could allow her to train locals to excavate properly, and that communities in the region could see

the work of their ancestors in their own local museums.

TWELVE MONTHS AGO: A sculptor living in a town near the archaeological site holds a clay object in his hand. He has learned, by studying intact pieces he has purchased from local farmers, and through discussions with friends living in France, what expressions and what styles a foreign buyer will expect to find in an ancient work. The sculptor remembers how his mother laughed when he asked her to teach him how to work in clay—the men of his family had always cast iron or carved wood and left the production of ceramics to women. But now he is a master. His friend the trader cannot distinguish between the figures the sculptor has bought at the site, and the figures he has made to replicate them. And while he and his associates are breaking national and international laws when they sell genuine archaeological objects, the sale of a newly made "antiquity" is completely legal.

FOURTEEN MONTHS AGO: A group of boys works swiftly, digging into the mound they found a day's walk from their village. They are glad to be on the surface—some of their friends died when a tunnel they had excavated collapsed and smothered them. One boy hears a sharp crack, and he realizes that his hoe has shattered yet another ceramic figure. He is disappointed, for he could have sold a complete object to the trader for enough money to feed his family for several months, and his brothers and sisters are always hungry. However, even the fragments will be worth a bit of cash. Unbeknownst to the boy, these broken pieces will allow a European laboratory to create sophisticated forgeries. Unlike the replicas produced locally, the European forgeries will provide "legitimately" old thermoluminescence dates. MBV

3-2. Figure, Nok Style, Nigeria, c. 800 BC– ad 200. Terracotta. Height 4½" (10.6 cm). National Museum, Lagos

The proportions of this small Nok figure are quite different from those used by the Egyptians and Nubians discussed in chapter 2, for the head is large in scale compared with the rest of the body. Today many African peoples, particularly those who live in the forest regions of West Africa, emphasize the spiritual importance of the human head in this way.

arm and head suggests that it may have been worn as a pendant. Although the surface of this seated or crouched figure is abraded, a broad collar, heavy bracelets and anklets, and distinctive chest ornaments are clearly discernible. Such regalia is similar to the ornaments depicted many centuries later on heads and figures from a civilization to the south, the Yoruba city of Ife (see fig. 8-11), but these similarities may well be coincidental.

Carbon-14 and thermoluminescence dating suggest that the production

of Nok images began about 800 BC and lasted until AD 600, a span of some 1400 years. Most, however, were made during a much shorter period of time, between 500 BC and the beginning of the Christian era. Unfortunately. most documented Nok sites had been disturbed by flooding and covered with sediment, their clay images shifted from their original resting places. We thus know little about how or why they were first deposited. Furthermore, contextual information may have been lost forever at the sites of clandestine digging that begain in Nigeria in the 1990s (see Aspects of African Cultures: Illicit Trade in Archaeological Artifacts, p. 78).

Merchants claim that large numbers of elaborate terracotta figures have been looted from these undisclosed Nigerian locations. A full figure (fig. 3-3) is an example of these works, many of which share stylistic affinities to earlier, documented objects in the Nok style. Other heads and figures are said to have been taken illegally from a site or sites near Sokoto, in Northern Nigeria. Thermoluminescence (or TL) dates for these Sokoto-style works are currently in dispute for a variety of reasons (see Aspects of African Cultures: Techniques for Dating African Art, p. 58, and the caption for figure 3-3), but they suggest that some works may have been fired about two thousand years ago-and were thus contemporary with Nok pieces. Sokoto-style terracotta heads are larger than lifesize and share some of the features (pierced eyes, smoothed surfaces, crisp details) found on Nok heads (fig. 3-4).

3-3. MALE FIGURE KNEELING ON INVERTED POT, NOK STYLE, C. 800 BC–AD 200. TERRACOTTA. HEIGHT 26" (66 CM). PRIVATE COLLECTION

CT scanning has recently revealed that many terracottas are pastiches made of unrelated fragments

> smuggled out of Nigeria, glued together, and covered with a uniform paste. The paste is composed of similar fragments ground into power, bound with an adhesive, and sculpted into a coherent form by a forger. As the broken pieces of ancient fired clay produce appropriate dates when sampled

for thermoluminescence analysis, they allow the entire figure to be considered ancient. However, such recent creations are neither old nor African, and they distort our understanding of Africa's art history.

3-4 HEAD, SOKOTO STYLE, 200 BC–AD 200. TERRACOTTA (?). PRIVATE COLLECTION

Bura

The Bura region of Niger lies to the northwest of the Nok area, just west of the Niger River. Terracotta sculptures there were first discovered by a hunter, who noticed two figures protruding from a sandbank. His find launched an archaeological campaign by the University of Niamey, which located many more ceramic works in a large cemetery at a site known as Asinda-Sika. The burial ground was used between AD 200 and 1000; the earliest Bura ceramic figures and the last Nok works could thus have been made during the same period of time.

Over six hundred ceramic vessels were found at Asinda-Sika. Each rested on its open mouth, as if placed upside-down, and most contained an iron arrowhead together with teeth and other portions of human skulls, suggesting that the vessels were spiritually empowered by the presence of ancestral relics, trophy heads, or sacrificed captives. In the ground beneath each funerary vessel, a man or a woman was buried. Some hemispherical pots had been given facial features. Others were surmounted by a cylindrical neck and a flattened head, so that the body of the vessel evoked the body of a figure. Ovoid jars formed bases for heads or for halffigures, while tall cylindrical vessels served as pedestals for full figures, many of which depicted horsemen.

Unlike the Nok terracottas, which have been found at numerous sites but share a common style, the Bura terracottas come from a single site but display an astonishing stylistic variety. Since it has not yet been possible to date individual works and establish a chronology, we do not

know whether differences in style and artistic quality reflect changes over time.

The bold geometric abstraction of one Bura style can be seen in the fragments of a horse and rider (fig. 3-5). The man's head is almost rectangular. Vertical lines mark the sides of his face and the concave curve of his forehead. The raised oval eyes of both horse and human are punctured by slits, like the underside of a cowrie shell or a coffee bean. Long, tubular sections form the arms and torso of the proud rider and the head of the marvelous horse. Textured bands cross the rider's chest and depict the horse's bridle. The series of rings on the rider's forearm is an accurate depiction of a heavy iron bracelet found on a male skeleton buried at Asinda-Sika.

A second Bura style is seen in two half-figures, possibly a man and a woman, broken from a round vessel (fig. 3-6). Although their smooth limbs, cylindrical torsos, and long necks are ornamented with the patterned bands seen on the equestrian figure, their heads are spherical rather than rectangular. The round volumes of their faces are emphasized by cir-

3-6. Drawing of two figures, Bura style, Niger, c. ad 200–1000. Terracotta. Institut de Recherches des Sciences Humaines, Niamey

Pottery found in Bura habitation sites was made from the same type of clay as funerary terracottas and is similarly ornamented, suggesting that both types of ceramic works were made by potters. Since the production of household pottery in the central Sudan is usually the domain of women, the Bura terracottas were probably made by female artists.

cular ears, eyes, and mouths.

After the Bura sites were abandoned, several centuries were to pass before the Hausa and the Songhai established centralized states in this region. While written sources exist to chronicle the history of the area after the rulers of these states converted to Islam, archaeology has given us our only record of the pre-Islamic peoples who once lived along this stretch of the Niger. As archaeological sites elsewhere in this region are being destroyed, archaeologists of Niger are providing future generations with valuable insights into the past.

Sao

A third terracotta tradition arose far to the east in the floodplains directly south of Lake Chad, a region divided today between northeastern Nigeria, northern Cameroon, and southwestern Chad. Here ceramic figures and other terracotta objects have been found in mounds. These low hills, enlarged by the remains of human habitation, rise above the surrounding plains, which are flooded during the rainy season. Some are still surmounted by towns and villages, but many are no longer inhabited.

Especially large mounds along the Logone River support the walled cities of the Kotoko people, who are Muslims. French scholars who visited the Kotoko during the 1930s searched for insights into the people who built up the mounds, the pre-Islamic predecessors of the Kotoko. Older chronicles and contemporary inhabitants of the region refer to any pre-Islamic population (including a mythical race of giants) as sao, and thus objects unearthed in the mounds south of

Lake Chad have been attributed to a generic Sao culture.

Researchers have explored over six hundred mounds in Chad and Cameroon. Unfortunately, the first excavators were trained as ethnologists rather than archaeologists, and they dug up objects without observing or recording the subtle clues that establish contexts and dates for buried materials. Since the 1960s, more scientific excavations have established historical sequences for mounds in Chad, Cameroon, and Nigeria, but relatively few metal or ceramic figures have been found at these new sites. A ceramic figure from Daima. in northern Nigeria, and a ceramic head from Messo, in southern Chad. have both been dated to the tenth century AD.

Like all of the Sao terracottas first unearthed by French ethnologists, the small ceramic head illustrated here was originally dated by guesswork to the fourteenth or fifteenth century (fig. 3-7). While the archaeological data from Daima and Messo suggest that it could have been fired as early as AD 900, we do not know when the production of these pieces ceased. We also know little about the function of the piece, which was found in Tago, an abandoned mound in southwestern Chad. It was part of a cluster of hundreds of ceramic fragments surrounding three figures or partial figures, also of terracotta. At least one of the three central figures had crossed bands depicted across its chest (perhaps representing a baldric), recalling those on some Bura sculpture. These three central images had been placed in the sherds of a funerary vessel, one of the large ovoid ceramic containers in which the inhabitants of the region

3-7. Head, Sao culture, before c. ad 1600 (?). Terracotta. Height 2½" (6.5 cm). Musée du Quai Branly, Paris

once buried their dead.

Circular lumps of clay applied between the eyes and ears of this Sao head may represent keloids, raised scarification patterns. Both the shape of the eyes and the presence of these patterns are typical of Sao heads and figures, as is the fact that it is solid rather than hollow. The protruding lips are found on heads of many Sao terracottas, even those assumed to be images of animals or other non-human beings. The attachment on the chin probably represents a beard, but may depict a lip ornament.

While ceramic figures are apparently no longer used in ceremonial contexts by the present occupants of the raised mounds south of Lake Chad, the Kotoko have identified some geometric clay objects found by excavators as offerings to supernatural forces. Today only Kotoko children form figures of people and animals, asking a sympathetic potter to fire their clay toys as she fires her pots.

LIVING ARTS OF SMALL COMMUNITIES

Vessels, figures, and other objects of fired clay are still very important in the lives of many rural peoples in the central Sudan. In these communities, ceramic arts can be studied in conjunction with architecture, body arts, and sculptural works in other media. Yet just as the archaeological record for the central Sudan is still incomplete, there are important gaps in our knowledge of its twentieth- and even twenty-first-century art forms. The accounts of the arts of various peoples discussed here are drawn from scholarly studies, but little has been written about the traditions of many of the other small art-producing groups in this region.

The Dakakari and the Nigerian Plateau

Numerous cultural groups now inhabit the Plateau region of Nigeria, the highlands north of the confluence of the Niger and Benue rivers. In contrast to the stylistic unity of the Nok figures unearthed in this area, the art forms now found on the Plateau are quite varied. These include the arts of the Nupe people, who live on the southeastern corner of the Plateau and have had an important impact upon their neighbors both north and south of the Niger River. Their pottery, textiles, domestic architecture, metalwork, and mysterious masquerades (featuring a mobile cylinder of ghostly white cloth that ascends to an awesome height) have intrigued art historians.

Research has also focused on the memorial figures made by the

Dakakari people. The Dakakari live northwest of the Plateau, a hundred miles or so down the Niger River from Asinda-Sika. They seem to have migrated into their present homeland from lands further north and west, which may explain why Bura figures from Asinda-Sika have their equivalent in the fired clay figures made by Dakakari female potters.

A male Dakakari figure once indicated the burial place of a man of distinction, such as a mayor, feast giver, high priest, hunter, blacksmith, military leader, champion wrestler, or productive farmer. Known as a "son of the grave," an image was imbedded

3-8. Female Figure, Dakakari, Nigeria, 20th century (?). Terracotta. Height 16" (40.6 cm). Fowler Museum of Cultural History, University of California, Los Angeles

in the earth covering the stone burial mound of the man and his family, and was surrounded by household pottery. Covered with a compound containing latex to give it a shiny, water-resistant surface, it may have been further protected from the elements by a small thatched shelter.

Grooves covering the face and chest depict the scarification patterns worn by the Dakakari until quite recently, and bands across the chest probably refers to the baldric worn by military leaders. However, memorial images are not a portrait of the deceased but an indication of his status; figures of women (fig. 3-8), equestrians, and large wild beasts may also be placed on a man's grave as a sign of honor. The open mouth is said to indicate a state of grief, and so the figure may be understood as a personification of mourning as well.

The Ga'anda and the Gongola River

While ceramic images of the Dakakari are made exclusively for tombs, clay images in cultures south and southwest of Lake Chad have a broad range of functions and meanings. This complexity of context is particularly striking among communities in the hills above the Gongola River, a tributary of the Benue River in northeastern Nigeria. Among these small populations, whose histories and languages reflect diverse origins, clay pots are used to address many spiritual needs.

The Ga'anda, a Chadic-speaking people of the Gongola River area, use fired clay vessels to give supernatural beings a tangible presence. The vessels allow the Ga'anda to have

physical contact with (and a measure of control over) potent spiritual forces. A particularly important spirit guardian named Mbirhlengnda is hosted in meticulously ornamented containers of fired clay (fig. 3-9). Mbirhlengnda is honored by individual families and usually resides in a vessel, itself usually surrounded by other sacred containers for associated supernatural beings. Elders offer the vessel libations of guinea-corn beer during ceremonies connected with rainmaking and agricultural fertility. This particular example is enshrined in the cleft of a rock on a hill where Mbirhlengnda can oversee the community below, protecting it from the destructive powers caused by high winds.

3-9. Terracotta figure of Mbirhlengnda ENSHRINED IN A ROCK CLEFT, GA'ANDA, Coxita Village, Northern Nigeria. PHOTOGRAPH 1980

The ceramic vessel is both a pot and an anthropomorphic being. The spherical shape that forms the "body" of the figure shares the profile of pots made by Ga'anda women for household use, but here the vessel's spout functions as the projecting mouth of the spirit's head. Tiny bent arms are attached to the smooth surface, and delicately textured ridges run vertically along the torso. Small round pellets fill an area that drapes over the head, neck, and shoulders and marks the line of the jaw. All these surface decorations have symbolic meaning. The bumps are probably an allusion to the skin diseases Mbirhlengnda may unleash to punish wrongdoers. However, the vertical ridges also refer to the Ga'anda practice of marking the skin of girls and young women with patterns of scars to celebrate their sexual maturity. These marks indicate that a girl has achieved responsible adulthood, and their depiction here suggests that spirit vessels are likewise thought to be human.

Sacred ceramics from the Gongola River region share motifs and underlying meanings with other art forms, including objects of iron and brass, domestic pottery, ornamented gourds, basketry, architecture, and body arts. Perhaps the most dramatic art form in the region is the mobile, tactile art of scarification. For several generations, the elaborate scarification patterns of men and women living near the Gongola River have been hidden under clothing. However, women once left visible much of their sculpted skin. Among the Ga'anda, this form of body art, called hleeta, is created by making hundreds of tiny cuts in the skin, small wounds that heal to

3-10. HLEETA (GA'ANDA FEMALE SCARIFICA-TION PATTERNS). DRAWING BY MARLA BERNS AFTER FIGURE CONTOURS BY T. J. H. CHAPPEL

The importance of human skin in social relationships can be seen in the Ga'anda belief that Mbirhlengnda punishes antisocial behavior with skin diseases. Throughout the central Sudan, civilized behavior and community membership are linked to the willingness of men and women to alter the surfaces of their bodies with marks of beauty and status. Unfortunately, European languages have no words which adequately describe this type of sculpted skin; the terms "scar" and "cicatrization" do not have positive associations in Western culture.

produce carefully spaced raised marks of identical size and shape. Lines of marks form single, double, or triple outlines for geometric shapes (fig. 3-10). Neither photographs nor drawings convey the subtle, textured effect of these patterns. The older women who perform *hleeta* are directed by a creative spirit named N'gamsa, and

3-11. Facial markings on mayor's wife, Tera, Kamo village, Nigeria. 1982

other supernatural beings may oversee the healing process.

Hleeta is done in several stages during a girl's lengthy betrothal to her first husband, beginning at age five or six. Every time she receives a new set of marks, her fiancé and his family must deliver gifts to her parents. There is thus a direct correlation between the sequence of hleeta patterns appearing on a girl's body and the number of bridewealth payments given to her family, and a girl may not consummate the marriage until she has received her final marks and the groom has fulfilled his obligations. New wives celebrate their completed *hleeta* at the annual harvest festival.

The marks of men and women in many other Gongola River populations identify them as members of a specific community or cultural group. The slightly asymmetrical markings of a village mayor's wife identify her as a member of a Tera community (fig. 3-11). The smooth grooves adorning these people were carved into their skin when they were babies.

Designs appearing on a woman's skin are also burned, impressed, or carved into the calabashes she owns. These gourds, whose outer rinds have been scraped, dried, and prepared for use as containers, are used by many peoples in Africa. However, they are the focus of especially elaborate aesthetic attention in the Gongola region. Beautifully ornamented

gourds embellish a household and are adorned and displayed primarily by women.

Among the Ga'anda, a basket filled with decorated gourds must be given by the groom's family to the bride. One of the calabashes arrayed in the Ga'anda bride's wedding basket illustrated here displays patterns similar to *kwardata*, the panels of double lozenges and vertical lines covering her upper thighs and the sides of her lower back (fig 3–12; compare fig. 3-10). Similar bands of lozenges encircle the large basket itself. The curved shapes in the centers of the

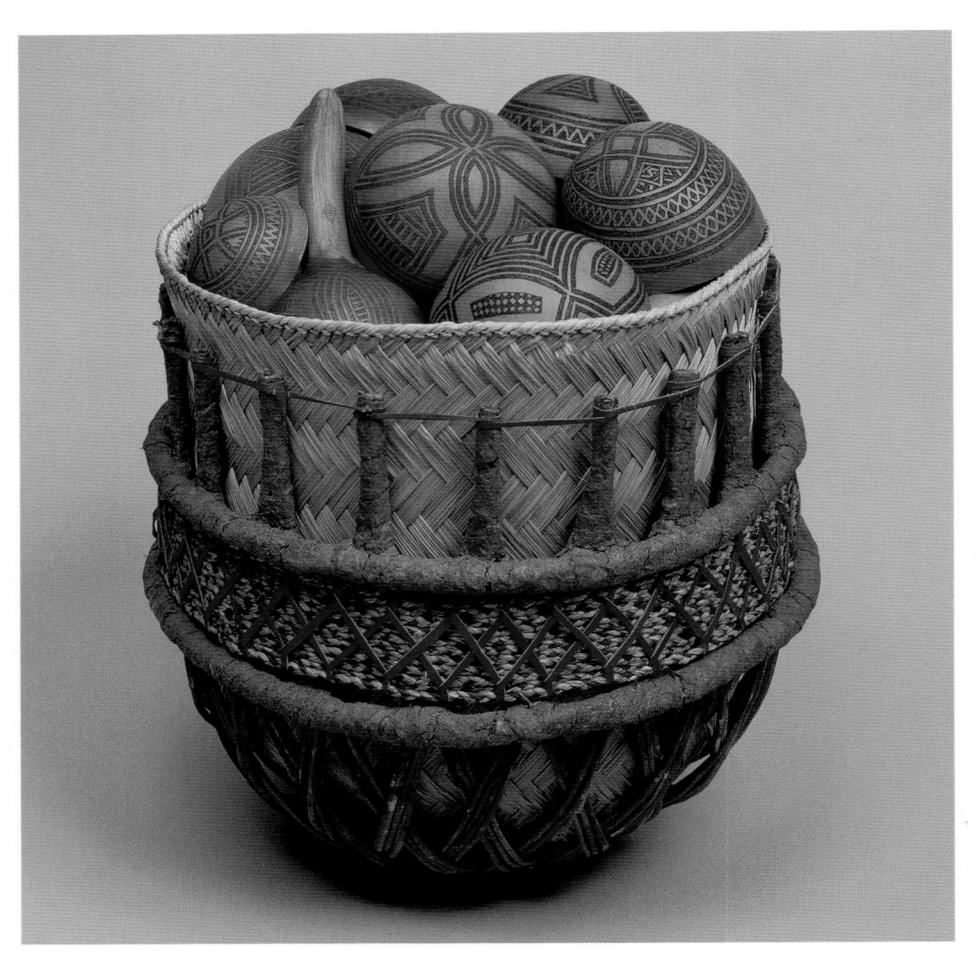

3-12. Wedding basket with engraved calabashes. Ga'anda, Nigeria. Fibers and Gourds. Height of basket 19½" (49.5 cm). Fowler Museum of Cultural History, University of California, Los Angeles

calabashes recall the pointed ovals on the woman's abdomen. Broad lines pressed into the surface of the gourds (a technique known as "pressure engraving") are formed of numerous fine dark marks, just as the lines of *hleeta* are made of tiny points.

Ceramic vessels, gourds, and baskets all display the patterns of *hleeta*. Ceremonial weapons are also given these designs, as is the entranceway that a groom weaves for his wife's new home. Ga'anda art is thus based upon an integrated visual system, full of related and concerted references to the world of women, marriage, and sexuality, to socialization, and to the wealth of community life.

tographed and sketched the tall conical structures that rose above the low curved walls surrounding each household (fig. 3-13). The structures' raised patterns, which varied from household to household, served to channel rainwater and to provide toeholds for repair work, but were obviously chosen for their aesthetic impact as well. The walls were thin but strong. The interiors, rarely photographed by outside observers, were also finely sculpted, and almost all shelves, storage units, beds, and interior divisions were of clay. The Musgum still live in the Logone River valley, but today they build smaller, simpler homes.

munities on the Logone River pho-

The iron weapons of the peoples who live south of Lake Chad have also impressed outside observers. The curved blades forged by blacksmiths in many of these groups are described as "throwing knives," for they can be hurtled sideways to slice through a target, or tossed into the air like a baton. Throwing knives vary in form, reflecting ethnic affiliation, individual workshops, intended use, and the social rank of the original owner (fig. 3-14). Musgum warriors and their neighbors once kept these graceful and dangerous blades in leather cases strapped to their backs. Although throwing knives are rare in the central Sudan today, men of high status

Musgum and the Logone River

The Ga'anda are not the only population to weave walls, roofs, and partitions to make structures analogous to baskets. Fiber-based architecture also appears in many other areas of the central Sudan. Still other communities build homes, furnaces, and granaries of modeled earth, buildings that are as carefully embellished as clay vessels. The Nupe have created faceted walls inlaid with shiny plates, while the Dakakari and their neighbors painted their walls in exuberant patterns. In fact, the domestic architecture of this region is among the most spectacular in Africa.

Stunning architectural forms built from compressed, sun-dried mud were once built by the Musgum and their neighbors, heterogeneous Chadic and Nilo-Saharan populations living east of the Mandara Mountains in southwestern Chad and northern Cameroon. During the early twentieth century, visitors to Musgum com-

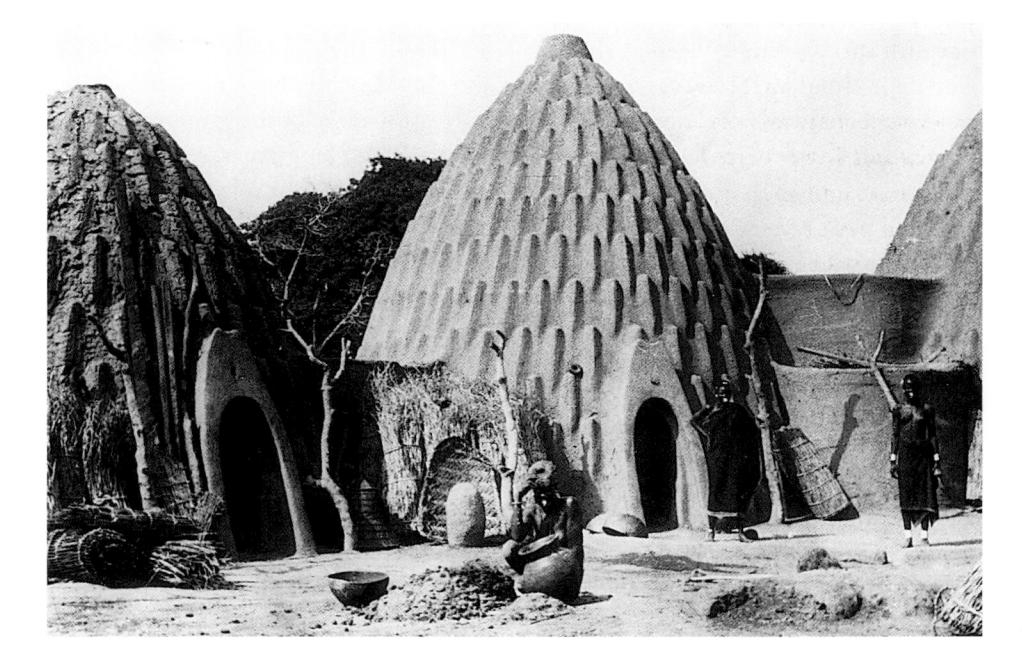

3-13. Musgum adobe compound with large dwellings and joining wall, northern Cameroon. Photograph ${\it c.}$ 1930s

In most communities of the central Sudan, families do not live in a single structure formed of many rooms but in a cluster of separate units encircled by a wall or fence. Each unit is a distinct building, often a single room, which is the property of an adult man or woman and may be abandoned when its owner dies. Women may share their housing unit with unmarried children and relatives. The individual buildings of a Musgum compound were of two basic types: large, domed dwellings divided into cooking and sleeping areas, and smaller, smoother granaries.

3–14. Throwing knives, Sara, early 20th century. Iron. Height of left-most knife 25% (64 cm). The British Museum, London

may still carry a single weapon slung over their shoulder. However, some of these weapons were not meant to be thrown but to be carried as prestige items. Iron knives that are ceremonial or sacred may receive sacrificial offerings, or be said to cause lightning storms. Some have associations with female ancestors, or (as among the Ga'anda) are carried by female dancers.

Apart from sacred ceramic vessels, few figurative images have been recorded among the peoples of the Logone River, the Mandara Mountains, or the Gongola River. Farther south, along the Benue River, wooden figures and a variety of masquerades appear along with arts in metal and clay. As a corridor for migrations, the Benue River valley has facilitated the movement of peoples and art forms. Of the intersecting groups who live between the Benue River of Nigeria and the Adamawa Plateau of Cameroon, those known as

the Jukun, the Chamba, the Mumuye, and the Mambila have been most fully studied. All four groups speak Niger-Congo languages, some of which are distantly related to the forms of Bantu spoken in the southern half of the African continent.

The Jukun of the Middle Benue River

The Jukun have a history of political authority in the middle Benue region, and they share art forms with former allies and vassals on both sides of the Benue River; cloth produced in the Jukun capital, Wukari, is exported to Cameroon kingdoms. The divine kings of the Jukun are rainmakers charged with responsibility for agricultural and human fertility. Their brass regalia are similar to the staffs and swords of many neighboring groups and appear to be part of a corpus of sacred metallic arts found throughout this part of the central Sudan.

A ceremonial brass adze collected among the Tiv people illustrates the cross-cultural interactions characteristic of Jukun arts (fig. 3-15). This adze was probably made by the Abakwariga, nominally Islamic Hausa artists who work in Wukari and who have produced regalia in copper alloys for Jukun kings. Yet the adze was carried in a Tiv healing dance led by Abakwariga women, who were possessed by spirits similar to those known as bori in other Hausa groups. The anthropomorphic brass head is adorned with a crest, as are most figures and even some helmet masks in the region. From its mouth issues an iron blade. In fact, this bold object may be the Jukun/Abakwariga/Tiv counterpart to the ceremonial knives used further north.

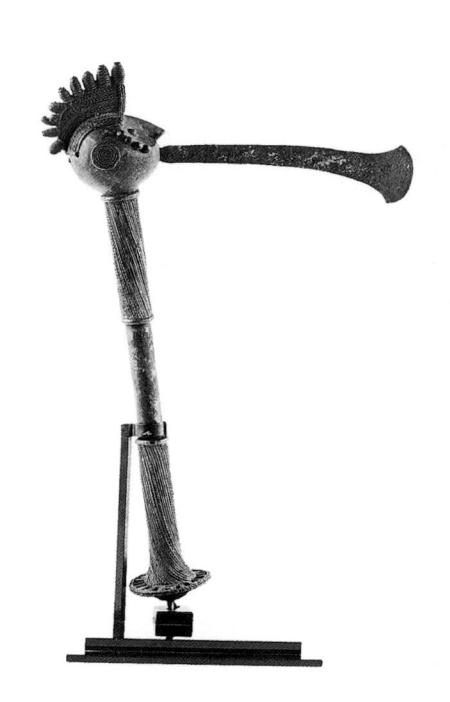

3-15. Adze, Abakwariga artist for Jukun or Tiv Patrons. Brass. Height 17" (42 cm). Fowler Museum of Cultural History, University of California, Los Angeles. Arnold Rubin Collection

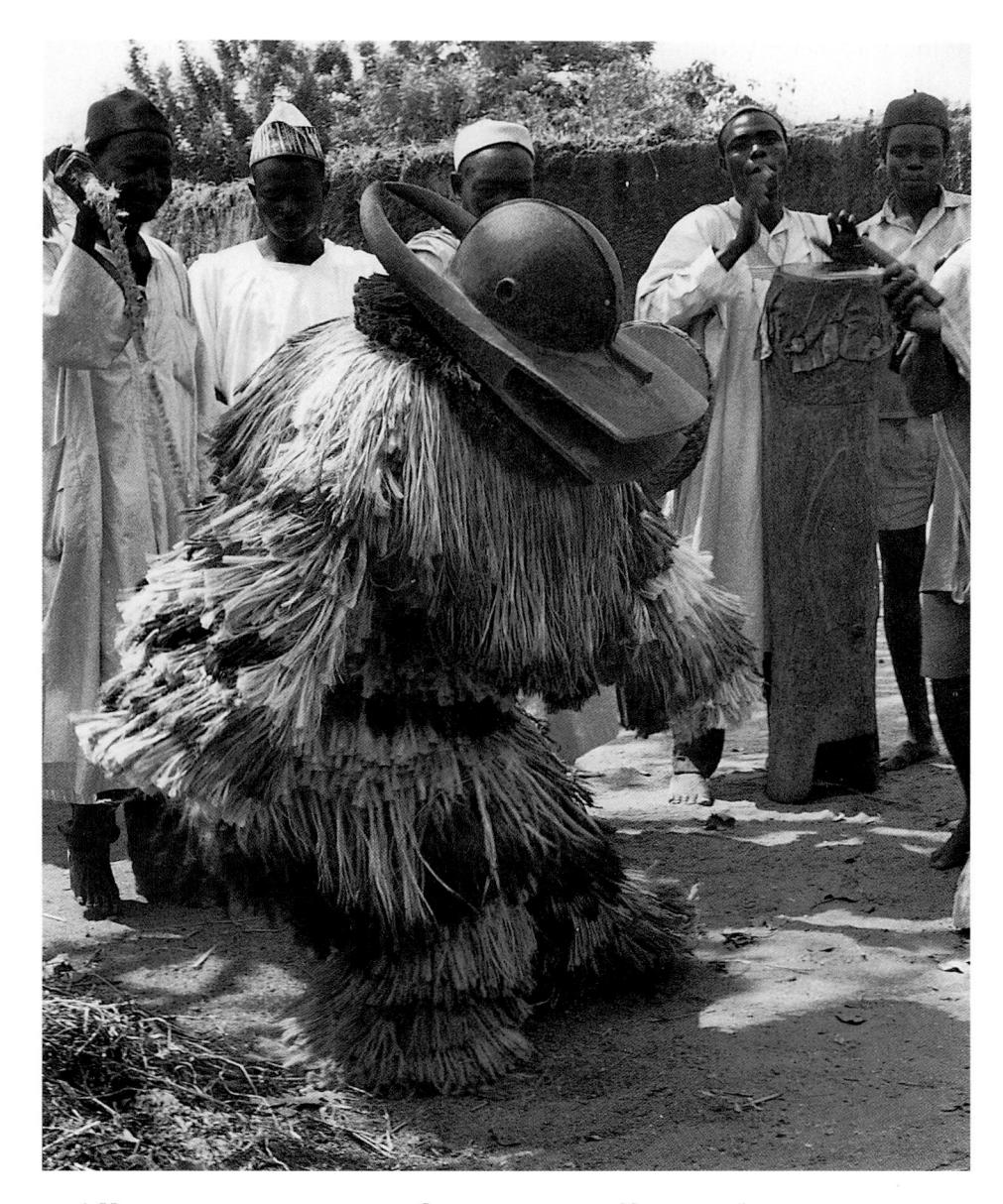

3-16. Helmet-mask in Performance, Chamba, Northern Nigeria. 1965

The Chamba of the Nigeria/ Cameroon Borderlands

Like the Jukun, some Chamba peoples have kings whose authority is mainly religious. These Chamba kings are assisted by royal women who serve as queens, and by members of their matriclans. Leaders of royal matriclans are sometimes responsible for the appearance of a masquerade,

known by many names, that incorporates powers of the ancestral dead and of the wilderness.

The masquerade is danced with a wooden mask that covers the top of the dancer's head like a helmet (fig. 3-16). From the helmet a muzzle projects forward and horns project backward in a single horizontal plane. Generically this is known as a horizontal helmet mask, a type of

zoomorphic mask that appears across western Africa. The hemispherical dome of this Chamba mask is related to death, for it is said to be like a skull, an ancestral relic taken from the grave of an elder. Other features are related to the wilderness: the open jaws are the jaws of the crocodile, the horns those of the forest buffalo. Painted red (the color of the blood of the hunt and of men), black (the color of night, witches, and women), or both red and black, the mask is linked to dangerous forces. The masquerader is hidden under a thick costume of plant fiber.

Royal matriclans claim descent from a forest buffalo that had been transformed into a beautiful woman, and in some way the Chamba queen is understood as her incarnation. In at least one Chamba region, the masquerade refers to this buffalo ancestor. For example, the king plays a crucial role in crop fertility, and the royal masquerader appears during planting ceremonies to assist its royal offspring in this important task. When the masquerader leaves the community to return to the river, it is understood to be returning to the site where the forest buffalo ancestor was seized by her husband.

Chamba boys learn the human identity of the masquerader when they are initiated. The legend of the royal matriclan's origin teaches them that a man animates the wild, deathmasked creature just as a woman had been hidden under the skin of a forest buffalo. The boys also learn that the royal ancestor killed her husband when he shared his knowledge of her true identity, and that therefore they should never reveal the secret of the masquerade.

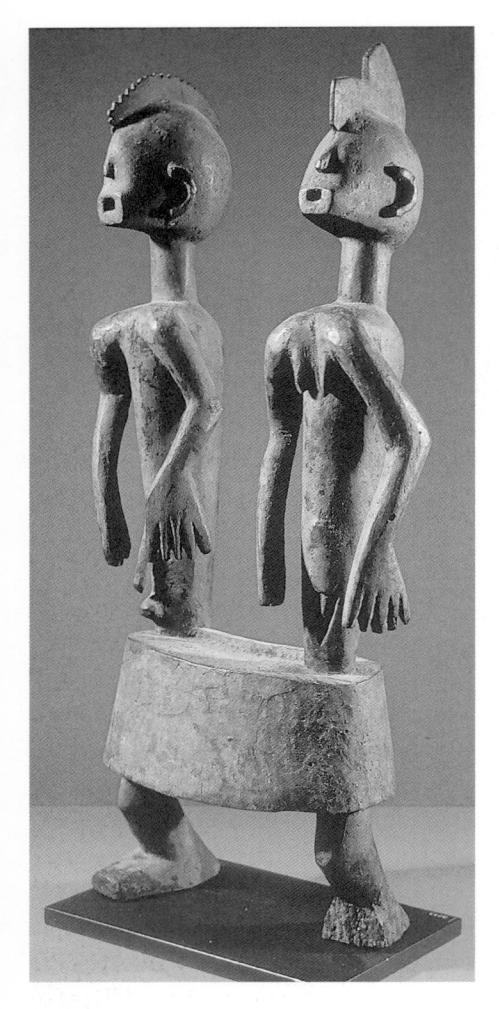

3-17. DOUBLE FIGURE, CHAMBA (?). WOOD. HEIGHT 21" (53.3 CM). COLLECTION OF ROBERT AND NANCY NOOTER

Sagital crests, the central ridges appearing on the heads of the ceramic and wooden figures as well as the masks of many peoples of the central Sudan, often represent specific hairstyles. Yet these prominent extensions may also be references to supernatural authority.

The masquerade appears at public funerals of elders and royals as well as during agricultural ceremonies. It thus presides at crucial times of transition in the life of the community. In fact, the masquerade dances when the world of the wilderness and the world of the dead merge with our own.

Other powerful objects are owned by Chamba clan organizations referred to as Jup or Voma, and are linked to their secret knowledge of remedies for illnesses and misfortunes. Among these highly charged works may be ceramics, brass figurines, musical instruments, and wooden figures. All are kept hidden in a bundle or under a large pot. The unseen presence of this sacred material transforms the pot or bundle into an altar, a place of contact between the natural and supernatural worlds.

A wooden image of a joined couple may once have belonged to one of the Chamba clan organizations that use statues rubbed with ochre to battle adultery and its corrosive effects on the community (fig. 3-17). Although no data accompanied the object when it left Nigeria, its composition and style suggest that it was carved by a Chamba artist and that it strengthened the marriage relationship. Here a male and female form are joined as one being, just as a husband and wife should form a single unit.

The statue's combination of curved and flat planes effectively evokes human forms without actually transcribing them. Facial features are reduced to semi-circular ears, small bumps for noses, and small hollows for mouths. Sexual attributes are simplified but easily recognizable. Arms spring from the front of the body rather than the sides. Shoulders, elbows, and wrists mark the junctures of diagonal lines, and the arms and hands curve gently as if to encircle the cylindrical torsos. Such interplay between "zigzag" limbs and long narrow bodies appears in compelling variations in the religious sculpture of the Chamba and many of their neighbors. The sculpture's high degree of abstraction also suggests that the statue supported a moral principle. The figures are not portraits but rather symbols of male/female union. By avoiding any direct link with particular human beings, the artist encouraged members of the group to reflect upon ideas about relationships between men and women generally in Chamba society.

The Mumuye of the Upper Benue River

The Mumuye peoples, the northern neighbors of the Chamba, also display sculpture in a variety of contexts. Mumuye wooden images may be associated with elders, rainmakers, diviners, and other religious leaders. Like Chamba sculpture, Mumuye figures are highly abstracted, perhaps in part because they invoke forms of human and supernatural authority. A particularly powerful Mumuye statue is formed of long fluid shapes (fig. 3-18). Springing from an abbreviated base of legs and hips, the slender torso is framed by arms that curve downward, backward, then forward from the smooth arch of the shoulders and neck. The head is a doublecrested abstract helmet with angular extensions, whose sharp front edge repeats the overhanging curve of the shoulders.

Mumuye wooden images are associated with elders, rainmakers, diviners, or other religious specialists and are often guided by a protective spirit known as Va. Many masquerades are known as vabo. Vabo masks may be carved for a newly trained age-grade that has demonstrated its prowess and

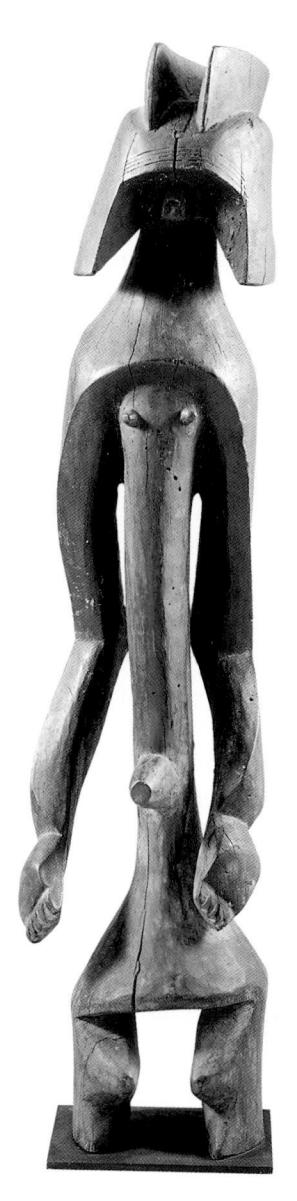

3-18. Figure, Mumuye. Wood. Height 36%" (93.3 cm). The Metropolitan Museum of Art, New York

is considered worthy of owning the masquerade and keeping its secrets. Identified with the forest buffalo, the masks have slit, cylindrical jaws, a central dividing ridge bisecting the rounded forehead, and upward-curving horns (fig. 3-19). Color defines and emphasizes features such as the circular eyes.

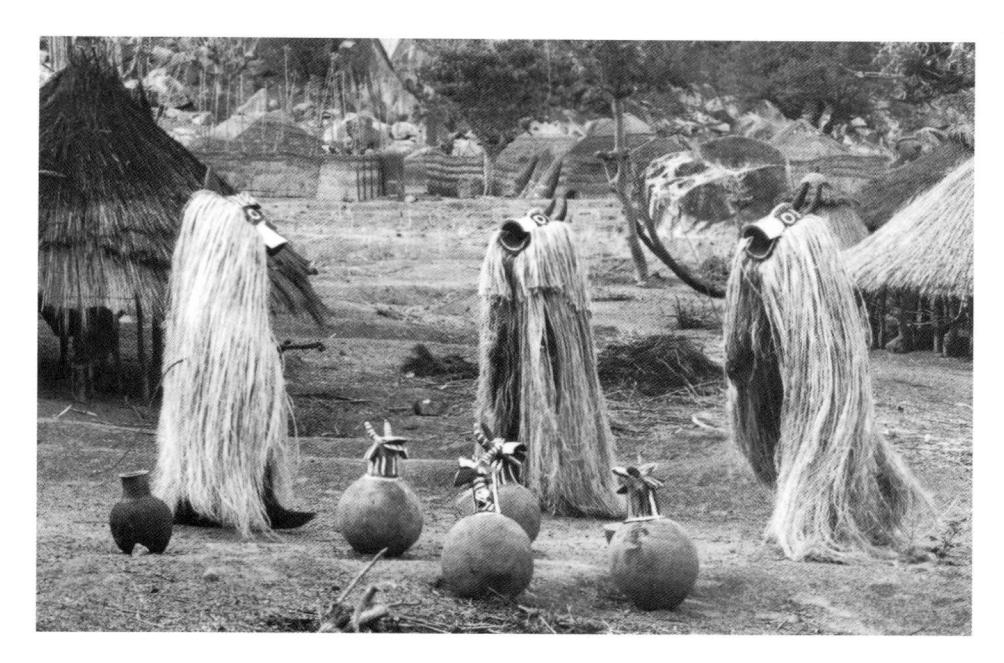

3-19. $\it VABO$ masqueraders and ceramic vessels at a funerary celebration, Mumuye, northern Nigeria. Photograph 1969

Vabo masquerades punish antisocial behavior and chase away criminals, and individual names given to each male vabo mask underscore their aggressive qualities. Yet there is also an element of playful banter and male solidarity in some vabo performances. A "wife" or female counterpart to vabo may appear with the principal masquerader, acting out feminine roles in a humorous way. Sometimes these companions take the form of a carved pole set up in the center of the community as a hanger for the masquerader's long fiber dress. In other cases vabo's female companion is danced, manifest as a sculpted head rising from a wooden support (fig. 3-20). The curved forms on either side of the head refer to Mumuye women's earlobes, formerly enlarged with wooden disks, just as the spiky protrusions in front may represent the brass nose ornaments they once wore.

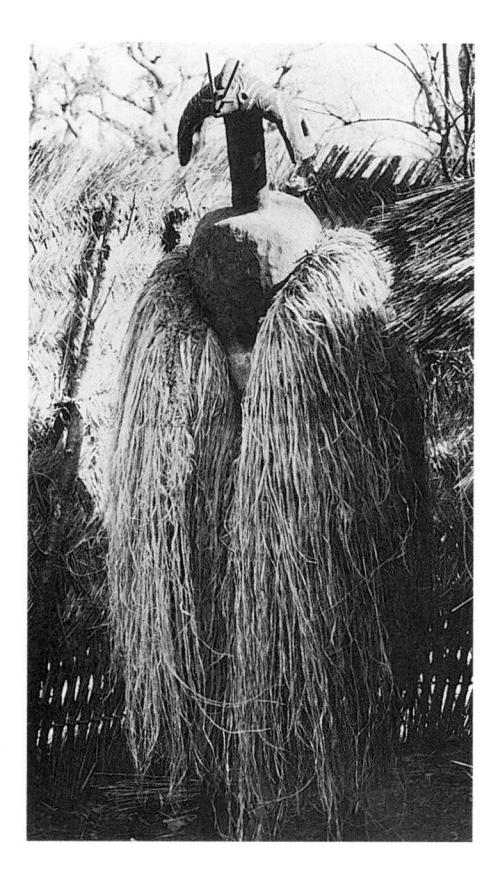

3-20. VABO DANCE IMAGE, MUMUYE, NORTH-EASTERN NIGERIA. PHOTOGRAPH 1965

Vabo's most important manifestation may occur during men's funerals such as the one photographed in figure 3-19. During these ceremonies, vabo masqueraders and their attendants gather ceramic vessels from the homes of all the men who have died during the year. Each spherical pot, whose finial is a miniature version of the forest buffalo mask, has sheltered the soul of the deceased since his death. After carrying the pots to a sacred area, the dancers remove their

masks and, as humans rather than spirits, smash the pottery to release the souls. Women organize similar ceremonies for deceased female elders.

Both Chamba and Mumuye masks bring dangerous animals from the wilderness into the community, and both appear at funerals. Further variations of the form and meaning of horizontal helmet masks in this region may be seen in the art of the Mambila people, who live southeast of the Chamba.

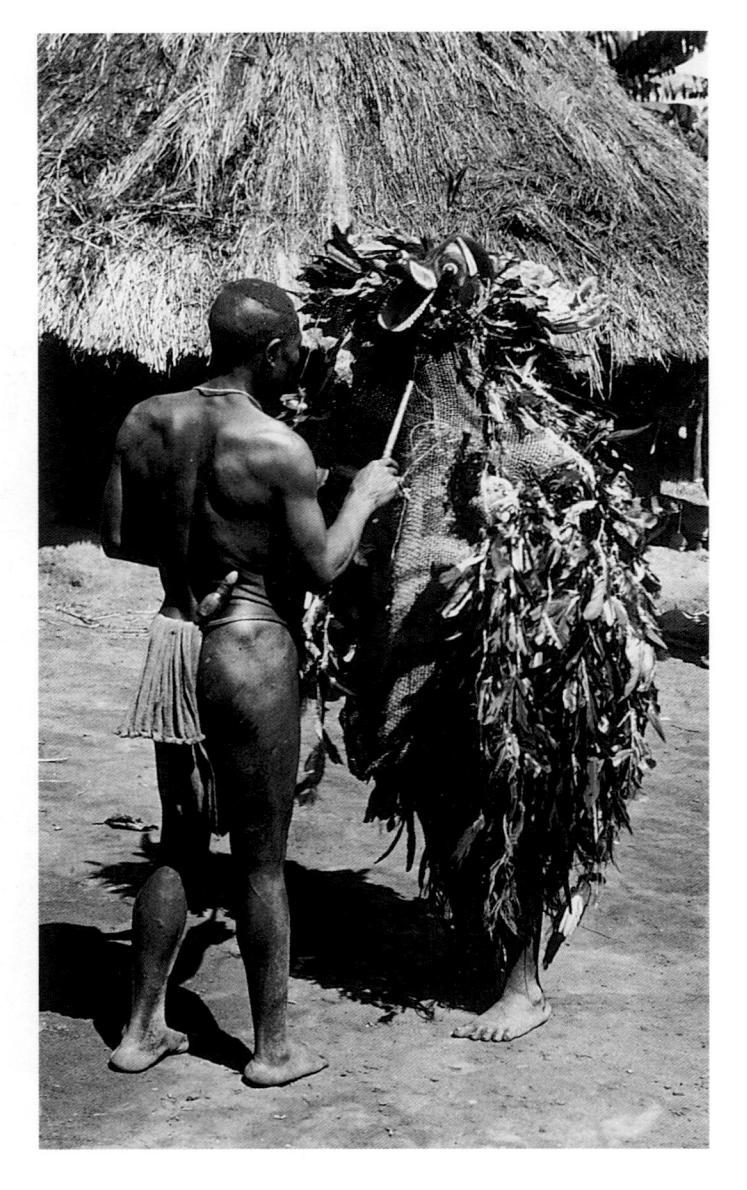

3-21. SUAGA MASQUERADER, MAMBILA. BEFORE 1960

The Mambila of the Nigeria/Cameroon Borderlands

Mambila art centers upon an association called Suaga. Unlike the Jup or Voma of the Chamba, Suaga is not primarily concerned with the illness and psychic healing of an individual, but with justice and supernatural cleansing within the community. Training in Suaga allows elders to extract powerful oaths from disputants, who know that they will receive supernatural punishment if they break (or have broken) their promises. Suaga may also protect a homestead or a community by spiritually "burying it," and placing it out of harm's way.

Every year or two, Suaga masquerades are performed in sequence, starting from a central community. Groups of boys are initiated into Suaga as it arrives in their region. When the masqueraders appear, women and young children retire, for women dressed in rags and vegetation present their own version of the masquerade at a different time and place.

Male masqueraders wear knitted or knotted fiber costumes of solid black or colored patterns. Masks with wide mouths, protruding eyes, and upright ears were formerly worn, although they are quite rare today. The example illustrated here resembles Mumuye *vabo* masks in its colors and proportions, though the curved planes of its surfaces are more exaggerated (fig. 3-21). The round eyes marked by concentric circles seem to burst from their sockets, while the flared jaws open in a gaping grin.

The costumes, musical instruments, masks, and figures used in

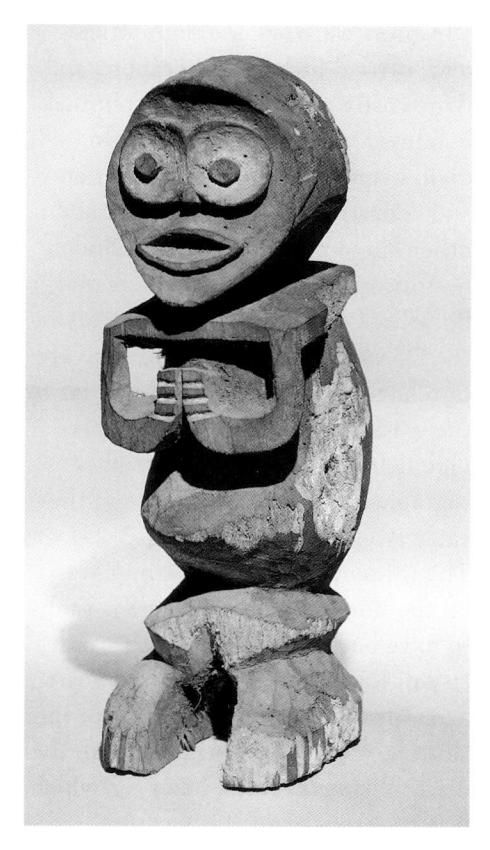

3-22. TADEP FIGURE, MAMBILA, 20TH CENTURY. WOOD AND PIGMENT. HEIGHT 17%" (43.5 CM). THE METROPOLITAN MUSEUM OF ART, NEW YORK. FLETCHER FUND

Suaga ceremonies may be stored in small granary-like buildings in the homesteads of their clan or family owners. The front walls of these storehouses were once covered by a painted wooden board. A net holding three-dimensional objects also protected and proclaimed the sacred power of the objects within. A painted wooden figure known as a tadep came from one of these storehouses (fig. 3-22). Just as the limbs of Chamba and Mumuye figures fold out from the base or front surface of the torso, the arms of this Mambila statue form semi-circles in front of the body. Spherical segmented shapes represent hips, knees, and feet. The separation

of the eyes and facial plane into a nested series of concave circles is specifically Mambila, as are the compressed (rather than elongated) proportions.

Today the Mambila carve few masks or figures for Suaga. As in past centuries, art objects are often adopted or abandoned by communities in response to shifting political and religious contexts. Mambila religious practices have been particularly affected by Christianity. The most potent agent of change in the central Sudan during the past four centuries, however, has been Islam.

THE IMPERIAL ARTS OF THE KANURI AND HAUSA

Islam was adopted in the central Sudan by three important groups, the Kanuri, the Hausa, and the Fulani. Each of these peoples, while strongly influenced by their non-Islamic neighbors, has in turn influenced the art and culture of broad areas of the region. The Kanuri and Hausa, the first peoples in the region to form centralized states, were also the first populations to convert to Islam, and their cultures thus share many features.

The Kanuri originated in the vast dry portion of the continent lying between Lake Chad and the Nile River. Like the ancient inhabitants of Meroe (see chapter 2), the Kanuri speak a Nilo-Saharan language, and their culture is centered on the institution of divine kingship. Kanem, the first recorded Kanuri kingdom, arose during the last centuries of the first millennium AD and was probably linked by trade to the Christian kingdoms of Upper Nubia. The king, mai, of Kanem converted to Islam during

the eleventh century, when the kingdom was at the height of its power.

By the thirteenth century Kanem was torn by dynastic disputes, and a clan broke away to form the kingdom of Bornu in the more fertile lands southwest of Lake Chad. During the sixteenth century Bornu absorbed Kanem and became the most powerful political force between Lake Chad and the Niger River. Although Bornu was superseded by Hausa and Fulani states during the eighteenth and nineteenth centuries, it remained an important kingdom until the beginning of the colonial era. Today Bornu is an emirate within the nation of Nigeria.

The Kanuri were a nomadic or semi-nomadic people for much of their early history, housing the mai and the royal court of Kanem in tents or portable structures of thatch. Bornu, however, had a walled capital. Courtiers dressed in fine textiles; during the early nineteenth century a European traveler noted that a ruler of Bornu distributed over a thousand robes to loyal subjects. One of the prestigious garments seen by this visitor may have been this vibrantly colored, densely ornamented men's robe (fig. 3-23). The back, shown here, is divided into square or rectangular panels. The central panel is crisscrossed by diagonal bands, while the surrounding sections alternate geometric shapes (particularly circles and triangles) with floral motifs or knots. While some of these designs are quite similar to triangular- and lozengeshaped motifs on textiles from North Africa, many are probably derived from patterns found on glass, pottery, or metalwork made in Islamic Egypt (see fig. 2-31).

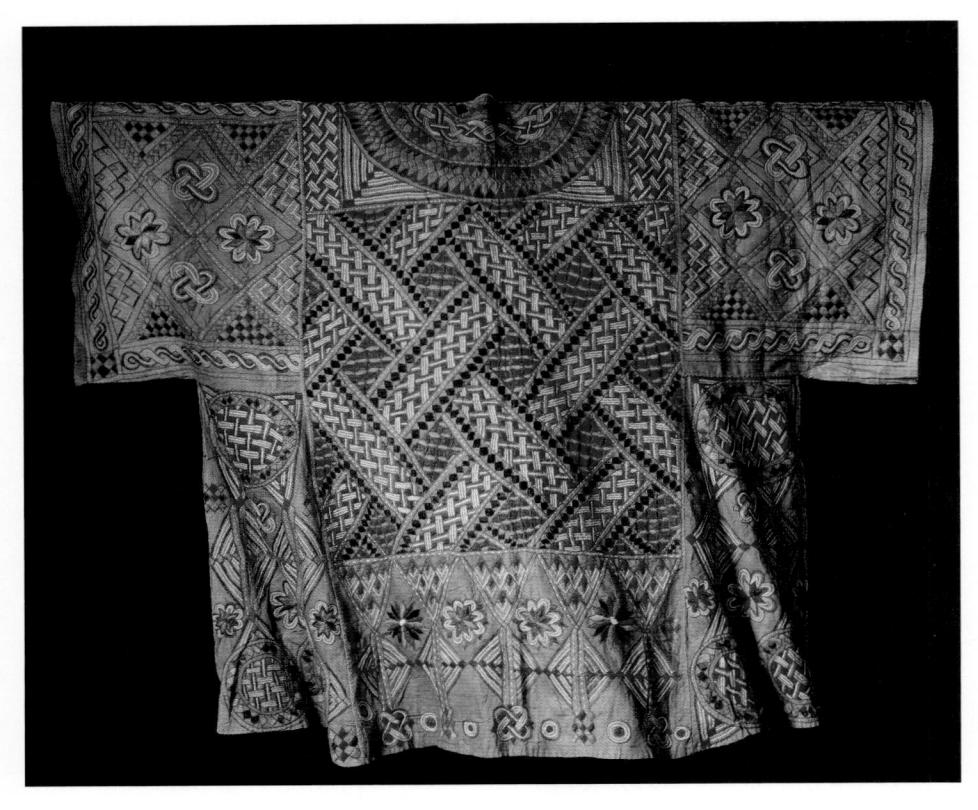

3-23. Embroidered Robe, Kanuri, Bornu, early 19th century. Cotton and silk. Length 39" (99 cm). Museum für Völkerkunde, Staatliche Museen, Berlin

Kanuri warriors and dignitaries once carried impressive weapons and wore costly armor, including plumed helmets and shirts made of chain mail. Even today, mounted courtiers and equestrian guards in Bornu and other kingdoms of the central Sudan perform spectacular maneuvers on horseback at festivals. Young riders of the Djerma or Zerma people, who are unrelated to the Kanuri and live far to the west of Bornu, nonetheless display helmets similar to those photographed on Kanuri warriors in the early twentieth century (fig. 3-24). The thick, quilted cotton armor worn by the horses and their riders is said to have been invented in the Hausa city of Kano some six hundred years ago. The bold stamped patterns of the cloth here are much brighter than the original Hausa armor, however, which was probably plain white cotton.

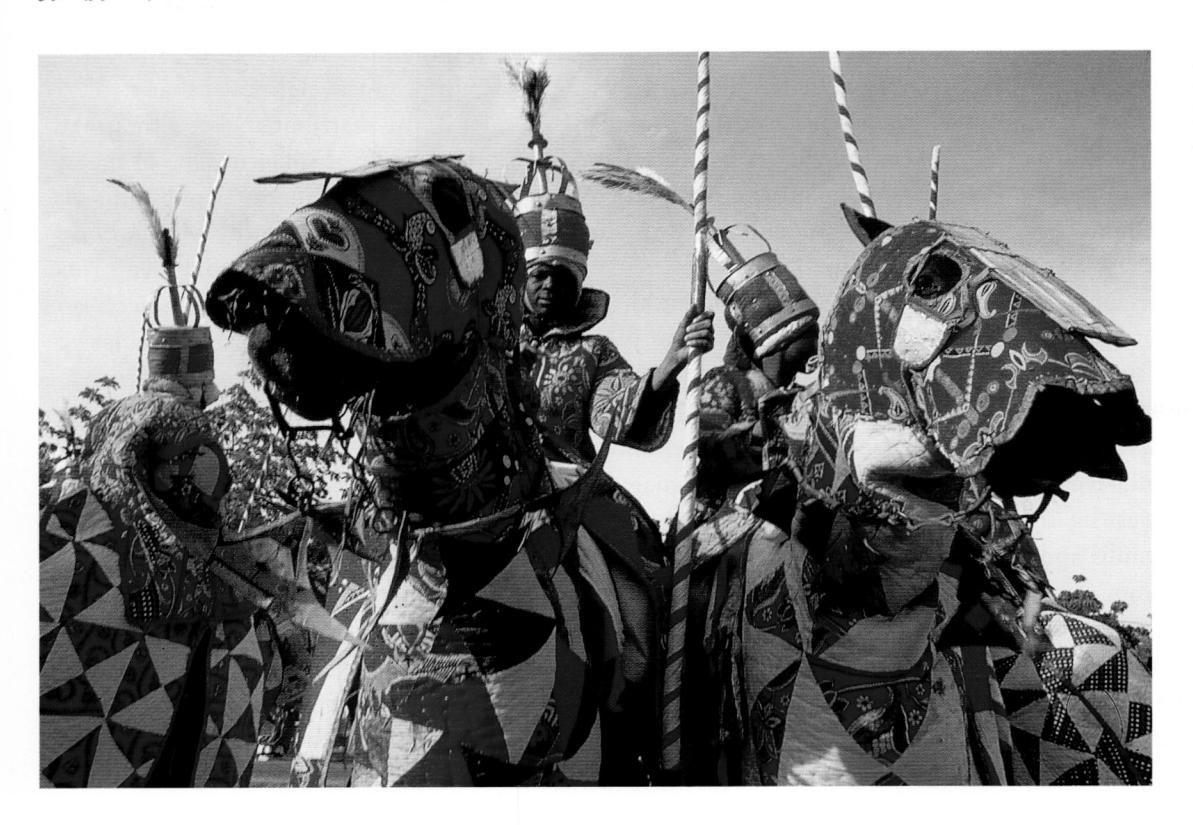

3-24. Hausa warriors in Quilted Cloth Armor, Niamey, Niger. 1971

The Djerma are allied to a Hausa city-state in Niger. These young Djerma equestrians could be the descendants of the warriors who were buried centuries ago beneath terracotta horsemen in the Bura region of Niger.

Hausa Mosques and Civic Architecture

According to legend, six of the original Hausa cities were founded by the sons of a heroic stranger who had slain a mighty serpent and married a local queen. Since the Hausa are a Chadic-speaking people, historians believe that they were one of many groups to move south and west to settle in what is now southern Niger and northwestern Nigeria, possibly over a thousand years ago. The legend may refer to these migrations.

By the sixteenth century, important Hausa city-states such as Kano, Katsina, and Zaria were fortified with thick adobe walls and administered large areas of neighboring territory. During this period the king, sarki, of most Hausa cities was a Muslim. His official allegiance to Islam allowed the Hausa to conduct alliances with the Islamic states of Songhai, a multi-ethnic empire further up the Niger River, and Bornu. During the early nineteenth century, many Hausa lands were conquered by the Fulani leader and religious reformer Usman dan Fodio, and the recent histories of the Hausa and the Fulani are thus intertwined.

The Friday Mosque of the old Hausa city of Zaria was designed during the first half of the nineteenth century by Mika'ilu, both a Great Artist, babban gwani, and a Hausa flag-bearer of Usman dan Fodio. Parts of the mosque were probably commissioned by Usman dan Fodio himself and by his son Mohammed Bello. Like all Hausa architects responsible for the design of important buildings, Mika'ilu was also a malam, a learned man who could read Arabic and inter-

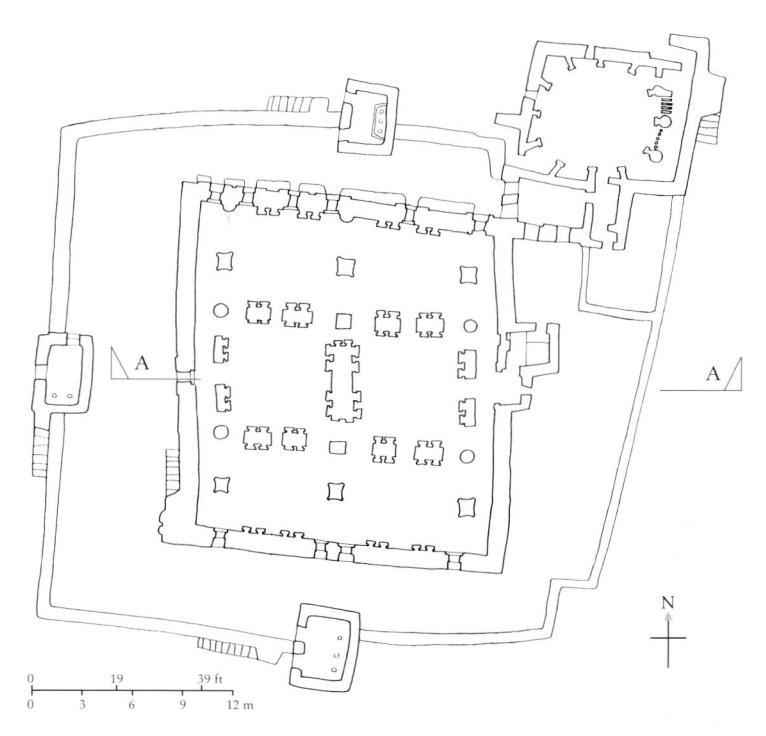

3-25 Plan of Friday Mosque, Zaria, Nigeria, early 19th century. Drawing by J.C. Moughtin

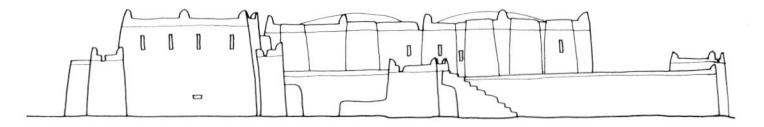

3-25A NORTH ELEVATION OF FRIDAY MOSQUE

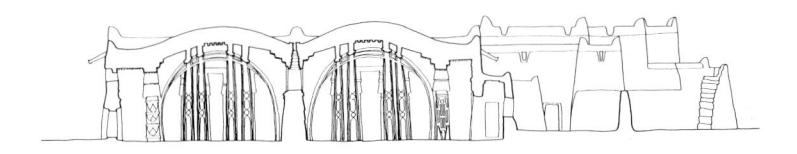

3-25B Section of Friday Mosque taken along the A-A axis marked in figure 3-25 $\,$

pret the Qur'an. Instructed in geometry, *malam* have the skills needed to plan a building complex, and as religious specialists they know the prayers and incantations required for such an enterprise. Having made at least one pilgrimage to Mecca, a *malam* such as Mika'ilu had also seen many mosques and architectural

forms in the course of his travels, and could incorporate this knowledge into his work.

Square in plan, the prayerhall of the Friday Mosque of Zaria is capped with six domes (fig. 3-25). It was once set within a square courtyard. Entry to the courtyard was through one of four entrance chambers built into the

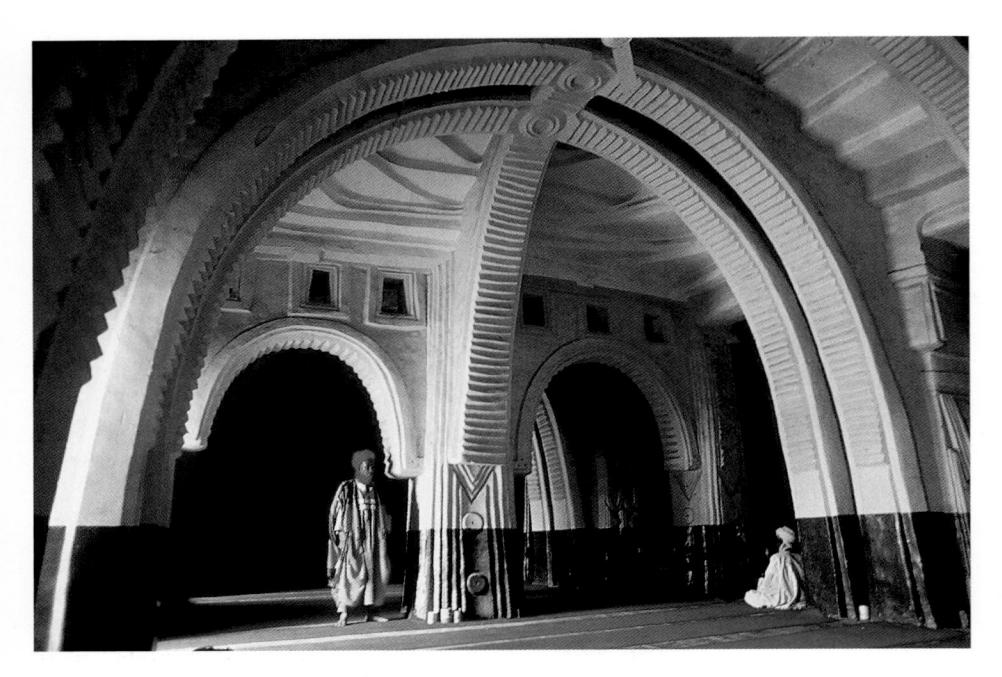

3-26. Interior of Friday Mosque, Hausa and Fulani, Zaria, Nigeria, Mika'ilu, early 19th century. Adobe with Palm-rib Vaulting

3-27. CEILING OF A
RECEPTION ROOM IN
THE PALACE OF THE
SARKI, HAUSA, KANO,
NIGERIA, 20TH CENTURY.
PALM-RIB VAULTING,
MUD PLASTER, PAINT

enclosing wall. Each entrance chamber, *zaure*, had a dome, a doorway leading to the exterior, and a doorway leading to the interior courtyard. Inside the prayerhall, the domes are crossed by ribbed arches resting upon large piers (fig. 3-26). The arches and piers are ornamented with ridges and other austere geometric designs. A Hausa *malam* has compared the white ribs of this mosque interior to the long white cloth wrapped around the head of a man who has made a pilgrimage to Mecca, and the photo-

graph reveals their grace and beauty. Unfortunately, the Friday Mosque has since been partially dismantled, repainted, lit with fluorescent lights, and placed inside a larger cement structure, resulting in the loss of much of its original character.

The mosque is situated on one side of a plaza-like area called a *dendal*. Major streets leading from the gates of the city intersect at the *dendal*, which acts as both a parade ground and the focus of public ceremonies. On one of the other sides of the *den-*

dal is the palace ("house of the king," gidan sarki) of the sarki of Zaria. Like mosques, Hausa palaces and private residences are walled, and are entered through a zaure. Inside the palace walls, small buildings may be set aside as reception rooms, which are particularly ornate. One of the reception rooms of the sarki of the Hausa city of Kano, built during the first half of the twentieth century, has a domed ceiling held in place by a network of arches (fig. 3-27). Patterns sculpted in relief are emphasized by contrasting areas of bright color. The paint may be given a light varnish containing bits of mica so that the entire surface sparkles. At the intersection of each ribbed arch may be a shiny enamel plate, now much more common in Hausa ceilings than the brass plates placed there in the past.

The distinctive form of the Hausa ribbed dome seen here has intrigued art historians. Small pieces of wood laid side by side in regular patterns are plastered with clay on the underside to form a ceiling, and covered with waterproofed mud above to form a roof. The gentle curve of this mudplastered surface is supported by arched ribs, which transfer the weight of the roof to walls or pillars. Each rib is made of lengths of palm wood embedded in mud, similar to the way ferroconcrete is made of steel embedded in cement.

This ribbed vaulting could be an imaginative adaptation of North African architecture; one of the oldest ribbed domes of the Mediterranean world is in the Great Mosque of Qairouan, a place of worship known to Hausa *malam* who travel to Tunisia for study and trade (see fig. 1-18). Yet the Great Mosque of

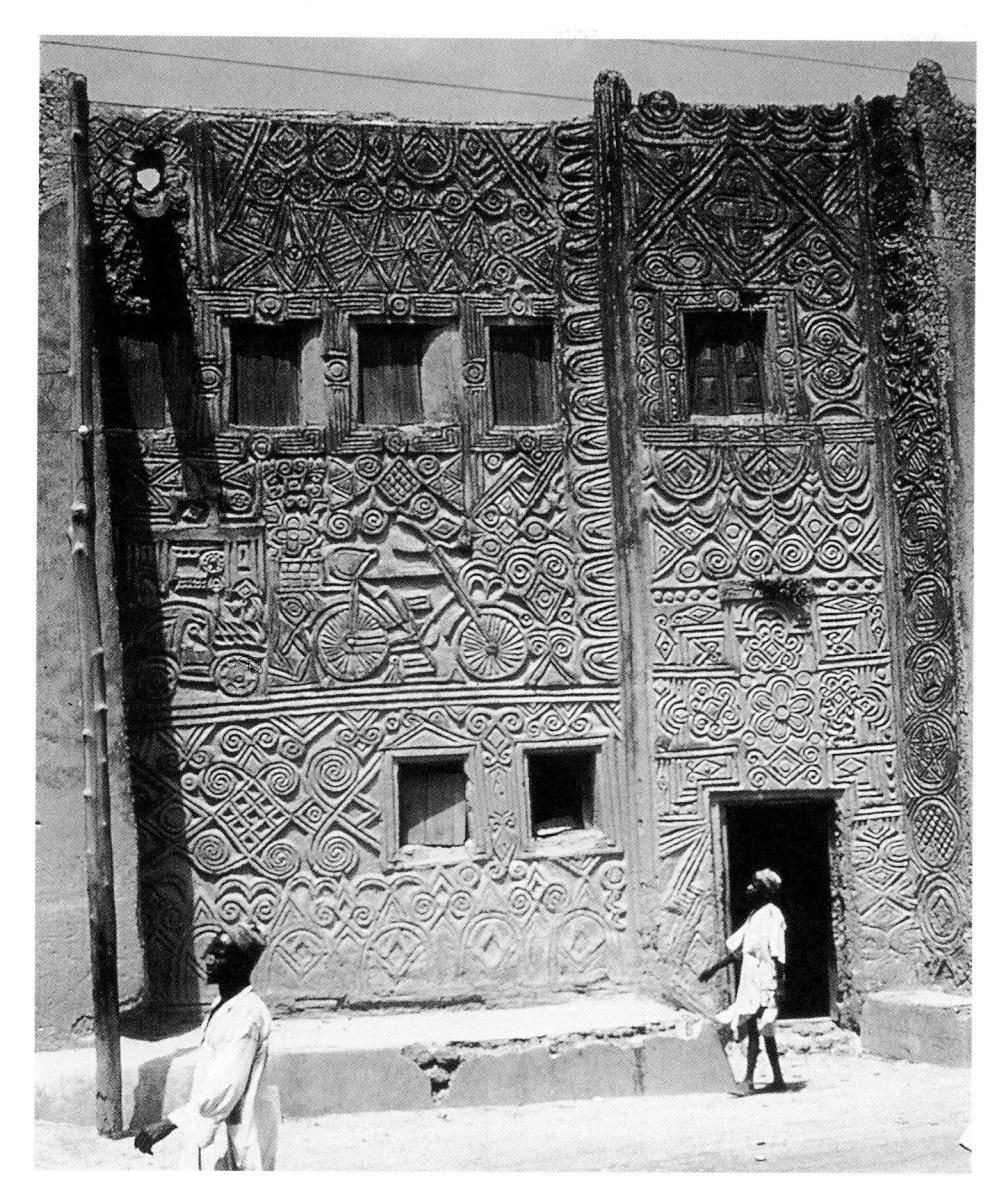

3-28. FACADE OF A ZAURE, HAUSA, ZARIA, NIGERIA. ADOBE. PHOTOGRAPH 1950S

Qairouan is built of stone blocks, not wood and clay, and its domes are almost fully hemispherical rather than gently convex. It seems more likely that this distinctive technology comes from the architectural traditions of the Hausa themselves. Like the Kanuri, most Hausa commoners lived until very recently in houses woven from thatch. The techniques used to bundle wood and grasses into

a framework for a dwelling of thatch are very similar to those used to construct the ribs of earth reinforced with wood.

Hausa adobe walls are also constructed using sophisticated techniques. Clay is mixed with organic material, dried, moistened, kneaded, then formed into irregular ovoid bricks. These are then laid in courses while still wet, and covered with a

smooth layer of mud and waterproofing material. Patterns are then pressed into the damp surface.

The wall that usually receives the most aesthetic attention is the facade of the zaure. Within the zaure of a household, guests are received, art objects and other trade goods are produced, and lessons from the Our'an are recited. During the early twentieth century, curved shapes in high relief surrounded the doorways of zaure. Horned projections on the roof above were similar to those found on the gateways of southern Moroccan towns (see fig. 1-21), possibly because both Berber and Hausa peoples seek to fortify doorways with references to spiritual powers imbedded in these shapes.

By mid-century, zaure reliefs had become both more calligraphic and more representational. Abstract designs were often invocations or adaptations of Arabic letters or words. As in the Mauritanian city of Walata (see fig. 1-27), the use of sacred script on portals evidently blesses and protects the owners while proclaiming their status and wealth. Other reliefs featured motifs evoking power and modernity such as swords, cars, rifles, or bicycles (fig. 3-28). More recently, the reliefs have been highlighted with bright pigments, and are dazzling announcements of the social role of the family that lives within the compound.

Art, Literacy, and Mystic Faith

Learned men in many Islamic African cultures are known as *malam*, a title akin to "master" or "teacher." In addition to designing buildings,

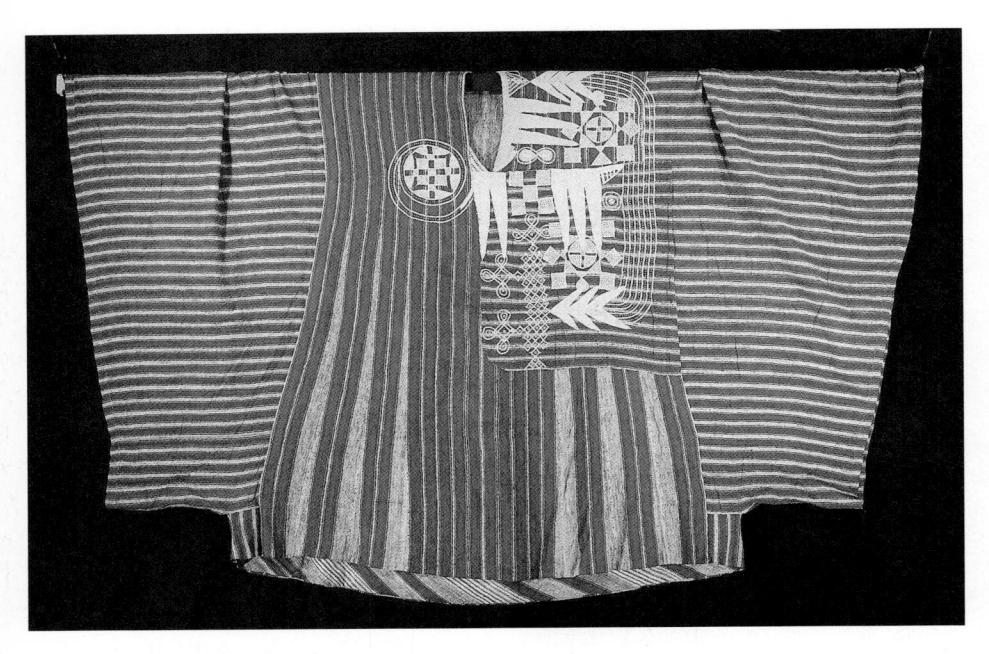

3-29 Robe embroidered with "eight knives" motif, Hausa, Nupe, or Yoruba, late 19th century. Cotton and TSAMIYA (wild silk). Length 4'2" (1.26 m). Textile Museum of Canada, Toronto

malam use their knowledge of geometry, calligraphy, and numerology to produce visually and spiritually effective works of art. Most rely on income from embroidering clothing, hats, purses, and from making charms and other protective devices to supplement the alms they receive from students and benefactors.

A "great robe," babba riga, may be embroidered by a malam with cotton or with tsamiya, the thread of wild silkworms. A particularly popular motif sewn onto the panel on the left side of such a garment is called "eight knives" because of the three long triangular forms at one side of the opening for the head of the wearer and the five long triangles in a row at the base of the opening. Such motifs were evidently protective devices, possibly similar to the horned and pointed motifs on Islamic arts from the Maghreb (see chapter 1).

These Hausa robes were both

exported for sale to non-Muslims, and created for the Hausa by neighboring peoples. The garment shown in figure 3-29, described as an agbada, was collected in the late nineteenth century. Attributed to the Hausa, this garment may actually have been woven (and perhaps even embroidered) by Nupe weavers. It was purchased in a Yoruba city far south of Hausa lands, and may thus have been made to accord with Yoruba tastes, or even made by Yoruba weavers who had learned Nupe textile techniques. Multicultural influences and interchanges such as these are typical of northern Nigerian arts.

Unlike the Kanuri garment, where designs cover the surface, ornamentation here centers around the opening for the head (just as architectural ornamentation is richest on the facade of the *zaure*, where the household opens onto the street). On the right shoulder is a segmented square with-

in a circle. Squares correspond to the four corners of the world and other Qur'anic images of God's creation and power. The divisions of this square, and its placement within a circle, are probably also references to "magic squares," which the Fulani call hatumere.

Drawn in ink by a malam on paper or cloth, magic squares are divided into compartments filled with letters or numbers. Since Arabic letters may be assigned a numerical value, letters may correspond to powerful holy numbers or sums of numbers, while a sequence of numbers may spell the name of God. Based in part upon ancient Jewish mysticism, this sacred numerology has been practiced for centuries throughout the Islamic world. Though it is rare to find a Hausa malam able to construct a true magic square, in which numbers actually correspond to letters and can be added or subtracted to produce holy numerals, most Islamic scribes in the central Sudan can construct convincing facsimiles, drawings of grids containing bits of script or simple geometric shapes. These are still viewed as effective, for the protective value of a magic square does not depend on the ability of its owner or even its maker to understand or interpret it. Magic squares are often enclosed within leather, cloth, or metal to form an amulet, a protective object whose power derives from the mystical wisdom hidden within. The square within the circle on the Hausa robe is thus the equivalent of an amulet that alludes to sacred power but does not display it overtly.

Muslims believe that the Qur'an contains the words of God as recited by his prophet Muhammad. The text

3-30. Allo Zayyana (writing board with permanent decoration), Salih Muhammad Sani Nohu, Hausa, Kano, Nigeria, 20th century. Wood, pigment, leather. Height 23½" (60 cm). Collection of Salah Hassan

itself is thus held to be imbued with God's power. Hausa respect for the sacred written word may be seen in their treatment of writing boards, allo. An allo is a flat piece of wood with a short handle. Students use it to practice writing verses from the Our'an, washing the ink from the board after each verse is memorized. As in many parts of Islamic Africa, upon completion of his studies a student writes a passage from the Qur'an onto his writing board in permanent colors rather than washable ink. The permanently adorned writing board, allo zayyana in Hausa, serves as a sort of diploma and testifies to the owner's ability to recite the entire Qur'an. The *allo zayyana* illustrated here was painted by Salih Muhammad Sani Nohu, a *malam* of the Hausa city of Kano (fig. 3-30). The crescent-shaped handle is covered with fringed red leather.

The decoration at the base is a zayyana, a decorative panel that may ornament a writing board or divide sections of a manuscript. The zayyana is also an allusion to magic squares, for its geometric design contains both square and circular shapes. The zayyana thus refers to the graduate's mystic knowledge of amulets, prayers, and medicinal charms, while the passage from the Qur'an refers to his familiarity with the principles of the Islamic faith

THE FULANI

As the Kanuri were forging the empire of Kanem on the Lake Chad floodplain at the end of the first millennium AD, another group of seminomadic pastoralists began to travel eastward from the arid savannah south of the Senegal River. These peoples are called the Fulani (after Fulbe, the West Atlantic language they speak) or the Peul (after pullo, their term for a Fulani man). However, they prefer to refer to themselves by the name of their lineage and their occupational group. A lineage is ranked by the Fulani according to whether its members herd cattle, weave cloth, compose songs, make objects of wood, leather, silver, or iron, or act as servants to other groups. The cattle herders, Wodaabe, consider their occupation superior to all others.

By the end of the first millennium AD the Fulani lived in the lands of the

Mande speakers north of the Niger River and found pasturage in the floodplains of the Inland Niger Delta. During the next few centuries they moved south to what is now Burkina Faso and began their westward migration toward the kingdom of Bornu. Isolated groups also brought herds of cattle southward along the Niger River to the highlands near its headwaters. This southern region, in the present-day nation of Guinea, is known as the Futa Djallon. Today there are Fulani groups from the Atlantic Ocean to the Nile River, and from the edges of the Sahara to the edges of the coastal rainforests, an area larger than the continental United States. Despite common features shared by all Fulani pastoralists, important regional variations in Fulani arts reflect separate histories.

The Futa Djallon

The Fulani who entered the Futa Djallon region gradually abandoned pastoralism and replaced their portable tents with permanent homes. At some point these "settled" Fulani adopted Islam. By the late eighteenth century they were the dominant ethnic group in the region, and during the nineteenth century they launched a military and religious campaign against their non-Muslim neighbors.

As visible symbols of their sacred and secular authority, the Fulani erected numerous mosques in the Futa Djallon. A mosque built during the late nineteenth century shows the scale of these impressive structures (fig. 3-31). The prayerhall is square, with mud walls, but it is completely covered by an enormous thatch roof, which rises from the ground to a

3-31. Great Mosque, Futa Djallon region, Guinea, Fulani builders working for El-Hadj Umar. c. 1883. Mud, thatch, wood

height of some thirty feet, pierced only by tiny doors. The faithful must crouch or kneel to enter the mosque, thus preparing themselves for the humble act of prayer. The plan of the mosque recalls the square-within-acircle motif on the Hausa gown above (see fig. 3-29), and signals the importance of magic squares in architecture as well as in two-dimensional arts.

During the first part of the twentieth century, Fulani women could be easily distinguished from women of other groups in the Futa Djallon by their distinctive hairstyles. A photograph taken during the 1950s shows the elegance of sculptural forms created from hair, silver, and other materials (fig. 3-32). The crests arched over the head of this young woman are constructed as if they were tent supports, and must have been particularly lovely in motion. The dramatic appearance of Fulani women was both a vivid reminder of the leisure and wealth of this elite group (who obvi-

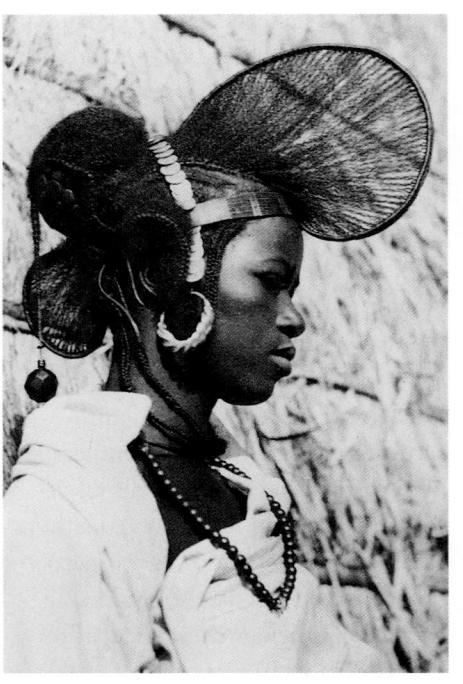

3-32. Woman, Fulani, Futa Djallon region, Guinea. 1950s

ously did not have to carry loads on their heads like their hardworking neighbors), and a demonstration of their refined tastes.

The Inland Niger Delta

The cultivation of physical beauty is a characteristic of Fulani culture and wealthy pastoralists present themselves in gorgeous attire (fig. 3-33). This young Fulani woman was photographed as she sold milk in the town of Mopti in the Inland Niger Delta region of Mali. Her normal business attire featured huge flared earrings beaten from solid gold and etched with discreet symbols, which were both items of display and a family investment. The gold or gold-plated pendant on her chest was made by a Senegalese jeweler in the style of the Wolof or Toucouleur people, and her machine-embroidered robe is

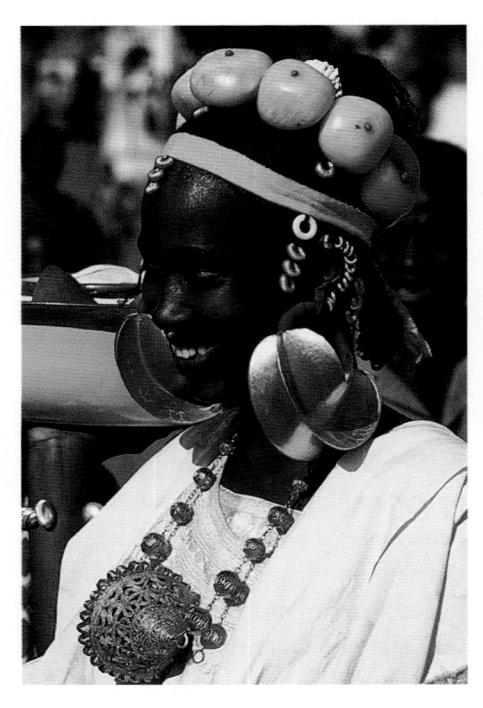

3-33. Woman in a market, Fulani, Mopti, Mali. 1970s

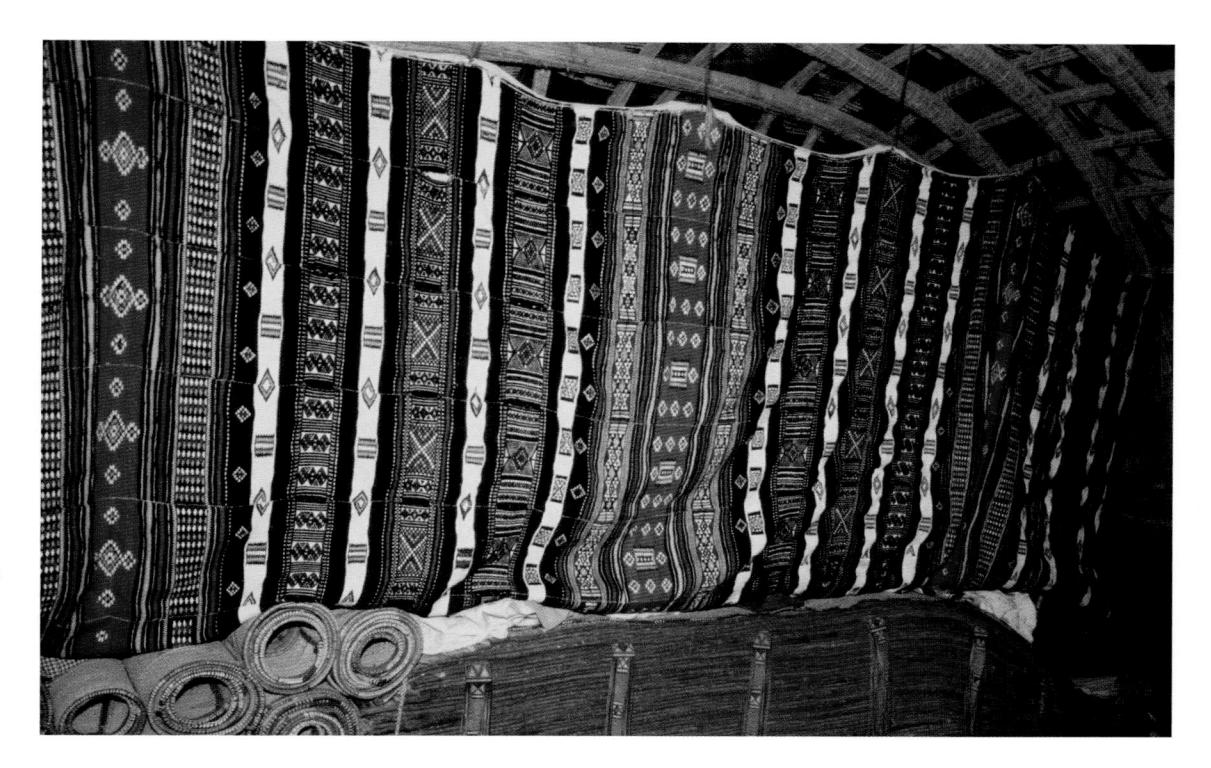

3-34. Tent interior with ARKILLA (WEDDING BLANKET), BELONGING TO MRS CEYDO BA-KUYATE, FULANI, N'GOUMA, MALI. PHOTOGRAPH 1982

Hausa in inspiration if not manufacture. The small circular ornaments are made of gold wire (or finely twisted straw, which looks like gold) and were purchased in Mali, while the massive amber (or imitation amber) beads in her hair may have been imported from the Red Sea. Each visual element has been gathered from complex international and inter-ethnic trade networks.

In a tent owned by another woman from a very prosperous family in the Inland Niger Delta, the marriage bed is shielded from view by a magnificent wool hanging known as an *arkilla* (fig. 3-34). Far wider than an ordinary blanket, it has four or five times the number of panels used in an average textile. The color red predominates, and each panel is richly ornamented with geometric motifs. Such large *arkilla* are rare today, for they are extremely costly to commission. Owned by Fulani women of the cat-

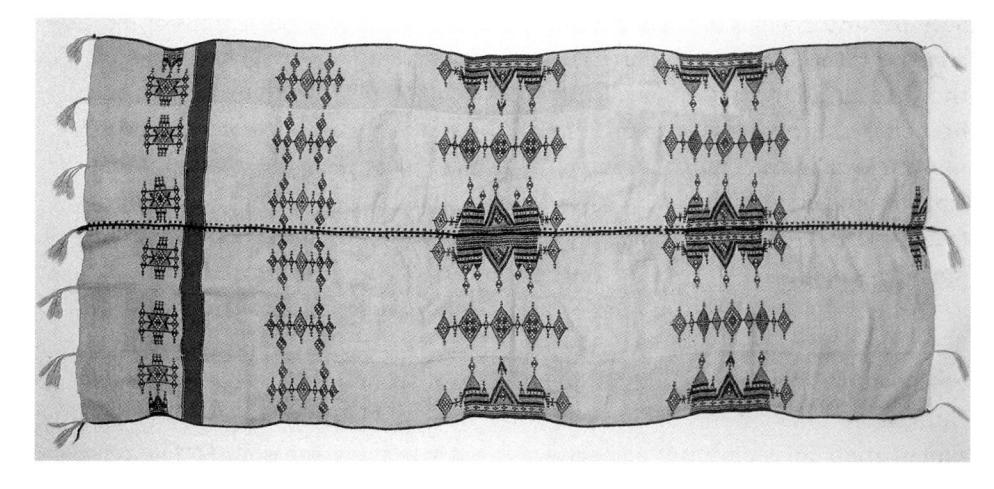

3-35. Khasa (Blanket), Fulani, Nigeria, Before 1928. Wool. Smithsonian Institution, Washington, D.C.

tle-herding group (Wodaabe), arkilla are woven by men of a different Fulani occupational group, the weavers, Maabuube. Fulani weavers often live in settled communities where they may also cater to non-Fulani clients. In some regions, Fulani pastoralists also purchase large blankets from non-Fulani weavers such as

the Djerma of Burkina Faso, who are able to work in a Fulani style.

A particularly fine example of a wool blanket, *khasa*, was purchased in 1928 in the Hausa city of Kano, in Nigeria, but may have been woven in northern Burkina Faso (fig. 3-35). Modern weavers have identified the designs as scenes from Fulani pastoral

life and ancient myths. The six motifs at the left are called either "water container" or "mother of the *khasa*." Appearing at the lowest portion of each strip, they are the first design to be woven. The blood-red stripe above them is described as a woman's mouth, and the stacked lozenges that follow are said to be fruit tree-like forms linked to the forked sticks used by the Fulani to support calabashes full of milk. All of these motifs are related in some way to women and fertility.

References to the land crossed by two brothers in Fulani mythology appear in the large central designs, but some of these repeated lozenge and triangle shapes may refer to another story about a leper. The name of one of these motifs, which occur in sets of five, is "hand of the leper." These are surely Fulani variations on the Berber five-fingered hand, *khamsa*, used to ward off the evil eye (see chapter 1), and they may similarly serve as protective devices.

Southern Niger

The khasa discussed above was brought to Kano along trade routes linking the Inland Niger Delta to the Fulani and Hausa emirates of northern Nigeria. Although an urban, settled Fulani elite now lives in this region, the lands to the north are still home to Wodaabe. These Fulani share some of the grasslands of Niger with the Tuareg (see chapter 1) and purchase silver jewelry and multicolored leatherwork from Tuareg blacksmiths. Cloth, brass, and decorated gourds are made for the Wodaabe by Hausa artists. In this dry region Fulani women do not build large mat-cov-

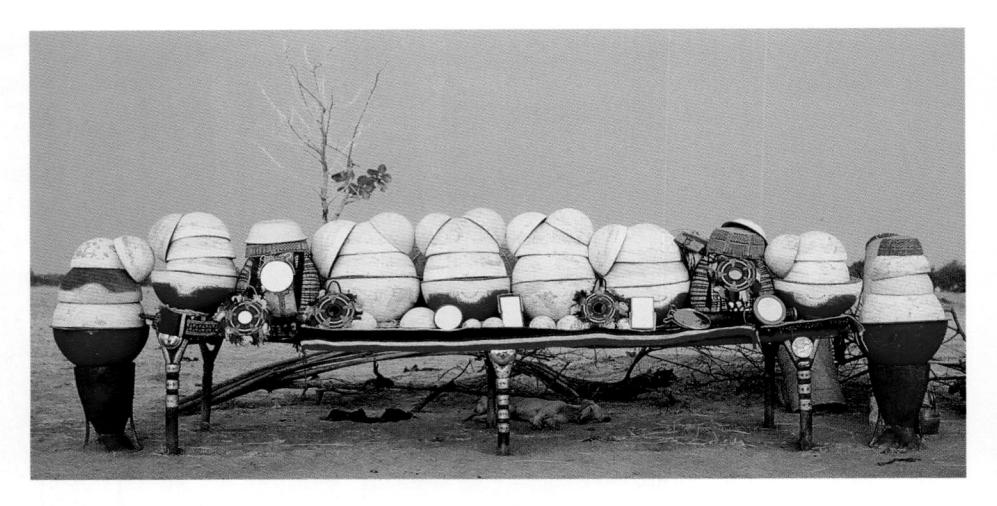

3-36. Calabash displays, Fulani (Wodaabe), southern Niger. Photograph 1980s

ered tents, but sleep in simple shelters of grass or woven materials. The shelter is placed within an area encircled by a brush enclosure and segmented by a rope to tether calves. Apart from the marriage bed, the only important furnishing of the woman's half of the enclosure is a type of table or rack where calabashes, mats, and other belongings may be stacked.

During annual lineage meetings, worso, married women bring their racks to a public area to display their calabashes formally (fig. 3-36). To amass such an impressive collection, a woman must sell many gallons of milk and spend many hours adorning or arranging the gourds. The centerpiece of this array consists of one or two elaborately wrapped packages of calabashes, cloth, and mirrors. The larger bundle, kakol, is given by a woman to her daughter when the young woman leaves her mother's home with her newly weaned firstborn child to establish a household with her husband. The smaller package, ehel, is a gift to the bride from her husband's mother. These presents acknowledge a woman's right to fill

gourd containers with the milk of her husband's cows, and they are carried on poles so that they can be seen as the household travels or sets up camp.

Calabashes are grown and prepared by farmers, and both Hausa men and Fulani women carve, burn, or press designs into their outer surface. In addition to valuing collections of calabashes as personal treasuries, pastoral Fulani women use calabashes for personal adornment. Calabashes filled with milk are carried to market on the heads of these graceful women, who believe that well-arranged images on calabashes both attract clients and accentuate their own slender beauty.

Though less prosperous than their counterparts of the Inland Niger Delta, pastoralist Fulani women of central Niger also create personal mobile art forms, covering themselves with multicolored wire, embroidered cloth, beads, and brass (fig. 3-37). Numerous small areas of color complement the women's feathery facial tattoos. The two unmarried girls shown here are participating in a gerewol, a Fulani festival celebrating

masculine beauty and charm. *Gerewol* is similar to other Fulani festivals that test the restraint and endurance of young men in that the dancers are not allowed to show signs of fatigue or discomfort. Women act as judges, selecting a champion from among the dancers. Unmarried women are also free to bestow their sexual favors upon a particularly attractive dancer, even though their averted gaze reflects the reserve women are expected to exhibit in public.

Fulani men are encouraged to flaunt their best features at a *gerewol* (fig. 3-38). Dancers celebrate their beauty even as they proclaim their

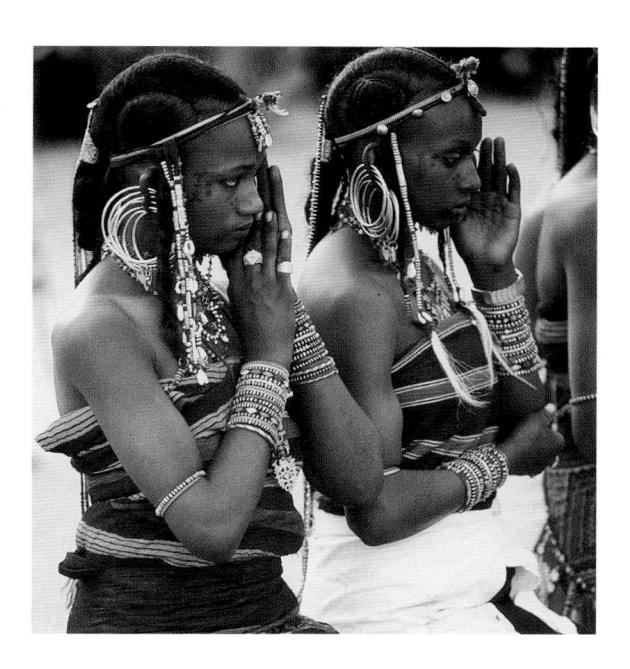

3-37. Women at a *GEREWOL*, Fulani (Wodaabe), southern Niger. Photograph 1980s

3-38. Men at a *Gerewol*, Fulani (Wodaabe), southern Niger. Photograph 1980s

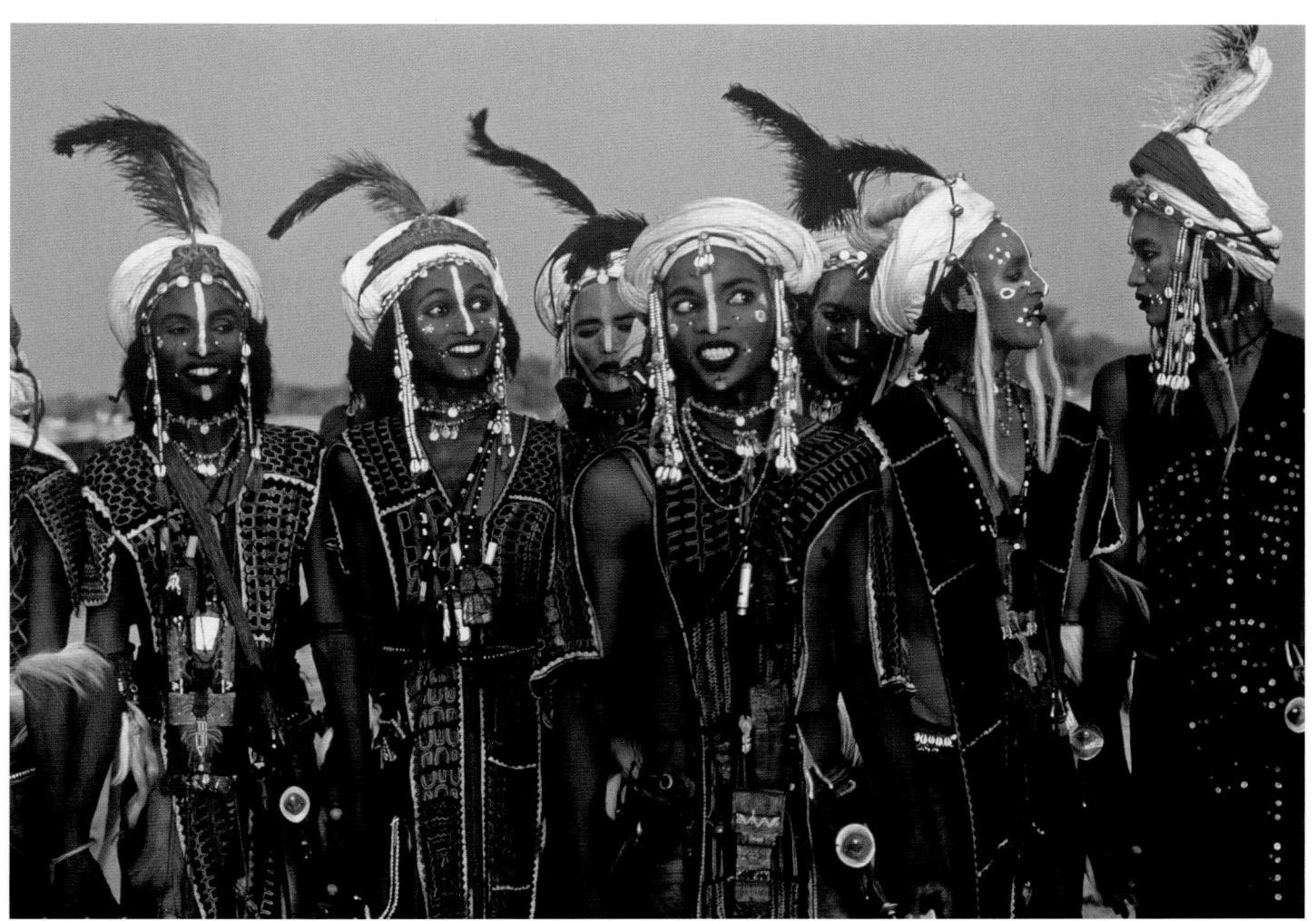

virility and strength. Clear eyes, white teeth, and well-formed noses are valued traits, and are thus accentuated by bright paint, big smiles, and wide-eyed glances. Friends and relatives assist each other in assembling ostrich feathers, weapons, hats, jewelry, and talismans for the hours of dancing and singing. Embroidered panels are contributed by sisters and girlfriends.

The *gerewol* reflects Fulani delight in male and female beauty and the culture's acknowledgment of sexual desire. This sensuality is directly linked to their desire for healthy and beautiful children, however, and is not solely oriented toward personal pleasure.

Northeastern Nigeria and the Adamawa

A generation after Usman dan Fodio founded the state of Sokoto, a Fulani warrior named Mobodo Adama brought Islamic armies to the lands north of the Benue River. The Adamawa Plateau of Nigeria and Cameroon, named for this leader, is still dominated by Islamic emirates. Settled Fulani live in the capitals of these Islamic states, and pastoralist Fulani drive their herds through the Adamawa and the upper Benue region. Both groups are known for their ornamented calabashes.

A drawing based upon a calabash collected in the valley of the upper Benue River records the delicate lines burned onto the gourd's surface by a young Fulani woman (fig. 3-39). She described the central motif as a tortoise and the square designs as writing boards (the Hausa *allo*). Other motifs were named for the fine,

3-39. Motifs from a pyro-engraved calabash, Fulani, Nigeria. Drawing after T. J. H. Chappel

feathery facial tattoos worn by Fulani women.

The artistically embellished calabashes in Fulani culture remind us of the importance of calabashes to peoples of the Gongola Valley discussed earlier in this chapter. Just as Fulani calabash displays at a worso proclaim a woman's status as mother, wife, and provider, the wedding basket of decorated gourds made by Ga'anda artists is linked to female identity (see fig. 3-12). Such parallels demonstrate how common artistic practices are shared by neighboring vet unrelated peoples in the central Sudan. The different styles and varied cultural references of their motifs also reflect the diversity of art in this region of Africa, whose history has yet to be fully studied.

ART AND IDENTITY IN THE MODERN WORLD

The territory surveyed in this chapter comprises portions of countries (northern regions of Ghana, Benin, Nigeria, and Cameroon, and westernmost Sudan) where there are no national capitals, and major art institutes were never established in Niamey (the capital of Niger), or Bangui (capital of Central African Republic). A school of fine arts was once active in Ndjamena, the capital of Chad, but it has been affected by the warfare wracking that nation. As a result, few contemporary artists from the region have received an education based upon European models. However, creative individuals throughout this vast section of the

African continent have experimented with new art forms.

Samuel Fosso (born 1962) is one of the few who have achieved international recognition. Born in northern Cameroon and raised in southern Nigeria, Fosso moved to Bangui as a teenager and was apprenticed to a photographer. Entrepreneurs with cameras have set up studios in African cities and towns since the beginning of the colonial period, and provided videotaping services since the late twentieth century. Yet when Fosso established his own photographic studio, he experimented with photography in a rather unusual way. After he had taken portraits of his clients, he used the extra film at the end of the roll to take photographs of himself. He posed for these self-portraits in varied clothing and in varied stages of nudity, self-consciously altering his appearance to create new characters. After Fosso had produced these images for almost two decades, his work was discovered by a French curator gathering photographs for an exhibit in Bamako, the capital of Mali, and that exhibition formed the nucleus for *In/Sight*, an exhibition held in New York City. This exposure led to critical acclaim and commercial success, perhaps because Western viewers can easily interpret Fosso's photographs as explorations of sexuality and ethnicity similar to those of artists of the African diaspora (see chapters 15 and 16). Fosso can now afford to work with color film, and he constructs ever more elaborate identities for the camera (fig. 3-40). The results are often as dramatic, as entertaining, and as carefully controlled as a Fulani gerewol performance.

3-40. The Chief: The One Who Sold Africa to the Colonials (Le Chef: celui qui a vendu Afrique aux colons), Samuel Fosso, 1997. C-Print Photograph. © The Artist and Jean-Marc Patras. Courtesy Jack Shainman Gallery, New York

Mande Worlds and the Upper Niger

4-1. EQUESTRIAN FIGURE, INLAND NIGER DELTA STYLE, ANCIENT MALI, MALI, 13TH–15TH CENTURY (?). TERRACOTTA. 27¾" (70.5 CM). NATIONAL MUSEUM OF AFRICAN ART, SMITHSONIAN INSTITUTION, WASHINGTON, D.C. MUSEUM PURCHASE

Sinland from the eastern hills of Guinea, the Niger River floods the marshy Inland Niger Delta in central Mali before turning to flow southward through Niger. Along this curved stretch of the river, known as the Niger Bend, inhabitants of the savannah encounter peoples of the desert, and traders from the coasts of northern Africa meet merchants from the southern forests.

Urban life developed in the Inland Niger Delta as early as the first century BC, eventually giving rise to the multi-ethnic empires of Wagadu (Ghana), Mali (Manden), Takrur, and Songhai, which flourished variously between the ninth and late sixteenth centuries AD. The peoples who live in this region today stress their historical relationship to these empires. The Soninke often identify with Wagadu; groups such as the Malinke ("people of Mali") and the Mandingo or Maninka ("people of Manden") are named for their links to the empire of Mali, as are the closely related Mande languages themselves. Some Mandespeaking groups are identified by their homeland, others by their occupation or their relation to Islam. The farmers of southwestern Mali who long resisted Islam are thus known as "pagans," bambara, and call themselves Bamana. The Bamana are famous for their metalwork, their mud-dyed cloth, their masquerades, and their sculpture.

The influence of Mande-speaking cultures has extended far beyond the banks of the Niger. The Jula (Dyula),

traders who speak a Mande language, established mercantile networks that still link the western Sudan to the Atlantic coastline. Over the centuries. the Jula converted to Islam, and some Jula groups formed independent Islamic states in Côte d'Ivoire and Ghana. Jula textiles, manuscripts, and amulets are still traded over vast distances. Peoples speaking Mande-related languages have also spread outward from the upper reaches of the Niger River to settle in Guinea, Mali, Senegal, Gambia, Guinea Bissau, and Côte d'Ivoire; their arts are discussed in chapter 6.

In Mande-speaking communities today, leaders take an active role in educating children and guiding youth. Art objects assist elders in their search for esoteric knowledge and encourage both young and old to pursue wisdom and justice, the foundations of the Mande worldview. As in the past, arts viewed as imbued with timeless power coexist with secular arts of entertainment, and artists create new art forms to address a changing society. Yet the diverse arts found along this section of the Niger River still instruct the viewer, imparting moral values and enforcing ethical behavior.

IN THE SPHERE OF ANCIENT EMPIRES

The floodplains of the Niger and Senegal rivers and their tributaries are dotted with raised mounds known as *toge* (sing. *togere*) to the Fulani herdsmen who live among them. Formed over the centuries by layers of sediment, *toge* are the remains of ancient towns. The oldest were occupied over two thousand years ago.

While most have been abandoned over the last five hundred years, some are still inhabited, or are connected with modern communities.

Wagadu

One of the first of these mounds to be excavated by archaeologists was Kumbi Saleh, a large site located just north of the present-day border separating Mali and Mauritania. The site has been identified as Qunbi, the capital of the early state known as Ghana to Arab historians and called Wagadu by the Soninke, the Mande-speaking people who are descended from its inhabitants. Arabic documents chronicle the foundation of Qunbi by a hero who lived many generations before the birth of the Prophet Muhammad, and suggest that Wagadu flourished from the ninth through the eleventh

centuries AD. Excavations of Qunbi/Kumbi Saleh support these dates, documenting occupation levels ranging from the sixth through the fifteenth centuries.

According to reports gathered by al Bakri, an eleventh-century Muslim scholar, Qunbi consisted of two towns. One, inhabited by Muslims, sheltered a dozen mosques. The other was the town of the king and his subjects. Surrounding the royal town were priests' dwellings and sacred groves housing prisons, royal graves, and what Muslim visitors described as "idols." The palace has not yet been located, and excavations thus far may have only probed the Islamic portion of the town.

The most important building yet unearthed is a mosque (fig. 4-2). The earliest level of the mosque at Kumbi Saleh dates to the tenth century AD,

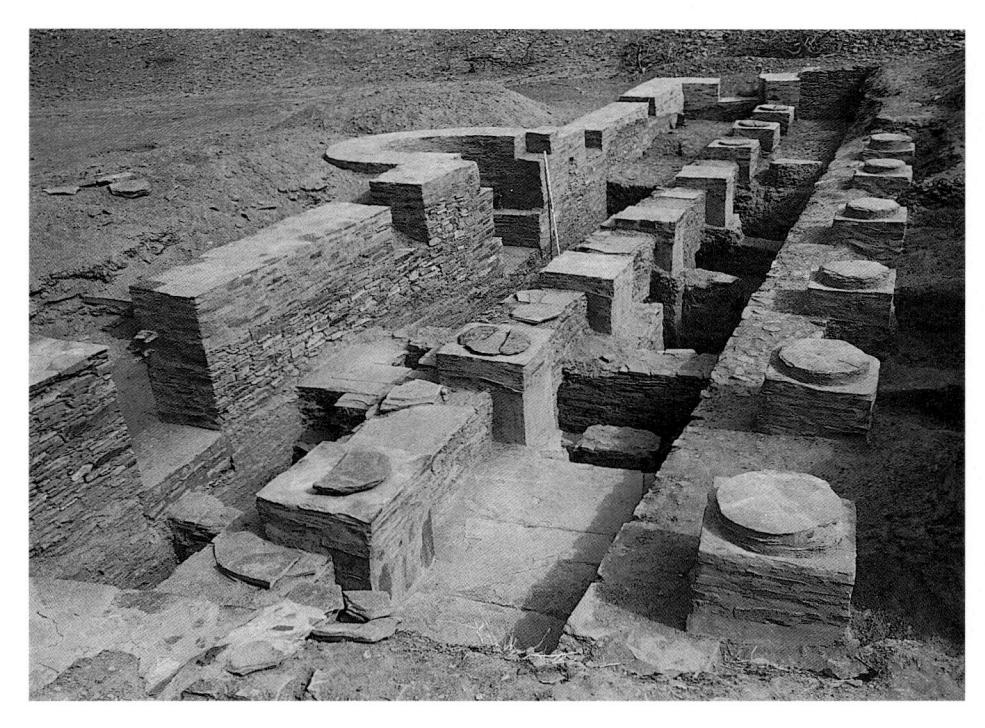

4-2. *QIBLA* of a mosque, Soninke Builders, Kumbi Saleh, ancient Ghana/Wagadu, Mauritania, 10th–15th century. Stone

4-3. Female figure from Kumbi Saleh, Mauritania, ancient Ghana/Wagadu, 6th—10th century. Terracotta. Height 4¾" (10.5 cm). Musée National, Nouakchott

only four centuries after the hijra (see p. 29). It was thus one of the earliest mosques constructed south of the Sahara. Later versions of the mosque, constructed prior to the fourteenth century, seem to have been influenced by the Great Mosque at Qairouan in Tunisia (see fig. 1-17), for in the prayerhall were rows of cylindrical columns, and the qibla wall was ornamented with painted stone plaques. Yet unlike Qairouan, where Roman and Byzantine ruins supplied builders with monolithic columns and capitals, Kumbi Saleh is located in a region where stone is found only in thin slabs. Builders created columns by stacking stone disks.

A pre- or non-Islamic presence in Kumbi Saleh was revealed by a few ceramic objects found in a layer of refuse beneath the eleventh- and twelfth-century levels of a dwelling. One of these objects, a fragment of a small female figure in terracotta, has a slim torso with a large protruding navel and strikingly pronounced buttocks (fig. 4-3). The excavators believe that it may have been made as early as the sixth or seventh century AD, before the arrival of Islam.

Dwellings of Muslim merchants dating from the eleventh to the fifteenth centuries have also been found at Kumbi Saleh. Like the mosque, they were built of layers of flat stone fragments, sometimes ornamented with triangular niches. Their rectangular plans and the techniques used to stack the locally quarried, irregular stones recall the architecture of Saharan cities such as Chinguetti, in Mauritania (see fig. 1-26). The similarities suggest that buildings throughout a vast area of the western Sahel were constructed by Soninke peoples, even when (as is the case with the Soninke-speaking Harratin of Mauritania) they were working for Arabic or Berber patrons.

Many toge in the Inland Niger Delta may well have served as burial mounds rather than habitation sites. One such mound near the town of Tondidaru, between the ancient cities of Jenne and Timbuktu, has been excavated and dated to the seventh century AD. Near this site are several clusters of monoliths. During the 1930s the largest cluster was set upright, and several of its stones were shipped to a museum (fig. 4-4). Even though this grouping is now disrupted and incomplete, an undisturbed

group of monoliths has allowed archaeologists to determine that the stones are contemporary with the nearby funerary mounds. The monoliths were thus erected by a people who may have been in contact with Wagadu, which was being established less than two hundred miles to the west.

The monoliths may have served as sanctuaries, stone equivalents of the sacred groves used by many cultures in the region to shelter boys during their initiation into adulthood. This impression is strengthened by some of the linear designs carved into the stones, which make their phallic nature clear. Ranging from 31 to 63 inches (80 to 160 cm) in height, the stones are about as tall as initiationage boys. One of the stones has a circular boss, possibly representing a navel or face (see fig. 4-4, left).

4-4. Drawings of two monoliths from Tondidaru, Mali, 7th century. Approximately 5' (150 cm) high

Mali and the Inland Niger Delta

South of Wagadu, in the hills along the Upper Niger, the kingdom of Mali (or Manden) arose during the twelfth century AD. According to the epic songs of Mande bards, Mali was organized as an empire by Sundjata. The son of Sundjata, who succeeded him as king (mansa), was a Muslim. During the fourteenth century, a king of Mali named Musa became famous in the Islamic world for the wealth and generosity he displayed during his pilgrimage to Mecca. Musa was instrumental in establishing the cities of Timbuktu, Walata, and Gao as centers of Islamic learning, and he controlled the oases of the Saharan trade routes.

Excavations at Niani, believed to be the ancient capital of Mali, have thus far vielded few objects of any esthetic interest; the most fascinating archaeological finds come from other sites connected to this wealthy kingdom. One of the most important is near the present-day city of Jenne, a site usually referred to as Jenne-Jeno, or Old Jenne. Archaeologists have determined that Jenne-Jeno was inhabited by the beginning of the Christian era. During the height of the Mali empire, its population was apparently related to, though culturally distinct from, the Malinke.

During the excavations at Jenne-Jeno, archaeologists unearthed a terracotta figure placed next to the foundation of a home or shrine. They consulted art historians for suggestions as to how such figures are used today, and how they might have been used in the past. However, the interest which these discussions generated led to widespread pillaging of ancient sites, and since the 1980s hundreds of terracottas have been illegally unearthed in Mali and sold to foreign art dealers (see Aspects of African Cultures: The Illicit Trade in Archaeological Artifacts, p. 78). Although thermoluminescence testing cannot accurately date individual figures without accompanying data from the sites where they were deposited, test results are able to show that the ceramics as a group were probably produced from the thirteenth to the sixteenth centuries.

The majesty and composure of the terracotta equestrian figure illustrated here amply demonstrate the appeal of the Jenne style (fig. 4-1). The artist has arranged the tubular limbs and torsos of both man and horse so that positive forms outline negative spaces of great formal beauty. The distinctive eyes, ovoid head, and naturalistic proportions are typical of works in the Jenne style. Details, especially on the face, seem to have been scratched or carved into the surface rather than modeled, a technique also used in the much older Nok terracottas (see fig. 3-1). It is interesting to compare this sculpture with the figures of mounted warriors produced in the Bura region of Niger at least three centuries earlier (see fig. 3-5). The Bura figures were found in a funerary context. This figure, however, was excavated illicitly, and thus we cannot know how it was originally used.

4-5. Figure in position of prayer, Jenne style, ancient Mali, 13th–15th century (?). Copper alloy. Height 3¾" (9.6 cm). Musée Barbier-Mueller, Geneva Archaeological excavations at Jenne-Jeno have also unearthed gold jewelry. However, the most spectacular metal objects have been pillaged from uncontrolled sites. These include a masterful small figure cast of copper alloy (fig. 4-5). The face of the personage has the clear features and protruding eyes of the Jenne style, and the limbs have the tubular look of the terracotta pieces. The pose of the figure is most intriguing, for a researcher has shown that the arms held across the chest indicate a posi-

tion of prayer in modern communities along the Niger River. While religious practices must have changed over the last five or six centuries, we may assume that this figure (and the many ceramic figures that share these gestures) is shown in an attitude of worship.

Terracotta figures in other styles have also been taken from mounds in other areas of the Inland Niger Delta. Apparently they date from approximately the same time period as the Jenne-style works. A figure seized by Malian authorities at a clandestine dig near Bougouni, in southernmost Mali, was seated in a cross-legged position with its hands on its knees, a pose similar to positions now used in the region for prayer or supplication.

Ornaments (or snakes?) were coiled around the neck and arms. The elongation of the arms and torso distinguished it from figures in the Jenne style, as did the softer contours and the spherical (rather than ovoid) shape of the head.

Other ceramic figures dating from the thirteenth to sixteenth centuries are said to have been found in or atop memorial mounds at Bankoni, near the Malian capital of Bamako. These stone-covered earthen domes were evidently raised to honor an ancestor or group of ancestors. The five figures illustrated here share the style and possibly the function of documented terracottas from Bankoni (fig. 4-6). The proportions of the figures resemble those of works from the Bougouni

region, but their distinctive heads are more crisply defined. The long noses are unique to the Bankoni style, as is the notched rim encircling each male face.

The Architectural Legacy of Jenne

Terracottas from the Inland Niger Delta were created during particularly turbulent centuries for the Mali empire. During the fifteenth and sixteenth centuries the empire of Songhai arose along the Niger Bend and conquered lands formerly controlled by Mali. During the sixteenth century, Mali's cities on the Niger were raided by soldiers from Morocco.

Stately houses in the Muslim city of Jenne were built during the sixteenth and seventeenth centuries for community leaders variously descended from Arab scholars, Berber soldiers and their Spanish slaves, Songhai lords, Jula traders, Sorko and Somono fishermen, and local Bamana farmers. Linked to Moroccan models but infused with Mande architectural traditions, these homes were the prototypes for the distinctive and dramatic houses found in Jenne today.

Contemporary Jenne dwellings constructed in this seventeenth-century style are similar in many ways to *tigermatin*, the fortified households of central Morocco (figs. 4-7, 4-8i, 4-8ii; compare fig. 1-22). Both are built of adobe bricks plastered over with a layer of mud, though Moroccan bricks are rectangular while bricks made by Jenne masons are oval, much like the ovoid bricks used by Hausa builders (see figs. 3-26, 3-28). Like *tigermatin*, Jenne houses

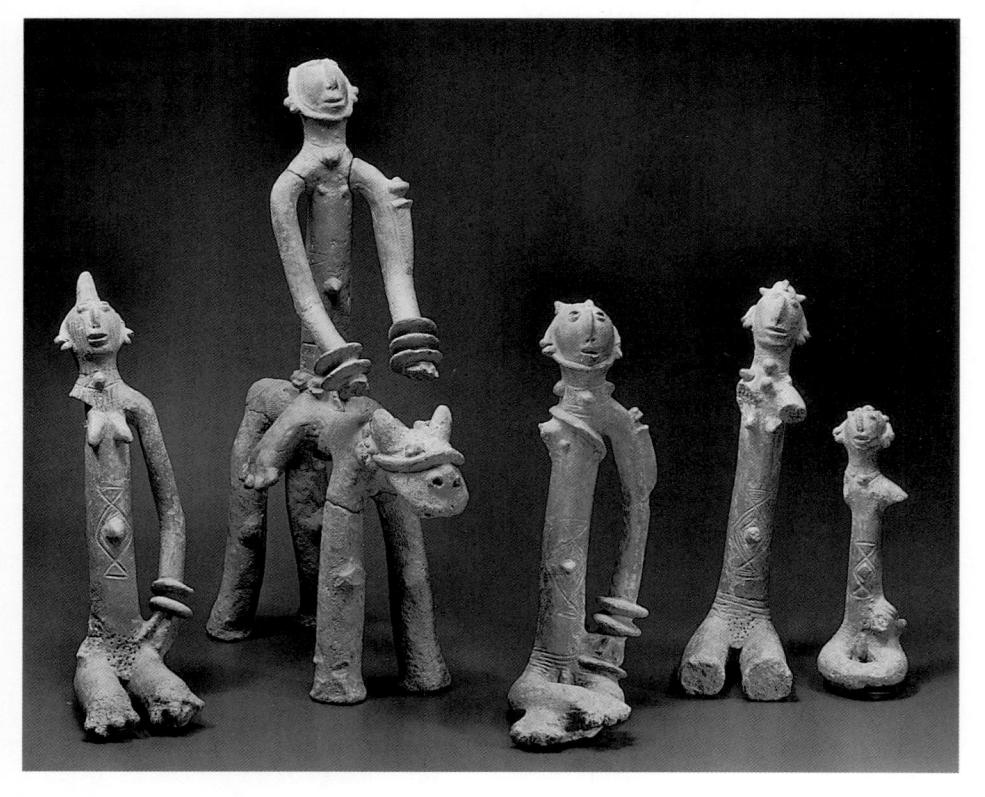

4-6. Five figures, Bankoni style, ancient Mali, Mali, 13th–15th century (?). Terracotta. Equestrian figure $27\frac{1}{2}$ " (70 cm). The Art Institute of Chicago, Ada Turnbull Hertle Endowment
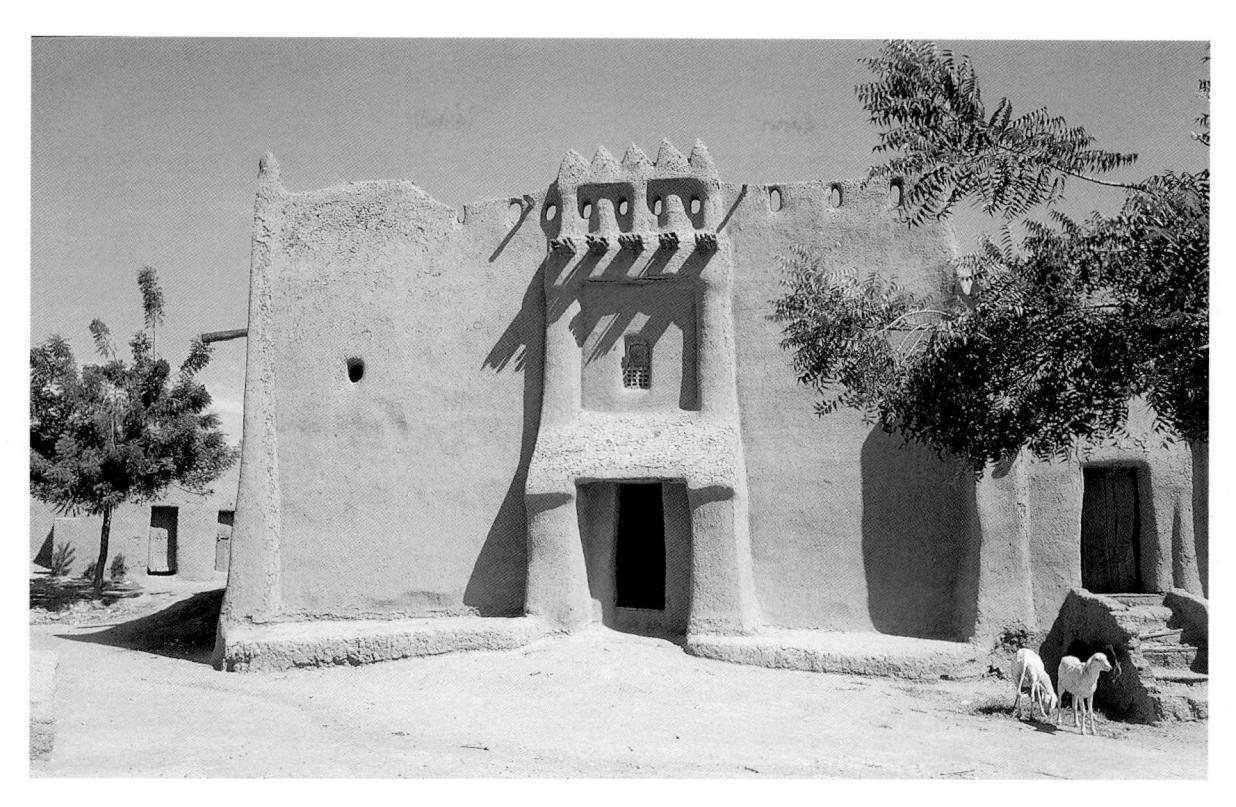

4-7. Facade of an Adobe House, Jenne, Mali. Songhai builders for Mande Patrons. After 16th Century

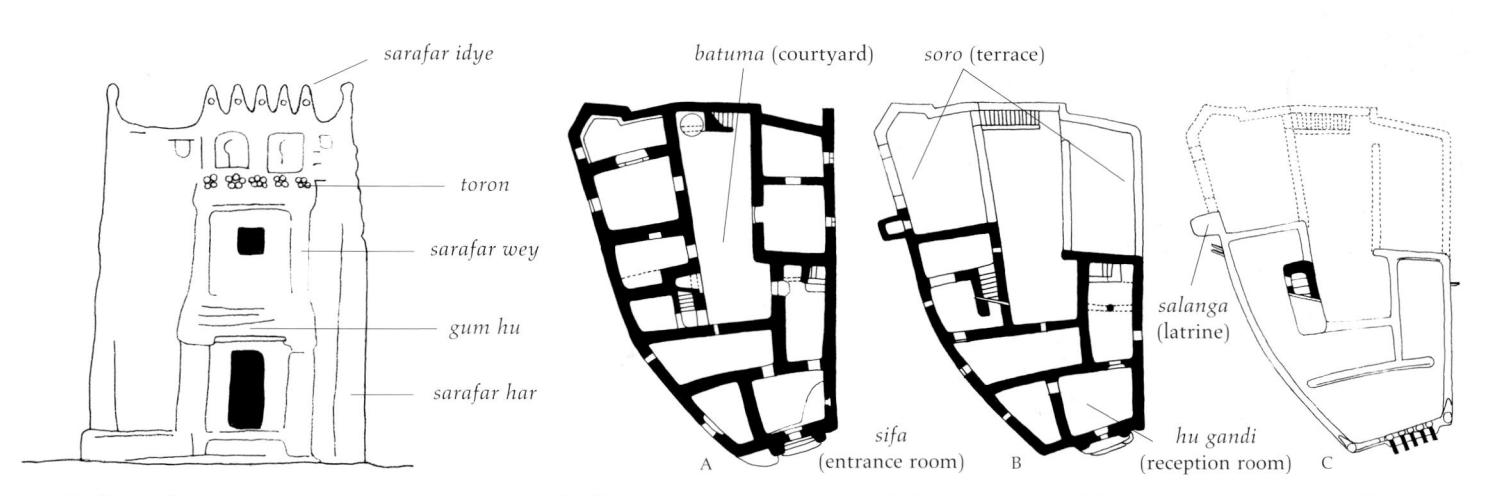

4-81. *Potige* (facade) of an adobe house in Jenne. Drawing after P. Maas and G. Mommersteeg

4-811. Plans of the ground floor (a), second floor (b), and rooftop terrace (c) of an adobe house in Jenne. Drawing after P. Maas and G. Mommersteeg

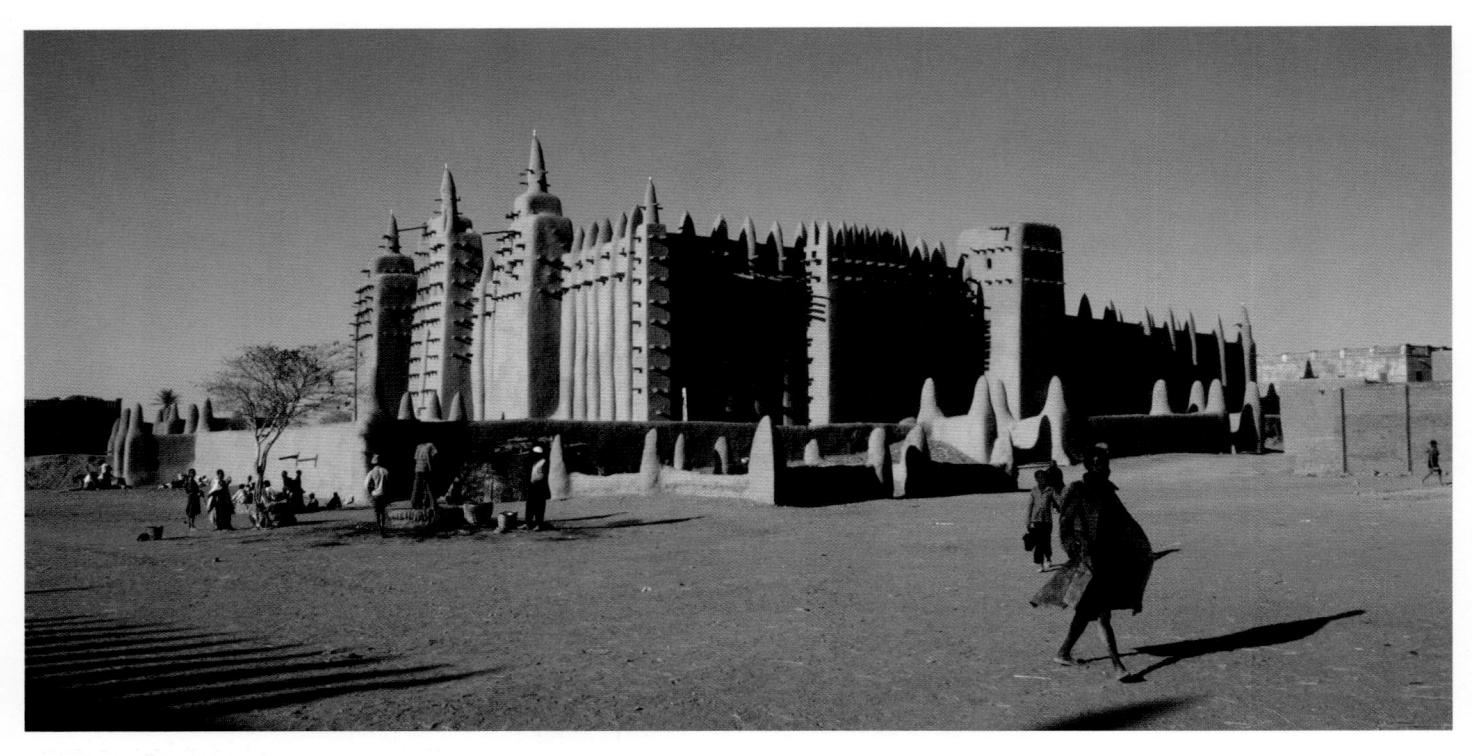

4-9. Great Mosque, Jenne, Mali, founded 13th century, rebuilt 1907. Adobe

are multistoried, with an interior courtyard, a formal reception room on an upper story, and a flat roof used as an additional working space. Multiple floors and multiple rooms distinguish homes at Jenne from most other dwellings found south of the Sahara, which usually have only a ground floor and an attic or roof area, and which are formed of separate, single-roomed buildings.

Facades of Jenne houses resemble those of *tigermatin*, and in some ways also mirror the gateways of *ksar*, walled Moroccan towns (see fig. 1-21). Protected by an overhang, doors in Jenne are set into an arch or a rectangular frame. Earthen benches along the base of the wall invite passersby to sit and rest even as they protect the foundation from water damage. A central window covered with an iron or wooden grill marks

the location of the formal reception area, *hu gandi*, on the upper floor. Some older window grills in Jenne are almost identical to those of central Morocco. Along the top of the facade are five cones, possibly invoking the protective five fingers or related numerical symbols of Berber and Arab art.

The interior rooms are divided into areas for men near the front of the house and areas for women at the back. The entrance room, *sifa*, is a semi-public space similar in function to the Hausa *zaure* (see chapter 3). Other rooms on the ground floor are set aside for storerooms and kitchens. The upper-floor reception room, *hu gandi* or *har terey hu*, belongs to the male head of the household and overlooks the street, while private spaces for women overlook the interior courtyard. A screened toilet is located

on the roof, over an earthen shaft that reaches to ground level. The shaft can eventually be broken open at the base and the decomposed waste removed for use as fertilizer.

Most architectural terms in Jenne are Songhai, for the guild of Sorko masons is Songhai-speaking. The names reveal an interest in identifying architectural elements with the family. The doorway is the "mouth of the house," me, and the "archway of the mouth," gum hu, surrounds it. The two central engaged columns are the "feminine pillars," sarafar wey, possibly in opposition to the obviously phallic projections of the framing columns at the corners, sarafar har. The five central cones are the "sons of the pillars," sarafar idye.

Mande influence is also strong in these Jenne homes, however. The term for the facade itself is *potige*, a

local adaptation of Mande words used in greeting a respected person. The house can thus be seen as a self-presentation by its owner, evoking honor and status. The features of the potige seem related to the importance of doorways and facades as the intersection of public and private domains. They also reflect ancient religious practices in Mande-speaking communities, where sacrifices to the ancestors are often poured out on doorways. Projecting from the potige are five bundles of wood known as toron (sing. *toro*). While their functions may be both aesthetic (an accent repeating the five projections and four recesses above them) and practical (as supports for masons repairing the adobe), the word toron connects them to the Mande term for a sacred tree, and they may be conceptually linked to the forked branches placed next to altars by Mande-speaking peoples.

A more dramatic use of *toron* can be seen in the Great Mosque of Jenne, one of the most imposing adobe buildings in all of Africa (fig. 4-9). According to Arabic accounts, the first version of this mosque was constructed during the late thirteenth century (seventh century AH), when the king of Jenne converted to Islam. He erected the mosque on the site of his palace, so that the new building absorbed the religious and political power of the old social order.

Subsequent rebuildings of the mosque reflected the tastes of later Moroccan and Songhai overlords of Jenne. In 1909, French colonial authorities allowed the city, then under Fulani leadership, to reconstruct the mosque under the direction of Ismael Traore, head of the masons'

4-10. Interior of the Great Mosque at Jenne, 13th (?), 20th Century. Adobe

guild. As was the case with earlier mosques, the varied ethnic patronage of the Great Mosque resulted in a building uniquely suited to this multicultural city.

The *qibla* wall forms a backdrop for the huge central marketplace that dominates the cultural and economic life of Jenne. The *mihrab* is located in the interior wall of its central tower. On the exterior, horizontal rows of toron balance the strong vertical lines of the square towers and engaged pillars, grouped in fives. Each pillar projects above the wall in a point, echoing the five "sons of the pillars" in the center of the potige of a Jenne house. The pinnacle of each square tower of the qibla wall is set with an ostrich egg. Eggs were similarly placed on the minaret of the mosque at Chinguetti

(see fig. 1-26). In Jenne, both Mande and Muslim philosophers see these white, moon-like objects as linked to fertility and the cosmos.

The main entrances and windows to the prayerhall are set into the north wall (in shadow in the photograph here). The slightly lower wall beyond it encloses the open courtyard, a parallelogram whose size and shape mirrors that of the covered hall. Inside the prayerhall, massive square adobe piers are joined by narrow pointed arches (fig. 4-10). Unadorned and unpainted, the interior is cool, dark, and austere.

Takrur and Jolof

In addition to founding Wagadu and Ghana, ancestors of Mande-speaking peoples had influential roles in the rise of other kingdoms and empires in the western Sudan. The Islamic empire of Takrur, Wagadu's western rival along the lower Senegal River, was firmly grounded in Fulani culture. However, an early dynasty may have been Mande-speaking.

Thousands of burial mounds in western Senegal were built in or near the territory of Takrur, now the home of the unrelated Serer and Wolof peoples.

Some of these funerary mounds are covered or encircled with small stones. The best documented are those of Rao, whose cemeteries were in use during the eighth through fourteenth centuries. One contained the remains of a young person wearing 138 gold rings, a silver necklace, and a spectacular chest ornament of gold. The gold pectoral is usually dated to the thirteenth or fourteenth century. If this dating is correct, the burial can be associated with the

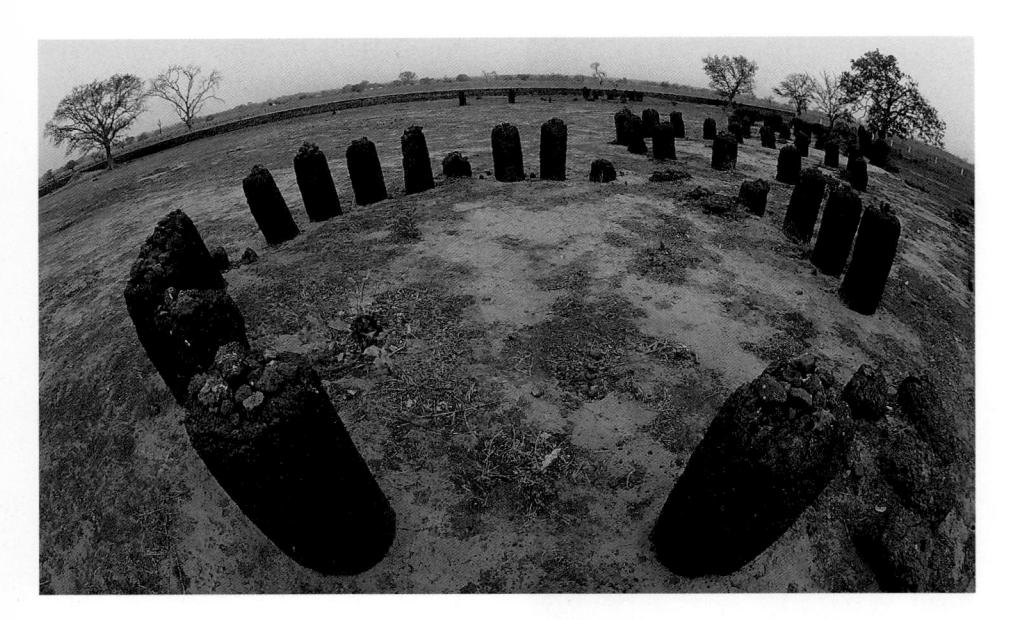

4-11. Circle of monoliths, Wassu, Gambia, ancient Mali (?), 8th–15th century (?). Granite. Photograph 1970s

Monoliths mark or encircle graves in many African cultures. Stone slabs were placed before the tombs of the kings of Kemet before 3000 BC, and stones incised with images of cattle were placed on Nubian graves less than one thousand years later. Prior to the Christian era, monoliths were erected over graves in the Buar region of Central African Republic. Large upright stones marking graves have been documented across central Nigeria, while smaller gravestones are found in Burkina Faso, Sierra Leone, and Guinea.

Wolof state of Jolof, which succeeded the empire of Takrur. The pectoral's finely wrought surface with its hemispherical bosses resembles Wolof gold jewelry made during the last two centuries.

Links between past and present populations are difficult to make in southern Senegal and eastern Gambia, which were once part of the Mali empire. Some 817 tombs have been noted in this region, each encircled by polished volcanic monoliths (fig. 4-11). While most monoliths are in the form of curved cubical or rectangular blocks, as here, some are partially bisected, giving them the appearance of two joined pieces. The grave circles were evidently erected over a very broad period of time from

the beginning of the Christian era to the sixteenth century.

RECENT MANDE ARTS: NYAMAKALAW AND THEIR WORK

The tombs and cities of ancient empires have not yet provided us with documented examples of sculpture in metal or wood, and we have little information on the role of art and artists in past centuries. Today sculpture in iron or wood in Mandespeaking regions is created largely by male blacksmiths, who with female potters form an endogamous group of specialists known as *numuw* (masculine sing. *numui*; feminine sing. *numumuso*). In part because of their

ability to take minerals from the earth and transform them into useful or even dangerous objects, *numuw* are believed to be particularly adept at manipulating a type of esoteric force, a mysterious power known as *nyama*. Along with bards, leatherworkers, and other unusually talented groups of people, sculptors and other blacksmiths are categorized as *nyamakala*, sometimes translated as "handles of *nyama*." *Nyamakala* lineages are found in many Mande-speaking groups, especially the Malinke and Bamana.

As we shall see, blacksmiths make a wide array of sculpture in wood. However, they are particularly proud of the staffs they forge from iron. These slender metal rods, created in secret and shaped with fire, are highly charged with nyama. They may serve as the insignia of leaders, or provide a spiritual charge for ancestral altars or graves. Staffs surmounted by figures are also placed near the sanctuaries of Bamana religious associations and are displayed during their initiations and funerals. These bisa nege ("rods of iron") or *kala nege* ("staffs of iron") receive libations of beer and other sacrificial drinks, and they warn visitors that potent forces are present.

Gwan and Jo

The religious associations that use these iron staffs are generally called *jo* (plural *jow*). While early ethnographies of the Bamana people described these associations as forming a highly organized and coherent social system, recent scholarship suggests that the number of *jow* varies from region to region, as do their names and the responsibilities of their members. For

example, in the south/central Bamana region, the principal jo is simply known as Jo. Here this single organization, which is dedicated to the harmonious continuity of community life, is charged with many of the roles handled elsewhere by separate associations; the initiation and education of the youth (supervised in other Bamana regions by N'tomo and Ci Wara), the control of spiritual forces for the betterment of the community (often the domain of Kono or Komo), and the nurturing of harmony within the community (sometimes the role of Kore). In this region another association, Gwan, addresses the creative forces responsible for human fertility. Its ceremonies, and its art forms, may sometimes be incorporated into Io.

The bisa nege or kala nege of fig. 4-12, topped by an obviously male equestrian figure, would have been a particularly appropriate image for Jo. The rider's erect pose and aggressive gestures allude to the heroism, occult power, and accomplishment of a leader of the Jo or Gwan association. His broad hands have been compared to the feet of a crocodile, a dangerous animal whose body parts are used by sorcerers as well as by members of benevolent associations. Other staffs used by Jo or Gwan are topped by female equestrians, or by female figures in similarly assertive positions.

Blacksmiths also carve wooden statuary for Gwan. An imposing seated figure of a mother holding a child (fig. 4-13), known generically as *gwandusu*, would have a personal name as well. Through verbal association, the compound term *gwandusu* links nouns such as soul, heart, character, passion, fire, courage (*dusu*) with adjectives such as hot, hard, and

4-12. Staff with equestrian figure,
Bamana, Mali, 19th–20th century. Iron.
Height 241/46" (61.2 cm). The Metropolitan
Museum of Art, New York. Michael C.
Rockefeller Memorial Collection.
Bequest of Nelson A. Rockefeller, 1979

difficult (*gwan*). The *gwandusu* here wears an amulet-laden hunter's or sorcerer's cap, an item of clothing usually owned by powerful men. She is exceptionally strong, a heroine and champion. Yet she also shelters a tiny baby, the deeply desired result of the successful pregnancy that the association works to obtain for its members. The child is so completely attached to her full abdomen that it merges into its mother, and her heavy breasts appear to be full of sustaining milk.

The *gwandusu* was probably the central image in a group of three or more statues once displayed during annual festivals. It was accompanied by other figures displaying extraordinary powers, such as horsemen. Figure 4-13 includes one of these attendants, a seated male leader, or gwantigi, who also wears a distinctive hat, carries a spear, displays a dagger, and is presented as a warrior. Other male and female figures in attendance performed the activities necessary for civilized life, such as carrying water pots or playing musical instruments. As a group, the displayed figures embodied the association's goals, which encourage both personal ambition and service to others, both "paternal" strength and passion and "maternal" responsiveness to family needs. They thus reinforce the duality seen in the gwandusu herself.

Jo organizes all of the young men of the community into age-grades, usually about every seven years; in some areas, *numuw* youths form a separate group, but often they are welcome to join all other youths. The new age-grade is assembled and taken to a sacred grove of trees, where the young men set up an initiation camp. There the leaders of Jo show them a

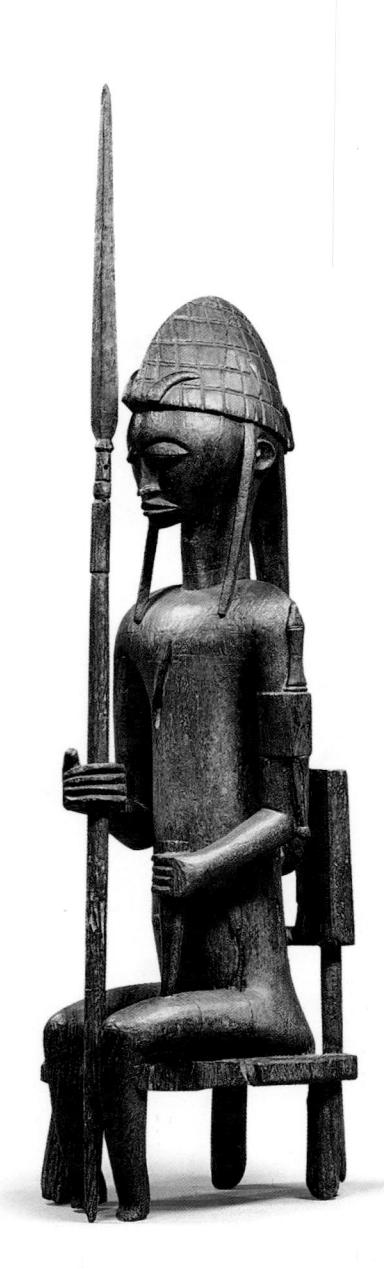

4-13. GWANDUSU AND GWANTIGI (PAIR OF DISPLAY FIGURES), BAMANA, MALI, 15TH-20TH CENTURY. Wood. Mother 48%" (123.5 cm). Male 35¼" (89.9 cm). The Metropolitan Museum of Art, NEW YORK. THE MICHAEL C. ROCKEFELLER MEMORIAL COLLECTION, BEQUEST OF NELSON A. ROCKEFELLER, 1979 AND GIFT OF THE KRONOS COLLECTIONS IN HONOR OF MARTIN LERNER, 1983

The gwandusu (mother-and-child figure) of this pair probably came from the region where the Bougouni and Bankoni terracottas (see fig. 4-6) have been unearthed, and it shares some of the stylistic qualities of the terracottas of ancient Mali. In fact, analysis has revealed that the wood from which it was carved is five or six centuries old. Since trees may have been standing for a hundred years or more before being used by carvers, the statue might date from the seventeenth or eighteenth century AD. It would thus bridge the time between the terracotta figures of the distant past and the wooden figures still being carved today.

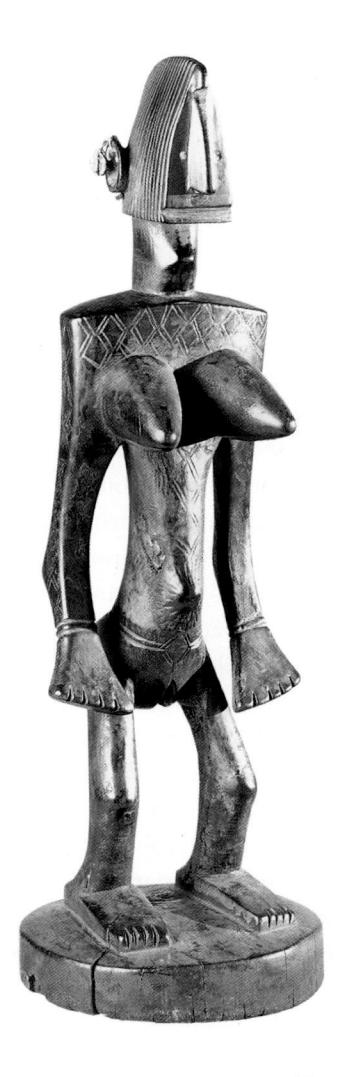

4-14. Figure, perhaps a *Jonyeleni* ("pretty LITTLE ONE OF JO"), BAMANA. WOOD. HEIGHT 24" (61 CM). THE NEW ORLEANS MUSEUM OF ART, BEQUEST OF VICTOR K. KIAM

Although the crested head of this female figure may refer to the rainbow-like arches of wood or fiber worn by new Jo initiates, we cannot be completely sure that it is a jonyele. It may instead be an image of a twin, a flanitokele. The Bamana consider twins to be living replicas of the first two human beings created, and a source of great blessing. When a twin dies in infancy, a wooden statue may be carved to represent the deceased child, and figures for deceased female twins are given the attributes of sexually mature young women. A female flanitokele is thus indistinguishable from a jonyele.

variety of objects, perhaps including sculptural groups and iron staffs, which are symbols of important principles and sources of Jo's sacred authority. At the end of their initiation, young men celebrate their new maturity and knowledge by dancing for their community. They then leave their hometown to visit neighboring and allied towns, where they meet future friends and potential wives. Each of these traveling groups of Jo initiates performs using costumes, musical instruments, and theatrical skits to entertain their hosts. Young blacksmiths may also carry small wooden figures dressed in fine clothing and jewelry (fig. 4-14). Called "pretty little one of Jo," jonyeleni (pl. jonyeleniw), these small statues remind both elders and eligible girls that the young men are seeking brides.

The polished and decorated surfaces of a jonyeleni do not detract from their strong, almost stark translation of the human form into geometric shapes and abruptly intersecting planes. This style contrasts remarkably with the style of the Bamana gwandusu and gwantigi figures discussed above. The jonyeleni's circular hips, narrow cylindrical torso, and conical breasts echo the praises of an epic sung by renowned Malinke bard Seydou Camara:

A well-formed girl is never disdained, Namu ... Her breasts completely fill her

chest,

Namu ...

Her buttocks stood out firmly behind her ...

Look at her slender, young bamboo-like waist ...

All of the jonyeleni's features are clearly visible; when it was in use, the dramatically organized shapes could have been easily read as a female form, even in a crowd or at a distance.

Ntomo and Ci Wara

As noted above, the roles played by Jo and Gwan in the southern Bamana region are divided among other associations in other Bamana communities. Elsewhere, the training of young boys is the domain of a jo called Ntomo or Ndomo. Ntomo gathers prepubescent boys, separates them from their families, organizes them into age-grades, and conducts the training that culminates with their circumcision.

As part of their training in Ntomo, boys wear masks alluding to principles of conduct they are being taught. Carved of wood, the masks may be covered with cowrie shells (a form of currency formerly used throughout the Sudan), blood-red seeds, or shining brass. A well-known example comes from Segou, in the eastern Bamana region (fig. 4-15). The oval face-mask is partitioned into the curved plane of the forehead and nose and the flat surface below, which stretches from brow to chin. Above the face stands a female figure flanked by four vertical horns.

French researchers who studied Bamana religion during the middle of the twentieth century were fascinated by the complexity of the themes raised during Ntomo initiation. According to their reports, which may have been somewhat enhanced by the philosophical orientation of the researchers, boys in training re-enacted the creation of the world. The fig-

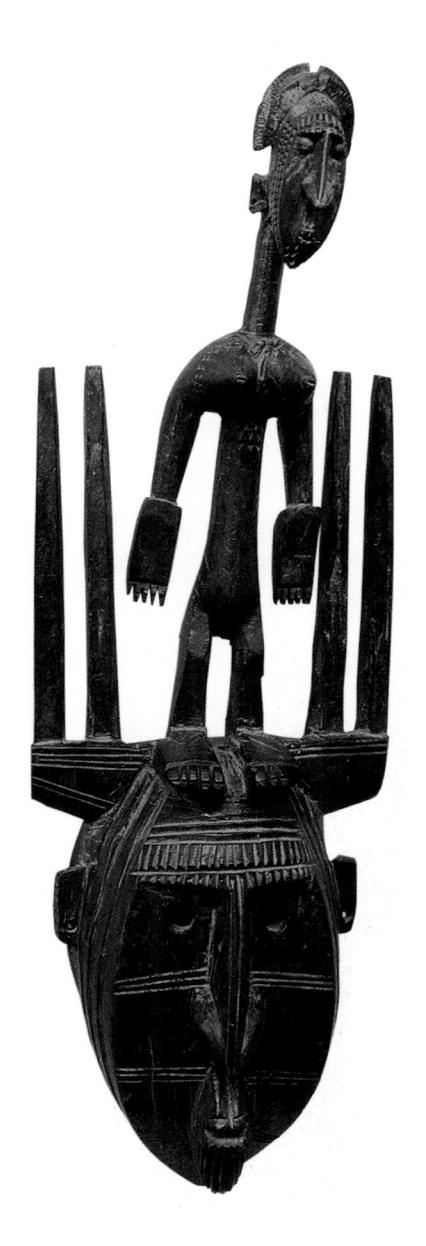

4-15. Ntomo mask, Bamana, Mali. Wood. Height 25¾6" (64.3 см). Musée du OUAI BRANLY, PARIS

4-16. Age-grade masquerade, Malinke (?), Guinea. Photograph 1970s

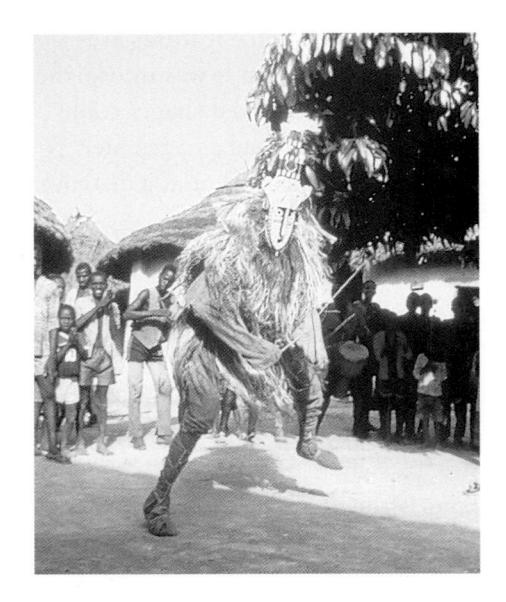

4-17. SAHO (YOUNG MEN'S HOUSE), SOMONO, MALI

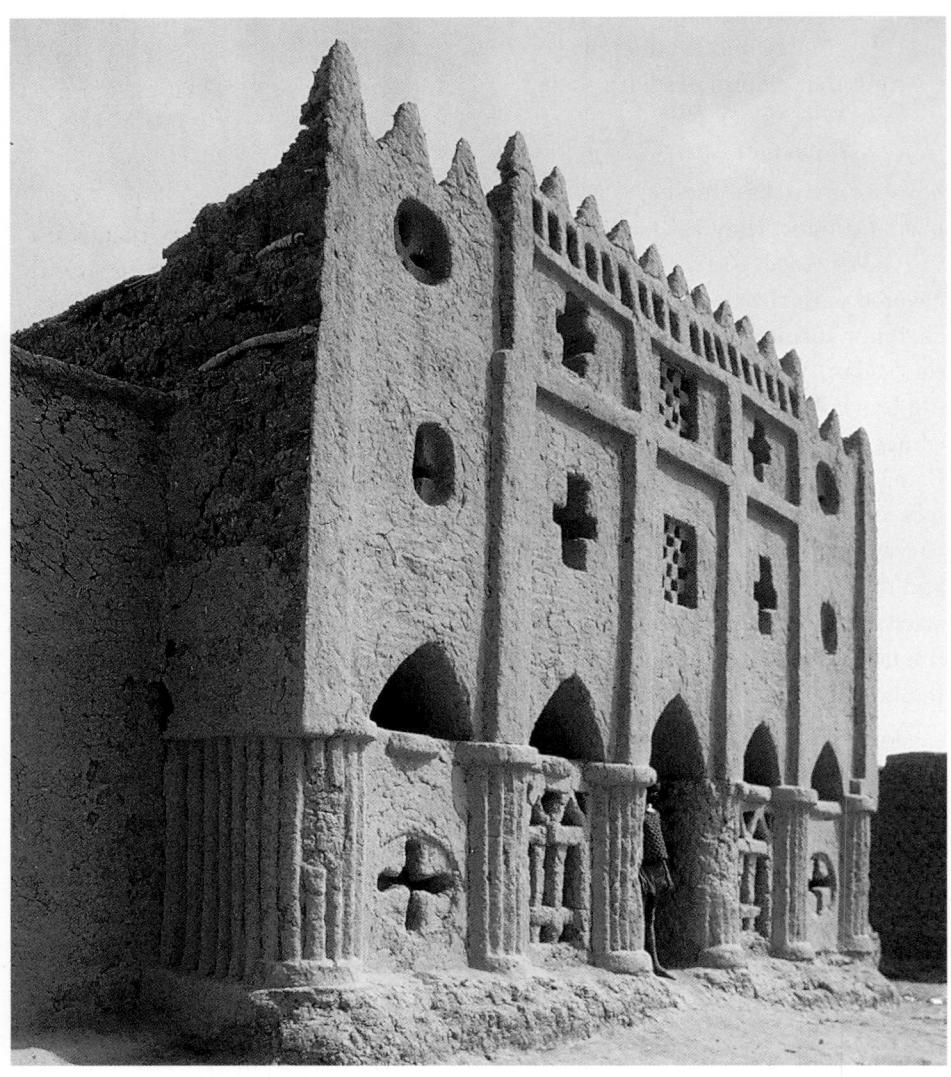

ures and the number of horns at the top of a Ntomo mask symbolized important principles; the four prongs shown here referred to femininity, while three was a male number, and seven the number for the couple. The female figure was also described as a reference to sacred history, when the human race was separated into male and female beings, and a reminder to the boys of the training they had received concerning the opposite sex.

Although Ntomo is by no means universal, even in Bamana lands, virtually all Mande-speaking communities have associations that group young boys into age grades and prepare them for circumcision. Muslim families may link the circumcision of their sons to instruction in a mosque, and both Muslim and non-Muslim age-grades may perform for their communities wearing special costumes and masks (fig. 4-16). When boys are undergoing Ntomo or similar training, they leave their families and may live in temporary shelters. Along the Niger Bend, however, a newly formed boys' age-grade or youth association is housed in a more durable adobe dwelling known as a saho, built especially for them. The recessed geometric patterns of one such dormitory, evidently built for initiates of a Mande-speaking group called the Somono, may have been chosen for symbolic as well as aesthetic reasons (fig. 4-17). The members of the age-grade eventually marry and move to their own homes, and the saho is left to decay.

In some Bamana areas, the training conducted by Ntomo is completed when the age-grade enters Ci Wara, or Tyi Wara (both ways of writing the term are pronounced *chi wara*). Ci

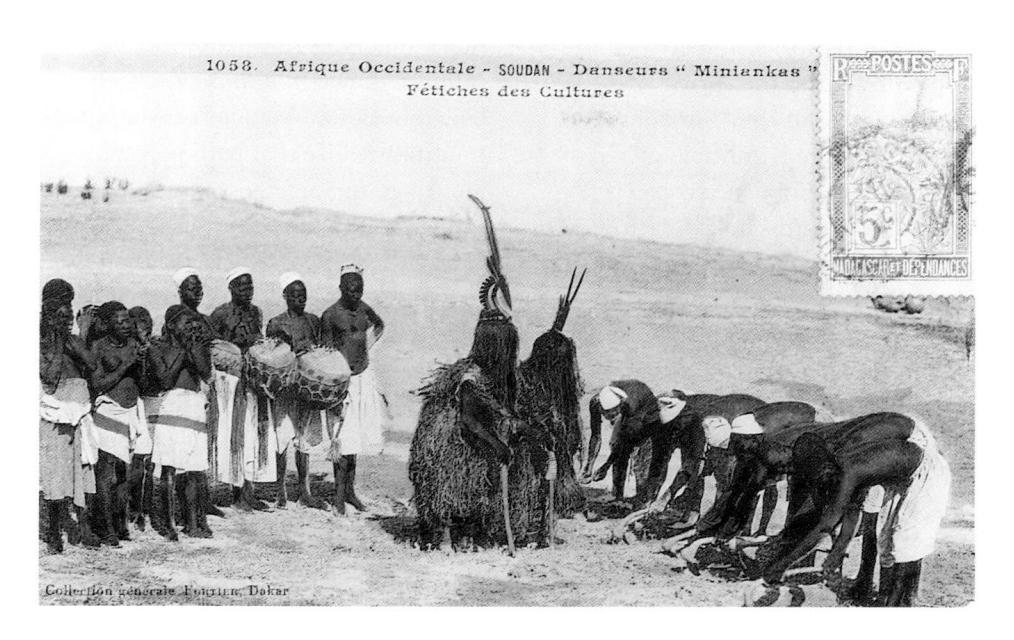

4-18. CI Wara masqueraders, Bamana, Mali. Photograph 1905–6

4-19.
HORIZONTALSTYLE CI WARA
DANCE CREST,
BAMANA, BAMAKO
OR BELEDUGU
REGION, MALI.
WOOD, IRON,
BASKETRY. HEIGHT
9½" (24 CM).
MUSEUM
RIETBERG, ZURICH

Wara prepares them for their future roles as husbands and fathers by pairing them with younger girls who become their partners. It also focuses upon the agricultural skills they need to become successful farmers who can provide for their families and contribute to the community.

In Bamana belief, the primordial being Ci Wara is a creature of the wild who taught mankind how to cultivate the fields. *Ci* is a term referring to farming, while *Wara* is a generic term for wild beast. This supernatural creature has given his name to both the *jo* and to its masquerade. During annual ceremonies, two members of the age-grade are chosen to dance as Ci Wara and his female consort. A photograph from the early twentieth century shows a Ci Wara masquerade in the fields (fig. 4-18). Both mas-

queraders are bent over, for an excellent farmer hoes the ground continually, without straightening to take a rest, and staffs transform the two-legged dancers into four-legged animals. The costumes of darkened fiber, the cloth band tying the basketry caps to their heads, and the tall wooden headdresses attached to the caps are all clearly visible. Drummers provide the beat for the dance and for the youths of the age-grade as they till the soil, while their female partners exhort them to greater efforts and praise Ci Wara.

Although the label of this old photograph claims that the dancers are "Minianka," the masqueraders shown here were probably from the eastern Bamana lands, where the Ci Wara headdress resembles the profile of a roan antelope. The antelope is an appropriate manifestation of this farming wild beast, for it arches its neck just as the cultivators bend their backs, and its long horns are as straight and slender as growing millet stalks. The headdress of Ci Wara's consort here depicts an antelope carrying a baby on its back, just as human mothers do. In other regions the two performers wear identical masks.

Ci Wara masks are crest masks or dance crests, for they sit on top of the dancer's head. Both the head and much of the body of the dancer are usually hidden by a costume. North of the Niger River, Ci Wara dance crests are carved in what observers have called the "horizontal style," as opposed to the "vertical style" of the eastern Bamana. As can be seen in fig. 4-19, their horns sweep backward rather than upward, and the snakelike horns may allude to some of the

stories told about Ci Wara. The body and head are almost canine. Beads, leather, and metal attachments may be added to embellish the masquerade; Bamana say that such ornamentation gives the dance crest *di*, "sweetness" or "tastiness."

Finally, an "abstract style" is used in the Bougouni region where the southwestern Bamana live (fig. 4-20). It combines curved antelope horns,

4-20. CI Wara dance Crest, Bamana. Sikasso region. Wood. Height 20" (51 cm). Staatliches Museum für Volkerkunde, Munich

fragments of horns, anteater snouts (for rooting into the earth), and the canine animal of the "horizontal style," to create a multiple image. As in all Ci Wara dance crests, a variety of textures marks each section of the sculpture, softening the austerity of the overall form. This style is closest in form to the headdresses of community age-grades of Bamana (and non-Bamana) groups whose functions and purposes may be quite similar to those of Ci Wara. Simply called "little antelope heads," soguni kun, such headdresses are performed both by age-grades and by the professional dance troupes that draw from them.

There are large numbers of Ci Wara dance crests in museums, and the "vertical style" of the eastern Bamana region has become one of the most recognizable and most reproduced of all African art forms. It appears in corporate logos in West Africa, on public buildings in Mali, and in hundreds of markets where objects are sold to tourists (see Aspects of African Cultures: Export Arts, p. 152). In recent years, American artist Willie Cole has constructed playful and enormously appealing vertical Ci Wara headdresses out of discarded bicycle parts; one is titled "Schwinn Chi Wara."

Bogolanfini

Male circumcision, the surgical removal of the foreskin, corresponds in Mande thought to female excision, the surgical removal of the clitoris. Just as all boys who wish to become adult men must be willing to undergo seclusion, training, and circumcision, girls who wish to become adult women

must undergo equivalent procedures conducted by a numumusu surgeon, usually a potter. Mande speaking communities realize that both procedures are dangerous, and possibly fatal, but foreign critics have thus far only voiced their opposition to excision (or clitoridectomy). In order to protect the girls from the dangerous levels of nyama released during excision, Bamana *numususuw* employ a variety of means. For example, they wrap the girls in mud-dyed cloths called bogolanfini or simply bogolan. Bogolan are created by women, who paint mixtures of iron-rich mud materials onto locally woven cotton cloth dyed in a vegetable concoction in several different stages. The chemical reaction taking place between the iron in the mud and the vegetable dyes in the presence of sunlight creates the rich, dark colors. The very complexity of the staining and washing processes may produce an object with the supernatural strength needed to guard the girls, just as the process of forging iron increases the nyama of a metal staff.

The geometric symbols that decorate the cloth illustrated here suggest that it is a *basiae*, one of the *bogolan* cloths used in Bamana excision (fig. 4-21). After a girl has worn a *basiae* during the ceremonies, she gives it to her sponsor, a female elder who is past menopause. When this old woman dies, she may be buried in the cloth in order to protect the mourners from the extraordinary amounts of *nyama* released at her death. These textiles therefore allow a community to acknowledge the power of women while deflecting its energy.

While hunters wear protective tunics of *bogolan* while facing the dangers of the wilds, mud-dyed cloth

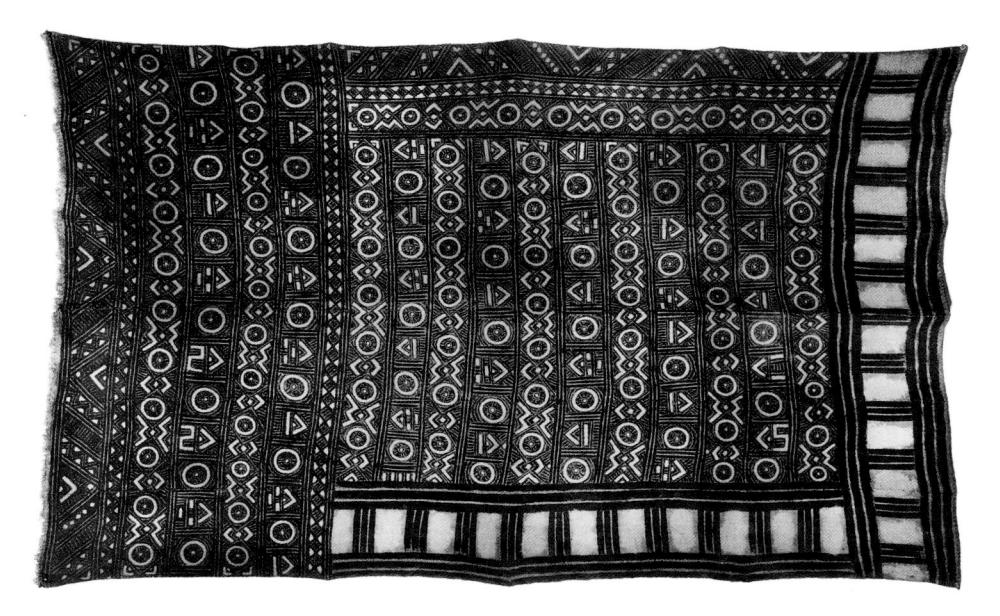

4-21. Bogolan. Bamana, Mali, 20th century. Cotton fabric. 53% x 32% (136 x 83 cm). The British Museum, London

While this bogolan was probably used during a girl's initiation, other types of mud-dyed cloth are sewn into shirts for hunters, who need to be shielded from the nyama lurking in the wilderness and flowing from the blood of the animals they kill. The women who paint these geometric shapes on bogolan often give them individual names and meanings. Some signs may refer to the great Mande epics, to ideal behavior, or to the problems encountered by women.

has always been an item of beauty as well as power; girls, female elders, and hunters appreciate the visual appeal of the art they wear as protection. Malian designers began to sew *bogolan* into fashionable clothing and accessories as early as the 1970s, and muddyed cloth can now be purchased in Europe and America as well as Africa.

Komo and Kono

The manipulation of *nyama* is even more central to the *jow* that have been characterized as "closed associations," "power associations," or even "secret societies." Each has a distinctive community shrine (fig. 4-22) housing the sacred belongings of the group. These might include iron staffs, masks, and masquerade costumes, but

the most powerful item possessed by a jo is an altar, or boli (pl. boliw). The boli illustrated here (fig. 4-23) is an amorphous three-dimensional object formed of dark layers of mysterious materials, all of them secret and all of them laden with nyama. The size of a small child, its ambiguous form seems to evoke an animal. A hollow channel running from "mouth" to "anus" may have allowed libations to be poured through it. The boli was activated, spiritually charged, when it received the libations, the blood sacrifices, and sometimes the spittle of the assembled members of the association. It was thus a reservoir of their *nyama*. This sacred object seems to have been confiscated by colonial authorities from a shrine used by the men's association known as Kono.

Kono was once an important *jo* among the Bamana, though it is now in decline. Evidently the leaders of

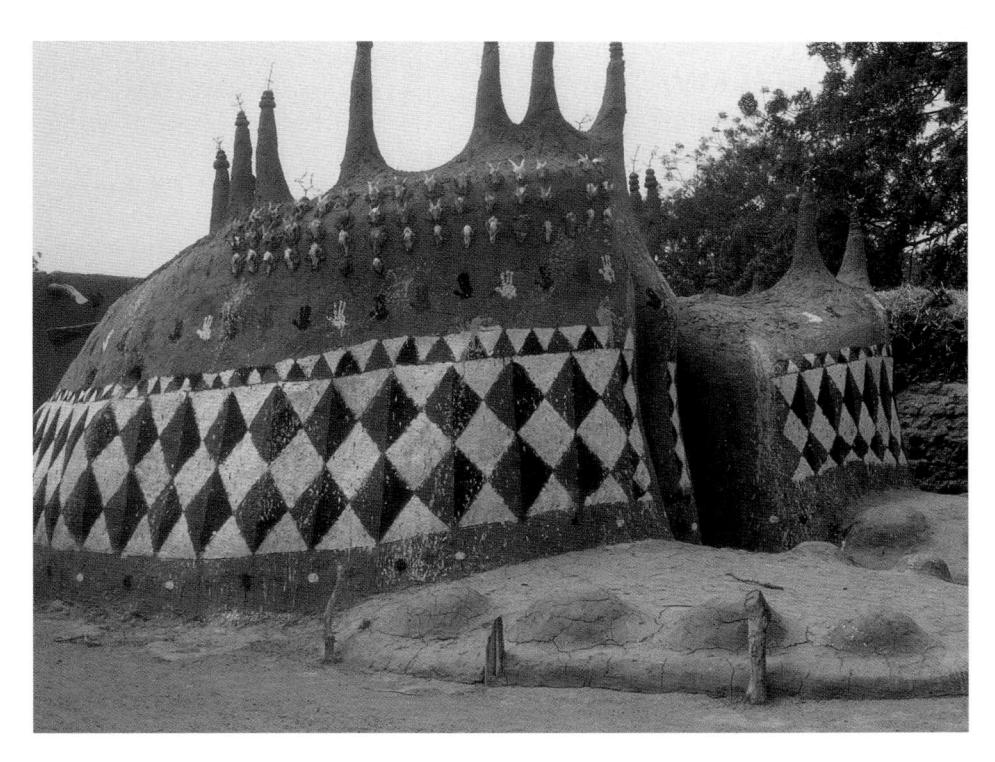

4-22. Kono society shrine, Bamana, Gomakoro, Mali. Photograph 1985

4-23. BOLI (ALTAR), BAMANA, MALI, BEFORE 1931. WOOD ENCRUSTED WITH SPIRITUALLY CHARGED MATERIALS. LENGTH 23½" (60 CM). MUSÉE DU QUAI BRANLY, PARIS

Kono were bards, the *nyamakalaw* who have served noble families as praise singers and leatherworkers, and who are noted musicians. The origin for Kono may extend back over seven hundred years. According to the writings of a fourteenth-century visitor to the Mali court,

When it is a festival day ... the poets ... come. Each one of them has got inside a costume made of feathers to look like a thrush with a wooden head for it and a red beak as if it were the head of a bird. They stand before the sultan ... and recite their poetry ... I was informed this practice is old amongst them ...

During the twentieth century, masqueraders for both Kono and a powerful *jo* known as Komo have worn feathered costumes, and the projecting jaws on their headdresses might be interpreted as a bird's beak. However, twentieth-century examples were not red.

Great amounts of *nyama* are wielded by the blacksmiths who direct

Aspects of African Cultures

Shrines and Altars

Shrines and altars are specially constructed sites of ritual objects and activity. They promote communication between humans and their gods, radiating spiritual energy from the earthly realm to worlds beyond. A charm worn on the body, for example, is a small altar whose single message, usually about personal welfare, beams constantly outward. Figural sculptures are often altars, as are power images such as those of the Fon and Bamana of West Africa and the Kongo of Congo, which assemble diverse materials. All shrines and altars are instrumental; they exist to accomplish something, to offer a charged site from which petitions and sacrifices are channeled to ancestors, spirits, and deities on behalf of people needing help.

Altars and shrines range from small portable objects to entire buildings full of sacred materials. Small altars such as figural sculptures among the Igbo and Baule may be invoked for personal or family benefit. Many shrines maintained by lineages focus on ancestors, both those who have actually lived and died, and founding ancestors whose historical existence may or may not be factual, but whose moral force is unquestioned. Ancestral shrines contain symbols—stones, ceramic vessels, trees, figures, or accumulations—which focus ritual and often involve sacrifice. Larger, composite shrines serve entire communities and incorporate specific and general

powers. The gods in such shrines are often called tutelary, meaning protective. They are often associated with various aspects of the natural world (local rivers or forests, the earth, the sky, thunder, iron, or other phenomena) and watch over human and agricultural productivity and the people's health and welfare.

Consecration rituals bring community shrines into worshipers' "lives," and rituals again activate their powers when worshipers need them. These rituals are generally overseen by a permanent priest or priestess, who is believed to have close ties with the god and has been trained in its needs and actions. Such rituals normally involve sacrifice, from an offering of coins or a splash of wine, to blood from a ritually killed animal. Sacrificial blood is seen as food for the god. The rest of the animal is suitable only for mere mortals, and is later divided ceremoniously and shared out among worshipers to be eaten.

A self-conscious, artistic arrangement of furnishings is common, although many shrines have what appear to outsiders to be disorderly arrangements. Large accumulations of offerings such as clay, shells, broken pottery, or metal blades are common. Blood and chicken feathers are the most usual sacrificial residue, proof that the gods have been well fed. Today, some shrine sculptures have been removed, often sold. Yet shrines remain active, proof that most cultures understand such images to be symbolic, and not deities in themselves. **HMC**

the social, political, religious, and judicial association known as Komo. Various accounts of its origin claim that Komo was spread through the Mali empire by a blacksmith who served Sundjata, or that a *mansa*, a king, purchased Komo during his stay in Mecca. Despite these attempts to link it with the spread of Islam, Komo has often been persecuted by Islamic

leaders. Its political roles brought it into conflict with colonial authorities as well. Yet in some areas this association has survived as a potent guarantee of public security, as a defense against witchcraft and anti-social behavior, and as an educational institution for men who seek to understand the secrets of the world around them.

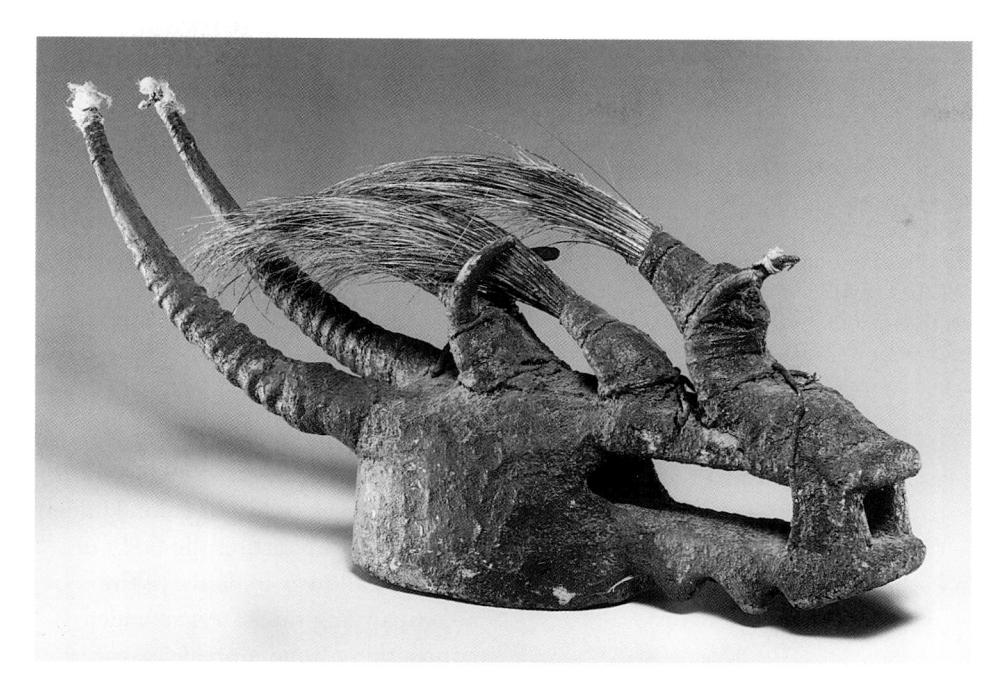

4-24. Komo Kun ("head of Komo"), Bamana, Mali. Wood, resin, feathers, quills, fibers, animal hair. Length 27" (68.6 cm). Indiana University Art Museum, Bloomington

Few photographs of Komo masquerades exist, for women and nonmembers are usually barred from Komo ceremonies. The dancers' costumes evidently consist of a series of rings into which feathers and other materials are set. The entire body is hidden. Upon the dancer's head is a headdress known as "head of Komo," komo kun (fig. 4-24). Sedu Traore, a Bamana numu, has said, "The komo kun is made to look like an animal. But it is not an animal: it is a secret." Indeed, although the domed central hemisphere, projecting jaws, and backswept horns of a Komo headdress, or a Kono headdress, recall the horizontal backswept horns of Ci Wara crests, the komo kun is startlingly different from Bamana art works described as having di (sweetness). It is caked with a gravish dark substance, once wet and glistening, now dry and flaking. Horns of slain

antelopes are lashed to the wooden substructure. Bundles of grasses and leaves, skulls, bones, and parts of animals may also be embedded in the thick surface.

Komo masters, komotigiw, cover a komo kun with mysterious materials to intimidate their audience and to refer to their secret knowledge of powerful substances. They further believe that the impression the headdress makes on the senses is but the outward manifestation of the *nyama* contained within it. By unleashing a properly prepared komo kun, a masquerader is empowered to perceive and destroy evil. In fact, a komo kun can be described as a mobile boli.

Kore, Secular Masquerades, and Puppetry

Another particularly powerful *jo* is called Kore. Seemingly less wide-

spread and influential than in the past, Kore once sponsored a vibrant form of theater, challenging immoral authority and hypocritical morality through the sexually explicit gestures and buffoonery of its masquerades. Dancers promoted common decency by mocking irresponsible and outrageous behavior. Kore performances seem to have featured both puppets and masqueraders, the latter wearing wooden face masks in the shape of the lazy or wily animals they portrayed.

A rare photograph of a Kore horse, kore duga, shows the dancer wearing a heavy wooden mask with long mule-like ears, a domed forehead, pierced eyes, and a square muzzle (fig. 4-25). In one hand he carries a long wooden imitation of a sword, and in the other he manipulates his beribboned penis-like "mount." The long slit in the oval object against one shoulder is a clear reference to female genitals. The rest of the net costume holds discarded objects and refuse. The kore duga is clearly the antithesis of a polite Bamana person.

Kore's role in exposing human frailties, and in reinforcing the common values of society, is partially filled today in Mande-speaking regions by community age-grades. These associations, usually called Kamelon Ton, organize young men and women into groups by age and act as self-help organizations. In order to raise funds and provide entertainment for a community, members of a Kamelon Ton (particularly those of the Somono, the Bozo, and the Bamana peoples) put on elaborate performances that can last several days. Today competitions between groups are sponsored by cultural

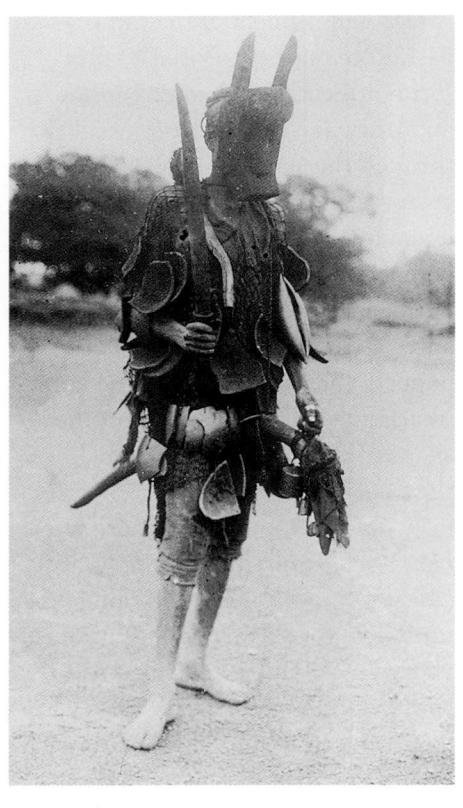

4-25. Kore duga ("Kore horse") masquerader, Bamana, Mali. Photograph 1931

Researchers in the middle of the twentieth century wrote that a man would need to join five major Bamana associations (Ntomo, Tyi Wara, Komo, Kono, and Nama) before being initiated into Kore. They believed that Kore masquerades such as this represented the culmination of a man's education, and served as the foundation for a just society. Although this research cannot be verified today, it does indicate that Kore masqueraders once played an important role in Bamana culture.

4-26. Performance of *Kamelon Ton,* Bomana, Nienou village, Segou, Mali. Photograph 1989 associations, but rivalries between groups have always animated the performances.

In addition to music and masquerades, a Kamelon Ton production features huge zoomorphic forms, which are constructed of brightly woven and appliquéd cloth and plant fiber on a wooden frame, and are fitted with carved, moveable heads (fig. 4-26). The heads are often adorned with multiple horns, and may be embedded with mirrors or covered with scintillating patterns in bright color. Hidden performers supporting the body of the beast allow it to dance to the accompanying music. As an added bonus, these huge mobile creatures bristle with rod puppets, consisting of wooden sculptures of heads, or partial figures on sticks. The brightly painted and clothed puppets are also manipu-

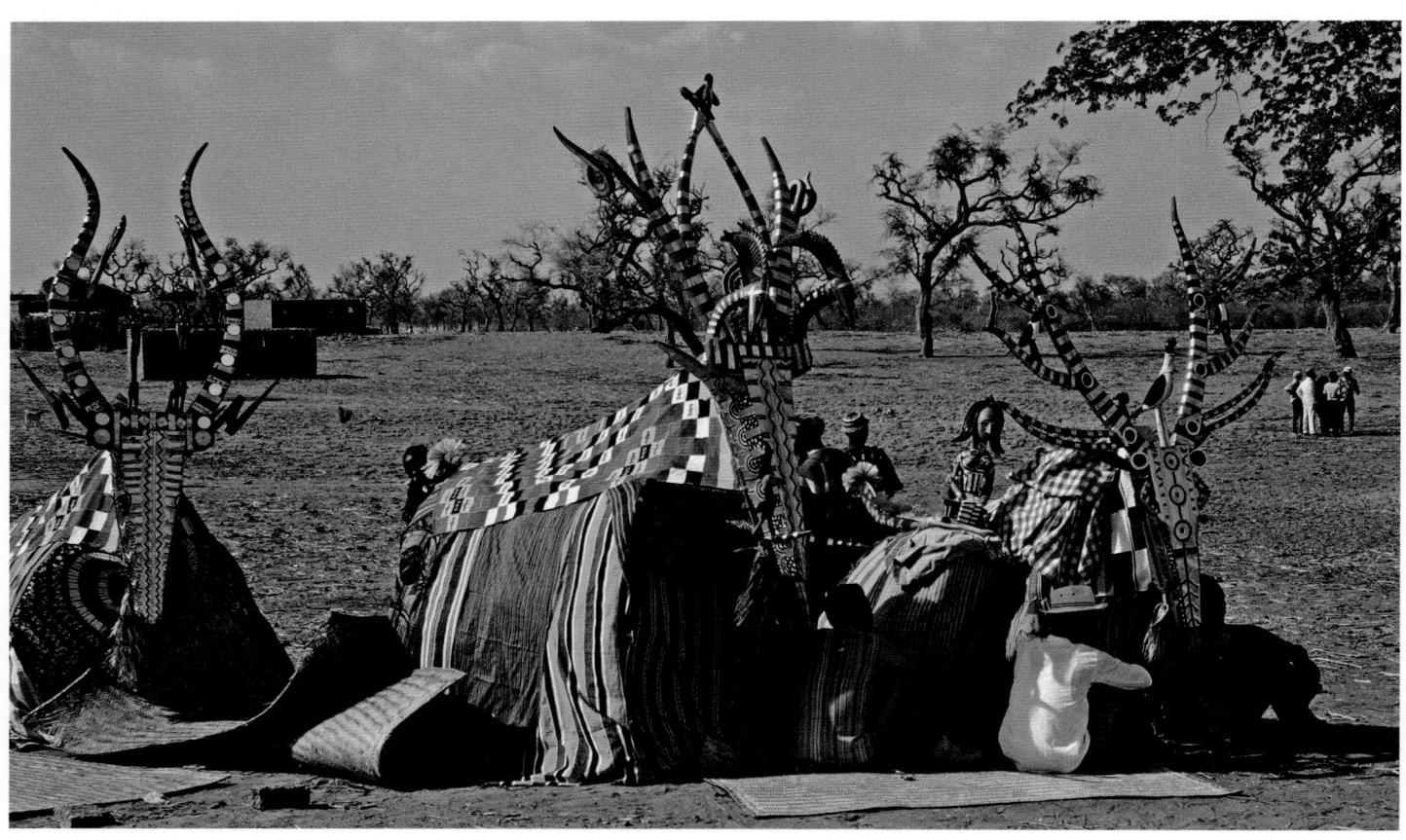

lated by the performers. These puppet characters are often generic (a typical "beautiful woman" may be seen on the beast at the left of fig. 4-26), but they act out various plots and subplots whose specific political and social references are couched within more generalized messages about leadership, heroism, and community relationships.

Age-grades and other theatrical groups among some Mande-speaking peoples may present only the animated stage-animal itself, without puppets. This is especially the case in southern Mali and Côte d'Ivoire, where the animal's head is the visual focus of the performance. In some southern Mande-speaking areas, these huge animal masquerades are considered secret, and may not be viewed by women. Usually, however, female singers in the audience provide important verbal, visual, and musical accompaniment.

Boundaries between secular and sacred performances in Mande-speaking communities are not always as clear as this discussion might suggest. The gaily colored animal who dips and swings and raises its head is able to do so in part because of the *nyama* of the dancers. A Komo masquerader who emits strange noises, breathes fire, and rises high into the air can entertain as well as inspire his audience. In both private religious ceremonies and public spectacles, displays of art lead communities to reflect upon their values and their history.

ARTS OF THE HOME

The puppetry, masquerades, and statuary described above are displayed at festivals and ceremonies, and then

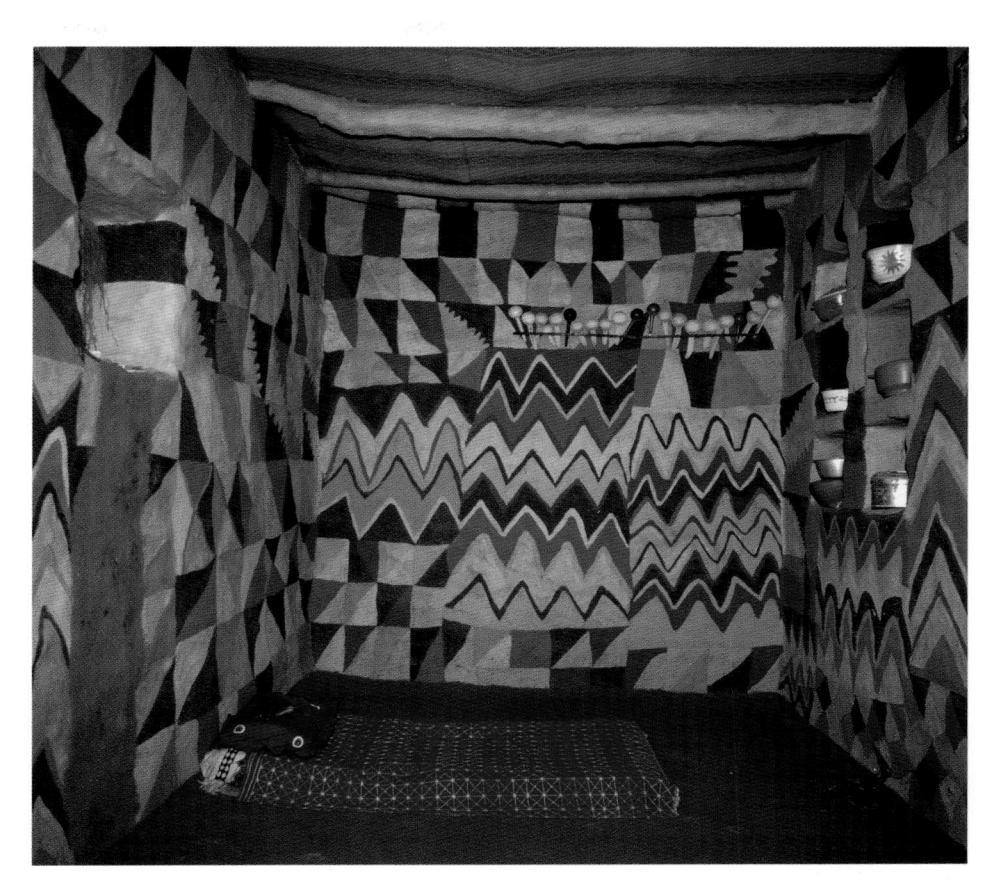

4-27. Painted interior by Habou Camara, Soninke, Ouloumbini, Mauritania. Pigment on Adobe

returned to storage. While these dramatic art forms impress locals and outsiders alike, well-made items used in everyday life are often overlooked by visitors. These household arts include the large ovoid water storage pots and other impressive ceramic vessels made by Mande-speaking numumusu and by other female potters in neighboring groups. In some Mande-speaking regions, domestic art forms made by women also include the painted and sculpted ornamentation of houses and compounds.

Soninke women who live along the Senegal River in southern Mauritania and eastern Senegal paint the interiors and exteriors of their homes. The bedroom of Mme. Habou Camara is an excellent example of this vibrant art (fig. 4-27). Unlike the more tightly organized shapes of Bamana women's bogolanfini, which are monochromatic, this mural uses a range of yellows and reds. Other Soninke women also use bright blues and greens in their energetic designs. Their murals may offer protection and blessing as well as beauty, just as the wall paintings created by Soninke-speaking Harratin women for patrons in the oasis city of Walata, Mauritania, relate to ideas of prestige, fertility, increase, and community (see fig. 1-27).

Men and women throughout Africa hang photographs on their walls both to embellish their homes

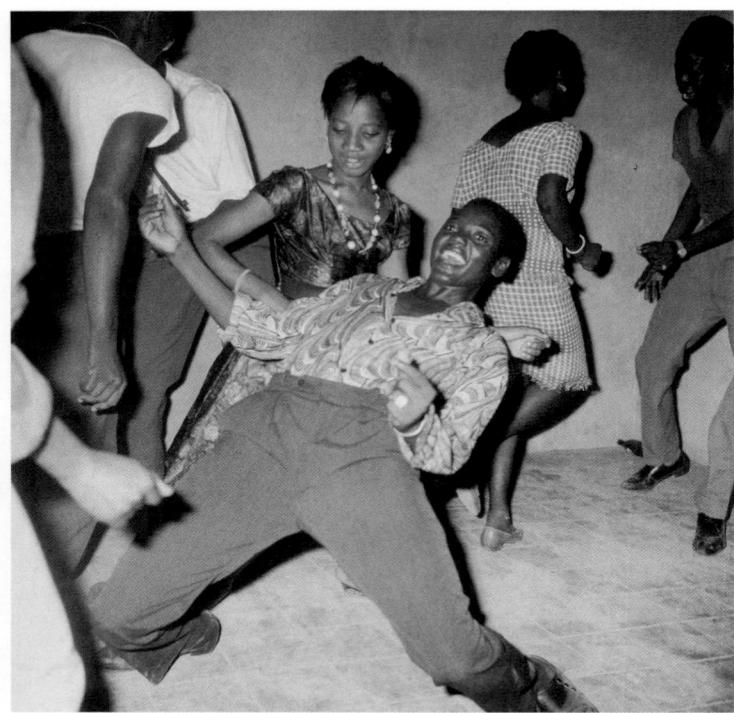

4-29. UNTITLED, Malick Sidibe, Bamako, Mali, 1962. GELATIN SILVER PRINT. 235/8 X 195/8" (60 x 50 cm). Contemporary AFRICAN ART COLLECTION— THE PIGOZZI COLLECTION, GENEVA

4-28. Untitled, Seydou Keita, Mali, 1958. BLACK AND WHITE PHOTOGRAPH. CONTEMPORARY AFRICAN ART COLLECTION— THE PIGOZZI COLLECTION, GENEVA

and to honor family members. In this region the practice began during the early twentieth century, when wealthy Africans in the cities of Dakar, St. Louis, and Bamako began to commission portraits from local photographers. One of the most talented photographers working in Bamako during the mid-twentieth century was Seydou Keita (1923-2004), who produced thousands of portraits between 1949 and his retirement in 1977. A photograph from 1958 demonstrates his meticulous craft (fig. 4-28). Keita has posed his pensive subject with a flower, created an interesting range of textures and patterns with his cloth backdrop, and selected an exposure that enhances

the range of light and dark in this black-and-white composition. The subject chose her own hat and her dress, which reflect both contemporary French fashion and Malinke preferences for elaborate headdresses and bright cloth.

Originally Keita produced fairly small prints for clients, and they were displayed in discreet glass frames in private homes. After Seidou's negatives were purchased by (or lent to) foreign entrepreneurs, professional photographers in Europe and the United States printed the images on an enormous scale on expensive paper, yielding deep, rich contrasts. Some of these splendid photographic prints are over six feet tall, and fill the walls of the galleries where they have been displayed. The photograph reproduced here was printed in Europe, and is at least four to five times larger than the photograph

originally printed by Keita for a customer. Critics have noted that European reprints of Keita's work raise interesting issues about authenticity and the photographic image, especially since there is no evidence that Keita himself approved of the ways in which his negatives were printed.

Seidou Keita's work was first brought to the attention of the European art world by Malick Sidibe, a leading photographer in Bamako. Sidibe has received critical acclaim for his own photographs of young men and women of the 1960s and 1970s, who danced, played, and posed in urban sites outside of the studio (fig. 4-29), and his success has inspired a new generation of photographers in Mali. By the late twentieth century, exhibitions of contemporary photography were being held regularly in Bamako.

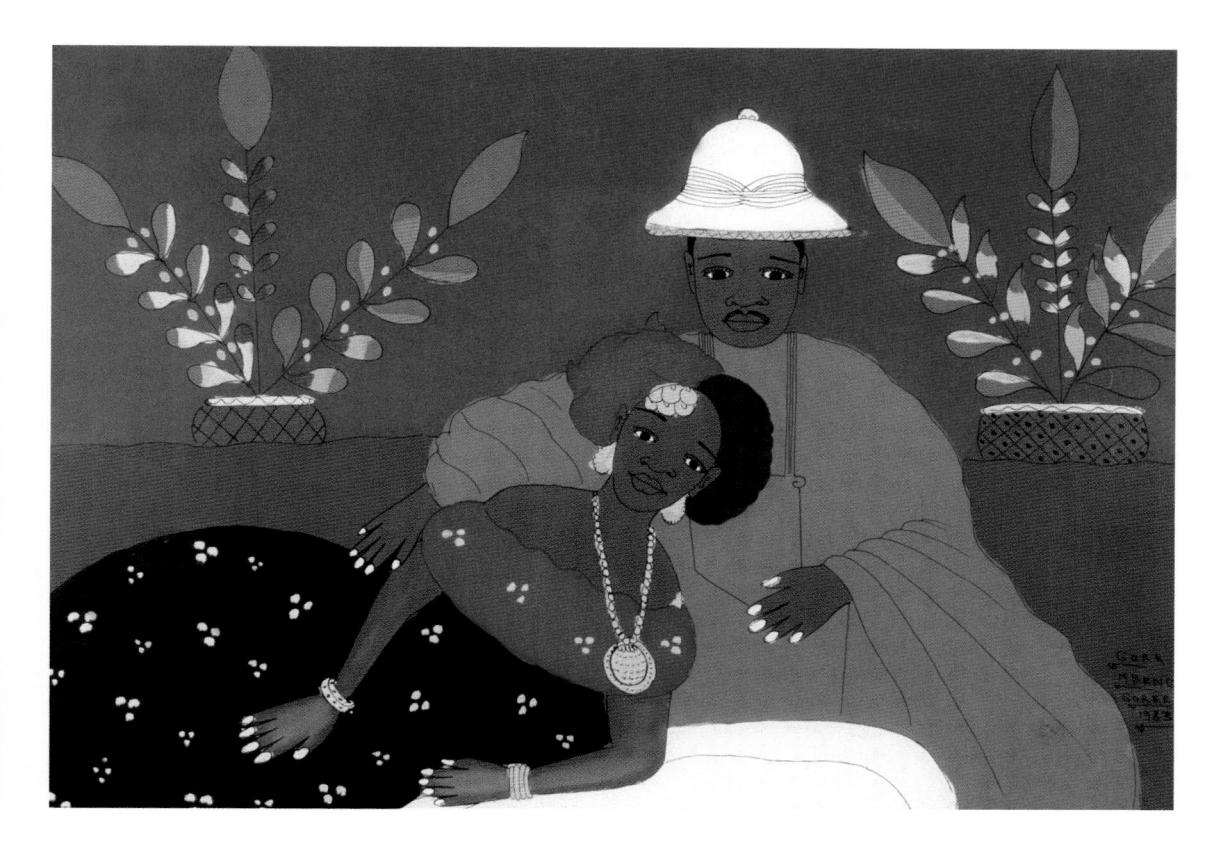

4-30. LES AMOREAUX, GORA M'BENGUE, SENEGAL, 1983. INK AND ENAMEL PAINT ON GLASS. 13 X 18¼" (33 X 48 CM). COLLECTION OF MR. AND MRS. M. RENAUDEAU

Photographs are easily damaged by sun, heat, and dust, and families throughout Africa have often opted for more durable painted portraits. In Senegal, Muslim families display devotional images as well as portraits in their homes. Views of Mecca, figures of holy men such as Cheik Amadou Bamba, and inscriptions from the Qur'an are often painted on glass, as are satirical and proverbial scenes criticizing misbehavior. Les Amoreaux, a painting on glass by Gora M'bengue (1931–88), depicts a contemporary couple (fig. 4-30). The man wears typically Senegalese robes and a French pith helmet, announcing his ability to work within both worlds. His wife wears granulated gold earrings made by Wolof or Toucouleur jewelers, while her large pendant is similar to the fourteenthcentury pectoral disk found in a burial near Rao. The black outlines filled in with flat, bright colors are typical of Senegalese paintings on glass.

TWENTIETH- AND TWENTY-FIRST-CENTURY ART IN SENEGAL

Glass painters such as Gora M'bengue, who sell their work in local markets and shops, rarely attend art school, but rather learn their trade by apprenticing themselves to established artists. Formally educated artists, in contrast, often work with the international art world in mind, with its network of galleries, museums, collectors, and critics. The art schools and institutions of Senegal flourished under the patronage of President Léopold Sédar Senghor during the two decades following its independence from France in 1960.

Perhaps the most influential artist of the Senegalese academies of this time was Papa Ibra Tall (born 1935). Tall studied painting and tapestry in France. Upon his return to Senegal, he taught at Senghor's École des Beaux-Arts in Dakar. The rhythmic, colorful images in his work were drawn from a heritage he (and the other artists working with government patronage) considered to be pan-African. Their art is sometimes described as a School of Dakar ("Ecole de Dakar"). In 1965, Tall founded the Manufactures Nationales des Tapisseries in the town of Thies. This unusual art school and manufacturing center trained and employed a generation of artists who produced stylized images of African scenes and African art forms using imported fibers and European weaving techniques. Tall's Royal Couple is a masterful example

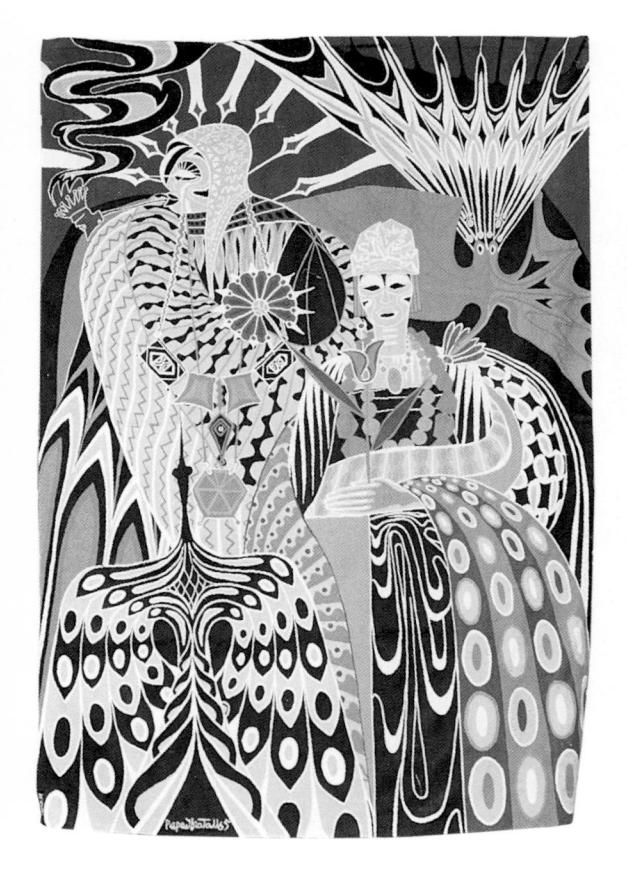

4-31. ROYAL COUPLE, PAPA IBRA TALL, THIES, SENEGAL TAPESTRY. 7'3½" X 5'1" (2.22 X 1.55 M). COURTESY OF THE ARTIST

The philosophical ideas of Négritude are evident in the poetic title, the mask-like figure, the simplified shapes, and the bright colors of this tapestry. Négritude, a philosophy espoused by Léopold Sédar Senghor, sought to build a modern Africa by drawing upon an idealized, pan-African past. Senghor believed that abstraction, rhythm, and expressive color were authentically African contributions to the world's art. music, and literature. He therefore encouraged these tendencies in Senegalese painting.

of one of these woven wall hangings (fig. 4-31).

Iba N'Diaye (born 1928), who also studied in France, joined Papa Ibra Tall from 1959 to 1967 as a department head at the École des Beaux-Arts in Dakar. Although N'Diaye has travelled regularly between Paris and Dakar, most of his work after 1967 has been produced abroad; it will thus be discussed in chapter 15. However, the confident, swift brushwork of his layered paintings influenced several generations of students and colleagues in Senegal.

One of the most gifted artists who drew upon the legacy of Iba N'Diaye was Mor Faye (1947-85), who participated in Senghor's 1963 Festival of Negro Arts as a teenager, and eventually taught at the Ecole des Beaux Arts in Dakar. Tragically, this fine artist contracted cerebral malaria, which caused him to suffer from bouts of insanity. During these episodes he destroyed his work, and he was placed a mental institution. After his death, friends discovered that he had left over eight hundred paintings, all in an intense and personal style. One particularly vivid example appears at first glance to be a rapidly executed abstract work (fig. 4-32). Closer inspection reveals it to be an image of the Senegalese icon al-Burag, the winged horse with the crowned head of a woman who is believed to have transported Muhammad through the night. Her wings have here become the wings of an airplane; her crown and robes are made of flames.

While few other careers ended so tragically, the 1980s were a difficult time for many Senegalese artists. When Senghor left the presidency,

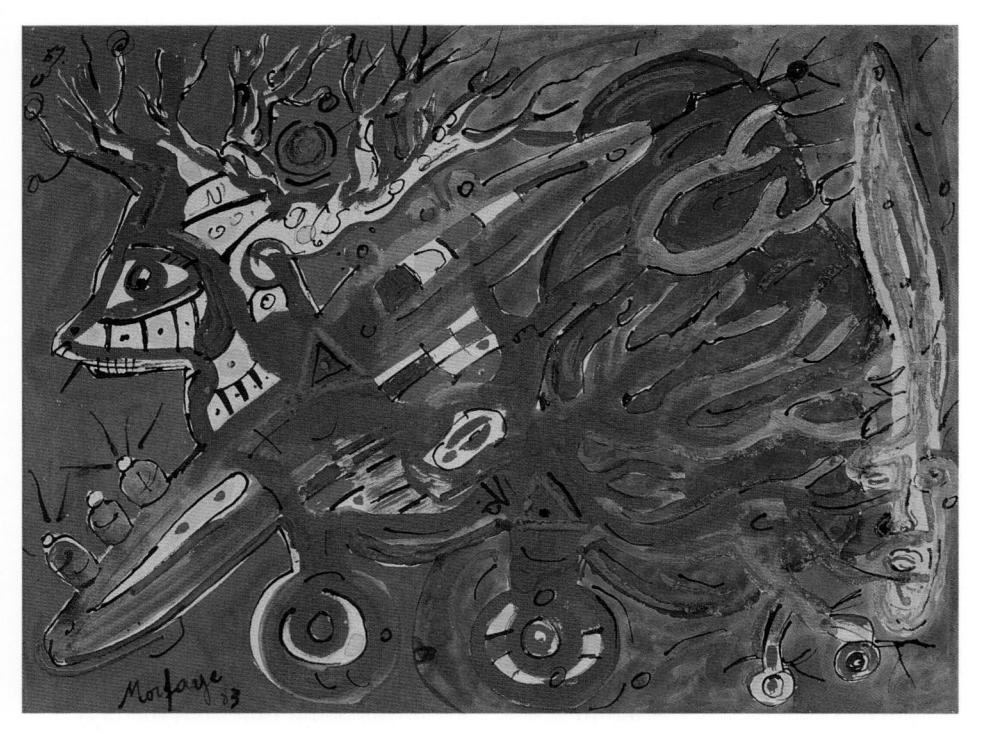

4-32. Untitled, Mor Faye, Senegal, 1983. Gouache and India ink on paper. $19\frac{1}{2}$ " x $25\frac{1}{2}$ " (50 x 65 cm). Collection of Diokhane and Lee

4-33. Le Vieux Nègre, la Médaille et la Statue ("The Old Man, the Medal, and the Statue"), Fodé Camara, Senegal, 1988. Collage and oil on canvas. 47½" x 78½" (1.2 x 2 m). Collection of Abdourahim Agne

the country began to cut back on its investments in culture, and in the visual arts. Painters and sculptors who were accustomed to state support needed to find new venues and new forms of patronage. Some enterprising artists turned this crisis into an opportunity for creative growth. A group of artists were involved with Set Setal, an anti-corruption and "clean-up" campaign of the late 1980s. These artists and their academically trained colleagues worked with sign painters, amateurs, and children to create murals and outdoor sculpture addressing the problems of urban Senegal. In place of expensive paints and imported canvases, artists in Dakar began to use recycled objects and to explore installations and performance. Instead of exhibiting in

spaces provided by the government, the artists displayed their work in private residences or on the street, where they were visible to the urban population. By the late 1990s, national and international funding for the arts increased, and a biennial called "Dak'art" was launched. Today that exhibition, like the festivals held decades ago, features new and exciting art from many nations of the African continent.

One of the many outstanding artists who worked throughout this turbulent period was Fode Camara (born 1958). His luminously beautiful canvases have addressed painful issues such as the slave trade. Le Vieux Nègre, la Médaille et la Statue ("The Old Man, the Medal, and the Statue"; fig. 4-33) explores identity

and the troubled past. Wearing the white beard and cap of an elder, the old man of the title turns to look at the statue, its face an elegant, Senufolike mask (see fig. 5-29). Pieces of tape attach him to the canvas and seal the mask's mouth. A medal lies upon his chest. We assume that the old man is a veteran, one of the thousands of African soldiers who fought for the French in Europe and southeast Asia. His relationship to a colonial past and a pre-colonial belief system is ambiguous.

Unlike Fodé Camara, Ousmane Sow (born 1935) was not trained as an artist. He earned a university degree in France in physical therapy, which he practiced there for many years before returning to Senegal at age 50 in order to devote himself

4-34. Two figures from *Battle of Big Horn*, Ousmane Sow, Senegal, 1999. Mixed media. Installation in Dakar, Senegal. Courtesy of the artist

entirely to sculpture. Since his first exhibit in 1987, he has created series of muscular figures, most larger than lifesize. None are based upon his own cultural heritage. Usually the figures represent men (and some women) from places and from periods that have captured his imagination. They have included Nuba wrestlers, Maasai warriors, Fulani herders, and Zulu kings. A recent work presents scenes from the nineteenth-century American battle at Little Big Horn (fig. 4-34). His modeled and painted figures dramatically capture intense expressions, tightened muscles, and shifting centers of gravity. Their rough, organic surfaces, formed of substances whose composition Sow will not divulge, are reminiscent of Bamana boliw.

Artists in Bamako

The Institut National des Arts (INA) in the Malian capital, Bamako, taught students the fundamentals of Western painting in the 1960s and 1970s. However, the approaches taken by graduates of the INA have led them to new and exciting dialogues with their own artistic heritage. Ismail Diabate (born 1948), a graduate and a professor of the INA, is a founder of Mali's Association Nationale des Artistes. His art transforms the sacred signs of Bamana jow into more personal abstract shapes (fig. 4-35). The title of this painting (Si Kolona, "The Earth") reminds us of the ways numbers and seemingly simple forms in Mande arts refer to elemental principles. Diabate has worked with monotypes, and in various media. This work, however, is created with the natural dyes of bogolan.

Diabate seems to have been inspired to explore this medium by a group of four young male artists, who all graduated from the INA in 1978 and went to live in a village in the Segou region in order to research the bogolan created by women in that community. They learned to manipulate the traditional dyes and processes of bogolan, and they learned to interpret the symbols displayed on the cloth. Some symbols, they have explained, refer to abstract concepts, while others recall the epic battles of historical figures such as the great Sundjata, or the nineteenth-century warrior Samory. Just as Bamana women work together to complete their bogolan, the young men vowed to work as a team, and to create their mud-dyed art works as a collective. They named their group Bogolan Kasobane, and they have worked together for over two decades on a variety of projects (see fig. 5-48).

Abdoulaye Konate (born 1953) also studied at the National Art Institute at Bamako, but he completed his training in Havana, Cuba. Returning to Bamako, he worked at the National Museum of Mali for many years before becoming director of the cultural center known as the Palais de Culture du Mali. Most of Konate's works are large mixed media installations addressing political and social issues. An early sculptural piece, The Drama of the Sahel (1991), is a memorial to the effects of the drought that devastated vast regions of Africa's Sahel in the early 1970s (fig. 4-36). As in all of his installations, Konate strives to use locally available materials and imagery, which can communicate to his fellow citizens of Mali. On many levels, his

4-35. SI KOLOMA ("THE EARTH"), ISMAIL DIABATE, MALI, 1972. COTTON FABRIC AND MUD DYE. NATIONAL MUSEUM OF NATURAL HISTORY, SMITHSONIAN INSTITUTION, WASHINGTON, D.C.

art draws upon the Mande world's traditions of puppetry and masquerades, where social commentary and political insights are provided through large-scale, dramatic art works.

4-36. The Drama of the Sahel, Abdoulaye Konate, Mali, 1991. Installation. Human skeleton and mixed media, $126'' \times 78\frac{1}{4}'' \times 94\frac{1}{4}'' (320 \times 200 \times 240 \text{ cm})$. Collection of the National Museum, Bamako

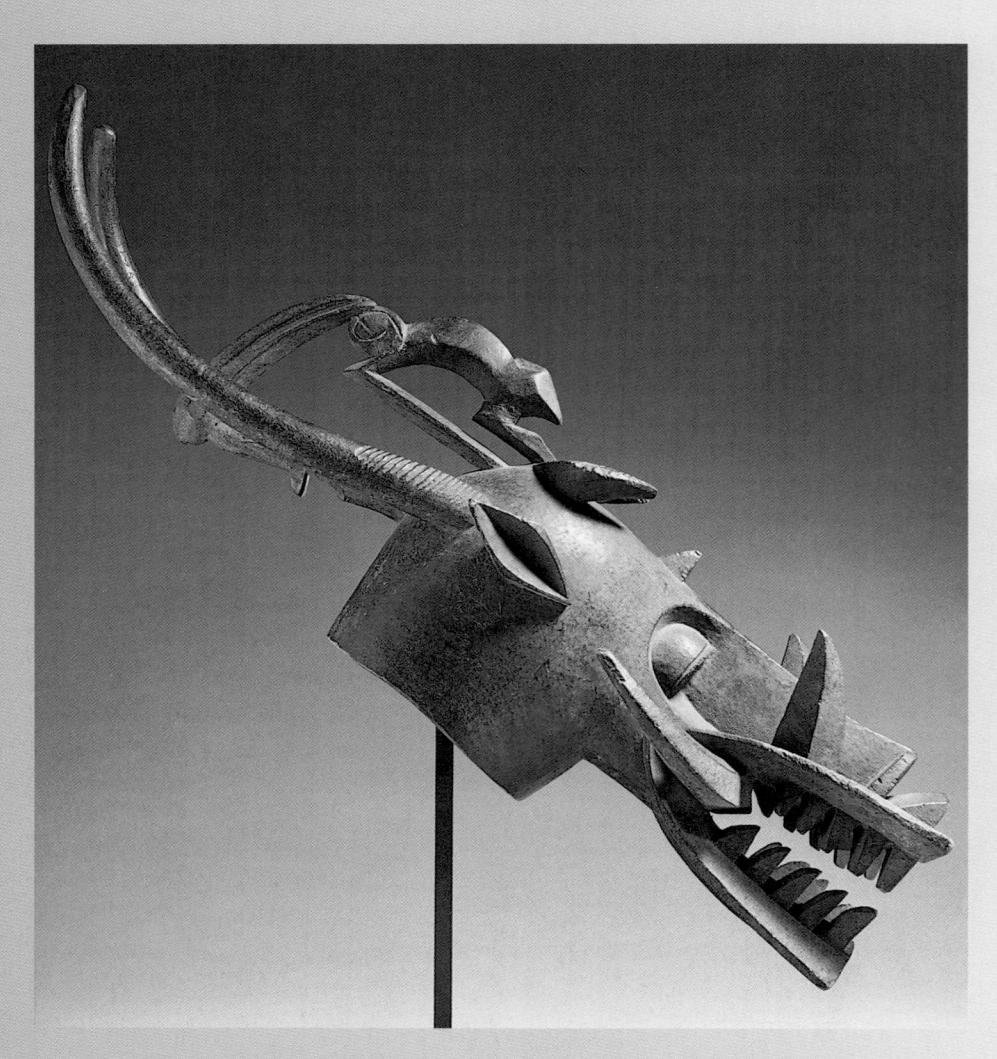

5-1. KPONUNGO ("funeral head mask"), Senufo, Early 20th Century. Wood. Length 40" (1.05 m). University of Iowa, Iowa City. University of Iowa Museum of Art. The Stanley Collection

In parts of Senufo country these masks belong to mens' antiwitchcraft associations outside of Poro. Both Poro and non-Poro masks of this form call upon spiritual powers that can be invoked against witches or criminals, the marauding spirits of the dead, or malevolent bush spirits. As the kinds of masks "sent by death" in legends, these powers engage in a kind of psychological and supernatural warfare, combating any forces that might disrupt the wellbeing of the community.

THE WESTERN SUDAN IS OFTEN defined as the broad savannah region whose heart is the great arc of the Niger River. In this book the term is given a more limited scope, and is defined as the lands bordering those of the peoples of the Central Sudan to the east (here placed in chapter 3), those of the Akan peoples to the south (here placed in chapter 7), and those of the Mande peoples to the north and west (here placed in chapter 4). Yet all such divisions must be arbitrary. For example, the Bobo, one of the major populations included in this chapter, are Mande speakers, as are some of the Senufo peoples whose art is discussed here.

The ancient empires were partially Islamicized from about the tenth century AD. Like the Bamana, however, most of the peoples examined in this chapter resisted Islam and its way of life for centuries, preserving their religions and other cultural traditions into the twentieth century. Linguistic borders in the Western Sudan tend to mark artistic borders as well, with each language group cultivating its own forms and styles. Dogon, Senufo, and the diverse Burkinabe peoples speak mutually incomprehensible languages. But the complete linguistic picture is still more complex, for the Dogon language includes several diverse dialects, while the Senufo actually speak several languageseven a single Senufo village will contain occupational groups with varied origins and different languages. There are, for example, cultural and historical links between Senufo and some Burkinabe peoples and the Mande. This situation reflects a long history of political decentralization, migrations, and interchanges among neighboring peoples, and it has led to a great variety of styles and substyles in the arts.

Despite such artistic and linguistic complexity, however, the peoples of the Western Sudan share belief systems, economies, and cultural institutions. Dwelling largely in rural towns and villages, they are farming peoples who raise subsistence crops in the rather dry climate of the savannah and semi-desert Sahel. With the exception of the Mossi, a Muslim Burkinabe people, they have neither kings nor any other kind of centralized political system. Their most common building material is clay, and their architecture generally has

a sculptural, earthbound quality. Some groups embellish their buildings inside and out with visually striking, symbolically rich designs, invariably painted by women. Almost all of them focus great attention on masquerades, ritual, competitions, and display. Across the region masquerades aid in transforming deceased people into productive and helpful ancestors and dramatize the crucial importance of good harvests in areas of poor soil and relatively little rainfall.

Finally, throughout the Western Sudan as in much of the rest of Africa, sculpture and masks are less literal representations of life forms than they are embodiments of complex ideas. Countless altars and shrines throughout the region are dedicated to nature spirits and ancestors that are embodied in wood,

metal, or mixed media sculptures. Blacksmiths are often the primary sculptors, and their wives are responsible for other art forms, especially pottery. Along with other artisan groups such as carvers and weavers, blacksmiths are usually segregated within the community and accorded considerable ritual power.

THE TELLEM

Running parallel to the Niger on its northward swing through present-day Mali is the Bandiagara escarpment (fig. 5-2). A spectacular cliff some 125 miles long and up to 2000 feet in height, it presides over an austere and dramatic landscape. For several centuries the cliff region has been home to the Dogon people, discussed later in this chapter. The Dogon were preceded in the area by a people

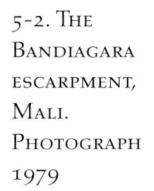

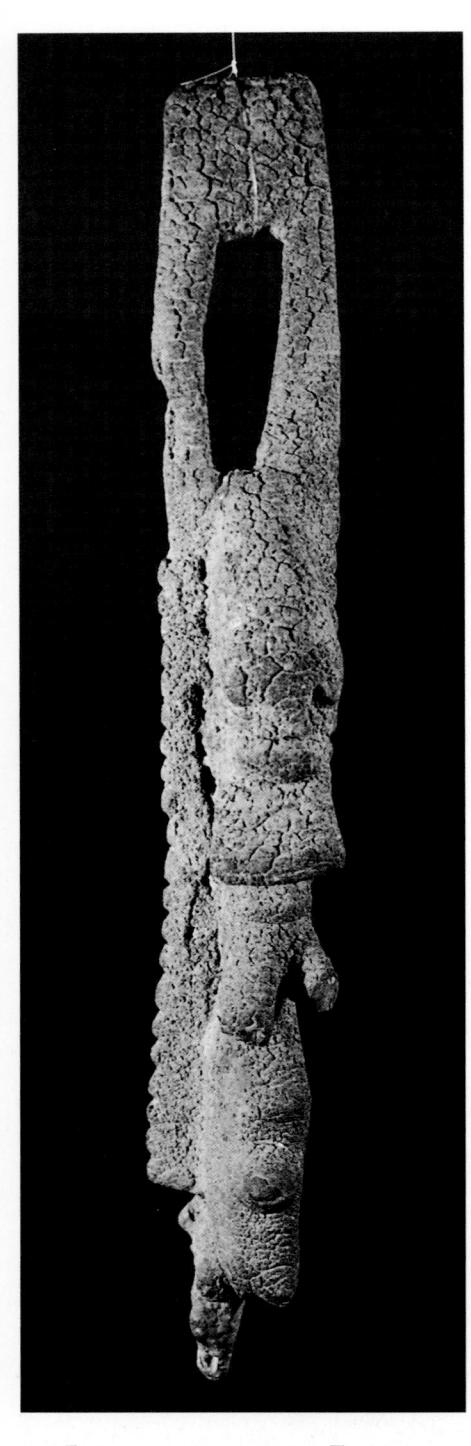

5-3. Figure with raised arms, Tellem, 11th–15th century. Encrusted wood. Height 18%" (48 cm). Koninklijk Instituut voor de Tropen, amsterdam

known as Tellem, whose burials, granaries, and artifacts have been discovered in the numerous caves that dot the cliff.

The Tellem seem to have flourished from about AD 1000 until the arrival of the first Dogon migrants some five hundred years later. Artifacts testifying to Tellem culture include carved figures and neckrests, pottery, implements such as hoes and knives, and the earliest known examples of woven cloth in West Africa. The artistic boundaries between Tellem and Dogon cultures are improperly understood. Several sculptures thought to be characteristically Dogon have recently been shown to date from the Tellem era, while a particular style long associated with the Tellem now seems to have continued into the twentieth century (see fig. 5-5). Clearly, Tellem and Dogon sculpture cannot be distinguished on the basis of style alone, and the nature of the relationship between the cultures remains a mystery.

By virtue of an early radiocarbon date, a fragmentary sculpture illustrated here is almost certainly Tellem (fig. 5-3; see p. 58). The body is simplified, showing an enlarged navel, pendulous breasts, and a proportionately very large head with a projecting chin or beard. Widely spaced eyes and a shelf-like mouth define the otherwise indistinct face, a lack of clarity increased by being covered with a thick encrustation. The legs are partly missing. The figure projects in high relief from a flat, partially notched plank (broken off on the right side), which, in its upper portion, becomes the figure's raised arms, connected at the hands. The entire surface is covered with hardened sacrificial materials. Undoubtedly a shrine figure, the carving cannot be further identified as to use or meaning, although its raised-arm pose is common in other Tellem statuary and is often found in later Dogon imagery.

THE DOGON

The Dogon migrated into the Bandiagara region mainly in the fifteenth and sixteenth centuries. Oral history traces their origins to the Mande territories to the southwest. Linguistic and cultural evidence, however, points to origins in the southeast, in the Yatenga region of Burkina Faso. Both theories may be correct, as the Dogon may well have multiple origins. Clearly they share some art forms with their neighbors.

In earlier centuries the Dogon built their villages on the top of the Bandiagara escarpment, on its rocky bluffs, or snuggled up under the vertical cliff faces on its steep talus slopes (see fig. 5-2). Such difficult-to-reach locations afforded some protection from periodic invasions by Mossi and Fulani cavalry. After the French colonial government established control over the region in the first decade of the twentieth century, many Dogon left the cliffs for the more welcoming Seno plain. Today, a Dogon population of nearly 300,000 is dispersed through some 700 villages, most of them averaging fewer than 500 people. Dogon country once supported abundant wildlife—leopard, lion, antelope, crocodile, and other animals—which the Dogon hunted and depicted in their art. The wildlife has largely disappeared, however, and like other people in the region, the Dogon

now rely on agriculture. Excellent farmers, they manage to wrest subsistence grain crops and onions as a cash crop from poor soil in an area that receives little rain.

The Dogon have been among the most intensively studied of all African peoples. Led by the French anthropologist Marcel Griaule, who first visited the region in the 1930s. scholars have constructed a vision of Dogon life and thought in which every detail of the culture can be seen to reflect the symbolism derived from elaborate creation legends. This cosmology, ripe with many layers of meaning, has provided a fertile resource for theorizing about Dogon art, and compelling interpretations have been based on it. Recently, however, scholars have called many such interpretations into question. Field workers among the Dogon have been unable to verify earlier findings, while on-site observations of how the Dogon actually use and think about their art have suggested less complex symbolic readings. In light of these disputes, many scholars now advocate a more conservative approach to interpreting Dogon art, relying on documented evidence of use and referring only cautiously to creation legends.

Sculpture

Most Dogon sculpture is created by blacksmiths, who work in wood as well as metal. As elsewhere in West Africa, Dogon smiths comprise a hereditary occupational group, respected and often feared for their deep learning and occult powers, and living somewhat apart from Dogon farmers. The works of these artists

are visually compelling as well as diverse in form and style. Their exact functions and meanings, however, often remain obscure. Virtually all scholars agree that Dogon sculpture was made for shrines. Most agree as well that the figures themselves are altars in the sense that they serve as consecrated repositories of sacrificial materials, which may be left nearby or dripped or rubbed over the figures for solutions to such problems as illness, infertility, or drought. On some images these materials have built up a thick crust, as on many Tellem figures.

As in most African cultures, the human figure is the most frequent sculptural motif. Such works have often been referred to as ancestor figures, yet the degree to which they actually represent legendary or historical ancestors is contested. It may be that they were originally created to represent shrine owners or other living petitioners to ancestors. If this is true, then most Dogon sculpture can be interpreted as orants, or praying beings, whose purpose was to intercede with the spirit world on their owners' behalves.

The most distinctive Dogon motif is a single figure standing with one or both arms raised, illustrated here by one of the largest Dogon sculptures known (fig. 5-4). Although the right arm of the sculpture has been broken off above the elbow, clearly it too was raised. The raised-arm pose has usually been interpreted as exemplifying prayer, especially for rain. Yet a variety of other meanings also may be implied. For example, the gesture may indicate penance for having caused a drought by breaking ritual law. It may relate as well to the ceremony of

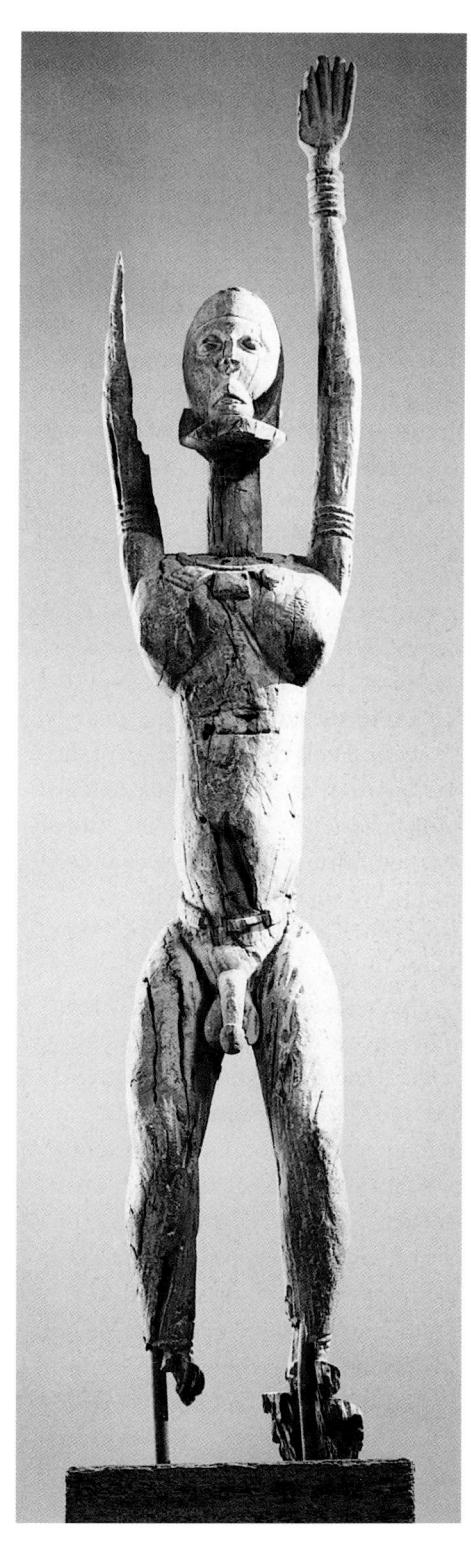

5-4. Standing figure with raised arms, Dogon, 16th–20th century. Wood. Height 6′10½″ (2.1 m). The Metropolitan Museum of Art, New York

casting grain from shrine roofs at the beginning of the planting season, and it also resembles a ritual motion made to ward off evil sorcery (defined as the harnessing of forces to cause action—see glossary) or other dangers.

Dogon sculptural styles vary from region to region. While not all sculpture can yet be assigned confidently to a particular area, the naturalistic, fleshy style of this life-size statue is associated with the Tintam region of northern Dogon country. Despite slightly bent knees, the figure stands with a stately erectness further emphasized by its elongated neck and strong oval head. Ample pectoral swellings, strongly suggestive of female breasts, undercut the clear masculinity of the figure's genitalia and beard. Bisexual images occur with some frequency in Dogon art, and so this figure too can be seen as androgvnous. As such it may relate to aspects of Dogon thought about beings called nommo.

The essence of nommo in Dogon belief is not altogether clear. Long understood by scholars following Griaule's lead as primordial, prehuman ancestors, nommo has recently been translated as "master of water," and may refer as well to a collectivity of powerful water spirits. Either way, nommo are bound up with ideas about couples, twin-ness, and sexual duality, all of which are important in Dogon thought. Like nommo, androgynous beings are associated with two presocial states of being, infancy and childhood. The Dogon practice both male and female circumcision; they believe these operations remove the female element from males and vice versa. Circumcision thus creates a

wholly male or female person prepared to assume an adult role without the ambiguities of childhood. Androgynous sculptures may thus refer to ideas of precultural, primordial beings—perhaps nommo, perhaps children—who preceded civilized institutions as they are now known. At the same time the figure's beard, as well as the jewelry worn on the arms and around the neck, suggest that the statue represents a personage—whether divine or human—of a social stature that matches its great size.

Dogon styles have surely varied over time, as well as from region to region. While not enough works have been scientifically dated for the construction of a chronology, tests conducted thus far indicate that simpler, more abstract figures are generally older than more detailed and naturalistic works. Thus the nearly abstract, encrusted figure in figure 5-5 is probably older than the life-size carving in figure 5-4. Here the torso is radically reduced to an elongated cylinder projecting from a flat, rectangular back and shoulders. Two more cylinders project upward as arms. Rising from a conical base, the work exerts an upward thrust that seems to embody the force of the gesture itself.

Human couples are the second most prevalent theme in Dogon sculpture. One of the finest of known Dogon works depicts a couple seated side by side on a single stool (fig. 5-6). The figures are virtually identical, to the point of near androgyny. The male is slightly larger and dominates by virtue of his apparently protective gesture, his right arm around the woman's neck, fingers resting on her breast. The man's left hand is con-

5-5. Figure with raised arms, Dogon, 16th–early 20th century. Wood and sacrificial materials. Height $16\frac{1}{4}$ " (42.6 cm). Musée Dapper, Paris

The simplicity and encrustation of this figure, formerly enough for scholars to label it as Tellem, are no longer deemed sufficient for such an attribution, although the possibility of its having been made by Tellem peoples remains.

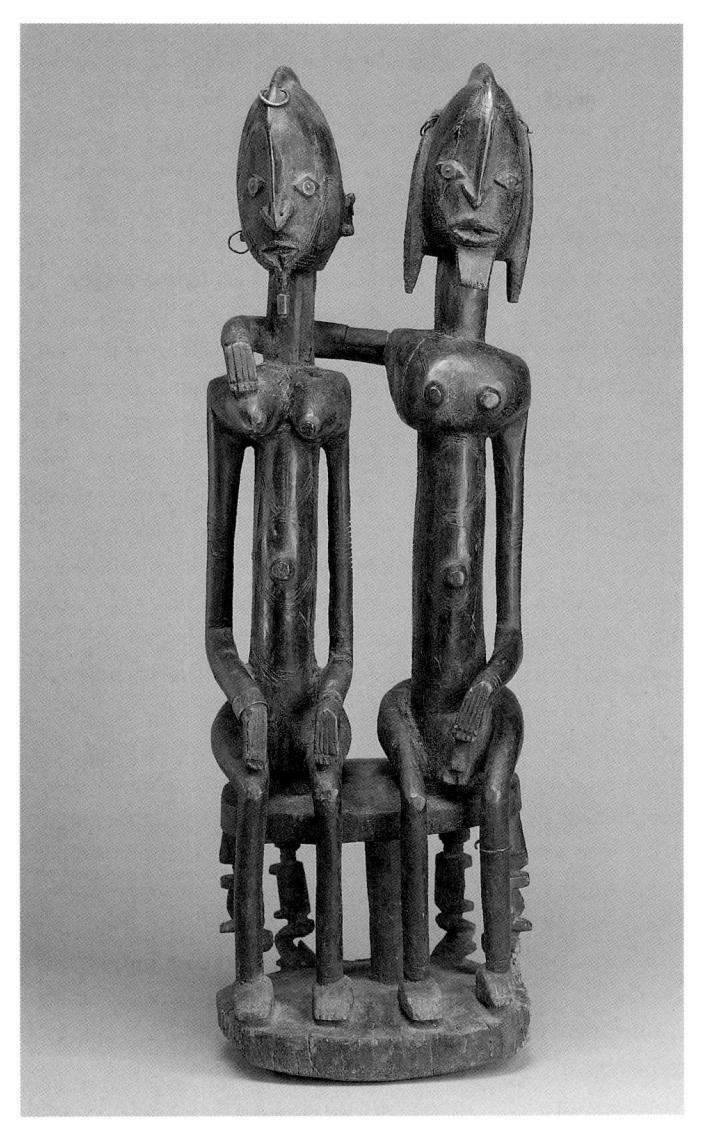

5-6. Seated Couple, Dogon, 16th–19th Century. Wood and Metal. Height 28¼" (73 cm). The Metropolitan Museum of Art, New York. Gift of Lester Wunderman, 1977

Equestrian figures are a third common theme in Dogon art (fig. 5-7). As here, horses are usually rendered more simply than their riders (compare, for example, the horse's curved, seemingly boneless legs with the rider's clearly articulated joints). Horses are generally associated with

between arm and torso or the torso-

woman. At the base of the sculpture,

four smaller figures help support the

stool the couple rests on. These may

refer to the support that ancestors or

other spirits are believed to provide

for the living.

width space between man and

5-7. Horse and rider, Dogon, 19th century or earlier. Wood. Height 31¹/₄" (81 cm). Musée Dapper, Paris

nected to his genital area, suggesting references to procreative powers. The woman carries a child on her back (not visible in the photograph) signaling her role as a nurturing mother. The man similarly wears a quiver, which implies his role as hunter, provider, warrior, and protector. Both torsos are elongated tubular shapes, with articulations more schematic and rectilinear than organic. Facial features too are highly conventionalized. Lightly incised straight lines, recalling scarification, appear on the faces and

torsos, reinforcing the rectilinear composition. This schematic, geometric style is associated with the southern Dogon region.

The work appears to be an idealized model of a nuclear family. Man and woman are here seen as interdependent and complementary, ideas expressed by their nearly identical portrayal, their unity on a common base, the visual bridge of the man's arm, and the rhythmic alternation of positive and negative spaces of equal weight, as in the arm's-width space

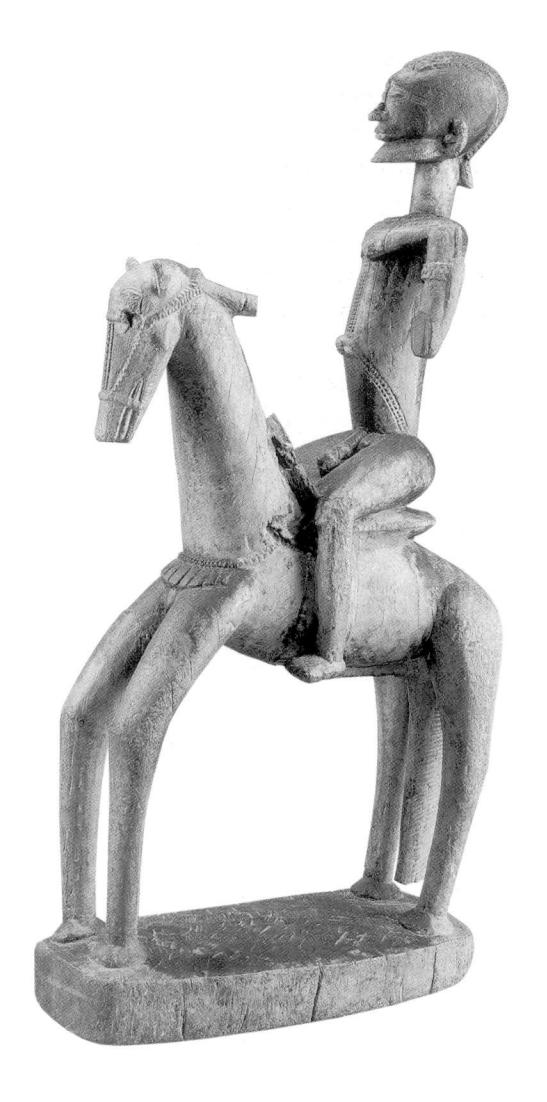

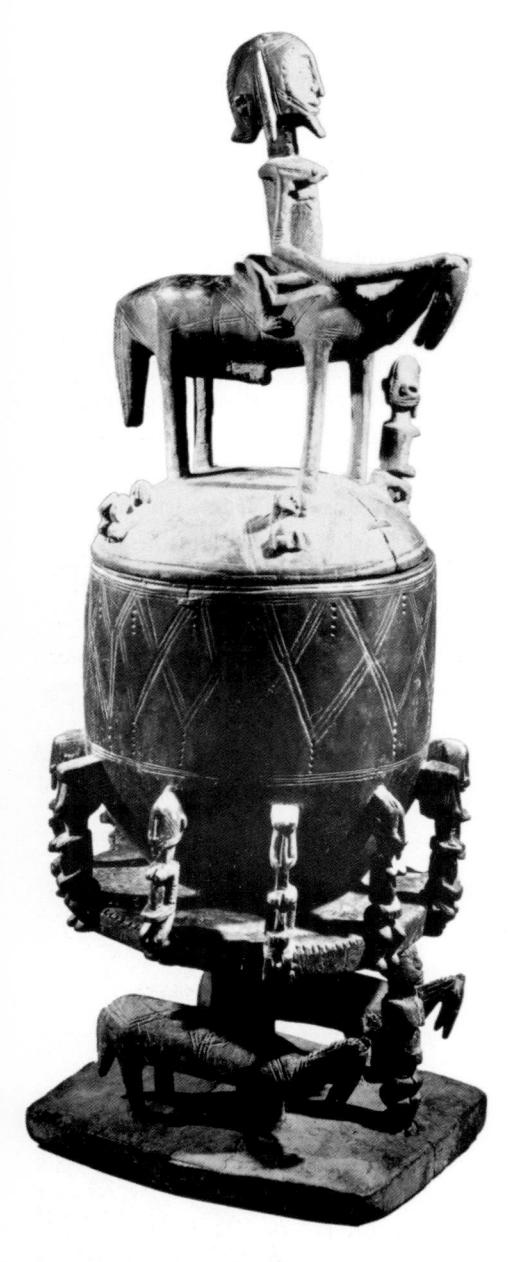

5-8. LIDDED CONTAINER WITH HORSE AND RIDER, DOGON, 16TH–20TH CENTURY. WOOD WITH METAL STAPLES. HEIGHT 33½" (85.8 cm). THE METROPOLITAN MUSEUM OF ART, NEW YORK. MICHAEL C. ROCKEFELLER MEMORIAL COLLECTION. PURCHASE, NELSON A. ROCKEFELLER GIFT 1969

wealth and power in West Africa. Rare and expensive, they are often owned by leaders. One of the few members of Dogon society likely to own a horse is the hogon. Priest of the worship of Lebe, a legendary ancestor and deity concerned especially with agricultural fertility and crop growth, the hogon is the most powerful person in the community. Dogon equestrian figures are thus often believed to depict hogons. Yet historically the Dogon have also known riders as invading warriors and as emissaries of foreign leaders, and these possible meanings should be kept in mind as well. The rider here wears a sheathed knife on his upper arm, and both rider and horse are adorned with carefully rendered ornaments. These signs indicate that the subject is an important personage, while the large size of the sculpture indicates that it is itself an important work. Note too that quite similar terracotta equestrian images are known from Jenne and other cultures linked to the kingdom of ancient Mali (see fig. 4-1).

An equestrian image more firmly associated with the office of hogon forms part of one of the more complex Dogon figural carvings known (fig. 5-8). This lidded bowl was owned by a hogon and was used to contain food at his rites of investiture. Elaborate embellishment marks it as a prestige vessel, possession of which indicated high status and probably wealth. The lower section, carved from a single block of wood, comprises a bowl ringed by eight seated figures and supported by two horses standing on a flat base. The separate lid is ornamented with small figures in relief and crowned with a large equestrian, which may invoke the

first hogon. Horses are often depicted on food containers. They may represent the primordial beings described in legends as having guided a sacred vessel to earth during creation time. This vessel contained everything needed for life, including eight original prehuman ancestors descended from the first *nommo*. It is tempting to interpret this sculpture, which contained life-sustaining food, as a more recent metaphorical extension of that original sacred vessel. The eight encircling figures would represent the eight ancestors, the figure between the two horses on the base would depict the original nommo, the equestrian on the lid would be the original hogon. All we can be sure of, however, is that the container is a virtuosic display of the woodcarver's art.

The iconography and use of wrought-iron figures are apparently similar to those of wood figures, although even fewer contexts for them have been recorded in field research. They are known to have appeared on shrines to Lebe, ancestors, and other spirits. The majority are (or were) attached to stakes, hooks, or canes that were both carried and inserted into the earthen bases of shrines.

Most iron figures, whether human or animal, are highly simplified, economical renderings, which stems partly from the difficulty of working iron. Several spare human figures in iron repeat the common armsraised posture. While a number of very simple wrought-iron horses exist, antelopes, like the one shown here, are rare (fig. 5-9). Here the smith has created a delicate but forceful sculpture with a few twists and bends, omitting the animal's

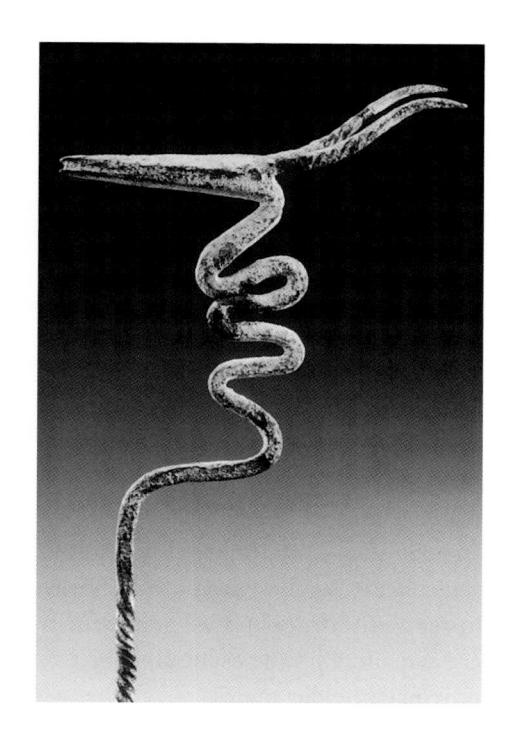

5-9. Stake with antelope head, Dogon, 20th century or earlier. Iron. Height 8¾" (21 cm). Musée Dapper, Paris

body entirely, and playing with the fanciful neck curves.

Architecture

Like much clay or mud architecture, especially in the African savannah, Dogon buildings are strongly sculptural. Some structures emphasize rounded, organic forms, while others are more severely rectilinear and geometric. The most fluid, organic Dogon structures are sanctuaries (fig. 5-10). Sanctuaries are dedicated to binu. immortal clan or lineage ancestors. Binu and their priests have several roles, but in the largest sense they are concerned with achieving and maintaining a balance between the supernatural world and the present world, itself divided into the two realms of untamed nature and human culture.

The rounded forms and fluid lines of sanctuaries may be interpreted as a manifestation of the natural realm, while the rectilinear checkerboard design often painted on the façade, as it is here, may refer symbolically to the ordered realm of culture.

Scholars have for some time pointed to such oppositions between the realms of nature and culture in various Dogon structures and symbols. While these interpretations can surely be taken too far, aspects of them seem to hold up under scrutiny. The mystical flow of water and energy in nature, animated by supernatural forces, is associated especially with women in Dogon thought, and is shown graphically as flowing or

5-10. Dogon sanctuary with sacrifice in progress on the roof

Visible at the far left is a granary. Typically tall, flat-walled rectangular buildings with circular thatched roofs, granaries are numerous in all villages. Each family has several, as if to indicate the importance of life-sustaining grains—and sometimes family shrines—contained within. Some reports accord granaries an elaborate symbolism derived from creation legends. These legends see the granary both as an anthropomorphic female and as a cosmological structure formed by god, with dozens of references to natural and man-made events and things. Regrettably, however, this intriguing and complex symbolism has not been confirmed in recent research.

5-11. *GINNA* (LINEAGE LEADERS' HOUSE) OVERLOOKING A VILLAGE, DOGON, BANDIAGARA ESCARPMENT, MALI. PHOTOGRAPH 1979

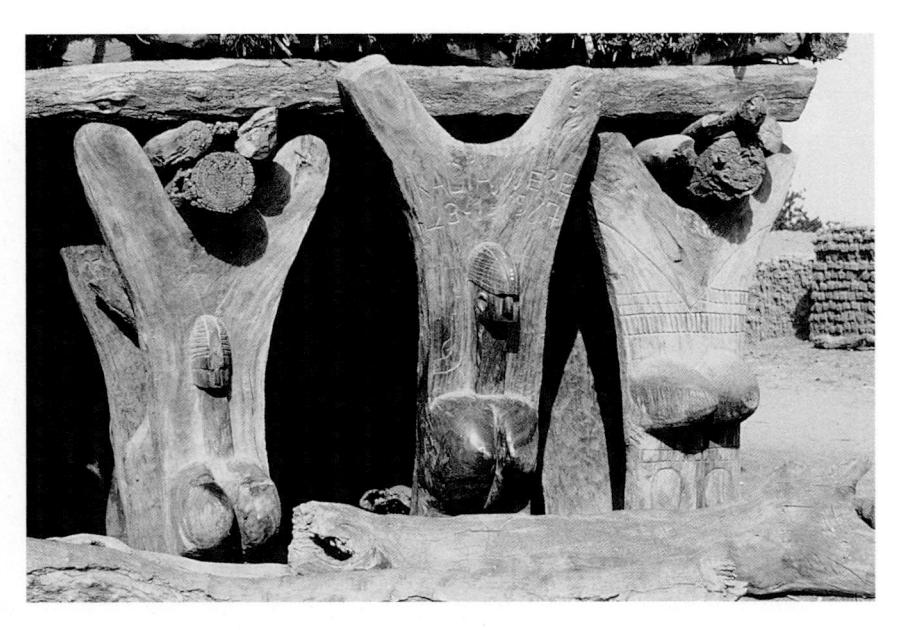

5-12. Togu na (men's meeting house), Dogon, Mali. Photograph 1989

zigzag lines. These are seen to contrast with the finite and crafted order of culture, which is associated with men and is represented in the geometry of weaving, the orderly divisions of cultivated fields, and such rectilinear structures as lineage leaders' houses, *ginna* (fig. 5-11).

Ginna have numerous rectangular niches that create a grid pattern on the façade (fig. 5-11, right); a geometric precision that contrasts with the Binu shrine's organic quality. As the residence of the elder lineage head and the site of additional altars to lineage ancestors, the ginna can be seen to represent order and wisdom, which are considered to be especially the province of elder males.

Similar geometrical concerns inform the men's meeting houses, togu na (fig. 5-11, left, and 5-12). Literally a "house of words," the togu na is considered the head of the community. Often sited in a high place overlooking the village, the togu na is an exclusively male domain; it is here that men convene for work and rational deliberation, the essence of civilized life. An open building supported on numerous vertical posts, its layered roof is made of stacked millet stalks laid down successively at right angles. The geometry of the togu na contrasts with the oval, closed adobe structures that women retreat to during their menstrual periods. These are organic, womb-like containers that suggest the promise of fruitfulness.

Many of the supporting posts of the *togu na* illustrated here are carved in symbolic representation of women, with simplified facial features, abbreviated bodies, and large protruding breasts. *Togu na* posts are frequently carved or decorated, with the female

form appearing as the most common motif, especially on older structures. One togu na originally had an astonishing 105 posts, each one carved with large breasts. Since only a fraction of this number of posts would be needed to support the roof, the repetition must be essentially symbolic. While the togu na is a male domain, it is said that female ancestors visit at night to share in the deliberations. and the female posts can be said to represent this feminine presence. More subtly, multiplied female symbols in such a male context reinforce the gender reciprocity and balance seen in other areas of Dogon culture. A quintessential example of such interaction is a motif that can be seen equally as a female head on a long neck with breasts, or as a male phallus with testicles. Visible on several of the posts in figure 5-12, this striking visual pun simultaneously refers to male sexuality and female nurturing and abundance.

Other Dogon architectural sculpture includes doors or shutters to granaries, shrines, and ginna. These may be carved from a single plank, or formed from two or three boards connected with wrought-iron staples. Motifs include lizards, birds, human figures, breasts, and geometric motifs, often in multiples. Older doors most commonly feature rows of simplified, vertical, attenuated figures (fig. 5-13). This door also includes a lock carved with a pair of figures that seem to be sitting atop the bolt case. The figures have been interpreted as male and female lineage founders, while the twelve figures on the lock case panel (the left panel) are said to be six pairs of male and female twins, symbols of fertility. This interpretive reading is

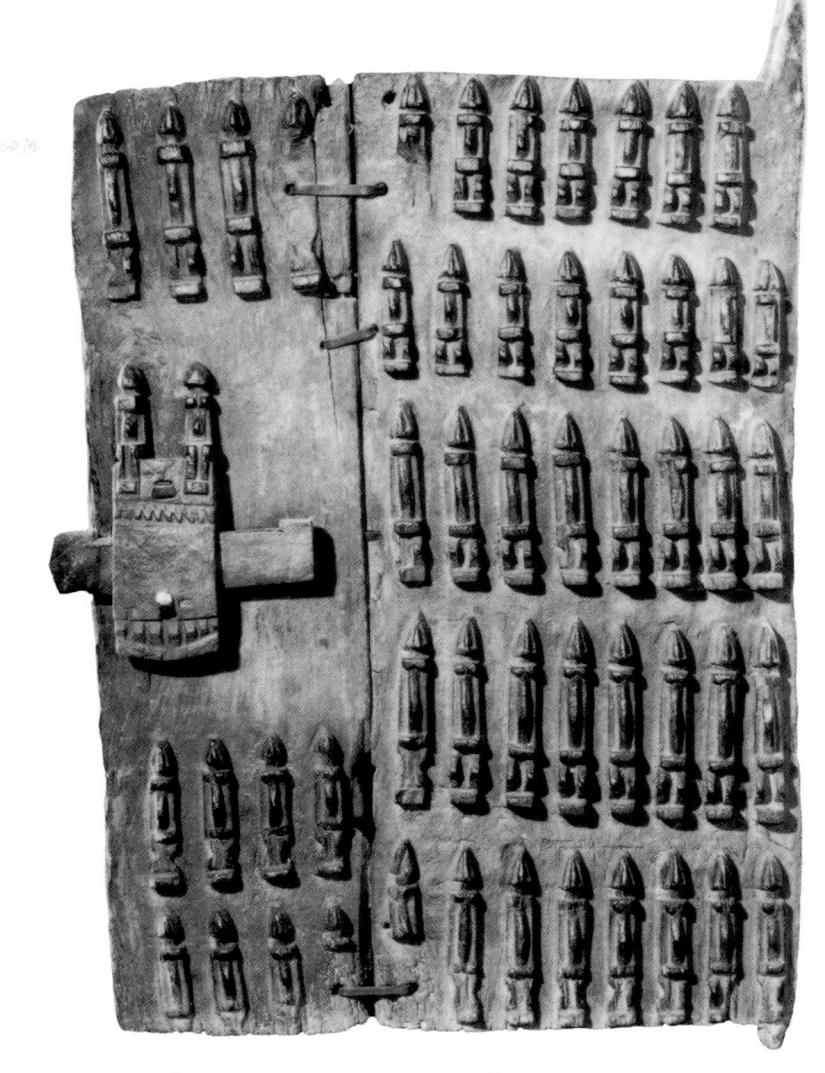

5-13. Granary door with lock case, Dogon, 20th century or earlier. Wood. Musée Barbier-Mueller, Geneva

not based in field information, however, so we cannot be sure of its accuracy. Working against it is visual evidence on the door itself that the figures do not seem to be differentiated in gender, nor are they depicted in pairs. Although the exact symbolism of this door eludes us, we may still see it as a valued marker of a passageway to an important enclosure. Thresholds are often viewed as vulnerable transition points. Here the transition is probably on some level guarded by multiple symbolic ancestors or spirits.

Although many forms of Dogon architecture changed little over the course of the twentieth century, togu na posts erected since about 1980 have introduced new and varied subject matter. Now they often feature more descriptive, even episodic and narrative scenes, sometimes brightly colored with imported oil paints (fig. 5-14). Greater naturalism and realism are evident, and some include written inscriptions. There are numerous small motifs, including airplanes, cars, iron plows, equestrians, hunters and their prey, and even a mosque. It is as

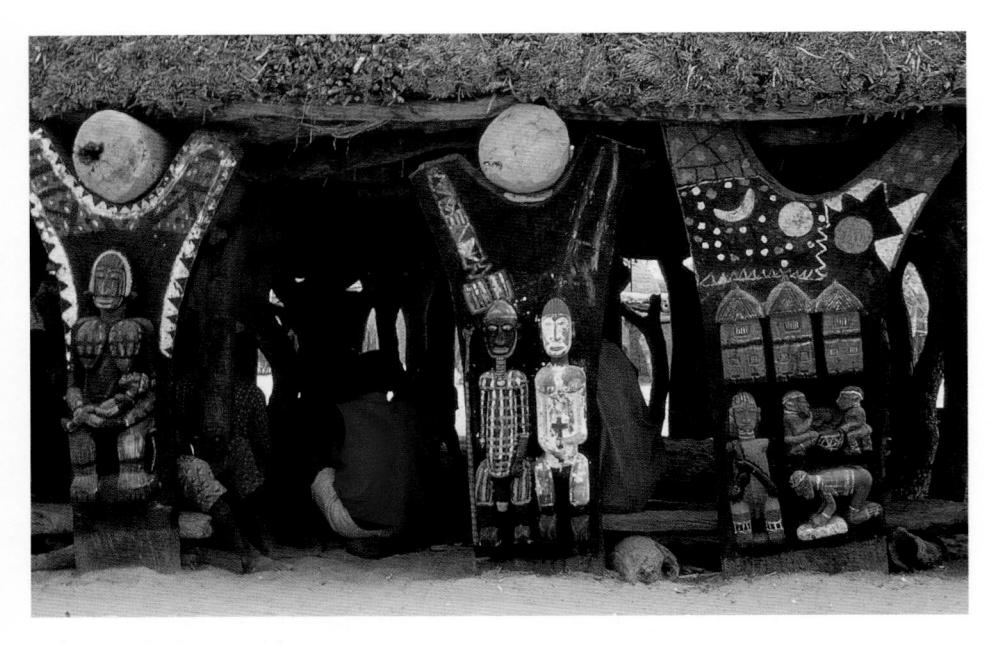

5-14. Togu na (men's meeting house), Dogon, Mali. Photograph 1989

sacrifices are made to this mask-altar, several men dance collectively with it before returning it to the bush. Public rites take place after actual burial and after the ginna has been purified. There are mock battles by men, wailing by women, and mimicry of wild animal behavior. The next day, a procession of mourners moves away from the community, symbolically expelling the dead man from the village. On the following day a masking sequence called bago bundo is performed by five masked dancers, four with masks of fiber and cowrie shells called bede, representing women, and

though it were a living being. After

though the singular and symbolic motifs that served an older, more self-contained Dogon world have given way to a kind of multicultural collection of images showing contact with wider and more diverse worlds. The artists responsible for these modern posts have been recognized in competitions.

Masks and Masquerades

Dogon masking ostensibly has a funerary function, but it touches upon many aspects of life and thought. Masquerades are performed by a powerful corporate body called Awa, into which virtually all men are initiated. Awa itself is led by elders, or *olubaru*. The *olubaru* initiate youths and are masters of *sigi so*, the ritual language of the nature spirits that the masqueraders make manifest. All Awa initiates learn *sigi so* along with mask rituals, dances, and gestures.

Awa has as its principal shrine a thirty- to fifty-foot tall Great Mask, also called the "mother of masks" (fig. 5-15). The mask commemorates the first death in Dogon culture as recounted in legend, the death of a personage named Lebe Serou, who was transformed into a snake that is symbolized by the mask's towering superstructure. Having absorbed the spirit power released by death, a Great Mask is exceptionally powerful. Stored in natural rock shelters outside the village, it is essentially an altar. It is not worn and danced in the usual sense of serving as part of a transforming disguise, but rather is called upon to energize all Dogon masquerading.

When an adult man dies, for example, the Great Mask is brought from its cave and stood against the *ginna* where the body lies. A live chicken is attached to the top of the mask, and the death is announced to the mask as

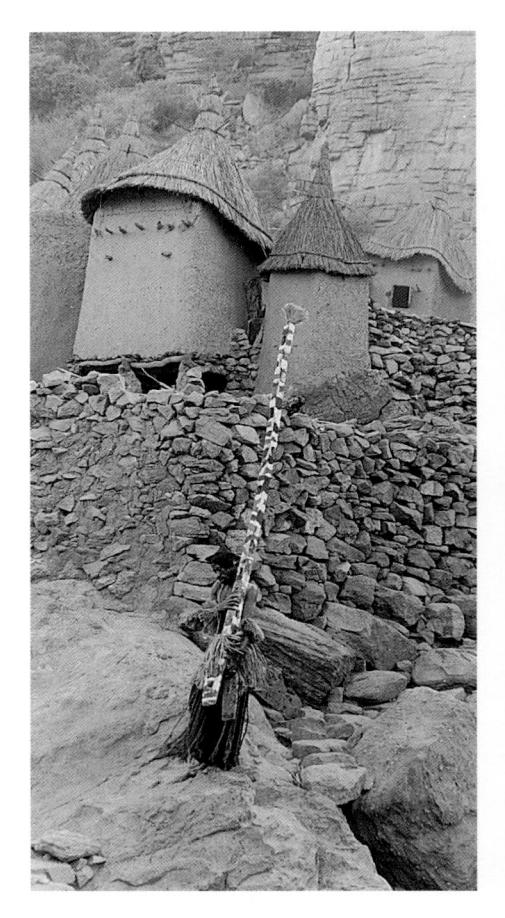

5-15. Great Mask with attendant, Dogon, Mali.

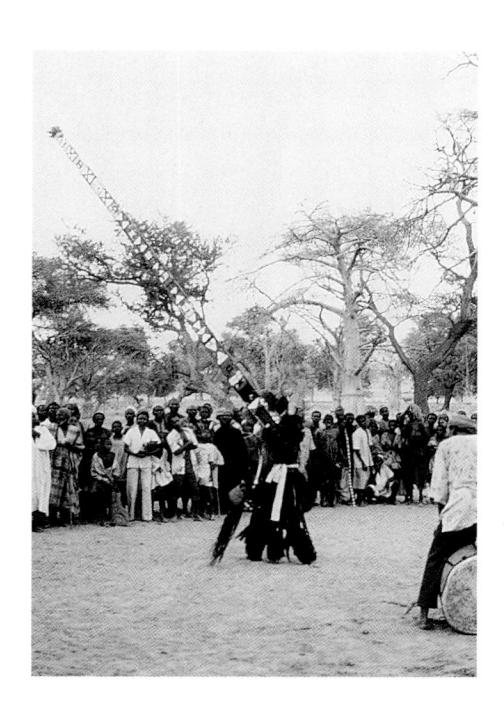

5-16. Sirige being danced, Mali. Dogon. 1988 or 1989

one with a tall male mask named sirige (fig. 5-16).

Bago bundo has been interpreted as a symbolic reenactment of male and female roles, at the same time stressing the chaos and destruction brought on by death. Sirige, which dominates bago bundo, appears to be the public and visible representative of the Great Mask, though it also has other associations of its own. Smaller than the Great Mask, sirige is usually painted with orderly triangular motifs that alternate with grid-like openwork rectangles; both patterns are repeated vertically on its long plank. The openwork rectangles have been interpreted as the many generations of a great family. The mask is called the "tree," "ladder," or "big house" (ginna), which it symbolically represents.

A far more elaborate Dogon masquerade is a collective funerary rite

called dama. A complex, multifaceted art form, dama takes place over a period of six days once every several years (thirteen is average). The rite effects the permanent expulsion from the human community of the souls or spirits of those who have died since the last dama, and their incorporation into the supernatural realm as ancestors. Dozens, even hundreds, of varied masked spirits participate (fig. 5-17). The wealth and prestige of both the living and the commemorated dead are expressed by the size of the dama masquerade celebration and its audience, and a village may accumulate costly resources of food and drink over a period of many months or even years in preparation. Awa members are secluded in rock shelters for a period prior to the start of dama to prepare and renew their masks, musical instruments, and costumes. With

pigments containing sacrificial blood, they paint designs on the walls of the bush shelter and touch the masks to them. *Olubaru*, who make sacrifices to the Great Mask for each *dama*, oversee this activity.

Dama begins with a serpentine procession of several dozen masked spirits from the bush into the village, made sacred by the presence of olubaru and the Great Mask. The power, danger, and ritual knowledge lodged in the wilds now enter the village. Women, who may not wear masks or even come close to maskers, watch only from a distance. The community is transformed for six days by the authority of these masked supernaturals, called into action by drums. On the first day maskers dance around the ritual seats of the deceased in the village plaza, and the legend of the Awa society's founding is recited.

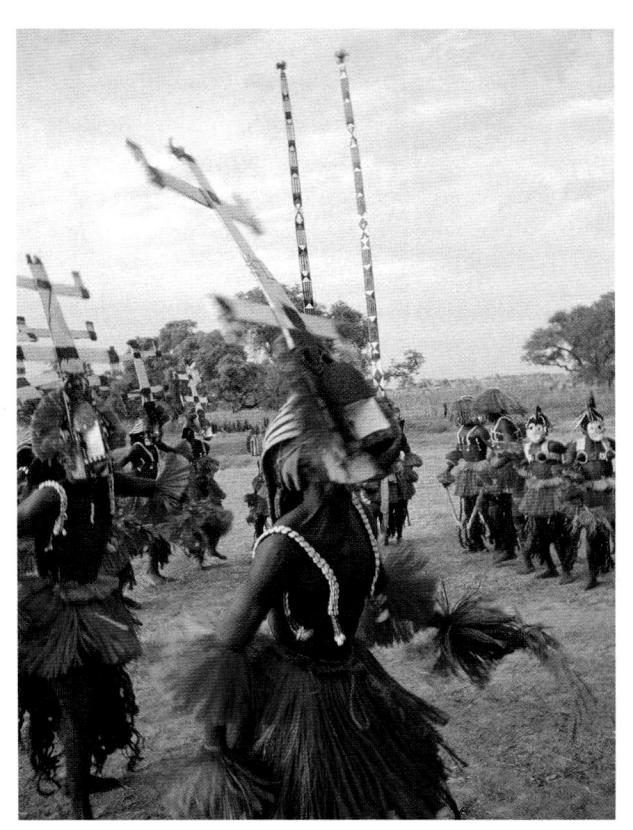

5-17. KANAGA MASKED DANCERS. SIRIGE MASKED DANCERS IN THE BACK-GROUND. DOGON, SANGA REGION, MALI. PHOTOGRAPH 1959

On the second day masked dancing alternates between the village square and the roofs of ginna. On the third day maskers dance on or near the hogon's fields, as well as in the plaza, while further individual and group dances mark the remaining days, often to huge audiences from surrounding communities. The liminal mourning period ends when the initial processional route is reversed: the maskers return to the wilderness, the Great Mask is returned to its shelter, and the many masked spirits leave the village. The classic threepart structure for rites of passage is followed here, for as the dead, ritually separated from the living, are incorporated as ancestors, the living community is reincorporated into ordinary time (see Aspects of African Culture: Rites of Passage, p. 413).

The masqueraders to the right of figure 5-17 wear masks made of fiber and cowrie shell representing maidens of the Fulani people, identified by their high-crested hairstyles. The tall masks in the background are known as kanaga. Kanaga and sirige have been seen by some scholars as a conceptual female-male pair. Like sirige, kanaga is unusual in its abstraction, and again like sirige, it has several interpretations. With its four-part, cross-like superstructure, kanaga is considered both a female spirit and a bird, possibly a stork. It is also interpreted as a lizard or a hand. Kanaga masks are supposed to be carved by individual Awa initiates and are linked to circumcision rites. The dances and gestures of both kanaga and sirige are unique in that their superstructures are vigorously whirled and swung down in an arcing

motion to touch the ground. The meaning of the gesture is unclear, though it appears to signify direct communication with earth spirits.

Kanaga and sirige take their place in an impressive array of Dogon mask types. Marcel Griaule recorded more than seventy-eight types of masks representing animals, male and female characters from within and outside Dogon culture, and abstract ideas. Recent scholarship has analyzed this large corpus into several conceptual sets, emphasizing dualistic but not necessarily parallel oppositions between male and female, wet and dry, death and rebirth, nature and culture, wilderness and village, destruction and order, predatory and nonpredatory, masks of fiber and wood, masks danced and not danced. Thus head-conforming fiber masks such as those representing young Fulani women in figure 5-17 are associated with birds, water, and rebirth. Other fiber masks embody intermediaries between this world and the supernatural realm: hogon, priest, blacksmith, and doctor. Wood masks do not conform to the head, but rather project forward in front of the face. They largely represent human or animal characters. Almost all are male, and associated with dryness, death, and transformation. Masks that do not actually dance usually embody negative, aggressive, or liminal characters—foreign men, priests, bandits who interact with the audience by talking, begging, and provoking fear or anger. Yet no maskers actually speak, for these are bush creatures, who can only utter animal-like cries, and who are spoken to not in Dogon, the language of civilized people, but in the secret spirit language, sigi so.

5-18. SATIMBE ("SISTER ON THE HEAD") MASK, DOGON, MALI, 20TH CENTURY OR EARLIER. WOOD, PIGMENT, ENCRUSTATON. HEIGHT 43½" (110.5 cm). THE METROPOLITAN MUSEUM OF ART, NEW YORK. MICHAEL C. ROCKEFELLER MEMORIAL COLLECTION. PURCHASE, BEQUEST OF NELSON A. ROCKEFELLER GIFT, 1961

Satimbe ("sister on the head") is the only wooden mask to depict a specific type of Dogon woman, the yasigine (fig. 5-18). These few female members of Awa stand for the collective women who, in origin stories, first discovered masks. This occurred in primordial time before men took over the privilege for themselves exclusively, barring all women except yasigine from contact with maskers or the mask society. Notably, these are the only Dogon women whose deaths are honored with a *dama*. *Satimbe* masks display a simplified, schematic, large-breasted woman who stands atop the vertically slotted, rectangular facial covering common to most Dogon wooden masks. Three stick-like extensions of equal length signify two up-stretched arms and a head on a much distended neck. We may suppose that in addition to representing *yasigine*, such dramatically female carvings also refer to the nurturing role expected of all Dogon women.

Dama is a dry-season rite that commemorates death. But it is also a festival in which varied levels of male-female opposition, embodied in a kaleidoscopic array of maskers, human and animal spirit characters, and other participants who sing and dance, celebrate life, which will resume again once the rains begin. Multiple forms of power and wisdom, materialized in the masks, have entered the village as if to revitalize it. Dama is therefore also a rite of hope, renewal, and fertility, an artful melding of masquerade, symbol, song, dance, prayer, and sacrifice that evokes the complexities of life itself. Notably, men are the performers, as if to say that they, not women, are in charge of power and fertility.

Masking and other art forms have been affected by the encroachments of Christianity and Islam, of course, as well as truncated drastically in "authentic" entertainments performed many times a year for tourists in Dogon villages. Some Islamicized communities have ceased dama rituals altogether. But masking is still strong, and will continue to be buoyed up by Dogon cultural pride.

New mask forms representing such characters as learned Muslim, Mossi horseman, and white man have appeared, reflecting forceful outside influences. The earliest "white man" masks depicted French colonial officers; today such masks depict a visiting anthropologist and tourists who jostle through the crowd taking pictures with wooden video cameras. In some areas where foreign visitors are frequent, both older and newer mask forms are now faithfully sketched by young boys using donated paper and colored pencils or markers. The boys sell those drawings and toy figures of masqueraders. Men carve extra masks these days because tourists want to buy them, just as blacksmiths sell replicas of sacred figures. While dama today is probably less orderly than this discussion has made it seem, it is a ceremony that continues in many Dogon communities, if simplified as a display for tourists in some areas, and with some new commercial dimensions.

THE SENUFO

Nearly a million and a half people who live in northern Côte d'Ivoire. Mali, and Burkina Faso are known collectively as Senufo. Village communities are the principal social units in this large area. Each community is divided into distinct residential areas, or wards. A single community may contain two or three wards for farmers, and two or three other wards for other groups. In one of those wards, the women make pottery. Their husbands may be blacksmiths, weavers, or leatherworkers. At least one ward is reserved for Jula weavers or traders. who are Muslim and who speak a Mande language. Another ward houses Kulebele woodcarvers. These farmers, artisans, and traders have diverse origins and speak separate languages, yet all are considered Senufo.

The multiculturalism of a Senufo community is reflected in the varied forms and styles of Senufo art. Yet common institutions and common themes link art works and their performance contexts throughout the Senufo area. In numbers, at least, farmers are dominant in most villages. The great importance of farming in Senufo life is signaled by a carving called a "champion cultivator's staff." Most of these works depict a seated girl in the bloom of youthful beauty (fig. 5-19). Fullbreasted, perhaps pregnant, she is a clear symbol of abundance and potential productivity.

The calm repose of the carved girl is a deliberate contrast to the active. striving work of the male farmers. Annual hoeing competitions are multimedia events, at once ritual and play, which celebrate values of strength, skill, and endurance among young men. Drums and balafons (xylophones with wood sounders and calabash resonators) establish rhythms for these grueling physical contests, which are accompanied by displays of one or more decorated staffs, carried by young girls from row to row. The winners of the competition bring honor to themselves, their lineages, and their wards. Heroes of the community, they gain high respect, an opportunity to marry the finest women, and the right to the most elaborate funerals. The staffs are held in trust by elders for successive champion cultivators in each age set, and are displayed at the funerals of champions and their mothers.

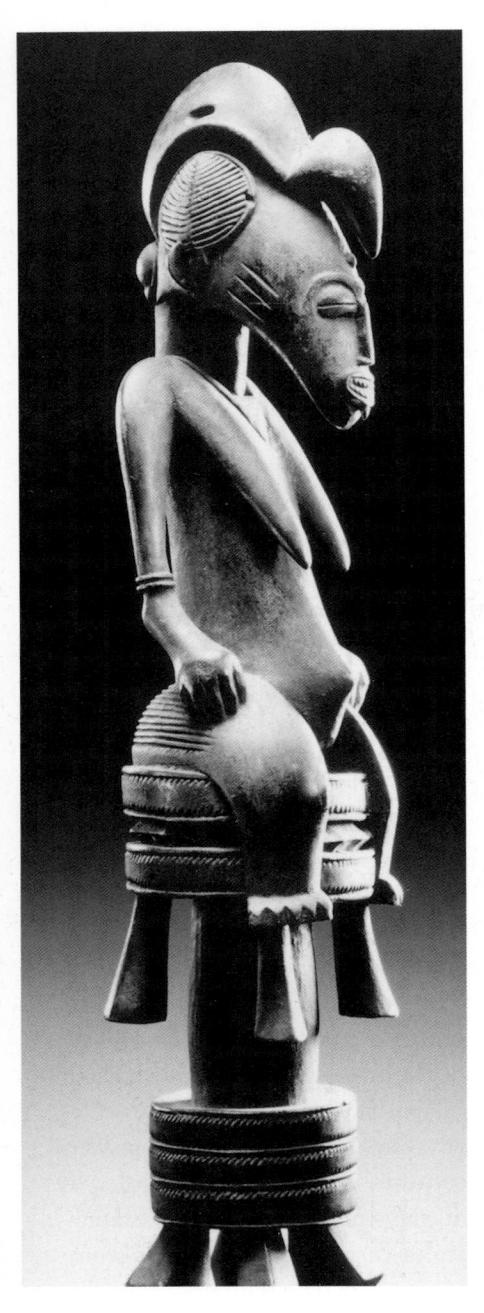

5-19. Champion cultivator's stafe, Senufo (Kulebele), 20th century or earlier. Wood. Height of figure 13½" (35.5 cm). Musée Barbier-Mueller, Geneva

The relationships manifest in the cultivating contest between youthful male farmers and young girls are aspects of larger male—female relationships also manifest in the art of the two central Senufo institutions, the male Poro society, and the female Sandogo. In both of these institutions, sculpted images of couples play important roles.

Poro

Poro provides the principal framework through which men learn and practice their social, political, and spiritual roles in society. Each occupational group in a Senufo community has its own Poro society, and all men belong. Males enter and pass through Poro in age groups. The solidarity and brotherhood of each group is sealed by the shared rigors of the protracted initiatory process, which takes place in three phases over the course of some twenty years. Young women participate in the first two initiatory phases but are excluded from the third. Graduation from the third and final phase of initiation signals that a man—now aged twenty-eight to thirty-two—is ready for responsibility and leadership in the community.

Art plays important roles in Poro activities; it is used and stored in the society's sacred grove, sinzanga.

Located outside of but adjacent to the village, this grove is usually fenced off, or surrounded by huge and ancient trees. Access is restricted to members, who, over the course of their own and others' initiations, will attend countless rituals, ordeals, and instructions within its borders.

Among the art belonging to Poro societies are pairs of medium-size or

large carved figures. Each pair portrays a male-female couple. Often called Poro, the spirit figures are brought out to reinforce the teachings of the society at initiations, and they appear as well at funerals of Poro members and their wives. The instructional uses of the figures are probably many. Few, however, have been confided to outsiders. We know that the paired figures are emblems of marriage, that they represent as well the primordial founding ancestors spoken of in creation legends, and that they also represent twins, which are sacred to the Senufo.

In some regions paired images which are also spirit figures—are carved with particularly massive bases. Known as "rhythm pounders," such figures are carried in procession by initiates, who swing them from side to side, striking the ground rhythmically (fig. 5-20). This is said to purify the earth and to call ancestral spirits to participate in the rites. The male figure here wears a Poro age-grade emblem headdress. While the headdress and extended base make his figure the taller of the two, his actual body is portrayed as smaller than the woman's. Senufo society is matrilineal, and the dominant female presence often found in such paired figures reflects the importance of females in Senufo life and thought.

The importance of women is explicitly acknowledged in statues of a personage known as Ancient Mother, who is typically depicted holding a small child on her lap (fig. 5-21). Ancient Mother is considered the head of Poro, as exemplified by the saying: "Poro is a woman." The sacred grove is considered to be her ward, or compound. She represents
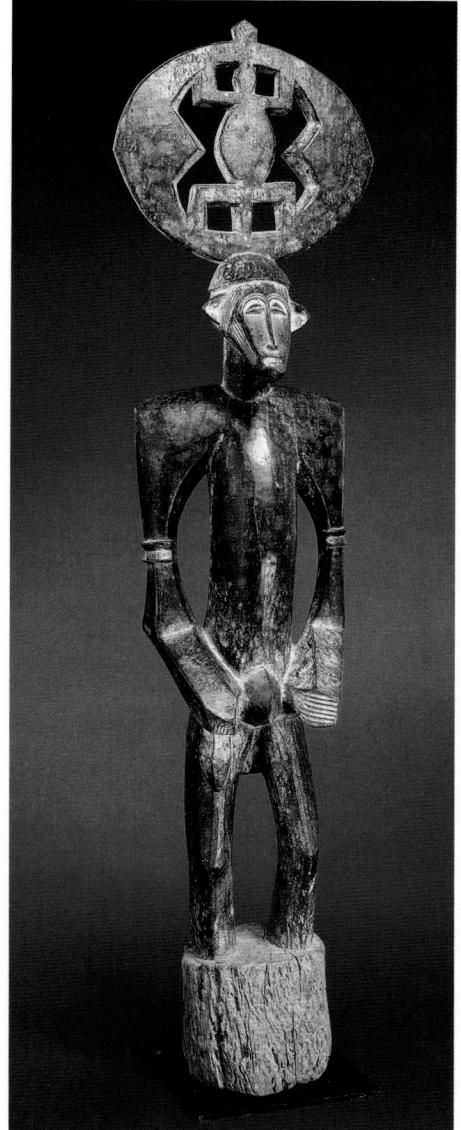

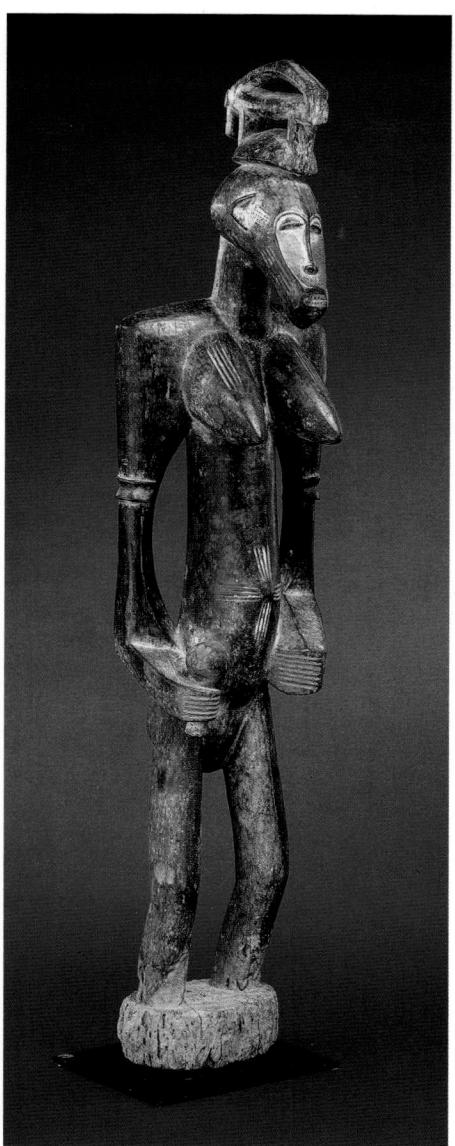

the female aspect of creation and is the founder and guardian of the matrilineage. She is the spiritual mother of all Senufo males who pass through Poro, and, metaphorically, the mother of the community itself.

According to some scholars, carvings of Ancient Mother are deliberately non-naturalistic so as to emphabiological roles in Senufo culture. A statue of Ancient Mother is shown to novices during the Poro learning process, in part as a reminder that beyond the obvious lies the hidden, an idea also exemplified by the secret Poro language learned by novices. Initiation begins with boys being

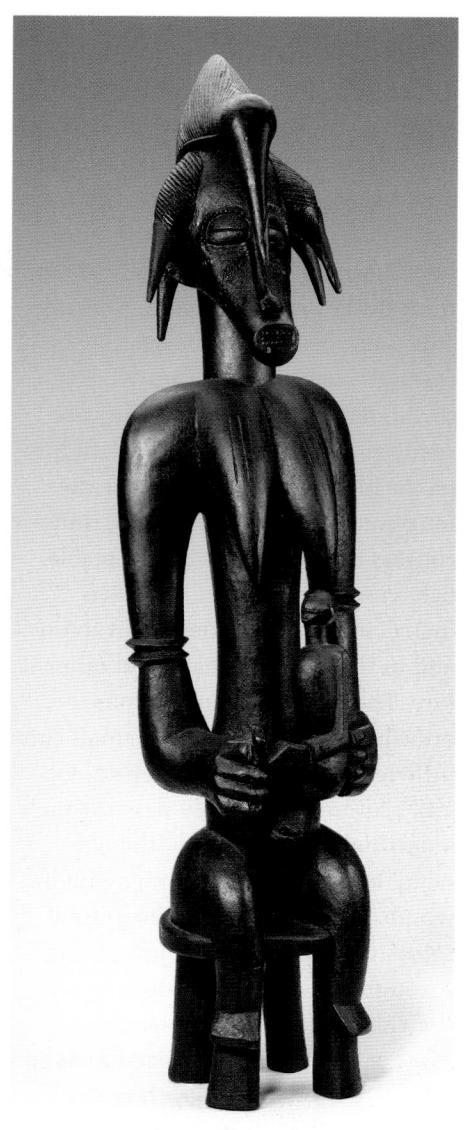

5-21. Figure of Ancient Mother, Kulebele CARVER FOR SENUFO PATRONS, EARLY 20TH CENTURY. WOOD. HEIGHT 351/16" (89 CM). THE NATIONAL MUSEUM OF AFRICAN ART. SMITHSONIAN INSTITUTION, WASHINGTON, D.C. GIFT OF WALT DISNEY WORLD CO., A SUBSIDIARY OF THE WALT DISNEY COMPANY

taken from their biological mothers to enter a period of dislocation in the compound of Ancient Mother and under her care. Ancient Mother is said to absorb or swallow the young novices, who are not yet seen as human. She will symbolically give birth to them many years later, after their initiation is complete. New initiates undergo a symbolic death through such rituals as crawling through a muddy tunnel. They are reduced to a kind of emptiness, a liminal or in-between status. Over the long course of their initiation, they confess their breaches of acceptable behavior, and undergo intensive instruction in the male arts of living and in the Poro language and other lore. They submit to numerous ordeals and tests, including small cuts inflicted by Ancient Mother's "leopard." At one point, they pass through a narrow opening called "the old woman's vagina" to enter a symbolic womb. At the end of the process, tutors lead graduating initiates out through an actual door, signaling their rebirth as issues of Ancient Mother. Now fully socialized men and complete human beings, they have been nourished by the "milk of knowledge" at their Mother's breast, as is keyed in the carving's iconography. Only superficially a biological nursing mother, then, an image of Ancient Mother is a veiled and rather abstract sign of the systematic body of knowledge acquired by Poro initiates.

Sandogo

The women's parallel to Poro, Sandogo, is a society that unites the females of a Senufo community. Its members, called *sando*, are trained as

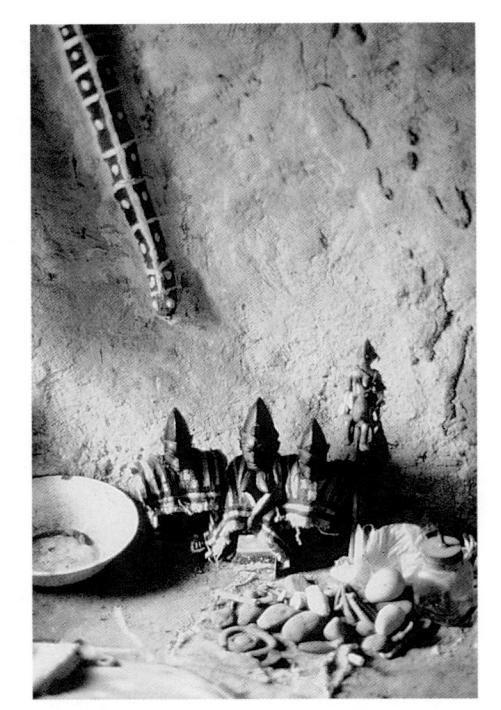

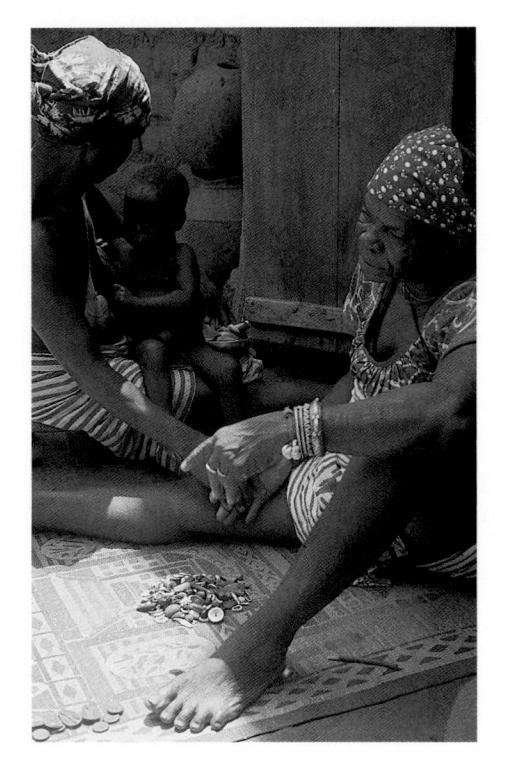

5-22. Interior of a Senufo diviner's shrine, Côte d'Ivoire. Photograph 1979

Fo, the messenger python, is modeled and painted on the wall behind a group of carved figures depicting male and female bush spirits. The figures wear garments made of a sacred fabric called fila, which is woven of cotton and dyed with mud and vegetal pigments by Jula craftsworkers. Making their will known through the diviner, spirits might order a client to wear a similar fila tunic for protection or to heal. The pile of objects in the foreground includes varied symbols of the bush spirits consulted by diviners, including metal jewelry such as bracelets and rings.

5-23. Senufo diviner with client, 1975

diviners. Collectively, they protect the purity of the several community matrilineages and maintain good relations with a hierarchy of supernatural beings.

Diviners' shrines, which function as consulting chambers, are themselves works of art and they contain others. Shrines are small, round houses barely large enough for the diviner, her client, and her apparatus (figs. 5-22, 5-23). Invariably there will be images of the sacred python, fo, the principal messenger between humans and supernaturals. Pythons appear in shrines as relief sculpture in mud, always on the inside and often outside, as well as on diviners' metal bracelets and rings. There will be a calabash rattle for calling the spirits, too, and an important set of small objects—castings, stones, bones,

shells, and assorted other items that are sifted and "read out" by the diviner to determine the needs of a client. Shrine statuary nearly always includes a fairly small female and male couple in wood, often one or more small brass figures, and sometimes a horseman. These represent nature spirits believed to inhabit the bush, streams, and fields beyond the village. Ambiguous and capricious, these spirits both cause and cure sickness and other problems, and it is they who order, through the diviner, a course of action for the client.

The spirits may order a client to commission and wear one or more brass amulets (fig. 5-24). Made by the lost-wax process, these small sculptures are the work of brasscasters who live in their own ward in the community. Amulet motifs include chameleons, turtles, crocodiles, snakes, birds, various quadrupeds, and twinned images. The motif of twins presents another aspect of the male-female duality that permeates Senufo thought. As is the case among many African peoples, the birth of twins is an auspicious yet equivocal event for the Senufo. Twins are considered lucky, but of course they bring special burdens to their mothers, who are more susceptible to disease and mortality than mothers of a single child. Following creation stories about the first Senufo couple giving birth to identical twins, a girl and a boy, twins should be of opposite sex, as paired diviners' carvings are. If they are of the same sex, or if one or both twins should die, their spirits can bring either danger and misfortune or, if properly placated, blessings and prosperity. Thus many people in families that have or in the past had

5-24. Amulets and YAWIIGE charms, Senufo, 20th century or earlier. Brass. Private Collection

These divination ornaments are worn as protective charms as prescribed by Senufo diviners. Animals especially associated with spirits of land and water, and as messengers to God, include from upper left to right: tortoise with mudfish, chameleon ring with a twins band, twins; lower left to right: tortoise, twins, python bracelet, crocodile.

twins take various precautions to acknowledge and invoke twin spirits, including the wearing of twin amulets.

Many forms of Senufo personal adornment, including scarification, amulets, and other jewelry, and certain garments, serve multiple purposes. Pleasant to wear and behold on the one hand, they are also a form of communication with unseen spirits and reminders or reiterations of basic values or cosmology. Women, for example, wear four sets of scars radiating from their navel, like those depicted on the statue of the woman in figure 5-20. Called "male-female twins," the scars celebrate each woman as a source of life and the guarantor of lineage continuity. They link her with Ancient Mother and

with the primordial couple, whose first children were twins.

Sandogo and other shrines were occasionally fitted with finely carved doors (fig. 5-25). The motif on the central panel of this example seems to have multiple interpretations, all of which reflect upon each other. At the most abstract level, it evokes the four cardinal directions that order the cosmos. It can also be seen as a bird's-eye view of the orderly divisions of a farmed field, a symbol of human culture. The circle at the center has also been convincingly interpreted as a navel, and the radiating elements as evoking a woman's scarification pattern and its attendant symbolism. In the lower panel are depicted at least four, and perhaps all five, of the primordial creatures that shared the

5-25. Door with relief carving, Senufo, c. 1920s. Wood. 67%" x 25%" (171 x 65 cm). Collection Helmut Zimmer, Zürich at Museum Rietberg, Zürich

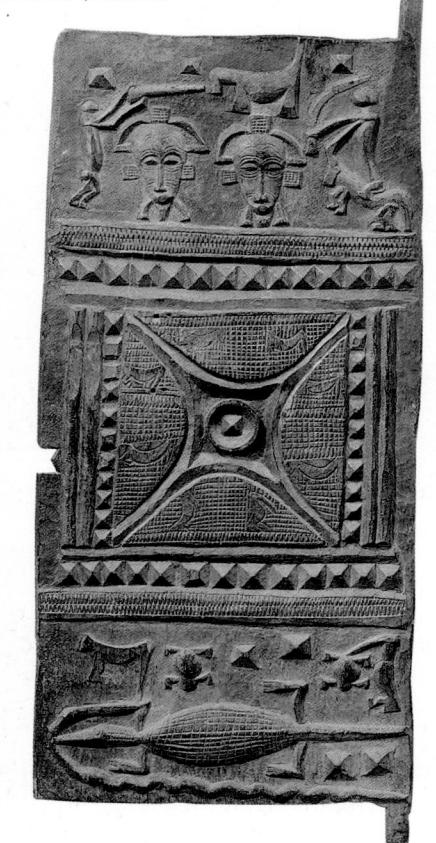

earth's beginnings with the original couple: python, tortoise, hornbill, crocodile, and chameleon. This lower panel may also be seen as portraying the idea of wilderness, competing supernatural forces, or untamed nature. The upper panel in contrast appears to present the spheres and symbols of civilized human life: a hunter and a leader (or warrior) on horseback, and face masks exemplifying Poro, the main unifying and socializing institution in Senufo culture. Creation stories credit the hunter with separating the humanized world of the village from the wilds beyond. If this interpretation is

correct, doors like this marked the potentially dangerous threshold between the profane world outside and the sacred interior of a shrine by portraying several levels or types of order, power, and knowledge, including as well the essential creatures that populate these worlds.

Shrines and other enclosed buildings contrast in northern Senufo areas with large open shelters, called kpaala (see fig. 5-30). These structures, like Dogon toguna which they closely resemble, are also men's shelters. The similarity suggests historical relationships between segments of these two Gur-speaking peoples. Ideally stacked with six and one-half lavers of branches laid down at right angles, the kpaala roof alludes to the Poro initiatory process, each phase of which lasts six and one-half years. The roof reminds the elders who convene there, and indeed all members of Poro, of their obligations, and of their rebirth as men from Ancient Mother.

Masks and Masquerades

The male–female dialogue so evident in Poro and Sandogo arts is implicit as well in Senufo masking. The Senufo have a large corpus of masks. Most masking is directed by Poro, and much of it is involved with the progress of initiation in its various phases. Maskers also perform at funerals and other public spectacles, and it is these contexts that are explored briefly here.

The most recurrent type of mask is a small face mask with clear, refined features (figs. 5-26, 5-29). Danced by men, these masks perform as female characters. They exist in hundreds of variations, with many different

names. Their symbolism is usually both rich and esoteric; invariably they represent far more than meets the eye. Many encode Poro knowledge, and appear in restricted Poro dances as well as in public dances that anyone may attend. Still others are owned by non-Poro organizations. Different versions, too, are made by carvers, blacksmiths, and brasscasters for their separate Poro groups, as well as by Jula weavers. For these reasons, it is normally impossible to understand the full symbolic ramifications of any one mask without complete field data.

The masquerader shown here wears a mask made of brass. He was photographed at the funeral of a female elder in a blacksmith Poro, one of several maskers, all initiates of the middle grade, who danced at this event. Funeral dancing is competitive, yet it is most essentially a celebration of the life and family of the deceased. The youthful energy of the dances is reinforced by the bright scarves and cloths worn by the masker as emblems of civilized life, and by active arm movements. In contrast, the mask itself is meant to remain nearly motionless. These forms, materials, and gestures are all considered nayiligi, "freshly beautiful," by the Senufo, and it is the complete character in motion that needs to be understood as a work of art, not its individual elements of mask and costume.

One popular female character, called "Beautiful Lady dance mask," wears a wooden mask with glistening black surfaces (fig. 5-29). Performed by a man, the dance incorporates women's gestures. A masker, for example, might rest "her" horsetail flywhisk on a ruler's shoulder to honor him, as a woman would do.

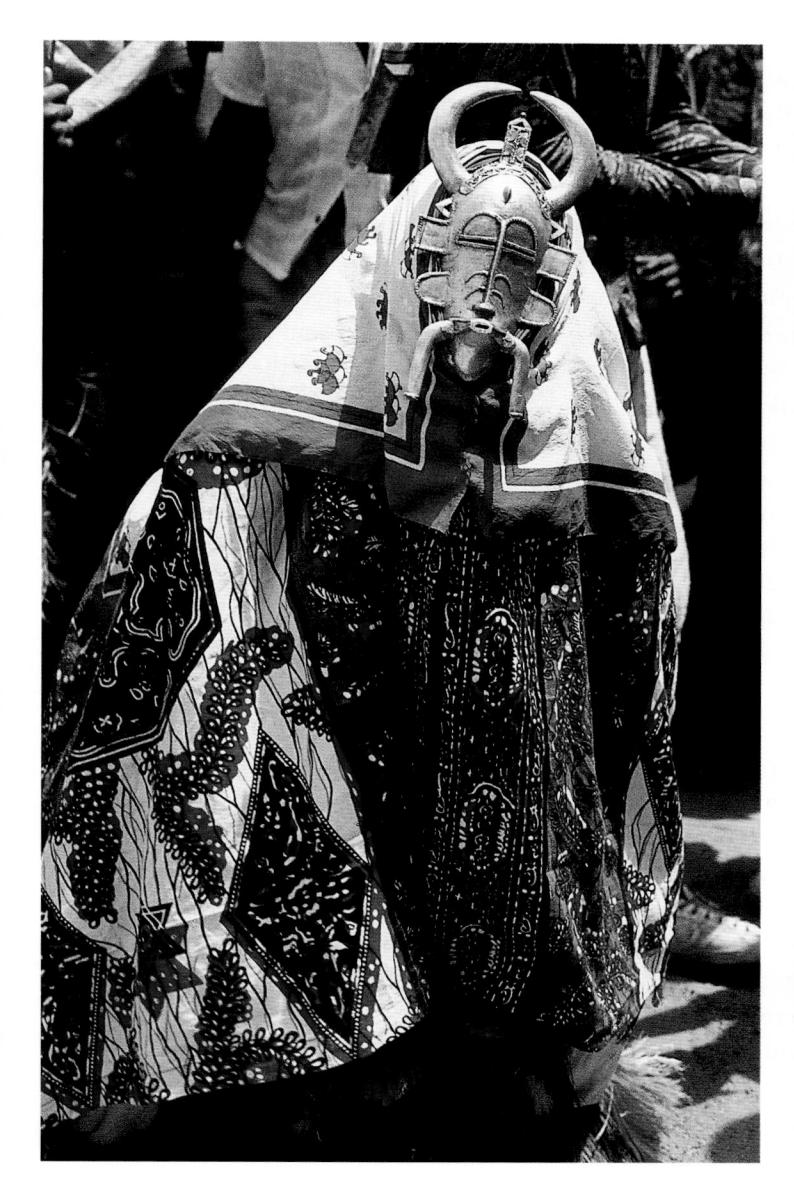

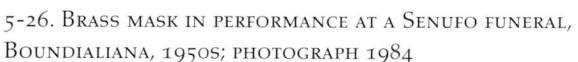

5-27. *GBON* AND OTHER MASKERS PERFORMING AT A SENUFO FUNERAL, PORO DIKODOUGOU DISTRICT, 1970

In this picture the Gbon masker swishes his raffia skirt over the wrapped body of the deceased three times to recall the three stages of Poro the man went through before becoming an elder, but of course the transition/transformation here is to revered ancestor, effected by this ritual.

5-28. Linguist masquerade for a Poro association, (Senambele) Senufo, colored fiber, Kufolo region of Côte d'Ivoire. Photograph 1980s.

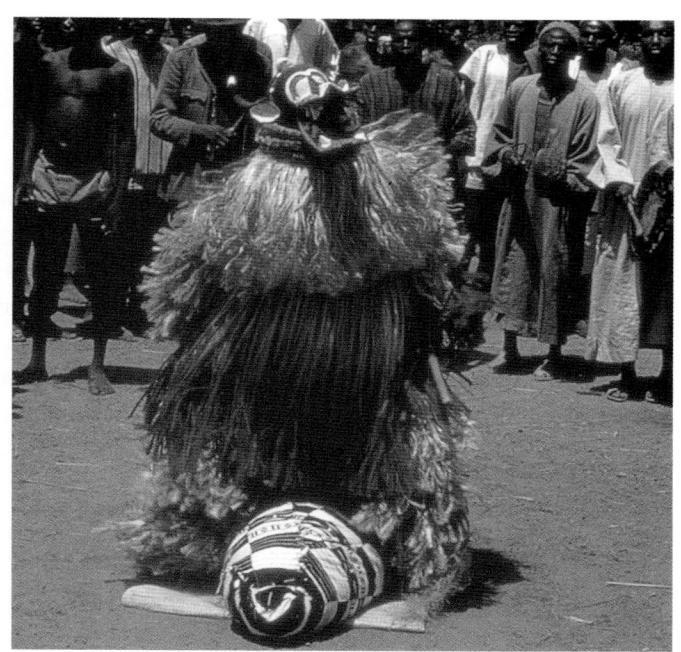

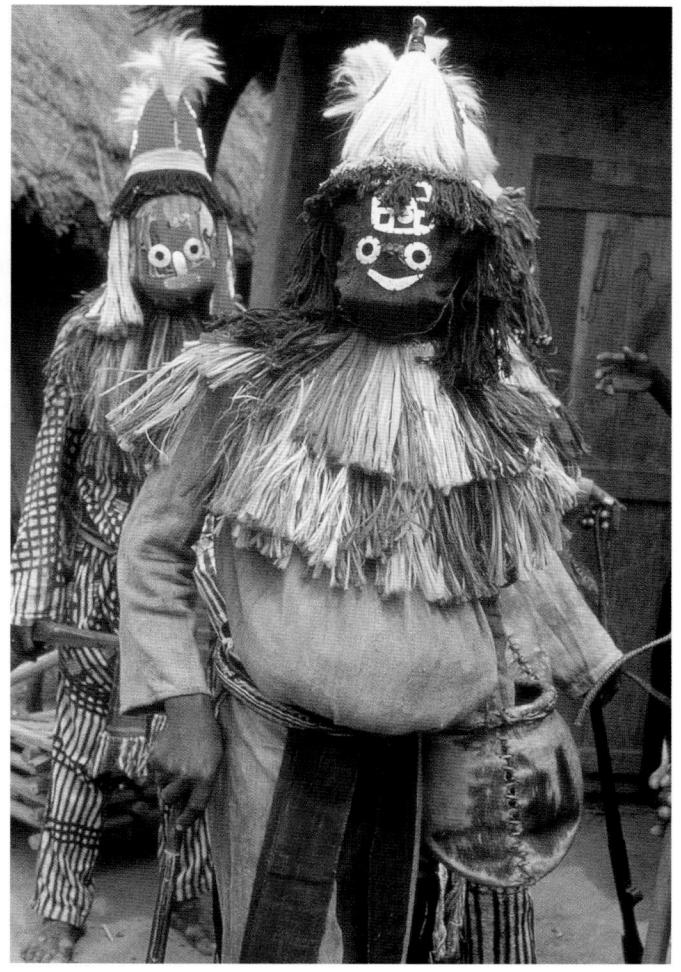

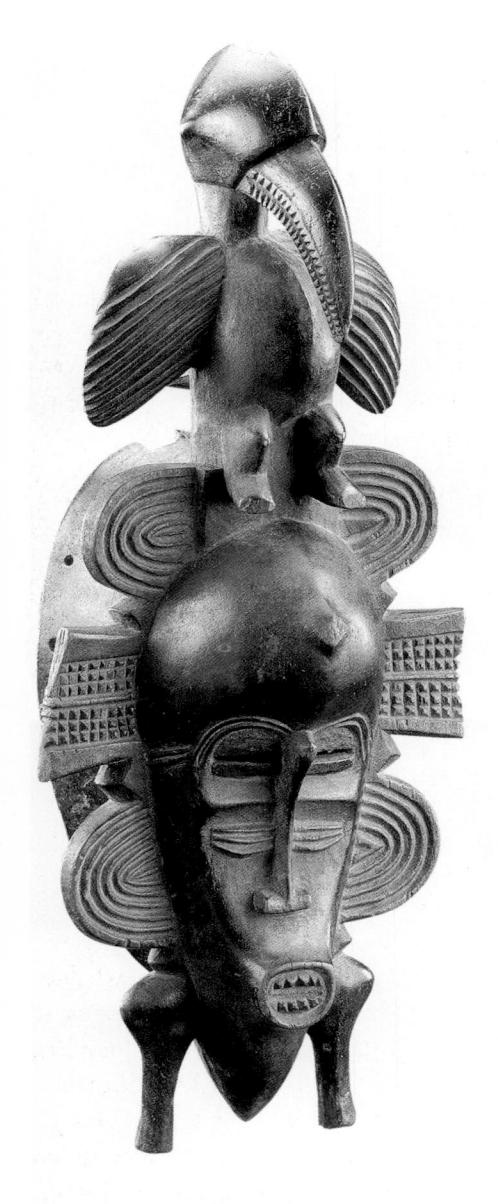

5-29. "Beautiful Lady" mask, Senufo. Wood. Musée Barbier-Mueller, Geneva

The other most recurrent Senufo mask type is the zoomorphic helmet mask, a form common to many West African peoples (fig. 5-1). Viewed as male, these composite, horizontal masks usually play more spiritually forceful, even violent and threatening roles. Like their female counterparts, they exhibit many variations in name, style, animal references, and

symbolism, and they appear in both Poro and non-Poro contexts.

Generically, the Senufo call them "funeral head mask," or "head of Poro," kponungo. Some types walk through, spit, or otherwise manipulate fire, giving rise to the name "firespitter," an outsider's designation that should be used cautiously, as many other masks of similar form have nothing to do with fire.

The mask illustrated in figure 5-1 includes many iconographic details that relate to the origin of the world, to important legends, and to the roles of certain animals in carrying out obligations to both ancestors and nature spirits. Quintessentially composite and even deliberately ambiguous, it fuses elements of antelope or buffalo (horns), crocodile (jaws), hyena (ears), bush pig or warthog (tusks), and humans (eyes), while incorporating a stylized hornbill and chameleon between the long horns. The latter two animals, present at creation, refer to specific sorts of knowledge to be mastered by Poro initiates. Combined, the animals are an embodiment of aggressive supernatural power associated especially with the wilderness, powers that are reinforced in Poro through blood sacrifices and incantations.

These bristling masks are critical participants in certain funerals conducted by Poro, when they help to expel the soul of the deceased from the living community. The mask seen walking over the wrapped corpse in figure 5-27 is a variant called *gbon*, an antelope—baboon composite. The soul of an important dead person is believed capable of escaping from the body during the period between death and burial to wreak havoc among the

living. Thus maskers, along with drummers and other supernatural forces marshaled by Poro, must control the soul until it is expelled. While other masqueraders attend, gbon straddles the cloth-wrapped corpse and, moving from head to foot three times over, effects the expulsion of the soul. The soul is sent to the ancestral village; the body is buried. Interestingly, the same maskers are also present at the symbolic death of new Poro initiates. Here, their purpose is to aid in the creation of a new being; there it is to create a new ancestor. In both instances maskers guard and guide dangerous and uncertain liminal periods, times when human beings are transformed from one status to another.

Secondary or more popular masqueraders dance for the large crowds attending important funerals, often attended and urged on by musicians and a dozen or more initiates who collect the cowrie shells showered on the masked dancer to honor his skill. Principal maskers also greet elders, chiefs, and other important onlookers. Masquerades therefore provide entertainment at the same time that they fulfill ritual obligations on behalf of Poro and the ancestors.

Quite a few other mask types are danced by Senufo men both within and beyond Poro and funeral contexts. Various types of fiber masquerades (with fully concealing costumes) are important beings in all Poro groves, and are normally renewed for each initiation cycle by members of the senior grade (fig. 5-28). The maskers shown here, called *yalimidyo* (or *yarajo*), speak through a voice disguiser for Ancient Mother, the ancestors, and the elders. At once satirical

clowns and serious spokesmen of Poro values and wisdom, these spirit beings have multiple and crucial roles in initiations, funerals, and as an instrument of policing and social control. The mask wearer must be particularly adept in aphorisms, punning, and other eloquent uses of Poro language. His costume is variable, being reinvented periodically and within a spirit of aesthetic competition: a harlequin-like assemblage of colorful stuffed fibers and bright textiles with metal and cloth appliqué, braiding, yarn, and other decorative flourishes. The masking ensemble represents well the Senufo aesthetic of naviligi, which references vigorous youthful beauty, a much sought after quality. At funerals yalimidyo extorts money from participants and mocks those wearing Western clothes or otherwise flouting accepted behavior. Part of his ritual duty is to challenge the men present, in the secret Poro language, to determine which among them may remain for the burial rites restricted to Poro initiates. The masker also blesses people in the name of the ancestors, calling for good health, prosperity, and many children. His deliberately pregnant belly refers metaphorically to the rebirths signified in both initiation and funerary rituals.

Celebrations

The foregoing discussion of Senufo arts may mislead readers into thinking that art is present and constant in everyday life, which would strongly distort the true picture. In fact, dayto-day life is repetitive and not very exciting here as in much of the world. Whatever art may be present is large-

5-30. KPAALA (PUBLIC SHELTER), SENUFO. PHOTOGRAPH 1979

ly hidden away in diviners' chambers, in shrines, and in Poro groves for occasional use. When displayed during funerals or initiations, art forms emerge as transient and ephemeral phenomena, affective and striking breaks from the relative monotony of normal life, providing color, drama, vibrant action, pulsing music, crowds, and feasting.

Festivals compress into short compass and expressively integrate the most revered values of Senufo life. Funerals reiterate and make public arts normally restricted within Poro groves, adapting them to public spaces and assemblies. Overt displays of balafon and drum music, singing and dancing, costuming and masquerading, drinking and feasting may prevail in these relatively brief public versions, but many of the more covert and esoteric symbols and gestures are there too, as if to remind Poro initiates and elders of the cosmology, history, and

values of their people. Dangerous nature spirits are there, though controlled, in the open jaws and sharpquilled accumulations of composite masks, and guests present for the funeral are tested in their knowledge of Poro traditions by the only apparently jocular yalimidyo. The founding couple of the senior matrilineage is there symbolically (or at least was before such figures began to be stolen and sold to art dealers, around 1960), in the carved female and male figures displayed near the kpaala, Poro's public shelter in the center of northern Senufo villages (fig. 5-30).

Tourist Arts in Korhogo

By the middle of the twentieth century, continuing modernization, conversions to Islam and Christianity, and local iconoclastic religious movements had diminished local demand for the works of Kulebele carvers. At the

Aspects of African Cultures

Export Arts, Copies, Fakes, Authenticity, and Connoisseurship

Since the late fifteenth century, when exquisite ivories were carved for Portuguese visitors to Sierra Leone and the kingdom of Benin (see chapters 6 and 9), African artists have created art works specifically for foreign clients. Much later, in the 1950s and 60s, thousands of outsiders flocked to eastern Africa to view wildlife, and artists/craftsworkers invented hundreds of new forms of art to sell to these crowds. Ebony (blackwood) carvings of wild animals, of elongated Maasai warriors, and of women carrying pots, as well as wooden salad servers, watercolors of idyllic landscapes, and a host of other things, were sold to tourists or exported abroad (see chapter 13). While none of these objects had ever been used in Eastern African cultures, some began to be sold to wealthy Africans as emblems of status and modernity. The manufacture and sale of these objects provided gainful work for thousands of Africans during this period, and "tourist arts" continue to allow people to made a living today (see p. 463).

Other forms of export art evolved in West Africa in the 1960s and 70s, when foreigners began to visit West Africa, often in search of their ancestral heritage. Artists then made copies of masks, figures, stools, staffs, metalwork, and other objects: replicas or interpretations of art used (or formerly used) in ceremonies or in domestic life.

However, Europeans and Americans who were building collections of African art sought to buy only objects that had been used in a "traditional" (preferably

sacred) context. They insisted that only well used family heirlooms, or ceremonial objects that had been stolen or abandoned, were "authentic" African art. Traders found it difficult to sell them new things, no matter how well made, no matter how respected the artist. Even art works made by an African artist, owned by an African client, and used in an African context would be rejected by these collectors if the object didn't conform to styles and forms they recognized as typical of "authentic" art from a region.

Thus began what is today a widespread practice: the creation of new objects that are careful copies of works illustrated in books on African art. These replicas are artificially aged to seem old and rare. Traders can often sell them at high prices. Today there are perhaps more of these artificially aged African art objects in collections, in shops, and on the internet, than there are antique art objects in museums. When Africa traders and artists see the exorbitant prices fetched on the international art market for fine old pieces—Benin bronzes, Dan or Songye masks, a Dogon figure—they naturally turn to creating more of them so as to enter that market. And again, many Africans have made a good livelihood by making and selling these objects

But this situation creates confusion for curators and collectors who care about the difference, who want to sort out genuinely old pieces made for African use, and actually used, from newly minted copies made to look old from the application of artificial surfaces (producing a deep shine, as if from decades of handling; or textured encrustations, from libations of cereals or blood), or by creating cracks and

abrasions, breaks that are repaired, and so forth. Here enters the connoisseur, meaning "the one who knows." Through years of experience in seeing and handling thousands of objects, such people believe that they can discern which artefacts show signs of recent manufacture and inappropriate use and are thus "inauthentic." This increasingly small group of experts can determine the aesthetic quality (and economic value) of an art object in relationship to other African works in public and private collections. They know materials and styles, the hands of individual artists, the iconography appropriate to a specific genre or historical period, and many other formal nuances and details that come from objectcentered study.

But the definition of "authenticity" is contested. Some researchers contend that the connoisseurs are intimately familiar with only a small proportion of African works—those that have circulated in Europe from the sixteenth to the midtwentieth century. These scholars argue that works in European collections do not represent the full range of artistic creativity in Africa, and they insist that works used by African communities during the postcolonial period should also be considered to be "authentic." Finally, some academics claim that any object that is made by an African artist is, in fact, African art, and they applaud fakers whose products can fool the "experts." We thus face several questions to ponder. What, exactly, does "authentic" mean when applied to African art? Can outsiders determine whether or not a work was used locally or is of high artistic value? If so, how, why, and by or to whom? HMC

5-31. Tourist wares on display, Korhogo, Côte d'Ivoire, 1979

In addition to wood sculpture by Kulebele and other carvers, figures made by brasscasters are also popular with tourists, along with paintings on cloth of animals, simplified versions of local masks, and adaptations of sacred fila cloth. Some of these wares are also visible on and hanging behind the trader's table here.

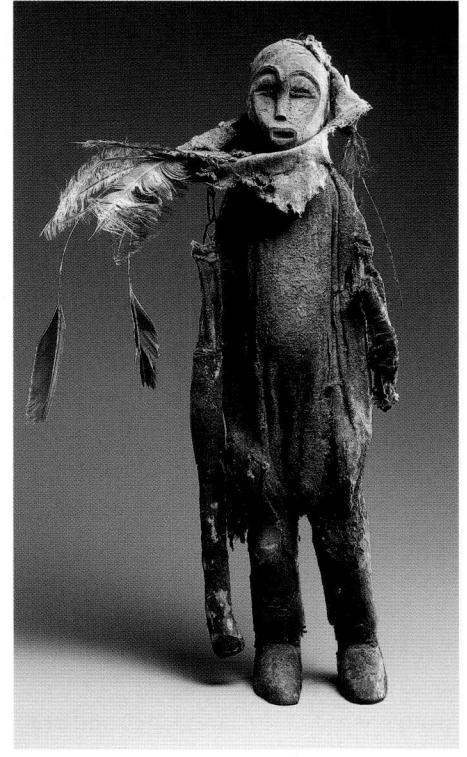

5-32. Figure of Kafigelejo, Kulebele, Senufo, 20th century. Wood, feathers, Quills, Cloth. Height 28¼″ (73 cm). Musée Barbier-Mueller, Geneva

same time, the arts of Africa, including those of Côte d'Ivoire, began to attract a broader audience in Europe and the United States. The Kulebele and other Senufo artisan groups have responded by creating art works for this new and growing market. Since the 1950s, they have in all likelihood produced more art works than were created during the entire nineteenth century. The expanding city of Korhogo, in Côte d'Ivoire, has been the main center for this production and its trade, and it was there that this photograph of wares was taken (fig. 5-31).

Two factors have helped Kulebele carvers cultivate this market for their work so successfully. The first is their long-standing asserted right to fell trees and use their wood without payment to people whose land they grow on. This assumed prerogative links with the second factor, control by Kulebele of supernatural sanctions located in a powerful deity called Kafigelejo, who is materialized as a wooden image wrapped in cloth soaked with supernaturally charged substances (fig. 5-32). Threats of Kafigelejo's powers give them an advantage in many transactions.

Kafigelejo thus represents a recently introduced power figure—a wooden figure with composite additions that we might easily assume was "old and traditional" if we were not aware of its history.

RELATED PEOPLES OF BURKINA FASO

The various peoples of Burkina Faso are agriculturalists, and most speak Gur languages. Archaeological finds from the country consist mainly of enormous burial urns which have not been dated and are difficult to link to

modern peoples. On the other hand geometric grave markers of stone in the north of the country have evidently been carved by a population now known as "Yatenga" for over a thousand years. Formerly known to scholars as the Voltaic peoples (after the former names of the three rivers that drain the region: the Black, Red, and White Voltas), the inhabitants of Burkina Faso are now referred to collectively as the Burkinabe. Among these are a dozen or more groups, some quite small, with distinctive art forms and styles. Aspects of the arts of five of these peoples will be surveved briefly here: the Lobi, the Bwa, the Mossi, the Bobo, and the Nankani. All except the Bobo (Mande speakers, like the Bamana and other groups) speak Gur languages and are sometimes called gurunsi peoples.

Lobi Sculpture and Metalwork

About 160,000 Lobi live in Burkina Faso, Côte d'Ivoire, and Ghana. Formerly warlike, even among themselves, they occupy defensible compounds with narrow openings and fairly high walls. They are primarily agriculturalists, like other groups examined here, with millet, sorghum, and corn fields surrounding their somewhat randomly dispersed compounds. These house from about a dozen or so people to sixty or eighty members of an extended family under the leadership of one older man, the family head.

The boundaries of Lobi communities are difficult to discern visually, for there is no center. Villages are comprised simply of several compounds living under the rules, protection, and beneficence of a particular

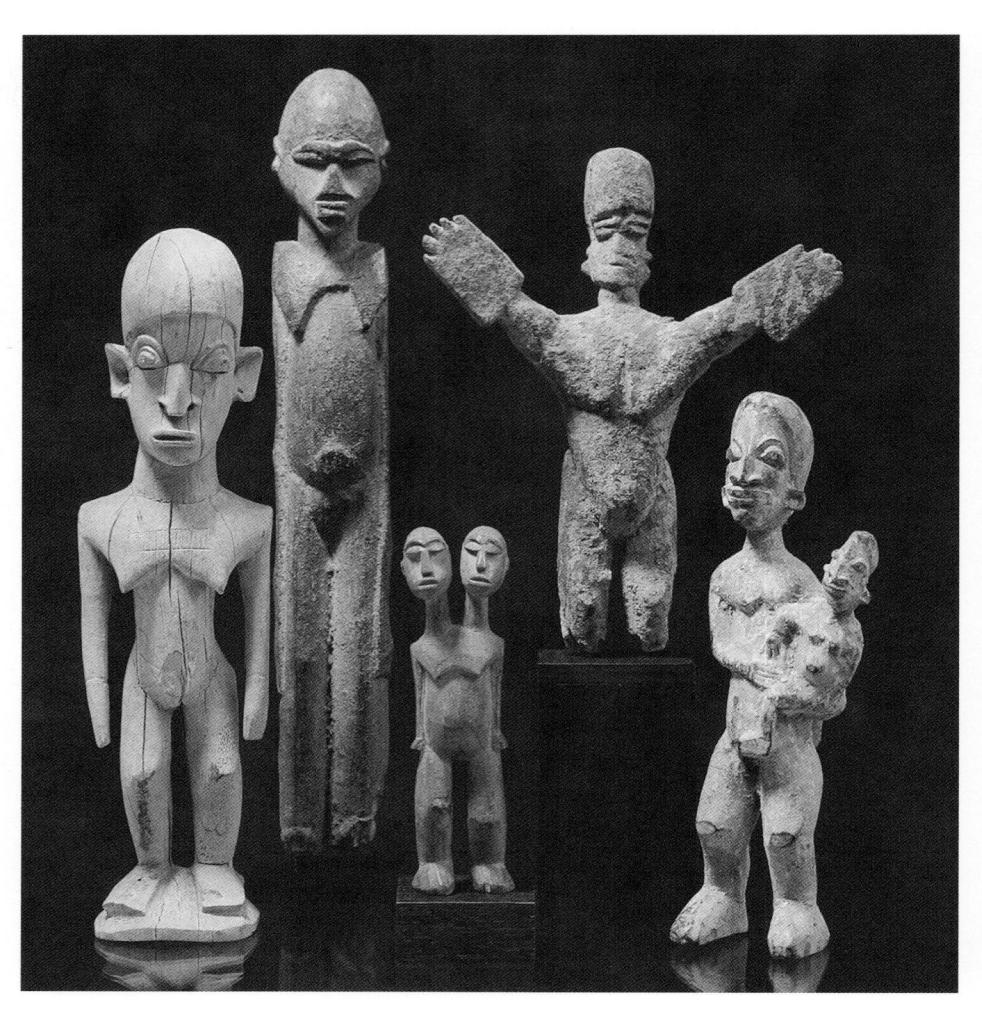

5-33. Five Bateba figures, Lobi. Wood. Height 10½–18″ (26–45.5 cm). Museum Rietberg, Zürich

deity, thil (plural thila), associated with their land. Each family compound too has at least one presiding thil. Social behavior is regulated and adjudicated by these thila, whose will is passed to ordinary people by priests and diviners. It is thila, for example, who order sculptures and other art forms to be made. The most important of these forms is the clay or wood sculpture called bateba (fig. 5-33). Human-like in form, a bateba acts as an intermediary between a particular thil and the human community.

Lobi carvers derive no special status from their work, perhaps in part because anyone can carve without specialized training. They are paid little; indeed, some *thila* are said to adversely affect a carver who takes any money at all. As a result, Lobi carvings are highly variable in style and degree of finish, a fact that does not in the least hinder their effectiveness in shrines. What seems to be more important to the Lobi, or better, to their *thila*, is that a *bateba* act, for it is considered a living being able to see, communicate, and intervene on

behalf of its thil. While stylized, bateba are complete in having the usual body parts, although most are highly simplified in their artistic renderings. Normally heads are enlarged, perhaps so the work of the god will be more effective. Other features may reflect specific powers. Bateba expected to fight for their owners, for example, have big hands. Others, considered dangerous, block entrance to harmful forces such as disease or witchcraft, and are depicted with one or both arms held up. Still others have sad expressions because their function is to mourn for their owners. Figures with two heads represent deities whose ability to see in several directions at once makes them exceptionally dangerous and powerful. Images without any specially defining posture or expression, and considered "ordinary" by the Lobi, nearly always have faces that can be seen as grim or angry, for it is thought that only in such a state can the bateba act forcefully. Such visual clues to meaning are not always clear, however; the Lobi themselves have conflicting and ambiguous interpretations of their imagery, and regional variations complicate things further. Thus it is always preferable to have data from specific shrine contexts.

Thila may be "found" or "taken." A deity is "found" when it appears as a piece of iron in the bush or when it affects someone strongly, usually through sickness or misfortune. A deity is said to be "taken" when its bateba is bought from the original owner and set up in a new shrine, where it continues its work. While shrines may be similar in appearance, each is in fact the unique result of orders received from the resident

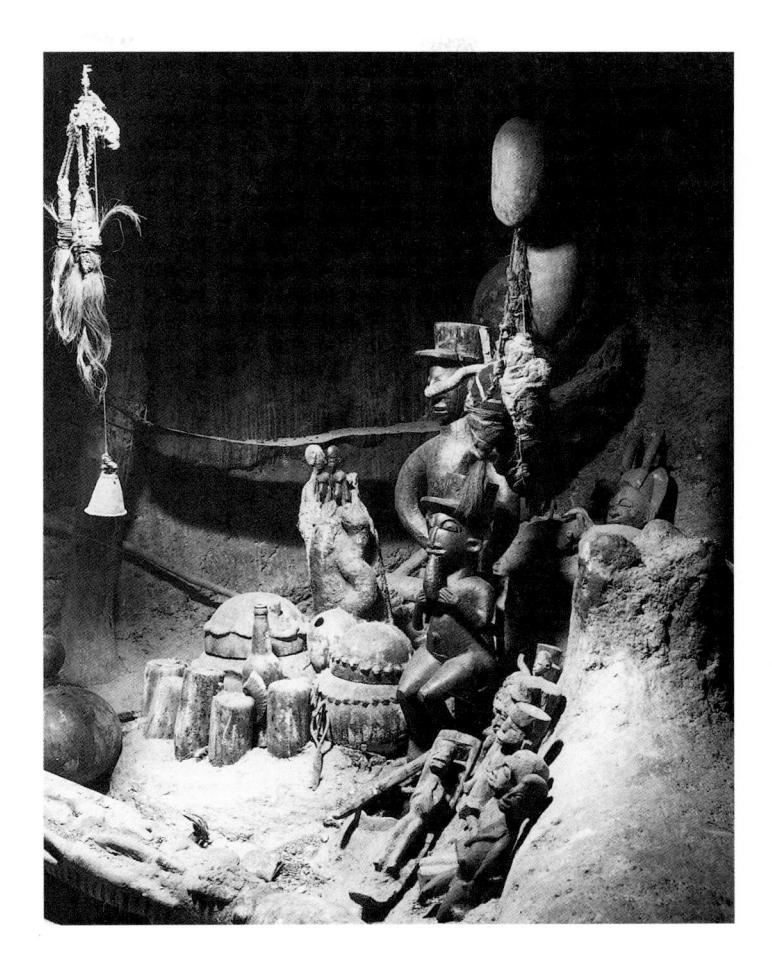

5-34. Shrine with BATEBA FIGURES OF WOOD, CLAY, AND TERRACOTTA, LOBI, MIDEBDO REGION, 1980

thila through a diviner. Some thila first want a roof terrace shrine, for example, and later request another inside the house or in a small separate building. The thila order what sorts of things the shrine must be equipped with; these often include sculpted figures of wood, clay, or metal, implements such as canes or bells, and ritual pottery. Many of these are present in the shrine in figure 5-34, which also includes bottles, other containers, and seashells, all as ordered by the god. A deity's request can be quite detailed: material, size, pose or gesture, facial expression, and other attributes may all be specified. Many of these differences are meaningful in the context of the god's shrine, priest, and work. A god is believed to work

for its owner/finder and his or her family after sacrifices have been made, and it will continue to work (protect, injure, heal, etc.) so long as its regulations are followed.

Lobi arts also include a wide variety of small human and animal images, implements, and more abstract symbols in copper alloy and iron (fig. 5-35). Some of these are worn as jewelry—ordered by a deity and for the most part protective (as among the Senufo)—and some appear on shrines. Their iconography is not fully known, partly because casters some decades ago competed and made lots of varied forms, some only worn as decoration. Yet others of these small sculptures have fairly specific work to do for the *thila* who ask for

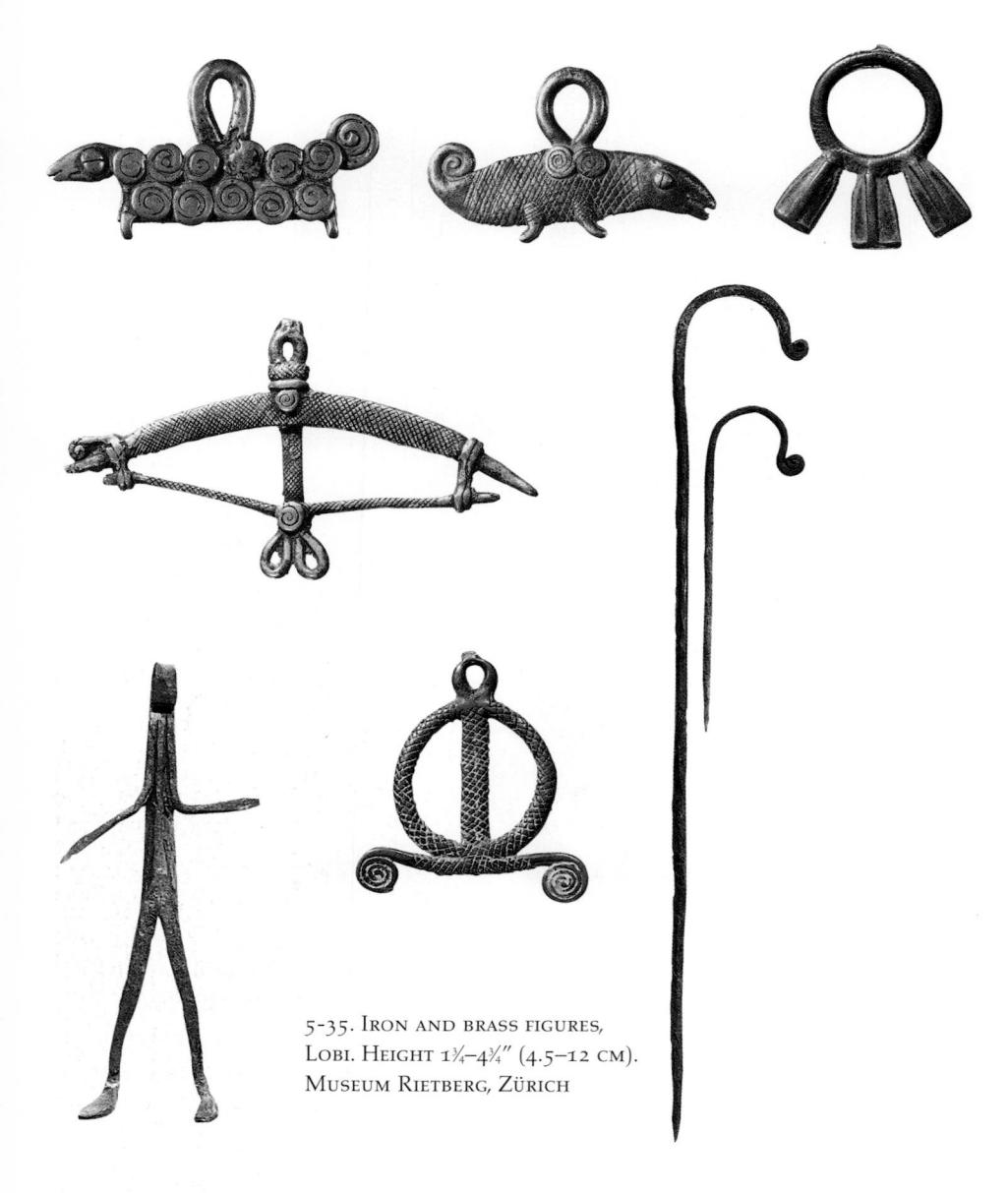

them on behalf of their owners, whether custodians of shrines or the people who wear them as charms. Small human figures of iron ("black metal") or brass ("red metal") fight against visible and invisible dangers, while chameleons bring riches and prosperity. Snakes appear in many sizes and shapes in both metals, worn on different parts of the body—strapped to lower legs, for example, as bracelets or chest ornaments; they are especially common "workers" for the

thila, and serve varied offensive and defensive roles. Spears, knives, or bows-and-arrows are weapons used by thila on behalf of their owners and, similarly, miniature pliers are tied around children's necks so the thila can "hold"—that is, protect—them well. Protection against diseases, evil spirits, and potential harmful neighbors are common themes.

Notably, the Lobi are surrounded by people who devote much energy to masquerades, but they themselves do not dance masks. The reasons for this are not clear but may relate to their lack of age-grade organizations.

Bwa Masquerades

The Bwa people inhabit a region in northwestern Burkina Faso and extend into Mali. The Gur-speaking Bwa have been quite receptive to change, having adapted or adopted masks, for example, from adjacent peoples such as the Nuna, Nunuma, and Winiama. Each Bwa village is governed independently by male elders, as the Bwa are hugely egalitarian. Communities comprise three occupational groups: farmers (in the majority); smiths, who forge tools, cast brass, and carve, and whose wives make pottery; and bards and musicians, who also weave and dye cotton and work leather.

A religious organization called Do, a Mande-derived term for "secret" or "spiritual," is a major unifying force in Bwa life. Each community has a Do congregation, led by the earth priest. Do is at once an organization and an anthropomorphic being, the son of the remote creator god. Considered androgynous, Do represents and embodies the life-giving powers of nature, especially the untamed bush. Do is incarnated at initiations and village purifications, held just after crops are planted, by an otherworldly spirit masker whose "skin" is vines, grasses, and leaves (fig. 5-36). In some areas, the vivid leafy green body is topped, as here, by an arcing crest of brilliant white eagle feathers. A conical tube of basketry in front forms a kind of mouth. Deliberately and radically non-human in shape, color, and behavior, these sacred organic

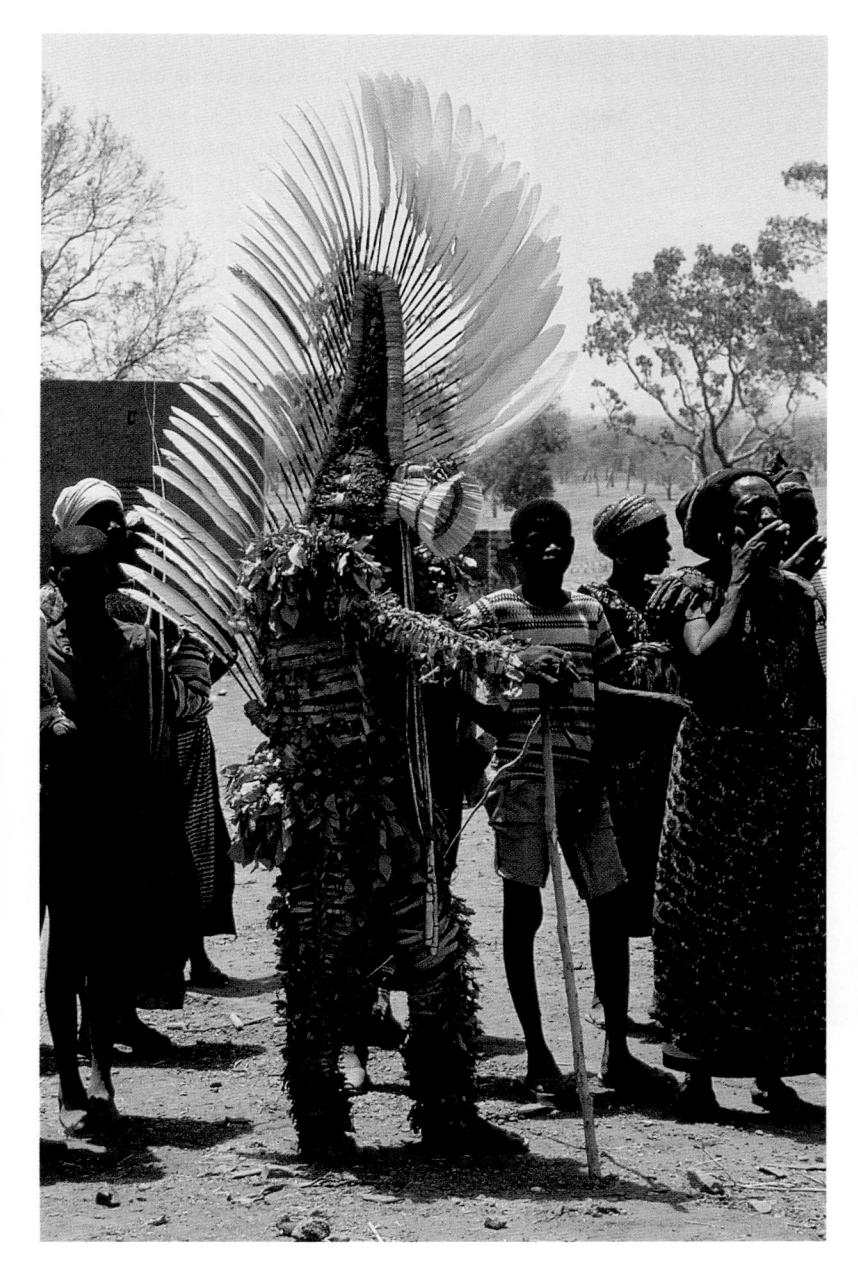

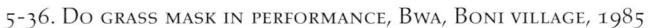

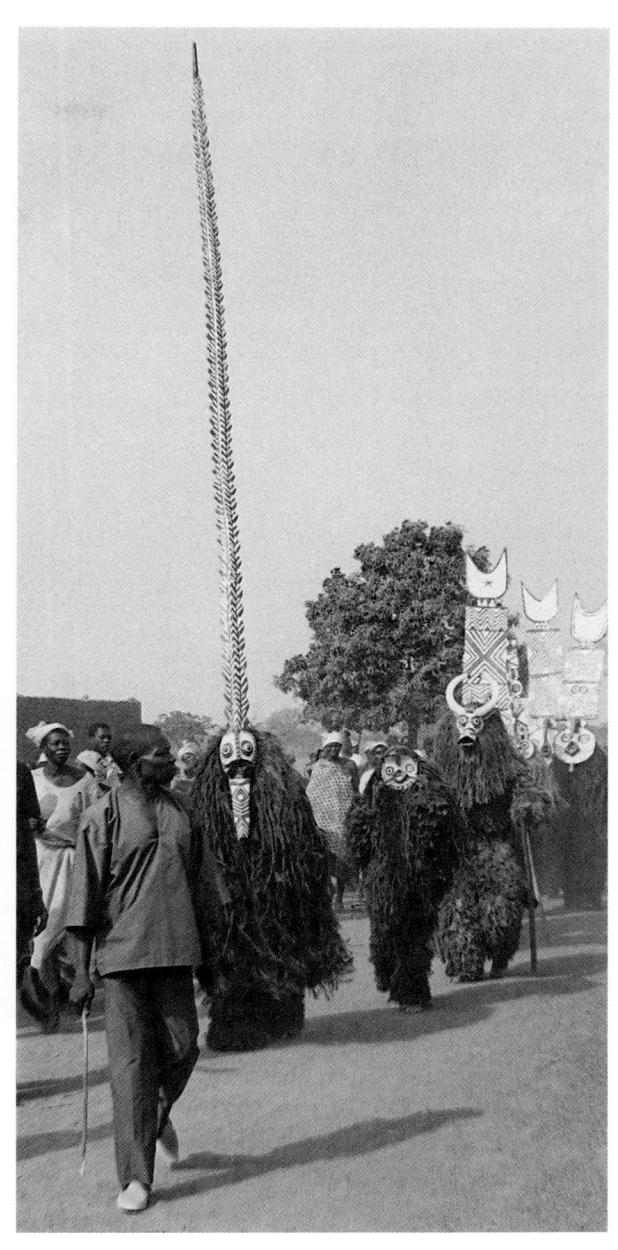

5-37. Serpent, monkey, and buffalo masks in performance, Bwa, Pa village, Burkina Faso, 1984

maskers celebrate life and help renew the forces of nature. Their power extends also to human fertility. The use of fresh verdant plant material in Do's costume directly evokes its function of regeneration. In wooden masks, on the other hand, a more abstract form of symbolism prevails. Bwa wooden masks embody nature spirits, who imparted rules for the proper conduct of community life and who are invoked—in masquerades—to benefit humankind and the natural forces on which life depends (figs. 5-37, 5-38). Some masks depict spirits of practical or ideological importance

more or less directly. The tall mask leading the procession in figure 5-37 represents a serpent. A monkey and a buffalo follow. More abstract masks consist of a shaped, partly openwork plank surmounting a normally circular facial section. These masks embody "the spirit of growth," dwarf

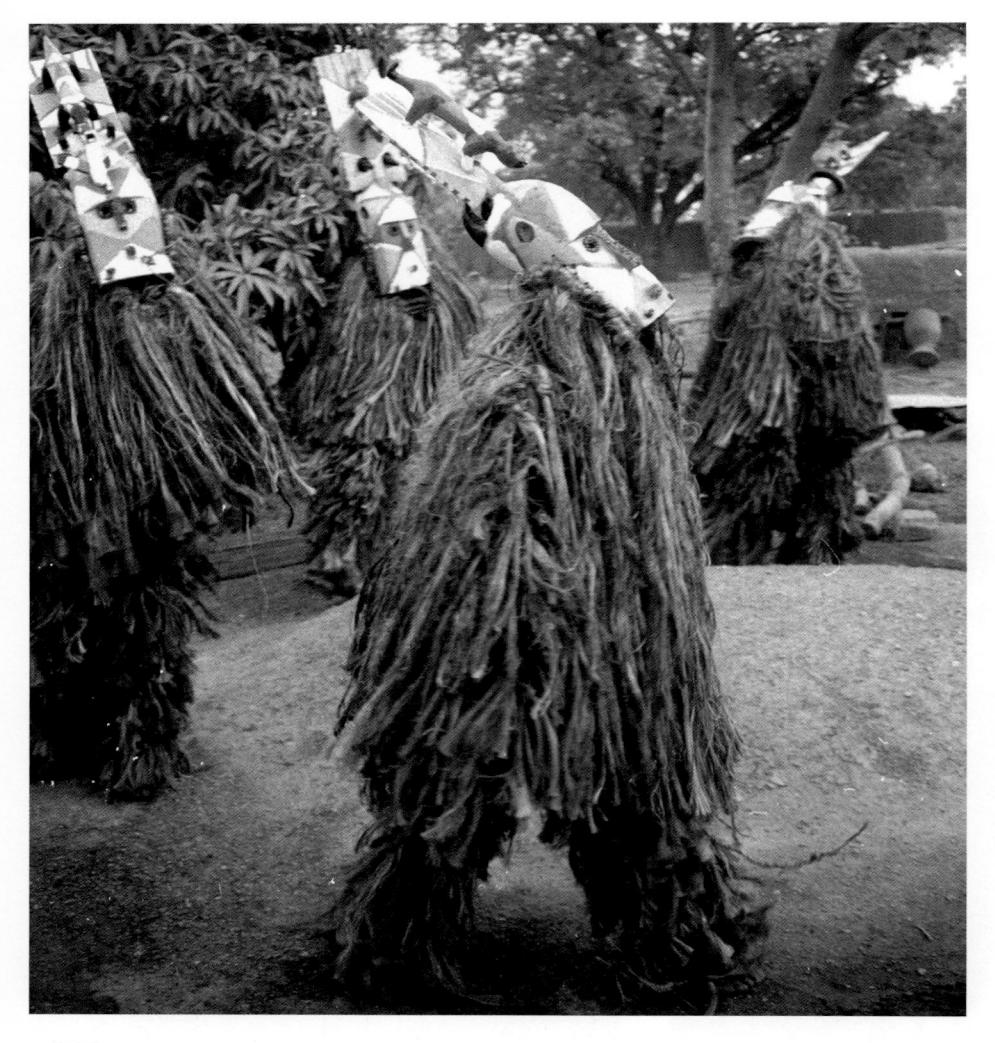

 $5\mbox{-}38.$ Hawk mask in Performance, watched by two plank masks, Bwa, Dossi village, Burkina Faso, 1984

spirits, or other supernatural and natural forces not readily apparent visually.

Nearly all wood masks are painted in black, white, and red with high-contrast geometric signs given to the people in primordial times. In general these are symbols or patterns of cultural order, whether economic, political, or spiritual. Their meanings are disclosed by older initiates to male and female novices (Bwa boys and girls in the same age-grade undergo initiation together but only boys wear

masks). It seems that at first only relatively simple meanings are imparted; more esoteric content is revealed as the initiates mature. Thus the interpretations of graphic signs vary according to age and initiatory level, as well as region. Few meanings, though, are codified or shared over time or space, even if the signs themselves—chevrons, zigzags, Xs, crescents, checkerboard patterns, concentric circles, sculpted hooks, and others—are widely distributed not only among the Bwa but also among

neighboring *gurunsi* peoples such as the Nuna, Nunuma, and Winiama, with whom many mask types and graphic symbols originated. Similar signs appear as well on Mossi and Dogon masks. It would seem that the symbolic interpretation of mask motifs is deliberately left open among the Bwa (and other groups), enabling a tutor to incorporate the latest or most important local teachings, thereby best preparing novices for adult life at that particular place and time.

Wooden masks stand in some degree of opposition to Do leaf masks in Bwa communities. Leaf masks are clearly the more ancient and indigenous form, and it is acknowledged that wooden mask types have been borrowed or purchased from neighboring peoples. In addition, wooden masks act as a divisive force in that they tend to foster competition, with families or clans vying fiercely to create the most elaborate, innovative displays. Leaf masks, on the other hand, cut across family or lineage divisions and act as a unifying force. Where leaf and wood masks coexist in the same communities, they perform separately and belong to rival religious associations. In some southern Bwa villages where both types appear, leaf mask owners consider wood mask users as heretical parvenus and forbid them to participate in Do rites. In the northwest, however, the two mask types embody a beneficial nature/culture interaction. There, leaf masks foster growth in the spring, while wooden masks perform after the harvest to help integrate people and foster harmony in village culture by promoting respect for the rules of proper social behavior.

Mossi Sculpture and Masking

Far more numerous than the Bwa are the Mossi people of Burkina Faso. whose society is organized into states. Mossi states were founded during the fifteenth and sixteenth centuries. when horsemen, arriving from a region to the southeast, in what is now Ghana, superimposed both a language and centralized political systems onto the indigenous farming communities. These farmers, called tengabisi, "rulers of the land," consist of the nyonyose and the sukwaba, who are both blacksmiths and sculptors. The *tengabisi* are subjects of the nakomse, descendants of the equestrian invaders. This dual aspect of Mossi culture is recognized today in that the king, called the Mogho Naba, and other nakomse rulers hold themselves apart from nyonyose earth priests, land owners, and elders, descendants of the tengabisi, who lived in the region for hundreds of years before the nakomse came. Mossi arts too record this double heritage, as certain figural sculptures are owned and used ritually by *nakomse* rulers in political contexts, whereas the tengabisi farmers use spiritually charged dance masks owned by clans and lineages. However, the varied styles of Mossi masks and figures signal an even more complex history of ethnic and cultural mixing in this region. For example, Mossi in the southwest, where the tengabisi are descended from Bwa and related groups (Nuna, Nunuma, Winiama), have masks resembling those of the gurunsi, whereas Mossi in the north, with different origins and influences, have masks related to those of the Dogon. In this region, art is a useful index in

mapping the history of its various peoples: their settlement, migrations, conquest, and other cultural interactions.

The Mossi employ two types of carved wood human figures: the first are full figures owned by nakomse leaders, the second are smaller, more economical or abstract renderings of females; they are owned by women or children. Mossi full figures, which represent the secular political power of chiefs, are carved in dynamic styles of simplified naturalism and in active poses (fig. 5-39). Most depict females. Some wear jewelry and cloth wrappers. The expressive pose of this figure, with bent legs, arms akimbo, and dramatic hand gestures, may emulate characteristic dance gestures of this area. The usual annual public outing of such rulers' figures is the year-end sacrificial rite, when royal ancestors are commemorated by dancing and feasting. In some places elders of local families bring tribute in the form of millet or other foodstuffs to the ruler, reinforcing their allegiance to him, while in other areas rulers ride out to their subject villages after sacrifices have been made to ancestors through the figures. As is common elsewhere, ancestors are believed to reward proper behavior with human and agricultural fertility and productivity, or, alternatively, to punish transgressors with disease or misfortune. Ownership of such figures, including those that belonged to earlier nakomse leaders, affirms a king's or other leader's secular right to rule.

The very numerous spare, abstracted figures, generally of cylindrical form and without arms or legs, but often with crescent-shaped heads and prominent breasts, represent young

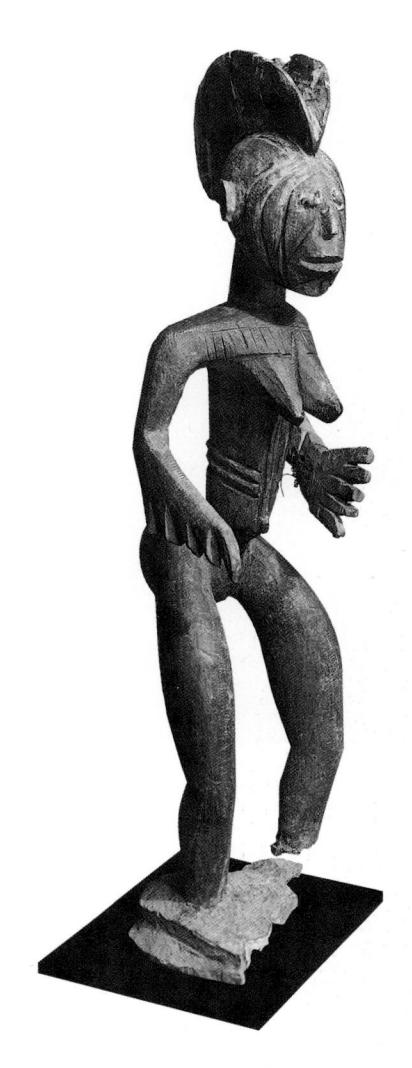

5-39. Standing figure, Mossi, 19th–20th century. Wood, glass, metal beads. Collection Thomas G.B. Wheelock

mothers and are often owned by them. Many have pendulous breasts recalling those stretched as a desired feature of motherhood, as well as scars radiating from the navel, which were applied in life to commemorate the birth of a woman's first child. The name for these images, in fact, is "child," biiga. The illustration (fig. 5-40) shows figures in several regional styles. Many such "children" were acquired by young wives as aids to conception, as well as to insure that a child will live after

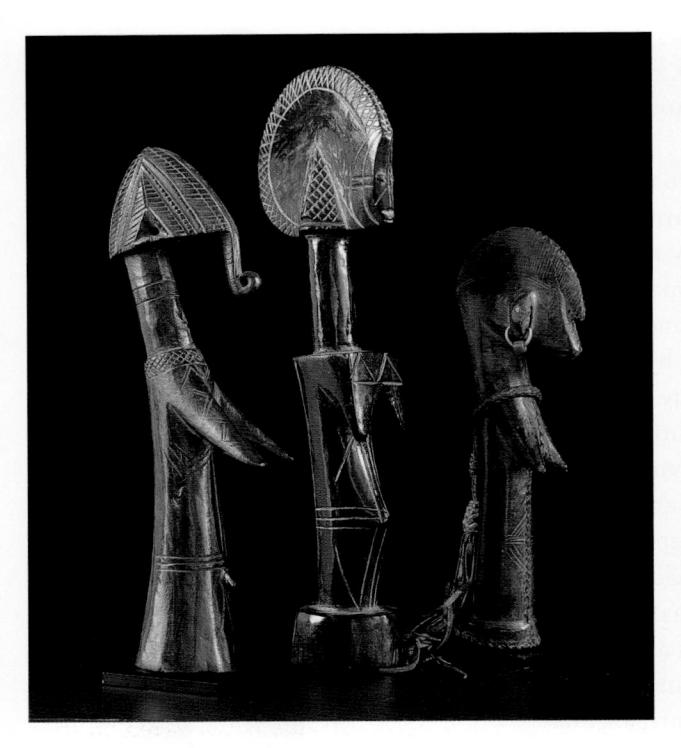

5-40. Children, Mossi, 20th Century. Wood. Height (L–r) 11½" (28.2 cm), 13½ $^{\circ}$ " (33.8 cm), 9½" (25.1 cm). Collection Thomas G.B. Wheelock

birth. In some regions the figure is treated as if it were a child: clothed, played with, offered milk, tied to its "mother's" back, and so forth. A second use was as a plaything, a doll for a girl child, who even at a very young age practiced being a mother with this surrogate child.

In contrast to figures, Mossi masks embody spirit powers, nature or ancestral spirits of the sort found among many farming peoples. In some regions masks are housed within ancestral shrines during periods when they are not being danced, to be augmented by powers that control the earth and productivity, all in the service of the well-being of the people and their natural environment. In some Mossi regions masks represent the spirits of ancestors, while in others, they are totemic nature spirits

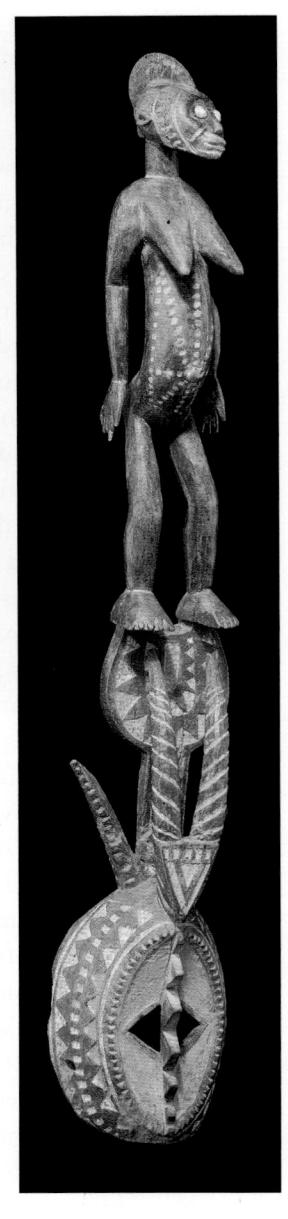

5-41. Mask with standing figure, Mossi, early 20th century (?). Wood. Height 4215/6" (1.09 m). Museum Rietberg, Zürich

Other masks in this style have tall openwork rectangular planks similar to Dogon sirige masks. Since the Dogon live only about thirty miles away from this region of Mossiland, historical interchange is evident. Prior to the twentieth century, the Mossi tried repeatedly to conquer parts of Dogon country, but obviously shared art forms indicate that peaceful exchange has occurred as well.

belonging to lineages or clans, associated often with a specific animal. A typical mask from the Mossi Yatenga region, near Dogon country, has an abstract head section faced with an oval (fig. 5-41). The oval is bisected vertically by a notched ridge, with triangular eve holes on either side. Two sets of animal horns spring from the top, and behind them rises a short plank on which stands a finely carved female figure. (Other Yatenga masks have tall openwork planks much like those on Dogon sirige masks.) The mask embodies a merging of bush and human powers, and suggests that human, perhaps ancestral, powers may be dominant. The human or animal figures or parts represented on such masks are spoken of by some scholars as "totemic," in that they represent sacred characters that participated in origin legends told by the clans or families that own the mask. At the same time they represent nature spirits responsible for the protection and productivity of the land and people. Masks dance at burials, funerals, agricultural rites, and other important events such as blood sacrifices to ancestors for the wellbeing of the clan.

Bobo Masking

The Bobo are a heterogeneous, Mande-speaking people with a complex history who have resisted centralized political institutions. Village organization is democratic and councils of elders are the decision-makers. Bobo farmers, especially, are almost certainly indigenous to their current area although some later immigrant groups from core Mande areas further north, such as traders and other

occupational groups, are now part of the Bobo amalgamation. As among the Mossi, there are literally dozens of Bobo mask styles and types in varied materials: leaves, cloth, fiber, and wood. An assortment of several can be seen dancing in a circle around the grave of a recently deceased man, to honor him and to insure that his soul reaches the ancestral realm safely. Some Bobo groups hold that a masker—a "shadow man" or double—must accompany a dead person's soul on its journey from this world to that of the dead.

Wooden masks, though carved by smiths, are danced by both farmers and smiths. Their imaginative reinterpretation of zoomorphic forms is remarkable, especially horns, which can be long or short, single or double, and curve backward or forward. Most are combinations of both animal and human traits cleverly merged. Other inventive masks that are neither human nor animal have long flat faces, sometimes with notched noses or edges, with horns or abstract openwork planks above, some with starlike projections. In earlier times the prevailing coloration of Bobo masks was black, white, and red, but these days a greater variety of colors is employed, including yellow and blue. Some of the heavily stylized and abstract forms represent sacred dwo spirits, sons of the remote creator god, Wuro, while other, less powerful masks are danced primarily to entertain. The latter, as helmet or cap masks, take a variety of animal forms: antelope, warthog, ram, monkey, rooster, hornbill. All these wood masks, like those of other Burkinabe groups, are completed by costumes of hibiscus fiber that swings, swishes,

and flows to exaggerate the already vigorous, sometimes staccato, and always athletic dances. Each mask, of course, has its own history, dance, gesture and music style, and name; its specific character also includes its role, vices and virtues, and its interactions with other masks and the audience.

In addition to their attendance at burials and funeral rites, Bobo masks appear in two other vital contexts: agricultural rites at harvest ceremonies, and during initiations. Masks of leaves and fiber (called Dwo after the nature spirits represented) help restore the balance between nature and culture; these are similar to Bwa examples discussed earlier (the Bwa are neighbors). These masks absorb evil or toxic forces from freshly harvested plants, which can cause sickness or conflict, returning the undesirable substances to the bush. Millet that is not "cleaned" by masks, for example, is believed to cause disease or infertility.

Initiation, which takes place on and off for a period of fifteen years, reestablishes the world order established in primordial times by Wuro, the creator. Masks of leaves, fiber, and then wood are danced, respectively, at the three main initiatory stages during which the novices, all males among the Bobo, are taught the ways of the gods and ancestors, the conduct of orderly village life, as well as the myths and important historical events of their people. They undergo seclusion, ordeals, tests, the learning of a secret language, multiple rituals including symbolic death and rebirth, and other facets of classic initiatory cycles. The making and dancing of masks, both by instructors and the

initiates themselves, has long been central to Bobo initiatory teachings, as are the public performances of masked dances at key times during the long initiation period. All told, Bobo masking is enormously complex, more so because it is in rather constant change, even today.

Koma Terracottas

South of the Mossi states, but north of Asante territories, numerous small populations have lived for centuries. Between about AD 1200 and 1800, in a district known as Koma (or Komaland), in what is now northern Ghana, the dead were buried with both human figures and animals of fired clay. Ornaments depicted on the figures seem to match the amulets and ceremonial dress of modern populations in the area, and archaeologists thus believe that local peoples are descended from the cultures that created these ceramic works.

Koma figures share a distinctive style—their faces have round eyes rimmed with coils of clay, and pierced nostrils (fig. 5-42). Noses and chins vary in shape, and the overall forms of bodies and heads seem to be somewhat haphazard. Few formal features link the Koma terracottas to those unearthed along Niger River sites (see chapters 3 and 4), but they do share some characteristics of the Dakakari terracottas from northwestern Nigeria (see chapter 3). Both Koma and Dakakari clay objects include human and animal figures, both seem to have been connected with funerals, and both include human figures whose mouths appear to be open in a funeral chant. Of course, the two traditions are separat-

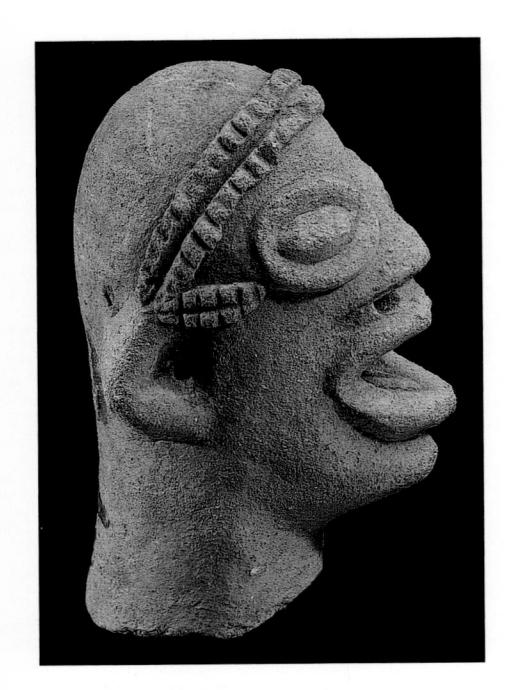

5-42. Head broken from figure, Koma region, Ghana. Terracotta. Department of Archaeology, University of Ghana, Legon

ed by several centuries and by hundreds of miles. Much shorter distances of time and territory separate the Koma work from the funerary terracottas of Akan peoples—but the Koma pieces look nothing like their Akan counterparts (see chapter 7).

Nankani Architecture

Like the mask styles of Burkina Faso, which tend to combine underlying organic forms with geometric surface patterns incorporating human and animal references, the built environments of the peoples who live in the southern border areas of the region share common stylistic vocabularies while exhibiting striking local variations, the latter being indications of cultural difference. The Senufo and the Lobi are the westernmost exam-

ples of these architectural forms, which can actually be linked to structures as far east as the Jos Plateau of Nigeria (see chapter 3). In fact the domestic structures of this broad band of savannah may represent the African continent's most impressive adobe and mud dwellings.

While many of the communities straddling the Burkina–Ghana border have been well studied and photographed, the homes of Nankani peoples, a Gurunsi group, are especially beautiful (fig. 5-43). As is true of most architecture of the region, walled compounds are surrounded by cultivated fields and scattered across the landscape. The plan in figure 5-44 depicts a relatively small compound, though it incorporates all the forms and ideas of larger versions. A single narrow entrance faces west. Outside

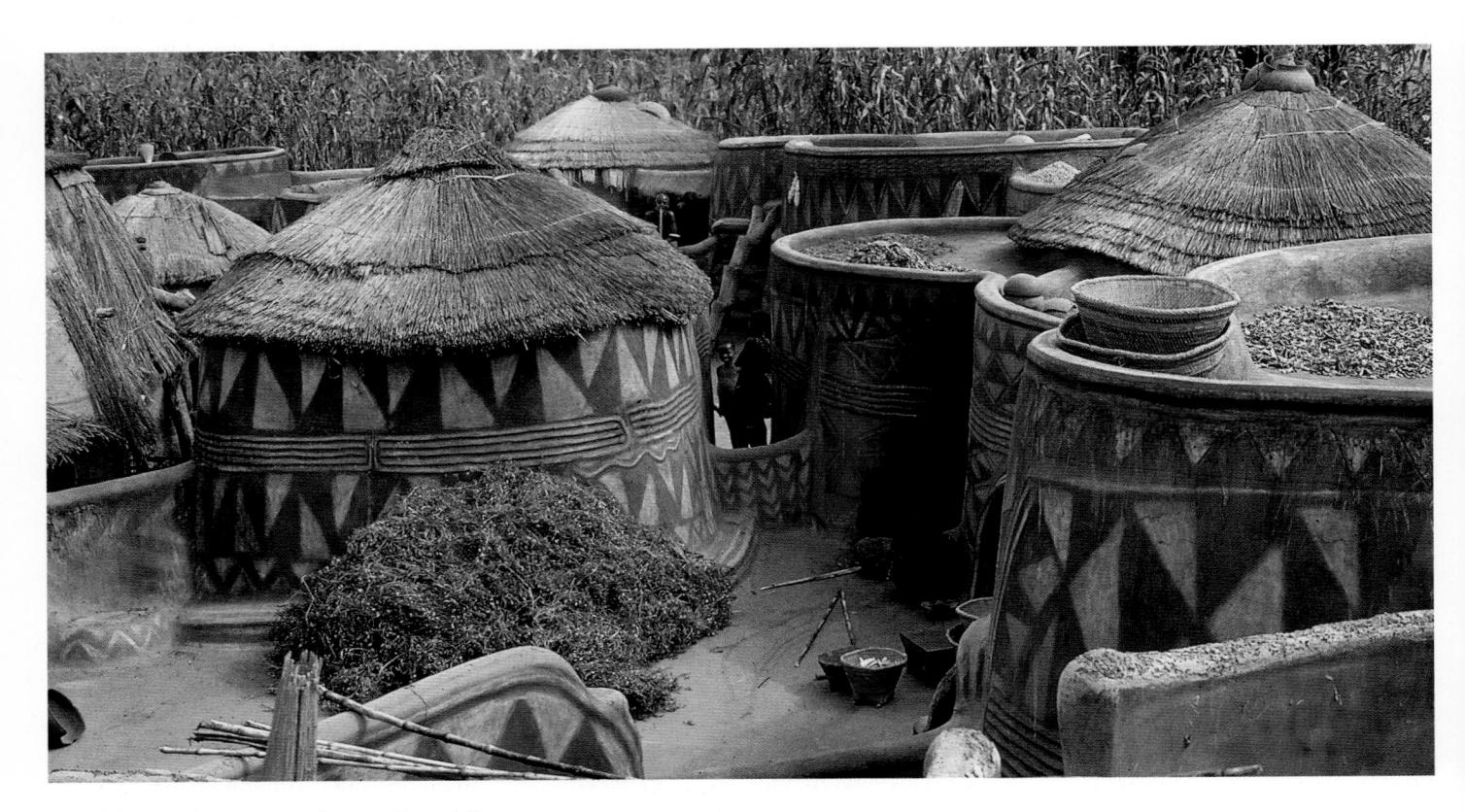

5-43. Nankani compound, Sirigu, Ghana. Photograph 1972

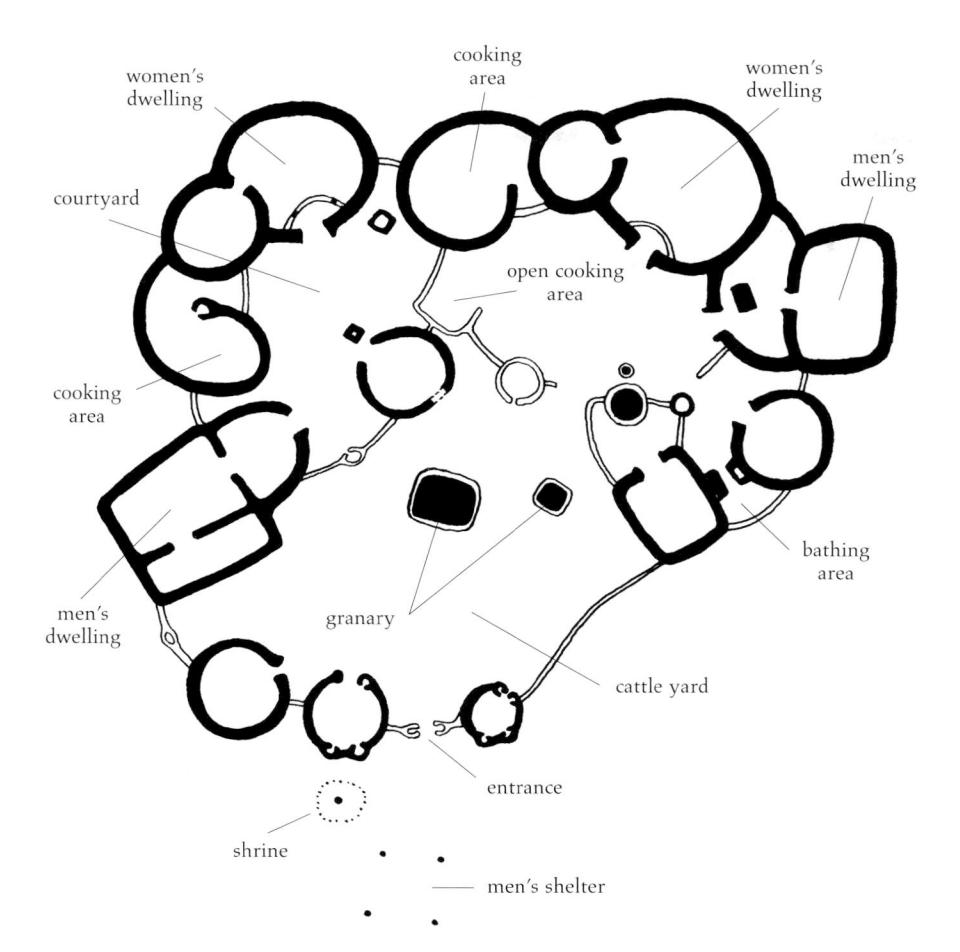

5-44. Plan of Nankani compound. Drawing after J.-P. Bourdier and T. T. Minh Ha

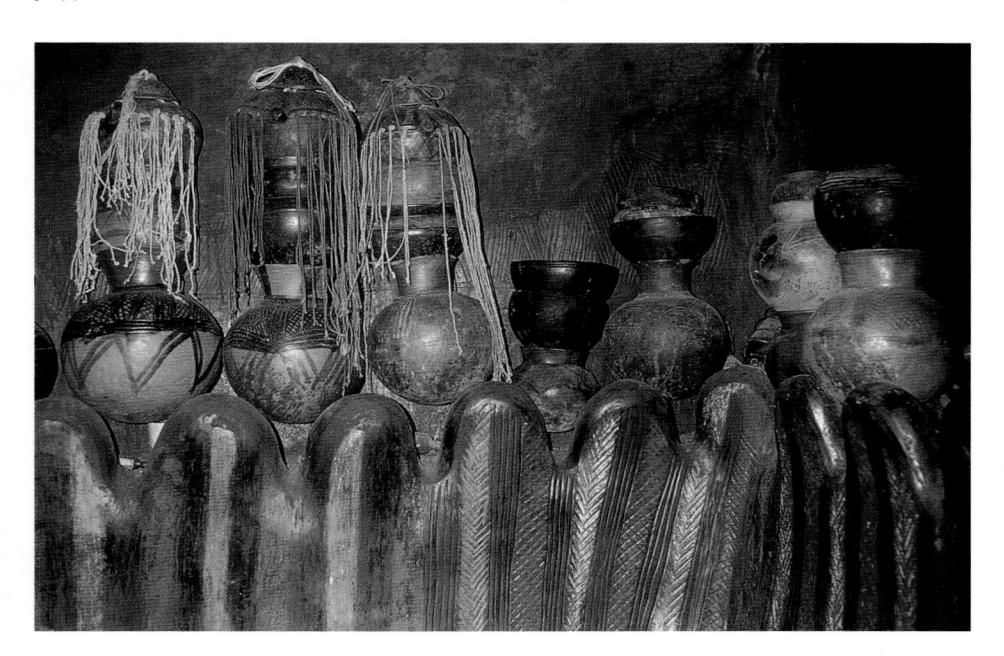

5-45. Interior of a Nankani woman's dwelling, with food storage wall and stacked pots, Sirigu, Ghana. Photograph 1972

the entrance in a cleared area is the open men's shelter. Immediately inside the entrance is the cattle corral. Dwellings are at the eastern side of the complex, their entrances oriented on a direct sight-line to the main compound entrance. A low barrier just inside the entrance to each house enables defenders to shoot arrows at invaders from dark interiors, an important feature in a land where farmers needed to protect themselves from unexpected attacks.

The creation of living areas is a cooperative yet gender-specific venture. Men do most of the building, while women decorate wall and building surfaces inside and out. The compound itself is also viewed as gendered. Areas outside the compound are male-oriented, as is the corral inside; the further interior courtyards and dwellings are female-oriented. Visitors thus pass from public and male realms to increasingly private and female ones. The protected interior spaces of women's houses include more private, intimate features: bed, food storage wall where pottery is stacked and food stored (fig. 5-45), grindstone and a net holding nested calabashes (fig. 5-46), interior cooking area, and shrines. The Nankani recognize symbolic correspondences among house, woman, and pottery, stressing the woman as childbearer and nurturer. Women's houses, then, are also wombs and, indeed, the plan shows well the rounded shapes of both women's houses. In contrast, the two houses occupied by men in this compound are rectangular.

A woman's house is a place of fertility and regeneration, where a woman conceives and nurtures her children, stores and prepares food, and enshrines her most revered possessions. Notably, these houses (and others) are built much as pots are, in courses, as if coiled. Like pots, too, their exterior surfaces are burnished with smooth stones and waterproofed after geometric patterns have been incised and pigments applied. Entries to houses and compounds are spoken of as "mouths"; doorways on women's houses are also called genital openings. Doorways are thus recognized as liminal spaces, vulnerable thresholds between places of contrasting quality and purpose.

Life transitions, too, are articulated architecturally. A woman's sideboard is called the "face of the deceased," for the senior woman, after death, is placed on her bed facing this carefully sculptured storage unit. Her death rituals also involve the breaking of her most revered calabash and her small personal, sacred pot. After a senior male's death, a hole is made in the house he slept in for the removal of his body directly to the farm area; thus the compound entrance itself remains undefiled by death.

The entire compound is embellished with and protected by richly meaningful, essentially geometric patterns (see fig. 5-43). The single most important decoration is a more or less continuous median band, ridge, or series of lines running horizontally around each structure. This is called yidoor, "lines running straight," a word that also means "rows in a cultivated field" and is used as well for the two parallel wooden base supports that strengthen the bottom of most baskets. The motif is also called "long eye," which signifies longevity, and it is sometimes rendered as a snake turning back on

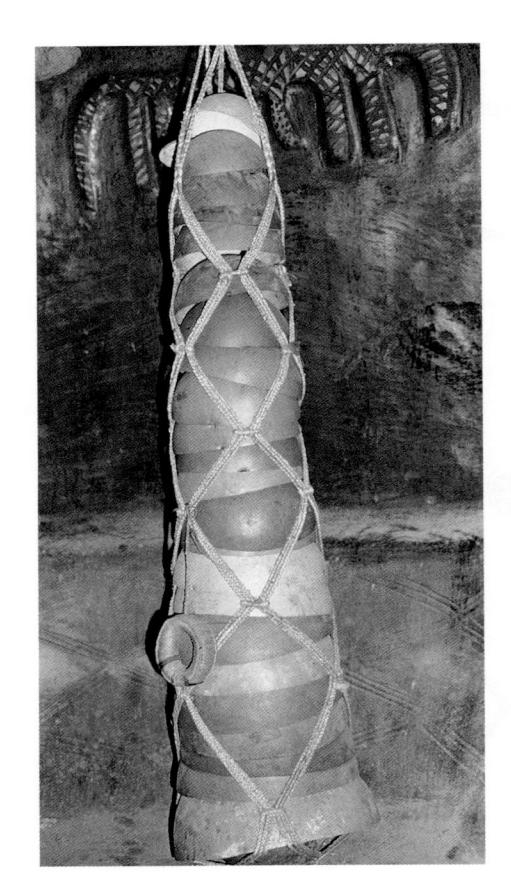

5-46. Calabash net and grindstone in a Nankani woman's dwelling, Sirigu, Ghana. Photograph 1972

itself, probably suggesting eternity. All together these various associations imply unity and continuity for the family and dwelling so encircled. The decoration is also practical, as it deflects the course of rainwater and thus impedes erosion.

Other patterns are notable. A bisected lozenge design, visible on the dwelling to the right in figure 5-43, is called *zalanga*, the name for the net sling that holds a woman's private calabash collection and her most revered objects and amulets, including her personal shrine (see fig. 5-46). Shapes are sometimes filled in with close cross-hatched grooves,

producing a field of countless nubs called guinea corn. Additional patterns are named broken calabash, cane, potsherd, triangular amulet, men's cloth, and cloth strips, among others. The same triangular motif is called both filed teeth and neck of the dove, depending on how it is read, apexes pointing down or up. The same rectilinear patterns are woven in baskets and applied to pottery. Analogous dense patterns are incised on men's and women's faces. The similar embellishment of houses. containers, and people reinforces the symbolic relationships among them. The prevailing design vocabulary has a consistency across object types, a style that the Nankani and their neighbors know and recognize. The Kassena, the Nuna, the Kusasi, and other nearby peoples have similar yet distinct styles. Thus it is abundantly clear that art participates directly in ethnic and cultural identity here, as it so often does on the continent.

OUAGADOUGOU AND CONTEMPORARY ART

As noted in the opening paragraph of this chapter, the peoples of the Western Sudan have been in constant interaction with Mande-speaking populations for at least a thousand years. It should therefore come as no surprise that Dogon artists now work in Mali, or that Ouagadougou (pronounced *Wagadugu*), the capital of Burkina Faso, has a burgeoning art scene that attracts artists from Mali and Senegal and welcomes international visitors.

Dogon artists have studied at the Institut National des Arts (INA) in

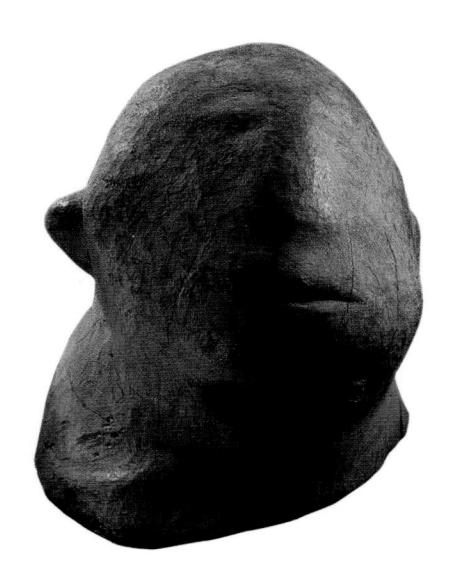

5-47. Ine-Kouh. Amahiguéré Dolo, Mali. Wood. Height 19%" (50 cm). Collection of Sergiane Cauwel, France

5-48. Still from the film Guimba the Tyrant. Oumar Sissoko (director), 1995

Bamako, the capital of Mali, and some of the art produced by members of the group Bogolan Kasobane refers to Dogon themes (see chapter 4). One of the graduates of the INA, Aminghere Dolo (born 1955) is from a family of blacksmiths, and therefore could have easily chosen to carve images for shrines, masqueraders, and foreign tourists in his home town. Instead, he sculpts twisted figures of wood in a studio located in Segou, a city in Mali whose population is primarily Bamana. His work has been featured in a festival of the arts in Segou, together with painters, musicians, and masquerade performers. Although the surfaces of Dolo's sculptures are clean and smooth, some of his work has the haunting formlessness of Tellem figures (fig. 5-47); their features are barely discernable and appear to have not fully been liberated from the surrounding material.

Burkinabe painters, sculptors, and installation artists are able to display their work in an arts festival in Ouagadougou, which began in the late 1990s. However, the fine arts festival is overshadowed by the influential FESPACO, the Panafrican Festival of Cinema and Television, which was first held in 1964. The winning film at this annual film festival is given a "golden stallion" in honor of the princess who rode a stallion into battle and whose son founded the Mossi state. In 1995 this award was bestowed upon the film Guimba, directed by Oumar Sissoko of Mali. The set and costumes for this epic drama of despotism and revolt were designed by the group of Malian artists known as Bogolan Kasobane (see chapter 4). The still photograph shown here (fig. 5-48) is from a scene featuring mounted warriors arrayed in historical costumes.

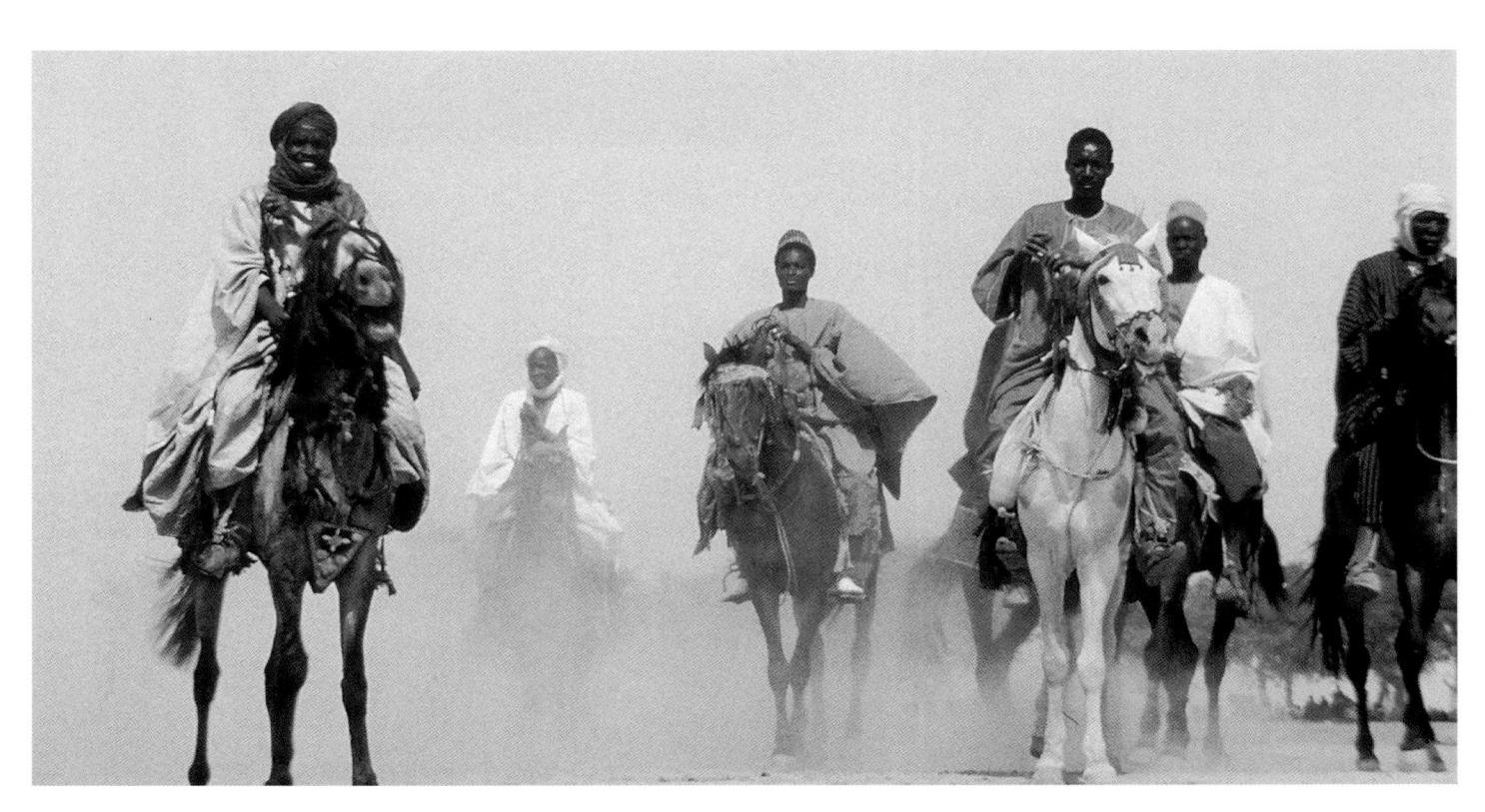

PART II

Western Africa

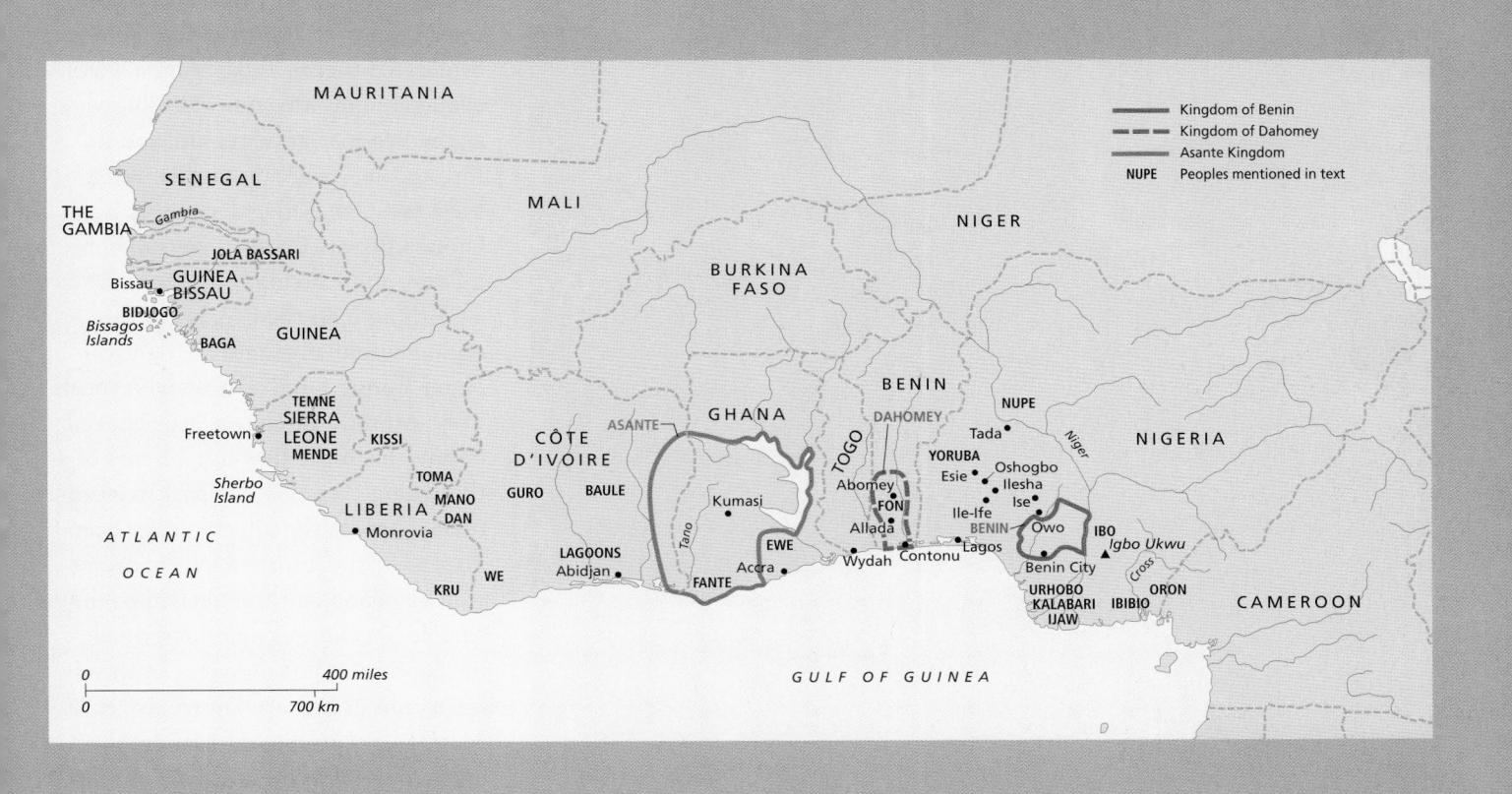

West Atlantic Forests

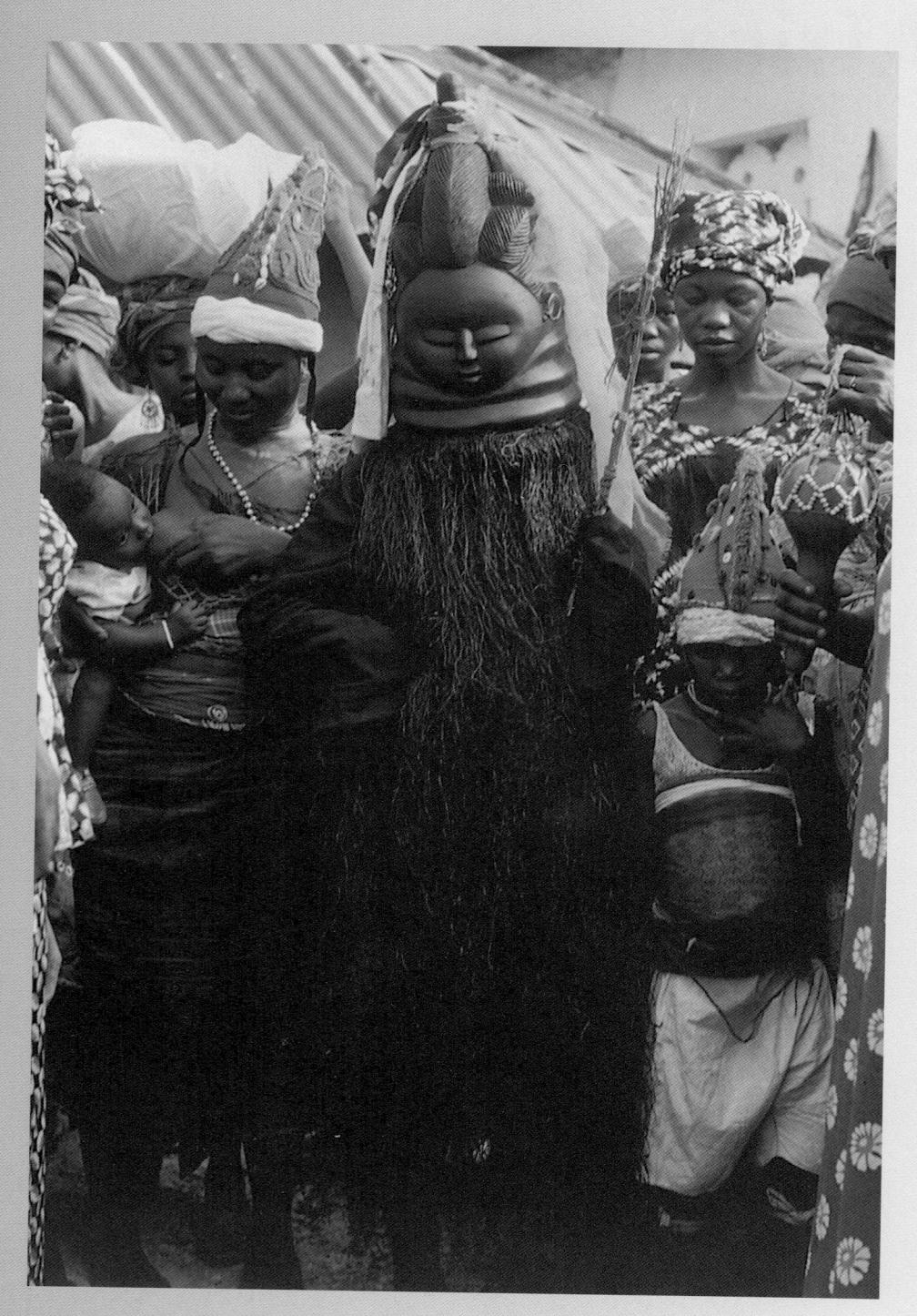

6-1. NÖWÖ MASQUERADE WITH ATTENDANTS, TEMNE, SIERRA LEONE, 1980

IFTEENTH-CENTURY PORTUGUESE adventurers sailing south along the arid coastline of northwestern Africa came to the lush green shores of a region they named Guinea. For centuries to follow. Europeans used the term "Guinea" to refer to most of the West African coast (and to the coins whose gold originated there). Today Africa's westernmost lands are somtimes known as the West Atlantic region, and its forested coasts are divided between the nations of Senegal, Gambia, Guinea Bissau, Guinea, Sierra Leone, Liberia, and Côte d'Ivoire

Although all the peoples of this region speak languages of the great Niger-Congo family, those who speak West Atlantic languages are believed to have been the first inhabitants of the region. Yet over the past five centuries these early cultures have been displaced and absorbed by the expansion of inland cultures related to the Mande-speaking peoples described in chapter 4. The languages of these later immigrants are known as "core Mande" or "peripheral Mande," depending upon their degree of relationship to the speech of the Malinke and Soninke. During the nineteenth century, former slaves from other regions of Africa, and settlers from the Americas, added to the ethnic complexity of the West Atlantic coasts.

Perhaps in response to these ethnic interrelationships, religious associations in the region cross linguistic and cultural boundaries. Art forms connected to these associations are shared

by neighboring cultures even when their languages are unrelated. On the other hand, peoples with similar languages and cultural origins may use very different types of art, or use them in differing contexts. Thus the history of art in this part of the African continent is particularly difficult to reconstruct; even if the name and usage of one specific art object has been documented, similar undocumented works may have served a very different function in other places and in other times.

The arts of the West Atlantic forests include bold murals, elegant ceramic vessels, ornaments and instruments of metal, intricately woven fabrics, and dved bark cloth. However, the region is particularly famous for its masquerades. This chapter therefore focuses upon these multimedia performances, which in some groups address almost every aspect of life. Although women elsewhere in Africa are often excluded from participation in masking, and they are usually barred from performing in wooden masks, here they may own particular masquerades, and even wear the masks themselves.

Masquerades bring together the creative efforts of sculptors, performers, attendants, musicians, and spectators. The artist who carves a wooden head or face for a masquerader may sometimes paint or embellish it, but usually the mask is ornamented and costumed by its owner. The dancer who performs a mask must be sensitive to both the expectations of its empowering spirit (as perceived by the performer and the audience) and the aspirations of its owner.

The ability to create art forms addressing many different needs has

allowed artists from the region to sculpt art forms for foreigners with great success. During the fifteenth and sixteenth centuries, coastal artists carved works in ivory for Portuguese patrons, which found their way to the courts of Europe. During the nineteenth and twentieth centuries, new forms of art and architecture have been made for Muslim communities and foreign settlers. These inventive and innovative art works meld foreign traditions with the aesthetic heritage of the West Atlantic forests.

EARLY ARTS

Very few archaeological excavations have taken place in the westernmost forests of Africa, and thus little is known of art produced in the region prior to European contact. Yet significant works of art, including figurative sculpture in stone and ivory, were being made at least as early as the fifteenth century, when the Portuguese first arrived in the region.

Stone Figures

For generations, farmers in Sierra Leone and adjoining portions of Guinea and Liberia have unearthed small figures carved of soapstone and other types of rock. The imagery and styles of these sculptures are quite varied, especially among those found in the lands now inhabited by the Kissi and Kono people. In lands now owned by the Mende people, farmers place excavated stone figures or freestanding heads in their rice fields or palm groves. Regarded as the representatives of previous owners of the land, the objects are given offerings and asked to bring abundant harvests. Unsuccessful, ineffective statues may be cursed or whipped.

The Mende call these stone images nomolisia (sing. nomoli) or mali yafeisia, "found spirits." When they find buried caches of metal rings, or of figures and heads adorned with rings, both the metal and stone objects are called "spirits of leaders," mahei yafeisia (sing. maha yafei). Mahei yafeisia are treated with great respect, and may serve as the visual and spiritual centerpieces of shrines and other assemblages of sacred material where important oaths are sworn.

Some art historians have chosen to use the Mende term *nomoli* for one distinct style of these stone figures, even though many examples come from non-Mende areas. Perhaps a better term would be "coastal style," since most are found within a hundred miles of the ocean. Coastal-style (*nomoli*-style) figures have domed foreheads, full noses and mouths, and

6-2. Reclining figure, Coastal (Nomoli) style, c. 15th–17th century. Soapstone. Length 14% (36 cm). The British Museum, London

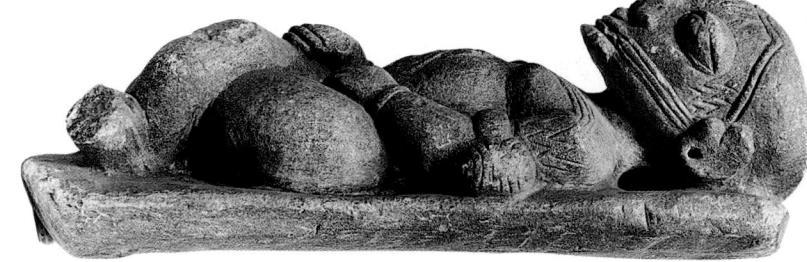

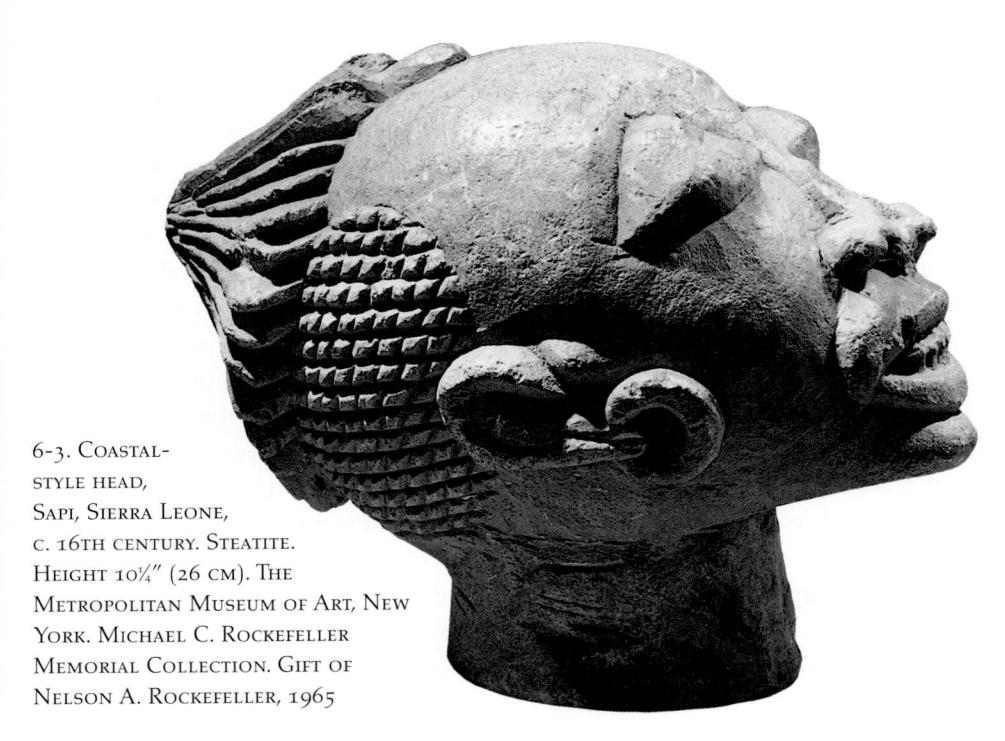

eyes that are precisely carved as spherical globes. An unusually long figure in this *nomoli* style may perhaps represent a corpse lying on a bier (fig. 6-2). The lines across the figure's mouth may depict a beard, common on figures in this style, or refer to the practice of binding a king as part of his installation ceremony, a ceremony still found among the Temne people today.

The sculpted stone head from Sierra Leone in figure 6-3 could have been called a *maha yafei* if it had been found by a Mende farmer. It is set upon a firm base formed by a thick, almost conical neck. Like other examples, this head was made as an independent work and did not once form part of a more complete figure. Although it shares some features with the coastal-style figures described above, some of its characteristics, such as the sharp division between head and neck and the

upturned position of the face, are found only in other stone heads. As is common in these heads, the hair is sculpted in a topknot, and large rings are shown in the ears. The heavy eyelids, almost closed, give the oval face an expression of reserved calm.

When the Kissi of Guinea and parts of Sierra Leone unearth stone figures (including those in a coastal style), they identify them as "the dead," pomtan (sing. pomdo). A Kissi farmer who finds a carved image has dreams linking it to a deceased family member. The dreams allow him to name it, and to place it, together with smooth uncarved rocks, in a community shrine dedicated to the ancestors. It may be first adorned with beads or coins and surrounded by cloth wrappings or a wooden case. Since a corpse carried on a plank by mourners is believed to cause the plank to move in response to questions, a swaddled stone ancestor figure may be placed

on a piece of wood and carried on the head of its guardian during divination ceremonies. In addition, a stone sculpture identified in a dream as the spirit of a powerful man may also be placed in a circumcision camp to protect and assist his descendants and the other boys undergoing initiation.

6-4. Bearded Rider, Inland/Kissi style, Guinea, Sierra Leone. Musée Barbier Mueller, Geneva

While the coastal ("nomoli") style apparently ceased to be carved after the cultural disruptions of the late sixteenth century, we have no way of dating objects in the diverse inland ("pomtan") styles. Some inland styles may be as old as the coastal style itself, yet others must be more recent; there is some evidence that Kissi and Temne artists carved stone images into the early twentieth century.

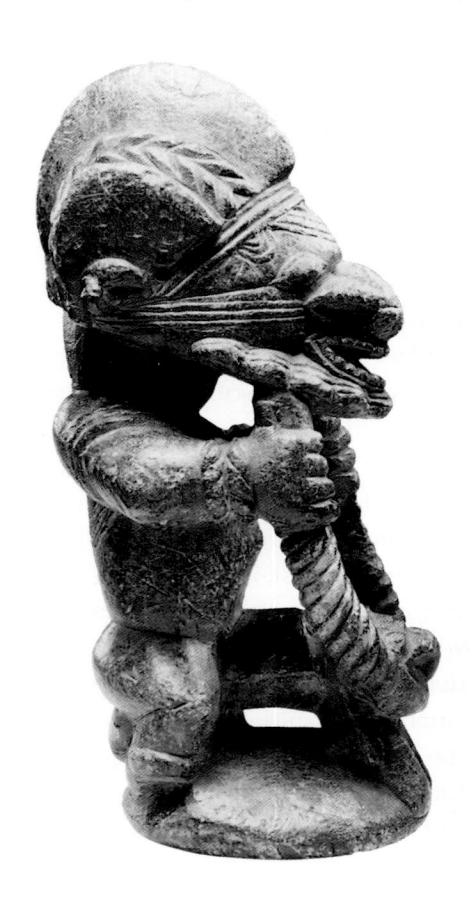

All stone figures in non-coastal styles have been given the Kissi names pomtan and pomdo by art historians, even if they were not found in Kissi territory. It would be better to refer to them as "inland styles." Some of these styles consist of simple cylinders with rudimentary faces, or spherical heads attached to cylindrical bodies, but others are quite detailed. A particularly compelling inland ("pomdo") style is exemplified by a seated figure with an open mouth and long teeth, who seems to be astride a mount whose horns or reins he holds (fig. 6-4). As is typical in this style, the eyes have the shapes of grains of rice, and the forehead merges with an elaborate hairstyle or crown.

Stone sculpture from the West Atlantic forests cannot now be dated by physical analysis. An eroded wooden figure in the coastal style has been given radio-isotope dates of approximately AD 1200 to 1400, suggesting that the stone figures of this style may be contemporary to Jenneand Sao-style terracottas (see chapters 3 and 4). Additional support for these dates comes from a remarkable body of art carved by Africans for European clients. These objects are known as the Sapi-Portuguese ivories.

Export Ivories

Portuguese explorers of the fifteenth century landed on the coastal sand bars northwest of the hills they were to name Sierra Leone. There they encountered a cluster of peoples they referred to as the Sapi. Apparently the Sapi extended from the central coastline of present-day Guinea to the central coastline of present-day Sierra Leone. Ancestors of the Bullom (some

of whom were also called the Sherbro), the Temne, and the Baga, they were related as well to the Kissi and to other groups speaking West Atlantic languages. A Portuguese book written by Valentin Fernandes and published in the early sixteenth century characterized the Sapi as peaceful and prosperous, and recorded that "the men are very ingenious, and they make ivory objects that are wonderful to see."

Portuguese sailors may have collected ivory objects as souvenirs during their first visits to the Sapi region. By the last decades of the fifteenth century, they were commissioning works of art from Sapi sculptors to bring home to patrons in Europe. Sapi-Portuguese ivories included spoons, cylindrical boxes, hunting horns, and covered bowls, all carved with detailed images.

Covered bowls such as the one in figure 6-5 resemble European lidded chalices in their overall shapes. However, written inventories of the sixteenth century show that these art

6-5. Saltcellar, Sapi, c. 1490–1530. Ivory. Height 13¾" (33.7 cm). The British Museum, London

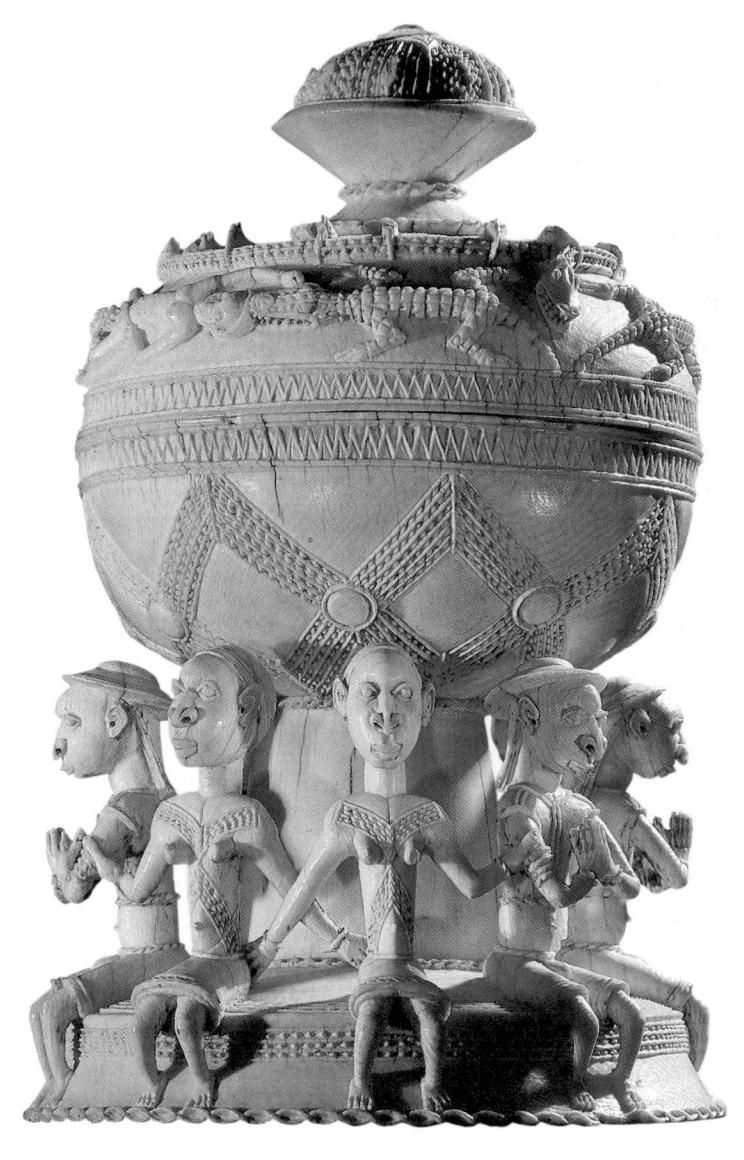

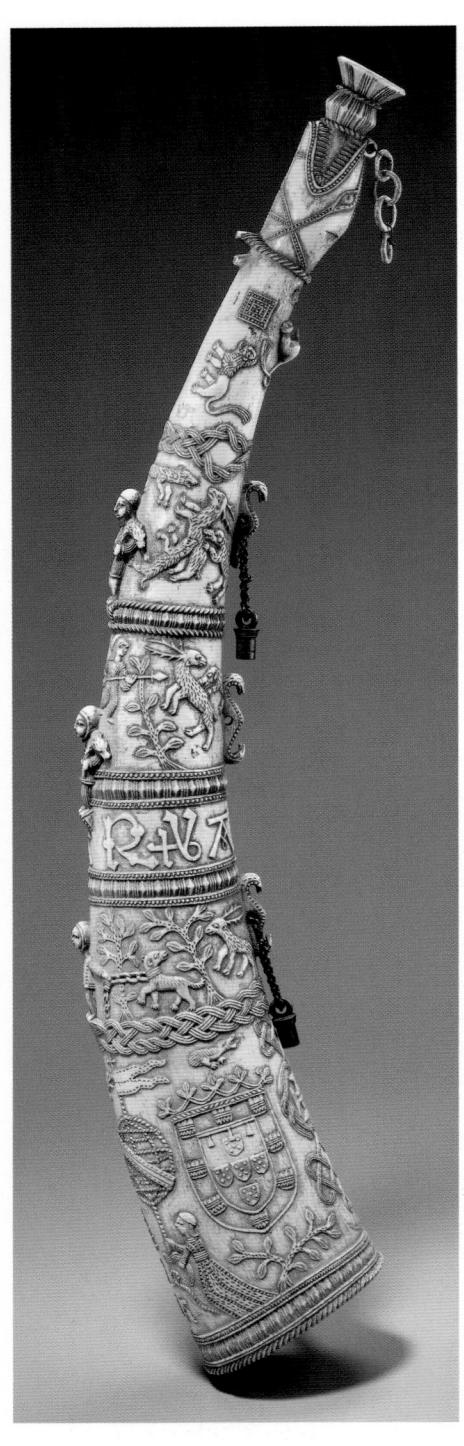

6-6. Olifant, Sapi-Portuguese, late 15th century. Ivory, metal. Length 25¹/₄" (64.2 cm). National Museum of African Art, Smithsonian Institution, Washington, D.C. Gift of Walt Disney World Co., a subsidiary of The Walt Disney Company

objects were used as saltcellars. Salt was a valuable commodity in Renaissance Europe, and elaborate containers for salt were popular with wealthy European merchants and aristocrats. The shape of this ivory saltcellar may have been based upon tableware owned by captains of Portuguese ships. Yet its geometric patterns may be derived from Sapi designs used for scarification, calabash decoration, pottery, or housepainting. On the lid of the vessel, crocodiles carved in shallow relief attack a nude figure not visible in the illustration. The crocodile is a potent image in coastal arts of Guinea today, and this gory scene may have been related to religious beliefs of the period. However, it may also have been an exotic or titillating element added primarily to interest European patrons.

The ring of figures encircling the vessel are carved in the coastal style; their heads are only slightly more delicate than that of the reclining stone figure (see fig. 6-2). The female figures wear only short wrappers or skirts, and appear to be Sapi women, while the male figures (with long straight hair, shirts, and trousers) join their hands in the position used by Europeans for prayer, and appear to be Portuguese. The supportive or possessive gestures of the female figures remind us that sixteenth-century marriages between Portuguese traders and African women were creating prosperous family partnerships in new settlements along the western coasts of Africa.

Today leaders of many communities in Sierra Leone and Liberia are accompanied by heralds blowing ivory horns when they appear at important events. Centuries ago such instruments may have inspired Portuguese visitors to request Sapi artists to carve imitations of European hunting horns, or olifants (fig. 6-6). Unlike instruments carved for local African usage, olifants (named for the elephants supplying the ivory) were blown from the tip of the tusk rather than from a hole on the concave surface. This Sapi-Portuguese olifant displays hunting dogs, stags, and other beasts. Its huntsmen have tiny coastal-style faces. These images were evidently taken from illustrations in Portuguese books, which were given to the Sapi artists as models. Braided, ridged, and twisted bands of ornament separate the scenes into registers, just as the pages of the books were framed by designs. The coat of arms and mottoes of the kings of Spain are accurately reproduced here, indicating that the horn may have been intended for a Spanish aristocrat. As Fernandes noted, "whatever sort of object is drawn for them, they can carve in ivory."

Sapi artists created such faithful renditions of European images that eventually these ornate horns were attributed to European artists; some have only recently been reidentified as African art. These Sapi-Portuguese ivories were able to lose their African identity so easily because they are the earliest West African examples of what art historians have termed "tourist art"; they were made to satisfy foreign visitors rather than to be used in their culture of origin.

Portuguese records indicate that Mande-speaking warriors arrived on the coast in the middle of the 1500s, disrupting and destroying Sapi communities. By the end of the sixteenth century, Sapi artists were no longer making ivories for export. Although many peoples of Sierra Leone now carve wooden figures, the modern styles are quite different from those of the Sapi.

MASKING AND RELATED ARTS

While some sculpture of the West Atlantic forests can be dated to the sixteenth century, masks are not mentioned in European accounts until the seventeenth century.

Masquerades were apparently documented first in the northern portions of the West Atlantic forests. The following brief survey of regional West Atlantic masquerades thus begins in the north and moves southward

Initiations of the Jola, the Bidjogo, and their Neighbors

In the last years of the seventeenth century, a European traveler named Froger reported seeing a "circumcised" man wearing a horned headdress in the town of Barra, on the banks of the Gambia River. Europeans knew the region south of the Gambia River as the Casamance, after the Kassa Mansa or king of the Kassa people, and the Kassa (a small West Atlantic-speaking community) still live in the Casamance region. Although the Kassa do not perform masquerades today, several neighboring groups do. Most information on seventeenth- and eighteenth-century masking in the Casamance region comes from the Jola (Diola) people. A researcher showed Jola elders photographs of woven, horned headdresses that have been documented as entering European collections (fig. 6-7)

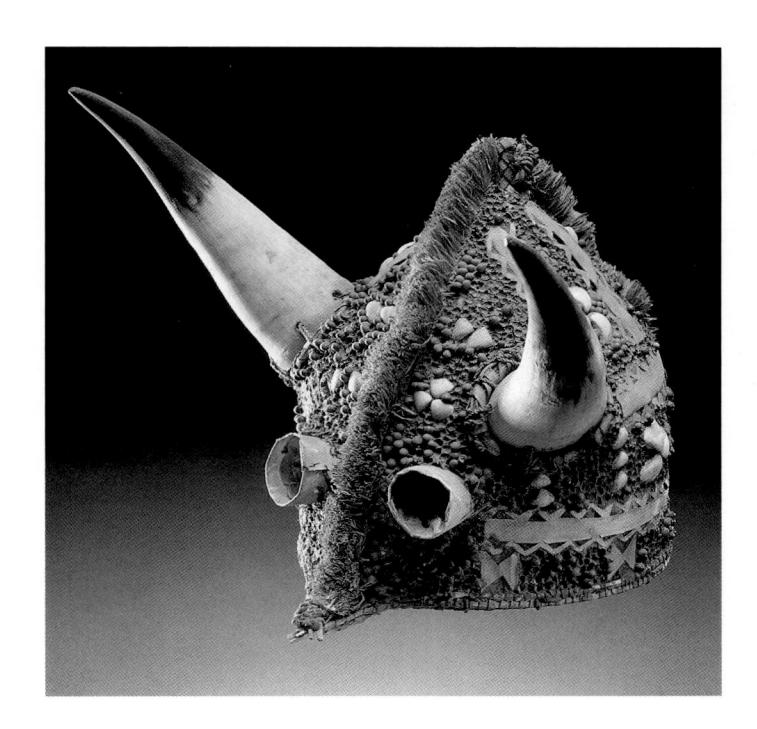

6-7. Kebul (Horned Mask), Jola or Neighboring People, Before 1942. Horns, Red Seeds, Shells, Raffia. Musée Barbier-Mueller, Geneva

during that period. The Jola identified them as a *kebul*, an older version of a rare horned mask called *ejumba*.

An *ejumba* may sometimes appear in Jola communities when the young men of an age-grade return from the ordeals and training period that have prepared them for adulthood. It is only worn by the spiritual leaders of the graduates, for the tubular eyes are associated with clairvoyance, their ability to perceive invisible supernatural forces. The fiery red color of the seeds affixed to the woven surface of the mask may assist these young men in their battles with sorcerers, while the white seashells are those used by diviners to predict the future.

Horned face masks like the *ejumba* are much rarer today among the Jola than they are among neighboring groups such as the Balanta. Yet in several Casamance groups (including the Jola), youths still dance in caps supporting a pair of cow's horns at the beginning of their initiation, and

some of these horned headdresses are elaborate constructions hung about with mirrors and cloth. Horns on both headdresses and face masks could once have been tangible evidence of the young men's success in cattle raids, for throughout the Casamance region of Senegal (and in the neighboring nation of Guinea Bissau), age-grades were expected to steal their neighbors' cattle. These cattle raids allowed them to accumulate enough wealth to marry, and provided proof of the age-grade's military abilities. Today the horns testify to the generosity and prosperity of the community supporting the initiates, for they are taken from the cattle slaughtered to provide meat for the feasts given on behalf of these young men.

These horned masks and headdresses have their counterpart in the dramatic age-grade displays of the Coniagui and the Bassari (Balian), who live to the southeast of the Iola

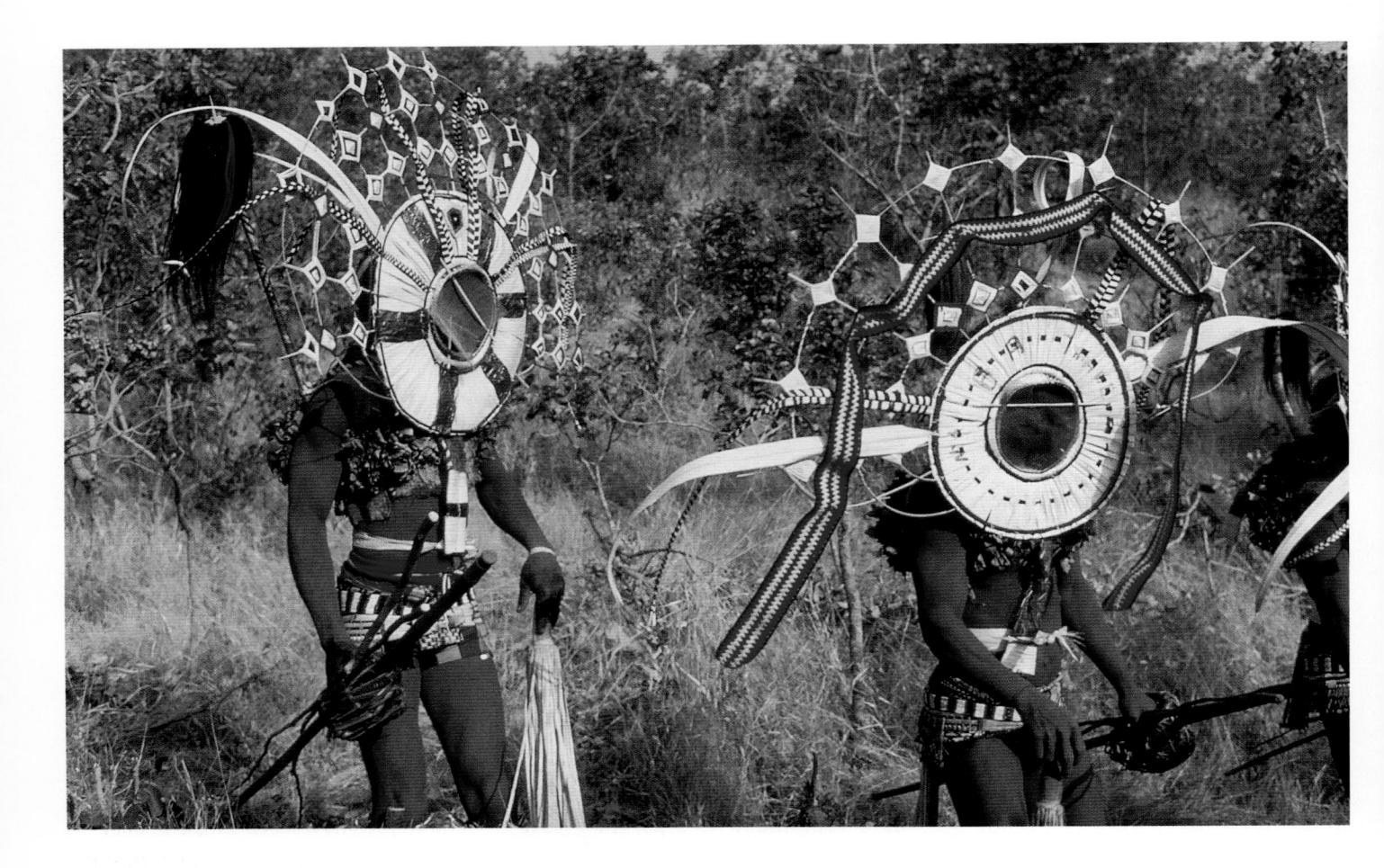

on the border between Guinea and Senegal. Circumcised boys of the Bassari are supervised by two older age-grades as they are symbolically killed and reborn as men, and each of the supervisory grades appears in elaborate finery. A series of photographs shows one of the three agegrades in a Bassari community wearing woven disks with radiating attachments of fabric and fiber; in some cases their faces are hidden behind veils of green mosquito netting (fig. 6-8). Evidently these boys are the younger supervisors; the older supervisors wear huge headdresses, crests woven of colored palm fiber.

The male age-grades of the Bidjogo, a West Atlantic-speaking group who live on the Bissagos Islands off the coast of Guinea Bissau, are also known for their striking costumes and masquerades. Just as Casamance boys wear horned caps to show that their age-grade is preparing for initiation, some Bidjogo boys wear horned headdresses when their age-grade is formed. Whereas Casamance peoples identify the young men with the bulls sacrificed so that the ceremonies may begin, the members of the youngest Bidjogo age-grade are dressed as calves. Bidjogo boys may also wear headdresses linking them to non-threatening species of fish.

When a Bidjogo age-grade has passed through this first level, its members become warriors, and prepare for initiation into mature adult-

6-8. Bassari male initiates, Casamance region, southern Senegal, 1980

Photographs of the spectacular arts related to the male age-grades of the Coniagui and Bassari peoples are not accompanied by documentation, while published descriptions of art forms from the region (including the crested roofs of the age-grade's dormitories, masks for male associations, and images carried by girls) were not illustrated by their authors. The Coniagui and Bassari are thus examples of the many African peoples whose varied and beautiful arts are virtually unknown to outsiders.

hood. The new warriors wear heavy headdresses and other wooden attachments (feet, fins, etc.) to mimic the appearance of swordfish, sharks, hippopotami, or crocodiles. All these wild animals are extremely dangerous for the ocean-going canoes of the Bidjogo, and the large heavy costumes demonstrate the courage and strength of the dancers.

Particularly evocative helmet masks allow some Bidjogo warriors to become untamed and ferocious bulls (fig. 6-9). The Bidjogo once sent their youths to the mainland to raid cattle, and (like Casamance peoples) they associate bulls with this type of warfare. Cattle masqueraders imitate the bellowing charges and wild behavior of untamed bulls, and must be held back with ropes.

Should Bidjogo youths die before their age-grade has been initiated into mature adulthood, they are believed to become restless spirits, ghosts who must be laid to rest by girls who undergo initiations on their behalf. During the final initiation ceremonies of the male age-grade, young women wear headdresses similar those worn by the boys for their first age-grade displays. Each young woman is possessed by the spirit of a youth, and during the ceremony the deceased youth speaks to his family through her chants and her gestures. The rites are a vivid reminder of each individual's value to his relatives and to the community.

The spectacular and theatrical nature of Bidjogo masquerades was once matched by the age-grade displays of peoples on the mainland. In the 1930s, Papel initiates dressed as enormous sea snails were photographed wearing models of sailing

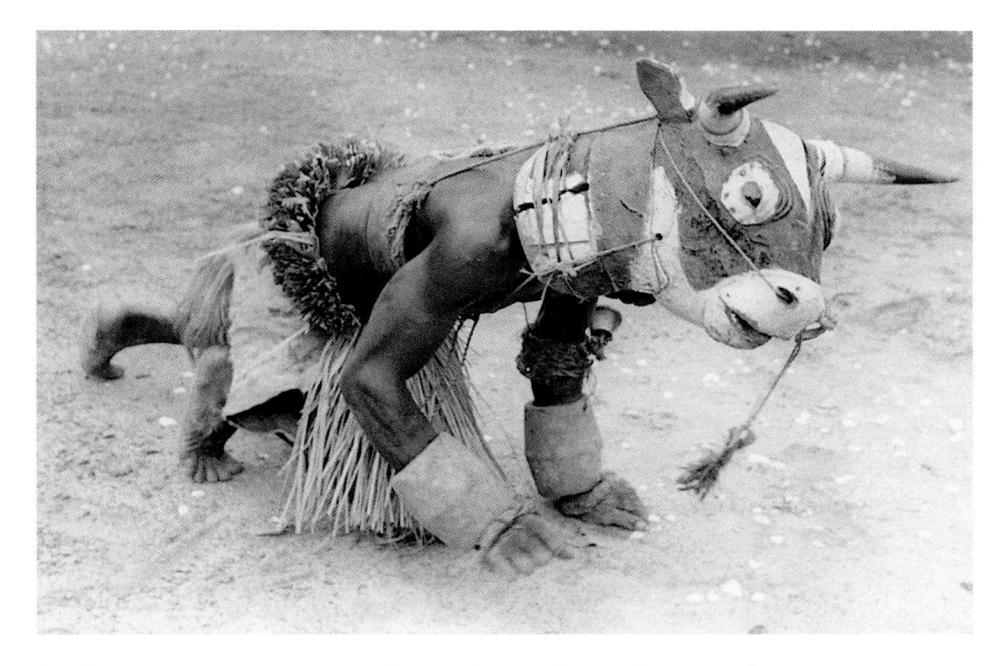

6-9. Bidjogo cattle masquerade, Urcane Island, Guinea Bissau, 1978

6-10. Carnival masquerader, Bissau, Guinea Bissau, 1987

ships on their heads. Other photographs of the era show Papel and Manjaka youths wearing constructions in the shape of airplanes. Today these peoples no longer have such elaborate age-grade ceremonies, but create wonderfully inventive masquerades for Guinea Bissau's Carnival celebrations.

Carnival in Bissau, the capital of the nation of Guinea Bissau, is linked to celebrations in the Cape Verde Islands and Brazil. Although inspired by the Christian calendar, the festival has a distinctly secular focus. Papiermâché costumes that appeared in a 1987 Carnival procession publicized the need for inoculations (fig. 6-10). One took the form of a syringe, and another the child to be inoculated. The expansive and bulbous shapes of the enormous faces and stomachs were enhanced by elephantine ears. Although these masqueraders may appear completely modern in both style and imagery, they are direct

6-11. Iran (shrine figure) for Orebok-Okoto, Bidjogo. Wood, pigment, metal, cloth. Height 17¼" (43.8 cm). Fowler Museum of Cultural History, University of California, Los Angeles

descendants of the sailing ships and airplanes of early twentieth-century masquerades.

Just as age-grade masquerades link the Bidjogo to peoples on the mainland, certain protective art works seem to be shared by West Atlantic speakers as well. The Bidjogo use hollow cylinders covered with red cloth to house guardian spirits; both the sacred object and its indwelling spirit are often known by the Krio (Creole) term *iran*. The most important of these spirit beings is the divinity who oversees a town or lineage, known as Orebok-Okoto. These images are owned by the male leader of the community, but both an *iran* and its shrine are cared for by a woman. One *iran* for Orebok-Okoto is surmounted by a human head wearing the nineteenth-century European top hat favored by coastal leaders (fig. 6-11). The imported metal set into the eyes adds aesthetic and economic interest to the sculpture.

Performed Art of the Baga and their Neighbors

A type of sacred object similar to the *iran* is found to the southeast of the Bidjogo, along the coasts of northwestern Guinea. These lands are inhabited by small populations, including Baga groups, the Nalu, and the Landuman. Here the protective image is known by a variety of names. Most of the Baga call it *a-tshol* (pl. *tshol*), a word they translate as "medicine," although other terms (such as *elek* or *nach*) may also be used by the Baga and Nalu.

Like the *iran* of Orebok-Okoto, an *a-tshol* has a cylindrical base with one or more openings where spiritually charged substances and regular sacrifices can be placed (fig. 6-12). However, the human forehead, ears, and nose of the head of the *a-tshol* merge into a long, curved, bird-like beak. It is said to be a composite creature, capable of traveling through air, water, and earth. An *a-tshol* also refers to wealth, elegance, and leadership through its expensive metal studs, its elaborate crested coiffure, and its base, which resembles the

stools used by leaders.

An a-tshol is owned by the head of a clan, and may be seen as a manifestation of God. It is judge, healer, and supreme authority within the clan. A Baga leader guards it in a shrine, together with an assemblage of relics, a powerful helmet mask, and substances containing supernatural power. Some of these potent materials may be inserted into the geometric holes in the head and cylindrical base. During important events in the lives of clan members, the head of an atshol can also be detached from the base, and can even be worn as a headdress by a dancer. These events include planting and harvest ceremonies and the settlement of major disputes. Before the colonial era, they had no kings, judges, lawyers, police, or prisons; their lives were regulated by elders, prophets, and the sacred powers embodied by art objects such as this.

Tshol are joined by a large number of other masquerades in this section of the West Atlantic forests. A particularly impressive type is called *a*mantshol-nga-tsho ("master of medicine") in one Baga group. Outsiders often refer to it by the foreign name basonyi, taken from the neighboring Susu people who have admired its performances. This is a serpent-like being, apparently danced by Nalu and Landuman peoples in addition to the Baga. Although each masquerade may be sponsored by a specific lineage, all are inspired by a serpent spirit common throughout the region, who is identified with the water and the rainbow, with fertility, and with wealth.

In one example, the diamondshaped markings on the undulating

6-12. A-Tshol ("medicine"), Baga or Nalu. Wood and Brass upholstery tacks. Length of Head 31%" (80 cm). University of Iowa Museum of Art, Iowa City. Stanley Collection

Although sacred art forms such as a-tshol were outlawed by the Marxist government of Guinea at the nation's independence in 1958, some shrines seem to have survived in secret. Since the fall of that government, some a-tshol have come out of hiding, and others are being carved by young men intent on reviving past traditions.

surface of the wooden snake balanced by the dancer are heightened by the patterns on the cloth surrounding its base and covering the dancer's raffia cloak (fig. 6-13). The round eyes of the serpent, always mentioned as frightening or piercing, are isolated and emphasized by their placement at the very top of the sculpture. Even though this photograph was not taken during a performance, it shows that the heavy wooden form was balanced on the dancer's head. However, peoples in the region describe the towering red, white, and black serpent as gliding smoothly over rice fields as it leaves the forest to appear on the outskirts of the community.

Yet another dramatic masquerade is known as *banda* among the Nalu

and kumbaduba among the Baga (fig. 6-14). The heavy wooden mask of banda combines the jaws of a crocodile, the horns of an antelope, the sensitive ears of a forest creature, and the tail of a chameleon (located between the horns of the masks here). Its prominent nose recalls that of a-tshol, although the other surfaces on the larger headdress are flatter and more geometric. The elaborate crested hairstyle of a-tshol also appears on banda, but here the incised details of scarification and coiffure are emphasized by painted decoration rather than by metal tacks. Some of the floral or stellar shapes ornamenting banda are similar to those found on imported dishes and other trade goods, and may be related

6-13. Serpent Masquerade, Nalu (?), Boke region, Guinea, 1950s

to motifs on textiles once woven in Senegal, Guinea Bissau, and the Cape Verde Islands for African and European patrons.

Banda is renowned for its spectacular dance movements, its ability to

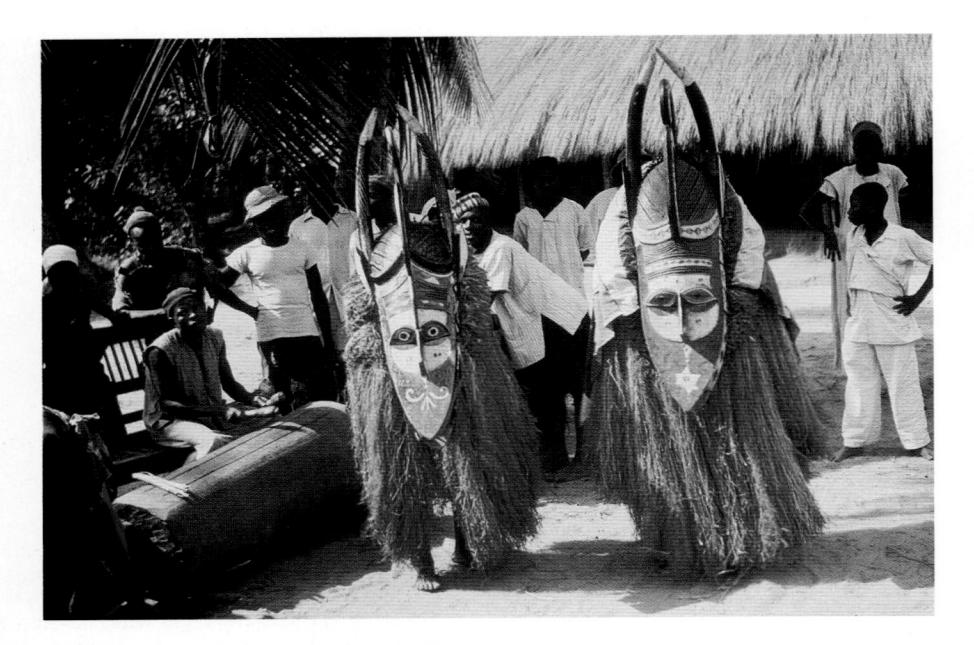

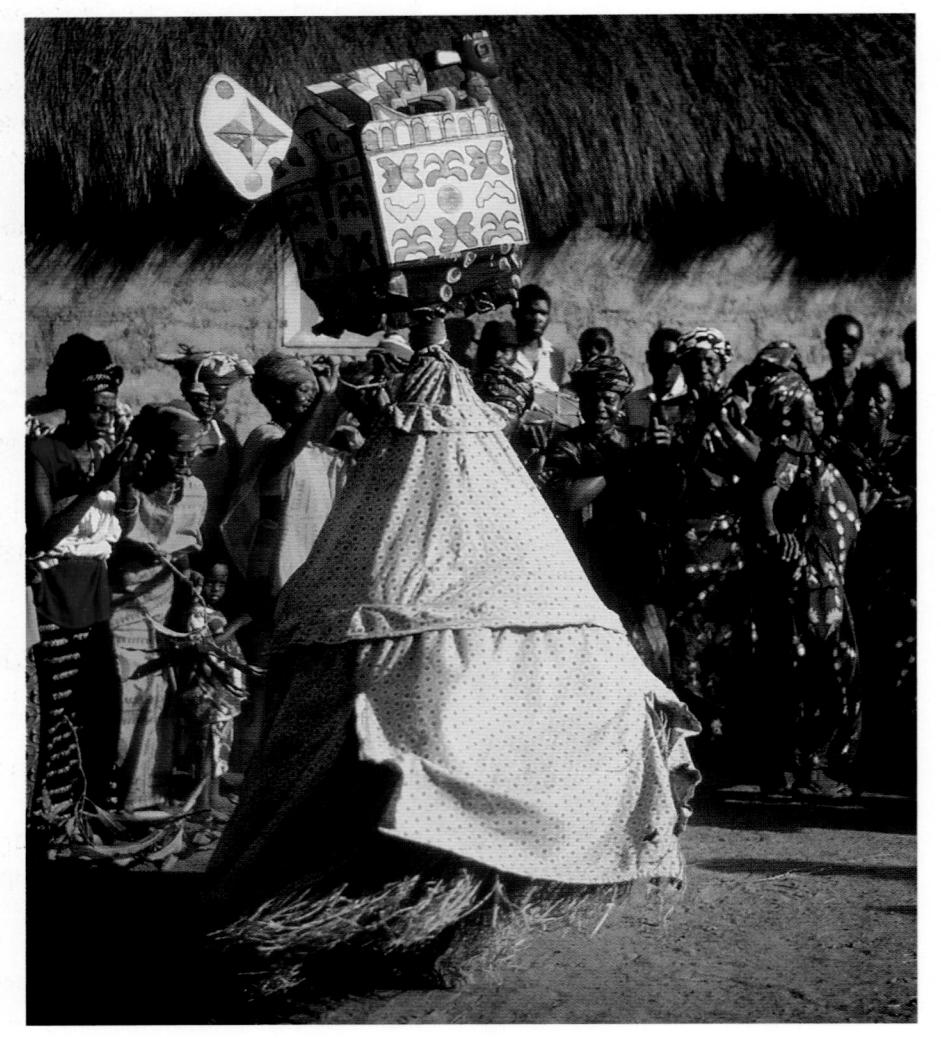

6-14. *BANDA* masquerades, Nalu, Koukouba, northern Guinea, 1950s

These Banda masqueraders danced for a photographer in the 1950s in the Nalu town of Koukouba, in Guinea. He may have provided the dancers with masks, since one of the masks is now in a European collection. Performances by the Nalu for outsiders were not new; an older photograph shows a group of four Banda masqueraders dancing in Paris in 1912.

spin high in the air and low to the ground. Its acrobatics are extraordinary when we consider the substantial weight of the mask itself. In the nineteenth century, *banda* seems to have appeared at initiations, harvest ceremonies, and funerals, but today this dramatic masquerade is danced primarily for entertainment.

Recent masquerades in this area are often associated with Islam. One well-documented form, named al-B'rak (or al-Barak), was invented by a Baga artist named Salu Baki (died 1993) in 1955 (fig. 6-15). Al-B'rak is a loose adaptation of the mysterious, winged, woman-headed mare who is believed to have carried the prophet Muhammad on a mystical flight. The body of the horse has been transformed into a box, while the female head is now male. Like the serpent masquerade and the danced a-tshol, al-B'rak is a three-dimensional wooden sculpture placed atop a narrow stem enveloped in raffia and covered with cloth. Salu Baki's son had learned to create shapes with rulers and compasses at school, and the artist adapted these for the designs on his masquerade. However,

6-15. *AL-B'RAK* MASQUERADE, BAGA, NORTHERN GUINEA, 1990

the multicolored shapes on the white surface also recall those of earlier banda masks.

At the time *al-B'rak* was invented, Muslim missionaries were converting many of the coastal peoples of Guinea, and destroying the sacred art objects of the past. This iconoclasm continued during the Marxist regime of 1958 to 1984, when most non-Muslim art forms were banned. Only ostensibly new masquerades associated with Islam, such as *al-B'rak*, could be danced without fear of reprisal.

One of the masquerades suppressed by Muslim leaders and the Guinean government was the famous d'mba (or nimba) of the Baga. D'mba had been a monumental image of a strong, mature woman. During masquerades her enormous wooden head towered over the celebrants (fig. 6-16). Her flattened breasts identified her as the ideal mother, who had suckled many children and tied them to her back. Her full body was composed of the raffia substructure common to other Baga masquerades, while her elaborate hairstyle (emphasized with shiny metal studs) was similar to the ornamentation of a-tshol.

Simply carrying the large, heavy sculpture would have been a feat of strength; only exceptional performers could have made this feminine ideal move gracefully and serenely through the town. *D'mba* greeted important visitors, and her image could be seen on other art forms (such as figures and drums) associated with female leadership. She appeared during harvest festivals and other celebrations, and was showered with rice. Women who touched her breasts

6-16. *D'mba* mask, Baga, Guinea. Wood, copper nails, pieces of fabric, fibres. Height 7'2½" (2.2 m). Musée du Quai Branly, Paris

or her swirling fiber skirts were blessed with healthy children and productive fields.

Since 1984, non-Islamic religious arts have no longer been illegal, and masquerades can now be danced more openly. Revivals of *d'mba* now join a host of newer performances, including several smaller and more naturalistic versions of female busts atop a cloth and raffia base. She is once again civilized, beautiful, and an inspiration to the women of a community. Of all the masquerades of this portion of the coastal region, *d'mba* is closest to women's masks of Sierra Leone and western Liberia.

Women's and Men's Societies: Sande/Bondo and Poro

Powerful pan-ethnic associations for women and men are an important feature of much of the West Atlantic region. The following descriptions of these widespread organizations are based upon extensive research, conducted prior to the civil wars and anarchy that destroyed many communities of Sierra Leone and disrupted most of Liberia during the 1990s. As the region attempts to recover from the horrors of these wars, men and women are evidently reviving some of the institutions that formed a foundation for civil society in the past.

The women's society known as Bondo or Sande is found among West Atlantic-speaking peoples (including the Gola and Temne), Mande-speaking peoples (including the Mende, Vai, and Kpelle), and the Bassa, who speak a language of the Kru family. Sande or Bondo officials take female children into a shelter in the forest, where the girls learn the secrets of womanhood, and undergo a clitoridectomy. When the initiates have completed their training, they are presented to the community as fully mature women. In all of these groups, carved wooden headdresses are danced by leaders of the women's association to make manifest the spirits who guide them. A masked spirit is seen as one embodiment of the mystical power (sometimes translated as "medicine") of Sande/Bondo. Although each masquerader has her own individual name and identity, generic terms can also be used, including ndoli jowei, "the Sande leader" or "the expert leader who dances" (in Mende communities).

These general references stress the masquerader's role as a lead dancer and as a high-ranking official of Sande/Bondo.

In a photograph taken during a Bondo ceremony of the Temne people, an important masquerader (here known as nöwö) is surrounded by her attendants (fig. 6-1). Every aspect of the masquerade is linked to the character of her spirit, and to the roles and values of the Bondo association. The white scarf tied to the central projection at the top of the helmetlike head of the nöwö shows her solidarity with the initiates, who are covered in white pigment during their initiation as a demonstration of their liminal, otherwordly status. The concentric bands at the base of the mask are compared by the Temne to the ridges ringing the hard black chrysalis of a species of moth. Since the nöwö is responsible for the transformation of children into fully feminine, sexually mature women, it is the equivalent of a chrysalis that protects the metamorphosis of a winged creature.

Among many Mende groups, the encircling ridges are also references to the origin of the mask. When a particularly wise and respected Sande official is renowned for her abilities as a dancer and choreographer, she dreams of plunging into a pool or river, the dwelling place of female spirits. As the leader emerges from this watery realm, she brings with her the conical head of the Sande spirit. The ripples formed on the water as she surfaces appear as rings around the base of the mask.

Other features also refer to the miraculous creation of the mask. The Sande official falls unkempt into the water, but emerges with beautiful

6-17. Mask for Sande/Bondo, Mende, or Bullon, Sierra Leone, late 19th–early 20th century. Wood, silver. Height 16" (40.5 cm). Brooklyn Museum, New York. Robert B. Woodward Memorial Fund & gift of Arturo and Paul Peralta—Ramps

clothing and elaborately braided hair. The coiffure of the wooden headdress is therefore complex and crisply carved. Girls who appeared to their communities at the conclusion of Sande and Bondo initiations once wore similarly elegant hairstyles, signs of orderly and civilized life. A helmet mask from Sierra Leone emphasizes the links between high status and exquisite grooming, for it wears an elegant version of a European crown (fig. 6-17). The surface of the mask is a glossy black, the color

of the mud on the river bottom (as is the costume of thick strands of raffia palm fiber). Black is also the color of clean, oiled, healthy, and beautiful human skin, and initiates are praised for their glossy complexions when they exhibit their virtuosity as dancers during the concluding ceremonies.

The delicacy and the reserved expression of the face of nöwö (mirrored in the demeanor of the attendants) are the result of the training girls receive during Bondo and Sande. The initiates learn wisdom, beauty, grace, and self-control, all of which they will need within the multigenerational, polygamous households of their future husbands. The antithesis of these values is demonstrated by the masked and unmasked clowns who accompany the nöwö, sowei, or ndoli jowei. A clown (known among the Mende as gonde) wears an ugly and disfigured version of the leadership masks, or a beautiful mask that has become old and damaged; it dances in an uncouth, clumsy manner.

A small, sculpted version of the lovely head of a Bondo or Sande masquerader appears on staffs and other objects used by officials of the association, reminding observers of the spiritual source of the women's authority. Freestanding figures may also be stored with the masks and other materials that act as a group's spiritual power ("medicine").

In many areas, Sande associations alternate their training sessions with those of the men's association, known as Poro. During the period set aside for Poro, a *sowei* or *ndoli jowei* may only appear for the funeral of an important Sande official, or when men break the sacred laws of the association and must be judged and
punished. Poro masquerades are only performed during Sande training periods when the same conditions apply.

Poro circumcises young boys and initiates them into adulthood, just as Sande excises young girls and prepares them for sexual maturity and married life. Poro groups of the Gola people may bring out a Gbetu masquerader who dances with a beautifully carved wooden helmet. Yet Poro leaders in Sierra Leone and Liberia often do not wear wooden masks, and in some cases do not even wear concealing costumes; the presence of the fearsome but invisible spirit, the Great Thing, of Poro is thus made known through its voice alone.

However, Poro groups among the Mende people own powerful masquerades such as goboi and gbini (fig. 6-18). Goboi appears for regional governors and other important leaders, and for the initiation of their sons into Poro, while gbini can be seen at many Poro events. Both make manifest the spirit of Poro, and emphasize Poro's role in supporting political authority. Unlike the masquerades of Sande, neither incorporates a wooden mask. They are constructed of leather, fabric, and layers of natural (rather than blackened) raffia fiber. Cowrie shells, leather, leopard or monkey skin, mirrors, and wooden tablets inscribed with Qur'anic verses may be attached to the cylindrical headdress and the tiers of fiber. All swing out into space as the dancer spins, or shake with his dance steps.

In the northeast portion of the territory controlled by Poro, Sande masquerades are relatively rare. Here Poro associations of the Gbandi, Kpelle, Kissi, and Toma (Loma) peo-

6-18. GBINI MASQUERADE, MENDE. LEATHER, LEOPARD SKIN, CLOTH, COWRIE SHELLS, RAFFIA

6-19. Toma LANDAI MASQUERADE IN PERFORMANCE

ples allow the Great Thing of Poro to be embodied in a frightful masquerade. Called *landai*, this masked being has a heavy wooden headdress with a great beaked nose, open jaws with jagged teeth, and a full crown of feathers (fig. 6-19). Its eyes stare upwards. *Landai*'s general shape recalls the *banda* masquerade of the Nalu and Baga, but here the effect is terrifying. The voluminous raffia fiber costume is white, but the mask is black, with a bloody red mouth.

Everywhere the Poro spirit is said to eat boys alive before spitting them out as adult men, so that the scars

6-20. NOYON NEA MASQUERADE, KONO, SOUTHWESTERN GUINEA, 1950S

Miniature versions of the mother of Poro may be given to Poro graduates as a sign of their spiritual identification with the association. In a similar fashion, Dan men and women (who live to the east of the region under Poro authority) may own miniature masks to show that their families are linked to a specific masked spirit.

borne by Poro initiates are the marks of his teeth. *Landai* gives this concept a physical presence, for red kola nut juice can drip from his mouth after he has "consumed" a youth. While both *gbini* and *landai* are non-human forms, *landai* belongs much more emphatically to the fearsome world of the forest. It reflects the influence of peoples living to the east, whose masquerades make manifest a variety of supernatural forest beings.

Poro masquerades are not always frightening. In many Kono and Mano communities of northeastern Liberia and southernmost Guinea, the guardian of Poro initiation is a beautiful female masquerade, honored as the mother of all other masked spirits, who appears to boys as they enter the Poro enclosure. She gathers food and supplies during the boys' seclusion, and may convey news to their families. Even though this female spirit is animated by a man, it is usually owned by the woman who is the only female elder allowed within the initiation center.

One of these female masquerades appeared in a Kono community, probably when the photographer commissioned a group of masked dances (fig. 6-20). The mask itself is polished a shiny black, and has subtly modeled eyebrows and cheekbones. The rounded forehead of the top half of the mask, and the slightly uplifted chin of the bottom half of the mask, form two tilted planes intersecting at the eyes. The eyes themselves are painted white, possibly as a reference to the far-sighted gaze of Poro, while the pursed lips seem to be drawn into a silent whistle.

A powerful masculine masquerade known as go may also visit Liberian youths being initiated into Poro. In some areas, the masqueraders are members of the Go, or Leopard, society, a closed association drawing its members from several different ethnic groups. Elsewhere, go is merely a respectful title for a particularly powerful masquerade. Go masks exaggerate the features of the female Poro spirit; soft cheekbones become sharp triangles, small noses spread outward and upward, closed oval eves become tubular protrusions, and the delicate chins and lips are transformed into wide muzzles.

A go ge (ruling spirit, or lord, of Go) was carved in the middle of the nineteenth century for a Mano judge and lawgiver (fig. 6-21). It was consecrated with human sacrifice and smeared with the blood of executed criminals; the uneven teeth may be those of a dead man. It was once owned by a respected Mano blacksmith named Gbana, who had inherited it from his grandfather. When the elders of neighboring communities assembled secretly at night to settle an urgent problem, Gbana would bring his mask, wrapped in black cloth. At the appropriate hour he unwrapped the object, laving it before

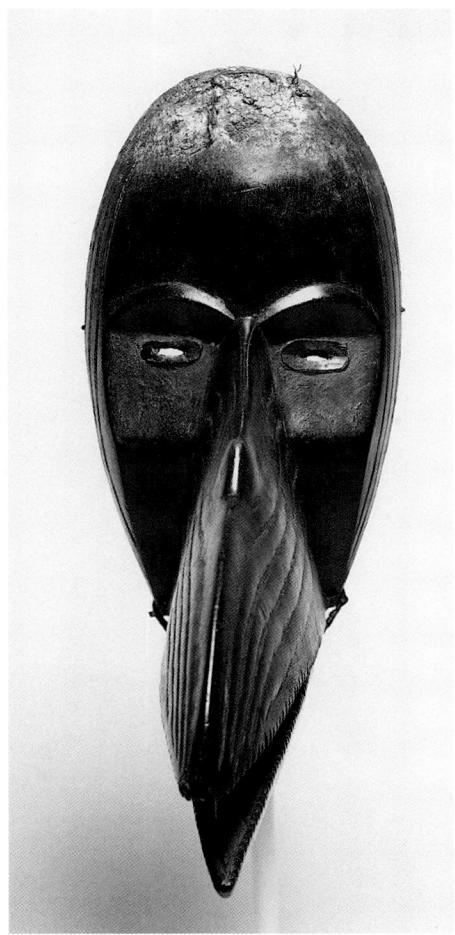

6-21. GO GE MASK, MANO, C. 1850. WOOD. PEABODY MUSEUM, HARVARD UNIVERSITY, CAMBRIDGE, MASSACHUSETTS. M.A. HARLEY COLLECTION

In the late 1930s, Liberian administrators forced judgment and lawgiver masks, such as this go ge, into retirement; all governing authority was to be in their hands. The mask thus came into the possession of George Harley, an American medical missionary who was a friend of the owner and his family.

him on a mat and asking it to support the decisions of the elders. Gbana alone was able to petition the mask and to interpret its response. The number of attachments hanging from the mask tallied persons killed by the mask's supernatural power or executed in its name.

Although only a few Mano masquerades have the status of a go ge, masks and costumes are kept in a shelter located within a sacred enclosure near the community's meeting place, and are brought out to bolster the authority of its leaders. Some masquerades judge disputes between families or individuals, collect debts, or supervise the distribution of food at funerals and other feasts. One of these important Mano masquerades takes the form of the hornbill (fig. 6-22). The nose and mouth merge into a graceful, curving beak, ridged here into rhythmic lines. Small striations along the open beak possibly represent teeth. Even though the hornbill is an ungainly bird, this mask is an

6-22. HORNBILL MASK, MANO, 19TH CENTURY. WOOD, METAL, TEXTILE, FIBER, INK. HEIGHT 15" (38 cm). Fine Arts Museums of San Francisco. Museum purchase, gift of the Museum Society Auxillary

elegant, elongated composition, incorporating many features (such as oval eyes and smooth brows) found in Poro feminine masks. Still, both the sacrificial material on the top of the head, and a protective grid of Arabic verses written in ink on the mask's interior, remind us of its supernatural power.

Masks and Sacred Authority: the Dan and their Neighbors

Hornbill masquerades are also popular among the Dan peoples, who are related to the Mano and also speak a peripheral Mande language. However, Dan hornbill masks are not necessarily revered as sacred messengers or obeyed as police officers; they are often the joyous companions of women, and appear at festive gatherings. In fact, forest spirits are believed by the Dan to inspire a wide variety of masquerades, including those that entertain a community.

According to the Dan, forest spirits select a human partner when they wish to participate in the human world. They reveal to him or her which masks, costumes, and dance styles will allow them to materialize. While masquerades may bestow fame upon the human associates of these supernatural beings, an old and powerful masked spirit may give a human leader the power to regulate human conduct and punish evildoers.

Except in northern areas, Dan groups do not participate in Poro, and their feminine masqueraders are generally considered to be minor spirits. Smooth, oval feminine masks are usually worn by young men whose spirits allow them to perform as singers, poets, gymnasts, or dancers. These female masquerades may

be sponsored by wealthy individuals (or by the masquerader's friends) both to please supernatural forces and to enhance the prestige of the patrons.

A few female masquerades take on a supervisory role in a Dan community; round-eyed masks with bright red surfaces are worn to chastise women who have lit illegal fires during the dry season. Another type of feminine round-eyed mask, with a smooth, dark face, is a running mask, gunye ge (fig. 6-23). The youth who wears the mask has won a series of races, proving that he is worthy of the masquerade; he will celebrate further victories with its blessing. In the past a gunye ge such as this would allow the champion runner to lead raids upon

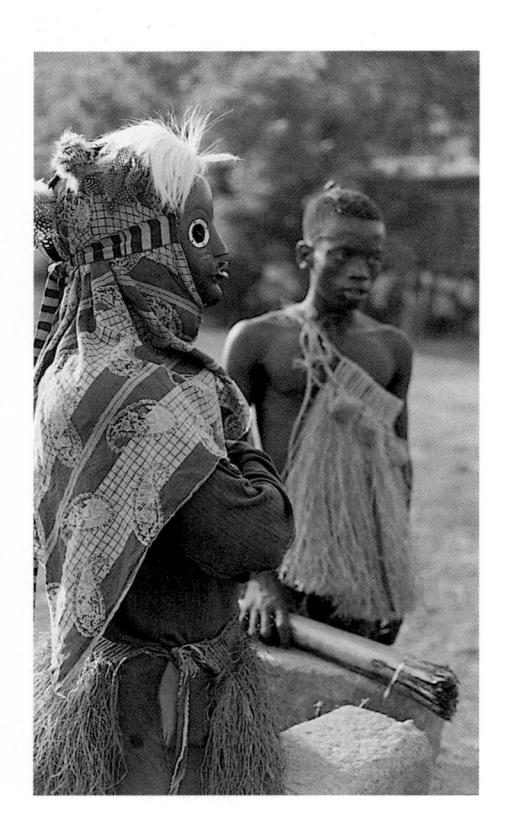

6-23. Northern Dan *Gunye Ge* (Running Masquerade) with assistant before a race, western Côte d'Ivoire, 1975

6-24. Kagle Mask, Dan or We. Wood, coins, Iron, Beads, Fibre. Height 17" (43.2 cm). Fowler Museum of Cultural History, University of California, Los Angeles. Joss Collection

enemy camps, for it bestowed supernatural powers for speed and protection upon the wearer.

Similar athletic skills are needed by a youth who animates the *kagle* masquerade, danced with an angular mask seen as masculine (fig. 6-24). *Kagle* appears at the performances of more serious masked beings, and steals the possessions of onlookers with his hooked stick. Those in attendance must keep their sense of humor and be willing to ransom their belongings with small sums of money. Every plane of this trickster mask is a clearly defined geometric form, and even the eyes are empty triangles.

Minor masquerades, such as a female singing mask or a masculine *kagle*, may become more important over the years as the wearer/owner acquires stature in a Dan community, and becomes more deeply involved with masquerade spirits. In time an entertaining masquerade may become a *go ge*, modifying the wooden mask and acquiring a new costume to reflect this new higher rank. Warrior masquerades, identified by their tubular eyes and crest of feathers, may be particularly suited for such transformations.

Warrior masquerades may have originated to the south of the Dan

6-25. Mask, Kru (Ubi group?), 20th century. Wood and vegetable fiber. Height 16½" (42 cm). Musée du Quai Branly, Paris

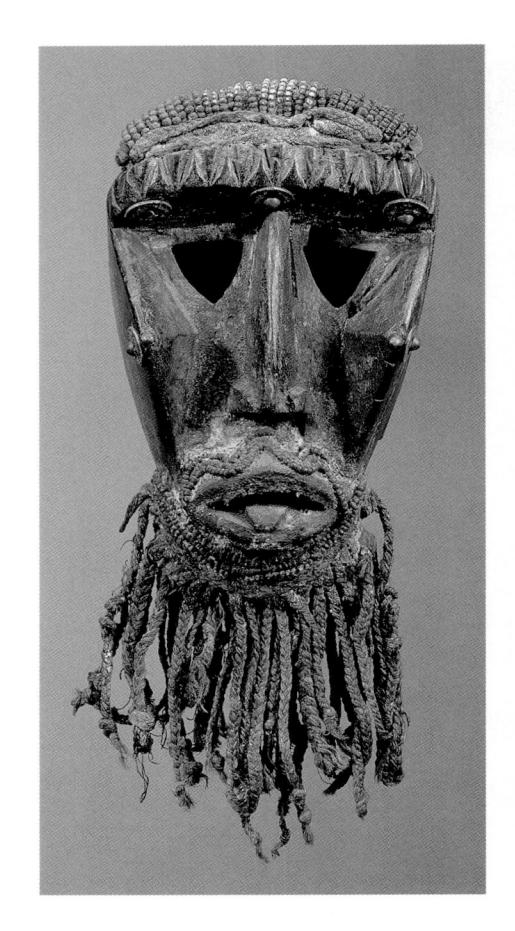

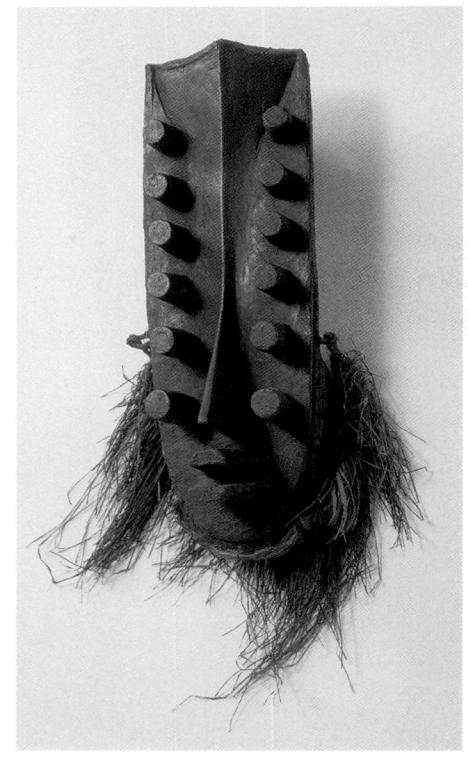

along the coasts of Liberia and Côte d'Ivoire, among populations who speak languages of the Kru family, and who did not identify themselves as distinct ethnic groups until the colonial era. Warriors of the peoples now known as the Grebo were once greeted by masqueraders after successful raids, and similar military masquerades inspired them to fight. Military masks taken from Grebo communities and other Kru-speaking areas are brightly painted, and display facial features that are attached onto (rather than carved into) the long, plank-like face. European artists were entranced by the reversals of positive and negative forms on these bold, arresting objects. One example in a uniform gravish brown rather than the usual polychrome uses an extraordinary series of tubular projections to represent several sets of extra eyes (fig. 6-25).

Between these coastal peoples and the Dan live the Kru-speaking We peoples (also known as the Gere, Kran, and Wobe). Like the Dan, the We perform a wide variety of masquerades, which hold important regulatory positions within their small, egalitarian communities. In the words of a scholar who is herself We, "the masquerade is a spirit which God has given to men to organize and discipline them ... the sacred masquerade is thus the stabilizing element of society." We groups also rank masquerades according to their masks, costumes, and performance styles. Beggars (the We equivalent of *kagle*) often have zoomorphic faces in the shape of warthogs, forest buffaloes, or other wild creatures. Singers are usually highly decorated versions of Dan feminine masquerades (fig. 6-26).

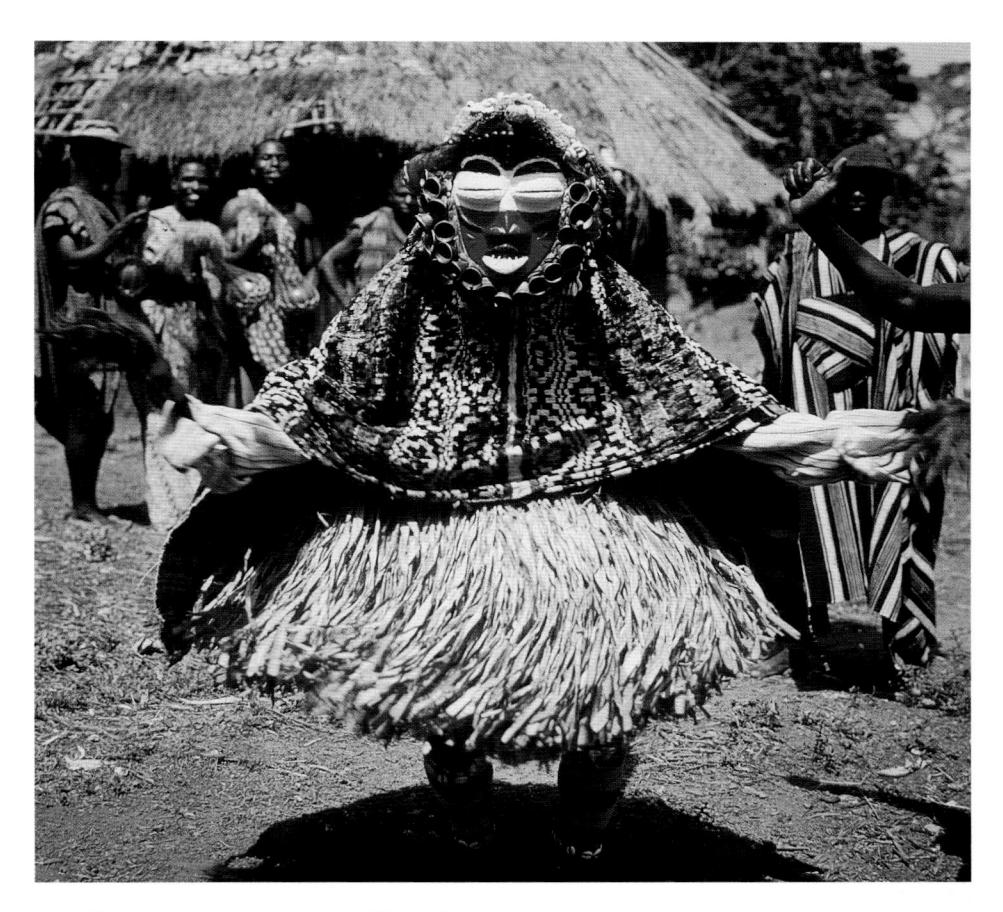

6-26. We masquerade, western Côte d'Ivoire, 1950s

Dancer and warrior masks have tubular eyes, broad triangular noses with prominent nostrils, arched tusks at each side of the face, and an immense curved forehead.

After several generations, as among the Dan, one of these masked spirits may be elevated into a more powerful being. Eagle feathers and the hair of a sacrificed ram on the mask's headdress announce that a mask is able to resolve disputes or locate evildoers. Added layers of leaves or palm fibers for the voluminous skirts, additional panels of leather or fur, and a fringe of brass bells or cartridges may indicate that a mask has become the assistant, or the bard, of a great mask.

The ji gla, the great masquerade itself, is shrouded in white (fig. 6-27). White is the color of bones and of the ancestors who first knew and served the mask spirit. The original bright colors are whitened, and the projecting tusks, horns, and eyes are hidden in the mass of protective and medicinal materials now placed on the mask. Raffia forms an enormous base for the *ji gla*, and it appears to roll or float above the ground. It only appears during times of great need, and no one may sit, or cough, or chat casually in the presence of this awesome power. The staff or spear it holds could once be thrown between two opposing armies and they would cease to fight.

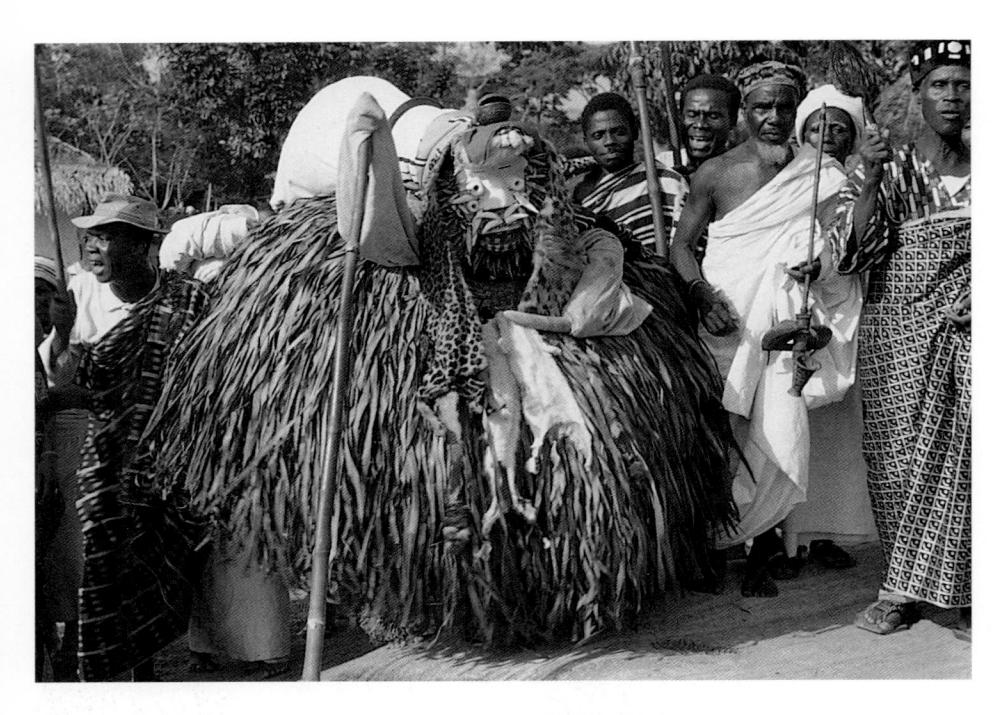

6-27. Peacekeeping mask (*JI GLA*), We, western Côte d'Ivoire

6-28. OUDHUE,
OR TITLED
FEMALE DANCER,
PERFORMING AT A
WOMEN'S FESTIVAL,
WE, OULAITABLI
VILLAGE, BÔ
REGION, WESTERN
CÔTE D'IVOIRE

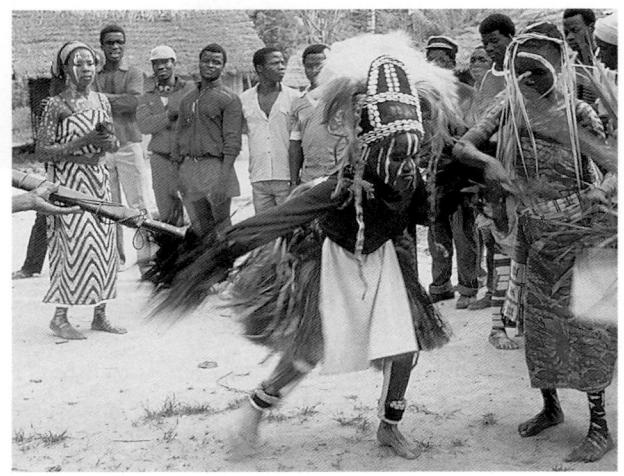

Women's Arts Among the Dan and the We

We women accompany masked dancers, and may even perform as masqueraders by painting bold designs upon their faces and dressing in a full raffia fiber costume and a headdress of shells and fur (fig. 6-28). Although they are able to bring a powerful spiritual presence to a community, and are thus given

honorary titles, these women never join the rank of a great masquerade, ji gla. Men say that women cannot host the most powerful spirits because female masqueraders are too easily recognizable behind their face paint; the men who lend their bodies to the most important masked beings need complete anonymity.

Like the girls of Sande and Bondo, We and Dan girls wear white pigment for their initiation into womanhood. Yet the faces and upper torsos of We and Dan girls are painted in particularly striking ways (fig. 6-29). Some groups cover girls' faces in diverse colors, or in glittering white designs in crushed shell and chalk. Talented artists paint the face and torso of each girl in a slightly different way, complementing her individual features.

The gleaming white patterns of We female initiates may also be related to the use of white in We masquerades, for their clitoridectomy is a dangerous operation that brings them close to death and the ancestors; white is the color of the ancestral world. White is also a symbol of purity and spiritual power, both of which are believed to result from the operation. The important role these girls will play as mothers and providers is emphasized by the chairs they carry; these delicately curved seats (seen on the head of the girl in figure 6-29) belong to a grandfather or uncle, and are normally only used by elders. For this period in their lives, girls are honored as the sources of a family's wealth and continued survival.

Women also have an important role in preparing a community for the arrival of masked spirits. When a We or Dan family invites a masquerade to appear in a community, its leaders must be sure that the women of the lineage will be able to provide food for the accompanying feast. Women of the lineage cook the rice stored in their own granaries, and prepare the sauce. Female farming abilities, organizational talents, and culinary skills are therefore necessary if the spiritual beings of the masquerades are to be properly welcomed and celebrated.

When a woman has been selected as the main hostess for such a feast.

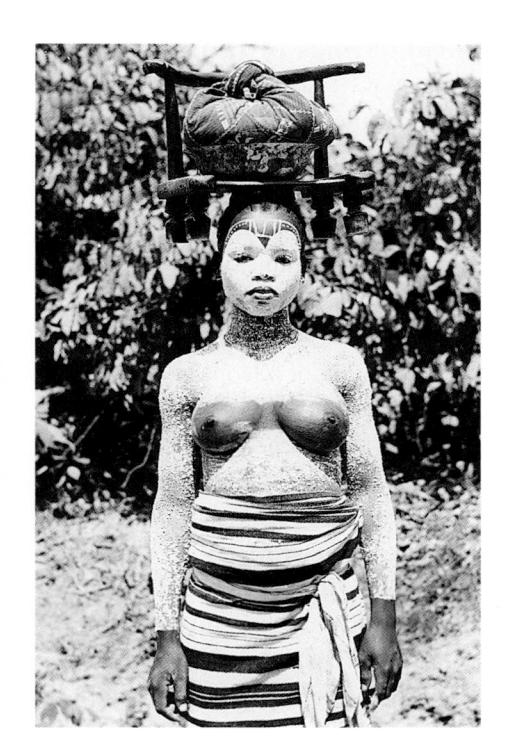

6-29. Initiate with throne, We, western Côte d'Ivoire, 1976

she is thus acknowledged as the most hospitable woman of her lineage. She parades through town with her female friends and family, carrying a large serving spoon as an emblem of her status. An assistant walking behind her carries the vessel that will contain the most important serving of rice for the feast.

The sculpted rice spoon or scoop of this hostess is the equivalent of a wooden mask. A woman who aspires to become the principal hostess of her lineage may see the spirit belonging to a carved spoon in a dream, just as a man may dream of a masked being when he is ready to offer his services to a spirit as its masquerader. When the custodian of a spoon (or mask) dies, or is no longer able to handle the responsibilities connected with its care, a successor will be chosen by the spirit.

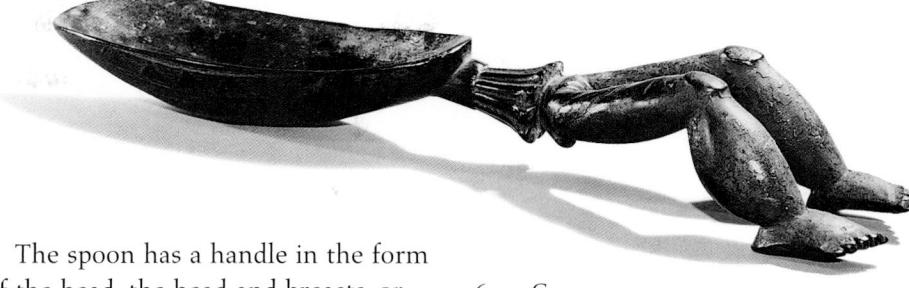

of the head, the head and breasts, or the hips and legs of a beautiful woman (fig. 6-30). In a sensuous visual analogy, it honors the hostess, and women in general, as a source of food and life; the hollowed spoon becomes the body or womb of a female figure. The curves of this example would fit comfortably in a hostess's outstretched hands, and be a lovely extension of the owner herself. The artist who carved the spoon took great liberties with the proportions of the hips, legs, and feet, emphasizing the calves and knees so that they balance the bowl of the spoon both visually and physically.

Artists throughout eastern Liberia and western Côte d'Ivoire have also carved freestanding figures of important women in wood, and cast jewelry and images for them in brass. The most famous woodcarver of the Dan or We region may be Zlan of Belewale, a sculptor who worked for clients in several ethnic areas during the middle of the twentieth century. The female figures he carved for wealthy patrons, often idealized portraits of the wife of the man commissioning the work, were prestige items, and Dan owners charged fees to visitors who wished to see them.

Even though these portraits were carved primarily for the aesthetic pleasure of their owners, they share the styles of masks and spoons, sacred objects housing supernatural beings.

6-30. CEREMONIAL LADLE, DAN (WAKEMIA OR WUNKIRMIAN), 19TH–20TH CENTURY. WOOD. LENGTH 18½" (46.4 CM). THE METROPOLITAN MUSEUM OF ART, NEW YORK

The shiny dark surface and bands of ornamental designs on one particularly strong figure by Zlan (fig. 6-31) are also found on feminine masks. Both the refined aesthetics of these figures, and the artistic inventiveness of masks of the region, are also seen in the art of the Guro, another peripheral Mande group who live to the east of the Dan in central Côte d'Ivoire.

6-32. Zamble in performance, Guro, Buafla, Côte d'Ivoire, 1975

6-33. Zauli mask addressing an elder, Guro, Tibeita, Côte d'Ivoire, 1983

Masquerades of the Guro

Guro families of high social standing may establish relations with a sacred triad of forest creatures who appear as masquerades. The first of these three characters is Zamble, whose sleek and shiny mask is said to combine the graceful horns of an antelope with the powerful jaws of a leopard (fig. 6-32). The sweeping curves flowing from the tip of the horns along the high forehead to the narrow muzzle are typical of Guro face masks. The costume worn by the athletic young dancer joins a scarf made of expensive and attractive cloth (a product of the orderly Guro community) with a cloak formed of the hide of a wild beast, a further juxtaposition of wild and civilized forces. A green and fragrant skirt of palm fiber and thick fiber ruffs at his wrists and ankles vibrate as he dances with small rapid steps. Bells on his wrists provide a counterpoint to the beats of the tall drums accompanying the masquerade.

Zamble is usually followed by his wife and consort, Gu. Her mask (worn, of course, by a male dancer) is a simple oval female face crowned with horns or an elaborate hairstyle (fig. 6-34). Today the mask is often brightly painted in red or yellow. Gu dances gently and elegantly. Rattles around her ankles are the equivalent of Zamble's bells, and the animal skin upon her back is normally that of an antelope rather than a leopard.

The uninhibited and uncouth Zauli (fig. 6-33) is the antithesis of both Zamble and Gu. Often identified as the brother of Zamble, he has bulging cheeks, prominent horns, and protruding eyes. His behavior is unpre-

dictable, and he may interrupt his dance to tease or even whip female spectators. His costume is a cheaper, unkempt version of that worn by Zamble. These three Guro masquerades are all sacred beings, whose altars receive sacrifices when individuals call upon them for supernatural assistance. Yet they also delight a family's guests at funerals and feasts, and bring prestige to the leaders of a lineage.

In addition to these forest spirits, other types of masquerades may be called forth in Guro communities. Some are danced primarily for entertainment, even though they may be sponsored by families or by groups who are negotiating for higher social position. A Flali masquerade developed in the 1970s was the result of a collaboration between the performers and an inventive sculptor named Saou bi Boti (fig. 6-35). The face of this Guro entertainment mask is that of a beautiful young woman painted in bright color, but the figure on top of the mask represents one of the musicians playing the instrument seen on the right edge of the photograph.

Yet other Guro masquerades are even more sacred and mysterious than Zamble, Zauli, and Gu. In northern Guro areas a highly revered being called Gye wears a heavy horizontal helmet mask with the powerful horns of a forest buffalo and wide, gaping jaws. Sacred masquerades in the southern Guro regions are known as $je\ (dye)$, and bring forth a host of human-like and animal-like beings. The zoomorphic face masks identify a spirit being linked to a single wild beast, such as an elephant, a hippopotamus, or an antelope (fig. 6-36),

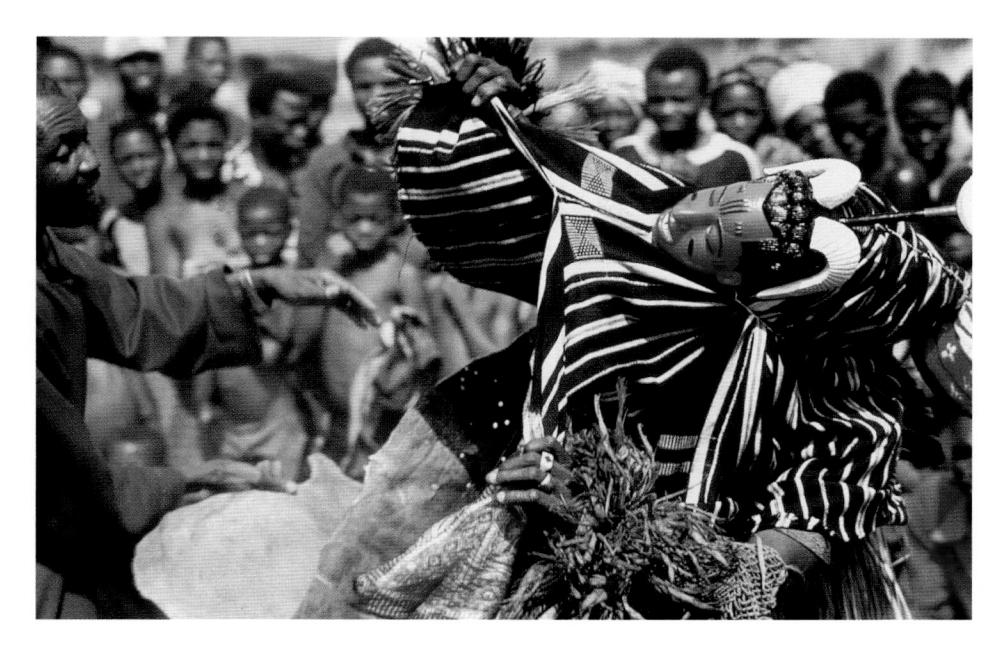

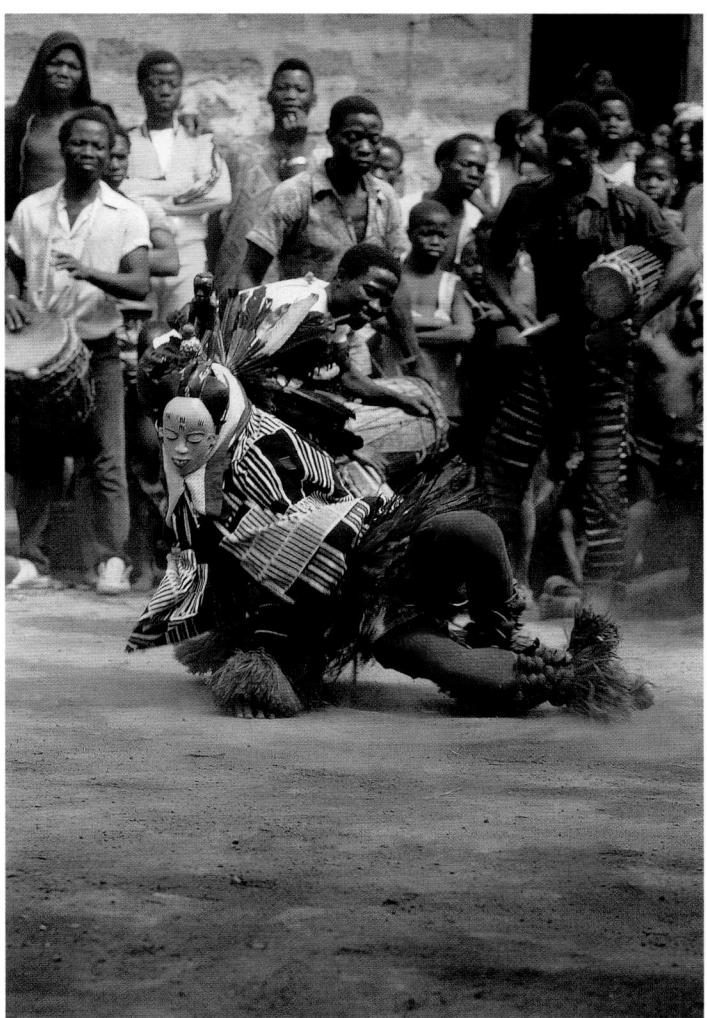

6-34. Gu dancing with an attendant, Guro, Zraluo, Côte d'Ivoire, 1975

Brightly colored, delicate female face masks of the Guro people can be danced in very different masquerades. This example is the prestigious being known as Gu. Virtually identical masks are used in masquerades danced primarily for entertainment, while others appear in potent masquerades seen only by men.

6-35. Flali mask in performance, Bangofla, northern Guro region, Côte d'Ivoire, 1983

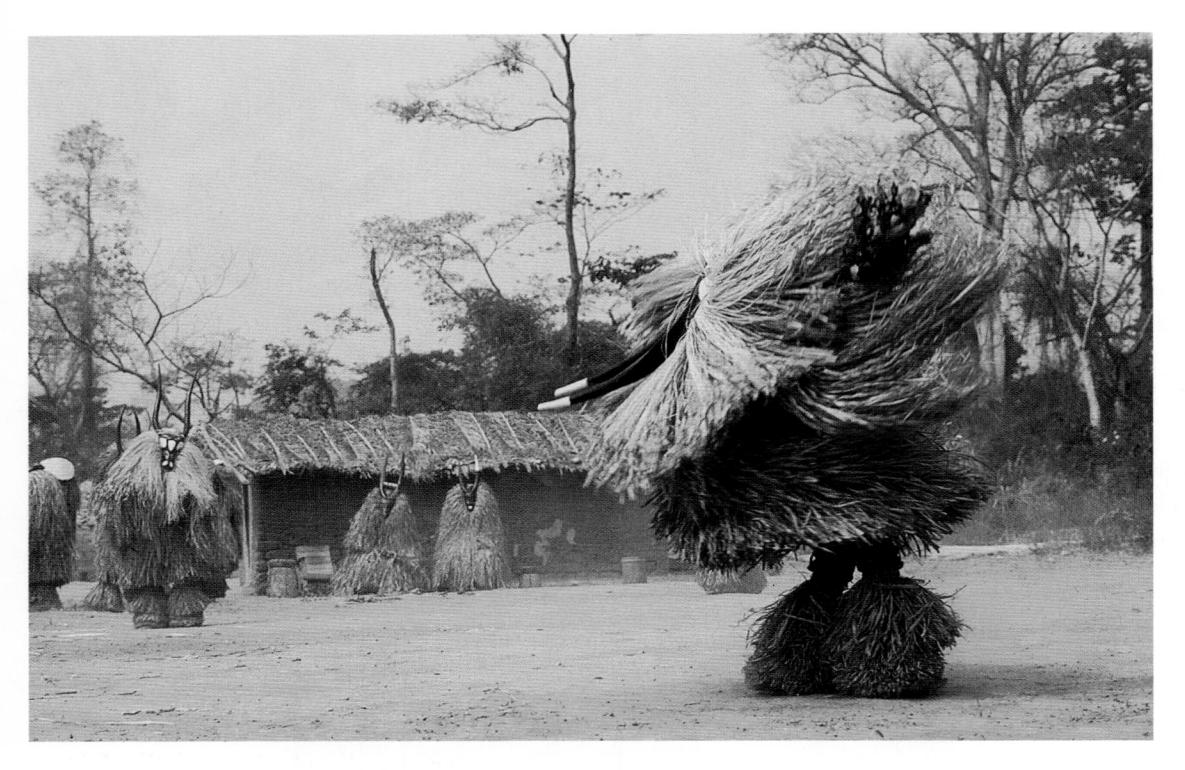

6-36. JE ANTELOPE MASQUERADE IN PERFORMANCE, DABUZRA, CENTRAL CÔTE D'IVOIRE, 1975

and masqueraders dance in a manner appropriate to the animal they resemble. Anthropomorphic masquerades lead the *je* group, who appear in voluminous layers of dried raffia fiber.

Both Gye and je are strictly limited to male participants and observers. According to widespread legends concerning the origin of these masquerades, the spirit beings they impersonate were once snubbed by women. As a result, the Guro believe, any contact with the masqueraders is normally very harmful for women and children. Yet the power of the greatest je mask in human form is based upon ceremonies conducted by old women. They carry this "mother of masks" to the site of girls' excision, and let the blood and tiny bits of tissue from the operation fall upon its face to empower it. The mask is then

carefully wrapped and returned to the men of the *je* association.

CROSS-CURRENTS AND HYBRID FORMS

All of the masquerades and portable art forms described in this chapter have traveled across ethnic boundaries and have changed over time. Yet the art forms of some coastal ports are even more multicultural in their origins and in their patronage.

American-African Architecture

Over the past four hundred years, marriages and alliances between Europeans and local entrepreneurs on the coast have created Creole (or Krio) communities, whose homes and business establishments are fascinating hybrids of foreign and African architectural forms. A distinctive domestic architecture was also developed by Americans of African descent who settled in Liberia.

In the decades surrounding the American Civil War, several thousand former slaves left the United States to found a new nation in Liberia. Many of these settlers were experienced in the construction techniques of the New World. On southern plantations they had erected the homes of their former masters, and had built more modest kitchens, shops, dwellings, churches, and schoolhouses for their own use.

This imported technology was used to construct Macon Hall House during the late nineteenth century (fig. 6-37). Like many homes of American Liberians, it was constructed of a

6-37. Macon Hall House, Fortsville, Liberia, late 19th century. Wood and tin. Photograph 1973

wooden frame covered with sawn planks. The roof was made of imported metal sheets, and given a wooden trim. Shuttered windows help cooling breezes circulate through the structure, and entrance steps lead to a covered verandah and central front door. Honored guests are taken upstairs to the second-story reception room of the shuttered second-story porch. This formal parlor, often called the "piazza" by Liberians, is thus similar to the library of a wealthy Jenne merchant (see fig. 4-8ii), particularly since both the Liberian and Malian rooms overlook the central entrance and are graced with openwork windows.

When the Macon Hall House was being built, it was strikingly different from the homes of important families in neighboring Vai, Gola, or Temne communities. For example, the space set aside for social gatherings of the Liberian Americans was located within the Macon Hall House itself; in neighboring towns social activities took place in a separate covered enclosure serving the entire community. To both the American immigrants and the earlier inhabitants of Liberia, homes such as the Macon Hall House were symbols of modernity and of imported cultural values.

Festival Arts

Foreign settlers have also played an important historical role in Freetown, the capital of Sierra Leone. The city was founded by English, Canadian, and American immigrants of African descent during the late eighteenth century, and Maroons from the Caribbean came to Freetown as soldiers and policemen. When the British outlawed the slave trade, they brought liberated captives to

Freetown as well. Although the freed prisoners came from many areas of Africa, most had been enslaved during civil wars in the area now known as Nigeria. Yoruba, Nupe, and Igbo immigrants from Nigeria thus joined Mende, Bullom, and Temne peoples in a city overlaid with European and New World influences.

Some masquerade groups in Freetown are affiliated with Bullom, Mende, and Temne communities, and dance with masks of Bundu and Poro. Other religious associations, such as Gelede and Egungun, remain fairly close to their Yoruba roots (see chapter 8), even though they admit men and women of many ethnic and religious backgrounds. Yet some appear to be blends of older sacred masquerades, and are joined by young men who live in the same neighborhood and who share common problems.

One of these spectacular masked forms, robed in imported cloth, is danced for the group of youths known as the Kaka society (fig. 6-38). The feminine face of the masquerade. and its colorful, elaborate superstructure, identify it as a "fancy" (showy, attractive, and flashy) rather than a "fierce" (dangerous and menacing) Kaka society performer. Little is known of its specific history, but it may have participated in the riotous processions that marked Christian and Islamic holidays. Other masks and masquerade ensembles have been created by Freetown artists, such as Ajani and John Goba, for Ode-Lay, a society whose performances are based upon Yoruba traditions. The wildly inventive constructions of these artists have been featured in exhibitions of contemporary art in Europe and the United States.

6-38. Kaka society masquerade, Freetown, Sierra Leone

6-39. DISPLAY SCULPTURE FOR RAMADAN CELEBRATION WITH TWO PERFORMERS, ROKPUR, SIERRA LEONE, 1967

Islamic festivals in Freetown and other towns in Sierra Leone are often celebrated with displays or processions of large tissue paper constructions. Although they need not be lit from within by candles or lamps, all are known as "lanterns." These ornate assemblages are given the shape of ships, animals, or a variety of fantastic images, and may be as large and as whimsical as American parade floats. The history of lanterns in Africa and the African diaspora is apparently quite complex; similar movable sculptures of wood, paper, and other media have been recorded in Morocco and Senegal, and they seem to have been particularly spectacular in the

Gambia, and in the Muslim communities of former British colonies in the Caribbean. A lantern in the shape of a cylindrical house or domed tomb (fig. 6-39) is related to the brightly colored, multitiered, temporary structures paraded through the streets elsewhere in the Islamic world that evoke the tomb of the seventh-century Islamic martyr Hussein. Although little is known about these lanterns, this photograph suggests that lantern processions in this town in Sierra Leone are similar to masquerades in that they are accompanied by assistants; the two female attendants appear to be mimicking nurses. The visual variety introduced by the layers of different textures and colors reminds us of the Carnival mask of Guinea Bissau as well as the Kaka society mask of Freetown.

CONTEMPORARY ARTS IN ABIDJAN AND OTHER URBAN CENTERS

Opportunities for artists living in the cities of this region vary considerably from country to country. Artists and musicians from the Cape Verde islands are linked to large communities of expatriates, even if resources on the islands themselves are quite limited. Brahaima Injai, a painter from Guinea Bissau, has lamented

6-40. ALIEN
RESURRECTION, ABU
BAKARR MANSARAY,
SIERRA LEONE/
NETHERLANDS, 2004.
BALLPOINT PEN AND
GRAPHITE ON PAPER. 59
X 80¼" (150 X 205 CM).
CAAC/THE PIGOZZI
COLLECTION, GENEVA

that he is not able to earn a living in his homeland, and is now based in France. In Guinea, art and artists have faced political as well as economic problems due to a harsh dictatorship in the last decades of the twentieth century. Although Liberia's colleges and universities had excellent reputations before the warfare began, they seem to have produced few artists of international renown, and in Sierra Leone, successful urban artists have usually received their training as apprentices in local workshops rather than as students in art institutes or post-secondary institutions.

One of the few artists from Sierra Leone to be shown in international exhibitions is Abu Bakarr Mansaray. Unlike other Freetown artists, Mansaray did not train with another artist, and did not work on commission for dance societies. Instead, Mansaray studied a variety of scientific subjects in high school, and began creating art (evidently for personal reasons) after he left his home in rural Sierra Leone to seek his fortune in Freetown at the age of seventeen. There his fantastic machines, constructed of recycled materials, and the imaginative, eccentric diagrams he used in their design, caught the attention of a French curator. European patrons have seen his drawings as playful and entertaining, or as postmodern critiques of Western technology. However, the artist himself has not been given many chances to speak about his own work, or to discuss it in the context of his life in Sierra Leone. In 1998, the bloody civil war forced

Mansaray to emigrate. He now lives in the Netherlands, and his recent drawings are huge posters of killing machines unleashed in an apocalyptic world (fig. 6-40).

Of all the countries in the region, Côte d'Ivoire has provided the most opportunities for artists. This is due in part to the influence of a few individuals who were active during the colonial period. The most renowned was Christian Lattier (1925-78), who was born in a Lagoon community but sent to France at a young age. He left a French seminary to study art in Paris, and he worked as a sculptor before returning to his native country in the years after independence. There Lattier created a series of large, almost whimsical figures of wire wrapped with lengths of twine (fig.

6-41. MASK, Christian Lattier, Côte d'Ivoire, 1975. Metal frame, cord, red patina. 20 x 12% x 6%" (51 x 31.5 x 16 cm). National Museum, Abidjan

6-41). Although the arts of Lattier's birthplace may not have had a direct effect upon his work, the gold objects worn in the Lagoon region are cast from molds created when wax threads are layered in exactly the same way (see fig. 7-6). Christian Lattier was given a special award for a lifetime of achievements at the First World Festival of Negro Arts in Dakar in 1966. After his untimely death, his sculpture was placed in the National Museum in Abidjan.

During the late 1970s and early 1980s, Lattier's influence was overshadowed by Jean Gensin, a painter from the Antilles (the French-speaking islands of the Caribbean), who worked with several other Caribbean expatriates and was a professor at the

Institut National des Beaux-Arts (the National Institute of Fine Arts) in Abidjan. There he inspired his students to search for new and relevant philosophies, media, and techniques. The students grouped themselves together under the name Vohou-Vohou, from the Guro word for "earth" or "mud." Consisting of about a dozen painters from several regions, the group sought to be firmly grounded in African traditions, and to produce an art rooted in their own land. However, most of the young artists were able to continue their studies in Paris before returning to teach in secondary schools and art institutes in Côte d'Ivoire, and the sensuous surfaces of most Vohou-

Vohou canvases clearly link their work to the French tradition as well.

Christine Ozoua Ayivi, born in the Guro region in 1955, was one of two women who were among the founding members of Vohou-Vohou. For an untitled painting from the 1970s (fig. 6-42), the artist located and prepared minerals and plants that she mixed with glue to form paint, and then applied directly to locally woven cloth. Some lines were created by gluing vines and other plant fibers to the surface of the painting. Ozoua Ayivi insists that the artists of Vohou-Vohou, although known for their unusual media and techniques, were primarily interested in the nature of the creative artistic process; their use

6-42. Untitled, Christine Ozoua Ayıvı, Côte d'Ivoire. Natural pigments on cloth

6-43. *Untitled*, Gerard Santoni, Côte d'Ivoire, 1993. Oil on canvas. 44% x 57% (114 x 146 cm). Collection of the artist

of natural pigments was but a byproduct of their fresh approach to painting.

Although not formally associated with the Vohou-Vohou group, Gerald Santoni shares many of their interests in the formal qualities of painting. Born in Divo to a Baule mother and an expatriate father in 1943, Santoni studied art in Paris and Nice and is now a professor at the Institut National des Beaux-Arts in Abidjan. Unlike the paintings of Ozoua Avivi, which are pure abstracts and are not meant to contain recognizable forms, the work reproduced here represents strips of indigo-dyed ceremonial cloth (such as that worn by the masqueraders in fig. 6-34, the young woman in fig. 6-29 and the Lagoon drummer in fig. 7-33). Santoni claims that this imagery is easily identified by most Ivorians, who consider the works to

be quite beautiful (fig. 6-43).

Yet perhaps the best known of all the artists from Côte d'Ivoire was not trained in an institute or university. Frédéric Bruly Bouabré was born in 1923 in a Kru-speaking Bete community in central Côte d'Ivoire. As an elderly man, he began to write down the philosophies and beliefs of his people, as filtered through his vivid personal vision. He draws scenes from Bete legends in colored pencil on sheets of paper, creating mysterious and repetitive images labeled with phrases in French or Bete (fig. 6-44).

Like the work of Mansaray, Bouabré's drawings seem to have been exclusively collected by expatriates. However, both his commercial success and his personal charisma have given him a respected position among the artists of his homeland. Critics may complain that Bouabré's

6-44. Untitled, from the Knowledge of the world series, Frédéric Bruly Bouabré. 1991. Colored pencil and ball point on cardboard. 6 x 3½" (15 x 9.5 cm). CAAC/ The Pigozzi Collection, Geneva

visionary art has been so popular with European patrons because he conforms to their stereotypes of the naive, untutored, or uninhibited African artist. Yet even cynics must concede that Bouabré's work is original, direct, effectively and even dramatically composed. It may be these qualities that attract buyers from other lands and other cultures. Just as Renaissance courtiers admired Sapi ivories over five hundred years ago, foreigners today can find much to admire in contemporary art of the West Atlantic coast.

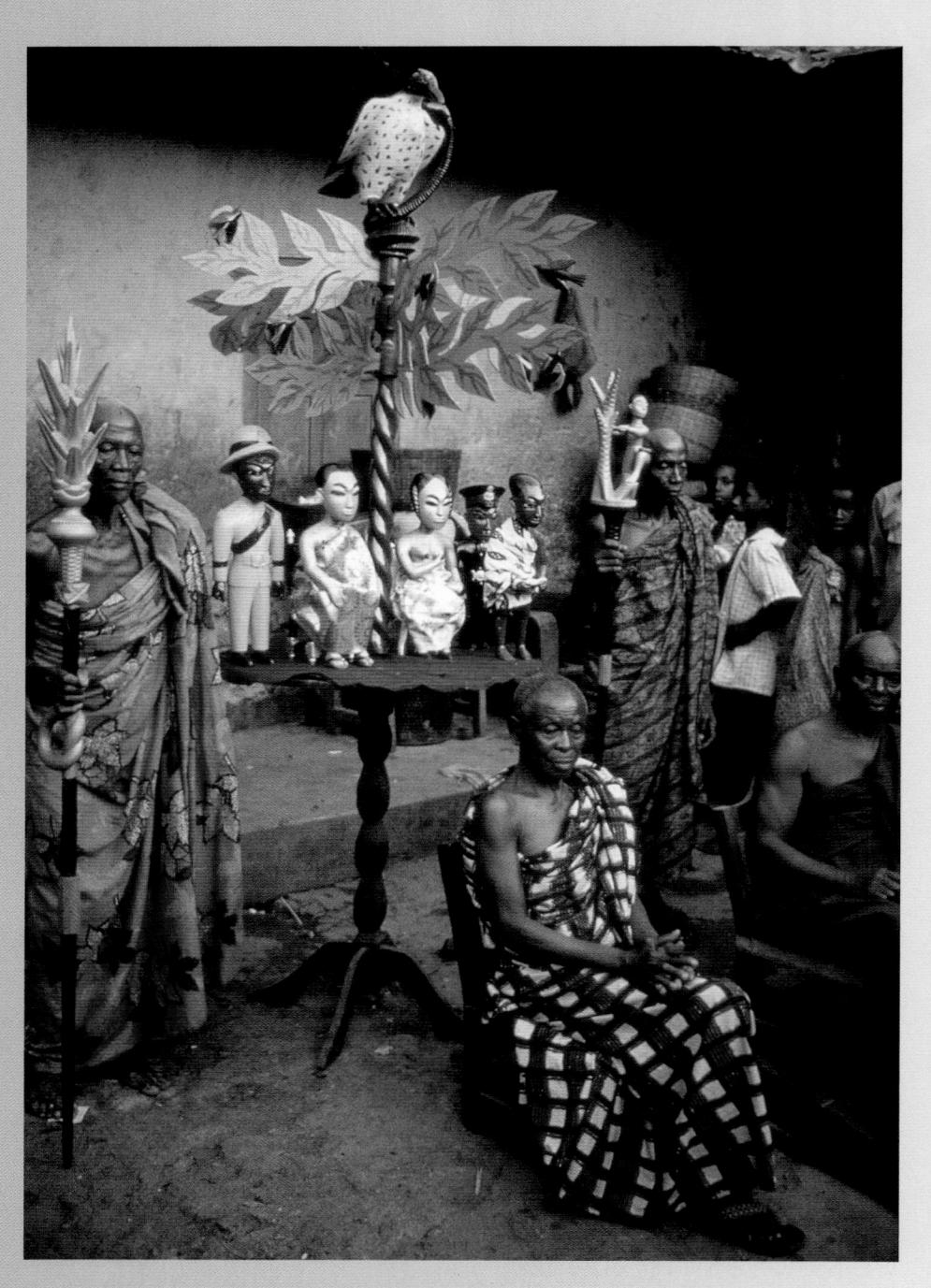

7-1. Figural group, Osei Bonsu (seated right), Asante, Ghana. Wood, pigment. Photograph 1976

OST OF THE PEOPLES WHOSE art we explore in this chapter speak Akan languages. The Asante, the Fante, and other groups in Ghana speak dialects of Twi, while the Baule and Anyi, who live mostly in Côte d'Ivoire, speak dialects of a related but mutually unintelligible language. The fifteen Lagoon peoples, and other small populations in the region, speak diverse Akan tongues that result from long periods of separate linguistic development. Surprisingly, these linguistic divisions do not correspond to cultural divisions, as the Baule and the Lagoon peoples are usually egalitarian in political structure while the Anyi and the Ghanaian Akan are more hierarchically organized. Nevertheless, all these Akan groups share important cultural forms, spectacular gold jewelry, and regalia among them.

As the southernmost participants in a trading network that extends across the Sahara to North Africa. the Akan have been in contact with Muslim traders and holy men for many centuries. Several centralized polities emerged among the Akan of Ghana during the fifteenth or sixteenth century, partly as a result of wealth derived from the gold that these people mined and traded northward. The most famous of these is known as the Asante Confederacy. Formed around 1700 under the Asante ruler Osei Tutu, the Confederacy depended on tribute from conquered Akan kingdoms such as Akwamu, Akyem, Denkyira, and Bono. Craftsmen and artists from the

conquered kingdoms were conscripted to the Asante capital at Kumasi, where they initiated an artistic flowering that lasted for almost two centuries.

While the Akan have long resisted adopting the Islamic faith, they have assimilated technologies, art forms, motifs, and styles from the Islamic north. European influences have also been absorbed and thoroughly "Akanized." Direct contact with Europeans, their artifacts, and institutions began for the Fante and the Lagoons peoples on the Atlantic coast in the 1470s, when Portuguese ships first reached these shores. The many European trading forts and castles built along this "Gold Coast," as the area was known and later named by the British, signal the impact of outside ideas, and institutions, and artifacts over more than five centuries of interaction with Europe.

The artistic culture of pre-Islamic and pre-European Akan peoples is not well known, but surely there were many purely local developments. Wood and terracotta objects for ritual and everyday use, in particular, probably evolved early. Thus three major historical currents—internal and locally generated creative developments, influences from the Islamic north, and appropriations from Europe—and several minor ones merge in Akan arts recorded in the late twentieth century.

THE VISUAL-VERBAL NEXUS

A distinctive feature of many Akan cultures is the dynamic interaction of visual motifs and verbal expression. The Akan, until recently oral and

without writing, have a special reverence for elegant, colorful, subtle, and allusive oral discourse and particularly for the use of metaphorical speech. Akan arts include a repertoire of several thousand visual motifs, from abstract symbols to representational objects and scenes. Each motif is associated with one and often more verbal forms, savings, or proverbs. A spiral shape recalling a ram's horn, for example, calls forth the maxim, "Slow to anger [like the ram] but unstoppable when aroused." A ladder motif, whether seen on ceramic funerary vessels or printed cloth, elicits the saying, "Everyone climbs the ladder of death," meaning that death is inevitable as well as democratic (see fig. 7-13).

Nearly all forms of Akan art have evolved so as to include one or many of these visual signs. Indeed, interest in visual-verbal relationships appears to have stimulated the deliberate development of objects that incorporate such subjects and the continuous invention of new visual motifs with a corresponding wealth of spoken meanings. Cast gold ornaments attached to state swords (fig. 7-2) are good examples. Some are merely emblematic. The head stands for a defeated (and decapitated) enemy, for example. Others, however, have more complex or multiple verbal associations. Mudfish (closely related to the catfish of North America) or crocodiles eating mudfish have several interpretations: "When the mudfish swallows something, it does so for its master," meaning that a chief benefits from the success of his subjects, or, "When the crocodile gets a mudfish it does not deal leniently with it," referring to the awesome power of a chief

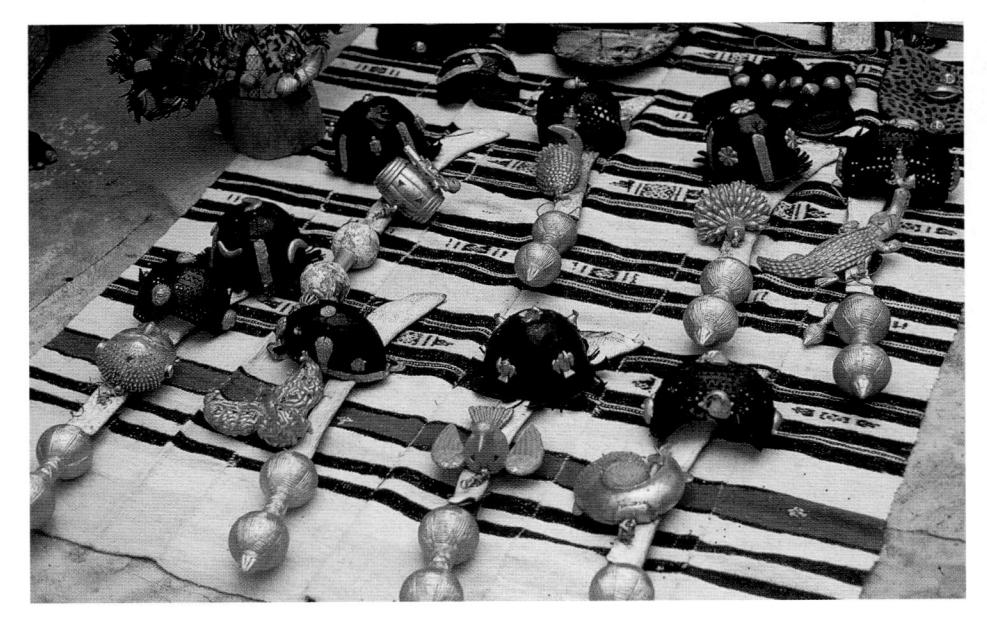

7-2. Display of State Swords, Akan, Kumawu State, Asante, Ghana. Wood, Gold, Iron, Cloth. Photograph 1976

The specific functions and forms of swords vary from state to state. In general, swords are (or were) used for swearing oaths, as symbols of ambassadorial rank and safe passage, during purification rites of chiefs and ancestral state stools, and for display

Aspects of African Cultures

Art and Leadership

Across history and in societies throughout the world, art has been used to support the authority of sacred and secular leaders and to legitimize the concept of leadership itself as a social institution. Leaders commission art, dispense it, send messages with it, and use it instrumentally both to perpetuate the status quo and to effect change. Leaders in African societies may use art in ways that are bold or subtle, active or passive, obvious or veiled, yet what is everywhere clear and sometimes surprising is the extent to which African art is leadership art—conceptually dense, layered with meanings, and concerned with power of various kinds.

Contrasted with popular arts, leadership arts are immediately seen to be richer, more elaborate and complex, more durable, detailed, and monumental. These ideas are expressed with special force by the regalia of the kings of Africa such as the oni of Benin, the fon of the Cameroon grasslands, the Yoruba oba, the Kuba kings, and those of the Zulu and the Swazi. In some eras and some societies, female rulers are vested with similar regalia; the best known examples are the kandake of ancient Kush (see chapter 2) or the gueen mothers of Benin and Asante. European kings and nobility have, for the most part, lost all but their ceremonial roles in modern governments. This is not necessarily the case in Africa. Even though many rulers were stripped of their power by colonial

armies, the uncertainties of contemporary life have led to new political responsibilities, renewed religious roles, and a plethora of art forms for African royals in the twenty-first century. Twentieth-century leaders as different as Jomo Kenyatta, Kwame Nkrumah, Mobutu Seke Seko, and Nelson Mandela have worn and carried regalia that establishes their position vis-àvis their people, their ancestors, and their fellow heads of state.

Sandals, footrests, stools, chairs, and raised platforms serve to isolate rulers and give them prominence. Their stature and bulk are expanded by sumptuous, expensive, symbolic materials such as eagle feathers, leopard skins, special cloth, and beads. A hand-held weapon may extend their reach. Other held objects-flywhisk, pipe, staff, scepter—magnify any gestures they make. Flanking or surrounding artifacts such as drums, vessels, statuary, or houseposts contribute to their centrality and visibility, as may a cloth backdrop or a hierarchical surround of courtiers. Umbrellas, fans, weapons, or shields provide both physical and spiritual protection. Regalia thus creates a presence magnified to the point where the individual seems almost overcome, even immobilized. the temporary holder of an office almost disappearing into the eternal idea of the office itself. A key element here of course is display.

Moving outward from the person of the leader we can see his or her influence in palace architecture as well as in the spatial

complexity of royal towns, which hedge rulers about both materially and spatially, protecting them, centering them, or focusing attention on them within a ranked hierarchy. These ideas extend also to royal shrines such as those of Benin. where spatial and compositional principles mirror those used to emphasize the sacred king and queen mother. More subtly, such ideas apply as well to palace associations, ranks of lesser chiefs and titled nobility, craftsmen's guilds, and other support groups and structures. In most centralized and hierarchical states there is a proliferation of offices, with each rank given distinct visible markers of identity.

In less centralized societies, control may be exerted through councils of elders, associations of titled men or women, or masguerade societies. Here leadership arts become more subtle and indirect, yet the masks, carvings, and title attributes characteristic of these institutions are no less effective than the regalia of kings. Less centralized polities are commonly marked as well by strong religious organizations whose authority is buttressed by art and architectural forms. So whether a culture organizes itself into a large state or a lineage-based, segmentary society, its leaders bring visual, kinetic, and aural arts to bear in creating pageantry and mystery, which in turn orchestrate a spectacle that both figuratively and literally moves people, profoundly and irrevocably affecting their lives. HMC

or king, or, "If the mudfish tells you the crocodile is dead, there is no need to argue about it," signifying (somewhat cryptically to us) that two people can report on each other's behavior. The "night bird" elicits the saying, "If you kill a night bird, you bring bad luck; if you leave it alone,

you lose good fortune," the equivalent of the American expression "damned if you do and damned if you don't." The powder keg shows how readily Asante artists incorporated outside motifs, in this case a European barrel, into their body of imagery.

REGALIA AND ARTS OF STATECRAFT

Regalia—adornments and implements worn or carried by kings, chiefs, queen mothers, and other royals and court members—help to create and legitimize royal authority

as well as show it off (see Aspects of African Cultures: Art and Leadership, p. 198). Under the patronage of powerful and wealthy chiefs and kings, weavers, umbrella makers, goldsmiths, leatherworkers, carvers, and others put much imaginative effort into fashioning regalia.

Ensemble and visual overload govern the aesthetics of regalia in southern Côte d'Ivoire and Ghana. Ensemble refers to the massing of several elements, each often a work of art in its own right, but depending for their rich, dazzling impact on their assemblage, which becomes a whole greater than the sum of its parts. Composed upon and set in motion by the armature of the human body, a sumptuous profusion of jewelry, textiles, and hand-held implements creates a dizzying sense of visual overload and reiteration that has been aptly called "intentional design redundancy."

Regalia in Ghana

Heads of state (known as "chiefs," "paramount chiefs," or kings in Ghana, and simply as "kings" in Côte d'Ivoire) wear rings on every finger, vards of heavy cloth, dozens of beaded bracelets and necklaces, not one but several amuletic charms at the elbow or ankle, as well as multiple castings or gold leaf symbols on hats and sandals (figs. 7-3, 7-4). Individual beads as well as small charms strung together or larger talismans packaged in gold, silver, leopard skin, and leather pouches render supernatural power to their wearer, at the same time protecting him or her against jealous rivals or threats from evil spirits. Often all this regalia becomes

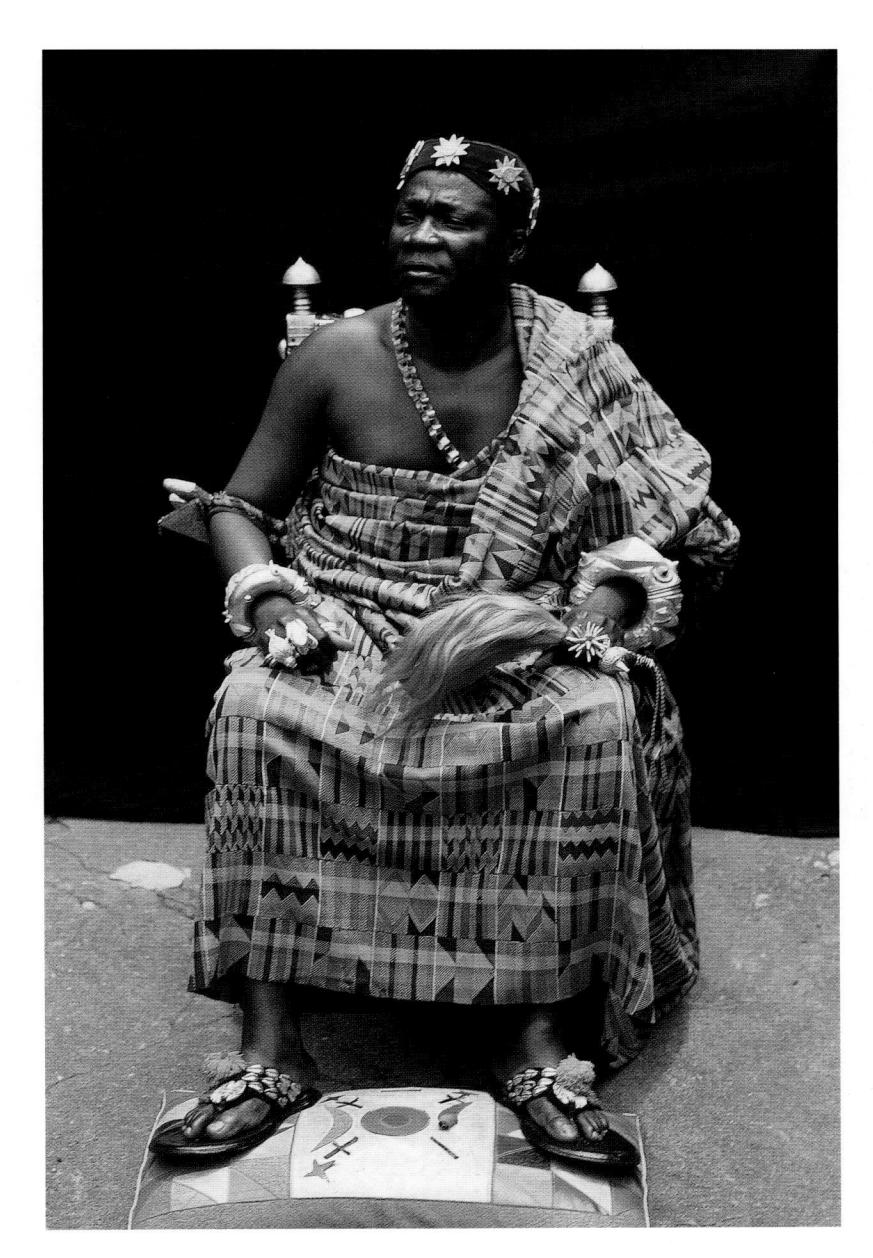

7-3. The Ejisuhene, ruler of Ejisu, Ghana, wearing gold and *Kente*. Asante. Photograph 1976

Members of royal families wear an astonishing variety of cast (and occasionally hammered) gold ornaments both abstract and representational in form (such as bells, locks, teeth, bones, and replicas of glass beads). Circular gold beads range in size from half an inch to six inches in diameter. Beads are the most common and universal form of personal decoration in Africa. Beads of stone, bone, vegetal matter, glass, or metal were worn by all classes of Akan people. They were decorative but also meaningful socially and ritually. Like gold itself, many beads were ascribed amuletic, protective properties. Some were worth more than their weight in gold. Others were thought capable of reproducing underground (where caches of beads, buried earlier, were sometimes found), and certain beads were ground into powder with which royal children were washed to make them grow.

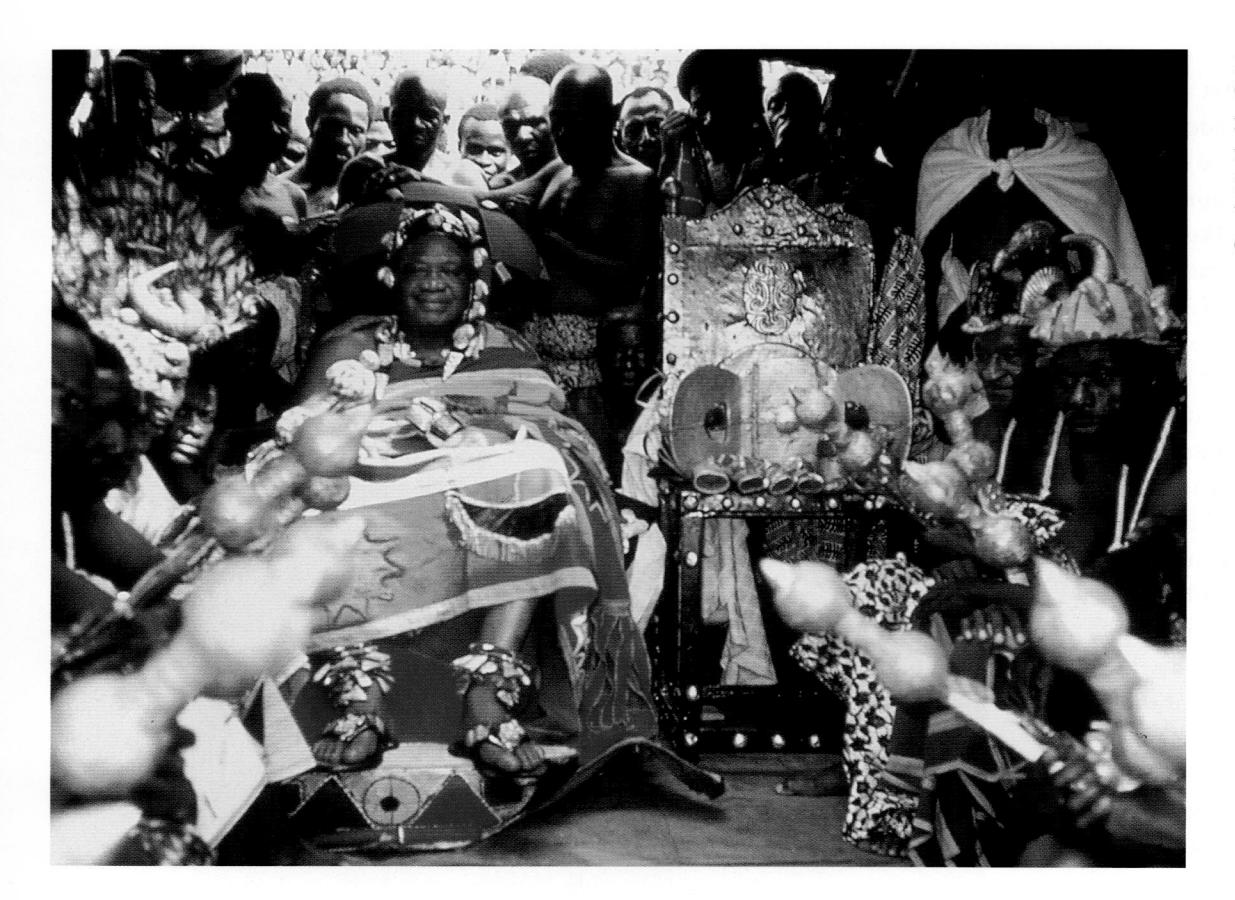

7-4. An asantehene, Opoko Ware II, seated in state with the enthroned Golden Stool next to him, Yam Festival, Kumasi, Ghana, 1986

very heavy and cumbersome. Thus it is not surprising that the Akan say of kings, "Great men move slowly."

The cumulative mass and effect of regalia ensembles make statements about political authority and financial superiority as well as spiritual protection, while specific verbal messages may also be projected by visual motifs. It is not that individual motifs are specifically read by the viewer, who then recalls the associated proverbs or emblematic maxims. Rather, shared knowledge among actors and audience alike carries richly layered collective messages: dignity, military might, endurance, wisdom, affluence, spiritual protection, and, above all, power.

Little Ghanaian Akan regalia is personally owned. Rather, it belongs

to the state and its collective ancestors and is called stool property. A chief or king is the custodian of these treasures for the duration of his reign, and he is expected to add to the legacy of gold and textiles for his successors.

Thrones, Stools, and Chairs

When the British first described the thrones of Akan peoples, they used the humble English word "stool" to indicate that these seats of power and authority were small and without back supports. The French use the word $si\`ege$, which more properly connotes the idea of throne. To signal its ownership by the kingdom as a whole, regalia in Ghana is spoken of as "stool property," for these

stools, along with other gold and gold-leafed items, are the central symbols of Akan states. The practical and ritual use of such seats is almost certainly ancient in Akan culture; it almost certainly predates contact with Islam and Europe. Throughout most of the Akan area, important persons commission carved stools for daily or ceremonial use. At a great man's death, his soul is ritually transferred to his personal stool, now blackened and consecrated for the purpose: it now symbolizes its former owner as an influential ancestor. In each Akan state, the blackened ancestral thrones of kings and other royals are kept in a shrine called a stool room, where collectively they represent the state's dynastic soul and history.

Most Akan stools consist of a rectangular base from which a partly open central column and four corner posts rise to support a saddle-shaped seat. The entire stool is carved from a single piece of wood. Many stool types exist, and like Akan culture itself they are hierarchical. The most famous African throne, which has never actually been used as a seat, is the Golden Stool of Asante, displayed on its own chair in figure 7-4. Oral tradition relates that it came into existence around 1700, during the reign of Osei Tutu, the first Asantehene, or king of the Asante. Osei Tutu founded the Asante Confederacy, and his clever priest, Anokye—as the oral tradition has it—caused the Golden Stool to appear from the sky, whereupon it fell onto the lap of Osei Tutu. The Golden Stool was said to contain the essence and history of the Asante nation.

Although it has never been blackened, the Golden Stool is considered spiritually powerful and even alive. It symbolizes to this day the unification of many Akan peoples under the Asante. It is still much revered, as may be inferred from its position on its own chair, higher than the Asantehene himself, beside whom it appears when both are seated "in state." It has both locally cast and European bells attached, which are rung to announce its presence on the rare occasions when it is seen in public.

Chairs, like other forms and motifs ultimately of European origin, entered the Akan artistic repertoire through coastal trading contacts. At least three types of seventeenthcentury European chairs have been thoroughly assimilated into Akan leadership arts. Reworked and of local

manufacture for centuries, these elaborately decorated chairs never supplant Akan stools, which remain primary objects, but they do contribute measurably to occasions of state. One type of chair supports the Golden Stool in figure 7-4. Called hwedom, which is interpreted to mean "facing the field" (or enemy), this type was used during declarations of war and for judicial deliberations. Some hwedom have spiral-turned legs, uprights, and stretchers; most are painted black, with silver finials and ferules used at the bottom of European walking sticks, and other decorations.

The most common type of chair is called asipim, meaning "I stand firm." The name refers to the chair's sturdy construction as well as to the strength of the chieftaincy. Asipim are constructed (construction itself being a European rather than an Akan technique) of heavy wood. The taut leather seat and back are attached with imported brass upholstery tacks. Backs are further embellished with locally cast finials and patterned repoussé panels, showing the extent to which the Akan have transformed their models. An example of an asipim may be seen in a sculpture depicting a queen mother seated in state (see fig. 7-20, and see also fig. 7.10 for another, cast as a gold weight). The other main adapted type of chair (not illustrated) has crossed legs and thus recalls European folding chairs. All adapted European chairs are studded with upholstery tacks, plus cast brass or silver ornaments.

State Swords

After the blackened ancestral thrones of deceased royals, the most impor-

tant material symbols of statecraft are swords. Like stools, these swords predate the Asante Confederacy, although wealthy Asante kingdoms today have the most visually and symbolically elaborate examples. Also like stools, swords originated as practical devices, then during the eighteenth and nineteenth centuries passed through a period of aggrandizement, taking on various non-practical yet even more valuable ideological and ritual roles.

Several of the most important swords in Asante states have their own names, histories, and appointed custodians; one, called Responsibility, has its own set of protective amulets. Many swords thus have spiritual and political associations taking them well beyond mere weaponry. Formal embellishments and dull blades, sometimes with openwork, parallel these ideological qualities.

The basic sword form is a simple, slightly curved iron blade with scabbard and a hilt shaped like a dumbbell. The grandest swords have cast gold figural ornaments attached, as well as other matching regalia worn by their bearers for ritual and festive events. The swords illustrated here, for example, are displayed with matching caps worn by the dignitaries who carry them at festivals (see fig. 7-2). The swords and caps have been laid upon a blanket made by Fulani weavers (see chapter 3); it reminds us of the importance of northern imports at Akan courts. Gold ornaments attached to the sheaths take many forms, most with corresponding verbal expressions. Many of the ornaments singled out earlier in the discussion of the visual-verbal nexus are visible in figure 7-2.

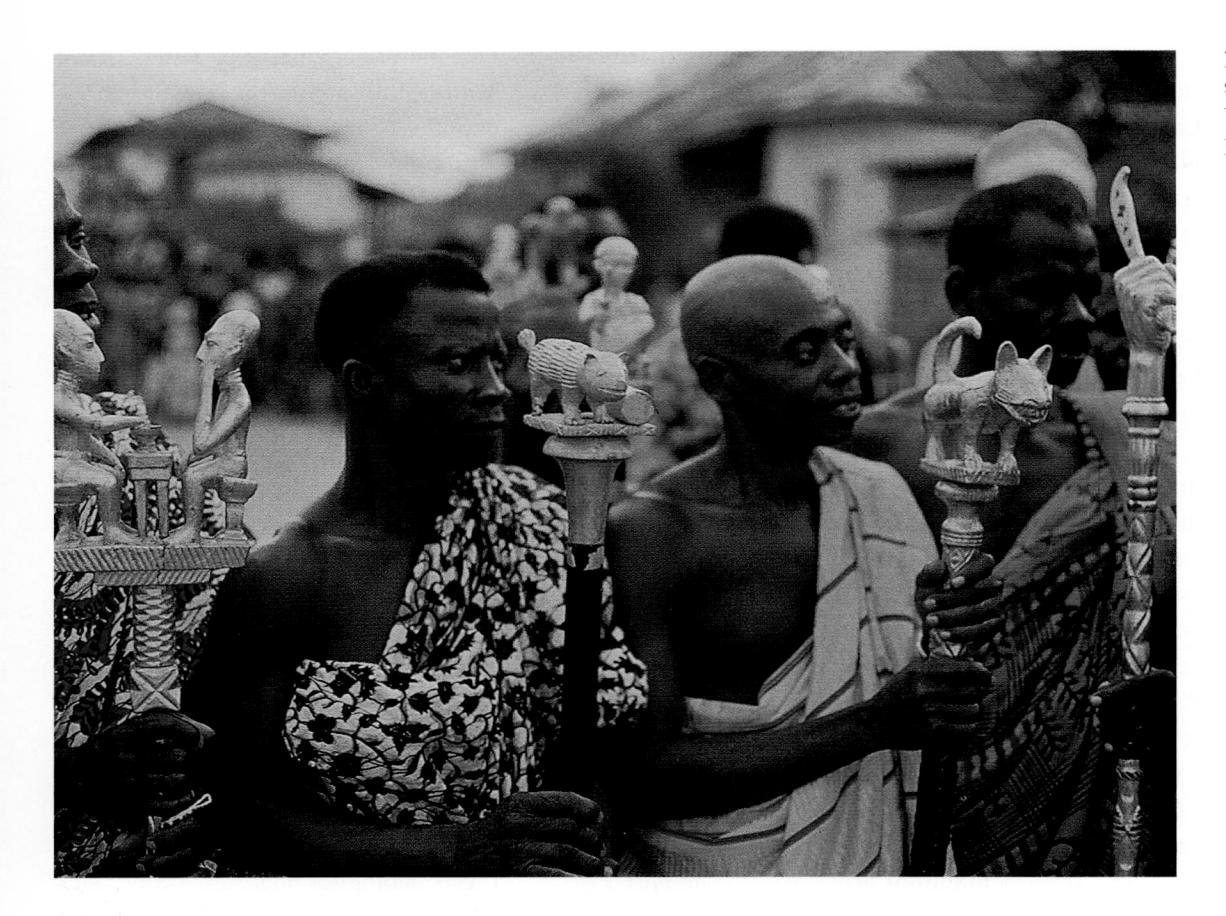

7-5. Linguists with staffs, Fante, Ghana. Wood covered in gold. Photograph 1974

Linguist Staffs

"We speak to a wise man in proverbs, not in plain speech," goes an Akan expression. Nowhere is refined speaking, embellished with proverbial wisdom, more apparent than in the institution of the linguist, a principal counselor and spokesman for a ruler (fig. 7-5). More than a translator, he is also an advisor, judicial advocate, prime minister, political trouble shooter, and historian of state law. lore, and custom—of course chosen for his sagacity, wit, and oratorical skill. Many kings have several linguists, in which case one will be designated chief among them. In the 1970s the Asantehene had thirteen linguists, and he may well have more today.

Since around 1900 linguists have carried carved, gold-leafed wooden staffs of office. Each staff is topped by a figural sculpture that elicits one, and more often several, proverbs. These multiple, overlapping meanings are available for use by the quick and witty linguist, who may have several staffs to choose among, enabling him to use the one whose imagery seems most appropriate for the situation at hand. Akan linguist staffs may have been stimulated by figural staffs from the Lagoons area, where as early as the seventeenth century metal-topped staffs or canes were carried by messengers. But their immediate prototype would appear to be British government staffs given during the late nineteenth century to chiefs, who used them to designate authorized

representatives in dealings with the colonial government. Some of these had figural finials.

Hundreds of linguist staff finials have been carved since 1900, an indication of how objects have been added at specific times to the corpus of regalia. These staffs provide a rich body of imagery with verbal allusions, most of which uphold or comment upon leadership or the reciprocal responsibilities of ruler and subjects. One frequently carved subject consists of two men sitting at a table of food (see fig. 7-5, left), evoking the proverb, "Food is for its owner, not for the man who is hungry." Here food serves as a metaphor for leadership, which belongs to the rightful heir to the stool, not to someone who might hunger for the office. Many

staff finials aggrandize the powers, wisdom, and grandeur of the chief and state. Leopards and lions, as symbols of rulers, broadcast their military prowess and grandeur. Other staffs address the power of the state, war, and peace. A hand grasping a sword (fig. 7-5, far right) signifies that "without the thumb (chief) the hand (state) can hold (accomplish) nothing," and of course this is a threatening, aggressive gesture.

Baule and Lagoons Regalia

Baule and Lagoons societies are mainly egalitarian, and for the most part the independent village is the largest political unit. Relatively affluent and influential community leaders wear gold objects at funerals and other celebrations (figs. 7-6, 7-7). Pendants hung around the neck, around the wrist, or in the hair are cast of solid gold, while walking sticks, crowns, and flywhisks have wooden finials covered in a layer of gold leaf. In the photograph reproduced here (fig. 7-7), an elder of the Adjukru, a coastal Lagoon group, holds a large staff in the shape of a crucifix. It may have been carved by an artist from any Akan group, but is probably not Baule—Baule work tends to be much more delicate, with finely patterned surfaces. Brocades, embroidered cloth, and eyelet are worn at such ceremonies, as is expensive kente imported from Ghana. In some regions participants wear cotton cloth dyed with indigo by Baule weavers, or raffia cloth tie-dyed in red and brown by coastal Lagoon artists and their neighbors. Visually striking figurative sculpture may be displayed; the highly naturalistic female nude kneeling

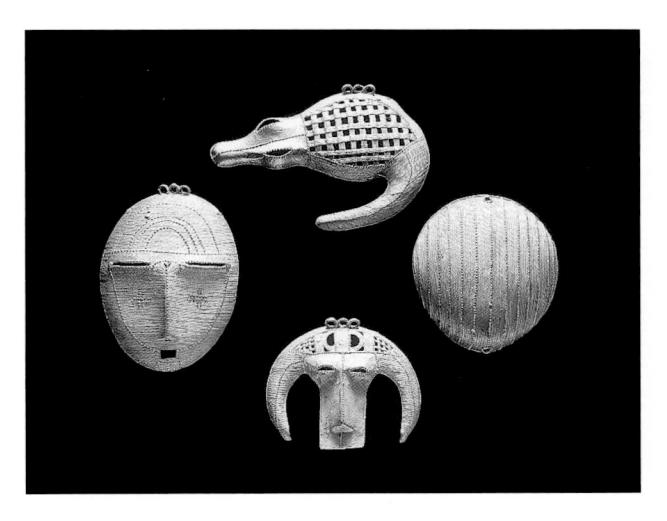

7-6. Ornaments, Lagoons peoples, Côte d'Ivoire. Gold. Musée Barbier-Mueller, Geneva

7-7. Lagoons (Adiukru) dignitary and his wife, Ysap, Côte d'Ivoire. Photograph 1990

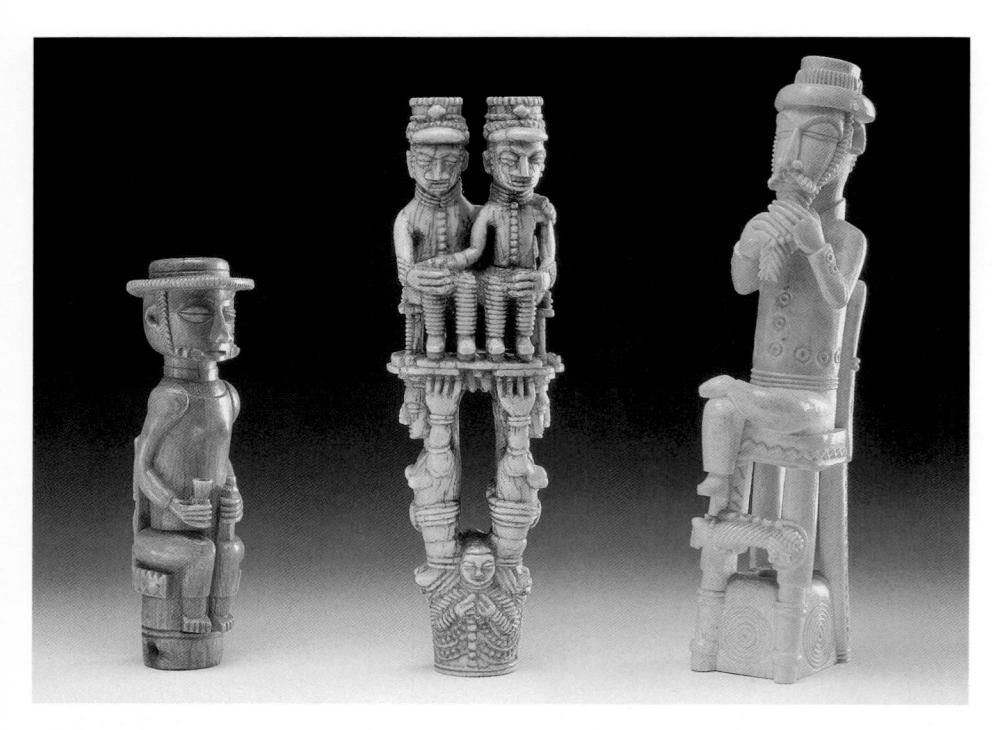

7-8. Three staff finials, Lagoons peoples, Côte d'Ivoire, 19th century(?). Ivory. Musée Barbier-Mueller, Geneva

near the feet of the elder in this photograph came from a workshop near Abidjan, the principal city of Côte d'Ivoire. It was carved around 1980.

In contrast to the state-owned regalia of Ghanaian Akan states, gold treasuries in these regions of Côte d'Ivoire are the property of the clan, the family, or even the individual. In the fluid social environment of Lagoon communities, leaders have accumulated their own influence and much of their wealth, some of which is shown off in "gold exhibitions" and age-grade celebrations. In a "gold exhibition," family heirloom gold is shown separately from an individual's acquisitions, emphasizing how many pieces he or she has amassed. Solid gold pieces made by Baule and Lagoon goldsmiths (especially those of the Ebrie, or Kyaman people) are notable for their fine striations, as

they were cast in clay molds whose impressions were formed from an object constructed of slender wax threads. Motifs of human hands and the heads of rams may refer to the hard work of acquiring wealth, while crocodiles and crabs allude to the hidden practices deemed to be necessary when collecting gold objects and manipulating economic power. Faces are often said to be the ancestors who contributed their gold to their descendants (fig. 7-6). None of the descriptions of Baule and Lagoon gold draw upon the extensive verbal-visual nexus so distinctive of Akan arts in Ghana. However, wealthy Akan patrons have often purchased items of regalia from outside their own ethnic group, and many regalia ensembles thus include objects in various styles, the origins of which are not always firmly known.

Staffs with sculpted finials serve leaders in Côte d'Ivoire as emblems of authority and status, rather than designating spokesmen. While gold-covered staffs are particularly popular today, Baule and Lagoon staffs and spears have also been carved of wood and ornamented with brass tacks, while Lagoon staffs have had finials of ivory. The earliest known examples of these date to around 1850, and may thus have inspired the linguist staffs of the Ghanaian Akan.

The staff topped by a gold-leafed crucifix, seen in figure 7-7, indicates that its owner is a Christian. The three carved ivory finials illustrated here, attributed to the Lagoons area, probably once surmounted leaders' canes or staffs (fig. 7-8). The items of European-inspired dress and the adapted European chairs featured in all three have been typical possessions of affluent Lagoons men and women in coastal centers for several centuries. The two sets of paired figures on the most elaborate ivory (center) represent Lagoons people, as does the man holding the gin bottle and glass (left). The casually posed man on the third ivory is more likely a European, who may have commissioned the piece or received it as a gift. All three are confident, refined carvings.

METAL ARTS: THE CULTURE OF GOLD

The technology of lost-wax casting came from the Western Sudan into the northern Akan areas during the fourteenth or fifteenth century, probably brought by the Jula, an Islamized Mande trading people (see chapter 9). Islamic formal influence was accepted as well, and Akan casters adapted

7-9. Group of three cast *Kuduo*, a spoon, and a hammered brass *Forowa* cosmetic box (far right), Akan, Ghana, 18th–19th century. Fowler Museum of Cultural History, University of California, Los Angeles

Islamic prototypes for their most important type of container, the *kuduo*. These vessels were owned by states and by particularly wealthy and powerful shrines, individuals, and leaders. As expensive heirlooms, *kuduo* were interred, dug up, and reused in several contexts. In shrines, they occasionally—and perhaps more commonly three or four centuries ago—house the sacred ingredients considered the heart and essence of a deity.

Kuduo exist in several distinctive shapes, many of which can be traced to prototypes originating in fourteenth- or fifteenth-century Mamluk Egypt (fig. 7-9; compare with fig. 2-31). Indeed, at least six copper alloy containers of Mamluk origin still do service today in northern Akan shrines; they had to travel about two thousand miles. The imported vessels are believed to possess supernatural power, though they are not considered gods. All have panels of Arabic writing alternating with circular pat-

terns, a type of decoration that was adapted by Akan goldsmiths when they cast their own versions. Yet the "writing" on Akan versions is not legible. We may suppose the panels of pseudo-writing and circular devices were believed by early Akan to provide protection for the contents of the vessels so decorated. The Asante employed Muslim amulet makers and record keepers at the Kumasi court, yet much evidence also suggests they were employed before 1700 by other Akan leaders, perhaps as early as the fifteenth or sixteenth century. Early Akan kuduo were probably cast before the sixteenth century in Bono or other northern Akan towns, but those with heads or figural groups on their lids—purely Akan creative additions—appear only later, during the eighteenth and nineteenth centuries, and most seem to come from Kumasi, by that time the Asante capital.

It was gold that stimulated the greatest creativity in Akan metal

artists. For the Akan, gold had inherent power and mystery; it was feared and magical, and was believed to grow and move in the earth. Sacred and numinous, gold was used in gods' power bundles and human burials, for medicine and protection. A show of wealth and artistic taste was essential to projecting the image of a spiritually sanctioned, prosperous, and powerful state, so vast amounts of energy and wealth were expended on gold regalia, which gives the art of this region its distinctive, radiant character.

Among the most intricate of Akan gold regalia are beads, each one individually modeled and cast, no matter how small (see the regalia of the Ejisuhene, fig. 7-3). In Ghana, huge gold circular beads or disks are worn singly on the chest by swordbearers, by other young men designated as "soul people," or by court servants who may be present at the purification, also called the "washing," of chiefs and ancestral stools. Called "soul washers' badges," these disks can also be worn by other court officials or members of a royal family, and sometimes doubled by royal women. Similar disks in Côte d'Ivoire have associations with purification and protection as well (fig. 7-24). Some, like smaller gold beads, have geometric subdivisions, often crossing at the center, and their overall design may again relate to protective Islamic patterns. Analogous rosettes are common in leatherwork across the Western Sudan, and may derive ultimately from North African Islamic motifs that protect against the "evil eve." Similar circular motifs are central in the silver (and rarely gold) appliqué patterns on some important

7-10. Goldweights, scales, and golddust box, Akan, Ghana, or Côte d'Ivoire, 17th–19th century. Brass. Length 1–3'' (2.54–5.08 cm). Fowler Museum of Cultural History, University of California, Los Angeles

Gold-weighing equipment included a set of approximately thirty standard weights for ordinary traders, although rich merchants and state treasuries might have had double that number. In addition to simple balance scales, each trader had small boxes, some finely cast with birds or other tiny motifs, as well as small cast or hammered spoons and larger scoops for handling gold dust. In spite of the charm of figurative, representational weights, the vast majority consisted of geometric forms, very few of which had verbal associations. Direct casts of a beetle and a peanut are at bottom left.

state stools that again recall Islamic magic squares.

Goldsmiths also created copper alloy counterweights, which were used on balance scales for the weigh-

ing of gold dust and nuggets, the main currency in pre-colonial times (fig. 7-10). Called goldweights, these small sculptures were each made to conform to a precise weight standard

in a system that may have entered the Akan region, again from the north, probably during the fourteenth century and certainly by the fifteenth, when Jula traders came south in search of goldfields. The earliest Akan goldweights are mostly rectangular and round shapes with nonrepresentational geometric decorations. Like early Akan weighing systems, these weights were of Islamic inspiration; analogous geometric forms have been found by archaeologists in the Western Sudan, some with Arabic, Egyptian, and even Roman prototypes. Goldsmiths throughout the Akan area, perhaps by the sixteenth or seventeenth century, also began to cast fairly simple figurative motifs such as birds, fish, and human beings. This representational sculpture is certainly of Akan inspiration and use. However, inter-ethnic trade may have stimulated the production of figurative goldweights in what is now Ghana, for by the eighteenth century the corpus of realistic weight motifs in those Akan states numbered in the thousands. Clearly there was a great proliferation of figural, representational weights during the two hundred years (1700-1900) of the precolonial Asante confederacy. Goldweights fell out of use in Ghana around 1900, when the British forbade using gold for currency in what was then the Gold Coast Colony, and they were gradually abandoned in Côte d'Ivoire as well. Nevertheless, in their astonishing quantity and rich variability, goldweights remain one of the marvels of West African art.

Individually modeled (first in wax), each weight is a study in miniature sculpture, and quite a few show virtuoso, inventive artistry. Nearly all locally available creatures, plants, and objects were cast into goldweight form. Weights in the form of human beings show an enormous variety of poses and activities, including many chiefs riding horses or seated in state, the gold weighing process itself, and a great range of genre scenes, vignettes of everyday and ritual life. Most of these date from the eighteenth and especially the nineteenth centuries. A number of objects such as beetles, crab claws, peanuts, and other seed pods were cast directly, that is, with the original model being burned up inside the clay mold, which was then filled with molten metal.

Many goldweight motifs belong to the vast lexicon of the visual-verbal nexus. A fascinating aspect of the transactions in which they once figured is the role played by the recitation of proverbs or other sayings prompted by specific weights. Few detailed reports exist on the use of proverbs in commercial transactions. Yet since buying and selling in Africa is usually a social process elaborated by extensive greetings and discussion, and since the Akan are well known for eloquent and metaphorical speaking, it is not hard to visualize the extended dialogue that must have accompanied transactions—an indirect, embellished discourse in which proverbs played a role, stimulated partly by each trader's collection of weights. Weights were also sometimes used to send messages. A crab claw meant "pay what you owe me or I will fight you for it," while an elephant tail goldweight meant the bearer came with the authority of the king. Occasional weights, too, were used as protective or healing charms when tied to a wrist or ankle.

7-11. Details of three major forms of Akan textiles. Top: Kente cloth. Middle: A stamped Adinkra Cloth. Bottom: An Akunitan, "Cloth of the great," with embroidered motifs of a Lion, porcupine, stool flanked by Swords, Airplane, Star, and Elephant. All Asante, Ghana, 20th century. Fowler Museum of Cultural History, University of California, Los Angeles

TEXTILES

Three principal types of cloth are worn by the Ghanaian Akan and their neighbors for ceremonial occasions: strip-woven cloth popularly known as *kente* (figs. 7-3, 7-11, 7-19), appliqué or embroidered cloth called *akunitan*

(fig. 7-4, 7-11), and stamped *adinkra* cloth (fig. 7-11). Also worn are amulet-laden cotton tunics called *batakari* (fig. 7-12). Some of these textiles are worn for specific occasions or to identify particular social roles. Often they are made in a hierarchical range of qualities. Simple versions of

7-12. BATAKARI with amulets and magic squares. Probably Akan, Ghana, 20th century. Cotton, leather, paper. 33 x 48%" (84 x 124 cm). The British Museum, London

kente, for example, are available to anyone who can afford them, while heavier, more elaborate, labor intensive, and costly kente are (or were) reserved in Ghana for kings or specific members of royalty. Akan men typically wear huge cloths (six or seven feet by twelve or thirteen feet), toga fashion, without belt or other fastener, and with the right shoulder bare. Women wear two or more smaller fabrics, one a skirt wrapper (worn these days with a blouse), a cover cloth, or shawl, and often a cloth for tying a baby to its mother's back.

The technology of strip weaving appears to have been introduced from the Western Sudan to the Akan area during the sixteenth century, perhaps somewhat earlier, by the Mande Jula. Narrow strip weaving on horizontal looms, worked exclusively by men, is widely distributed across West Africa, yet it takes on particularly elegant and complex form among Ghanaian

Akan and neighboring Ewe weavers, whose kente cloth is made from twoto four-inch strips sewn together, selvage to selvage. Kente range from plain striped cotton weaves, owned by most people, through an extensive hierarchy to dense, color-rich fabrics with complex geometric patterning in fine units. Most kente alternate plain weave and inlay designs in more than three hundred named patterns, organized as checkerboards, stepped diagonals, or asymmetrically, sometimes in random compositions. Ewe kente may also incorporate pictorial symbols such as drums, birds, and human figures, and even lettering.

Verbal-visual correspondences are present, as they are in most Akan arts, and many royal cloth patterns and colors are associated with specific social or ritual roles. The richest *kente* are often primarily silk (early examples having been woven partly with thread unraveled from European cloth), and woven on looms with six

heddles rather than the normal four. Asante versions of this richest *kente*, called *asasia*, have a shimmering, twill-like texture and were exclusively royal weaves (see fig. 7-3). The greatest *asasia* cloth was reserved for the *Asantehene* or those whom he permitted to wear it.

Stamp and comb-line designed adinkra probably originated as mourning cloth among the Asante. Typical mourning *adinkra* are dark brown, brick or rust red, and black, worn differentially depending on the mourner's closeness to the deceased. Most adinkra are patterned in numerous squares that are again subdivided by combed or stamped designs (see fig. 7-11, middle). Patterns are stamped with carved calabash stamps and combs using a dve made from a tree bark boiled with iron-bearing rock or slag. Most known adinkra use European milled cotton vardage as the base fabric. White and many other bright colors, called "Sunday" or fancy adinkra, are probably late additions to this cloth tradition and can be worn for most festive occasions or even daily, though not for mourning.

Most *adinkra* designs are named after natural or crafted things, but many appear to be abstract (fig. 7-13). Nearly all have linked verbal maxims or proverbs. As many as two hundred different stamp designs exist, though some have fallen out of use and others are added periodically.

The Asante may have borrowed the idea of *adinkra* cloth from the Gyaman, a small group to the northwest who had a seventeenth-century chief named Adinngra and another early nineteenth-century leader named Adinkra. A prominent Akan

7-13. ADINKRA STAMP MOTIFS

Adinkra stamps are carved from pieces of calabash: a Aya, "fern," and the word also means "I am not afraid of you" h Ram's horns

c Nyame dua, "except God" meaning that the wearer is afraid of nothing except God d Musuyidie, "something to remove evil," and probably based on an Islamic charm shape e Ladder

scholar, on the other hand, glosses adinkra to mean "to be separated," or "to leave," or "to say goodbye" (from di, "employ," and nkra, "message left on departing"), an interpretation that strongly supports the mourning function. Still a third theory links adinkra cloths to Islamic-derived protective magic squares of the sort seen on some batakari. The Bamana, Senufo, and other Western Sudanic peoples make protective garments with rectilinear painted patterns, but these do not closely resemble either each other or adinkra. Still, adinkra may be part of a large complex of West African cloths with mystical, protective properties, perhaps inspired in part by Muslim technologies of inscription and pattern-making with magical inks.

Chiefs often wear locally produced or designed fabrics such as *kente* or *adinkra*, but they also own rich European textiles such as brocades, velvets, and damasks. At some point after imported cloth became more plentiful, probably during the nineteenth century, Akan-designed appliqué or embroidered chiefs' cloths were invented. Called "cloth of the

great," akunitan, these are divided literally or implicitly into a checker-board, each square of which contains an appliqué or embroidered motif (see fig. 7-11, bottom; see also fig. 7-4). Motifs range from abstract or geometric through pictorial, and many have verbal associations. Clearly each "cloth of the great" is a more or less systematic set of allusions to royal power, responsibility, and wealth.

Many peoples in West Africa wear tunics made of coarse cotton strips woven by men, often with added charms. They are prevalent among the Dagomba and Mamprussi of Northern Ghana and possibly were first imported into Asante lands from that region. Called batakari among the Akan, these tunics feature pendant amulets, and sometimes other attachments such as horns and claws, which have been prepared by spiritual adepts and are believed capable of protecting and empowering their wearers. While elsewhere they are made by blacksmiths, most among the Akan seem to have been prepared by Muslim charm makers. It is said that each charm includes an inscription from the Qur'an (though some

have been opened to reveal only powder, presumably also viewed as spiritually effective), thus invoking the powers of Allah to serve people who are not in fact Muslims. The Akan are nevertheless impressed with Islamic technologies, including writing. Some batakari from Ghana are inscribed with both writing and subdivided rectilinear patterns called magic squares, which also are believed to have mystical power (see fig. 7-12). The very pigment with which Islamic script and symbols are drawn is believed powerful (and thus is drunk in liquid form), and drawn magical patterns are even more so. These garments are worn by hunters, warriors, and their leaders, not just Akan royals, and some have had their efficacy increased with blood sacrifices. "Great" batakari worn by Akan chiefs and kings for mourning festivities and other rites are especially laden with charms, sometimes hundreds of them. Many amulets are cased in gold and silver as well as animal horn, leopard skin, red cloth, and the more common leather. The metal cases are usually further ornamented with embossed or repoussé patterns, as if to redouble their mystical potency.

TERRACOTTA FUNERARY SCULPTURE

Several generations ago, some Lagoon groups, some Anyi kingdoms (especially the Sanwi and Aowin), and some Ghanaian Akan states (especially in the southern Akan regions), commemorated the deceased with terracotta figural sculpture (fig. 7-14). The clay images included isolated heads, heads attached to rudimentary bodies, and heads attached to funer-

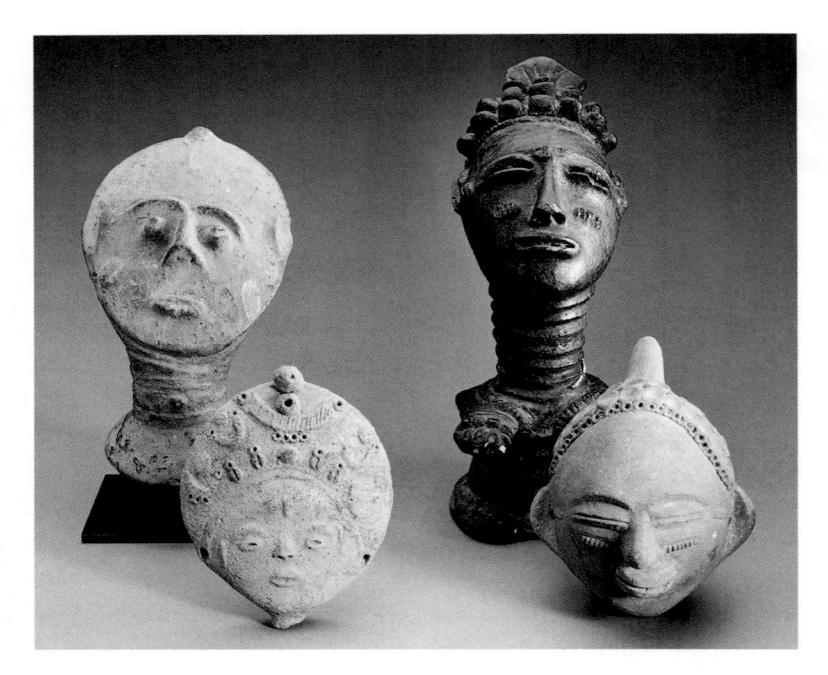

7-14. Memorial Heads. Clockwise from Left: Kwahu (Ghana), Anyi (Krinjabo, Côte d'Ivoire), Twifo-Hemang (Ghana), Ahinsan (Ghana), 18th (?)—Late 19th Century. Terracotta. Average Height 6" (15.24 cm). Fowler Museum of Cultural History, University of California, Los Angeles

Most terracotta images were made by women, in keeping with the almost universal African association of females with clay and pottery. While to outside eyes the sculptures do not appear to be descriptive portraits, artists who were interviewed insisted that they took special pains to model a close likeness of the deceased.

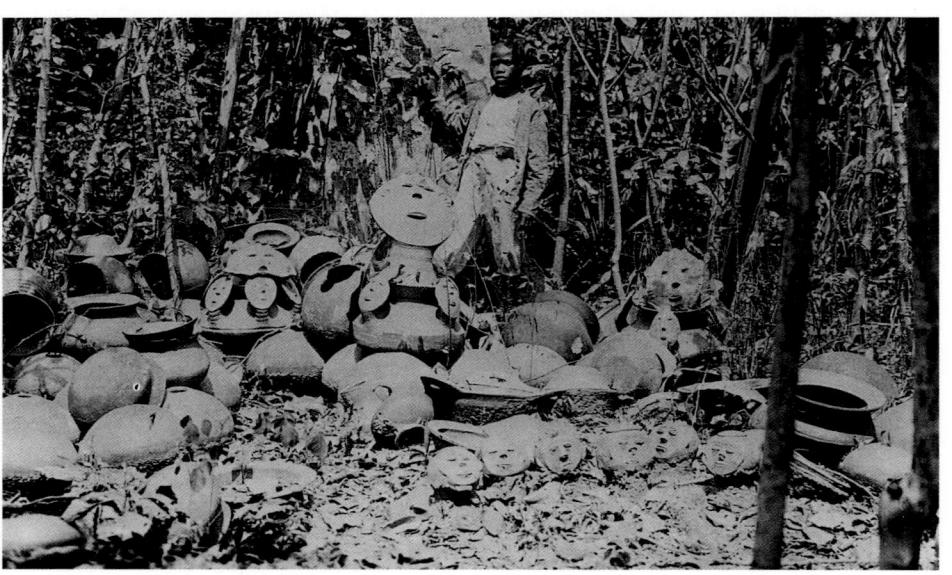

7-15. "Place of Pots," probably Kwahu region, Ghana. Photograph 1930s (?)

ary vessels, and they often had royal contexts. These terracotta traditions go back at least to the sixteenth century. Writing in 1602, for example, Pieter de Marees, a Dutchman who had voyaged to the coast, described elaborate royal Fante burials that included painted clay figures portraying the deceased leader and all the

members of his entourage.
Archaeological excavations at a
Lagoon site in southern Côte d'Ivoire
brought to light clay heads dating to
the seventeenth and eighteenth centuries. However, most Akan terracottas now in Western collections were
taken from their original locations in
the early twentieth century.

Royal terracotta images were occasionally adorned with fine cloth and seated in state on chairs for royal second burial ceremonies, surrounded by both terracotta and actual human attendants. The dressed sculptures were later paraded through the streets of the community to the royal graveyard in a festive procession, drawing crowds of people who shouted farewells to the departed. In some areas annual rites of commemoration were held at such sites as the "place of pots," adjacent to an actual graveyard (fig. 7-15). In other areas, however, little attention was paid to the figures after their initial presentation.

The people of most areas recognize these terracotta heads or figures as portraits. As in other African portraiture until the last few decades, however, this did not involve descriptive imitations of actual human models, but rather generic renderings of heads with a few individualizing details such as scarification or hairstyles. Many sculptors followed the widespread Akan convention of flattening

7-16. AKUA MA ("AKUA'S CHILDREN"), EARLY 20TH CENTURY: LEFT IS FANTE, MIDDLE ASANTE, AND RIGHT BRONG-AHAFO, GHANA. WOOD. AVERAGE HEIGHT 8" (20.32 CM). FOWLER MUSEUM OF CULTURAL HISTORY, UNIVERSITY OF CALIFORNIA, LOS ANGELES

Such figures are usually called Asante fertility dolls, an unfortunate phrase on two counts. First, while the Asante perhaps originated the form and surely have made thousands, most other Akan make them too. Second, since most such images start out their lives as spiritually activated power figures, the word "doll," so secular in modern usage, is probably not the most accurate descriptive noun, even if in some cases children are later allowed to play with them.

the head, a reference to idealized beauty. Such heads are often schematic, quite flat and thin, with simplified features applied or incised. Other heads are fully round and quite naturalistically modeled, although simplified and idealized in showing neither age marks nor blemishes. Many styles and types of heads are known, a variety that suggests regional developments and changes over several centuries. Such terracottas are more prevalent among the southern Akan (Fante, Aowin, Anyi, Twifo, and others) than among the Asante, so a southern origin is likely. A large group of memorial figures comes from the town of Krihjabo, in southern Côte d'Ivoire, a capital of an Anyi (Sanwi) kingdom (see examples in fig. 7-14).

WOOD SCULPTURE AND SHRINES

Akan deities are thought of in human terms: kind or angry, generous or withholding, neither always bad nor good. Invisible nature spirits—lesser

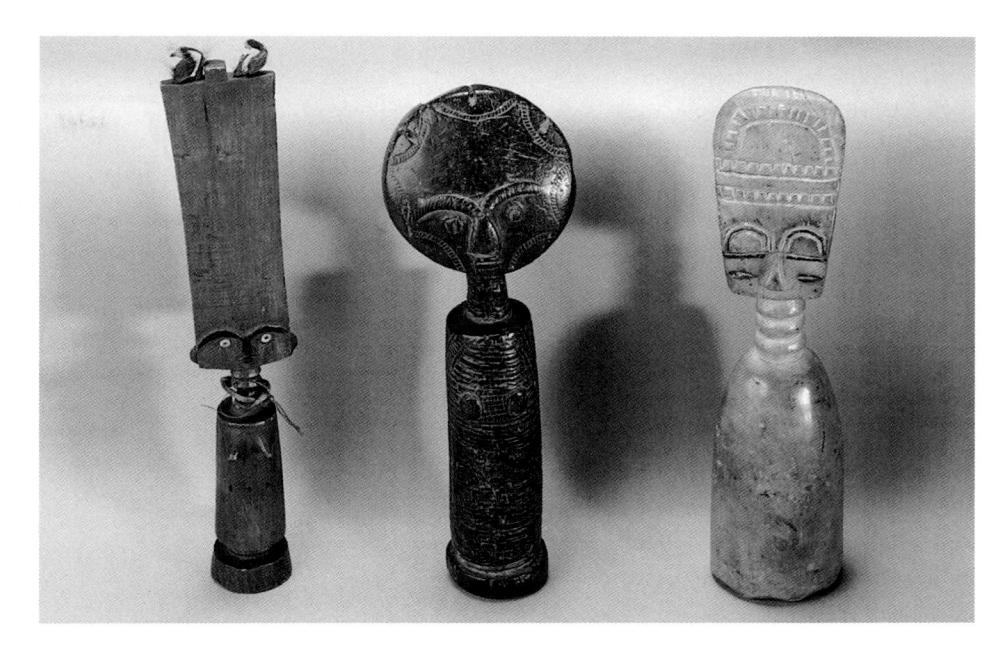

deities who meddle constantly in human life—may be considered dirty and ugly, hostile dwarfs with skin disease and backwards feet, but they are nevertheless carved as handsome, well groomed, and highly civilized in order to avoid their wrath and charm them into benevolent behavior. Thus they are rendered with long necks, often ringed, precisely carved scarification on torsos, necks, and heads—called "marks of civilization" by the Baule—finely plaited hair, erect posture, and other attributes of ideal men and women. These attributes vary regionally among the Akan; whereas the Baule appreciate bulging calf muscles, for example, the Asante and other Ghanaian Akan admire long, flattened, sloping foreheads. Exaggerated in many images, they were formerly effected on actual people in a mild form when, as infants, their cranial bones were gently modeled by their mothers.

Shrine sculptures are sometimes requested by the deities themselves, or they may be given to the shrine by

grateful devotees, or by a priest or priestess seeking to create a more impressive environment. Adding to a shrine's mystique, some figures are ascribed miraculous origins: they were found in the forest, fell from the sky, or appeared in flames. But of course most are products of professional though part-time sculptors whose individual styles can often be recognized within a larger framework of regional Akan styles and major iconographic types.

Akua Ma

Small figures found in shrines of the Ghanaian Akan are among the best-known images from all of Africa (fig. 7-16). Their bodies are cylindrical, with or without arms, and most have thin disk-shaped heads, suggesting that their sculptors carried to an extreme the sloping forehead convention evident in most of the terracotta heads discussed above. The figures are called "Akua's children," akua ma (sing. akua ba). Oral traditions (now

of course written) recall a woman named Akua as the first woman to own and care for a consecrated human figure on instruction from a priest. A figure was ordered from a carver and taken to a shrine to be empowered. Barren, and mocked for carrying a surrogate baby made of wood, Akua is said to have gotten pregnant nevertheless, eventually giving birth to a healthy baby girl. Thus divine intervention was in part responsible for conception as well as the safe delivery of a healthy child, and small figures of analogous "children" are common in many parts of Africa.

Female children are preferred among the matrilineal Akan, and akua ma are almost always carved as female. Having learned from the experience of the legendary Akua, other Akan women desiring children, ever since, have ordered small figures from artists, had them consecrated at shrines, and waited hopefully, often carrying the "child" tied at their back the way real children are carried. They were given beaded jewelry and sometimes clothes; they were fed and cared for as the hoped-for child would be. Many regional styles of akua ma exist, just as one carver's version of the figure will differ from another's. Although it is true that these figures were sometimes given to children as playthings, or "dolls," we avoid using that word because it tends to trivialize traditions that are spiritually based here as they are in most parts of the continent.

Asante Carvings and Shrines

Shrines are locations of deities and their symbols, often considered their

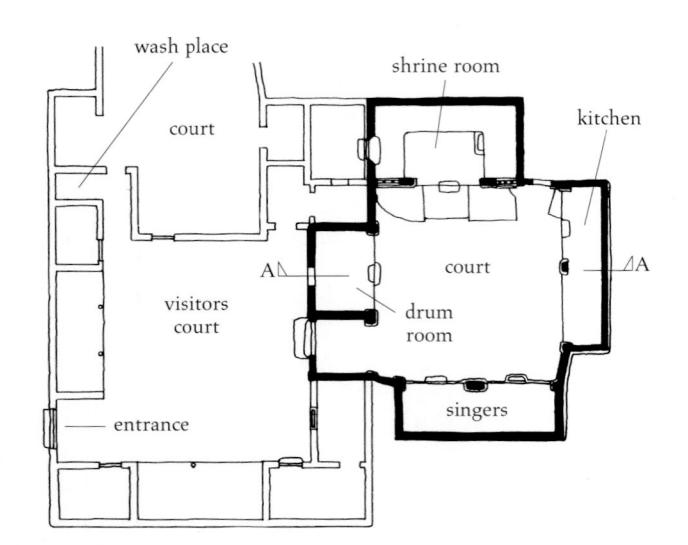

7-17. Plan of a shrine, Asante, Ghana. Drawing after M. Swithenbank

7-18. A. SECTION OF A SHRINE BUILDING, ASANTE, GHANA. DRAWING AFTER M. SWITHENBANK B. DETAIL OF OPENWORK PANEL FROM A SHRINE BUILDING, ASANTE, GHANA. DRAWING AFTER M. SWITHENBANK

"homes." In former times, shrines were housed in splendid buildings dating back at least to the nineteenth century (figs. 7-17, 7-18). A few of these have been restored and preserved as Ghanaian national monuments. Some have openwork screens or reliefs with interlace patterns of Islamic origin. Specialized Muslim builders were often brought in from the north to create these temples, whose decoration, accorded power, was intended to protect the sacred contents housed within.

Shrine rooms or buildings contain smaller or larger ensembles of varied sacred materials together with props such as furniture, utensils, regalia, and offerings. They may also contain figurative images. Figure 7-19 shows the interior of an atano shrine housing several separate altars, all dedicated to the powerful deities associated with the Tano River. Visible are three brass pan altars arranged hierarchically on stools draped with kente cloth, two pans flanking an elevated third. Each pan contains a different manifestation of the deity, the sacred materials that comprise the essence or heart of the god. Formerly, these ingredients were sometimes housed in *kuduo* vessels. Imported brass pans have long been more commonly used, however, and such shrines are called "brass pan shrines" after this feature. The shrine shown here also houses several other lesser brass pan altars. Brass basins were imported from England, supplanting locally cast

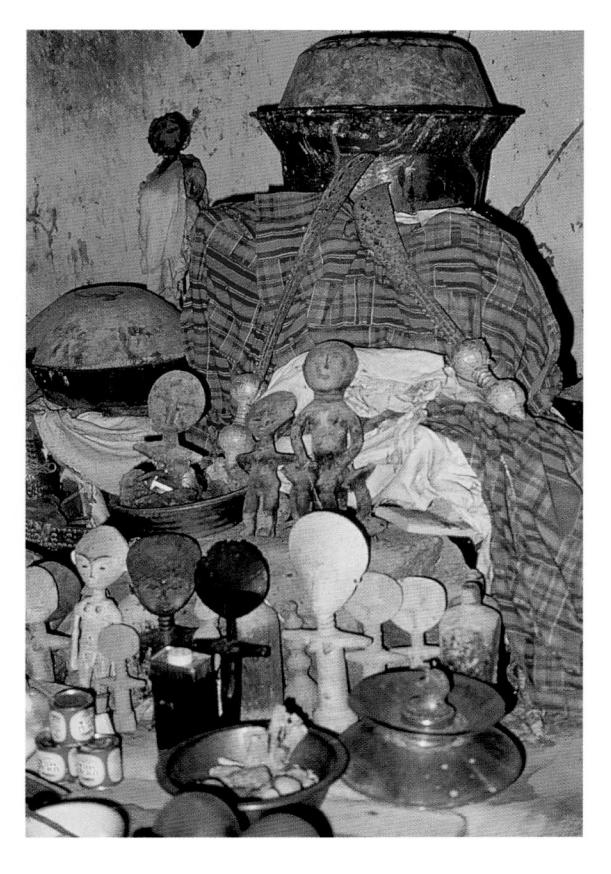

7-19. *Atano* shrine, Asante, Kumasi region, Ghana. Photograph 1976

Large shrines such as this one address a host of community issues under the auspices of a resident priest or priestess. Atano deities, deriving their power and identity from the River Tano, are tutelaries considered responsible for the health and general welfare of the people, their animals, and crops. Ultimate power, however, comes from the high god, Oyame, who is prayed to but is more remote and not represented in figural sculpture.

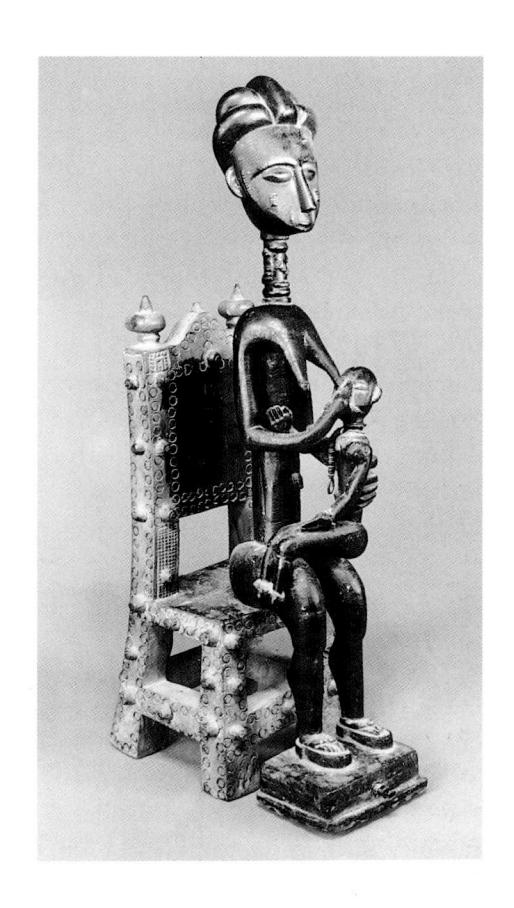

7-20. Queen Mother and Child. Asante (?), Ghana, late 19th–Early 20th Century. Wood, pigment, glass, beads, fiber. Height 22½" (57 cm). Collection of Mr. and Mrs. Arnold J. Alderman

kuduo probably in the nineteenth century.

Also here are akua ma in varied styles and forms. Akan shrines are likely to have six or ten or more akua ma. Most of the twelve figures visible on this shrine were consecrated there, then later returned to it as thank offerings after their owners successfully gave birth. A few are full figures, with more naturalistic arms and legs; these are more recent than the abstracted versions. The figure positioned highest among the akua ma (between the state swords) is made of terracotta, and was carried by a woman in the ceremony in which her akua ba was empowered by the god Tano through prayers by his priest.

The *kente* cloth and state swords here are examples of royal regalia, which is often stored in shrines so

that it may absorb the spiritual powers that render leadership more effective. Evidence of the wealth of the deities and their shrine, regalia also serves to partially anthropomorphize the god(s), who "wear" these items. Shrines may also include musical instruments, containers of gourd or ceramic and other kitchen equipment, as well as books, diplomas, photographs, and other "modern" artifacts that signal the literacy or progressive outlook of a priest or custodian.

The Asante, Fante, and other Akan peoples in Ghana refer to all human figural sculpture as *akua ma*, although not every image was used to help bring forth children. Larger, more elaborate statues were commissioned for direct use on shrines, in palace stool rooms, and for some secular purposes (fig. 7-20).

Unfortunately no data survive on the original context and purpose of this masterful, virtuoso carving. The stately woman, shown seated upon a European-derived asipim chair with her sandaled feet elevated on a footstool, is clearly a queen mother. The carver worked in a detailed and attenuated, thin-limbed style; the figure has long slender legs, proportionally a still longer torso, and an enlarged and somewhat flattened head on a long, scarified neck. She sits proudly erect, her back cut well away from the chairback. In keeping with Asante preferences for glistening dark skin,

the figure was painted a shiny black, while the chair was left the natural color of the wood. An absence of facial expression adds to the impression that this woman is aloof, that she is not emotionally involved with the child she is suckling. Yet impassive faces are common in African sculpture, so it would be a mistake to read a temporary emotion into it. Rather, it is the permanent quality of human dignity that is emphasized, properly for the office and person of queen mother.

Baule, Anyi, and Lagoon Sculpture in Wood

Baule statuary is among the most celebrated of West African art traditions by virtue of the subtle refinements and careful detailing of many older carvings, such as the confidently rendered male/female couple shown here (fig. 7-21). These images, nearly identical apart from the clear indications of gender, show the absolute control a master carver had of his tools, his ability to create exactly the figure he intended. In keeping with other spirit representations, the faces are impassive. The surfaces of both figures have been modified by ritual use, and jewelry has been added. Their original use is uncertain, although the somewhat "messy" surface, resulting from sacrificial libations (now partly cleaned), suggests they may have represented nature spirits or diviner's spirits.

The areas beyond and outside the village, called the Other World, are, for the Baule and some of their neighbors, the locations of two important classes of spirits with whom people maintain contact on a daily basis. Unlike the creator god, often consid-

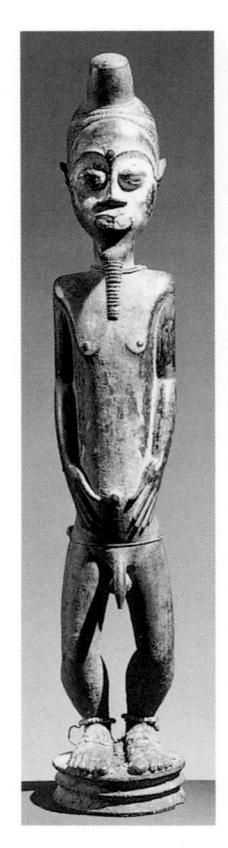

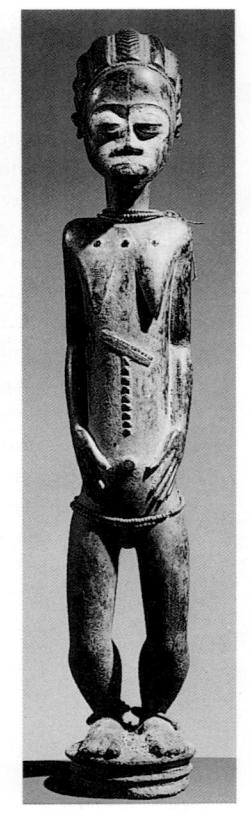

7-21. Pair of figures, probably for ASIE USU, Baule, Côte d'Ivoire, 19th–20th century. Wood. Height of Male 21¾" (55.4 cm), female 20½" (52.5 cm). The Metropolitan Museum of Art, New York. Michael C. Rockefeller Memorial Collection. Gift of Nelson A. Rockefeller, 1969

lives, these nearby spirits intrude themselves more or less constantly. Earth spirits, asie usu, for the Baule are among the kinds of nature spirits also feared and revered across much of West Africa. Some are associated with the sky or earth, others with water, still others with the uncut forest, the wilderness or "bush," as it is commonly called. Sickness, infertility, crop failure, and other misfortunes are attributed to the actions of asie usu. Alternatively, personal difficulties—especially those involving mar-

riage, the family, children, or finances—are often ascribed to the jealousy or unhappiness of a person's "otherworld spirit lover." The Baule hold that all adults have a mate of the opposite sex living in the Other World, and that his or her activities and thoughts affect the person of this world, and vice versa.

Both asie usu and otherworld lovers can ask, through a diviner, to be materialized as a "person of wood," a statue, and thus to be honored in this world. A carver is sought and commissioned. The spirit, the diviner, or the client determine the specific attributes of the figure—pose, type of clothing or hairstyle, whether or not a female will carry a child, and so forth. The completed image is consecrated through sacrifice and prayer, and the client or specialist must subsequently make periodic food offerings and follow other procedures. The shrine of the otherworld woman illustrated here contains gifts of eggs and a mound of white chalk requested by the spirit (fig. 7-23). Persons with otherworld spirit mates normally dedicate one night per week to him or her, when they will not sleep with their this-world spouse. The spirits may also dictate other prescriptive activities that enable clients to gain satisfaction or regain health and equilibrium.

The fashionable spirit-spouse in figure 7-22 is adorned with imported paint. The upscale dress, high heels, watch, handbag, and finely plaited hair all suggest the kind of urban sophistication sought by some Baule people around the middle of the twentieth century. The man who commissioned this spouse figure, for example, might have been seeking employment in the capital city of

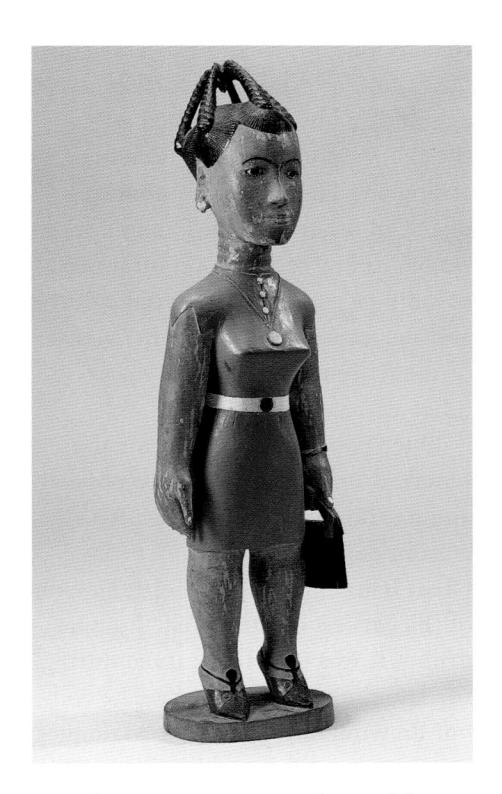

Abidjan, spurred on by his decidedly stylish, rather affluent otherworld mate. Her presence in his household shrine might well have pointed to such desires, suggesting underlying marital problems. A functionalist explanation for such helping and healing shrines sees the spirit figures as scapegoats whose tangible presence facilitates change or recovery (from job loss, for example) because they help the client to externalize his or her desires or problems.

Anyi and Lagoons figures were usually created for diviners, religious specialists whose practices are very similar to those of the Baule. These statues were thus equivalents of a Baule *asie usu*, and were also kept in shrines or displayed during public

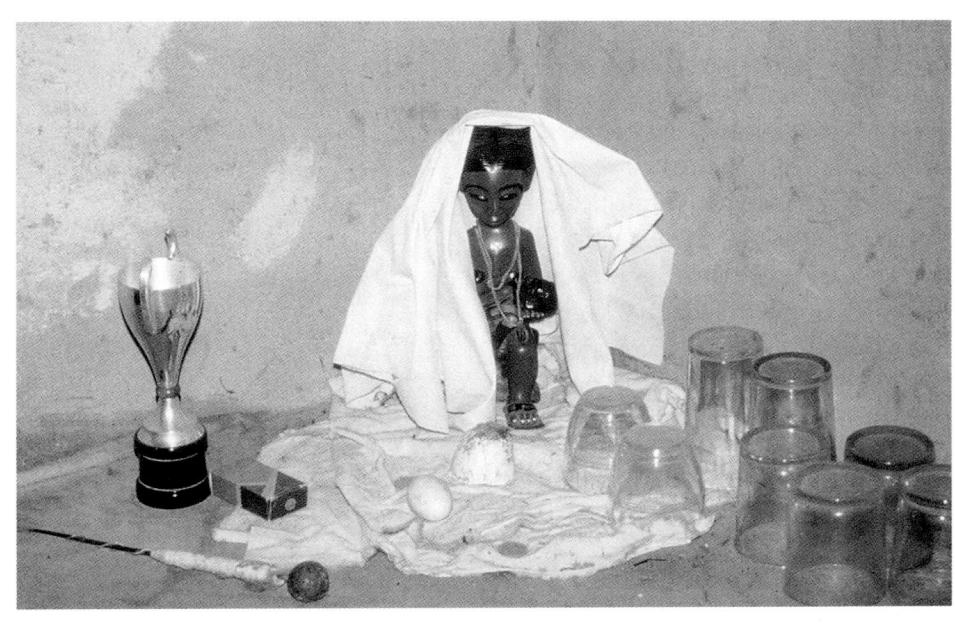

7-23. Otherworld-spouse shrine of sculptor Koffi Niamnien, Baule, Toumodi region, Côte d'Ivoire. Photograph 1981

consultations. However, some Lagoon groups also carve figures to serve as "otherworld" partners or as stand-ins for a deceased twin, and much Lagoon sculpture is displayed as sacred or secular objects at age-grade contests, funerals, or "gold exhibitions" (see fig. 7-7). The small statue in figure 7-24, made by a sculptor of the Akye, the Ebrie (Kyaman), or another Lagoons people, may have been the seat of a supernatural force—a forest spirit, and a diviner's helper—or it might have been a more secular "guardian of the dance," awarded as a prize to an excellent performer. Throughout this region the use of a figure can therefore rarely be discerned simply by looking at it; one also needs to collect its history.

Despite the functional continuity between Lagoons and Baule sculptures, the Lagoons figure is very distinctive in style. The rhythms of bulges and constrictions in the sym-

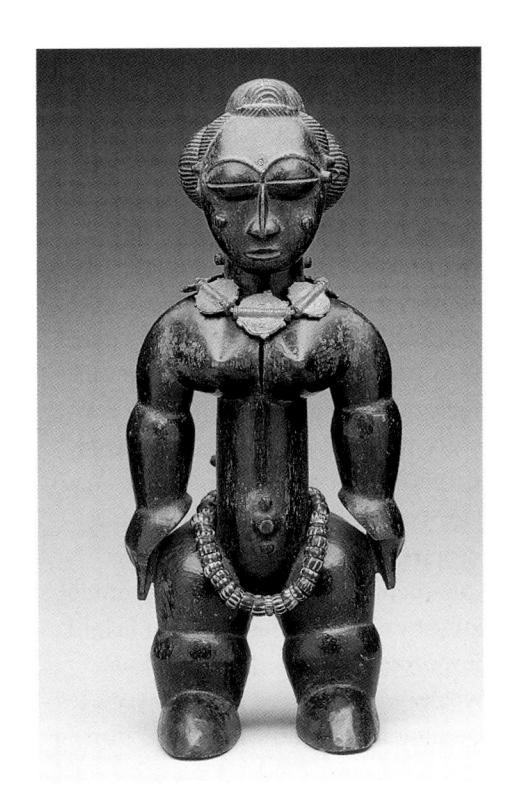

7-24. Standing figure, Lagoons, Côte d'Ivoire, 20th century. Wood, glass, brass beads. Height 9½" (24.5 cm). Musée Barbier-Mueller, Geneva

metrical figure's legs and arms build up to emphasize a greatly enlarged head, which itself has much enlarged eyes. Another distinctive feature is the presence of small pegs—sometimes for the insertion of medicines—placed on the torso to emulate decorative keloidal scars. The conventions of this early twentieth-century Lagoons figure contrast well with the later twentieth-century and much more realistic, naturalistic Baule female figure (fig. 7-22 and see fig. 7-7).

Secular Carvings

As noted above, it may be impossible to distinguish whether a statue was sacred (carved for spirit forces) or secular (carved for display and entertainment) without information on its original context. Documentation exists, however, for the figural groups and other secular forms that were a specialty of the famous Asante carver Osei Bonsu. During his long and distinguished career, Bonsu created examples of virtually every type of Akan wooden object, including carvings later goldleafed as regalia for three Asante kings. He also carved for colonial administrators and for early tourists who visited the Gold Coast. Bonsu's figure ensembles usually feature a chief, queen mother, linguist, swordbearers, and other members of a royal entourage under an umbrella, often painted in bright imported enamels (fig. 7-1). Such works were ordered as display pieces by popular drumming groups during the 1930s and 1940s. Bonsu's personal style is recognizable in his naturalistic treatment of somewhat enlarged facial features beneath a sloping forehead.

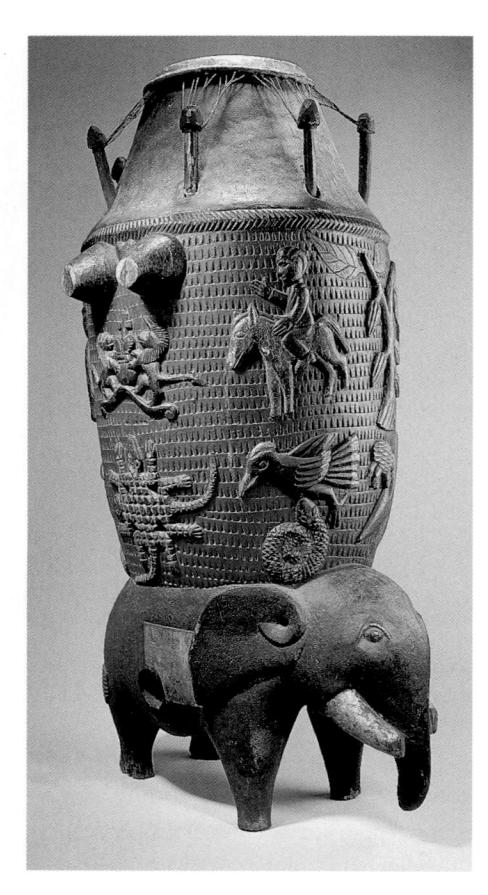

7-25. Drum, Osei Bonsu, Ghana, Early 1930s. Wood, Hide. Height 44" (111.7 cm). Fowler Museum of Cultural History, University of California, Los Angeles

The same performing groups also commissioned elaborately carved drums (fig. 7-25). The example shown here was carved by Osei Bonsu during the early 1930s. Two breasts (now partially broken) signal that the entire drum is to be understood as a female body. Between them is a carved heart and, beneath, the British royal coat of arms, an indication that the group obeys all colonial government rules. Female gendering of such drums is typical, and while the exact meaning is not known, it accords with the fact that the largest, most important drum of an ensemble is known as the "mother of the group." This and other similar drums are further aggrandized by being carved as though supported on the back of a strong animal—in this case an elephant, in others, a lion. The images carved in low relief represent aspects of daily or ritual life, material culture, and the natural environment. Many of them are linked to proverbs or other verbal forms.

One possible inspiration for the female drums that became so popular among the Fante during the 1930s is a drum depicting Queen Victoria of Great Britain (ruled 1837–1901). One of the earliest documented "human" drums, it was probably carved during the late nineteenth century. The rollout drawing in figure 7-26 catalogues the many motifs carved in low relief on the drum's body. The largest figure depicts Oueen Victoria herself. At a level with her head are five Native Authority policemen, each holding an object associated with control. To her left is a seated Akan chief, holding a state sword and shaded by an umbrella. Beneath him in turn are figures holding symbols of Akan power: stool, state sword, linguist staff. Elsewhere are tools, implements used for personal grooming, a building (probably meant to be a castle) flying a British flag, and numerous animals and insects. The imagery has to do with British power, Akan chieftaincy, and suggestions that the drum group is well dressed and groomed and has many up-to-date material objects. The animals are a rich source of traditional wisdom, because nearly all of them are associated with savings that cover a wealth of social, political, economic, and spiritual issues. All told, the complicated embellishment of this instru-

7-26. Roll-out drawing of motifs carved on an Akan drum

ment is a compendium of many historical, colonial, and local Akan references, almost a microcosm of life around the turn of the twentieth century.

ROYAL FESTIVALS IN GHANA

If there are many fine sculptures and other objects in Ghana considered works of art from foreign points of view, the largest and most significant art forms from the Akan perspective are surely the elaborate royal festivals held annually in most states, which bring together regalia, art objects, music, and dance to renew the state spiritually and politically. Important rituals are carried out, including purifying the king and the ancestral stools, feeding the local gods with sacrifices, mourning the dead of the past year, and reaffirming political loyalties and allegiances. There are also lavish public displays of personal decoration and state regalia, dancing and drumming, singing and speech making. Formalized dress and behavior prevail, along with feasting, for the gods and the people alike are offered the "first fruits" of the agricultural year. In many areas attendance at such events is mandatory; those that miss them are fined, so even if one works in a city some distance away, he or she is encouraged to return home for this annual spectacle.

Multiple processions surge through streets and plazas, set in motion by state orchestras whose master drummers beat out praise poems glorifying chiefs and state history on "talking drums" whose tones reproduce speech patterns. A dozen or more chiefs and their entourages participate. Some chiefs walk while more important ones ride in palanquins gesturing with flywhisks or weapons to the crowds. Dozens of colorful umbrellas with golden finials pass by, including the double dome of the king (fig. 7-27). Several drum orchestras plus groups of elephant tusk trumpeters supply rhythm and tonal vibrancy, while many voluntary organizations

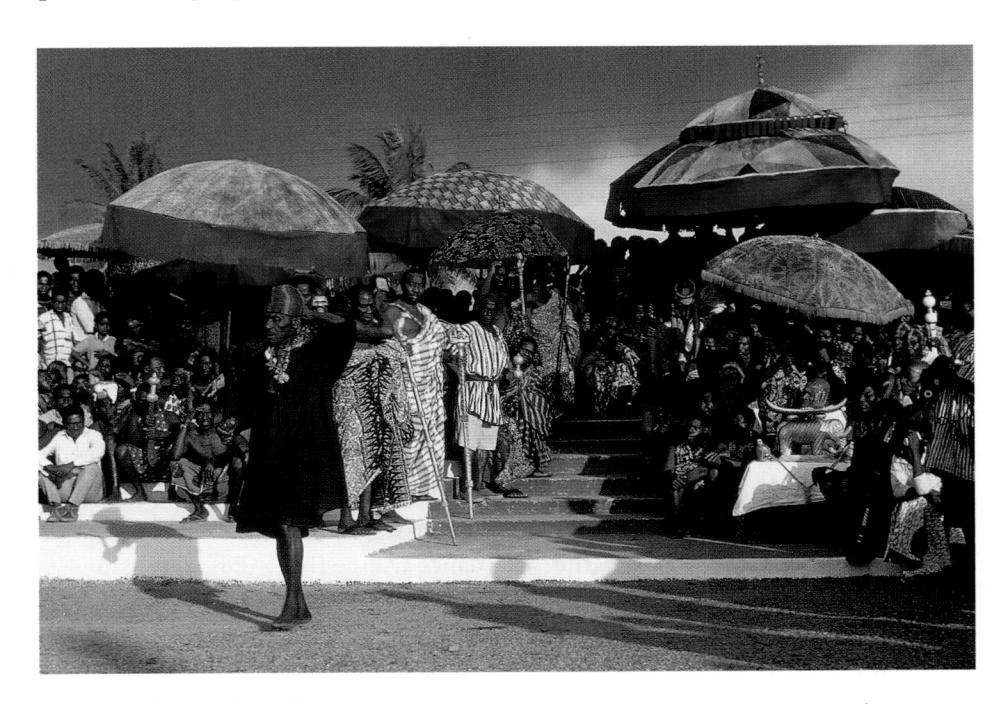

7-27. King Kwame Fori II under his double umbrella at the royal festival of Akuropon, Ghana, 1972

whose members dress and move as one add color and texture to the whole.

Great festivals are well staged and precisely choreographed, as much by history and tradition as by individuals. Events are composed in space and time, framed by beginning and closing rituals, with intricately orchestrated themes, colors, textures, rhythms, patterns, and dramatic thrust—the same elements present in any art object, such as a sculpture or a complex kente. Scenes and rites are acted out, tempos and moods are established, working toward climax and resolution, all in the service of meaning. The strength and unity of the state are reaffirmed, gods and ancestors are honored and thanked. major concerns of royals and the people at large are aired and resolved. At least these are sought ideals. The atmosphere is dignified and cool for restricted or solemn rites, vibrant and pulsating for public displays. Excess and confusion are frequent visitors, as many activities happen simultaneously in different places, overlapping and coalescing, with hundreds, even thousands of people taking part. The entire spectacle as a unity subsumes its parts—people, arts, events—into a whole of magnificent intensity and scale.

BAULE MASKS AND MASQUERADES

If the Ghanaian Akan channel great aesthetic energy into regalia and the festivals that make them visible, the Baule in contrast seem to focus much of theirs in an array of masquerades. Living at the northern and western edge of the Akan world, the Baule have been influenced by neighbors

7-28. Moyo Yanso's portrait mask in performance, Baule, Kami village, Côte d'Ivoire. Photograph 1979. Mask carved by Owie Kiemo c. 1912 in Kami village

who use a variety of powerful masquerades, and the Baule have adapted some features of these masquerades for their own use. In some cases, the Baule seem to have transmitted their own masquerade forms to Akan groups further south and east.

Portrait Masks

The most secular of Baule masquerades are known by a variety of names. They all feature dancers wearing beautiful cloth and oval face masks honoring the female leader of a dance troupe (fig. 7-28). While in many ways the equivalent of a secular display carving (such as a Lagoons figure, an Asante sculptural group, or a Fante breasted drum), these smooth, idealized faces are designated portraits

of a specific woman (or women). The dancer portraying the honored woman is sometimes accompanied by the woman herself, or by her representative, as he performs. Even though these smooth and restrained portrait masks are explicitly oriented toward the community rather than the spirit world, some are virtually indistinguishable from the sacred masks of the Yaure, a non-Akan group living to the west of the Baule, and the social context of the Baule masquerades links them to Guro masquerades such as Flali (see fig. 6-35).

Goli

Another popular masquerade form was adapted by the Baule from the Wan, a Mande people contiguous to the northwest and expanded upon by the Baule. The discussion here combines Wan and Baule versions, which in any case vary from village to village. Goli, a popular Baule masquerade, is substantially secular today but with serious social commentary implied and a basis in beliefs about supernatural powers, their sources, effects, and hierarchies (figs. 7-29, 7-30). The most usual venue for *goli* is the funeral of a prominent person, for which the all-day masking sequence provides both protection and entertainment. More powerful forces of nature and its spirits, amwin, in earlier times, goli masks in recent decades have become progressively weaker as supernatural vehicles. Still, the masks are ritually activated and their bearers wear empowering substances and must obey dietary and other restrictions.

The ideal sequence of Baule *goli* dances includes four successive male–female pairs of virtually identi-

7-29. KPLEKPLE (JUNIOR MALE) MASKERS, BAULE, BOKPLI, CÔTE D'IVOIRE, 1982

7-30. GOLI GLIN (SENIOR MALE) MASQUERADE, BAULE, CÔTE D'IVOIRE, 1978

cal masks, one usually black, the other red. All are danced by men. The mask pairs, along with metaphorical associations made for each by some Baule (and outsider) analysts, are:

associated with

mack nair

mask pam	associated with
kplekple	weak youthful wild
(junior male)	animal/boy/goat
goli glin (senior male)	strong elder bush spirit/messenger/ forest buffalo
kpan pre (junior female)	girl merges bush and village/soldier/ antelope (?)
kpwan (senior female)	idealized village woman/leader/ leopard

For the Baule there is no logical inconsistency in the fact that each mask name, seemingly single and gender-specific, actually describes a male–female pair of masks. Indeed, the couples imply marriage, family, and children—all fostered by the masquerade.

Through their sequential appearance, the masks trace a progression from foolish youthfulness to stronger, more aggressive danger, then from youthful female grace to fully realized womanly beauty and wisdom. The first two pairs, essentially animalistic, signify unruliness and forest power, contrasting with the second two civilized human pairs, which represent the dignified order of the village and its leaders. The progression, though, is not inviolate. The Wan dance only three masks (omitting junior female), and their masks are not pairs but single. Nor does every Baule village dance all eight. Nevertheless the sequence and its associations are generally observed.

Each masked presence combines several sometimes ambiguous traits, exemplified with particular force in the senior male, goli glin (see fig. 7-30). The formal complexity of this mask—curved and straight lines and planes, voids, and solids—implies its complex meanings. The mask is a composite of buffalo, antelope, crocodile, and perhaps bird, as feathers of a powerful bird are attached and "eagle" is one of the mask's praise names. It is painted with red medicinal pigment, implying blood, danger, trouble, aggression, but also black and white. The masker executes a rapid, aggressive, and difficult dance. Goli glin is feared and linked with killing and death, yet he is also protective, his fresh young palm fiber cape symbolizing life and continuity.

Junior females, the penultimate pair, wear face masks surmounted by horns. The final and hierarchically highest mask, eagerly awaited throughout the day, is kpwan, senior female, the embodiment of cool, pure, life-giving womanhood. Her mask is small, with balanced harmonious features. The costume emphasizes whiteness, which implies peace and wellbeing. Yet the mask is considered difficult to wear and dance, even dangerous, and carries numerous restrictions. A man without children may not wear it, and an error in the dance could bring on a poor harvest. Here artistry and ritual purpose merge. In some areas, at the end of the sequence the senior male returns to the arena to enact a love scene with the senior female. Then she departs the dance ground; he sets out later to find her, angry that she has left. Together they then retreat to their sacred sanctuary in the forest. There, well away from

the audience, the masks are retired.

Goli meanings are layered and metaphorically rich. The sequence, while entertaining and dramatic, with elaborate costuming, well-carved masks, clever songs, and affecting dances, is at the same time a compressed version of Baule/Wan values, a microcosm of age, gender, aesthetic, knowledge, and wilderness/village follower/leader hierarchies and oppositions. Performing at a man's funeral (more rarely a woman's), to which ancestors are invited so as to welcome their newest member, the maskers celebrate life, beauty, elders, wisdom, and women. Thus the masquerade comments upon human existence and many of its essential categories, and at the same time it enriches and deepens that life by its allusions, its drama, and its art.

Bonu Amwin and Do

While the Baule masquerades described above are primarily called forth for celebrations, a particularly powerful category of Baule mask generates fear and is intended to combat evil forces in times of danger. Such are the sacred bonu amwin (fig. 7-31), similarly shaped animal composite masks related to the horizontal helmet masks of the Gur- and Mande-speaking peoples who live north of the Baule. Men in many Baule communities have collectively at least one of these, some seven or eight, each with a different name and related if discrete purposes. Activated and empowered by sacrifice when donning costume and mask in the forest sanctuary where they live, the masks require strict precautions from the male population, and especially

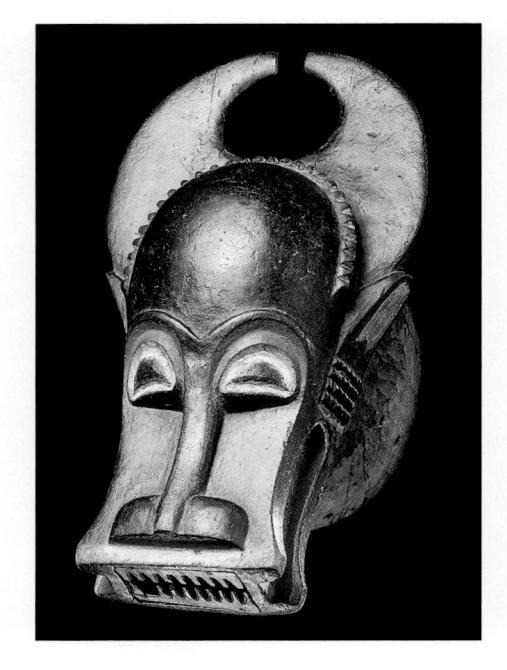

7-31. *Bonu Amwin* mask, Baule, Côte d'Ivoire, before 1939. Wood. Height 19¾" (49 cm). Musée Barbier-Mueller, Geneva

from their carriers, before entering a village. The maskers (one or several) have come out for the past several decades at dry season festivals and for funerals of respected elders, but earlier they appeared whenever something seriously threatened village order. At death celebrations they attend the preparation of the corpse and the vigil, returning again at the end of the mourning period, thus helping to banish death from the community, just as analogous Senufo composite masks and the even more complex Dogon dama do (see chapter 5). Announced by buffalo horns believed to be their voices, bonu amwin maskers, with costumes of forest materials, carry whips and lances to terrorize the crowds, menacing people with wild, erratic behavior. Women, who are especially threatened, retreat to their houses.

Bonu amwin operate—and espe-

cially did some decades ago—to protect communities against hidden or overt dangers such as negative witchcraft, disease, or threats of warfare or catastrophe. These masks are also purifiers, judges, and settlers of conflict. Through intimidation and threatened or actual violence, this masquerade represents the male ethos of dominance, pointing out by contrast the restraint and order preferred in village life. Significantly, the only amwin stronger in Baule life belongs to women, who never use masks, and this is invoked only when men's efforts to avert misfortune have failed.

Some bonu amwin are known as Do. This name further links these masquerades to those of peoples to the north, for the term seems to be of Mande origin. The term also refers to masquerades with secret powers in Burkinabe societies (see chapter 5), and to men's masquerades in Muslim and non-Muslim communities in

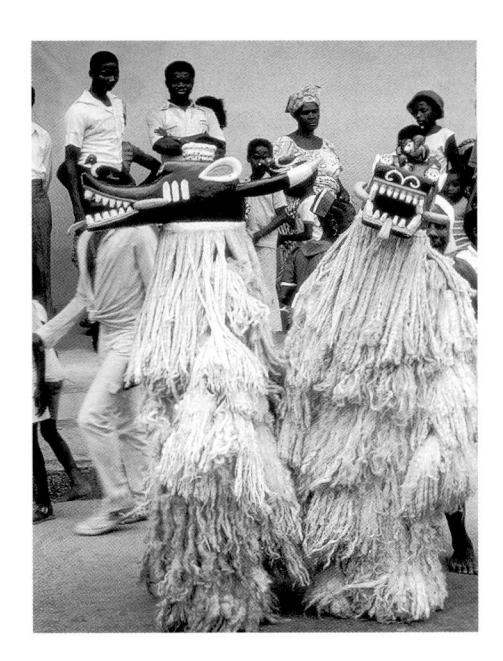

7-32. Do Maskers, Fante, Cape Coast, Ghana, 1979

northeast Cote d'Ivoire. Masquerades by Akan peoples other than the Baule are rare, but Do masquerades, which use these horizontal helmet mask forms, have also been documented among the Anyi and in some Lagoon groups. Generally the centralized Akan kingdoms of Ghana do not engage in masquerades at all, but the appeal of these mysterious males is so strong that they have been danced by a Fante military association (Asafo) in the town of Cape Coast (fig. 7-32).

AGE-GRADE ARTS OF LAGOONS PEOPLES

Occasionally masks may appear at ceremonies of Lagoon age-grade associations. Age-grades, an institution not found in Ghana, are formal divisions by social age of the male population. As in most Akan groups, inheritance is based upon a person's matrilineage, but age-grades and other types of military groups are organized according to a man's patrilineage. Formerly, some stages of the age-grade system prepared young men to be warriors; their age-grade proved its courage and unity to men of older age-grades in contests of supernatural strength. Today, a series of ceremonies still determines whether or not a generation of men is fit to take on leadership positions. Monumental drums are visual and spiritual focal points in these ceremonies (fig. 7-33). Formerly they called men to war and led them to battle; today they still summon men to the funerals of age-grade members.

In addition to drums, age-grades have displayed flags and carved figures. In the last decades of the twentieth century, new generations of fight-

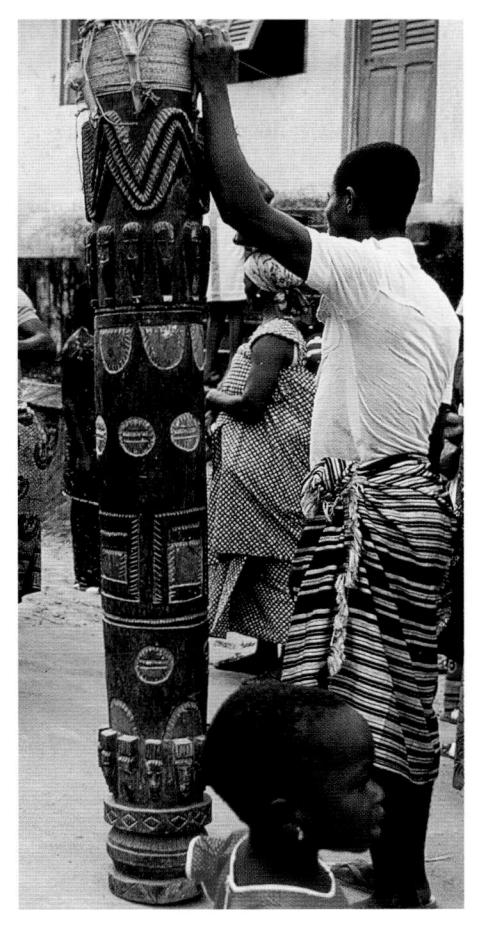

7-33. Akye (Lagoons) drum in an age-grade ceremony, Côte d'Ivoire. Polychrome wood. 1981

ers carried or dragged life-sized figures of people and animals, carved and painted to appear shockingly lifelike (a smaller version of one of these figures is visible in the gold display illustrated in fig. 7-7). While generals of the age-grade wear distinctive costumes identifying them as warriors, the heads of the generation are adorned with the costly cloth, ivorytopped staffs (fig. 7-8), and gold ornaments (fig. 7-6) described above. And although age-grade festivals are said to be strictly a male endeavor, women dressed in equally rich attire accompany and protect these leaders.

ARTS OF FANTE MILITARY COMPANIES

Military associations among the Fante, known as Asafo, provide even more elaborate artistic displays than their Lagoon counterparts. Despite the centralized nature of Fante states, Asafo groups are essentially egalitarian, and both men and women are active in Fante Asafo groups. Having been in constant contact with European powers along this coast since the late fifteenth century, and having served as reluctant hosts to European-designed trading and slaving forts and the garrisons that staffed them, Fante military organizations have absorbed and adapted European ideas, motifs, objects, and technologies into their own artistic culture.

For many decades now Asafo groups have been "fighting with art," for first the British, then the Ghanaian government usurped military functions once performed by Asafo members. Otherwise they are essentially social organizations, although they still serve as a democratic counterbalance to royal hierarchies, playing a role for example in selecting and enstooling a paramount chief. Each state and most large communities have from two to a dozen Asafo companies, setting up an automatic rivalry played out in festivals and the arts. Each company owns certain exclusive colors, motifs, musical instruments, and other insignia, with any violation of such prerogatives by

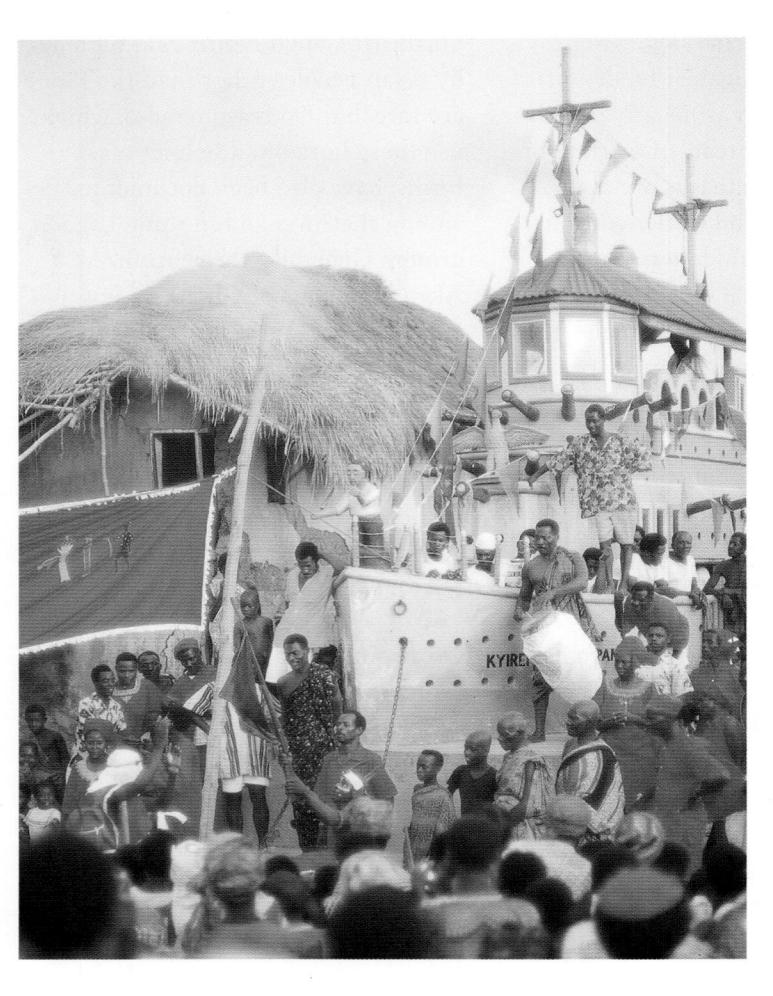

7-34. Asafo
POSUBAN AND
FLAG DURING A
FESTIVAL, FANTE,
ANOMABU,
GHANA, 1976

another company being considered an act of aggression. Art, then, may and does cause disputes, which in the old days erupted into bloodshed.

For many Asafo companies, a concrete shrine, building, or monument serves as a rallying point. Called *posuban*, these structures developed during the 1880s, slowly replacing previous rallying points such as fenced shrine mounds or sacred trees. Over the course of the twentieth century they were elaborated into fanciful, even flamboyant civic markers.

Posuban are built of European-introduced concrete and related materials, drawing upon local castles and Christian churches for some of their architectural elements and from earlier Akan impulses for their essential and sometimes whimsical visual character. A posuban houses its company's sacred drums and symbols. Although most have little interior space, they serve as centerpieces for meetings, funerals, and festivals, and as ostentatious flagships for Asafo activities—sometimes literally (fig. 7-34). This

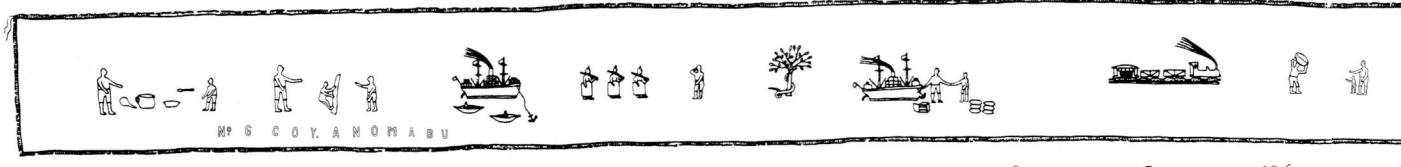

0 5 10 ft 0 1 2 3 m 7-35. Asafo flag, elephant grasping palm tree, man with bird on head, and bystander, by A. Achempong, Fante, Ghana, c. 1935. Cotton. Fowler Museum of Cultural History, University of California, Los Angeles

In this flag, the palm is credited as the strongest plant, the elephant, the strongest animal. "Only the elephant can uproot the palm" asserts the superiority of the elephant, the animal kingdom, and the company that owns the flag. "When no trees are left [elephant got the last one], birds will perch on a man's head," or when you see something unusual—such as a bird perching on a man's head—something caused it. This reminds the company to look for reasons behind the strange behavior of others. The linguist with the staff, to the right, explains all this.

warship is one of five in Fanteland, where two other *posuban* take the form of airplanes.

Most posuban, however, are built as multistoried structures. Many have a wedding-cake stack of progressively smaller stories, and most are ornamented with sculpture. As with other Akan arts, sculptural subjects may be emblematic, or they may be linked with proverbs. Motifs generally aggrandize the company, often while belittling rivals at the same time. A common proverb for lions, for example, is "A dead lion is greater than a living leopard," meaning "Even at our worst we are stronger than you." Notably, the lion became a popular Akan motif in part because of its use in British heraldry and commercial logos.

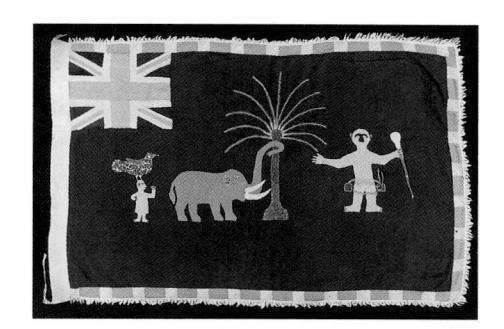

The same types of imagery, with the same origins, are seen in two dimensions in flags, an Asafo company's most important portable symbol. Inspired by flags of European visitors, Asafo flags have been aggrandized in form, use, and meaning. Most of their appliqué motifs are linked to verbal expressions, giving them a particularly Akan inflection. As with posuban imagery, these expressions commonly vaunt the strength of the owning company, often at the expense of the diminished and weaker rival. Generally measuring about four feet by six feet, flags are sewn and appliquéd with bright cotton cloth by male artists. The British Union Jack occupies an upper corner of earlier

flags (fig. 7-35), replaced by the Ghanaian flag after independence in 1957. Asafo flags have been made for at least three hundred years. Each new officer commissions one that later enters his or her company's collective property; many groups had several dozen until these flags became popular among European art collectors and were sold off to dealers. Such has been the fate of all too much African art. Less easily alienated are those locally invented flags, some as long as three hundred feet, with thirty or more appliqué motifs, that are a playful, almost illogical, extension of the flag maker's art (figs. 7-34, 7-36). Unlike posuban, which are of course permanently on view, flags and uniforms come into their own when animated in festivals.

Many Fante states celebrate an annual festival largely given over to Asafo displays, though their ritual base points up the traditional civic and spiritual responsibilities of these military groups. One such is the path-clearing festival, *akwambo*. The paths are those to local shrines and

7-36. Asafo company flag sewn by Mr. McCarthy in 1952, Fante, Ghana. Drawing by Patrick Finnerty

Currently in the collection of the Fowler Museum of Cultural History in Los Angeles, this flag was originally made for display by Asafo No. 6 Company in Anomabu, Ghana. A rival Asafo successfully challenged its maroon background color in court, however, and the company was prohibited from using it (which is why it could be purchased by the museum). No. 6 Company eventually had a duplicate flag made on a correct bright red background, which they still legally display (see fig. 7-39). The flag is almost 100 feet (30 m) in length. Its nineteen motifs do not form a continuous narrative, but they variously refer to the strength, wisdom, preparedness, and invincibility of the company and the foolishness, timidity, and weakness of competitors.

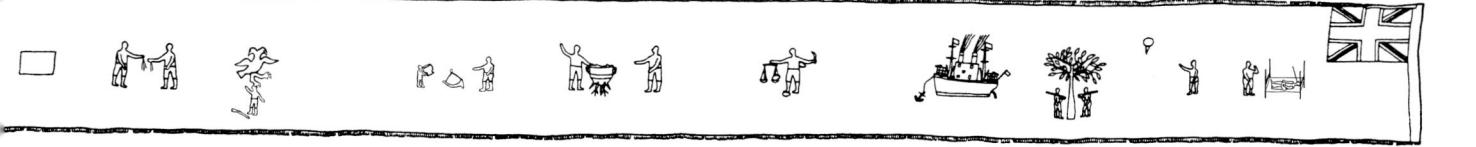

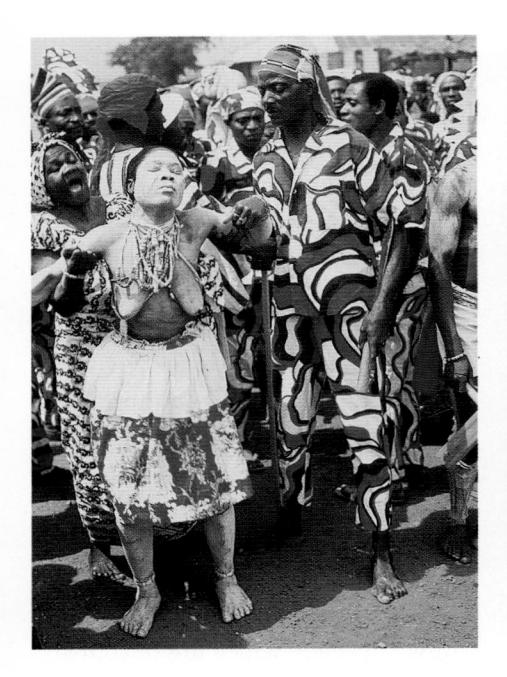

7-37. Priestess with uniformed dancers from No. 1 company, Fante, Legu, Ghana. 1974

Religious specialists, such as the priestess here, are either members of the Asafo company with whom they parade, or their deities are given special protection by the military group.

water sources. After company members have cleared these overgrown trails, which may be a mile or more long, rituals are performed for major deities to placate and thank them for granting and preserving prosperity (figs. 7-37, 7-38).

The principal source for the example of *akwambo* described here is Legu, a coastal fishing community with two rival Asafo companies. This *akwambo* transforms the town with costumed marching groups, singing, skits, flag dancing, chanting, and dancing for some six hours, with each company allotted equal time. Up to eighteen subgroups of each company

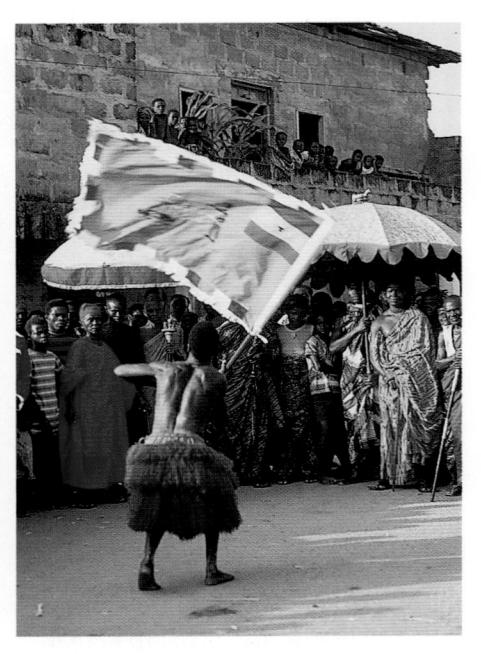

7-38. Flag dancer at an *AKWAMBO* festival, Fante, Anomabu, Ghana, 1972

A typical flag dancing sequence, actually a brief martial drama, unfolds to the rhythms of drums and gongs, and with the support of uniformed divisions. The dancer proudly carries his banner into a skirmish. Then he hides it, rolls it up, and tosses it to another soldier for protection. He later retrieves it, unfurling it victoriously.

appear, with vibrant, distinctive uniforms in company colors: red, white, and blue for one company (see fig. 7-37), and yellow, orange, green, and purple for the other. Some subgroups dress as soldiers, boy scouts, girl guides, and police, with uniforms faithfully copying the originals. The two companies compete in outdoing one another in the brightness and numbers of uniforms, in marching and chanting, and in skits interspersed in the flow of subgroups entering and leaving the main town plaza in quick succession. Thus an officer mimics sounding the water's depth with a lead line, a mock police

officer directs the truly heavy traffic in the plaza, two "soldiers" speak to each other over string telephone wires stretched between their wooden handsets, and a flag dancer acts out a brief scene.

Flag maneuvers and elaborations figure strongly in Asafo displays. Specially trained flag bearers twirl, throw, protect, and otherwise dance their flags, which graphically broadcast their company's military prowess (fig. 7-38). Companies with long flags may suspend them from their posuban (fig. 7-34) or carry them in serpentine processions through town streets, as if clearing away anything in their path. These spectacular banners have names such as "river" or the "runoff of rainwater," metaphors for the company's power to sweep obstacles away as they inundate their outclassed enemies.

Competition between companies is serious, yet playfulness also pervades Asafo imagery and martial activity. Since the Fante understand well that actual warfare is a thing of the past, they let imagination, humor, and a spirit of play enliven their "fighting with art."

LIVES WELL LIVED: CONTEMPORARY FUNERARY ARTS

Competition among Asafo companies stimulates varied art forms, but this is not the only arena in which inventive new arts have appeared. Businesses in the cities of Ghana and Côte d'Ivoire have patronized a lively commercial art market since the colonial period. Artists and their apprentices, often based in small street-side studios, paint signs for clients. Some advertise

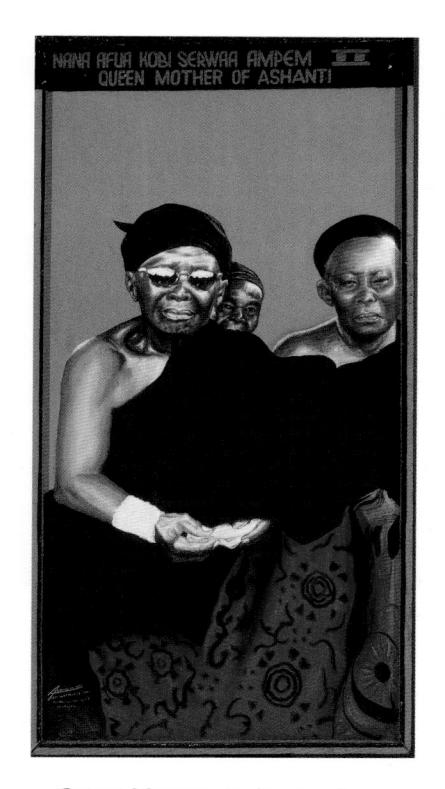

7-39. *Queen Mother of Asante,* Almighty God, Ghana, 2002. Pigment on Board

the exciting shows provided by traveling theatrical groups, and their videos. Painted portraits are also made as inexpensive, durable substitutes for photographs. Portraits of celebrities, often quite naturalistic, are sold alongside other work. The example here, a multiple portrait from a photograph of the Asante queen mother with attendants, was painted by a Kumasi artist who works in this ancient Asante capital. Known as "Almighty God" (fig. 7-39). (originally Kwame Akoto), this painter (born 1950) has attracted foreign clients because he also creates some personal religious works expressing his own beliefs. These straddle the Euro-American categories dividing "fine art" (for self-expression) and "commercial art" (for clients). The gueen mother in this lifelike

portrait is shown wearing mourning attire. In fact, funerals are an important context for innovative arts. These are usually "second burials," colorful. joyful celebrations of the lives of the prominent dead. They occur months or even a few years after interment. Vast sums of money are channeled into commemorative sculpture and lavish festivities, following a belief that amounts to a formula: status in the ancestral world is directly proportionate to social position and generous expenditure in the living world. Much in keeping with the accommodations that Fante Asafo companies have made over the centuries to European ideas, materials, and images, funerary arts too have been modernized to keep pace with changing cultural conditions. The early decades of the twentieth century, for example, saw the rise of cement memorial sculpture, a direct legacy of the terracotta memorials discussed earlier. Stimulated in part by European mausoleums and graveyard statuary, many West Africans began to erect monumental sculptural groups in permanent materials, often polychromed. By the 1960s and 1970s, cement memorials were common. ranging from single figures to large

sculptural groups, some in abbreviated architectural settings (fig. 7-40). In addition to the commemorated man, sculpture may depict other family members, drummers, angels, police or guards, equestrians, felines, all more or less symmetrically and hierarchically arranged. Inscriptions record the relevant names, community, and dates, sometimes along with biblical passages if the family is Christian. These modernized commemorations accord with overall tendencies in contemporary African art toward permanent materials, vibrant colors, descriptive portraiture, and artists desiring acclaim for their skills.

During the 1970s in Accra, the capital of Ghana, a carpenter named Kane Quaye (1924–92) began a parallel tradition, the construction and sale of a remarkable series of fancy coffins. His subjects—cocoa pod, Mercedes Benz, rooster, outboard motor, among others—catalogued both aspects of everyday life and concerns with prestige and wealth. Coffins were painted with bright enamels and lined with sumptuous fabrics. The very piecing together of objects with shaped wood, nails, and glue is introduced

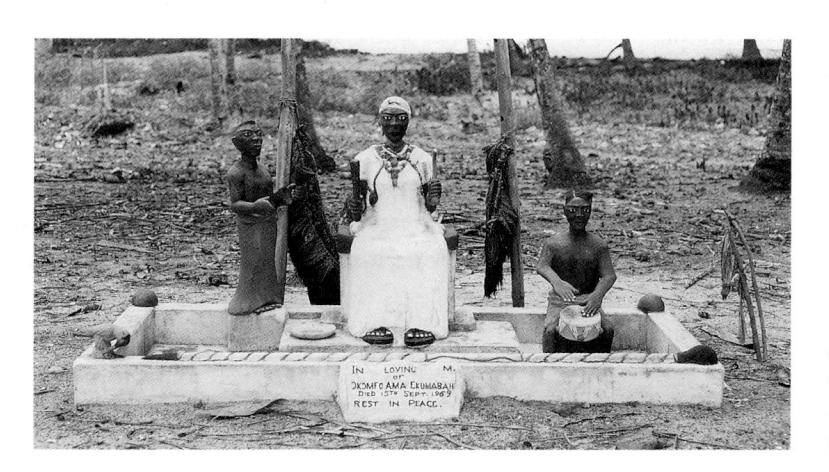

7-40.
MEMORIAL
SCULPTURAL
GROUPING,
GHANA.
CEMENT AND
PAINT

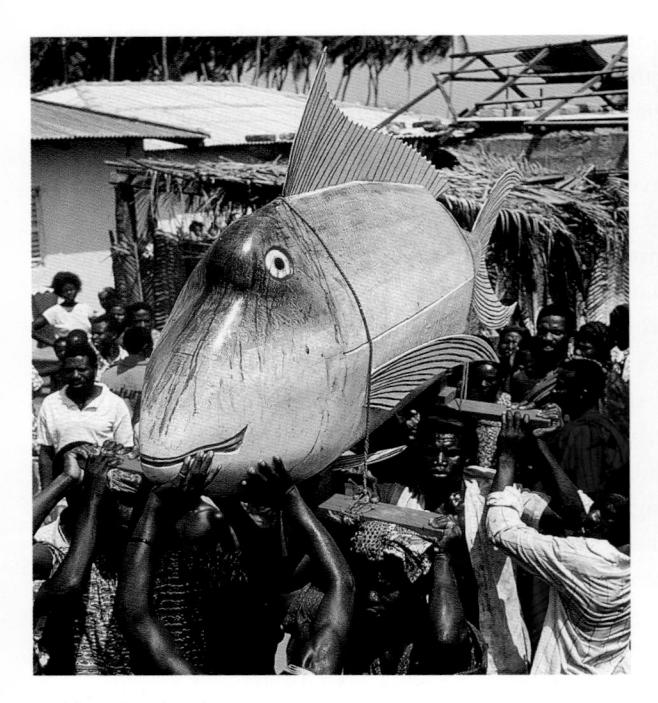

7-41. Funeral procession with fish-shaped coffin, built by Paa Joe, Ga or Ewe, near Accra, Ghana, 1992

7-42. Market Lanes, Ablade Glover, Ghana, 1994. Oil on Board. 30 x 40%" (76 x 102 cm). Private collection. Photo courtesy October Gallery, London

technology (also seen in European chair adaptations), earlier wood sculpture having been carved from single pieces of wood.

Kane Quaye's son and former apprentices carry on a lively business in this updated art form, which accords so well with long-established lavish sendoffs for the respected dead. Expensive coffins are commissioned by middle-class or wealthy families, yet their cost is only a fraction of the outlay for an entire funerary celebration. The coffin generally refers to the dead person's special concerns: an onion for an onion farmer, a boat or fish for a fisherman (fig. 7-41). A globe-trotting businessman might ask for a fancy car or a plane to reflect his hard-earned status and wealth. Coffins stressing traditional regal motifs—leopard, eagle, elephant, stool, state sword—are popular with chiefs and other leaders. The choice of

subjects is dynamic; new images are constantly being invented.

ARTISTS AND ACADEMIES IN GHANA

Invention and reinvention within the context of tradition have been the sustaining forces behind the training provided by universities and art institutes in Ghana. The first formal art instruction on the post-secondary level was provided by British colonial authorities in Accra in 1919, and in 1928 the fledging Achimoto College began to offer classes in art. From its inception, Achimoto College was dedicated to "parallel education in European and African culture," and students were urged to study "tribal life and customs" as well as Western models. The famous Asante sculptor Osei Bonsu (see fig. 7-1, 7-25), who had no Western art training, was

recruited to teach wood carving at Achimoto alongside European expatriates. This approach differed radically from that taken in Nigerian universities at the time, and produced artists whose work differed significantly from the modernist painting being produced by contemporaries in other regions. For example, Vincent Kofi (1927–74) made rough wooden, stone, and metal forms that seem unfinished and that reflect his interest in Akan spirituality, while Grace Kwami (born 1923) sculpted images of clay that relate to the memorial images of her Akan ancestors.

In 1952, the Achimoto art department was incorporated into what became the Kwame Nkrumah University of Science and Technology (KNUST). During the period when Ghana gained independence, Kofi Antuban (1922–1964) adopted a natu-

7-44. Detail of *Rwanda Genocide*, Kofi Setordji, Ghana, 1994–99. Mixed media. Courtesy the artist, Arthaus, Ghana

7-43. OLD MAN'S CLOTH, EL ANATSUI, GHANA/NIGERIA, 2003. ALUMINUM AND COPPER WIRE. SAMUEL P. HARN MUSEUM, UNIVERSITY OF FLORIDA, GAINESVILLE. MUSEUM PURCHASE WITH FUNDS FROM THE FRIENDS OF THE HARN MUSEUM

ralistic style; he painted and carved clearly recognizable political images in support of Nkrumah. Varied styles were developed by other KNUST artists. Ablade Glover (born 1934), a former dean, paints bright canvases filled with what he calls "a sort of colour movement" (fig. 7-42). On close inspection, the thick brushstrokes become recognizable as roofs, vehicles, and people in a crowded market.

Another KNUST graduate, El Anatsui (born 1944), moved to Nigeria in 1975 to teach at the University of Nigeria, Nsukka, where he works with members of the Uli School (see chapter 9). Until recently, his main medium has been wood (sometimes recycled), the most "traditional" of materials, which he literally assaulted with power tools, as if deliberately to violate the conservative canons of woodcarving. Since 2000 he has been using other recycled materials (fig. 7-43). His dramatic wall sculptures made from bottle caps and their foil sleeves, painstakingly wired together, strongly evoke strip cloths such as kente: their opulent shimmering surfaces folded and draped, almost as if dancing. Anatsui comes from an Ewe weaving family, though he has never actually woven himself. His earlier wood pieces also quote from the rich textiles of Ghana and Nigeria.

At the end of the twentieth century, a cartoonist named Yaw Boakye founded an art institute called Ghanatta in Accra. This school has fostered a lively new art scene. One Ghanatta-trained artist, Kofi Setordji (born 1957), created a monumental

work, Genocide, in response to the massacre of some 800,000 people in Rwanda (fig. 7-44). Despite the great weight of the some three hundred pieces comprising this mixed-media work, Setordii has installed it in several exhibitions. The detail shown here focuses on partial faces of clay sinking into (or emerging from) framed plaster, suggesting the anonymity of the victims' deaths. While this is a very personal artistic statement about a specific twentieth-century tragedy, it draws upon earlier Akan arts in intriguing ways. The materials, the scope, and the imagery of Genocide all recall Akan groves filled with memorial terracottas (fig. 7-15). In a way, Setordji's piece allows Akan ancestors to lend their dignity to the dead of a distant African nation.

The Yoruba and the Fon

8-1. Mask, Yoruba, Pavement period, Ife, Nigeria, 12th–15th century. Copper. Height 13" (33 cm). Museum of Ife Antiquities, Ife

THE YORUBA ARE PERHAPS THE most urban of all African **L** groups. By the eleventh century AD, what they consider to be their founding city, Ile-Ife, was a thriving metropolis, the center of an influential city-state. Over the ensuing centuries, numerous city-states evolved, all claiming descent from Ile-Ife. This urban tradition continues to the present day, when Yoruba cities may number in the hundreds of thousands. The Yoruba peoples of southwestern Nigeria and southern Benin did not consider themselves a single group in the past. The term "Yoruba" was first used to describe people of the Oyo kingdom, which once dominated most of the region. British colonizers noted similarities of language and culture among those peoples tracing descent from Ile-Ife and referred to all of them as Yoruba.

To the west of the Yoruba, in the Republic of Benin and Togo, live the Fon and their relatives, the Ewe and the Popo, collectively called the Aja. According to tradition, the dynasties of Aja kingdoms originated in Tado, located in what is today Togo. Legend claims a Tado princess had union with a leopard spirit and gave birth to Agasu, whose descendants founded the kingdoms of Ardra and Dahomey. Tado may have developed as early as the twelfth or thirteenth century, Ardra by the sixteenth century, and Dahomey by the seventeenth century.

Fon traditions claim close relationships to the Yoruba, and some versions of Aja origin stories claim that the first Tado king was Yoruba. Although Yoruba and Fon cultures are distinct from each other, they have interacted for centuries through both trade and warfare. The Fon share many elements of Yoruba culture, including the institution of centralized kingship, a system of divination for communicating with the spirit world, and a similar pantheon of gods and spirits. Artistic influence has also flowed from the Yoruba to the Fon.

EARLY IFE

In Yoruba mythology the city of Ile-Ife is "the navel of the world," where creation took place and the tradition of kingship began. There the gods Oduduwa and Obatala descended from heaven to create earth and its inhabitants. Oduduwa himself became the first ruler, *oni*, of Ile-Ife. To this day Yoruba kings trace ancestry to Oduduwa.

The largest and most coherent body of artistic and archaeological evidence for the proto-Yoruba culture of early Ile-Ife dates roughly between AD 1000 and 1400, an era known as the Pavement period. Numerous finds predate these centuries, however, and there is evidence that the site was occupied by at least the eighth century AD. While little is known about these earlier centuries, scholars have proposed two broad periods of development, an Archaic period, to about AD 800, and a Pre-Pavement period, from about AD 800 to 1000.

Archaic and Pre-Pavement Periods

Among the most remarkable works surviving from the Archaic period are a number of stone monoliths. A dra-

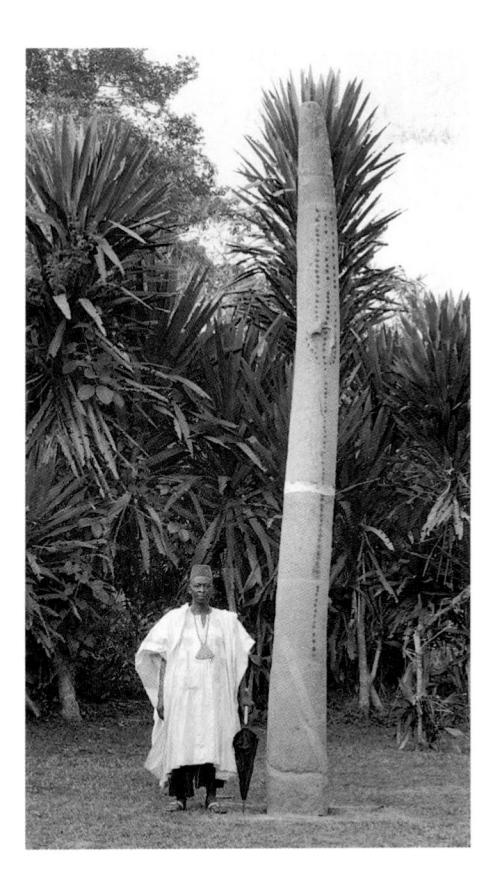

matic granite gneiss monolith known as Opa Oranmiyan, the largest of these, set with spiral-headed iron nails in a trident pattern, rises over eighteen feet (fig. 8-2). There is no way to know exactly what the monolith represents. Its name, meaning "the staff of Oranmiyan," dates from recent times. Mythical son of the god Oduduwa, Oranmiyan is associated with the founding of the dynasties of both the kingdom of Benin (see chapter 9) and the Yoruba city-state of Oyo.

In contrast to the abstract, radically simplified forms of Archaic sculpture, Pre-Pavement figures depict human and animal subjects in more naturalistic styles. One of the most famous Pre-Pavement works is known to present-day inhabitants of Ile-Ife as Idena, "gatekeeper" (fig. 8-3).

8-2. Monolith known as Opa Oranmiyan ("Staff of Oranmiyan"), Yoruba, Archaic period, Ife, Nigeria, before c. ad 800. Granite and iron

Similar monoliths ranging from one to twelve feet in height can be found at several sites in Ile-Ife. Today, many of the monuments are associated with Ogun, the god of iron. The combination of iron and stone in Opa Oranmiyan and other Archaic objects suggests that they were created during a period that witnessed the transition from a Neolithic technology to a technology based on iron. Metal would have enabled not only more effective farming implements but also more effective weapons, and it has been suggested that monuments such as Opa Oranmiyan served to commemorate the victories of an early warrior-ruler and acknowledge his association with Ogun.

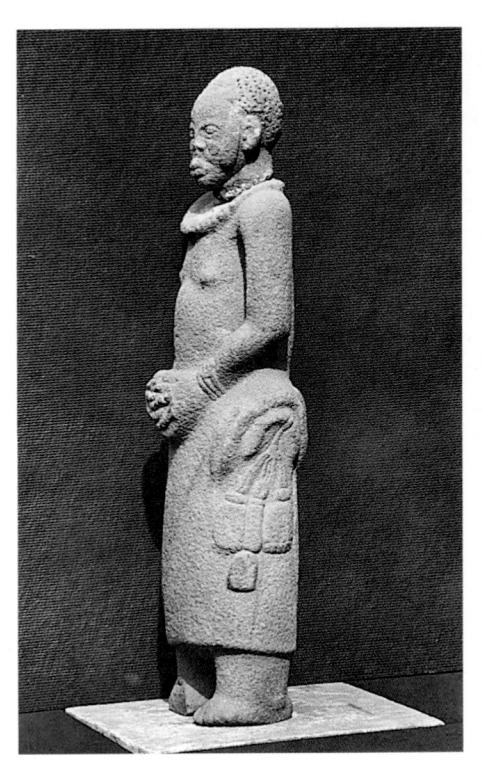

8-3. Figure known as Idena ("Gate-Keeper"), Yoruba, Pre-Pavement period, Ife, Nigeria, c. ad 800–1000. Granite and Iron. Museum of Ife Antiquities, Ife

Exaggerated columnar legs provide a stable base for the bare-chested male figure standing with its hands clasped at the waist. Spiral-headed iron nails embedded in the head suggest the texture of hair while linking the figure back to the iron-and-stone works of the Archaic period. The heavy collar of beads, the bracelets, and the intricately tied wrapper suggest a person of high rank.

Pavement Period

During the eleventh century Ile-Ife blossomed into a substantial urban center. Beginning in the thirteenth century, as rivalry between neighboring city-states intensified, Ile-Ife fortified itself with a defensive moat and earthen ramparts. Intermittent warfare between city-states continued into the nineteenth century and is probably in part responsible for the Yoruba cultural pattern of living in densely populated, walled cities surrounded by radiating farmlands.

Excavations suggest that early Ile-Ife was laid out in an orderly plan (fig. 8-4). Like most Yoruba cities it was roughly circular, with the palace at the center. Two concentric systems of walls surrounded the city. Near the palace, but also sprinkled throughout the city, were shrines to the deities. Major roads radiated outward, linking Ile-Ife to neighboring cities. Marked by a large gateway that likely housed guards, each opening in the moat and wall complex was both a military post and a ritually consecrated space.

The basic unit of architecture seems to have been a square or rectangular courtyard surrounded by a veranda. Most homes would have been formed of several such court-

8-4. Plan of Ile-Ife. The LETTERS INDICATE WHERE WORKS ILLUSTRATED IN THE TEXT WERE FOUND OR ARE LOCATED: a ONI'S PALACE (SEE FIG. 8-1) **b** Іта Үемоо (SEE FIG. 8-8) c Wunmoniie (SEE FIG. 8-10) d Opa Oramiyan (SEE FIG. 8-2) e Ore grove (SEE FIG. 8-3) f Obatala shrine g Oduduwa shrine h Olokun grove i Obalara's land (SEE FIG. 8-7) i Lafogido (SEE FIG. 8-6)

8-5. Pattern of a pavement excavated at Ile-Ife. Drawing by Peter Garlake

Short lines indicate pottery shards set into the earth on edge in herringbone patterns. Small ovals indicate stones that filled the spaces between rows of shards.

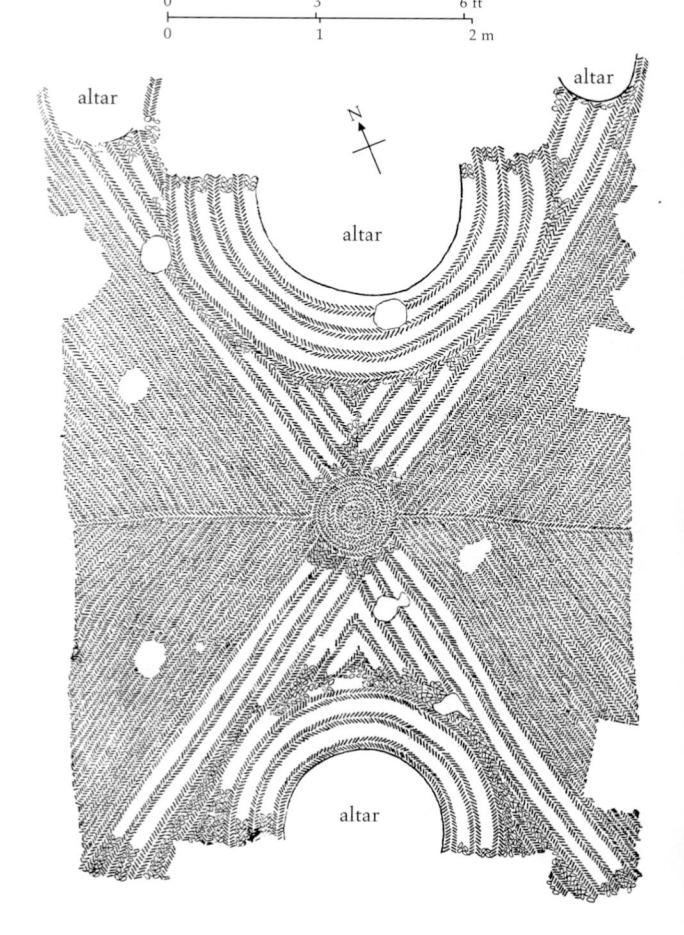

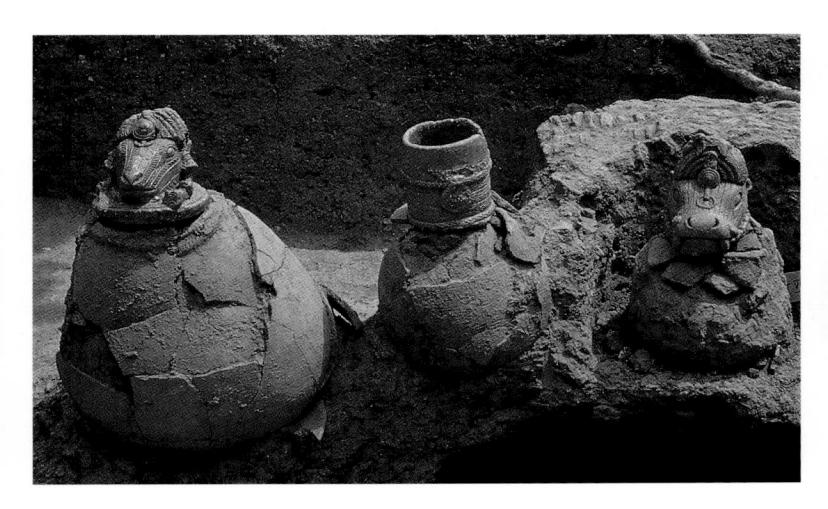

8-6. Animal-headed terracotta vessels excavated at Lafogido site, Yoruba, Pavement period, Ile-Ife, c. 1000–1400; photograph 1979. National Museum, Lagos

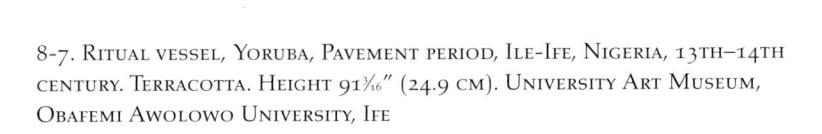

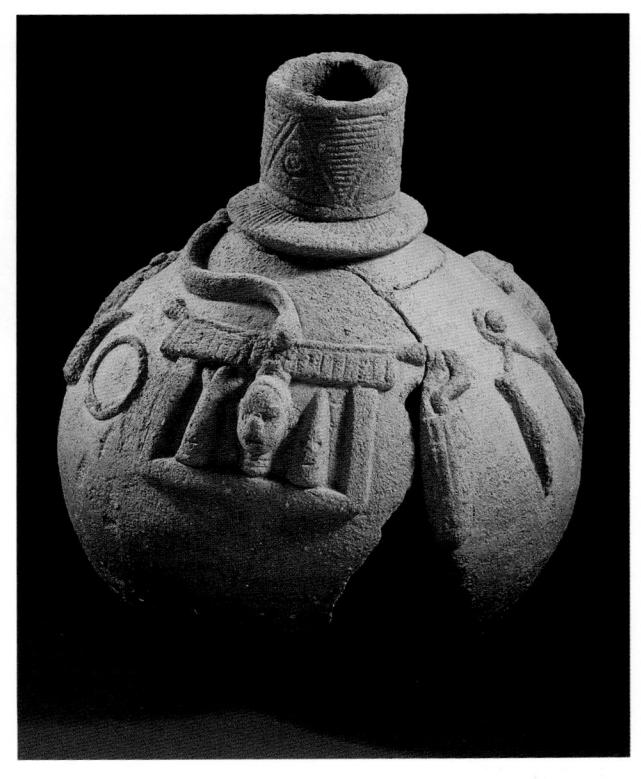

yards, while the palace probably had great numbers of them. At least one palace courtyard of great size accommodated a large portion of the population for ceremonies. The most important courtyards in palaces, shrines, and gateways were decorated with elaborate mosaic pavements of stone and pottery shards (fig. 8-5).

Paved courtyards were sacred spaces. The semi-circular voids at the top and bottom of the diagram indicate where raised altars made of packed earth would have stood, their sides inlaid with shard mosaic designs. Ritually buried pottery has been recovered from such courtyards. One courtyard yielded fourteen buried pots set into the earth along the pavement's border and fitted with lids depicting the heads of various animals (fig. 8-6). The ram's head, at the left, wears a royal crown, suggest-

ing that the animal served as a metaphor for kingly power. Other animals such as the elephant, leopard, or what may be a hippopotamus on the pot at the right, may also refer metaphorically to the *oni*, for they too wear elaborate beaded headdresses with a royal crest and forehead pendant.

A single vessel was often set into the center of the courtyard, its position emphasized, as in figure 8-5, by a circular arrangement of stones and shards around the protruding neck. One of the most interesting of these vessels to have been recovered is shown in figure 8-7. Typical of such vessels, the bottom was broken prior to its burial so that libations poured into it penetrate directly into the earth. Decorations in relief depict a series of eight undoubtedly potent symbols, similar to symbols found on

fragments of other vessels. Among them is an altar or shrine such as those that probably stood in the semicircular spaces framed by the courtvard pavement. A snake, whose sinuous body moves over the shoulder of the vessel, hovers over the altar. Just to the right, two human legs project from a basket, suggesting sacrifice. Next to the basket, a pair of carved blades connected by a cord loop around a knob. Barely visible is a tall drum. The circular form to the left seems to represent a curved rod, its ends slightly overlapping. Next to the rod, a pair of horns connected by a cord loop around a knob.

Perhaps the most intriguing image on the pot is the altar. Enclosed by posts supporting a roof of palm fronds, it is set with three sculpted heads. The central head is in a fully naturalistic style, while the flanking

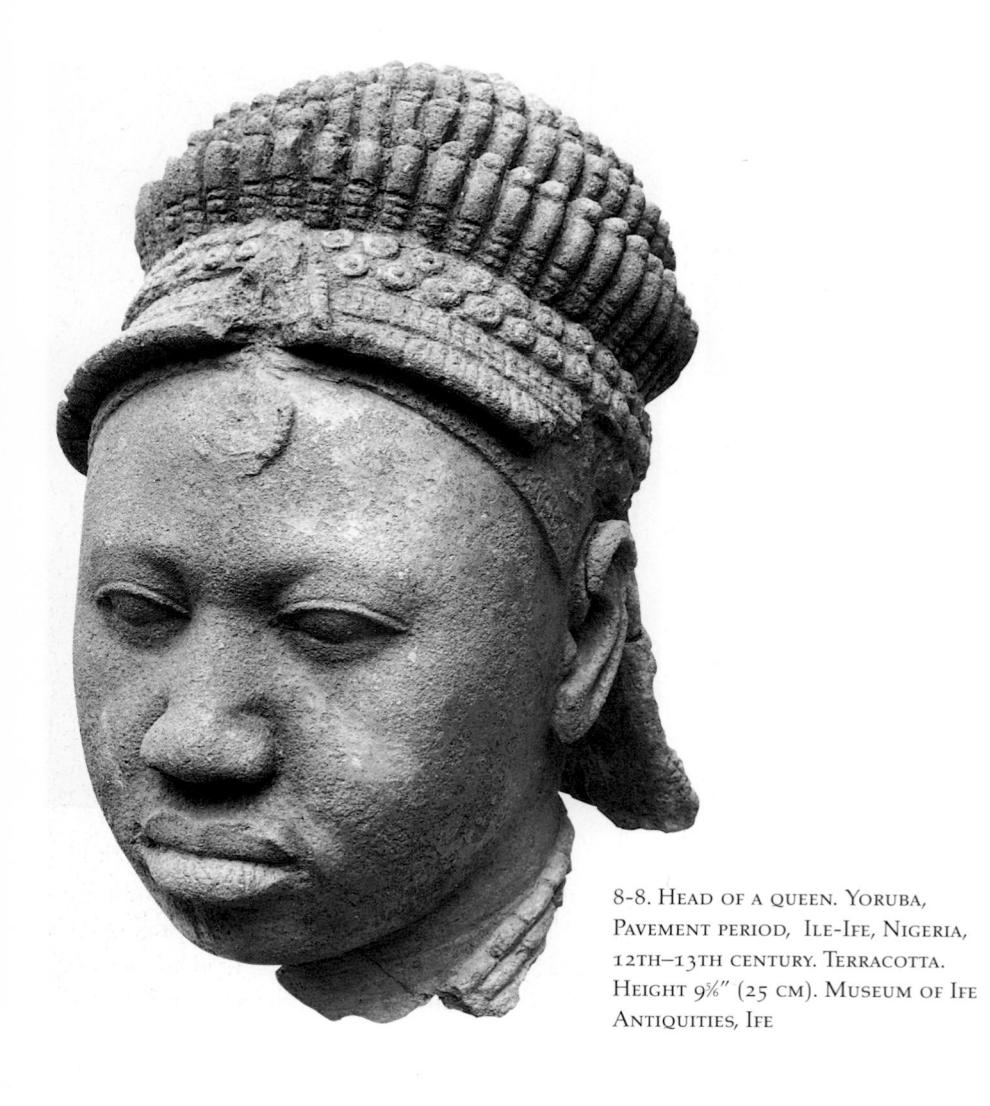

works are abstract. Both styles closely resemble works that have been found at Ife and allow us to assume that these seemingly disparate styles were created concurrently and served similar purposes.

As the descendant of Oduduwa, the *oni* of Ile-Ife was viewed as a godking. Confined to the palace, his life was lived as a continuous set of rituals. Much of the art of ancient Ile-Ife was probably created for the royal court, including figures that may have been intended as portraits of rulers, officials, and their families. The naturalistic style of Pavement period

sculpture is beautifully illustrated by the terracotta head in figure 8-8. The most elaborate terracotta head thus far found, it depicts a queen wearing a complex crown with five tiers of beads. A row of feathers projects over the serene face. The crest that once adorned the front of the crown has broken off, leaving evidence of a circular pendant on the forehead. Traces of pigment suggest that the sculpture was once painted in bright colors. Many of the terracotta heads discovered at Ife are complete works in themselves and were destined for use on altars, as the vessel in figure 8-7

makes clear. The way the neck is broken on this head, however, indicates that it once formed part of a larger, perhaps complete figure.

In modeling the face, the artist has faithfully rendered the way flesh and muscle lie over bone, yet this closely observed naturalism embraces a marked degree of idealism as well. Many parts of the anatomy are noticeably stylized, especially the lips, eyes, and ears. This restrained, idealized naturalism is characteristic of the early centuries of Pavement period sculpture, which became freer and more expressive in later centuries. We do not yet know exactly what to make of such images of women who wear crowns such as this or who are shown in other works of art. Some Yoruba kingdoms' "kings lists" include women as rulers and, in more recent times, some kingdoms have royal positions that are specifically for women.

A typical example of the abstract Pavement period style is the cylindrical head illustrated here (fig. 8-9). Two holes suffice for eyes, a simple wedge-shaped cut indicates the mouth, and rounded horn-like knobs sprout from the top. The simultaneous use of two such radically different styles may reflect the need to embody two quite different ideas. The inner head, ori inu, and the outer head, ori ode, are important concepts in Yoruba thought. The terms reflect complementary spheres of being. The inner head is spiritual and invisible. Perceivable only through the imagination, it embodies a person's spiritual and true being. The outer head is the physical entity perceived through the senses. The terracotta heads of early Ife are thought to

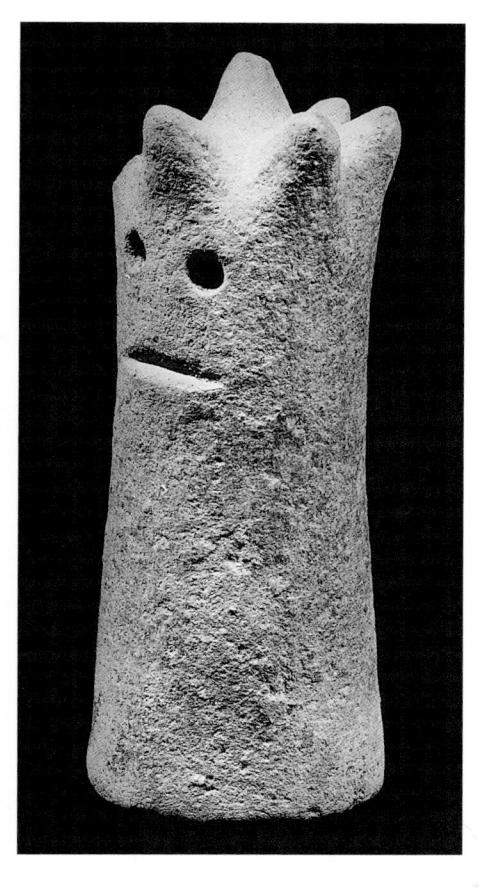

8-9. Cylindrical Head, Yoruba, Pavement period, Ile-Ife, Nigeria, 13TH–14TH CEN-TURY. TERRACOTTA. HEIGHT 6½" (16.2 CM). MUSEUM OF IFE ANTIQUITIES, IFE

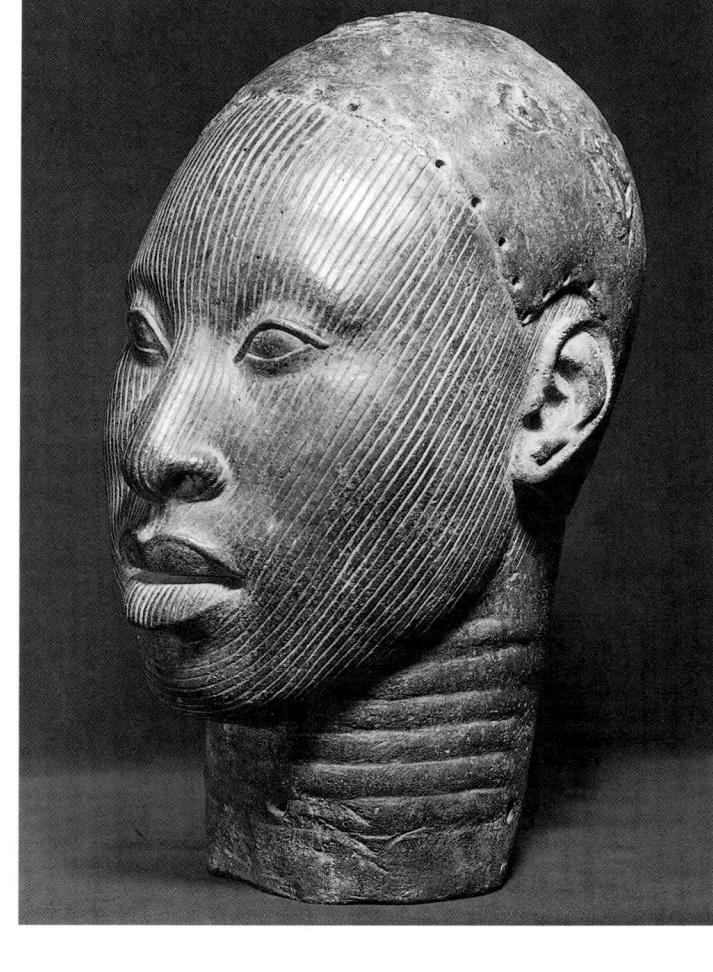

embody this duality, with the abstract style depicting an inner, spiritual reality and the naturalistic style depicting the outer, physical reality. An altar such as the one depicted on the vase in figure 8-7 may have been used in blessing the inner head of the king, a custom that survives in present-day

Pavement period artists also produced works in cast metal. While these sculptures are often spoken of as bronzes, most were created from alloys of zinc, lead, and copper more properly classified as brass. A few are almost pure copper. Although some recent scholars argue that copper may have reached Ife from deposits located less than a thousand miles away, we do know that metals were obtained through trans-Sahara trade networks

Yoruba courts.

8-10. HEAD, YORUBA, PAVEMENT PERIOD, IFE, NIGERIA, 12TH— 15TH CENTURY. ZINC BRASS. MUSEUM OF IFE ANTIQUITIES, IFE

that extended to northwest Africa and even tapped into routes that continued to central Europe.

Cast by the lost-wax process (see Aspects of African Cultures: Lost-Wax Casting, p. 234), these sculptures show the same idealized naturalism as the early Pavement period terracotta heads, and thus were probably produced during the same centuries.

The life-size brass head shown here stands on a cylindrical neck (fig. 8-10). As on the terracotta head earlier, the eyes, lips, and ears are stylized according to ideal models. Yet the features are still strongly individualized, and the head may well have been intended as a portrait. The face bears

the vertical striations found on many terracotta and brass heads at Ile-Ife. While these markings are often thought to represent scarification, the Yoruba in recent times have not been known to use this particular scarification pattern, and it is entirely possible that the striations are purely an aesthetic device.

Holes along the hairline were probably used to attach headgear, most plausibly a crown. Other heads feature holes along the lower part of the face, just above the jawline and across the upper lip, perhaps for attaching facial hair to heighten the effect of realism. More probably, however, they allowed a beaded shield

Aspects of African Cultures

Lost-Wax Casting

The lost-wax casting process, still in use today, was first employed in the ancient Near East during the fourth millennium BC. The technique was used early in China, and subsequently passed along as well to the many overlapping civilizations that ringed the Mediterranean, including Kemet. Although copper was cast in the southern Sahara by the seventh century BC, the earliest evidence for the process south of the Niger River is from the tenth-century site of Igbo-Ukwu.

The drawings below illustrate the steps used by sculptors in Benin. A heat-resistant core of clay is formed, approximating the shape of the sculpture-to-be. This core is then covered with a layer of wax, which the sculptor models, carves, and incises. Wax rods and a wax cup are attached to

the base of the completed wax model to prepare it for casting. A thin layer of finely ground liquid clay is painted on the wax model, and the entire assembly is then covered with increasingly thick layers of clay. When the clay is completely dry, the assembly is heated to melt out the wax, leaving an empty image or mold of the sculpture for the molten metal to fill, and channels where the wax rods have been to allow the metal to be poured in. The mold is turned upside down to receive the molten metal, which is generally a copper alloy approximating brass. When the metal has cooled, the outer clay casing and inner clay core are broken up and removed, freeing the brass sculpture. After the pouring channels are filed off, the image is ready for final polishing. A sculpture produced with this method is unique, for the mold is destroyed in the process. HMC

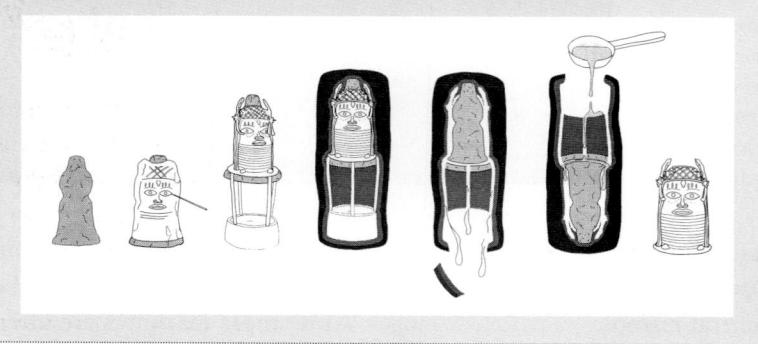

to be attached, which hid the lower portion of the face. The custom of veiling a sacred ruler to protect him from the gaze of his profane subjects is found in many African societies. Yoruba kings in more recent times have held a fan over the mouth when eating or speaking and have hidden their faces during public appearances behind a beaded veil that falls like fringe from the rim of the crown.

Four large holes appear around the base of the neck. Like their terracotta

counterparts, brass heads may have been placed on altars. The holes at the bottom of the neck may also have allowed the head to be attached to a carved wooden body, thus creating a full figure. A number of Yoruba funeral rites witnessed during the early twentieth century included an effigy of the deceased, and such ceremonies in early Ife may similarly have included effigies (see fig. i, p. 10). It has also been suggested that the heads served as mounts

for displaying crowns during annual rites of renewal and purification when the ruler's inner head was blessed.

While many of the terracotta heads found at Ife originally formed part of a larger figure, most of these have survived only in fragments. A worker digging a road to an Ife shrine unearthed a particularly intriguing sculpture. It may depict a king and queen (or queen mother), or two allied rulers, or deified royal ancestors such as Obatala and his consort, Yemoo (fig. 8-11). The brass, barely one-sixteenth of an inch thick, attests to the skill of the craftsmen who cast it. While detailed, the proportions of the figures with their oversized heads are not naturalistic, further emphasizing the conceptual nature of Ife sculpture. Each wears beaded collars, necklaces, bracelets, anklets, and a crown of beads, not unlike that in figure 8-8, all connoting royal position. The male figure hooks his index fingers together in a symbolic gesture, while the female figure locks her arm through his. Their legs entwine. We may never learn the precise meanings of these gestures. The combined figures representing male and female possibly allude to the interdependence of male and female, an idea of importance in the art and thinking among the Yoruba peoples today, many of whom claim descent from Ile-Ife.

The most remarkable of all Pavement period sculpture was found some 120 miles away in a shrine on the banks of the Niger River near Tada (fig. 8-12). Dated to around AD 1300 and cast in almost pure copper, the figure is distinguished by its relaxed asymmetrical pose, the palpa-

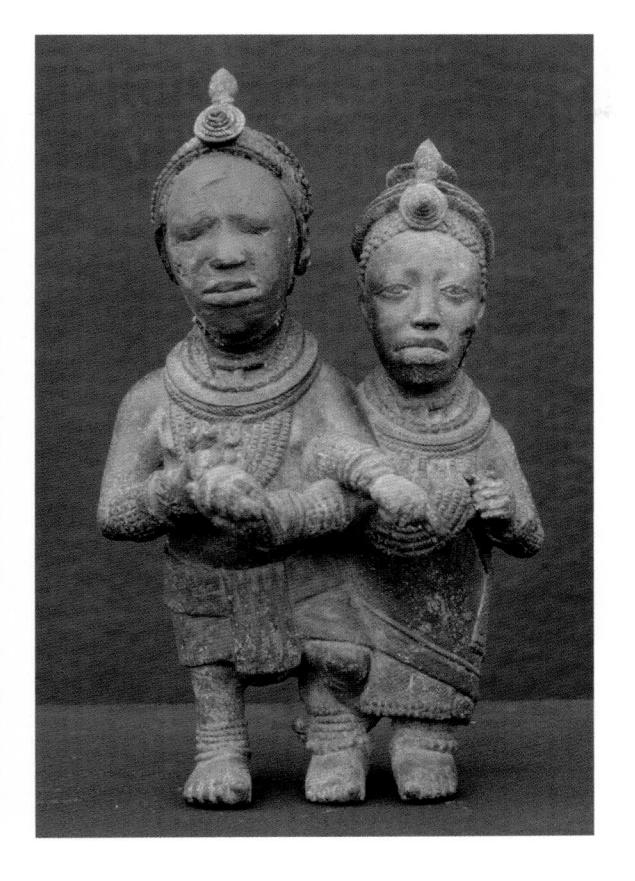

8-11. Pair of figures, Yoruba, Pavement period, Ife, Nigeria, 11th–12th Century. Zinc Brass. Height 7½" (19 cm). Museum of Ife Antiquities, Ife

This figural pair was unearthed in 1957 during work on the road to Ilesha. In the process, the face of the male figure was destroyed. A recent attempt to reconstruct the missing face, as evidenced in this photograph, was not entirely successful.

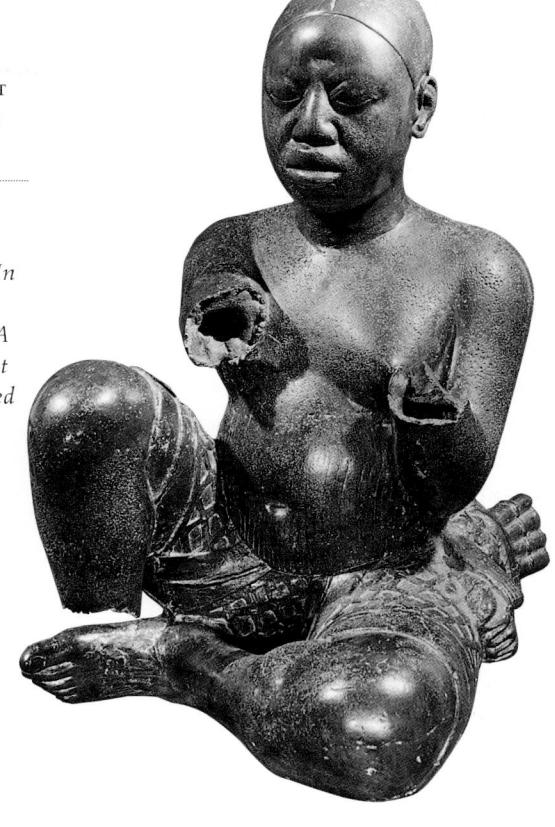

8-12. Seated figure (Tsoede bronze), Yoruba, Tada, Nigeria, 13th–15th century. Copper. Height 21‰" (55.7 cm). National Museum, Lagos

ble sense of weight conveyed by rounded fleshy forms, and the more naturalistic proportions of head to body. The face wears an attentive and dignified expression. A patterned wrapper around the waist falls over the thighs and is fixed on the left hip with an elaborate tie.

How this extraordinary work came to be in Tada is a subject for speculation. It may have been sent from Ife as a token of authority, and may thus mark a boundary of Ife's influence at a certain moment. It may also have been carried off as a trophy of war. The sculpture is one of eight metal figures found around Tada and nearby Jebba Island. According to oral histories of the Nupe people, the present-day inhabitants of the region, the works were stolen from Idah, the capital of the Igala people, by the

Nupe folk hero Tsoede. During the sixteenth century the Nupe were in fact involved in wars with the Yoruba city-state of Oyo, which was then extending its boundaries. Oyo claimed close ties with Ife, and it may well be that the statue was taken by the Nupe from Oyo. As many as four different styles are represented by the eight works, supporting the theory that they were imported into the area from various sources. The variety of styles also suggests that casting technology was known outside Ife, though these other ancient casting centers remain to be discovered.

In view of the widespread use of masks and masquerades in African art, the discovery of masks at Ile-Ife is particularly fascinating. Two masks are known, one of terracotta, the other, shown here, cast in pure copper (fig. 8-1). Copper is exceedingly difficult to cast, and the flawless casting of this mask is a tribute to the high level of technical skill attained by Ife artists. The mask is said to represent Obalufon II, the third ruler of Ife, who is credited with introducing the techniques of casting. Narrow slits below the eyes suggest that the mask was made to be worn. Holes along its back were likely used to attach a costume. The work is kept on an altar in the palace of the present-day oni of Ife, where it is believed to have resided since its creation some five hundred to seven hundred years ago.

EARLY OWO

The city of Owo lies about eighty miles to the southeast of Ile-Ife. In centuries past it was a powerful citystate whose influence extended over a broad area. Owo traditions maintain that the kingdom was founded from Ife and that the first ruler, *oba* or *olowo*, was the youngest son of Oduduwa. Archaeological evidence suggests strongly that Owo indeed had material ties to Ife.

Excavations have unearthed a number of terracotta sculptures, some of which were concentrated in an area that may have served as a storehouse for important shrine objects. The figures have been dated to the early fifteenth century, making them roughly contemporaneous with the Pavement period in Ife art. Some of the Owo terracottas share characteristics with those from Ife, including idealized naturalism and vertical striations on the face. Some, on the other hand, seem to be in a distinct style, while still others reflect contact with the kingdom of Benin to the south (see chapter 9).

The fragment of a male figure shown here consists of a carefully modeled head placed on a more coarsely treated body (fig. 8-13). The face differs from those of Ife in that the eyes are more widely spaced and the corners of the lips are pressed firmly into the cheeks. The pose is dynamic, with the arms raised to the chest. Jewelry includes a complex necklace of beads and tassels, large bracelets covering the forearms, and a band of beads at the waist.

Sacrifice is a persistent theme in the early art of Owo. A great variety of sacrificial offerings are depicted—a chicken carried under an arm, for example, or an animal head proffered by two hands. Sacrifice was and is an integral part of Yoruba religious practices. In the past, no sacrifice was con-

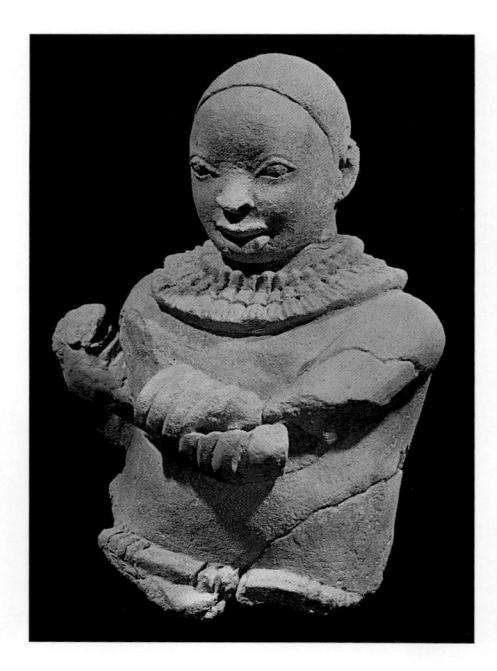

8-13. Figure of a man, Yoruba, Owo, Nigeria, early 15th century. Terracotta. Height 9%" (25 cm). National Museum, Lagos

sidered too costly if it brought peace and prosperity. To this end, it was sometimes necessary to make human sacrifice. Since it was forbidden to sacrifice a native of one's own town, strangers or slaves taken in war would be offered to the deity. Among the most remarkable of Owo sacrificial representations is a terracotta sculpture depicting a basket of decapitated heads, strangers who had been given as a precious gift to one of the gods (fig. 8-14).

Owo stories of origin maintain that the first *olowo* was not only the son of Oduduwa but also the brother of the ruler of Benin. The cultural and artistic traditions of Owo and Benin have clearly been intertwined for centuries. A strong overlay of Benin tradition is apparent in Owo, and Benin was receptive to Owo styles and forms. Early Owo was a major ivory

carving center, and some objects once attributed to Benin are now believed to have been made in Owo itself or by Owo carvers working in Benin.

The ivory sword shown here is of obvious Owo manufacture (fig. 8-15). It is an *udamalore*, a prestigious type of ceremonial weapon still worn by the olowo and high-ranking leaders in important festivals. The sword indicates that the wearer is from a respected family, that he is a man of maturity and influence, whose power is felt throughout the kingdom. Although an udamalore can be made of a number of materials such as iron. brass, or bead-covered wood, the most prestigious material is ivory. Such swords are worn by high-ranking chiefs today when they salute the king in festivals such as igogo, which reenacts events in the life of an early queen of Owo.

A pair of bracelets from Owo demonstrates the skills of Owo artists (fig. 8-16). Carved from a single piece of ivory, each bracelet consists of interlocking cylinders. The outer cylinder is an openwork configuration of symbolic representations of sacrificial rams' heads and crocodiles. Serpent forms issuing from the noses of rams' heads link the two primary elements into an elaborate design. Inside this cylinder, a smaller cylinder is locked by means of a relief carving of a catfish, which allows the inner element to move slightly to the left or right. The surface of the inner cylinder is decorated with bands created by holes pierced through it, producing an almost lacey appearance. The top and bottom of each armlet once had numerous spherical ivory jangles that clattered as the chief who wore it danced before the king. Such

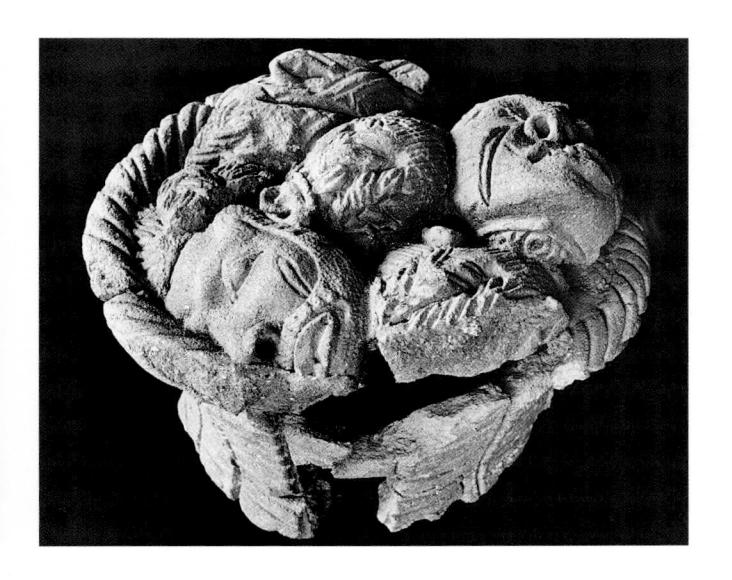

8-14. Basket of Human Heads, Yoruba, Owo, Nigeria, Early 15th Century. Terracotta

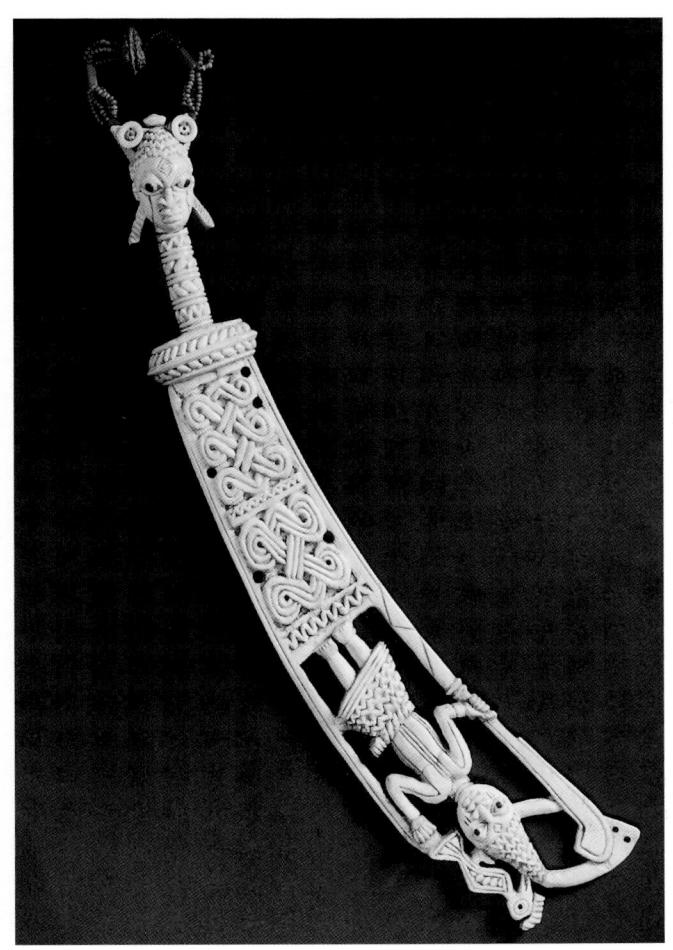

8-15. UDAMALORE
(CEREMONIAL SWORD),
YORUBA, OWO,
NIGERIA. IVORY. THE
BRITISH MUSEUM,
LONDON

Depicted on the elegantly carved hilt is a human head, its graceful neck encircled with royal beads. Motifs on the openwork blade include a man grasping a sword and a bird perched on a tall headdress. The human figure refers to the wearer of the udamalore himself or to his position in the hierarchy. The bird alludes to the supernatural powers of women that he must use for the good of his people. The interlace patterns on the blade symbolize aristocratic position.

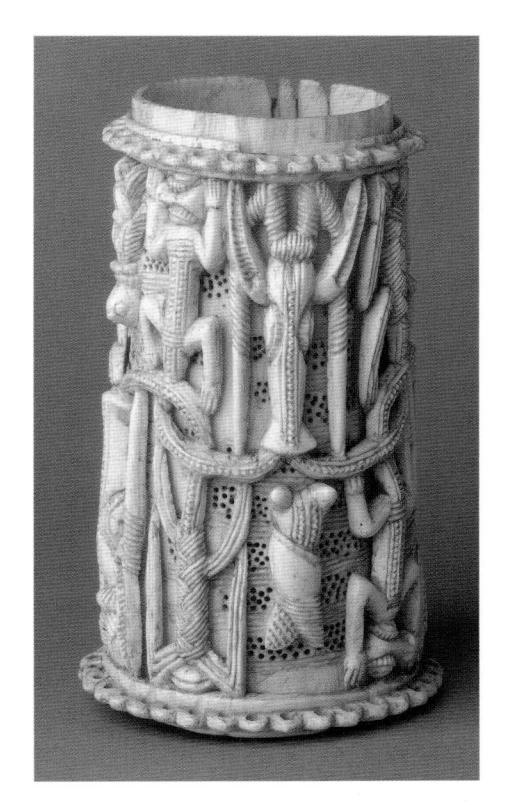

8-16. One of a pair of double-cylinder bracelets, Yoruba, Owo (?), Nigeria, 17th century. Ivory. Diameter $6\frac{1}{4}$ " (17.1 cm). World Museum, Liverpool

ornate status objects helped differentiate titled leaders from lesser personalities. They were worn with ostentatious costumes that called attention to the wearers, underscoring their aristocratic lineage and the authority they had been granted by the *olowo*.

ESIE

While archaeology, oral histories, and cultural continuity have helped scholars gain some insight into the art and history of Ife and Owo, many other aspects of the Yoruba past remain shrouded in mystery. Such is the case with the largest group of stone figures ever found in West Africa, a mass of over one thousand works that

until recently stood in a field outside the town of Esie, sixty-two miles north of Ile-Ife. The imposing personage in figure 8-17 sits with hands firm on his knees. An ornate coiffure, necklaces, and armlets indicate high status. Such elegance is typical of hundreds of figures that once littered the ground of the sacred precincts. Esie carvings range in height from a few inches to several feet. Some depict animals, but the majority portray individuals, both male and female, often with elaborate coiffures or ostentatious headgear. Many are seated. Some play musical instruments, while others carry weapons. Such attributes suggest that the figures represent dignitaries, perhaps royalty. Intriguingly, numerous facial types and scarification patterns are portrayed, suggesting that the personages are drawn from diverse cultures. The distinctive style of the works and the high level of artistic development suggest they were made by a group of people who were socially stable and politically organized.

The present-day inhabitants of Esie, a Yoruba people who arrived from Old Oyo during the fifteenth or sixteenth century, claim to have had nothing to do with making the images or with moving them to the site. Several stories have arisen to try to explain their presence. One tells how people from various distant lands came together in search of a place to stay. A misunderstanding with the ruler of Esie sent them in a state of rage back to their camp on the outskirts of town, where they were turned to stone by a Yoruba deity.

Researchers are at a loss as to how to explain the origins of the figures. Some attempt to link the figures with

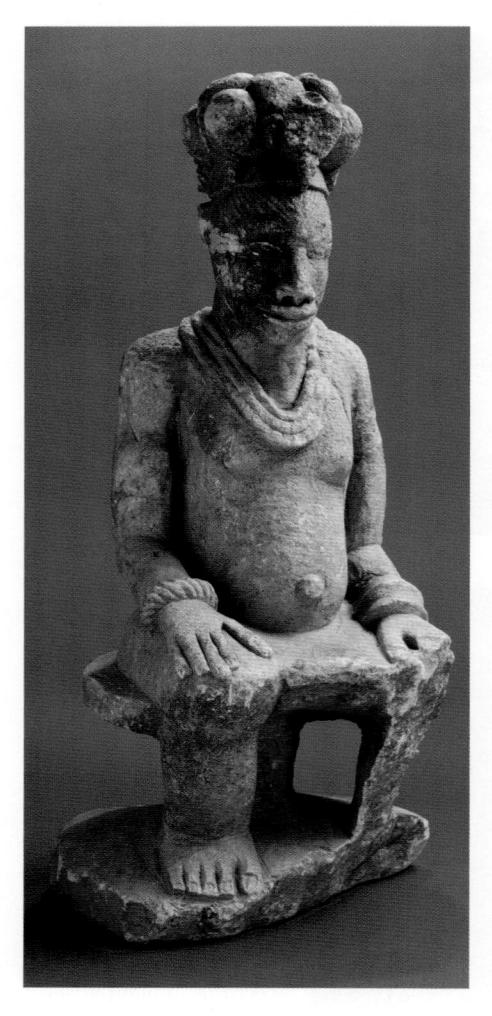

8-17. Figure, Esie, Nigeria, 12th–15th century. Soapstone. Height 26¾" (67 cm), National Museum, Esie

the former capital of the Oyo Empire. Others think there may be links to Ile-Ife. Still others suggest local origin, and stone sculpture has recently been found at other Igbomina Yoruba sites. Locally available stone seems to have been used in their manufacture.

Today housed in a museum on the site, the stone figures continue to play an important role in the religious beliefs of the local people, who view them as the owners of the land, overseers of general welfare, and providers of fertility. A priest contin-

ues to watch over the figures even in the context of a museum setting.

RECENT YORUBA ARTS

After the early splendors of Ife and Owo, a series of horrific civil wars led to the deaths or the enslavement of vast numbers of the Yoruba, the Fon, and their neighbors. During this dark period, their homelands became known by Europeans as the Slave Coast. Only the abolition of the transatlantic slave trade in the early nineteenth century allowed Yoruba kingdoms to regain stability. By the late nineteenth and the early twentieth century, a wide range of objects, forms, art styles, and art events had developed in a number of Yoruba centers. Some of the art forms were found throughout Yorubaland, while others were purely local. Although art production in this region had changed significantly by the twenty-first century, some Yoruba artists continue to create works to underscore the leadership systems of the royal court and the society of elders known as Ogboni, or to address the spirit world and facilitate communication between the humans and the realm of gods and spirits.

Royal Arts

Much of the art produced in the Yoruba region calls attention to the king and his court. As a visible symbol of the deity, the king is the high priest of the community. Although Yoruba kings are free to appear in public today, in the past they were confined to the palace, making public appearances only when the welfare of the state required them to participate

in public ceremonies. Even in those instances, the individual who held the office was not really seen, for royal garb concealed his identity, emphasizing instead his mysterious, sacred nature.

The king shown in figure 8-18, Ariwajoye I, *oba* of the Igbomina Yoruba, wears and carries a number of references to his position as sacred descendant of Oduduwa. Bead embroidery is normally reserved for the *oba*. The beadwork on the king's robe, on the cushion that elevates his feet above the earth, on the tall staff in his right hand, and on the intricate crown signals that this is the sacred ruler, descendant of gods.

The crown is the foremost attribute of the sacred king. Yoruba crowns are made of a wickerwork cone covered with stiff fabric or canvas. Glass trade beads are strung and attached to cover the entire surface in boldly colored designs. The beaded fringe veil, the prime symbol of kingship, is supposed to be worn only by those kings who can trace their lineages to Oduduwa. In fact, legal cases have challenged the rights of certain kings to wear the beaded crown. In the past, the sanctity of his very existence prevented the king's being seen by ordinary people, and the fringe protected him from the gaze of the profane when he made public appearances.

Three tiers of abstracted faces (their staring eyes clearly discernible) decorate the body of the crown. Depicting royal ancestors, ultimately Oduduwa, they refer to the mystic union of the living king with his deified predecessors. As delegate of the ancestors, the king relies on their wisdom and powers. The multiplicity of faces alludes to the all-seeing

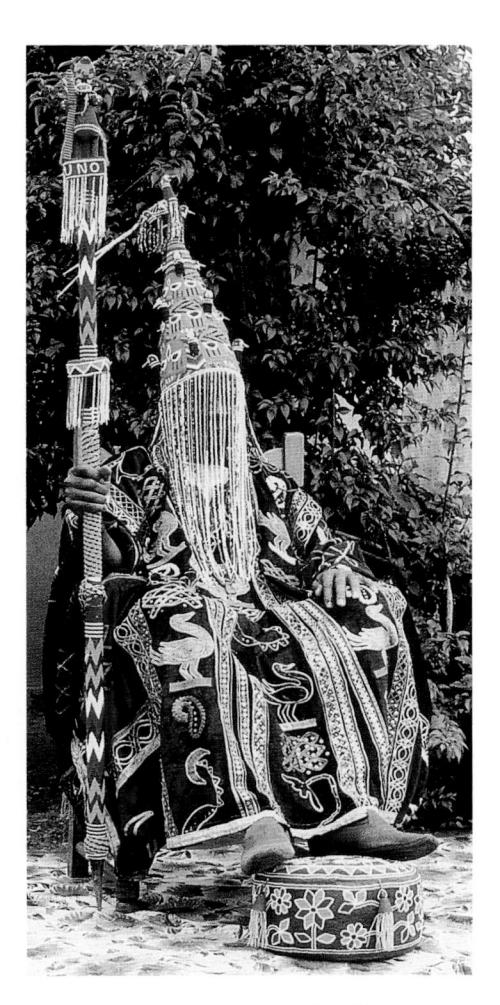

8-18. Ariwajoye I, ruler of Ila-Orangun, Yoruba, Nigeria, 1977

nature of ancestors and spirits and thus to the role of the king whose supernatural vision allows him access to such authority.

Attached between the faces are small, three-dimensional beaded birds. A larger beaded bird ornamented with actual tail feathers tops the crown. Birds are another important element on Yoruba crowns. The great bird at the top is said by some to represent the egret, the bird of decorum, a symbol of orderliness and settler of disputes. Others suggest it is the paradise flycatcher, a royal signifier whose tail sports extremely long

feathers, or the pigeon, a symbol of victory and political power. Still others see the birds as a reference to the special powers of "night people" such as Osanyin priests, Ifa priests, even the king himself, all of whom must ingest a secret substance in order to work either with or against mystical powers described as sorcery, or witchcraft. In some regions of Yorubaland, such birds are references to "Our Mothers," a collective term for all female ancestors, female deities, and elderly living women. "Our Mothers" are believed to have special powers and to be able to transform themselves into birds of the night. Kings cannot rule unless they are able to control or counteract the powers of such beings. References to witchcraft and similar manipulations of power appear in popular Nigerian culture as well as in Yoruba royal arts, and characters labelled as witches are the wicked protagonists of many television shows and videos catering to Yoruba audiences today.

When the king wears the sacred fringed crown, his being is modified. His outer head is covered by the crown, and his inner head becomes one with the sacred authority and power, ashe, of the ancestors. He cannot touch the earth, and thus stands on a mat or cloth. Seated in state, his feet rest on a decorative cushion or footstool. His own face disappears behind the veil, and the faces of the royal ancestors stare out instead. It is the vision of dynasty that is emphasized rather than the individual who wears the crown.

The king dwells in the *afin*, the royal palace. The most imposing architectural structure in a Yoruba city, the *afin* is also the site of the

most sacred worship and celebrations. As in early Ife, the palace stands in the center of the city, and all roads lead to it. The king's market, usually the most important market in town, lies at its door. An *afin* consists of numerous courtyards of varying sizes, most surrounded by verandahs. Steep roofs, once thatched, are today covered with corrugated steel.

In the nineteenth and early twentieth centuries, artists fashioned wonderful objects to enhance the splendor of the palace, record the exploits of the kings and chiefs, and display religious symbols and metaphors to the public. In making such commissions, kings historically sought the most skillful artists from their own realms and beyond. The best artists achieved the title *are*, which literally means "itinerant," suggesting that they moved from kingdom to kingdom accepting work from a number of patrons.

One such artist was Olowe of Ise (died 1938), one of the best-known Yoruba sculptors of the twentieth century. Praise poetry still chanted in his memory calls him "the leader of all carvers," one who carves the hard wood of the iroko tree "as though it were as soft as a calabash." Olowe was born during the nineteenth century in Efon-Alaiye, famed as a center of carving. He grew up in Ise, to the southeast. Over the course of his career he produced doors, posts, chairs, stools, tables, bowls, drums, and ritual objects for palaces and shrines in the kingdoms of Ijesa and Ilesha, and in various smaller kingdoms of the Akoko region of Yorubaland.

Between 1910 and 1914 Olowe worked at the palace of the king,

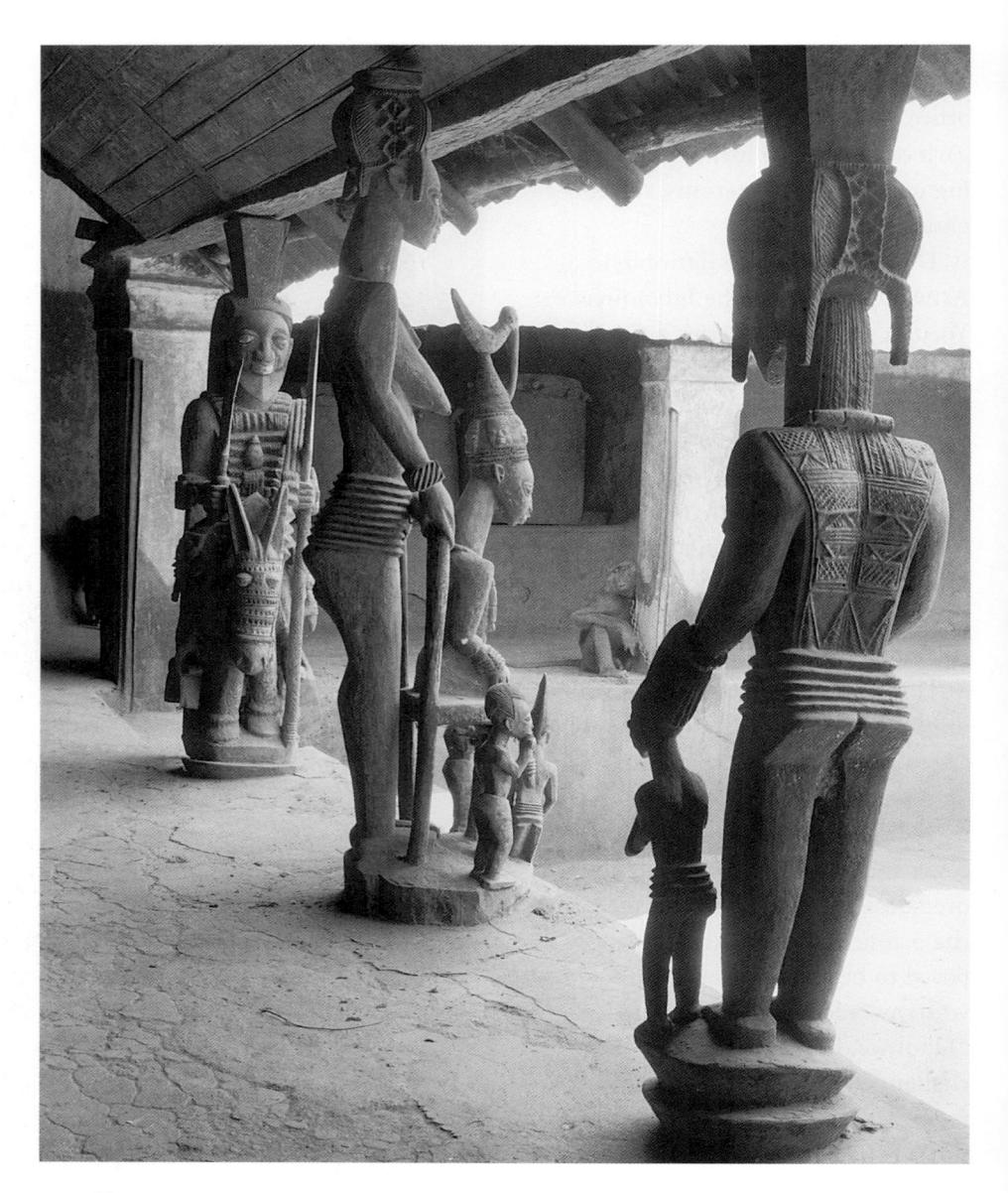

8-19. Verandah posts, Ikere palace, Ikere, Olowe of Ise, Yoruba, Nigeria, 1910–14. Wood and pigment. Photograph 1959

ogoga, of Ikere, in northeastern Yorubaland. The ogoga was probably familiar with the works that Olowe had carved for the palace at Ise and wanted to make his own afin equally magnificent. Among the works Olowe created at Ikere are three verandah posts that once stood in the courtyard in which the ogoga sits in state for ritual and ceremonial occasions (fig. 8-19). The central group, a freestand-

ing sculpture only appearing to serve as a post, represents a king seated in state. A woman kneels before him. To his immediate left a palace servant carries a fan; to his right a herald blows a whistle. Behind his throne stands a tall and stately queen, whose bulk frames his figure when the grouping is seen frontally. Compared to his queen, the king is quite small. Seated on his throne, his feet dangle

in mid-air. By adjusting the scale of his figures, Olowe evokes two concepts. The first is that the power of a Yoruba king is not in his physical stature but in the mystical powers that he derives from his royal ancestors. These powers reside in the crown, which dominates the composition. Repeating textured bands, ancestral faces, and an enormous bird whose beak touches the crown just above the central ancestral face all draw our attention to the crown, whose carefully textured surface contrasts with the more plainly carved form of the king.

The second concept Olowe evokes is the power of women. The imposing bird atop the crown concedes that the king relies on forces that women control. The large, physically imposing figure of the queen, painted a startling blue, also alludes to the supporting power of women. Although the power of the king is overt, that of women is hidden. The king and all creation rely on the energies that women command.

Two weight-bearing posts flank and face the central group. To the right, another queen, wearing an elaborate coiffure, presents her twin children. To the left, a warrior on horseback approaches, holding a cutlass in one hand and a spear in the other. A European gun rests at his waist. A small herald to his side announces him with a Y-shaped whistle. The horse is the most profound of his attributes, for it is symbolic of great cavalries in the days of Yoruba warfare. The secret powers of dynasty, the military might of men, and the hidden and reproductive energies of women are all evoked in this set of posts.

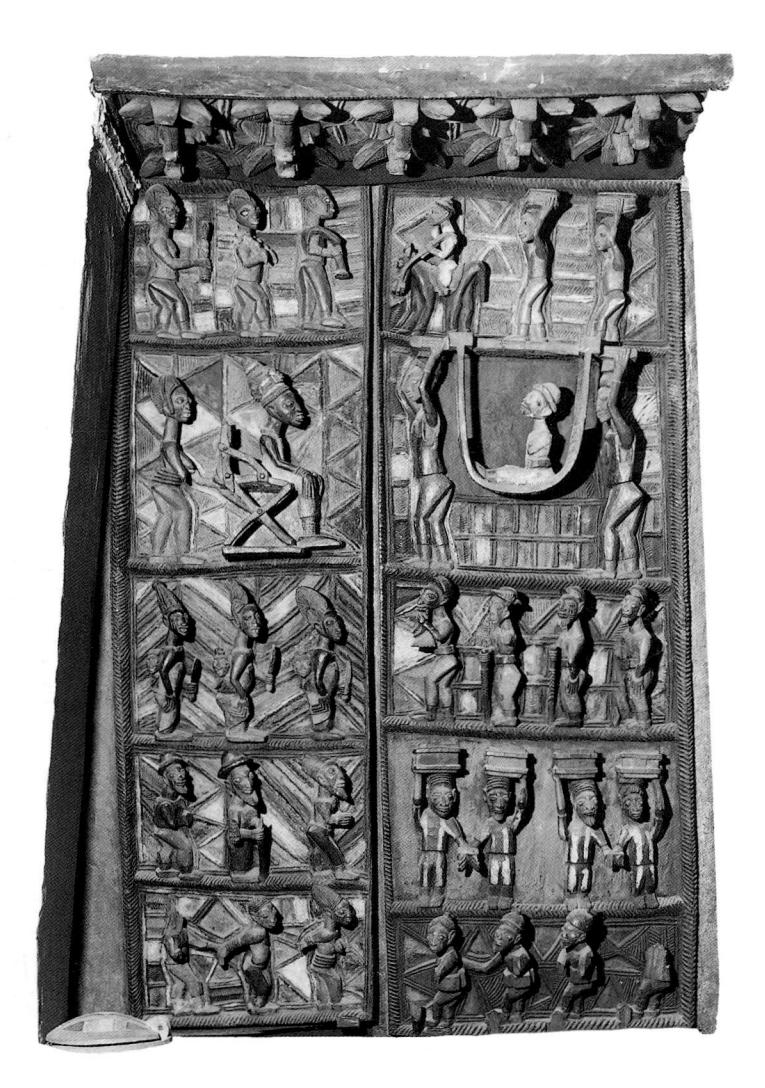

8-20. Door from the Ikere Palace, Ikere, Olowe of Ise, Yoruba, Nigeria. 1910–14. Wood. The British Museum, London

Such works of art were not entirely the work of one individual, for like other artists of his stature, Olowe of Ise maintained a workshop staffed by assistants and apprentices. Patrons had a say in the creation as well, and advisors to the ogoga probably deliberated with each other and the artist on the subject matter of Ambrose's visit and the symbols that would most effectively convey the appropriate message. In addition, Yoruba communities are known to have had critics. Their criteria for evaluating art works would have been known to an artist such as Olowe, who would have tempered his work in response to their judgments.

Olowe also produced a door for the same courtyard (fig. 8-20). A remarkable example of palace art, it depicts the *ogoga*'s reception in 1897 of Captain Ambrose, the British Commissioner of Ondo Province. Each of the door's two vertical panels

is divided into five registers. In the foreground, figures carved in high relief carry out the action of the story; the backgrounds are carved in low relief and the patterns are picked out in color. On the left, in the second register from the top, the king is

shown seated on his throne, wearing his great crown, his senior wife standing behind him. The registers above and below depict other wives, palace attendants, and slaves. To the right, in the corresponding register, Captain Ambrose sits rather uncomfortably in a litter carried by porters. His retinue fills the other registers—an equestrian figure, porters with loads on their heads, and shackled prisoners also bearing loads. The contrast between the two panels may be a conscious comment on Yoruba and European ways. On the left, free people go about everyday tasks and honor the king. On the right, attendants forced into service accompany the uneasy European. This magnificent door was taken to England where it was displayed in the British Empire Exhibition of 1924. When colonial officials asked to purchase the piece, the ogoga refused to sell it, requesting instead that an English royal throne be given to him in exchange for the door. The ogoga then commissioned Olowe to sculpt a replacement door for his palace.

The Ogboni Society

Yoruba kings rule with the assistance of a number of councils and associations. Ogboni, an association consisting of both male and female elders, is one of the most prominent. As with many organizations in African communities that are limited in membership and not open to public scrutiny, there is much debate about Ogboni's meaning and purposes. It is understood, however, that the organization serves to check the abuse of power by rulers, for the collective moral and political authority of these eminent

citizens is as great as that of kings, royals and officials. In the past Ogboni acted as a judiciary in criminal cases and was responsible for removing despots from office. Although its authority has been diluted, Ogboni still exercises significant power in traditional Yoruba politics, and its leaders still control the choosing, inauguration, and burial of kings.

Ogboni has a special relationship with Earth, who is seen as a deity.

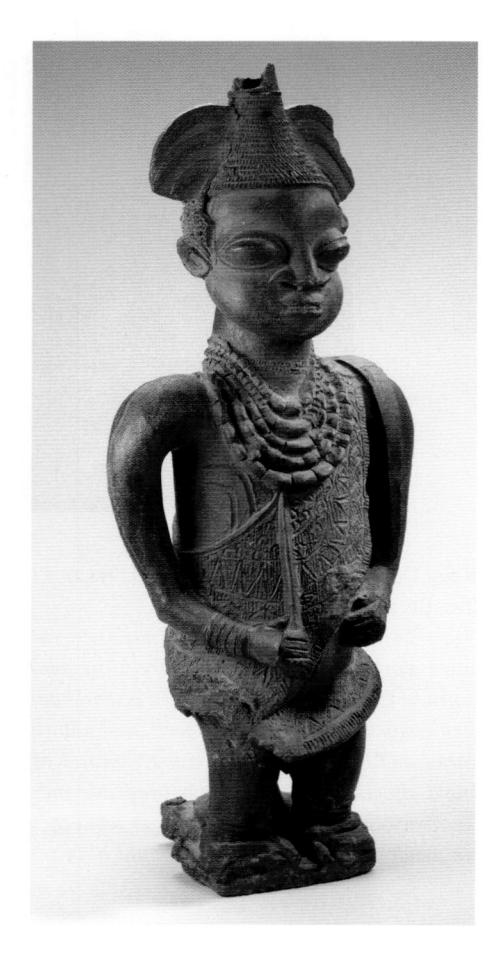

8-21. Male *Onile* ("owner of the house") figure, Yoruba, Nigeria. Terracotta. Height 30%" (76.5 cm). National Museum of African Art, Smithsonian Institution, Washington, D.C. Gift of Walt Disney World Co., a subsidiary of The Walt Disney Company

Earth is both the giver and taker of life, both mother and father. Earth as the land is the abode of numerous spirit forces and beings as well as of ancestors. Ogboni connects those who live upon the earth and those who dwell within, acknowledging the omnipresence of spirits and ancestors, who observe all acts of the living and hear every spoken word.

Ogboni employs a variety of art forms in its work, foremost among them paired male and female figures. Large, freestanding pairs placed on altars are referred to as "owner of the house," onile. Hidden away within the Ogboni lodge, they are accessible only to the most senior members. The pair is treated as a single unit, referred to as Mother, iya. Onile perhaps alludes to dual aspects of Earth, on the one hand hard, negative, and masculine, on the other soft, positive, and feminine. Normally cast in copper alloys, onile are created under ritual circumstances and prepared with sacred substances. Considered to have great sacred authority and power, ashe, the figures emphasize the importance of men and women working together within Ogboni and in the community at large.

A large *onile* from the Ijebu Yoruba region is unusual in that it is made of terracotta (fig. 8-21). Scarification marks on the figure's chest indicate membership in Ogboni. Beaded necklaces acknowledge office in the organization. A cloth lushly decorated with geometric patterns, representing a textile called *itagbe*, is draped over the left shoulder. The conical cap recalls the Yoruba royal crown, and its arching feathers are reminiscent of those that adorn the heads of kings. The visual play

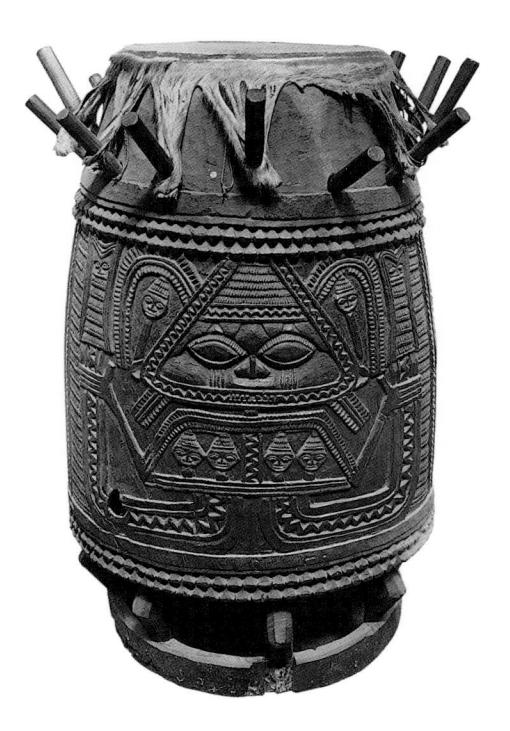

8-22. AGBA (OGBONI SOCIETY DRUM), YORUBA, NIGERIA, 1890S. WOOD AND SKIN. HEIGHT 3'6½" (1.1M). THE BRITISH MUSEUM, LONDON

between the intricately textured headgear and cloth and the smooth surfaces of the body produces a lively effect.

The large wooden Ogboni drum, agba, shown here was probably carved during the 1890s (fig. 8-22). The hollow, tapered cylinder was carved from the trunk of a tree. An animal skin membrane is stretched and pegged at the top. Its sides are carved with images in sharp, low relief. The central figure has a large triangular head with imposing eyes. The conical cap and drooping feathers recall those of the large terracotta onile in figure 8-21. The figure holds aloft its own legs, which have been transfigured into stylized catfish.

This *agba* would have been part of a group of such drums, thought of as a family. As the largest, it would have

been called the "mother" drum. The smaller drums that accompanied it were likely carved with related motifs. Agba function in a variety of ways. On a practical level, they announce the meetings of the Ogboni lodge every seventeen days. They are also sacred objects, and in yearly rituals the blood of sacrificial animals is rubbed into its sides. Because of its sacred character, the intricate iconography of this drum would never have been seen by anyone other than initiated members. In nocturnal but public memorial services for deceased elders, for example, the sides are ritually covered to ensure that the surface designs are not seen by the uninitiated.

Four small heads, connected in pairs, are carved on the body of the central figure as though tucked into its belt. Two more heads at the tops of stakes can be seen just beneath the arching feathers of the headdress. These images refer to another type of Ogboni sculpture called edan. Although edan, like onile, are filled with ashe, non-members are allowed to see them. *Edan* serve as public symbols of the power and presence of Ogboni. They also refer to the male and female founders of the community and express the cooperation between men and women in society and the need for a balance of power between them.

The Ogboni elder shown here (fig. 8-23) wears a brass *edan* over his shoulders as an emblem of office. The male and female figures, connected by a chain, are considered to form a single entity. Commissioned for a new member at the time of his or her induction into the society, the *edan* is a more personal art form than *onile*. It serves as a badge of membership

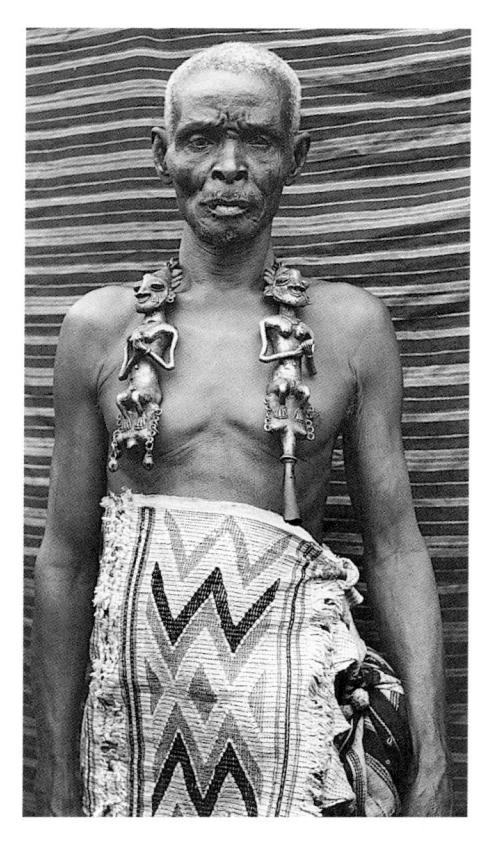

8-23. Ogboni society member wearing an *EDAN* (pair of figures) and a title-cloth, Yoruba, Nigeria

and an indicator of status within the organization. It may also convey messages and protect its owner.

Many Yoruba rituals that acknowledge advancement in position or membership in an organization include the tying on of a distinctive cloth. A number of such special textiles, generically called title-cloths, are closely associated with the Ogboni society. The elder in figure 8-23 wears a title-cloth around his waist. Created by a woman on an upright loom, it is embellished with richly colored geometric designs based on natural forms. Although weavers of such cloths are certainly familiar with the designs and symbols they are asked to create, they are not privy to their

underlying meanings unless they too are members of the society, for interpretation is reserved for those who have the right to wear them. Even outsiders, however, know that Ogboni robes celebrate the richness and diversity of their owners' experiences.

The way the Ogboni cloth is finished also carries meanings. The fringes at the end of this example (seen at the right of the photograph) are divided and wrapped with threads to create seven tassels. Seven is a ritually significant number in Ogboni.

Art and the Spirit World

The Yoruba venerate an infinite number of gods, orisha. Some are primordial, created in the beginning of time by the Great God, Olorun. Among those we will discuss here are Orunmila, Eshu, and Ogun. Some natural powers such as rivers, mountains, stones, or thunder and lightning may be perceived as orisha, and heroes may be apotheosized as well. The god Shango embodies both of these ideas in that while he is the personification of thunder, he is also a deified culture hero, fourth king of the Oyo empire. The very concept of orisha suggests an endless number, and there is always the possibility that new ones will make themselves known to a particular human community or even to a particular family or individual. Thus an orisha acknowledged in one part of Yorubaland may not be known elsewhere, or may be thought of quite differently.

Orunmila and Eshu

Two primordial *orisha*, Orunmila and Eshu, serve as mediators between gods and humans. Seen as embodi-

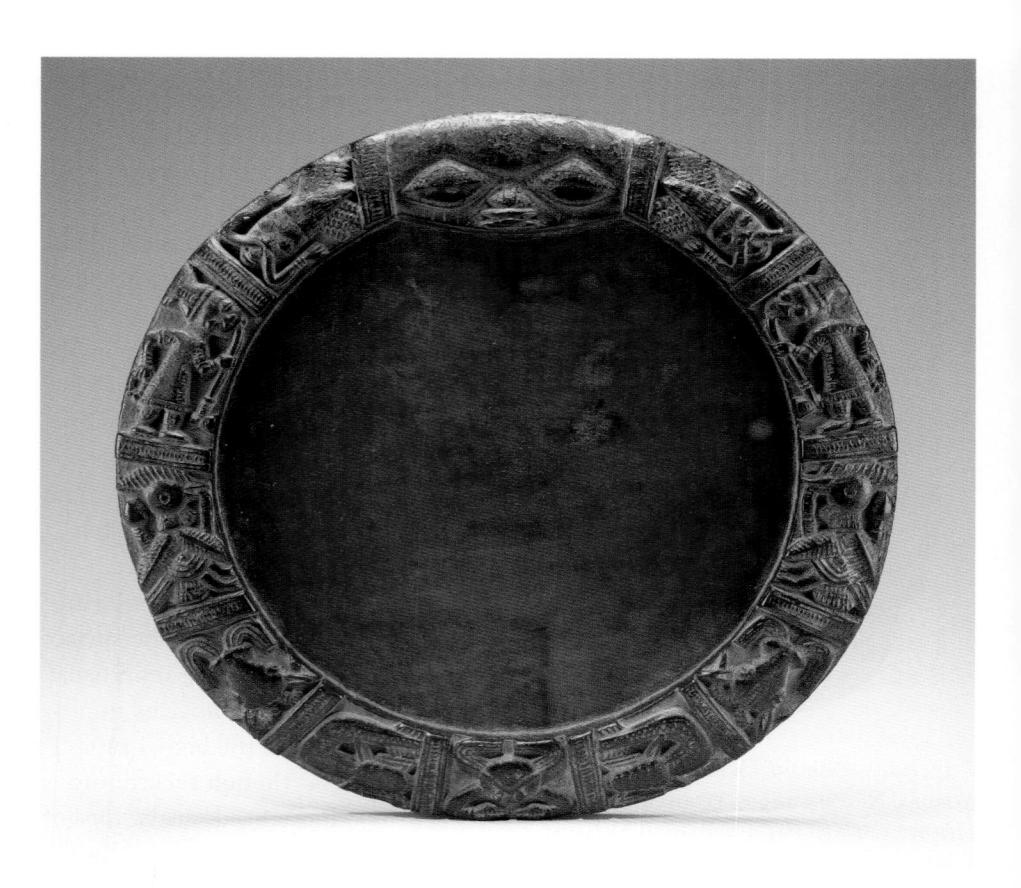

ments of the principles of certainty and uncertainty, the twosome is intimately connected in the minds of the Yoruba, for order does not exist without disorder, and disorder requires order by definition. Orunmila, the orisha of destiny, embodies certainty, fate, equilibrium, and order. In Yoruba belief, each person chooses a destiny in the presence of the Creator God prior to birth. Orunmila can help people to gain knowledge of their destinies as they live them out. Through him, they can learn which forces control their future, and how to manipulate these forces in their favor. Uncertainty, chance, violence, and trouble define Eshu. Ironically, the disorderly and mischievous Eshu is also the messenger of the gods, and to gain Orunmila's attention, one must first approach the trickster Eshu.

8-24. Opon IFA (divination board), Yoruba, Nigeria, 19th–20th century. Wood. Height 14½6" (3 cm). National Museum of African Art, Smithsonian Institution, Washington, D.C. Gift of Walt Disney World Co., a subsidiary of The Walt Disney Company

Flanking the Eshu face are heads with conical caps, each with four radiating forms issuing from the side, recalling the crownlike forms seen on Ogboni paraphernalia. From the nostrils of each head issues a pair of arms. A full figure wearing a gown and cap and holding a long pipe to his mouth appears in the next zone. Among the Yoruba, the pipe is an image closely connected to Eshu, and such figures may represent either the trickster god himself or one of his worshipers. A rooster holding a snake in its beak appears next, followed by a horned animal with curving forms issuing from its nostrils. A dried, skewered catfish, a reference to sacrifice, is the final repeated motif before the single crab.

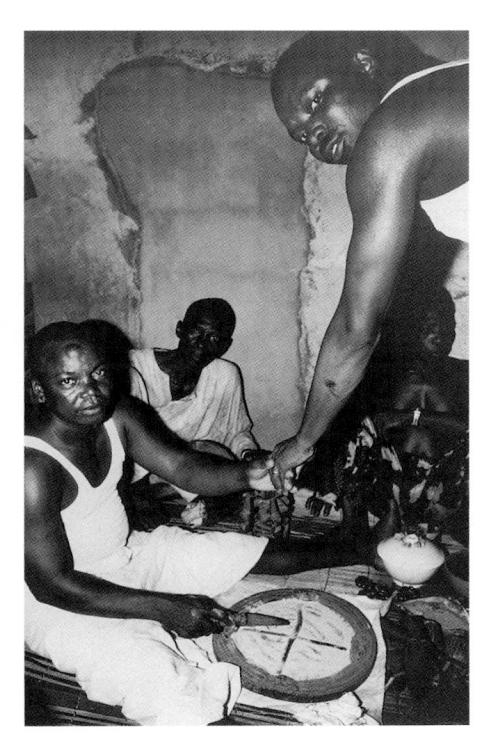

8-25. Yoruba divination session, Nigeria

A diviner, babalawo, mediates between Orunmila and the human community through the divination process known as ifa, understood to have been instituted by Orunmila himself. A babalawo employs numerous art objects in communicating with the spirit world. The essential sculptural object for ifa is a divination board, opon ifa (fig. 8-24). Like most Yoruba opon ifa, this one is circular in design, its flat, plate-like surface surrounded by a raised border filled with an assortment of images carved in low relief. The stylized face of Eshu fills the top center portion of the border. Five additional motifs appear left and right in mirror image, creating a bilaterally symmetrical composition. Opposite Eshu is a crab, itself bilaterally symmetrical. The motifs were probably chosen by the carver, though they are not specifically linked to the divination process or to Orunmila.

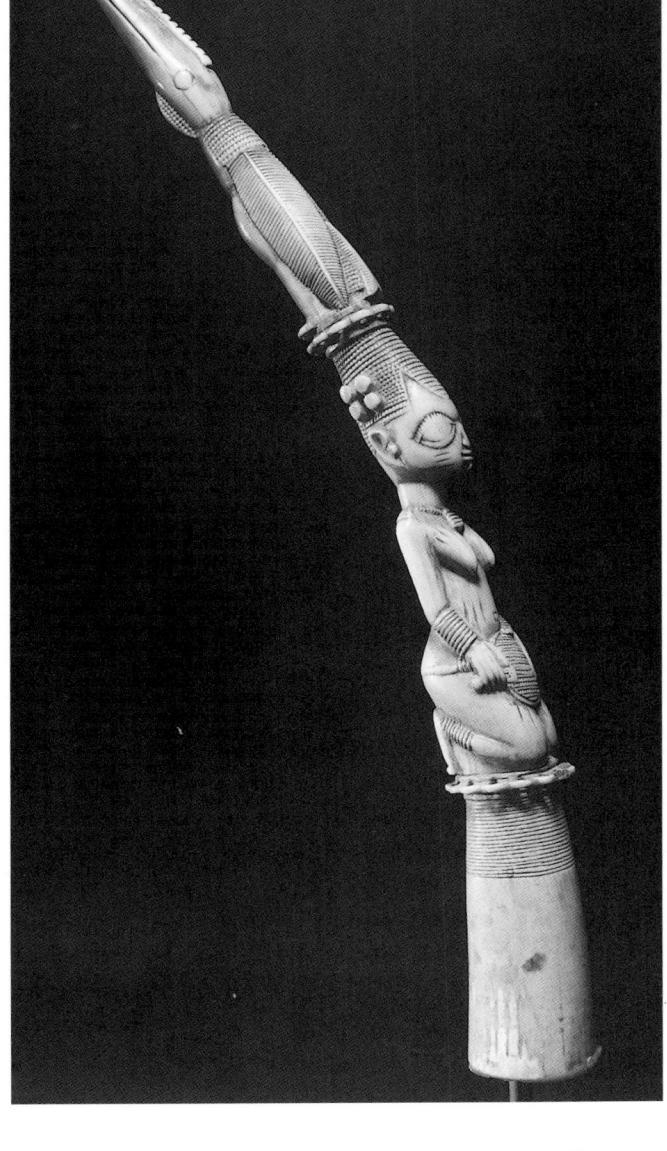

8-26. IROKE (DIVINATION TAPPER), YORUBA, NIGERIA. IVORY. FIELD MUSEUM OF NATURAL HISTORY, CHICAGO

In use, the tray is sprinkled with dust from a special wood (fig. 8-25). The *babalawo* throws sixteen palm nuts to determine a configuration of eight sets of signs. He draws the signs in the dust, then erases them. Each of the 256 configurations that can occur is known by a name and is associated with a body of oral literature. As the *babalawo* chants the appropriate verses, clients interpret them to apply to their own situations. The *babalawo*

shown here is in the process of attracting the attention of Orunmila and Eshu by rapping a special tapper, the *iroke*, on the center of the *opon ifa*, and at the same time reciting verses to acknowledge and honor Eshu, the messenger.

A woman and bird, a hornbill, are depicted on the beautiful ivory *iroke* shown here (fig. 8-26). Finely carved textural areas contrast with smooth forms, providing the eye with a tactile

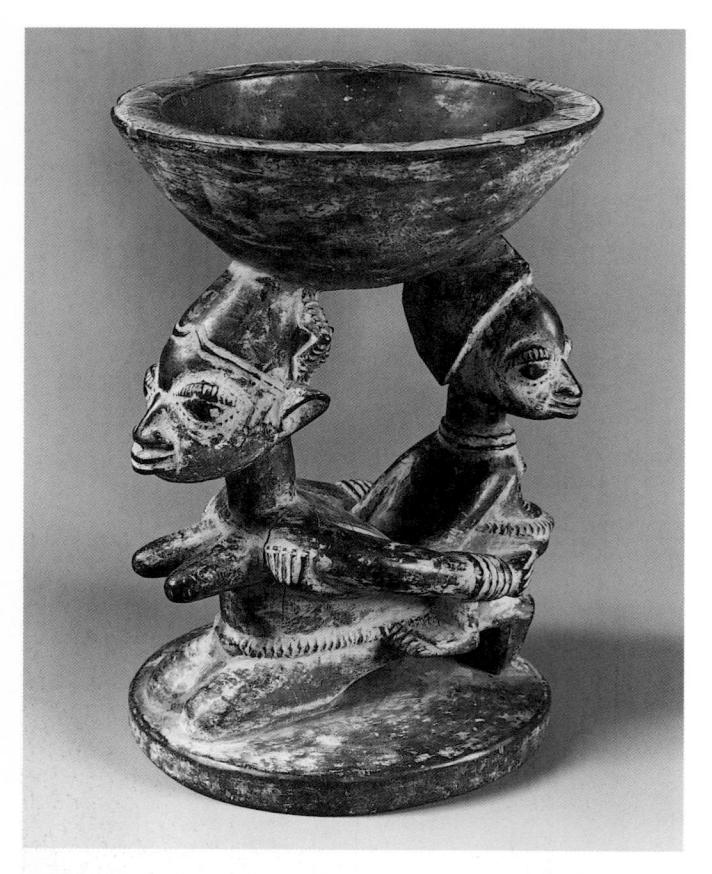

8-27. AGERE IFA (DIV-INATION CUP), YORUBA, NIGERIA OR REPUBLIC OF BENIN, BEFORE 1912. WOOD, KAOLIN. HEIGHT 8¾" (21 CM). MUSEUM FÜR VÖLKERKUNDE, STAATLICHE MUSEEN, BERLIN

child tied to her back. The disc upon which she kneels repeats the circular form of the cup-like container above, whose rim is enhanced by an incised pattern of repeated triangles. The dark, worn wood has been rubbed with a light-colored substance that fills and defines the crevices of the carving. The maternity figure is but one subject among many that might support such a cup. Also in the carvers' repertoire are human, animal, and abstract forms, and the iconography often reflects the needs of a *babalawo*'s clients.

Other divination paraphernalia may be stored in large, multi-compartmented, lidded containers, or divination bowls called *opon igedeu* (fig. 8-28). Areogun of Osi-Ilorin

experience. The woman's kneeling pose suggests worship and supplication, while her fan and jewelry indicate aristocratic status. The image of a woman in a pose of supplication is believed to be an ideal intermediary. Her kneeling position recalls the fact that she once knelt before Olorun to select her destiny. Women are considered to be the ultimate containers for ashe or life force, and representations of nude female figures in a kneeling position become visual metaphors for those who seek their fates through divination. Her nakedness, normally taboo in Yoruba culture, may well refer to the belief that that the most powerful prayers and curses by Yoruba women were carried out in this state of nakedness. At the same time, the state of undress indicates the condition in which one communicates with the Creator. The coiffure or crown-like headdress adds emphasis to the head, recalling the Yoruba philosophical concept of *ori*, which may be interpreted as "head" or "destiny," and which embraces a person's past, present, and future. A reference to *ori* is thus also a reference to fate, the concern of divination.

The palm nuts used in *ifa* are kept in a carved container called *agere ifa* (fig. 8-27). Fashioned of wood or more rarely of ivory, *agere ifa* vary greatly in form and may range in height from a few inches to over a foot. The exquisite example here is supported by figures of a mother and child. The mother kneels in supplication, her prominent breasts projecting to repeat the forms of her knees and to serve as counterthrusts to her arms, which reach back to encircle the

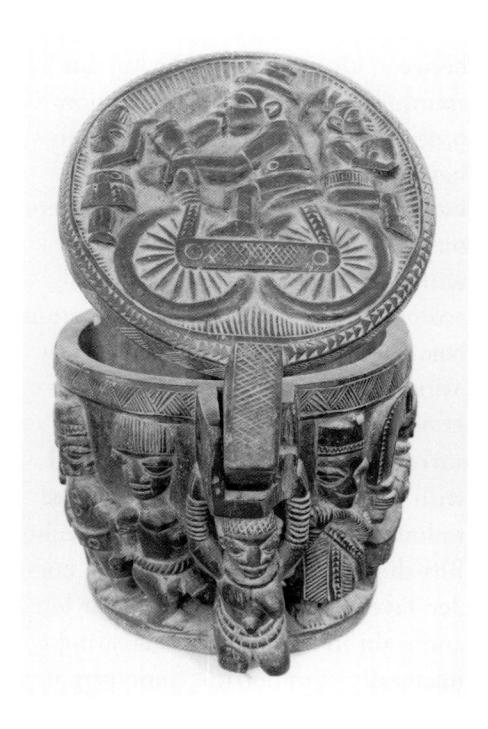

8-28. Bowl (OPON IGEDEU), AROWOGUN (AREOGUN) OF OSI-ILORIN, NIGERIA.
WOOD, PIGMENT TRACES. HEIGHT 12'/"
(31.11 CM) MUSEUM OF FINE ARTS,
BOSTON. GIFT OF WILLIAM E. AND BERTHA
L. TEEL, 1991

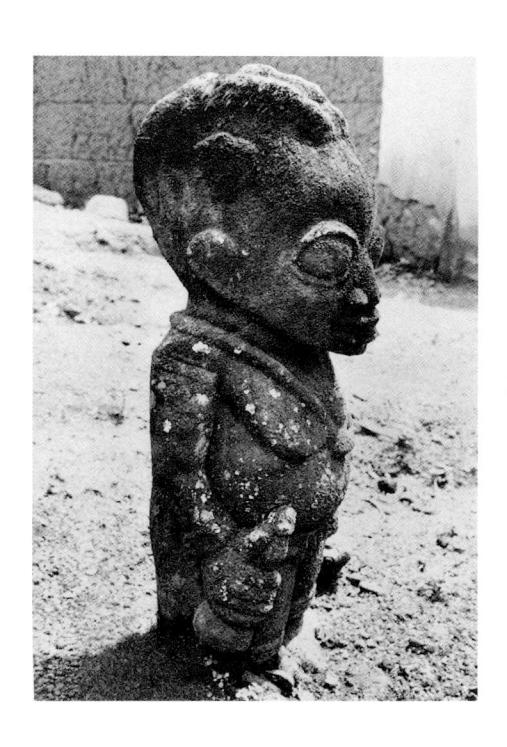

8-29. Stone figure of Eshu, Igbajo, Yoruba, Nigeria

(1880–1954), one of the great Yoruba sculptors of the twentieth century, created this richly carved bowl. Areogun's style is easily recognizable by its bold relief. Like Olowe, Areogun was granted major royal commissions for palaces such as verandah posts and doors. Here Areogun has created a cylindrical vessel with a strikingly innovative feature—a hinged lid. Seated figures surround the bowl, while the lid reveals a man on a bicycle.

While Orunmila is never depicted in shrines or on divination paraphernalia, Eshu is portrayed repeatedly. The only Yoruba *orisha* consistently represented, Eshu appears on houseposts, lintels, doors, and bowls. As a go-between for gods and humans, his image embellishes many shrines. As the god of the marketplace, the gateway, and the crossroads, he is often represented in these places as well. Figural representations in public places, however, are rare. Instead, a

8-30. Dance wand in honor of Eshu, Yoruba, Nigeria. Wood, leather, cowrie shells, brass, bone. Height 19¼" (50.7 cm). Indiana University Art Museum, Bloomington. Raymond and Laura Wielgus Collection

piece of unworked stone usually suffices to represent the god, and even then it may be buried beneath the earth or in a wall. Occasionally a figure carved of wood or more rarely of stone may be set up in a marketplace (fig. 8-29). The figure shown here was photographed in the center of the town of Igbajo, some thirty-five miles from Ile-Ife. At least two other stone Eshu figures had once graced parts of the town. The style is not like that of the early stone figures of Ile-Ife, but it is more reminiscent of more recent Yoruba woodcarving. The trickster god is depicted with a large head, and

Although the followers of other *orisha* call upon Eshu, his own special congregation of worshipers make use of a number of types of objects including dance wands, assemblages, and altar figures. The dance wand in figure 8-30 once decorated a shrine for Eshu and would have been used in processions and festivals, danced with by a worshiper in honor of the god.

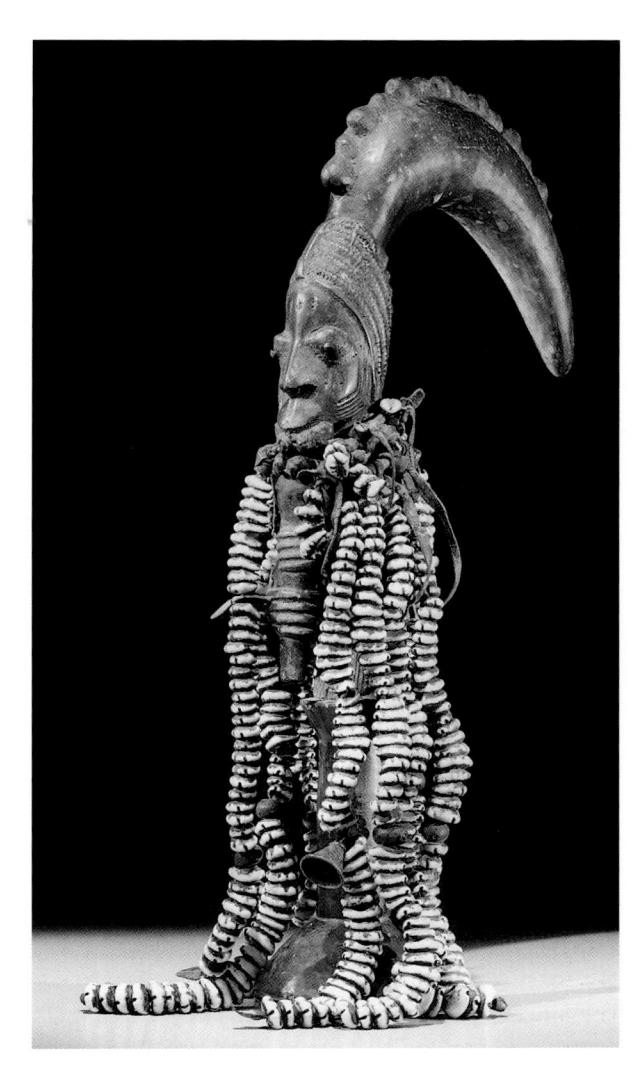

with a figure of a worshiper, the figure here may actually represent Eshu himself. Long strands of beads and cowries, once used as money by the Yoruba, cascade from the neck in reference to the wealth brought by this god of the marketplace. The long, projecting hairdo, common to most Eshu figures, arches up and away from the head. Such phallic coiffures refer to Eshu's involvement in male sexuality and romantic entanglements. Miniature gourds along the crest of the hair allude to the powerful medicines at Eshu's disposal. The whistle held to the lips suggests Eshu's role as supernatural herald. Although this figure is male, similar ones may be carved as female, for the enigmatic Eshu may be represented as either

While such wands are usually carved

The gods Orunmila and Eshu make us aware of the possibility of change in Yoruba society and art. Eshu is a dynamic *orisha*, one who cannot be pinned down to remain the same. The very fact that Orunmila is sought on every occasion and that *ifa* is cast every four days suggests that change is vital, even in thinking about fate or destiny. Such change must be seen as a part of Yoruba artistic expression as well.

Ogun, Osanyin, and Eyinle

Ogun, the lord of iron and war, and Osanyin, the source of herbal medicine, are also primordial *orisha*, having come to earth at the time of creation. Like Eshu, each is a paradox. Although Ogun is the ferocious and vehement bringer of war, he is also the founder and champion of civilization, a maker of paths, tiller of the soil, builder of towns. The tiny

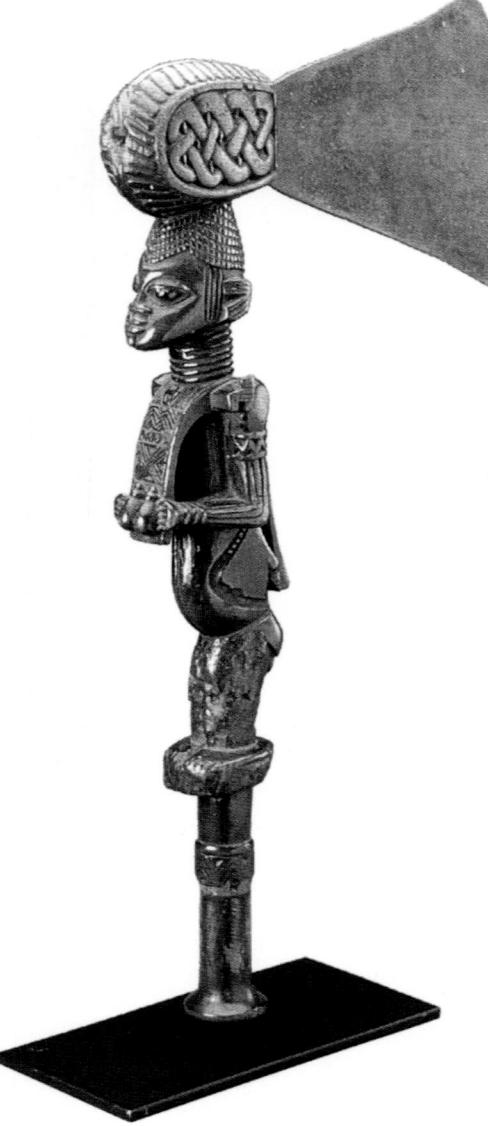

Osanyin, visualized as having but one eye, one arm, and one leg, and having numberless problems of his own, is the bringer of healing, completeness, and well-being to the human community. Eyinle is a local *orisha* of hunting, rivers, and healing leaves, a companion of Osanyin.

As the god of iron, Ogun's impact is ubiquitous, for metals affect every facet of civilization. As warrior, Ogun moves forward and conquers, expanding frontiers. As the defender, he uses weapons to protect and shield. As 8-31. AXE IN HONOR OF OGUN.
OWO YORUBA, NIGERIA. WOOD,
IRON, PIGMENT. HEIGHT 20"
(50.8 CM). SAMUEL P. HARN
MUSEUM OF ART, UNIVERSITY OF
FLORIDA, GAINESVILLE. GIFT OF ROD
MCGALLIARD

master blacksmith, he is patron of smiths, makers of tools and weapons. As the ultimate artist, he oversees any who manipulate adzes and knives. As the consummate farmer, he oversees farm implements made of his iron. In modern times he continues to gather adherents, for all who use steel are his, including hunters, soldiers, truck drivers, auto mechanics, and computer technicians.

Ogun's embodiment in shrines may merely be a bit of metal, raw or carefully worked, or a sacred plant or a stone. Several art forms are specifically identified with Ogun, among them ceremonial swords, staffs, iron pokers, and axes (fig. 8-31). This axe is typical of those used in Ogun's worship in eastern Yorubaland. A beautifully rendered human figure adorns the handle, complete with markings of civilization and aristocracy: a well-coiffed head, jewelry, poise, and dignity.

As maker of roads and penetrator, Ogun readies the way for all the *orisha*, and references to Ogun are thus present in the shrines of many gods. Diminutive forged iron implements—hoes, knives, arrows, swords, and bells—announce the intervention of Ogun in the work of healing deities, for his slashing blades permit healers to venture into the depths of the forest for curative materials. Iron

staffs enhance the worship of healing deities, while expressing their link to Ogun.

Iron staffs are commonly dedicated to the *orisha* of curative medicine, Osanyin and Eyinle (fig. 8-32). This graceful staff refers to the vitality of Osanyin and evokes his relationships to Ogun and to Our Mothers. The powers of Our Mothers may be represented here by a large bird hovering over a circle of sixteen smaller birds raising their heads toward the larger. Osanyin has the ability to cancel the negative powers of Our Mothers or to work in harmony with them, encour-

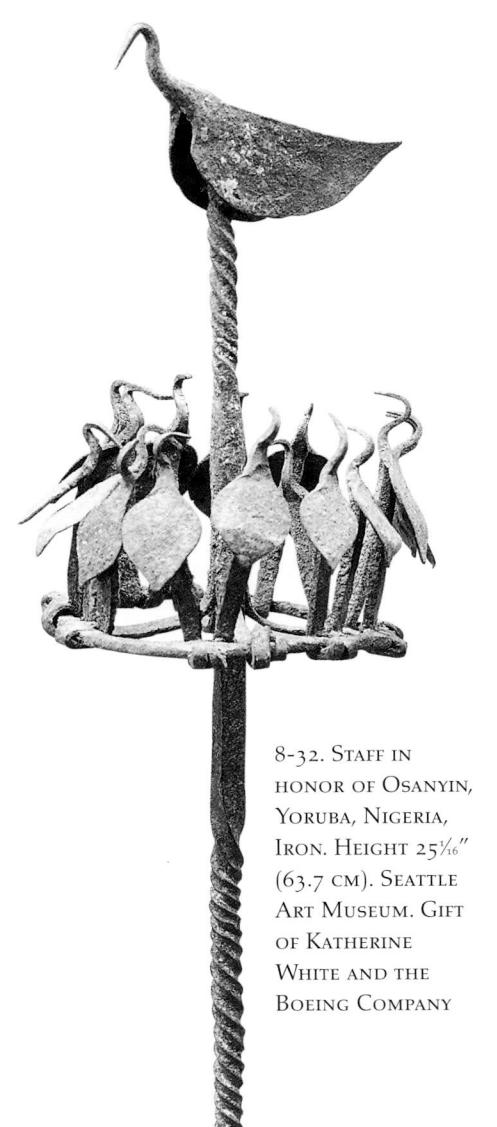

aging them to cure rather than hurt. At the same time, the cluster of bird forms may recall leaves on a tree. The herbalists who depend on Osanyin create their medicines and curative drugs from leaves, barks, and roots from the forest, where the metal tools of Ogun have allowed entry.

The terracotta receptacle in figure 8-33 honors the god Eyinle. It was created around 1900 by Agbedevi Asabi Ija (died c. 1921), a highly regarded ceramic artist of the Egbado Yoruba. Like her mother before her and her daughter after, Agbedeyi was renowned for her Evinle vessels, and her reputation spread far beyond the confines of her own town. The large central figure on the lid is said to represent Eyinle's royal wife. The straplike forms that serve as her abstracted body can also be perceived as a crown, referring to her royal status. She is surrounded by four of her children, one on her back, and three before her. The largest of the children holds a miniature bowl for offerings of kola nut and cowries. Studded with small conical projections that allude to river stones and decorated with symbolic images in low relief, the vessel serves to hold stones, sand, and water from the river, all of which contain and protect the ashe of Eyinle. Such containers are placed on sculpted earthen platforms stained with indigo and spread with white river sand. Iron staffs of Eyinle's companion Osanyin may be placed nearby.

Altars

As in most African cultures, shrines are places where human beings interact with deities and spirits (see Aspects of African Cultures: Shrines and Altars, p. 120). Ensembles of

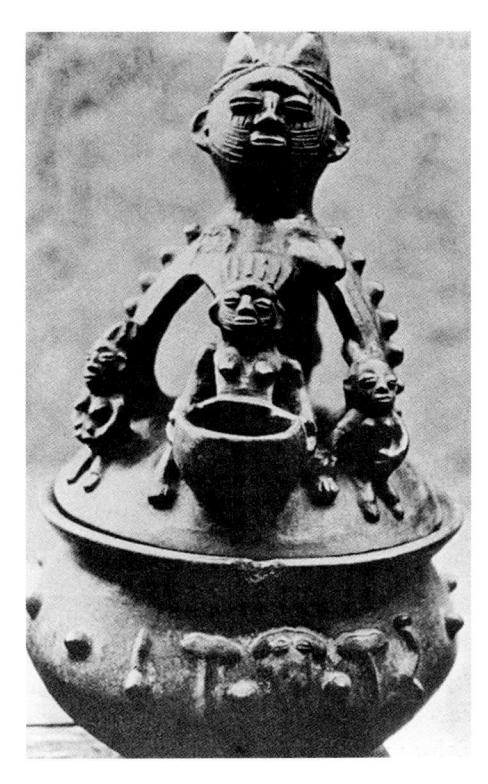

8-33. Vessel in honor of Eyinle, Agbedeyi Asabi IIa, Nigeria, C. 1900. Terracotta

materials given as gifts to the deity remind devotees of the presence and powers of the deity, or serve to locate power (ashe) associated with that deity. The Agbeni Shango shrine in Ibadan, shown here, was photographed in 1910 (fig. 8-34). As with other sanctuaries for orisha, the altar accommodates numerous objects that celebrate and help communicate with the deity. A long row of fifteen brightly painted houseposts once braced the massive clay frieze. Allusions to Shango's royal status, the posts were carved to depict devotees, orisha, images associated with the ancestors, and other subjects.

Sculptural forms are added to the shrine as gifts to the *orisha*. One extraordinarily complex and

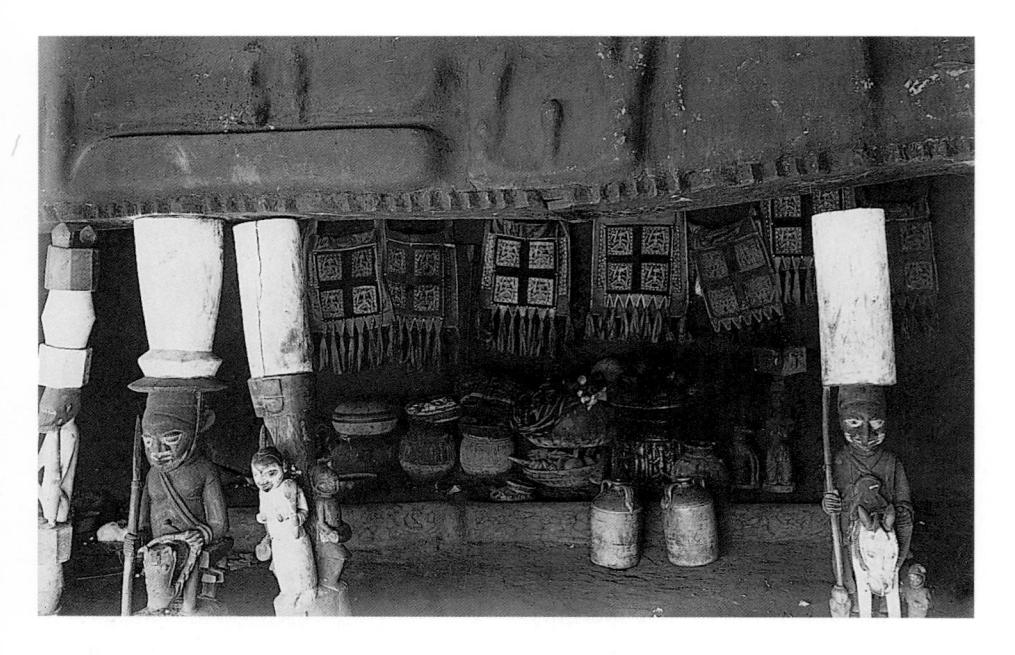

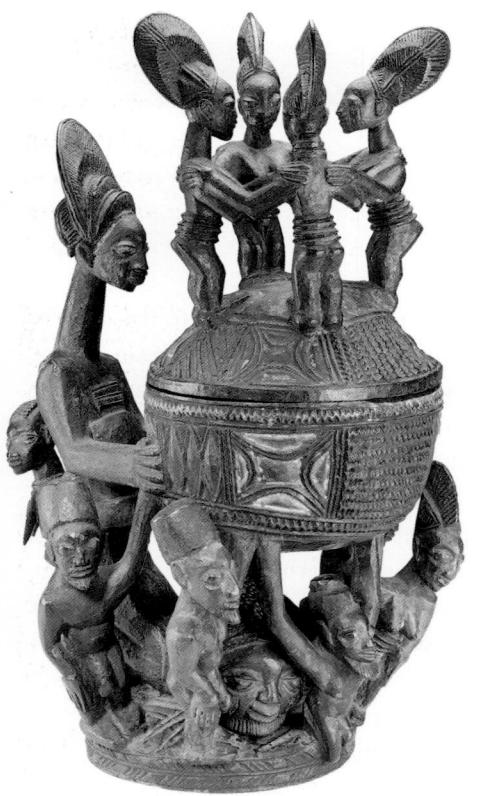

8-35. Olumeye (altar bowl), Olowe of Ise, Nigeria, c. 1925. Wood, pigment. Height 25½" (63.7 cm). National Museum of African Art, Smithsonian Institution, Washington, D.C. Bequest of William A. McCarty-Cooper

8-34. The Agbeni Shango shrine, Ibadan, Yoruba, Nigeria. Photograph 1910

dynamic bowl, probably intended for the altar of an orisha, was created by Olowe of Ise (fig. 8-35). The bowl is covered with abstract designs carved in low relief and painted. Four female figures dance arm in arm atop the lid, their arched coiffures adding height and movement. The bowl is presented by a spectacular elongated female figure, whose head is held high on a splendidly long neck. Her baby, held against her back by a cloth, peers to the side. A retinue of male and female assistants, painted in earth colors, lean precariously from their positions on the base to lift the bowl. The complex sculptural form of the lower portion of the configuration is monoxyl, carved from a single piece of wood. Olowe demonstrated his mastery of the art of wood carving by carving a freerolling head in the space beneath the bowl, imprisoned within the group of supporting figures.

The form is called the *olumeye*, "one who knows the honor," in reference to the female figure supporting the bowl. As with the mother depicted in the shrine image in figure 8-33, this mother serves as a messenger to the orisha, offering the bowl and its contents to the god to whom it is dedicated. In this olumeye, Olowe's use of standing nude males on the support structure is a drastic departure from the conventions of Yoruba art. He challenges the convention in which males are normally depicted fully clothed while females are more often represented in the nude.

Shango and Ibeji

Shango, who controls thunder, is associated with the expansion of the Oyo empire in western Yorubaland. The historical personage Shango, a descendant of Oranmiyan, was the tyrannical fourth king of Oyo. Oral traditions maintain that he was a despot, coerced into surrendering his crown and committing suicide. His supporters denied his death and declared that he had become a god, merged with the forces of thunder and lightning, which they could call down on their enemies. The Shango legend illustrates a significant aspect of Yoruba orisha: they are not idealized. Shango was a sacred king, but he is still presented as a remorseless despot whose need for control overstepped the boundaries suitable to political authority. In his attempt to control mystical and magical powers, he was unable to master them and was eventually controlled by them. Once a mortal, Shango did not die, but he commands great powers of nature as an orisha. In dreadful storms he hurls flashes of lightning

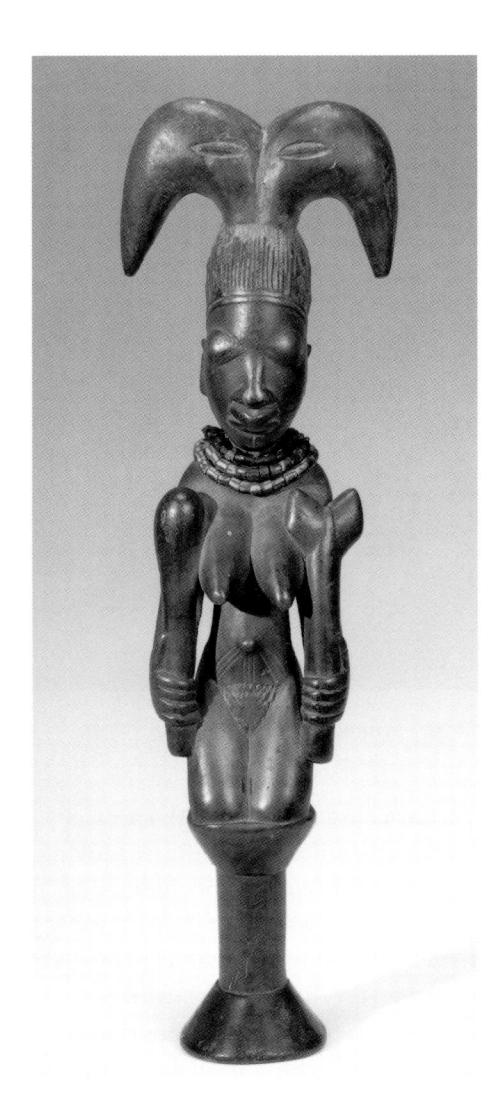

8-36. Oshe Shango (dance wand in honor of Shango), Oyo style. Yoruba, Nigeria. 19th—early 20th century. Wood, beads, height 15 ½" (39 cm). Robert and Lisa Sainsbury Collection, University of East Anglia

upon those who do not respect him. These thunderbolts take the form of ancient stone axes that are exposed on the surface of the earth after heavy rains.

The shrine in figure 8-34 was dedicated to Shango. Brightly colored, fringed leather bags hang from the rear wall. Each bears four appliqué

panels with images of Eshu. Called *laba shango*, the bags are used by priests to transport thunderbolts discovered in the earth to Shango's altar. An upside-down wooden mortar, ceramic containers with painted and relief ornamentation, and calabash containers all serve as repositories for the stone axes that contain Shango's *ashe*. Other objects include cloths, prayer rattles, a sculpted figure of a female devotee with double axe forms sprouting from her head, figures representing twins, and rams' horns.

Devotees carry, cradle, wave, and thrust oshe shango, carved dance wands such as that in figure 8-36, during dances in Shango's honor. Among the most abundant of objects consecrated to the orisha, oshe shango most often bear the image of a female worshiper, her head supporting the double axe form, modified here to suggest a hairdo. The axe is thus related to the head, the symbol

of the inner being, ori inu, playing an important role in the communication between orisha and follower. In initiation, the head is shaved, and small cuts are made into the scalp into which substances are rubbed. The cut in the head is the primary way through which the orisha becomes one with the devotee, and it is through the head that the orisha mounts the devotee in possession. The figure in this example holds an oshe shango in her left hand and a dance rattle in her right.

The twin figures (or *ere ibeji*) lying in the container just to the left of the pottery jugs (fig. 8-34) are present because of the special relationship between Shango and twins (*ibeji*), sometimes called "children of Thunder." The Yoruba perceive twins as spirited, unpredictable, and fearless, much like their patron *orisha*. Seen as spirit beings with exceptional abilities, they bring affluence and well-being

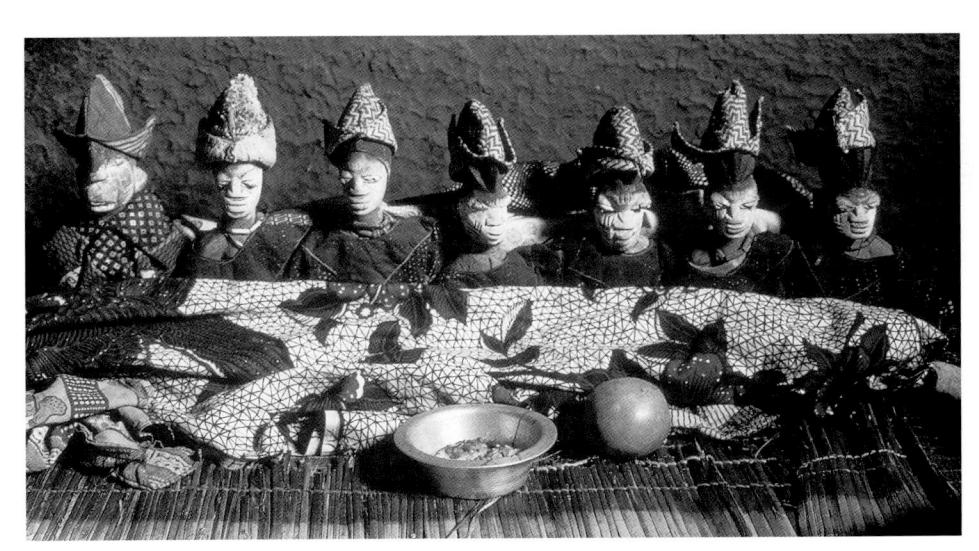

8-37. Ere ibeji (twin figures), Yoruba, Nigeria

These ere ibeji are kept by remaining family members. Others may be placed in a shrine to Shango, or be taken over by a "mother of twins," iya'beji, who cares for twin figures who have lost their caretakers. Still another possibility is that heirs may sell the intriguing little figures to traders, and they will become objects for sale on the international art market.

to those who respect them. Mothers of twins, even the most prosperous and dignified, must beg for their special offspring in public places, singing their praises and dancing with them. People who give them token gifts are blessed. Twins, however, have a high infant mortality rate. When a twin dies, its parents consult a babalawo to learn how to placate the spirit of the dead child, for neglect may cause a dead twin to tempt its surviving sibling to join it. The babalawo normally advises the parents to procure an ere ibeji, a small carved figure of the same gender as the deceased twin, to serve as a dwelling place for its spirit (see Preface, fig. iii.) Ere ibeji are normally cared for within the home (fig. 8-37). Here seven small figures have been dressed in tiny garments and caps, fitted with necklaces of beads related to various deities and organizations, rubbed with cosmetics, placed on a mat, and covered against cool weather.

The mother attends to the *ere ibeji*, handling it with tender care to pacify the soul of the dead child and to ensure its benevolent presence. She bathes it, feeds it, clothes it, and applies cosmetic powders, oils, and indigo. When she begs and performs for the surviving twin, she carries the *ere ibeji* and begs for it too. Eventually, the surviving twin may assume custody of the figure.

While twins continue to be honored among the Yoruba, *ere ibeji* are not carved as often as they once were. Instead, photographs, especially photographs in which the surviving twin poses as the deceased twin, may serve the purpose of the *ere ibeji*, and in many instances plastic dolls take the place of the traditional wooden figures.

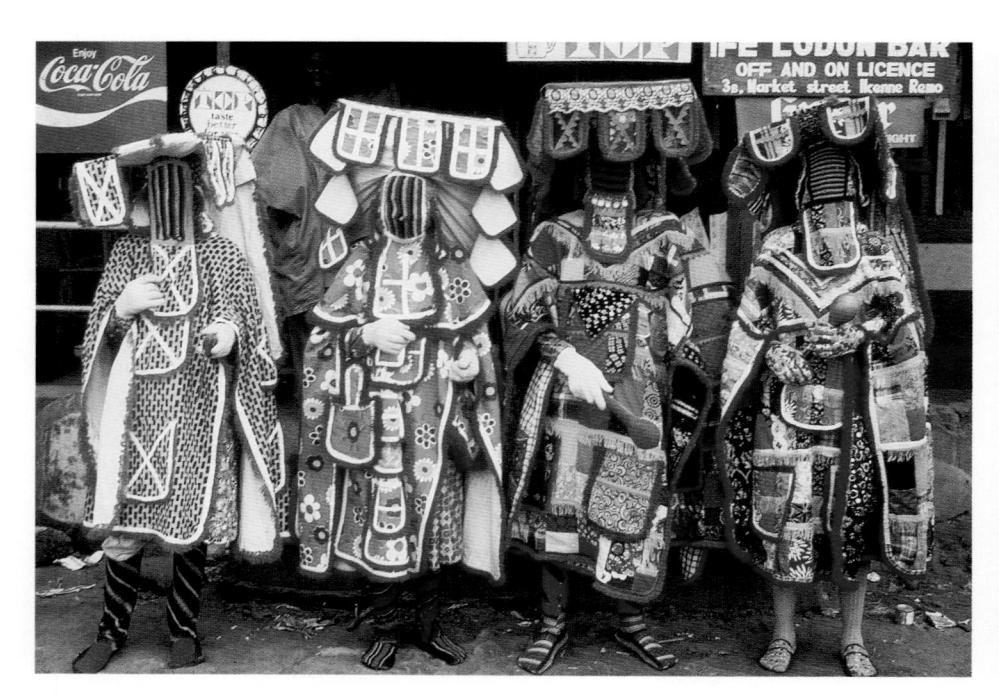

8-38. Four textile egungun masquerades, near Remo, Yoruba, Nigeria

Masks and Masquerades

Perhaps the most thoroughly dynamic art forms of the Yoruba are masquerades. As elsewhere in Africa, Yoruba masks are not created or perceived as static sculptural entities but as components of a larger, multimedia art of performance that includes costume, dance, music, poetry, and interaction with a participating crowd of onlookers. A variety of masks and masquerades aid Yoruba communities in communicating with the spirit world while they entertain the living.

The most widespread is egungun, found throughout Yorubaland. Myths and legends preserved in divination poetry support the belief that egungun first appeared among the Oyo Yoruba. This dramatic Yoruba masquerade may have developed in response to ancestral celebrations of the Nupe peoples, who live to the northeast of the Oyo region. Nupe

ancestors are honored with spectacular masquerades consisting of moving cylinders made of white cloth, columns that rise mysteriously to tower high above the participants (see chapter 3). Whatever its history, egungun is particularly important in Oyo. There, egungun celebrations take place over a period of several weeks, manifested in performances within lineage compounds and in public performances.

Many Yoruba associate *egungun* with the veneration of ancestors, believed capable of helping the living community if they are properly honored. Some *egungun* masquerades impersonate the spirit of the recently departed, returning to ensure that all is in order prior to making the final journey to the spirit world. In other situations the *egungun* merely appears to entertain when ancestors are venerated. *Egungun*, like the ancestors they are associated with, are
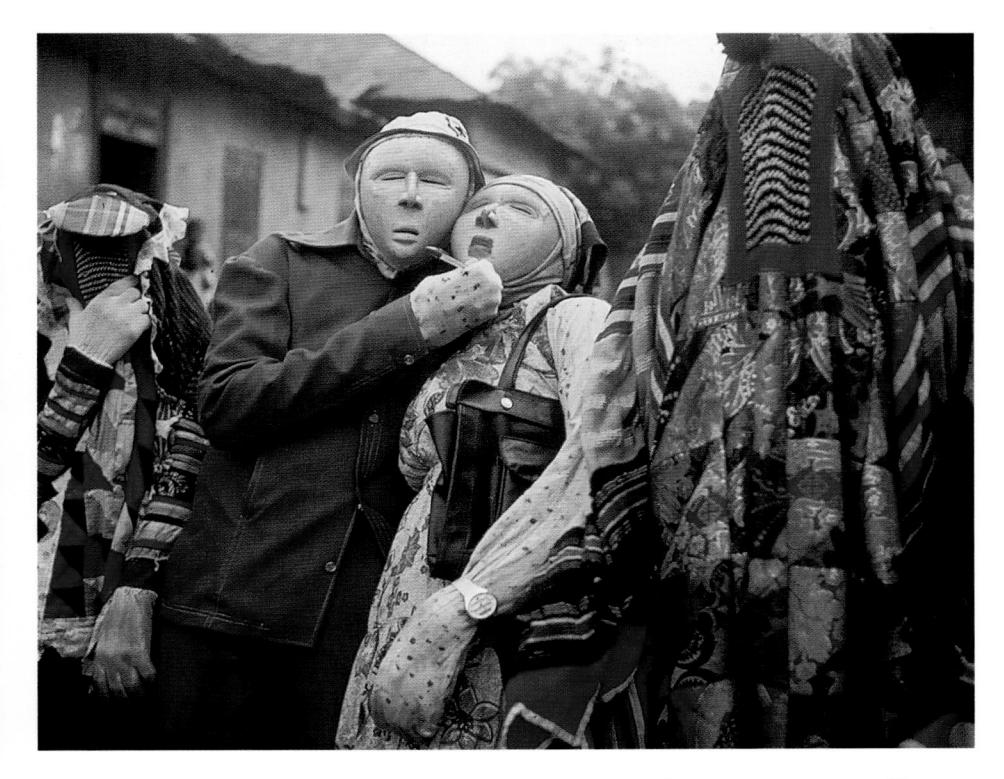

8-39. EGUNGUN MASQUERADES, TWO OF WHOM ARE PORTRAYING EUROPEANS, CARVED BY KILANI OLANIYAN OF OTTA, YORUBA, NIGERIA

The behaviors of egungun are as different as their forms. Some cavort passionately with the vigor of youth, while others move with the reserved stateliness of elders. Some move sympathetically with the throng of onlookers, while others threaten their watchers with canes, beating all who come too close. Attendants may hold them back and attempt to control their actions. Many egungun serenade the crowd with a litany of their powers and their actions, some chant poetry, and others speak in throaty spirit languages. Some alter their shapes magically in the midst of the crowd, turning their outfits inside out to become some other creature. Some, like those of Europeans, make social commentary, entertain, and provide comic relief.

identified with specific families. They play a regulating role in the family and serve as a link between the living and the dead.

There is an air of the sacred attached to the *egungun* and to the rites and celebrations of which they are a part. They are prepared for action within a sacred grove. Prayers are said, *ifa* is cast, and charms are attached to the body of the masker and placed within his costume. Donning the costume, the masker is depersonalized, ritually transformed

into a human repository for the spirit of the returning ancestor. When he enters a state of possession, he speaks with the voice of the deceased.

Varying throughout the Yoruba region, egungun may be discussed according to type or style, according to seniority or status within the organization that enacts the event, or according to the deportment of the dancer wearing the costume. Styles and types of egungun may be transferred from one area to another, allowing for the blending of styles.

Several styles may be seen side by side, even within a single community.

The egungun in figure 8-38 are from the southern Yoruba, in the Remo area. Like all egungun from that region, they are fashioned of cloth. Costumes of brilliant patchwork panels trimmed in red move and flare, rise and fall, as the dancers whirl. A boxlike construction covered with matching fabric surmounts the head. Such egungun are intended to be beautiful to the eve. In some areas wooden facemasks or headdresses top the masquerades, while tray-like forms embedded with charms and animal skulls complete others. Two types of egungun appear in figure 8-39. To the right is a fabric egungun of traditional type, its costume made of pieces of textile sewn in a dizzying assortment of colors. A crocheted rectangle of black and white bands over the masker's face allows him to see. The two carved wooden masks to its left parody a European couple. Dressed in contemporary clothing, they carry accouterments associated with these strangers—a large purse and watch for the woman, a ballpoint pen and a pad of paper for the man. These satirical egungun do not wield power but add a note of levity to the festival. Their performance here began with the man kissing the woman on the cheek and pretending to write over her heart with the pen. Occasionally he feigned taking notes on the pad, for Europeans seem to write everything down. The couple waltzed slowly to frenetic drumming and then performed a getdown disco number, after which they mimed copulation. Masks that followed represented a properly behaving Yoruba couple. The moral is that although Europeans are associated

with literacy, they are too demonstrative in public and are promiscuous. Yoruba, by no means stodgy, at least know how to act appropriately.

Whereas egungun is manifested all over Yoruba country in one form or another, there are other masquerade types that are restricted to specific regions. The masquerades of the Gelede society are limited to the southwestern region. Gelede's origins are often attributed to the kingdom of Ketu, situated in the present Republic of Benin, and to another kingdom, Ilobi. Some suggest that Gelede evolved from celebrations performed in honor of the patron orisha of small children, and that the masquerade was modified in response to disputes over royal succession in these two ancient kingdoms. Today the festivals focus on the placation of the great goddess, Iyanla, and on the general well being of the community.

Made up of both men and women and led by an elderly woman, the society organizes a lavish masquerade as an offering to Our Mothers. The aesthetic power of sculpture, dance, and song is intended to persuade Our Mothers to use their special powers for the good of the entire community, instead of wielding them destructively.

In some places, a number of Gelede masquerades appear on opening night. In some instances herald masks or a mask representing Eshu may appear. Immediately after a number of sacred masks emerge that perhaps represent the very essence of Gelede. One mask of this sort is that of a bearded woman, *Iyanla* or Great Mother. The other is *Eye Oro* or Spirit Bird. Mother masks and bird masks refer to and dramatize the spiritual side of womanhood. The Great

Mother features a long, flat extension below the chin that is referred to as a beard. To provide a woman with a beard suggests her elder status and all the connotations of wisdom and knowledge associated with the role.

The Spirit Bird combines the image of the bird with that of a woman. The bold simple forms of the carved head are emphasized even more by the fact that it is worn with a strikingly simple costume of white, allowing the imagery of the mask to dominate. The large, pointed beak dominates, its reddened tip referring to the possibility that unappeased or vengeful female elders may be transformed into birds of prey so that they can eat victims. A coiffure humanizes the creature, sug-

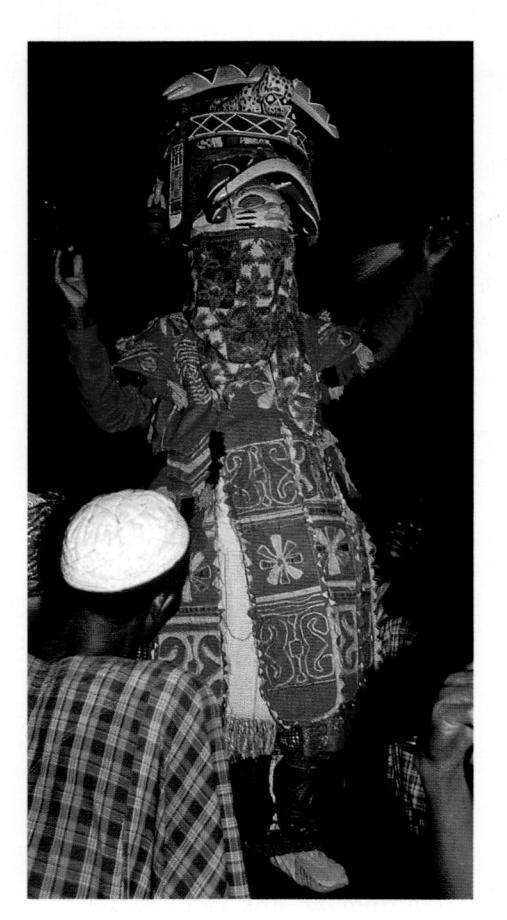

8-40. Oro efe masquerade, Yoruba, Nigeria

gesting one of the praise names of Our Mothers that refers to powers of transformation—"the one with two bodies."

In evening performances is a singing masquerade named oro efe who emerges for a nightlong presentation of songs, proverbs, praise poems, riddles, and jokes (fig. 8-40). The performer's face here is concealed by a veil that allows him to see. Atop his head sits a complex mask painted a cool white, with eyes, lips, and scarification patterns in contrasting colors. A multicolored, towering superstructure consists of a perplexing juxtaposition of curving, spiraling forms that allude to pythons and other animals, the crescent moon, a turban, a cutlass, and interlace motifs. Themes of aggressive action persist. Hoops beneath the costume and layers of cloth panels expand the size of oro efe and magnify his physical appearance. Ornate embroidered and appliqué panels display an abundance of colorful motifs, and mirrors are set into the fabric to reflect light in the night performances.

Oro efe, perceived as a male leader of the society and a servant of the Mothers, imparts an image of physical and supernatural power, position, and spiritual authority. His songs include humor and sarcasm, but they are filled with vital power, ashe. They act as an invocation, calling on the powers of Our Mothers. They teach precepts advocated by ancestors, gods, and the Mothers through ridiculing and condemning the actions of those who violate their objectives.

The following afternoon, numerous masquerades appear in sequence. The youngest performers dance first, dressed in partial costumes and striv-

8-41. Gelede society daytime masquerades resting before performance, Yoruba, Idahin town, Ketu region, Nigeria, 1971

The widespread conviction that women, especially older women, control extraordinary powers, perhaps even greater than those of the gods and ancestors, is acknowledged in Yoruba songs that refer to them as "the gods of society," and "the owners of the world." Women hold the secret of life itself. They possess the knowledge and distinctive capacity to bring human life into being, and conversely they have the potential to remove life. With these powers, Our Mothers can be either beneficial or harmful. They can give vitality, prosperity, and productivity to the earth and its inhabitants, or they can bring cataclysm, disease, scarcity, and plague.

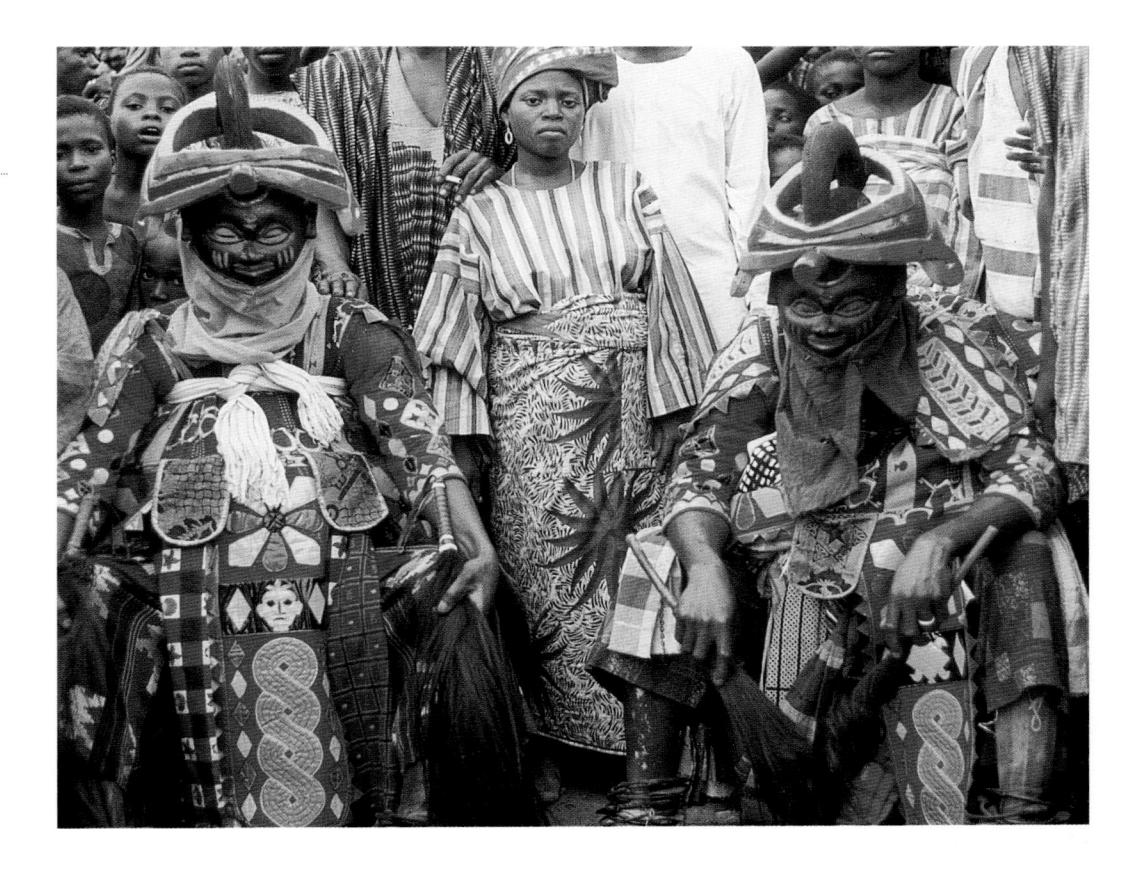

ing to equal their elders. Older children take their turn, followed by teenagers. Finally master dancers, all men, appear as identically dressed pairs in an extensive cast that includes male and female characters as well as animal masks. In the example shown here, the beautifully carved masks are painted black with vivid blue accents (fig. 8-41). Elaborately carved and painted headdresses represent fancy headties worn by women and give an appearance of stately height. The faces of the wearers are covered but not necessarily concealed by colorful scarves, providing the illusion of long and graceful necks. Costumes constructed of multicolored appliqué cloths vie with the costumes of other maskers for magnificence. Shown at rest here, the

performers dance to an orchestra of drums, brandishing horsetail whisks. Sounds made by iron ankle rattles repeat the complex rhythms as they compete for the crowd's admiration. At last a single masquerade representing a deified female ancestor appears to reassure the crowd of her blessings. The spectacle is over. The extended two-day display has entertained the crowd, but more meaningfully it has pleased Our Mothers, who will now exercise their powers to bring success and goodness to the community.

In the northeastern regions of Yorubaland, among the Igbomina and Ekiti Yoruba, maskers celebrate social roles in celebrations referred to as *epa* (fig. 8-42). Costumes of palm fronds cascade from the bottoms of brightly

painted masks, and snail-shell rattles encase the dancers' lower legs. The lower part of an epa mask is a large, pot-shaped form with a minimally represented, abstracted human face. Considered to be the actual mask, it is associated with mystical powers. On top of the mask sits an exuberant superstructure, which represents the social role honored by the mask. Superstructures draw praise from the crowds and depict a range of subjects—a leopard pouncing on its prey, a warrior mounted on horseback and surrounded by a retinue of soldiers and praise singers, a herbalist priest, a hunter, a farmer, the king enveloped by his entourage, or the mother surrounded by her many offspring. With the orderly appearance of epa masks in performance, the various social

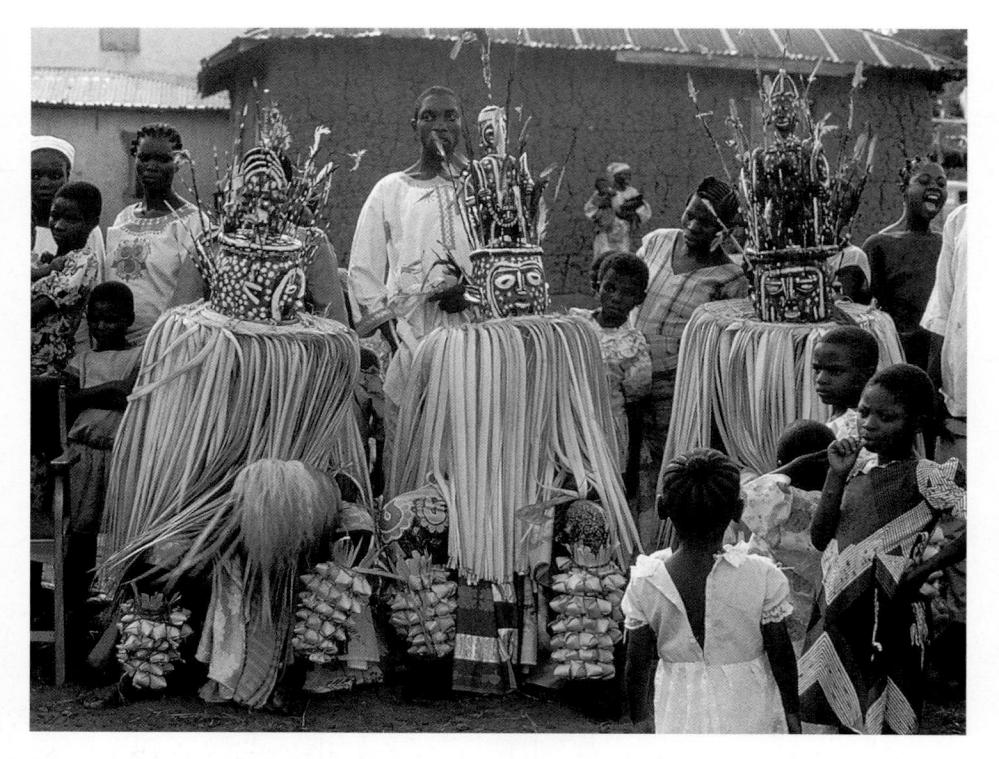

8-42. Three *EPA* masquerades, Yoruba, Nigeria

roles of farmer, hunter, soldier, priest, king, and mother are established, gender roles are acknowledged, and cultural achievement is celebrated.

The superstructure over the epa mask in figure 8-43 is a sculptural tour de force. The work of Bamgbose (died c. 1920), one of the great carvers at the turn of the twentieth century, it celebrates the "mother of twins," iya'beji. Bamgbose portrays the mother as a dignified woman holding a twin on each knee. Each twin touches the mother's breast with one hand and holds a tray for receiving gifts with the other, reminding us of the begging iya'beji must perform. At the base, four female figures offer gifts to the orisha who have given blessings to the mother. Such grand accumulations of images around a large central figure can be seen as

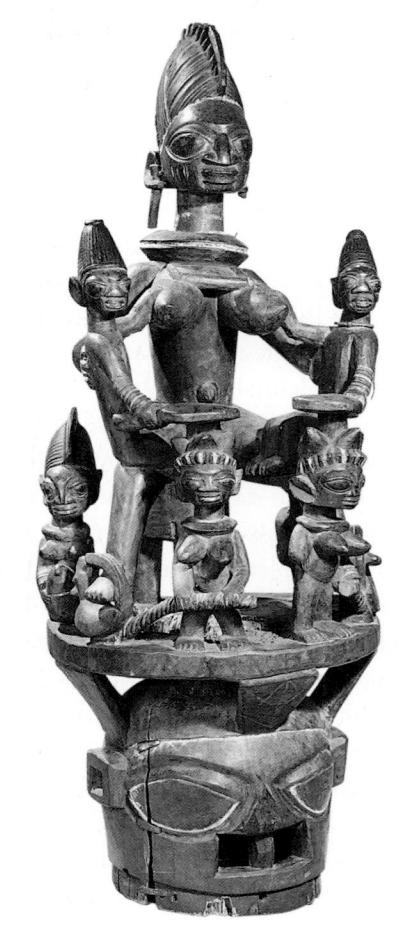

visual praise poems in honor of the character, a celebration of the role played by that personage in the cultural organization.

DAHOMEY

The neighbors of the Yoruba to the west are the Fon and other Aja peoples. Oral traditions suggest that the Agasu, a ruling clan of the Aja, migrated from the city of Tado, in modern Togo, to establish the city of Allada, near the coast of the present day Benin Republic. Allada became the capital of Great Ardra, reaching its peak in the sixteenth and early seventeenth centuries. About 1625, a succession dispute over who should rule Ardra sent one brother to found the inland city of Abomey. The Agasu of Abomey merged with local groups to become the Fon people, and they developed the powerful centralized kingdom of Dahomey. By the late seventeenth century Dahomey was a major military power, raiding neighbors for slaves to sell through coastal middlemen to European slavers. King Agaja (ruled 1708–32) subjugated most of the southern coasts, and during his reign some twenty thousand slaves per year passed through this section of the Slave Coast.

The kings of Dahomey were almost constantly at war with the Yoruba kingdoms to their east, and were forced to pay tribute to the powerful state of Oyo from 1738 to 1818. Under the kings Guezo (ruled

8-43. *EPA* MASK, AREOGUN OR BAMGBOSE, NIGERIA, 1930S. WOOD, PIGMENT. HEIGHT 49½" (126 CM). TOLEDO MUSEUM OF ART. GIFT OF EDWARD DRUMMOND LIBBEY

1818–58) and Glele (ruled 1858–89), Dahomey regained its power and established a prosperous trade in palm oil. However, the French conquered the kingdom at the end of the nineteenth century during the reign of Behanzin.

Royal Arts

Like the Yoruba, the Fon used art to praise and reinforce royal authority and to address superhuman forces. A divination process known as *fa*, Fon equivalent of the Yoruba *ifa*, largely determined art forms and subject matter. The ongoing use of divination and the reciprocal relationship of Fa, the god of divination (Fon equivalent of Orunmila), and Legba, the god of change (Fon equivalent of Eshu, shortened from his full name, Eshu-Elegbara), worked together to make change itself an important aspect of Fon life and art.

Upon taking the crown, a Fon king was given a unique sign that had been divined for him. The sign was known as his fa name or strong name. Verbal images drawn from the great body of oral literature surrounding that name were translated into art forms that enhanced the glory of the court and the magnificence of the palace. Artists in the royal city of Abomey were organized into palace guilds according to the medium in which they worked. Members of the textile workers' guild designed pavilions, canopies, umbrellas, and banners embellished with symbolic appliqué designs. Metal workers constructed images of deities and symbols of state in iron and brass, and produced small ornamental figures and tableaus for the aesthetic pleasure of the elite. Wood carvers

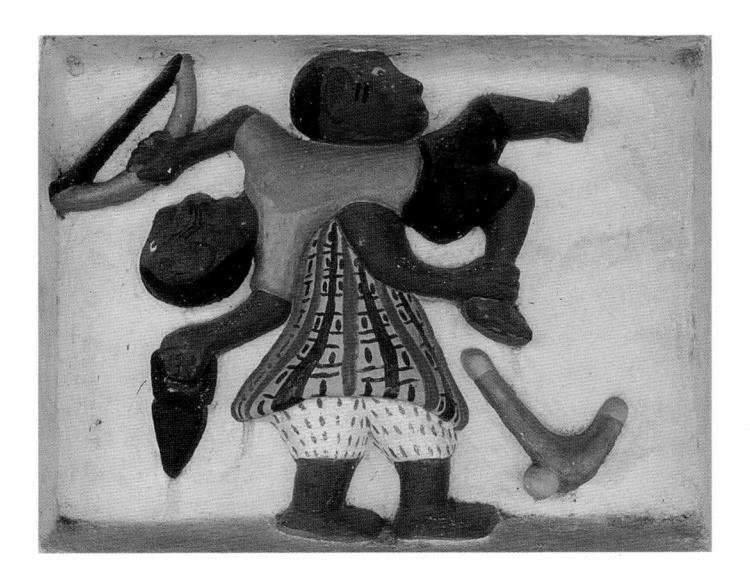

8-44. PAINTED CLAY RELIEF PANEL FROM THE PALACE AT ABOMEY, REPUBLIC OF BENIN. FON. CLAY, PIGMENT

created metaphorical portraits of the king and symbolic sculpture based on their *fa* names.

Each king had a separate palace in a sprawling complex that once covered some 190 acres, but all were neglected when the kingdom fell to the French. Only those of Guezo and Glele survived and have been restored and maintained as part of the Historic Museum of Abomey.

The exterior walls of the palace were ornamented with painted clay reliefs that heralded the exploits of the king and referred to the pantheon of gods (fig. 8-44). The example here illustrates an aspect of wars with neighboring Yoruba peoples during the reign of Guezo. Throughout Guezo's portion of the palace images of female warriors, referred to by the French as Amazons, appear again and again. Here an Amazon carries a Yoruba captive, still armed with his bow, on her shoulder.

Within the palace complex, tents and banners called attention to the members of the court and provided splendid backgrounds for festive occasions. In 1849, a European visitor to

the court described a pavilion of crimson fabric soaring to a height of forty feet, emblazoned with appliqué images of human heads, bulls' heads, skulls, and other motifs. From beneath it the king and dignitaries watched the proceedings as some six thousand carriers processed through the market and back to the palace, each carrying some portion of the king's wealth to be displayed before the public. Numerous colorful umbrellas marked the places of chiefs and their entourages. A faint echo of this spectacular display may be seen in the appliquéd hangings surrounding Agoli Agbo, the king of Dahomey who succeeded Behanzin but was deposed by the French (fig. 8-45). This photograph from the 1950s shows him wearing a silver sieve over his nose, which filters the air he breathes and gives him a feline look appropriate for a descendant of the leopard spirit. A royal axe or makpo, an item of regalia that the French called a reçade, balances on his shoulder. Both the makpo and the colorful cloths are emblazoned with the fa names of past kings.

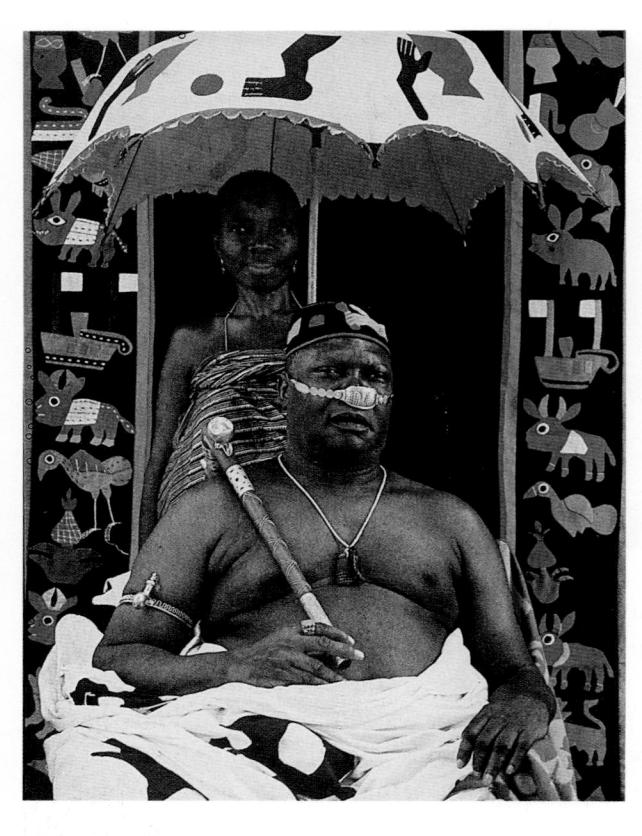

8-45. Agoli Agbo, ex-King of Dahomey. Fon, Republic of Benin, 1950s

Agoli Agbo's umbrella displays his royal sign, a foot stumbling on a stone.
Banners framing the former king provide a royal lineage with icons referring to specific kings: among them Guezo's buffalo and Glele's lion.

8-46. Bocio for a commoner. Fon, Republic of Benin, 19th–20th century. Wood, Bones, shells, fiber. Height 15" (38 cm). Brooklyn Museum, New York

Sculptural forms, bo, were considered empowered objects in Dahomey. They were believed to work in conjunction with the energies of the gods, vodun, to protect against evil, sorcery, illness, and theft, providing power and success. Bo took various shapes. Those carved to represent a figural form are generically known as bocio.

The *bocio* used by commoners and those used by royalty serve similar purposes, yet their aesthetic is markedly different. In Fon culture, things considered attractive are ornamental, delicate, refined, decorative, dressed, and tidy. Royal *bocio* reflect these ideas. The *bocio* of commoners contrast markedly with such ideals (fig. 8-46). Disorderly, rough, and incomplete, they seem to be concerned with an anti-aesthetic. Empowering materials, generally

secreted inside royal *bocio*, are here often attached outside, in full view. Materials, including metal, beads, bones, hide, rags, fur, feathers, and blood, are selected for their physical and symbolic potency. Likewise, techniques of knotting, binding, and tying used in their manufacture provide both actual and metaphysical strength. Materials and techniques are deliberately revealed to make the object visually powerful, shocking, and astonishing. The grotesqueness and ugliness of such *bocio* are part of their strength.

Royal *bocio* served to protect the king and to bolster his authority. A range of human and animal forms appears in royal *bocio*. Some animals are representations of the kings themselves, for Dahomean kings were said to be able to transform themselves into a variety of powerful ani-

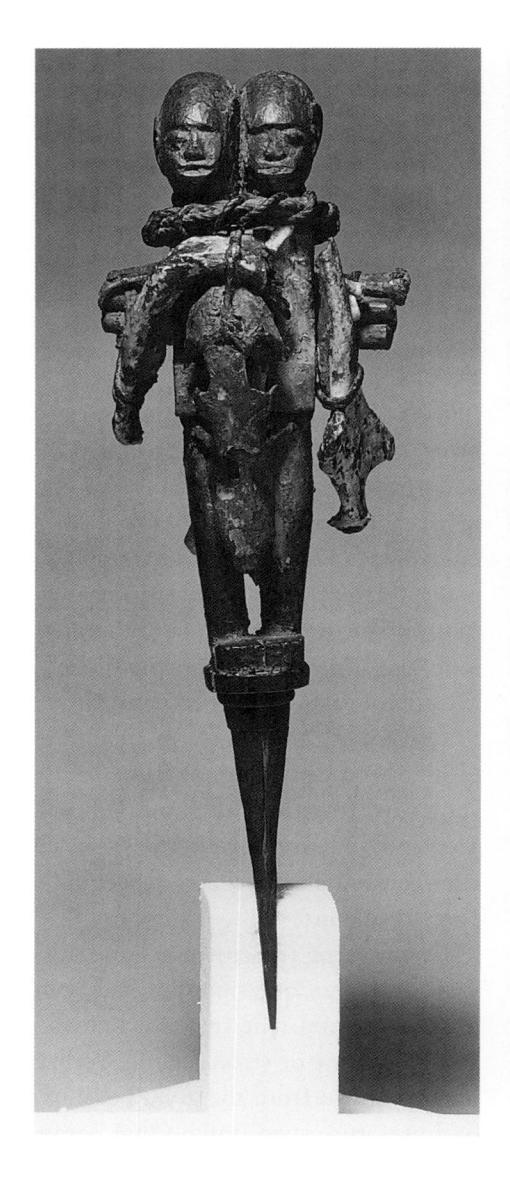

mals to spy on their enemies or flee problematic situations in battle. One of the best-known *bocio* is a large anthropomorphic lion carved during the late nineteenth century by the artist Sosa Adede (fig. 8-47). Apparently this lion-man, which once carried a sword in each hand, was dragged on a cart into battle to create an image of royal fury and strength. As tall as a man, brandishing weapons in a dynamic pose, the sculpture embodies Glele's power, strength, and courage. Lions appear frequently in

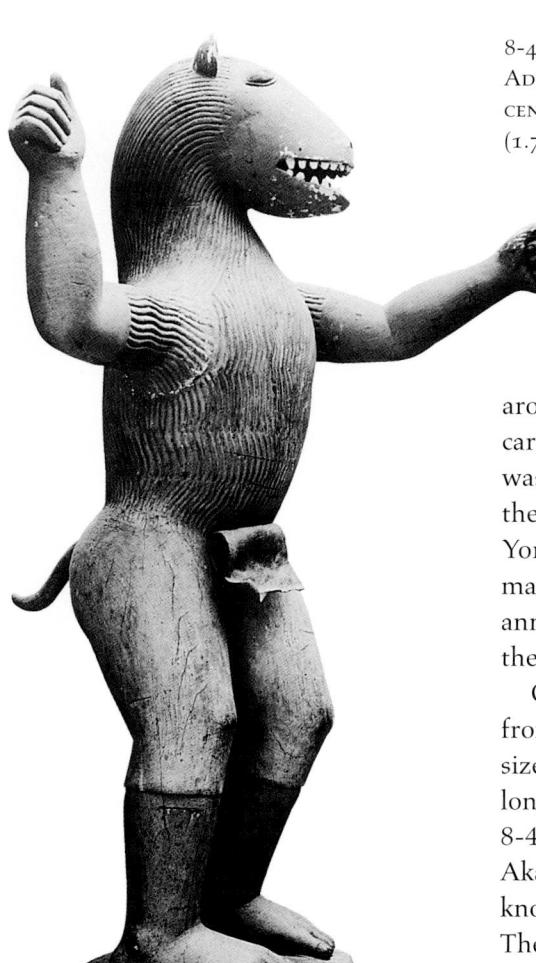

8-47. BOCIO IN HONOR OF KING GLELE, SOSA ADEDE, FON, REPUBLIC OF BENIN, LATE 19TH CENTURY. WOOD, BRASS, SILVER. HEIGHT 5'7" (1.7 m). MUSÉE DU QUAI BRANLY, PARIS

around and to speak. When not being carried into battle, this sculpture was kept in a temple dedicated to Gu, the god of war (cognate with the Yoruba god Ogun), and displayed in magnificent processions during annual ceremonies commemorating the royal dead.

One of the most striking works from Abomey is a magnificent lifesize iron warrior striding forward on long, sinewy legs and huge feet (fig. 8-48). Forged for Glele by the artist Akati Akpele Kendo, this bocio is known as Agoje ("watch out above"). The sculpture served to protect the king and his kingdom in time of war and unrest, and its massive headdress of iron weapons and tools refers to Gu. Like the lion-man figure, Agoje holds aloft a heroic sword, further recalling Gu and yet another phrase associated with Glele's fa signs, the "audacious knife that gave birth to Gu." In response to this phrase, Glele received as another of his strong names Basagla, the name of a special type of sword that he chose as a visual symbol of his reign. Images of such swords are found in many reliefs, banners, and sculptural forms of Glele's court. To emphasize the connection between this bocio and the strong name it referred to, Glele commissioned the same Akati Akpele Kendo to forge a group of gigantic

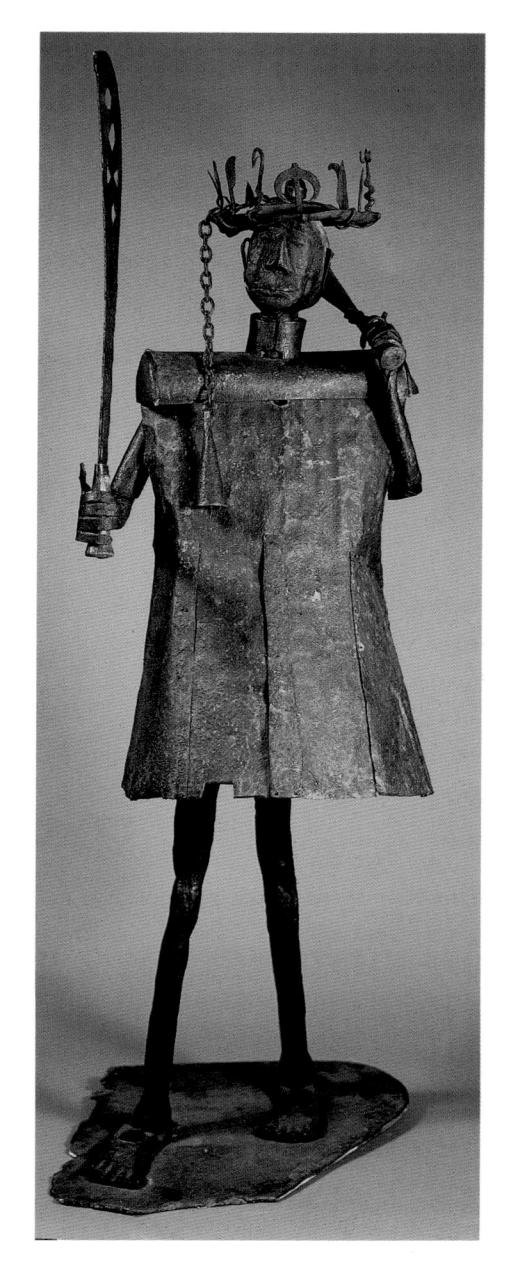

8-48. Bocio known as Agoje, Akati Akpele Kendo, Fon, Republic of Benin, 1858–89. Iron. Height 5'5'' (1.65 m). Musée du Quai Branly, Paris

At the time it was taken by the French, the bocio had been transported by Glele's troops to Wydah, a coastal city, probably in anticipation of a run-in with the French

art used in Glele's court, on reliefs on the walls of the palace, in royal scepters, in wooden carvings sheathed in sheet brass or silver, in copper staffs used in memorial shrines, and in appliqué banners, pavilions, and umbrellas. They draw on such phrases as "No animal displays its anger like a lion" and "Lion of lions," which are embedded in the poetry composed for Glele's fa sign.

Spiritually charged materials secreted within such royal *bocio* were believed to empower it, rousing the figure and giving it the ability to walk

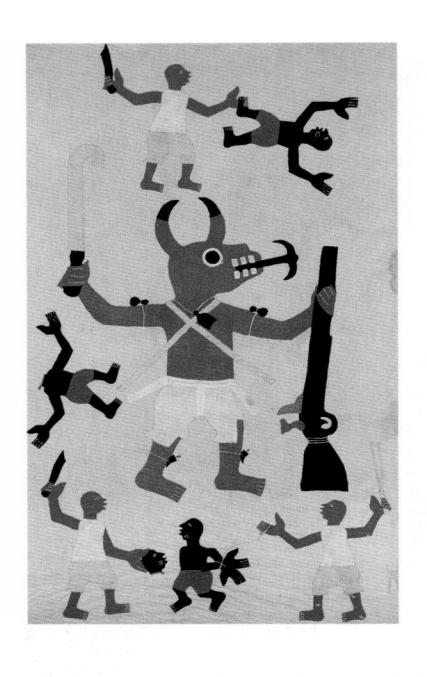

8-49. APPLIQUÉ
BANNER, YEMADJE
FAMILY WORKSHOP,
20TH CENTURY.
HEIGHT 5'10" (178
CM). COLLECTION
CURTIS GALLERIES,
MINNEAPOLIS

8-50. LION BOCIO IN HONOR OF KING GLELE, ALLODE HUNTONDJI, FON, REPUBLIC OF BENIN, 1858–89. SILVER ON WOOD. HEIGHT 11½" (30 CM). MUSÉE DAPPER, PARIS

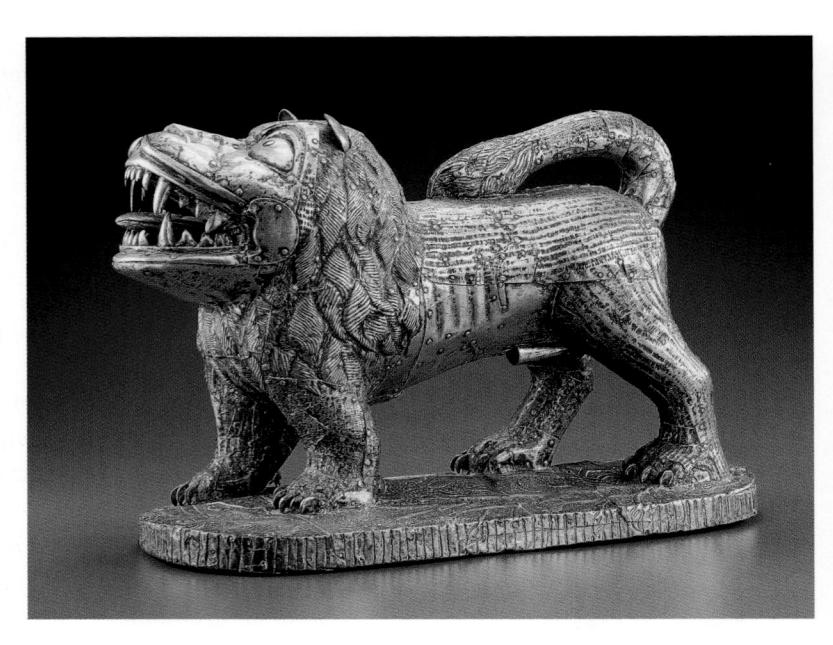

swords to encircle this figure while it was displayed in the palace. The swords vividly evoked the role of vengeance in Glele's reign.

Another bocio commissioned by Glele is known from drawings by European visitors and its depiction on textile banners that were used in the court at Abomey (fig. 8-49). Known as Daguesu, the bocio depicted a being with the head of a ram or buffalo (both are called agbo in Fon) and a human body. Dagueso invoked the Fon thunder god Hevioso, who, like his counterpart the Yoruba god Shango, is associated closely with the ram. The bocio accompanied Glele's troops into battle, calling on Hevioso's power to speak through the thunderous blaze and blast of guns.

Many royal *bocio* were carved of wood and covered with thin sheets of beaten brass or silver (fig. 8-50). These were not taken to the battle-field but were displayed during annual rites for the New Year and at other state events. This silver-sheathed *bocio* depicts a striding lion that

opens his great mouth in a roar to reveal sharp teeth, thus recalling a variation on Glele's strong name, "the lion of lions grew teeth and fear arrived in the forest." It was created for Glele by the artist Allode Huntondji during the last few years of the nineteenth century.

Art and the Spirit World

The Fon believe that the living and the dead remain closely linked. Spirits of the departed must be revered by their descendants in order to continue their lives serenely in the other world. In return, they protect the living and grant them access to a realm of higher powers. An art form expressing this connection is the memorial altar, asen. Asen take the form of an iron staff topped with an inverted cone that supports a lid-like disk, which serves as a platform for brass figures. An asen made to honor the memory of Glele is crowned with an openwork cone of spoke-like supports (fig. 8-51). Pendant elements

hang from the disk, which serves as a platform for a complex and enigmatic figural grouping: a dog shaded by an umbrella stands on the back of a horse, at whose shoulder a small bat flies. The umbrella is a metaphorical reference to kingship. The dog alludes to Glele's sponsoring ancestor, whose patronage was arrived at through divination. The first syllable of one of the names of this ancestor is the same as the word "dog." The word for "horse" alludes to the name of the quarter in which the ancestor lived. When the words for "dog" and "horse" are combined, they form the word for "bat," whose image thus becomes a double reference to the ancestral sponsor and the quarter of Abomey in which he lived. Until 1900 almost all artists were in the employ of the royal court, and figurative asen are said to have been used exclusively in Abomey shrines honoring deceased members of the royal family. After the French abolished the court, however, wood carvers, metal workers, and textile

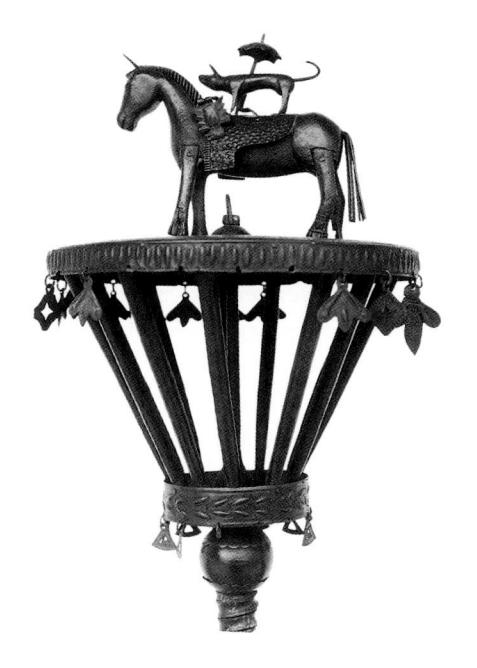

8-51. ASEN (MEMORIAL ALTAR) TO KING GLELE (DETAIL), TAHOZANGBE Huntondji, Fon, REPUBLIC OF BENIN, 1894-1900. Iron. Musée Historique, ABOMEY

artists sought new patrons in the general populace and among foreigners. The precise meanings of many hitherto royal art forms were diluted as they became items of trade. Asen, however, not only continued to have ritual meaning but proliferated in response to the patronage of commoners, who had previously used plain iron objects to commemorate ancestors.

The collection of asen shown here (fig. 8-52) belongs to a single family. Each asen commemorates a deceased family member, and in theory every deceased family member is represented by an altar. A family's asen are arranged in a one-room structure, called dehoho, opening onto the home's central courtyard. Within the sacred space communion between the living and the dead takes place.

Like the figures atop royal asen, figures on asen for commoners are enigmatic and can generally be read several ways. In fact, the Fon maintain that only the donor and the maker of the asen can fully interpret 8-52. Interior of A FON DEHOHO (FAMILY SHRINE) WITH ASEN (ALTARS) AND BOCIO FIGURES

the mixture of messages on it. Some figures depict the deceased, accompanied occasionally by surviving family members. Other images may depict the fa sign or fa name of the deceased. Some motifs evoke values of Fon culture through references to deities or allusions to proverbs and praise songs. Others, like the dog on the royal asen discussed earlier, are meant to be read as a rebus.

The religious traditions of the Fon have many parallels with those of the Yoruba. For example, several orisha of the Yoruba have equivalents in the Fon vodun. In the Americas, Yoruba and Fon survivors of the Middle Passage merged these deities into the sacred beings described in chapter 16. On the African continent, however, their identities and attributes remain

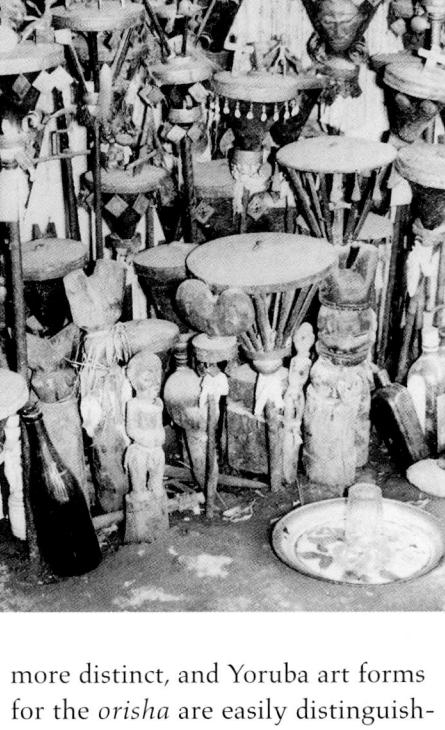

able from the art of the Fon, Aja, or the neighboring Ewe.

Among the Fon, divination and the gods associated with it have inspired a variety of art forms. A beautiful divination board collected as early as the mid-seventeenth century in the Aja kingdom of Great Ardra is among the oldest of African objects in European collections (fig. 8-53). Its flat, platelike surface is surrounded by a raised border (compare fig. 8-24). Although the design was undeniably based on Yoruba prototypes, the distinct carving style insinuates that an Ewe, Aja, or Fon artist carved it. The human figures reflect a sober rectilinear style closer to that of Ewe carving than to the humanistic forms of the Yoruba.

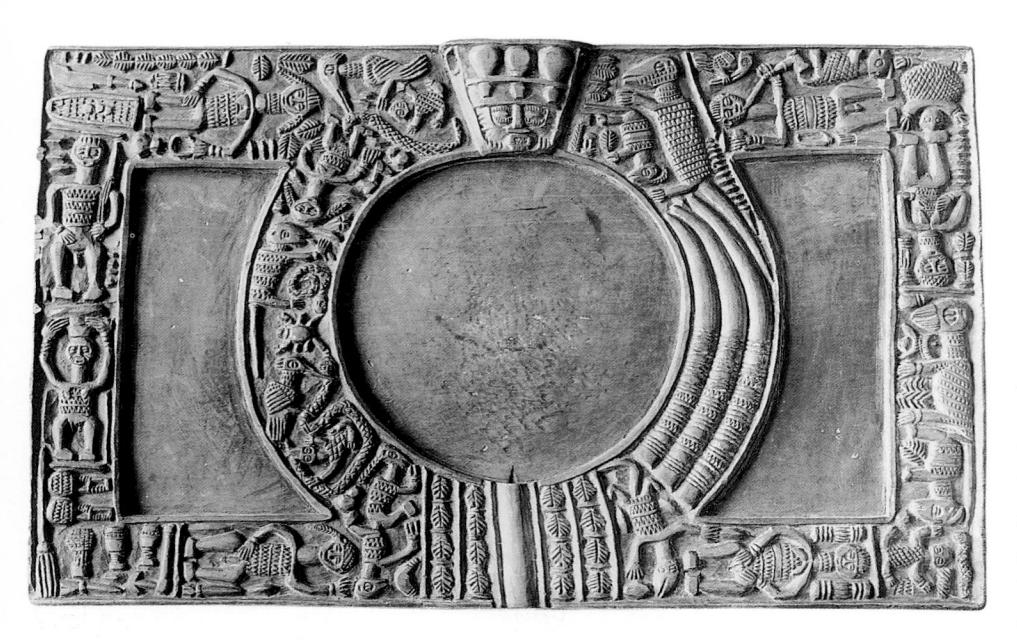

8-53. Divination tray, Aja or Fon, Republic of Benin (?), before 1659. Wood. $13\frac{1}{2}$ " x $21\frac{1}{2}$ " (34.7 x 55.5 cm). Ulmer Museum, Ulm. Weickmann Collection

The earliest documents about the Ulm tray state it was a royal gift from the King of Benin, but its style suggests that it was actually made in the Aja or Fon kingdoms instead.

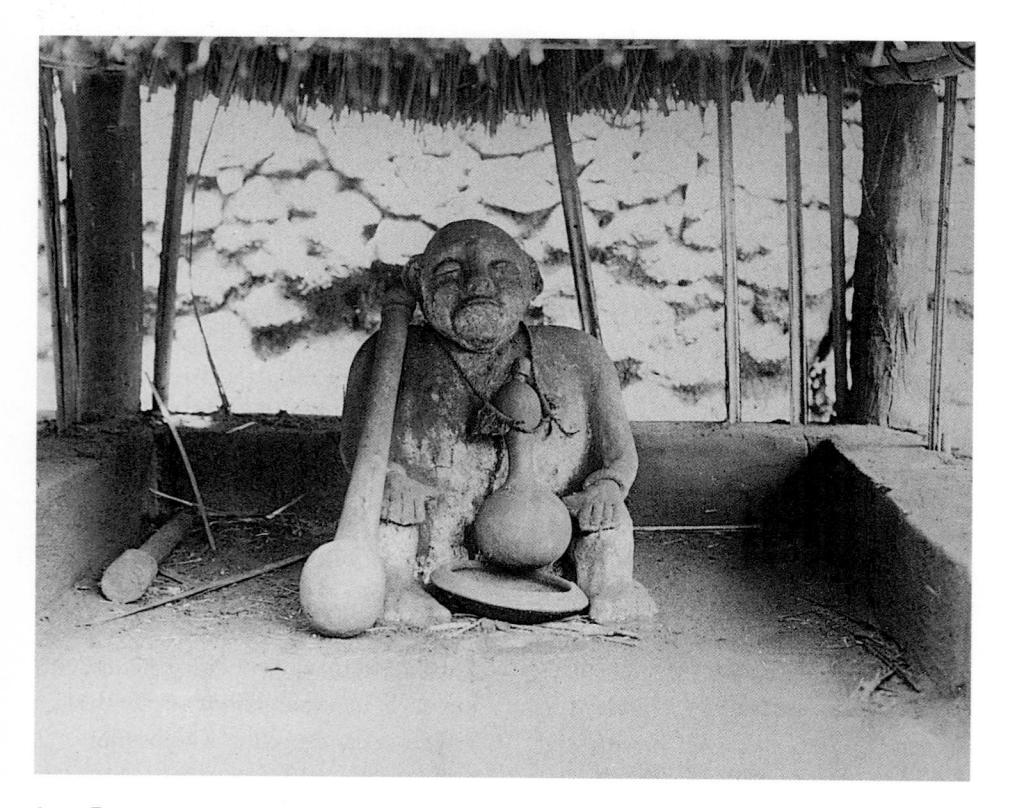

8-54. Palm-leaf shrine with earthen figure of Legba, Fon, Abomey, Republic of Benin, late 19th century

The unknown artist of the board has used both symmetrical and axial balance in the service of a system of ideas. The board is symmetrical in its major forms, a circle centered within a rectangle. The stylized face carved at the upper center depicts Legba, the trickster messenger god. Small medicine gourds top Legba's head in reference to his powers. Legba's face is symmetrical, as are the vertical chains of cowry shells at the lower center of the border. The remaining border motifs, however, do not mirror each other exactly across the vertical axis, but rather provide interesting variations on either side, seemingly rotating them around the central point. Broadly carved animals, birds, and various accoutrements are crowded together. This radial approach to symmetry brings opposing and dissimilar objects into equilibrium in a way that may parallel how the dissimilar gods Fa and Legba work together in the lives of the Fon. Zigzag patterns decorate details of most of the images on the board, helping to unify the disparate motifs.

Attention to detail and the beauty of the harmonious design suggest that a professional artist, likely employed by the court, carved this object. In contrast, an earthen figure of Legba was created with less care (fig. 8-54). Seated in a palm-leaf shrine, it seems to have been made more directly, almost crudely. In Fon thought, the strong object does not have to be beautiful or even attractive in order to work effectively. In fact, many forms used by the Fon show a type of roughness and inelegance that suggests the raw power associated with the work of the spirits they are made for.

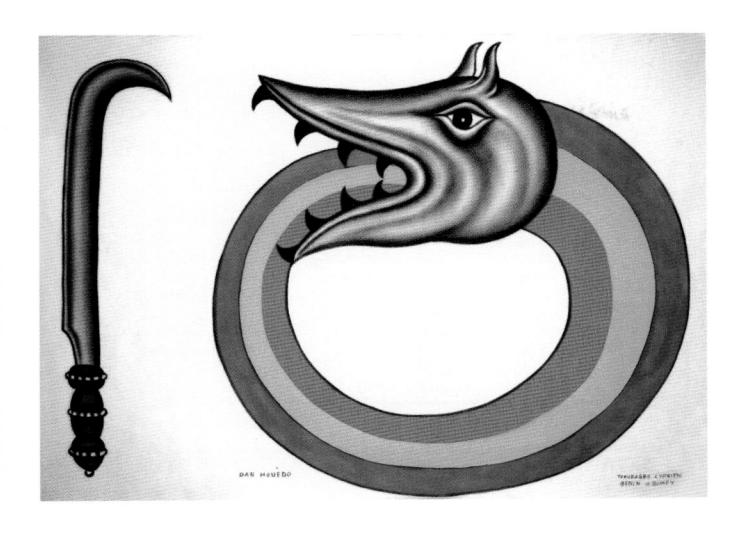

8-55. DAN-AÏDO
HOUEDO ("RAINBOW
SERPENT"), CYPRIEN
TOKOUDAGBA, REPUB-LIC OF BENIN, 2000.
ACRYLIC ON CANVAS.
COURTESY OCTOBER
GALLERY, LONDON

8-56. *Cakatu*, Théodore and Calixte Dakpogan, Sacred forest of Ouidah, 1994. Scrap iron

Paintings and decorations in vodun shrines by artists such as Cyprien Tokoudagba (born 1939) pay respects to these deities. Initiated into the worship of Tohosu, vodun of sacred springs, royal ancestors, deformed children, and twins, Tokoudagba has been commissioned to create reliefs, sculptures, and wall paintings for vodun temples. In 1987 he was employed to assist in restoring the royal palaces at Abomey. Impressed by Tokoudagba's work, French curator André Magnin included it in the Paris exhibition "Magiciens de la Terre" in 1989. This exposure to imported materials and foreign markets encouraged Tokoudagba to paint vodun imagery on canvas for European collectors. His work now appears in foreign galleries and museums as well as in Tohosu shrines.

One example of his acrylic paintings depicts the rainbow serpent, Dangbe Ayidohwedo (fig. 8-55), the *vodun* whose body encircles the earth to hold it up. An ellipse of primary colors represents the serpent's body. The menacing horned head with hooked teeth swallows its own tail. Whereas this image would be imme-

diately recognizable to passersby on the walls of a shrine in the Republic of Benin as a straightforward representation of a popular *vodun*, the same image seems exotic, mysterious, and even surreal in a European art gallery. Tokoudagba thus serves to remind us of how shifts in the context of African art can completely transform the ways in which it is perceived.

Cyprien Tokoudagba participated in a festival held in the coastal city of Ouidah in 1992, which featured many art works inspired by the vodun. Among the other artists displaying their work were Theodore Dakpogan (born 1956), Calixte Dakpogan (born 1958), and their cousin Simonet Biokou. The Dakpogan family are blacksmiths who have served the kings of Porto-Novo and who honor the vodun Gu. Palace workshops, often managed by clans, were an important source of royal Fon arts; the Yemadje family still produces appliquéd textiles and the Huntondji family still works in brass and silver.

Discarded automobiles, bicycles, and other industrial equipment provide an ever-present supply of scrap

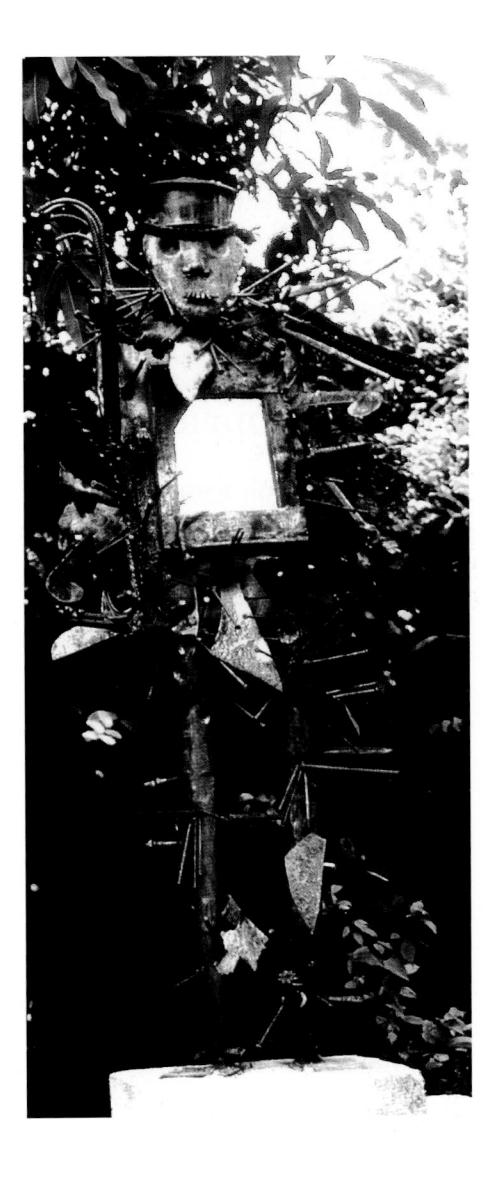

metal for the Dakpogan smiths for their production of household objects and their fantastic sculptures created for both local and foreign clients. *Cakatu*, created for the Ouidah festival and now displayed in a grove known as the Sacred Forest (fig. 8-56), depicts supernatural power that can be transmitted in a variety of ways and results in unbearable and devastating pain for its victim. The targets of such attacks supposedly feel as though their bodies are pierced by slivers of glass, nails, and metal frag-

ments. Although this figure thus seems to perpetuate stereotypical views of one of the more sensational aspects of *vodun* belief (a concept which any American would call "voodoo"), it follows in the tradition of the *bocio* made for Fon kings, and is a more complicated object than it may appear.

ART AND MODERNITY

The late nineteenth century is seen by some as a time when the political, cultural, and artistic underpinnings of Yoruba and Fon culture were crumbling in the face of European colonial presence and the drastic changes it brought about in Africa. It is true that numerous art forms declined in importance or ceased to be made at this time. In many ways, however, the period was also one of redirection and renewal, a time for exploring new possibilities. In Dahomey, as we have seen, artists who had been tied to the palace found new markets and modified their products for new patrons. Yoruba artists also found new patrons and markets. Wood carvers, for example, accepted commissions for works destined for Christian churches and governmental buildings. In addition, new materials and techniques introduced through contact with European culture enabled new art forms and styles.

Brazilian Architecture

Toward the end of the slave trade, great numbers of Yoruba were taken to the Caribbean and South America to work in the sugar industry. In Brazil and Cuba they became a dominant force in the local African

8-57. Central Mosque, Lagos, Nigeria, Joao Baptist Da Costa, Afro-Brazilian, 1908–13 (destroyed 1980)

cultures that developed. As slaves gained their independence, many Yoruba returned to West Africa. The technical knowledge brought back to the African coasts by these returnees increasingly spread to the other parts of the population. Their sense of finely finished work was admired, especially as it manifested itself in architecture. The architectural ideas they brought back with them changed the urban landscape in West Africa.

Other Africans taken to Brazil were Muslim; and after winning their freedom in the New World they settled in Yoruba and Fon lands. During the 1890s a Muslim repatriate, Muhammad Shitta Bey, commis-

sioned two mosques in Lagos. The work was entrusted to a Yoruba Brazilian Catholic architect, Joao Baptist Da Costa. Until its destruction in 1980, the Central Mosque, the second of Bey's commissions, stood as a splendid example of the new Brazilian style (fig. 8-57). Da Costa drew on the architectural vocabulary of Portuguese Baroque colonial churches and administrative buildings he had known in Brazil. The ornate and dynamic style, with arches, pilasters, curves, and volutes, reaches ultimately back to seventeenth-century Europe, and its appearance in Africa marks the second time it crossed the Atlantic. Many such buildings along the coast of West Africa have been

8-58. Exterior of the palace at Ado Ekiti,
Nigeria, Afro-Brazilian.
Photograph 1960

destroyed or are in need of repair. Even when there is a will to restore such structures, much past knowledge of techniques for woodwork, plastering, and decoration has been lost.

Commercial buildings and homes were also constructed in the new style. As the Brazilian style caught on along the west coast of Africa and moved inland, creative variations filtered into vernacular architecture. In the modern portion of the palace at Ado Ekiti, in northern Yoruba country, a grand staircase calls attention to an entrance (fig. 8-58). Most noticeable is the symmetrical gateway at the top of the stairs. Here a cement openwork form is decorated with two heraldic lions above a group of three figures. The walkway along the upper level is protected by a balustrade, some balusters replaced by ornamental cement latticework and a rising sun. Balusters support the staircase railing, while another cement openwork design takes their place on the small projecting balcony at the landing. Such features, originally inspired by Brazilian prototypes, gave way in some instances to figural forms and words. For example, the cost of construction might serve as a motif in a building's decorative openwork.

Pioneers of Nigerian Modernism

By the first half of the twentieth century, art based on Western art practices appeared in Nigeria. One of the pioneers, Aina Onabolu (1882–1963), taught himself to paint with oils on canvas in the first few years of the century. Entranced by the ability of British

artists such as Sir Joshua Reynolds to capture the outward appearance of people and objects, Onabolu sought to master European conventions in his portraits of influential Nigerians. Ironically, Onabolu's contemporaries in Europe, Modernists such as Picasso and Matisse, were abandoning those conventions in favor of new approaches informed by African art. Onabolu was largely responsible for bringing Kenneth Murray (died 1972) to Nigeria to create a fine arts curriculum at King's College in Lagos in 1927, and he encouraged younger artists to study Western art at home and abroad. He had an important impact upon the pioneering generation that included Akinola Lasekan (1916-72) and Ben Enwonwu (1918-94).

Lasekan, an accomplished draughtsman, addressed political issues in his newspaper cartoons as early as the 1940s. Enwonwu, an Igbo (see chapter 9), was representative of the creative energy found in the teeming metropolis of Lagos, then the capital city. Here great numbers of Nigerians gathered to participate in a modern cultural milieu that was not so much Yoruba as Nigerian or African. Having studied in Lagos with Murray, Enwonwu left for England in 1944 to study at the Slade School of Fine Art and Goldsmiths College, and he attended Oxford University. He was the first Nigerian artist to win international acclaim, and in 1957 Oueen Elizabeth II visited his studio to sit for a portrait commissioned by the colonial government. Although his controversial statue of the queen indicates that he was supported by colonizing authorities, Enwonwu was an ardent supporter of independence:

We were fighting for the freedom of the black man all over the world including the Black Americans and of the diaspora. We were aware of our responsibilities, not just to our individual countries but to Africa as a whole. . . . We were all so conscious of the struggle against colonialism, and of nothing else.

Perhaps our view of the bronze sculpture *Anyanwu* (1961) (fig. 8-59) should be seen in the light of those ideas. One cast is displayed at the United Nations in New York and another at the Nigerian National Museum in Lagos. The title is sometimes translated as "The Awakening"

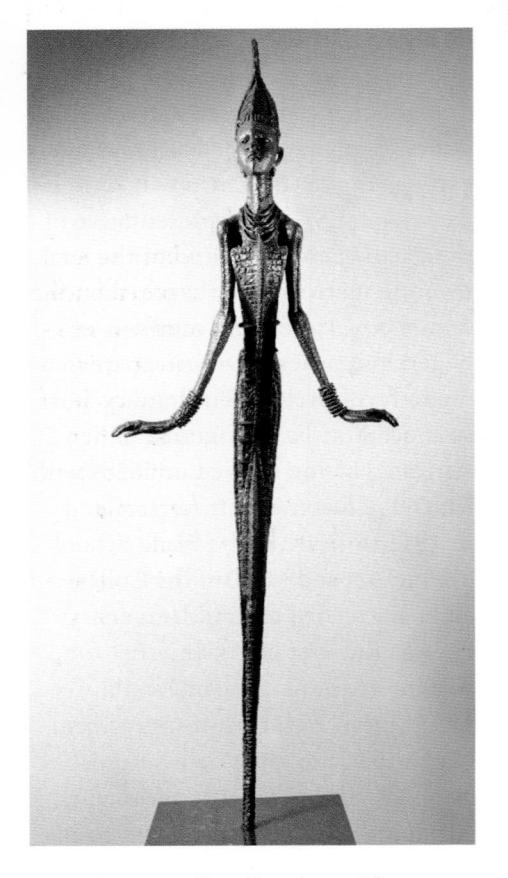

8-59. Anyanwu, Ben Enwonwu, Nigeria, 1961. Bronze, marble base. Height 6′10″ (208 cm). United Nations Building, New York

8-60. Olokun, Erhabor Emokpae, Nigeria, 1967. Cowries, manillas, coins. Height 144" (365.7 cm). Standard Bank of West Africa, Lagos

but also as "The Rising Sun." Produced soon after Nigeria attained independence, the allegorical female form may be seen as a symbol of African self-determination. Some critics saw a pleasing contrast between the sinuous and abstracted body and the more naturalistic face. The headdress recalls the beaded crown of the Queen Mother of Benin (see fig. 9-61), adding a regal and historical reference (see chapter 9).

Other students who worked with Murray became established artists as well, among them Christopher Ibeto, A. P. Umana, Uthman Ibrahim, D. L. K. Nnachi, and J. Ugoji. By 1952 an art school was established at Yaba Technical Institute in Lagos (now Yaba College of Technology). College art departments soon followed, and they in turn merged into the universities of the 1960s.

Erhabor Emokpae (1934–84) studied at Yaba College and in London. He too was not Yoruba, but Edo. Emokpae worked in Lagos as a muralist, painter, and sculptor. Although some of his paintings are dramatically stark, he is best known for the elaborate mural he created for the Standard Bank (fig. 8-60). In keeping with the setting, the work incorporates images of African money, ranging from the cowries and manilas introduced into Africa centuries before, to modern coinage. The title *Olokun* refers to the Edo and Yoruba god of water and wealth (see fig. 9-6).

Mbari Mbayo and Oshogbo

National independence was a time of excitement and idealism in Nigeria. Artists who had been taught in universities, and artists who worked in traditional workshops, hosted African-American and European visitors. Two of the best-known cultural explosions in Yorubaland were cen-

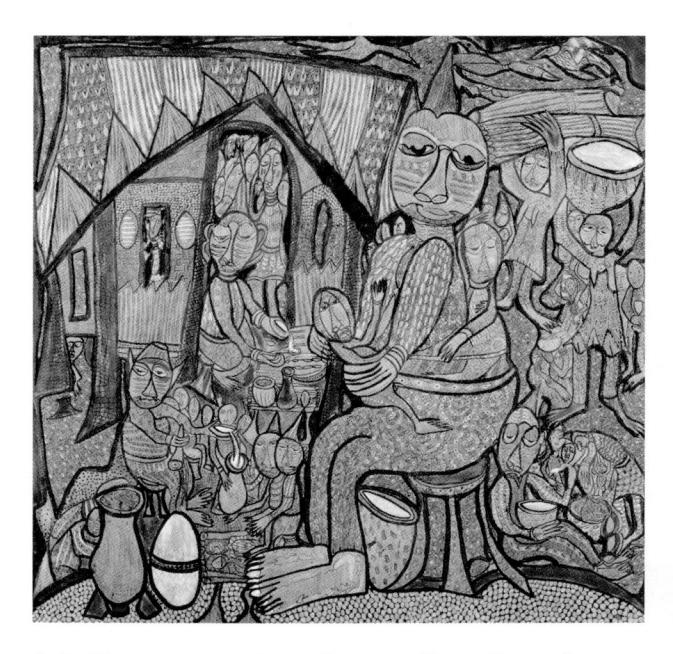

8-61. Healing of the Abiku Children, Twins Seven-Seven, 1973. Wood, paint, ink, varnish. 51% x 51%6'' (130.4 x 130.9 cm), Indianapolis Museums. Gift of Mr. and Mrs. Harrison Eiteljorge

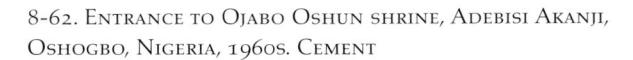

tered in the city of Oshogbo, where two groups of artists began working in the 1960s, both inspired and supported by expatriates from Europe.

A number of well-known Oshogbo artists developed from the Mbari Mbayo workshop, including Muraina, Ovelami, Adebisi Fabunmi, Twins Seven-Seven, Rufus Ogundele, Jacob Afolabi, and Jimoh Buraimo. Of this group, Prince Taiwo Olaniyi Oyewale-Toyeje Oyekale Osuntoki, better known as Prince Twins Seven-Seven, is the most colorful figure. His assumed name alludes to the fact that he was the last and only surviving child of seven sets of twins born to his mother. Sometimes referred to as a true renaissance man, Twins Seven-Seven is an entrepreneur, a politician, a sportsman, and a singer, dancer, and

bandleader whose troupe has performed around the world. Like many of the Oshogbo School, Twins Seven-Seven does not limit himself to one medium. Best known for his paintings based on traditional Yoruba themes, he also draws, creates sculpture, designs textiles, and works in metal.

Twins Seven-Seven creates canvases filled with fantastic images, some based on Yoruba myths and folktales or drawn from personal experiences and the imagination. His style is demonstrated in this early work in which the entire surface is covered with intricate abstract patterns that fill the background as well as the spaces within the outlines of the figures (fig. 8-61). The subject matter, *Healing of the Abiku Children*, refers to *abiku*, spirits who tease women by being born as children

but then die, only to be reborn several times more to the same mother. Such mothers may visit the *babalawo* seeking a means to bring to an end this seemingly endless and painful cycle of death and rebirth. Here, the mother, seated on a stool with her child tied to her back and another in her arms, awaits the word of the priest.

Adebisi Akanji (born 1930s) started as a bricklayer on a 1960s project to restore the shrine of Osun in Oshogbo, undertaken by Austrian artist (and Yoruba priestess) Suzanne Wenger. Although a Muslim, Akanji was inspired to add his own relief touches to the wall (fig. 8-62). Here expressive relief images of *orisha* and human beings enliven a quasi-architectural structure in concrete. Akanji was inspired during this

8-63. Adire Cloth, Yoruba, Nigeria, 20th Century. Cotton, Indigo. Width 5′9″ (1.75 m). The British Museum, London

8-64. Oshun Goddess, Nike Davies-Okundaye, Nigeria. Batik wall hanging. Nike Center for Art and Culture, Oshogbo

period to respond to a competition to design an openwork balcony in the Brazilian style. Successful in the competition, Akanji went on to become a master of sculptural screenwork for balustrades and balconies. He expanded the form to create entire openwork walls, and his works were installed in such prestigious locations as the palace at Otun, the University of Ibadan, and the Nigerian Embassy in Washington, D.C.

Yoruba women have long practiced a form of resist dyeing called *adire* (fig. 8-63). In *adire*, the design is painted onto the fabric using a starchy paste made from the cassava yam. The fabric is then dyed in a bath of indigo made of the leaves of a forest vine. The yam paste repels the dye, leaving the design in white against an indigo background. The pattern here is a traditional design called Olokun, after the sea goddess.

Such *adire* patterns have been passed from mother to daughter, as have the techniques of stenciling, painting, and tying used to create them.

Drawing on a heritage of textile arts in both weaving and dyeing, Oshogbo artists, both men and women, experimented with fabric and dye techniques. A later Oshogbo group artist, the textile artist Nike Davies-Okundaye (born 1951), learned textile arts and related skills from her family. Her great-grandmother, the *iyadole* or head of the women in her home town, practiced weaving as well as indigo adire dyeing. Davies-Okundaye was also among many who worked in the theater and art groups in Oshogbo. Inspired by Georgina Beier's workshops of the 1960s, she later established the "Nike Center for Arts and Culture" in Oshogbo in order to create jobs for young Nigerians and to encourage Nigerian women into the arts. Here Davies-Okundaiye and master teachers instruct students in sculpture, painting, embroidery, drawing, batik, adire, appliqué, and quilting.

In her own adire and batik, Davies-Okundaye often includes a moral lesson, warning against the intentions of ill-willed persons or suggesting that the poor can be rich. Yoruba stories provide a wealth of subject matter, and although she was raised Catholic, she often refers to orisha (fig. 8-64). In this work, the focus of attention is centered on the sacrifice to Oshun. orisha of the Oshun River, balanced on the head of a woman. The central character brings to mind those images of bowl bearers in figures 8-27, 8-33, and 8-35, again referring to the efficacious spiritual role of the female worshiper. To the far left, a

priest rings bells for the *orisha*, while drummers on either side beat rhythms for the goddess, who appears as an apparition over the drummer on the right.

The Ona Group and Nigerian Universities

The pioneering artists of the first half of the twentieth century were trained to a large extent at Yaba College or abroad. By the second half of the century a number of art departments had been established at universities across Nigeria, notably at Amadou Bello in Zaria, Nsukka, in the east, and at the University of Ife, later Obafemi Awolowo University.

Founded at the University of Ife in Ile-Ife in 1989, the Ona group united a number of university-trained artists. Artists of the group grappled with the issues raised by the transformation of their society, which is in the process of recreating itself in response to its cultural roots, the colonial experience, and modern international urbanism. Their art consciously challenged ideas about modernism, about being African, about being modern artists in Africa. The Yoruba term ona refers to decoration. embellishment, design, or motif. As used by these artists, ona also relates to artistic vision. Many of the artists still explore the decorative motifs of the Yoruba past, looking to the rich history of pattern and design found in such Yoruba traditions as shrine painting, textile arts, and sculpture.

The founder of the group, Moyo Okediji (born 1956), was then a professor of art at Obafemi Awolowo University. Holder of undergraduate and graduate degrees in art and a

8-65. ERO, MOYOSORE OKEDIJI, NIGERIA/US. TERRACHROME ON CANVAS. 5'11" X 5'10" (1.8 X 1.78 M). COLLECTION OF THE ARTIST

Ph.D. in art history, Okediji now teaches and has a curatorial position in Denver, Colorado, but he returns frequently to Ife. To establish links between his Western training in painting and his own cultural heritage, he has made an intensive study of the images painted by women on the walls of shrines. Yoruba shrine paintings are rare today, and little has been recorded about them. Okediji visited shrines that his grandmother helped to paint and observed the painting techniques. One of the problems he assigned himself was to come to grips with the color palette used by Yoruba shrine artists. Following their lead, he learned to work with natural colors present in the environment or available in local markets. He mixed them with commercial binders for greater permanency. For Okediji the use of a Yoruba natural palette is a political statement, a conscious rejection of dependence on supplies

from former colonial sources. In the process, he ties himself more closely to the earth and its products.

Okediji used such pigments, which he calls "terrachrome," in the large painting entitled Ero (fig. 8-65). The work raises issues that have to do with Yoruba ethnicity, but it also goes beyond such local concerns. The word ero means "propitiation." The central image is the giant snail, which is used in all rituals of purification in Yoruba culture. Ceremonial objects are washed with snail liquid at the beginning of each year to cleanse them of all evil and malevolent powers to which they may have been exposed. Most Yoruba medicinal preparations include the liquid for its prophylactic and therapeutic qualities. The awe with which the snail is regarded as a magical creature is exemplified in the saying, "With neither arm nor leg, the snail patiently climbs even the tallest of trees." The metaphor alludes

8-66. Openwork frieze, Agbo Folarin, Obafemi Awolowo University, Ife, Nigeria. Aluminum

to the way disadvantaged people challenge and even surmount the most difficult problems.

Around the snail are images from the everyday lives of Africans, including some introduced and adopted following the colonial encounter, such as cars and bicycles. The painting suggests that the snail, as a purifying agent, cleans Africa of the impurities and maladies resulting from colonial contact and contamination.

Another Ile-Ife artist, Agbo Folarin (born 1936), holds graduate degrees in both fine arts and architecture. He has also designed sets and costumes for films, Olympic Games performances, and theatrical productions. In the tradition of such Yoruba masters as Olowe of Ise, and like the Oshogbo school artist Akanji, Folarin produces sculptural works that become part of an architectural structure, creating shapes in fiberglass, aluminum, steel, or copper, riveting or welding them together.

Figures involved in student protest, soccer, netball, calisthenics, and weight training parade across the large-scale, riveted aluminum screen

Folarin created at Obafemi Awolowo University, where he teaches (fig. 8-66). Perhaps recalling figural compositions on door panels created by Yoruba masters of the past, they demonstrate that although the subject is modern and the techniques are foreign, Folarin is able to create an art that melds the Yoruba past and present.

Contemporary artists in Lagos

Lagos is not only the largest city in Africa; it is still the cultural center of Nigeria. As in the years after independence, it is a place of innovation. Urban planners look to Lagos, with its flourishing informal sector and a population that survives in spite of inconceivable problems, as a twentyfirst-century megapolis. While many Yoruba maintain their identity as a distinctive ethnic group in the metropolitan region of Lagos, they interact with a huge population of foreigners and people from almost all the ethnic groups in Nigeria, providing an astonishing cultural environment and contributing to the reinforcement of

the cosmopolitan nature of the city,

One of the artists working in this multiethnic milieu is I. D. 'Okhai Ojeikere (born 1930). Ojeikere has worked as a photographer for the government and for an advertising agency, and now is head of his own photographic studio. In 1968, when he was employed by the Nigerian Arts Council's Festival of Visual Arts, he decided to document the intricate. stunning hairstyles popular in Nigeria at the time. He has produced about a thousand black and white photographs of women's hair arranged for traditional ceremonies or styled by experts in Nigeria's beauty salons (fig. 8-67).

Among the Yoruba, coiffure reinforces the importance of and emphasis on the head as the seat of the individual's spiritual being, the inner head. Yoruba women regard dressing the hair as a mark of honor to the inner head as well as an important social signifier that indicates possibly her marital status, her state of mind, or some important occasion. Yoruba women grow their hair long and work it into complicated crown-like designs not only to honor the ori inu but also to enhance their physical beauty. This photograph by Ojeikere seems to document a hairstyle that would exemplify these social, aesthetic, and philosophical ideals

For Ojeikere, these photographs of glorious crowns serve as a documented memory of the past and a witness to a culture in constant evolution. The images that Ojeikere carefully recorded over three decades not only predate many of the scholarly studies of the distinctive art form of hair sculpture, but underscore the everchanging nature of the form. As

8-67. Untitled (Adebe), from Hairstyles series, J.D. 'Okhai Ojeikere, Nigeria, 1975. Gelatin silver print. 23½ x 19½" (60 x 50 cm). CAAC/The Pigozzi Collection, Geneva

Ojeikere says, "All these hairstyles are ephemeral. I want my photographs to be noteworthy traces of them. I always wanted to record moments of beauty, moments of knowledge. Art is life. Without art, life would be static."

Contemporary Art in the Republic of Cotonou

The contemporary art scene in Cotonou, the modern capital of Benin, has been somewhat modest in comparison to Lagos. The universities of the Republic of Benin have produced art graduates, but many fewer than those coming from Nigerian universities. In fact, Benin's most famous artist never studied art at the university level. Georges Adéagbo (born 1942) completed a two-year law course in Côte d'Ivoire and continued his studies in France, before returning to Benin in 1971. Living in a Cotonou

neighborhood, Adéagbo began to cover the surfaces of the courtyards and streets with hundreds of found objects, with pages from books, and with passages from his own writing. The objects were selected and arranged in accordance to Adéagbo's views of philosophy and political science, but the finished art works are not easy to interpret (fig. 8-68).

Adéagbo has suffered conflict with his family and has endured bouts of mental illness. Foreign critics thus see Adéagbo as a troubled individual, an archetypical artist, driven to create fantastic scenes in response to inner desires. African artists who have trained in academic institutions or been apprenticed to demanding masters in community-based workshops do not share these views of artistic experience, and find Adéagbo's position much more difficult to understand. Western critics use the terms "assemblage," "installation," and "site-specific sculpture" to describe his work, but those concepts arise

from a series of experiments by modern and postmodern artists in the West, and they have no direct equivalent in Benin. Publications about the artist address issues of current interest but do not address how the artist himself would describe his work.

In 1993, a French curator visited Adéagbo's home and photographed what he saw. Since then, Adéagbo has prepared installations in Venice and won numerous awards. Collectors and curators have reconstituted his art for expositions in Geneva, London, Copenhagen, Johannesburg, São Paolo, Philadelphia, and Houston. Although Adéagbo's work is intensely personal, and although it fits comfortably within the quirky postmodern art world of the twenty-first century, some of its underlying ideas (such as the play of word and image) draw upon Fon royal arts of the eighteenth and nineteenth centuries, while the accumulation of mysterious, powerful objects can be linked to the shrines of vodun.

8-68. Abraham, L'ami de Dieu ("Abraham, Friend of God"), Georges Adéagbo, Cotonou, Benin, Philadelphia version, 2000–06. Philadelphia Museum of Art

The Lower Niger

9-1. IKENGOBO (PERSONAL ALTAR), BENIN, 18TH CENTURY. BRASS. HEIGHT 18" (45.7 CM). THE BRITISH MUSEUM, LONDON

HE LOWER REACHES OF THE GREAT Niger River embrace diverse cultures as well as varied topographical and ecological features. The lowlands and mangrove swamps of the delta region, where the river fans into the Gulf of Guinea, are home to the Ijo peoples. Immediately northward, in a region of tropical rainforest now largely cleared for farming, live various Edo (Urhobo, Isoko, Itsekiri, and the Benin kingdom) and Igbo groups. Further north the forest shades into hilly grasslands, home to still other Edo (e.g. Okpella) peoples, and to the Igala and the Idoma. The Ibibio live in the far eastern coastal area near the Cross River.

The notable artistic diversity of the area, however, appears to stem less from environmental factors than from social and political institutions, as well as historical experiences and interactions. Lower Niger societies range in structure from the egalitarian communities of the Igbo to the hierarchical, centralized Edo kingdom of Benin, which begins this chapter. Benin was and is an important regional power that received European envoys from the late fifteenth century onward. The Ijo, too, have traded with Europeans for most of their known history. A fishing people, their society is organized into trading houses, also called canoe houses, whose leaders are quite powerful. Fewer European influences were evident in the northern grasslands until recently. There, Edo and Idoma farmers are grouped in chieftaincies, while the Igala form a kingdom that was in contact with, and at times a vassal to, Benin. In fact most of these cultures have been interacting with one another in various ways for many centuries.

BENIN: SIX CENTURIES OF ROYAL ARTS

The kingdom of Benin became centralized during the thirteenth or early fourteenth century under a dynasty that is now considered mostly legendary. It was further consolidated under a second dynasty, founded from the Yoruba city of Ife by a prince named Oranmiyan (see page 229). This second dynasty, which is believed to date to the late fourteenth century, continues to the present day. During the fifteenth century Benin became an imperial power, conquering several neighboring peoples and extending the borders of her empire in several directions. In part with the help of the Portuguese, who established relations beginning in 1485, the empire reached its greatest geographic extent during the sixteenth century.

Viewed as sacred, the king or *oba* of Benin is at the ideological center of Benin culture, even today, just as his palace is at the geographical center of much of the Edo-speaking world (see fig. 9-3). Most Benin art forms feature the king and, secondarily, his court officials, chiefs, warriors, or musicians. The king is also the principal patron of the arts, and oral histories remember specific kings in part for the sorts of art objects they introduced.

While some archaeology has been conducted, the art of Benin survives primarily through its continuous res-

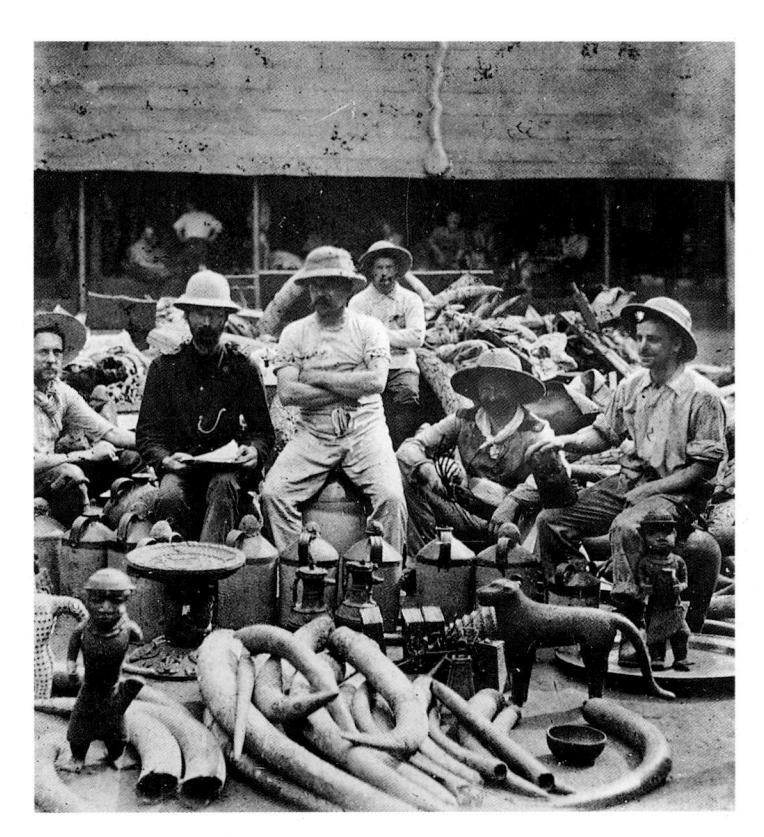

9-2. Members of the British Punitive Expedition in the Benin palace with the treasury of royal Ivory, brass, and other arts, which were removed to London. 1897

idence in the royal palace and in chiefs' houses. Its presence today in museums and private collections in Europe and the United States is a result of the notorious events of 1897. In January of that year a British officer wanted to visit the king in Benin City during a period when the king was offering sacrifices to his ancestors. Deeming a visit at this time inauspicious, chiefs warned the officer to stay away, to return later. He pressed on, however, and as he neared the city warriors ambushed and killed him and most of his party. The British navy quickly retaliated with an attack known as the Benin Punitive Expedition. Encountering human sacrifices as they entered the capital, the British officers burned much of the palace and city, exiled the kings, and removed thousands of art objects associated with Benin's reli-

gion and kingship (fig. 9-2). These were sent to Europe, where they were sold as curios. In 1914 the king's son was allowed to restore the monarchy and to begin rebuilding the palace, but Benin as an empire was a thing of the past. Some of the finest Benin art has since been returned to Nigeria, and can be seen in museums there.

The arts of the Benin court have been active instruments and more passive mirrors of leadership, ritual, belief, policy, and propaganda for over five hundred years. Interpretations of the place of art in the worldview and belief system of Benin, and of this art's historical and stylistic changes, are the focuses of this section. The very extensive literature on Benin art and culture, the corpus of several thousand known works of art, and this art's historical depth, all militate against any one interpreta-

tion being definitively true, and the interpretations offered here are similarly tentative.

Art, Ideology, and the Benin World

The map on page 131 indicates both the extent of the Benin empire during the sixteenth century, the time of its greatest territorial reach, and the location of the capital city, also called Benin, roughly at its center. And a plan of Benin City prior to its sack in 1897 shows the palace at the center, surrounded on most sides by the compounds of lesser chiefs, titled nobles, craftspeople, and other court members (fig. 9-3). The map and the plan, both of a roughly concentric design, bear out Benin ideology. In Benin thought, the sacred king is the center point. From him, a sequence of circles radiates outward. The first circle includes his chiefs, the nobles, protectors, and supporters; the next embraces guilds of craftspeople and artists. Next are villages that pay allegiance and tribute. Farther out still are enemy peoples or strangers, such as the Portuguese who came from across the seas, or the Igala, who became vassals.

In processions and other ceremonies, the *oba* is central among his court members, flanked by, with his arms often supported by, designated titleholders (fig. 9-4). He is transformed by his costume and regalia into a work of art, a walking pyramidal assemblage of symbolic materials and emblems. He wears cloth woven by his weavers' guild and embellished with many regal motifs. His tunic and headdress are fashioned of coral beads, his armlets of ivory. In fact

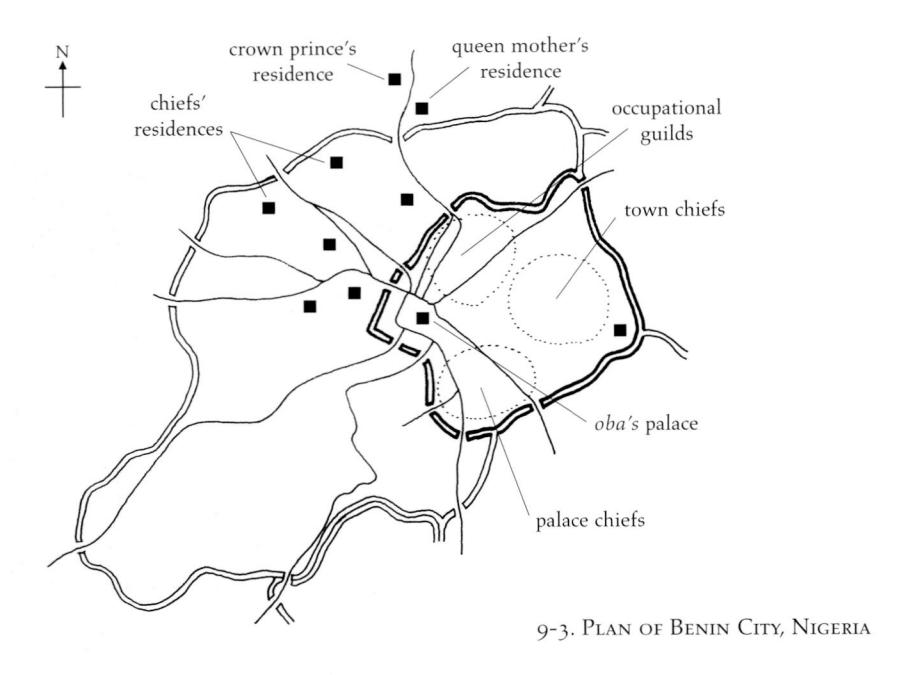

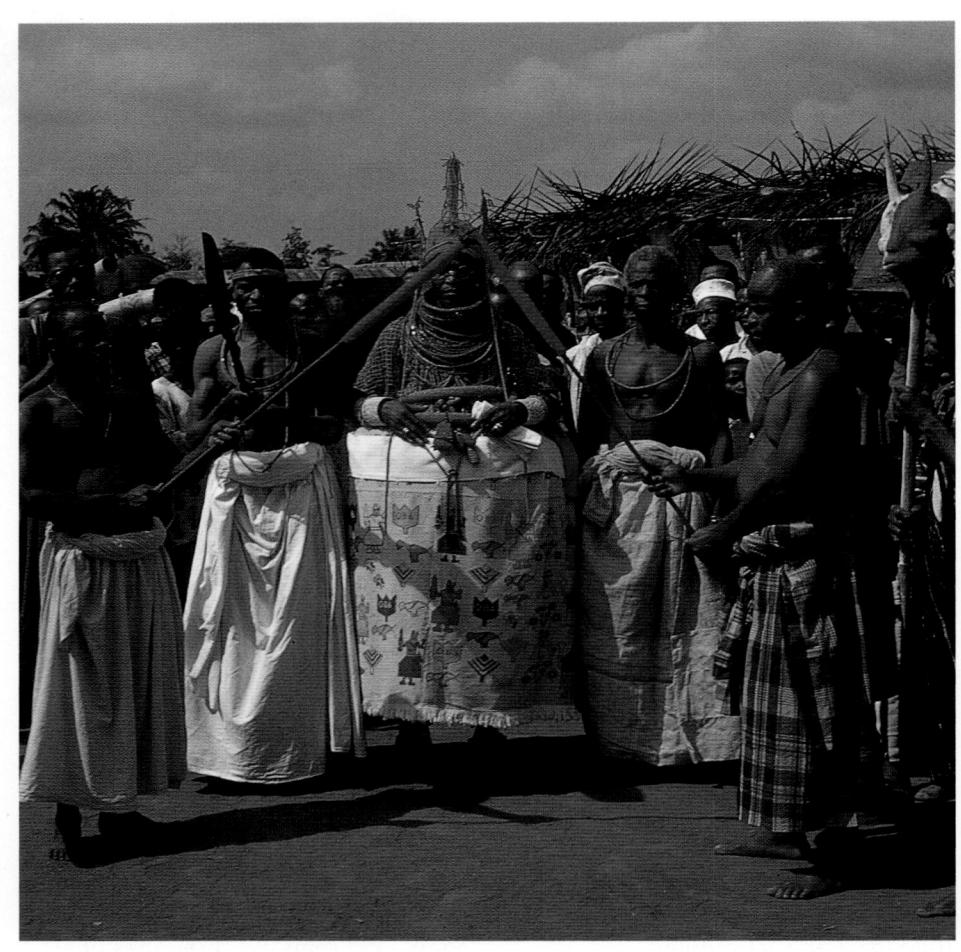

9-4. Oba Akenzua II (ruled 1933–78) in regalia, Benin City, Nigeria. Photograph 1960s

every aspect of the king's dress, as well as all his ritual gestures, contributes to his central role in maintaining order in the universe. His multi-layered wrapper creates a wide conical base, expanding him to largerthan-life size, as befits a divinity. The wrapper also hides his legs, considered dangerous and mysterious. His headdress points upward like a spiritual antenna to the celestial realm while adding height to the regal image. The result is a living version of the hierarchical composition notable in such art objects as the ikengobo, the altar to the hand, prowess, and accomplishment of the king (see fig. 9-1, discussed in more detail below). This complex copper alloy casting, with high relief forms around the cylinder in two registers, and an hierarchical group rendered in three dimensions on the top, was made for an eighteenth-century king. The monumentality of the oba, shown enlarged relative to others here and in most Benin art forms, is also evident in equestrian statues, where the size of the animal is diminished in relation to the dominant king. The horse also elevates the oba, whose position should be both physically and figuratively superior to the peoples under his rule.

The king is also at the center of his world viewed as a vertical continuum, for he and his visible earthly palace stand between the sky-world of Osanobua, the remote creator god, and the worlds of ancestral and other spirits (underground but also at large in the world), including powerful Olokun, god of wealth, fertility, and the great waters of the world (Olokun's wives are the rivers). The palace turrets (one is seen partly bro-

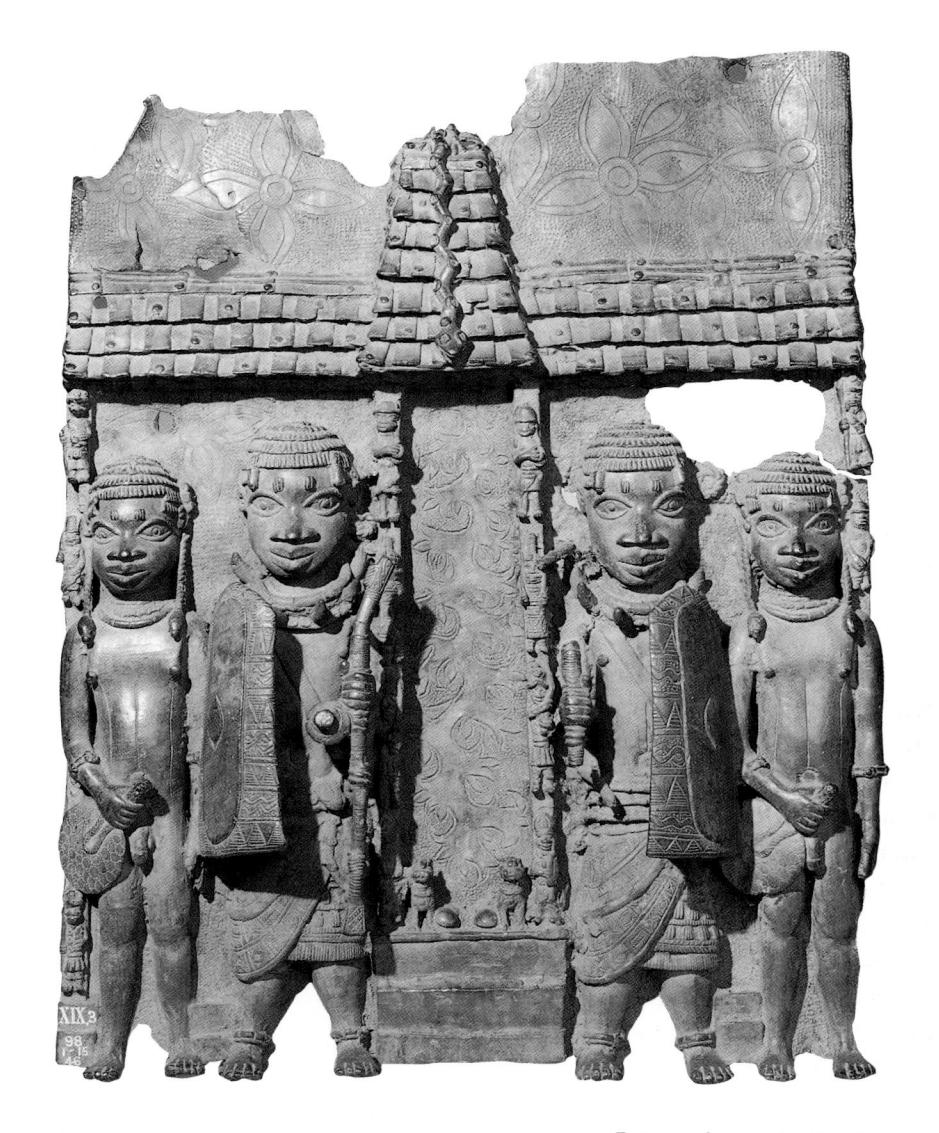

9-5. Plaque depicting architectural facade and figures, Benin, 16th–17th century. Bronze. 21 x 14'' (53.3 x 35.6 cm). The British Museum, London

ken in fig. 9-5), vertical transition points where the terrestrial realm touches the celestial, are pyramidal, a stable form that evokes the mass of the *oba* in his ceremonial regalia. Both shapes recall a segment of the annual *igue* ceremony, a rite dedicated to blessing the *oba*'s head, thus renewing his access to spiritual power, when an official attempts unsuccessfully to physically move the seated king. Symbolically, both the person and the office are to be seen as

unshakable. During *igue*, the sacred king is both proven to be enduring and spiritually reenergized so that he, and his kingdom, can carry on.

The pyramidal shapes of steeples and king are linked symbolically to the towering termite mounds found in this region of Africa. One of the king's praise names is "Termite Mound," an allusion to his mysterious, fertile, and impregnable nature. In Benin belief, termite hills are held to be numinous and spiritually pow-

erful. Their sundried, cement-hard clay is a metaphor for the king's invulnerability, and the queen termite, like the *oba*, is a font of fertility.

Long snakes of cast copper alloy were affixed to the sides of palace turrets (they are documented in photographs of the palace taken just after the British raid, see fig. 9-2; one is depicted on the plaque in figure 9-5). At the top of each steeple stood a figure of a bird with outstretched wings, also cast in a copper alloy (a bird, since broken off, was originally depicted atop the turret on the plaque in figure 9-5). The roof snakes undulate downward, as if connecting the bird's sky-world with the king's earth.

Most scholars refer to the snakes as pythons; a few believe them to be puff adders. The Edo associate the adder with accumulating wealth, and wealth in Benin is accumulated by the king. Poisonous puff adders also suggest the power of the oba to take human life. The puff adder has other characteristics as well that make its symbolic identification with the king persuasive. It is a stout, slow, heavy creature that waits for its prey; food comes to it. It is placid, but with deadlv venom. The oba, slow because weighted down by regalia, waits in the palace for tribute and visiting dignitaries to come to him. Indeed, before the twentieth century the king rarely left the palace. Thus the puff adder is a symbol of good luck and abundance and, specifically applied to the king, a metaphor for his ability to sit placidly, if grandly, inside the palace, where he receives precious goods, medicines, and tribute. The palace entrance is called "rushing gate" for precisely this reason. Still

another serpent, the red-lined snake, is often associated with the gentle deity Olokun because of its beauty. aquatic habits, and non-poisonous nature. Pythons too are considered beautiful and are said to be the rainbows that arc through the sky, another phenomenon associated with Olokun, in association with whom they are called "beauty snakes." Clearly, different snakes enact various metaphorical roles, and ambiguity seems deliberate, as it is in poetry. Benin artists were not always concerned with anatomical accuracy in their renderings, and their snakes appear to have stood for multiple species.

The birds, for their part, may well be fish eagles, emblems in Benin of high rank, achievement, wisdom, and dignity. These noble birds may be raised within the palace (as they are among the Benin-influenced Oguta Igbo); they were sacrificed during igue, formerly, along with a pair of leopards, considered kings of the wilderness. The bird is typically shown grasping a snake in its talons. The bird-serpent combat may be another instance of a motif distributed widely in the world, often with cosmological implications. Here in the Benin palace, specifically because of the king's superhuman and mediating powers, "the snake and eagle meet the world's foundations tremble," in the words of the English poet Percy Shelley, who was not referring, of course, to Benin iconography.

Termite hill clay is employed in many rituals. It is among the mystical ingredients used, for example, to construct shrines to Olokun. The name *Olokun* means "owner of the ocean." He is the popular, benign god of

childbirth, water, wealth, harmony, purity, beauty, and goodness. He is worshiped largely by women. His principal color is the white of riverine clay and cowrie shells, both given as offerings, both seen in abundance in his shrines (fig. 9-6). In the shrine shown here, the stepped platforms and some of the figural inhabitants are painted white; strings of cowries hang from the ceiling, while others adorn the platform and the offering bowl in front of the deity. Cowries, once a form of currency in this region, stand for Olokun's wealth.

The reciprocity between Olokun and the Benin king is layered and complex. The red coral beads worn by the king were originally Olokun's. The fifteenth-century king Ewuare is believed to have wrestled them away from the deity during the period when the Portuguese were in fact trading them into the kingdom. The king's coral, part of his vast wealth, is said to be stored in Olokun's underwater palace. The deity's earthly shrines, like his image, imitate Benin royal precepts: hierarchical composition, an entourage of supporters, elaborate regalia, a rich palatial environment. The shrine figures are modeled by devotees from a combination of river mud, white sand, and anthill clay. In addition to a representation of the deity, shrine figures often include Olokun's wives, some with children, and his servants. As with his worshipers, more women than men are represented, for Olokun's special concerns are women's fertility and productivity. In the shrine shown here, a coral-bedecked Olokun sits high on the left, while off to the right is an unusual, white-robed image of Osanobua, Olokun's father (creator

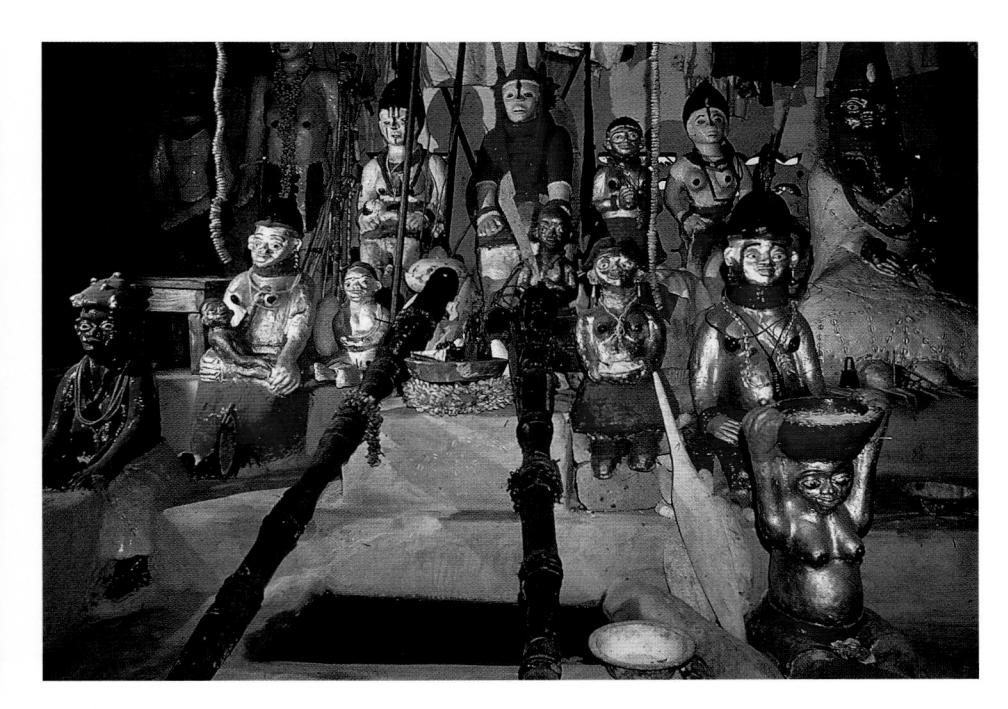

9-6. Shrine to Olokun in the home of a priestess, Benin City, Nigeria, 1976

gods are very rarely depicted in African art). Several figures in the shrine have been adorned with silver and gold pigments, as if to emphasize the god as a font of wealth and abundance; these rich colors are fairly recent additions to Olokun symbolism. Earlier photographs of Olokun shrines often show an abundance of pure white clay found on riverbanks; this clay (called kaolin), symbolic of Olokun's purity and beauty, is given Olokun by worshipers in sacrificial offerings.

Plaques

Prominent in the artistic legacy of Benin are brass plaques that depict various motifs and scenes in relief (see figs. 9-5, 9-7). Nearly one thousand plaques are known, many of them masterful lost-wax castings. Most plaques depict royals, chiefs, court members, warriors, musicians,

and sometimes Portuguese men, who traded with and aided Benin in the late fifteenth and sixteenth centuries. Human figures are usually modeled in high relief, with static poses, on a comparatively neutral, textured background, often a quatrefoil design associated by scholars with Olokun. Attendants of varying sizes stand in stiffly frontal poses, as if in a kind of ceremonial posture, with many details of their regalia or dress and held objects precisely rendered. Still other plaques show animals such as leopards (symbolizing the king), mudfish and crocodiles, familiars of Olokun, as well as occasional domestic animals. Not many plaques appear to have any narrative content, although a few seem to record important historical events.

Scholars have suggested that the plaques served as mnemonic devices, recording the dozens of ranks and many ceremonies at the Benin court.

They may indeed have done this, but probably as a secondary function. Their primary purpose appears to have been to embellish the pillars and perhaps the walls of the palace. Most plaques are dated to the sixteenth and seventeenth centuries, when contact with the Portuguese was intense. It was the Portuguese who brought quantities of metal used by the royal brasscasters' guild to make plaques and other court objects. Some scholars believe the rectangular plaque format to be a Portuguese influence, derived perhaps from illustrated books.

The *oba's* identification with Olokun is dramatized in a plaque that portrays the king in a mystical, spiritual aspect (fig. 9-7). The king is shown grasping apparently docile leopards by their tails and holding them aloft in a heraldic pose. Another of the king's praise names is "leopard of the house," a reference to his authority as the only person in the

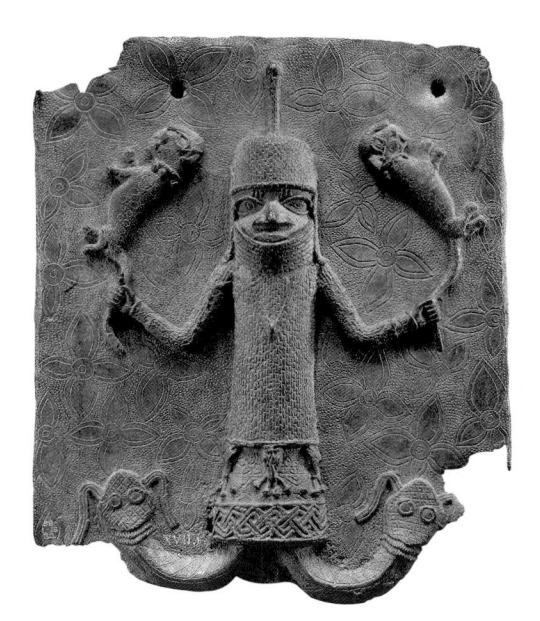

9-7. Plaque depicting an *OBA* with mudfish legs, Benin, 16th–17th century.
Bronze. 16 x 12½" (40.6 x 31.75 cm).
The British Museum, London

kingdom who can take human life or authorize the taking of it. This symmetrical balancing act—one nobody wants to attempt even with domestic kittens—is clearly metaphorical, an expression of the king's control over the leopard, ruler of the forest, and thus over all creatures. The king sacrifices a pair of leopards at his installation and formerly sacrificed them as well at *igue*, the rite that reaffirms his powers and the world order. For ideological purposes in aggrandizing the king, the leopards here are rendered the size of house cats.

From the bottom of the king's robe extend two mudfish where we would expect legs. On a simple symbolic level, the fish suggest the king's identification with Olokun, whose realm is water. A more complex interpretation derives from oral traditions about the early fifteenth-century king Ohen, who apparently was paralyzed. To hide his deformity in a culture where this would have been taken as indicating infirmity in the kingdom itself, he had himself carried into public audiences. Notably as well, some species of mudfish give off an electric charge, which would be appropriate in symbolism of the king. In any case the plaque must be seen as a means of visibly declaring the oba to be divine, mysterious, and of superhuman strength, notions reinforced elsewhere in Benin iconography. An alternative interpretation focuses on the king's dual powers to take human life, symbolized by his control over the leopard, and to create or produce life, suggested by his identification with Olokun, god of fertility and wealth.

Another plaque apparently reproduces the interior of a palace court-

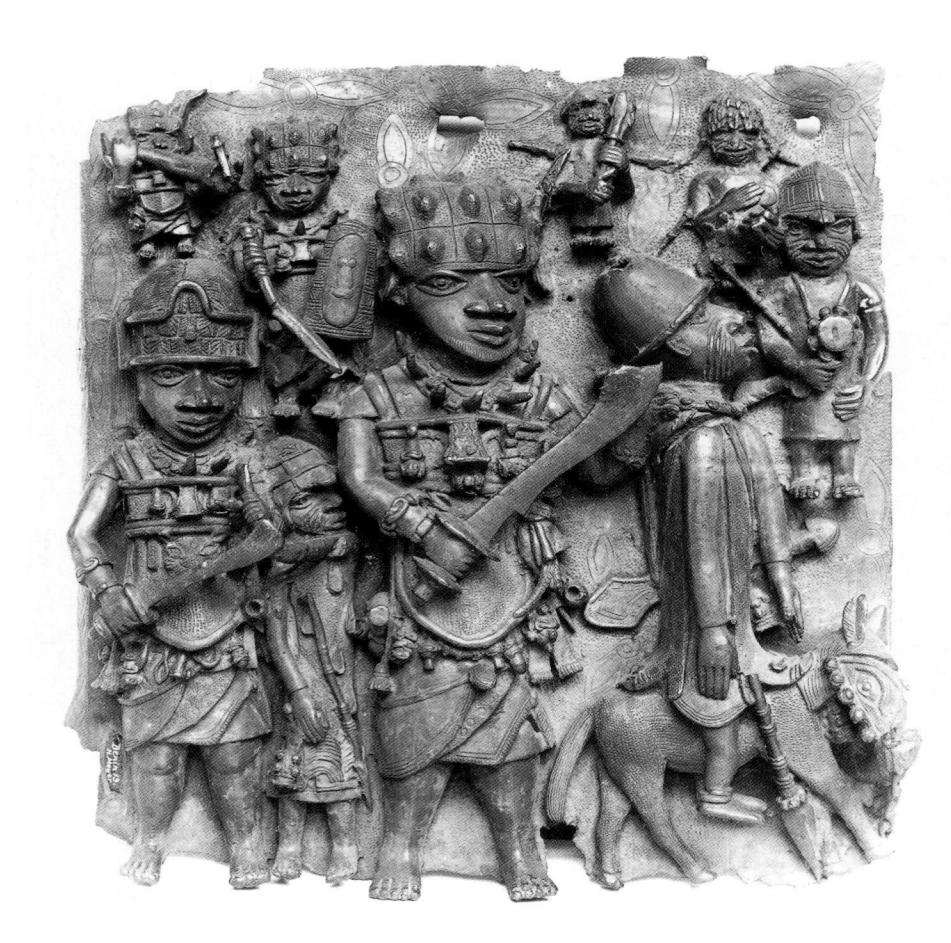

9-8. Plaque with captives. Museum für Volkerkunde, Leipzig

yard shrine with its sloping steepled roof (fig. 9-5). Two posts flank what seems to be an altar, and two more support the roof at its ends. On the altar's top step between the two center posts are two stone axes and two guardian leopards. Warriors holding shields and spears flank the altar, with slightly shorter attendants beside them. The posts are decorated with even smaller vertically stacked figures in relief. Interestingly, these figures probably represent plaques—many show single figures—as they were once displayed.

Yet another plaque depicts two elaborated dressed Benin warriors, each of whom grasps and threatens enemy captives (fig. 9-8). The latter are differentiated from Benin men by both their garments and their facial scars, and well as by smaller stature. Six much more diminutive ancillary warriors and musicians fill the rectangular plaque format with dense detail. This obvious record of both warfare and action—possibly the depiction of a specific battle now lost to scholarship—is relatively rare in the vast inventory of plaques, and this one is also composed asymmetrically, which is also uncommon. What is very typical, on the other hand, is the meticulous recording of clothing, military regalia, and handheld objects.

Royal Altars

"Great Head" is another of the king's praise names, and one that serves well to introduce royal altars, which are dedicated to the heads of past kings as well as that of the current ruler. The head leads the body; it is the body's most important part, the seat of wisdom and judgment and well-being, just as the Great Head leads the Benin body politic. In depicting full figures, Benin sculptors emphasize the importance of the *oba*'s head by enlarging it and his neck proportionally to about a third to a fifth of the total figure height, as, for example, the *oba* depicted on the altar to the hand, ikegobo (fig. 9-1). This portable alterpiece once received sacrifices to promote the king's (and kingdom's) skill and success in physical undertakings, such as warfare.

Royal ancestral altars, on the other hand, are composite complexes of charged materials and objects arranged on a semi-circular clay platform (fig. 9-9). The one shown here is that of the early twentieth-century king Eweka II (ruled 1914-33). Its dramatic impact comes mainly from the four sculpted heads and the great carved elephant tusks that seem to sprout from their crowns. These four elements frame the shrine and focus attention inward. The dark cluster of staffs (ukhurhe), used to call ancestral spirits, stacked against the wall, and especially the figurative centerpiece in front of them, add visual interest, depth, and further support to the overall hierarchical structure, which the central sculpture reiterates in its own composition. Several bells and other small objects add further texture (and symbolism), as do the state

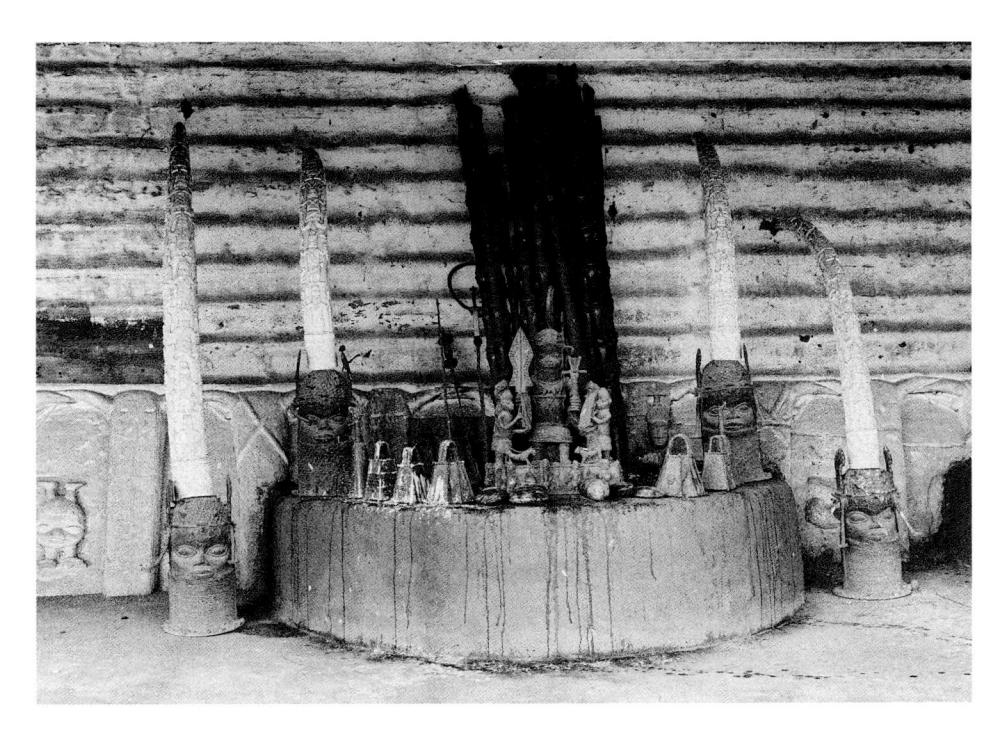

9-9. The palace altar to Oba Eweka II, Benin. Photograph 1964

In 1897, at the time of the sack of Benin, there were seventeen such altars. In earlier times there were still more—in theory, an altar for every deceased oba. Since the 1914 restoration, a single altar has served as the collective shrine for all past rulers except for the last four, each of whom has his own altar, as does the living king. There is also a shrine to queen mothers in the palace, and at least one more in the queen mother's compound north of the palace.

swords leaning against the wall. Even the sacrificial blood dripping down the front of the platform contributes to the visual experience, leading the viewer's eve up and back to the sculptural group. Horizontal ridges on the wall behind effectively stop one's view, directing it to the center or perhaps laterally, to other altars nearby. All these components have constellations of meaning that contribute variously to the importance and enduring value of Benin kingship, which is what this and similar "head" altars are all about. It is here that ancestral kings are fed (with sacrificial blood) and prayed to, so that they will protect the kingdom and aid in its prosperity. The main officiant is the living *oba*, whose power derives from these ancestors and from the coral beads they have passed down to him.

Many sculpted heads are known from Benin, created variously of brass, ivory, terracotta, and wood. The materials are used hierarchically, with brass heads reserved exclusively for altars to kings and queen mothers, because cast brass is enduring; like kingship, it does not rust or corrode. In earlier times, brass heads were polished to a brightness appreciated as beautiful and inviting, yet simultaneously to a color considered red, and thus threatening. The king, too, attracts people with his beautiful gar-

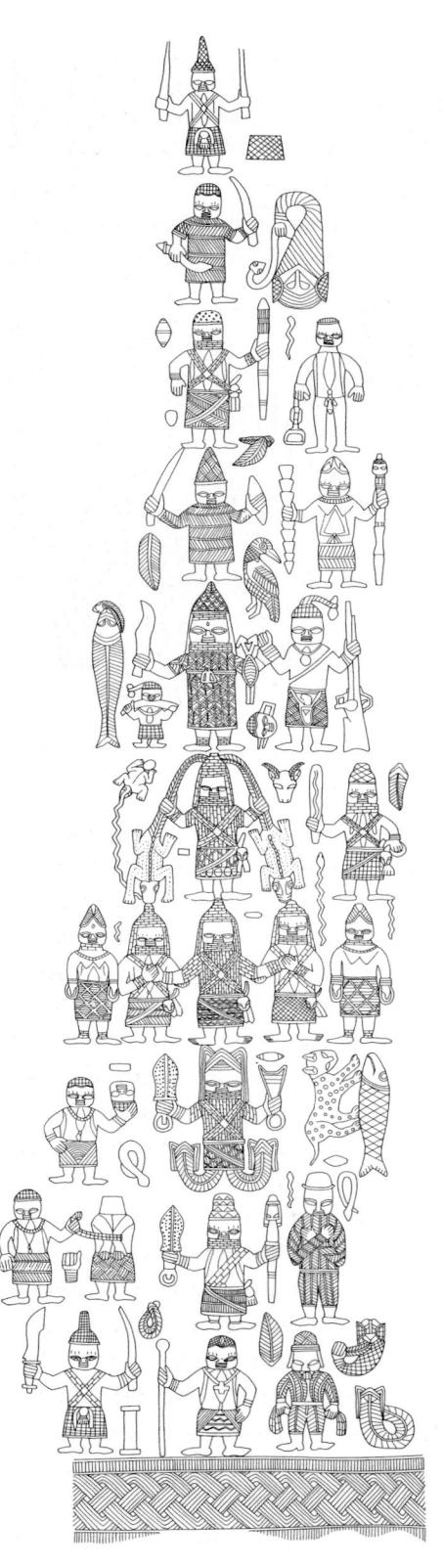

9-10. Motifs engraved on an elephant tusk from Benin. Drawing by Joanne Wood

ments, but he also repels with the power of his red coral beads, which are re-consecrated annually with sacrificial blood. Similarly, the imposing tusks on these altars are the weapons of the mighty elephant, who, like the ferocious leopard and predatory eagle, is a metaphor for the king and his powers. "Wherever the elephant faces is the road" is a proverb about the elephant's, and the king's, military might. But here the tusks have been tamed, as it were, transformed into works of art by the detailed relief carvings that cover their surfaces. The drawing in figure 9-10 catalogues the motifs carved on one such tusk, which include the *oba*, royal supporters, metaphorical animals, and other key symbols. The *oba* is often shown multiple times on carved tusks; here, a column of kings and officials extends along the central axis. Each king once commissioned a set of tusks for the altar he consecrated to his father's head and memory. Ivory itself was a valued commodity in external trade and brought much revenue to Benin, especially to the king, who received one tusk of every elephant killed in the kingdom. Tusks on altars were often bleached and sometimes rubbed with white clay, kaolin, to

pure whiteness, another reminder of the king's relationship to Olokun.

Each newly installed king also pours the first crucible in casting the central altarpiece that becomes the focal point of his father's shrine, the figural group that depicts his father with major courtiers and chiefs. In the centerpiece on the altar in figure 9-9, the former king is shown in full ceremonial regalia, including the powerful garment made of Olokun's coral beads. He holds aloft a ceremonial sword, *eben*, with which he dances to honor his ancestors. An actual sword leans against the back of the shrine.

Both a certain redundancy and a multi-referential quality pervade Benin shrine complexes, as they do other aspects of art in this kingdom. The small brass altarpiece echoes the larger altar, which is composed from many materials and objects. One commemorative head or tusk is not enough, there must be four or six. Not a few beads, but an entire garment of them. Not one bell to call the ancestral spirits, but several, most being miniature versions of palace steepled roofs. Not one wooden staff, but many, which together—each with its piling up of bamboo-like segments

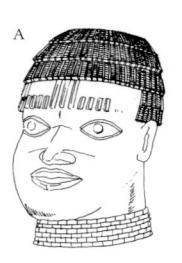

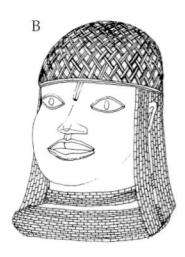

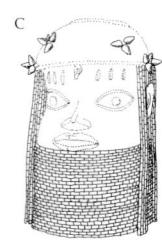

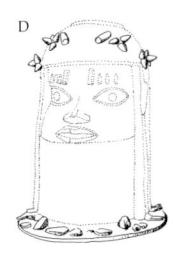

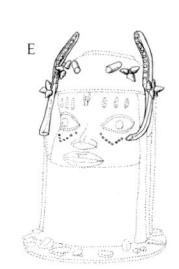

9-11. STYLISTIC CHRONOLOGY OF BENIN BRASS HEADS PROPOSED BY W. FAGG AND P. DARK. DRAWINGS AFTER C. VANSINA

Solid lines indicate new, distinctive elements. The progression from the earliest head (a) to the most recent (e) may span as much as four centuries.

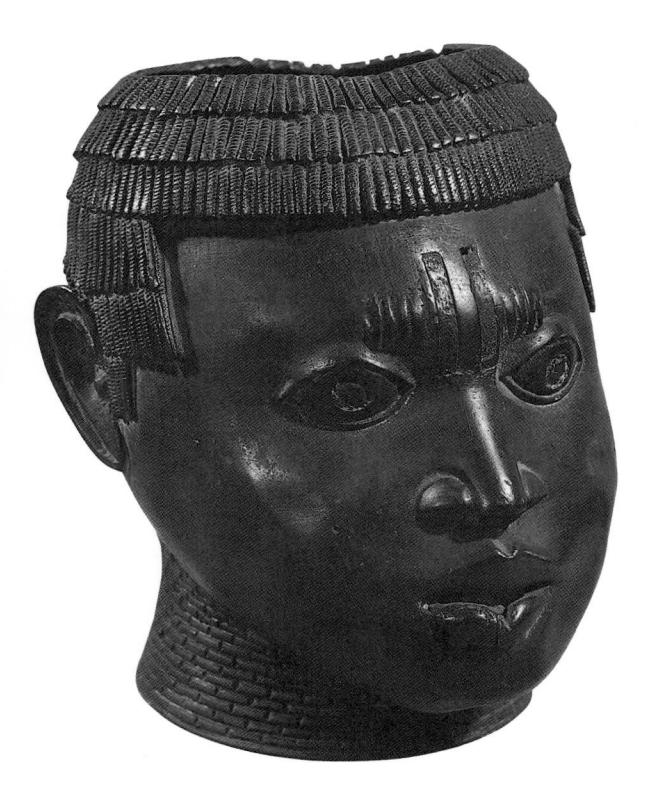

9-12. Head from a royal altar, Benin, Early period (15th–16th century). Brass and iron. Height 8¼" (21 cm). University of Pennsylvania Museum, Philadelphia

9-13. Head of an oba, Benin, Middle period (17th–18th century). Brass, iron. Height 131%" (33.3 cm). Metropolitan Museum of Art, New York. Gift of Mr. and Mrs. Klaus G. Perls, 1991

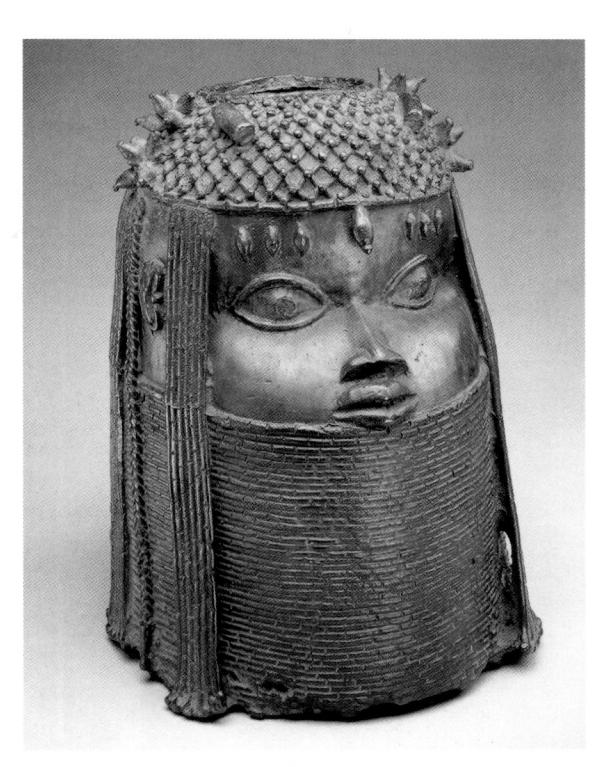

that signify the piling up of generations—represent the temporal depth of a family dynasty as well as its multiple powers.

The many extant cast brass heads also represent more than four hundred years of commemorating Benin kings and queen mothers, from the fifteenth until the late nineteenth centuries. While an exact chronology is not agreed upon, the historical progression of styles shown in figure 9-11 is generally accepted. According to this rough chronology, the thinnest castings, usually the most naturalistic of the heads, are the earliest (fig. 9-12). Although the facial features on these early works are not realistic enough for imitative portraits (lips, noses, ears, and sometimes eyes are conventionalized), the heads are quite sensitively modeled, and many are very strong sculptures. Some scholars believe that heads of males such as

this example do not commemorate Benin kings but rather depict conquered rulers, and that they were displayed on war shrines as trophies of victory. However, early period heads of females clearly depict a queen mother with characteristic tall conical hairstyle overlain with coral beads.

Middle period heads, usually dated from the late seventeeth through early nineteenth centuries, are heavier, bulkier, and taller than early examples, and were meant to support ivory tusks (fig. 9-13). Beaded collars, which on early period heads conform with the neck, now form a cylinder from which the head seems to emerge. This head represents an *oba*, with a hole in the center of the head to hold the elephant tusk. Facial features are both larger and more conventionalized than those of the early period. The heads on the altar

discussed earlier (see fig. 9-9) are middle period examples, cast after the 1914 restoration of the monarchy. They are distinguished from early and late period heads by the flanges encircling their bases, and by their elaborate crowns.

The origins of the custom of casting commemorative heads and the source of the casting technology itself are uncertain. Oral traditions record that the current Benin dynasty was founded by a Yoruba prince from Ife (see chapter 8), and reciprocal ritual relations have long been maintained between the two kingdoms. The relationship between Ife and Benin is in fact demonstrated by a small sculpture depicting an oni of Ife wearing full regalia that was dug up in Benin (fig. 9-14). Some scholars believe that the techniques of lost-wax casting and the relative naturalism of early period heads derive from Ife and this sculp-

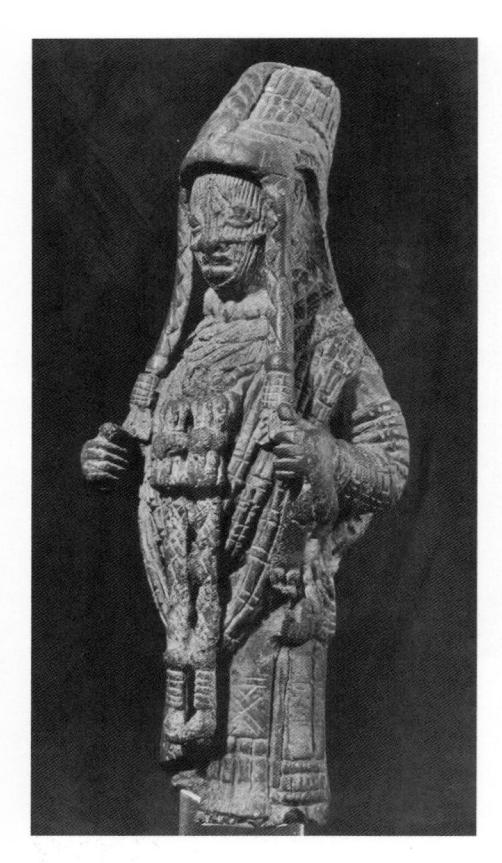

9-14. Figure of an ONI of Ife, found in Benin City. Height 4%'' (12.4 cm). Museum of Ife Antiquities, Ife

ture would seem to corroborate such a view. Others accept the Yoruba origins of casting technology but dispute the stylistic links. Judging from the evidence of the art works themselves, it seems unlikely that the Benin heads, confidently cast but stylized, are the direct descendants of the supremely lifelike and naturalistic heads of Ife, however idealized both sets of castings may be.

Portuguese Presence in Benin Arts

Portuguese ships arrived on the Atlantic shores southwest of Benin in the 1480s, and immediately a trading

relationship was established for mutual benefit. From the Portuguese Benin received cloth, cowrie shells, coral, brass, and eventually weapons, offering in return ivory, spices, and later slaves. For some years scholars have postulated that these light-skinned foreigners arriving over the ocean in huge ships bearing exotic kinds of wealth may have been perceived by the Edo as emissaries of their popular deity Olokun. The apparently warm reception given the Portuguese, and especially their dynamic integration into Benin art forms, most of which are adjuncts to ritual, would seem to confirm this theory.

Images of Portuguese in brass, ivory, and wood appear on regalia, on plaques, and even as freestanding statuary probably displayed on altars. The finely detailed Portuguese soldier illustrated here almost certainly stood on a royal altar prior to its removal from Benin in 1897 (fig. 9-15). The man holds a matchlock at the ready and wears precisely rendered military garments of a style dated to the sixteenth century. The alert, slightly bent-kneed stance and the position of the arms give the figure a more dynamic posture than those in which Benin officials or Portuguese are usually shown. Benin artists did not discriminate against the Portuguese outsider. No hint of criticism or caricature is visible here. Rather, as in nearly all Benin art, the Portuguese are depicted with the kind of objective neutrality that implies their full acceptance and participation in Benin despite, or perhaps because of, their "stranger" status.

Portuguese visitors are also depicted on two sensitive and exquisitely carved ivory faces of Edo queens,

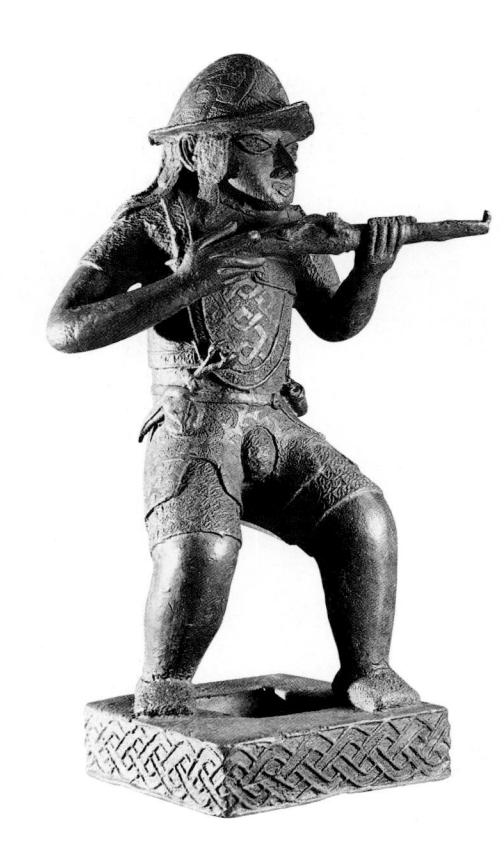

9-15. Portuguese soldier, Benin, 16th Century. Copper alloy. Height 15" (38 cm). The British Museum, London

where a series of their bearded heads appear in a kind of corona at the top of the head. One of these beautiful objects, believed to have been carved around 1540-70, is illustrated here (fig. 9-16). These rare and precious objects are among four ivory works said to represent the queen mother, Idia, wife of oba Ozolua and mother of oba Esigie. Judging from recent ritual practice, they did not cover a wearer's face like a mask, but were suspended from the waist or chest of the king. Today similar ivory pendants (leopard heads and plaque-like objects with hieratic motifs) are worn at the king's waist. The exact meanings of these pendants are not known. They may have been protective, or

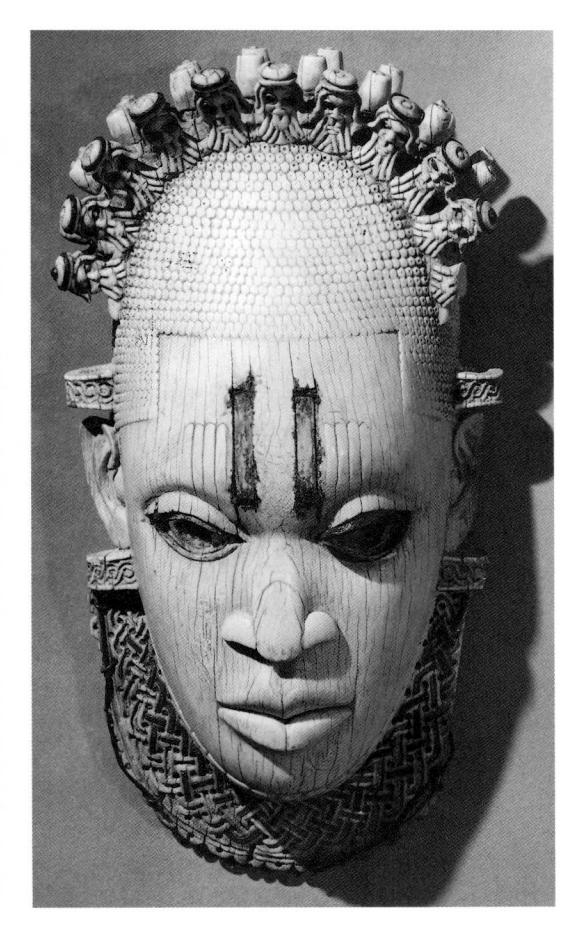

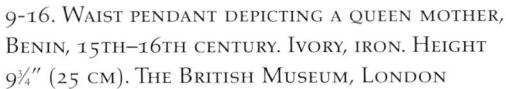

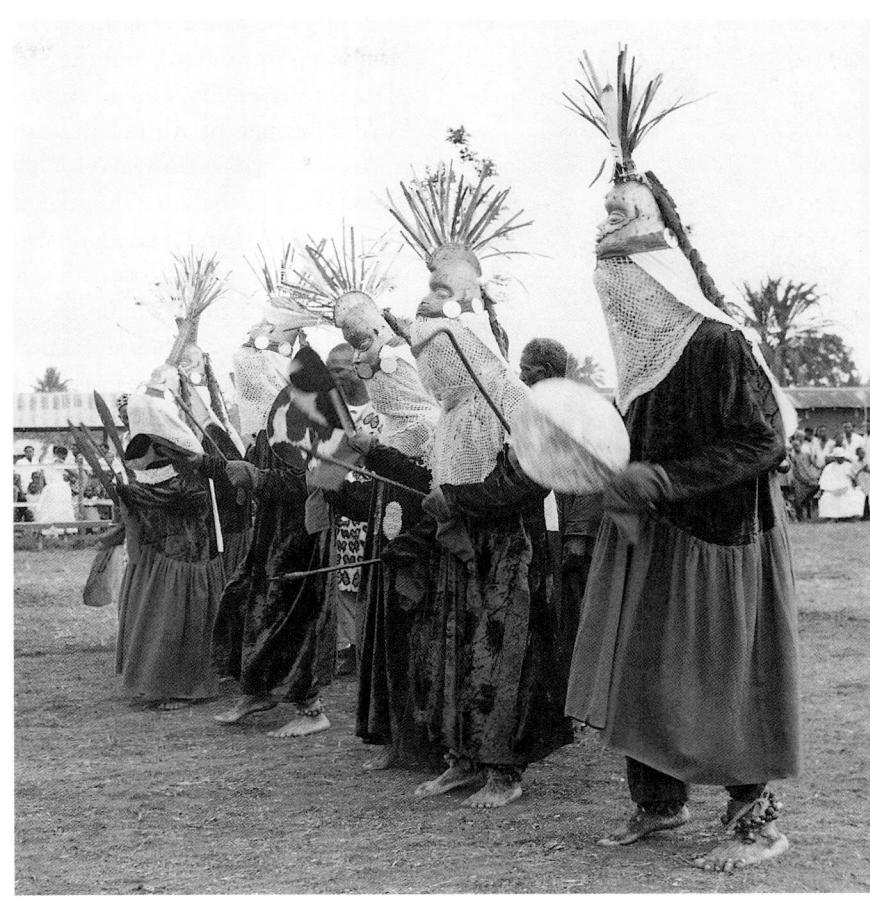

9-17. ODUDUA MASKERS AT THE COURT OF BENIN, C. 1960

they may have identified the king with certain powers such as the queen mother's supernatural abilities, the leopard's military ferocity, and Olokun's wealth and beauty.

Masks and Masquerades

Although this ivory face, along with a large number of copper-alloy pendants representing human and animal heads, is often referred to as a "mask," none is the sort of mask worn over the face to create a new persona, in the manner of most masks discussed in this book. Normally only one type of face-concealing mask is danced in Benin City, in a masquerade known as odudua (fig. 9-17). In keeping with the materials so frequently used for court-related art forms. odudua masks are brass. They appear as part of the new vam harvest and first fruits festival in a ritual titled ugie odudua, named after the Ife king whose princely son Oranmiyan founded the current dynasty. The masquerade itself was initiated by Oba Eresonyen (ruled c. 1735) to represent and commemorate the founding members of that new line. A quintessentially royal masquerade in history, form, and purpose, ugie odudua features seven maskers who

gesture with sacred implements as they dance back and forth seven times before the king. Masking officials are important chiefly titleholders and caretakers of deities brought from Ife. Their dancing expresses their loyalty to the living king and his protection by them and by the dynastic ancestors embodied in the masks.

With a few significant exceptions during *igue*, no other masquerade is allowed to perform in the palace or in Benin City. At the same time, chiefs of all ranks wear (or once wore) mask-shaped brass pendants at their waists, as the king himself wears one of ivory. By banning all "true" mask-

9-18. BIAFRA WAR MONUMENT, PRINCESS ELIZABETH OLOWO, NIGERIA, 1984. CEMENT

ing apart from *ugie odudua*, which so explicitly supports the king, the Benin hierarchy keeps the sorts of power embodied in typical masquerades at a non-threatening distance. It would seem that the king wants to keep away the kinds of anonymous and often unruly maskers who, elsewhere, sometimes take both spiritual and political power into their own hands. The wearing of mask-like pendants at the waist would seem to express royal control of powers elsewhere embodied in true masks.

Today, the king of Benin is still a viable, powerful leader of his people despite—and perhaps because of—the existence of the national and state governments. The king and the rituals he still conducts, such as *igue*, which annually revitalizes the very concept of sacred kingship, provide focus, continuity, and stability for the Edo people and their neighbors.

Benin City today is a thriving modern metropolis, and the seat of a major university. One of the artists who has taught at the University of Benin is Princess Elizabeth Olowo, a daughter of the late Oba Akenzua II (see fig. 9-4) and a sister of the reigning king. Her royal status has allowed this sculptor to cast in both cement and bronze even though women (who cannot join the king's brass casting guild) never worked in these media in the past. A prolific artist and noted teacher, Princess Olowo has created a monument to the Nigerian Civil War (also known as the Biafra War), the conflict of the late 1960s that brought bloodshed and suffering to this region of Nigeria (fig. 9-18). Although many of the dead were civilians, this lifesize work shows two of the soldiers who fought in the horrendous civil war. Unlike older historical Benin art, this sculptural group depicts vivid action, and in keeping with earlier arts of this kingdom, it shows meticulous descriptive detail.

IGBO UKWU

The earliest art yet discovered in the Lower Niger region comes from an archaeological site in the heart of Igbo territory named Igbo Ukwu, after a nearby village group. Excavations at a single family compound there have uncovered a rich burial, a shrine-like cache of prestige goods, and a refuse pit with additional artifacts. The objects form an extraordinary corpus of copper-alloy (mostly leadedbronze) sculpture and decorated pottery in a refined, meticulous style that has no parallel elsewhere in tropical Africa. On the evidence of several radiocarbon samples, the finds date to

the ninth and tenth centuries AD, making them the oldest known firmly dated copper-alloy castings south of the Sahara. Many other cast bronzes associated with leaders and ritual all over the Niger Delta, moreover, suggest that these early finds from Igbo Ukwu are part of a large complex of arts forms made for and revered by many different peoples. It is even possible that West African copper alloy casting originated in this region.

Archaeological evidence combined with recent ethnographic work indicates that these superb works were associated with an early specialized clan of ritual leaders, the Nri, an Igbo people whose direct descendants still live in the same area. The Nri today continue to perform some of the rituals that they apparently did during the tenth century. They also pay allegiance to a king, or *eze*, who was probably then, as he is now, more a ritual leader than a political one.

A painting based upon archaeological data reconstructs the probable original appearance of the burial uncovered at Igbo Ukwu (fig. 9-19). The deceased was seated upright. If he was not the king of the Nri peoples, he must have been a very high official, judging from the sumptuous regalia he wore and the fine artifacts that accompanied him. One of his feet was raised on an elephant tusk, and another tusk lay nearby. Cast and hammered copper-alloy ornaments adorned him or were placed nearby, including a fan-like object and a headdress, both probably once decorated with eagle feathers. The burial contained more than one hundred thousand beads, many of which had been imported from Indian Ocean sites well beyond Africa. Considered valu-

9-19. Burial Chamber at IGBO Ukwu, showing workers sealing the tomb. Reconstruction painting by Caroline Sassoon

able, beads often serve as a form of currency in Africa, and such a vast accumulation suggests that tenth-century Nri peoples were very wealthy. Clearly they were engaged in long-distance trade.

One small casting found with the burial implies both travel and trade (fig. 9-20). Depicting an equestrian figure, it served as either a flywhisk

handle or a staff finial. Horses even today are prestige animals associated with leaders and title-taking among the Igbo and their northern neighbors, the Igala, who are related to the Nri. In recent centuries, and probably earlier, all horses were imported, as sleeping sickness precluded a long life for them in the forest zone. The rider's face displays scarification pat-

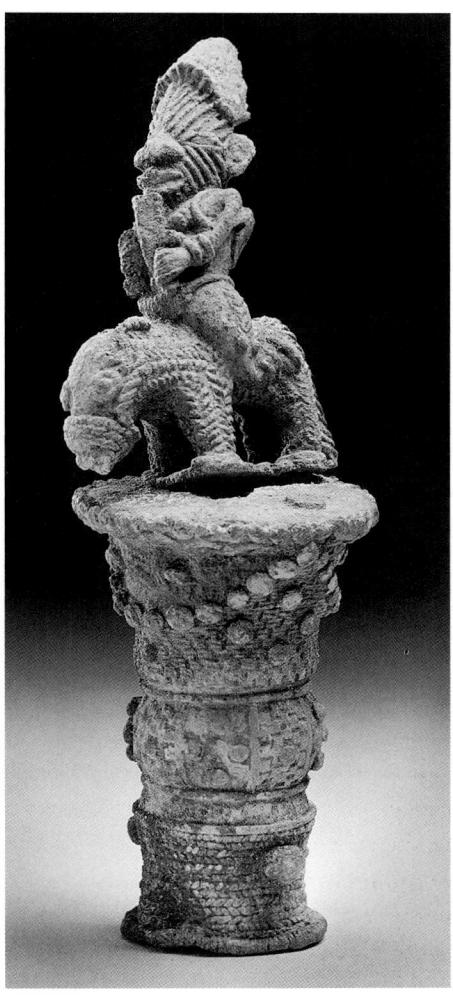

9-20. Staff finial or flywhisk handle, Igbo Ukwu, Nigeria, 9th–10th century ad. Leaded bronze. Height 6 ¾6" (15.7 cm). National Museum, Lagos

terns called *ichi*, which are still linked with both titles and the Nri people. In all likelihood, then, the horseman represents an early Igbo leader. The rendering of the mount, which may be a mule or donkey, is schematic, as if the wax model had been composed of many small rope-like and chevron units. The rider's body too is simplified, and his head is disproportionately large. Yet the skillful handling of detail is remarkable on so small a casting.

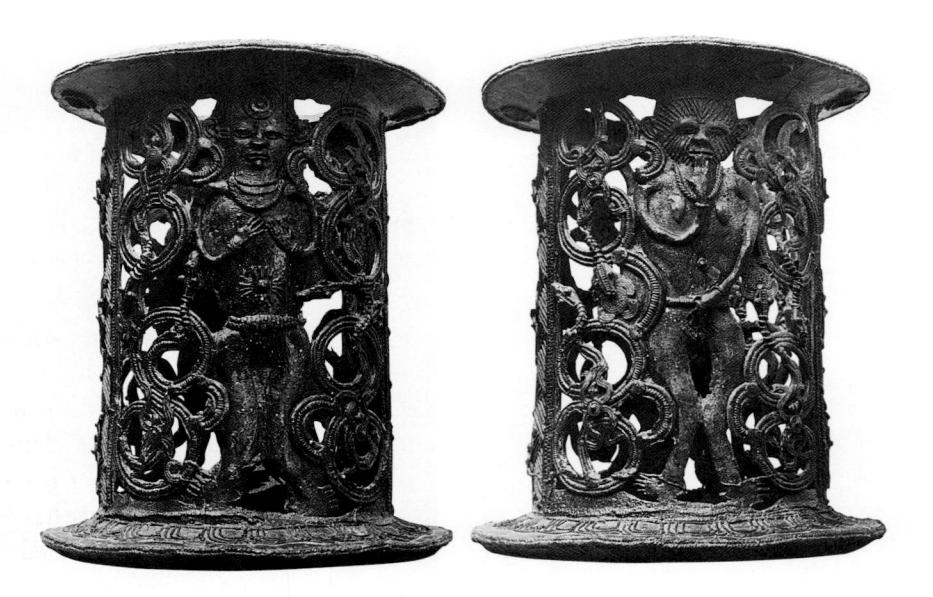

9-21. Altar stand (two views), Igbo Ukwu, Nigeria, 10th century ad. Bronze. Height 10%'' (27.4 cm). National Museum, Lagos

The two human figures stand in an openwork cylinder depicting delicate, curvilinear tendrils—perhaps stylized yam vines—and snakes that grasp frogs in their mouths. It is tempting to associate the amphibians with the putative powers of the Nri king to cause or prevent swarms of harmful insects, birds, and snakes, as well as to stimulate the fertility of plants and animals. Oral traditions report these as ancient Nri powers.

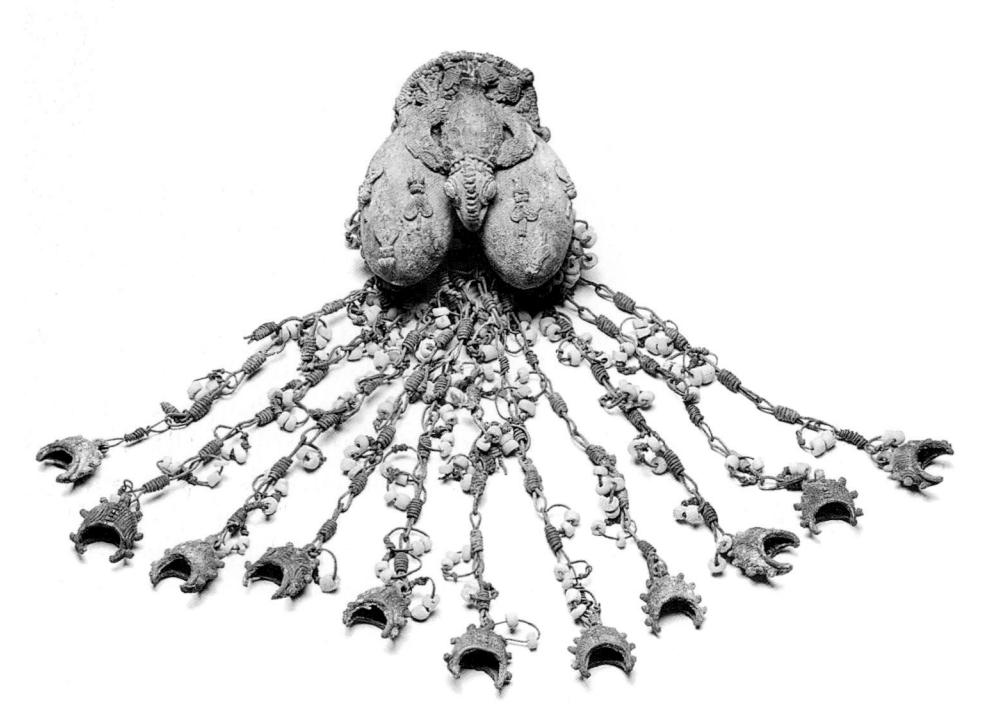

9-22. Double egg with pendant bells and beads, Igbo Ukwu, Nigeria, 9th–10th century ad. Leaded bronze. Height 8½″ (21.6 cm) overall. National Museum, Lagos

The Igbo Ukwu shrine or repository vielded dozens of items, including containers, staffs and ornaments, jewelry and regalia, and finely decorated pottery. Among its treasures was a hollow cylindrical stand depicting a pair of human figures amidst openwork arabesques (fig. 9-21). One of the figures has facial scars like those of the horseman. This elegant stand was probably used to raise a ritual vessel off the ground. The couple may recall Nri creation legends about the first male and female, children of the first legendary king. The king was ordered by God to scarify his children's faces, then to decapitate them and bury their heads as if planting a garden. The planted heads later grew to be the first yams. Thus the technology of agriculture was invented along with yams, the most important Igbo prestige crop. Yam medicines are still prepared by Nri ritualists. The same creation legends relate that Nri people were given the right to confer ichi facial scars, grant titles, prepare vam medicine, and purify the community. While ichi have recently fallen out of favor, contemporary Nri Igbo still grant titles, make medicines, and ritually purify communities.

Another particularly fine although puzzling Igbo Ukwu find depicts a pair of joined eggs with a bird attached on top of and between them—an image that can also be read as male genitalia (fig. 9-22). A number of flies are cast on the eggs and other parts, and eleven bead-decorated chains ending in small bells are attached to the base. The virtuosity and delicacy of this casting would be an accomplishment in any period, but it is particularly remarkable at such an early date. Eggs commonly appear

as fertility symbols in Igbo and other West African rituals, and although the meaning of this particular object remains uncertain, a plausible interpretation is that the egg/bird/genitalia motifs symbolize human (and perhaps animal) fertility and productivity. The sculpture is also a visual pun, and no doubt an intentional one. It was probably used in rituals of increase of the sort more recent Nri kings are known to have conducted.

Also found at Igbo Ukwu was a hollow casting, probably a ritual drinking vessel, in the form of a shell supporting a stylized leopard. A casting depicting a leopard skull was also unearthed near the buried leader. Small pendants depicting leopard, elephant, ram, and human heads were among other regalia unearthed. These leopards and elephants undoubtedly tie in with Nri spiritual leadership and with the practice of title-taking.

RECENT AND CONTEMPORARY IGBO ARTS

Many of the ideas, motifs, and probable rituals that originated at Igbo Ukwu a thousand years ago have persisted into twenty-first-century Igbo art and life. The Igbo today constitute a large, diverse group of agricultural, trading, and professional peoples living in contiguous territory just north of the Niger delta. Though linguistically related, the Igbo (Ibo in earlier publications) were not otherwise unified until grouped together by British colonial officers after the turn of the twentieth century. Egalitarian and individualistic, they strongly resisted pacification and domination by the British. Various Igbo groups have

long histories of warfare against both outsiders and each other. Much of Igboland, too, is heavily populated, and in the past this caused some groups to expand outward, taking over the lands of their neighbors. In precolonial times, then, the Igbo were an aggressive, expansionist people receptive to change, qualities that translate today into the dynamism and progressivism evident in their embrace of Western education and enthusiastic entry into the market economy.

Igbo political structures vary considerably from one area to another. A cluster of villages claiming common ancestry is nearly everywhere the largest political unit. Most of Igboland has never embraced centralized political authority, or even the idea of a single ruler, preferring to vest political power in councils of elders and titled men. The oldest, core area of Igboland (which includes the Igbo Ukwu village group) usually bestows the title "king," eze, not on one person alone, but on several who earn the highest title in a society called Ozo. A few regions, however, have long had chiefs, and a few towns, such as Onitsha and Oguta, have chiefs and kings modeled in part on those of the kingdom of Benin. Even in these areas, though, people normally distrust any individual who gathers very much power. Igbo arts similarly retain a regional character, for apart from personal shrines, most Igbo art is associated with institutions rather than individuals. Art forms are commissioned mainly by members of title societies, by members of religious groups for their shrines and compounds, and by masquerading organizations.

Title Arts

Igbo men and women (in some areas) seeking stature and prestige join graded title societies. These are hierarchical in nature, and only a few people will reach the highest levels in any one community. Visual forms are prerogatives of most ranks, and a person's status is therefore evident from his or her dress, personal adornment, and possessions. The styles and some of the object types are different from those found at Igbo Ukwu, but the practice of visually setting off titled individuals remains the same.

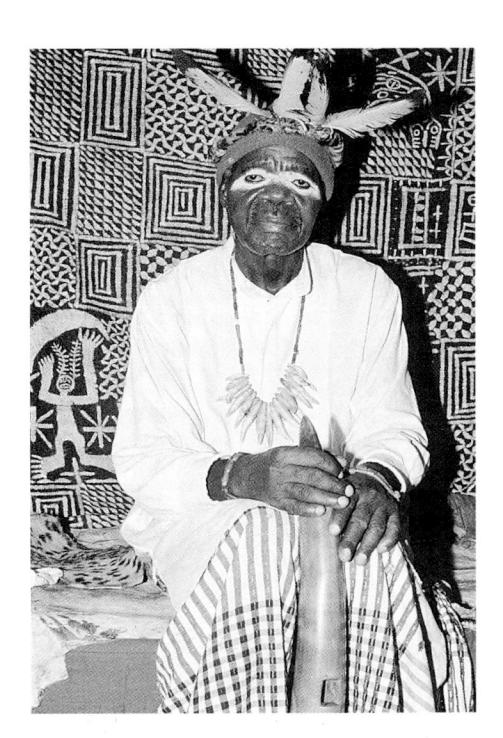

9-23. Igbo man with title insignia, Oguta, Nigeria, 1983

The man shown here, a chief in the Benininfluenced town of Oguta, near the Niger, wears and holds insignia typical of high titles of the central region: an elephant-tusk trumpet, leopard teeth on a necklace, eagle feathers in his knit cap, and a distinctive garment. Titled men possess such art objects as stools, staffs, elephant tusk trumpets, leather fans, and flywhisks, which are carried on ceremonial occasions. They wear distinctive garments, eagle feathers, and jewelry made from elephant tusks and leopard teeth (fig. 9-23). Until recently they wore *ichi*, the facial scars depicted in Igbo Ukwu arts. In most areas, the architecture and decoration of domestic compounds continues to be an indication of status.

In Igboland to the east, toward the Cross River, there exists a different form of title society called Ekpe (or Ngbe). *Ekpe* means "leopard," and graded men's leopard societies are found among several Igbo and other ethnic groups living near the Cross River; in earlier times they constituted the government of their communities (see chapter 10). Nearly all freeborn men of this region join Ekpe. As

in the Ozo society in central Igboland, grade and status levels of Ekpe are marked by art objects and varied sorts of privileges. Among Ekpe's most distinctive insignia is indigo-and-white ukara cloth, worn here by a procession of ranking members (fig. 9-24). Ukara are designed by male Ekpe members, then sewn and dyed by women, whose remarkably precise and detailed work embraces representational motifs, cryptic ideographs called nsibidi (see fig. 10-4), and geometric designs. Most are secret Ekpe emblems only poorly understood by non-Ekpe members.

Celebratory dress for both men and women also includes cursive indigo patterns called *uli*, which are painted on visible parts of the body. In figure 9-25 they are worn by a man and his wife on the day he achieved his high Ozo title. *Uli*

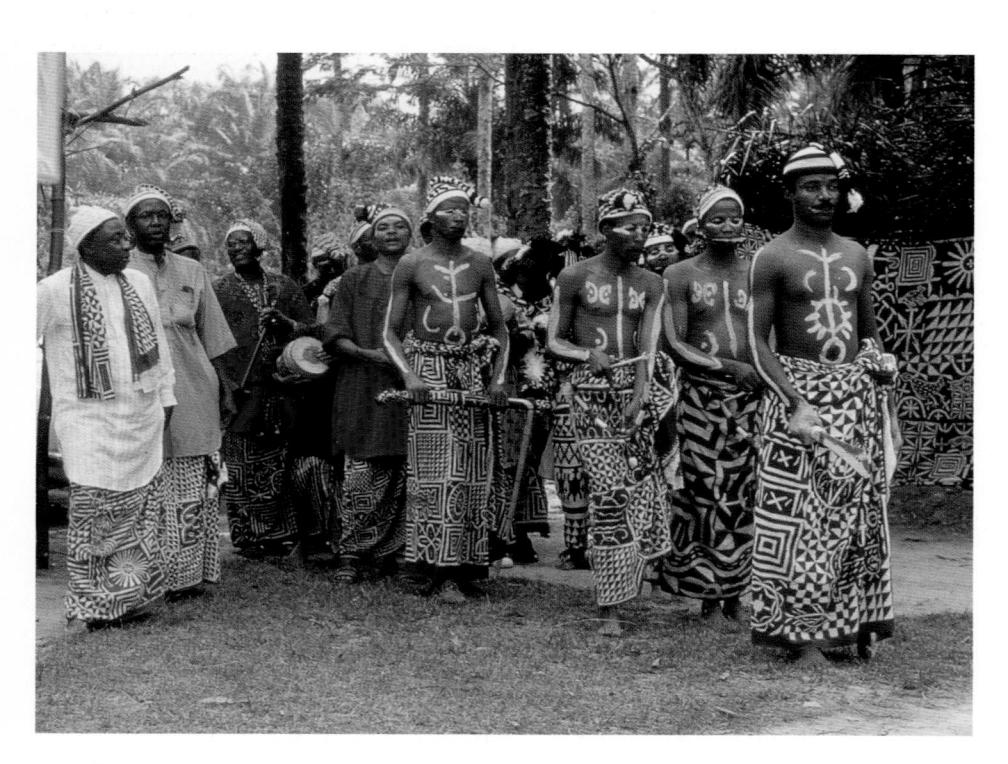

9-24. EKPE MEMBERS IN PROCESSION WEARING UKARA CLOTH, IGBO REGION, NIGERIA, 1988

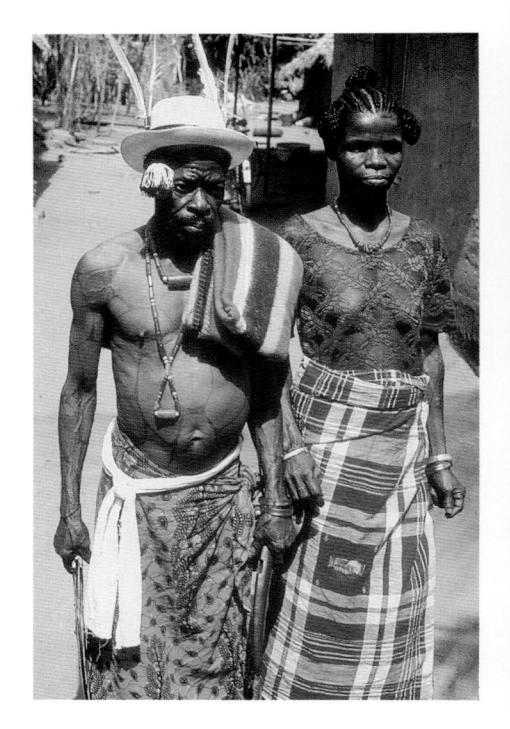

9-25. Ozo titleholder and his wife, Mgbala Agwa, Nigeria, 1983

designs are painted by women, who also paint similar and other motifs in earth colors on the walls of domestic compounds and shrines. Both body and wall patterns are named for various local natural and crafted objects, and while the designs are rarely overtly symbolic, a full catalogue of them includes many things of value, and the extensive corpus of named patterns thus reveals aspects of the Igbo worldview (fig. 9-26).

Until recently, the walls of both domestic and deity compounds were also often painted by women using colored-earth pigments (fig. 9-27). Sometimes, as in this wall, simplified representational images were included along with abstract motifs: a pair of lizards, a coiled python, a humanoid form. This wall was decorated by a team of women each of whom painted one or more rectangu-

9-26. IGBO *ULI* PATTERNS. DRAWING AFTER WILLIS

Uli patterns may be abstract and non-representational, but many are also named by their female painters. Named patterns here are: (a) kite's wing, (b) cloth, (c) lizard, (d) head of kola nut, (e) lightning/thunder.

lar section. The entire surface is unified by the rhythmically repeated sections, the four repeated colors, and the uniform speckling of many larger surfaces. By the 1980s and 1990s, both wall and body painting were deemed "old fashioned" and were largely abandoned. In the cyclical nature of things, however, *uli* was revived, but mainly by male artists, and not on bodies or walls.

Uli and other arts once created by women have served as inspiration for

the work of the renowned Nsukka Group of artists, all but three of whom (Marcia Kure, Ndidi Dike, and Ada Udechukwu) are men. The artists in this group have been associated with the University of Nigeria campus located in the Igbo town of Nsukka, whose art department was revitalized after the end of the Biafran War by Uche Okeke (born 1933). Okeke, one of the artists known as the "Zaria Rebels" because he sought to create art that expressed

a "natural synthesis" of ancestral traditions and modern life, investigated the *uli* painted by his mother. His research into this art form encouraged several generations of students to incorporate the linear styles and even some of the symbols of uli and nsibidi (see chapter 10) into their drawings, paintings, and prints. The Nsukka Group began these explorations during the 1970s, the decade when the Ona Group was studying shrine painting (see chapter 8), the Bogolan Kasobane Group was researching boglanfini (chapter 4), and artist Farid Belkahia in Morocco was experimenting with hides painted with henna (chapter 1). Surprisingly, none of the Nigerian artists was then aware of these similar impulses, in part because communication between art departments and artists on the African continent was so limited during these years.

Okeke has retired from his teaching position at Nsukka, and the senior member of this renowned group of Nigerian artists is now Obiora

9-27. Exterior shrine compound walls, Agbandana Nri, Igbo, Nigeria. Photograph 1983

9-28. Our Journey, Obiora Udechukwu, Nigeria, 1993. Acrylic and ink on four panels of canvas. $6'6 \frac{1}{4}'' \times 21' (2 \times 6.4 \text{ m})$. Collection of the artist

Udechukwu (born 1946). In his painting Our Journey (fig. 9-28), Udechukwu uses the common Igbo motif of a python, shown both stretched out, as if on a journey, and coiled, as if at home. The coiled snake evokes a common proverb, "Circular, circular is the snake's path," which refers to the cyclical, repetitive aspects of life; the stretched out body symbolizes the road of life. Showing faintly through the python's yellow wash are finely drawn scenes of people and events on this road. At the center of the large, four-part canvas are two four-pointed black uli motifs called "head of kola." The motif depicts the four-lobed kola nut, which is considered auspicious when shared at hospitality ceremonies.

Other motifs in this work include both curvilinear body patterns and more rectilinear patterns of the sort carved on the wooden portals of titled men's houses. Until the 1970s the compound portals of men of high title in the central region featured carved and painted doors and side panels in addition to the painted murals described above. As in this example, doors and panels were carved with largely geometric patterns, usually rectilinear, comprised of closely spaced grooves in shallow relief in clay or wood (fig. 9-29). This technique or style in wood is called chip carving, and its hard-edged, tight geometric character contrasts with the looping, cursive quality of women's painted designs. Inside the compound, a lofty thatched roof marked the

meeting house, where the man's title regalia and personal shrines were stored. Such architectural elements have been replaced in recent decades, however, by huge wrought-iron gates with fancy decorations and, inside, a palatial reinforced concrete or cement-block house. Yet the principles of making status visible remain the same, even when the materials and styles change.

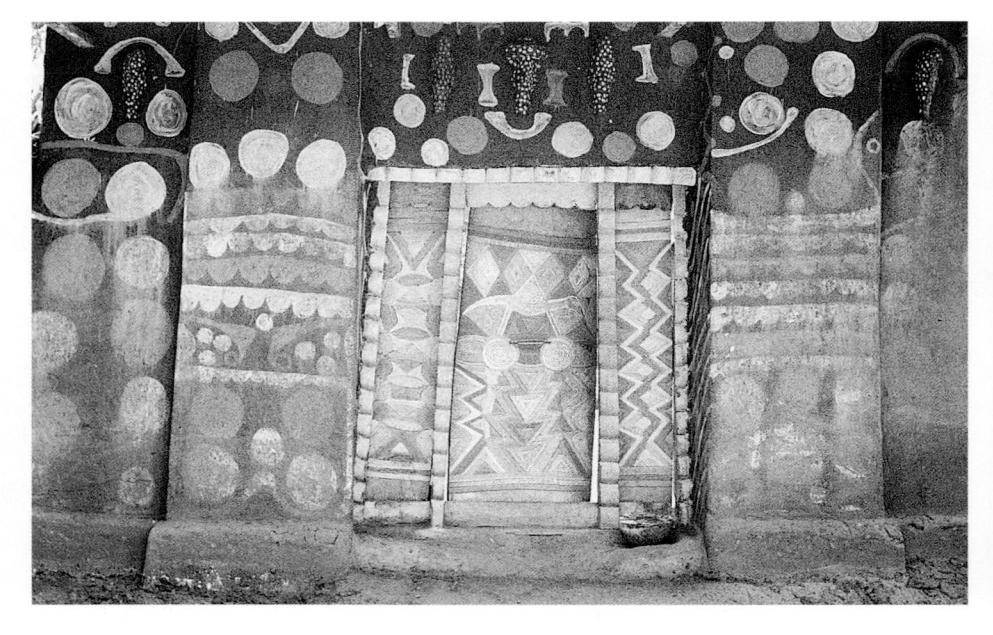

9.29 PORTAL TO THE COMPOUND OF A TITLED IGBO MAN, NNOKWA, NIGERIA. PHOTOGRAPH 1966

Aspects of African Cultures

Mamy Wata

While thousands of Mamy Wata shrines exist in Africa, and each presents a slightly different interpretation of her nature, there is general agreement that she is a foreign, exotic, light-skinned, long-haired, voluptuous, charismatic, and very beautiful woman with a penchant for seduction. Her visual image (reproduced in paintings, murals, and sculpture throughout West Africa) is based upon an early twentieth-century European print (a chromolithograph) which originally advertised the performances of a snake charmer. Her name seems to refer to her role as "Mother of the Waters", and she is said to emerge from springs, rivers, pools, or oceans. In Benin she is the female equivalent of Olokun, and as can be seen in figure 9-30, her shrine shares many features with that of the male deity (compare 9-6). In other regions of Africa, such as the Democratic Republic of the Congo, she is shown as a mermaid, a siren who lures men into her clutches. Elements of Mamy Wata worship link easily to devotional practices of vodun in the New World (see chapter 15).

Although Mamy Wata provides protection, health, and productivity, she has a particular role in the distribution of wealth, which she can bring or take away, and in mental disease, which she can cause or cure. Her concerns are contemporary, such as helping to improve employment opportunities, pass exams, upgrade from a motorbike to a car, or deal with a marital problem brought on by money or jealousy. Although Mamy Wata is notoriously fickle, what she offers people usually depends on how they have treated her, that is: what kinds of offerings they have made to her and to her shrine.

A Mamy Wata shrine in an Igbo community in Nigeria, is an assemblage of items that her priestess (or priest) has collected for her, in part to enrich her environment and attract clients (fig. 9-30). It also includes objects her devotees have given in supplication or thanks. The chromolithograph responsible for her imagery is visible in this illustration on the back wall. This print is a favored decoration of such shrines, along with imported goods having to do with vanity and personal beauty: glittery jewelry, perfume, powder, pomade, and soap. A mirror is usually included, both allowing the vain Mamy

Wata to admire herself, and to represent the miraculous surface of water from which she appears. Mamy Wata also likes sweet drinks and rich foods, candles and flowers, and almost anything of European or American manufacture. Several wood sculptures painted in bright colors are visible on a table at the back of the room. Other presents may include devotional images and objects from Christian, Hindu, and various other religious practices. These are absorbed and reinterpreted as further evidence of Mamy Wata's exoticism and power.

Some Mamy Wata specialists conduct group seances or meet at the waterside for rituals, meals, and dances; they may use paddles, boats, and model snakes or fish as props. Devotees often become possessed by the deity while singing and dancing her praise. Other devotions are more private and meditative. The worship of this modern "outsider" is enormously varied, and it continues to spread. Supremely syncretistic in its ability to absorb and rework local and foreign spiritual symbols and practices, belief in Mamy Wata serves many current needs as Africans deal with foreign problems, products, values, and people. HMC

Shrines and Shrine Figures

Men in many Igbo regions sacrifice to personal altars (see Shared Themes in Lower Niger Arts, pp. 302–03). The most artistically impressive Igbo altars, however, are those that were erected until recently within shrines for deities worshiped either by entire communities or by large segments of them (see Aspects of African Cultures: Shrines and Altars, p. 120). The painted walls illustrated above (in fig 9-27) embellished just such a

shrine. Another shrine serving a group of families (fig. 9-31) contains about a dozen carvings, including personal altars for the two senior male deities and a four-headed image called *ezumezu*, "completeness," representing the four days of the Igbo week and their markets, the cardinal directions, and the auspicious "complete" number four so prevalent in Igbo ritual.

The more figures a shrine contains, normally, the more wealthy and powerful the main deity and shrine are.

Some such gods are well known, often as oracles, far beyond the village group where they are located. In this Igbo shrine there are also "power bundles" of protective materials and staffs for the deities, who are considered to be titled. Ozo status is indicated by depictions of *ichi* scars on the figures' foreheads; the anklets carved on the central male figure also signal status. The Igbo are clear about these figures being representations, not true embodiments. Through them the unseen gods receive small sacrifices

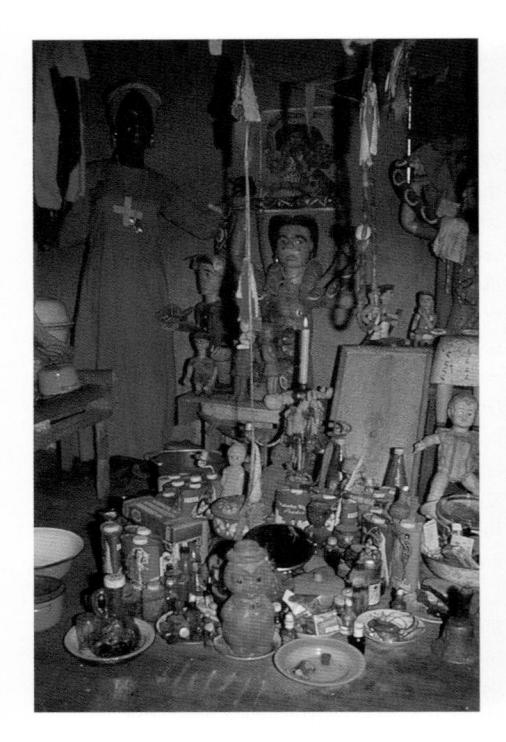

9-30. Shrine to Mamy Wata, Owerri region, Nigeria. Photograph 1974

This Igbo Mamy Wata shrine contains many gifts to the goddess from her devotees, including a copy of the chromolithograph that stimulated the spread of her worship (center, above the large figural carving), smaller carvings, powders, perfume, local plastic and imported dolls, a mirror, candles, drinks, coins, kola nuts, and cloths. There are also basins, plates, and utensils for serving food.

periodically and major ones annually.

The Igbo gods are understood through the model of the family. Larger sculptures represent the more important male and female gods, often considered to be "married" to one another and "parents" of lesser deities. These gods are approachable tutelaries, nature gods such as earth, rivers, and forests, or other features of the local environment such as mar-

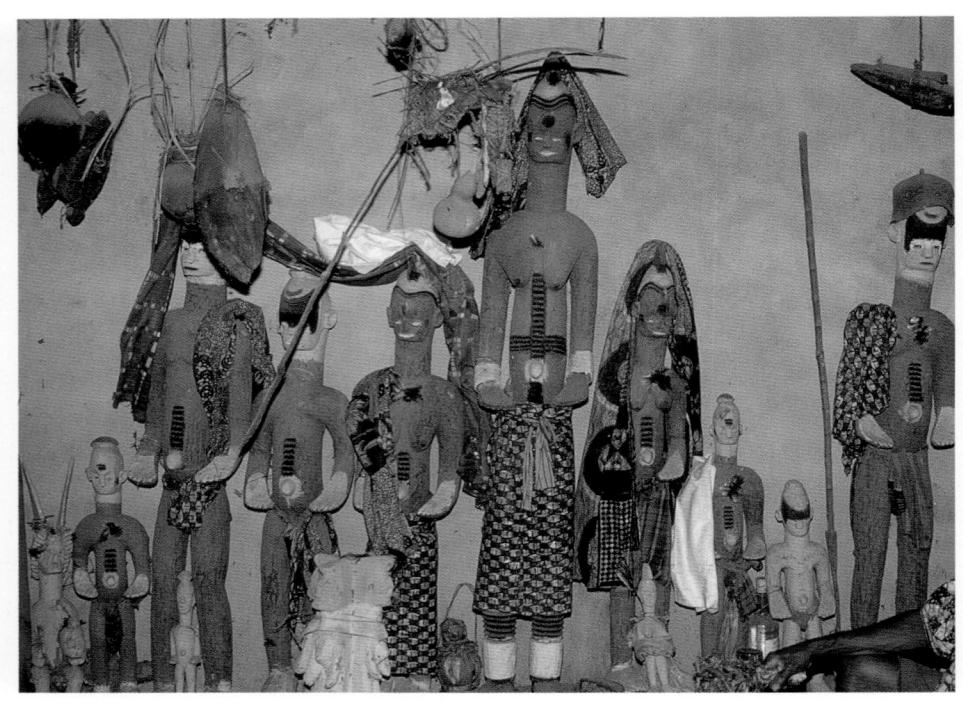

9-31. IGBO SHRINE ALTAR WITH SCULPTURE, OBA UKE, NIGERIA. PHOTOGRAPH 1983

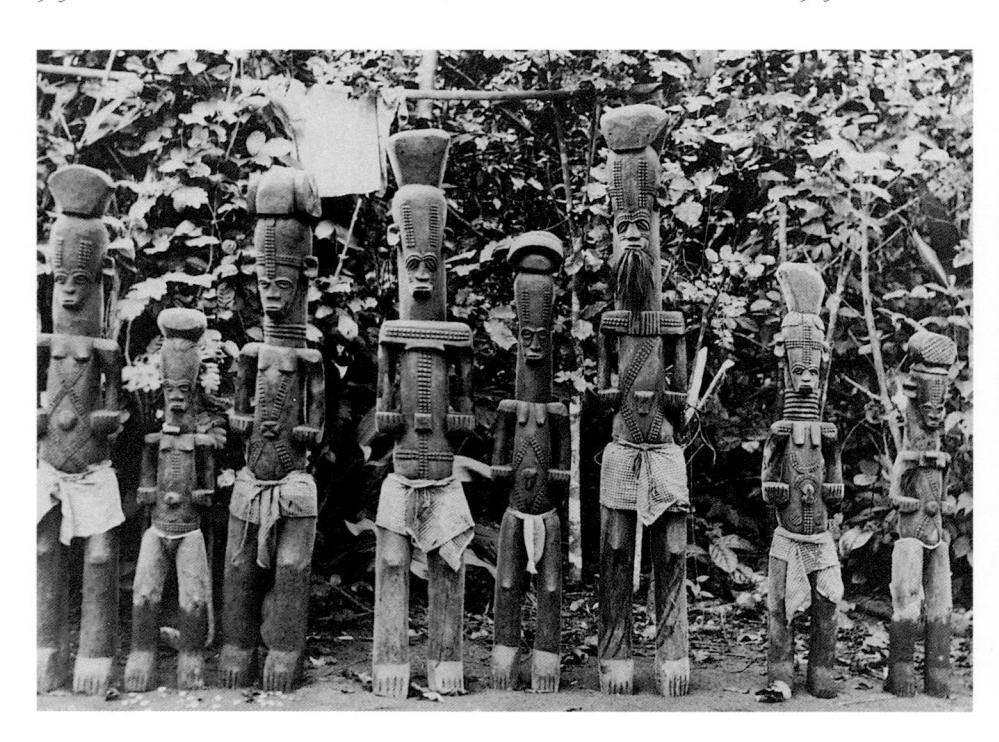

9-32. Display of shrine figures, Owerri Igbo region, Nigeria. Photograph c. 1928

kets, weekdays, and cardinal directions. These deities provide, protect, and heal in return for respect, sacrifi-

cial food, and adherence to their rules. The gods are beneficent or malevolent, depending on how humans treat them, as indicated in central region Igbo style in part by the ambiguous gestures of the figures' forearms and hands: extended to receive gifts, open to show their open-handed generosity. The gesture also means "I have nothing to hide," implying honesty. Carved from hardwoods by men, the figures are painted by women, who also renew their surfaces (and those of shrine walls) prior to major annual festivals for these gods. In another region, the area around the town of Owerri to the south, carvers developed a rectilinear, geometric style (fig. 9-32). Shoulders are squared off, and overall the images are blocky. There are also regional variations in the names and characteristics of Igbo deities, though the family model is widespread.

Mbari

Also in the Owerri region, the most powerful local deities occasionally call for an extraordinary sacrifice in the form of a building called mbari. Mbari are usually built in response to a major catastrophe, such as a plague of locusts or an especially high rate of infant mortality. Filled with painted sculpture, mbari houses require enormous commitments of human effort, money, and time, and thus are never lightly undertaken. Mbari may be dedicated to one of several local tutelary deities, but most are made for Ala, or Earth ("Earth" is as much a principle as a goddess), usually the most powerful local deity. The plan in figure 9-33 records an mbari opened in 1963. It housed seventy-five painted figures.

Very important to *mbari* houses is their ritualized construction process,

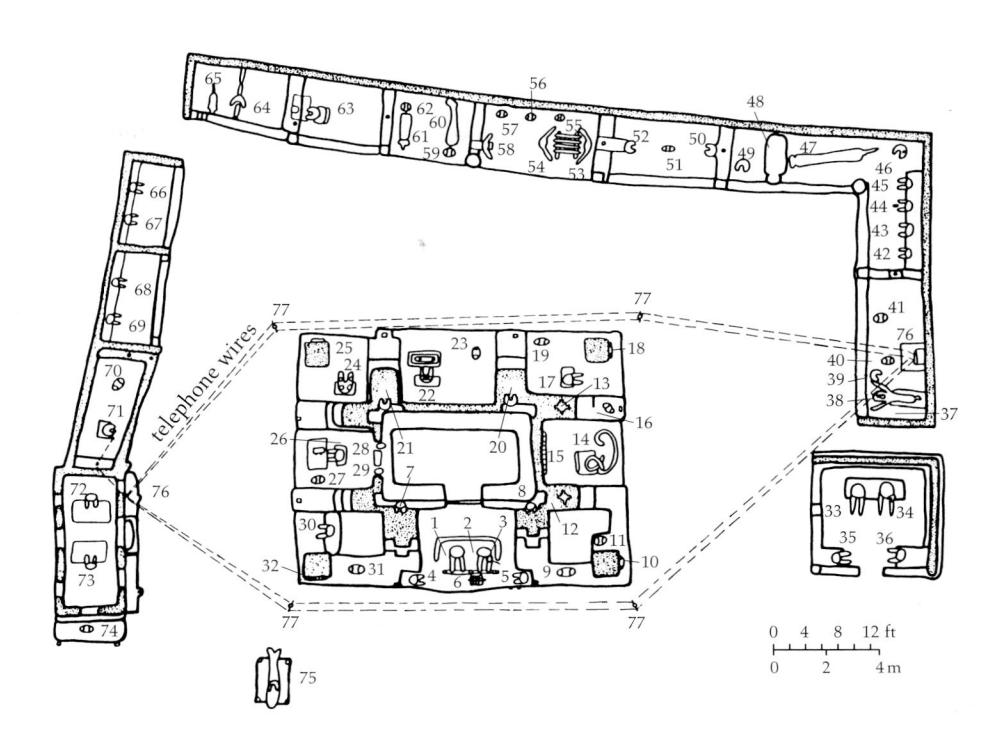

9-33. Plan of the ${\it MBARI}$ to Ala in 1963 at Umofeke Agwa, Nigeria. Drawing by Herbert Cole

1 Ala's husband; 2 Ala; 3 Ala's child; 4 Ala's first son; 5 Ada, Ala's first daughter; 6 tortoise; 7–8 daughters of Ala; 9 police (bodyguard); 10 mbari worker; 11 guitar player; 12–13 guinea fowl; 14 Mamy Wata; 15 python; 16 hunter; 17 Chief Emederonwa (Ala's brother); 18 mbari worker; 19 football player; 20 initiated female mbari worker with mirror; 21 a lady (onye missus); 22 female tailor; 23 a lady; 24 Ala's queen among women (ezenwanyeala) with four children; 25 viper; 26 a father; 27 his son; 28–9 white men; 30 Oriefi Ala (a deity); 31 police for Ala; 32 snake; 33–6 Amadioha Ala (the god of thunder associated with Ala), his wife, his son, his daughter; 37–41 delivering mother, her child (emerging), midwife, standing nurse, standing nurse; 42–5 four spirit mbari workers; 46 orphan; 47–9 leopard, lion, ape man; 50–2 drummer and two dancers; 53–8 musicians and dancers; 59–60 hunchback copulating with a woman displaying herself; 61–2 goat man copulating; 63 man writing a book at desk; 64–5 motorcyclist and dog; 66–7 Odube Ala (a god) and his wife; 68–9 diviner's wife, diviner; 70–1 masker, pretty woman; 72–3 telephone officer, businessman; 74 court messenger; 75 airplane pilot; 76 telephone switchboard; 77 telephone pole

which may last over a year. Constructing a large *mbari* involves at least three professionals: the priest of the deity demanding the *mbari*, a diviner, consulted often about the desires of the gods, and an artist/master builder who designs the building and models much of its sculpture. Most physical labor is done by two groups, several hired laborers and a

larger group of "spirit workers." The hired men dig literally tons of earth from nearby pits and with it form the core *mbari* buildings. The spirit workers, representatives of the town's major lineages, are initiated into the ritual process and work for free. When these workers first enter the *mbari* enclosure they are symbolically killed as humans. Reborn as spirits

these men and women dedicate themselves to serving the god.

The construction process includes a series of rites and events that recall the founding of the human community and its institutions: peace is declared, symbols of the gods are established, a farm is planted, and the cycle of life—birth, death, and rebirth—is reenacted metaphorically through the spirit workers. Numerous animal sacrifices mark the progress of the project inside the fence that shrouds the secret activity from the community, though of course everyone knows that an mbari is taking shape within. After the core building is erected, imported white china plates are embedded in its earthen walls, columns, and buttresses. This process signals the true beginning of the sacrificial activity. Large *mbari* may be embedded with more than four hundred plates, given by all major families in the community. It is now announced that "people are dancing mbari." During this time, at night, the spirit workers go in procession to a "farm" to harvest "yam." In fact they go to a huge termite hill or nest, where they dig deep within to procure its clay.

Termite nests and their clay are sacred to the Igbo, who call these spectacular structures, often six or even eight feet tall, the "porches" of the spirit world. Deceased ancestors are said to reincarnate from these nests, which are held to be both dangerous and numinous, as are all abodes of spirits. Masquerade spirits are said to emerge from the hills when they visit the human community. Notably, too, termite nests house marvelously fertile queens that produce about thirteen million eggs per

year. Termites also tunnel underground for water, and the resulting deep passages attract pythons—Ala's messenger—and other animals. Termite hills, then, are quintessential symbols of fertility and proliferating new life, both major goals of the *mbari* effort.

The harvested termite clay is soaked, then pounded in mortars just as real yam is; the balls of pounded clay "yam," are given to the artists, who model the figures on light wood armatures. Twice processed, by sacred termites and by sacred workers, the clay is both spiritually charged and an excellent medium. *Mbari* artists, like Igbo wood carvers, sometimes achieve local recognition for their considerable skill but neither they nor their patrons care much about the distinctions of individual style, even though these are quite evident to outsiders.

Intended as the "crown of the god," an *mbari* must be beautiful, good, and ritually effective, so it must be a consciously artistic monument. It should be grander than any recent nearby *mbari*, for the Igbo are fiercely competitive in the arts, as in other arenas. The figures are carefully modeled, and all surfaces are neatly decorated with geometric patterns or illusionistic paintings of celestial bodies (sun, moon, rainbow), cloths, or imaginary scenes. No sloppiness is tolerated in modeling or painting.

As an *mbari* nears completion, it is inspected by community elders. Flaws must be corrected before it is unveiled, which takes place in two stages. The first is a midnight ritual when the spirit workers denounce their role in the process and run out through a hole cut in the fence, reborn as people. A few minutes later

the fences are torn down, heaped into piles, then lit, so the new *mbari* is first publicly seen by firelight. The second stage occurs on the next major market day. Spirit workers reassemble at the mbari site, then lead a cow to the market. There they are given gifts and praise for their efforts on behalf of the community. Upon their return to the mbari, the cow is killed in a final sacrifice, after which feasting, drumming, and dancing open the mbari to the public. Visitors come from miles around. A village group will build only one large mbari, on average, per generation, so an opening is a major event, a festival. The deity has embraced the sacrifice, the community has regenerated itself; it has erected a richly inhabited house in honor of its most powerful goddess

Despite its ritualized building process, a completed mbari is a secular monument, at once a microcosm, an art gallery, a school, and a competitive boast. It is really not a shrine, since it is offered in sacrifice and may not be altered. In fact, once finished, it is left to disintegrate. As a monument, it reverses our expectations of closed interior rooms, foregoing an enclosing exterior wall to reveal a series of open niches containing figures and scenes. The one interior space at the core of the central building is not used; its high walls support the roof (see fig. 9-34). The outer walls of this room imply a second story, sometimes with sculpted figures looking out of windows.

A gift for the deity, an *mbari* is meant to be the grandest house in the community. As such, many *mbari* had metal roofs in the 1930s before local people had them. Ala herself, sculpted

9-34. Ala flanked by her "children" and supporters, detail of an Igbo mbari, Umugote Orishaeze, Nigeria. Ezem and Nnaji, sculptors. Photograph 1966

9-35. Cement MBARI House, Owerri region, Igbo, Nigeria, 1982

larger than (human) life-size, presides over the principal building (fig. 9-34). At her side and scattered throughout the *mbari* compound are smaller depictions of community members, spoken of as her "children."

That large mbari are also microcosms is proven by the sun, moon, and rainbow sometimes painted high on a wall, and by the great variety of modeled subjects. About these an elder said, "You will come to understand that they put four things into mbari: very fearful things, things that are forbidden, things that are very good [and/or] beautiful, and things that make people laugh." Here then is the richness of life itself, for what cannot be included in one or more of these categories? The mbari to Ala at Agwa (see fig. 9-33) contains among its seventy-five figures an office building with a telephone operator nearby and four telephone poles wired with strings, an airplane (on stilts), several birds and animals, and a maternity clinic with nurses and a woman giving birth. Mbari imagery is drawn from real life, artists' dreams and imaginations, folklore, and history. Some subjects are clearly didactic; parents bring children to mbari houses expressly to teach them about the past, about the gods, and about unacceptable behavior. Things only heard about or hoped for are also included. The maternity clinic modeled in the Agwa mbari was built in that community a few years after the mbari was unveiled.

During the late 1960s the building of all but very small *mbari* ceased due to both extensive conversions to Christianity and the Nigerian Civil War (1967–70). Exceptions to the virtual demise of the *mbari* tradition are

two middle-sized mbari houses built during the 1970s out of cement (fig. 9-35). Commissioned by the government rather than asked for as sacrifices by local gods, these two mbari preserve some of the forms of earlier ones but few of their spiritual values, except as "illustrations." One, for example, contains a cement image of a termite hill, as if to remind the audience of the materials from which mbari figures used to be made and of their spiritual symbolism. Unlike earlier *mbari*, these cement compounds will not decompose, returning their sacrificial "yam" to the goddess Earth to complete the cycle of birth, death, and regeneration. Nevertheless, they are manifestations of efforts being made in many parts of the continent to preserve or revitalize earlier cultural patterns that the engagement with modernity has suppressed or eliminated.

Ugonachonma

Mbari houses, made only in the Owerri area, are surely artistic displays because their patrons are explicit about wanting beautiful works of art. Artists in the central Igbo region (around the Igbo Ukwu sites) also created display figures in wood (fig. 9-36). Called ugonachonma, meaning "the eagle seeks out beauty," these wholly secular figures contrast with those carved for shrines (see fig. 9-31) in being far more lifelike, although the exaggeratedly long neck, considered by the Igbo an attribute of great beauty, indicates that ugonachonma are not without their conventions. Also beautiful are the delicate raised keloidal scars that are depicted running from the girl's neck to her navel

9-36. Ugonachonma (display figure, "the eagle seeks out beauty"), Igbo. Wood, pigment, mirror. Height 50" (1.27 m). Seattle Art Museum. Gift of Katherine White and the Boeing Company

and the enlarged navel itself. The figure has the ample fleshiness of a marriageable teenage girl. The carved versions of brass leg coils, armlets, and hair mirrors indicate that she comes from a wealthy family. She carries a mirror in a carved frame in one hand and what was originally an umbrella in the other, both linked with vanity and prestige. The white face exagger-

ates the Igbo preference for light-colored skin and evokes the practice of washing dark skin with a chalky solution to create a contrasting ground for celebratory indigo *uli* patterns, which are also painted here. The figure's crested hairstyle is of the sort evoked in countless masks.

Ugonachonma served as centerpieces for largely secular age-grade dances for both men and women. Some figures depict male-female couples, but most, like the example here, depict a beautiful young woman. In Igbo thought there is a connection between such youthful maidens and older titled men. Both are beautiful in their respective ways; both too are linked with eagles. The man is "the eagle that strengthens kinship," a praise name for titled men. He is also "the eagle that has flown very high seven times," a proverb that alludes to the sevenfold cycle of killing that an eagle is said to undertake to achieve its radiant whiteness, which in turn is a reference to the successive moltings eagles undergo, starting out gray, ending up pure white as they grow older. Maidens, on the other hand, are praised by being called "eagle's kola," after the rare, prized form of light-colored kola nut shared at every Igbo ceremony.

The titled man, then, is the predatory eagle, king of the sky, aggressive warrior, competitive and ruthless in his quest for trophies and stature. He wears white eagle feathers to show his ritual purity, strength, and high status. His is the "beauty of power," whereas the maiden, serene and cool, shows off the "power of beauty," for she is ripe and ready for motherhood and finely painted with *uli* designs. Both power and beauty are desirable ideals, and both are achieved, if differently, in

these complementary male and female notions and the art forms that embody them—the *ugonachonma* as they represent women, and title arts for men. Notably, the Igbo combine the instrumental and the contemplative in their aesthetic notions, as exemplified by the reciprocal phrases, the "beauty of power" and the "power of beauty." The same ideas are seen in masquerades.

Masks and Masquerades

Igbo masking became progressively more secular with the march of the twentieth century. Before 1900 and early in the colonial era, powerful masked spirits, deputized by elders, frequently had broad governmental authority, policing, fining, and judging. Most of these roles were taken over by British colonial authorities; after the recognition of Nigerian independence in 1960 they passed to the Nigerian government. Yet some masks radiate an aura of power even today, and many still have locally effective regulatory roles. Masks satirize unacceptable behavior, for example, and provide models of both male and female ideals. Indeed, if there is an overriding theme in Igbo masking it is gender relations. Even though nearly all masquerades are male constructions and instruments, many glorify women, praising their grace and beauty in contrast to a somewhat ironic celebration of masculine aggression, power, and even ugliness. Masking thus clearly separates the genders. Excluded from most masquerade activity and oppressed by certain masquerade characters, women generally keep their distance when maskers are abroad.

One masquerade that is still per-

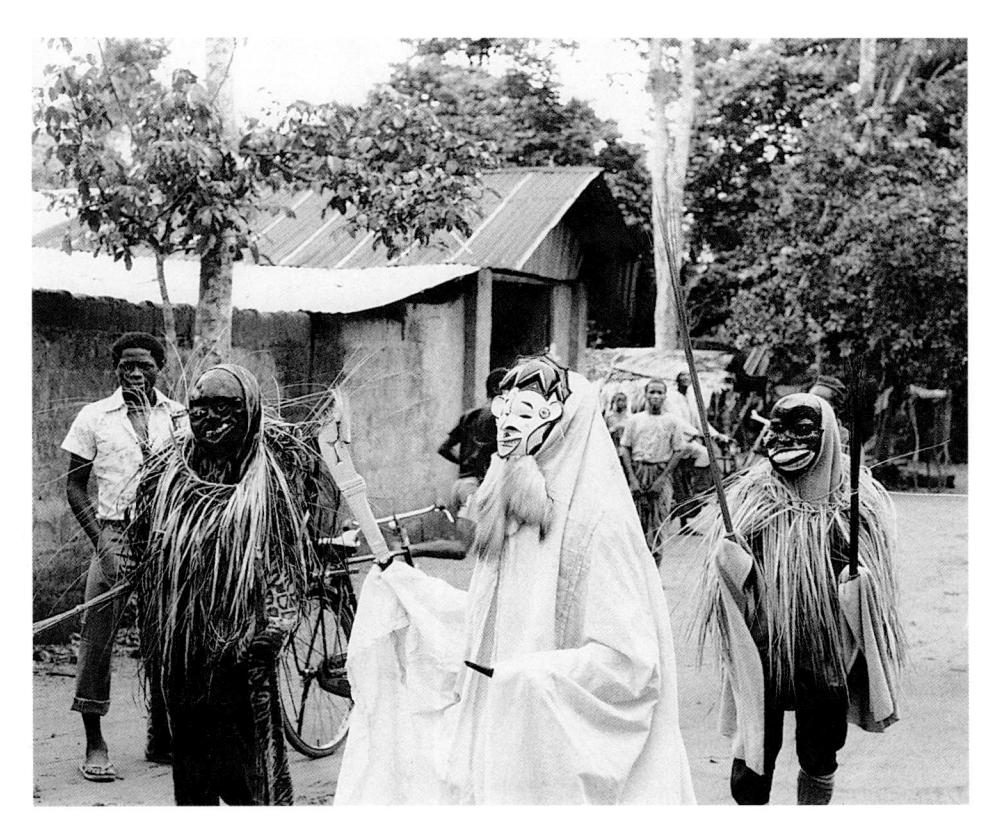

9-37. Female (Light) and male (Dark) Igbo Okoroshi Maskers, Agwa, Nigeria, 1983

formed over a fairly broad area near the southern town of Owerri is okoroshi. There are several regional variants of the masquerade. The version discussed here opposes two classes of masks: white or light masks, and dark ones (fig. 9-37). The small light masks, carved with refined delicate features, manifest female spirits. The larger dark masks, often carved with grotesque features, manifest male spirits. This dualistic, complementary opposition characterizes much masking among the Igbo and their neighbors in southeastern Nigeria. The masks are further associated with similarly opposed realms. In the communities where this version of okoroshi is danced, for example, masks evoke these contrasting overtones:

female (light) beauty, purity village, safety daytime, daylight order, clarity

peace, calm

male (dark)
ugliness, dirt
bush, wilderness
nighttime, dark
chaos, obscurity,
mystery
danger, conflict

Okoroshi maskers come out during an annual, six-week masking season. Female masks, water spirits said to be descended from benign white cumulus clouds, normally dance prettily in large arenas for people of all ages. Their lyrical songs are about love and money and beauty. Only a few such masks appear during the six-week season, and only on a few days. In contrast, dozens of dark masks, representing water spirits descended from threatening gray

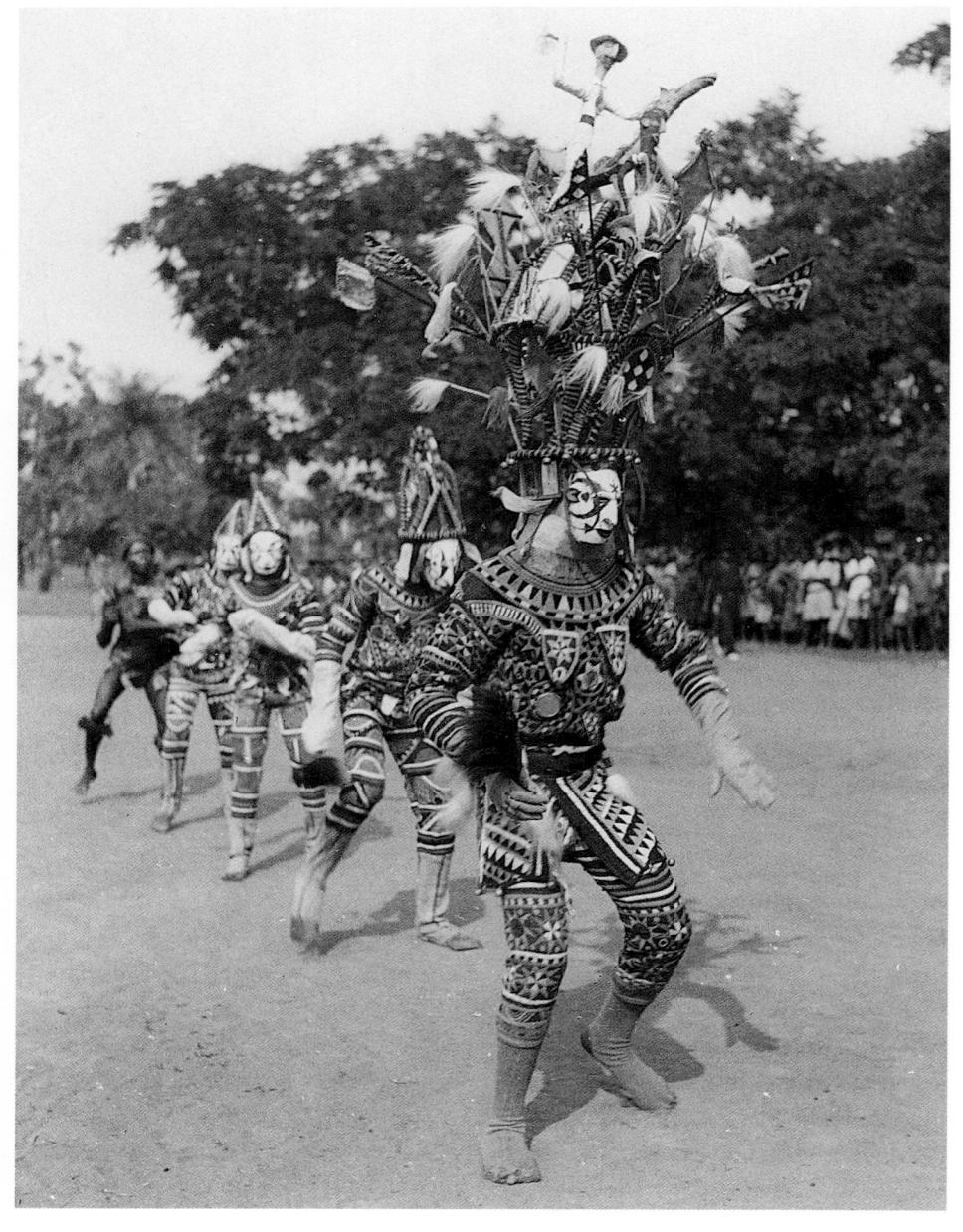

9-38. IGBO MAIDEN-SPIRIT MASKERS NEAR AKWA, NIGERIA, C. 1935

rain clouds, appear day and night, rain or shine, nearly every day. The forms of these dark masks and the names of the spirits they manifest are markedly diverse. In this one community alone, they are variously named for plants, birds, animals, and insects, for natural phenomenon such as rivers and lightning, for human types or behaviors, for

artifacts, emotions, abstract ideas and conditions, and for proverbs such as "Earth swallows beauty" or "Death has no friend." Taken together these names embrace very broad swaths of human life, activity, and nature. They constitute a kind of verbal text that expresses the breadth of ideas found in *okoroshi*, at least in this one community.

Most dark masks are runners and chasers, worn by younger men who direct their energies toward women and children. Near the end of the season, several ritually powerful, "heavy" dark masks come out, often with an entourage of male followers carrying clubs and singing dirges about war and conquest. These masks are three or four times as big as other dark masks, and most have strongly distorted, enlarged, often asymmetrical features, perhaps with snaggle teeth or open sores.

Rarely do light and dark masks appear together as in figure 9-37, so their "beauty/beast" opposition is mostly a conceptual one played out over the course of the masking season. This opposition is also deliberately violated in several ways. One of the white masks has horns, a black beard, and wears short pants, so he is a male among females. A few of the dark masks are named for women. And on the final evening of the season a masker called Paddle appears, wearing a white mask and long pants. He/she is the only masker to sing or speak, and in contrast to other white masks who dance in bright daylight, he/she emerges at night. Considered both a wise old man and a foolish young virgin, Paddle sings praises of the great local families while moving from compound to compound blessing all pregnant women. Paddle and other ambiguous spirit characters appear to blur neat categories, as if to suggest that life is composed of varied shades of gray rather than overly simple white/ black, good/bad oppositions.

The six weeks of *okoroshi* masking occurs during the heavy rains.

Okoroshi water spirits bless the

ripening yam crop and prepare the community for the ritual presentation of new yam, which is ceremonially eaten on the day after all okoroshi have departed for their homes in the clouds. People say, "Okoroshi marks the calendar." While its major purpose seems to be to foster productivity of both the fields and women, it also comments on gender behavior and roles. Men say that women are honored by the masquerade, yet they are also chased and harassed, so the women themselves find masking more tiresome than adulating. Through the masquerade, men characterize themselves as dark and often ugly, and life itself as both complex and difficult-more dark or shades of gray than pure white.

About one hundred miles north of Owerri, in the core central Igbo region, an analogous masking tradition conceptually opposes pretty maiden spirits to horned, grotesque, masculine masks, the latter known generically by their most prevalent name, mgbedike, meaning "time of the brave." The white maiden masks, all danced by men, have superstructures of several types, indicating spirit characters of different ages (fig. 9-38). The eldest daughter, called Headload because of her mask's large figured superstructure, leads the others. Her vounger sisters, following, have elaborate crested hairstyles and small pointed breasts. All wear bright, polychrome appliqué cloth "body suits," whose patterning loosely recalls monochromatic designs painted on voung women and female sculpture (see fig. 9-37). Other characters in the drama are a mother, a father, sometimes an irresponsible son, and a suitor costumed as a titled elder, whose

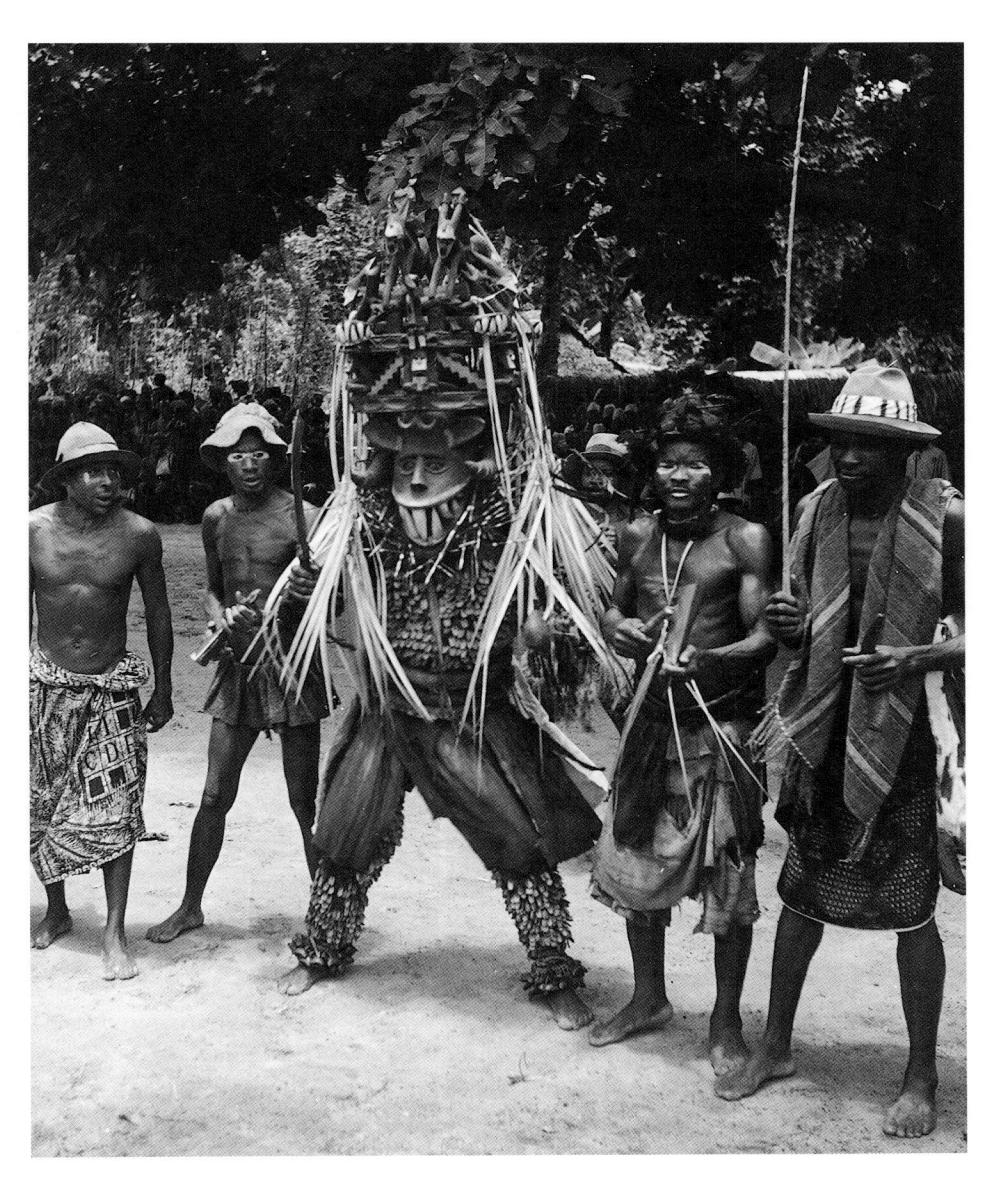

9-39. IGBO MGBEDIKE ("TIME OF THE BRAVE") MASKER NEAR AKWA, NIGERIA, C. 1935

amorous, often bawdy advances to one or more of the "girls" are invariably rebuffed. The play unfolds predictably, with the maidens' dances becoming ever faster and more virtuosic as the maskers compete with one another for audience approval and even financial reward.

Mgbedike, on the other hand, are large masks with bold, exaggerated features, usually including open,

snaggle-toothed mouths and horned superstructures (fig. 9-39). While they do not dance in the play described above, in evoking aggressive and powerful spirits and being danced by middle-aged men, they are linked with—and oppose—the maidens. As in the opposition discussed earlier of titled men and ugonachonma figures, power here contrasts with beauty. Power is implied by the horns and

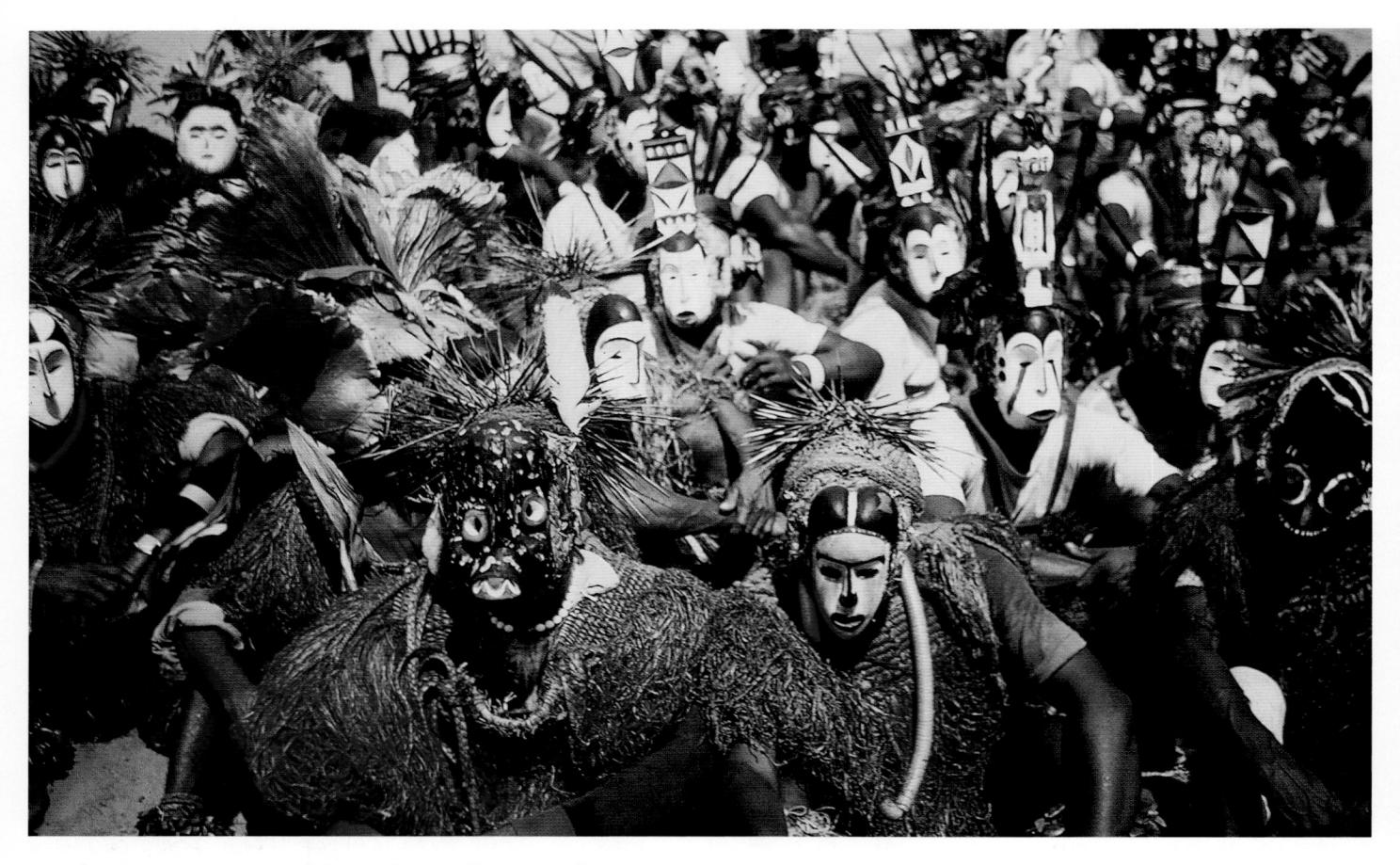

9-40. IGBO MASKING FESTIVAL, MGBOM AFIKPO, NIGERIA, 1960

teeth of the mgbedike mask, by its enlarged features, and by its ponderous, aggressive dancing style. Beauty in the female masked characters is expressed by their more elegant, lyrical dancing and by the masks' refined facial features, delicate openwork hairstyles, and colorful bodysuits. As in okoroshi, these masqueraders play out gender roles, at times caricaturing them, at times idealizing or mirroring them in dances calculated primarily to entertain. There is no strong ritual component to this masquerading, even though the maskers are considered spirit beings.

Literally hundreds of distinct Igbo masquerades exist, so it is surely a misrepresentation to reduce them to

oppositions between dark males and light females. Among the eastern Afikpo Igbo communities, for example, more than a dozen kinds of masks are danced in several separate masquerade genres, some for an audience of men only, others for splendid public festivals (fig. 9-40). All masking is sponsored by male initiation societies. There are skits providing topical social commentary and criticisms of elders' behavior. Other playlets address foolish, dishonest, or greedy men or women, naming individuals, who are even supposed to reward the masked players with money! Some songs and dialogues are set pieces repeated from past years, while others are newly composed. Another mas-

querade presents a parade that, like okoroshi and the iconographic programs of *mbari* houses, represents an exceptionally broad range of local types past and present, including foreigners such as Muslims, Hausa cattle herders, and white district officers. Afikpo initiations also involve extensive masking; sometimes leaf, fiber, and grass masks are used, or masks made from gourds, while carved wooden versions cover a range of human and animal types. The diverse masks of Afikpo comprise but one of more than a dozen regional mask traditions, each with dozens of spirit characters.

One truly exceptional Igbo mask can be seen as the "crown" of all

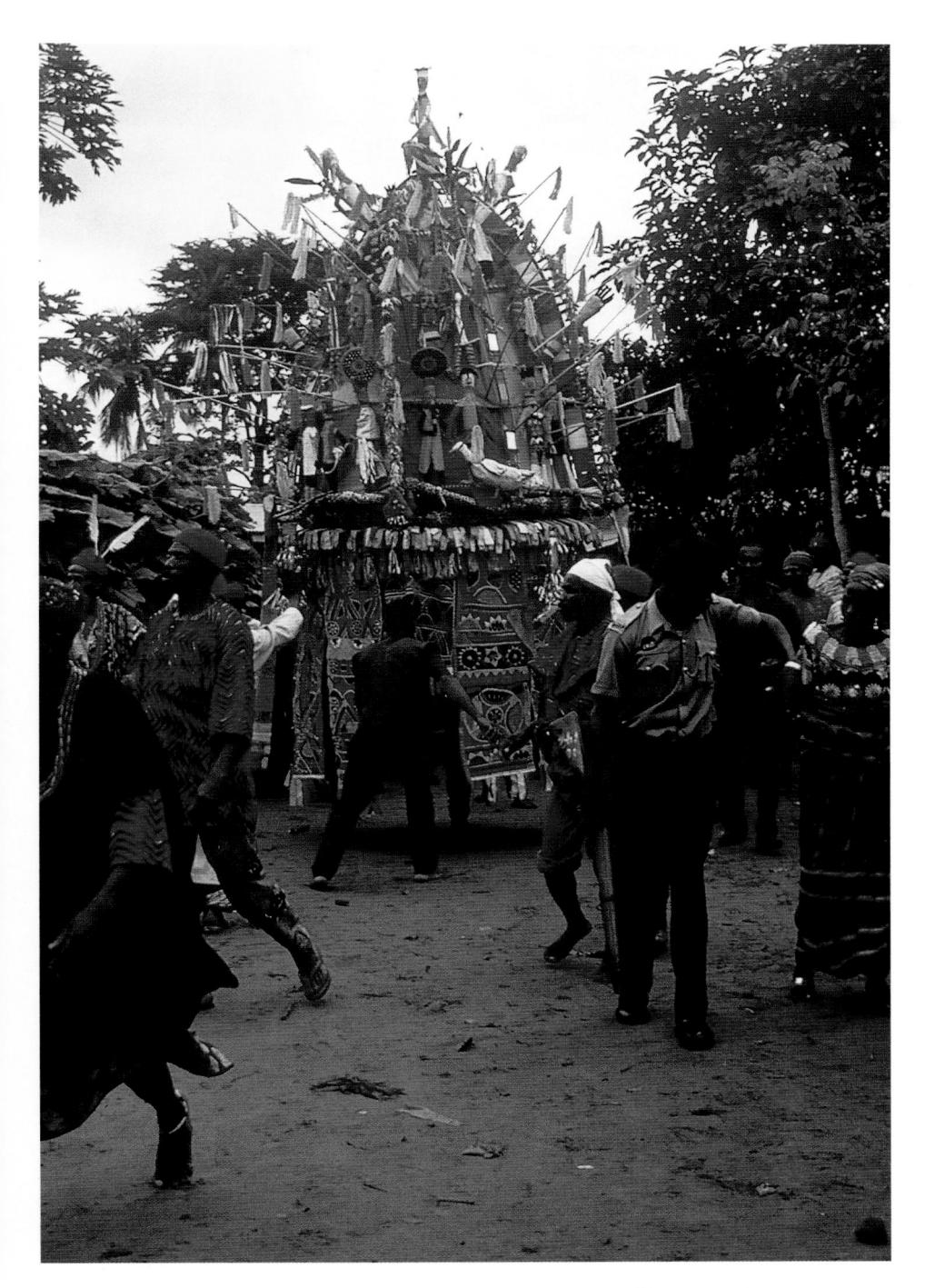

9-41. IJELE MASK AT AN IGBO SECOND-BURIAL CEREMONY, ACHALLA, NIGERIA, 1983

In its dazzling complexity and size, an ijele combines most of the important or "root" symbols of Igbo thought either explicitly (images of elephant, eagle, leopard, python) or metaphorically (great sheltering trees with flowers and fruit, high human status and titled leadership, ancestor veneration, spirit anthills and their abundance, wealth, and the richness of nature and everyday life). Foreign ideas and materials too, so readily embraced by the Igbo, are present in mirrors, imported cloth, images of colonial officers, and the horseman (or, recently, an airplane) that surmounts most ijele.

other masquerades from the lower Niger area. This is *ijele*, whose praise names include "great spirit," "elephant," "king of masks," and "ijele, the very costly" (fig. 9-41). Constructed of light wood and covered in multicolored cloth, an iiele may be sixteen or eighteen feet tall and seven or eight feet in diameter. It weighs about two hundred pounds, vet it is danced by a single individual. The base is a disk of wood that ultimately rests on the dancer's head. On this disk sits a red cloth cone, from which a slender mast, understood as the trunk of a tree, projects upward, stabilized by two openwork arches intersecting at right angles at the top. Densely crowded into the "branches" of this metaphorical tree are many mirrors, hundreds of tassels, streamers, flowers, and dozens of multicolored, stuffed figures. Figures of an elephant, leopard, and eagle are usually found, as well as a variety of human types, genre scenes, and small versions of other masks danced in the region. The assemblage, constructed by male tailors, is completed by a long stuffed cloth python tied on to encircle the wood base, from which hang more tassels and twelve appliqué panels. These in turn recall the bright "body suits" of maiden maskers also featured in these communities (see fig. 9-38). Ijele moves in quite a spirited fashion, with dips, shakes, and twirls, its panels flying outward. The effect is dazzling.

In times past an *ijele* came out only for the funeral of an exceptionally well-respected, wealthy, and prolific titled man. The mask's great stature and status are suitable for such an event; its iconographic program brings together several

metaphors of human leadership and spiritual power. First, it is an aggrandized version of the colorful crowns worn by rulers in the city-state of Onitsha (along with Oguta, one of the few Igbo communities traditionally ruled by a single chief). The red cloth cone, out of which the "tree" grows, simulates a termite hill with all its attendant symbolism and spiritual associations. Trees, especially large old ones, are multidimensional symbols of leaders, who customarily convene councils of elders and titled men beneath their sheltering branches. Impressive trees are often the sites of shrines to nature deities as well. When an important person dies in this region it is said that "a mighty tree has fallen." Trees provide many human needs, from building materials to edible fruit, and as "trees of life" they are prominent symbols of growth. An ijele is usually also anthropomorphized, with a stylized face on one of its panels and two large arms projecting outward from the "tree". In this guise, ijele is a great ancestral spirit who has emerged from a termite hill to honor the deceased elder, to welcome him to the land of spirits. Ijele has a dozen or more black and white "eyes," called "danger," that recall the multifaceted eyes of insects. It is as if the many watchful eyes of the spirit world are there to survey the living human community.

Ijele are such strong magnets for crowds that they have recently been commissioned by politicians, who hire maskers to dance them expressly to rally supporters. The symbolic presence of *ijele*, then, has changed, yet they retain commanding powers in contemporary Nigerian life.

SHARED THEMES IN LOWER NIGER ARTS

In addition to their own distinctive art forms, two of the largest ethnic groups of the lower Niger, the Edo of Benin and the Igbo, have several important forms in common, which they share as well with many smaller neighboring groups such as the Ibibio, the Ijaw, the Urhobo, the Isoko, the Igala, and the northern Edo Okpella. These shared forms include personal shrines or altars, light/dark mask complexes, and hierarchical groupings of figural sculpture.

Personal Altars

Men among several ethnic groups commission (or used to commission) personal altars, to be dedicated and consecrated to their personal strength, success, and accomplishments, and sometimes as well to their protection. Warriors, farmers, traders, smiths, and others prayed and sacrificed to these altars before important undertakings, offering further gifts after meeting with success (or sometimes berating the altar after failure). The Igbo, who have the greatest numbers and most variable forms of personal altars, call them ikenga, the Igala know them as okega, and among the Edo of Benin the term is ikengobo. That these names are cognate virtually proves a historical relationship, even if scholars are uncertain which of the three groups originated the idea.

Personal altars among these three groups are dedicated to the hand, specifically the right hand (and arm) among the Igbo and the Igala. Strong hands and arms are agents of physical prowess, necessary for success in such activities as hunting, farming, and

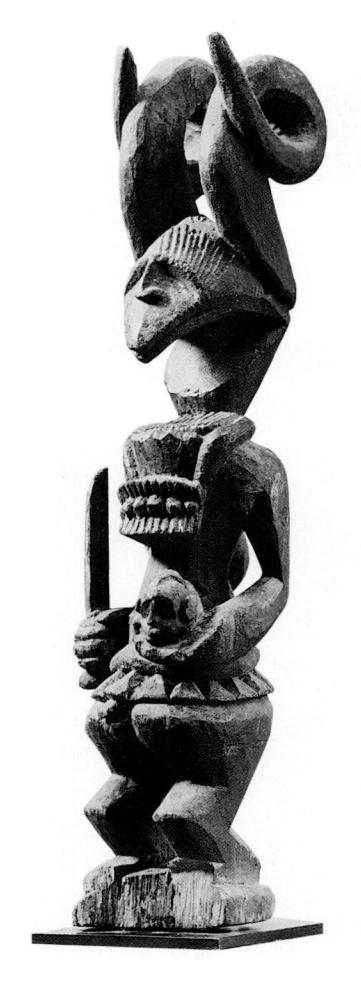

9-42. *IKENGA* (PERSONAL ALTAR), IGBO, 19TH–20TH CENTURY. WOOD. HEIGHT 19½" (49.53 CM). THE METROPOLITAN MUSEUM OF ART, NEW YORK. THE MICHAEL C. ROCKEFELLER MEMORIAL COLLECTION PUR-CHASE. GIFT OF JOHN R. H. BLUM GIFT 1971

warfare. The iconography of many altars reflects these associations. Igbo *ikenga*, for instance, typically show a horned warrior holding a knife in his right hand and a human trophy head in his left, symbols probably established long ago when the Igbo were active head hunters (fig. 9-42). Similar iconography appears in some Igala *okega*, although the one shown here, like many Igbo examples, depicts only a horned head above a

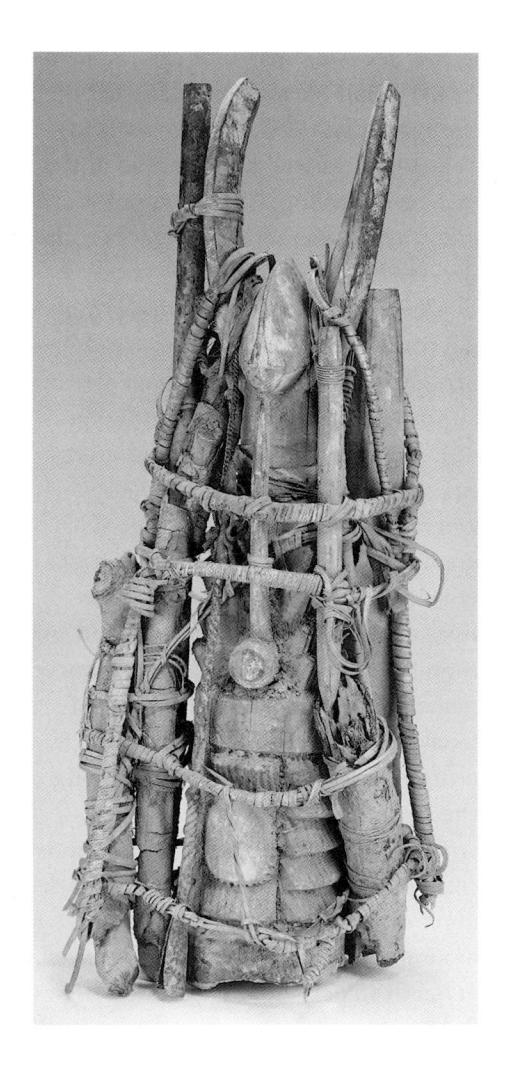

9-43. OKEGA (PERSONAL ALTAR), IGALA, NIGERIA, EARLY 20TH CENTURY. WOOD, FIBER, PIGMENTS, KAOLIN, STRING, IRON. HEIGHT 24½" (62.2 CM). NATIONAL MUSEUM OF AFRICAN ART, SMITHSONIAN INSTITUTION. GIFT OF ORREL BELLE HOLCOMBE IN MEMORY OF BRYCE HOLCOME

This particular okega retains the heads of some animals that were sacrificed to it. The heads were probably lashed on to advertise and increase the altar's powers.

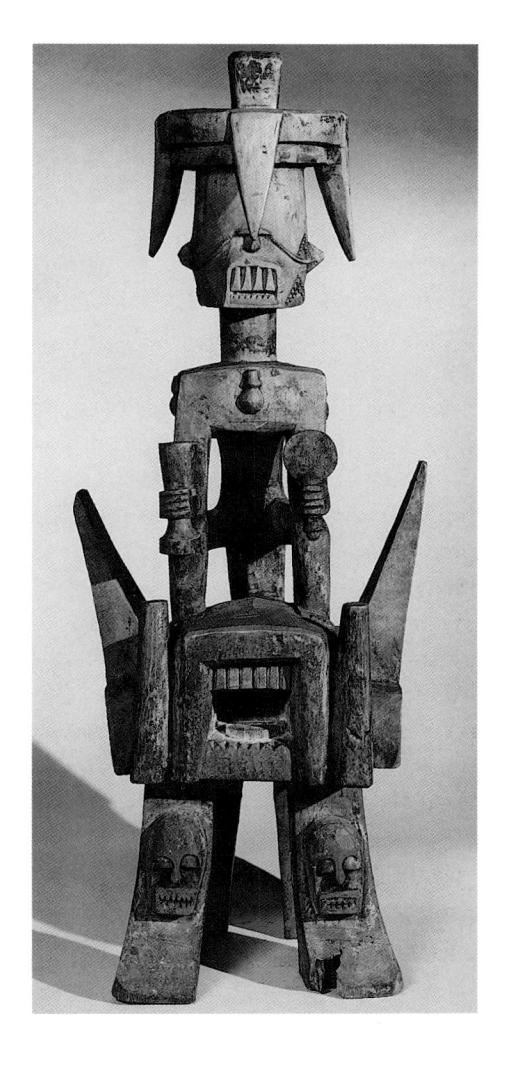

9-44. *Ivri* (personal shrine), Urhobo, Nigeria, 19th century. Wood. Height 39" (99 cm). The British Museum, London

geometrically abstracted, spool-like body (fig. 9-43).

Horns are the most essential feature of Igbo and Igala altars to the hand. Some are straight, others are spiral, still others are fancifully curved and elaborated with perching animals. All are commonly referred to as ram horns, even though they often do not resemble them. Yet since virtually all animal horns are power symbols, an identification with a specific animal hardly seems imperative, for it is animalistic aggression in general that is evoked.

A richly figured, texturally sumptuous, cast copper-alloy *ikengobo*

from the court of Benin includes depictions of right and left hands in its lower zone, where they alternate with the heads of miniature leopards and cows, the latter sacrificed to help insure success (fig. 9-1). The figures depicted in relief on the side of the altar, as well as the three that crown its top, depict the king flanked by attendants, a typical motif from this culture's courtly tradition, which repeatedly emphasizes the centrality of its ruler.

Lesser Benin chiefs and ordinary men also used to commission *iken-gobo*. These were generally carved of wood, although several cast metal examples are known. Most are crowned with a spike on which an elephant tusk was almost certainly displayed, echoing again the theme of the animal horn familiar from Igbo and Igala examples.

Very similar personal shrines are found among the Isoko and the Urhobo, Edo-speaking peoples living south of Benin. They prominently display the horns and teeth of imaginatively conceived (and unidentifiable) quadrupeds. These altars, both called *ivri*, explicitly merge human and animal imagery. In large Urhobo altars, the animal is often dominant (fig. 9-44). Here the animal prevails

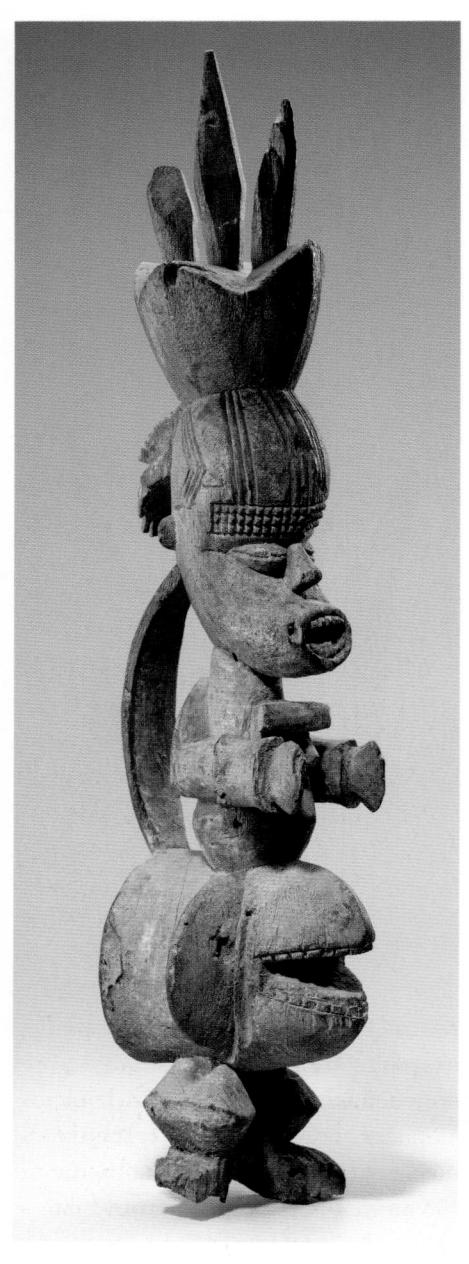

9-45. Ivri (Personal Shrine), Isoko, Nigeria, early to Mid-20th Century. Wood. Height 26" (66 cm). The National Museum of African Art, Smithsonian Institution, Washington, D.C. Gift of Walt Disney World Co., a subsidiary of The Walt Disney Company

because of its scale, whereas the comparatively larger human dominates the animal in the stunning Isoko example shown in figure 9-45, a masterful composition whose sculptural power is appropriate to its (former) job as a protective, aggressive combatant for its owner. The teeth and horns on these images—sharp, bared, and exaggerated—signal their pugilistic purposes. Both carvings are symmetrical on the vertical axis. The Urhobo ivri is weighted and more stable on its animal base, whereas the Isoko figure, built up as a rhythmic series of bulges and constrictions from bottom to top, points upward and almost seems to soar.

Light/Dark Masking: Beauties and Beasts

The discussion of Igbo masquerades earlier in this chapter stressed the complementary opposition of light and dark masks and their associated qualities. Nearly all the neighbors of the Igbo also have versions of this light/dark, beauty/beast masking concept, yet it is uncommon beyond this area. Clearly these varied manifestations represent shared historical traditions, probably of considerable antiquity. Each masquerade has its own characteristics and nuances of both form and meaning, however, often indicating many decades or perhaps a century or more of separate, local development. The density and multiple variations of the theme in Igboland, as well as occasional oral traditions, suggest the Igbo as the originators, but this is far from proven in all cases.

Apart from the many Igbo variations, the clearest examples of this

theme are ekpo masks of the Ibibio, a rather small population southeast of the Igbo. *Ekpo* is the Ibibio word for "ancestor," as well as the name of the principal masking society, its masks, and the dances that commemorate the deceased. White- or yellow-faced masks, mfon ekpo, come out during daytime second-burial festivities honoring the recent dead, and also at annual agricultural festivals (fig. 9-46). Their dances are slow and graceful, with costumes made of many bright-colored cloths. Considered good and beautiful, mfon ekpo masks embody the souls of people whose lives on earth were productive and morally unblemished. These are not named ancestors, but rather the collective community of souls whose positive influence is welcome among the living.

Complementing these in form and concept are the more numerous black idiok ekpo, representing corrupt, amoral, ugly, and evil souls sentenced at death to perpetual ghosthood (fig. 9-47). They appear only at night, well after the pretty masks have retired. Costumed in unruly hanks of blackdyed raffia, they dance erratically, at times with deliberately wild movements, to inspire terror in those they encounter. Some shoot arrows, apparently quite randomly, as if to reinforce their reputations as unreliable, capricious spirits. Many dark Ibibio masks have skillfully carved, distorted facial features, sculptural exaggerations that parallel their behaviors. These grotesque faces are interpreted as advanced states of disfiguring tropical diseases such as yaws, leprosy, and ulcers. Such punishing deformities, people are told, await those who willfully or continually violate the

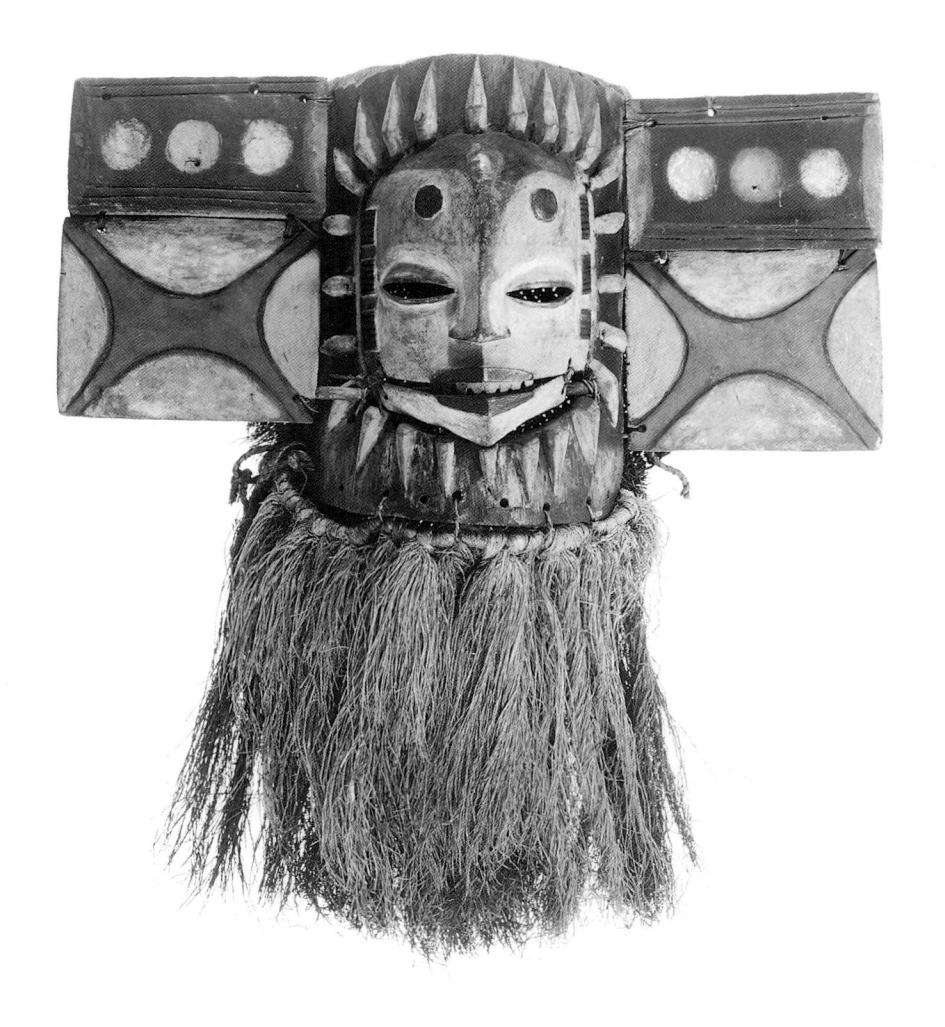

9-46. Mfon ekpo (light mask), Ibibio, before 1915. Wood, pigments. Width 20" (51 cm). Field Museum of Natural History, Chicago

9-47. IDIOK EKPO (DARK MASK), IBIBIO, 20TH CENTURY. WOOD. HEIGHT 11" (28 CM). FOWLER MUSEUM OF CULTURAL HISTORY, UNIVERSITY OF CALIFORNIA, LOS ANGELES moral codes on which orderly society is based.

The symmetrical balance and relative naturalism of *mfon ekpo* contrast markedly with the expressive distortions and asymmetrical twists of many dark *idiok ekpo*. Unfortunately, detailed information on the full range of names and meanings of light and dark Ibibio masks is lacking. The variety of forms in the surviving corpus of masks suggests that a broad spectrum of human and animal spirits is represented. Many examples are beautifully carved.

More is known, on the other hand, about beauty/beast oppositions in the diverse masquerades of the Okpella peoples, Edo speakers who live north of Benin and northwest of the Igbo. Here, in fact, we have direct evidence of Igbo influence in the person of a mask carver and costume tailor who came into the Okpella area from the Igbo–Igala borderland around 1920. He introduced several forms and ideas that became localized over time, mixing them with preexisting mask traditions, some of which also originated among other peoples.

The influence of Igbo originals can be seen on both sides of the Okpella beauty/beast opposition. Appliqué body suits with crested cloth masks, as well as wood masks, often but not always white, with carved hair-crests and superstructures featuring multiple figures appear on the "beauty" side of the equation (fig. 9-48). Such masks recall the maiden masker called Headload and her sisters, among other Igbo forms (see fig. 9-38). On the "beast" side is the large wild beast mask called idu, with several horns, large snaggle teeth in a rough face, and a costume of seed-pods bristling

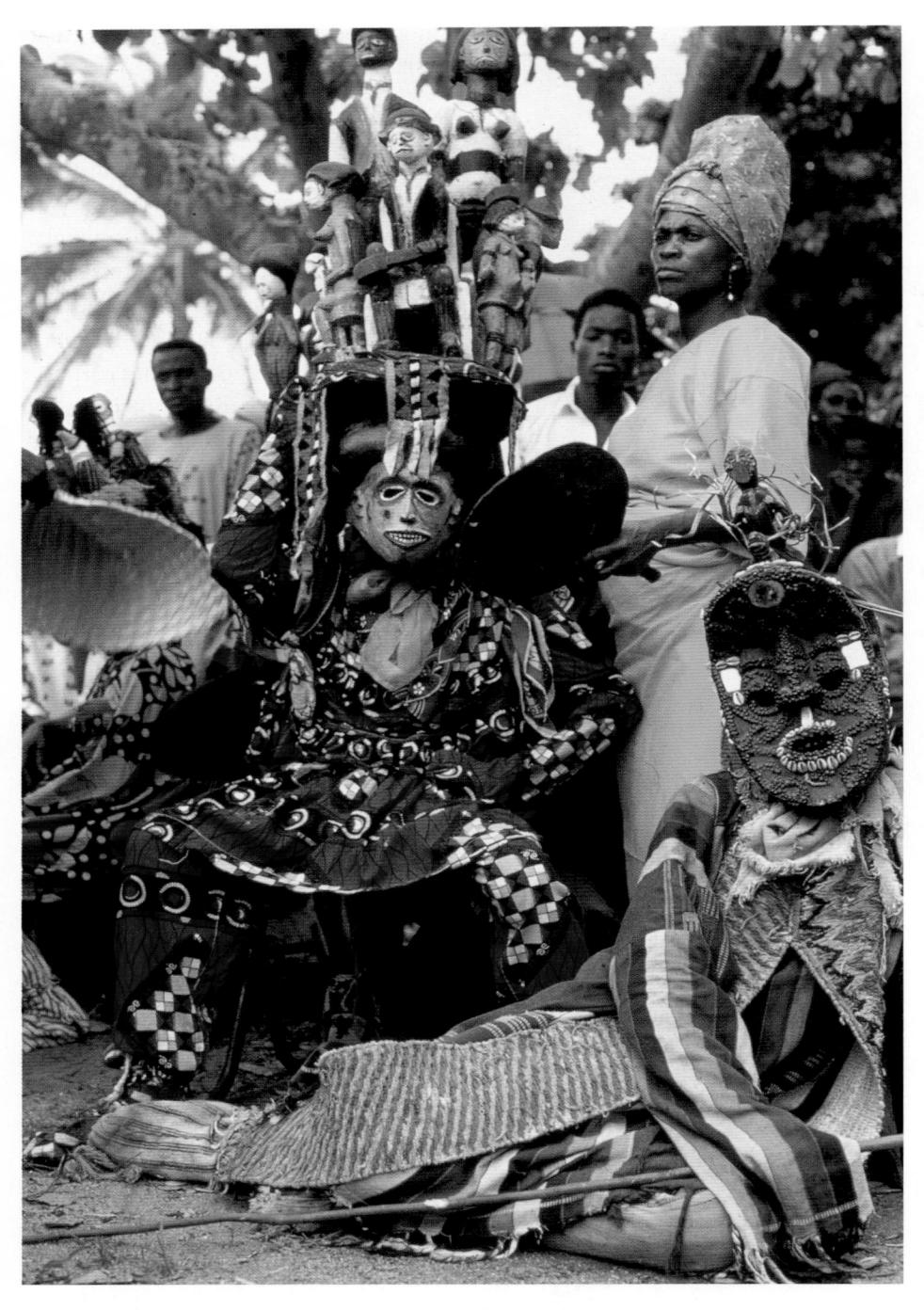

9-48. "Dead mother" (left) and *Anogiri* (right) masks in Performance, Okpella, Nigeria, c. 1973

Crested masks such as the one on the left embody "dead mothers." They are commissioned and owned by Okpella women and take women's names. Though they are danced by men, women accompany them. The older women who own and sponsor these masks take expensive festival titles and are inducted as members of the largely male masking society. They are powerful and usually quite wealthy. After a woman dies, her mask is still danced to commemorate her useful, productive life, and it continues to bear her name.

with quills (fig. 9-49). Clearly *idu* is a variation on the Igbo *mgbedike* (see fig. 9-39). A local Okpella grotesque mask, not of Igbo origin, is *anogiri*, a festival herald. Visible at the right in figure 9-48, *anogiri* is a dark, often misshapen mask decorated with seeds, cowrie shells, and mirrors. A single flat plane with a heavy overhanging forehead often serves for the face, and human features are minimally suggested.

The Edo peoples are most famous for the royal arts of Benin, discussed at the beginning of this chapter. Yet Edo villages outside Benin city and its court have long had art forms linked with shrines dedicated to nature spirits, heroes, and ancestors. These are of local and non-royal origin, and in fact many of them came to prominence partly because they opposed and criticized the imperial power of Benin kings, whose persisting efforts to dominate and extract allegiance and tribute from outlying villages understandably aroused resentments.

The Ekpo masking society found in many Edo communities to the east and south of Benin city was founded during the eighteenth century or before by a strong village chief and warrior, a rival of the king of Benin. There had been a debilitating outbreak of infectious diseases, and it was believed that they had been caused by the Benin king's sorcery. In a dream, the chief envisioned his late grandmother as a masker curing his people. The dream provided a model for the Ekpo shrine and masquerade. The chief ceased waging war to concentrate on healing, which was successful thanks to the shrine, its masking spirits, and the sacrificial and purifying rites they brought about.

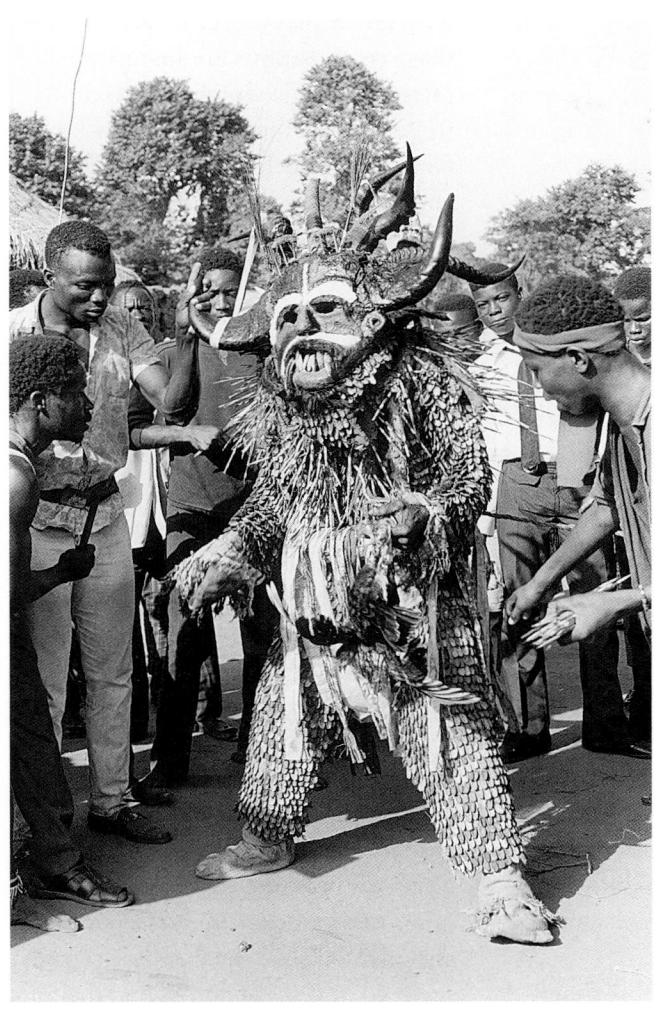

9-49. *IDU* MASK IN PERFORMANCE, OKPELLA, NIGERIA, 1970S

9-50. Ekpo maskers, Avbiama, Edo, Benin Region, Nigeria, 1967

The Ekpo masquerade is the province of warrior age-grades, vigorous men who sometimes fought for the Benin king and yet had ambivalent feelings about his great power. So while the masquerade expresses a number of royal ideas, it also stands in opposition to courtly imperialism. Partly for this reason, presumably, the masquerade is seldom allowed to perform in Benin City.

Viewed as effective, the masquerade association was exported to other communities. (Note that Edo Ekpo is distinct from the Ibibio society of the same name discussed above.)

The photograph in figure 9-50 shows six Ekpo maskers. The two black masks represent the chief who founded the association (third from the left) and a local doctor. The color black here manifests varied sorts of power: physical, magical, medicinal (for healing and warfare). In some rites these dark masks, clearly male, act as flanking supporters of a taller, chalky white, two-faced mask called "mother of Ekpo," *iyekpo* (fig. 9-51). The most senior mask in Ekpo, it

9-51. Bini (Edo) *Iyekpo* ("mother of Ekpo") mask. Drawing after Paula Girshick Ben Amos

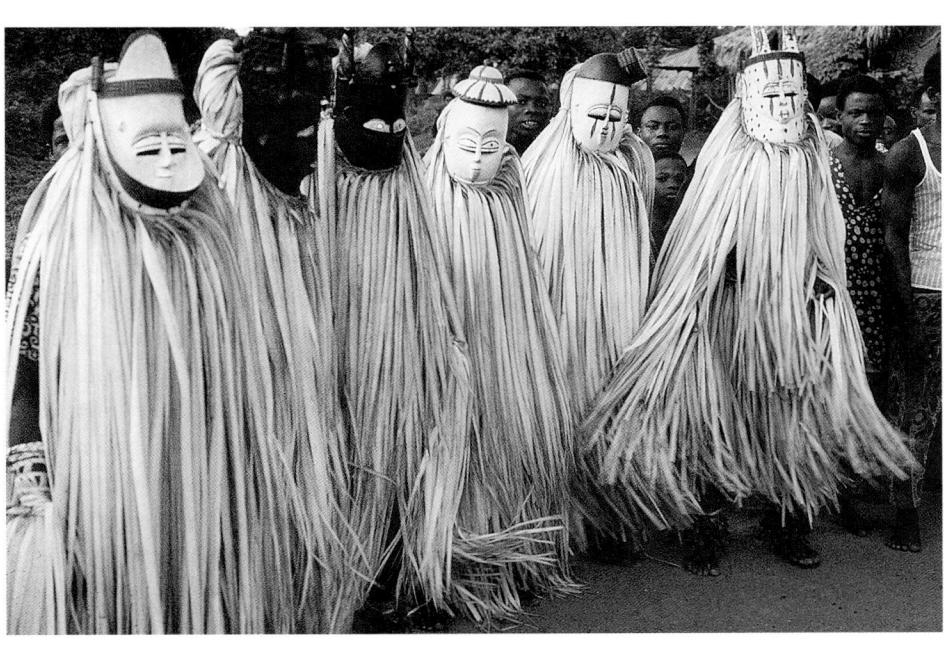

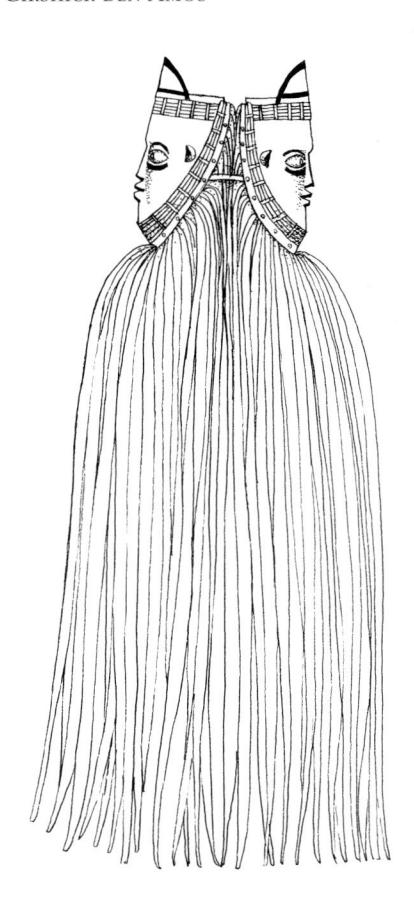

commemorates the founder's grandmother. Together, the three senior masks-the two black masks and ivekpo—express the main concerns of Ekpo: healing disease, ritually purifying the community, and assuring abundant human fertility. The other white masks in figure 9-50 represent a benign chief, a helpful white man (a district officer), a policeman, and a leopard. The role of the leopard is to scare away disruptive evil forces. Additional Ekpo masks that may appear on other occasions include Olokun (Edo god of the sea), various chiefs, a horned animal, and a handsome man. Clearly the white masks here are not all female, yet they seem to have been whitened as an expression of the goodness and beauty of their characters. For the Edo (as for the Igbo and Ibibio), white clay symbolizes goodness, beauty, abundance, and health, and as such it figures strongly in Ekpo rituals. Pregnant women praying for a safe delivery and barren ones begging for children bring white clay to iyekpo, for example, who places it within the shrine as a gift.

Light/dark, beauty/beast masking is both more complex and more widespread than this brief overview may suggest. Ethnic groups not surveyed here, such as the Ogoni, the Igala, and the Idoma, have their own variants, and the traditions of the Ibibio, the Okpella, and the Bini are richer and more nuanced than their presentation here has been able to convey.

Hierarchical Compositions

Many African arts, indeed many world arts, have developed conventions for conveying social, political, or

spiritual hierarchies (see, for example, the discussion of hierarchical proportion in ancient Egypt, p. 46). The arts of the lower Niger are interesting in that several cultures share the same compositional strategy for showing hierarchy, creating figural groups that are triangular, symmetrical, multiunit, detailed, and heraldic. These hierarchical groupings, moreover, all make analogous ideological statements and seem to be related to one another on spiritual, psychological, and economic levels as well. Each features a magnified, exaggerated, weapon-bearing central figure with an enlarged head, who is clearly a leader. He or she is flanked by two or more smaller supporting people, some of whom may be brought forward or pushed back in space. The central leader is largest in scale, reflecting his or her spiritual and ideological focus as either a sacred king, a strong deity, or a revered ancestor. Receding threedimensional space is implied, and is often made explicit.

Looking back through this chapter, this composition can be seen in the central sculptural groupings of Igbo mbari houses, where the goddess Ala is shown flanked by her smaller "children" (see fig. 9-34). The composition appears again in ikengobo and many other arts from the Benin court, where the enlarged king is flanked by smaller attendants (see fig. 9-1). The composition is implied as well in the Ekpo masquerade of the Edo, where the white "grandmother" mask may appear flanked by the two black masks, next in rank. Many more examples could be culled, both from within the cultures treated in this chapter and from other neighboring peoples not discussed here.

While it may never be proven that these compositions are historically related, their geographical proximity to Benin, and the power of this kingdom, where such groups recur in widely varying situations, strongly suggest a single original source: Benin. Such commonality does not, of course, preclude separate meanings. While all these compositions have spiritual dimensions and represent people of wealth and stature who command an entourage, those from Benin are strongly political, while Igbo mbari and other shrine groups, which take the domestic family as their model for a revered deity, link the social and spiritual.

IBIBIO MEMORIAL ARTS

Ibibio Ekpo masquerades, touched on above (see figs. 9-46, 9-47), may appear publicly to commemorate deaths of prominent persons. Two other, less transient Ibibio arts that also memorialize the dead are figures sculpted of cement and pictorial cloths called *nwomo*. Both art forms appear to have developed during the twentieth century, with *nwomo* probably the earlier practice.

Nwomo were hung as "facades" on shrines erected during second-burial rites, which occurred as long as three years after interment (fig. 9-52). They were created for an elite clientele, prominent male members of a warrior society. Sewn by professional male artist-tailors, the cloths usually depict the deceased person and members of his family in festive dress, carrying prestige objects. Although the earliest *nwomo* cloths appear to have been painted, as were the interiors of the earliest shrines, most known

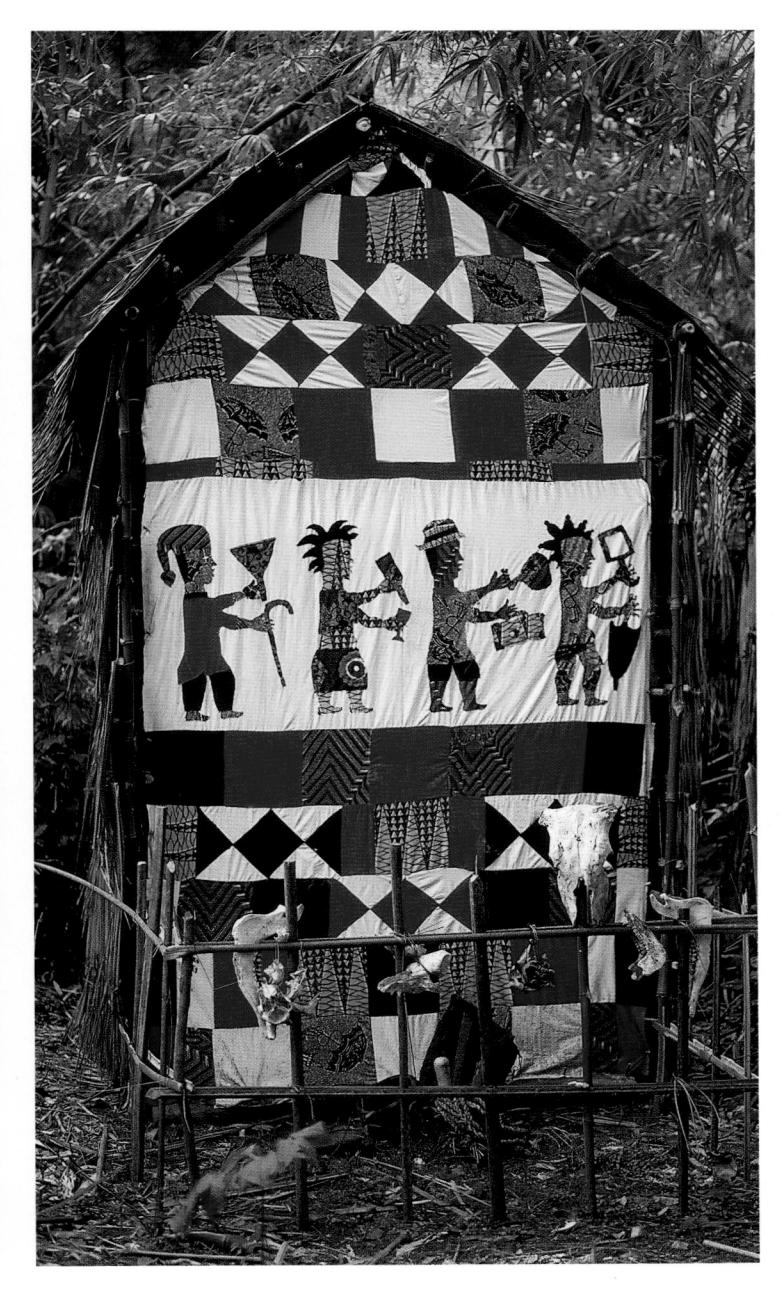

9-52. NWOMO (funerary cloth), Ibibio, Nigeria, c. 1973

nwomo cloths were pieced together from factory-made cloth. They are often multicolored, although red, black, and white are normally stressed. The images are sewn to a background cloth of contrasting color so that they stand out boldly when viewed from a distance. The skulls of animals sacrificed during the opening festivities were hung from the struc-

ture itself or a fence in front of it, and within the shrine were placed the gun and some clothing and household goods of the deceased, as if to add to the "portrait" implied by the *nwomo* motifs.

For much of the twentieth century, cement sculptures have honored the gravesites of respected Ibibio men and women, a broader public than was

served by nwomo. Since the 1950s and 1960s, they have been erected in increasingly large numbers, largely supplanting the nwomo tradition. In part this is because Christian groups discouraged nwomo while encouraging the cement works, which are modeled to some extent on European graveyard sculpture. Some cement figures are set in open enclosures rather like nwomo, while others are conceived as freestanding monuments, often raised on pedestals. Though they were often inscribed with the name and dates of the deceased they commemorate, most have until recently depicted generalized humans, without individualizing detail. Since the 1970s, however, the artist Sunday Jack Akpan (born c. 1940) has led a movement toward highly realistic, imitative portraiture (fig. 9-53). Working from photographs and using imported cement

9-53. Memorial figure, Sunday Jack Arpan, Uyo Ibibio, Nigeria, c. 1984. Cement and oil paint. Height c. 50″ (1.27 m)

and commercial oil paints, Akpan and others are following a trend toward closely observed naturalism also evident elsewhere on the continent. While these lifelike images respond to the contemporary tastes of local patrons, they have also caught the attention of both European and American collectors. Akpan's detailed works (like that of sign painters such as Almighty God, fig. 7-39 and popular Congolese artists such as Chéri Samba, fig. 11-72) have been featured in international exhibitions.

ORON ANCESTRAL FIGURES

The Oron, a relatively small clan related to the Ibibio, produced a striking series of hardwood sculptures to commemorate their ancestors (fig. 9-54). Presumably carved by a number of artists and over several decades mostly before 1900, the figures are varied, yet they subscribe to a consistent set of conventions. The human form is presented along a strong vertical axis. Some body parts, such as heads, beards, and torsos, are emphasized by exaggeration, while others,

such as legs, are minimized or reduced. Most figures hold their beards or a status implement such as a horn, and most have hats. The carving of these figures apparently ceased around 1900, but sacrifices have been continually offered to the group, assembled in a sanctuary called *obio*, twice annually. Regrettably, figures seem to have been stolen from the site in the 1970s, after this field photograph was taken.

KALABARI IJAW FESTIVALS AND MEMORIAL ARTS

The Kalabari Ijaw peoples, fisherfolk and traders who have lived for centuries in the mangrove swamp low-lands of the eastern Niger delta, have various art forms that bear the imprint of their long exposure to European ideas and materials. Prominent features of Kalabari society are corporate trading houses, also known as canoe houses. Led by strong chiefs, these houses have traditionally assimilated outsiders (slaves and members of other ethnic groups) as well as cultural patterns from outside

the delta region. Kalabari festive dress, for example, includes Igbo and Yoruba textiles along with a number of European garment types and artifacts such as shirts, hats, walking sticks, and mirrors (figs. 9-55, 9-56). Few sartorial ideas are adopted wholesale. Rather they are adapted and reworked, especially in their combinations and color schemes.

The Kalabari accord extraordinary cultural value to cloth, even though, or perhaps because, they do not weave their own. Family wealth is measured in part by the numbers and "depth" of heirloom cloth boxes, which contain literally hundreds of textiles imported from within and beyond Africa. Funerary commemorations are occasions for displaying family riches and good taste in cloth and the accessories of dress, both as worn by mourners and as displayed in the house of the honored dead person. Rooms and the beds within them are decorated with elaborate, sumptuous textile ensembles, arranged by the women of the deceased person's family (fig. 9-57). Some displays are sculptural and abstract; some may form an anthropomorphic tableau

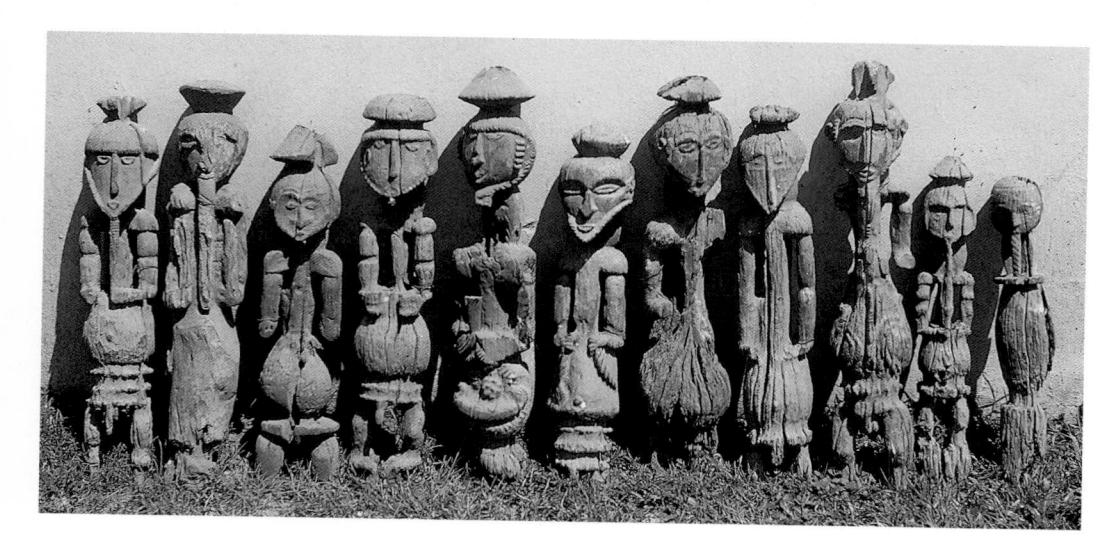

9-54. Oron commemorative figures, Nigeria, 1980s

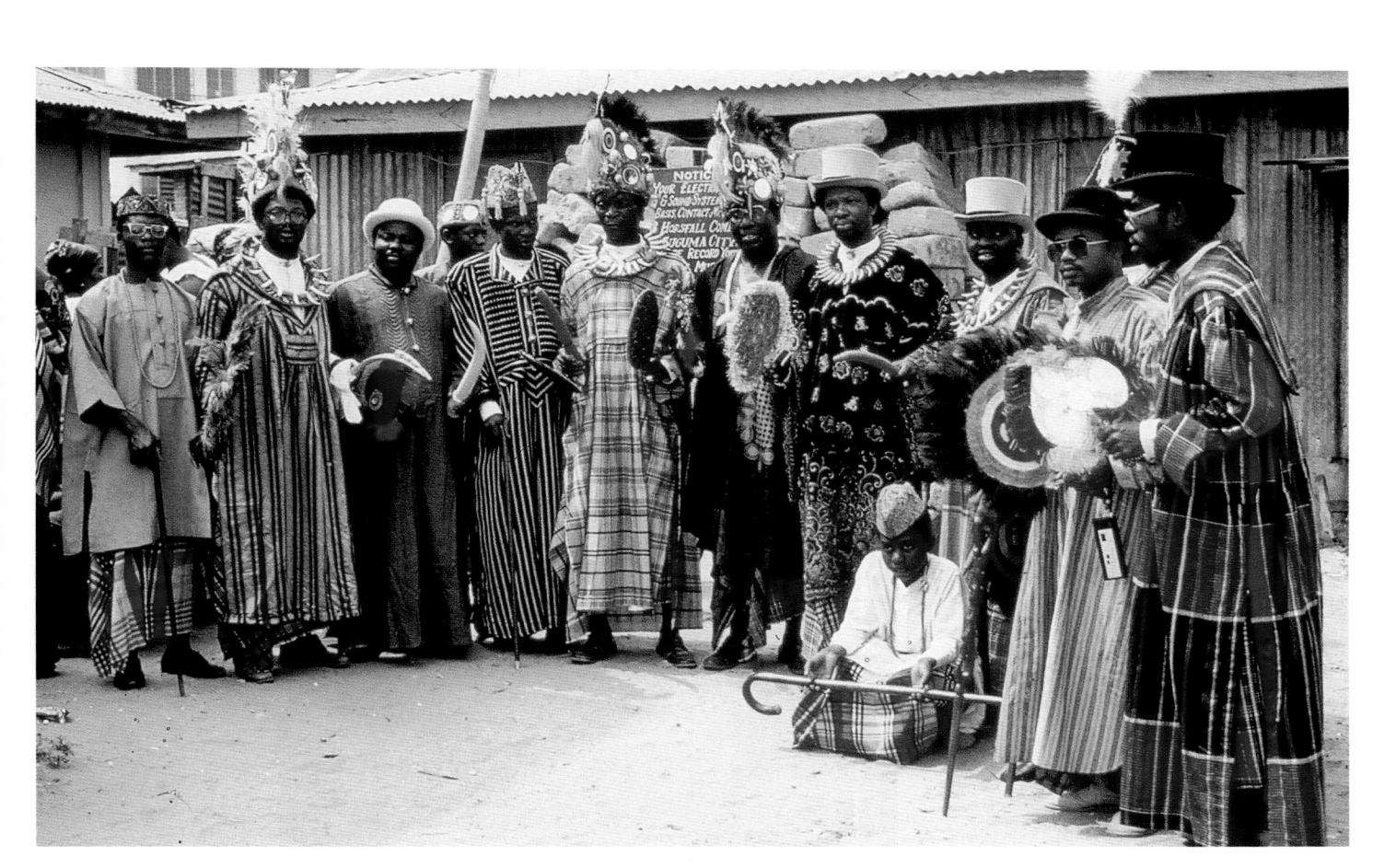

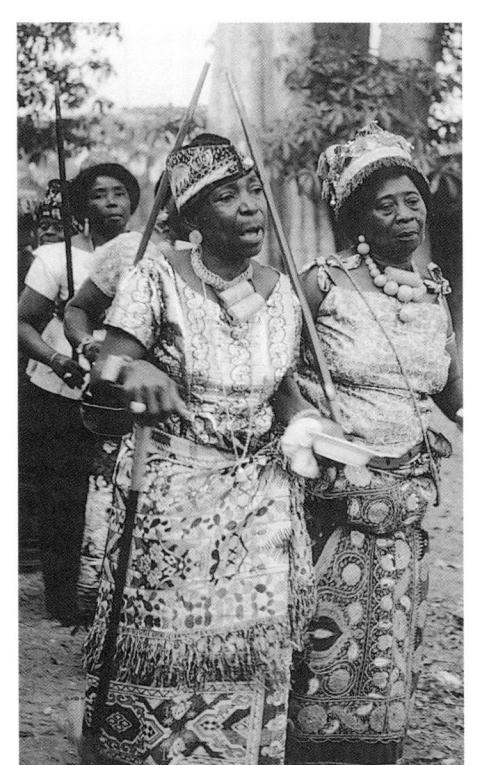

9-55. Kalabari Ijaw men in festive dress, Amabro, Nigeria, 1980s

9-56. Kalabari Ijaw women, Buguma, Nigeria, 1967

9–57. Kalabari Ijaw funerary textile display in the "jellyfish" pattern, Buguma, Nigeria, 1983

together with jewelry, a hat, and other accessories. Guests at these funerals comment on cloth juxtapositions and qualities, and their aesthetic judgments have much to do with the reputation of the family in question. It could almost be said that imported cloth rules the Kalabari aesthetic system.

In addition to processions of variously dressed groups of mourners and visitors, funerary festivals mounted for prominent Kalabari persons also feature water-spirit masquerades favored or danced by the deceased person's family. Masking is the province of the male Ekine society, also known as Sekiapu, "the dancing people." Water spirits are believed to control the rivers and estuaries, and thus both fishing and trading, as well as creativity and innovation. The spirits, materialized by masks, are invited into the community during funerals both to honor them directly and to honor the deceased. Several dozen water-spirit mask characters exist, so many in fact that it takes fifteen to twenty-five years for all of them to manifest themselves in the community, as only a few appear at each annual festival. (Funerary festivals are separate events.) Some are culture bringers, others legendary heroes, still others the spirits of animals—crab, tortoise, crocodile, shark—that populate the environment.

One mask, called *otobo*, formally a loose interpretation of a hippopotamus head, is actually a composite spirit, for it mingles animal and human features (fig. 9-58). In performance, *otobo* is worn on the top of the dancer's head, facing the sky. The costume again dramatizes the importance of cloth, which is believed to be

9-58. Otobo Mask,
Kalabari Ijaw,
19th–20th Century.
Wood, Pigment,
encrustation.
Height 18½" (47
cm). Indiana
University Art
Museum.
Collection of
Raymond Weilgus

one of the gifts of the water spirits to the Kalabari people. Although we may admire the buildup and play of geometric forms in an *otobo* mask when it is displayed frontally as a sculpture in a museum setting, this is notably an outsider's point of view. The Kalabari neither ascribe beauty to such forms nor do they make them very visible to dance audiences. Many masks or headdresses in performance are obscured by feathers or raffia, or are oriented to the sky rather than the audience. More important to the

local viewing public is a masker's skill in dancing and gesturing, his virtuosic responsiveness to subtle changes and signals in the music that drives and gives meaning to the performance. Dancing skill, not carving, is appreciated and discussed in aesthetic terms by the Kalabari, as are cloth ensembles.

It is the animated quality of a masquerader in motion that the contemporary sculptor Sokari Douglas Camp (born 1958) so convincingly evokes in a welded steel sculpture (fig. 9-59). Metal forms enable her to capture a

9-59. Otobo

Masquerade, Sokari

Douglas Camp,

Nigeria/England,

1993. Wood, Steel,

Palm-stem brooms.

Height 6' (1.83 m).

The British

Museum, London

masker's airy, spatially activating essence. She freezes action in midmotion with light openwork. She plays with wavy cloth and other projections, creating a delicate equilibrium between form and the space it enlivens. Camp grew up in the Delta region but was educated in art schools in England and the United States. She now resides in London, and her recent work has included installations linking oil to the degradation of her people and their environment. As a female artist who has been inspired

by the sculpture and masquerades of her male ancestors, Camp is a counterpart to the (mostly) male artists of Nsukka who are inspired by female *uli* patterns; both are crossing gendered cultural boundaries. Ironically, perhaps, while the Kalabari have never accorded either sculptors or their products much respect, this expatriate Kalabari artist has attained an international reputation.

Another form of Kalabari Ijaw sculpture much appreciated outside of Africa is the ancestral screen, *nduen*

fobara (fig. 9-60). An nduen fobara commemorates the deceased chief of a trading house. The chief is depicted at the center, flanked by smaller images of his attendants. Carved trophy heads of conquered rival chiefs sit at the base of the rectangular screen, while heads representing house retainers or slaves are attached to its top. The chief's facial features are subject to the same conventionalized rendering as the heads of retainers or enemies; trading house members know who is represented in each screen, so naturalistic renderings are quite unnecessary. Chiefs are partly individualized, on the other hand, by the prestige and power implements they wield, here an actual silvertopped trader's staff and a curve-bladed knife, and by the masquerade headdress they wear, which evokes the water spirit they identified with (or actually danced). The headdress here is probably the one known as "white man's ship." A model of a nineteenth-century European sailing vessel of the sort that came to the delta region, the headdress implies successful trading. Outside contact is seen too in the rectangular, framed form and pieced construction of the screen itself, which were probably adapted from European conventions and techniques, while its hierarchical composition may have been influenced by the arts of Benin.

A CONTEMPORARY NIGERIAN SHRINE

Bruce Onobrakpeya, born in Urhobo country in 1932, was one of the Zaria Rebels, joining other students at the Nigeria College of Arts, Science and Technology (including Yusuf Grillo,

9-60. Nduen fobara (ancestral screen), Kalabari Ijaw. Wood, split vegetable fiber, pigment, textile, fiber. Height $45\frac{1}{2}$ " (1.16 m). The British Museum, London. Donated by P. A. Talbot

The work is constructed of many individually shaped wood parts lashed, pegged, nailed, and stapled together, creating a densely textured surface, which was then painted. Ritually consecrated and placed in the meeting room of a trading house, ancestral screens are visible points of contact between the house's living members and those revered men who continue to influence life from the afterworld.

Demas Nwoko and Uche Okeke), who protested the exclusive emphasis on European academic painting in their curriculum. One of Nigeria's most influential artists and art educators, he is a prolific printmaker who uses complex techniques to draw and create etchings of local subjects and images related to Urhobo (and other Nigerian) communities. Onobrakpeya has also produced elaborate composite sculptures, or installations. Akporode, described as a "shrine," has been evolving since it was first shown in London in 1995. Our illustration (fig. 9-61) is from the 2002 "Ways of the River: Arts and Environment of the Niger Delta" exhibition at UCLA's Fowler Museum, where it was shown together with masquerades, with older sculpture, and with the work of Sokari Douglas Camp (see fig. 9-59). Onobrakpeva himself has said of this work:

Akporode represents a striving toward higher, richer, and bigger life. The word *Akporode* is derived from two Urhobo words, Akpo (life, world) and Orode (big, great). It is an assemblage of artworks (both linear and sculptural) of different shapes, color, design, and materials, which together reflect the grandeur and beauty often associated with Nigerian traditional religions, shrines, and the architectural décor of palaces. The art pieces—created through experiments over a period of two decades—have themes based on the worldview of our people and their cultural values, wisdom, beliefs, mythology, and cosmology. Some crave ethnic and national unity, religious tolerance, as well as

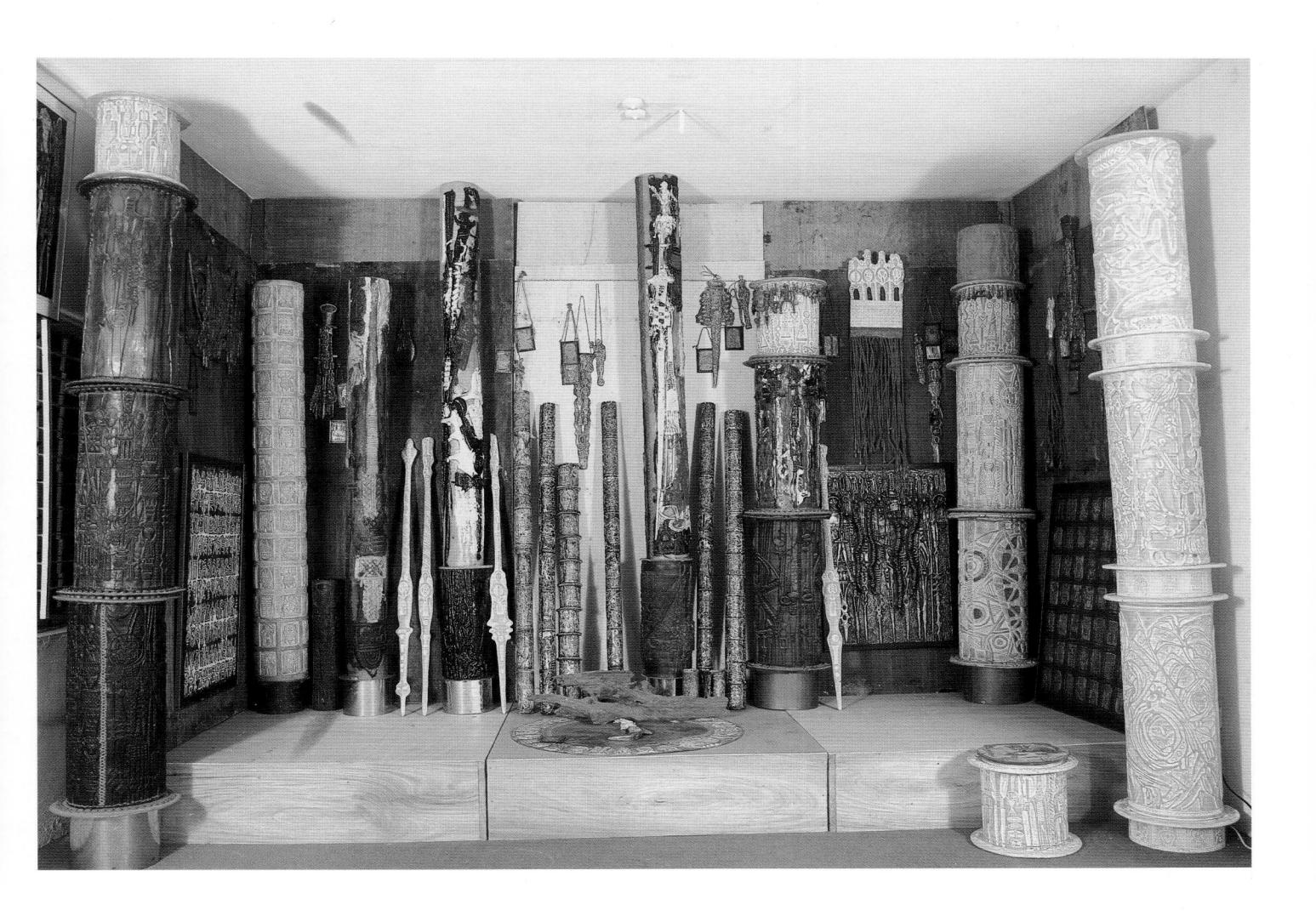

prayer for a better environment. The varied themes are repeated in different techniques and materials ... in an attempt to discover the best visual representation of the ideals, local and foreign, which have been synthesized in response to change. The process results in a kind of metamorphosis, which is in tune with traditional shrines that diminish for lack of repairs or increase when new items are added to them. Finally, the predominantly vertical natures of the artworks, a concept derived from the Urhobo pillar symbol for Oghene, the supreme intelligence, has another meaning for the installation. It is a prayer for divine support and continued growth toward divine greatness.

9-61. SHRINE PIECE (AKPORODE), Bruce Onobrakpeya. Mixed MEDIA: PHOTOGRAPHS, PAPER, PLASTIC, METAL, IVORY, STEEL, BRONZE, LEATHER, AND FOUND MATERIALS. APPROXIMATELY 14 X 7 X 8' (4.2 X 2.1 X 8 M). COLLECTION OF THE ARTIST

PART III

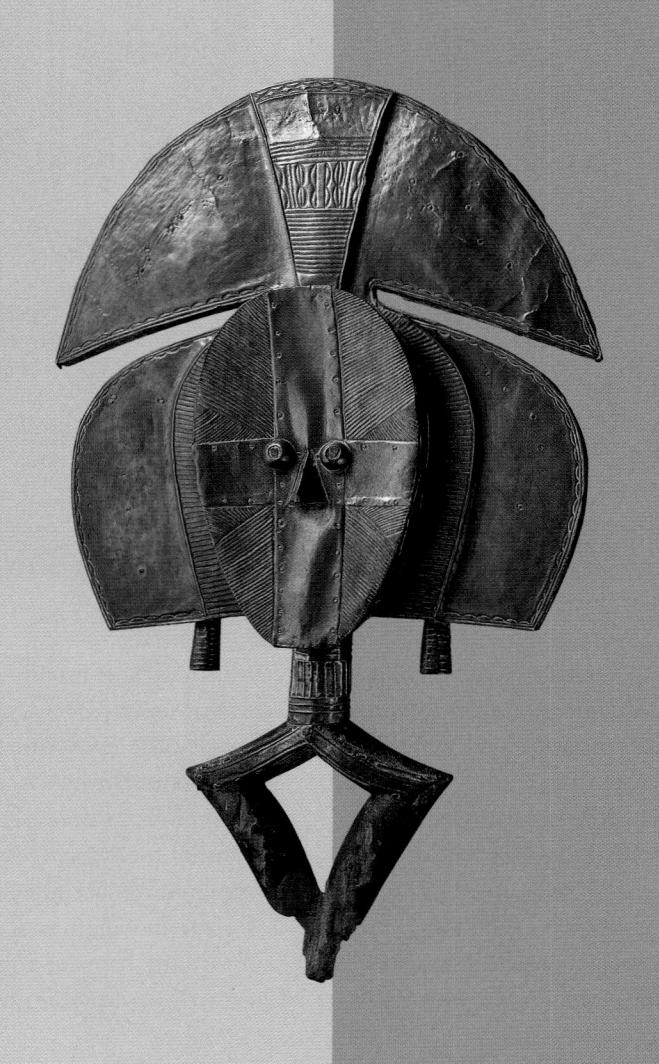

Central Africa

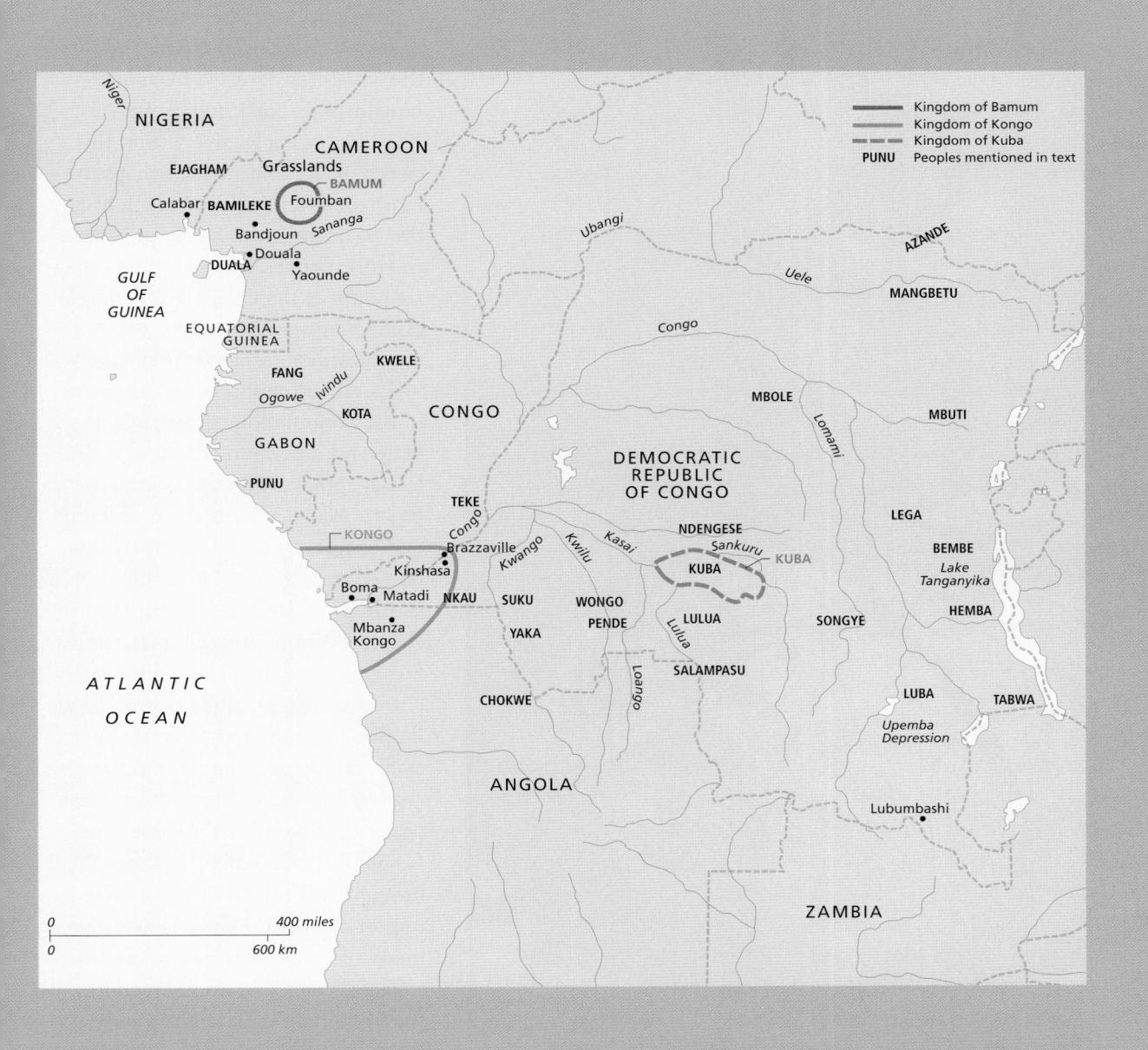

Cross River, Cameroon Grasslands, and Gabon

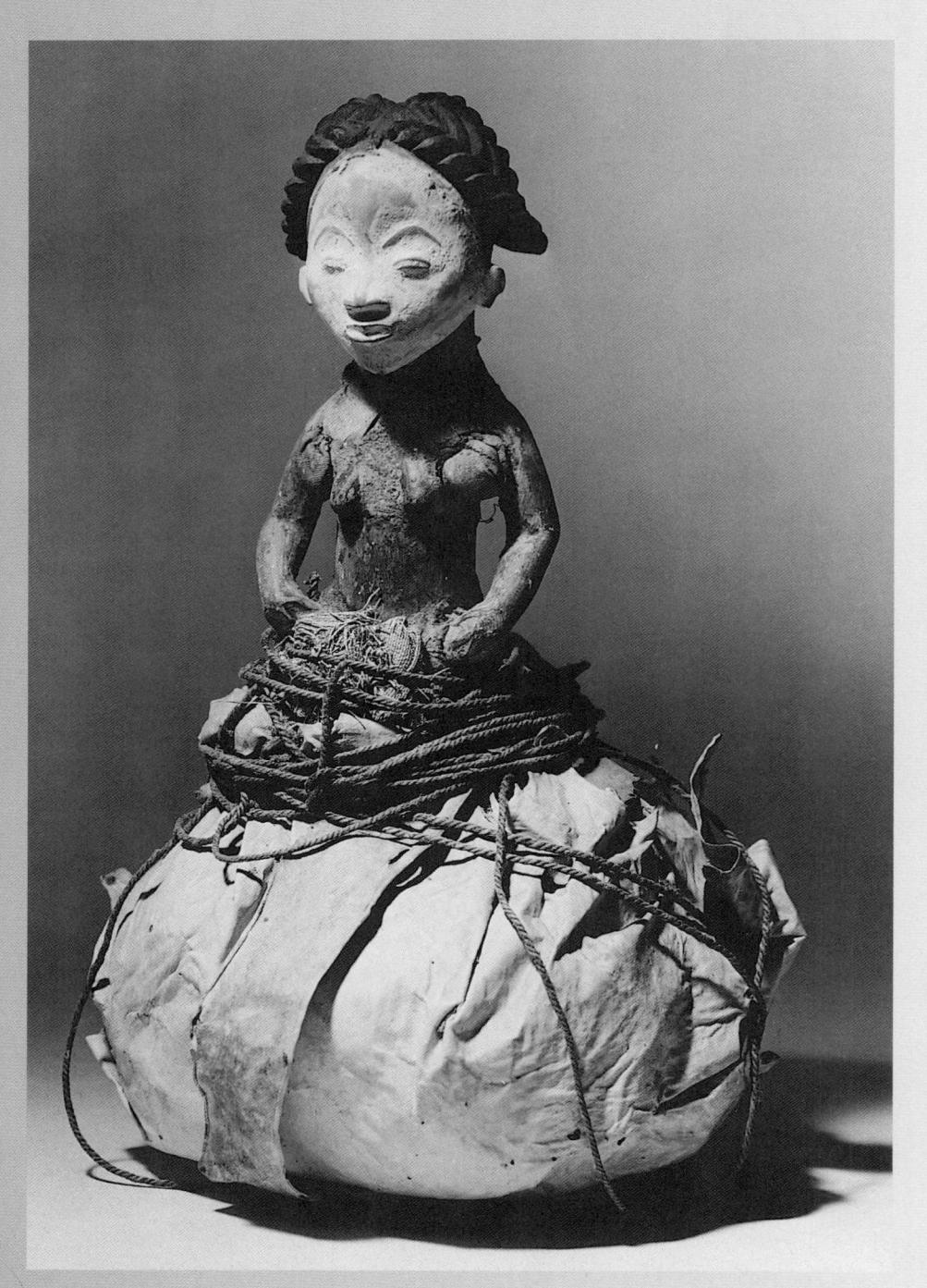

10-1. Reliquary figure, Punu. Wood, rattan. Height 11 $\frac{11}{5}$ " (30 cm). Musée du Quai Branly, Paris

THE AREA TREATED IN THIS chapter is diverse both geographically and culturally. Beginning at the Cross River basin, which overlaps Nigeria and Cameroon, it extends into the mountainous grasslands of western Cameroon, along the estuaries and rivers of coastal Cameroon, and into the equatorial forests of Gabon, Equatorial Guinea, and Congo. Numerous peoples live within this sweep of the continent. Perhaps the most consistent cultural element is the small scale of the communities in the forest zones, most of them organized only at the village level and governed by groups of elders or men's organizations rather than by chiefs or kings. An exception is the kingdoms in the mountainous grasslands of western Cameroon. Yet these realms. too, are small in comparison to the territories ruled by the oba of Benin (see chapter 9) or the Yoruba kings (see chapter 8).

All of the societies discussed in this chapter were profoundly affected by European presence, though in different ways. The appalling commerce in human lives, the transatlantic slave trade, disrupted many cultures in this region, as it did in many other areas of the continent. At the same time, European trade along the Cross River brought wealth and increased the importance of local men's societies, many of which became commercial organizations. The small kingdoms of the Cameroon grasslands imported prestige materials such as beads, brass, and fabric, used to create ever

more luxurious art objects for royal treasuries. In the coastal region of Cameroon, individuals involved in European trade were acknowledged as headmen or chiefs, leading to a new type of political leadership supported by new forms of prestige art. In the equatorial forests of Gabon, on the other hand, fundamental cultural practices were banned by the colonial administration, and many of the art forms linked to them survive only in museum collections.

CROSS RIVER

From its origins in the hills of western Cameroon, the Cross River runs westward into Nigeria then curves to the south to flow toward the Gulf of Guinea. Navigable by local craft for much of its length, the river has historically served as a means of transportation and trade for the many peoples who live within reach of its banks. Most of them speak languages known as semi-Bantu. Ethnolinguists and historians have traced the origins of many peoples in central, eastern, and southern Africa that speak languages referred to as Bantu to this region. (See chapters 11 and 12.) Culturally as well as linguistically related, the peoples of the Cross River region share a number of political, religious, and economic institutions in which art plays an important role.

Early Arts

In recent times, artists of the Cross River region have worked primarily in wood. The earliest known works. however, were formed from more durable materials such as terracotta. Unfortunately, few of these objects found at Calabar have been dated or even accurately described, for they are usually unearthed by accident rather than in controlled and documented archaeological excavations. They may have been made by ancestors of the current populations, in which case they represent artistic traditions that have been discontinued. Or other peoples who preceded them

may have made them. Until more is known, they can only be appreciated as mute and mysterious evidence of an unknown past.

The two stone monoliths in figure 10-2 belong to a group of eighteen stones standing at the site of a deserted village in the area occupied by the Nnam group of the Bakor-Ejagham peoples. Some three hundred such monoliths have been documented in this area. Ranging from one to six feet in height, they are usually found in groups, often in a circular arrangement. All were probably at one time associated with habitation sites, which have since been abandoned. Scholars believe that some of the monoliths may date back as far as the sixteenth century, and that their manufacture may have continued into the nineteenth century.

The makers of these works selected roughly columnar stones from riverbeds, then used abrasives—most probably other stones—to further shape and incise them. All of the stones depict bearded figures, usually,

10-2. Carved monoliths, Akwanshi, Nigeria, 16th century (?). Basalt. Photograph 1974

The Bakor-Ejagham people refer to these monoliths as akwanshi, "dead person in the ground," and revere them as special objects. In some areas, the monoliths are given the names of former ntoon—priestly leaders whose role was largely ceremonial and religious. During annual ceremonies acknowledging past ntoon, offerings are given to the akwanshi as village ancestors. Interestingly, the akwanshi are asked for blessings and protection even though the political and religous system in which the ntoon worked has disintegrated.

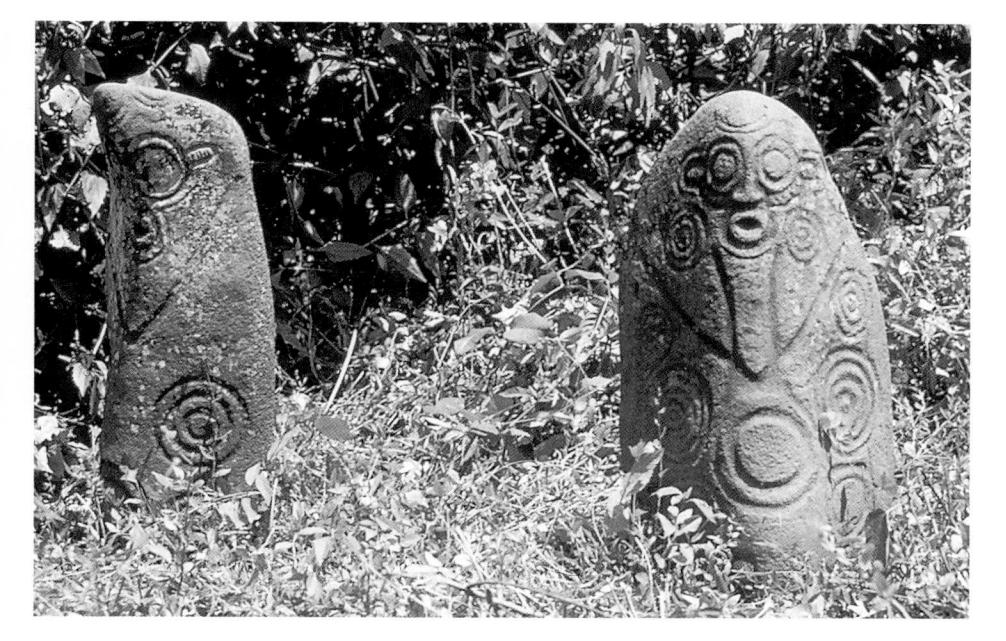

10-3. LEOPARD SKULL. "LOWER NIGER BRONZE INDUSTRY." CAST COPPER ALLOY. 7" (17.8 CM). COLLECTION OF TOBY AND BARRY HECHT

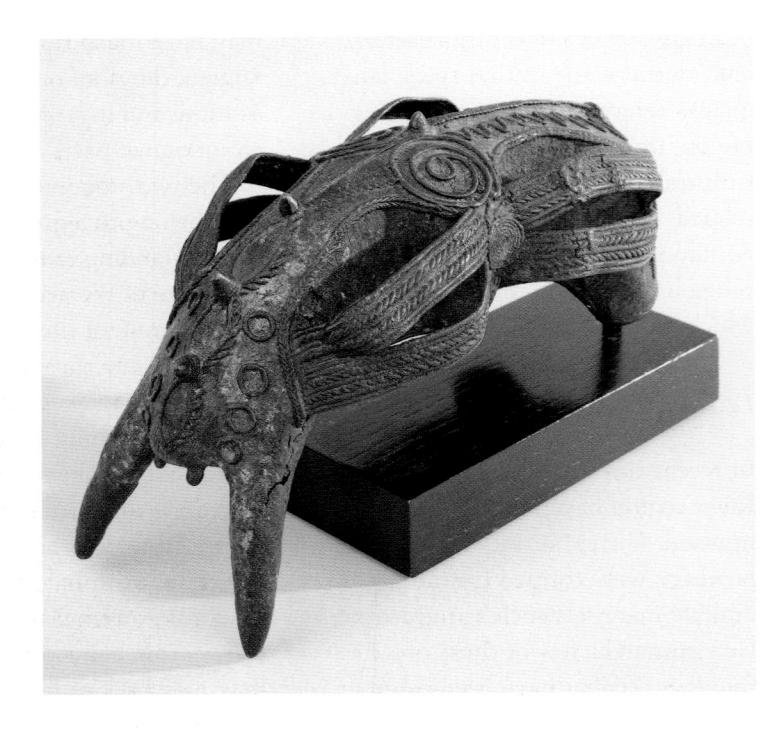

as here, including a navel rhythmically emphasized with concentric circles. Several regional substyles have been identified, some of which coincide with subgroups of the Bakor-Ejagham peoples. The Nnam style, shown here, is distinguished by its especially profuse and elaborate decoration. Sculptors working in this style altered the natural shape of the stone itself less than sculptors of other regional styles, who often smoothed the stones to a more symmetrical columnar form, sometimes explicitly phallic.

The phrase "Lower Niger Bronze Industry" has been employed by art historians to organize copper-alloy objects discovered from the Delta region of the Niger River northward to its confluence with the Benue river. Stylistically diverse, they include figures of humans and animals as well as such objects as bells and staffs. Where the centers of this industry were and what culture they belonged to we do not know. Some works are

clearly linked to the Benin court in subject matter, suggesting that they may have been made by outlying groups of Edo-speaking peoples (see chapter 9). Others seem related to copper alloy objects from the Igbo site of Igbo Ukwu (see chapter 9). The Yoruba (see chapter 8) have also been posited as the possible creators of some of the objects, as have several other regional peoples. The cast leopard skull in figure 10-3 can be compared to a number of cast copperalloy carnivore skulls in southern and eastern Nigeria and certainly with a leopard skull discovered in the grave at Igbo Ukwu (see fig. 9-19), which dates to the ninth century AD. Other skulls of copper alloy in southern Nigeria have been dated to the mid to late seventeenth century. Although we cannot be sure of the usage of such finds, a local chief at Oron in Cross River State, where another feline skull was excavated, seemed to believe that it was part of a predecessor's grave goods. It is conceivable that the distribution of such carnivore skull castings in the region from the Niger Delta to the Cross River suggests the movement of traveling Igbo metal workers and merchants. The leopard was a significant icon among many groups in this region, and the most noteworthy manifestations of leopard imagery were in the context of secret societies and leadership.

Recent Arts of Secret Societies

Cross River communities are usually governed by groups of elders. The power of each elder is in turn enhanced by membership in various societies. A typical community includes numerous societies, each with its own purpose. In the past, these included associations for warriors, hunters, entertainers, and for combatting witchcraft. Many continue into the present day as fraternal, political, or commercial associations. Women as well as men belong to societies, though rarely to the same ones.

Society members communicate through a complex system of secret gestures and *nsibidi*, a repertoire of ideographic signs (fig. 10-4). (See also p. 288.) Nsibidi embody power as well as signify meaning, for mastering the obscure system of signs and symbols is one way in which leaders of the organizations establish their authority. Nsibidi symbolize ideas on several levels. Most people, even those not initiated into a society, recognize signs that have to do with human relationships, communication, or household objects. At another level, "dark" signs of danger and extremes, often actually bolder in

form and darker in value, have to do with moral judgment and punishment. Finally there are complex signs whose meaning and use is vouchsafed only to the most privileged levels within the associations. These indicate rank and secrecy. Considered vital forces in themselves. nsibidi are often considered to be the very essence of a society. The most powerful signs are intricate diagrams drawn on the surface of the earth in times of crisis or as sacred acts. Only those who have the proper rank and knowledge are authorized to see such powerful signs. Nsibidi signs are also used as an aesthetic enhancement on fans, trays, drums, cloths, masks, and other objects used in Cross River associations.

The oldest Cross River secret society may be the all-male Ngbe society. Although Ngbe likely originated as a warfare society among the Bakor-Ejagham populations of the central Cross River region (ngbe is an Ejaghem term meaning "leopard"), it has spread through the entire area. The association is known as Ekpe in some areas, and the Ekpe of the eastern Igbo was described in chapter 9. The importance of Ngbe, or Ekpe, was partially a result of the slave trade, which was centered in Calabar and was dominated by the Efik people by the end of the eighteenth century. In their search for wealth, power, and prestige, Efik patrilineages bought and sold membership in Ngbe/Ekpe to other groups.

Ngbe still provides a means for maintaining the welfare of the community, assuming responsibility for political, economic, judicial, and social aspects of life. The ultimate source of authority in the association comes from the leopard spirit itself, which embodies the collective spirit of the membership, living and dead. Leopards allude to the natural forces that remain outside of and beyond the ken of the human community, while invoking the traditions and continuity of the human community. The leopard spirit is ritually invoked to release Ngbe's/Ekpe's power for the well-being of members and the community at large. Members achieve the status of elder as they advance through a hierarchy of grades.

Each Ejagham community has an Ngbe lodge, usually the most impressive structure in the village, where secret meetings are held and secret objects stored. The presence of the leopard is suggested by a special place within each lodge, a recess within the precinct refering to the forest domain of the leopard. From here the "voice of Ngbe" may be heard in the form of a friction drum. Symbolic and

abstract designs play across the ukara cloth displayed outside or inside the lodge (see Igbo use of ukara by Ekpe members in chapter 9, fig. 9-24). In these banners, stitched with raffia fibers before being dyed in indigo, the leopard may be referred to in abstract designs indicating its spots, in special nsibidi symbols or in figurative renderings of the leopard or of the masked dancer that enacts the role of the spirit. A rectangular assemblage made of cane, covered with animal skulls, horns, sticks, leaves, carved objects, pieces of rope, brooms, and drums, and fringed with raffia is typical of objects prominently displayed inside the lodge (fig. 10-5).

In addition to the objects that belong to the entire lodge, each grade has a distinctive set of costumes, rituals, dances, and masks. The elaborate trading network along the river formerly involved the selling of rights to Ngbe and other associations, includ-

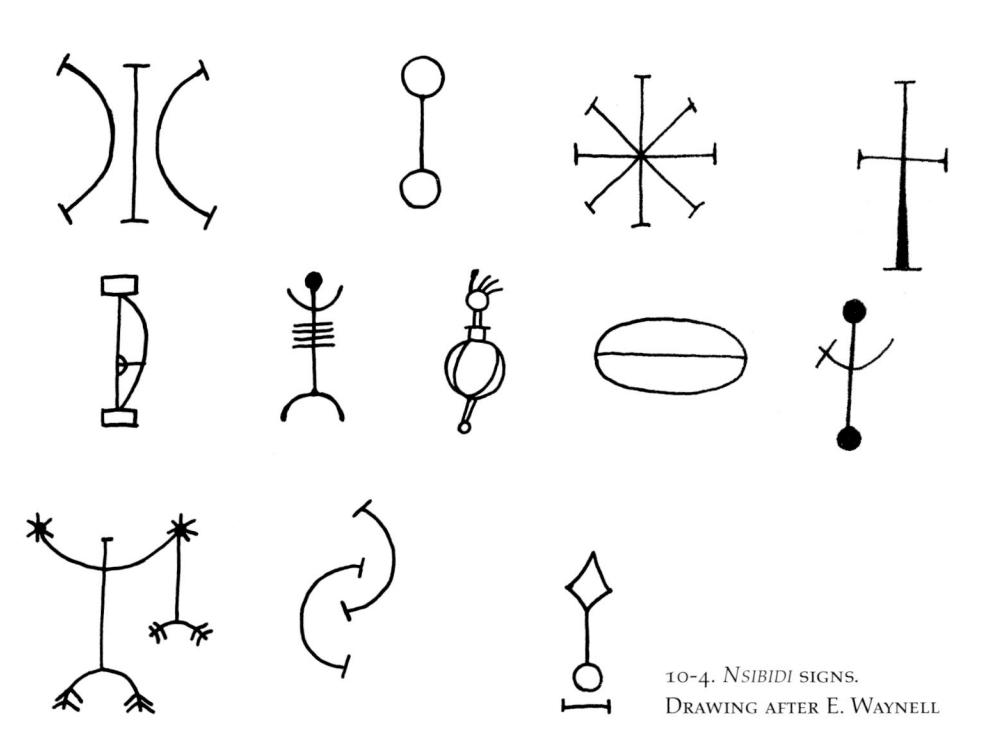

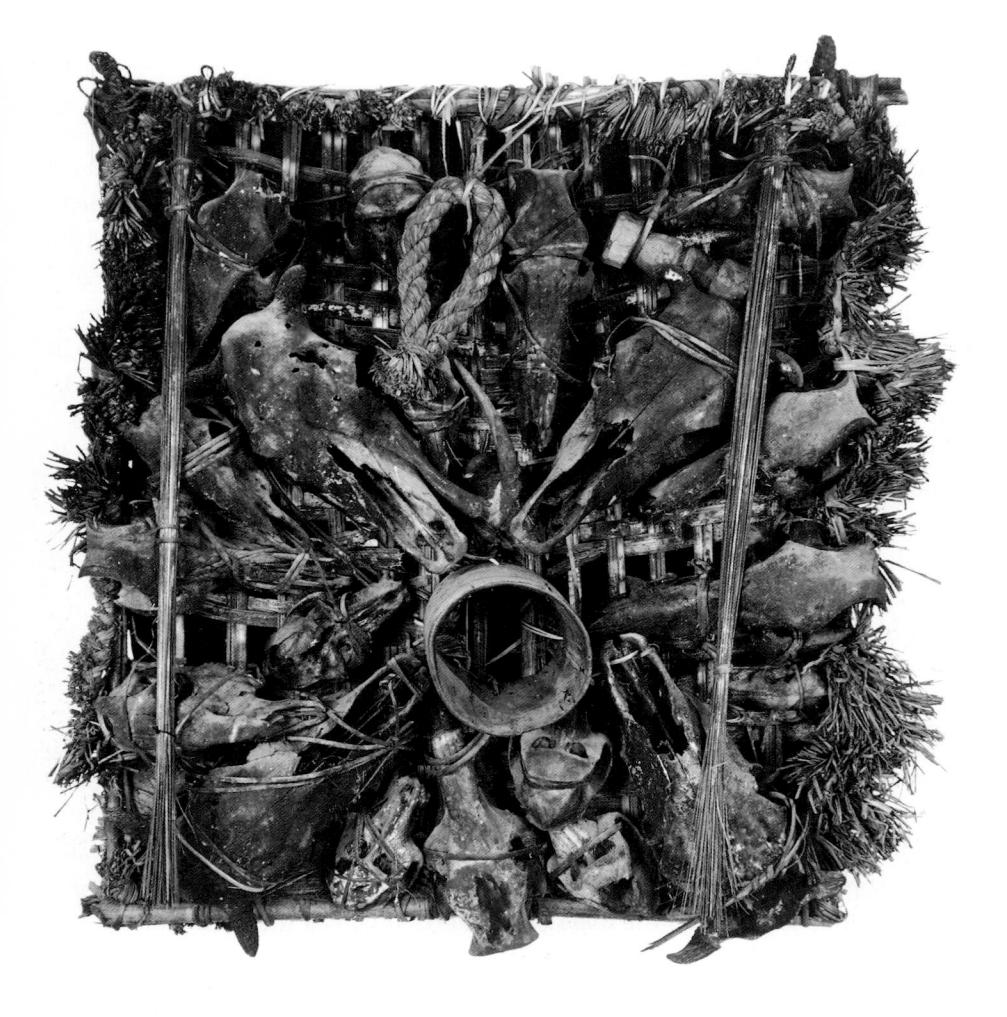

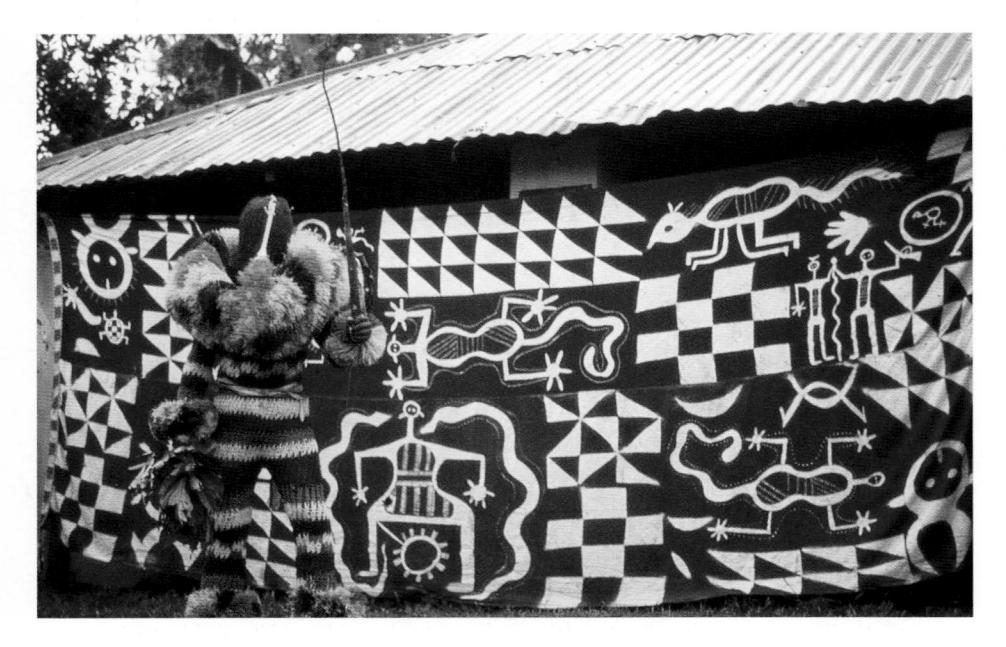

10-6. Nyankpe Photographed in Front of Ngbe Lodge, Ejaghem, 1980s

10-5. NGBE SOCIETY EMBLEM, EJAGHAM.
RAFFIA FIBER, ANIMAL SKULLS, CANING WOOD,
ROPE. 48 X 42 X 11" (121.9 X 106.7 X 27.9
CM). NEW ORLEANS MUSEUM OF ART.
MUSEUM PURCHASE

Although Ngbe members are secretive about the function of such objects, researchers have been able to discover some information. Skulls and bones are the remains of animals eaten in rituals. Brooms are used for sweeping away hostile magical substances from the lodge. Drums are of the type used in Ngbe masquerades and for making announcements to the community. The sticks are memory aids used in Ngbe deliberations. Rope coils invoke those placed on the tops of the stone pillars within the lodge to restrain the leopard spirit. Thus the assemblage is a visual reminder of the role of the society and its actions.

ing the right to perform their various masquerades (see Aspects of African Cultures: Masquerades, p. 324). The group selling the rights would perform the masquerade in the village of the buyer group, then return home, leaving their masks and costumes behind. The river trade thus helped to spread related art events and art objects among diverse peoples over a broad area, though changes in both form and meaning took place as local copies of masks and costumes were made and time passed.

The leopard dance includes the appearance of the leopard spirit in the form of a masquerader (fig. 10-6). Okum-ngbe, the term used for all masquerades representing the spirit, appears in several forms, usually associated with specific grades. The most universal variation is called Nyankpe, which entertains or performs in initiations. Nyankpe wears a body suit with orange, black, and white horizontal stripes. Raffia ruffs

surround the neck, wrists, and ankles, a reference to the natural environment from which the leopard comes and to the mystery and danger of the wilderness and of Ngbe. Nyankpe carries leaves in his left hand, conveying ideas of tradition and continuity. His right hand manipulates a whip symbolizing authority. A feathered rod atop his head hangs forward over the face, symbolizing leadership. The bell suspended at the left hip signals his approach.

When *Nyankpe* emerges from the lodge, he seems to be vigilant, seeking hidden leaders so he can bestow his blessings. His movements then become flamboyant and aggressive, seeming to defy gravity as he lunges, shimmies, teeters, and careens, catches himself, stands at attention, paws the earth impatiently, throwing a foot forward in challenge. Graceful, creeping, prowling moves give way to staccato action.

Numerous people along the river have adopted carved wooden forms of masks as well as the fiber masked costumes of Ngbe. Masquerades are performed by accomplished dancers at funerals, initiations of new members, and other events sponsored by associations. Two types of masks dominate: helmets masks and crest masks. The helmet mask in figure 10-7 covers the entire head of the wearer like an inverted bucket reaching to the shoulders. When the mask was made, fresh animal skin was stretched and tacked over the soft wood from which it was carved. After the skin dried, it was stained with pigments made from leaves and barks. The opposing sides of the double-faced mask represent male and female faces. The male face is normally stained dark all over,

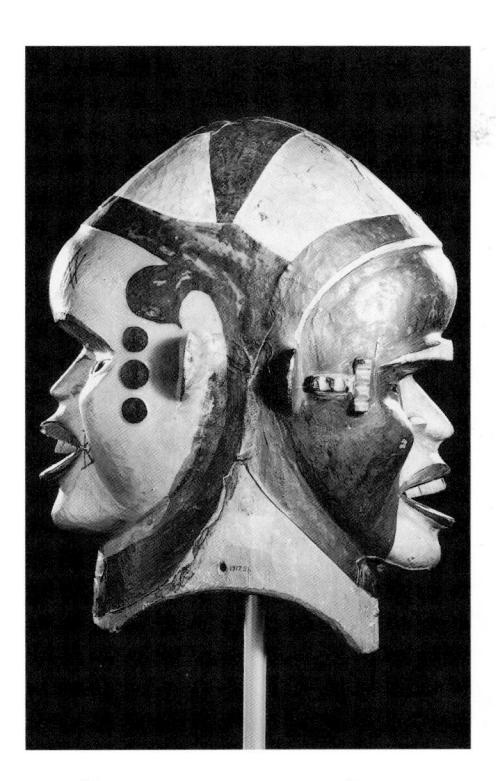

10-7. Two-faced helmet mask, Ejagham. Wood, animal skin, pigment. Cambridge University Museum of Archaeology and Anthropology

while the female side has portions left in the natural color of the animal skin. Similar masks may have three or four faces. Feathers, quills, and other objects would have ornamented the mask in performance. On many masks, messages are painted in nsibidi markings.

Crest masks do not cover the head but rather sit on top of it. They are attached to a basketry cap, which is held on the wearer's head by means of a chinstrap. The long neck and towering coiffure of the elegant crest mask in figure 10-8 would have emphasized the height of the masked character who wore it. The skin sheathing imparts a startling realism. In some masks attaching real hair to the scalp may heighten this effect.

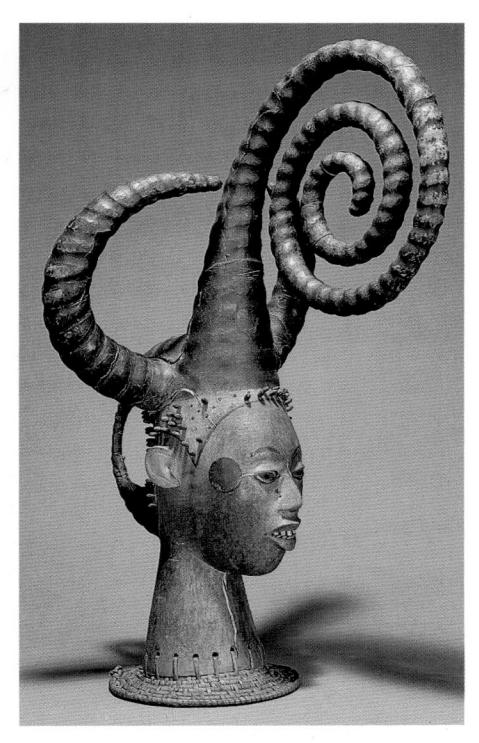

10-8. Crest Mask, Cross River region,
Nigeria. Wood, stained animal skin, basketry. Fowler Museum of Cultural
History, University of California,
Los Angeles

Inserts of metal pieces for eyes, wooden pegs for pupils, and the use of bone, ivory, metal, or small pieces of palm rib for teeth may add further to the realistic impact. Circular darkstained relief forms on the temples represent scarification patterns. Such masks were worn with elaborate flowing gowns.

CAMEROON GRASSLANDS

To the east of the Cross River, in western Cameroon, lies a mountainous region known as the Cameroon grasslands. Numerous small groups of disparate origins spread throughout this region prior to 1900. Stateless societies as well as highly centralized kingdoms arose and participated in a

Aspects of African Cultures

Masquerades

Masks are among the most widely known, collected, and admired of African arts. Outside of Africa they are generally displayed and appreciated as sculpture. Their dazzling inventiveness, expressive form, and evident craft certainly reward that form of attention, yet the isolated and inert public display of sculpture is utterly alien to an African point of view. A mask is never seen publicly in Africa except in performance, in motion, at which time it is not an object called "mask" at all, but the head or face of an otherworld being that has appeared amid the human community. In fact, most African languages do not have a word that can be accurately translated as "mask." Instead, the name for a particular mask is generally the word for the being that the mask helps make manifest.

The masker—the human wearing a mask and its associated costume—is a transformed being: not a person imitating a spirit, but a person whose identity is subsumed into the otherworld being who is now truly present. The appearance of such beings is not casual or undertaken lightly. Instead, maskers appear in the context of a masquerade, a ritual or performance art which takes place in a

time and space normally isolated from the routine of daily life. Played for an audience, a masquerade is usually activated by music and includes dancing or other dramatic action and sometimes singing and other verbal arts. Each spirit masker has its characteristic gestures and movements, which are also part of its essence. While virtually all African masks are used to manifest spirits—usually spirits of nature or ancestors—a continuum exists from those characters that are largely secular, on the one hand, to those that command, manipulate, and represent powerful spiritual, natural, and social forces, on the other.

Masquerades are normally performed as an element of still larger rituals, especially rituals of human passage, the passing of seasons, or the stages of the agricultural year. Yet they are also considered by Africans themselves as discrete ceremonies in their own right, indicated by the fact that each masquerade generally has a name. Since most masks are worn only by males and most masquerades are male dominated, they are an especially fruitful arena for invoking gendered values and behavior. At the same time roughly half of all maskers embody female characters. Many maskers also evoke animals or more abstract, composite powers of nature.

In all cases masquerades are performed not simply to entertain, however entertaining they may be, but to effect change in their communities. Indeed, a prime characteristic of the African masguerade is its capacity to get things done. As active agents of transformation and mediation, spirit maskers help effect many kinds of change: children into adults. nominees into leaders, elders into ancestors, seedlings into productive crops, sickness into health, or crime into judicial resolution. Such occasions are the masquerade's most frequent contexts. Even the expressive, entertaining aspects of masquerading move the community: away from the humdrum of everyday life toward the excitement, excess, and release of festivity and spectacle.

For all of these reasons, it is appropriate to speak of masking as an "embodied paradox." The masquerade is symbolic and allusive, but tangible. It is an illusion, but at the same time real. The characters are invented, yet are quite capable of inflicting damage. The masquerade will affect its audience on one level, its participants on others. Masking always has both emotional content and some degree of instrumentality; it is affective as well as effective, and one of the continent's most expressive and content-rich art forms. HMC

flourishing trade network. The best known of these are the Bamileke and the Bamum in the east, and the Tikar in the west. The rulers, or fon, of the numerous kingdoms used art to bolster the prestige and authority of their courts, and alliances among kingdoms involved exchanges of art objects identified with the royal structure. Over time, these exchanges caused many cultural features to be shared among grasslands courts, which has permitted scholars to speak

of an overriding "grasslands art style."

The development of grasslands courts reached a peak in the nine-teenth century during a period of flourishing trade that increased the availability of imported materials and luxury goods. Believed to be sacred, kings were spiritual as well as secular leaders. Beneath the king, society was comprised of a hierarchy of titled nobility and commoners. Nobility was further divided into those descended from the sons of kings

(nobility of the blood) and those descended from commoners rewarded for their service to the king with a title (nobility of the palace). In a typical grasslands community, a large percentage of the population was considered noble. Commoners had no claim to any art, which was used exclusively by the king and, by his grace, the nobility. Whether it was employed directly in the king's service or used by a retainer or a prince to exhibit his own rank, all art theoretically
belonged to the king who also had a monopoly on all precious materials—brass, imported fabric, and imported beads. Theoretically the *fon* also owned the hides, teeth, and claws of animals such as the leopard, elephant, buffalo, crocodile, and serpent, as well as the right to use them as symbols.

The authority of the king decreased with colonial domination in the early twentieth century and has been regarded with suspicion by modern governments. However, each king remains the symbolic sovereign and acts in a fundamentally ceremonial capacity in his realm today. Art is still used as a means of bolstering the authority of the elite.

Palace Architecture

The most conspicuous symbol of kingship in the heyday of grasslands splendor was the royal residence. Although many palace compounds have been replaced by tin-roofed, concrete block buildings, some have been maintained or restored, and a few have been proclaimed national monuments by the Cameroon government.

Numerous domed units made up the palace at Foumban, the capital of Bamum (fig. 10-9). By the end of 1910, this magnificent building had been destroyed, but photographs and detailed descriptions exist. Long straight rows of tall, domed houses connected by saddle-like roof sections created a complex of several distinct areas, each centering upon a courtyard. The basic building unit was a

10-9. Interior courtyard of the palace at Foumban, Bamum, showing reception area and carved pillars. Photograph 1907

square room surmounted by a domed roof. Lattice walls made of three layers of palm rib were assembled on the ground and lifted to be joined together. Frameworks for the ceiling and roof sections were similarly completed on the ground and hoisted into position. The completed roof was topped with thatch and the walls were sometimes plastered with clay. In addition to the multiple units that served as domiciles for members of the court, there were granaries and gatehouses. Larger separate buildings served as audience halls, clubhouses. and market buildings. Great courtyards served as settings for a variety of activities. Upwards of three thousand people were housed in the palace and its adjoining buildings, including the king's 1200 wives and 350 children.

This photograph taken in 1907 shows Njoya, king of Bamum from 1885 or 1887 to 1933, standing in the inner courtyard of the palace near the reception hall. Carved pillars supporting the roof depict paired male and female retainers dressed in loincloths and headdresses indicating high status. A double-headed serpent motif is burned into the grass frieze over the

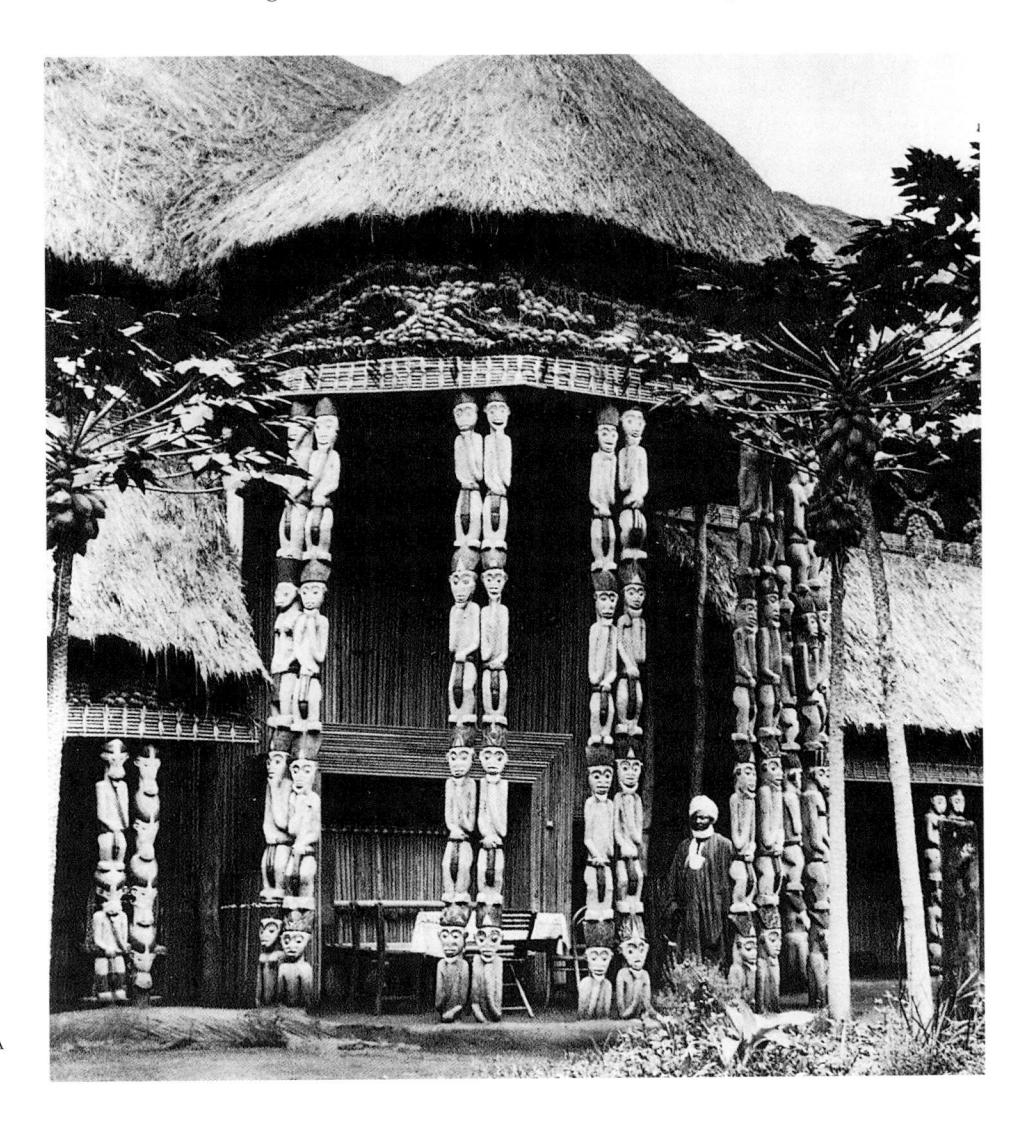

columns. As royal symbols, doubleheaded serpents suggest that the king can assure military victory by striking on two fronts simultaneously.

Sculpture played an important role in the decoration of grasslands palaces. Structural elements such as houseposts and doorframes were often carved, sometimes with considerable depth and openwork.

Grasslands doorways are raised from the ground and resemble windows set low enough to step through. Their frames are usually carved in relief and sometimes painted in polychrome. Figure 10-10 shows Obemne, king of Baham, seated at a door in his palace. His predecessor, Poham, commissioned the doorframe. Compared to the more restrained posts in the Bamum palace (see fig. 10-9), the doorframe here is a lively, dynamic composition in which voids interact with solids to suggest energy and movement. The carvings tell a cautionary tale about Poham himself. whose unfaithful wife left his court to have a child with one of his subjects. Poham, depicted seated and smoking his pipe at the lower left of the composition, ordered the punishment of the immoral couple and the beheading of the unfortunate child.

A doorframe from the small kingdom of Fungom shows a less flamboyant style (fig. 10-11). Here the frame is manifestly solid, its rectangular beams carved in low relief with human, animal, and abstract geometric forms. While the carvings add to the architectural beauty of the building, they also offer symbolic protection against evil and unwelcome callers by referring to the power of the king and his royal ancestors.

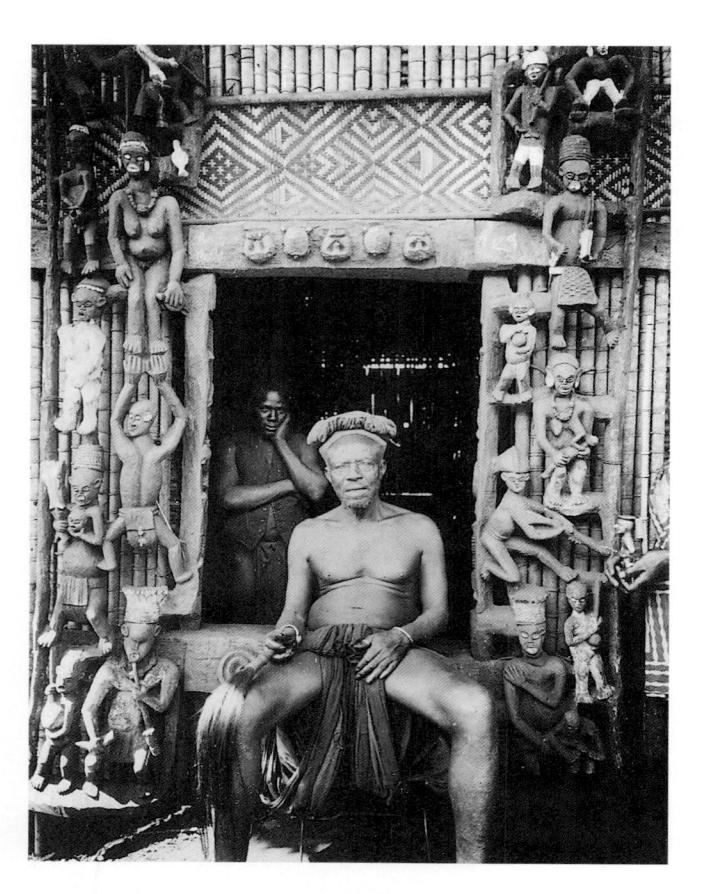

10-10. Obemne seated before a palace door, Baham, Cameroon, 1937

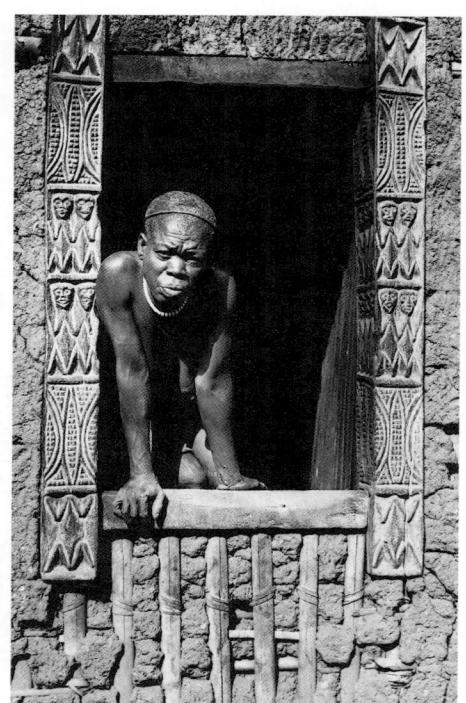

10-11. DOORFRAME OF THE PALACE AT FUNGOM, CAMEROON

Arts of the Royal Treasuries

In the palace, the king surrounded himself with elaborate, sometimes massive visual displays that declared his economic, socio-political, and religious authority. These constituted the royal treasury, a rich accumulation of textiles, clothing, portable objects, furnishings, sculpture, and masquerades. The king brought together great numbers of artists, the best of whom might be rewarded with noble status for their work. The availability of brass, beads, cloth, and other luxury goods in the nineteenth century inspired artists of the time to develop great numbers of spectacular royal art forms. During the colonial period, the abundance of royal art decreased dramatically and its quality diminished. Today, artists still create some forms

for royal courts, but most of their work is now produced for foreign buyers.

Perhaps the most significant status symbol in the grasslands area is the carved stool. A typical grasslands stool has a ring base, a central and often cylindrical supporting portion, and a disk-shaped seat. Nearly everyone in the region owns a stool, however humble. The most impressive stools are carved for the king and serve as thrones. Grasslands artists lavished considerable inventiveness on royal thrones, which are often embellished with the likenesses of leopards, pythons, elephants, and buffalo—all animals symbolizing sovereignty.

At some point, probably at the beginning of the eighteenth century, a larger version of the cylindrical stool-throne, one that included a back, was introduced. One of the finest examples is the throne of Nsangu (ruled c.1865-72 to c. 1885-87) (fig. 10-12). The cylindrical openwork support depicts interlaced double-headed serpents. Rising from the back of the seat are two figures representing high-ranking retainers serving the king. The male retainer holds a royal drinking horn, the female a bowl. Two figures of warriors carrying flintlock guns stand atop a separate openwork rectangular footstool. Retainers carved in sunken relief dance on the front panel. The entire ensemble is covered with heavy fabric richly embroidered with cowrie shells and colorful beads.

Royal thrones are believed to receive life force from their owners. Thus at the death of a king, his throne dies as well, and it may be buried with him or exposed to the

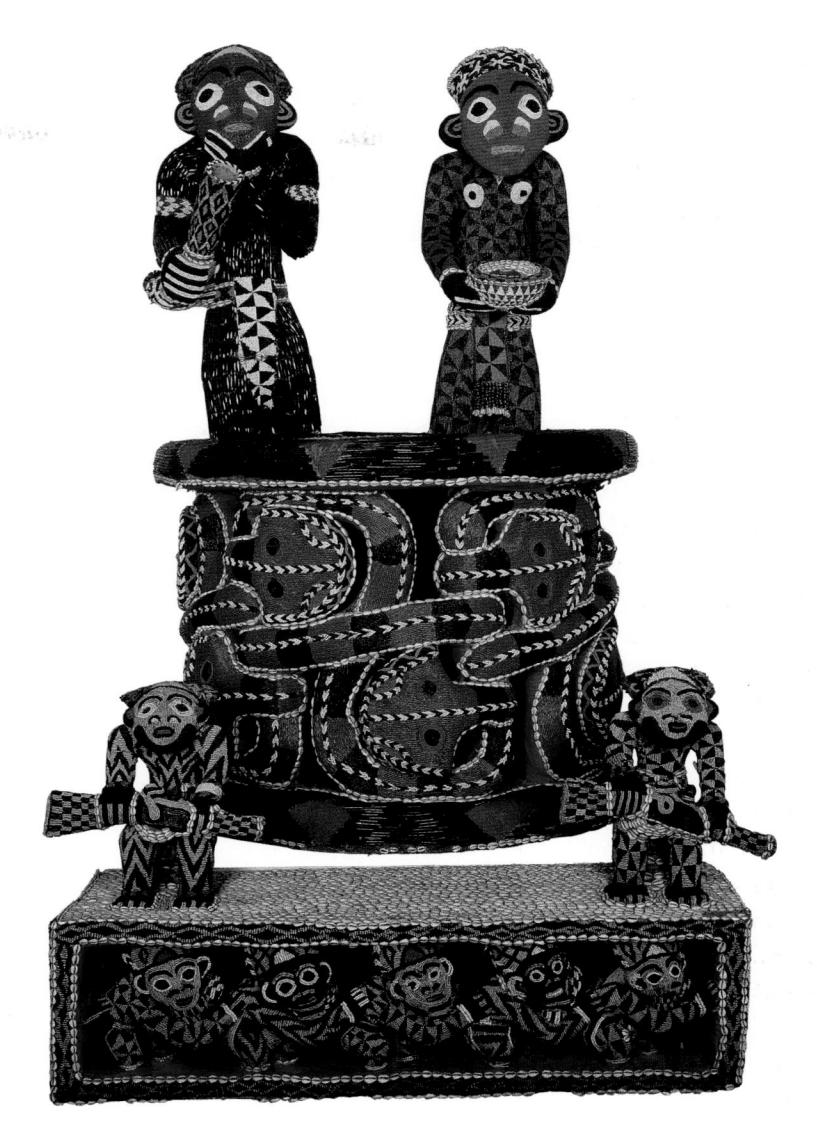

10-12. Throne and footstool of Nsangu, king of Bamum, Cameroon, c. 1870. Wood, textile, glass beads, cowrie shells. Height 5'8%'' (1.75 m). Museum für Völkerkunde, Staatliche Museen, Berlin

Nsangu's throne was presented to German emperor Wilhelm II in 1908 by Nsangu's son Njoya. Before they are introduced into the palace, thrones are consecrated in ceremonies that transform them from bead-decorated carvings to powerful pieces of regalia. In these ceremonies of installation, the new throne is taken into a room where relics of past kings are stored. The sacrificial blood of a ram is smeared on its interior. Thereafter, only high-ranking retainers may touch the throne, for the act of touching the power-laden object is considered dangerous.

elements to decay. Some thrones are given away as gifts to visiting dignitaries. Some seem to have been inherited by a successor, but a king rarely uses a predecessor's throne as his state seat. Instead, soon after his coronation, a king orders the creation of a new stool, specifying the motifs to be associated with his reign. In this spirit, Nsangu's son Njoya commissioned

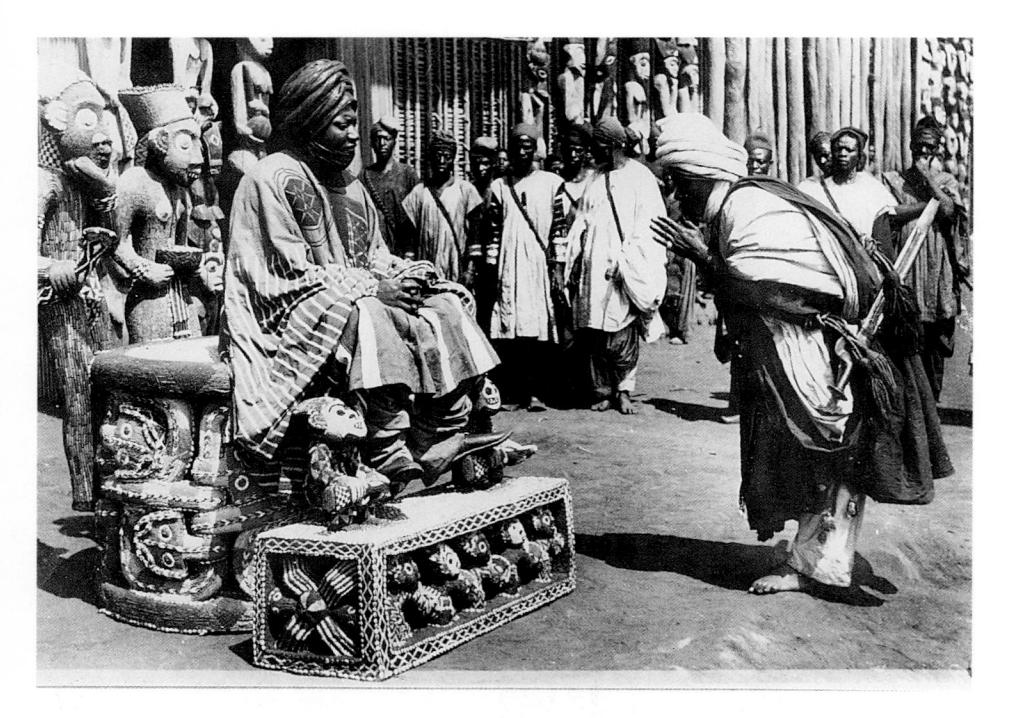

10-13. King Njoya seated on his throne, Bamum, Cameroon. Photograph 1912

10-14. A King seated in state before a textile backdrop, Dschang region, Cameroon. Photograph 1930

a new throne for his own use (fig. 10-13), and gave Nsangu's throne to German associates as a gift. Interestingly, the photograph shows that Njoya requested a duplicate of Nsangu's throne, instead of specifying a new iconography.

Textiles are included in the royal treasury as well. Indigo-dyed cloths are often draped within the palace or in an outdoor arena to provide a backdrop for an appearance by the king (fig. 10-14). The royal cloth is rich in patterns with specific meanings, some of which are also used as beadembroidery designs on thrones. Many grasslands kingdoms import such cloths from the Jukun people of Wukari, a town in northeastern Nigeria. The kingdom of Kom was long the exclusive importer of Wukari cloths into the grasslands area.

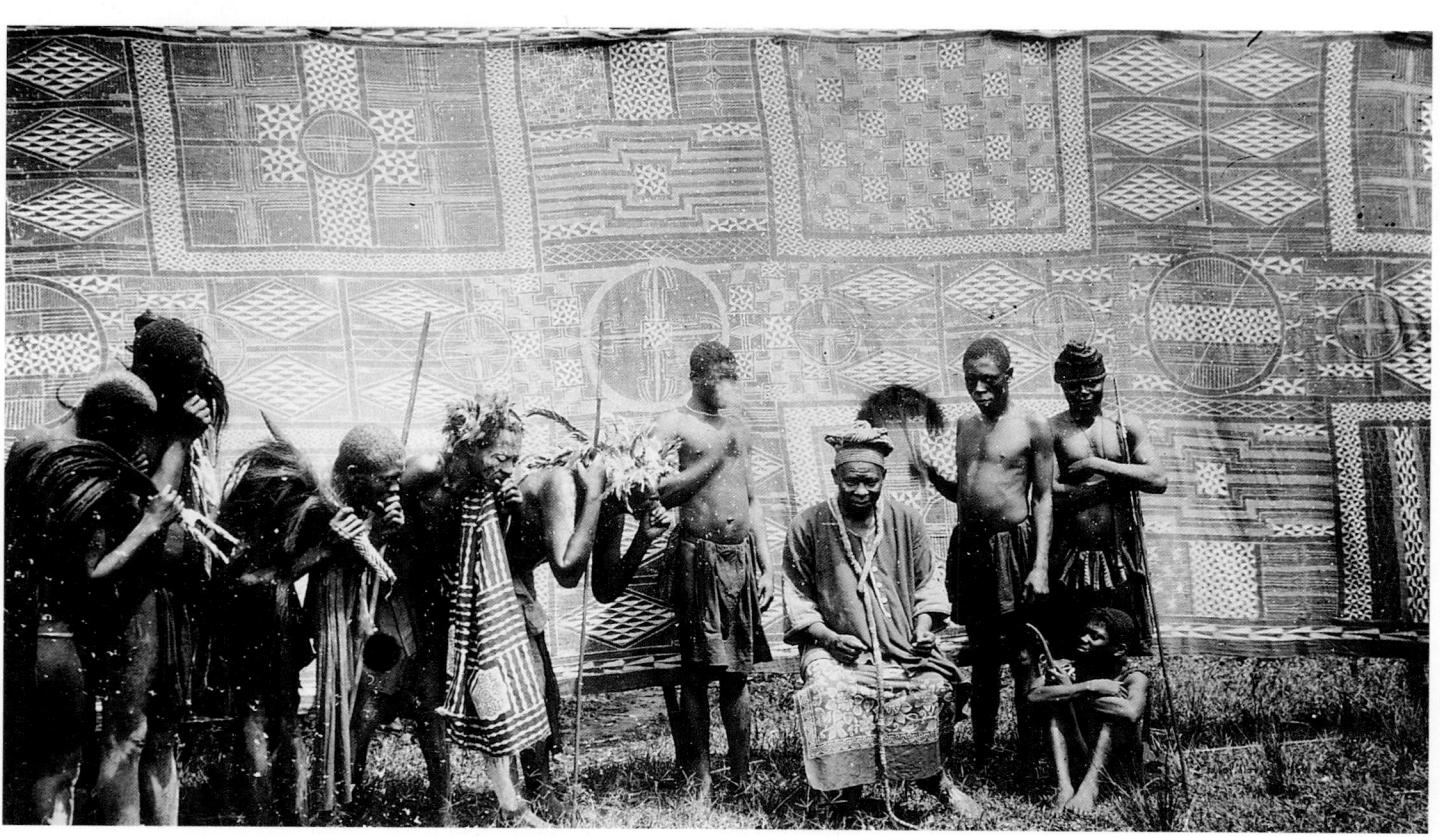

Drums, sculpture, stools, and numerous smaller objects from the treasury may be displayed around a king seated in state. These smaller objects may be held by retainers or by wives of the king. Figure 10-15 shows the king of Babungo attended by four of his wives, each of whom holds a portable object from the royal treasury. The woman to the left lifts a bead-decorated calabash used as a container for palm wine. An important item of regalia, the calabash often appears as an attribute in royal portraiture, where it may be shown in the hands of a wife. The wife to the right foreground holds a drinking vessel carved from buffalo or cattle horn and adorned with abstract designs that allude to status. The wife to the rear holds a ceremonial flywhisk whose handle is worked with bead embroidery. The woman at the king's shoulder carries a brass pipe, a symbol of high status and an important ceremonial object. Cast using the lost-wax technique, the pipe depicts a German officer, a reminder of Germany's colonial presence during the early twentieth century. Almost everyone in grasslands society smokes tobacco, but the pipes associated with important men are extravagantly different from the everyday types used by ordinary people. While ordinary pipes are usually made of terracotta or wood, royal ceremonial pipes may be made of brass, stone, bone, or even ivory.

Furniture and containers were ornately carved with motifs that alluded to rank and power. A photograph taken in 1908 documents a number of royal wooden bowls used in the Bamum palace during Njoya's reign (fig. 10-16). Such bowls served

netwickers and a transmission

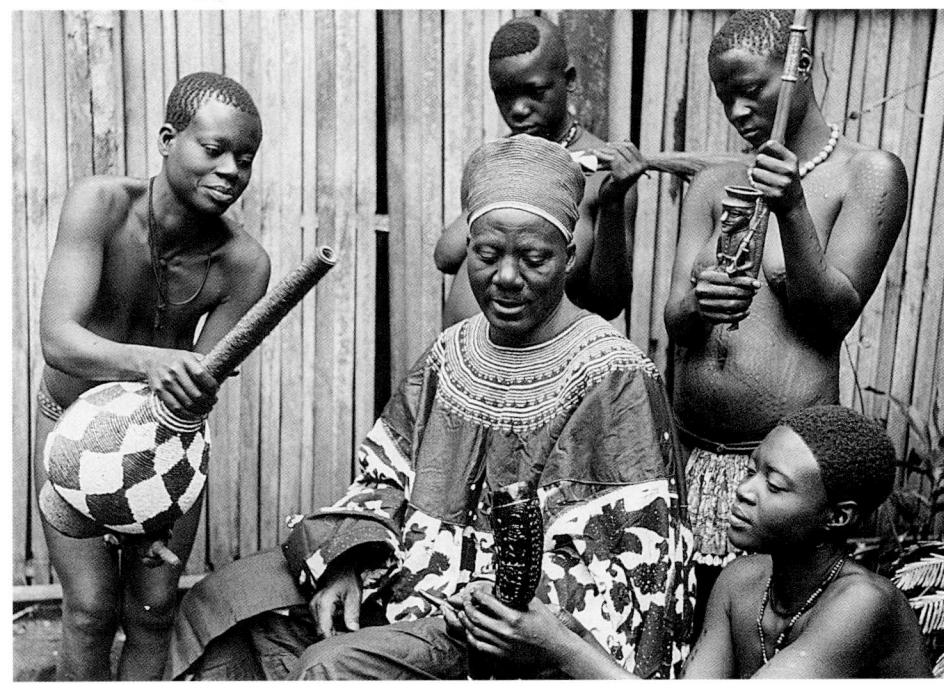

10-15. Chief Zake, a king of Babungo with royal wives holding objects from the treasury, Cameroon. Photograph 1938

The king had the privilege to use such objects at all times. Other titleholders, such as some royal women, princes, high-ranking heads of lineages, and court functionaries, inherited the right to use regalia, but such rights had to be confirmed for each generation by the ruling king. Granting entitlement to such objects intensified the alliance between the king and his favorites.

a variety of purposes. Some are food bowls, while others supported calabashes filled with beverages. Sacrifices were also placed in such bowls to propitiate supernatural or ancestral powers. Some are kola nut receptacles, which were kept near kings so that the kola was ready to be offered to guests. Bowls of terracotta were also used in the palace, and the vessel shown in figure 10-17 was a container for sauces.

Grasslands artists employ a number of abstract, sometimes geometric motifs derived from depictions of various symbolic animals. The openwork base of this ceramic bowl is carved in a motif of bands and knobs known as the

spider motif. The motif evokes the large earth spider, which lives in a burrow below the ground and is thus believed to connect the realm of humans (above ground) with that of the ancestors (who were buried in the earth). Active at night, it sees things humans cannot see, such as wandering spirits and nocturnal beings. The spider is a symbol of supernatural wisdom and auspicious power. Ultimately the motif refers to the importance of ancestral spirits who guide the king and his people. The spider motif is also noticeable on the end of Njoya's footstool (see fig. 10-13), where it served to remind the court that Njoya was an agent of the royal ancestors.

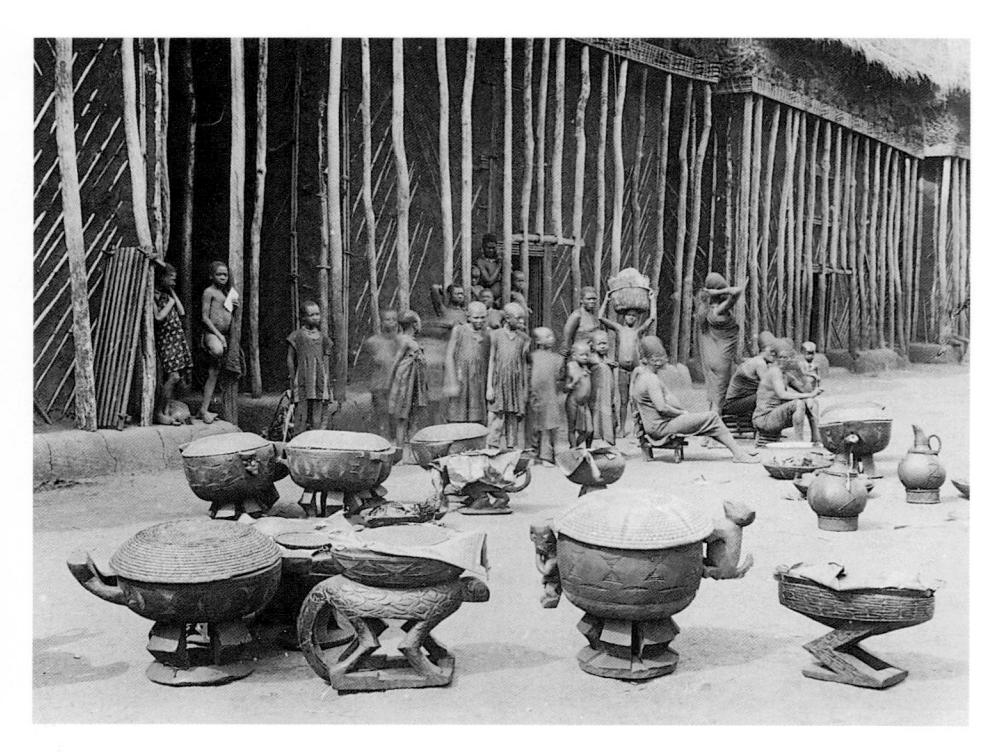

10-16. Bowls displayed in a courtyard of the palace at Foumban, Bamum, Cameroon. Photograph 1908

Most of the bowls shown in this photograph are hemispherical containers carved in relief and with openwork bases. Some, such as the one in the center foreground, have figural bases, in this case a leopard. The bowl to its right has handles carved in the form of a human figure on one side and an animal figure on the other.

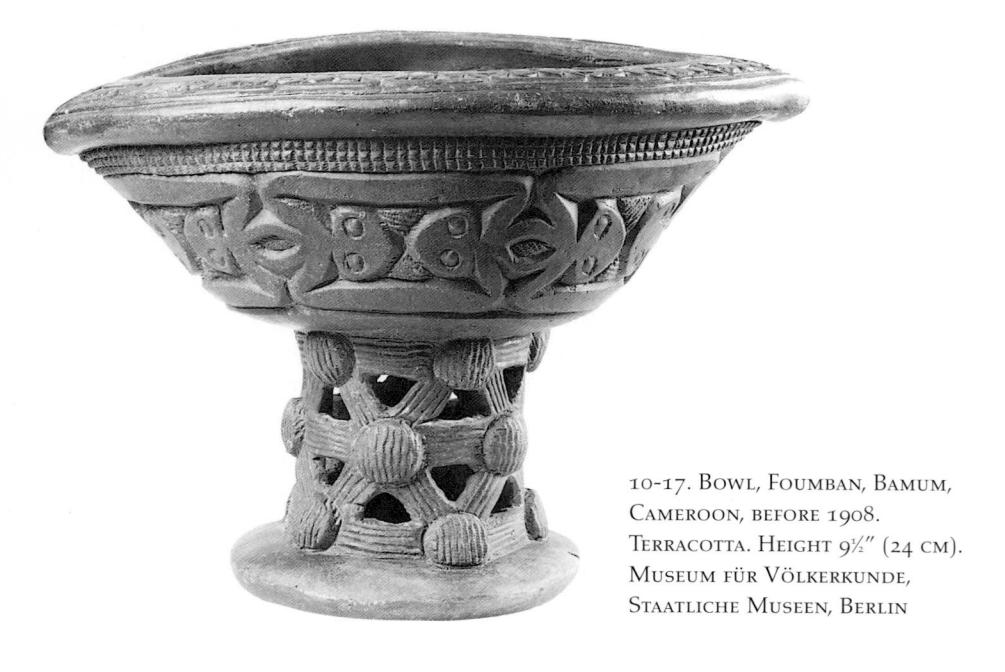

The belly of the bowl and the upper portion of its rim are decorated with the frog motif. More directly representational than the spider motif, the frog motif depicts the heads and forelegs of two frogs joined back-to-back to a single, abbreviated body. The motifs are linked together by joining the forelegs of each unit to the next. The frog is the second most frequently used motif on grasslands prestige arts. Grasslands belief systems associate the frog with human fertility, a concept central to ideas of strength and power as measured in the numbers of people that support the king and provide his kingdom with a work force and an army.

It is customary in the grasslands for a king to have his portrait carved during his reign, along with portraits of titled women such as the more important royal wives and the queen mother. In some regions, a king's portrait is carved during the reign of his successor. The artist Bvu Kwam carved a portrait of Bay Akiy, king of Isu, in the eighteenth century (fig. 10-18). The ruler is shown seated on a four-legged animal. He lifts a cutlass with his right hand and holds in his left hand the head of the king of a small neighboring state, a trophy of his triumph over the enemy. The expressive facial features are accentuated by the addition of ivory teeth. The head turns to the right, helping to activate the vigorous figure. A cord with a huge bead and a piece of human femur hangs from the neck. Attitudes of victory, rejoicing, and ferocity are all encompassed in the figure, which was carved to serve as a symbol of Bay Akiy's reign as well as to evoke the power of his office and his family.

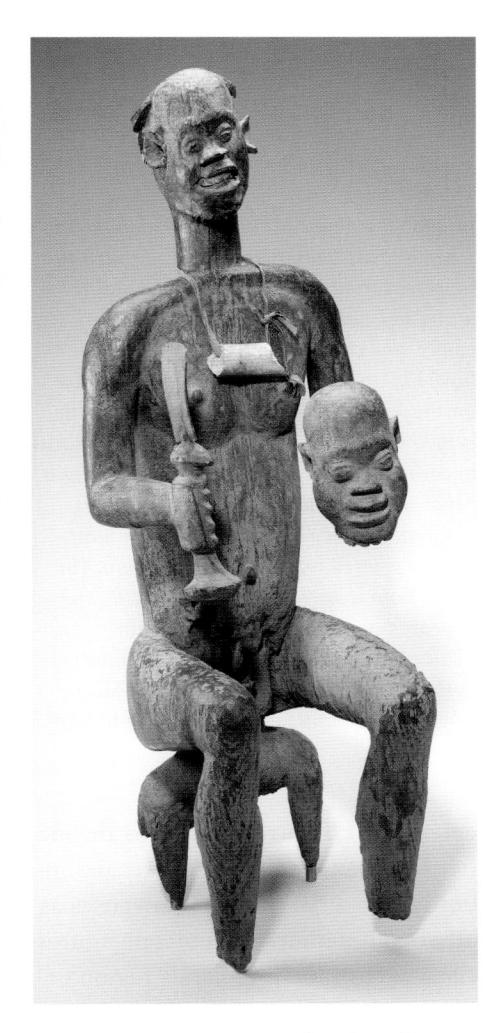

10-18. PORTRAIT FIGURE OF BAY AKIY, BVU KWAM, ISU, CAMEROON, 18TH CENTURY. Wood, Ivory, Pigment, Hair, Bone. The NATIONAL MUSEUM OF AFRICAN ART, SMITHSONIAN INSTITUTION, WASHINGTON, D.C. GIFT OF WALT DISNEY WORLD CO., A SUBSIDIARY OF THE WALT DISNEY COMPANY

A portrait figure of a king is sometimes displayed surrounded with portrait figures of wives and retainers, just as a living king is surrounded by wives and retainers in court to reinforce his power and to indicate his rank and position. A portrait figure of a king is intended to preserve the kingdom's history, its genealogies, and its legends. It has a narrative function in telling the lore of the group. Groups of such figures will often be placed near the doorway of the king's residence to signify the origins and the future of his people.

Grasslands portraiture does not stress physical likeness. It is not so much the physiognomy of the individual that is depicted but the position the person holds and his character. The individual is recognized by attributes rather than by physical appearance. Several features suggest that this image is a symbolic portrait of a king. The pose of the figure indicates status, for sitting suggests rank. Normally, a person of great status sits in the presence of his lessers, who must stand. The ceremonial knife and the trophy head that the figure holds are likewise indicators of royal authority.

The dynamic dancing woman in figure 10-19 is one of the best-known of the grasslands sculptures. Created in Bangwa in the nineteenth century, the figure presents a figure of mature womanhood marked by both sexual and social maturity. Attributes such as collars of beads and leopard teeth pendants, beaded loin cloth, and armlets allude to her special status in grasslands hierarchies. She may represent a royal wife, or she may be the mother of twins. But the attributes of the figure suggest she played another role as well. She holds a basketry rattle carried by the woman who leads the dance in honor of the earth, and while she may indeed represent a royal woman, she also represents a priestess of the earth. The vigorous movement of her body shows her in the act of singing praises to the earth, perhaps as she would at the funeral rituals for a king.

In the kingdom of Kom, portrait figures include a representation of a royal stool. The stool serves as a base from which a standing figure, shown from the thighs up, seems to be

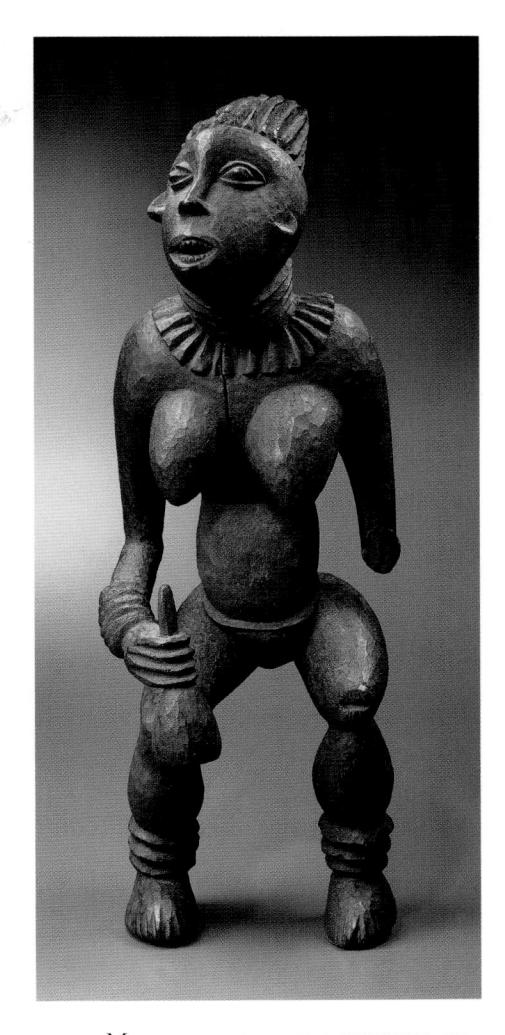

10-19. Memorial figure of a priestess of THE EARTH, BANGWA, CAMEROON, 19TH CENTURY. WOOD. HEIGHT 331/3" (85 CM). Musée Dapper, Paris

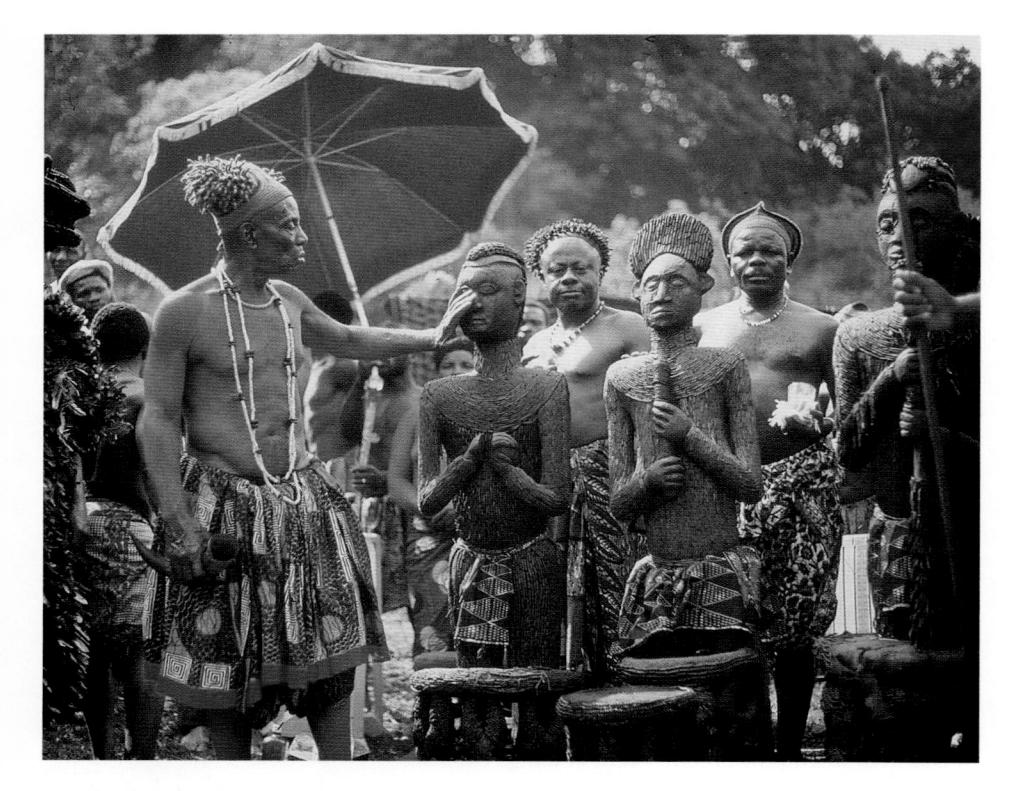

10-20. King Jinaboh II at his enthronement with the *AFO-A-KOM* ("Thing of Kom") and subsidiary portrait figures, Kom, Cameroon. Attributed to Yu, king of Kom. Photograph 1976

Jinaboh, his body ritually colored with camwood or red ocher, reaches out to touch the representation of a titled wife of Yu. She wears her hair in a style associated with the palace, and clasps her hands in respect for her husband and the queen mother, the figure on the far right. The office of queen mother is held by a woman of especially high status in court, and her effigy is carved wearing a royal coiffure and carrying a royal staff. The figures have been covered with wrappers of printed fabric for the occasion. The afo-a-Kom was stolen in 1966, but it later appeared on the cover of an exhibition catalogue. An American Peace Corps volunteer noticed it, which led to a New York Times story that led to its eventual return to Kom.

10-21. The Chronology of Bamun Kings 1915–32, Ibrahim Njoya. Cameroon, 1932. Watercolor and crayon on paper. 21%x 29%" (54.6 x 70.2 cm). Musée d'Ethnographie, Geneva

emerging. Often referred to as throne figures, they are not used as chairs but rather serve the same purposes as other commemorative portrait figures elsewhere in the grasslands region. The stool can be seen as an attribute, a reference to status, much as trophy heads or calabashes in other royal portraiture traditions.

Kom figures were carved in sets that included the king and some of his wives and retainers. Three figures of one set are still used in Kom (fig. 10-20). A king of Kom named Yu carved the set, which originally included six figures, in the first decade of the twentieth century. Carving is seen as an honorable profession in the grasslands, and some kings have had considerable reputations as carvers. Yu, who reigned from 1865 to 1912, is said to have organized a group of his fellow sculptors to produce a prodigious amount of

art for his court. A number of these artists are still remembered in Kom by name.

The central figure in the photograph is known as the afo-a-Kom, or "thing of Kom." The people of Kom consider it to be an effigy of Yu himself, and thus a type of self-portrait that now serves as a memorial ancestor figure. Yu is depicted wearing a cap and holding a short staff. Although a photograph of Yu himself with at least two of these Kom figures shows their surfaces to have been unadorned, the bodies have since been covered with cylindrical beads. The rose-colored beads covering the afoa-Kom evoke the reddish color of the camwood cosmetic that ritually covers the body of the king during his installation.

A variation on royal portraiture was introduced in the 1920s in the work of Prince Ibrahim Njoya, a kinsman of Sultan Njoya (fig. 10-21). Prince Njoya created wonderful action drawings in a series of illustrated chronologies of the history of Bamum. Despite their unconventional design and use of Western materials (watercolor and crayon on paper), Ibrahim's king lists shifted percep-

tions of royal grasslands portraiture, yet still reflect traditional practices of recording dynastic succession through royal portraiture.

Royal Spectacle and Masquerade Arts

Not only was the grasslands palace a work of art and a repository for numerous art forms, but it also served as backdrop for special events that reinforced ideas of central control and hierarchy. A particularly striking festival called nja formerly occurred annually in the kingdom of Bamum during the dry season. Prestige and beauty seem to have been its focus. All the king's subjects met at the palace dressed in their finest raiment. The facade of the palace was festooned with royal textiles, and the ceremonial site before the palace was enhanced with objects from the treasury, including the royal throne. The king made an appearance before his subjects as the incarnation of wealth and might.

During the festival, which was an art of spectacle, the king, his retainers, his councilors, indeed, all significant persons of the kingdom, danced

in special dress. Some retainers appeared in disguise, wearing masks, followed by councilors in batik dress and wearing headdresses similar to the king's. Princes, descendants of former kings, followed in their own elegant dress, holding symbolic flywhisks.

Njoya's costume for the nja festival was photographed in 1908 (fig. 10-22). In posing for the photograph, Niova himself chose to wear a colonial uniform and to have a surrogate model the nia garment. According to the photograph, when Njoya appeared in the festival, he wore a fake beard of tubular beads. Armlets and anklets of beads weighed down his limbs. A voluminous loincloth of cloth from Wukari draped to the ankles in massive folds between his legs. From his hips hung bead-embroidered otter pelts. A belt with double serpent heads girded his waist. A bead-covered figure of a man served as the handle of the white horsetail flywhisk in his right hand. A bead and leopard tooth necklace cascaded over his abdomen and chest. A ceremonial sword boasted a serpent head hilt suspended from his shoulders by a clothcovered scabbard decorated with bead-

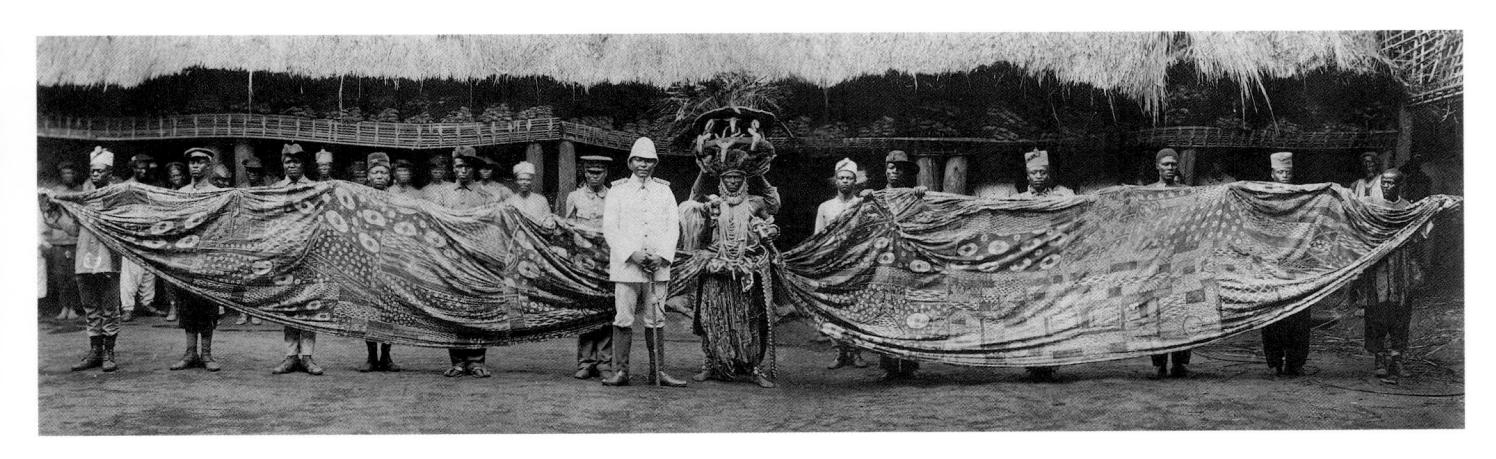

10-22. NJOYA WITH SURROGATE WEARING HIS COSTUME FOR THE NJA FESTIVAL, BAMUM, CAMEROON, 1908

work spiders. On his head Njoya wore a huge headdress known as *mpelet*, with flying fox figures made of cloth, beads, and feathers. A double train of Wukari cloth draped from his waist, supported by numerous retainers in this dramatic photograph.

Masquerades appearing in royal festivals are usually performed by men's societies, whose membership is determined by status or achievement and is highly regulated. Each society has its own special house, its own masks, costumes, dances, and secret language. Each acts on behalf of the king to establish order and to preserve the social and religious structure of the kingdom.

One such society is Kwifo. While the king hears complaints and counsels his people, it is the awesome Kwifo that acts as a police force, carrying out punishments and executions at night (kwifo means "night"). As an agent of the king's administration, Kwifo also mediates significant conflicts and pronounces sentence in both civil and criminal cases. Each Kwifo society has a mask that serves as a spokesman and representative. Known as *mabu*, this mask presents the decrees of the society to the community. It ushers the members of Kwifo through the village, alerting the people of the approach of the group, and compelling them to behave appropriately. Other masks are credited with supernatural strength generated by the "medicine" of Kwifo, and embody the aggressive and terrifying nature of the society. Because of the gravity of the events surrounding their arrival, their wearers do not dance.

The photographs in figures 10-23 and 10-24 are typical of Kwifo masks.

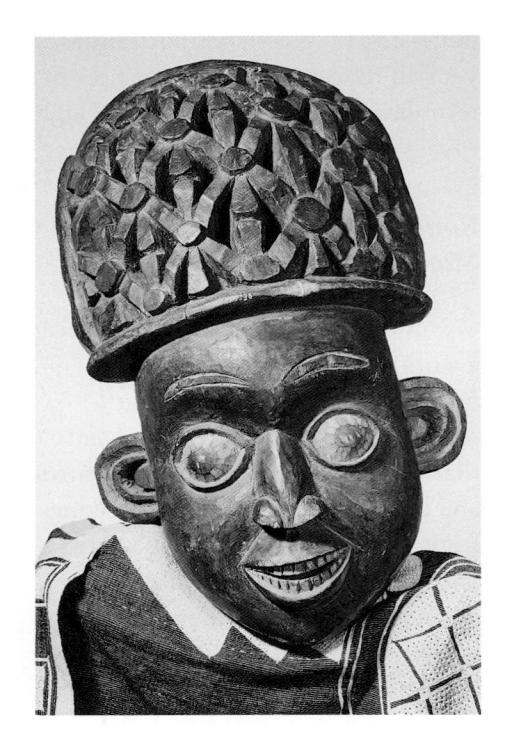

10-23. Mask with earth spider motif headdress, Grasslands region, Cameroon, before 1914. Wood. Height 27" (69 cm). Field Museum of Natural History, Chicago

Such masks usually perform in groups of eight to thirty, accompanied by an orchestra of drums, xylophone, and rattles. When they make special appearances at the burial and commemorative death celebrations of a member of the group, they are viewed with awe and reverence.

The mask in figure 10-23 is typical of grasslands masks that depict human-like male figures, with its exaggerated features, open mouth, and bulging eyes. Large and helmetshaped, it is worn at an angle on the top of the masker, whose own head is covered with a cloth through which he can see. The headdress carved on the mask's crown alludes to a prestige cap worn by kings and titleholders, reminding viewers of the high status of the group performing the masquerade, while the repeated earth spider motif carved on it alludes to the awesome powers of ancestors and spirits. The forest buffalo represented in figure 10-24, along with the leopard, elephant, and serpent, are royal icons symbolic of the privileges and authority granted to the group by the king. The mask here is worn with a costume of feathers.

In the Bamileke region of the grasslands, a society known as Kuosi is responsible for dramatic displays that involve spectacular masquerades. Formerly a warrior society, its membership is now composed of powerful,

10-24. Horizontal buffalo mask from Babungo, Cameroon, 1940

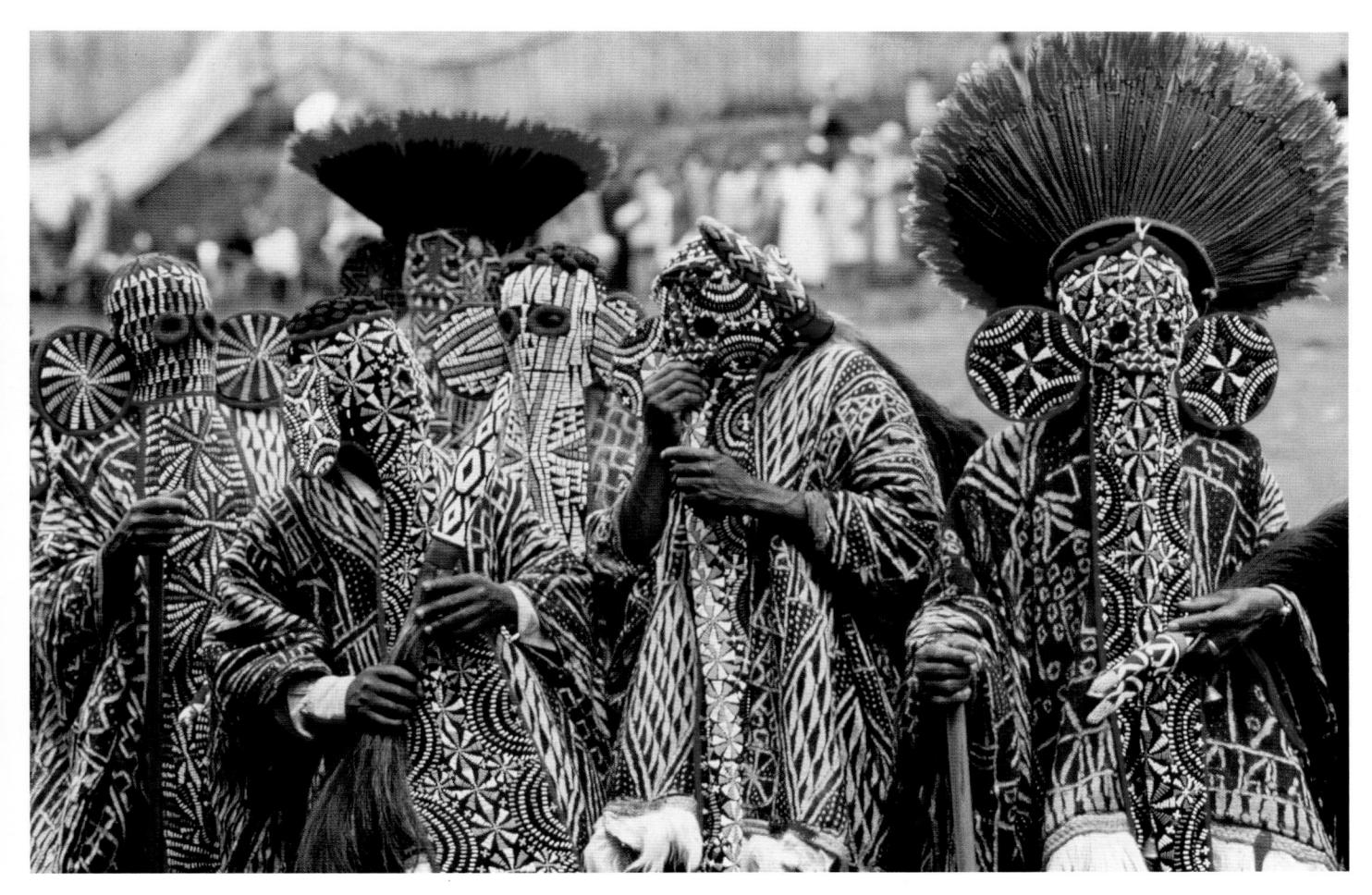

10-25. Kuosi society elephant masks in performance, Cameroon. Photograph 1985

wealthy men. The king himself might even don a mask for appearance at the Kuosi celebration, a public dance sponsored every other year as a dazzling display of the kingdom's wealth. Kuosi elephant masks such as those in figure 10-25 have large flaps of cloth that cascade over the masker's chest and down his back. Covered with beaded designs, the flaps symbolize elephant trunks. Costumes worn with the masks include beaded garments, tunics of indigo-dyed Wukari cloth, and leopard pelts. Headdresses may be attached to the masks or worn by themselves with a costume. Some headdresses, great expanding forms

covered with red parrot feathers, look like extravagant flowers. Leaders of the Kuosi society report directly to the king, and may be allowed to wear beaded sculptural crests that represent leopards or elephants, both royal animals.

Perhaps the most famous of all masks from the Cameroon grasslands is a sculpture so formally compelling that many scholars consider it to be one of the masterpieces of African art (fig. 10-26). This style of forcefully abstracted mask probably dates at least to the eighteenth century. While similar masks have been found in several grasslands kingdoms, the his-

torical center of production seems to have been the kingdom of Bandjoun. There the masks, called *tsesah*, were instruments of a closed association known as Msop. They were brought out to participate in the enthronement of a king or to act in the mourning festivities of great personages. They also came out to perform the tso dance at the palace, accompanied by ritual flutes. The tso dance symbolized the sovereignty of the kingdom and took place at the funeral of a king or a queen, at annual agricultural rituals that marked the end of the harvest and the new year, at special rituals that had to do with

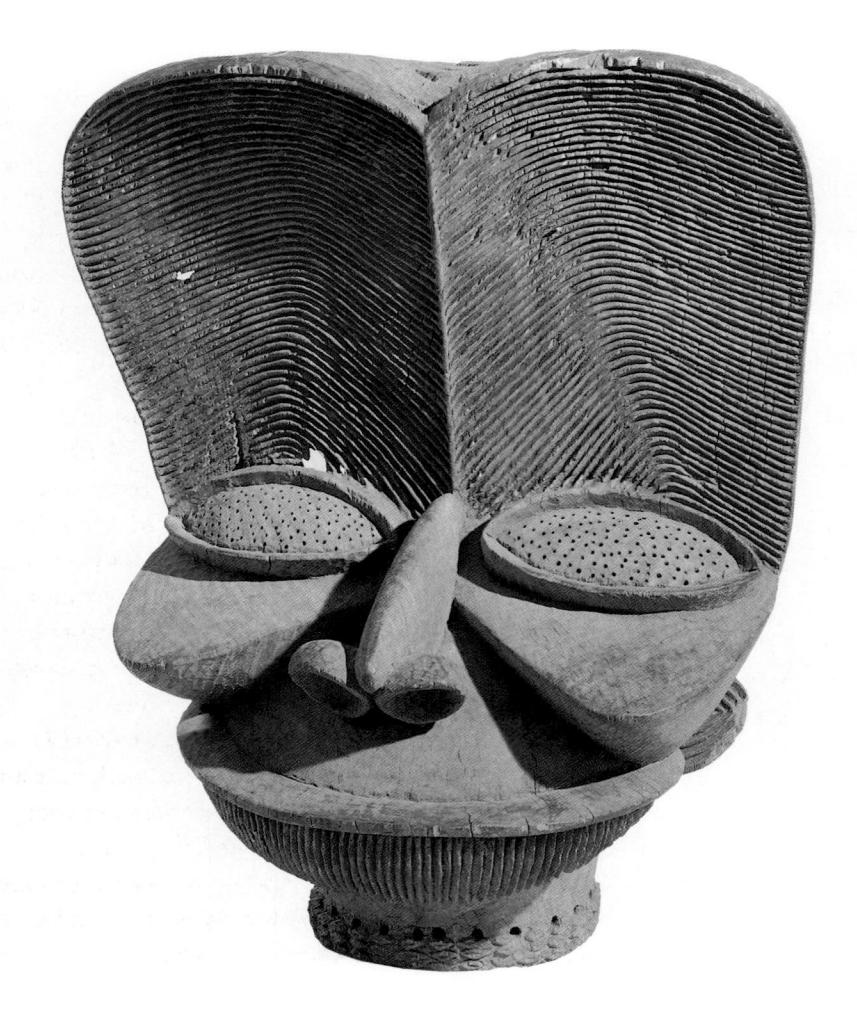

10-26. Mask, Grasslands region, Cameroon, 18th century. Wood. Height $18\frac{1}{2}$ " (47 cm). Museum Rietberg, Zürich

The mask represents a face with extravagantly exaggerated brows, their towering forms emphasized by parallel striations. Large, almond-shaped eyes, their surfaces animated by numerous tiny holes, sit on voluminous cheeks that project outward like ledges over a broad mouth whose vertical striations indicate teeth. The nose, its gentle curve rhyming with the curves of the cheeks and eyes, is tipped with two dilated, cup-shaped nostrils, whose form is echoed in turn by the low-set ears. The mask sits on a hollow cylindrical neck which is pierced with a ring of holes, perhaps for the attachment of a garment. Just below the holes, a band of cowrie shells is carved in relief.

transcendent power, and at certain meetings of Msop. As with most of the works from the grasslands kingdoms, the form of this headdress conveys something of the spiritual and social authority of its owners. The sculptural style embodied in *tsesah* is no longer a part of the grasslands repertoire.

MARITIME ARTS: THE DUALA

Far to the southeast of the grasslands region, on the coast of Cameroon, a number of peoples live in close relationship to the waters of the ocean, estuaries, and rivers. Both their economic and spiritual lives have long been connected to the maritime environment, and many of their arts reflect this tie.

When European ships first appeared off the Cameroon coast some five hundred years ago, one of these peoples, the Duala, initiated a trading relationship that lasted for centuries. By canoe they transported such goods as ivory, palm oil, rubber, and slaves to European ships anchored offshore, receiving in return European goods that were quickly integrated into Duala culture. The long centuries of trade influenced Duala social structure as well. Among the Duala, as among others in the region, lineage leaders had governed small groups of people. But because Europeans seemed to prefer negotiating with one recognized authority in any given area, the Duala came to raise certain lineage leaders over others, giving them the role of spokesman and creating a new position of chief. Objects such as the ornate stool shown here were created

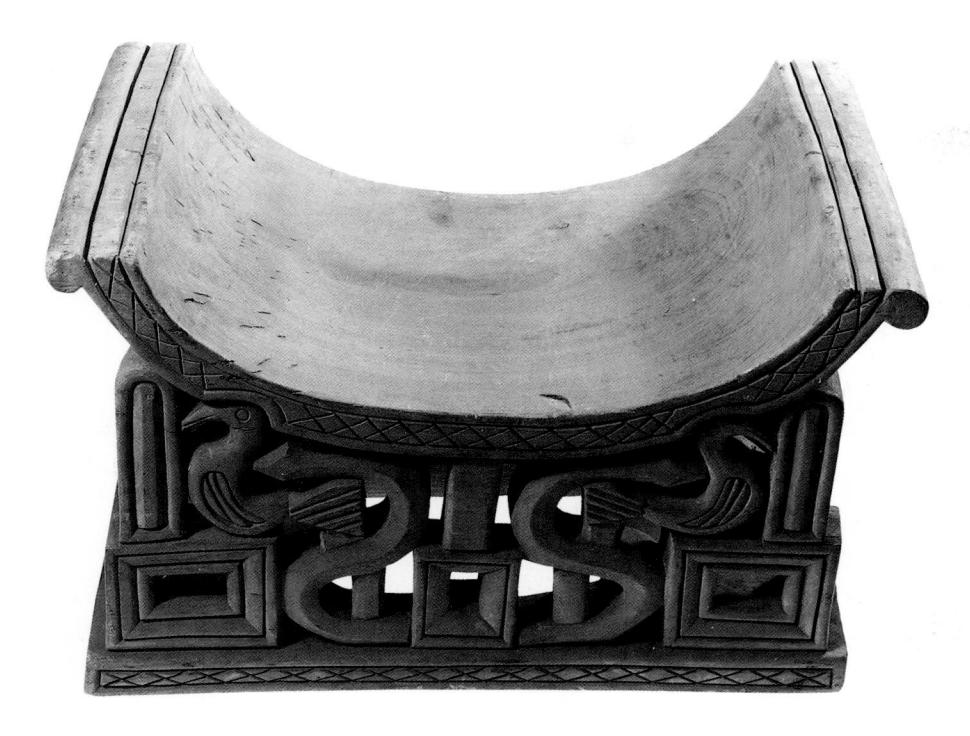

10-27. Carved Stool, Duala. Wood. National Museum of Natural History, Smithsonian Institution, Washington, D.C.

as prestige objects that supported the position and authority of these newly created chiefs (fig. 10-27). Duala stools typically have a wide horizontal base and a curving seat. Geometric motifs interspersed with animal images decorate the bases. Here, serpents and birds are worked into a symmetrical design.

The canoe and the arts associated with it have become a cultural metaphor for the Duala. Sacrifices to water spirits who controlled success in fishing in the rivers and estuaries were offered from canoes, and it was canoes that enabled the Duala to carry on their European trade. This trade fostered the growth of prosperous families, who competed with each other not only in business but also in canoe races. Such competitions are still important to the Duala. Racing dugouts today measure about fifty to

seventy-five feet long and some three-and-one-half feet across. Up to thirty paddlers, each with his own personally decorated paddle, help to speed these crafts in competition. The surfaces of the sleek canoes are painted in a variety of geometric patterns, and the name of each craft, carved in relief, is also painted in the same bright colors. An elaborate openwork ornament called a tange is attached to the prow. The tange shown here is painted in bright colors (fig. 10-28). Typical for the form, it is carved with an abundance of human and animal images engaged in a variety of activities. Tange iconography is chosen to intimidate rivals, and the figures depicted are usually expressions of power.

Serpents and birds dominate canoe iconography. Usually the two are shown in confrontation. Here, a large

snake writhes along the underside of the tange. Rising up over the tip, it has begun to swallow a bird standing on the upper side, even as it is being attacked by a second bird from below. The violent action underscores the superior strength of the canoe's owners. The lethal serpents symbolize a force that leaves no room for retaliation. Birds, on the other hand, may symbolize speed, suggesting rapid movement over the water. At the same time, they also signify power and strength. Other animals on the tange may refer to family totems or represent strength. They may also refer to Duala organizations. For example, the leopard depicted standing at the rear of the projecting section, while it is associated with leadership and connotes authority and chieftancy, may also refer to closed associations in the Duala area.

Images of humans on a tange may represent mortals of special rank or spirits in human guise. On both the long projecting element and the plaque-like crosspiece at its base, the central figures are dressed in European clothing and posed symmetrically. The man depicted on the crosspiece carries Duala dance wands; the man on the projecting section carries dance wands and wears an elaborate headdress indicating special status. Since both figures are dressed as Europeans but have non-European attributes as well, they may represent Duala persons of high rank, for Duala chiefs frequently greeted the ships of trading agents in European military garb. Europeans were associated with wealth and power, and it is possible that the intent of such images was to suggest an economic alliance between the owner of the canoe and the pow-

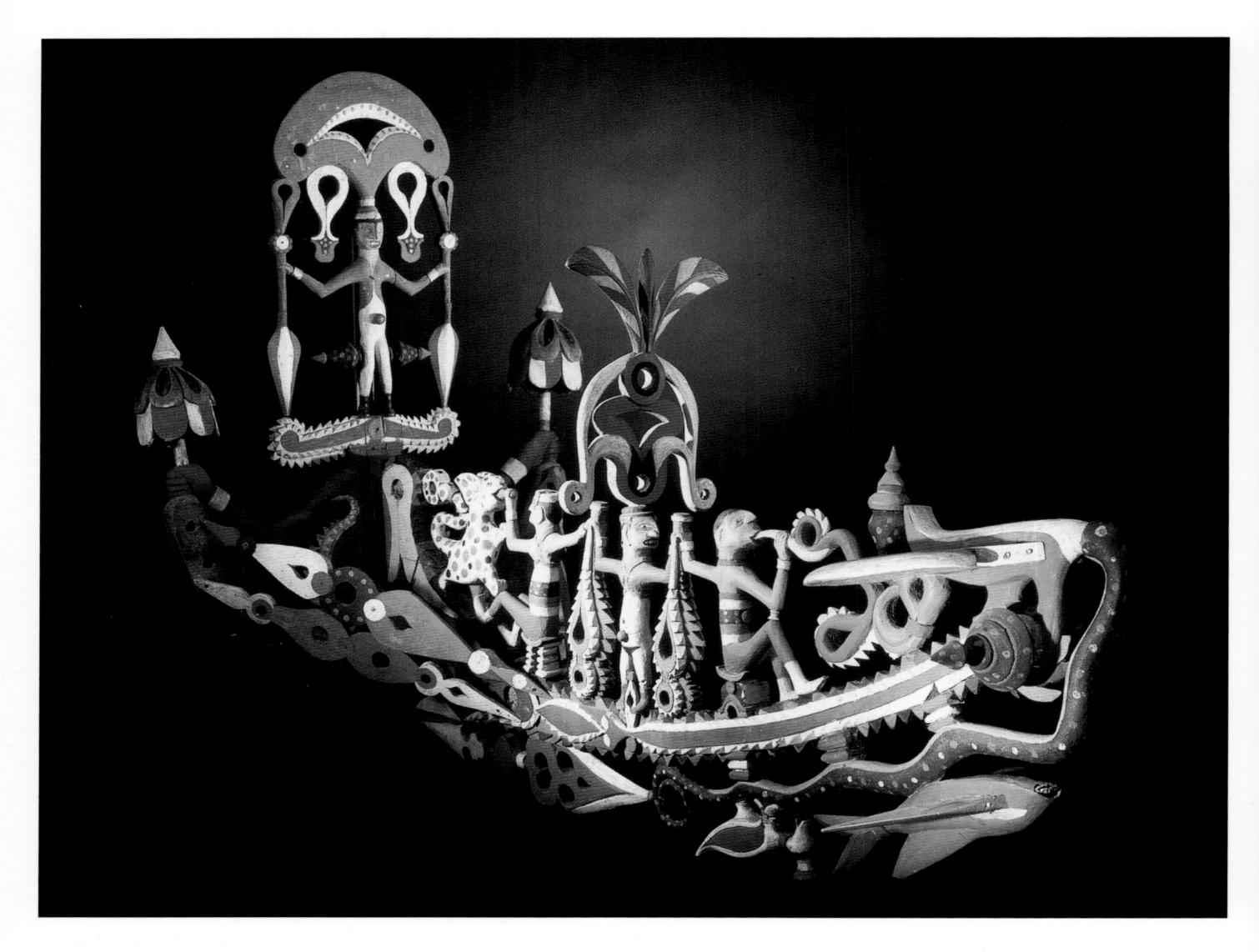

10-28. *Tange* (prow ornament), Duala, 1890 or earlier. Wood, polychrome. The National Museum of Ethnology, Stockholm

The tange is not merely a sculptural form. The canoe to which it is attached and the family to whom it belongs interact within the context of the race, where the symbols of power are not just seen but acted out in performance. Human beings working together as a team in concert with spiritual agencies activate the powers alluded to in the sculpture of the tange.

erful European traders that he controlled.

Seated secondary figures in this tange also wear European clothing and footwear, but they participate in non-European activities. One reaches out and grasps the tongue of the leopard, while the other grasps the tail of a serpent. This type of imagery, in which humans demonstrate mastery over animals without the apparent use of force, occurs repeatedly in Duala arts, and suggests ritual activity and supernatural abilities. Such figures thus combine

attributes of persons of power in two worlds, the economic world of the Duala with its European trade, and the spiritual world.

Duala artists often integrated European-inspired motifs into their iconography. Such motifs were carefully chosen and imbued with meaning. Images of trade goods, including weapons, European furniture, goblets, trays, oil lamps, decanters, and clothing, are references to social status, for example. On this *tange*, imported parasols serve as finials on either side of the crosspiece.

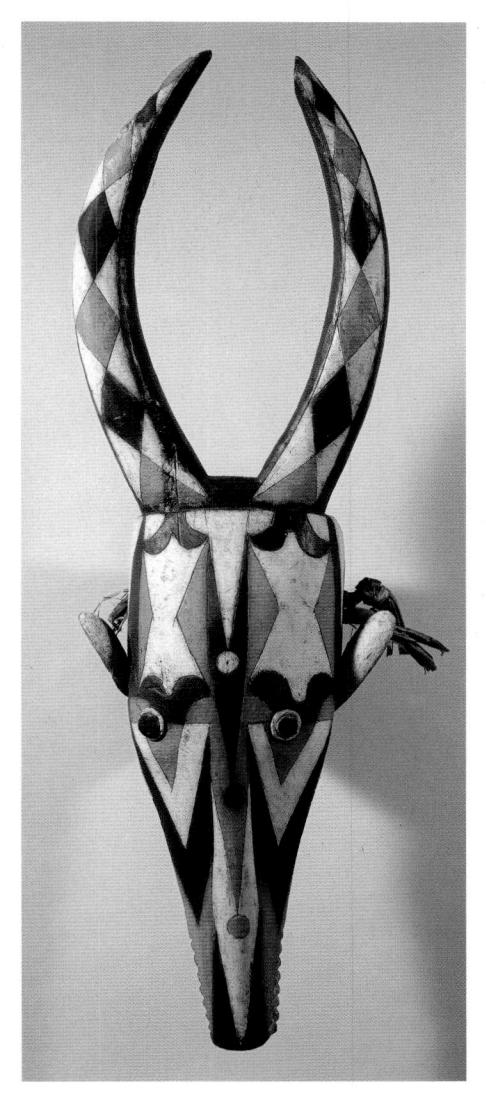

10-29. *ISANGO* MASK, DUALA, CAMEROON, BEFORE 1908. 35½ X 12½" (90 X 32 CM). WORLD MUSEUM, LIVERPOOL

The Duala no longer carve wooden masks or perform with them, and in fact, they seem to be unaware that their predecessors did. Most masks collected by Europeans are painted horizontal headdresses with geometric designs carved in relief, painted with bright European enamels (fig. 10-29). Descriptions of performances suggest that masks were worn atop the performer's head with the image facing upward. Research has estab-

lished that masquerades were performed in conjunction with secret associations known as losango (sing. isango). These organizations reflected the nineteenth-century Duala social system, organized according to a person's status as freeborn, half-free, or slave. Each category had its own losango. Nineteenth-century European accounts mention four major Duala losango. Three of them are known to have employed masks in their activities. Although we are familiar with a number of the masks collected by Europeans, we cannot be sure of the way the masquerade appeared and how the costume was worn. An 1884 account described a Duala Ekongolo society funeral in which a masker who wore a carved wooden antelope mask was dressed in a costume of European and African fabrics.

GABON

The dense rain forests of Gabon, which extend through Equatorial Guinea and into southern Cameroon as well, are home to at least forty ethnic groups that share a number of traits and similar institutions. They live in small, independent communities. Centralized political institutions such as those of the grasslands area of Cameroon are unknown. Instead, men's organizations help bring about social cohesion.

Reliquary Guardians

Almost all these groups venerated the relics of ancestors. These were bones and other objects belonging to important deceased relatives—those who were leaders, courageous warriors,

village founders, artists or superior craftsworkers, and especially fertile women. Relics were believed to be imbued with the powers that those extraordinary people had during their lives, powers that could be drawn upon to help the living.

French colonial officials banned reliquaries (the containers for relics) and the priests who controlled them during the first decades of the twentieth century. Until then, consultation of the ancestral relics preceded all significant events. Reliquaries took on different forms among various groups, but they fulfilled similar functions. A carved wooden head or figure often surmounted the container. Although museums display these sculptures unadorned, they were decorated with feathers and collars when they were in use. Such heads or figures were not understood as portraits of an ancestor or even as symbolic of ancestors. Instead, each was a guardian of the relics, a warning to those who approached that sacred materials were within. In these forest regions young men were introduced to the reliquaries of their family or association during the exciting and traumatic events surrounding their initiation into adulthood.

Among the best known of the regional reliquary traditions is that of the Fang people. The Fang and related groups are said to have migrated from the northeast over the past several centuries, entering the coastal areas of Gabon by the mid- to late nineteenth century. Historically, the Fang were itinerant, and it is only recently that they have settled into a broad area from the Sananga River in Cameroon, near Yaounde, to the Ogowe River in central Gabon.

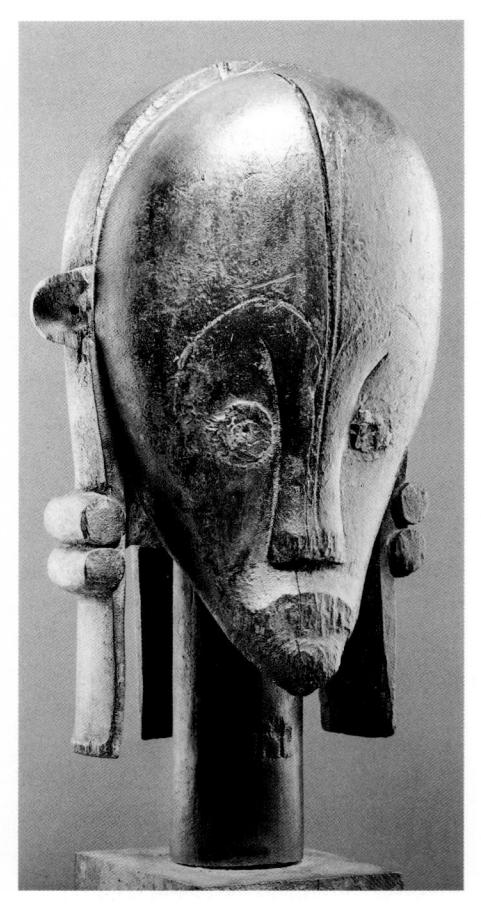

10-30 NLO *Bieri* Head ("Great Bieri"), Fang, 19th–20th Century. Wood, Metal, Palm Oil. Height 18%" (46.5 cm). The Metropolitan Museum of Art, New York. The Michael C. Rockefeller Memorial Collection, Bequest of Nelson A. Rockefeller, 1979

Nsek-bieri were consulted before any important undertaking. An old man considered close to the ancestors was in charge of the assemblage of relics and officiated at consultations. Such rituals usually took three to four days. The relics were taken out and covered with a substance to activate them. The nsek-bieri had to be fed to increase its strength and to stimulate fate when it was consulted. Animals were sacrificed to the ancestors and their blood smeared on the skulls.

The migratory existence of the Fang prohibited the creation of ancestral shrines at gravesites. Instead, the remains of the important dead, in the form of the skull and other bones, were carried from place to place in a cylindrical bark box, the basis of a transportable ancestral shrine called *nsek-bieri*. Within the container were represented a family's illustrious dead. Skulls were the most important, and the number of skulls in a box was a tangible reference to the antiquity of the lineage and the power it manipulated.

The migratory history of the Fang has made it difficult to sort out stylistic groups. Individual artists moved from place to place, and styles were transmitted and absorbed easily. Moreover, reliquary figures collected from the region early in the twentieth century were routinely attributed to the Fang, even though they may well have been created and used by other groups. Nevertheless, a northern and a southern Fang style are easily discernible.

The imposing head with its ornate hairdo shown here is typical of the southern style (fig. 10-30). Standing over 18 inches tall, it is the largest such head known. The hairline across the top emphasizes a broad forehead. The hairdo recalls the wiglike headdress called ekuma worn by Fang warriors in the nineteenth century. Disks of metal are attached for the eyes. The large mouth fills the narrow chin. The lustrous dark brown and black surface, typical of the southern Fang style, is the result of regular anointing with palm oil and copal resin. The long neck was originally attached to the lid of a bark container for relics, which

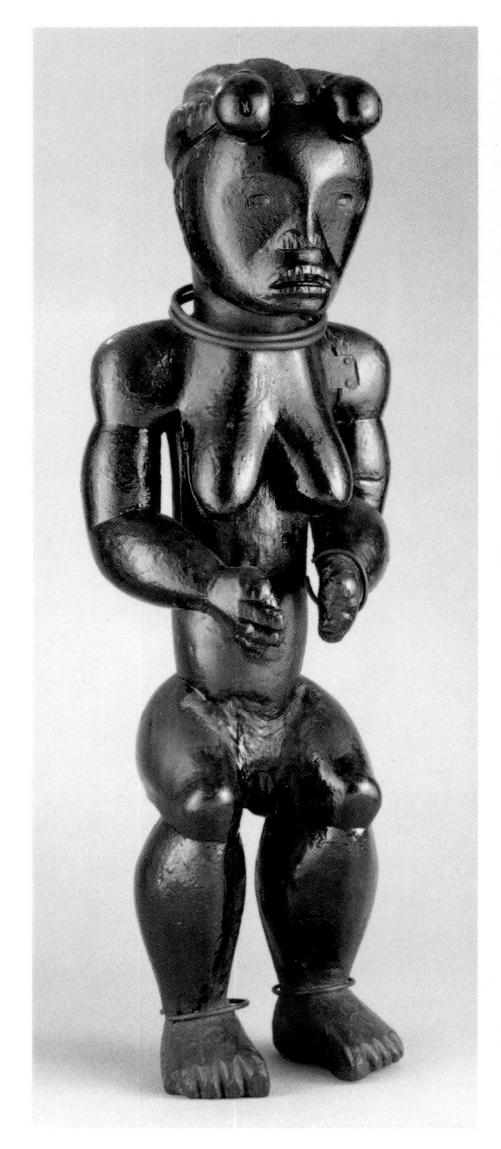

10-31. NLO *Bieri* figure, Fang (Okak), 19TH–20TH CENTURY. WOOD AND METAL. THE METROPOLITAN MUSEUM OF ART, NEW YORK. THE MICHAEL C. ROCKEFELLER MEMORIAL COLLECTION. GIFT OF NELSON A. ROCKEFELLER, 1965

would have been understood as the torso. Stylistic evidence suggests that the figure originated among the Betsi people, a southern Fang group located along the Ogowe River in central Gabon. The style of the object is very much like that of the heads of figures and half figures

used for the same purpose in the region.

The nineteenth-century southern-style *bieri* from the Okak Fang region in figure 10-31 glistens with resinous secretions from the oils and resins rubbed into its surface over years of use. Its bulging forms define the body of a mature woman, while the face is like that of a child. The combination of bulging muscles and stable symmetrical pose creates an anxious sense of balance and embodies an important Fang concept of opposing forces brought into balance and thus providing vitality.

Fang artists from the north carved only full standing figures as reliquary guardians (fig. 10-32). The beautiful female figure shown here may once have been accompanied by a companion male figure on a second reliquary. It was created among the Mabea, who live on the southern coast of Cameroon and in neighboring parts of Equatorial Guinea and Gabon. The Mabea are part of a group of peoples who arrived in this part of Cameroon and Gabon before the Fang. Though linguistically unrelated to the Fang, they have nevertheless become Fang in culture.

This very accomplished work is typical of the Mabea substyle of Fang sculpture, in which the head is less than one-fourth the height of the elongated figure. A double-crested helmet form tops the forward projecting head. Almond-shaped eyes with their clearly defined pupils fit into slightly sunken orbits, while an open mouth with teeth exposed through thin lips juts forward over a negligible chin. Tall and thin, with an elongated torso and slender extremities, the body is naturalistically carved with rounded forms and well-mod-

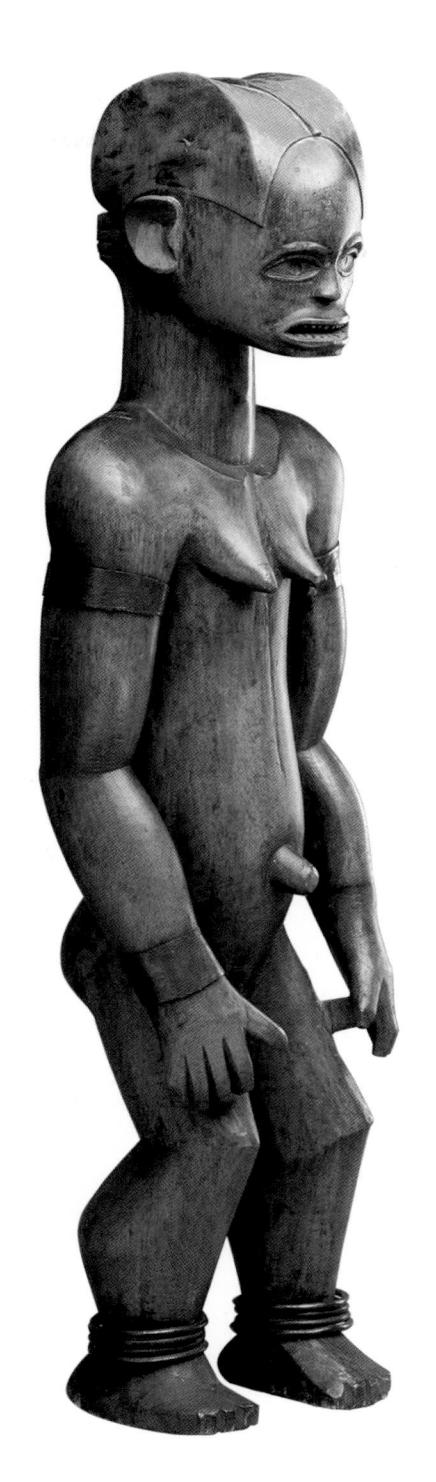

10-32. *Bieri* figure, Fang (Mabea). Wood. Musée Barbier-Mueller, Geneva

eled musculature. The elongated arms reach to the thighs, and the hands are separated from the thighs by carved projections. The distended belly is typical of all Fang-related figures. Like other Mabea-style figures this one has a light patina and smooth, well-finished surfaces contrasting to the dark and oozing surfaces of southern examples.

In addition to ancestral consultations, bieri figures were used during initiations. The consumption of a plant with stimulant properties induced a trance lasting for hours during which the "resuscitation of the ancestors" was enacted by detaching figures from reliquaries and moving them behind a raffia screen as puppets. In the heightened atmosphere of ceremony, music, dance, and altered consciousness, this show must have been particularly dramatic.

Adjacent to the Fang in the Upper Ogowe River area of eastern Gabon and into the Congo Republic live the Kota peoples, a number of groups with common cultural traits. Their present position is due to their movements under pressure from the Kwele peoples, who were driven from their own territories between the seventeenth and nineteenth centuries by the Fang. Kota subgroups such as the Shamaye, Hongwe, Obamba, Mindumu, and Shake each stayed more or less together as entities during migrations over the past several centuries, but many others were broken up and scattered. Although they share many cultural traits, the groups are by no means homogeneous. They live in villages comprising two or more clans. Clans in turn comprise several lineages or family groups that trace descent from a common ancestor. This is an important point related to their art, for like the Fang, the Kota revere the relics of ancestors.

The Kota keep bones and other relics of extraordinary ancestors in baskets or bundles called *bwete*. Bound into a packet and lashed to the base of a carved figure, the bones formed a stable base that allowed the image to stand more or less upright. The type of bundle varied according to location. The figures, called *mbulungulu*, like the guardian figures on Fang *nsek-bieri*, served as protectors of the bundle (see fig. 10-30).

At times a community brought all its reliquaries together in the belief that their combined power would offer greater strength against a danger. In some instances a group of families kept their reliquaries together under a small shelter erected away from the houses.

Bwete was called on in time of crisis to combat unseen agents of harm. Its intercession was sought in such vital matters as fertility, success in hunting, and success in commercial ventures. A husband could use it to guard against his wife's infidelity, for it was believed that if he placed pieces of her clothing in the reliquary, an unfaithful wife would be driven mad. Families took their bwete to ceremonies of neighboring villages to strengthen the allied community. The display of the bundles and their shiny, visually riveting figures was accompanied by feasting, dancing, and the making of protective medicines.

Several types of *mbulu-ngulu*, and a number of substyles, can be identified. All are based upon the human face, even though they are abstracted and refer to non-human spiritual forces. All are carved of wood, then

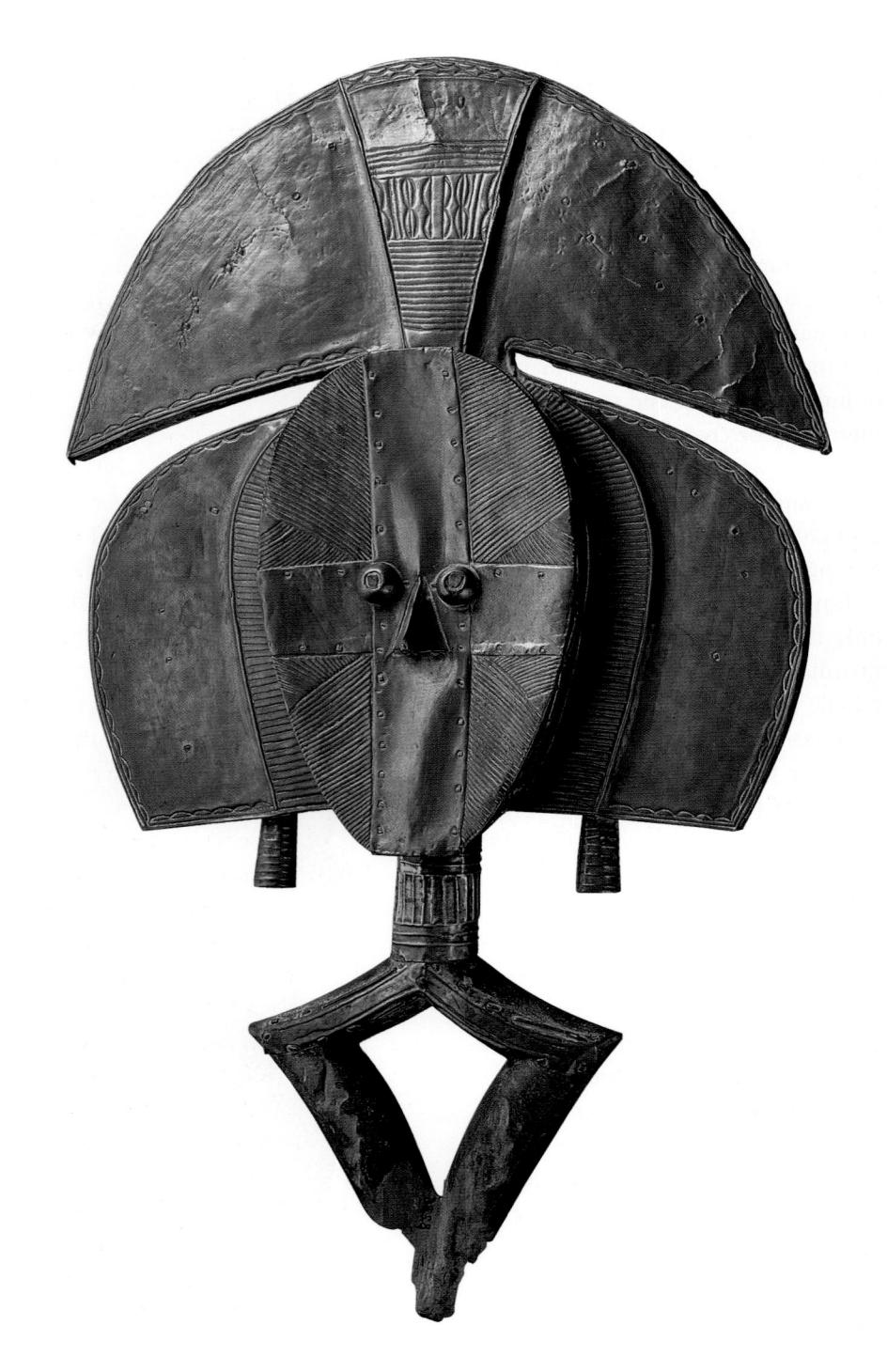

10-33. Mbulu-ngulu (reliquary figure), Kota. Wood, brass, copper. Height 30¼" (78 см). Völkerkunde Museum der Universität, Zürich

Metal, usually copper or copper alloy, formed the basis of currency in most of Central Africa prior to the colonial imposition of European coinage. Copper thus clothes these forms in prosperity and wealth, as well as giving them a reflective, gleaming surface.

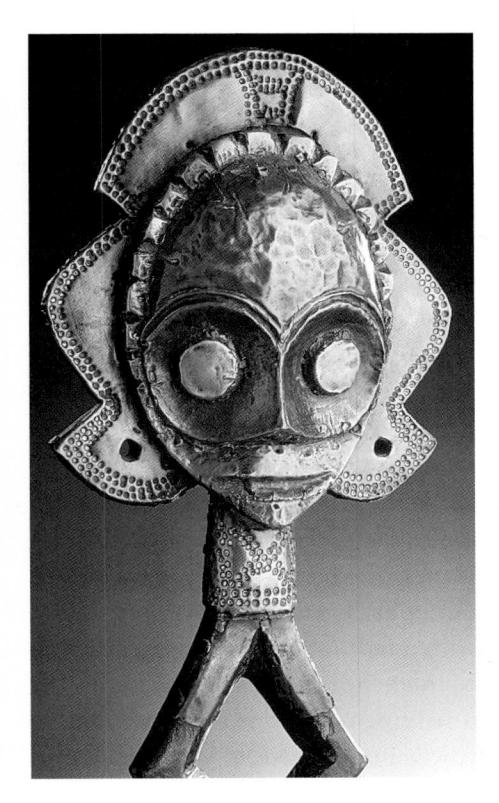

10-34. MBULU-NGULU (RELIQUARY FIGURE), Kota. Wood, brass, copper. Height 161/16" (41 CM). Musée Barbier-Mueller, Geneva

have copper and brass sheeting or strips applied to the surfaces. This shining material both attracts our attention and acts as a shield, and it is possible that it was seen as being able to deflect evil forces.

The plane of the face is almost two-dimensional in conception on the southern Kota mbulu-ngulu in figure 10-33. A distinctly concave, oval face is framed by a transverse, crescentshaped crest above and two lateral wings that suggest a hairdo. Cylindrical pegs drop from the wings, suggesting ear ornaments. Diskshaped eyes were created by applying metal bosses. Sheet metal in alternating segments of brass and copper forms a cross-shape on the face and

completely covers the front of the crescent and the wings. A long, cylindrical neck connects the facial configuration to an open lozenge, which can be read as the arms of the figure, and which was once used to lash the mbulu-ngulu to its bwete bundle.

The smaller mbulu-ngulu in figure 10-34 is a variation on the theme. The transverse crest is much narrower than the crescent-shaped crest in figure 10-33. The lateral wings are curved, and there are no eardrops, though holes in the wings may have held earrings. The face of the figure is convex rather than concave, with a bulging forehead and eye sockets. Both sheet copper and sheet brass have been used to cover the form. A diadem motif frames the forehead, picked out in copper. The circular, projecting eyes are unusual for Kota figures.

Faces of reliquary figures sculpted by Hongwe artists are shovel-shaped (fig. 10-35). The Hongwe are one of the many groups who live in close proximity to the northeastern Kota. Hongwe reliquary figures consist of three distinct sections: the oval, concave face cut off at the bottom to produce a shovel-like form; the cylindrical neck; and an oval, openwork base. On the figure here, a vertical sheetmetal strip divides the face in two. Parallel strips of brass are hammered into the wood like long staples. Brass bosses situated about two-thirds of the way down the central strip serve as eyes. The nose is a beak-like piece of brass below the eyes. Strips curve vertically from the eyes to the base, giving the appearance of a mustache. There is no mouth. A fillip at the top seems to represent hair projecting to the rear. The cylindrical neck is

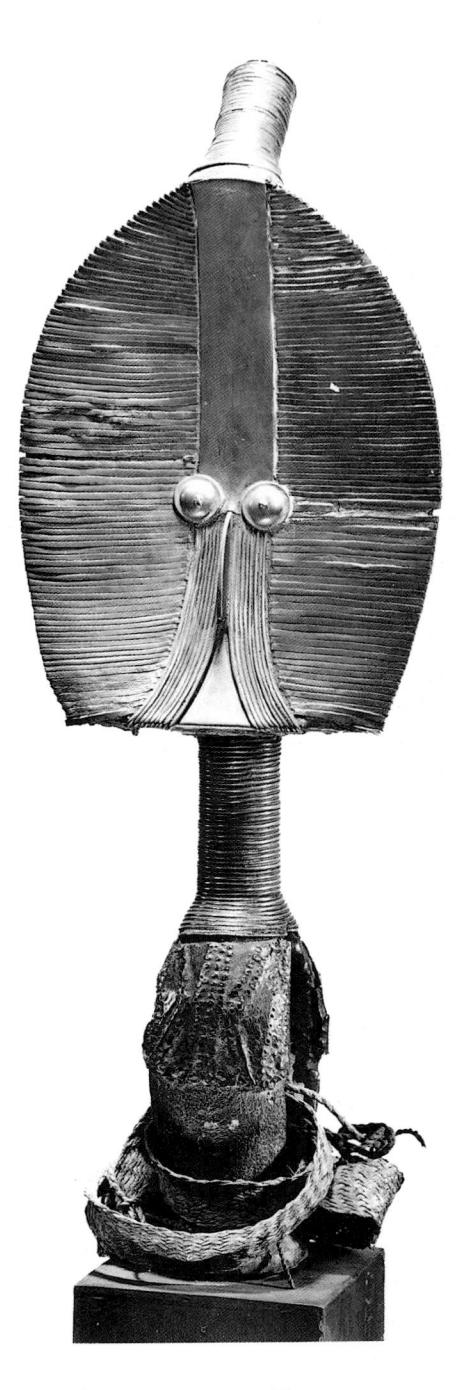

10-35. Reliquary figure, Hongwe, before 1886. Wood, Brass, Copper. Height 194" (49 cm). Musée de l'Homme, Paris

wrapped in copper wire. The open oval base covered with sheet metal served to lash the figure to its *bwete* bundle.

Many other peoples in the region use figures to guard reliquaries, including a number of related peoples in southeastern Gabon such as the Shira, Punu, Vungu, and Lumbo. Although the guardian figures created by these groups are functionally akin to those of the Fang, the southern Kota, and the Hongwe, formally they resemble sculpture from the area of the lower Congo River (see chapter 11). One particularly fine example of a reliquary from southeastern Gabon is in the so-called white-face style shared by the Punu, the Lumbo, and a number of other groups (fig. 10-1). Here the delicate features are picked out in white and accentuated with black markings.

Masks and Masquerades

Many of the peoples of the region use masks to initiate men into powerful fraternities. Some masks establish the position of families within the larger community, while others acquire supernatural powers for their owners. This section looks briefly at the masks of three groups, the Fang, the Kwele, and the Punu.

While lineage groups organize most aspects of Fang life, a number of secret societies cut across lineage lines to address the community as a whole. One such society, now outlawed, was Ngil, a fraternity with judicial and police functions. Ngil settled disputes between clans, punished criminals, and searched for and destroyed evildoers and witches who acted against the community. Within a village,

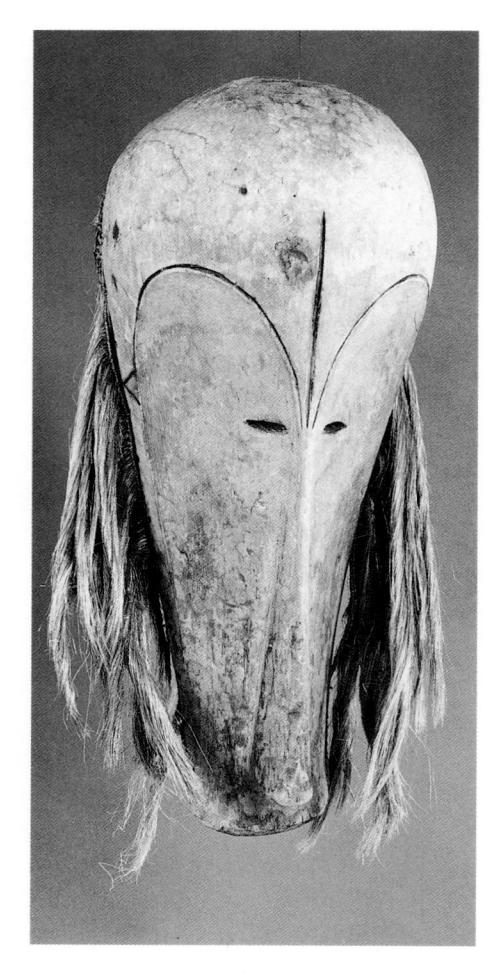

10-36. NGIL SOCIETY MASK, FANG, BEFORE 1890. WOOD, RAFFIA, KAOLIN. HEIGHT 21½" (54.7 CM). THE DENVER ART MUSEUM

Ngil represented several lineages and clans, but its impact reached beyond the family, and it could even be involved in the judicial affairs of several villages.

Spirits made manifest by maskers carried out the decrees of Ngil. Like the agents of Kwifo in the Cameroon grasslands, Ngil masks arrived at the home of a suspect in the dead of night, accompanied by a throng of members carrying torches. The masks were said to protect individuals against evil spells, poisonings, and recognition by outsiders. The word

ngil means "gorilla," and masks worn by the association members shared the awesome size and dramatic elongation of this mysterious and powerful forest creature.

The abstract, elongated Ngil mask in figure 10-36 is almost two feet tall. Made of soft wood, it is whitened with kaolin, which for the Fang symbolizes the power of the spirits of the dead. Beneath a massive domed forehead, high arches over the eyes taper to a narrow chin, forming a heartshaped face. A long, narrow nose separates the concavities of the cheek planes. The brows and eyes are picked out in black, burned into the surface with a red-hot blade. The serene countenance of the mask belies its terrifying role, for it represents a horrific being whose role was to eradicate evil. Ngil masquerades brought punishment to adulterers, thieves, debtors, poisoners, and those who were disrespectful in their dealings with society members. In use, a collar surrounded the mask, and a headdress made of feathers and raffia added to its size and bulk. The masker's body was painted black, white, and red, and he spoke in a raucous and forbidding voice.

The mask here was taken from an Ngil fraternity in 1890. Before French colonial officers banned Ngil in 1910, such masks may have aided in governing Fang communities for centuries. Ngil masks have not been used since the beginning of the twentieth century, but other styles and types of masks have succeeded them. Many newer masks seem to be modeled to some extent after the formal characteristics of Ngil masks such as the heart shape and the white coloring with black trim.

One newer type of Fang mask is ngontang. Ngontang masks were probably introduced in response to the coming of Europeans, for they began to appear in the 1920s, and the term *ngontang* literally means "voung white woman." The mask is said to represent a female spirit from the land of the dead. Because Europeans are so pale, the Fang initially believed that they were spirits returning from the dead, and the link between white people and dead people is expressed in this masquerade. Ngontang masks are used in rituals aimed at locating sorcerers who misuse spiritual powers for their own gain. They also appear to entertain on the occasion of solemn family events involving the dead and ancestral spirits, such as death rituals, mourning, and birth celebrations.

The *ngontang* shown here is a cylindrical helmet mask ringed with four oval faces (fig. 10-37). Each face, with its concave heart shape, is painted with white kaolin. Delicate designs in black burned into the surface vary from face to face. A dozen slender horn shapes once sprouted from the top of the head, only two of which remain. In the past when such a mask was worn, the masker's body was concealed with raffia fibers. Today, clothing, socks, and a fiber collar attached to the mask serve to conceal the wearer.

The Kwele are a fairly small group of forest people who in the early decades of the twentieth century moved from the headwaters of the Ivindu River into the Kota area, thus forcing the Kota into new territories. Like other peoples in the region, the Kwele formerly drew on the power of the relics of the dead for the benefit

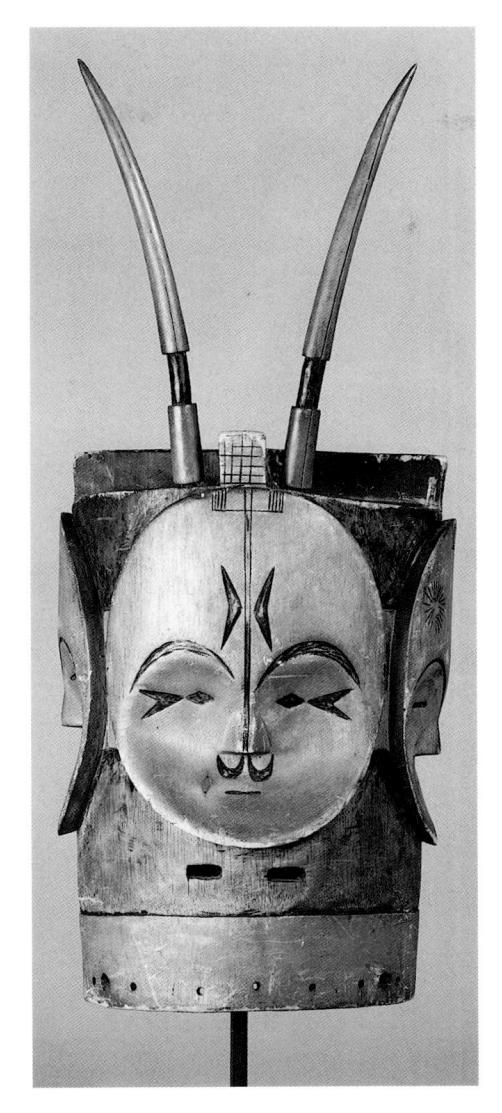

10-37. NGONTANG ("YOUNG WHITE WOMAN") MASK, FANG. WOOD, PIGMENT. HEIGHT 24\%" (61.9 cm). THE UNIVERSITY OF IOWA MUSEUM OF ART. THE STANLEY COLLECTION

of the living, a practice they called beete. Beete was considered medicine for an ailing people. Relics were called upon in times of crisis, such as epidemic, famine, multiple deaths, or the deaths of great men or women. Disputes between family-based men's societies, ebaaz (sing. baaz), sometimes also required the healing power of ancestors.

The community was expected to reach a certain level of energy or animation before the remedy of beete was applied, because medicine should be applied to something hot. In Kwele belief, hot people are less susceptible to illness. To bring themselves to the necessary heated state, the community invited forest spirits, ekuk (sing. kuk), to lead them in dance. As neutral outsiders, ekuk could bring together a possibly riven community in a way that human leaders, such as the leaders of rival ebaaz, could not. Maskers made the spirits manifest. Entering the village to the accompaniment of music, male spirits pranced rhythmically, while female spirits (also danced by men) shuffled slowly. Human followers mimicked their dance steps.

The mask shown in figure 10-38 is typical of the *kuk* masks used to lead dances in preparation for *beete*. The concave, heart-shaped face is painted white with kaolin. The eyes and nose are blackened, as is the area that surrounds the face. Superstructures indicate specific types of *ekuk*. The superstructure of this mask is a large zigzag form with four smaller renderings of the characteristic heart-shaped face carved in low relief.

Other types of Kwele masks belong to *ebaaz*. One of the most important of these is the *gon* mask, which displays the sagittal crest, triangular forehead depression, and canine teeth typical of the skulls of the adult male gorilla. Like other *gon* masks, the one shown here is stained dark and its fangs, mouth, and triangular forehead section are painted red (fig. 10-39). The *gon* masker darkened his body with charcoal and wore a minimal loin covering of mongoose skin. In his

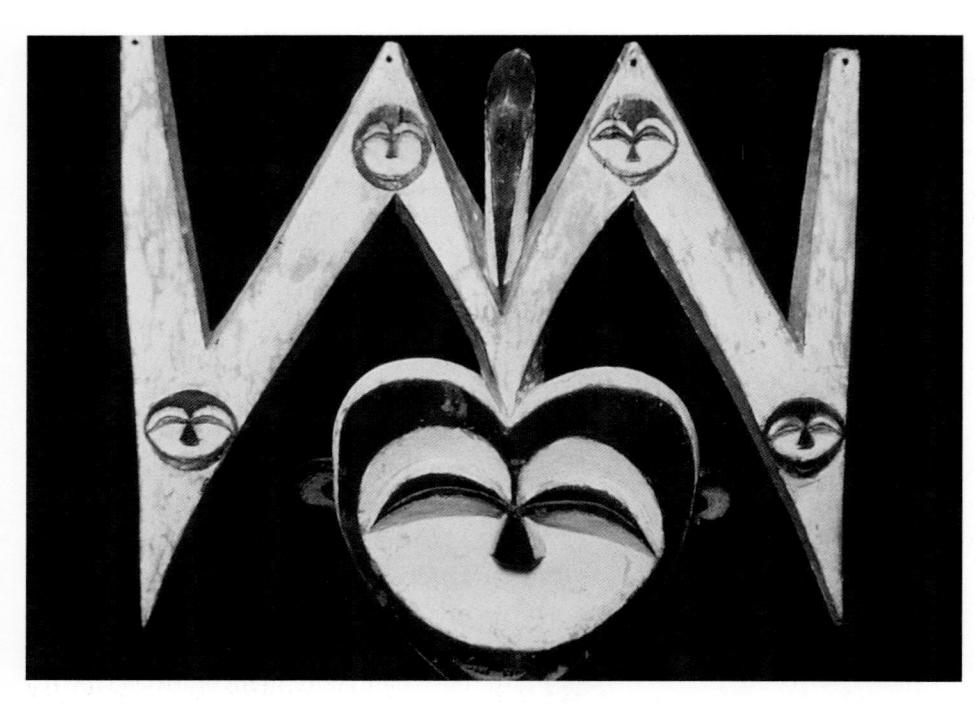

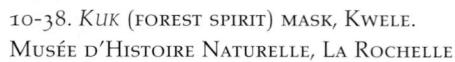

Such a mask would have been danced in a costume combining sumptuous loincloths of woven raffia, a product of the civilized world of men and women, with pelts of animal skin, used in witchcraft and associated with the occult world of the forest. The masker's body was fantastically patterned in red, black, and white. Nutshell anklets created rhythmic sounds as the ekuk pounded their feet.

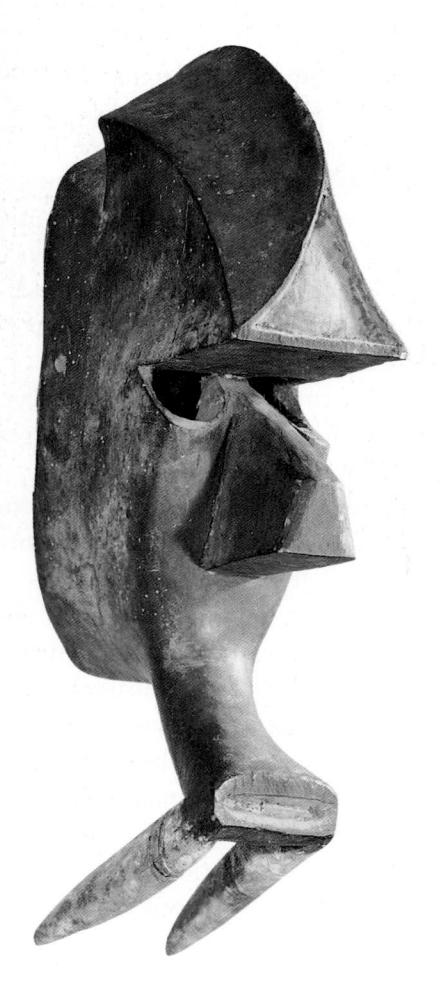

10-39. GON MASK, KWELE. WOOD, PIGMENT. MUSÉE DU QUAI BRANLY, PARIS

hand he held five javelins. His attendants controlled him and held him back by means of a rope around his waist. Gon ran around the village throwing his spears at anything in sight, trying to kill loose animals. The ferocity of gon made him a "kuk of medicine." He was considered antisocial, acting the role of a leader of war. Aggressive, uncouth, and fearsome in his actions, gon was sent out by a baaz to test the mettle of others. He could be sent out for retribution, for punitive action, or to extort other ebaaz.

A number of groups in southern Gabon share a style of mask that has come to be known as the white-face style. Like the masks of the Fang, the Kota, the Kwele, and other peoples of Gabon, the faces of their masks are whitened with kaolin, the color of spirits and the dead. But while most masks in Gabon are abstractions of human and animal features, the white-face masks tend toward an idealized vet naturalistic human female face. Various groups make the masks, but those of the Punu and the Lumbo are probably the best known. The Punu mask shown in figure 10-40 is typical of these refined, lovely maidens. The rounded contours, naturalistic proportions, narrow slit eyes with swollen lids, high arched brows, fleshy lips, and ornate coiffure distinguish these masks from other whitefaced female masks such as the ngontang (see fig. 10-37) or the Igbo maiden-spirit masks (see figs. 9-37, 9-38). The red scarification patterns keloids in a lozenge formation just above the bridge of the nose and in rectangular formations at the temples—tell us that this mask represents a female character. The elaborate hair-

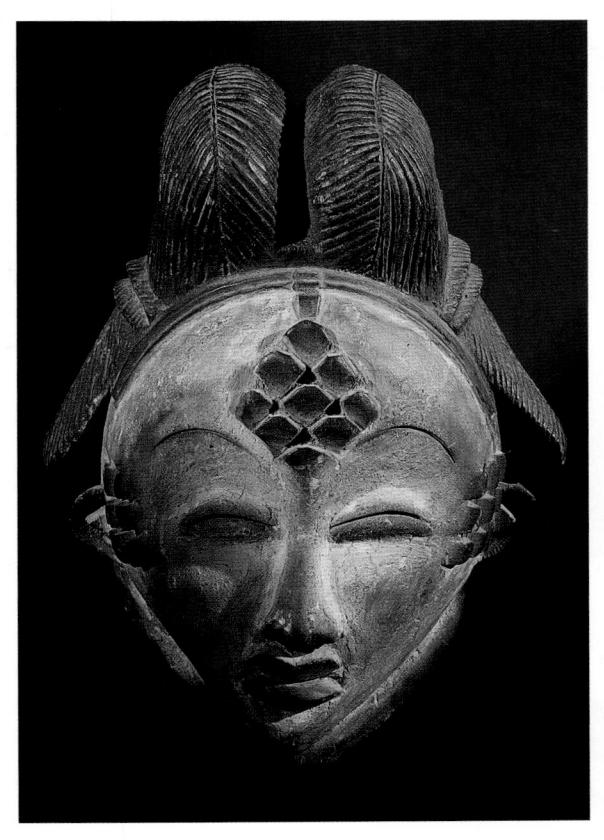

10-40. *Mukudi* mask, Punu, 19th–20th century. Wood, pigment. Height 13" (33 cm)

do is black, while the sensuous lips are red. Such masks are called *mukudj* by the Punu and are still worn during public ceremonies and at funerals. The performance, which is extraordinarily beautiful, requires great skill, for it is accomplished on stilts that raise the dancer as much as ten feet above the ground (fig. 10-41).

While the mask performance brings joy to the community, apprehension and uneasiness accompanies its appearance, for talented dancers are vulnerable to envious adversaries who may attack with sorcery. The *mukudj* performer must be continually vigilant and acutely aware of his surroundings to guard against mystical onslaught. The stilts provide a panoramic vista, permitting him to anticipate and dodge likely strikes by any who come with sinister schemes.

10-41. Punu *Mukudj* mask in Performance, Louango, Gabon. Photograph 1993

The elevated position is also a reference to the source of his powers of agility and balance, which are said to be obtained from birds, also elevated above the earth. Symbolic acts such as throwing leaves or pouring water into the dancing arena and symbolically sweeping it are also used to counter supernatural attacks. Additional mystical security is gained by wearing or

holding protective "medicines" in the form of charms. Finally the performer must himself acquire powers of clair-voyance. Snakes, with their flexibility and undulating movement, may also bestow agility on the dancer. Snakes' ability to scare potential antagonists is also a crucial attribute for the dancers, who draft a band of bodyguards and assistants.

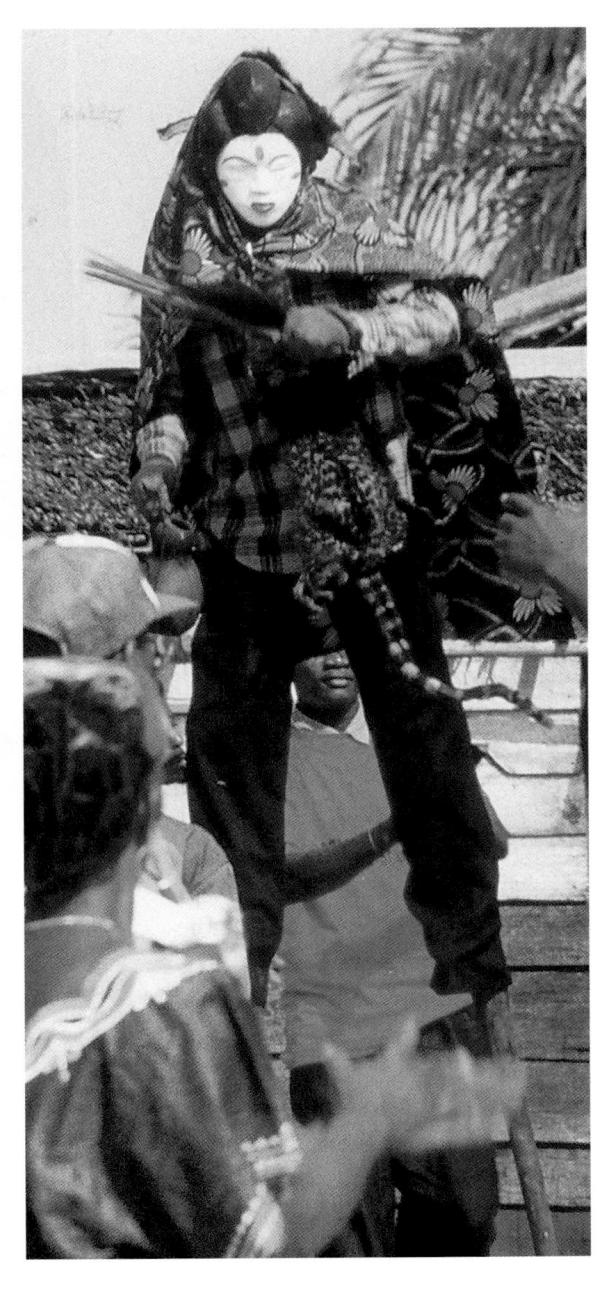

CONTEMPORARY INTERNATIONAL ARTS

Many artists in Central Africa today are self-taught or trained as sign painters. Others receive formal, academic training on the Western model and produce art for an international clientele. While most of the great heritage of African art is threedimensional, many first-generation international artists in Africa seemed to prefer the medium of paint and two-dimensional forms. An exception is the sculptor Leandro Mbomio Nsue (born 1938), from the small country of Equatorial Guinea. Mbomio studied in Spain in the 1960s. He subsequently lived in exile for many years before returning to his native country, where he served as minister of culture. Mbomio's father and grandfather were both Fang sculptors, who carved masks and bieri figures in wood. Mbomio, in contrast, casts his figures in bronze. Nevertheless, the rounded shoulders and overall proportions of the piece titled Mascara bifronte recall those of older Fang works (fig. 10-42). Mascara bifronte may suggest to Western eyes the types of sculpture that European artists of the first half of the twentieth century were producing in response to the inspiration of African forms. Perhaps a similar spirit of homage is at work in Mbomio's sculpture as well, for the artist has stated that "we have a human debt to make the ways and customs of our ancestors fruitful, prolonging them in time in keeping with new necessities."

Pascal Kenfack (b. 1950) has taught at the University of Yaoundé, where he is both artist and art historian, Like the forms created by Mbomio,

10-42. *Mascara bifronte*, Leandro Mbomio Nsue, 1970s. Bronze. Fundación Escultor Leandro Mbonio Nsue, Malabo

those painted in oil on canvas by Kenfack recall twentieth-century experiments by European artists. Here the allusions to an African past lie not in the style, with its elegant abstract shapes, but in the title, "The Child and the Ancestor," which stresses the continuity of life across generations (fig. 10-43).

While the bronzes of Mbomio and the oil paintings of Kenfack seem to be rooted in European modernism, sharing its quest for formal beauty, a number of artists from this part of Africa are now tuning to the contemporary, postmodern world. They work in multimedia, installations, video, and other forms of art associated with the new century. Despite the fact that there are hardly any galleries that present contemporary art in Cameroon and Gabon, quite a number of talented artists work in cities such as Douala and Yaoundé. Here work often addresses social issues.

Joseph Francis Sumégné (b. 1951) works in Yaoundé, fabricating sculptural personages from recycled materials. In works such as *Les 9 Notables* ("The 9 Dignitaries") (fig. 10-44), Sumégné presents the viewer with an installation of nine figures seemingly drawn in three-dimensional line through manipulating recycled wire and rods. He fills the faces with other materials recovered from the modern waste heap and clothes them in remnants of blankets and scraps of fabric

10-43. L'Enfant et l'Ancêtre ("The Child and the Ancestor"), Pasacal Kenfack, 1985. Oil on canvas. 24%x 24% (46 x 62 cm)

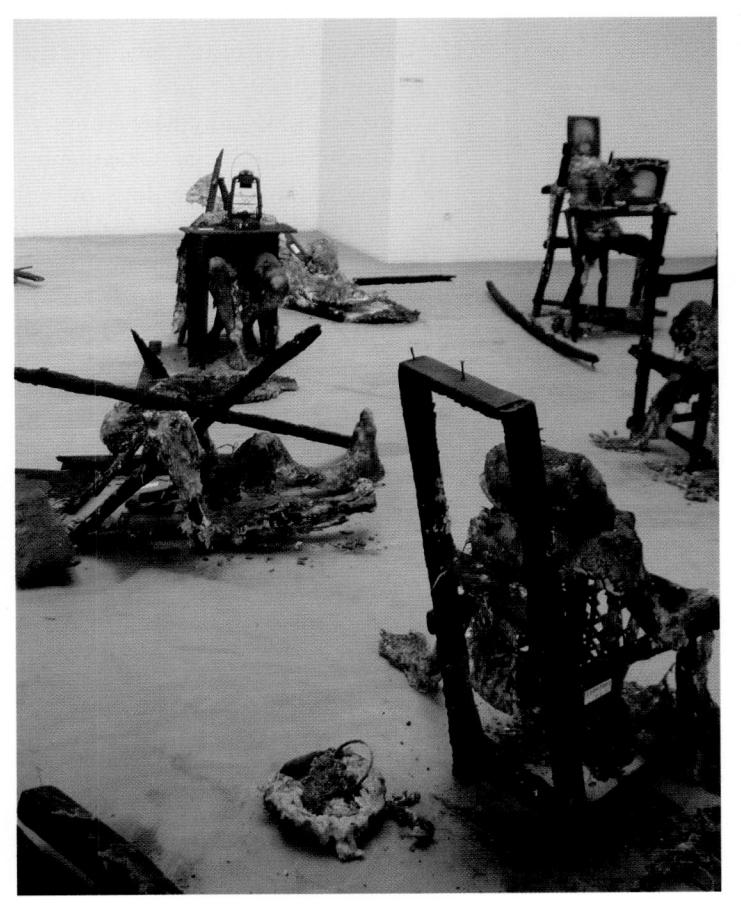

10-44. LES 9
NOTABLES ("THE 9
DIGNITARIES"),
JOSEPH FRANCIS
SUMÉGNÉ
(DETAIL).
INSTALLATION
ESPACE
DOUAL'ART,
DOUALA,
CAMEROON. 2005

10-45. MALAM
(ISAAC ESSOU)
(DETAIL).
INSTALLATION.
MIXED MEDIA.
ESPACE
DOUAL'ART,
DOUALA,
CAMEROON, 2005

to suggest living personages, perhaps alluding to royal portraits of leaders of the past. The figure illustrated here is crowned with a headdress that recalls the bifurcated crowns of grasslands leaders. The beard of cowrie shells and soft drink can tabs is reminiscent of faux beards of cowries or beads worn by grasslands rulers.

Isaac Essoua, a Douala-based artist who goes by the pseudonym Malam, not only paints and sculpts but also creates installations that confront the viewer with raw, often shocking imagery. In response to the shock of the September 11, 2001 attack on the World Trade Center Towers, Malam recorded his emotional response in expressionistic plaster forms to embody the feelings that overcame him as he viewed the live coverage on television. In a remarkably short time he created these dramatic and poignant pieces to display at a special exhibition in Douala, known as Doual'Art (fig. 10-45). The terror felt around the world on that day is suggested in the raw forms that evoke images of charred human remains intertwined with architectural remnants. Malam says:

"My works deal with the reality of life, the suffering and the inequality, the slavery that still exists today. In everyday life everyone witnesses poverty, war, murder, abuse, hunger ..."

The Western Congo Basin

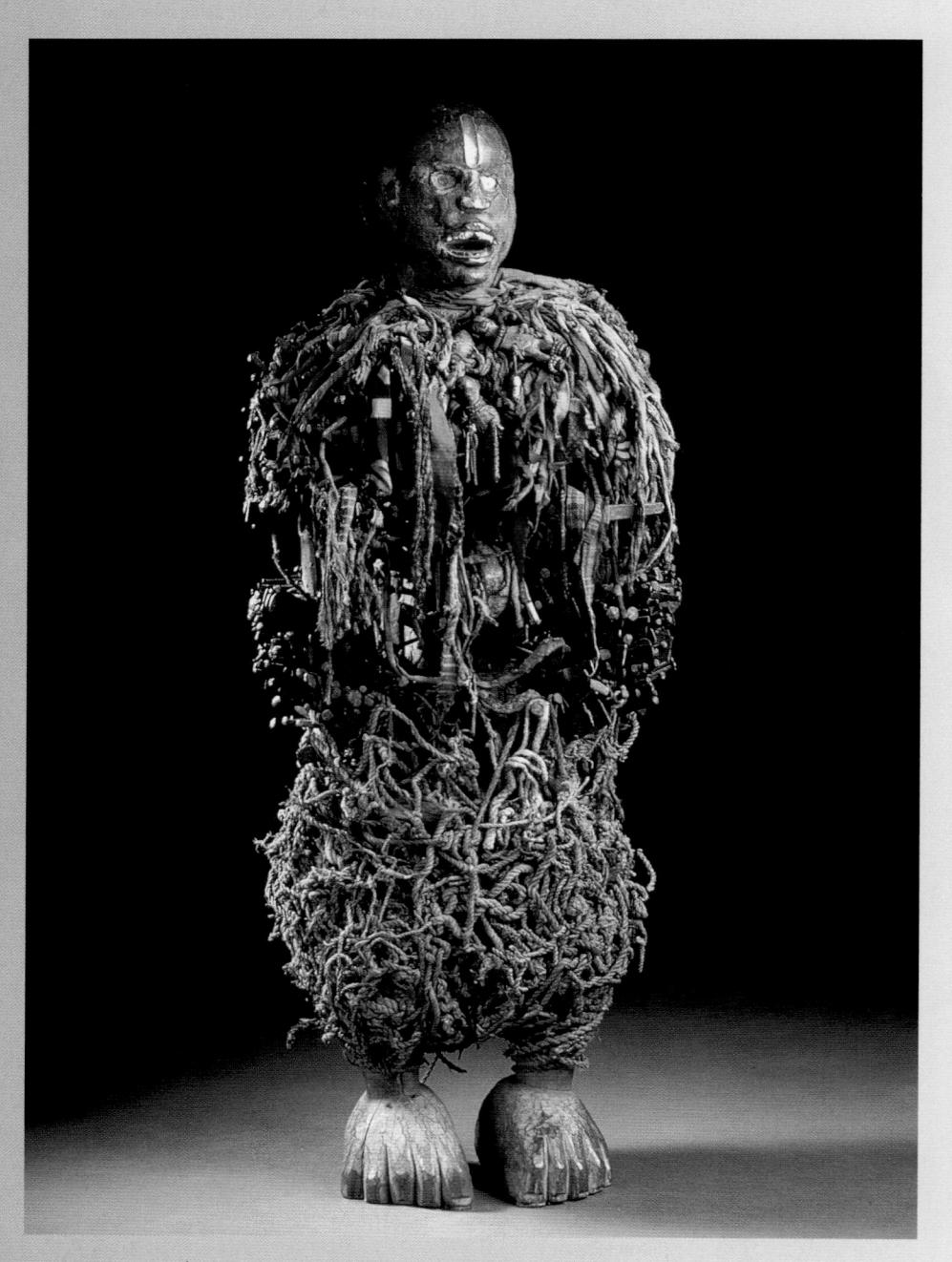

11-1. NKONDI FIGURE, LOWER CONGO, BEFORE 1878. ROYAL MUSEUM FOR CENTRAL AFRICA, TERVUREN

During the colonial period minkisi played important roles in resisting foreign ways imposed from without. European missionaries saw them as evidence of paganism and had them destroyed or sent them home as evidence of idolatry. European military commanders captured them as documentation of an opposing political force.

ENTRAL AFRICA IS DOMINATED by the Congo River and its numerous tributaries, which drain a vast region embracing several climatic zones and a landscape that varies from high-altitude tropical rain forests to savannah-woodlands and semi-arid plains. This huge river system has historically served as a primary means of transportation, and thus also of cultural diffusion and influence. The region's dense rain forests apparently discouraged human habitation for many centuries, for in comparison to other parts of Africa the Congo basin has been settled only recently. Linguistic studies suggest that Bantu-speaking populations from the northwest began to move into the area during the first centuries AD, possibly encouraged by new crops introduced via the Indian Ocean and the newly acquired technology of iron, which allowed them to make tools capable of cultivating the forested lands. Fanning outward over succeeding generations, speakers of Bantu languages came to dominate the region, as indeed through their various migrations they did the entire southern portion of the continent. Those who settled in the rain forest zones, much like those people in the forests of southeastern Nigeria or Gabon (see chapter 10), established small-scale societies governed by lineages or associations. Those that settled in savannahs often established more centralized systems of chieftaincy or kingship.

Art among peoples of the western portion of the Congo basin is used in

leadership, funerary, and commemorative contexts, for the manipulation of mystical powers, and during rites of initiation and passage. These uses can be discussed in the context of several stylistic and cultural clusters. The first cultural cluster centers around the lands once controlled by the kingdom of Kongo, which gave its name (Congo) to the Congo River and two modern nations. Lands along the Atlantic coast both north and south of the river were part of this kingdom, which was inhabited by the Kongo people themselves as well as by other groups such as the Yombe, Bwende, Beembe, and Boma, Rival kingdoms and neighbors included Loango and the Teke. Today their territory is in the Democratic Republic of Congo (formerly Zaire), the Republic of Congo (the former French Congo), the enclave of Cabinda, and the northwestern corner of Angola. A second cultural cluster is found in the Kwango and Kwilu river valleys, now located in southwestern Republic of Congo and north-central Angola, where the Yaka, the Suku, the Pende, and the Salampasu live. Many of the groups in this region were dominated by rulers of the Lunda Empire. The Chokwe, who were controlled by the Lunda before they began a period of expansion from northern Angola into the Democratic Republic of Congo and Zambia, can be tied to these groups as well. The third cultural cluster is located in the lands along the Kasai and Sankuru rivers. This region of the Democratic Republic of Congo is home to the many peoples associated with the centuries-old Kuba kingdom, a confederation consisting of some nineteen ethnic groups.

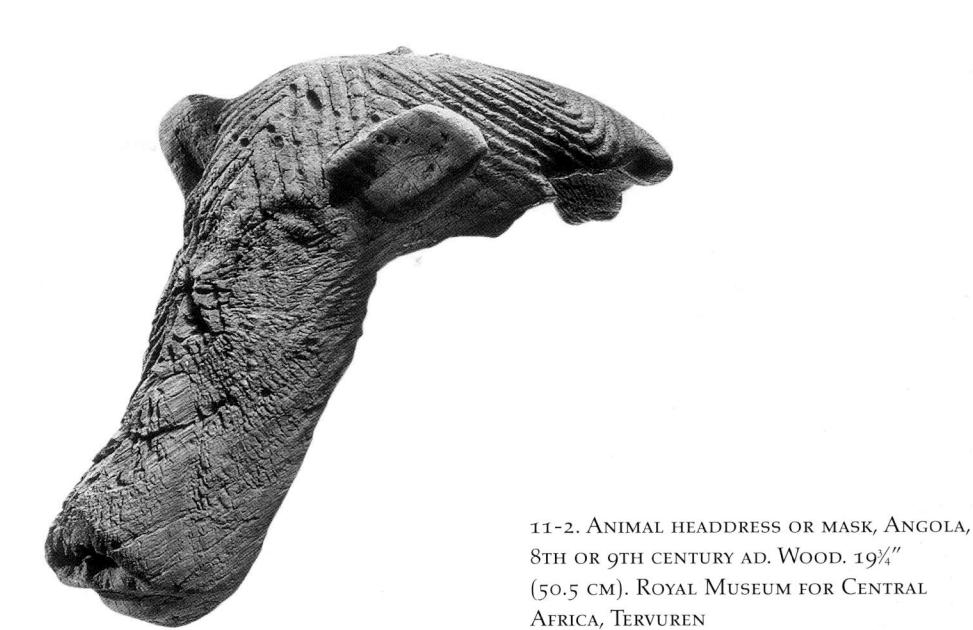

EARLY ART

Iron implements were in use throughout the region by around AD 500, as were other technologies characteristic of settled agricultural life such as weaving and pottery. Gravesites from early periods suggest that material goods such as copper, iron, and beadwork were associated with status, and they point to the development of craft specialization, long-distance trade, and hierarchical political structures.

One of the oldest extant carvings from Central Africa was found in Angola (fig. 11-2). Made of wood, it appears to be a headdress or a mask representing an animal of some sort, with tapered half-closed eyes, large nostrils, and pointed ears. The greatly simplified body suggests four tiny legs and a tail; engraved lines suggest the stripes of a zebra. According to radiocarbon dating it was made during the eighth or ninth century AD. The tradition of masking and the practice of creating beautiful art

objects would seem to extend far back into the history of the area.

THE KONGO KINGDOM

One of the best known and best studied political units in all of Africa is the kingdom of Kongo. According to oral tradition, Kongo was founded toward the end of the fourteenth century by a ruler named Nimi a Lukemi, who established dominion over the area around Mbanza Kongo, his capital south of the mouth of the Congo River. The kingdom grew through the conquests and alliances made by his successors, and by the time Portuguese explorers arrived in 1483 it had become perhaps the largest state in Central Africa, a centrally organized nation with governors ruling over provinces on behalf of a king. In 1491, the Kongo king Nzinga aNkuwa converted to Christianity and was baptized as Joao I. His son and heir Afonso Mvemba a Nzinga established Christianity as the state religion, thereby fostering

11-3. Textile, Kongo, early 17th century. Raffia. $9\frac{1}{2}$ x $28\frac{1}{4}$ " (24 x 72 cm). Pitt Rivers Museum, Oxford

friendly relations with several European countries. However, the Portuguese launched a transcontinental slave trade that led to bloodshed, instability, and civil war. By the end of the sixteenth century up to ten thousand slaves a year were being sent from the region to Portuguese holdings in Brazil. When the Dutch, British, and French arrived in the region in the seventeenth century, the kingdom of Kongo had broken up into a number of fragmented kingdoms. A century later its expansion had ended.

Early Leadership Arts

During the sixteenth and seventeenth centuries, art proclaimed the sacred authority of the Kongo kings. Luxury goods testified to their status, wealth, and privilege. Figures, stools, staffs of office, textiles, and other wonderfully embellished utilitarian objects set the king and his chiefs apart from commoners and established their right to rule. A beautiful textile made of raffia fiber was collected in Kongo in the seventeenth century (fig. 11-3). Such luxurious cloths were produced by a special weaving technique that created patterns of raised lozenges, some of

which were snipped after the weaving was completed to create a plush or pile effect. Most such cloths are monochrome, but here color has been applied to create a two-toned design.

Raffia textiles may be depicted covering the stepped platform in a seventeenth-century drawing of the king of Loango and his court, once a subsidiary of Kongo but which had gained its independence from the kingdom by this time (fig. 11-4). The indigenous weaving industry died out after European contact in favor of imported material, though many other decorative arts associated with nobility continued to be made. Ivory,

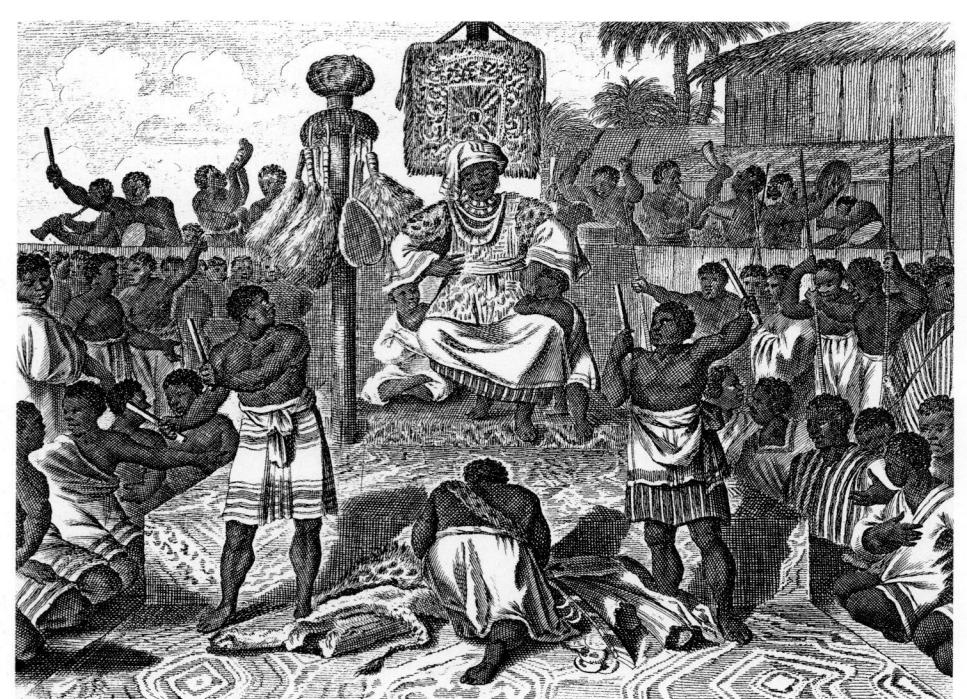

11-4. The court of the King of Loango, Lower Congo, c. 1668

Early drawings by European visitors were probably not based on scrupulous observation, yet they are still valuable witnesses to their time. Here the "king of Loango" is shown seated on a stepped and raised platform covered with a textile decorated with geometric patterns. Another textile is suspended on a frame from a pole behind the nobleman. Other typical leadership emblems are noted in the drawing as well. An orchestra of drummers and trumpeters can be seen over a fence. The aristocrat wears the skin of leopards, symbolic of noble status. A man bows before him presenting bracelets, pelts of leopards, and ivory tusks.

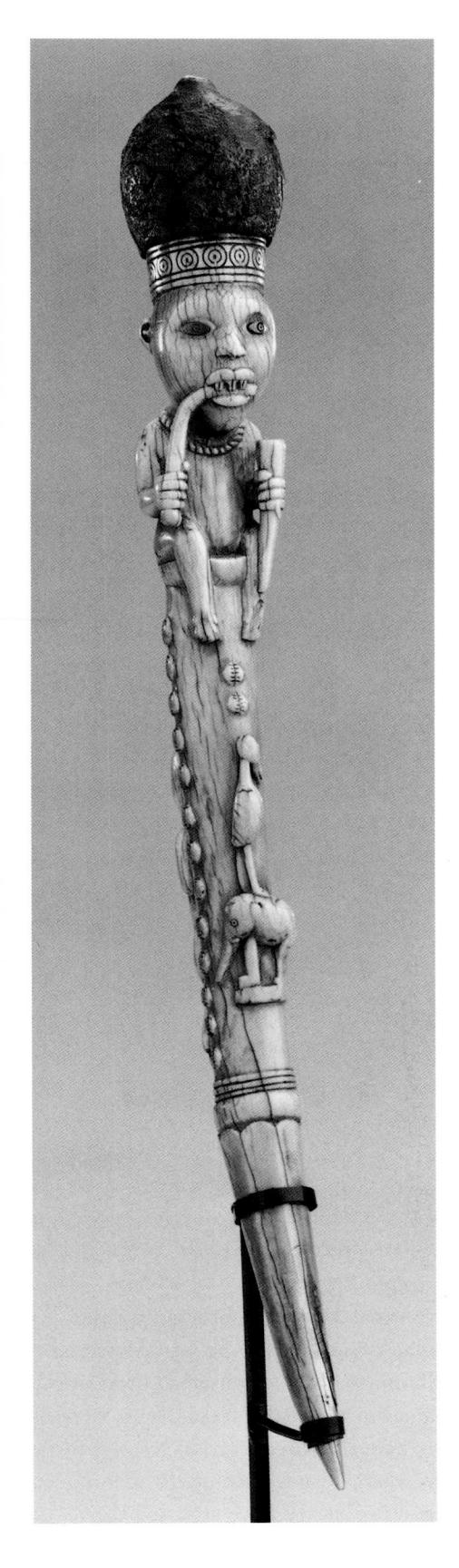

for example, was carved into flywhisk handles, scepters, and staffs. The staff for a Kongo ruler shown here contained spiritually charged substances (some of which are visible on the head of the seated figure), thought of as medicines, or as points of contact where supernatural powers intersect. Both the substances and the object they activate are called *nkisi* (pl. minkisi), a term with no equivalent in English (fig. 11-5). In fact, ritually invested rulers were themselves once considered to be minkisi, for they were conduits for extraordinary powers. The ruler shown seated in state on this scepter holds a staff of authority in his left hand and chews on a special type of root associated with medicines of chieftainship held in his right hand. The type of root the king is shown chewing is a mild drug expected to make his judgments impartial.

Religious Arts

While the peoples of Kongo believed in a supreme being, referred to as Nzambi Kalunga, there was the belief that it was ancestor spirits and lesser spirit beings that communicated with the human community. The earth and the spirits of ancestors buried within it played an important role in Kongo religious beliefs and practices. Much attention was paid to concepts of fertility and the continuity of the community.

11-5. ROYAL SCEPTER, YOMBE, 19TH CENTURY. Ivory, Iron, Earth, Resin. Height 181/2" (47 CM). VIRGINIA MUSEUM OF FINE ARTS, RICHMOND, VA. ADOLPH D. AND WILKINS C. WILLIAMS FUND

11-6. PFEMBA (MOTHER-AND-CHILD FIGURE), YOMBE, 19TH CENTURY. WOOD. HEIGHT 111/4" (30 cm). Museum für Völkerkunde. STAATLICHE MUSEEN, BERLIN. GIFT OF Wilhelm Joest

These religious concerns inform a beautiful mother-and-child carving in figure 11-6. It is typical of numerous maternity images called pfemba produced along the Yombe and Kongo coast. Although extant examples date to the nineteenth and early twentieth centuries, they evidently draw upon much older traditions, which may have their roots in the pre-Christian period. Kneeling on a base and supporting a nursing child on one knee, the mother wears her hair in a

11-7. Crucifix, Kongo, before 1987. Copper alloy. Height 12½" (31 cm). Museum für Völkerkunde, Staatliche Museen, Berlin

mitered style that was once fashionable among both men and women in the region. Her teeth have been filed to points. Her body, adorned with richly textured scar patterns on the shoulders and across the upper breast, is further embellished with bracelets and a necklace of beads. The hairdo, filed teeth, jewelry, scarification, and the maternal pose suggest ideal womanhood. The red coloring of the example here may reflect this, for red is related to birth and death, both of which are viewed in Kongo thought as transitional states. While the original functions of pfemba are not known, today they

are used in connection with women's fertility practices.

Kongo artists began to work with the established iconography and artistic forms of Christianity in the sixteenth century, producing objects such as the crucifix in figure 11-7. Cast in copper alloy, the object follows the essential form of its European prototypes. While the earliest Kongo versions of crucifixes were naturalistically modeled, later examples such as this imply local proportions and changes in meaning as well. Here the exaggerated flattened hands and feet are entirely abstracted. Facial features are Africanized, and the prayerful secondary figures, perhaps mourners, are severely abstracted. Their placement—one in relief on the base of the cross and two perched on its arms, would be unusual for a European crucifix, but such treatment is not uncommon in Kongo examples.

Although Christianity withered after the dissolution of the Kongo kingdom in 1665, elements of Catholic ritual found their way into the contexts of many Kongo religious beliefs and practices. Christian images persisted even when their meaning shifted. Crucifixes, for example, became symbols for the meeting place of the worlds of the living and the dead, for cross forms were identified with crossroads, long an important concept in local philosophical and religious thinking.

One Christian saint who was turned to a new purpose was the Portuguese-born Anthony of Padua (c. 1193–1231). Called Toni Malau ("Anthony of good fortune") in the KiKongo language, he became popular in Kongo during the seventeenth century. During the early eighteenth

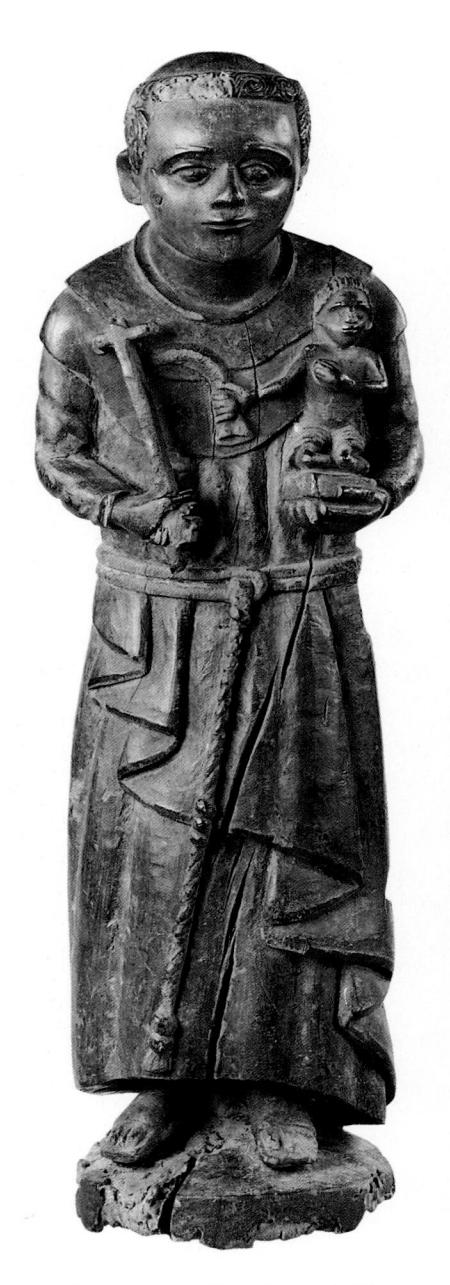

11-8. Saint figure (Toni Malau), Kongo, 19th century (?). Wood. Height 20¾6″ (51 cm). Museum für Völkerkunde, Staatliche Museen, Berlin

century, a young Christian woman who declared that she was possessed by his spirit was convicted of heresy and burned at the stake. Her goal as a female royal seems to have been to recreate a united Kongo Kingdom, and her martyrdom signaled the

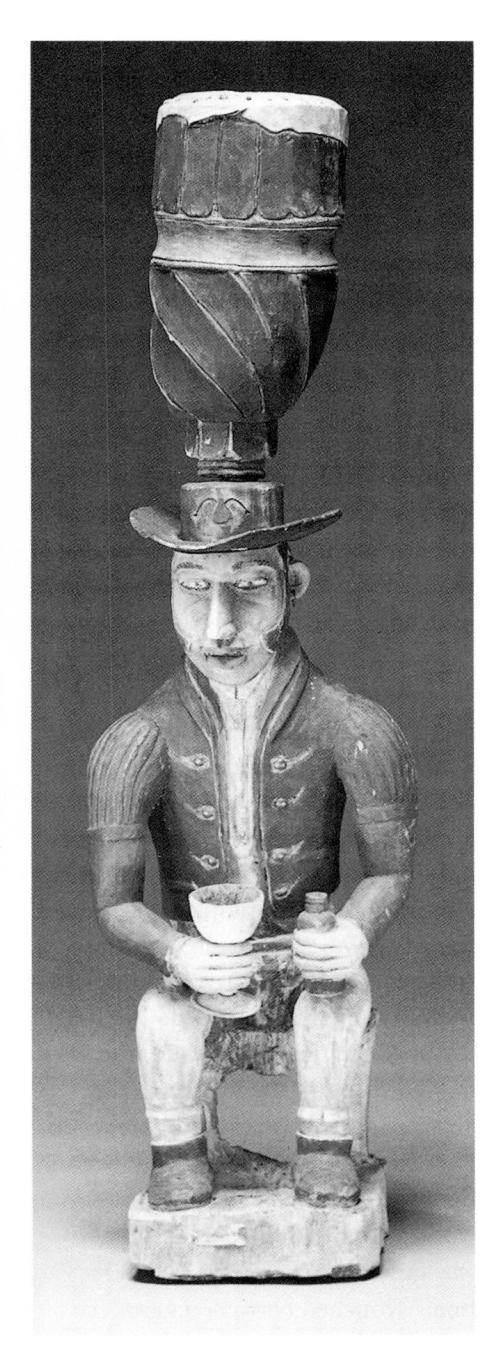

11-9. Drum, Vili, early 19th century (?). Peabody Essex Museum, Salem, MA

beginning of a movement for the revival of the kingdom. Within the religious sect that honored her memory, figures of Toni Malau were used as instruments of healing. The statue of Toni Malau shown here probably dates from the nineteenth century (fig. 11-8). Details such as the saint's tonsure and the robe with its folds of cloth and rope sash are clearly based on European prototypes that have been carefully reproduced. But the infant in his arms, a Christ child in European depictions of the saint, here appears very African, seated on what seems to be a Kongo box throne and carrying a flywhisk, both traditional African symbols of leadership.

It was not only in the area of religious imagery that the Portuguese made an impact: the Portuguese themselves became subject matter for the Kongo artist. The base of the drum in figure 11-9 depicts a Portuguese sailor holding a goblet and a bottle of gin. It was probably carved early in the nineteenth century, when the slave trade was still an important economic activity in the area. Depictions of Portuguese were also carved in ivory or wood as mementos for visitors to take back to Europe.

Funerary and Memorial Arts

An eighteenth-century description of a funerary procession by a European visitor to the region reveals the spectacular nature of Kongo burial rites. According to this account, the body of the king was covered with mats and raffia cloth. Imported linens, cotton prints, sheets, and silk goods were then wrapped around the bundle, and fabrics were sewn edge to edge on the exterior. This enormous cloth construction formed a "body" at least twenty feet long, fourteen feet high, and eight feet thick, topped by a head representing the deceased ruler who was being buried. The entire structure was placed into a wheeled cart, which was pulled to the grave by over a dozen straining men, and was followed by mourners.

Perhaps inspired by such funerary rites, the Bwende, a subgroup of the Kongo area, formerly transformed their most illustrious dead into ritually wrapped mummies called *niombo* (fig. 11-10). The custom of niombo burials apparently flourished during the late nineteenth and early twentieth centuries. On the death of an important chief, mats and cloths were collected. Niombo makers studied the corpse carefully, noting such details as filed teeth or tattoo markings, for the work was to be a symbolic portrait. The body was smoked, dried, and wrapped, first in fine raffia cloth mats, then in brightly colored cloths and mats, both imported and locally produced. Hundreds of cloths might be used until a massive bundle swelled out. A reinforcing frame of canework was placed around it to create a trunk, arms, and legs, and the completed bundle was finished in red blanket fabric, red being a color associated with the mediating powers of the dead. The fabric portrait head topped the figure, stuffed with soft grasses and cotton. Occasionally an important man commissioned his portrait head prior to his death.

The *niombo* in figure 11-10 towers over the entourage transporting it to its final resting place. Within a strongly delineated diamond shape a field of embroidered spangles suggests the spotted pelt of the leopard, avatar of royal power. The diamond shape, or lozenge, appears frequently in Kongo art. Here it probably indicates that the four corners of existence (four stages of life) have been

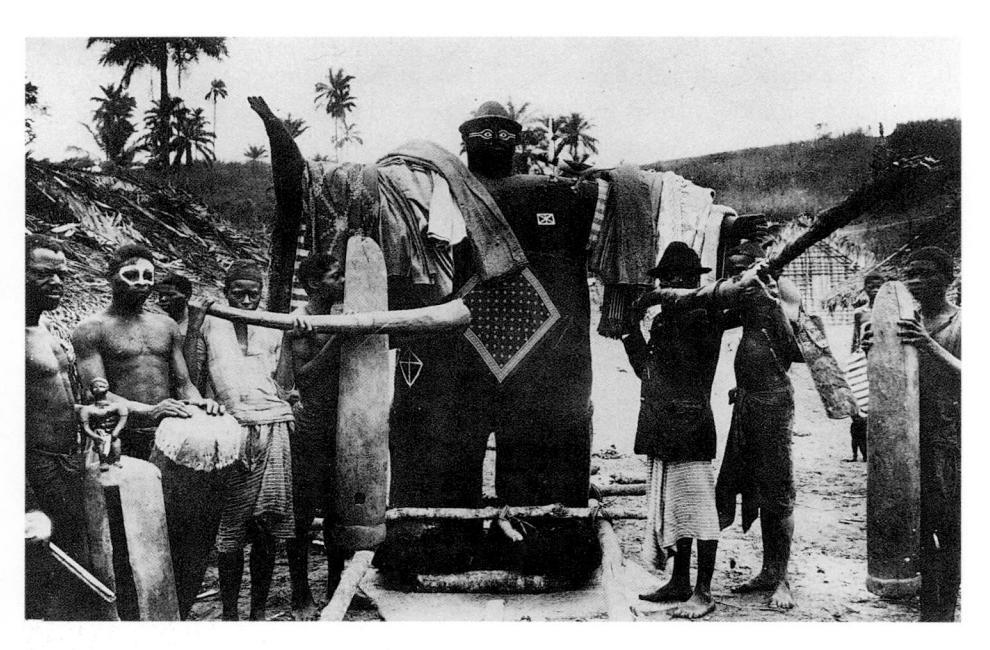

11-10. NIOMBO BURIAL PROCESSION, LOWER CONGO

An orchestra plays as the niombo processes to the grave. We see in the left corner of the photograph a beautiful slit gong, nkonko, carved with a human figure in mourning pose. Next to it is an ngoma drum. The eyes of its player have been symbolically "opened up" by circles of white clay, a sign that the musician becomes a medium whose drumming unifies the worlds of the living and dead. Side-blown trumpets and tall vertical trumpets are viewed as mediators who return the cries of the living. Oddly shaped flutes made of roots allude to the king. Roots are used for making medicines, and in this context the sounds produced on such instruments become medicine.

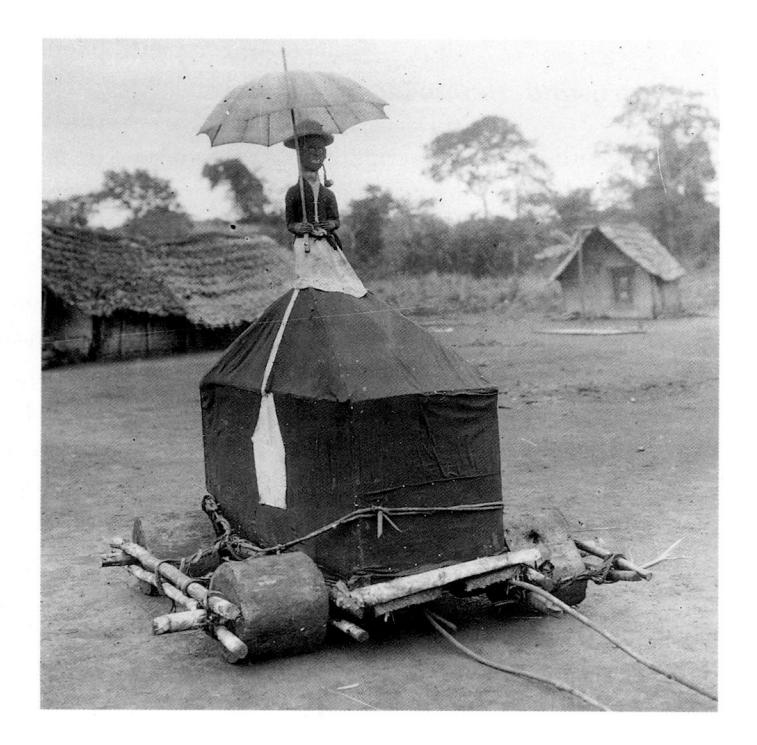

11-11. YOMBE FUNERARY CART, MADUDA, LOWER CONGO. PHOTOGRAPH 1909

completed by the deceased. In combination the lozenge and leopardskin motifs may signify that the ruler now not only governs the clan but also has dominion over relatives in the world beyond. The open mouth of the figure indicates the speech of the deceased, uttered on behalf of the living in the world of the ancestors. The right hand up, left hand down gesture, called the crossroads pose, refers in part to the boundary to be crossed between the living and the dead. The gesture is that of a mediator, for the community believes that the honored niombo will intervene on their behalf with spirits in the other world.

In ordinary burials among the Bwende, dancing and singing builds to a level of high fervor. Everything was intensified even more in a niombo burial. Dancing took place for a number of nights in succession, not only in the village of the deceased but also in surrounding villages. On the day of the interment, the dancing suddenly stopped. After a generous feast in honor of those who provided cloths for the burial, the niombo was carried through the village to the accompaniment of a special orchestra. Hundreds of people may have been in the procession, dancing, singing, working, and joking as the niombo was guided to the grave. When it finally touched bottom, a great cry issued from the crowd as they simultaneously jumped into the air. Their mediator had entered the world of the dead.

A related practice is seen in a photograph taken in 1909 in the Yombe town of Maduda (fig. 11-11). Here a corpse has been prepared and placed in a box-like bundle covered with cloth and surmounted by a carved

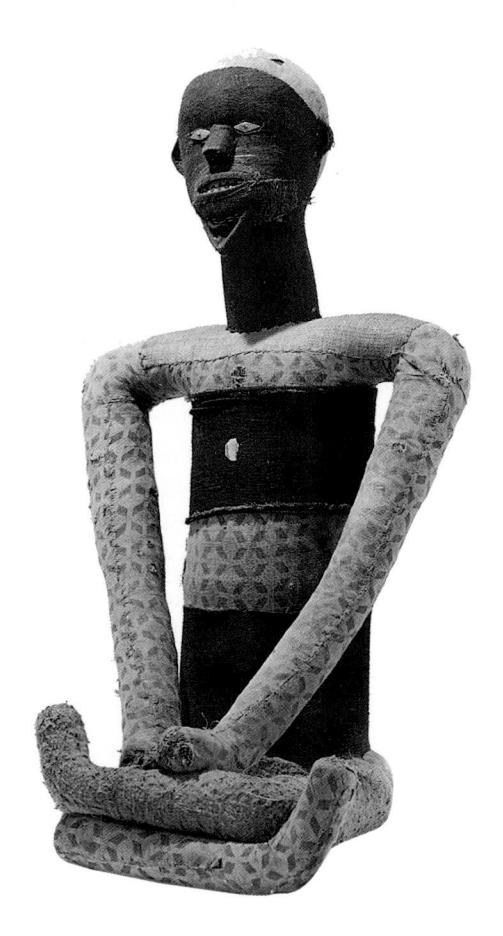

11-12. Muzidi (mannequin for the deceased), Bembe, before 1930. Cloth and plant material. Height 17¾" (45 cm). Musée du Quai Branly, Paris

figure. The representation of the deceased, dressed in European clothing and smoking a pipe, holds a parasol in his hand, a mark of status and dignity.

The Beembe, yet another group associated with Kongo, create cloth mannequins called *muzidi* for their deceased (fig. 11-12). Unlike the *niombo* of the Bwende, *muzidi* are not buried, but rather pacify a deceased spirit by serving as a reliquary for his disinterred bones. The Beembe normally bury their dead under a structure made of poles and thatch. Should the village subse-

quently experience misfortune, divination may reveal that the dead person is demanding a more fitting site. The body is disinterred, and its bones are wrapped and then placed in a *muzidi* made of a cane armature, sometimes stuffed with dried banana leaves, and covered with red and blue cotton cloth. The magnificent example shown here assumes the burial pose. A *muzidi* is kept in its own house, from which it might be taken out to serve as judge in disputes.

The cemetery itself is an important part of the community in Kongo thought. A grave is viewed as *nkisi*, as it contains ancestral forces and other spirit powers and makes them available to humans. In fact, the entire cemetery with all its graves is a source of substances used as protective medicine. It is placed near the entrance to a village as a shielding force and a source of ordering power for the community.

On a grave may rest an assemblage of possessions such as guns, umbrellas, vessels, hoes, and other objects that symbolically summarize the life of the deceased. Included is usually the last object that touched his lips before he died. The objects provide strong links to the spirit and bind the living and the dead. Also on the grave or in a small house nearby may be a carved wooden or stone figure called a tumba (pl. bitumba). Serving as a guardian of the grave, the tumba represents the person who lies within, usually a distinguished member of the community. It provides a focus for those who come to the grave to consult the ancestor.

The *tumba* in figure 11-13 represents a ruler. He is portrayed in a meditative pose, one knee brought to

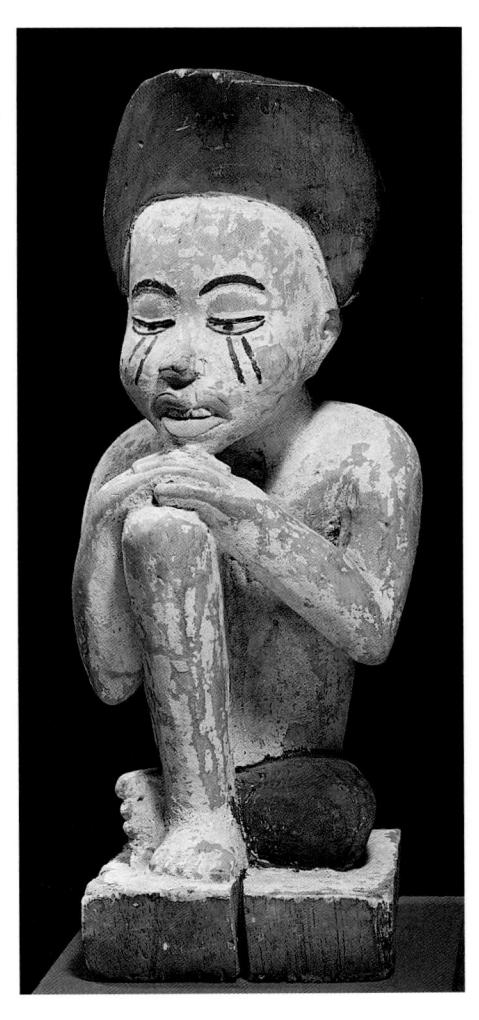

11-13. TUMBA (FUNERARY FIGURE), BASUNDI, 19TH CENTURY. WOOD. HEIGHT 20" (51 CM). MUSEUM RIETBERG, ZÜRICH. EDUARD VON DER HEYDT COLLECTION

his chin, his hands clasped over it. The pose is said to communicate sadness, both the sadness of the man who has left his family and his people, and the reflected sadness that they experience in his loss. His downcast eyes focus his attention inward as he concentrates on his new role as mediator between the living and the dead. Painted tears convey his own weeping as well as that of those who mourn him.

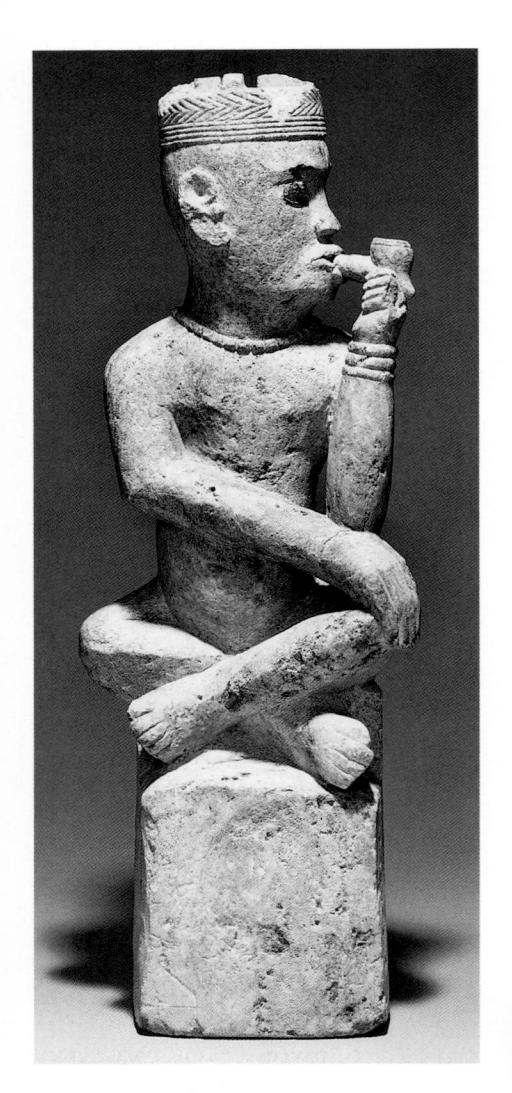

11-14. NTADI (FUNERARY FIGURE), MBOMA, 19TH CENTURY. STEATITE. HEIGHT 23" (58.4 CM). BROOKLYN MUSEUM, NEW YORK. MUSEUM EXPEDITION 1922. ROBERT B. WOODWARD MEMORIAL FUND

Soapstone (steatite) bitumba were often referred to as mintadi (sing. ntadi). The marvelous example illustrated here shows a ruler seated cross-legged on a base, his head turned to the left, smoking a pipe (fig. 11-14). The pose reveals Kongo attitudes toward the role that the deceased dignitary was to play in the spirit world. As mediator between the living and the dead, he was to assume

the role of listener and decision-maker that he had played in the world when he was alive. When a king smoked, all others were silent. Smoking was a sign demonstrating that the king needed distance from his affairs; it created time for thought and prevented things from unfolding too rapidly. In this sculpture, the ruler turns his head away from the ordinary. Further distancing himself from the everyday, he places his arm over his knee, creating a symbolic barrier between his inner thoughts and the world.

In Yombe country *bitumba* may be placed in shrines built for ancestors. A 1908 photograph of a Kongo shrine in the Boma area shows two of these small structures (fig. 11-15). These diminutive houses are walled with vertical posts that create a sort of surrounding palisade that protects the miniature city thus contrived. The shrine both shields the dead from

forces without and protects the living. Visible in the foreground shrine are three wooden *bitumba* whitened with kaolin. The color evokes the white skin of the dead and is associated with moral correctness and spiritual perception.

Bitumba are made in a relatively restricted area on the left bank of the Congo River between the cities of Matadi and Boma. In some neighboring areas, the illustrious dead are commemorated instead with funerary ceramics. The hollow ceramic cylinder (diboondo) shown here once marked the tomb of a wealthy and socially prominent person (fig. 11-16). Raised moldings divide its surface into five horizontal registers above a base. Meaningful patterns fill the three uppermost registers. The openwork lozenges in the fourth register from the top stand for the emptiness of death. The lozenge evokes the path of the sun, which in Kongo belief jour-

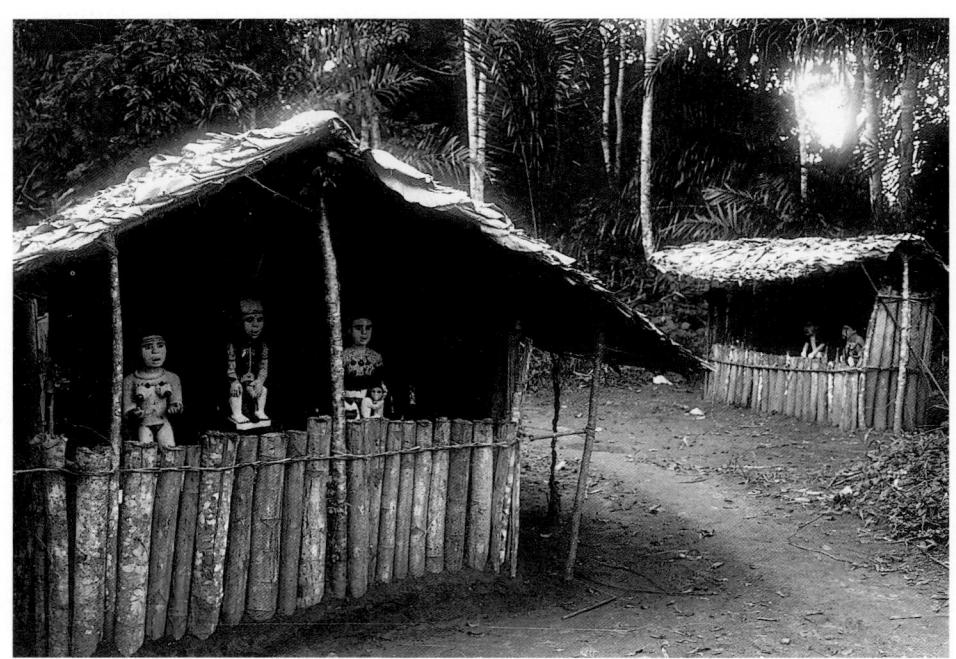

11-15. Memorial Houses with BITUMBA, Boma, Lower Congo. Photograph 1908

11-16. Funerary cylinder (*DIBOONDO*), Kongo, Congo. Royal Museum for Central Africa, Tervuren

neys between the living and the dead. Lozenges, although not open, in the running frieze in the third and uppermost registers, also refer to death in that they mark points of birth, life, death, and afterlife. The diamond shape is compared to a type of crystal that the Kongo view as a mystical lens through which the other world can be viewed. Rectangular panels filled with rows of small raised bosses and marked with a hole at each corner appear in the top two registers. The bosses in these panels suggest to the Kongo the counters in a traditional game in which players jump through a maze of stones. While the game is beautiful to watch and requires skill, at a deeper level it is said to inform about the realities behind the apparent ending of life. Thus, the panel instructs viewers that death begins a new life in a new realm. In the uppermost register, contiguous diamonds with tiny bosses at their angles refer again to the cosmogram, this time marking the positions of the sun at dawn, noon, sunset, and midnight as it moves from the world of the living above to the nether world of the dead.

Minkisi

Close communication with the dead and belief in the efficacy of their powers are closely associated with most important art forms used by the Kongo and many other groups throughout Central Africa. All exceptional human powers are believed to result from some sort of communication with the dead. Notable among people with such powers are agents known as banganga (sing. nganga), who are believed to be able to see hidden things. They work as healers, diviners, and mediators who defend the living against witchcraft, and provide them with remedies for diseases resulting either from witchcraft or the demands of spirits, bakisi, emissaries from the land of the dead.

These remedies, minkisi, are primarily containers—ceramic vessels. gourds, animal horns, shells, bundles, or any other object that can contain the spiritually charged substances also known as minkisi. As discussed earlier, graves are considered minkisi, and these containers have been described as portable graves. Many include earth or relics from the graves of powerful individuals as a prime ingredient. The powers of the dead thus infuse the object and allow the nganga to control it. Such minkisi served many purposes. Some were used in divination, many were used for healing, and others insured success in hunting, trade, or sexual activitv. Important minkisi were often credited with powers in multiple domains. Up until the beginning of the twentieth century, many minkisi took the form of anthropomorphic or zoomorphic wooden sculptures, and it is these that have principally interested art historians. In 1921 a Kongo prophet led a great revival of Christianity in the region, bringing about mass conversions, and convincing many to relinquish their minkisi. Since that time, few of these powerful objects have taken the form of masterfully carved images.

The group of minkisi shown here was photographed in 1902 in a Yombe community (fig. 11-17). The large nkisi in the center is an nkondi (plural minkondi), perhaps the best known of the many types of *minkisi*. Associated with formidable powers, minkondi were greatly respected. As hunters, they were said to pursue witches, thieves, adulterers, and wrongdoers by night. At the turn of the twentieth century, each Kongo region had several local varieties of minkondi. Most were activated by driving nails, blades, and other pieces of iron into them to provoke them into delivering similar injuries to the guilty.

The *nkondi* in figure 11-17 appears to be almost life-size. Centered on its abdomen is a bulging form where the substances that empower it have been sealed in with resin. The word used for belly also means "life" or "soul," and activating materials were most commonly placed there, though they were also placed at the top of the head, on the back, or between the legs. Called *bilongo*, activating substances included three main types of ingredients: clays from the land of the

11-17. MINKISI FIGURES, BOMA, CONGO, 1902

11-18. NDUDA figure, Lower Congo, before 1893. Wood, glass, leather, feathers, cloth. Height $13\frac{3}{5}$ " (34 cm). Staatliches Museum für Völkerkunde, Munich

dead: items chosen for their names: and metaphorical materials. The most important clays include kaolin, the white mineral closely linked to the world of the dead, and red ocher, whose red color refers to blood and danger because the dead have the power to both afflict and cure the living. Ingredients chosen for their names include certain leaves or seeds whose names are puns for the attributes and functions of the nkisi. Metaphorical materials include such things as the heads of poisonous snakes, the claws of birds of prey, and nets, all of which suggest the power to attack or capture, to produce death or sickness. The *bilongo* in the belly of the smaller figure to the left are sealed with a mirror. Such mirrors enabled the nkisi to see witches approaching from any direction and thus served as a sort of compass that told the *nganga* where evil lay. The glitter of mirrors was also believed to frighten witches. The torsos of the minkisi bristle with assortments of objects. An nganga petitioned the nkisi by driving nails into it, and each blade thus represents an appeal to the figure's power. Other materials such as ropes, carvings, hides, and mirrors were added as well. Without such an accumulation of materials, in fact, a figure was meaningless.

The form of an *nkisi*, then, is a record of its use and results from the collaboration of the sculptor and the *nganga*. Their primary intention was not the creation of a work of art but the organization of a visual effect in the context of ritual use, augmented by prayers, songs, drumming, dancing, the heightened emotion of the occasion, and various devices reinforcing the amazement of onlookers. The
sculptor did not always know what purpose the figure was to serve, what powers it was to have. Sometimes the pose of the carved figure seems meaningful. For example, some *minkisi* have aggressive poses, with the right arm lifted to hold a spear, or the hands placed defiantly on the hips. At other times the figure, while it may well have details that call attention to the carver's skill, seems conceptually neutral, a mere vehicle for the meaningful additions of *bilongo*, nails, and other materials.

Certain forms of *minkisi* have specific meanings. The small four-legged *nkisi* to the right in figure 11-17 takes the form of a two-headed dog. Known as *kozo*, this figure underscores the role of dogs in Kongo thought. As natural hunters, dogs live both in the village and in the forest, which is associated with the home of the dead. They are said to have four eyes, two for this world and two for the spirit world (thus the figure's two heads). As a hunter, *kozo nkisi* helped the *nkondi* to track witches.

An especially striking *nkondi* was created before 1878 among the Boma group of the Kongo (fig. 11-1). Its role as hunter is emphasized by the actual hunting nets tangled around its legs. Its open mouth seems to have received food in activating rituals. Nails are especially noticeable at the mid-section. Twine, miniature carvings, knives, and other tokens of the figure's supernatural violence are visible. Bits of fabric attached to such objects may be referred to as "dogs," further implying that this is a hunter who can track down and catch witches.

The *nkisi* in figure 11-18 has been identified as an *nduda*, a generic term associated with *minkisi* linked to war-

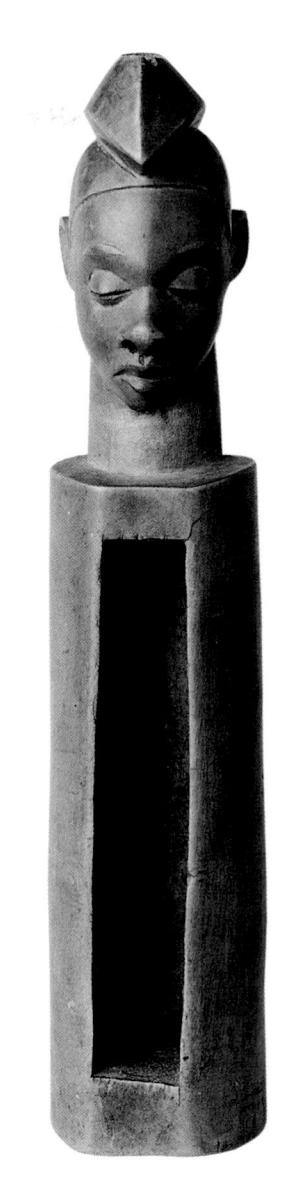

11-19. Slit gong, Sarongo, before 1897. Height $10\frac{1}{2}$ " (26.67 cm). World Museum, Liverpool

fare. In the minds of Kongo people, its feather headdress connected it with the sky and with violence associated with the "above," manifested often in such phenomena as rain and thunderstorms. These *minkisi* are usually small figures with mirrors attached for use in divination. The *nganga* was able to look in the mirror and discern a warrior's vulnerability on a given day. Packets of medicines surround the neck, and strips of hide that form a dress probably represent animals used as diviners' familiars. Such animals appeared in dreams to the *nganga*.

Musical instruments such as those that accompany the burial procession of a *niombo* were also considered to be minkisi (see fig. 11-10). Instruments such as double bells, rattles, slit gongs, and whistles were believed to facilitate communication between this world and the world of the spirits. Such instruments are often beautifully carved and further empowered by medicines embedded within them or attached as packets. A slit gong, a type of drum, shows the finesse with which such instruments were carved (fig. 11-19). Here the gong has been hollowed from a length of wood, and a delicately contoured head has been carved on one end, much as a mourning figure tops the gong in figure 11-10.

The fascinating miniature figures of the Beembe group are distinctive among the sculpture created in the region (fig. 11-20). Although they may not necessarily have been used as *minkisi*, such figures are said to represent ancestors, both male and female. The ancestor represented here holds a knife in one hand and a gourd, perhaps alluding to the power wielded on behalf of the living by

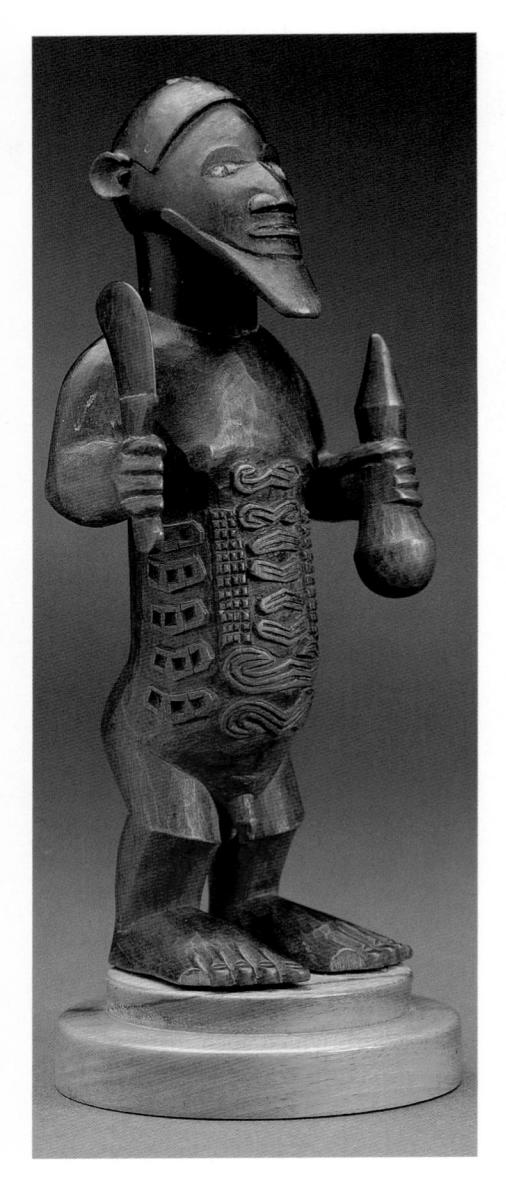

11-20. Ancestor figure, Beembe, Congo. Wood, shell. Height 7%" (19.5 cm). Samuel P. Harn Museum of Art, University of Florida, Gainesville. Museum purchase, museum visitor funds

those who have gone into the realm of the ancestors. This figure, like most Beembe examples, has an elongated torso covered with elaborate scarification markings, which no doubt referred to specific patterns associated with the body of a specific ancestor.

Sculptural forms are also created

by the Teke, who live northeast of the Kongo. These harness the powers of spirits, both nature spirits, who serve as intermediaries between God and humans, and spirits of ancestors, who may bring health and well-being to the living. Teke spirits may be given material form either as containers or as carved wooden figures. These figures serve diverse functions, and may be used in divination, for protection against evil powers, to get revenge, or to gain in wealth and power. The stiff frontal pose of the example shown here is typical of Teke objects, as is the angular style (fig. 11-21).

The trapezoidal beard that hangs from the chin is a sign of excellence in Teke society and a sign of the sacred as well. The facial striations represent a distinctive scarification pattern associated with the Teke. The torso is usually summarily carved, since it is destined in the normal life of the figure to be covered with medicinal substances or fabric.

Consecration ritual convinces a spirit to take up residence and transforms the figure from a mere object into a living presence and a representation of an ancestor. Protrusions from the chest and head of this figure contain consecrating substances, bonga. Bonga usually includes white clay or chalk, referring to ancestral bones, a powerful substance believed to counteract disease. Other materials may include leaves, plants, animal parts, and hair from venerated persons. In this object, resin was molded over the bonga to create egg-shaped forms. Bonga often cover the entire trunk from shoulder to hip and may be wrapped with fabric, making a powerful visual statement about the potency of both the materials and the object/being.

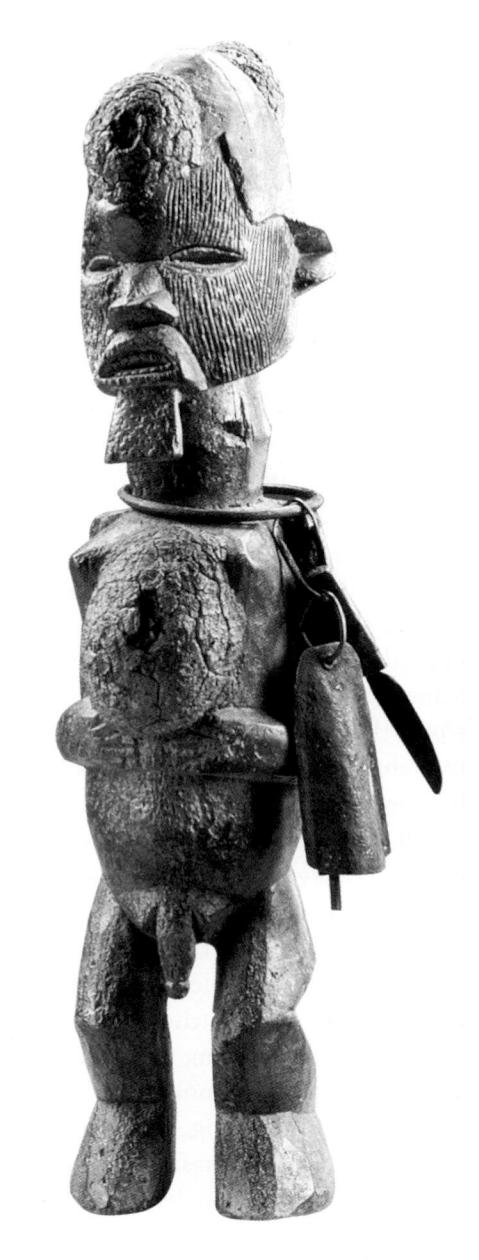

11-21. NKISI FIGURE, TEKE, CONGO. ROYAL MUSEUM FOR CENTRAL AFRICA, TERVUREN

Attached objects may impart further meaning. The small iron bell here was probably used to call the indwelling spirit, and the knife perhaps assisted the spirit in annihilating a sacrificial victim. Kept in its (male) owner's room, such a figure is considered personal property. Its specific power is a secret known to the owner alone.

IN THE SPHERE OF THE LUNDA EMPIRE

The area to the south and southeast of the Kongo kingdom was once dominated by the Lunda empire, which flourished between the sixteenth and nineteenth centuries. According to legend, the empire was founded by Chibinda Ilunga, a prince of sacred blood, who came from the east where his father, Kalala Ilunga, ruled as a Luba king (see chapter 12). A renowned hunter, Chibinda Ilunga traveled far, crossing into the area where Lunda chiefs led small groups under a ruler whose inherited authority was symbolized by a special bracelet. When Chibinda Ilunga arrived, the bracelet was in the possession of a woman leader, Lueji, who welcomed the aristocratic foreigner. After their marriage, she handed the bracelet of her rule over to him. Chibinda Ilunga imposed a new system of governance over Lunda lineages and introduced more efficient techniques for hunting. These new techniques established the Lunda as great hunters (especially for elephant) and helped them to expand their territory and power. Eventually Lunda influence was felt from the region of Lake Tanganyika in the east to the Atlantic Ocean in the West.

The Lunda ruler, called the Mwaat

11-22. Mwaat Yaav of Lunda. Photograph 2005

The transverse repeated bands of the headdress of the Lunda ruler are decorated today with colorful imported beads.

Yaav, ruled over the empire with input from a council. Local leaders, even those who had been rulers of subservient groups, were allowed to oversee their home territory as long as they paid tribute to Lunda overlords. Lunda royal regalia was worn both by Lunda and non-Lunda leaders throughout the region. A distinctive headdress worn by chiefs within the Lunda Empire has expansive, broad forms (fig. 11-22), and it is depicted on art forms such as an elaborate vessel made by one of the smaller populations in the region (fig. 11-23). This royal headgear has had an obvious influence upon the regalia of the Chokwe, and upon other groups once under Lunda authority, as can be seen in their figures of royal personages (fig. 11-24).

Although the Lunda were powerful

and well organized politically until at least the mid-nineteenth century, there is no art style or form associated specifically with them. They borrowed extensively from their neighbors, and the art forms used to bolster their political authority and initiate their youth have long been provided by artists of the groups over which they established control. The Lunda who live to the east use art created in a style like that of the related Luba peoples (see chapter 12); those to the west use a style like that of the Chokwe peoples. The beautiful water pot shown in figure 11-23 is a good example. The basic form is found over a broad area. To the east, such pots are topped with heads in a Luba style, while the head here is reminiscent of Chokwe forms from the west.

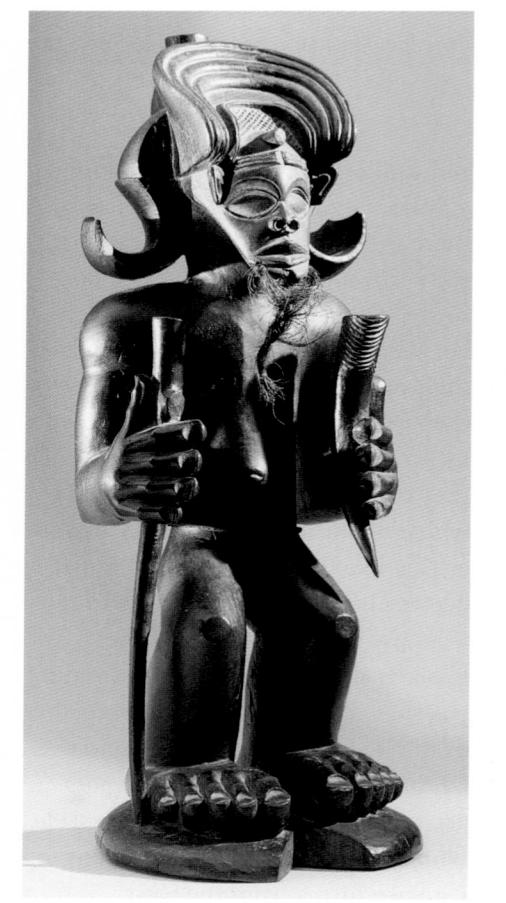

11-24. Chibinda Ilunga figure, Chokwe, 19th–20th century. Wood, human hair. Height 16" (40.6 cm). Kimball Art Museum, Fort Worth, Texas

Chokwe Leadership and Initiation Arts

Local traditions maintain that when Lueji gave her sacred bracelet to Chibinda Ilunga, her brothers left in resentment and formed their own groups. They took with them, however, many of the cultural institutions that Chibinda Ilunga had introduced and transmitted them to the people they settled among. One of the resulting groups was the Chokwe, centered in northern Angola. Chokwe chiefs are descended from Lunda nobles who imposed their system of rule over the Chokwe during the seventeenth century. The Chokwe lived long under Lunda suzerainty, but during the mid-nineteenth century, in response to changing economic conditions, they expanded their territory, eventually populating the region between the upper Kwilu and Kasai rivers in southern Democratic Republic of Congo and northeastern Angola. Some spread into Zambia.

As Chokwe chiefs increased in wealth and influence, the arts associated with chiefdoms blossomed. Local peoples had long traditions of woodcarving, and their artists produced utilitarian, leadership, and luxury objects in a powerful and refined style. With its swelling musculature and preponderance of curving elements, the figure of Chibinda Ilunga shown here is typical of Chokwe style from this time (fig. 11-24). Such idealized representations of ancestors and important historical personages were carved by professional artists and served to underscore the rank and position of chiefs. The legendary hunter and culture hero is portrayed in full hunting gear. His muscular body, huge hands and feet, and broad facial features give a sense of power, while the delicate details of toenails and fingernails and other minute details give a sense of refinement. The sweeping, ornate headdress identifies him as a chief, and the long plaited and bound beard of real hair alludes to his aristocratic position. His massive shoulders are thrown back and, from the rear, emphasize the concave forms of his back. The objects he carries refer to his role as hunter. In his right hand he supports a staff used for holding a sack of power substances. In his left he carries a medicine horn full of substances that assist the hunter, alluding to the role of the supernatural in hunting. Large hands and feet further allude to qualities of skill and fortitude that serve him during long ventures.

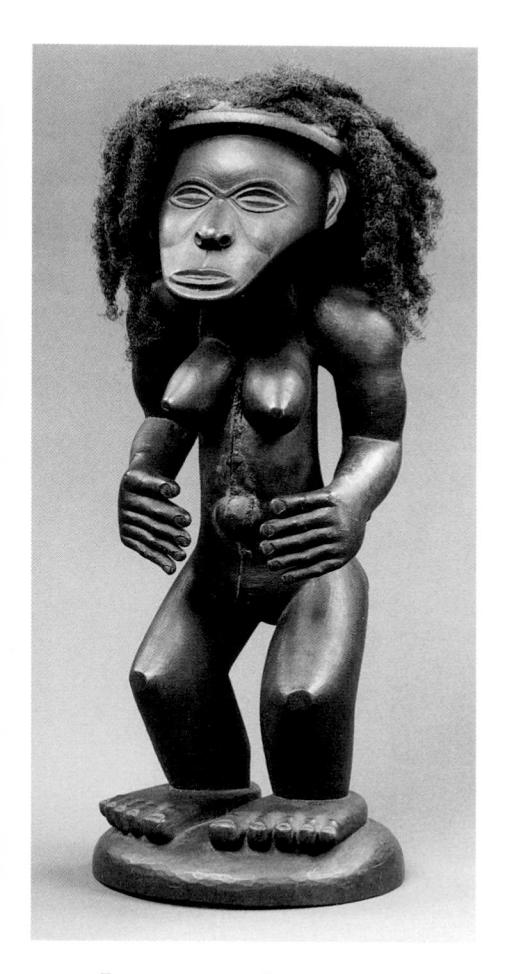

11-25. Female figure, Chokwe, before 1850. Wood, hair, red ritual mud. Height 13¼" (35 cm). Museum für Völkerkunde, Staatliche Museen, Berlin.

Chokwe society is matrilineal, and women thus play an essential role in extending, transmitting, and solidifying power. Female figures from the period of Chokwe expansion reflect the importance of the matrilineage and the transmission of power through women (fig. 11-25). Such a figure may represent the queen mother or the senior wife of a chief and refer to the memory of the female ancestor. The robust musculature and assertive forms of out-thrust chin, breasts, buttocks, and limbs give

an impression of great vitality. The coiffure is made of real human hair.

We do not know why Chokwe artists attached actual human hair on some figures. Locks of hair and nail clippings are carefully disposed of (or are jealously guarded) in many African cultures because it is believed that these materials can be used in witchcraft. These Chokwe pieces, together with a few mask forms from other cultures, are thus among the rare examples of African art that use human hair for the beard or the hair of a sculpted head.

While such imposing figures underscore the dramatic roles played by kings in Chokwe society, diviners also contribute to the social and spiritual well-being of the community. In fact, their position of leadership is next in importance to that of the chief. Their abilities are bestowed by powerful ancestors, and they must

undergo extensive training before they can be possessed by the ancestral spirit that guides divination. Diviners hold public sessions, and may enhance their ability to "see" by applying kaolin and red ocher to their eyes, and by manipulating a basket of objects.

In the method of divination called *ngombo ya cisuka*, a specialist shakes a chaotic collection of seemingly miscellaneous objects in a basket (fig. 11-26). The contents of the basket, both natural and man-made objects, are collected by the diviner over time. Among the many objects, referred to as *tuphele*, are tiny figures, bits of wood, seeds, nuts, animal remnants, and stones. The collection might be seen as a microcosm, representing all materials and many social situations encountered by human beings.

In the consultation, the client sits opposite the diviner, who holds the

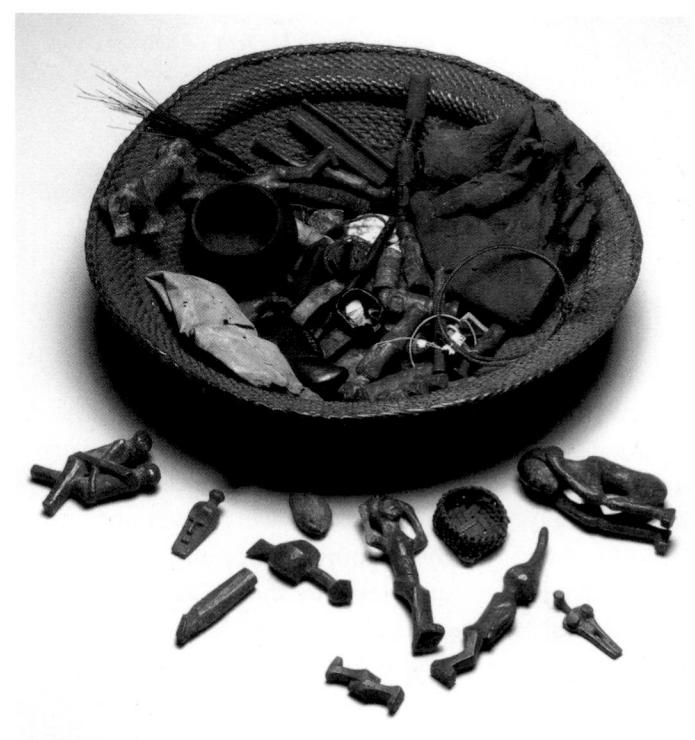

11-26. NGOMBO YA CISUKA BASKET WITH RITUAL ITEMS, CHOKWE, LATE 19TH-EARLY 20TH CENTURY. BASKETRY. WOOD, HIDE, SEED-PODS, GOURD, TALONS, METAL, FIBER, CLOTH, CERAMIC, SHELL, HORSEHAIR, MISCELLANEOUS MATERIALS. DIAMETER 12" (30.4 CM). THE BALTIMORE MUSEUM OF ART. GIFT OF Aaron and Joanie Young, Baltimore, Maryland

Aspects of African Cultures

Divination, Diagnosis, and Healing

African peoples share a prevailing belief that there are explanations for any situation, and answers to all questions. Like virtually all the world's populations, Africans have systems by which they seek reasons for suffering and loss and solutions to puzzling dilemmas. Necessarily, all these many local systems are about the knowledge and values that create order in life. All cultures too have specialists whose training enables them to help ordinary people find solutions and uncover the hidden or unknown: the cause of misfortune or disease, for example, or an auspicious time for planting or a journey. These practitioners are called diviners (or fortune tellers, soothsayers, psychologists, or analysts) and the systems are called divination. Both words contain "divine" because many of these specialists and systems invoke ancestors or other spiritual beings to aid in the processes of discovery, and to help in bringing order, stability, and health, whether to an individual or to the body politic.

As aids to their practice, most African diviners construct shrines, sophisticated, often complex installations often featuring varied art works. In fact, many of the illustrations in this book are of objects used by diviners. These may include figures,

metal castings, or masquerade materials providing a support for the spirits invoked by the specialist, and the drums, gongs, whistles, and other devices used to summon them. Gifts made to the diviner, and offerings left for the spiritual forces, may be displayed. As the process of divination often requires the diviner to interpret the arrangement of objects shuffled in a basket, thrown on a platter, disturbed by animals or insects, or rubbed on a surface, divination equipment used to store or manipulate these objects may also be placed in the shrine. Apparel and regalia (jewelry, beads, headgear, face or body paint) may also be kept in the shrine. The striking appearance of a specialist becomes a part of the mystique of the divination session, which is itself frequently a performance; it is set apart from the rest of ordinary life, often in a special place and may involve prayer, chant, percussion, dance, or visual effects; it may encourage the diviner to enter a trance, or into a state of clairvoyance.

Although the divination session allows the diviner to interpret a set of symbols, or recite a sacred verse, or speak words of prophecy, the client must apply these revelations to his or her own personal situation. Often the diviner is adept at assisting the client afterwards as he or she determines what course of action to pursue. Diviners, then, are essentially

diagnosticians, and as such, heal both mind and body. Many, too, were "called" to their profession by sickness or an extraordinary event that caused them to seek help from a diviner, the same way many psychiatrists in Western culture have been led to their professions. In fact there are many analogies between African diviners and psychiatrists: both are normally wise, have good memories, extensive training, and deep knowledge of and insight into both cultural mores and human nature. Both may prescribe a variety of herbs and other medicines to heal the body and address physical symptoms while providing interventions that will repair disordered social or ritual relations with family members living or deceased.

Diviners often oppose anti-social individuals who are believed to use their knowledge of physical substances and their abilities to manipulate supernatural forces for personal gain. They may also identify men or women as witches who consciously or inadvertently cause infertility, misfortune, illness, and death. Yet diviners, because of their own deep knowledge of the occult, are sometimes themselves accused of witchcraft. Furthermore, as practitioners of ancient forms of therapy, they may be feared or despised by Christians, Muslims, and those trained in Western medical techniques. HMC

basket and shakes it and its contents, causing different configurations of objects to appear. Those that come to rest on the side near the client are seen as particularly significant and are read by the diviner as a response to the problem for which a reading has been undertaken. Interpretation is based on the symbolic meaning of the objects and their relative positions in

the basket. Hypothetically, the basket and its *tuphele* stand for all the variables in the client's life, and the combinations and relative positions of the *tuphele* provide meanings that are interpreted by the diviner. In the example in figure 11-26, an assortment of *tuphele* includes miniature carved figures and objects, a miniature basket, seed pods, a gourd, ani-

mal parts such as talons and claws, shells, horsehair, cloth, and even ceramic tile.

Diviners and chiefs display objects linking them (and their spiritual powers) to the ancestors. One of these distinctive artworks served as a royal scepter (fig. 11-27). The elaborate headdress of chieftancy with its ribbon-like volute frames the chief's

broad head. It is placed over an ornately shaped panel sinuously decorated with angular and curvilinear elements. Tacks of brass, the metal of authority among the Chokwe, decorate a volute that projects from the front of the panel. Figures and faces incorporated in chiefly staffs could be seen as symbolic portraits of the chief himself as well as a chiefly ancestor. Antelope horns on the back of the ceremonial headdress of great sweeping curves held magical ingredients and emphasized the role of the supernatural in the chief's reign. A page carried such a scepter as part of the chief's regalia as he went about on state visits.

Hourglass-shaped stools were seats of authority for ancient Chokwe and Lunda chiefs. The stool shown here preserves the circular top and bottom of such thrones and introduces a supporting figure between them (fig. 11-28). Such supporting figures are found on Chokwe stools only from the region between the Kwilu and Kasai rivers. The Chokwe expanded into this region during the nineteenth century, and the supporting figures may reflect the influence of the beautiful thrones of their new neighbors, the Luba (see fig. 12-1). While some supporting Chokwe figures are depicted in a standing pose, most are as here: a female sitting with legs bent and hands to head, a pose of mourning and lamentation. European brass tacks cover the top and surround the base of the stool.

During the seventeenth century contact with European products inspired new leadership arts. The chair or throne, made of separate pieces of wood joined together rather than carved of a single block, devel-

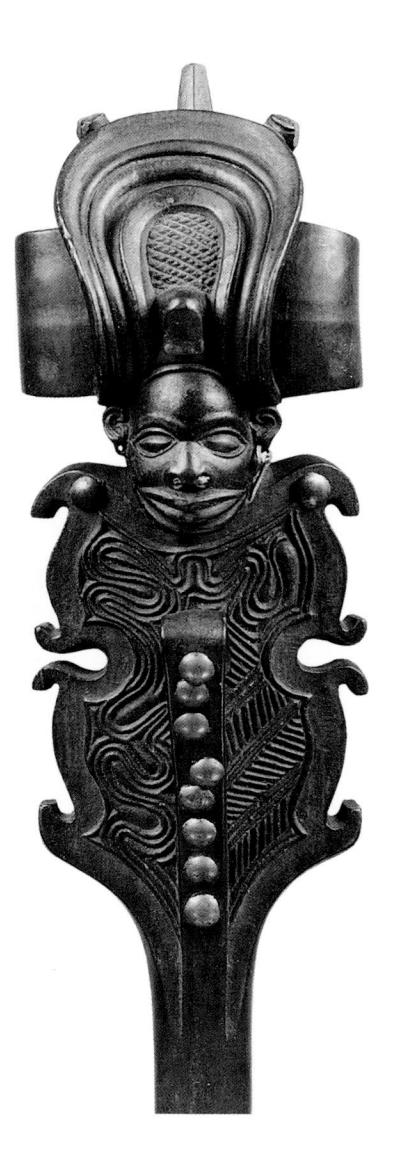

11-27. CHIEF'S STAFF, CHOKWE, BEFORE 1876. WOOD AND BRASS. HEIGHT 12%" (32 CM). MUSEUM FÜR VÖLKERKUNDE, STAATLICHE MUSEEN, BERLIN

11-28. Stool, Chokwe. Wood. Height 8½" (21.3 cm). Royal Museum for Central Africa, Tervuren

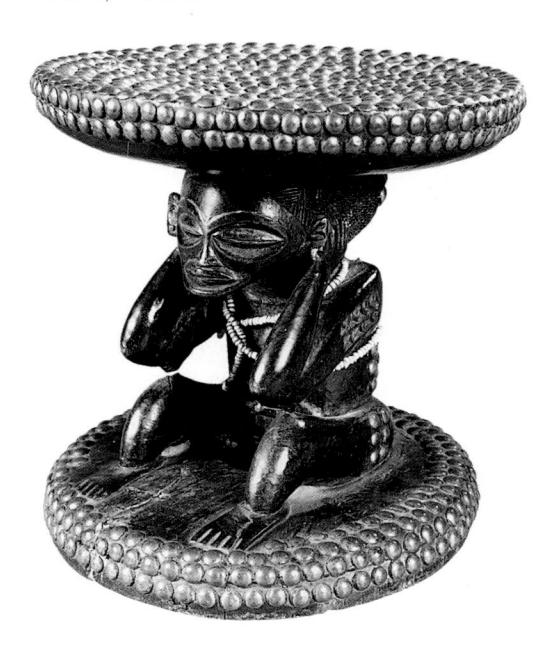

oped from a type of Portuguese chair with leather seat and backrest (fig. 11-29). Carved for chiefs, probably as an interpretation of a prestige gift of a European chair, they quickly became the primary symbol of chiefly authority.

Chokwe artists reinterpreted and embellished the European prototype with multiple figures from within the Chokwe sculptural tradition. The carved head wearing the headdress of chieftancy tops each upright on the back. Two birds drink from a shared vessel on the center portion of the top

crosspiece, or splat, while a scene alluding to initiation fills the lower splat. Frogs are carved on the front legs, and a variety of anecdotal images of daily life line the stretchers between the legs, such as women preparing food, a man leading an ox, and men carrying a pole. Tacks of brass, the most precious of metals for the Central African region, decorate the legs, stretchers, and uprights.

In addition to referring to the wealth and attributes of the king and his court, this throne includes references to masquerades, and to the

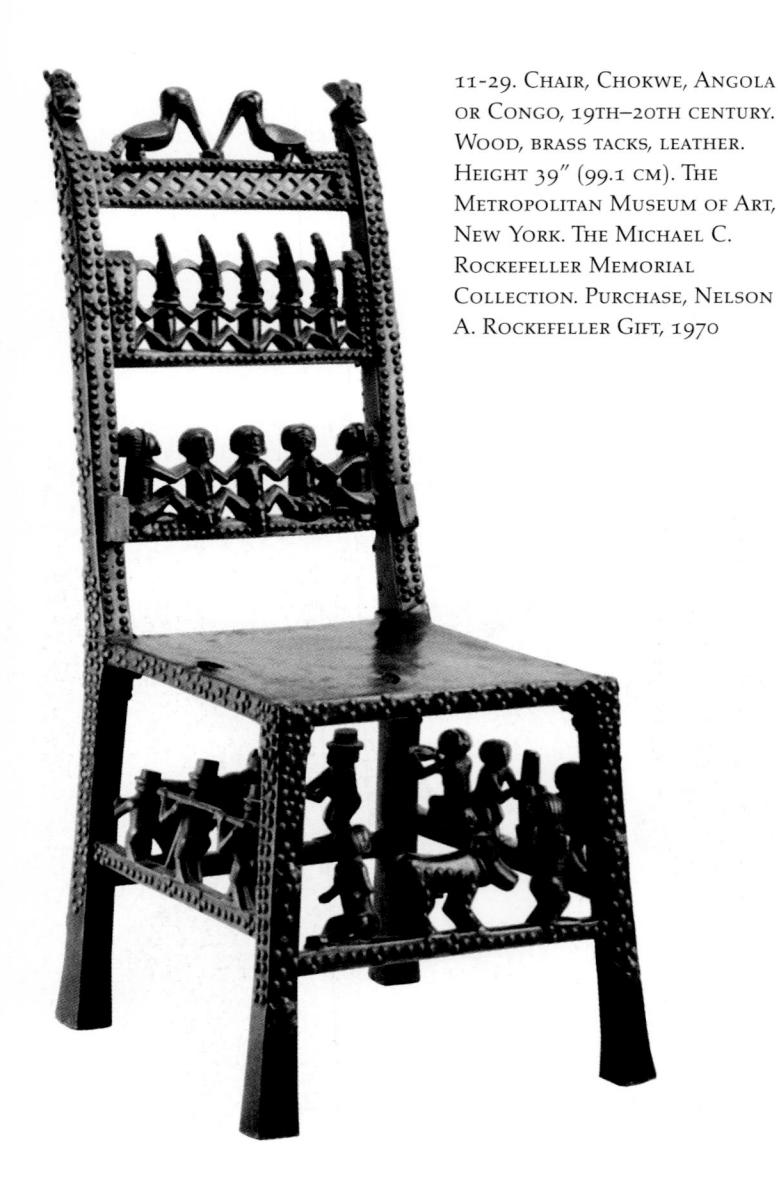

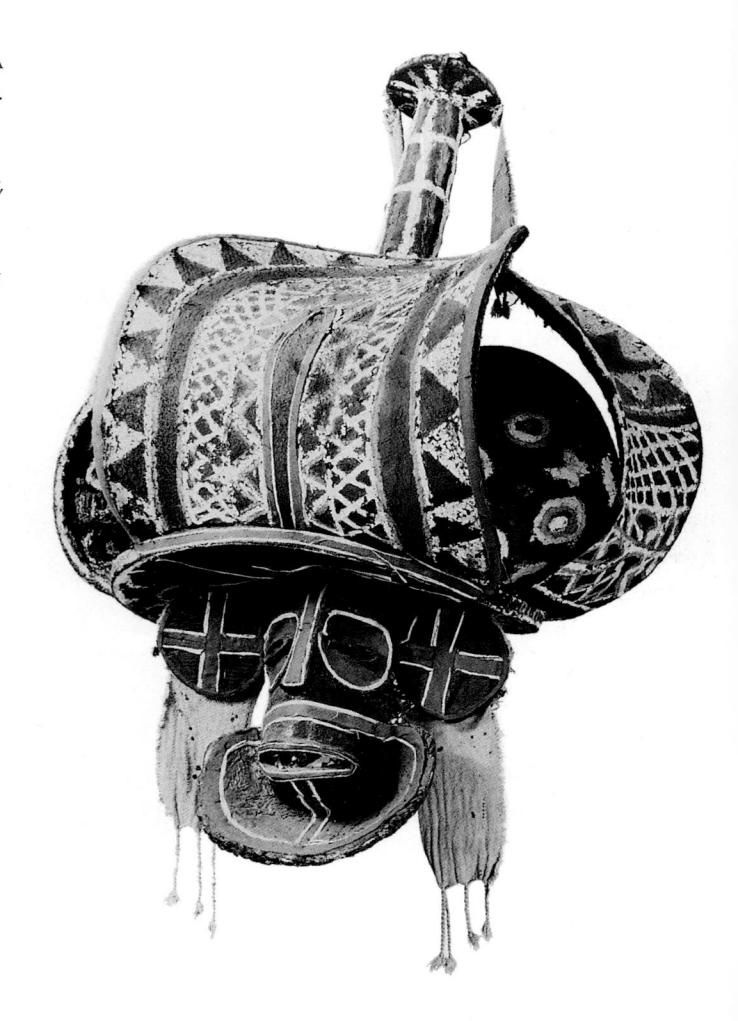

11-30. Chikunga mask, Chokwe, Angola. Cloth, twigs, resin. Height 46% (1.18 m). Museu do Dundo, Luanda

contexts in which masquerades appear. For example, the center splat on the back of the chair is carved with a row of seated masked figures. These depict *chikunza*, a masquerade associated with fertility and hunting. Beneath *chikunza*, boys in the act of being circumcised refer to *mukanda*, the male initiation into adulthood where *chikunza* and other masquerades appear.

Chokwe masks are collectively called *mikishi* (sing. *mukishi*), after the spirits they are said to represent.

The most powerful and important mask found among the Chokwe is known as *chikunga* (fig. 11-30). Highly charged with power and considered sacred, *chikunga* is present during investiture ceremonies of a chief and sacrifices to the ancestors.

The *chikunga* shown in figure 11-30 is made of barkcloth stretched over an armature of wickerwork, covered over with black resin, and painted with red and white designs. The towering headdress is clearly recognizable as a complex royal crown,

similar to those depicted on the figure of Chibinda Ilunga and the carved scepter discussed earlier (see figs. 11-24, 11-27). Said to look like a stern royal ancestor, *chikunga* is worn only by a chief.

While *chikunga* is primarily linked to royalty, other *mikishi* (such as the two masquerades in the photograph in figure 11-31) are specifically associated with *mukanda*. *Mukanda* is found over most of Central Africa in one form or another; it is an institution through which religion, art, and

social organization are transmitted from one generation to the next. *Mukanda* training lasts from one to two years. Boys between the ages of about eight and twelve are secluded in a camp in the wilderness, away from the village. There they are circumcised and spend several months in a special lodge where they are instructed in their anticipated roles as men. As part of their instruction, the boys are taught the history and traditions of the group and the secrets associated with the making and wearing of masks.

Mukanda is organized and supported by village chiefs and may thus be seen as an extension of chiefly authority. Paraphernalia for mukanda, including masquerade materials, are stored across a square from the chief's house. The central square between the chief's house and the storage building is the setting for the opening and closing ceremonies of mukanda. The sequence of events serves to impress on the boys the rightness of the political status quo and teaches them the historical basis for class distinctions. Some thirty or so mikishi are stock characters considered to be the spirit guides for mukanda. Like the chikunga mask of chieftancy, mukanda masks are made of barkcloth over an armature of wicker. They are covered with a layer of black resin, which can be modeled to some extent before it is ornamented with pieces of colored cloth.

The most significant *mukanda* masquerade is *chikunza*, to the right in figure 11-31 and depicted on the chair in figure 11-29. The mask of this *makishi* is topped by a tall conical headdress ringed by raised bands. The nose juts out from the face and curves

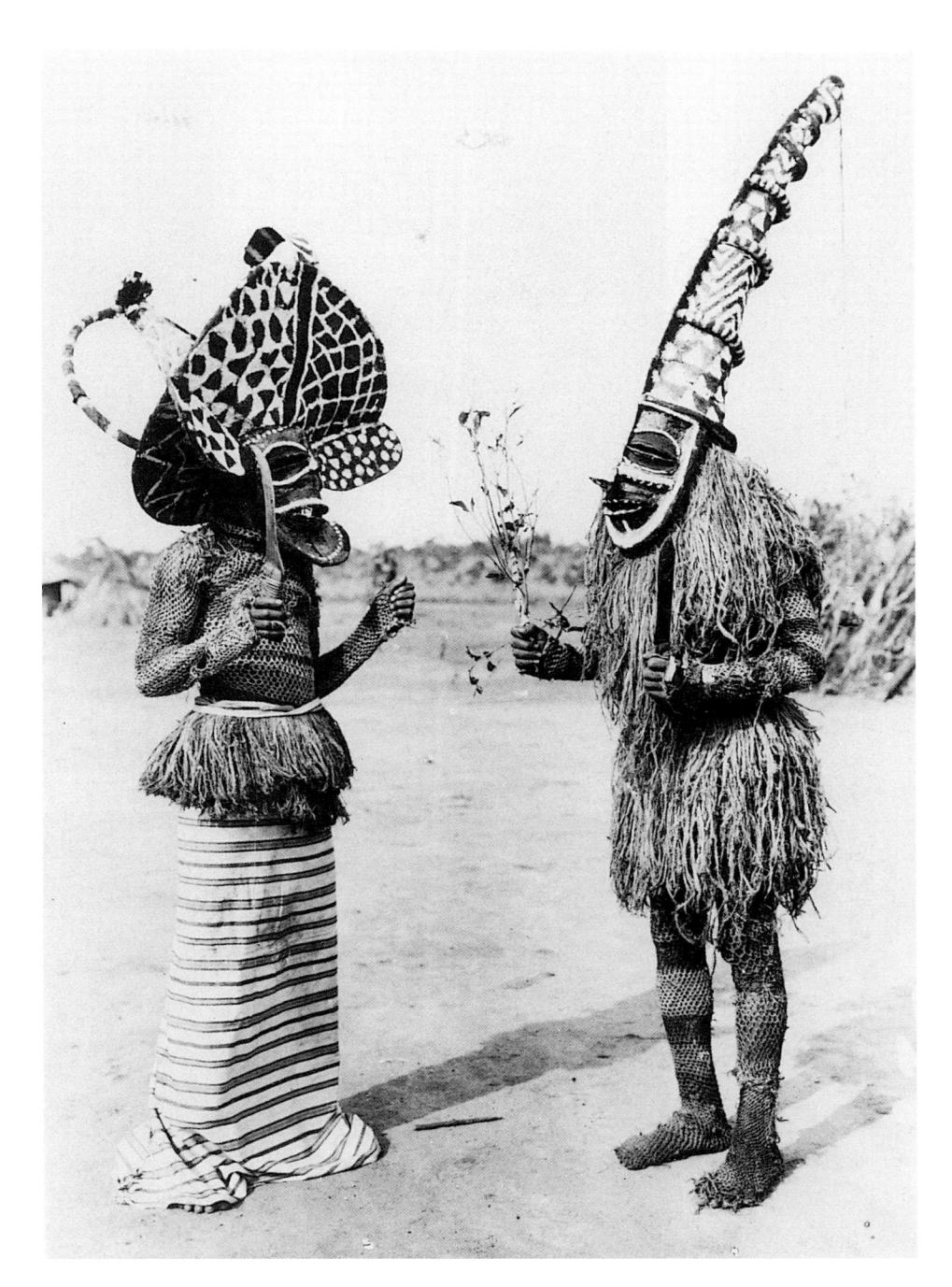

11-31. Two Chokwe *Mukanda* masks with costumes, Chikopa, southwest Kasai, Congo. Photograph с. 1935

11-32. CHIHONGO MASK, CHOKWE, CONGO. ROYAL MUSEUM FOR CENTRAL AFRICA, TERVUREN

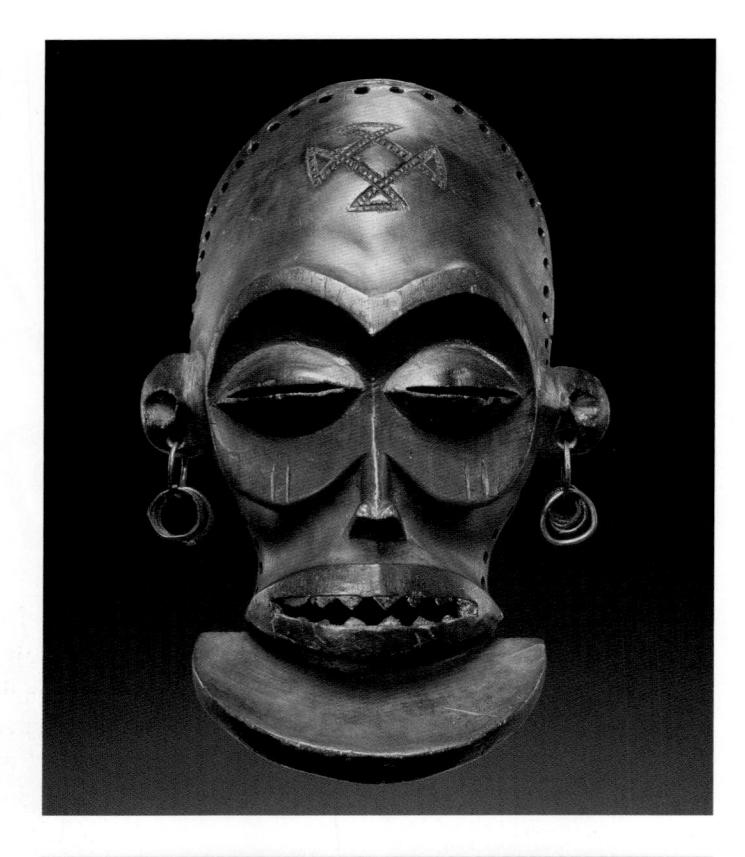

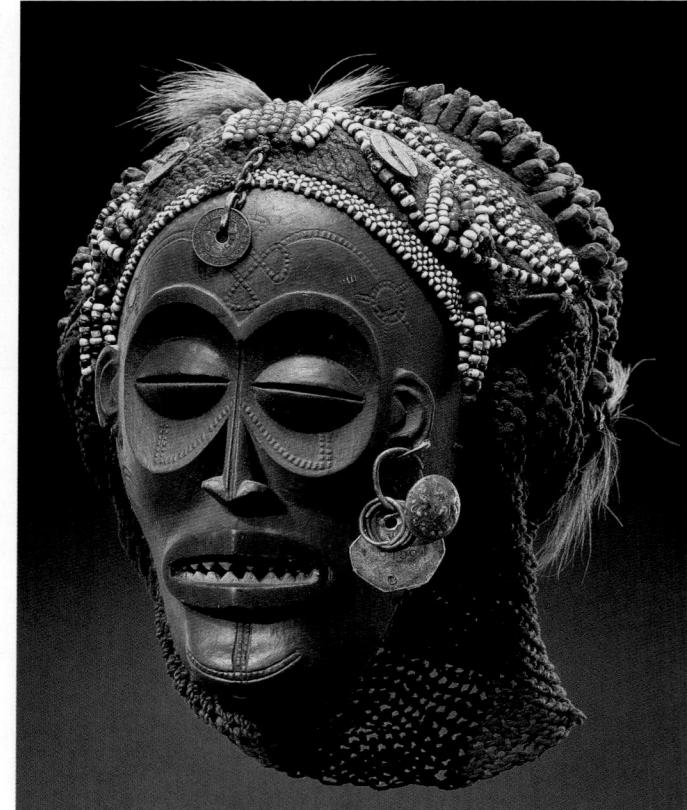

11-33. PWO MASK, CHOKWE, CONGO. WOOD, RAFFIA, CAMWOOD, PEARLS, COINS, METAL TAX-TAGS, BIRD'S LEGS, FUR, INSECT'S HUSK. HEIGHT 9" (23 CM). ROYAL MUSEUM FOR CENTRAL AFRICA, TERVUREN

upward, reaching all the way to the top of the headdress, from which a tassel dangles. The costume is made of close-fitting net with fiber skirt and collar. Like chikunga, chikunza represents a stern old man. He is praised as the "father of masks" and the "father of initiation." As the master of the mukanda lodge, he presides over the initiation events. Associated with goodness, plenty, success, and fertility, chikunza protects hunters as they move through the wilderness and women in childbirth. As such, he is often depicted on hunting whistles and on charms suspended from guns or worn by barren women. The makishi to the left in figure 11-31, kalelwa, is modeled to some extent on the leadership masquerade, chikunga, as are numerous other mukanda characters.

While in former times they probably played important roles in religious beliefs and institutional practices, many other Chokwe masquerades have come to be used primarily for entertainment. Itinerant actors wearing these masks travel from village to village, living on gifts received at performances. Although a few entertainment masks are made of resin over wicker armatures, most are carved of wood, for wooden masks are more practical for traveling. The most popular and best-known entertainment masks are chihongo, spirit of wealth, and pwo, his consort.

The gaunt features, sunken cheeks, and jutting beard of an elder characterize *chihongo* (fig. 11-32). *Chihongo* was formerly worn only by a chief or by one of his sons as they traveled through their realm exacting tribute in exchange for the protection that the *mikishi* gave. Folklore sug-

gests that *chihongo* has noble status, and this may be reinforced to some extent by the fact that the mask is worn with the elaborate headdress of an aristocratic chief. A net costume and a broad fiber dance skirt complete the masquerade. When it is not being worn, *chihongo* is kept in a safe place along with the mask associated with chieftancy, *chikungu*. Unlike a number of other Chokwe masks, these two royal masks have not spread to neighboring groups.

While chihongo brings prosperity, his female counterpart, pwo, is an archetype of womanhood, an ancestral female personage who encourages fertility (fig. 11-33). As an ancestor, she is envisioned as an elderly woman. The eyes closed to narrow slits evoke those of a deceased person. The facial decorations on the surface are considered female, as are the hairdo and material woven into it. The costume includes wooden breasts and a bustle-like appendage behind, allowing the male masquerader to imitate the graceful movements of women.

Recently *pwo* has become known as *mwana pwo*, a young woman, and has been adopted by neighboring groups. This reflects a change in Chokwe society in which young women have become more desirable than older, more mature women. *Mwana pwo* represents young women who have undergone initiation and are ready for marriage.

The Yaka and the Suku

During the eighteenth century Lunda chiefs came to dominate the area to the north of the Chokwe along the Kwango River, a tributary of the

11-34. Chief's headdress, Yaka, before 1906. Raffia. Height 9¾" (25 cm). The British Museum, London

Congo River. They entered the region as adventurers in search of conquest and established administrative centers from which they exerted political leadership over local peoples, including the Yaka and the Suku, two culturally related groups.

Yaka and Suku societies are organized into strong lineage groups headed by elders and headmen. Chiefs are believed to have extra-human abilities, ruling the underworld or spiritual realm as well as the ordinary world. A chief is said to participate in sorcery so that he can tap these powers for the good of the community. When the fertility of the chief is evident, his judicial authority is said to be strong and the relationships among lineages are secure. To this end he has many wives and children.

Regalia make manifest the legitimacy of a chief's authority and allude to his special powers. The most important elements of regalia are a bracelet and anklet inherited from predecessors, a special sword, and headdresses. Many other objects of regalia are produced as well to differentiate chiefs from ordinary men,

including woven hats, adzes and axes, staffs of office, drinking vessels, combs, flywhisks, leopard skins, leopard-tooth pendants, musical instruments, and stools.

A chief's headdress of woven raffia, bweni, is considered a powerful object that must be worn continuously (fig. 11-34). Though their form may vary, many feature the central front-to-back crest, evident on this example. Linear designs, knobs, and a variety of textures may embellish such crests. Evidence suggests that the form may be related to a type of flower associated with male fertility.

Crested headdresses are often represented on objects associated with chieftancy such as the ceremonial adze, *khaandu* (fig. 11-35). Such adzes are carried over the left shoulder of chiefs, lineage headmen, and diviners as symbols of authority. The *bweni* headdress that tops the head carved on the handle alludes to rank and importance. The forged iron blade issuing from the mouth symbolizes the decisive power and authority of words of the dignitary who carries the adze.

11-35. Khaandu (ceremonial adze), Suku, Congo. Wood. René Vanderstraete Collection

11-36. Kopa (Ceremonial Cup), Suku, Congo, Before 1906. Wood. Height 3¼" (8.5 cm). The British Museum, London

Another prestige object connected with leadership among the Suku is the two-mouthed vessel used for the ritual drinking of palm wine (fig. 11-36). Known as a kopa, it is carved from a single piece of wood, its outer surface carved with a lozenge filled with a field of smaller repeating lozenges. While today such cups are produced as novelties for tourists, the kopa was formerly one of the symbols of office presented to a new chief or lineage leader at his investiture. No one else could touch it without proper authority. At the owner's death, a kopa was presented to his successor accompanied by a recitation of the names of its previous owners and admonitions on just rule. The kopa symbolically invested the new headman with powers of vigor and

fertility received from ancestors; it was henceforth his duty to bestow these powers on lineage members through blessing and sacrifice.

Like the Kongo, the Yaka and the Suku use power figures, here known as biteki (fig. 11-37). The exaggerated nose, the bulging downcast eyes, and the recessed area around the eyes are typical of some objects among the Yaka and Suku. The typically Yaka hairdo recalls the bweni headdresses worn by chiefs. Like the minkisi of the Kongo area, biteki serve as repositories for power ingredients and are manipulated by a ritual specialist, an nganga. A cavity in the abdomen of this example once held medicinal materials; other materials are attached to the surface. A figure without such added materials would have no pur-

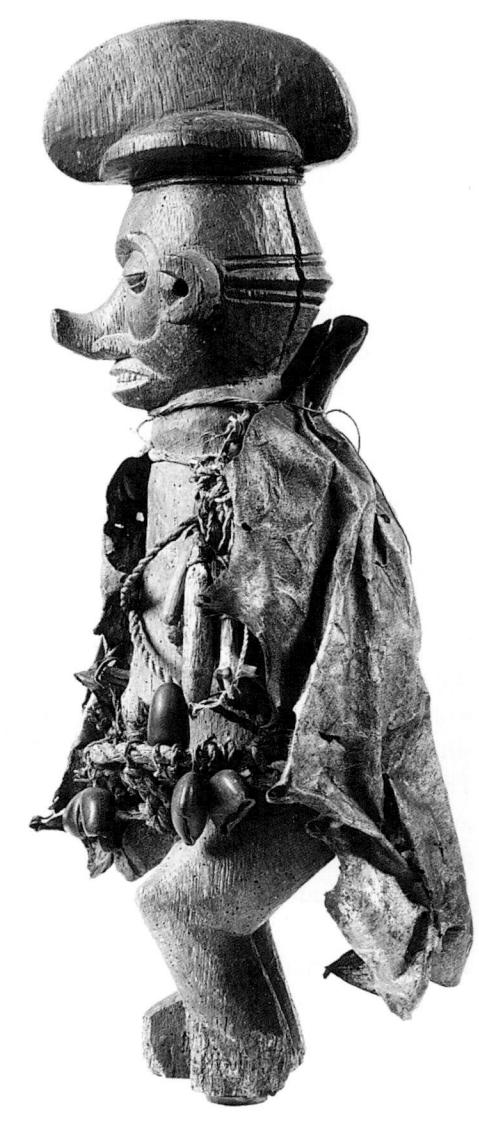

11-37. BITEKI FIGURE, YAKA, BEFORE 1919. WOOD, ROPE, SKIN, SHELLS. HEIGHT 16%" (41 CM). MUSEUM FÜR VÖLKERKUNDE, STAATLICHE MUSEEN, BERLIN

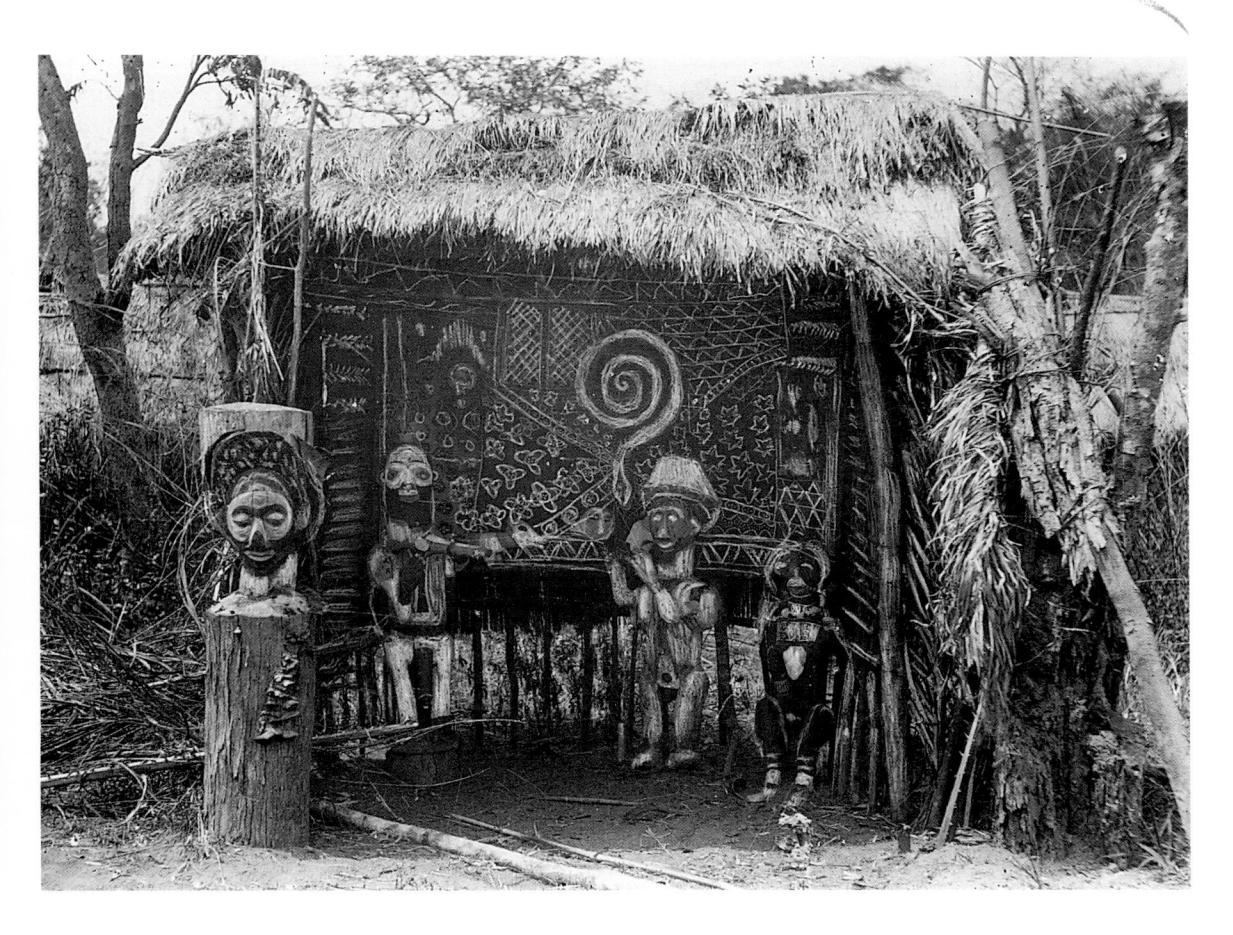

11-38. Initiation structure, Nkanu region, Congo. Photograph 1903

pose and therefore have no meaning to the Yaka.

As among the Chokwe, art among the Yaka and the Suku also finds a place in boys' initiation training, *mukanda*. As elsewhere, the boys are separated from the sphere of women and removed from their influence. They are instructed over a period of one to three years by a ritualized community of males in a secluded camp.

Among the Nkanu, neighbours of the Yaka and Suku, a small three-sided structure is set up at crossroads near the place where *mukanda* takes place (fig. 11-38). Here two-dimensional and three-dimensional images interact in panels lashed together to create a composition on the back wall of the construction, and other figures

may be placed in front of them. A number of themes are suggested in these structures, including cooperation, mutual respect, and regard for the authority of the chief and for the ancestors, Themes of sexuality and procreation are often emphasized in the panels and figures, just as lyrics in songs sung in the camp refer to gender differences and male dominance. The goals of the assemblages are to instruct the youths through visual references to these themes, but these art works also serve a protective function, warding off evil forces that might interfere with the process of initiation. This photograph taken in Nkanu country in 1903 shows such a structure. Inside can be seen human figures and a snake on a ground of polychrome floral and

foliate designs. The panels in figure 11-39 refer to newer forms of power embodied in a colonial administrator and the Congolese soldiers accompanying him.

The large post in front of the structure in figure 11-38 is topped by a carving that represents an initiation mask. Masks among the Yaka and the Suku belong almost exclusively to the mukanda rituals and constitute the major art form within the context of the initiation camp. They include helmet masks and face masks as well as large assemblage masks that cover much of the body. Masquerades are seen as a means of protecting the boys while they are involved in this liminal, ritually hazardous period of their lives. They guard the future fertility of the boys and shield them

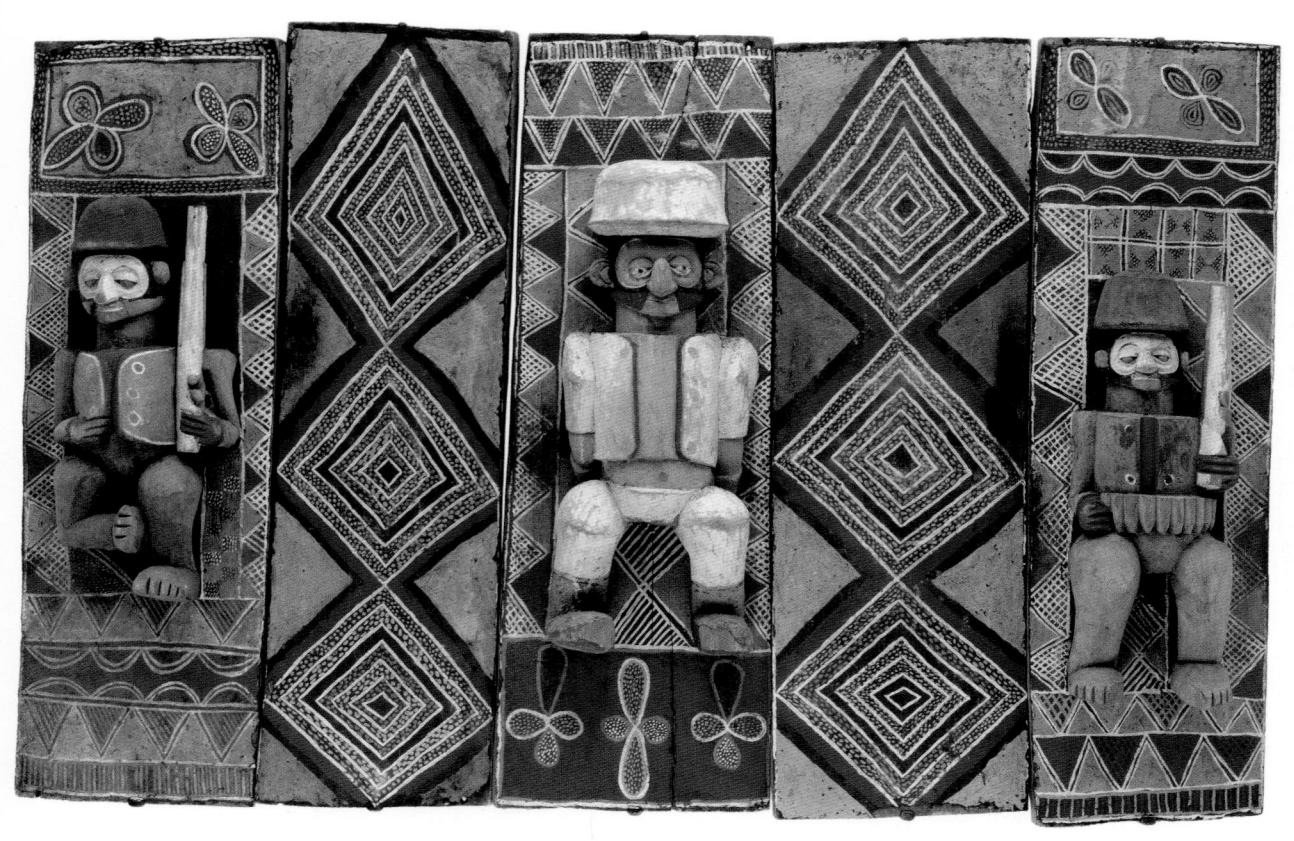

11-39. Initiation WALL PANELS, Nkanu, CONGO, EARLY 20TH CENTURY. Wood, Pig-MENT. 33% X 5115/16" (84.8 х 132 см). NATIONAL Museum of AFRICAN ART, Smithsonian Institution, WASHINGTON, D.C. Museum PURCHASE

against the harm they will face when they return to their homes and have contact with women, with forbidden foods, and with community discord. Masquerades in general can be seen as serving as a collective image of all the elders who have departed, the male ancestors and culture heroes who established circumcision. When the initiation camp is over, masks were formerly destroyed, although today many of them are sold.

One masquerade, *mweelu*, found among both the Yaka and the Suku, has a head covering of twined raffia to which a great number of feathers are attached. In the example shown here the eyes are made of miniature gourds and the nose is the beak of a hornbill (fig. 11-40). A great ruff of raffia falls over the wearer's chest. Some consider *mweelu* the most

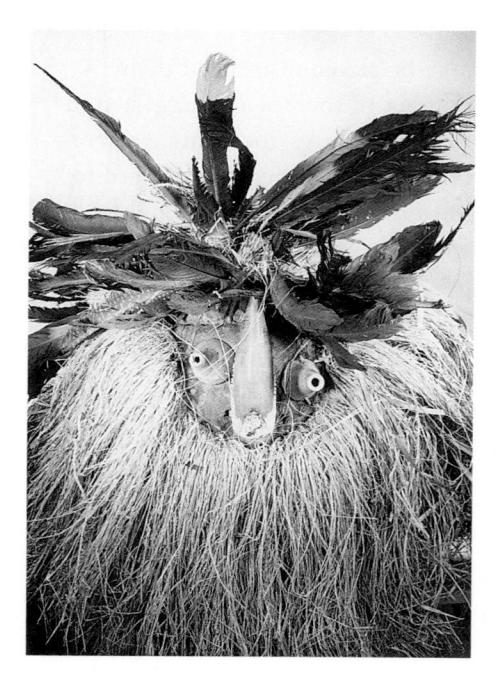

11-40. MWEELU MASK, NORTHERN YAKA, BEFORE 1976. RAFFIA, FEATHERS, GOURDS, HORNBILL BEAK. INSTITUT DES MUSÉES NATIONAUX, KINSHASA

essential of *mukanda* masquerades and see it as playing a parental role. *Mweelu* is in charge of gathering food for the boys during their training, and eventually it is *mweelu* that leads the newly initiated boys back into the village.

Some of the most powerful masquerades are associated with the religious specialist in charge of the boys' training. These masks do not dance or entertain; their task is to terrorize. The most notable is known throughout the region as *kakuungu* (fig. 11-41). The gigantic wooden mask worn by *kakuungu* may be almost three feet in height and often has a handle hidden under the raffia fringe for controlling its bulkiness and weight. The face is characterized by immense, bloated features, often including a swelling chin and ballooning cheeks.

Red and white paint divides the face into zones. *Kakuungu* represents an apparition of an elder with anti-social powers. It appears on several key occasions to frighten the youth into submission and to gain their respect for the elders. It is also seen as a hazard to any who harbor evil designs against the initiates. Because of its protective powers, lineage elders may invite *kakuungu* to perform in the community as well.

The mask in figure 11-42 is used in a low-ranking masquerade that dances and entertains. A projecting circular form with painted trapezoidal panels frames the boldly carved, polychromed face. The eyes bulge and an exaggerated nose curves and points upward to the forehead. Its open

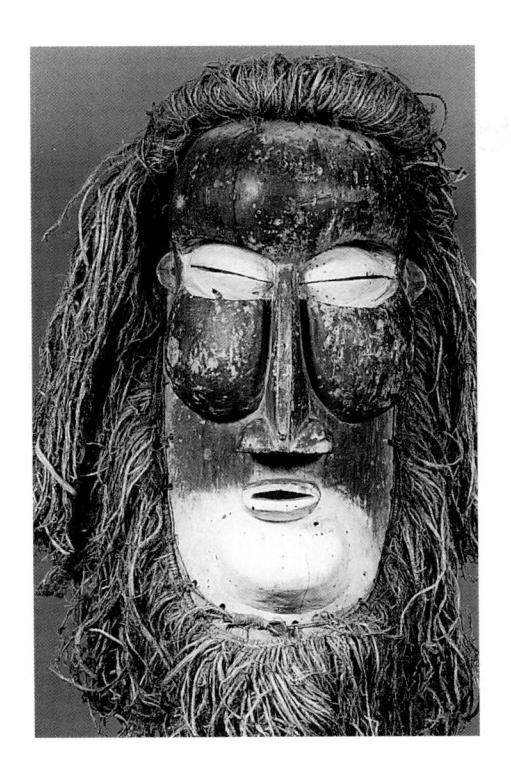

11-41. KAKUUNGU MASK. SUKU. WOOD AND RAFFIA; HEIGHT 3½" (8.97 CM). ROYAL MUSEUM FOR CENTRAL AFRICA, TERVUREN

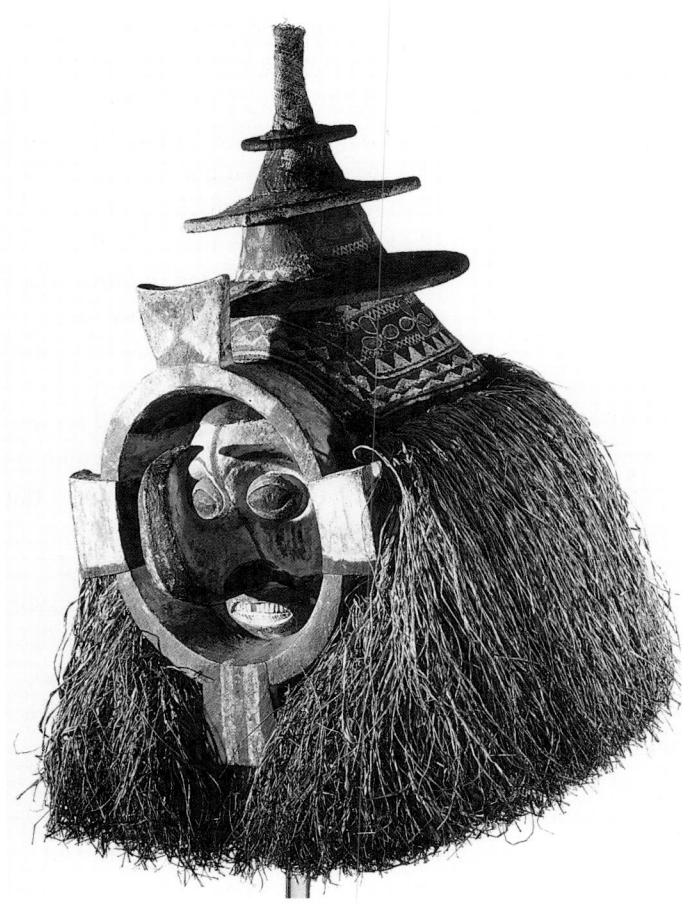

11-42. MASK. YAKA. 19TH CENTURY. WICKER, RAFFIA, PIGMENTS; HEIGHT 21¼" (54 CM). MUSEUM RIETBERG, ZÜRICH

mouth reveals bared teeth. The superstructure is a cone formed over a wicker armature stretched with raffia fabric or cotton cloth. The panels of the superstructure are painted a variety of patterns in white, red, black, blue, and orange. A hanging raffia coiffure hides a supporting handle at the base of the mask. Sources suggest that the circle around the eyes and nose depicts the cosmic beginning of the sun. The bulging eyes refer to the lunar cycle and the procreative capacity of women. The upturned nose, thought of as an erect phallus, relates to the insemination of mother earth by the sun, while other elements of the mask refer to the orifices in a woman's body. Thus the complex iconography of the mask form itself reveals both cosmology and sexual education to the Yaka initiate.

The Pende

The Pende originated in northern Angola but were forced into the Kwango region to the north of the Chokwe, in present-day Democratic Republic of Congo. In the course of their migrations they were split up into eastern, central, and western segments, all eventually incorporated into Lunda political structures. Pende art styles vary widely, with a more abstract, geometric style in the east and a more naturalistic style in the central area and to the west. The function of art varies from one region to the other as well.

Eastern Pende chiefs have special houses designated for storing sacred objects and for the performance of ritual acts critical to the lineages over which they preside. Great chiefs, those who control their own land and

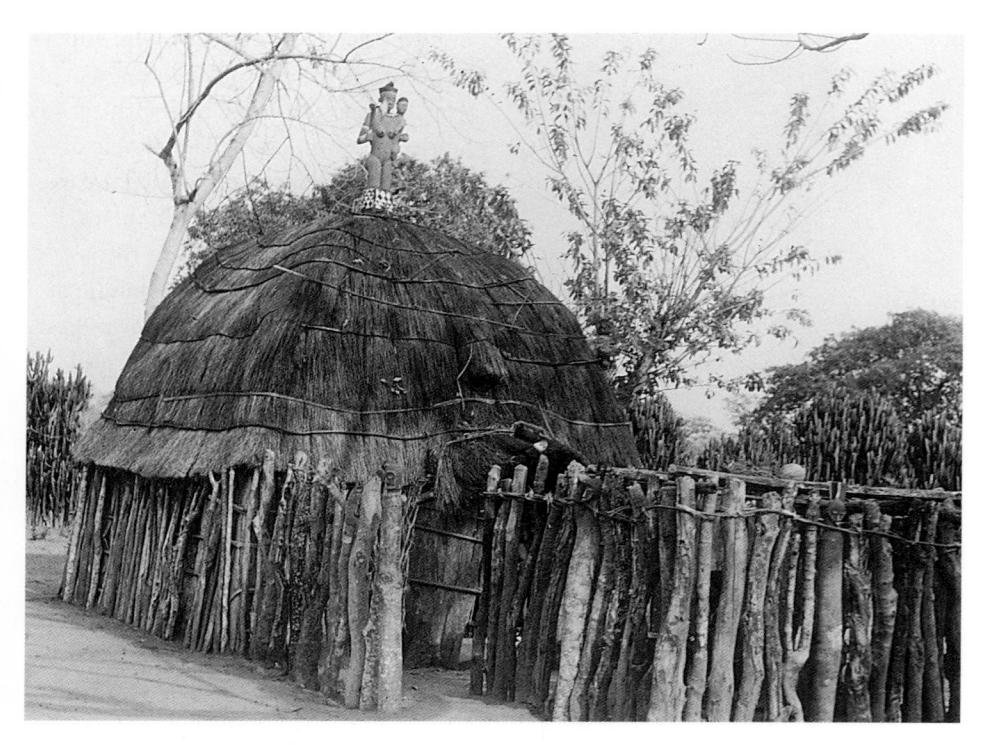

11-43. Kibulu (ritual house), Eastern Pende, Mukanzo, Mbelenge, Congo. Photograph 1955

Before 1960 only chiefs of the very highest rank were allowed to use figurative architectural sculpture. Chief Kombo-Kiboto (ruled 1942–1987) commissioned two sets of sculpture during his administration, including the doorway panels and rooftop figure by Kasea Tambwe that grace this kibulu. Kasea was the most sought-after carver of architectural sculpture during the 1950s and 1960s. Commissions on this scale were rare, however, and thus Kasea, like other well-known artists, made his living by carving masks.

make land available to subordinate chiefs, live in a ritual house called a *kibulu* (fig. 11-43). Although ritual houses vary from region to region, the *kibulu* is usually a four-sided structure with side walls about ten feet long and a central support pole about ten feet high. The dome-shaped roof makes the *kibulu* distinctive among Pende structures.

Built in a single day by all the able-bodied men of a community, a *kibulu* may not be repaired; its impermanance reminds the chief that his position is tenuous, and that he (like all mortals) will pass away. It alludes

symbolically to the ancestors and their fertility-enhancing powers and it is associated with the well-being of the environment of the community. Seeds of the plants that the Pende cultivate are buried beneath its central pole. A small courtyard in front is defined by a fence of stakes or tree cuttings, whose sprouting indicates the approval of the ancestors. The fence defines the boundary between the royal sphere and that of the populace; it is also seen as a fover to the spirit world populated by the ancestors. Passersby can only glimpse into the enclosure through the narrow

opening. The door, distinguished by a projecting vestibule, is often guarded by panels carved in relief with male and female figures. Although not visible in the photograph, this Kibula featured an elaborate female figure on a plinth that projected from the relief panel beside the door.

A hierarchy of rooftop sculptures denotes chiefs' ranks. Lesser chiefs may have animal and bird figures on the roof, but only great chiefs may have a human figure. Such figures are said to protect the entire village. They warn persons of evil intent that the house and the village are both safeguarded by the powers of the chief and by those spirits that protect him. The sculpture shown here, by the celebrated Pende artist and blacksmith Kaseya Tambwe Makumbi, depicts a mother and child. Kaseya is credited with developing this motif, which since the middle of the twentieth century has become by far the most popular. It is said to signal the death of a close female relative of the chief, usually a sister. In this matrilineal society, the loss of a sister is the ultimate loss, for it represents the loss of a generation, or in some cases the loss of future generations.

Within the *kibulu* two small rooms are filled with symbolic objects and materials. The outer room contains the chief's bed and symbols of his reign such as axes, bells, mats, skins, and royal garb, and is the dwelling place of his first wife, who supervises the women of the village. Only the chief, his first wife and their children, and a few high-ranking ministers are allowed in this room. The objects within are believed to exert a direct influence on community health and well-being since the chief is the source

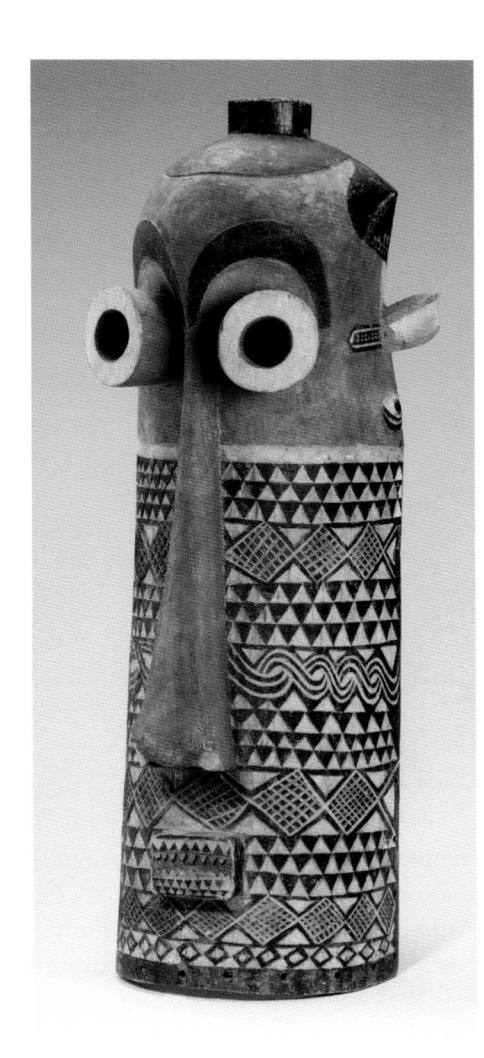

11-44. Pumbu mask, Eastern Pende, Congo. Wood, pigment. Height 31%" (81 cm). Early—mid-20th century. The National Museum of African Art, Smithsonian Institution, Washington, D.C. Gift of Walt Disney world Co., a subsidiary of the Walt Disney Company

of fertility and life for the community.

The inner chamber stores the chief's treasury, which contains his (future) coffin, special medicine that protects his community, and three masks associated with his rule, pumbu, kipoko, and panya ngombe. This inner sanctum may only be entered by the official who oversees the treasury, for not even the chief himself is allowed in this sacred space.

The two most important masks kept within the inner chamber represent the dual nature of the chief who owns them. *Pumbu* is considered the most fearful and dangerous, for it represents the warlike nature of the chief. Called an executioner by some, it is used by only a few of the most powerful chiefs. The huge pumbu shown here is a halfcylinder (fig. 11-44). Two enormous eyes project as tubes from the red upper third of the face, their white rims signaling great anger. Below, bands of black and white triangles alternate with registers of lozenges or interlace patterns, their busy geometry contrasting dramatically with the plain red upper portion. The long red nose on this example bridges the plain and patterned areas. A box-like mouth projects below the nose.

Pumbu symbolizes the power of the chief. It dances only on rare and terrible occasions determined by divination, such as when the chief himself is seriously ill or when epidemics or famines rage, indicating that ancestors may be unhappy. When pumbu dances, the mask, framed by raffia wig and beard, is so large that its chin is at the wearer's waist. He holds weapons of war as he presents himself before the chief's subordinates to collect tribute. Young men restrain him with cords attached to his waist.

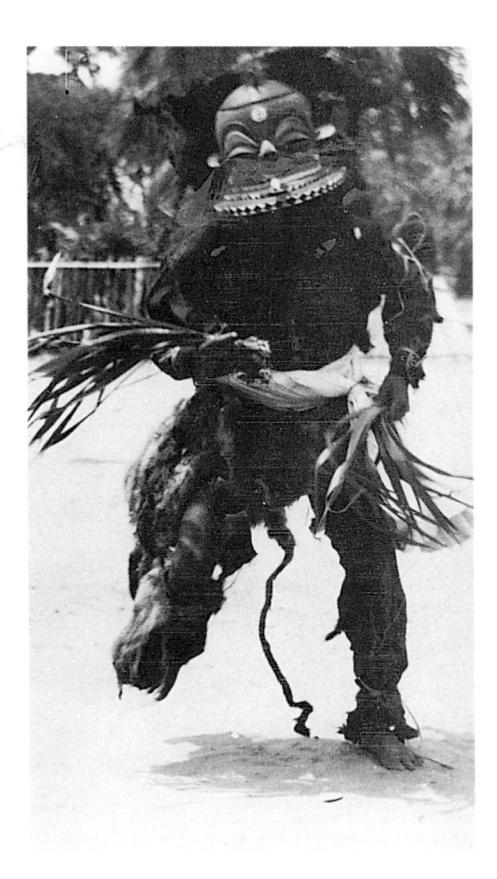

11-45. KIPOKO MASK, EASTERN PENDE, KITANGWA, KASAI, CONGO. PHOTOGRAPH 1958

Others in his company carry whips. Before he returns to the *kibulu*, *pumbu* must kill, so he finds a stray chicken or goat on the path. Back at the *kibulu*, *pumbu* spins around to face the crowd and dramatically cuts his restraining cords as onlookers flee. The threatening *pumbu* signifies the courage the chief must sometimes summon to confront questions of life and death.

While *pumbu* rages through the village, *kipoko* takes charge of the *kibulu* (fig. 11-45). *Kipoko* symbolizes the benevolent nature of the chief. The pot-shaped *kipoko* sports a top-knot, ears that project outward, a narrow projecting nose, and a thrusting,

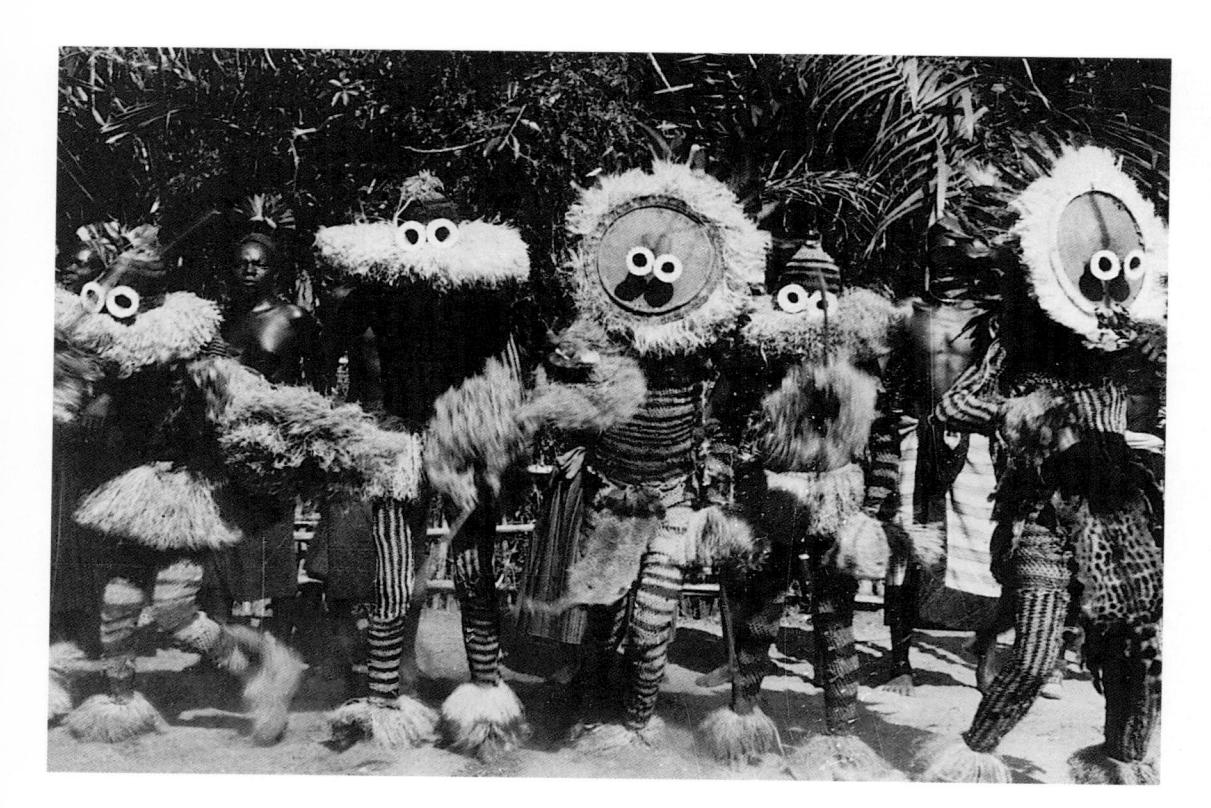

11-46. MINGANJI DANCERS INCLUDING TWO GITENGA MASKERS, PENDE, GUNGU, KWANGO, CONGO. PHOTOGRAPH C. 1950

plate-like beard. The face is usually painted red, while geometric designs in black and white cover at least the edge of the beard. Kipoko, too, symbolizes the political power of the chief and ancestral authority, but unlike *pumbu*, he is not terrifying. He embodies the nurturing side of the chief and his powers. The large ears, eyes, and nose remind the chief that he must be aware of all that goes on in his domain. The large tragus of the ear refers to a proverb recommending that the chief pay little heed to small slights or insults thrown his way. He listens thoughtfully, not responding to everything he hears. The small mouth, seen here as a tubelike form, but nonexistent in some examples, cautions kipoko, as well as the chief, to think before he speaks.

The third mask associated with the *kibulu*, *panya ngombe*, is more rare today than either *pumbu* or *kipoko*.

Panya ngombe, like pumbu, is reserved only for the highest levels of chieftancy and appears in the clothing of a high chief at the time of circumcision during initiation. Its rarity nowadays may have to do with the fact that since the 1930s circumcision has been performed at birth.

While the masquerades of the eastern Pende as a general rule serve an administrative purpose, those of the central and western Pende are largely used in the context of the mukanda initiation (fig. 11-46). These fiber masquerades, called minganji, embody ideas of death, uncertainty, and darkness. They take on various forms, though all have protruding cylindrical eyes and netted fiber costumes. Gitenga is said to be the chief of the minganji. The mask for gitenga is a red-colored, rayed disk of fiber, said to represent the sunset. In performance gitenga moves in a stately

manner, while the rest of the *mingan-ji* are emphatically aggressive. Although *minganji* appear at a number of functions, their most important role is as guardians of *mukanda*.

The wooden mbuya masks are perhaps better known outside Pende country. Appearing alone or in pairs, mbuya portray a wide variety of characters, including the sorcerer, chief, clown, and a number of types of women such as the chief's wife, the beauty, and the seductress. While mbuya are associated with mukanda, they may also be seen in other contexts, and masquerades allow performers to be recognized in their drive for celebrity. They attempt to develop mask personas that will draw attention to performances that will awe and entertain audiences.

Knowledgeable observers critique the entire masquerade ensemble—the costume and its accoutrements as well

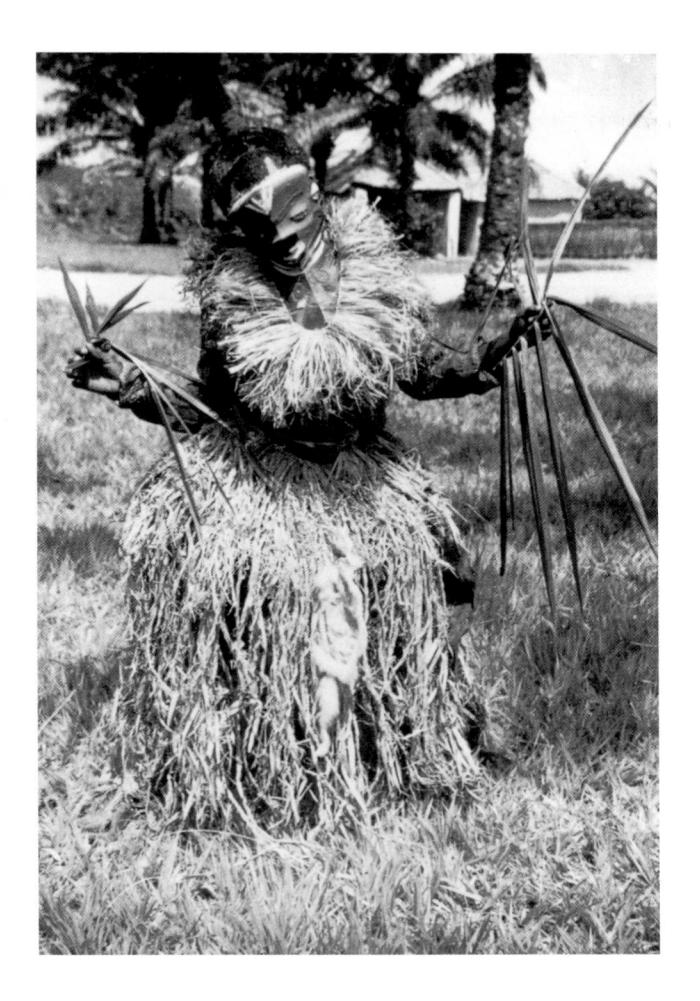

11-47. *Mbuya* masker, Pende, Kilembe, Kwango, Congo. Photograph c. 1950

The mask is worn over the forehead of the dancer; his face is covered with raffia and a raffia cloth fringe. Here a skirt of raffia fiber completes the costume, but others may have clothing of imported fabric. Dancers carry objects in performance, here leaves from the palm frond. Others carry fluwhisks as sumbols of leadership or wear the skin of certain cats as signs of leadership and symbols of the hunt. The characteristics suggested by attachments and objects clutched in the hands are reiterated in songs and dances.

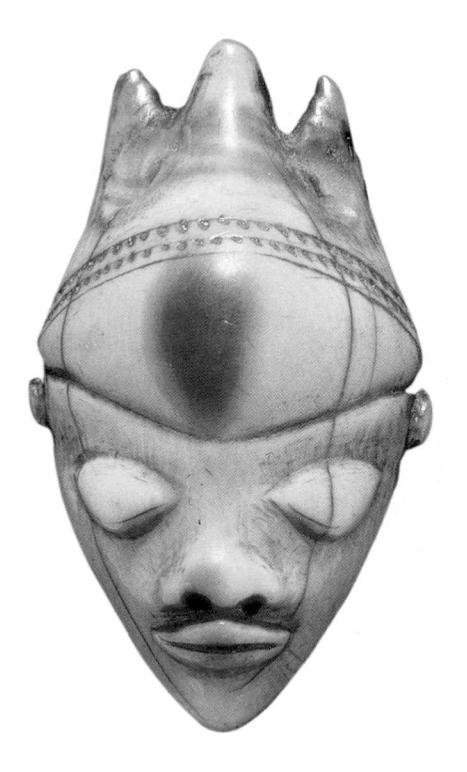

11-48. *IKHOKO* MASK-PENDANT, CENTRAL PENDE. IVORY. HEIGHT 2½" (6 CM). ROYAL MUSEUM FOR CENTRAL AFRICA, TERVUREN

as the dance steps and songs that are a part of the event, especially when some elements identify the mbuya as an innovation. Western and central Pende mbuya appear in a variety of styles. The mask shown in figure 11-47 is from the Central Pende region. Recognized by its bulging forehead, continuous V-shaped brow in relief over heavily lidded and downcast eves, high cheek bones over tightly drawn cheeks, and a turned up nose with nostrils drilled as wide openings, the mask's style seems to have originated between the Kwilu and Loango rivers. The mask shown here has a beard-like chin extension, perhaps a reference to the powers of the ancestors.

Delicate miniature versions of mukanda masks carved in ivory or hippopotamus bone are worn as pendants around the neck (fig. 11-48). Called ikhoko, they are scrubbed daily with sand to preserve their natural color, and their features thus appear gently worn and smoothed. It has been suggested that these exquisite miniatures were created for purely aesthetic purposes, to beautify and to enhance the impression of elegance and style presented by its wearer. However, similar wooden miniatures seem to have been used in healing processes.

THE SALAMPASU

Differing from the peoples under the Lunda umbrella are a number of small, non-centralized groups who live on the border of the Democratic Republic of Congo and Angola. One of the least understood of these is the Salampasu, an enclave of loosely connected peoples who live to the north and east of the Lunda and the Chokwe in Kasai province. Although surrounded by peoples who do have some form of centralized political organization, the Salampasu have remained fiercely independent, and have succeeded in remaining aloof from the Lunda empire. In fact, the area in which the Salampasu

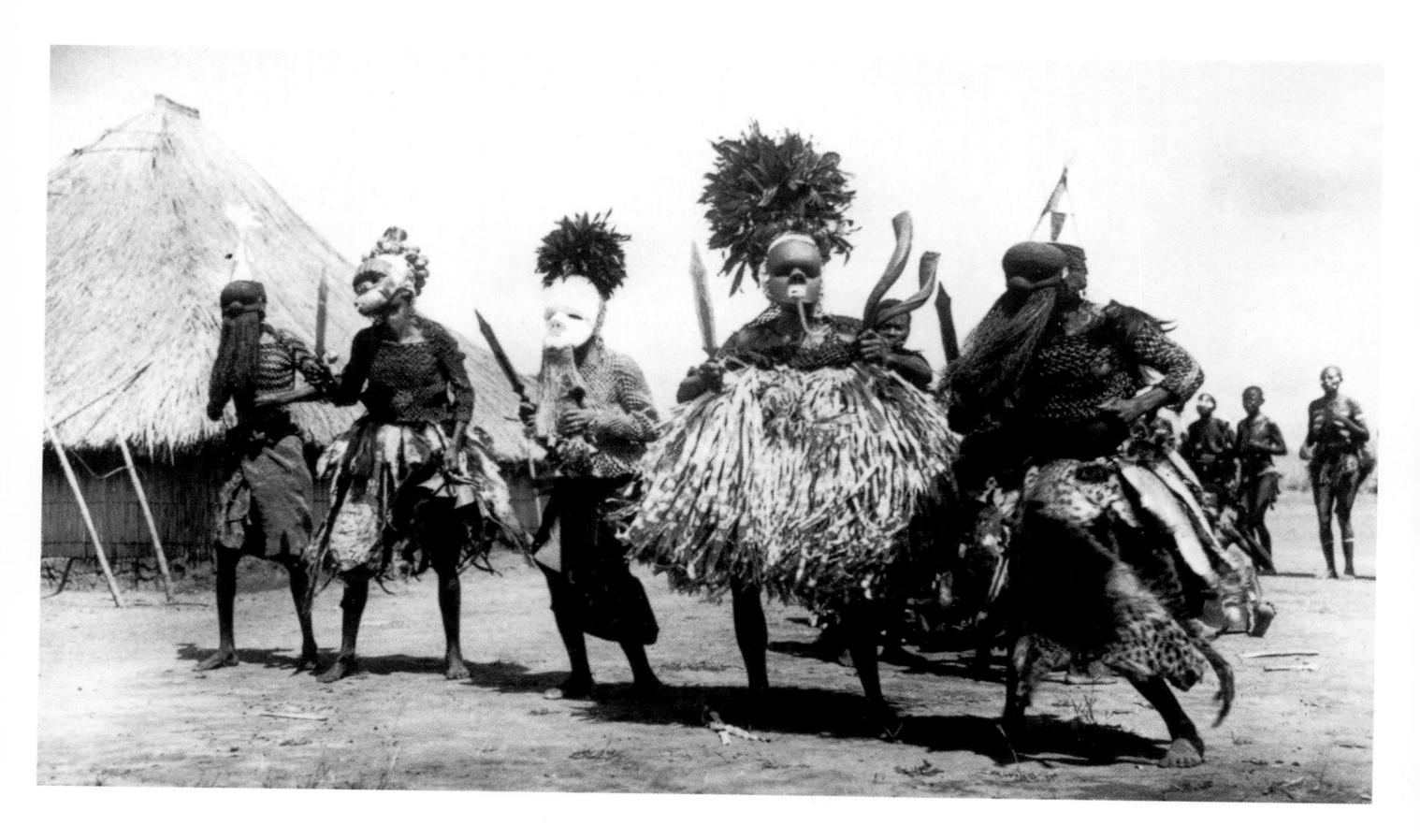

live became a haven for those small groups that wanted to escape incorporation into Lunda polities.

Today, art among the Salampasu is made primarily for export, but in the past much of it was used in the Mugongo society. Although Mugongo today is seen as a collective instrument for governing, it may originally have been a variation on mukanda. Boys were initiated into the Mugongo society through a circumcision camp. They rose through its ranks by gaining access to a hierarchy of masquerades and esoteric knowledge (fig. 11-49). The right to own and understand each successive masquerade in the hierarchy was procured through specific deeds and payments. Masked performances were witnessed only by those men who had the right to wear the mask. Those who owned

many masquerades possessed both wealth and knowledge. Lower-level masks are carved of wood and painted. The senior-most mask is covered with sheet copper (fig. 11-50). Most masks have pointed teeth, referring to the process of filing the teeth: this operation was a part of initiation and indicated the novice's strength and discipline.

Very little is known of the other art forms of the Salampasu. Dance enclosures about three feet high were surrounded by carved relief panels (fig. 11-51). Female figures and masks were carved in relief on the sides. The masks refer to the different titles to which a man could rise, reflecting the acquisition of knowledge and the accumulation of metaphysical and material power along the way. Only select members of Matambu, appar-

11-49. Salampasu masks being performed at Salushimba, Kasai, Congo. Photograph 1950

The Salampasu have experienced many social, political, and economic changes during the twentieth century, and these changes have directly affected their art.

Local religious zealots traveled through the Salampasu region in the 1960s, destroying masks and sculptures. Nevertheless masks are still danced at male circumcision ceremonies. In this photograph from the mid-twentieth century, fiber masks flank three wooden masks. Various costumes complete the masked characters

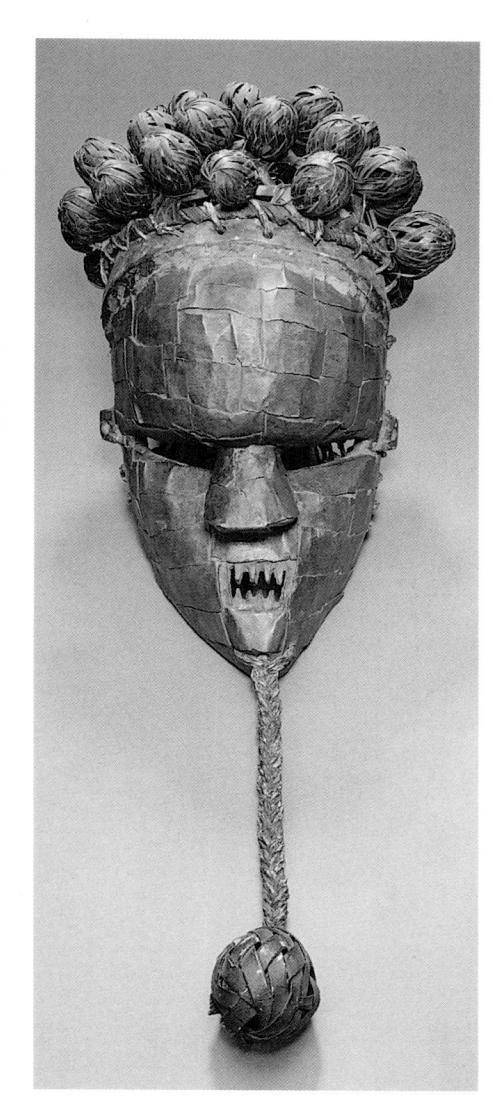

11-50. Mask, Salampasu. Copper cover. Fowler Museum of Cultural History, University of California, Los Angeles

The cane-work spheres that top this coppercovered mask and the one suspended from its beard reflect those worn by dancers in the photograph in figure 11-51.

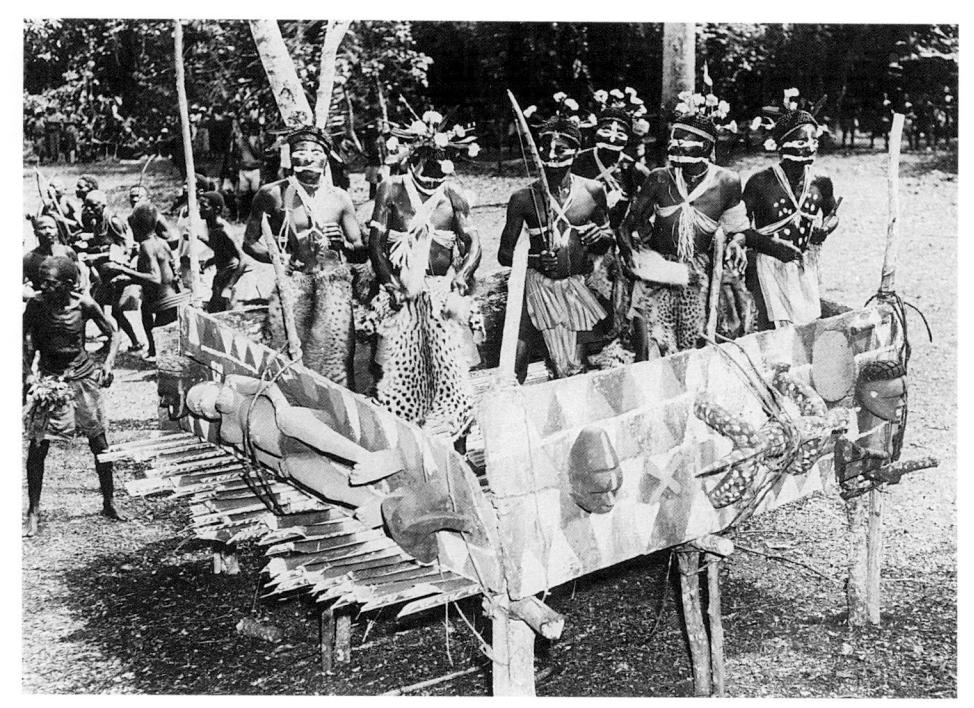

11-51. Salampasu dance enclosure, Mukasa, Kasai, Congo. Photograph c. 1950

ently a warriors' association, had the right to dance within the enclosure.

THE KUBA

The Kuba live to the east of the Yaka, the Suku, and the Pende in the area of central Democratic Republic of Congo bordered by the Sankuru, Kasai, and Lulua rivers. Traditions suggest that the leaders of several groups came from the north and established themselves over local farming groups of Kete peoples. By the sixteenth century a number of large chiefdoms of various ethnic identifications had developed, and an amalgamated culture using elements of both invading and local groups emerged. About 1625 a man known as Shyaam aMbul a-Ngoong, or "Shyaam the Great," arrived and brought the disparate groups together into a single kingdom. Oral histories

suggest that he had traveled west, perhaps to Kongo territories, and thus was able to introduce foreign concepts and products into his new kingdom such as raffia cloth (see fig. 11-3). Among the things with which Shyaam is credited are the introduction of new technologies based on iron and new crops, such as maize, cassava, and tobacco, which had arrived in the west from the Americas. He is also said to have reorganized the political system so that a cluster of some nineteen ethnic groups of diverse origin could live under the authority of the king, *nyim*, from the Bushoong group. Titles were now earned, providing for the distribution of power from the nyim to titleholders, and this became a means of promoting titleholders' loyalty to the central government.

Diverse groups of peoples were joined in the complex Kuba political

structure. A council of ritual specialists and titleholders representing the capital and all territorial units formerly advised the Bushoong nyim. In addition, a number of councils played a role in governance, and various sets of courts heard cases on behalf of the king, providing one of the most sophisticated judicial systems in Central Africa. The present Bushoong dynasty was established with Shyaam's arrival in the early seventeenth century. The kingdom reached the geographical limits of its expansion by the middle of the eighteenth century, and during the last quarter of the nineteenth century it reached a pinnacle of development and wealth.

Although today most Kuba ethnic groups are organized into independent chiefdoms, they still recognize the authority of the Bushoong king. Within each village, regardless of the distance from the capital, there are a large number of titles, and a large percentage of the population are titleholders. One's standing within the hierarchy is perceived in terms of wealth and rank, and material possessions serving to express status. Each titled position has its set of emblems, symbols, and praise songs. Much Kuba art, then, is associated with leadership and prestige, making the king and the nobles of Kuba culture, both in the capital and in the faraway villages, the main patrons of the arts.

Leadership Arts

Among the most important art forms for the king and titleholders are modes of dress, for garments, accessories, and held objects signal clearly the prerogatives and ranks of nobility

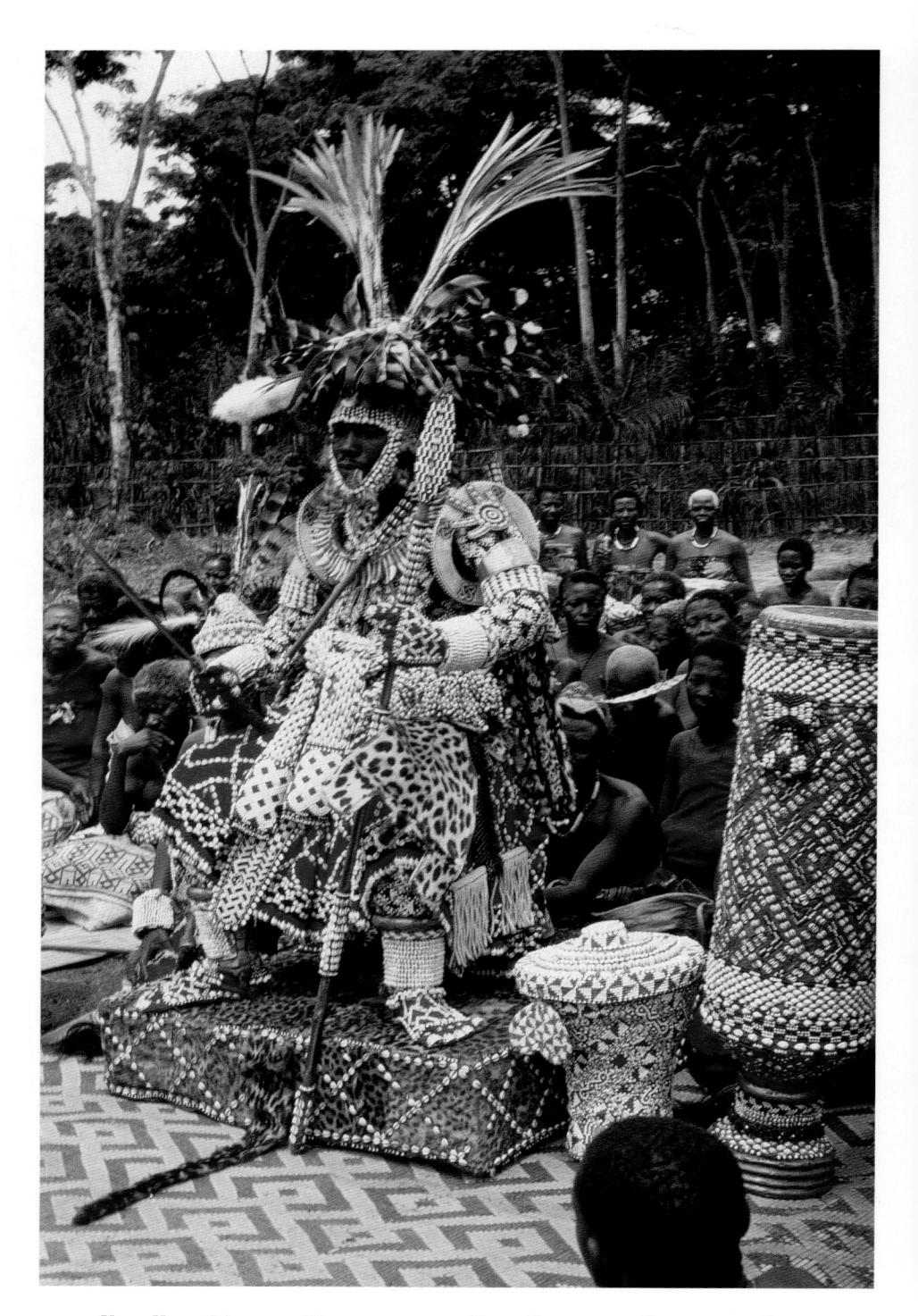

11-52. King Kot a Mbweeky III in State dress, Kuba, Democratic Republic of Congo. Photograph 1971

and royalty. In a hierarchy of costumes, each ensemble is more sumptuous and splendid than the one below it. At the apex of the hierarchy are the opulent garments of the king, a variety of weighty and complex ensembles that indicate his various roles. To the Kuba, these ensembles and their attendant ornaments and paraphernalia evoke the idea of sacred kingship, the continuity of dynasty, the individual who fills the position, and links to the original peoples of the area and to the land itself. Taken in 1971, the photograph in figure 11-52 shows the then reigning king in state dress, bwaantshy. A raised dais covered with skins, cowries, and patterned mats separates the sacred king from the earth. To either side stand drums of office covered with beads and cowries in designs that mark his reign. He sits almost immovable in his massive costume, which all but conceals the individual man from onlookers, who see instead an embodiment of kingship itself.

Each succeeding ruler commissions his own bwaantshy. He wears it on the most important occasions of state, and he will be buried in it. The sumptuous garment, an accumulation of some fifty symbolic objects, weighs as much as 185 pounds. The principal element is a tunic made of interlaced strips of raffia cloth covered with an abundance of beads and cowries. Thigh and arm pieces of beaded interlace further exaggerate the size of the king's body. A red wrapper trimmed in cowrie patterns covers the lower portion of the body, while a raffia cloth belt some eight to ten inches wide and up to thirteen feet long, completely covered with cowries, wraps around the waist. Beaded and

cowrie-covered sashes, bracelets. anklets, and shoulder rings add visual and actual weight, as do leopard skins, leopard-skin bags and satchels, and metal ornaments. Even the hands and feet are covered with gloves and boots decorated with cowries and ivory nails. The headdress supports a massive bouquet of feathers and long white plumes. A fringe of beads covers the forehead, and an artificial beard of beads and cowries encircles the face. In his right hand the king holds the sword of office: in his left, a cowrie-encrusted lance. These are always held when bwaantshy is worn. The virtual sheathing of the king in cowries reminds onlookers that he is a descendant of Woot, the mythical first king and founder of Kuba.

Ndop

Among the best known of Kuba art forms are royal portrait figures, ndop (fig. 11-53). The example shown here represents the seventeenth-century king Shyaam aMbul a-Ngoong, who is credited with introducing the tradition of royal portraiture. Like other ndop figures, this one is an idealized representation. The ruler is shown seated cross-legged on a rectangular base decorated with patterns that appear as well on certain textiles that allude to high status. The base recalls the dais upon which the king sits in state, and the sword of office in the left hand reminds us of the weapons held by the actual monarch.

The costume represented on *ndop* concentrates on a few especially symbolic elements of the full royal panoply: crossed belts over the chest and cowrie-encrusted sash and arm

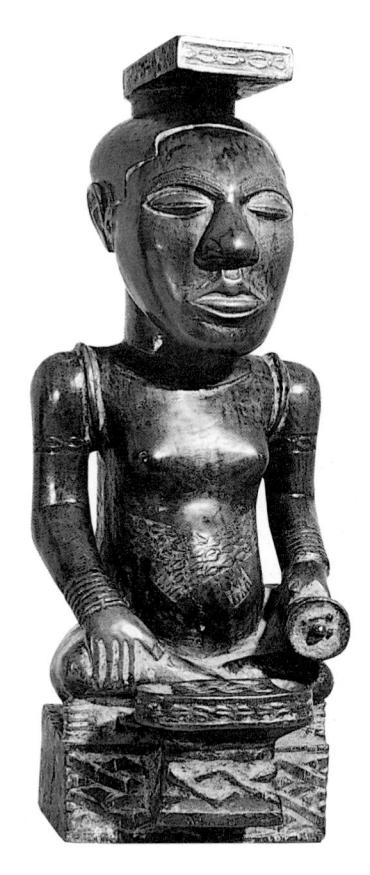

11-53. *NDOP* (ROYAL PORTRAIT FIGURE) FOR SHYAAM AMBUL A-NGOONG, KUBA, 18TH CENTURY. WOOD. HEIGHT 21¾" (55 CM). THE BRITISH MUSEUM, LONDON

An ndop was regularly rubbed with camwood and palm oil, giving it a reddish, glowing surface over time. It may have played a role in the installation of the king, and during his life it is said to have been not only a portrait but also the soul double of the king. Whatever happened to him was believed to happen to it as well. Closely associated with the king's fertility, the ndop was kept in the women's quarters, and was placed next to his wives during childbirth to ensure safe delivery. Some claim that at the death of the king the life force and power of kingship passed from the dying king to his ndop and subsequently to his successor during rituals of installation. Thereafter, the figure served as a memorial and was placed with his throne in a storeroom near his grave, to be displayed on important occasions. bands. The headdress, a *shody*, is a crown with a projecting visor worn only by the king or by regents. Projecting from the base in front of the figure is an *ibol*, an object symbolic of the king's reign. The *ibol* of Shyaam aMbul a-Ngoong is a board for a game of chance and skill, one of the many amenities of civilization said to have been introduced by this culture hero.

Kuba traditions maintain that if the *ndop* is damaged, an exact copy is made to replace it. It is probable that the original *ndop* representing Shyaam aMbul a-Ngoong was replaced by this figure at a later date, for it postdates the seventeenth century. Each king after Shyaam aMbul a-Ngoong theoretically had a portrait made. The most recent official ndop was carved for the king Mbop Mabiine maKyen (ruled 1939-69). Many similar figures were carved during his reign and have been produced since, not for actual use but for sale to outsiders.

Architecture

The Kuba capital at Nsheng has long been recognized for its sophisticated layout (fig. 11-54). The palace itself consists of numerous buildings arranged in distinct sections, the two primary sections being the yoot, where the king himself lives, and the dweengy, the section reserved for the royal wives. The *yoot* consists of the most beautiful buildings in a mazelike assembly of courtyards. Each structure and each courtyard serve a specific purpose. Each successive enclosure leads further into the inner portion, open only to the king and his most trusted advisors.

The structures themselves are not formally elaborate and consist of simple rectangular buildings with pitched roofs and gabled walls. What differentiates palace structures from those of ordinary people are their size and the decoration of the exterior walls (fig. 11-55). In architecture as in other arts, the Kuba seem to stress line and pattern over sculptural volume, and the surfaces of most luxury objects, including prestige architecture, are beautifully and elaborately

embellished with geometric decoration, often modeled after designs associated with or derived from textiles. Walls of horizontally laid palm ribs are lashed with vines to create an assortment of designs. Bands of rather plain patterning, *mashooml*, alternate with bands of more ornate geometric designs, *mabaam*. Each *mabaam* pattern is named. The structure in figure 11-55 features two *mabaam* patterns. The lower- and upper-most bands of each wall are

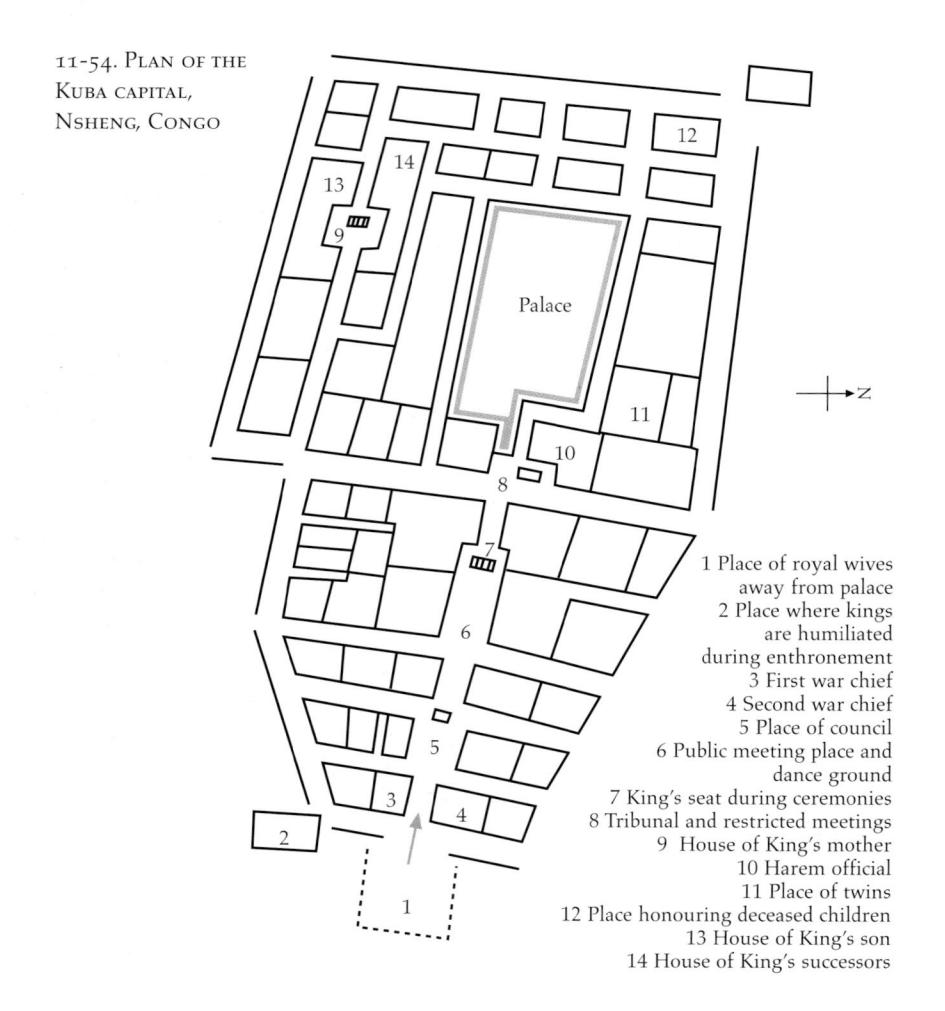

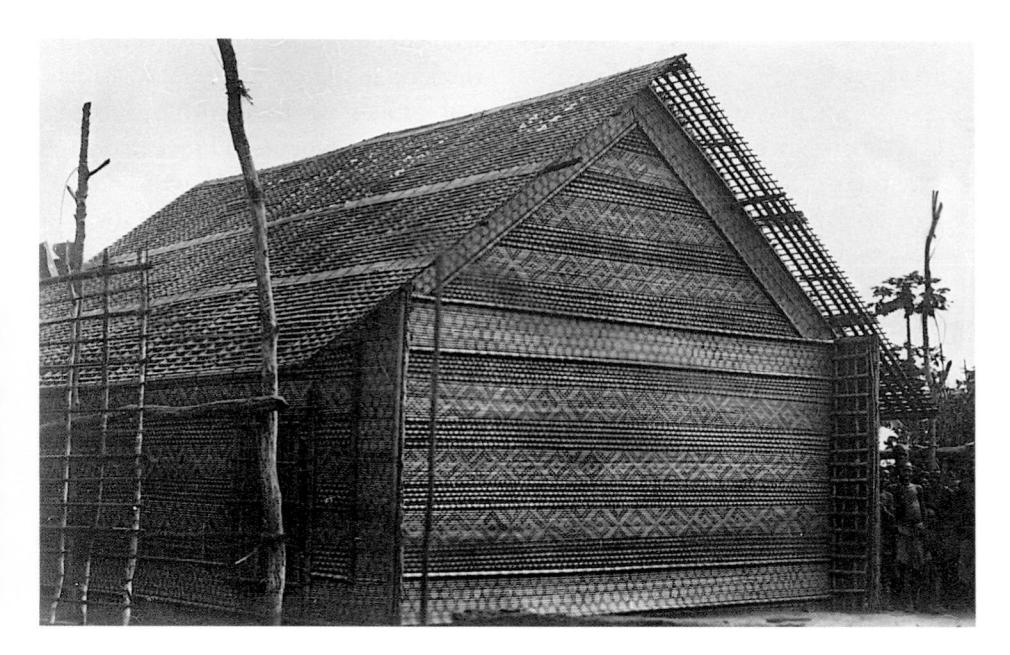

11-55. Palace Building, Nsheng, Congo. Photograph c. 1935–8

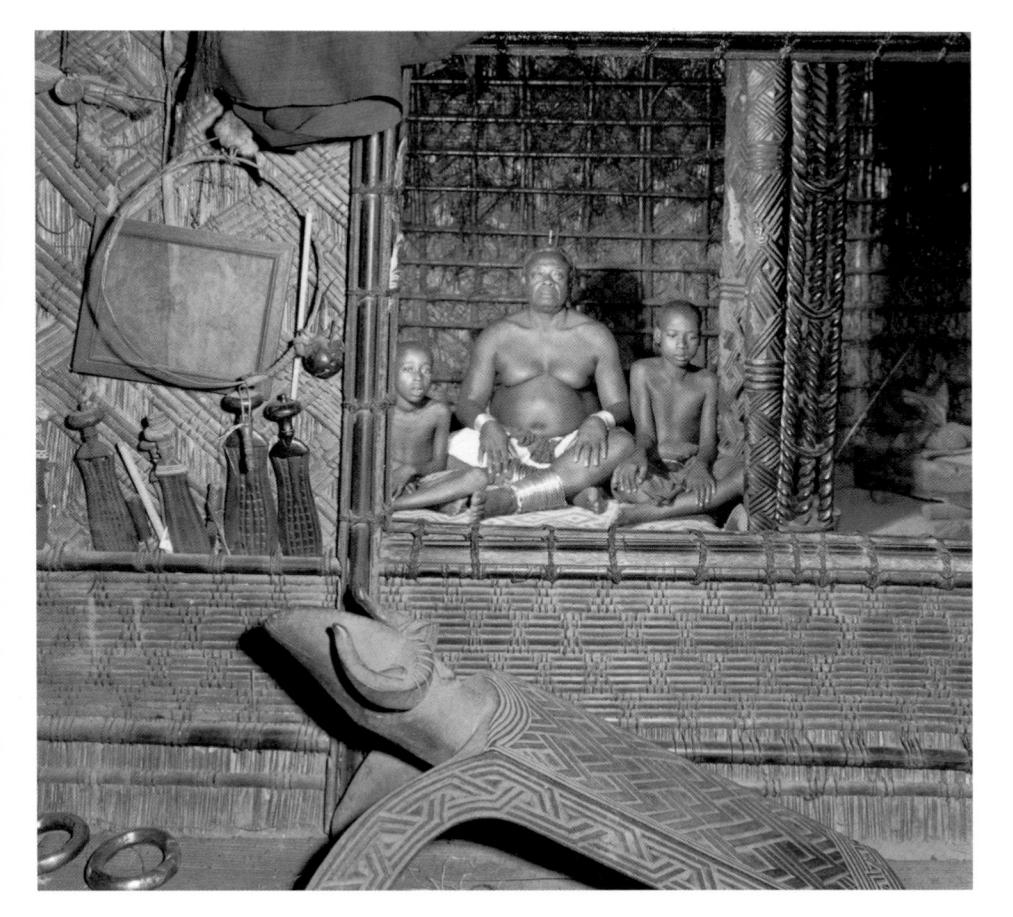

11-56. Interior of Royal Sleeping House, Nsheng, with King Mbop Mabiinc MaMbeky, Belgian Congo (Now Democratic Republic of the Congo). Photograph 1947

patterned in *mabuush*, "bundle," referring to the hourglass-shaped designs of lashings. The other *mabaam* bands, three on each wall and three on each gable above, are *mbul bwiin*, a pattern in which two angles enclose a small diamond shape, the module separated from its repeats by V-shapes. *Mbul bwiin* is reserved for the houses of high nobility, and its name derives from that of the woman credited with its creation, either a wife or a sister of a former king.

Palace building interiors are decorated as befits the home of a king. A 1947 photograph of King Mbop Mabiine maKyen shows him seated in his royal sleeping house, mwaan ambul (fig. 11-56). The mabuush pattern sets off the upper and lower portions of the wall, while the central section sports a design of diagonal patterning. Intricately carved geometric patterns cover the supporting post in the background, near which the king sits with his pages. His cross-legged pose evokes the representation of the king on the ndop in figure 11-53.

Prestige Objects

The *nyim* and titleholders in the kingdom commissioned elegant and well-designed art works, including stylized weaponry, containers, and textiles. Such objects demonstrate the love of pattern and decoration, for their surfaces are often covered in named designs that are used in many different types of objects.

Several prestige objects can be seen in this photograph of the sleeping house in figure 11-56. Stuck in the wall to the left are short swords known as *ikul. Ikul* is perhaps the

most commonly seen type of Kuba weapon, and it is said a true Kuba man is never without one. Tradition maintains that it was Shyaam aMbul a-Ngoong who introduced the form, with its sensuously curving blade of forged iron and carved wooden hilt. The most common type of ikul has an unadorned, leaf-shaped iron blade. The most sumptuous ikul belong to the high nobility or the king himself, and their blades are inlaid with red or vellow brass. Some royal ikul boast openwork designs on the blade. Kuba traditions suggest that some kings were themselves smiths, forging wonderful weapons that are even today part of the royal treasury.

On the floor in front of the opening into the sleeping chamber is a wonderfully designed backrest, whose rectangular face is covered with an elaborate pattern based on overlapping angles. Royal stools, chairs, platforms, mats, and backrests all ensure that the king will not touch the earth. The edge of the rest is covered with an interlace design known as nnaam. Used widely on carved objects, beadwork, and textiles, its name suggests an association with vines, perhaps based on the intertwining linear elements. A stylized ram's head projects from the top of the backrest. Rams' heads, which also appear on beaded items of regalia and on luxury cups (see fig. 11-57) may be understood as a royal icon. Flocks of sheep were kept on the royal preserve, and the image of the ram is a visual metaphor of the relationship of the king to his subjects: he is strong, authoritative, and a source of fecundity.

Such wonderful utilitarian objects were prominent in the art forms that underscored kingship and the nobility

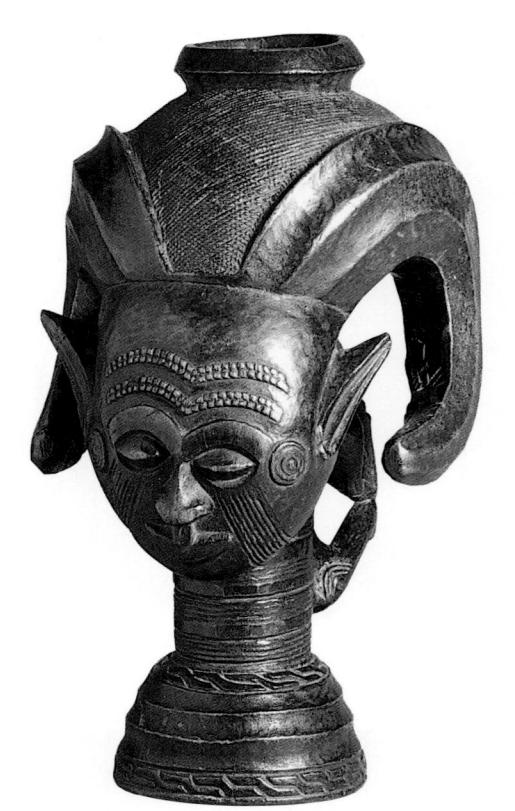

who supported it. Other treasures of the kingdom included royal costumes and textiles, works in such precious materials as ivory and brass, and pipes, spoons, cosmetic boxes, and other luxury objects. Some of the most spectacular Kuba prestige objects are cups for palm wine (fig. 11-57). The ram horns sprouting from the head indicate that this cup belonged to a senior titleholder, again a reference to the royal prerogative of keeping sheep, which was occasionally extended to some members of the royal clan. The Kuba predilection for two-dimensional surface design is once more evident in the forehead

11-57. Cup, Kuba. Wood. Height 10¹¹/₆" (27.2 cm). Indiana University Art Museum, Bloomington

11-58. TUKULA OR
TOOL CONTAINER,
KUBA, DEMOCRATIC
REPUBLIC OF CONGO,
C. 1950. WOOD, TRACES
OF PIGMENT. SAMUEL
P. HARN MUSEUM OF
ART, UNIVERSITY OF
FLORIDA, GAINESVILLE.
GIFT OF ROD
MCGALLIARD

scarification patterns and the bands of patterning on the base.

The ornate lidded cosmetic box in figure 11-58 mimics the form of a specially woven basket, the squared corners of the bottom and the lid moving gracefully into the cylindrical body of the container. The bands of shallow relief patterns refer to named designs that are used on architecture, on other utensils and containers, on textiles, and even on the human body. Ornate containers were often used to hold tukula powder, or camwood, a cosmetic made from the bark of a tree. Tukula was used both as a cosmetic on the body and hair, and for the preparation of the deceased for burial.

Textile Arts

The designs on architectural structures and utilitarian objects are closely related to those that appear on Kuba textiles. Textiles are among the most widespread types of prestige goods. They figure prominently as the possessions of the elite, yet they

are also created and used by all levels of society.

The Kuba have long placed a high value on producing textiles. Perhaps one of the oldest types of Kuba fabric is that made from the beaten inner bark of certain trees. In fact, the Kuba refer to felted barkcloth as the apparel of the ancestors. The most beautiful and prestigious barkcloths are made by sewing small sections together. The exquisite skirt shown here combines pieced barkcloth with a border of raffia textile and imported European cloth (fig. 11-59). What at first seems to be an ordered and regular pattern within the central, barkcloth portion reveals itself on closer inspection as a complicated design with minor variations. Two triangular pieces of light, natural-colored barkcloth are sewn to two darker dyed pieces. The resulting small squares make up rectangular portions pieced to other rectangles of slightly varying hue.

The production of fabrics and the patterns associated with them reflect Kuba concepts of social status, ethnic

unity, and religion. This is especially true of raffia textiles, where production and design are collaborative undertakings. Men cultivate the palm trees, which produce exceptionally long fronds. The outer layers of the individual leaflets provide the raffia fiber, collected by men and woven by them on a diagonal loom into rectangular panels of cloth slightly more than two feet square. Both men and women decorate the textiles and sew them into garments. Men fashion men's skirts, and women create women's skirts. A number of decorative techniques are used by both genders, including embroidery, appliqué, patchwork, and dyeing. In addition, women employ other decorative processes such as openwork and cut-pile embroidery.

Women's skirts may be up to nine yards long and are worn wrapped around the body. Men's skirts, bordered with raffia tufts, may be even longer, and are worn gathered around the hips, with the top portion folded over a belt. A woman's skirt like the one shown in figure 11-60, over

11-59. Beaten Barkcloth, Kuba. Barkcloth, Raffia, European Cloth. $58\frac{1}{2}$ x $27\frac{1}{2}$ " (149 x 70 cm). Indiana University Art Museum, Bloomington. Gift of Henry Radford Hope

twenty feet in length, may incorporate over thirty panels of cloth. Each doubled, natural-colored rectangular panel is covered with lively appliqué designs in shades of tan and brown, outlined in fine black stitching. Many women may have worked individually to produce the sections that make up the skirt. The result is an organic arrangement of quasi-geometric forms reflecting the repertoire of designs and the varying abilities of the many women who contributed to the project.

Women use cut-pile embroidery to create rich and varied geometric

designs (fig. 11-61). In this example patterns based on triangles, lozenges, and rectangles placed on the diagonal predominate. Dark patterns of dyed raffia play against the light natural hues of the ground. As is typical of the cloths produced by women, sudden changes break the surface up into sections of striking differences in thickness and width of line. Bold. band-like elements in the central panel to the left contrast with the delicate, linear elements to the right. At least four contrasting border designs provide a restless and changing pattern of great visual immediacy.

11-60. Woman's wrap skirt (detail), Kuba, 19th–20th century. Raffia cloth. 20'9" x 31" (6.32 x 0.79 m). Virginia Museum of Fine Arts, Richmond, VA. Kathleen Boone Samuels Memorial Fund

11-61. Cut-pile embroidery cloth, Kuba, late 19th–20th century. Raffia cloth. 50 x 19%'' (128 x 50 cm). The British Museum, London

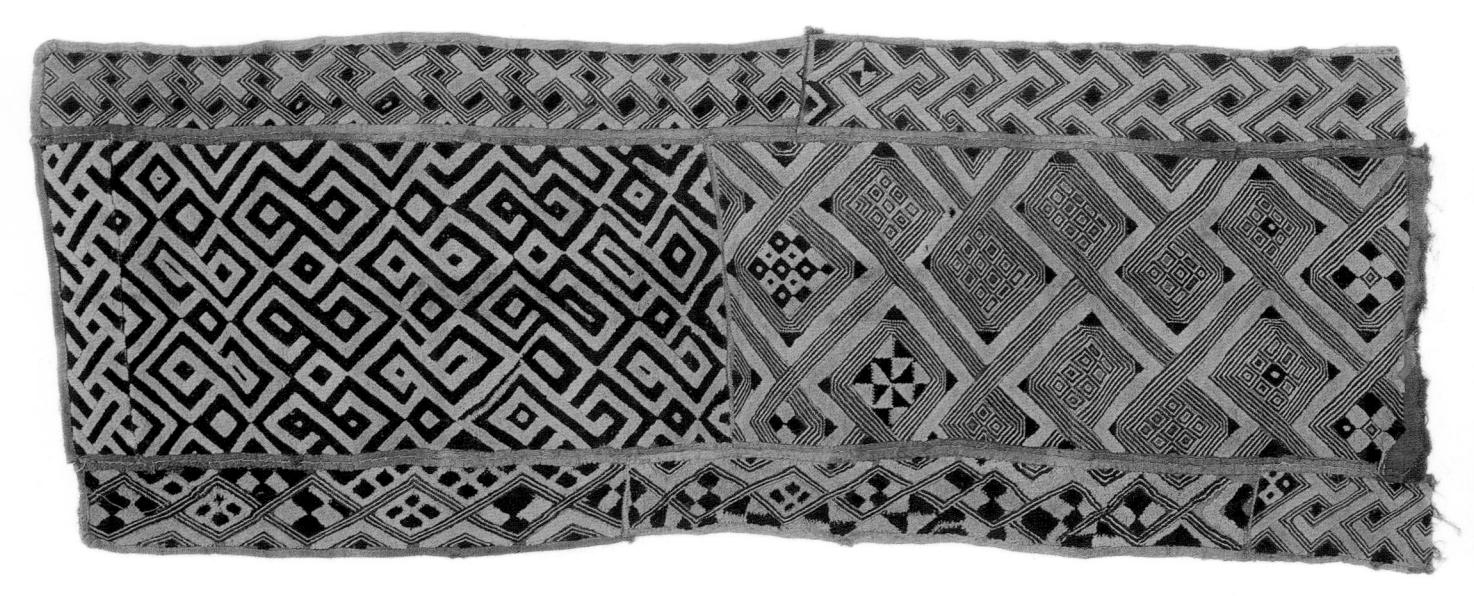

Raffia cloth played an important role in Kuba society in the past. Squares of raffia cloth were once used as currency and figured in marriage contracts and legal settlements. The wearing of Kuba-produced cloth and the display of embroidered raffia squares was an important element in court ceremony and in funerals. Today, raffia cloth is still a reminder of loyalties, histories, and relationships, and it is considered the only appropriate burial cloth. The body of the deceased is dressed in a prescribed number of textiles of varying size and style depending on social rank. Multiple skirts placed on the body are a mark of prestige. Heirloom skirts are offered as memorial gifts by the spouse of the dead and by friends. The generosity of the surviving spouse may be questioned and the gift refused if the donated memorial skirt is not beautiful or fine enough to satisfy the family of the dead spouse. Additional textiles may be added in layers over the dressed corpse, especially squares of cloth decorated with cut-pile embroidery. Originally, cut-pile embroidered fabric seems to have been used largely in funerary contexts.

During a burial ceremony, the dressed and decorated body is set upright for viewing before it is placed in an ornate coffin made of large decorated mats over a bamboo frame. Coffins were sometimes made to imitate the pitched-roof Kuba houses, with meticulous attention given to architectural detail. At the grave, the coffin was lowered, and items such as carved drinking cups, costume elements, and more textiles were added to it—gifts to accompany the deceased into the world of the dead.

Masks and Masquerades

The striking masks of the Kuba are also wonderfully decorated with geometric surface designs in dazzling contrasts of color, pattern, and texture. Hide, animal hair, fur, metal, and feathers further ornament the masks, and costumes of barkcloth, raffia fiber fabric, and beaded elements complete these manifestation of nature spirits, intermediaries between the Supreme Being and the people. Over twenty types of masks are used among the Kuba, with meanings and functions that vary from group to group. In Nsheng, the Kuba capital, all masks belong to the king and may not be danced without his express permission. The three most important masquerades in Nsheng have been referred to as the royal masks, mwashamboy, bwoom, and ngady a mwash.

Mwashamboy wears a large mask made of a flat piece of leopard skin (fig. 11-62). Eyes, nose, mouth, and ears are carved of wood and attached. Other details are added with shells and cowries. Animal hair provides the impressive beard, and a huge headdress made of eagle or parrot feathers, like that worn by the king himself, reinforces the mask's royal status. The masquerader wears a costume made of barkcloth and raffia cloth with a variety of symbolic objects attached, also recalling the great beaded and cowrie-covered dress of the king.

Although the mask is referred to as the king's mask, the king does not wear it himself, but rather chooses someone to do so. The mask has no eyeholes, and thus *mwashamboy* dances a slow, dignified dance. A man-

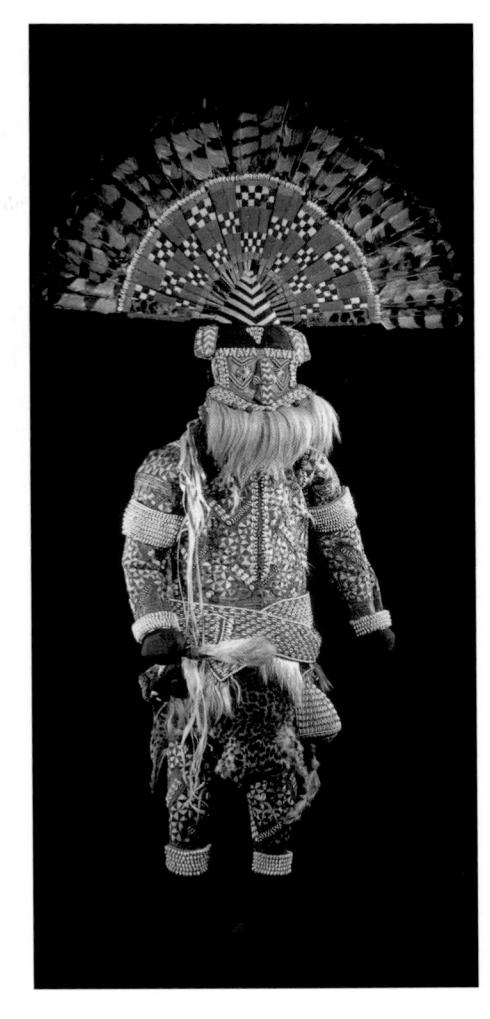

11-62. MWASHAMBOY MASK. KUBA, CONGO. Wood, pigment, raffia, fiber, metal. Royal Museum for Central Africa, Tervuren

ifestation of Woot, the royal ancestor and founder of the Kuba kingdom, *mwashamboy* appears in three variants. In one version, the king's mask is crowned with a feather headdress. Another variant has instead a cone that extends forward to mimic an elephant's trunk. A third version is said to be placed over the face of a dead monarch before burial, transforming him symbolically into Woot, his founding ancestor.

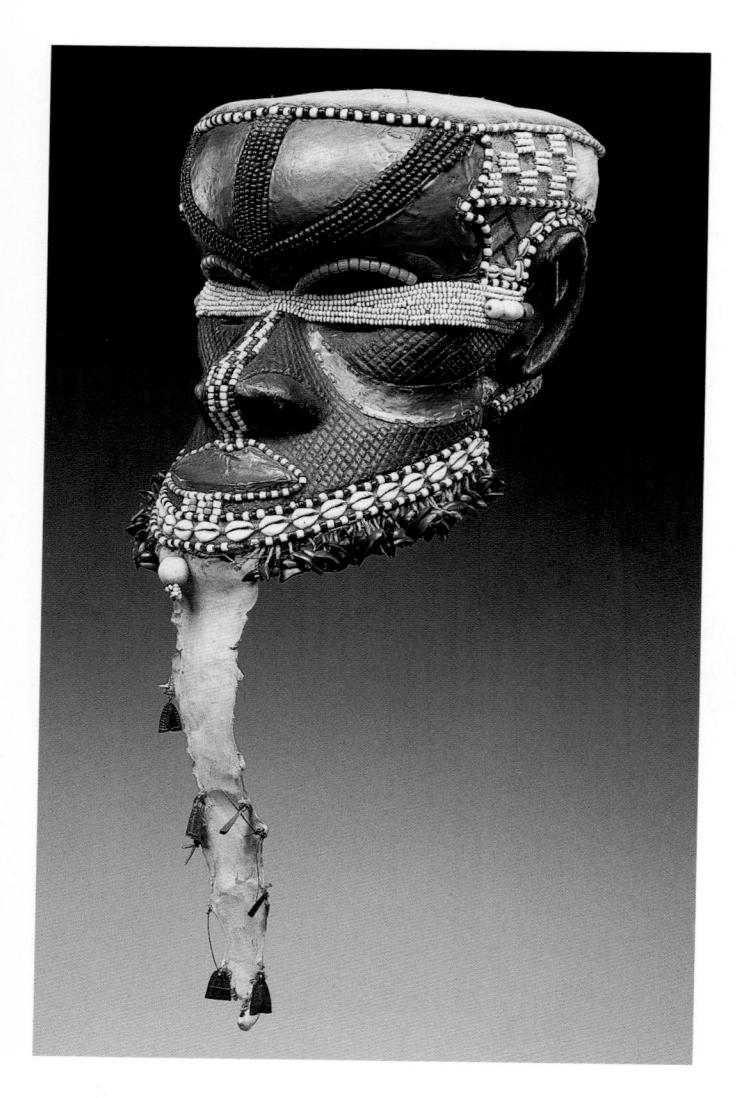

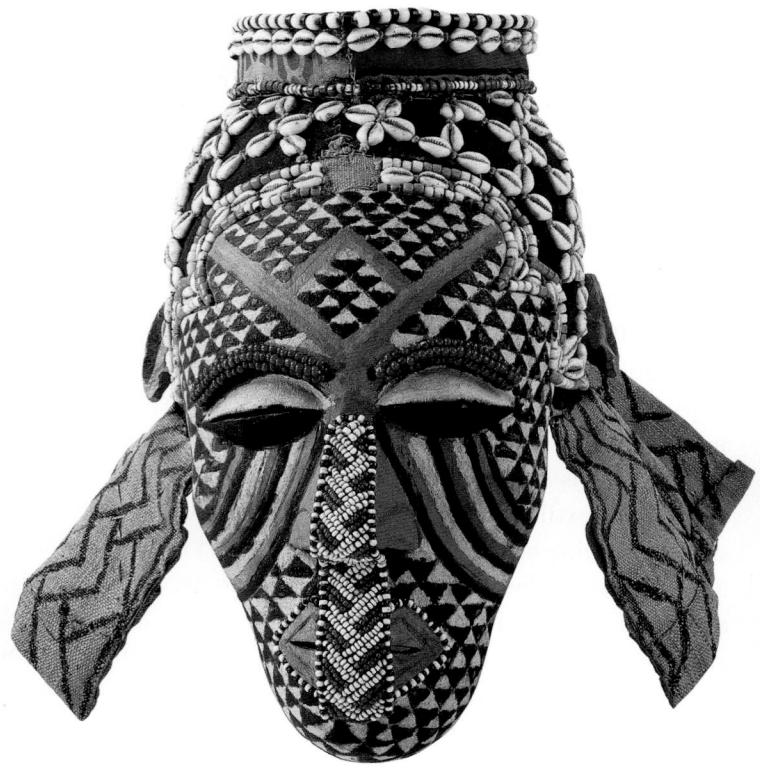

11-64. *Ngady a mwash* mask, Kuba, before 1917. Wood, raffia cloth, shells, beads. Height 15″ (38 cm). Peabody Museum, Harvard University, Cambridge, MA

11-63. BWOOM mask, Kuba. Wood, sheet copper, beads, shells, hide. Height 13" (32.8 cm). Royal Museum for Central Africa, Tervuren

A wooden helmet mask is worn by bwoom (fig. 11-63). Its wide forehead bulges above sunken cheeks, here covered with fine hatching. Sheet copper, associated with leadership in most Central African cultures, covers the forehead and decorates the cheeks. The lips, too, are covered with copper and outlined with red and white beads. As a royal mask bwoom is profusely decorated with imported beads and cowries. Bands of black beads divide the forehead into sections. A strip of blue and white descends the bridge of the nose to the lips. Like mwashamboy, bwoom's mask has no

eyeholes (its wearer sees through the pierced nostrils when the mask is worn diagonally). A strip of beads covering the eyes like a blindfold accentuates the "blindness" of the mask. A beard of beads and cowries lines the lower portion of the mask, and a hide strip descends from it. Bwoom maskers are completely covered by their costume, which is less refined and less ostentatious than that of the lordly mwashamboy.

With its distinctive bulging forehead, *bwoom* may caricature the head of a Tshwa pygmy. Some traditions say it manifests a hydrocephalic prince or a spirit. In Nsheng, bwoom ranks second to mwashamboy. Although bwoom is referred to as a royal mask and is seen as a brother of Woot, in performance it presents simultaneously the image of a commoner, a prince, a pygmy, or a subversive element in the royal court. Events in the dance, in which the two male masks interact, are said to refer to the origin myths of the Kuba kingdom and to episodes of Kuba history.

Ngady a mwash is a carved wooden face mask with narrow eye-slits that allow the wearer to see (fig. 11-64). A wig of raffia cloth and

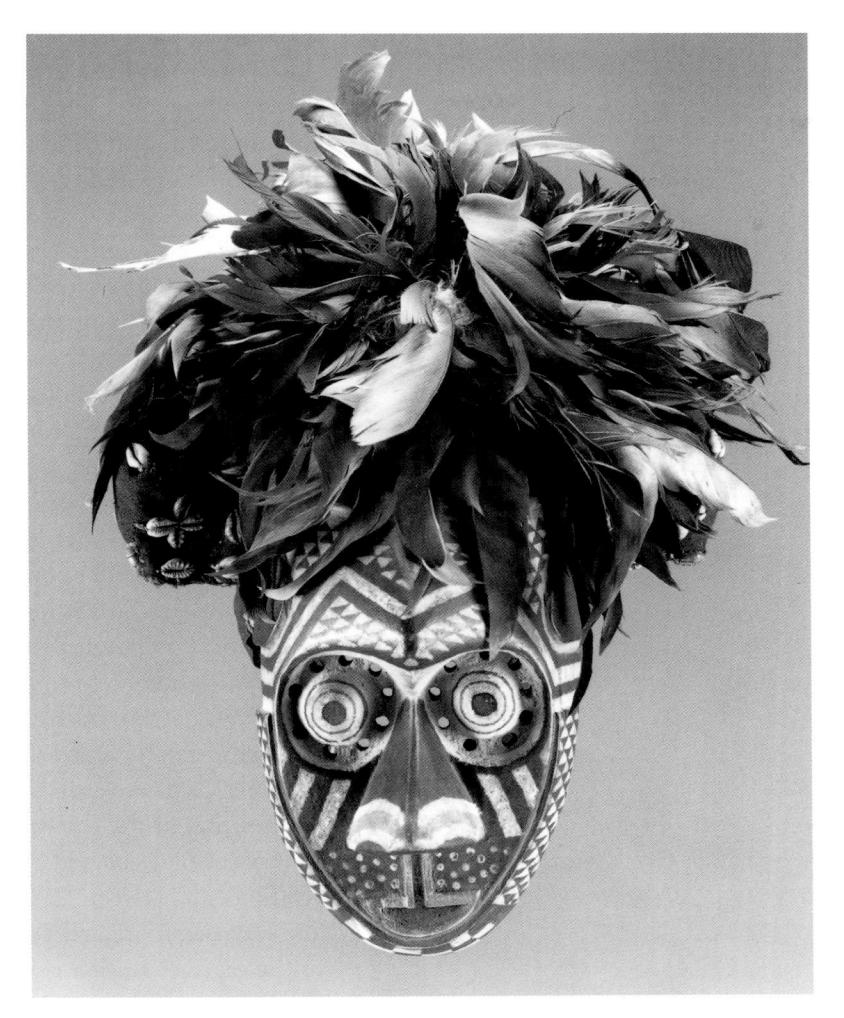

11-65. Ishyeen Imaalu mask, Kuba, Congo, late 19th–early 20th century. Wood, cloth, feathers, fiber, cowries, pigment. Height $15\frac{1}{4}$ " (40 cm). Baltimore Museum of Art. Gift of Jamosil Foundation, Alexandria, VA

cowries is topped by a cap form. A strip of beadwork covers her nose and descends over her mouth. Her face is entirely covered with bold geometric designs. Black and white triangles across the forehead, temples, and lower face represent the black stones of the hearth and domesticity. They also recall the triangles of dark and light barkcloth in pieced fabrics that are associated with ancestral clothing and still worn during periods of mourning (see fig. 11-59).

Said to be Woot's sister and his

wife, ngady a mwash is the female ancestor and essence of womanhood. The use of the barkcloth motifs may be a conscious device to indicate the ideas of suffering and mourning and to allude to ancestral ties. Diagonal lines below ngady a mwash's eyes symbolize tears and refer to the hardships of women. The juxtaposition of white, a color associated with the sacred but also with mourning, and red, associated with suffering and fertility, underscores these ideas yet again. The feminine attributes associ-

ated with the mythic character are accentuated by the carefully choreographed movements danced by the male performer. In the mime acted out in the capital, ngady a mwash is fought over by the royal mwashamboy and the commoner bwoom. The name ngady a mwash means "pawn woman of mwash," and her sorrow is also the result of her treatment by her master, Woot.

The royal context of masks has perhaps been over-emphasized in literature on the Kuba because early visitors documented the masking activities at the capital. In fact all Kuba groups use masks, and those beyond the area around Nsheng are less likely to have specifically royal connotations. One widespread context for masking is initiation. Every fifteen years or so a group of boys will be inducted into manhood through the mukanda institution, which as elsewhere in the region transforms uncircumcised boys into initiated men who possess esoteric knowledge. The making and display of masquerades are fundamental components of induction, and a hierarchy of both male and female masked figures dominates the ceremonial performances, all danced by men.

Funerals are a second important context for masks throughout the Kuba area. Ngady a mwaash and mwaashamboy, for example, may be used in funeral context outside the capitol. Some masks appear at funerals even of untitled men, although they are especially important at the funerals of titleholders. Senior titleholders, whether they live in the capital or in outlying areas, have the right to have important masquerades at their funerals.

An example of masks used in the context of both initiation and funeral is Ishyeen Imaalu, danced among central and northern Kuba groups. Ishyeen *Imaalu* masks rank in the middle range of the mask hierarchy and are used in the context of an initiation society known as Babende. The example in figure 11-65 shares many characteristics with other Kuba masks, including the intricate polychrome surface and the layering of costume elements. The jutting eyes are compared to those of the chameleon. The holes that encircle the central cones allow the dancer to see, but they also serve as a decorative device. As with ngady a mwash, parallel diagonals under the eyes refer to tears, in this case those shed for the recently deceased in whose honor the mask appears. A bouquet of feathers attached to the raffia clothcovered framework suggests the mask is a warrior.

IN THE SHADOW OF THE KUBA: THE NDENGESE, THE BINJI, AND THE WONGO

The forms and styles of Kuba art pervade the Kasai–Sankuru region, suggesting the intermingling and interactions that have taken place over long periods of time. Three peoples, among many others, whose art has functional or formal parallels to Kuba works are the Ndengese, the Binji, and the Wongo.

The Ndengese, who live just to the north of the Sankuru River, seem to have preceded the Kuba into the region. Their early occupancy is perhaps suggested by the fact that when the Kuba *nyim* is installed, emissaries must go to the Ndengese to collect

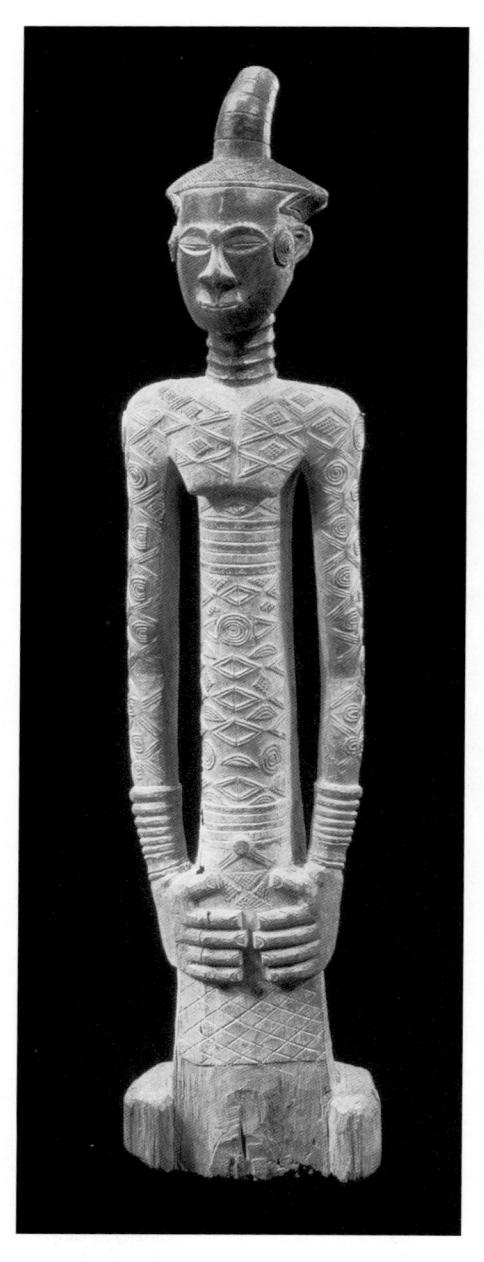

11-66. *Isikimanji* figure, Ndengese. Royal Museum for Central Africa, Tervuren

sacred earth for the ceremonies. Relationships between the groups are further entwined by the Ndengese myth that the first Ndengese king was the seventh son of Woot.

The elegant, elongated Ndengese figure shown here is called an *isikimanji* (fig. 11-66). It represents a

chief or a king and is said to hold the power and guard the clothing of a ruler after he dies. The flared shape of the head is not unlike that carved on palm wine cups and on the bwoom masks of the Kuba. The headdress, a distorted cone, represents the one placed on the king's head during his installation and symbolizes understanding, intelligence, distinction, respect, and unity among chiefs. The placement of the hands on the belly refers to the common origins of the king's subjects, from whom he anticipates cooperation. Numerous symbols are carved on the neck and on the elongated torso and arms in imitation of scarification patterns. The patterns allude to aphorisms and praise phrases that encode the mysteries of Ndengese chiefly authority. For example, concentric circles pertain to the position of the chief in relation to the people he leads and also to the relationship between the community and the cosmic sphere. Spirals allude to the saying "all that comes from the chief returns to the chief," referring to political authority. Lozenges on the arms indicate chiefly protection. Conceptually, Ndengese isikimanji invite comparison with Kuba memorial royal figures, ndop.

The Binji peoples are not organized into a political unit but several clans and chiefdoms share a language and cultural traits. Their origin myth suggests Kuba ancestry. Art forms such as pipes, cups for palm wine, and oracles in the shapes of animals are very like those of the Kuba. Masks used in initiation are powerfully formed, and it has been suggested that one type may be the prototype for the *bwoom* type of mask of the Kuba (fig. 11-67). The swelling forehead, the shape of

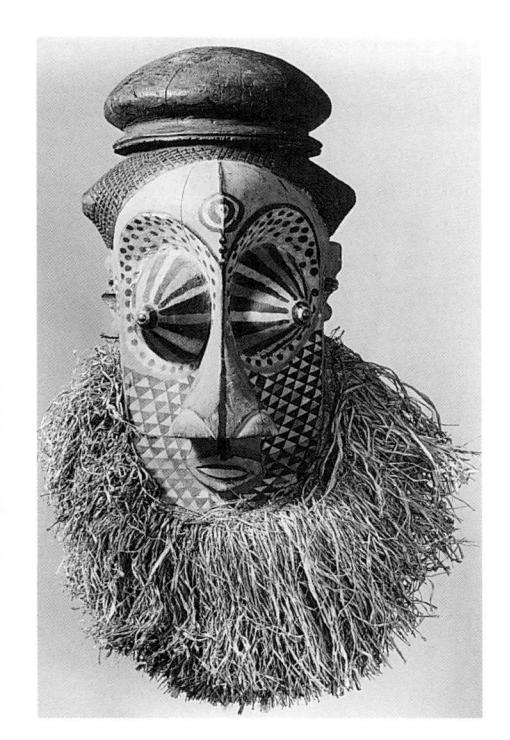

11-67. Mask, Binji, Congo, 1910 (?). Wood. Height c. 25½" (65 cm). Museum für Völkerkunde, Staatliche Museen, Berlin

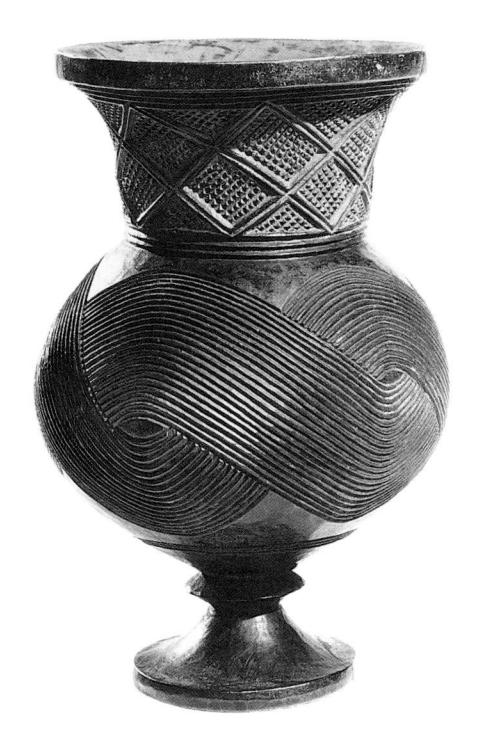

11-68. Cup, Wongo, before 1909. Wood. 8¼" (21 cm). The British Museum, London

the nose and mouth, and the triangular patterns on the lower portion of the face are all suggestive of the masks of the eastern Kuba. Powerful cone-shaped eyes announce the great force within the mask.

The Wongo are not formally part of the Kuba cluster, though they share many artistic and cultural features. Collected in 1909 in the Wongo area to the west of the Kuba, the elegant cup shown in figure 11-68 invites comparison with the aesthetic of Kuba cups in its pairing of elaborate surface patterning and simple, elegant form. Masterful control of adze and knife are evident in the cup's almost perfect symmetry and in the precision of its finely carved decoration.

THE LULUA

Lulua is an umbrella term that refers to a large number of heterogeneous peoples who populate the region south of the Kuba between the Kasai and Sankuru rivers. They have never united as a political entity, and the name itself merely reflects the fact that they live near the Lulua River. Luba incursions from the east and north forced these peoples to the south, driving them into places where contact with many neighbors, among them the Kuba, the Pende, the Chokwe, and the Songye, promoted an active interchange of cultural characteristics.

The Lulua are celebrated for elegant and graceful figurative sculptures. Complex raised patterns carved on the neck, abdomen, face, and limbs recall old Lulua customs, now long gone, of beautifying the body through elaborate scarification. Most figures are commissioned for

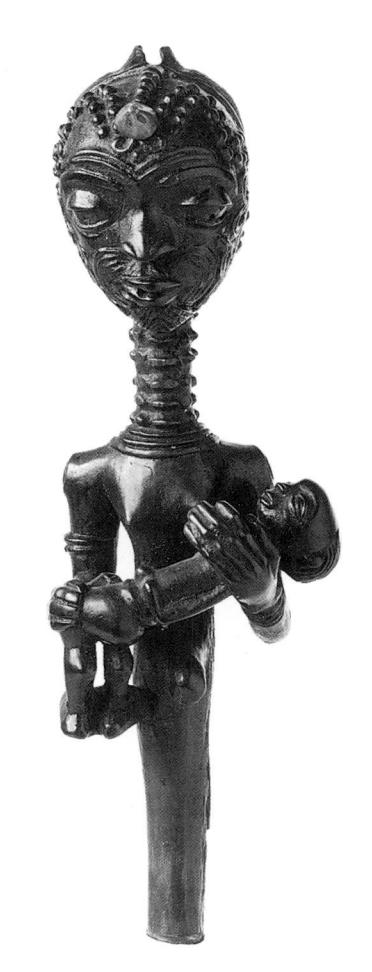

11-69. Mother-and-child figure, Lulua, Congo, 19th century. Wood and metal. Height 14" (35.6 cm). Brooklyn Museum, New York. Museum Collection Fund

use in a religious association concerned with issues of childbirth and human fertility. When a woman loses a number of children through miscarriage, stillbirth, or postnatal death, witchcraft is suspected. An appeal is made to a diviner for advice, and the problem may be attributed to the presence of an ancestral spirit, *tshibola*. After being initiated into the association, such a woman would often be given one or more figures depicting aspects of motherhood.

The mother-and-child figure shown here represents a highly placed

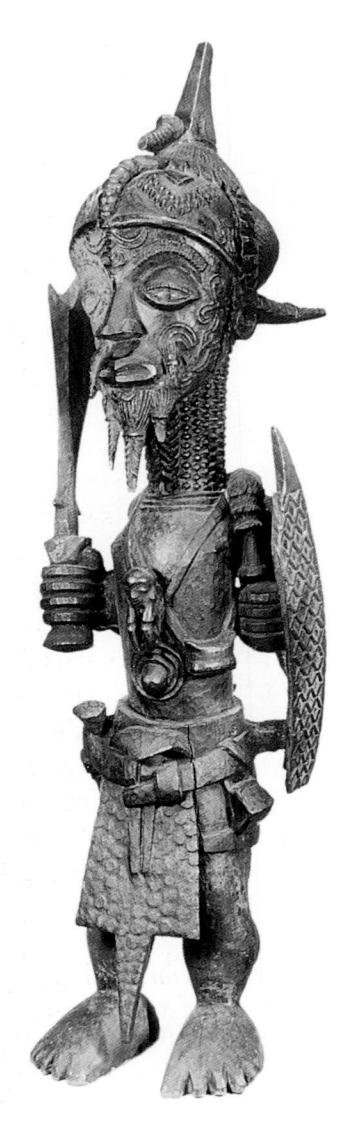

11-70. Warrior figure, Lulua, before 1885. Wood. Height 29¾″ (74 cm). Museum für Völkerkunde. Staatliche Museen, Berlin

The red cosmetic made from powdered camwood and oil or water to anoint the body is also applied to Lulua sculptures. In this example, only the left side of the face has been covered with red camwood.

woman (fig. 11-69). The large head, the elaborate coiffure, the long neck, the elaborate body marking, and abundant jewelry conform to Lulua ideals of adult female beauty. Yet scarification and the emphasis on certain parts of the body allude to more than the tradition of body adornment. Decorative motifs often embody deeper significance. Concentric designs accentuating the swelling navel, for example, are seen not only as referring to the link between mother and child but serve too as a metaphor for the close connection with the ancestors and the continuity of generations. The beautifully formed, bulging eyes refer to the ability of an individual to detect the malevolent intentions of witches in time to avoid harm. Marks on the temple indicate the point where wisdom, perceptiveness, and understanding penetrate. Concentric circles and spirals in general may refer to great heavenly bodies and are symbols of hope and life. The double line across the forehead stands for life in the human body, specifically the heart beating in the breast and the child growing in the womb.

Aided by various rituals, the beauty of the figure with its intricate surface and wonderfully arranged hair is believed to attract the *tshibola*. The ancestral spirit will be reborn in the next infant in the family and will ensure the child's survival into adulthood. Rubbed daily with a mixture of oil, camwood powder, and kaolin, the figure attains a rich, glossy patina. The child who is born as the result of such ritual processes is also rubbed with the same oils and cosmetics, and its glistening reddish tone demonstrates its special status to all.

Lulua chiefs display works of art that allude to their position. The large figure shown here is of a fairly rare type, part of the regalia of a leopard chief, the highest of chiefly rankings (fig. 11-70). Seen as living continuations of their predecessors, those who attain this rank are believed to have a spiritual connection with the leopard and to draw upon its power. As in the tshibola figure above, abundant detail embellishes an elegantly elongated form. An elaborate hairdo of braids gathered upward to a point suggests a helmet; the beard, too, is braided and plaited. Intricate scar patterns adorn the forehead, brow, cheeks, and neck. At the waist hangs a leopard skin, the primary symbol of office. A power object in the form of a crouching figure is suspended from the neck. The motif of the crouching figure, knee on elbow, is widespread among the Lulua and other regional groups. It has been interpreted as a chief reflecting on his social commitments and obligations. At the same time, such crouching figures are attached to the belt or the rifle of hunters and are used in rites that prepare him for the successful hunt. Other attributes bear out the depiction of the leopard chief as the ideal hunter, including the knives and other implements worn at the waist and the shield carried in the left hand. The right hand holds a ceremonial sword.

Such figures are used as mediums in rituals believed to fortify the life force of the chief, to perpetuate ties with the ancestors, and to keep the community free from adversity. Formerly, some are said to have accompanied warriors into battle to provide moral support and courage and to revitalize the power of

chiefs. On these occasions supernatural ingredients from the personal reserves of chiefs and counselors would have been added to the sculpture.

ART IN KINSHASA AND BRAZZAVILLE

In the nineteenth century, European colonizers divided up the lands of this region so that Portugal administered Angola and the enclave of Cabinda, France administered the lands on the northwestern bank of the Congo River, and the vast territory southeast of the Congo river was under Belgian control. Artistic patronage by kings, initiation groups, and diviners diminished in the face of widespread cultural dislocation, especially in the Belgian territories. However, in the early decades of the twentieth century, artists in colonial cities began to find

new markets and new roles for art. Historians have discovered that artists of the early twentieth century drew cartoons and illustrations for local newspapers, while others created advertisements for local merchants, or took photographs of urban clients.

The legacy of these artists lives on today in the work of the many painters who create visual reminders of local stories and contemporary events in addition to producing advertising art. Offered for sale on the local market or sold in the artists' studios, these popular paintings decorate the homes of citizens of urban centers. In fact, their primary subject is often life in African cities, and they are usually both provocative and entertaining.

Monsengwo Kejwamfi, known as Moke (1950–2001), was one of the artists who have produced paintings for ordinary people in the Democratic Republic of Congo. He came to Kinshasa as child to look for work, and soon taught himself to paint landscapes on cardboard. As he became more accomplished and more economically secure, he painted the local urban scene, especially life on the streets. Moke's interests seem to be in commentary, or narrative, rather than aesthetic concerns. Like many commercial artists, his style is quite naturalistic, allowing the scenes to be easily "read," but the stories are often rather conventionalized. Many of his paintings are only slightly changing variations of subjects or themes that appeal to his clients.

In figure 11-71, Moke records a visit paid by François Mitterrand, President of France, to Mobutu Seke Seko, President of Zaire, as the Democratic Republic of Congo was then known. Using a flour sack as a canvas, Moke shows the political pair escorted by soldiers and motorcycle

11-71. MITTERRAND
AND MOBUTU,
MOKE, 1989.
OIL ON CANVAS.
44 X 72" (112 X
185 CM). COURTESY
OF THE ARTIST
AND CAAC/
THE PIGOZZI
COLLECTION,
GENEVA

11-72. Enfin!... Après tant d'années ("Finally!... After All Those Years"), Chéri Samba, 2002. Acrylic on canvas and glitter. 78¼ x 129½" (200 x 300 cm). CAAC/The Pigozzi Collection, Geneva

police and watched over by a helicopter as they ride in a limousine along a street lined with French and Zairian flags. Mitterrand waves as Mobutu lifts his signature cane. Members of the enthusiastic crowd wave miniature flags, and two women in the foreground wear commemorative cloths featuring the Zairian flag and a portrait of Mobutu, providing further splashes of the greens and reds that pulsate through the composition. Here Moke assumes no political position in this straightforward observation of political power. He makes no commentary on issues such as the West's support for the regime of the dictator Mobutu, whose rule was marked by corruption and widespread abuses.

On the other hand, another popu-

lar artist, Chéri Samba (born 1956), offered a more caustic view of modern life. Samba's personal views and ethical positions are clearly presented. As in masquerades from the region, there are morals to the tales he tells. An educated and articulate man, he instructs not only members of his own society (who can read the inscriptions in Lingala, which he writes on some paintings), but also viewers who live elsewhere. Samba started his career as an illustrator and as a painter of billboards, and his early work critiques the African urban experience and the plight of the country formerly known as Zaire. Topics he has addressed in paintings purchased by clients in Kinshasa commented upon unscrupulous business practices, the struggle against AIDS,

and relationships between men and women.

In the 1980s Chéri Samba's work became known outside of Africa. After being selected by a French curator to participate in the acclaimed "Magiciens de la Terre" exhibition, he was offered gallery shows and museum exhibitions in Europe and New York. He is currently represented by a gallery in Paris, but he still lives in Kinshasa, and he continues to exhibit his paintings in the front of his shop before they travel to Europe. Samba's images continue to refer to the modern African city, but now he presents them in a way that is accessible to outsiders. And more and more he addresses issues such as the critical reception of art and the inequities of the art market.
In Finally!... After All those Years, Samba shows himself and his friend Moke in a gallery surrounded by recognizable works by both African and Western artists (fig. 11-72). Like many of Samba's paintings, this 2002 work includes naturalistic depictions of recognizable people and objects with written texts. The French title of the piece, "Enfin!... apres tant d'annees," appears in both red and blue. Unlike many African artists now patronized by European and American collectors, Samba has been able to insist upon speaking about his own work. Thus Samba states:

This painting has a double meaning. 1) It is a tribute to my friend and colleague Moke who had died just when the art world was starting to acknowledge us as great artists. 2) After all these years, I am very proud that our works are exhibited in Western museums.

The work of Bodys Isek Kingelez (born 1948) was also included in the "Magiciens de la Terre" exhibition, and his work, like Samba's, has since been shown around the world. Whereas Samba began his career as a commercial artist, Kingelez left his job as a secondary school teacher and took a position restoring art works housed in the National Museum in Kinshasa. In his free time, Kingelez began to create large three-dimensional models of idealized modern metropolises. As one would expect, given Kingelez's lack of economic resources, the exquisitely rendered models are made of rather simple materials—paper and cardboard even though they are worked with scrupulously painstaking detail.

11-73.

KIMBEMBELE

IHUNGA, BODYS

ISEK KINGELEZ,
1994. FOUND

MATERIALS

INCLUDING PAPER,
CARD, AND PLASTIC. 51½ X 32½ X
118½" (129.8 X
82.9 X 300 CM).

CAAC/THE

PIGOZZI

COLLECTION,
GENEVA

Unlike any buildings in twenty-first century Kinshasa, the imagined structures are spotlessly clean, shiny, and decorated in brilliant color (fig. 11-73). Anyone who has visited an overpopulated African capital, where teeming crowds struggle to survive, will notice immediately that no people inhabit these spaces. The contrast between Kingelez's vision and the reality of urban life in the Democratic Republic of Congo after a decade of civil war is particularly strong. However, is Kingelez's work a postmodern critique of the limitations of modernist utopias, or is it simply a playful diversion that can delight viewers from any background? And how does the work of this educated artist, a man familiar with the art history of his nation, relate to the work

of an artist such as Moke, who grew up in the streets of Kinshasa?

While the predecessors of Moke and Chéri Samba were developing new forms of art for urban clients, new forms of patronage were being provided by several Europeans who set up workshops in the rapidly expanding cities of these colonies. They encouraged talented locals to produce art objects for expatriate clients, or for export to foreign markets.

Evidently the first of these teacher/patrons was a missionary, Frère Marc-Stanislaus, who established the Ecole St. Luc in what is now the Democratic Republic of Congo in 1943. Convinced of the superiority of European traditions, he taught students how to paint using

the techniques of pre-modern Europe. Five years later, the Belgian painter Laurent Moonens founded what was to be known as the "School of the Stanley Pool" (École du Pool Malebo) in Léopoldville (modern Kinshasa, the capital of the Democratic Republic of Congo). Moonens had a more relaxed approach to instruction, and simply gave young men paint and canvas to create landscapes. The picturesque views produced in this workshop may have influenced generations of artists working for tourists in Central and Eastern Africa.

After Moonens left Kinshasa to start a formal program of art instruction in what is now Lumbumbashi, his protégés received support from a businessman, Maurice Alhadeff. In 1951 some of Alhadeff's artists were recruited by a French artist, Pierre Lods, to join the workshop he was organizing in Brazzaville (now the capital of the Republic of Congo). Lods named his workshop the Centre d'Art Africaine, but it is better know as Poto-Poto, after the quarter in Brazzaville where it is located. Lods believed that participants in his workshop should tap into their inner, innately African creativity, an approach that led to Lods's visits with President Senghor of Senegal (see chapter 4). Similar attitudes were to be expressed over the next few decades by other expatriates in Africa, such as Uli and Georgina Beier in Nigeria (see chapter 8). When Lods left Poto-Poto, some of his artists continued to work together, and several (such as Iloki) have mentored younger artists.

The artist known as Thango (1936–81) frequented the School of the Stanley Pool when it was man-

11-74. Untitled, François Thango, late 1950s. Water-based paint on board. 20% x 31½" (53 x 80 cm). Private collection

aged by Alhadeff, and he was one of the original artists chosen by Lods to work under his direction at Brazzaville. Under Lods, Thango developed a highly distinctive personal style. His canvases are filled with bright unmodulated areas of color defined by black outlines. As in a Kongo raffia textile, all areas of the composition have equal balance they are not distributed between positive (primary) and negative (background) shapes (fig. 11-74). Here a mysterious composite creature can be seen. It has horns on a humanized head, a snake-like body, a single leg. and the tail of a fish. Artists who worked with Thango in Kinshasa have said that abstracted zoomorphic and anthropomorphic forms such as this are based upon the beliefs of his Woyo ancestors, who were once part of the Kongo kingdom. However, we have no documentation of this from the artist himself—the images may

be purely personal inventions. Thango worked both with Poto-Poto artists and with artists in Alhadeff's workshop during the 1960s and 1970s. Having been oriented toward foreign art markets in his youth, Thango did not achieve commercial success in the capital city of either nation after their independence.

As art instruction in the Republic of Congo became more formal, and a national art institute grew from these early workshops, younger artists became more adept at working within the international art world. Current graduates sometimes train in Europe as well as in the Republic of Congo, and they are familiar with foreign museums, galleries, and exhibitions, with critics and patrons, theorized viewpoints, and shifting preoccupations.

Trigo Piula (born c. 1950) exemplifies this level of sophistication. A professor at Brazzaville's national

11-75. MATERNA, TRIGO PIULA, 1984. OIL ON CANVAS

art institute, he uses his mastery of Western styles and techniques and his knowledge of regional art histories to comment upon contemporary African experience. In Materna, (fig. 11-75) Piula addresses the evils of consumerism and the rapacity of Western megacorporations, in a moralistic message similar to those in the work of Chéri Samba. The cross-legged figure with armlets and anklets is lifted directly from Kongo prototypes such as the pfemba (see fig. 11-6). But the mother's head is that of a blonde European woman blankly looking out at the viewer. An African slogan expresses a view that might be implied by the artist: "We can see where her head is: it has become the head of a white woman." The mother does not nurse her child. In fact, the pose of the child may even suggest that it is dead. Arranged in front of the pair is an assortment of burning and melting candles, and opened and unopened cans of imported evaporated milk. These remind the viewer that milk and infant formula imported into Africa are often mixed with tainted or disease-laden water. They have thus become a deadly substitute for the breast milk that protected babies from illness. Small figures project from the two cans in the lower corners of the composition, suggestive of protective and curative nkisi figures and the need for African mothers to defend their children from those who would risk human lives for personal profit. Trigo Piula, like so many accomplished artists, is providing us with a message that is both highly specific in its references and universal in its appeal to our moral values.

The Eastern Congo Basin

12-1. STOOL, FROBENIUS'S WARUA MASTER, LUBA. WOOD AND GLASS BEADS. UNIVERSITY OF PENNSYLVANIA MUSEUM. PHILADELPHIA

This throne was created by the artist referred to as the Warua Master, celebrated for a body of excellent works, including bowstands and figures. The earliest known work by this hand was collected in 1904 by the German ethnographer Leo Frobenius, who was told that it had been made by a sculptor of the Warua "tribe" (who cannot be linked to any specific population). The figure's massive, beautifully rounded forehead and large head with small rectangular chin characterize his work. Arms outline a rectangular space enclosing the head and supporting the seat. Raised cicatrization patterns dominate the cylindrical torso. while legs, reduced to pasta-like forms, lie in low relief on the base.

VARIETY OF CULTURES developed in the eastern reaches of the Congo basin. In the southern savannahs Luba kingdoms, related to the Lunda to the west (see chapter 11), along with other groups, established centralized governments that employed art to undergird notions of sacred leadership invested in kings, chiefs, and other titleholders.

In the forests to the north of the savannahs, centralized systems of government are noticeably absent. Communal organizations attended to the smooth running of the community. Here, art played a role in the initiation and instruction of members of the organizations and served to instill philosophical precepts.

On the northern fringes of the forests, at least two groups, the Azande and the Mangbetu, seem to have migrated from the northern savannahs to develop chiefdoms and kingdoms in the forest belt. As in the southern kingdoms, art established the importance of leadership, but the objects here did not connote the sacred as they did in the south.

EARLY ART FROM THE UPEMBA DEPRESSION

The archaeological record suggests that artists and craftsmen were at work early on in the region. Iron technology was used in the eastern part of what is now Congo by the middle of the fourth century AD, and by the sixth century it was used in the Upemba depression, a vast,

12-2. Axe from a burial in the Upemba depression, Kisalian period, 8th–10th century. Iron head, wooden handle set with iron nails. Drawing by Y. Bale

swampy rift valley covered with lakes. An abundance of pottery, charcoal, and stone tools, and some iron implements (barbed arrowheads, spearheads, curved knives, and hoes) have been found from the Kamilambian period (between the sixth and the eighth centuries). Graves from the following early Kisalian period (from the eighth to the tenth century) contain iron hoes, knives, spearheads, and axe heads (fig. 12-2). Axes with carefully shaped blades and handles decorated with iron nails are not unlike axes of authority used throughout the region today, which suggests that social hierarchies had developed already. The smith who created the ceremonial axe illustrated here strove to give aesthetic form in the forging process, working a complex symmetrical silhouette, reinforcing it with a central spine, and decorating its surface with incised patterns. Ancient axes provide evidence for the antiquity of political orders based on metal technologies.

The Classic Kisalian period begins with the tenth century. Although we have no means of determining what types of objects were created in perishable materials, numerous graves with many objects in durable materials, an abundance of copper in the form of utilitarian objects as well as ornamental luxury goods and ivory objects such as armlets and necklaces, suggest further development of a hierarchical society. Copper necklaces, copper and iron armlets, shell beads, iron pendants, and ivory objects on the body indicate status and power. Beautifully designed pottery seems to have been in abundance. Graves have been uncovered that were filled with well-made vessels in a variety of shapes, some with footed bases, and others with spouts and handles. Rounded bottoms, marked necks and shoulders, and in-turned lips are characteristic of vessels in Classic Kisalian graves, decorated with channels, incisions, comb stamps, and impressions.

Although everyday utilitarian objects were buried with the dead, much of the pottery seems to have been symbolic or ritual in function. The size of burial vessels seems to be proportional to the age of the deceased, the larger vessels placed with older persons, suggesting a symbolic role. Graves with more pots contain the most uncommon materials, such as cowrie shells and ivory, pointing to an even more stratified society by the beginning of the second millennium.

Throughout Central Africa, copper has long been a medium indicating status and associated with the formation of central authority systems. The amount of copper increases in Classic Kisalian graves, and luxury objects, such as bells and bracelets, suggest continued and greater trade with the copperbelt to the south. It is likely that the peoples who produced the objects discovered in Kisalian period graves were the ancestors of the Luba peoples.

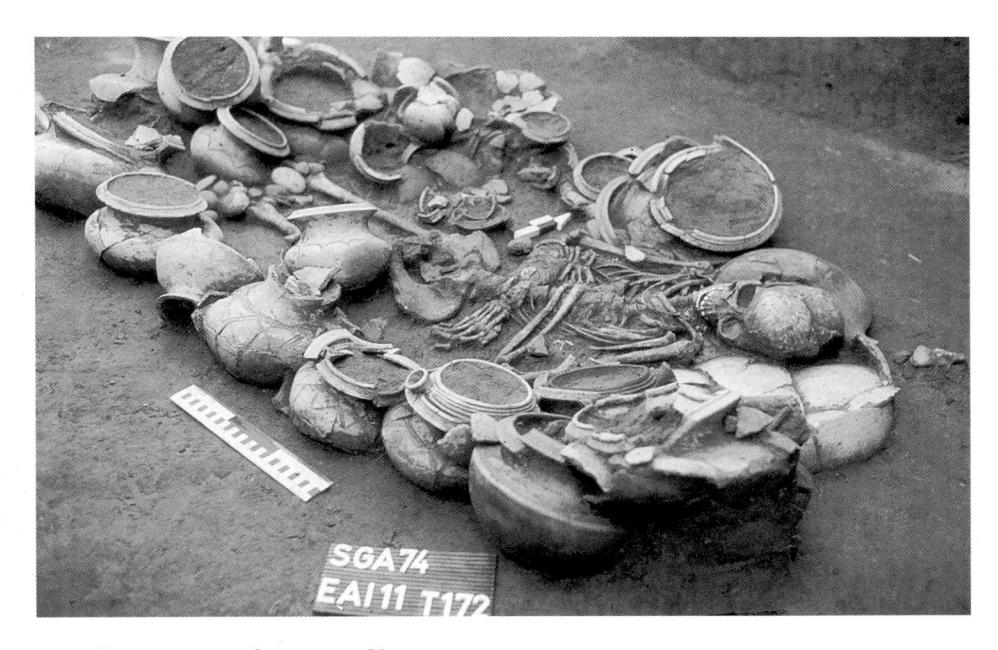

12-3. Grave No. 172, Sanga, the Upemba depression

IN THE SPHERE OF THE LUBA EMPIRE

The Luba live along lakes and rivers in the savannah region of southeastern Congo, their heartland lying in the area of the Upemba depression. They took advantage of the many natural resources, using rivers for fishing and as avenues for long-distance trade. All helped in the creation of hierarchical societies not unlike those to the west (see chapter 11), and eventually led to the establishment of influential kingdoms that made an impact throughout the region and beyond.

In oral histories, the tyrant Nkongolo Mwamba ruled over the region. A handsome young hunter, Mbidi Kiluwe, arrived and married Nkongolo Mwamba's sister, fathering a son, Kalala Ilunga. Kalala, a heroic warrior, defeated his despotic uncle and ascended to the seat of authority. Kalala became the embodiment of the new political structure of sacred kingship introduced from the east by his father. Among the patchwork of chiefdoms in the region today, each claims descent from the founders of Luba sacred kingship, Mbidi Kiluwe and Kalala Ilunga. (Chibinda Ilunga of Lunda and Chokwe fame was the son of Kalala: see chapter 11.)

Leaders in neighboring areas affirmed political and economic alliances with Luba chiefs and kings through gifts recognizing seniority. This network of gift giving as well as cultural similarities at one point led scholars to assume that there was once a Luba empire. Over time, Luba cultural identity was emulated by neighboring peoples, lending credence to the idea of such an empire.

However, today such assumptions are being reevaluated. Although it is evident that there were numerous similarities among many rulers in the region and the objects used to support royal authority, it is perhaps a fiction that there was ever a single authority dominating the entire region. Luba culture and influence peaked in the seventeenth century and collapsed in the late nineteenth century, a result of the Arab slave trade. Today significant elements of the precolonial political infrastructure still exist, but Luba chiefs work within the structure of a modern national state.

The Luba Heartland

Magnificent regalia once called attention to Luba chiefs and kings. Stools, staffs of office, bowstands, cups, headrests, and ceremonial weaponry were distributed at the installations of chiefs to extend royal power to outlying areas. Human images, usually female, decorate such objects, perhaps representing the daughters and sisters of kings given as wives to provincial leaders to solidify political relationships. Such figures display elaborate coiffures and beautifully scarified bodies, signs of rank and position.

Luba power was not entirely vested in a single monarch. The king reigned over subordinate chiefs, and power was shared by numerous people in several professions, including title-holders, diviners, healers, and members of secret associations. All were initiated into a body of sacred knowledge taught through Mbudye, an association guarding political and historical precepts and disseminating knowledge selectively and discretely through ritual. Insignia for those ini-

tiated into Mbudye were often shared—stools, staffs, spears, and other weapons, symbols of power, authority, and wealth.

While such symbolic objects denoting high office are often highly visible, this was not always the case. For example, the superbly formed bowstand shown here, with three projecting, slightly curving branches sprouting from the head of a female figure, was rarely seen (fig. 12-4). Textured designs of lozenges and triangles incised into the surface of the prongs refer to scarification patterns that relate to royal prohibitions. The elegant female form exhibits the characteristic Luba style with its highly polished surface, broad, rounded forehead, and elaborate hairstyle and scarification. The image of the female with her hands to her breast refers to certain women who guard the secrets of royalty within their breasts. While such figures may represent a wife or sister of a ruler, in some areas they are said to represent specific women of Luba history such as those who led migrations of people. Another explanation of the female figure states that the spirit of a Luba king is incarnated in the body of a woman after death and that the depiction thus commemorates the incarnation of the dead king. Originally such bowstands were utilitarian objects used by hunters for hanging bows and arrows. They eventually became royal authority symbols, ultimately referring to Mbidi Kiluwe, the renowned hunter whose bow was his most cherished possession. According to the origin stories, Mbidi was also a blacksmith and introduced advanced technologies in both hunting and smithing from the east.

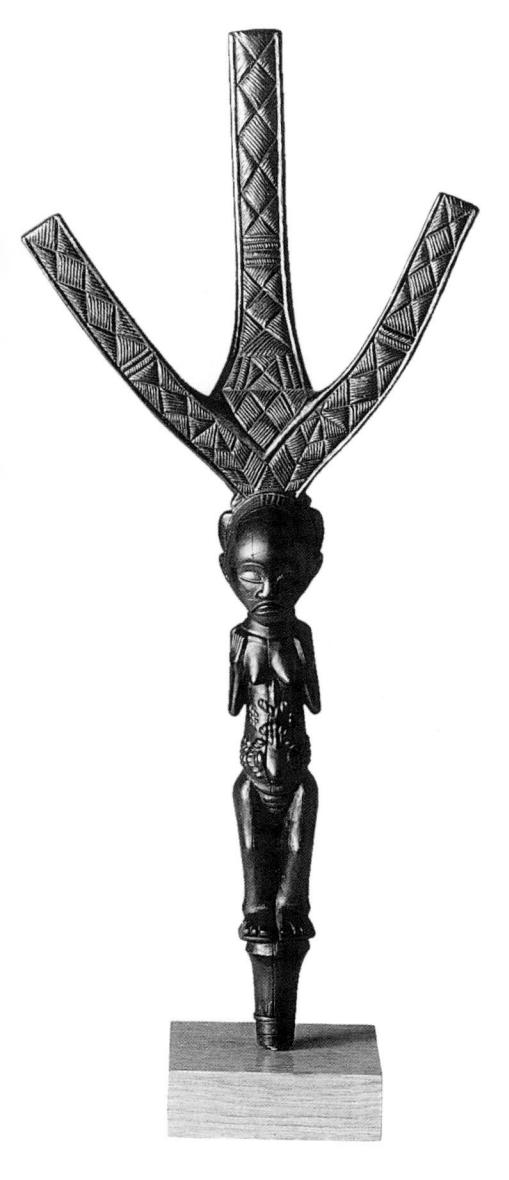

12-4. Bowstand, Luba. Etnografisch Museum, Antwerp

Bowstands refer to the origins of kingship with Mbidi Kiluwe and the role of hunting in relation to leadership. Although no longer used as symbols of royal authority, they were once potent objects and were never displayed in public. Kept in secret places containing sacred relics of past rulers, they were treated with ritual and prohibitions and approached with prayer and sacrifice. When the king appeared in public, the object itself was never seen. Instead the female guardian of the bowstand followed him, clasping a simple bow between her breasts, becoming a living bowstand.

The ceremonial axe is one of the most important objects produced by Luba blacksmiths. Axes are still often worn over the shoulder of Luba kings, chiefs, and counselors as signs of status and wealth. Incised crosshatched patterns cover the curving wrought-iron blade of the example shown here (fig. 12-5). The bulbous handle, its shank wrapped with copper, ends in the skillfully rendered head of a woman. Her delicate features and high forehead are typical of Luba style. The complex hairdo, kaposhi, in which the hair is gathered into four tresses and formed like a cross, is a classic style found on most Luba carvings.

Axes were used as indicators of authority probably as early as the eleventh century, when they were buried in graves of high-ranking individuals during the Kisalian period. In addition to being prestige objects, axes are often wielded in dance and in important court ceremonies, carrying profound messages and playing a central role in the initiation rites of Mbudye. Symbolically, the axe is used to clear the path that leads to civilization. The notion of cutting paths and making traces upon the land is metaphorically expressed in the delicately engraved patterns on the blade. These marks, ntapo, represent scarification worn by women, referring both to beauty and to erotic pleasure. Ntapo is seen as a form of symbolic writing communicating identity and social status, and conveying ideas of order, cosmos, and physical and moral perfection.

As in many parts of Africa, the right to sit during ceremonial and religious events is limited to highranking individuals. Elaborately

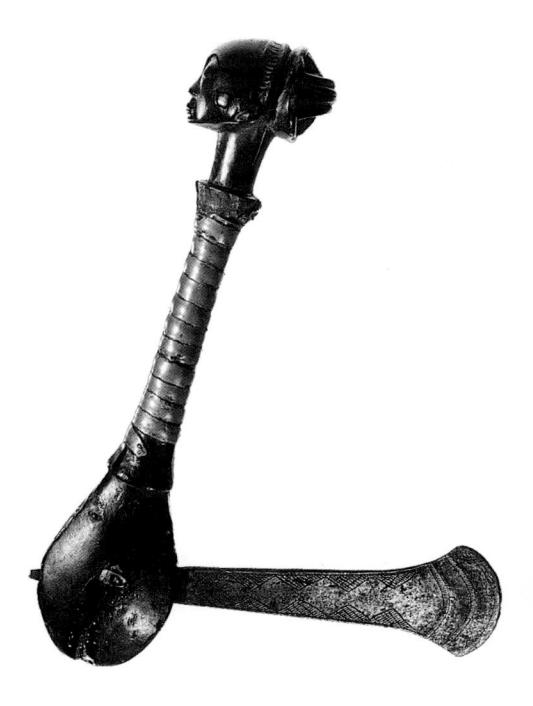

12-5. Ceremonial axe, Luba, 19th century. Iron, copper, wood. Height 14¼" (36.5 cm). Museum Rietberg, Zürich

Beautifully wrought ritual axes, kibiki and kasolwa, belong not only to kings and chiefs but also to high-ranking titleholders, female mediums, secret association members, and diviners. Like the bowstand, axes are symbolic rather than utilitarian. Blunt blades, incised with geometric designs, copperwrapped handles, and the sometimes complex carvings on the ends do not allow their use as tools or weapons. They serve as a visual enhancement and metaphorical extension of leadership.

carved Luba stools, serving as thrones, allude to the complex hierarchy of seating privileges distinguishing members of the court (figs. 12-1, 12-6). They figure prominently in investiture rites, marking the moment when the new ruler declares his oath of office and speaks for the first time as king, setting him apart from society. State stools are so potent a symbol

12-6. STOOL, THE BULI MASTER, LUBA PEOPLES, DEMOCRATIC REPUBLIC OF CONGO. 19TH CENTURY. WOOD, METAL STUDS. HEIGHT 24" (61 CM). THE METROPOLITAN Museum of Art, NEW YORK. PURCHASE, BUCKEYE TRUST AND CHARLES B. Benenson Gifts. Rogers Fund AND FUNDS FROM VARIOUS DONORS, 1979

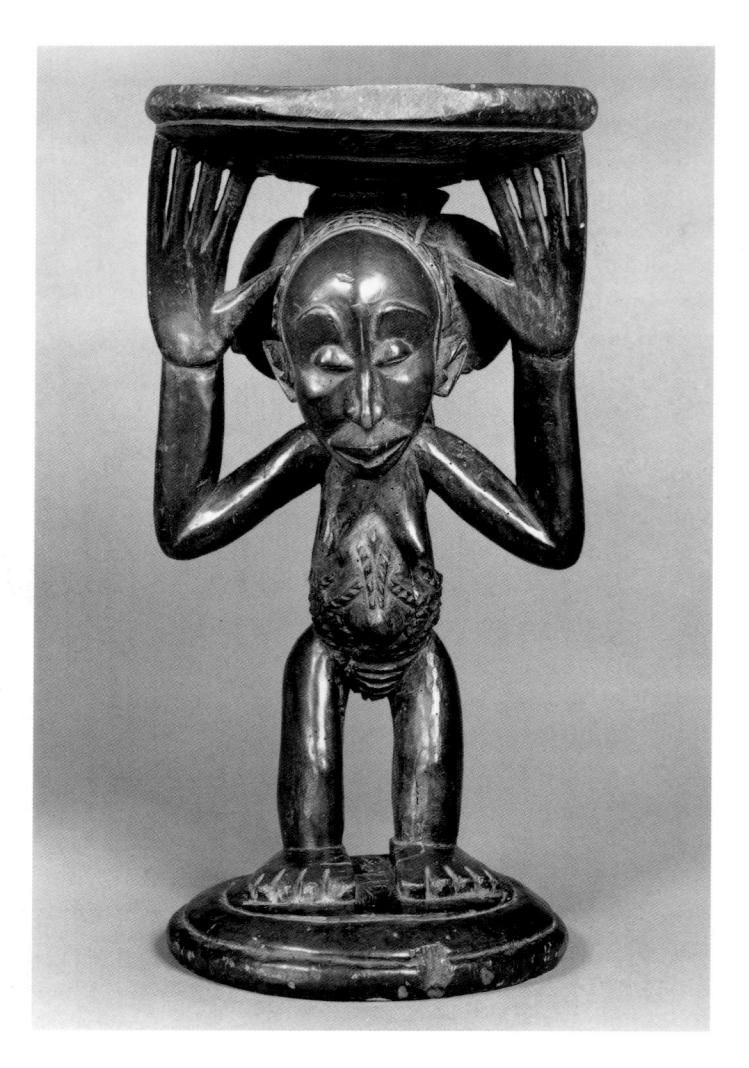

that they are kept in different villages from the possessor's home to diminish the possibility of theft or desecration. A throne is perceived not so much as a functional seat as a receptacle for a king's spirit. Wrapped in white cloth and fastidiously preserved by an appointed official, it appears only on rare occasions. It is not intended for human eyes but for the eyes of the spirit world. When a Luba king was inaugurated his throne was placed on a leopard skin, prohibiting his feet from contacting the ground and symbolically suggesting his supremacy over even the majestic leopard. Other attributes of leadership

positioned nearby included a staff and a spear, each emblazoned with the female figure.

The royal residence of a Luba king is called "the seat of power," and a stool that served as his throne is believed literally to enshrine the soul of each king. When a king dies, his residence becomes a metaphorical seat of power, preserved as a spirit capital in which his memory is perpetuated through a female spirit medium, mwadi, who incarnates his spirit. The throne stool, a concrete symbol of this "seat," expresses the most fundamental concepts of power and dynamic succession.

In the best-known type of Luba thrones, a single female figure supports the seat. Elaborate hairdos and scarification are marks of Luba identity and physical perfection. Personal adornment suggests the figures represent highly positioned women. The figure refers simultaneously to the supporting role of women, the notion of ancestral continuity through women, specific royal women influential in the expansion of the kingdom, and the sacred roles played by women in religion.

Both of these stools were carved by great artists whose styles are recognized in numerous objects now in museums. The artists had earned renown throughout the region during their lifetimes, but the Europeans who collected their works almost never recorded their names (see Preface, pp. 10–13). Art historians therefore group stylistically similar objects, assuming each is made by a single artist, or "hand." They give each "hand" a title, following the example of scholars who work with art of Renaissance and Mediaeval Europe. Thus the elegant stool in figure 12-1 was created by the Warua Master (a title based upon a term given to the collector by traders), while that in figure 12-5 was created by the Buli Master (a title taken from the town where one of his works was purchased). As is the case with art from other regions of the continent, art historians have only recently been able to identify some of the artists of the past. Masters who created these two stools are only two of several recognizable hands from the Luba region.

Although they are both in recognizable Luba style, sharing broad,

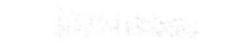

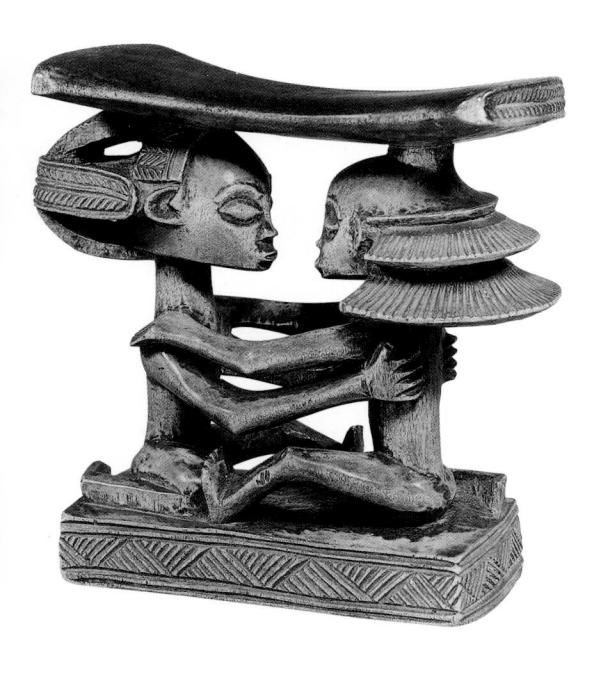

12-7. Headrest,
Master of the
Cascade Hairdo,
Before 1936.
Wood. Height
7½" (19 cm).
National
Museum of
Denmark,
Copenhagen

12-8. MBOKO
(FIGURE-WITH-BOWL), MASTER
OF MULONG,
19TH-2OTH
CENTURY.
AMERICAN
MUSEUM OF
NATURAL
HISTORY, NEW
YORK

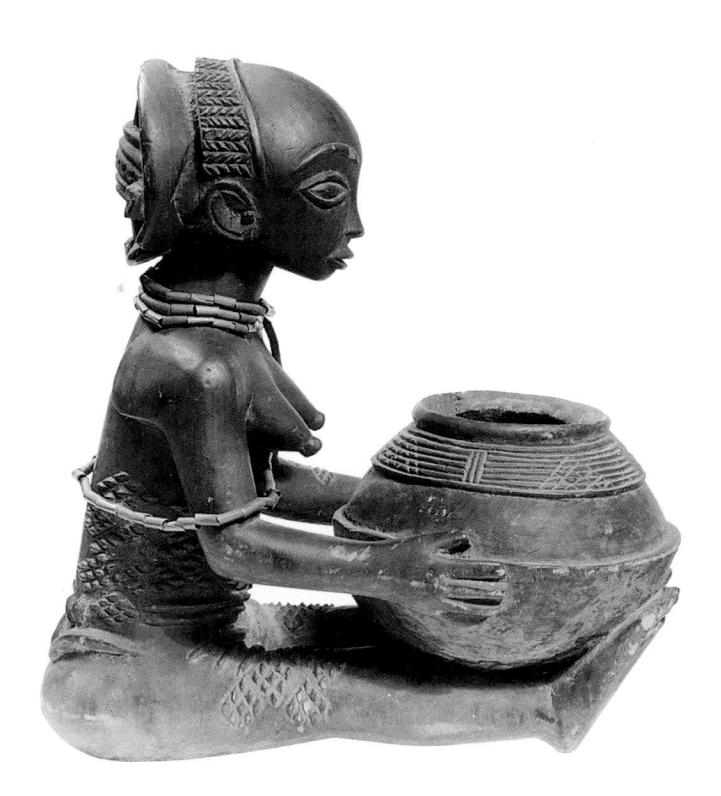

rounded foreheads, downcast eyes, similar coiffures, and concentration on beautiful bodily scarification, the thrones exhibit many stylistic differences as well. While the body of the Warua Master figure is elongated, that of the Buli Master is almost miniaturized. The legs of the Warua figure are reduced to spaghetti-like forms on the base, while those of the standing Buli figure are accentuated. And the hands and arms of the two demonstrate further the different ways in which artists may structure a threedimensional composition. The large hands are broad and turned so the viewer is immediately aware of their size. Figures by the Buli Master are further recognized by a number of characteristics, including an elongated face with an expression often read as "mournful." The long nose, accentuated cheek bones and pursed lips are typical of his style. The Buli Master is

also known to have carved a number of headrests.

Luba headrests are similar to stools in the use of supporting figures (fig. 12-7). This small utilitarian object was used by high-ranking dignitaries for sleeping comfort and for keeping its owner's head cool by raising it above the mat. More importantly, it protected elaborate hairdos for up to two or three months. Such coiffures were important (and still are) as indicators of profession, title, status, and personal history. Thus although the headrest is not sacred and is not as symbolic as stools, axes, or bowstands, its function extends beyond utility to provide status and prestige associated with leadership.

The dynamic pose, delicately chiseled features, and dramatic tumbling coiffure on the figure on the right are hallmarks of a series of headrests attributed to a nineteenth-century master carver from the Shankadi

area. Because many of his works have the beautiful and luxurious hairstyle, *mikada* ("cascade"), he is known as the Master of the Cascade Hairdo (or, more inaccurately, the Master of the Cascade Headdress). *Mikada* took about fifty hours to complete and involved working the hair over a frame of cane.

Scarification, like coiffure, is a reference to a person's social worth and self-esteem. It is especially noticeable on figures such as the one illustrated here carved by the Master of Mulongo, in which he has embellished the thighs and torso with gently rounded patterns (fig. 12-8). Large almond-shaped eyes, smooth skin, outstretched legs, arms clasping the bowl, elegant kaposhi hairdo, and the shape of the high rounded forehead are typical of the Master of Mulongo's work and that of the Mulongo region. The form of the bowl suggests a type of pottery that

goes back to the Kisalian period or earlier.

The figure-with-bowl is often referred to as mboko, actually a term for the ritual bowl or gourd held by the figure. Actual mboko are used in divination much like Chokwe baskets (see fig. 11-26). Ritual objects representing a female figure supporting such a bowl or gourd are owned by chiefs and diviners to honor and remember the critical role played by the first mythical diviner in the founding of kingship. The female figure is identified as the wife of the diviner's possessing spirit. Diviners' wives are commonly accepted as having oracular powers, serving as mouthpieces for spirits, and the portrayal of the spirit wife underscores the role of the diviner's own wife as an intermediary in spirit invocation and consultation. The mboko figure, placed next to the diviner, as his own wife sits beside him, reinforces the notion of women as spirit containers in both life and art. Rulers keep mboko figures at their doors, filled with a sacred chalk associated with purity, renewal, and the spirit world. Visitors take the substance to rub on chests and arms in gestures of respect prior to kneeling before the king. If a ruler loses his *mboko* figure, he is required to furnish another quickly, for it is the only tangible proof of his authority.

Lukasa is the highest stage of royal initiation, attained by only a few members of three principal branches of royal culture: kings, diviners, and members of Mbudye. Such men, looked upon as "men of memory," are genealogists, court historians, and the "traditionalists" of society. Lukasa is also the term used for a physical

emblem for those initiated, a memory aid assisting in initiation ceremonies to recall a complex body of knowledge, which is also used in performances honoring the king and his retinue (fig. 12-9). The near-rectangular wooden board fits comfortably in the hand to be easily manipulated. It is sometimes seen as embodying an emblematic royal tortoise that recalls and honors lukasa's founding female patron. A configuration of beads, shells, and pins coded by size and color on one side refers to kings' lists. Beads may stand for individuals, a large bead encircled by smaller ones perhaps representing a chief and his entourage. Bead arrangements also refer to proverbs and praise phrases. The configuration is a diagram representing the landscape, both actual and symbolic, referring to ghost capitals of former kings, a map of the residences, seating arrangements, shrines, and other significant points in the court. Lines of beads may also indicate roads or migrations. The lukasa provides a means for evoking events, places, and names. In Mbudve induction, it stimulates thought and instructs in sacred lore, culture heroes, migrations, and sacred rule.

A non-royal form of divination, kashekesheke, involves manipulating a small, sculpted instrument in the form of a human figure (fig. 12-10). The body is a hollowed rectangle topped by an anthropomorphic head. The diviners' consulting spirit dictates its form in a dream, and the figure is called by the name of that spirit. Although the spirit may be male or female, the sculpted figure is always referred to as female, even when the body is an abstract rectangular frame like the example shown here. The

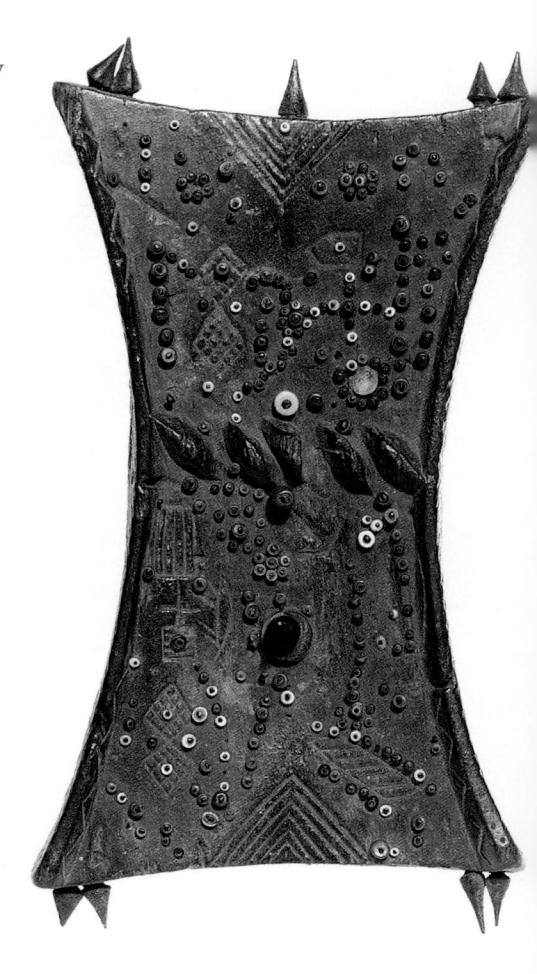

12-9. Lukasa (initiation emblem), Luba, Congo, late 19th–early 20th century. Wood and beads. Height 10" (25.4 cm). Brooklyn Museum, New York. Gift of Mr and Mrs John A. Friede

diviner and client each holds a side of the implement with two fingers as the diviner addresses the ancestral spirit and asks questions. The motion of the *kashekesheke* is interrupted when the spirit replies through coded movements. One of the oldest forms of Luba divination, perhaps existing long before the introduction of sacred kingship, *kashekesheke* is still used to solve problems.

Of the several mask types used by the Luba, one of the better known is kifwebe (plural bifwebe), a mask elab-

12-10. Kashekesheke divination, Luba, Shaba area, Congo. Photograph c. 1936

orated with parallel grooves, usually whitened on a dark ground. The large example shown here, with typical Luba eyes and rectangular mouth, was worn with a raffia costume (fig. 12-11). Little is known about the kifwebe tradition among the Luba, and the tendency in the past has been to muddle information with that which is known about Songye masks of the same general form and name. Among the Luba, mask shape seems to have been closely associated with gender identity—round or hemispherical masks, like that in figure 12-11, being female, and oblong masks representing male spirits. At one time it seems that bifwebe were danced in male/female pairs and represented spirits, connecting this world and the spirit world. Over time it seems that round masks have become rarer and the oblong masks have

proliferated. Today performances more often include a single female mask accompanied by up to eight male masks.

Although Songye and Luba bifwebe are distinct traditions, the masks are indeed similar in form and seem to share other aspects as well. While the Songye claim that bifwebe originated in Luba country, to the east, Luba traditions maintain that they originated in Songye territory to the west. This must be read as an attempt to emphasize the "otherness" of these phenomena—reiterat-

ing their strangeness by assigning their appearance to realms outside the familiar.

Luba *bifwebe* play a beneficent role, and Luba maskers refer to themselves as *nganga*. They appear at rites associated with the new moon, at funerals and at initiations and serve to rid the community of evil presences.

Other mask types among the Luba are even more enigmatic. While we know there were both anthropomorphic and zoomorphic masks, few were collected in the region, and little is

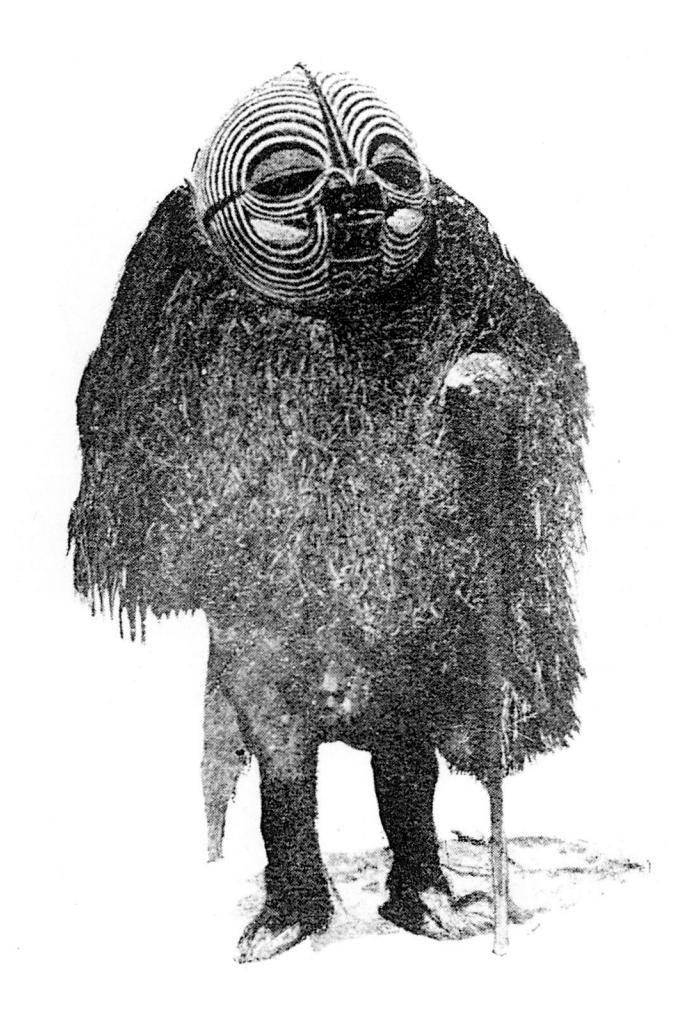

12-11. KIFWEBE MASKER, LUBA, CONGO. PHOTOGRAPH 1913

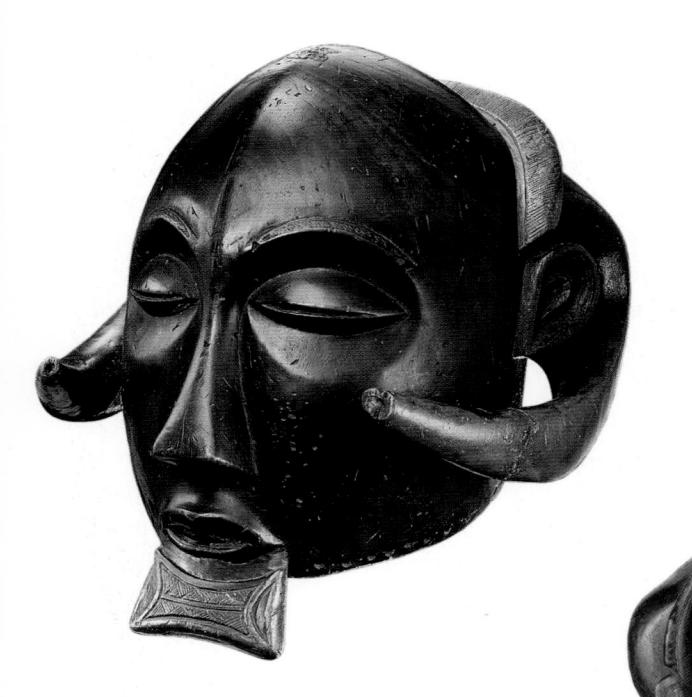

12-12. RAM'S HORN HEL-MET MASK, LUBA, CONGO, BEFORE 1914. ROYAL MUSEUM FOR CENTRAL AFRICA, TERVUREN

12-13. Male ancestor figure, Hemba, Congo. 35" (89 cm). Etnografisch Museum, Antwerp

known about the contexts in which those masks were used. A remarkable helmet mask with ram's horns was collected prior to 1914 (fig. 12-12). Exactly where this magnificent mask originated is not known, and we have no idea how it might have been used, yet it is a superb sculptural work.

The Hemba

The Hemba, to the north of the Luba, were once incorporated into the sphere of Luba activity. Several groups claim to be Hemba, although there are differences among them. Veneration of ancestors in large family groups is a trait shared by many Hemba, and beautiful male ancestral carvings called attention to great lineages (fig. 12-13). The rounded face and high, broad forehead reflect the impact of Luba style. The Hemba see the serenely closed eyes and the rounded face as reflecting the ancestor's interior calm. Splendidly formed shoulders and arms frame a contoured torso that narrows at the waist and then swells to a protruding belly, emphasizing the navel, a sign of family and continuity. The Hemba vernacular term for "stomach" also indicates a segment of the lineage. Hands on each side of the swelling belly thus indicate the ancestor embracing and watching over descendants.

Some Hemba ancestor portraits date to the nineteenth century, some conceivably to the seventeenth or eighteenth centuries. Not being based on individual visual traits of a specific person, their purpose is not to celebrate an individual but to reflect on familial continuity and the perpetuation of lineage. Ancestors are counted, named, and arranged according to seniority in a line of descendants. Names are kept in a genealogy reflecting the social structure of clans and family groups. Any one figure may refer to a specific generation or to an entire genealogy. A chief often had three to four figures, calling attention to his being a part of a great family.

The mwisi wa so'o mask is used in So'o, a semi-secret society (fig. 12-14). It represents a strange werechimpanzee, partaking of characteristics of both the animal and the human order, but really being of neither. The wide, grimacing mouth with notched upper lip is regarded as horribly strange. High raised brows, notched and forming a counter curve to that of the mouth, are associated with wildness and craziness. The entire configuration of the mask, worn with a wig and beard of white and black monkey hair, suggests an untamed, uncontrolled presence. Pelts from both domestic and wild animals. along with materials of both village

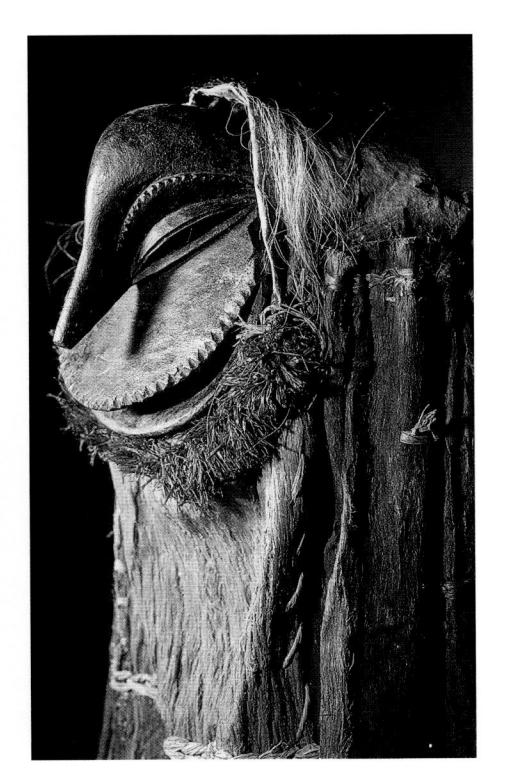

12-14. Mwisi wa so'o. Hemba, Congo. Length (excluding fibers) 7" (18 cm). Linden-Museum, Stuttgart

and forest, comprise the costume for the intimidating *so'o*. The use of bark cloth for a large cape and leggings associates *so'o* with the distant past.

Neither human nor animal, so'o is outside anticipated categories. Neither of the village nor of the forest, it has characteristics of both. In its liminality, so'o is like the spirit of the deceased, not yet installed in the world of the dead but no longer part of the world of the living. In funerals so'o enters the village, the domain of humans. In its first appearance at funerals this strange creature with no arms runs wild in the village, making no utterances or sounds. Small iron bells, associated with liminal creatures such as ghosts, provide its only warning. It chases all young people and women, who run terrified from it.

12-15. MALE AND FEMALE FIGURES, TABWA, CONGO, 18TH-19TH CENTURY. WOOD. HEIGHT OF MALE 181/2" (46.4 CM), FEMALE 181/4" (46.3 CM). THE METROPOLITAN Museum of Art, New York. The MICHAEL C. Rockefeller Memorial COLLECTION. GIFT OF Nelson A. ROCKEFELLER, 1969

The Tabwa

The Tabwa, who live in regions adjacent to the Luba, have no unified history, and the relationships of the many people who claim to be Tabwa are complex. One shared characteris-

tic is that none developed central states. Local chiefs merely led the community but had no ultimate authority over any individual. Being less well organized politically, they were easy prey to raids, eventually suffering at the hands of African enemies as well as Arab slave traders.

Tabwa art developed over a fairly short period during the mid-nine-teenth and early twentieth centuries. Sculpture reflected more on great families than on leaders. Tabwa lineage elders kept small wooden images to represent and honor ancestor spirits, great healers, and occasionally earth spirits. The female figure of the male and female pair shown here (fig.

12-16. MPUNDU (TWIN FIGURE), TABWA, 19TH CENTURY. WOOD. HEIGHT 9" (23 CM). MUSEUM FÜR VÖLKERKUNDE, STAATLICHE MUSEEN, BERLIN

12-15) is differentiated from her male counterpart by a cap-like hairdo close to the head, while the male figure wears long braids looped behind. Oval face, straight chin, small almondshaped eyes, thick lips, elongated torso, and stiff limbs are typical of

this Tabwa style. The figures display elaborate scars in double rows of raised patterns. Such adornment was aesthetically pleasing and served an erotic role, but also served as visual metaphors that implied positive social values and the harmony of natural forces. For example, the vertical axis down the midsection embellishes and emphasizes body symmetry, but it also ends at the navel, referring to one's beginning. The vertical axis cuts through open isosceles triangles on chest and abdomen and a diamond shape on the torso, a reference to the rising of the new moon; this is an important pattern used not only on the human body and on carved figures, but also on masks, headrests, instruments, stools, baskets, and mats.

Such figures, *mikisi*, were given specific names and kept in special buildings. Lineage elders occasionally slept near them to receive ancestral inspiration. *Mikisi*, some charged with power substances, were placed near sick people to heal, or at the entrance to a community to guard and protect. Catholic missions, arriving in the late 1870s, forbade the use of *mikisi*, resulting in the Tabwa destroying great numbers. Today, most Tabwa sculptures are in Western collections.

An exception is the *mpundu* or *pasa* (fig. 12-16). Consisting of a head with extended neck on an elongated, cylindrical body terminating just below the navel, these simplified figures commemorate and venerate dead twins. Three protuberances on the cylindrical torso represent breasts and navel, and scarification, again, is organized along a vertical axis. Commissioned on the death of a twin.

an mpundu was cared for with food and offerings, and treated as an equal to the living twin. Twins are rare and special beings, believed to mediate between nature and humans. When born, they are secluded until the umbilicus falls off. Special rituals assure their well-being, and they are given special names revealing birth order. When a twin dies, it is not mourned, for it has not died but "returned home." The wooden figure, carried by the mother until the surviving twin can walk, is kept in the house or a shrine. The practice is still observed in Tabwa country today.

The Tabwa use both anthropomorphic masks and those that mimic the features of a buffalo (fig. 12-17). Both types are fairly rare. In the buffalo mask, graceful horns sweep to the sides, and the mouth is open as if the animal is panting or bellowing. Eyes are inset with cowrie shells. Scarification on the muzzle refers to the cosmology suggested by human scarification. The heavy mask is held in place in front of the dancer's face by his hands. The costume is a moving "haystack" of loose raffia with a variety of animal pelts attached.

Little is known of the function of buffalo masks. Sometimes performed with an anthropomorphic female mask, the buffalo may represent masculinity, associated with violence, aggression, and the vengeful actions of the wild animal. Formerly, buffalo lived in herds in the grassy plains, but by the 1970s they were encountered only in remote areas. Females are red, and old males are black, and red/black opposition is an important Tabwa concept referring to violent change and secret knowledge. When hunted in the wild, buffalo seem to have the

12-17. Tabwa buffalo mask, Tanzania

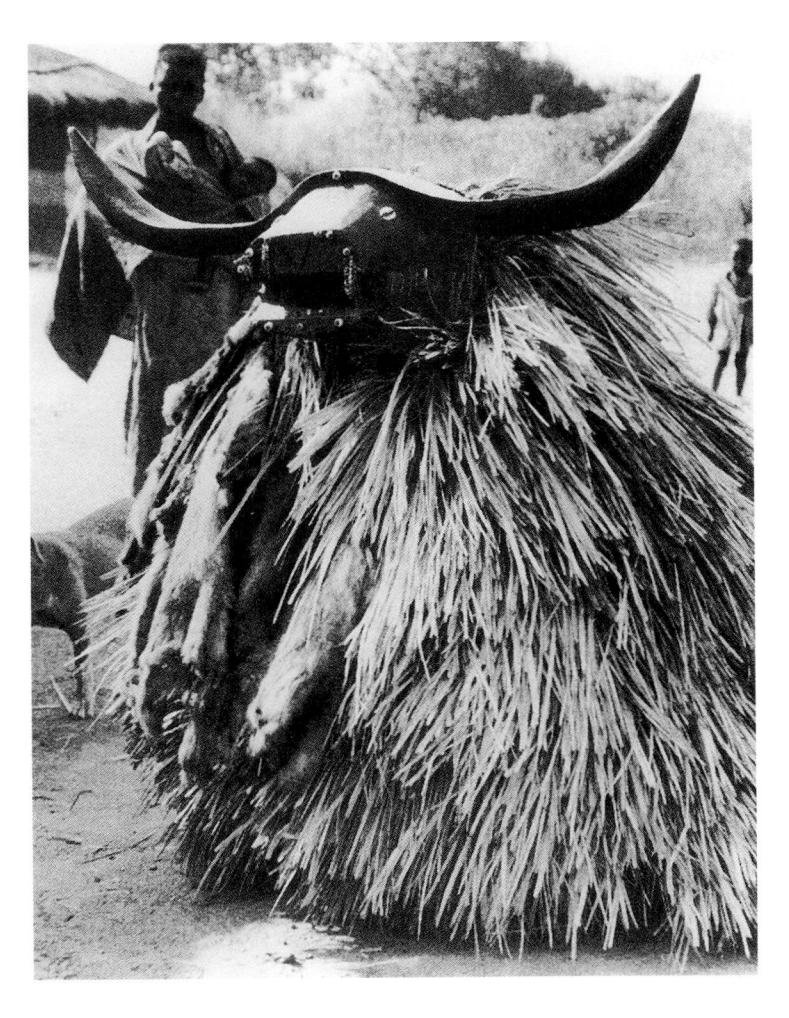

ability to disappear, only to reappear behind the hunter, thus embodying such notions in their actions.

The Songye

The Songye live to the north of the Luba to whom they are linguistically and culturally related. A number of sub-groups have political systems based on chiefs and titleholders like those of the Luba. Songye country was once distinguished by a very high population density and the formation of large villages and towns. In the 1870s the Arab slave trade, the arrival of Belgian colonizers, and internal conflict over succession threatened

the way of life established in the region. The most powerful regional chief, Lumpungu Kaumbu, was inducted as supreme chief by the colonial authorities. By the beginning of the twentieth century, however, the hierarchical system fell as a result of prolonged upheaval.

While the Songye produced leadership arts, such as stools with supporting figures, most art was associated with manipulating spiritual powers. Powerful associations developed throughout the region as the result of political factions, many of them in response to succession disputes and rivalry between potential successors to chieftainships. Such organizations challenged political centralization and were concerned with religious and anti-sorcery matters. Their ultimate aim was to check the power of the chiefs.

Some were masking societies, used as agents of social and political control. Masks, called bifwebe (sing. kifwebe), were used by one such organization, Bwadi bwa kifwebe, an authoritative instrument associated with healing and mystical control. As powerful social devices, organizations such as Bwadi bwa kifwebe wielded great power as socially benign instruments to bring good fortune, protect, heal, and counteract evil. They were at the same time secret regulatory societies and sources of entertainment. In regions where chiefly authority was powerful, such organizations had a more secular function. In areas in which power was shared and rotated among influential men rather than given to one powerful chief, the society served as a mechanism for controlling the community. Maskers were visual emissaries of the society.

As with Luba masks of the same name, the information on Songye bifwebe is fragmentary from the precolonial and early colonial periods. The Songye suggest that the mask type originated among the Luba, but as with the Luba assertion of a Songve origin, this seems to be an attempt to emphasize the strangeness of the beings represented by the masks, a reiteration of their "otherness." Not human, not animal, and not spirit per se, bifwebe defy categorization. Energetic movements and strange sounds energize the arena in which they appear. Male and female masks, all worn by men, are differentiated by form and coloration.

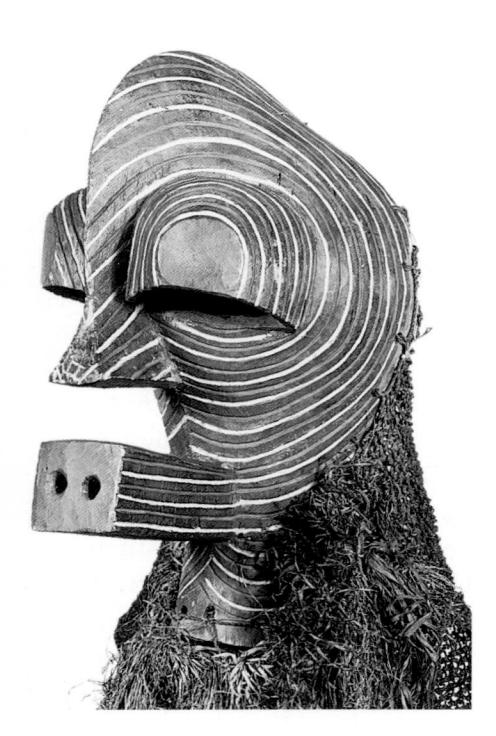

12-18. Male *Kifwebe* mask, Songye. Wood. Height 21½" (5.6 cm). Royal Museum for Central Africa, Tervuren

The male mask in figure 12-18 is aggressively formed, its bulging eyes jutting well past the facial plane, its exaggerated mouth projecting to the level of the flattened nose. A crest form merging with the nose runs over the top of the head. In comparison to female masks, which have a simple color scheme of white accentuated with black, male masks have a busier color program of red, black, and white, and sometimes browns, pinks, and oranges.

Male masks, which appear in large numbers, are differentiated into two groups by size. The elder mask is normally much larger than the youth, for the larger the crest the greater the magical potential and mystical strength of the character. Male bifwebe exercise mystical powers overtly and involve themselves in

political action and social activities. In these spheres they supervise the maintenance of roads and fields, guard circumcision camps, and, in the past, involved themselves with preparation for warfare.

Female masks are primarily white, with black accentuating the eyes and mouth, and a low crest running over the head. White is associated with ritual, an auspicious and positive color suggesting inner and outer being, goodness, health, purity, reproductive capacity, peace, wisdom, and beauty. Although they perform in regular, staged dance events to activate benevolent spirits and detect malevolent powers, female masks are passive in their use of mystical powers. Their role is linked to the lunar cycle and the death and investiture of chiefs. There is only one female mask in an organization.

Bwadi bwa kifwebe initiates learned the secret names and meanings for every part of the costume and the mask. Nostrils could be called "the openings of a furnace," the chin "the snout of a crocodile," and the eyes "the swellings of sorcerers." These secret phrases served as vehicles for a constellation of meanings understood only in part by any given member of the society at any time.

In some Songye regions, exposure to Western culture through Christianity, education, or trade made a negative impact on masking organizations. Although some masks are used for entertainment, they are no longer used in ritual, and production is primarily for sale on the Western art market. In areas less affected by Western culture, masks and figures continue to be made for local use.

Among the Songye, figure sculp-

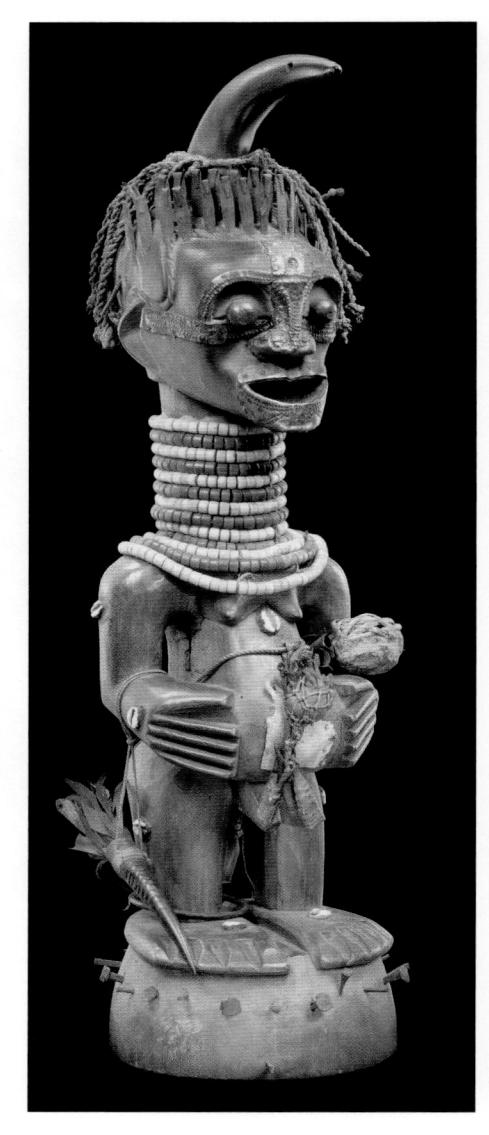

12-19. NKISHI, SONGYE. HEIGHT 345/8" (88 CM). ROYAL MUSEUM FOR CENTRAL AFRICA, TERVUREN

Sculptural form and aesthetic considerations are secondary to the nkishi's ingredients. It is a ritual container with powerful substances embedded in openings made into the swollen abdomen or head. These substances derive from body parts, such as the teeth, hair, feathers, or sexual organs of powerful animals including leopards, lions, birds of prey, crocodiles, and elephants. They may also be contained in horns and calabashes. The horns normally project from the top of the head; other horns, calabashes and smaller mankishi may be attached to the figure to increase its power charge.

tures, mankishi (sing. nkishi), are socially benign instruments that bring good fortune, protect, heal, and counteract evil. While a carver produces the wooden figure, a ritual specialist, nganga, adds a multitude of substances and objects that give nkishi its power, change its patina, and enhance its visual impact (fig. 12-19). Ritual specialists create two kinds of mankishi—small ones for individuals and families for household use, and large ones embodying ideas of power and aggression used publicly for the entire community. Each nkishi is imbued with an individualized identity, given a name, often that of a well-known chief, and treated as an individual.

The exuberant cascade of additive materials on some mankishi helps to individualize them. A horn and segments of rope accentuate the top of the head on figure 12-19). Brass bosses form the eyes. Strands of trade beads emphasize the elongated neck, and cowries dot the body. A horn holding powerful substances suspended from the arm adds power upon power. Pelts of wild animals and smaller mankishi, each with its own additive materials, might be among those things that make larger mankishi strikingly powerful accumulations of forms, suggesting not only visual power but, more importantly for their users, conceptual and spiritual powers as well.

SOCIETIES OF THE LEGA, THE BEMBE, THE MBOLE, AND THE AZANDE

In contrast to kingdoms in the savannahs, the peoples of the forests of Central Africa did not by and large develop centralized political entities.

Aspects of African Cultures

Rites of Passage

"Rites of passage" has been an important phrase in anthropological literature since Arnold van Gennep's classic 1907 study of that title. The phrase refers to the rituals that accompany changes of status among all the peoples of the earth. Many specific passages of this sort exist, marking such transitions as child to adult, ignorance to knowledge, asexuality to sexuality, low to high status, profane to sacred space, life on earth to existence in the afterworld of ancestors. The "passage" metaphor is at once psychological, developmental, and spatial. Doors, thresholds, and even processional avenues are sites of passage from one kind of place to another, qualitatively different kind of place.

A three-segment structure, first elaborated by van Gennep, characterizes all rites of passage: separation, transition, and incorporation. Initially, the process involves the separation of the novice from his or her current, soon to be previous, state. Separation is typically marked by the symbolic death of the novice, who thus enters the limbo of transition, the second segment of the structure. This is an inbetween or liminal state, which may last only minutes or extend for months, occasionally even a few years, as when a family postpones the second burial rites for an important deceased person long enough to amass the resources needed to provide an appropriate sendoff. Often, the transition is a time of mystery, fear, ordeal, and stress. Typically, and even upon elevation to kingship, the novice is at least symbolically reduced to a raw and unformed state during the liminal phase, which is left behind as rituals and instruction impart the secrets and other prerogatives of the higher status. Incorporation, the third segment,

names the acceptance of the initiate into the new position. He or she is now "reborn" and stable, as the passage is now complete.

In most cases art forms are invoked, worn, manipulated, or displayed as essential components of the transitional process, with another set for celebrating the new position. Why is it, we may ask, that art is inextricably bound into rites of passage? Because in Africa, as elsewhere, the symbolic system that embodies values, ideals, sacred history, and the gods is insistently present at just such times to sanction and inform the process. Symbols, being expressive, are often visually elaborated. The passages too must be rendered visible and memorable, focusing attention upon the occasion and its participants, marking them off as distinct.

Art is perfectly suited for such roles. Art forms are useful in evoking both tradition and mystery, inherited ancestral symbols and the powers of gods and ancestors whose presence is crucial to the success of the ritual. In some cases the mere presence of symbolic forms and processes is enough to create the appropriate atmosphere, while in others art objects as well as conventionalized gestures and acts are instrumental in moving the rite forward. Akan state swords with cast gold sculptures, for example, are used in swearing oaths of allegiance and fealty between chiefs. These ornamental swords are viewed as powerful in their own right, as are masked dancers in cultures where masquerade embodies the ancestral or spirit power and presence often so essential to effecting change in a community. In all, a great many visual art forms partake, whether passively or actively, in rites of passage. Their presence proves the cultural importance of these rituals while helping to create them. HMC

Instead, these small groups are governed through communal voluntary associations. Initiation societies are important in running village affairs. governing relationships among people, and guiding the moral development of individuals. Among the Lega, the Bwami society constitutes the most important instrument for organizing the community. The nearby Mbole have Lilwa, and the Bembe have a number of organizations, such as Elanda and 'Alunga. The Azande are an exception in that they organized themselves into several centralized kingdoms. Here, a secret society called Mani served not to govern but to provide ordinary people with supernatural protection against the abuses of rulers and the upper class.

Bwami

All Lega art is used within the context of the Bwami society, an organization that permeates every area of life. A philosophical society, Bwami teaches principles of moral perfection through proverbs, dances, and the presentation of objects in special contexts. While it is a voluntary association, it maintains and reinforces bonds of kinship within the community, lineage, and clan. Initiations into various grades and levels of Bwami are cohesive events that bind individuals, kinship groups, and generations.

Bwami produces, displays, and explains thousands of pieces of sculpture, including anthropomorphic and zoomorphic carvings, masks, caps, spoons, miniature implements, as well as abstract objects. Each miniature object is part of a multifaceted visual vocabulary employed by the society to instruct members in their moral

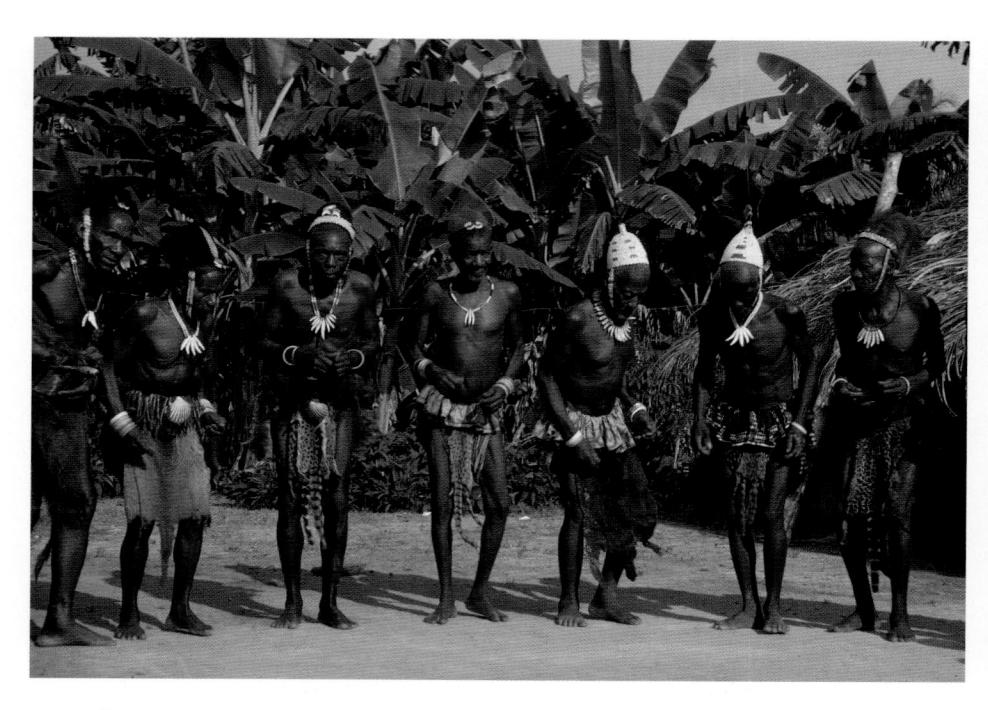

12-20. Bwami members dance in celebrating the initiation of a member onto the YANANIO grade. Lega, Congo. Photograph 1967

Note the caps, necklaces, and animal skins that make up the garb for Bwami performances. Hats may be covered with goatskin, nutshells, elephant tail, cowries, beads of imported buttons.

code. Most anthropomorphic figures are called *iginga* ("objects that sustain the teachings and precepts of Bwami"). Each is a symbolic representation of a named personage with specific moral qualities, either good or bad, further expressed through proverbs and songs as they are manipulated during initiations. Displayed and danced in various contexts, objects change meanings according to the context in which they are used or according to other objects displayed with them.

Performances, referred to as dances, in which natural objects and art objects are manipulated, take place in cycles throughout an initiation event. The dance is a multimedia display, and the preceptor or teacher takes pride in his creativity in organizing

the various elements. In these events. Bwami initiates are introduced to the artworks in an established order. In initiations into the first of the grades, proverbs and other verbal forms help to construct layered metaphors. Drama, music, and some natural objects are then added. Eventually art objects in the forms of animals, and ultimately humans and masks are revealed. Endless possibilities for arrangements and configuration of all the various elements (fig. 12-20) provide a wide range of possible connotations for each performance as well as for each object, providing richness of meaning.

Although a great number of manufactured and natural objects are used in the progression through all Bwami grades, only individuals in the two

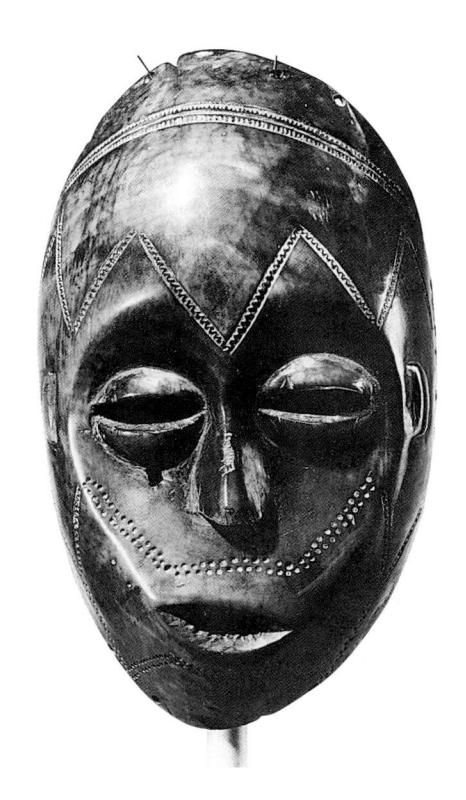

12-21. BWAMI SOCIETY MASK, LEGA, CONGO, 19TH–20TH CENTURY. IVORY. HEIGHT 8½" (21.6 CM). THE METROPOLITAN MUSEUM OF ART, NEW YORK. THE MICHAEL C. ROCKEFELLER MEMORIAL COLLECTION. BEQUEST OF NELSON A. ROCKEFELLER, 1979

highest grades own art and manipulate it, and only members of the highest grade own ivory. The ivory mask shown here manifests the typical, concave, heart-shaped face of Lega carving (fig. 12-21). Aesthetically it is smooth, well-patinated, glossy, controlled, and stylized. Of the idumu class, the highest category of Bwami objects, it is used in a variety of contexts in the highest rites. Each object is associated with a body of proverbs and placed in configurations of displays, or danced and held as proverbs are revealed. Idumu objects are owned and used by members of kindi, the very highest level of Bwami grades.

In performances, idumu may be

attached to a framework surrounded by other masks. In these configurations, *idumu* may be placed in association with the small mask known as *lukwakongo* (fig. 12-22), typically heart-shaped and carved of wood. Kaolin smeared on the concave portion whitens the characteristic features of slit eyes, open mouth, long nose, and fiber beard. *Lukwakongo* are owned individually by men initiated into *yananio*, the second highest grade of Bwami.

The whitened, heart-shaped face characteristic of masks is also apparent in Bwami figural sculpture. The highly stylized object shown in figure 12-23 has such a face on either side of its flat, board-like body. It raises stumpy arms and rests on bent legs. The body is perforated with many holes. The object is from one of two baskets owned collectively by members of the highest Bwami grade. Ritually transferred at each initiation, the baskets are held in trust by two of the newest members of the grade. Each contains a number of anthropomorphic and zoomorphic wooden carved objects that serve as symbols of solidarity and social cohesion within the group. The baskets must be present at any initiation: objects are removed one by one and commented upon or placed in groupings to be explained and interpreted.

Bwami was outlawed in 1933 and formally abolished in 1948. In spite of alternate toleration and persecution during the colonial period, it continued to exist underground or in altered forms. With Congo independence in 1960, it was made legal again. However, its struggle to survive continues. In the 1990s, the region was at the center of political

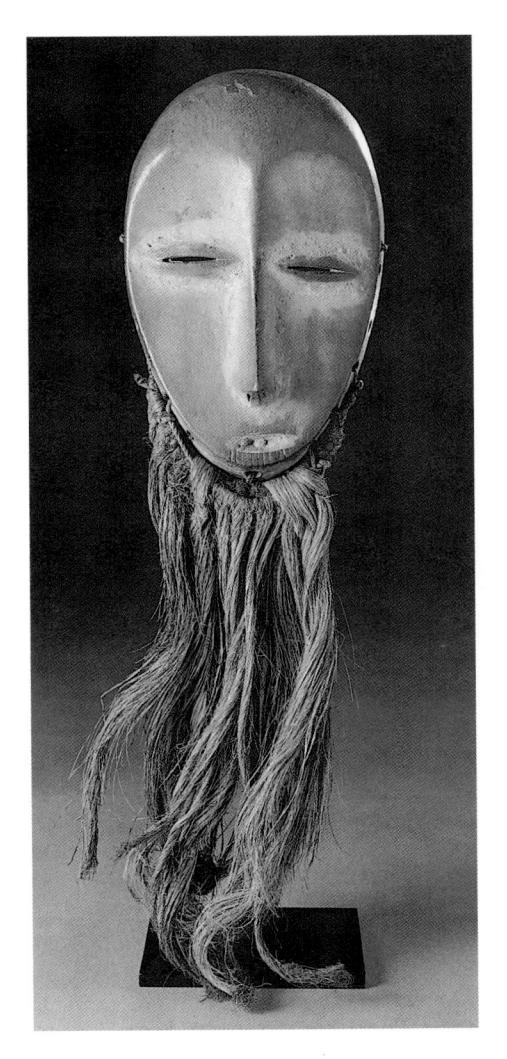

12-22. Lukwakongo, Bwami society Mask, Lega, Congo, early 20th century. Wood, pigment, fiber. Height 7½" (19.3 cm). The University of Iowa Museum of Art, Iowa City. The Stanley Collection

Lukwakongo is used in dramatic performances and may represent various characters or refer to numerous social, judicial, moral, or philosophical principles. It may be carried in the hand, fixed to the side of the face, attached to the side or back of a hat, placed in a linear grouping with like masks, heaped in a pile with other masks, dragged by its beard, or attached to a wooden frame with other objects. Such groupings symbolize specific relationships between living and dead members or special ties between living initiates who inherit masks from one another.

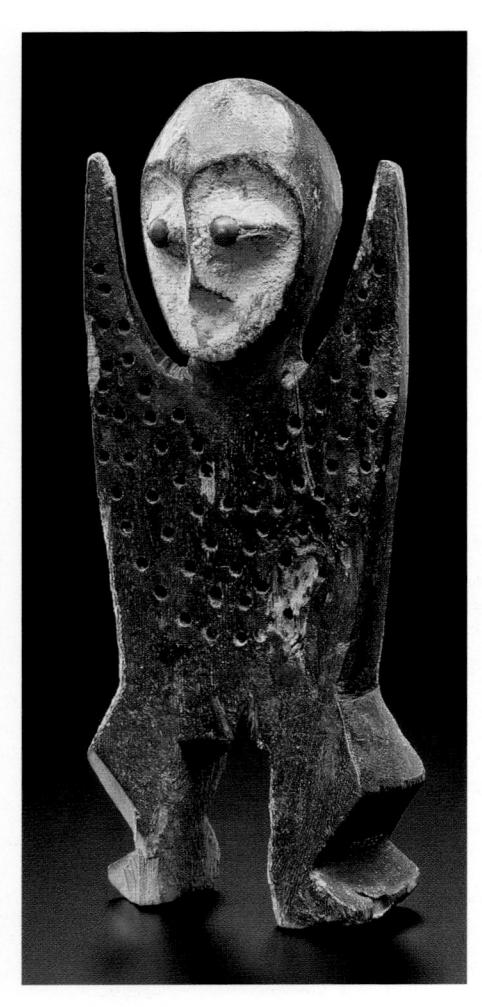

12-23. Bwami society figure, Lega, Congo. Wood. Royal Museum for Central Africa, Tervuren

upheaval, and this was followed by the horrific warfare that engulfed vast territories in Congo, Uganda, Rwanda, and Burundi.

Elanda and 'Alunga

The Bembe live on Lake Tanganyika to the east of the Lega, a traditionally restless area characterized by the migration of peoples. The Bembe are culturally eclectic, accepting influences from many directions in an area with complex historical relationships.

This is reflected in their art, for various elements are traceable to different sources, making classification difficult. A number of cultural elements, especially the importance of the Bwami society, can be traced to contact with the Lega. Some art forms are unique and associated only with the Bembe, others are distinctly like those of the Lega, and others seem related to the art of Luba-related groups to the south.

Apart from Bwami, with its Lega roots, there are a number of initiation associations. Elanda, a male association of young men already circumcised but not yet married nor initiated into Bwami, focuses on ancestors who make their will mystically known through dreams, sickness, the last words of a dving father, or transgressions of Elanda taboos. Elanda initiation centers on a mask made of bark and lambskin, covered with beads and cowries, and finished with feathers (fig. 12-24). The mask is considered to be a terrifying and mysterious force, ebu'a, and must not be seen by those not initiated into Elanda, although they hear its mysterious voice.

The initiation system called 'Alunga seems to have derived from a hunters' organization; and its mask is ibulu lya alunga ("the protector of honey") (fig. 12-25). The 'Alunga masquerade is also ebu'a; another name is m'ma, an ancient spirit of the wild, for it is considered to be an aweinspiring and powerful "something" from remote times. The double-faced helmet mask is a striking vision of abstract forms. Conical eyes on black crosses project from huge, whitened, concave eve orbits. A feather- and porcupine-quill bouquet tops it. In performance, the wearer's body is

covered with a banana leaf and fiber costume. The frightening character it represents calls with a harsh, hoarse voice, and the men who wear it are chosen partly for their ability to make appropriate sounds.

As ibulu lya alunga dances, a trumpeter calls members of 'Alunga together in neighboring villages, announcing its arrival. The role of the mask and its treatment vary during the course of its appearances. In secret places in forests or in caves, its use is a guarded secret involving ancestors and nature spirits. In a shrine outside the village, where it dresses for community appearances, its activities are still secret. In the men's house, it is transformed from a frightful bush spirit into a friendlier, more acceptable persona, and finally, in the village, the performer takes on a differ-

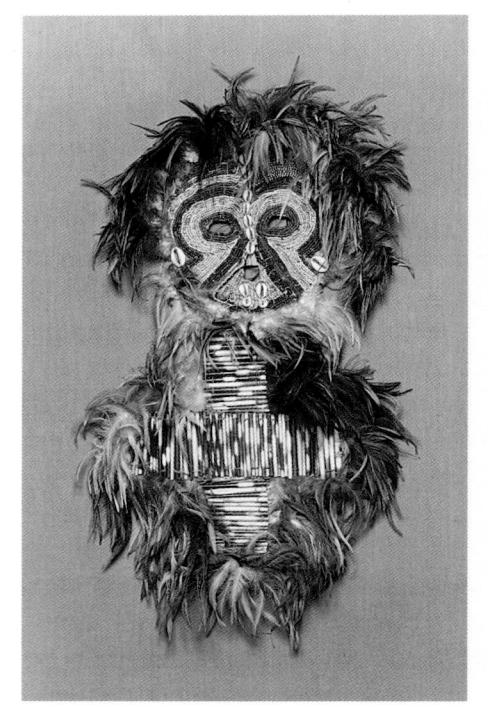

12-24. Elanda mask, Bembe. Leather, cloth, beads, cowries. Indiana University Art Museum, Bloomington

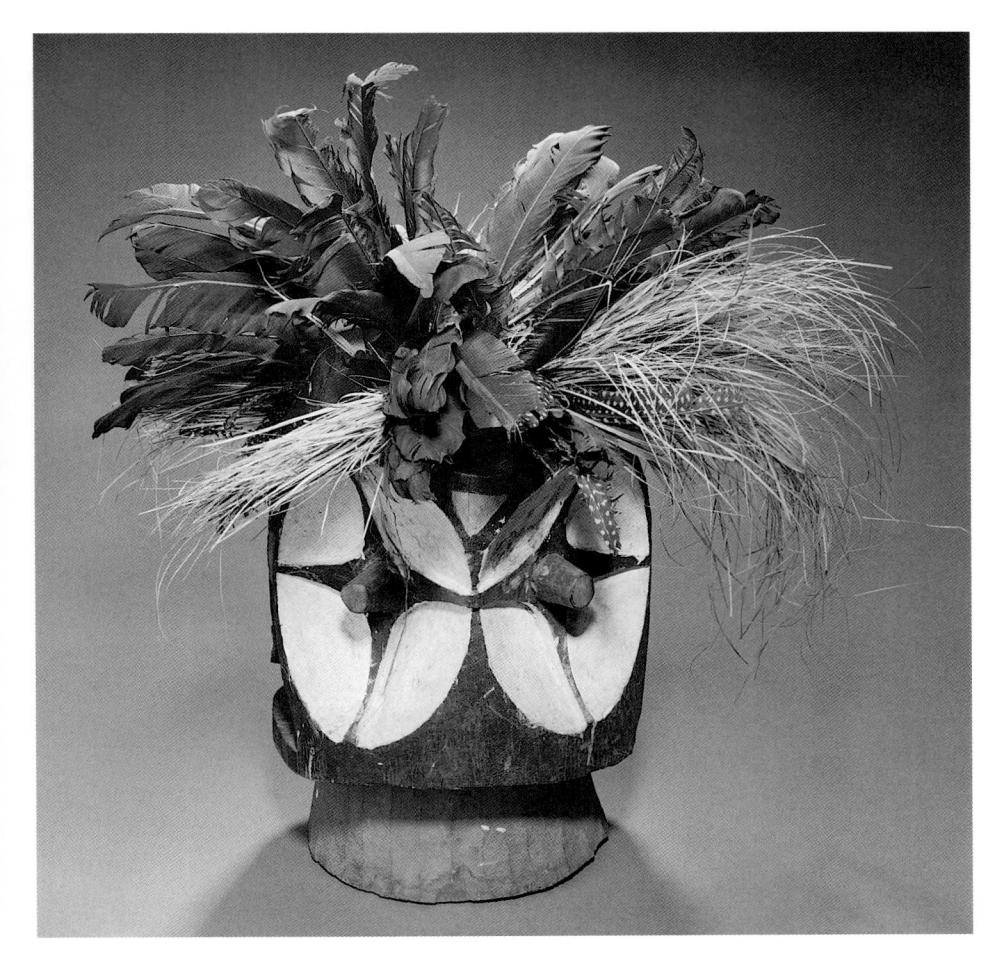

12-25. *IBULU LYA ALUNGA* ("PROTECTOR OF HONEY") MASK, BEMBE, CONGO. FOWLER MUSEUM OF CULTURAL HISTORY, UNIVERSITY OF CALIFORNIA, LOS ANGELES

ent gait and voice. The perceptual confusion is intentional and a desired aspect of the mask's appearance.

Lilwa

The Mbole people along the Lomami River to the northwest of the Lega produce easily recognized figures known as *ofika* for the Lilwa society (fig. 12-26). The example shown here is typical, with broad forehead and crest-like hairdo running across the head. Eyes and mouth are narrow slits in the concave, heart-shaped face. The whitened face and yellow ocher

chest contrast with the dark of the hair and body. The elongated body hunches shoulders forward, while loosely hanging arms touch the thighs. Feet do not rest flatly on the floor, for the figure was intended to hang suspended by cords laced through holes in the shoulders and in the buttocks.

Lilwa, a graded men's organization, dominates Mbole life. Lilwa is not unlike Bwami, for it fulfills ritual, educational, judicial, social, political, and economic functions. As in Bwami, a sophisticated moral philosophy underlies its teachings and rituals.

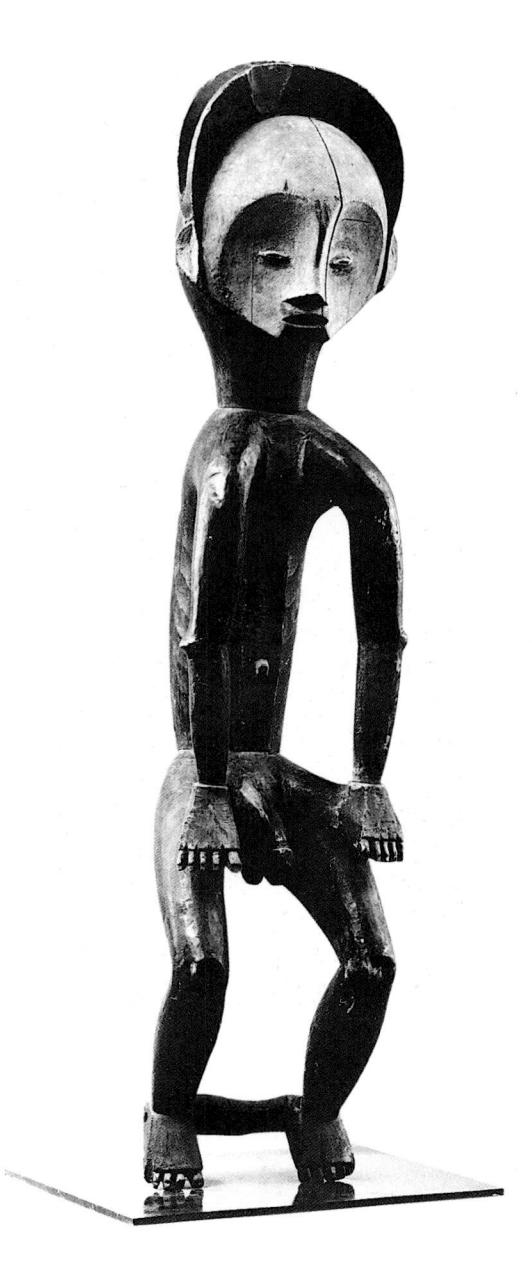

12-26. Lilwa society *OFIKA* figure, Mbole, Congo, 19th–20th century. Painted wood. Height 32%6" (82.4 cm). The Metropolitan Museum of Art, New York. The Michael C. Rockefeller Memorial Collection. Purchase Nelson A. Rockefeller, Gift 1968

Boys of seven to twelve years old are isolated in the forest for circumcision and initiation, undergoing ritual purification and proving themselves through ordeals and fasting. They are instructed in appropriate moral, ritual, and social behavior and receive a practical education. Objects, such as ofika, are purportedly used to impress on the boys the importance of secrecy within Lilwa. Execution by hanging was the punishment for a number of crimes among the Mbole, especially for revealing secret information. Each ofika, hidden from the uninitiated, bears the name of a hanged individual. In the first phases of initiation, boys are beaten and shown the images, which have been strapped to a decorated litter. The young men learn the circumstances of the condemnation, trial, and execution of these individuals who infringed Lilwa's moral and legal code. It is a powerful warning of the need for social rules and the teachings of Lilwa.

Mani

Numerous secret societies spread through the northern reaches of the forest zone, including Mani, which appeared among various small ethnic groups in the northern Congo basin toward the end of the nineteenth century. By the early twentieth century it had reached the banks of the Uele River, where it was firmly established among the Azande peoples. Mani, composed of local lodges with male and female membership, provided success and general well-being, ensuring effective hunting and fishing, guaranteeing fertility, protection against evil and sorcery, and harmony within family and community. Among the Azande, Mani

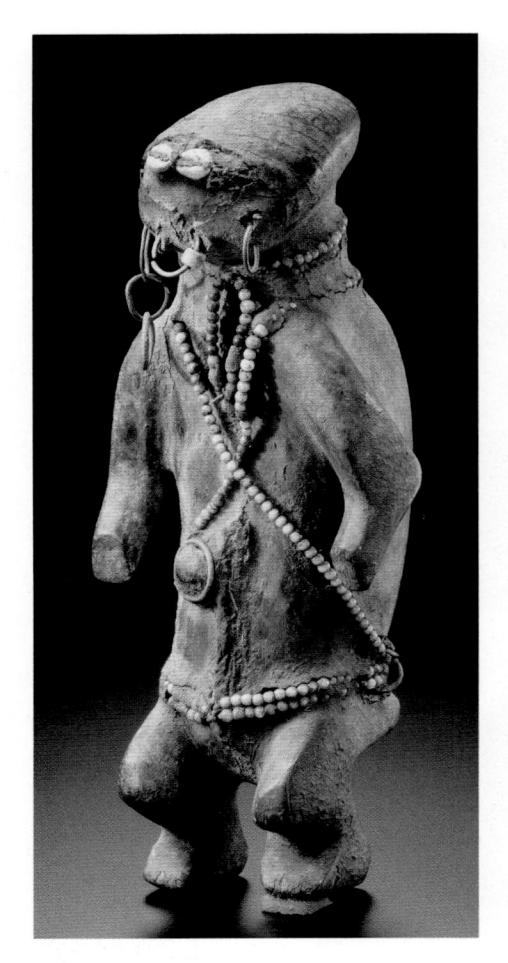

12-27. YANDA FIGURE, ZANDE. HEIGHT 12½" (32 CM).

also served to protect members from oppression by the upper classes through supernatural means. Azande chiefs saw it as subversive, an outlaw cult. Its activities were eventually curtailed in the early twentieth century by the colonial administration.

Numerous small wooden and terracotta figures used within Mani were classified according to several types and generically known as *yanda* (fig. 12-27). The term designates mystical power and refers as well to the spirit or force to which Mani was dedicated. Most *yanda* are standing, abstracted anthropomorphic figures reduced to

the essentials. Most *yanda* figures lack arms. Legs, if included, are minimal, often reduced to a cone-shaped base with the umbilicus dominating the torso. Although *yanda* figures are referred to as female, their sex is most often not recognizable.

Yanda figures assisted members in achieving goals and protected them from adversity. Their power derived from several sources. The wood came from sacred trees, providing mystical potential in its very being. The figure was activated through ritual, as a substance prepared of ingredients selected for medicinal properties was applied to its surface. In subsequent rituals its keeper smeared activating substances over it and provided it with gifts of food, building up a crust of magic substance. When prayers were offered, gifts of beads, metal rings, or coins were attached to the torso, neck, waist, and ears. Thus the yanda changed over time as it gained a patina of crusty offerings and decorative attachments.

COURT ART OF THE AZANDE AND THE MANGBETU

Whereas most peoples in the forests of eastern Congo were widely dispersed and politically decentralized, the Azande and their Mangbetu neighbors formed centralized kingdoms along the Ubangi and Uele rivers. The Azande developed from an assortment of peoples organized by Avongara chiefs from the north. They never established a single entity, but several Azande kingdoms were active. Unlike kingdoms far to the south, the Azande and Mangbetu did not pass royal heirlooms down through generations.

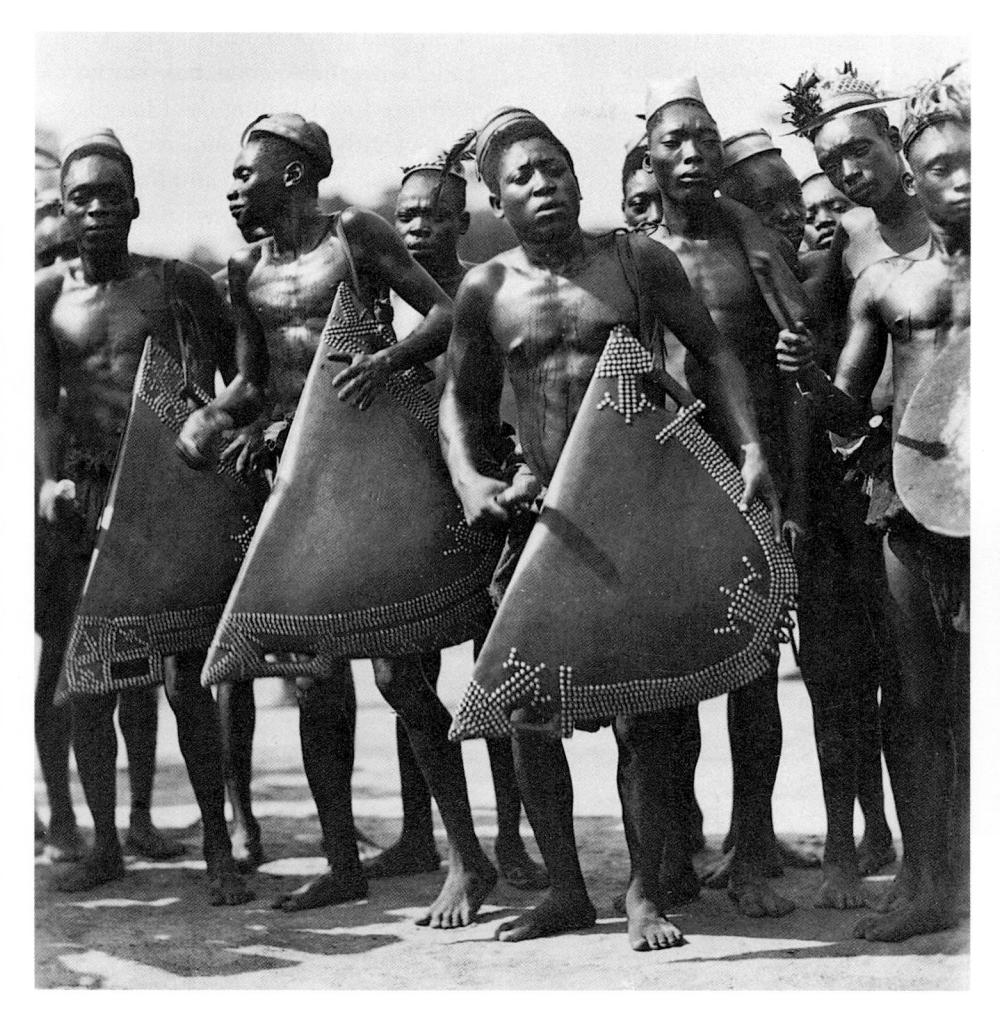

12-28. Mangbetu musicians playing wooden gongs, Uele region, Congo. Photograph c. 1935–8

Regalia and ritual art were scarce. Most sacred art for Azande aristocrats tended to be minimal adaptations of practical objects such as pottery, stools, headgear, harps, slit gongs, shields, and weapons, all of superb craftsmanship but not limited to royalty.

Court items included a variety of musical instruments. A photograph from the 1930s shows a group of Mangbetu musicians carrying flat, bell-shaped wooden gongs (fig. 12-28). These portable instruments were played in royal orchestras that also included drums, iron bells, and horns.

They performed for formal, ceremonial occasions; gongs were also used to communicate during military expeditions. Distinct tones of different gongs allowed tonal languages to be mimicked, and those whose tones carried long distances were much esteemed. They were carefully designed, beautiful objects, their surfaces blackened with mud and embellished with designs of copper alloy studs.

Smaller instruments such as sanzas, or thumb pianos, and harps accompanied songs for less formal occasions and for personal pleasure. The sanza consists of a number of vibrating keys positioned over a sound box. Keys cut at various lengths produce a range of tones when struck with the fingers. In many regions of Central Africa parts of the sanza are compared to those of a woman's body. In the example shown in figure 12-29 the comparison is explicit, as the instrument represents a woman lifting her arms in dance.

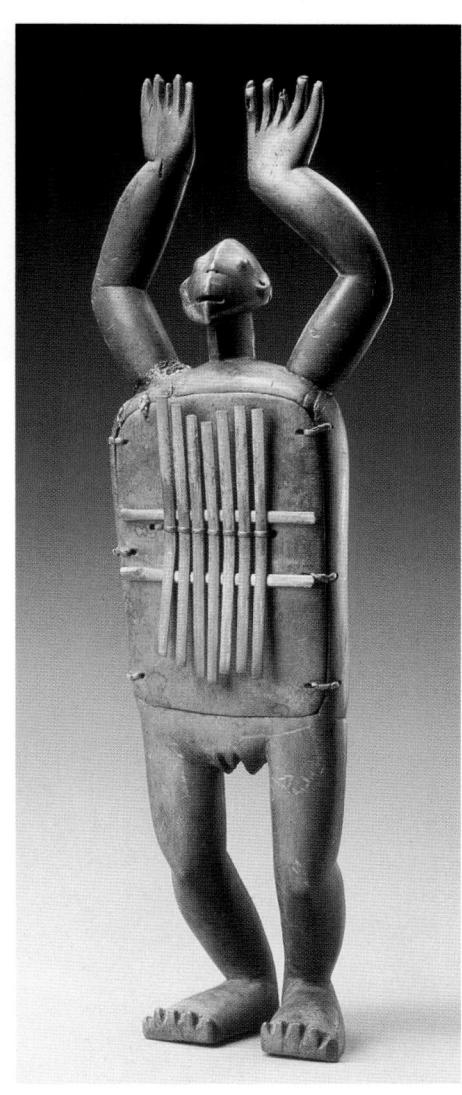

12-29. Sanza, Azande, 19th Century. Wood. Height 24" (61 cm). Royal Museum for Central Africa, Tervuren

12-30. Harp, Mangbetu, Congo. Musée Barbier Mueller, Geneva

12-31. KING MBUNZA. MANGBETU, CONGO, 1874

King Mbunza holds a spectacular sickle knife of a type known as emamble, a symbol of power that is carried like a scepter. Such knives, often with two or three holes worked into the blade, were works of exceptional merit and highly prized for fine craftsmanship. They often required artistic collaboration, a smith creating the blade and a worker in wood or ivory carving the hilt and wrapping it with copper or iron wire. An assortment of objects surrounds Mbunza and speaks of his position and wealth. Two small carved stools serve as tables, positioned on either side of the king. On one a curved, superbly formed knife rests; on the other, a small terracotta water bottle.

Figured harps seem to have originated with the Azande, but many were produced among the Mangbetu to the south of the Uele River (fig. 12-30). Made of wood and lizard skin, such harps were not important in court orchestras, but kings commissioned them as prestige gifts.

The Mangbetu established a major kingdom in the eighteenth century and influenced many neighboring peoples. By the mid-nineteenth century several European visitors had written enthusiastic accounts of their courts. While each Mangbetu ruler had a number of traditional symbols—leopard pelts, red tail feathers of the gray parrot, and iron gongsno specific art forms were associated with his reign other than ornate knives. Upon his succession to the throne, each ruler built a new capital and commissioned objects associated with wealth. His treasury included knives with wood or ivory handles, headrests, stools, and items of personal adornment, none limited in use to the king, for any person of wealth could own them. Not symbolic of kingship, they carried no ritual meaning. Upon his death, the treasury was destroyed and buried with him.

Early visitors to Mangbetu were impressed by the opulence of the courts but recorded little in the way of figurative art. Georg Schweinfurth's description of King Mbunza in the 1870s provides details of the court and its visual forms. A drawing by Schweinfurth shows Mbunza on a distinctive bench pieced together from carved pieces of wood and raffia palm fiber (fig. 12-31). The seat is backed with a tripod backrest made from a tree trunk with projecting limbs as supports. Chiefs' backrests

12-32. Mangbetu woman, Okondo's village, Congo. Photograph 1910

were elaborately decorated with metal wrappings and studs, as in this example. Metal, especially copper, was associated with wealth, since both the highly valued copper and copper alloys had to be imported from the south.

All Mangbetu spent a great deal of time embellishing themselves. The arts of personal adornment are evident in the drawing of King Mbunza. A variety of copper objects adorn the king, reinforcing ideas of power and wealth—copper bars project from his pierced ears, and there are copper rings on his arms, legs, neck, and chest, and a copper crescent on his wrapped forehead. Around his waist

the distinctive barkcloth wrapper, nogi, made from the inner bark of two species of fig tree, passes between his legs and is belted at the waist, allowing large folds to project stiffly above.

In Mangbetu personal aesthetics, the head was the focus of attention. An infant's head was lengthened by rubbing and binding, later extended by exaggerated hairdos or headdresses such as Mbunza's narrow basketry cylinder, a foot-and-a-half high and decorated with rows of red parrot feathers. A pompom and cascading plumage emphasize the head length even more.

Both women and men wore hairdos that sloped back at an angle (fig. 12-32). The hair was worked so that the emphasis was from the forehead to the rear. Extra hair, sold in the market, was worked over a funnel-shaped form of reeds for dramatic effect. String made of human hair and plant fiber bound the forehead. Both men and women wore prestige hair-

pins of wood, iron, copper, brass, silver, or ivory. Ivory hairpins especially indicated wealth.

A second Schweinfurth illustration shows Mbunza dancing before an audience (fig. 12-33). Royal wives sit atop carved stools to admire Mbunza while nobles line the walls of the imposing structure. The formation of their heads is conspicuous. The Mangbetu called attention to the body by rubbing it with fragrant colored oils. Body ornament helped to express individuality and personal. aesthetics, and special events called for striking body painting. Here, each wife used the juice of the gardenia to adorn her entire body. Everyone, according to Schweinfurth, tried to outshine her peers with an inexhaustible number of elaborate patterns applied freehand or with stamps, including stripes, stars, Maltese crosses, flowers, and other designs. These lasted about two days before having to be replaced.

In Mbunza's town the court con-

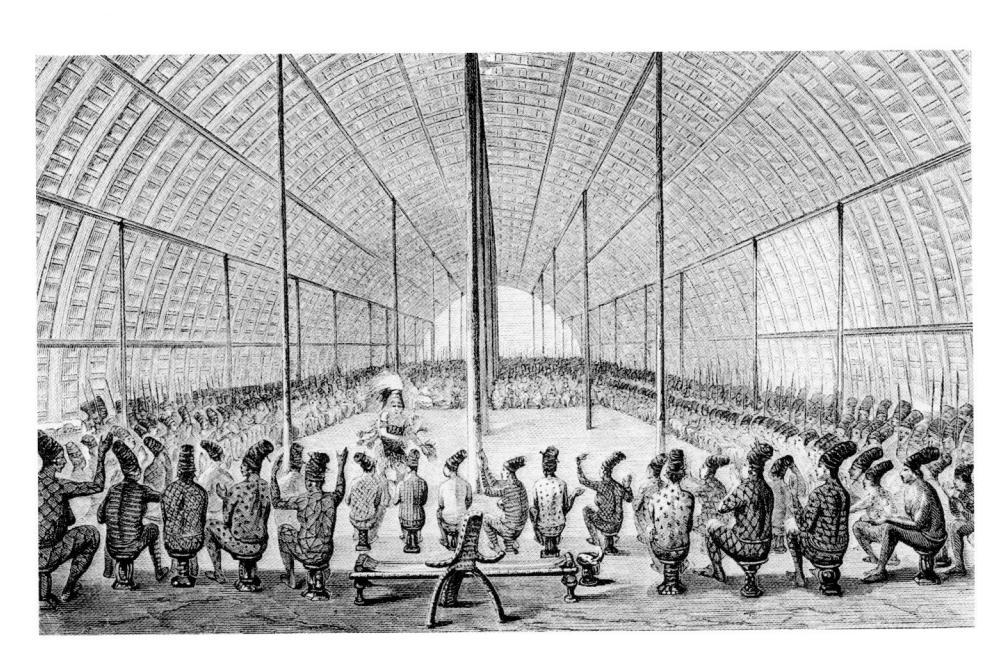

12-33. KING MBUNZA'S AUDIENCE HALL, MANGBETU, 1874

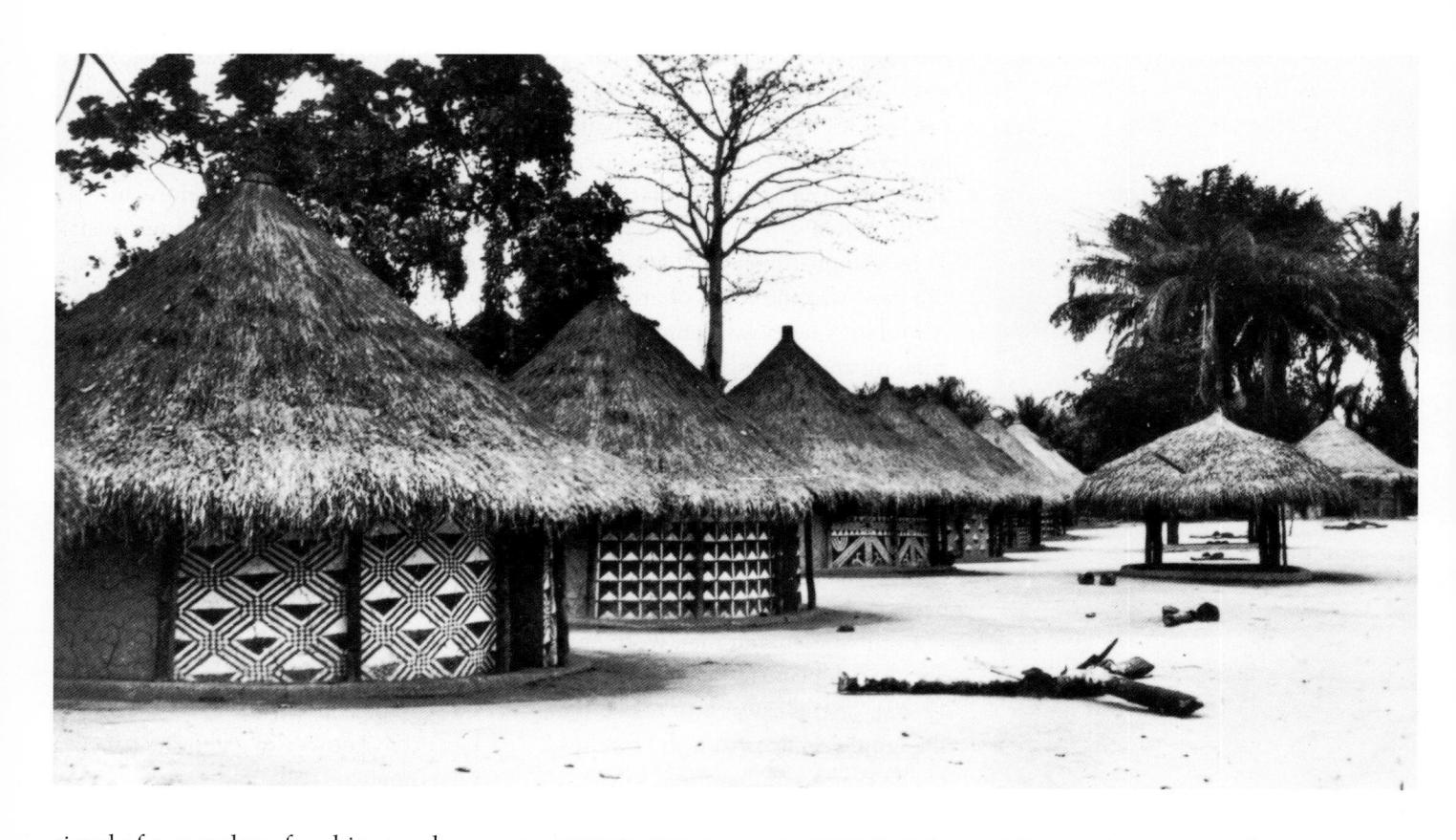

sisted of a complex of architectural structures—audience halls, royal residence, wives' houses, and houses for officials, soldiers, advisors, craftsmen, relatives, servants, and slaves. The spacious audience hall shown in figure 12-33 was 140 feet long, 40 feet high, and 50 feet wide. The bold arched vault, supported by rows of perfectly straight tree trunks, was roofed and walled with midribs of raffia palm. Woodwork was polished to a sheen, and the red clay floor was burnished. Schweinfurth's description suggested that there was a still larger reception hall, 150 feet long and 50 feet high. These imposing structures were used for feasts and royal audiences. The interior of the structure illustrated here was decorated with a display of the wealth and magnificence of the kingdom. Hundreds of metal lances and spears arranged on

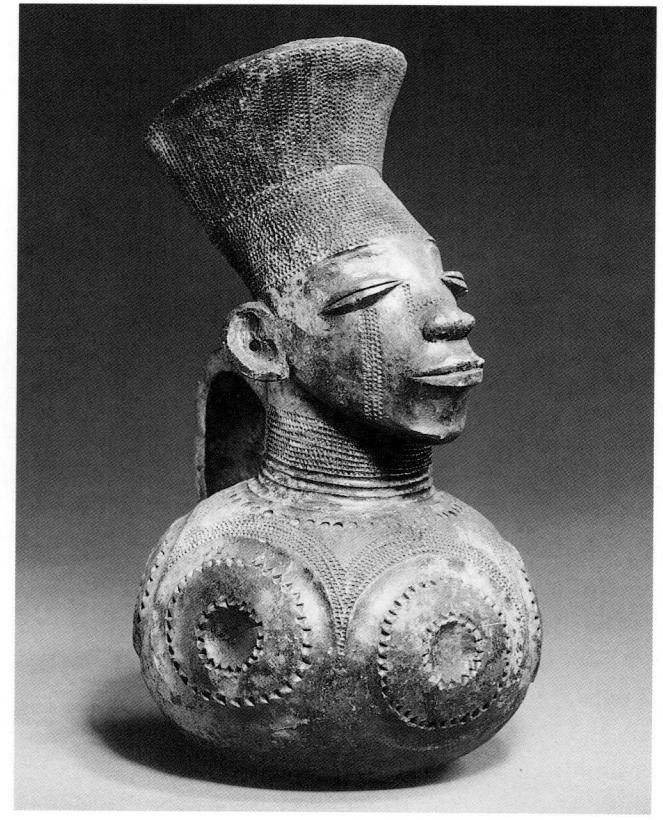

12-34. EKIBONDO VILLAGE, UELE, CONGO. PHOTOGRAPH 19TH CENTURY

12-35. Figural Pot, Mangbetu, before 1913. Ceramic. Height 10¾" (26.5 cm). American Museum of Natural History, New York

temporary scaffolding were admired, while trumpeters blew ivory horns and musicians struck iron bells.

Nineteenth-century houses were normally constructed of reeds. Visitors compared beautifully worked reed patterns to brocade and mosaic designs. By the late nineteenth century reed walls were gradually replaced by plastered mud and stick walls. Although reed walls were still fashionable when the photograph in figure 12-34 was taken, a new cylindrical style with mud-plastered walls had gained favor. Spacious communal areas lined by neat cylindrical houses with conical thatched roofs provide beautiful views. Bold geometric patterns symmetrically arranged on either side of the entrance perhaps derived from abstract patterns previously woven in reeds. Such designs are also known from body painting and barkcloth skirts. Attention was lavished on the aesthetic enhancement of the interior of the house as well. Support posts were each carved with a different set of geometric patterns and then burnished and blackened with dark mud.

The European presence during the colonial period expanded the market for art and encouraged the anthropomorphizing of previously nonfigurative objects. Whereas figurative ornament on objects such as harp necks, knife handles, and box lids had been rare in pre-colonial times, these art forms were produced in greater numbers by the Mangbetu and neighboring groups in the early colonial period. The ideal of feminine beauty with elongated bound head was mimicked in figurative art.

Both the Azande and Mangbetu had traditions of making elaborate

pots with a broad range of types, styles, and surface design. Now, inspired by European preferences, heads and bodies were added to previously non-figurative types. The pot illustrated here, like a number of objects, depicts a Mangbetu woman (fig. 12-35). A woman often made the pot, embellishing its surface with traditional patterns, while a man added the head. By the first decade of the twentieth century, pots and other figurative objects were given as prestige gifts to foreign visitors and were being used by dignitaries themselves, but anthropomorphic objects never really became part of daily living even for aristocrats. They were made for only a short time during the early colonial period, and their production soon died out.

THE MBUTI

The Mbuti are nomadic foragers of the Ituri forest, descendants of the ancient populations known as "pygmies." Living in small groups, they are famous for their polyphonic music and dancing, mentioned in ancient Egyptian documents. In yodeling they interlock discrete units of sound. In storytelling they easily switch back and forth from one language to another in the same narrative, placing seemingly unrelated elements next to each other in a provocative and effective way.

The aesthetics of verbal and musical arts are reflected in their barkcloth paintings, the visual art for which they are best known. Prior to the colonial period, barkcloth was the primary fabric used by all people of Central Africa. Men normally created a soft, flexible fabric from the inner

12-36. Mbuti women holding barkcloth designs

bark of a specific tree. Among the Mbuti, women decorate it with spontaneous expressive patterns painted with gardenia juice and carbon black. The freely painted abstract, linear designs form a wide variety of patterns that seem to shift radically even within the same piece. Here two Mbuti women hold up cloths painted with seemingly random patterns across the uneven barkcloth (fig. 12-36). On the left, broad spaces between the linear elements above are reduced below as lines bump into and cross the meandering parallel path. To the right, tendril-like patterns twist and curve across the upper two-thirds of the cloth, but below, a radical change occurs as two vertical bands of parallel lines with curling forms projecting

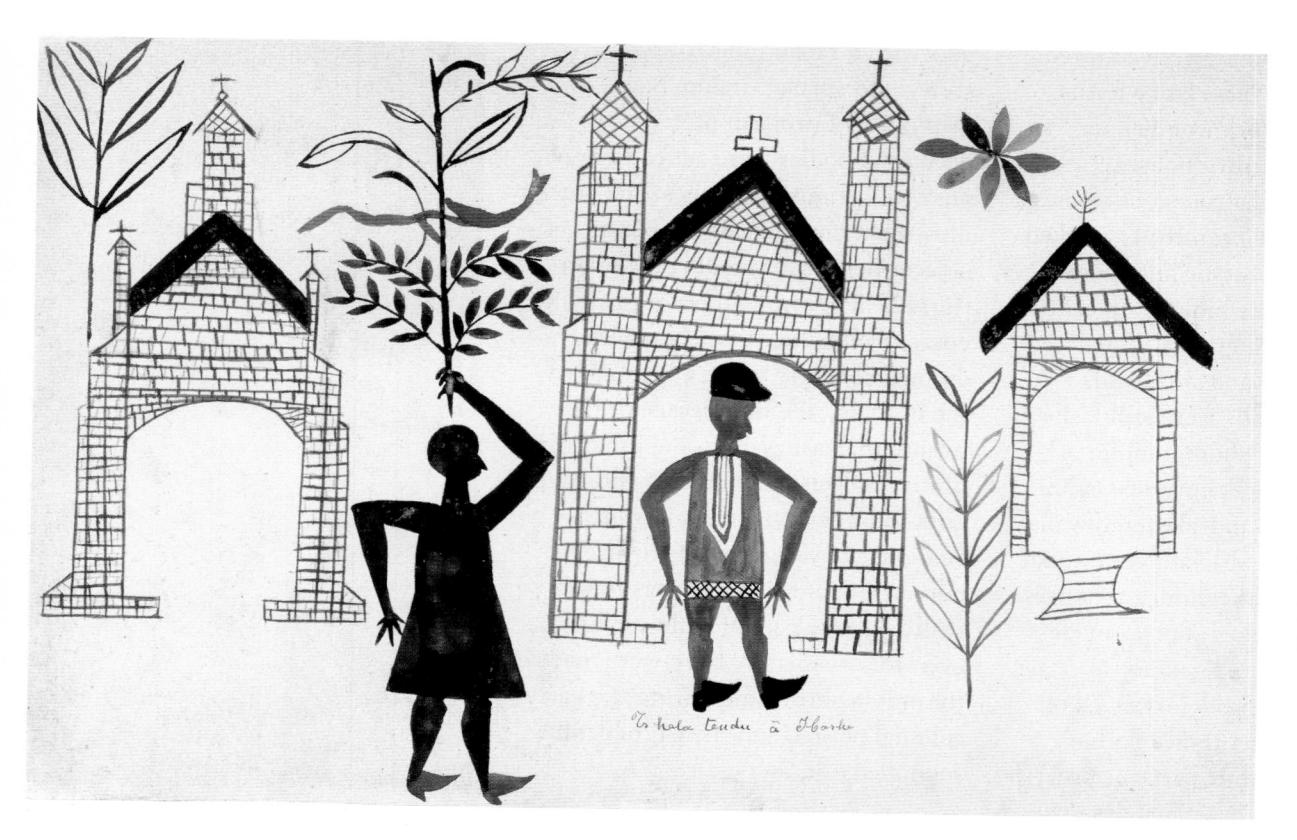

12-37. L'ÉGLISE ("THE Church"), DIILITENDO (TSHYELA NTENDA), Congo, C. 1930. WATERCOLOR ON PAPER. 1211/16 X 1911/16" (32.3 X 50 CM). National Museum of AFRICAN ART, SMITHSONIAN Institution. WASHINGTON. D.C. Museum PURCHASE

to the right dominate. These sudden pattern shifts are related to the interaction of seemingly unrelated elements heard in Mbuti yodeling and storytelling.

The meaning of Mbuti iconography is not known. Possibly linear designs stem from or are at least related to patterns on the faces and bodies of both men and women. Such designs are considered sacred, an indication that the wearer is a child of the forest, protected by a forest animal totem. They are signs of respect for the rituals and the tools of the forest and its people.

During the last years of the twentieth century, an international conflict erupted along the northeastern border of Congo (then Zaire), provoked by civil warfare in neighboring Rwanda. For over a decade, communi-

ties of forest dwellers (such as the Mbuti) and town dwellers (such as the Lega and Bembe) have been disrupted by refugees fleeing westward, and have been attacked by the militias, mercenaries, and soldiers sweeping through the region. We do not yet know how the cultural institutions and arts of these peoples have survived under this onslaught.

PAINTING FROM LUBUMBASHI

Although the city of Lubumbashi, in the southeastern corner of the Democratic Republic of Congo, has been spared much of this recent civil strife, it has been affected by the social and political instability of the country as a whole. Founded by Belgian colonizers as Elizabethville,

it was once both a booming mining center and a thriving trading depot. In the early years of the twentieth century, it attracted African entrepreneurs from many ethnic groups, as well as Belgian merchants and engineers.

A Belgian colonial official provided several local men with paper, colored pencils, brushes, and watercolors in the late 1920s. Although at least one of the men evidently had been painting murals for African clients, the patron was convinced that they were self-taught, and that their drawings were thus spontaneous expressions of their African sensibility. When the work of these artists was exhibited in Europe in 1929–31, some critics were indignant that the images included such "non-African" items as umbrellas or bicycles. The most prolific

12-38. Birds Eating Fishes, Pilipili Mulongoye. Oil on canvas. 26% x 29%" (67 x 76 cm). Private collection, Gothenburg

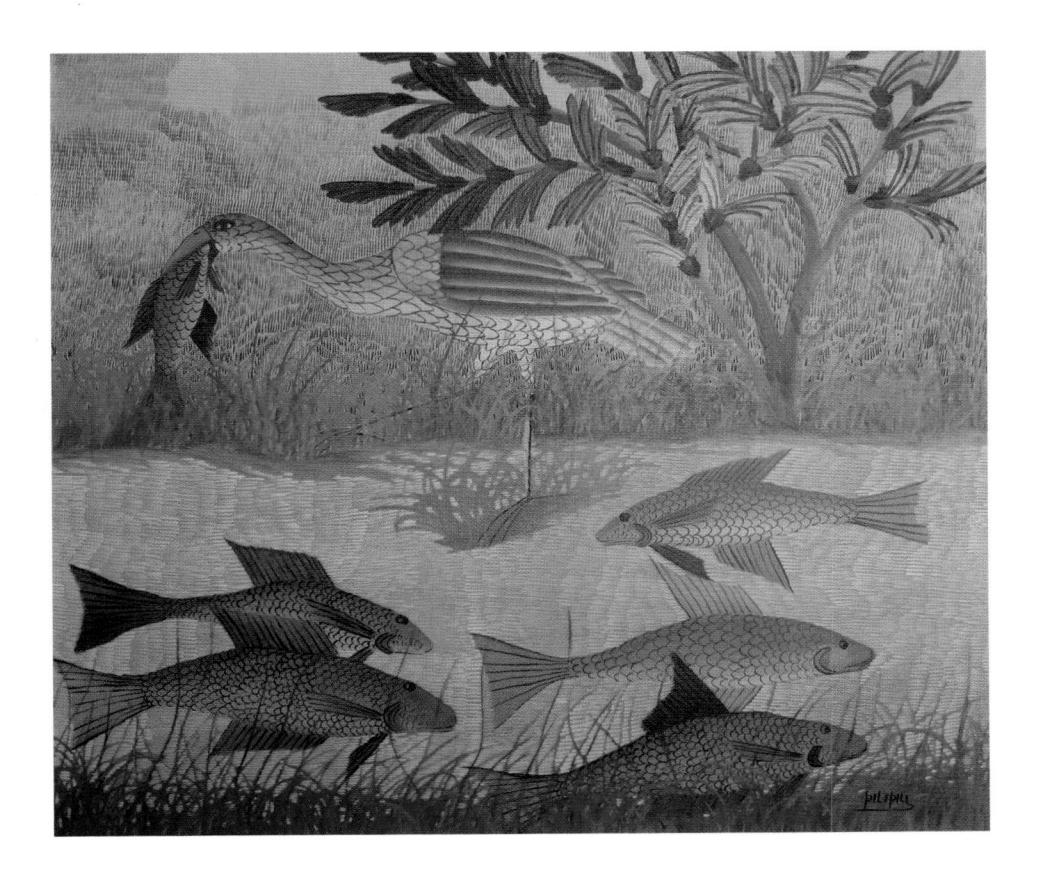

artists in this group included Andre Lubaki and Tshvela Ntendu, known to his patrons as Djilatendo. The work illustrated here (fig. 12-37) demonstrates the playful, colorful style of Diilatendo, which charmed foreign collectors and fascinated European artists involved with the movement known as surrealism. The lack of documentation available for either Diilatendo or Lubaki is a reminder of how little has been written about the painters, sculptors, illustrators, and photographers who worked in African cities in the first few decades of the twentieth century.

The "discovery" of these artists by colonial authorities may have encouraged a French painter named Pierre Romain-Desfossés to establish an art center in the city immediately after World War II. Called "Le Hangar,"

Romain-Desfossés's studio trained an influential group of artists. At least one would eventually teach at Lubumbashi's Académie des Beaux Arts. Romain-Desfossés, like Pierre Lods in Brazzaville (see chapter 11), provided artists with materials to produce drawings and paintings, twodimensional art forms in the European tradition that could be clearly differentiated from threedimensional indigenous arts. Unlike Pierre Lods, Romain Defossés insisted that Le Hangar participants carefully observe the world around them. The result was the production of decorative, stylized paintings of nature, all marketed to European clients. These were interpreted as being "typically African" for a variety of reasons, and the artists of the group soon received international recognition.

One of the best known was Pilipili Mulongove (born 1914), who until his association with Le Hangar had been a house painter in Lubumbashi. Among the first to associate themselves with Romain-Desfossés, he assumed a role of leadership in the group. Pilipili's paintings demonstrate a highly personal style identified by refined drawing in which delicate lines are set against a delicately brushed, flat background of a single color. Decorative and beautifully colored, Birds Eating Fishes (fig. 12-38) is typical of Pilipili's style. He produces an attractive design in which delicate lines define a tiered view of nature. His stream, hemmed in by green strips of grass, is populated by fish in various tones of blue, repetitions of similar shapes. A bird on the opposite shore is in the act of eating a 12-39. LA MORT HISTORIQUE DE LUMUMBA,
MPOLO ET OKOTO, LE 17
JANVIER 1961 ("THE
HISTORIC DEATH OF
LUMUMBA, MPOLO AND
OKOTO, 17 JANUARY
1961"), TSHIBUMBA KANDA
MATULU, 1973.
COLLECTION OF BOGUMIL
JEWSIEWISKI, KOSS

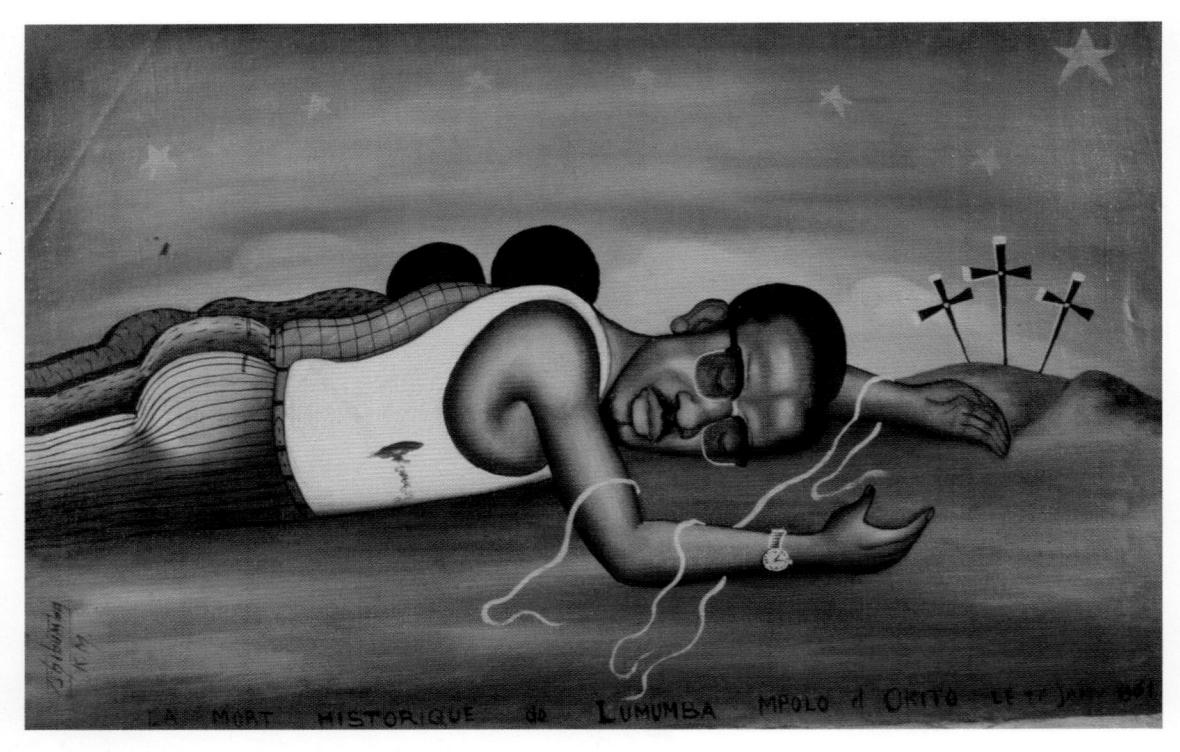

fish. Linear patterns form the fins and scales of the fish and the feathers and wings of the bird. A single tree defines the far shore, and subtle tones of red and blue create a screen against which this action takes place. Pilipili seems to have no need for shading, overlapping, or linear perspective. While the painting is lovely to look at, the subject matter of birds hunting and eating the fish suggests the strife and anguish characteristic of the lives of Africans during the colonial period, when African resources were taken away and African labor was exploited.

The paintings of Le Hangar form a marked contrast to work created a generation later in Lubumbashi (then Elizabethville). These artists, who began working in the 1960s, addressed not the natural scene, but the conflict, pain, and apprehension experienced at the end of the colonial

period and the beginning of the period of independence. Unlike the artists of Le Hangar, who produced for a foreign audience, these artists created art to be displayed in the homes of their fellow city dwellers. They were, like Cheri Samba (see chapter 11), very much a part of the urban conversation of the time. Not only did their art record and reflect the urban experience, but it also helped to shape it.

While painters at Le Hangar and other expatriate-run workshops received minimal instruction (but maximum guidance), these painters received a limited amount of training by apprenticing to (or by closely observing) other urban artists. Whereas European mentors encouraged colonized Africans to limit themselves to purely aesthetic concerns, these painters (and their clients) were engaged with the social

and political issues of their day. Some of their themes included images of an ancestral past, but others recorded specific historical individuals in explicit acts. Some literate artists augmented their specificity with inscriptions, either within the painting itself or on the margins.

Tshibumba Kanda Matulu (1947–82?) painted in Lubumbashi in the 1970s and saw himself as a painter-historian. The task of painting the history of Zaire in one hundred paintings came to him in a dream. Accepting the charge, he attempted to present the entire story of Congo-Zaire, beginning in the pre-colonial past. The resulting hundred or so paintings are quite unlike the decorative paintings of Pilipili. Making no attempt to be decorative, his paintings present the viewer with stark subjects that expose government excesses during the colonial period and address

bothersome issues of the newly independent nation of Zaire.

Honoring the role of leaders such as Patrice Lumumba and Joseph Kasa-Vubu, Tshibumba painted many images to show events in the fight for independence and the turmoil that followed independence. His paintings offer history from his unique perspective, but they reflect the thoughts and fears of those who were his clients as well. He witnessed the exhilaration brought on by newly gained independence, but he was also aware of the violent internal conflicts stemming from it and the problems introduced by the demagogue Mobutu and his regime. The rise and fall of national hero Patrice Lumumba (1925-61) figured in many of his paintings (fig 12-39). In fact, Lumumba became a popular subject for many painters of Zaire. In some ways we can see his rise as cultural hero of mythic proportions in modern

paintings as paralleling the roles of past cultural heroes such as Chibinda Ilunga. Although Lumumba was more or less erased from the official history during Mobutu's administration, episodes of the life and death of Lumumba in paintings such as this transform the historical man into a symbol that embodies the ideas of African self-determination, national unity, and democracy.

In "La Mort historique de Lumumba, Mpolo et Okoto, le 17 Janv. 1961," (fig. 12-39), Tshibumba does not present the hero Lumumba as an historical personage, but as a messianic figure. The president's face is modelled on photographs. The close-up of his body, paralleled by those of his fallen comrades, can almost be read as hills in the land-scape. The wound at Lumumba's side recalls the spear wound of Jesus, and the three crosses of Golgotha seen in the distance reiterate the comparison

of Lumumba with Jesus. Artists such as Tshibumba, who disappeared in the 1980s, were seen as heroes themselves, willing to lay their lives on the line for the truth, in the harsh last decades of Mobutu's rule.

A number of painters from the former Zaire have migrated to Lusaka, in Zambia, but patronage has shifted throughout the region. As an economic "middle class" has evaporated, impoverished urban populations have little money to purchase paintings, and the very rich disapprove of social commentary. Several gifted painters in Lusaka, such as Stephen Kappata (born 1936), represent masqueraders and refer to the values of traditional cultures. Yet most of the paintings now for sale on city streets in Congo and neighboring countries depict, once again, the idyllic landscapes of "airport art," and are, once again, predominantly marketed to foreign visitors.

PART IV

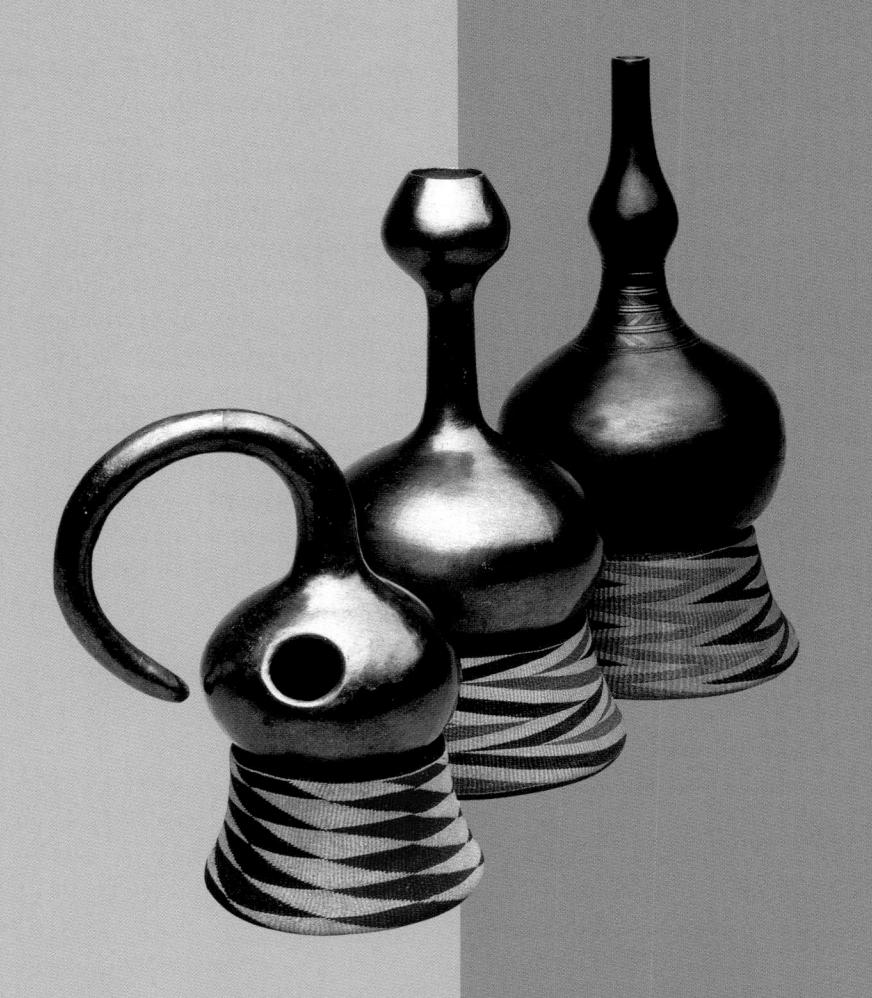

Eastern and Southern Africa

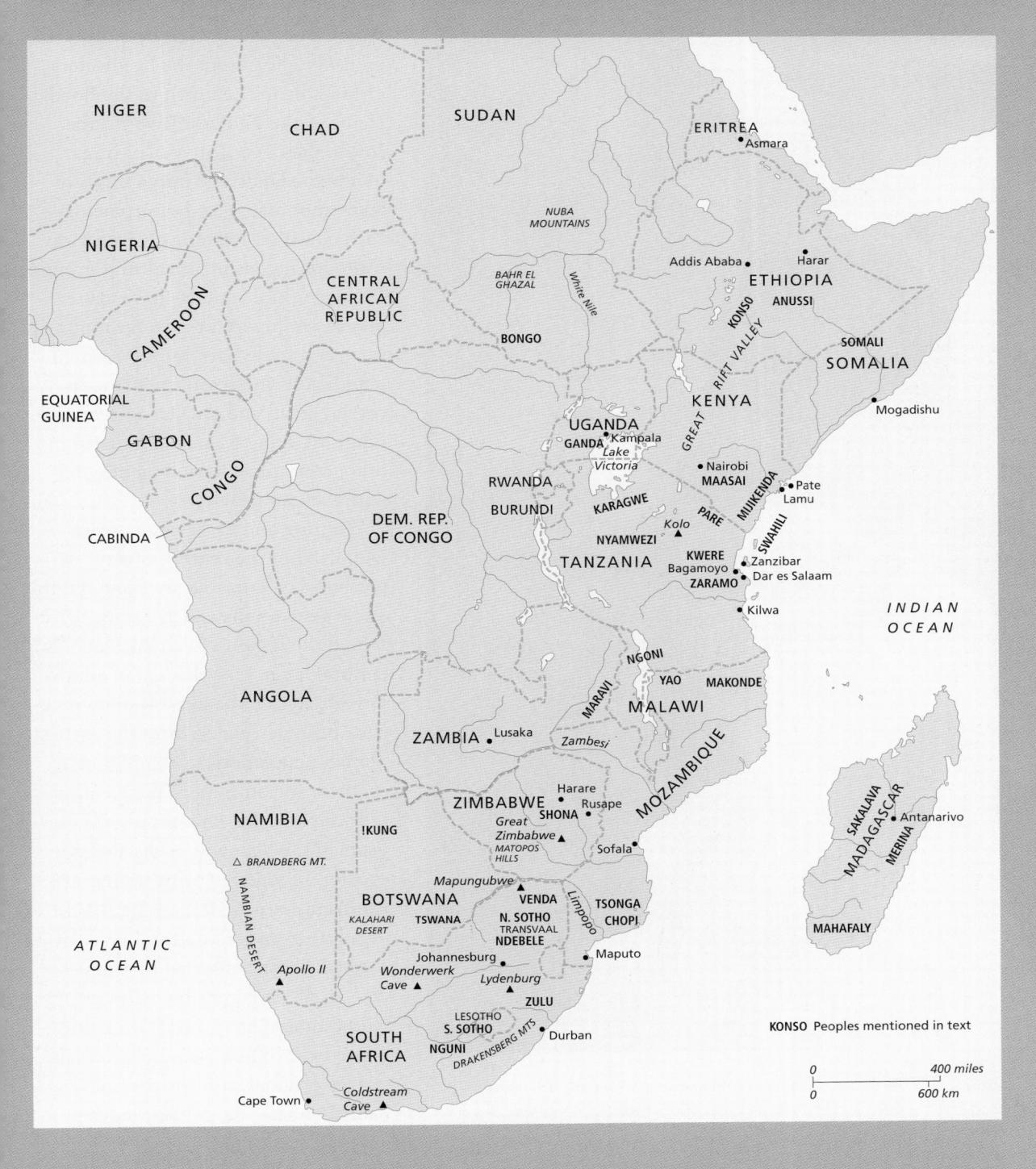

Eastern Africa

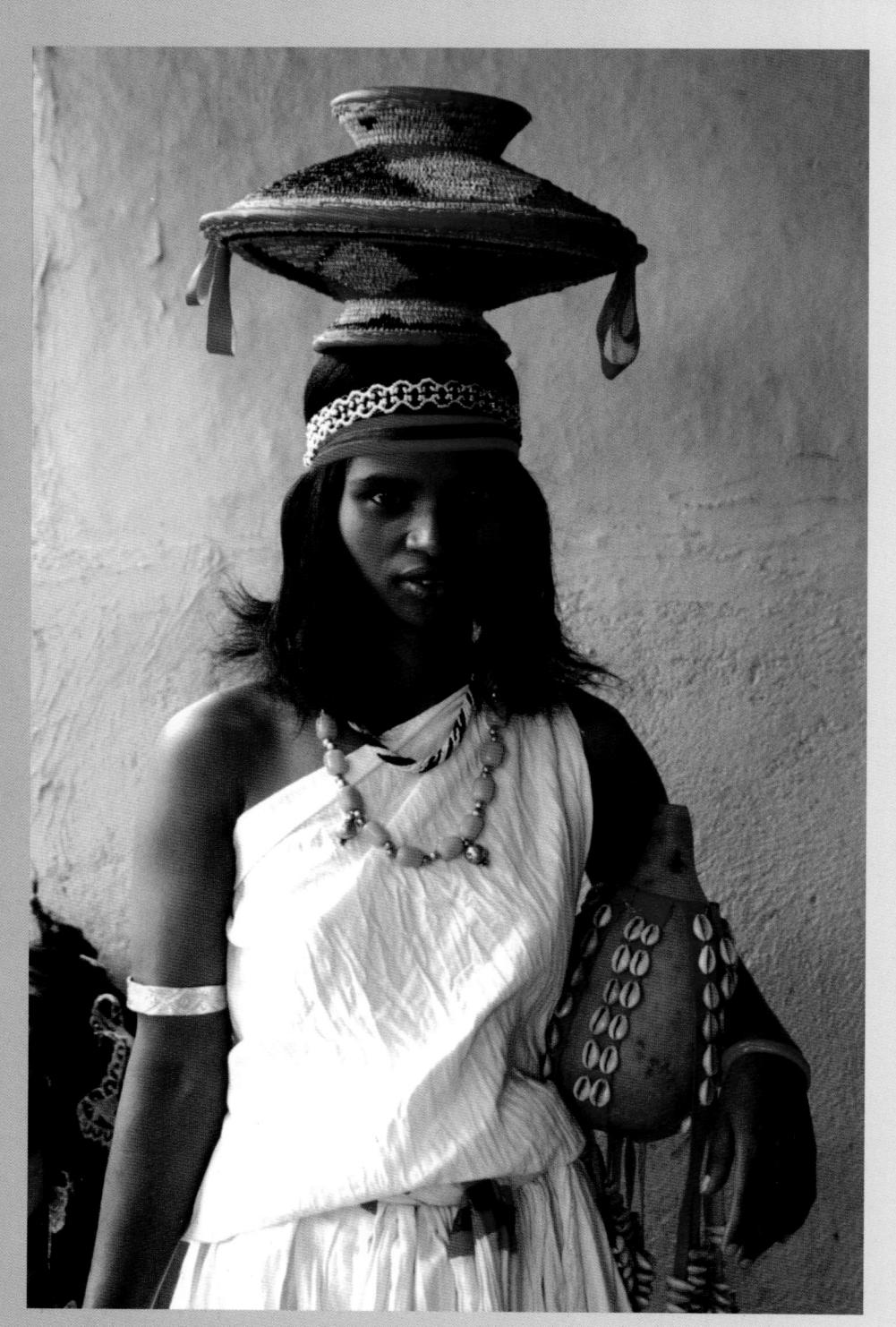

13-1. Woman from Eastern Hararghe wearing traditional dress (*SADDETTA*), BELTED WITH A *SABBATTA*, AND IMITATION AMBER AND SILVER JEWELRY, ADDIS ABABA, ETHIOPIA, 1999

F ALL THE REGIONS OF THE continent, eastern Africa is perhaps the most culturally and ethnically diverse. In part, the region's complexity has been fostered by geography. From the headwaters of the Nile in the north to the floodplains of the Zambesi River in the south, the Great Rift Valley fragments the landscape into a series of lakes, mountains, and escarpments each elevation forming an ecological niche for independent cultural groups. Cross-cultural contacts have also played an important role, for migrations and trade have brought varied populations into eastern Africa. In coastal areas, and on Madagascar and other off-lying islands, settlers from other continents have long mingled with African peoples.

Hunting and gathering peoples who lived in the central hills of present-day Tanzania and Kenya until a few generations ago probably represented the region's most ancient cultural layer. Like the San of southern Africa (see chapter 14), they may have been descended from the earliest human populations of the region. If so, their ancestors were the creators of rock paintings now thousands of years old (which will be discussed in chapter 14 together with similar art from southern Africa; see fig. 14-8).

Another ancient cultural layer in eastern Africa is formed by peoples who speak divergent branches of Nilo-Saharan languages. Some linguists believe that Nilo-Saharan languages originated in the central Sahara, during the millennia when it

was a hospitable region of lakes and grasslands (see chapter 1). With the gradual emergence of the desert, these peoples migrated elsewhere. Nilo-Saharan-speaking populations such as the Kanuri and Tebu now live in the central Sudanic region (see chapter 3). Others once formed kingdoms in Nubia (see chapter 2). In eastern Africa, some of the groups in this widespread linguistic family are primarily farmers, while others are cattle-herding pastoralists. They are known for their spectacular body arts.

A third presence are Cushite speakers of the northeastern portion of the region, whose languages belong to the Afro-Asiatic family and are related to Chadic languages such as Hausa (see chapter 3). Cushite-speaking nomads have raided and traded with settled communities in Ethiopia and the Nile valley for thousands of years. Smaller Cushite-speaking groups have settled in mountainous regions to raise crops. These farming groups build tombs and carve memorial figures similar to those of some of their Nilo-Saharan-speaking neighbors.

The fourth and most widespread population comprises Bantu-speaking groups, descendants of peoples who are thought to have migrated into the region over the course of the first millennium AD from homelands in western Africa. Today, Bantu speakers make up the majority of the agricultural population of East Africa. In the present-day nations of Malawi, Mozambique, Zambia, and southern Tanzania, Bantu-speaking groups use both regalia and masquerades that mirror those of the Congo region (see chapter 12). In Kenya and in the interlacustrine nations of Uganda,

Rwanda, and Burundi, Bantu speakers live in close proximity to non-Bantu groups, and may share the cattle-raising economies and dramatic ceremonial dress of their neighbors.

Along the coast of eastern Africa, Bantu-speaking peoples were linked by an ancient maritime trade to Arabia and India. The Arabs, whose ships came to dominate this trade, called these coastal peoples and their language Swahili, a term derived from the Arabic word for "shore." The Swahili were early converts to Islam, and their art and architecture have been greatly influenced by the art of other Islamic peoples. Additional influences have been absorbed through Swahili trade with China, India, Madagascar, Europe, and the interior of eastern Africa.

The culture of Madagascar also presents an intriguing blend of influences. Malagasy, the name for the language as well as the people of this enormous island, is not an African language at all, but rather belongs to the Malayo-Polynesian family, a group of languages spoken on the islands of Indonesia and the South Pacific. Malagasy vocabulary includes Bantu and Arabic words, however, reflecting long interaction with mainland East Africa. Malagasy art reflects this same blend, a fascinating mixture of styles originating in both Africa and Asia.

The diversity of East African peoples thus makes it difficult to place their art into any readily definable categories. As might be expected in such a multicultural region, many art forms that are worn or carried serve to identify the owner's ethnicity as well as his or her age and status. Lineage affiliation, leadership roles,

and adherence to Islam are also proclaimed by some forms of art and architecture. However, no artistic traditions are shared by all, or even by most, East African cultures. Even contemporary East African artists work in a range of styles that defies any attempt at generalization.

THE SWAHILI COAST

By the time the great Muslim traveler Ibn Battuta visited the eastern coast of Africa during the fourteenth century AD (seventh century AH), Swahili culture was well established. Through trade and migrations, the Swahili established a long chain of Islamic towns that stretched along the coast from Mogadishu, in present-day Somalia, to Sofala, in present-day Mozambique. Although he noted both the piety and riches of the merchants of Mogadishu, Ibn Battuta was most impressed by the city of Kilwa, now in southern Tanzania, which he described as "the most beautiful of cities."

Islamic Arts

In Kilwa, Ibn Battuta would certainly have seen the Great Mosque, one of the most celebrated of all Swahili buildings. Unlike the mosques of northern Africa and the Western Sudan, the Great Mosque at Kilwa has no minaret or central courtyard (fig. 13-2). The plans of Swahili mosques resemble instead the early prayerhalls of Arabia and Yemen. The original structure, a simple rectangular prayerhall, had been built soon after the city was founded, possibly in the eighth or ninth century AD (second or third century AH). Before the

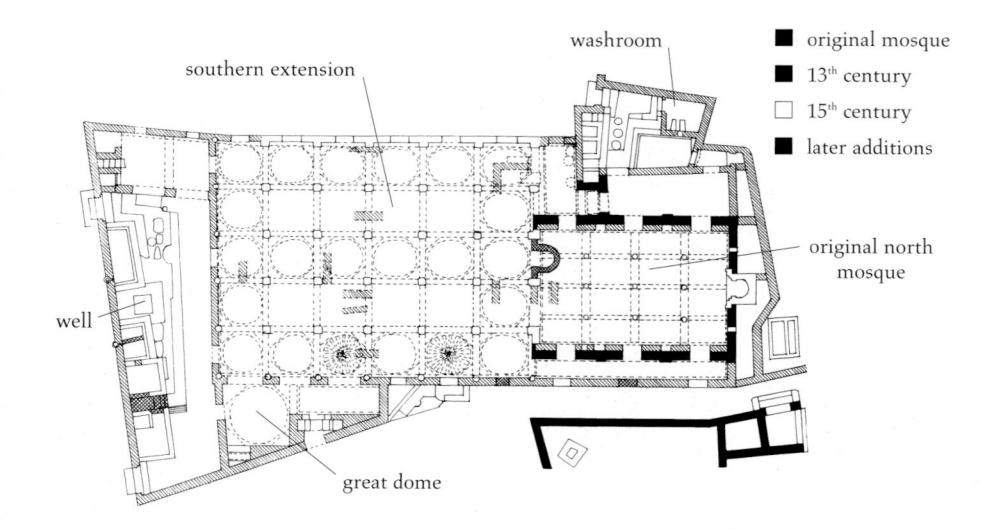

13-2. PLAN OF THE GREAT MOSQUE AT KILWA, TANZANIA. DRAWING AFTER PETER GARLAKE

thirteenth century this was surrounded by a much larger stone prayerhall. By 1440 (800 AH), the aisles of the mosque had been roofed with stone barrel vaults alternating with rows of small domes. The most impressive dome in the mosque rose over the entrance next to the forecourt, where worshipers washed and purified themselves. Fluted in a manner reminiscent of the dome above the mihrab in the Great Mosque of Qairouan (see chapter 1), the dome is mentioned in the Kilwa Chronicle, a history of the city written in the mid-sixteenth century.

The Great Mosque at Kilwa was constructed of rough chunks of fossilized coral (a type of limestone), imbedded in a type of cement made of weathered and crushed fragments of the same stone. The interior walls were finished in a white plaster also made from crushed coral, then burnished to a glossy sheen. Doorways and portions of arches were made of blocks of limestone, carved with bands of geometric decoration. The shimmering white interior of the

mosque must have once been both elegant and austere (fig. 13-3). Interestingly, while the mosque's pointed arches formally resemble those found in northern Africa and elsewhere in the Islamic world, they are not constructed in the same way, with an arc of stone blocks (voussoirs)

13-3. Interior arcades of the Great Mosque at Kilwa

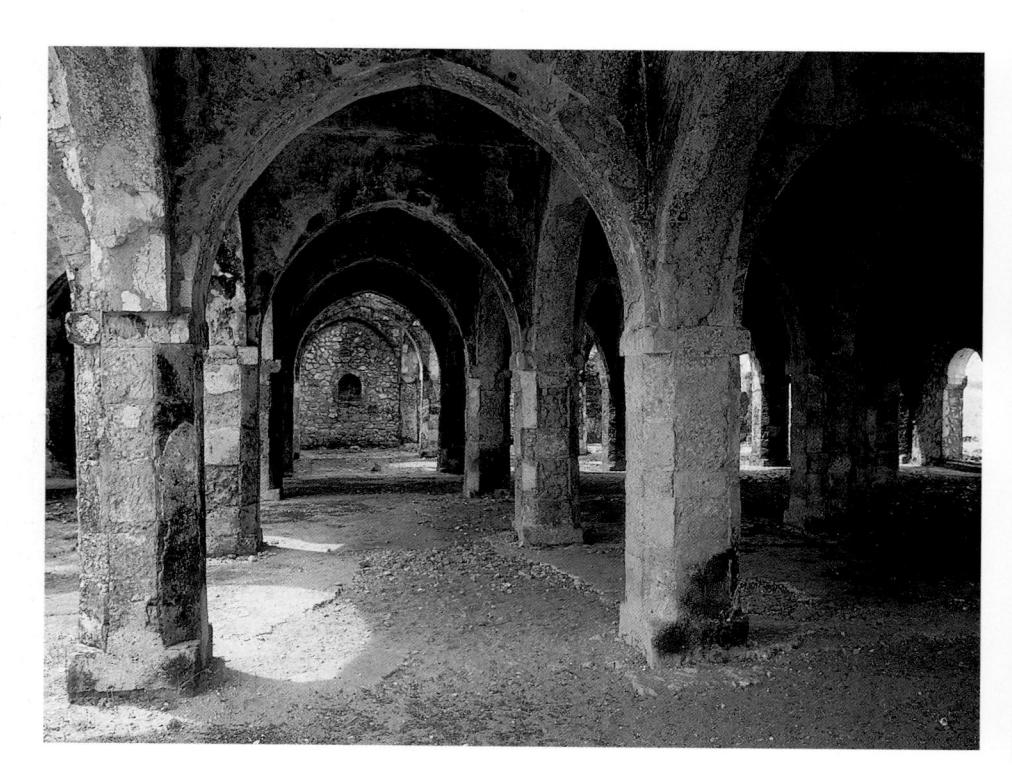
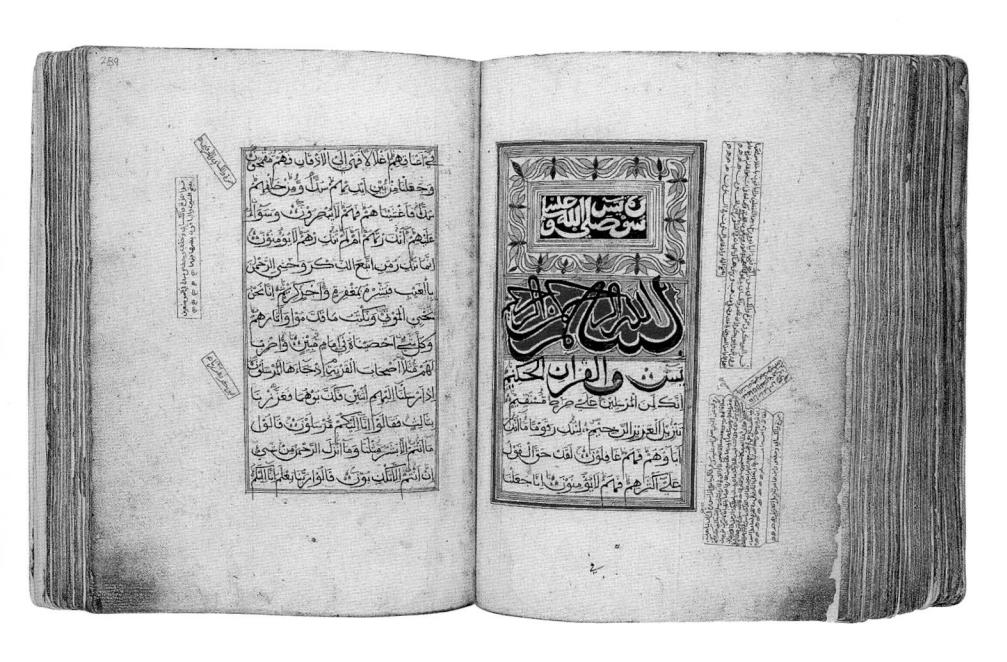

13-4. Qur'an, Swahili, early 19th century. Ink and pigment on paper, bound in leather. Height 10%" (26.5 cm). Fowler Museum of Cultural History, University of California, Los Angeles

Although artisans in Siyu, where this Qur'an was probably produced, manufactured some books entirely from local materials, the paper and some of the inks used for this Qur'an were imported from Europe or Asia. An inscription records that the descendants of a daughter of Shaykh Dumayl bin Muizz bin Umar gave this Qur'an to a mosque. Unfortunately, it does not tell us where the mosque was located.

held in place by a central keystone. Instead, they are corbeled—successive courses of stone or brick, each one projecting slightly beyond the one beneath, eventually meet to produce an arch-shaped opening.

Worshipers who entered the Great Mosque of Kilwa knelt upon beautifully patterned mats and teachers read from precious copies of the Qur'an. The Qur'an shown in figure 13-4, which was produced in the early nineteenth century, is probably very similar to the sacred books that were used centuries ago in Kilwa and other Swahili cities. The book was probably made in Siyu, a town on Pate Island

off the coast of northern Kenya that excelled in the production of manuscripts, embroidery, fine furniture, and other crafts. The scribe who transcribed and ornamented the pages of the Qur'an was a religious scholar as well as a painter and calligrapher, and he or she provided the commentary that appears in boxes in the margins of the text. The headings of each verse are framed by foliate motifs heightened with red and yellow pigment.

Just outside the Great Mosque, near the exterior of the *qibla* wall, is the tomb of a saint or leader. As in many Muslim cultures, the Swahili

often place tombs near a mosque. A pious man spends much of his time in the mosque, the cemetery, and the madrasa (the Islamic school attached to a mosque), since all three areas are suitable places for prayer and meditation. Yet to the Swahili, tombs are not merely the focus of religious devotion. They are also tangible expressions of a family's ancestral heritage, and they allow the living to celebrate their ties to the founders of the patrilineage. Tombs also honor the men and women who established a Swahili city, and who are believed by the Swahili to have brought the purity and civilization of Islam to a pagan land. Tombs are thus evidence of a social covenant, even if they are so old that no one can remember exactly who was buried within them.

Some of the oldest tombs were erected in the Swahili heartland, the coast of southern Somalia and northern Kenya. Ornamented with square or rounded columns, these "pillar tombs" were the inspiration for later stone monuments built in several Swahili cities. The pillars on some sixteenth-century tombs from Kaolo, near Bagamoyo, Tanzania, rise to a height of some twenty feet. Pillars on some tombs are carved in relief with blind windows or doors, as though they were the houses of the deceased. Some pillars were inset with niches to hold porcelain bowls, just as niches in Swahili houses were used to display Chinese ceramics (see fig. 13-9). Other stone tombs are rectangular, often constructed of slabs of limestone carved with geometric patterns in low relief (fig. 13-5). The patterns echo the ornamentation of doorways and mihrabs found in stone mosques of this period.

of power," kiti cha enzi, is often handed down through generations, and those in current use may thus be several centuries old. Yet others may be recent; woodcarvers such as Said Abdullrahan El-Mafazy of Lamu faithfully reproduce antique furniture owned by their relatives and neighbors. A kiti cha enzi is usually made of ebony, inlaid with small pieces of ivory as shown here (fig. 13-7). The use of ivory or bone inlay on furniture is very ancient in northeastern Africa (see fig. 2-25).

Arts of Leadership

Both the cemeteries and the mosques of many Swahili cities now lie in ruins. Kilwa and other important sites were sacked by the Portuguese in 1509, and Swahili cities went into decline as European ships disrupted trade throughout the Indian Ocean. However, some Swahili centers regained a measure of independence and prosperity over the course of the seventeenth and eighteenth centuries, before their eventual colonial domination by Omani Arabs in the nineteenth century and by Europeans in the twentieth.

Some of the regalia and symbols of office from this brief period can still be seen, including carved wooden drums and magnificent side-blown horns carved of ivory or cast in brass. The horn, siwa, of the city of Pate on Pate Island is formed of three great carved elephant tusks (fig. 13-6). Its creation is described in the chronicle of that city.

At formal gatherings, Swahili elders and the rulers who direct their councils are seated upon elaborate thrones. Like a siwa or drum, a "chair

13-5. STONE TOMBS, SWAHILI, MOMBASA, Kenya, 16th-19th CENTURY

13-6. Man sounding A SIWA (SIDE-BLOWN HORN), SWAHILI, FROM PATE ISLAND, KENYA, 17TH CENTURY. PHOTOGRAPHED IN LAMU, KENYA

The man in this photograph wears the distinctive white robe and embroidered cap of a Swahili patrician, a member of one of the aristocratic patrilineages descended from the city's founders.

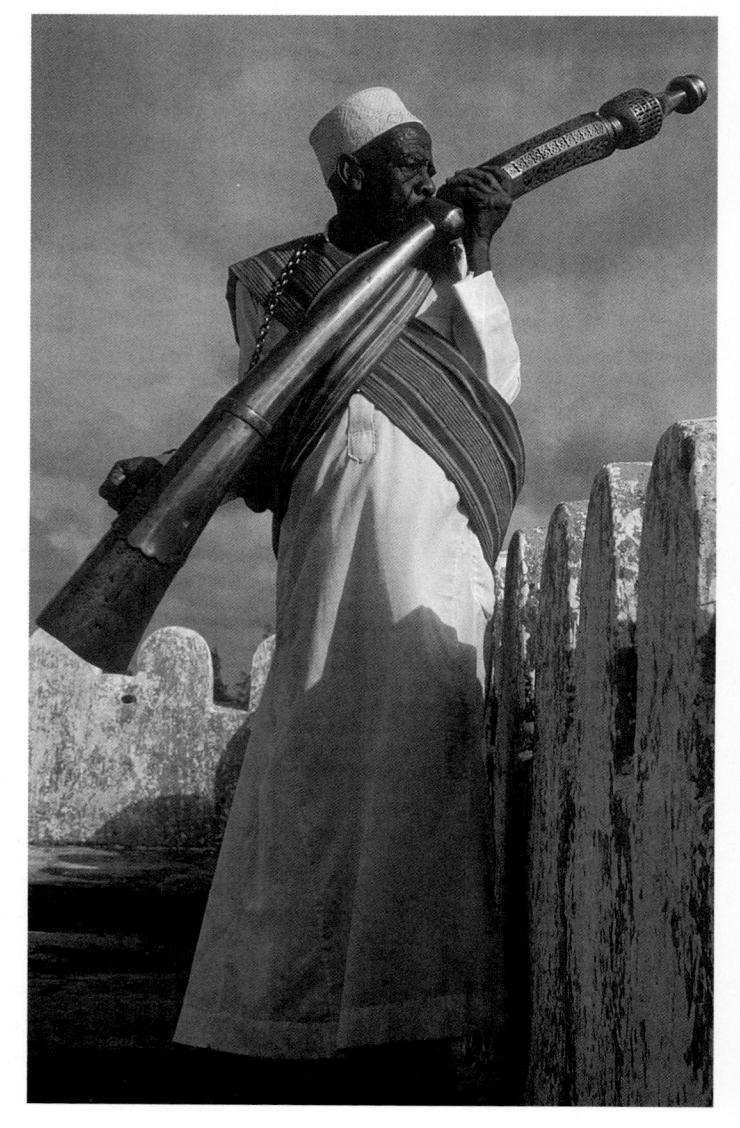

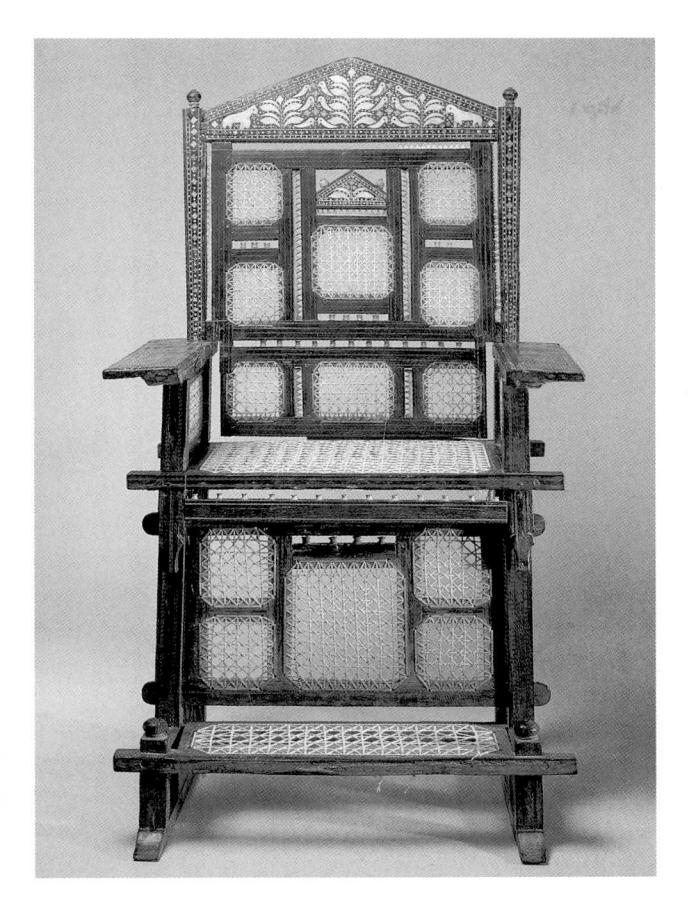

13-7. KITI CHA ENZI
("CHAIR OF POWER").
SWAHILI. WOOD, IVORY,
AND STRING;
HEIGHT 48½" (1.23 M).
FOWLER MUSEUM
OF CULTURAL HISTORY,
UNIVERSITY OF
CALIFORNIA, LOS ANGELES

ings of fertility and wealth.

The plan of a ruined stone house from Lamu shows some of the basic features of a jumba (fig. 13-8). The walls of this jumba, like those of the Great Mosque at Kilwa, were constructed of rough pieces of fossilized coral limestone bound with a cement of crushed limestone and covered with smooth white plaster. This plaster is said to purify and protect the home, and it is an essential feature in any room assigned to a patrician man or woman. The flat roofs were constructed of cement laid over a wooden ceiling, probably made of mangrove saplings.

Domestic Architecture

By the fourteenth century, the patrician elders who ruled the most powerful Swahili cities lived in homes built of stone. Swahili patricians still distinguish between walled areas of a city containing stately (if crumbling) stone residences, and the surrounding areas of more modest thatched buildings. Like a monumental stone tomb, a stone house, *jumba*, is closely identified with the noble past, and with family honor, ancestry, and prosperity. It is also believed to maintain the religious purity and physical wellbeing of a family's living members.

While Swahili mosques are almost exclusively reserved for men—only a few mosques have areas where women may worship—a *jumba* is the

domain of women, the focus of their religious and social activities. A stone house, in fact, is built as a gift from a father to his daughter upon her marriage. Even today, when a daughter is born to a patrician couple, the father may begin to gather and prepare building materials. Upon the daughter's engagement, he constructs a second or third story for her over his own (more properly, his wife's) house. If relatives live nearby, the upper stories are connected by a bridge, wikio. The ground floor may eventually be given to servants so that the women who own the house can live in the better-ventilated upper floors. In well-preserved Swahili communities like Lamu, in northern Kenya, a jumba still represents the continuity of lineages and the bless-

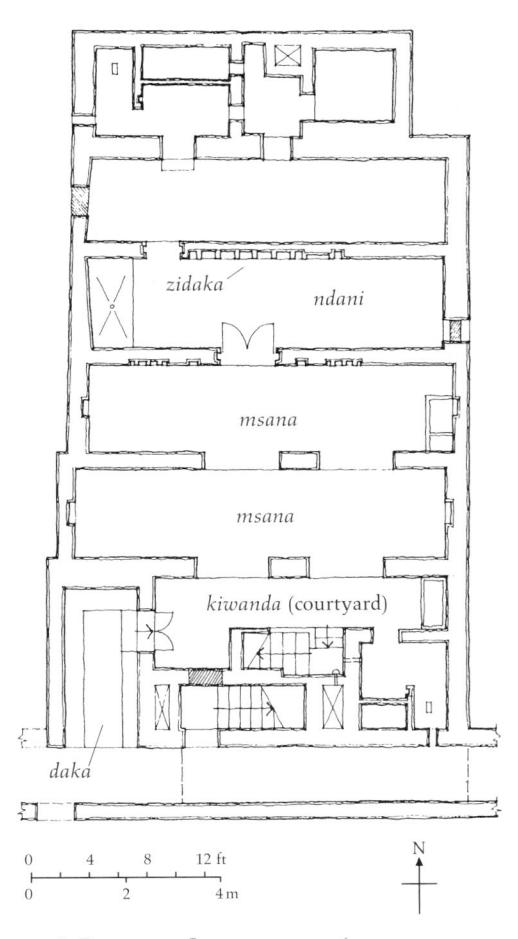

13-8. Plan of a Swahili *Jumba* (stone house), Lamu, Kenya. Drawing after Linda Donnaly

The entrance to this house was through a small porch open to the street, called a *daka*, a word also meaning "niche." Benches for casual visitors lined the porch. At one side of the porch was a double wooden door set in a majestically carved frame, the only adornment to the plain, high wall. Privileged guests were invited into the open courtyard, *kiwanda*, on the other side of the door. A guest room may have been placed on the landing of the stairway to an upper story. Servants would have slept in the area under the staircase.

Female guests and members of the family were welcomed into the house proper, with its long, shallow galleries, *misana* (sing. *msana*). The longer walls of these interior rooms ran east/west, so that doorways between them pointed the entrant northward, in the direction of Mecca. The house here had two *misana*. Beds could have been placed at the ends of each gallery, possibly screened with hanging curtains or rugs. Carved chests, matching chairs, and stools would also have furnished these rooms.

The first gallery was raised a step above the courtyard, and each subsequent gallery was raised a step further. The darkest and highest gallery was the ndani, the "inside" of the house. This cool, private room was occupied by the woman for whom the house was built. Behind the ndani of this particular jumba was another gallery, an extra room not usually found in this location. However, the rear bathroom (entered from the left door) and the innermost room (entered from the right door) are typical of stone houses. Usually directly behind the ndani, this inner-

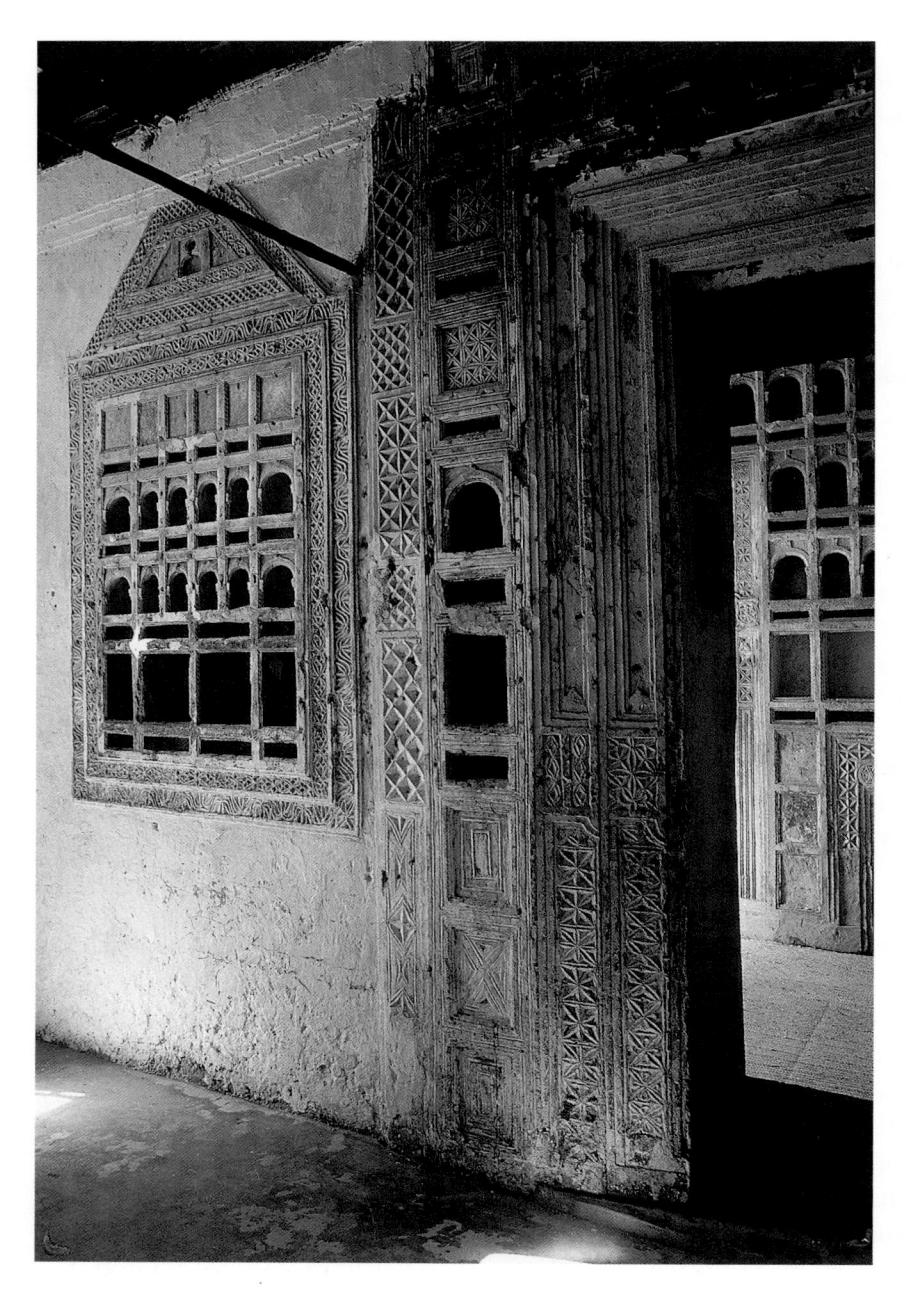

13-9. Interior of a *JUMBA* (stone house) showing *ZIDAKA* (storage niches), Swahili, Lamu, Kenya, 18th–19th century. Carved coral limestone, lime plaster

The most elaborate of a house's zidaka was filled with copies of the Qur'an, manuscripts, writing implements, and blue-and-white porcelain bowls imported from China. These were the family's treasures, cherished for their beauty and their cost. Sacred writing and shiny ceramic dishes were also believed to protect family members from supernatural harm, and the zidaka was thus a mystically charged space. As houses of the dead, Swahili tombs also came to be inset with zidaka, which were likewise filled with valuable and protective objects.

most room is the site where the most sacred of all women's activities take place. Here a woman would have given birth, buried stillborn children and protective amulets, washed corpses, and secluded herself while mourning the death of her husband.

The interior walls of misana are inset with carved storage niches, zidaka. The plan of the jumba here shows zidaka set into the wall of the second msana, and a second, more extensive set of niches in the wall of the ensuing ndani, where it probably framed the woman's bedstead. Zidaka photographed in another ruined residence in Lamu give us an impression of the original splendor of the Swahili stone house (fig. 13-9). This particular set of niches framed the doorway of a msana leading to the ndani, whose own zidaka may be glimpsed through the doorway.

The patterns of the *zidaka* were sculpted using a technique known as "chip-carving." In each panel the background has been chipped away, often with just one or two strokes per segment, leaving the surface of the stone to form the lines and shapes of the design. This technique is popular in many of the lands bordering the Indian Ocean, but seems most highly developed along the coasts of East Africa and Madagascar. Here we see a variety of patterns, some formed of lozenges or triangles, others of organic, almost floral motifs that clearly share the same aesthetic as the decorative border of the Our'an discussed earlier (see fig. 13-4).

The wooden doors at the entrance of the stone house at Lamu were once held in a rectangular wooden frame carved in the same manner as this

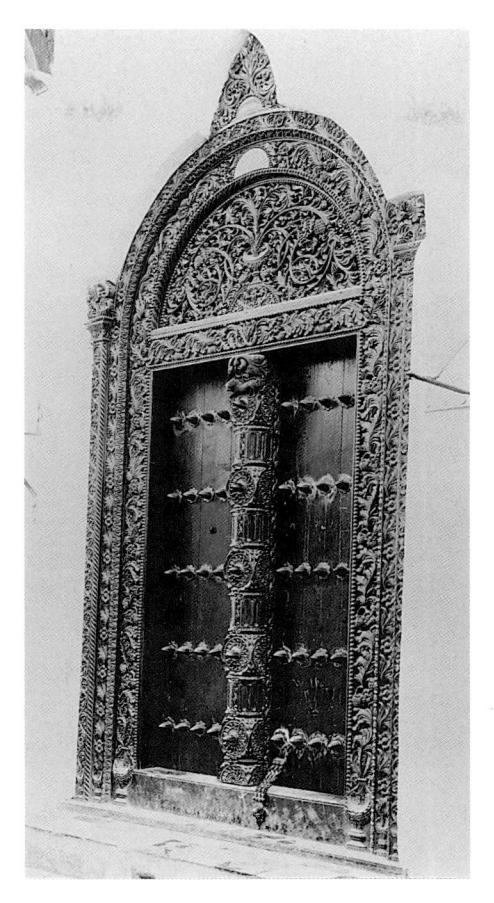

13-10. Carved doorway of a house, Swahili, Zanzibar, Tanzania, 19th century. Wooden doorframes, coral masonry

zidaka. A central post might have been covered with more deeply carved floral motifs, or with stylized fish and plants. In Lamu today several different styles of doorframes can be seen. Some follow a trend established in Zanzibar during the height of Omani Arab colonial rule in the nineteenth century, when Arab, Indian, and Swahili merchants commissioned doors with a more "international" flavor from both local and expatriate artists.

The doorway from Zanzibar shown here is an excellent example of this ornate style (fig. 13-10). The crisp abstraction of earlier frames has given way to highly detailed and naturalistic vegetal forms, which writhe across the densely packed surface. Shield-like bosses punctuate the central post, and a semi-circular area arches over the lintel. Although related to Swahili prototypes, this door is clearly tied to foreign tastes. Doorways such as this seem to have been exported from Zanzibar to arid Muslim regions around the Red Sea and the Persian Gulf, where such large pieces of carved wood were a luxury.

As cosmopolitan trading centers, the cities of the Swahili coast developed a multicultural population and a correspondingly hybrid architecture. One particularly spectacular building in the city of Zanzibar, on the island of the same name in present-day Tanzania, was constructed by a wealthy Indian businessman and designed by an architect from Delhi. Known as the Old Dispensary, its facade presents a wonderful, motley mixture of Arab, Indian, African, and European elements (fig. 13-11). It was built using the materials and technology of Swahili architecture; thus the walls and decorative details are of coral limestone coated with plaster. The front balconies are loosely based upon the wooden screens covering the upper windows of Egyptian and Arabian homes. The carved columns of the lower porch, and the trefoil arches between them, are Indian inventions, while the fanciful peaked roofs and gables may derive from the exuberant folk architecture of late nineteenth-century Europe. It is interesting to compare the inventive eclecticism of this civic building with the hybrid architecture commissioned

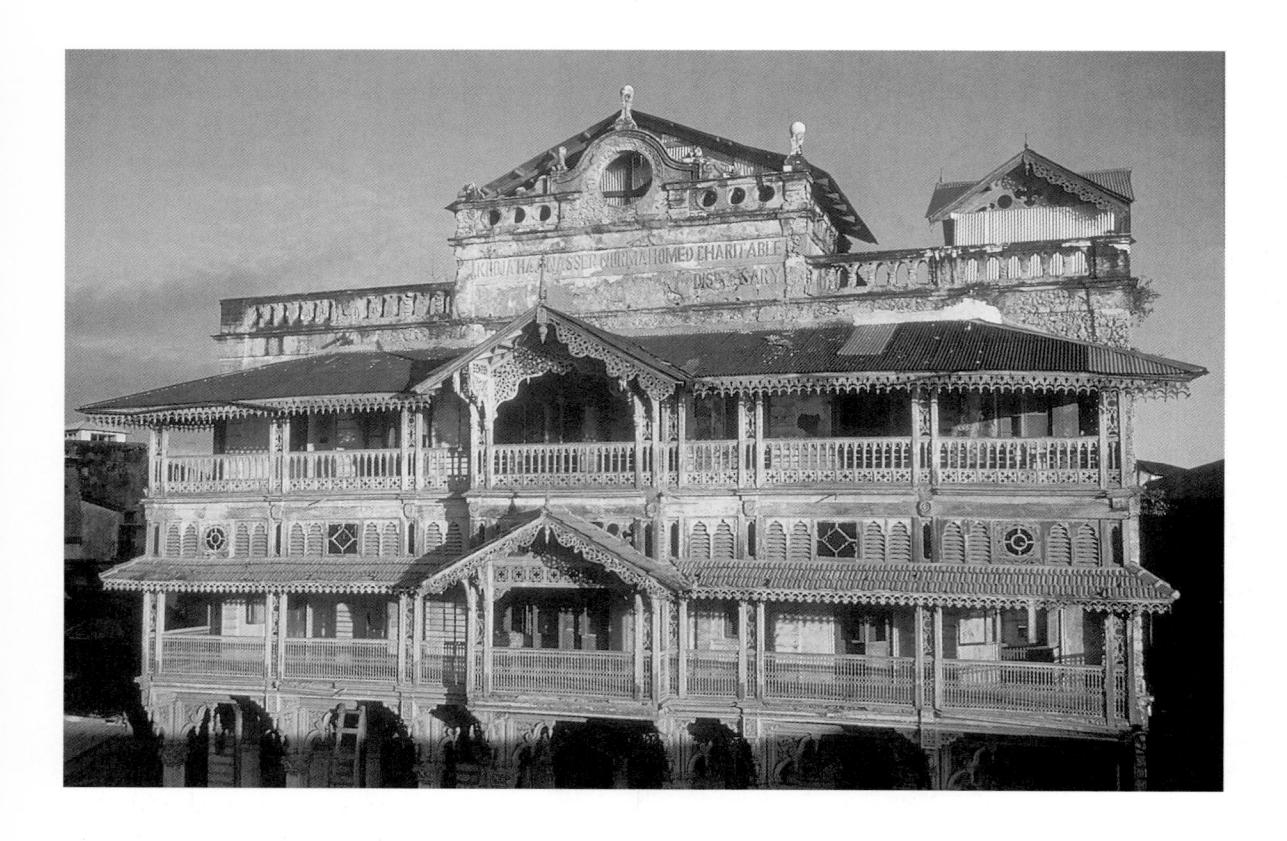

13-11. The Old Dispensary, Zanzibar, Tanzania, Hashan Virjee Patel, 1887–91

Tharia Topan, the Muslim Indian businessman who commissioned this building, laid the cornerstone to mark the Golden Jubilee of the reign of Queen Victoria of Great Britain. He intended to offer the building to the populace of Zanzibar as a hospital, and he was knighted by the queen in recognition of his gesture of allegiance to the British Empire. Unfortunately, the dispensary was only finished after Topan's death in 1891. It was then sold and divided into private apartments. The building has now been restored as a cultural center.

on the western coast of Africa by other cosmopolitan merchants (see figs. 6-37, 8-57).

OTHER COASTAL BANTU CULTURES

Along the East African coastline, inland from the cities of the Swahili. are several major clusters of Bantuspeaking peoples. Bantu-speaking Mijikenda groups, for example, live in the hills above the central and southern Kenya coast. They share many cultural features with the Swahili. though few have converted to Islam. Whereas the Swahili honor their ancestors by building stone tombs, the Mijikenda carve tall planks to venerate the dead. The most elaborate memorial planks, vigango (sing. *kigango*), are erected to appease the spirits of deceased members of Gohu,

a benevolent association. The most thoroughly documented *vigango* are those of the Giriama people of the Mijikenda cluster.

The vigango of the Giriama are cut from living trees by a delegation of men. The circular head, short neck, and rectangular body of the image are carved, smoothed, and ornamented with triangles and facial features incised with chip carving. The sculpture is then painted with bright red, black, or white pigment mixed with latex. The final stages are completed during a single night, so that the statue may be consecrated at dawn. It is this dedication ceremony that is illustrated here (fig. 13-12). A white cloth has been tied around the neck of the kigango, and the men who participated in the night's creation are pouring libations and eulogizing the deceased.

The Zaramo and their neighbors, a

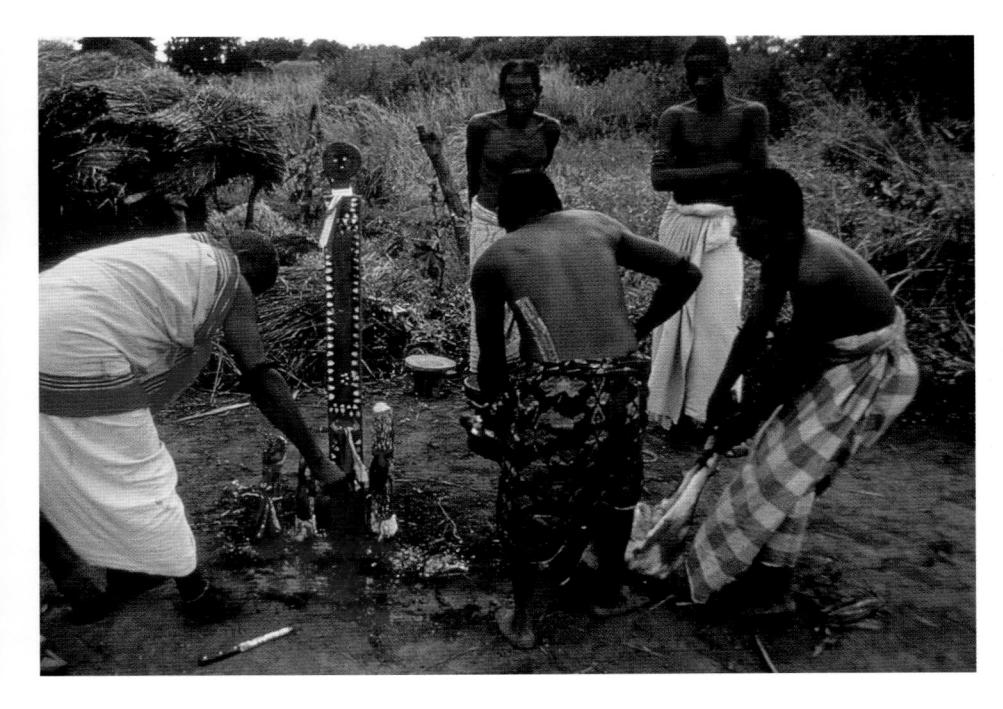

13-12. GIRIAMA
DEDICATION CEREMONY
FOR A KIGANGO
(MEMORIAL FIGURE),
COASTAL KENYA.
PHOTOGRAPH 1981

13-13. Jointed funerary figure, Zaramo, Tanzania, 19th century. Wood. Height 33½" (85 cm). Museum für Völkerkunde, Staatliche Museen, Berlin

Zaramo elders recall that such large, movable images were made to speak during extraordinary funerary ceremonies, when the absence of a male heir demanded that the statue deliver the oration.

13-14. Memorial post, Zaramo, 19th century. Wood. Height 13%" (35.3 cm). Museum für Völkerkunde, Staatliche Museen, Berlin

homogenous cluster of Bantu-speaking peoples who live in northeastern Tanzania, also carve poles as references to the deceased. An unusually naturalistic figure with jointed limbs was evidently taken from a pole set over a Zaramo grave in the early twentieth century (fig. 13-13). The smooth head and the heart-shaped contours of the face are also found on the *vigango* of some Mijikenda groups.

The second Zaramo grave marker shown here is more typical, with the human figure reduced to a cylindrical torso set upon two faceted bases (fig. 13-14). The head is a helmet-like form composed of a cone covered by a semi-circular arched ridge. This economical and evocative composition is a manifestation of a symbol known throughout northeastern Tanzania by variants of the term *mwana hiti*.

Mwana hiti (or mwana nyahiti) has been translated as "daughter of the chair" or "(female) child of the one who is enthroned." The symbol is said to be both female (because of the tiny breasts) and male (because the mwana hiti image as a whole is phallic in shape). Mwana hiti evokes the lineage-founding ancestral couple, and by extension ancestors and their authority in general. The symbol appears in a variety of contexts, but it is most commonly embodied in the small figures used during female initiations (fig. 13-15). The term "female

13-15. MWANA HITI ("DAUGHTER OF THE THRONE"), ZARAMO, TANZANIA, 19TH CENTURY. WOOD, HUMAN HAIR, FIBER. HEIGHT 6%" (17 CM). MUSEUM FÜR VÖLKERKUNDE, STAATLICHE MUSEEN, BERLIN

child of the one who is enthroned" refers directly to the girls who are undergoing this period of training, for they are briefly seated upon the ancestral stool or chair of their mother's lineage when they are presented to the community at the end of their seclusion. The name of this symbol, as well as the image itself, thus celebrates the heritage of these young women, whose beauty, health, and fertility are viewed as gifts of the ancestors.

A girl is given a *mwana hiti* by her father's sister when it is time for her to begin her seclusion. After the girl has had her hair cut in the distinctive crested style worn by initiates, she ties tufts of it to the holes in the crest along the head of the *mwana hiti*. A very personal and highly charged substance, the hair is usually removed before the girl returns the figure to her guardian. The *mwana hiti* illustrated here may thus have been taken from a girl or her family without their permission.

All mwana hiti share the same basic form, yet no two are exactly alike. The peoples of northeastern Tanzania are masterful sculptors, and they exploit the subtle variations on this abstract theme to the fullest. The range of their abilities is also striking, encompassing the rigorous geometric harmonies of a mwana hiti, the more naturalistic grave marker described above (see fig. 13-13), and the female figure and child from the top of a staff shown here (fig. 13-16). All of these objects are attributed to Zaramo artists, but their styles are strikingly different. The diviner or leader who once owned the staff would have been able to allude to ancestral power, fertility, and blessings of all kinds by commissioning a scepter with a mwana hiti, as was often done. Instead, this mother with a child on her back, possibly a reference to the lineage and its progeny, the leader and his family, or to the initiator and her initiate, is a distinctive and descriptive statement. The curved contours of the woman's body and the precise placement of the child on the woman's back form a very appealing image.

Figures of women and children also

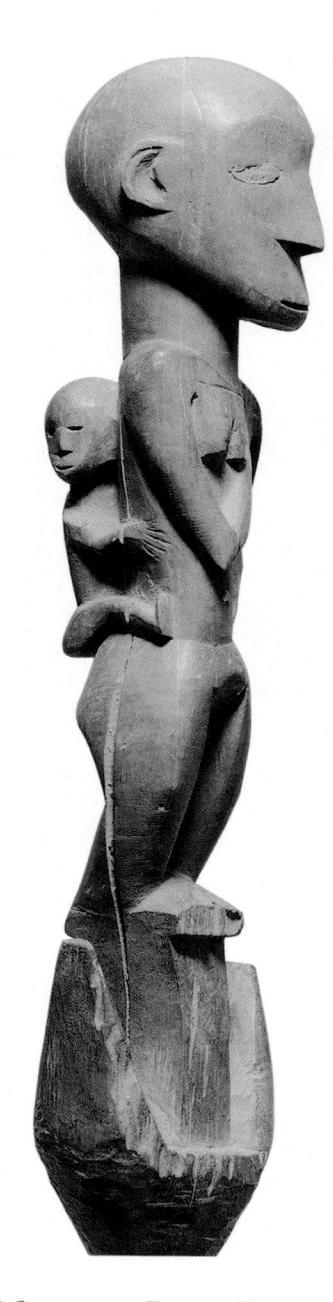

13-16. Staff finial, Zaramo, Tanzania, before 1917. Wood. Staatliche Museum für Völkerkunde, Munich

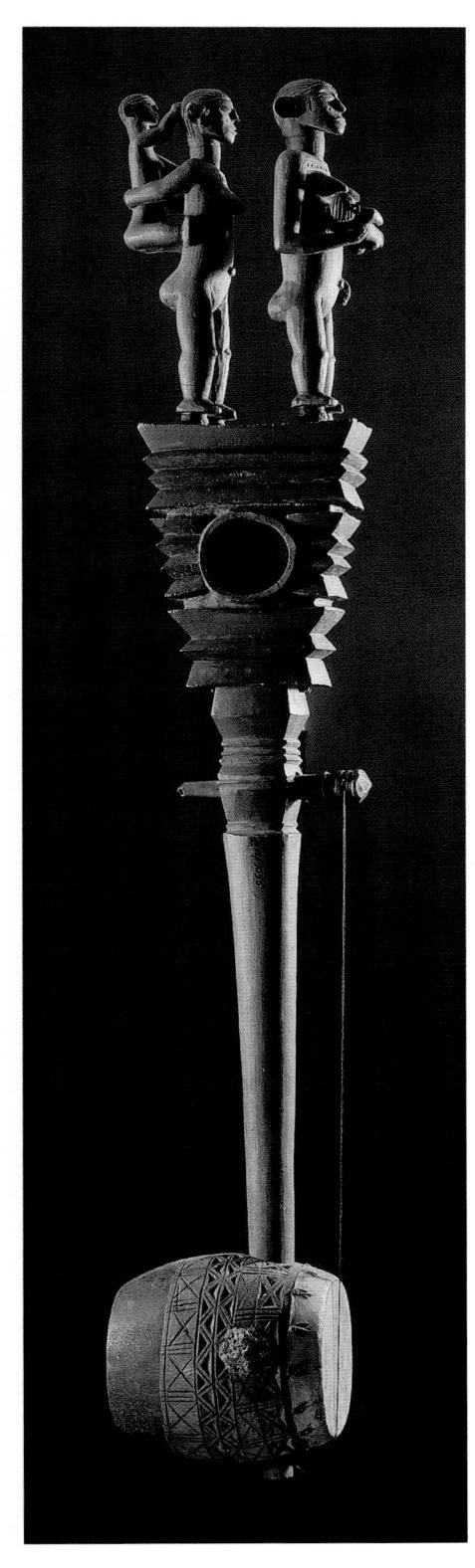

13-17. Musical instrument with figures, Kwere, Tanzania, 19th–Early 20th Century. Wood. Reiss-Museum, Mannheim

appear on a musical instrument attributed to the Kwere, another group in this cultural cluster (fig. 13-17). Set atop an abstract base of great compressed energy, one carries a baby in her arms, while the other carries a child on her back. The belly of the instrument is embellished with chipcarved geometric shapes similar to those found in Mijikenda and Swahili art. While the meaning of the figures is unclear, the beauty of these carefully placed images is quite apparent.

As the term mwana hiti itself reminds us, thrones may be the central focus of ceremonies involving leadership and initiation. This is particularly the case with the Luguru, a large Bantu-speaking group culturally related to the Zaramo and the Kwere. One very fine throne, taken from a Hehe community in central Tanzania but probably carved by a Luguru artist, is composed of a broad circular seat backed with a rectangular slab (fig. 13-18). Small conical breasts and the fully three-dimensional head above it identify the backrest as a female torso. It is quite fitting that such a symbol of ancestral authority should evoke a female form, for Luguru culture is matrilineal. Stylistically, the combination of a spherical head and flat torso is similar to the forms of some Mijikenda vigango. The crested hairstyle and small, flat face, however, are typically Luguru.

There is much contact between the Mijikenda of Kenya, the peoples of northeastern Tanzania (such as the Zaramo and the Kwere), and the Bantu-speaking groups who live further inland on both sides of the Kenya/Tanzania border. Among all of these peoples, sculpted art works have

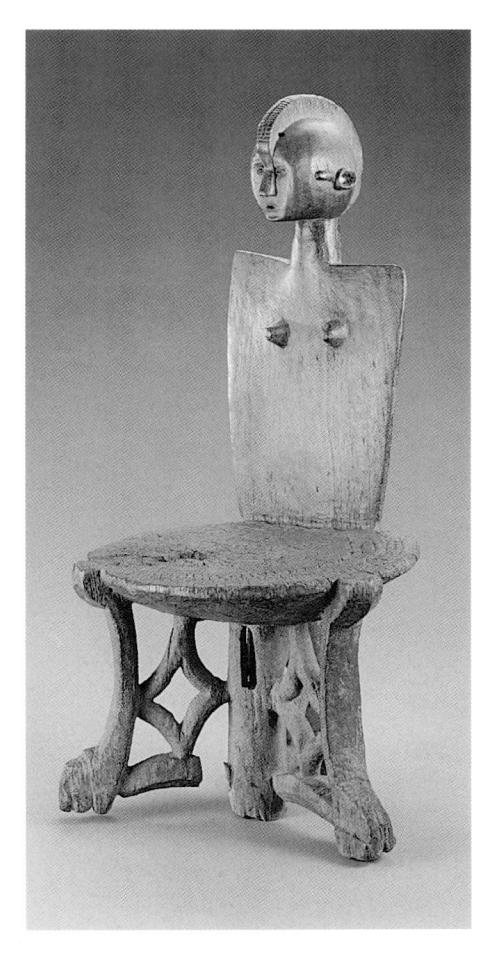

13-18. Throne, Luguru, Tanzania, early 20th century. Wood. Height 31½" (80 cm). National Museum of African Art, Smithsonian Institution, Washington, D.C.

been owned by healers. In northeastern Tanzania, *mwana hiti* still serve as corks or stoppers for containers of medicine, invoking the powers of ancestors against supernatural dangers. A stopper may also be used to apply medicine to a patient. In southeastern Kenya, carved heads or partial figures once sealed antelope horns containing medicine, the points of which were driven in the ground near the healer during consultations.

Two carved stoppers with their medicine containers were collected in

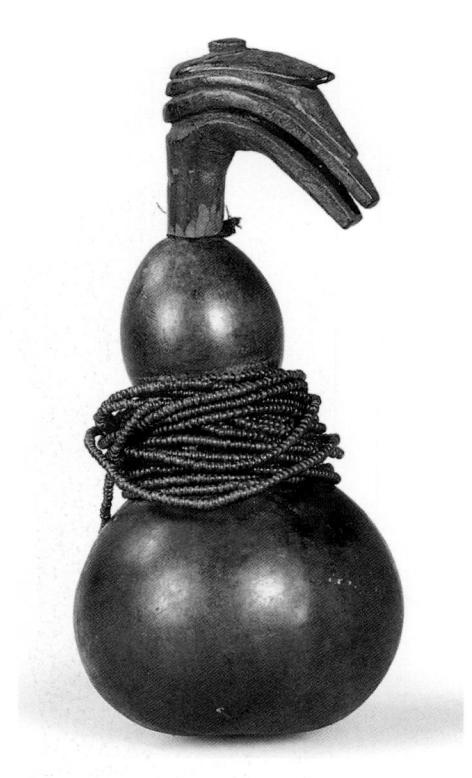

13-19. Calabash container with carved stopper, Pare (?), Tanzania, 19th–early 20th century. Gourd, glass beads, wood. Height 6" (15 cm). Linden-Museum, Stuttgart

northern Tanzania in the early twentieth century. One stopper is a particularly striking zoomorphic form, which fits into the opening of a beaded gourd (fig. 13-19). Another, knotted and tied to a container made of horn, depicts a human head with emphatic arches for ears and eyebrows (fig. 13-20).

Photographs taken in the 1950s show male and female healers in coastal Kenya wearing beaded veils and bags, full cloaks, ornate head-dresses, and leather masks. In addition to stoppered containers, they carried carved figures, staffs, and musical instruments. Healers in northeastern Tanzania still display art forms, yet little is known about their statuary.

A wooden figure with outstretched arms from northern Tanzania seems to have been prescribed for clients with particular needs by a diviner of the Pare people (fig. 13-21). The small beads placed in the eyes are almost hypnotic.

Other images used or ordered by religious specialists of coastal highlands Bantu-speaking peoples are evidently made of clay. In addition, both fired and unfired clay forms are known to have served as instructional aids in the initiation of young men and women in northern Tanzania. They may relate to large reliefs modeled on the ground in Zambia for girls' initiations and other sacred uses, or to the use of wooden structure used for the initiations of young people in areas of southern and eastern Africa (see chapter 14). However, since these initiations are held in secret, outsiders do not know whether (or where) the works are still in use.

PRESTIGE ARTS OF THE INTERLACUSTRINE REGION

During the eighteenth and nineteenth centuries, a vast network of trade routes linked the Swahili ports on the Indian Ocean to the peoples who lived in the interlacustrine region, the lands along the lakes and waterways of the Great Rift Valley. Merchants, warriors, and slave traders moved along these routes, as did art works and artists.

The Nyamwezi

In western Tanzania much of this trade was organized by the kingdoms

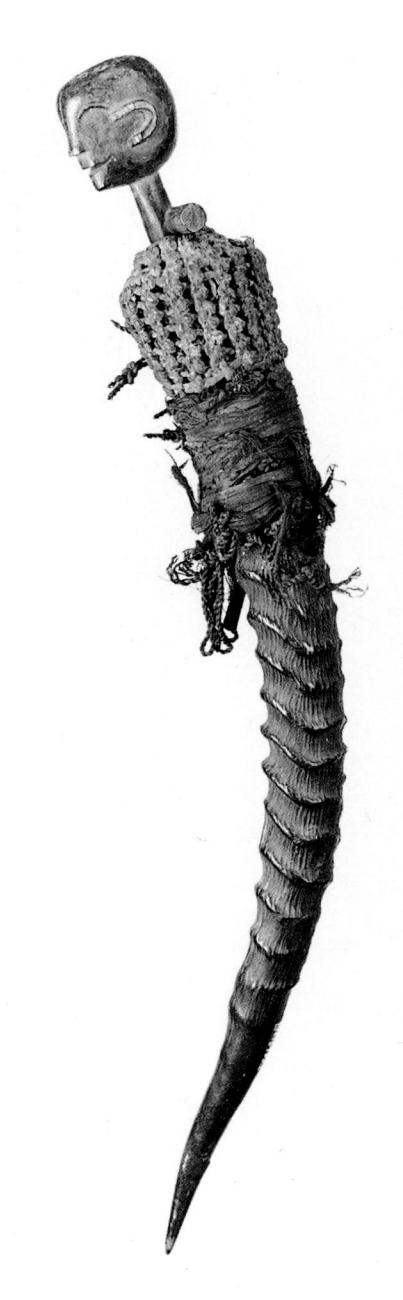

13-20. HORN CONTAINER WITH CARVED STOPPER, SHAMBAA (?), TANZANIA, 19TH CENTURY. HORN, FIBER. HEIGHT 21¹/₄" (54 cm). Museum für Völkerkunde, Staatliche Museen, Berlin

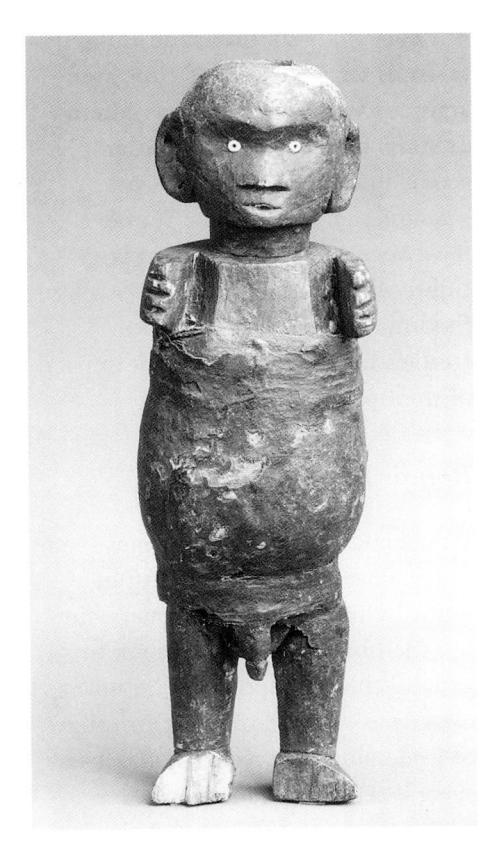

13-21. Protective figure, Pare, Tanzania, 19TH-EARLY 20TH CENTURY. WOOD, GLASS BEADS, TEXTILE. HEIGHT 81/4" (21 CM). Museum für Völkerkunde, Staatliche Museen, Berlin

This small sculpture was commissioned in order to enforce good behavior or punish misdeeds, for it was said to protect against theft. Its owners (or the specialist who advised them) encircled it with a cloth to bind spiritually powerful materials to its torso. Evidently this roughly carved but forceful wooden figure is the eastern African equivalent of the nkisi of the Kongo peoples (see chapter 11).

and associated communities of a people known collectively as the Nyamwezi, or "people of the moon." The remarkable Nyamwezi throne shown here was carved during the late nineteenth century (fig. 13-22). Formally and conceptually it is linked to the thrones of the Luguru in the east and to the seats of authority on the western flanks of the Great Rift Valley in the Democratic Republic of Congo (see chapter 12). Seen from the front, the curved backrest of the Nyamwezi throne appears to merge with a head and a pair of hands to form a figure, as in the Luguru throne discussed above (see fig. 13-18). A rear view of the Nyamwezi work, however, reveals a slim and elongated body with bent limbs, carved in high relief, embracing the rectangular back of the throne. Only the head and hands extend past the edges of the backrest and are visible from the front. The leader or elder who sat on this throne would thus have been visually framed and conceptually embraced by ancestral authority.

The shiny finish of the Nyamwezi throne is very different from the rough, grimy surface of the Pare protective figure (see fig. 13-21), but they share the same eyes of inlaid beads. In each case the artist did not smooth away the carving marks of his adze or knife, and both figures display unusual proportions: the Pare image is compacted while the Nyamwezi figure is stretched thin. Many of the features found on the figure attached to the Nyamwezi throne—including the spherical head, uneven surface, and semi-circular ears-may have once been typical of art produced all along the trade

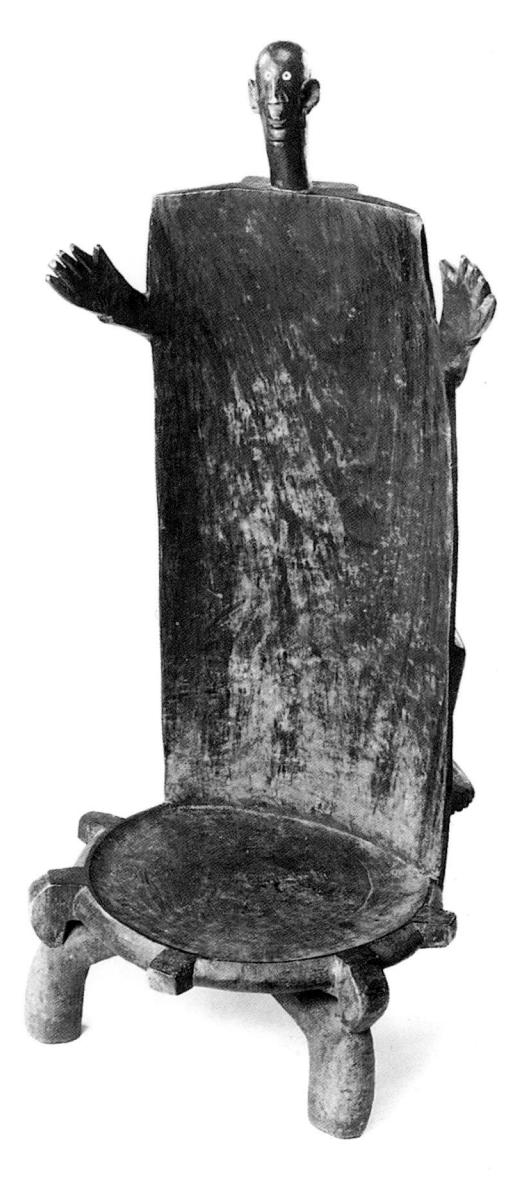

13-22. Throne, Nyamwezi, Tanzania, late 19TH CENTURY. WOOD. HEIGHT 42" (1.07 M). Museum für Völkerkunde, Staatliche MUSEEN, BERLIN

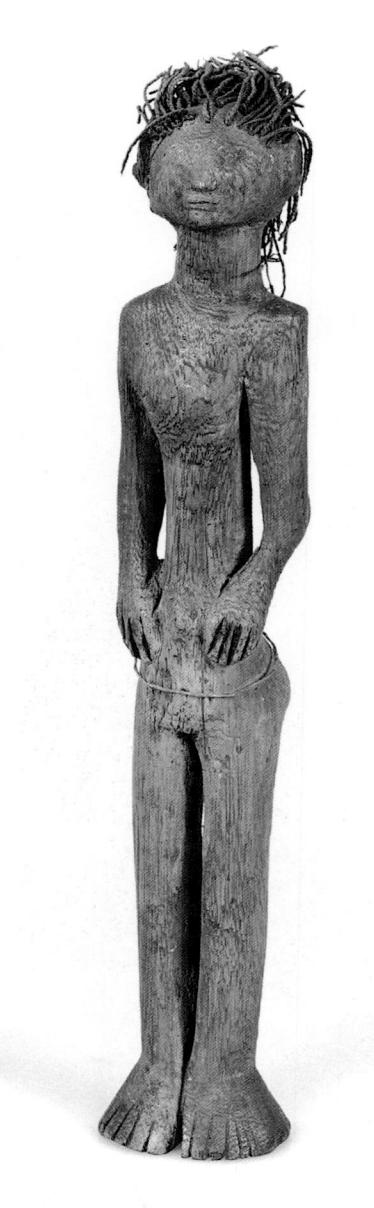

13-23. Standing figure, Sukuma (?), Tanzania, 19th–early 20th century. Wood, fiber. Height 14½" (36 cm). Linden-Museum, Stuttgart

routes joining the Tanzanian interior to the coast.

Freestanding figures have also been collected among Nyamwezi groups. Some of the most fascinating seem to have been sculpted by artists of northern Nyamwezi peoples such as

the Sukuma. One of these works, possibly once part of a pair or a group of figures, comes from an island in Lake Victoria (fig. 13-23). The facial features are barely distinguishable, the hands merge into the hips, and the feet form a notched conical base. Yet although the surface is rough and the gender undefined, the hair was painstakingly constructed of attached twisted or braided fibers. The contrast between clear outlines and uneven surfaces, between crisp braids and vague face, gives this figure an aura of mystery, an aura heightened by our regrettable ignorance of its name, history, or meaning. Available information on similar works suggests only that it may have been owned by a king or community leader as part of his personal treasury.

Similar questions surround another work attributed to the northern Nyamwezi (fig. 13-24). Breathtaking in its abstraction, this attenuated figure achieves a beautiful, slow rhythm as subtle details punctuate

13-24. Display figure, Nyamwezi, Tanzania, 19th–Early 20th Century. Wood. Collection of Jean Willy Mestach, Brussels our eyes' long vertical slide along its lustrous surface. Similar elongated statues were carried by the Sukuma as staffs in dances, but this example seems too fragile to have been manipulated by a dancer. It may have been the predecessor of large figures displayed since the 1950s by Sukuma and Nyamwezi dance troupes to enhance the visual impact of their performances.

Royal Treasuries

Wooden sculptures and thrones seem to have been acquired as prestige items by interlacustrine leaders during the nineteenth century, yet in general these sculptures were not directly connected to the institution of leadership. The royal treasuries of several centralized interlacustrine states did, however, include metal objects associated with the mystical powers of kings and their ancestors. The largest of all royal treasuries may have been located in the small kingdom of Karagwe, on the western banks of Lake Victoria. When the American adventurer William Stanley arrived in Karagwe in 1876, he saw some of the hundreds of iron and copper objects owned by Rumanika I, the king of Karagwe, including ceremonial anvils and images of cattle. A spare and elegant bovine form was one of the items of regalia taken from the Karagwe treasury by German soldiers in 1906 (fig. 13-25). The smooth curves of the horns, limbs, tail, and hump, and the delicate muzzle and ears of the creature. are very difficult to achieve in iron, and the technical skills displayed here are considerable

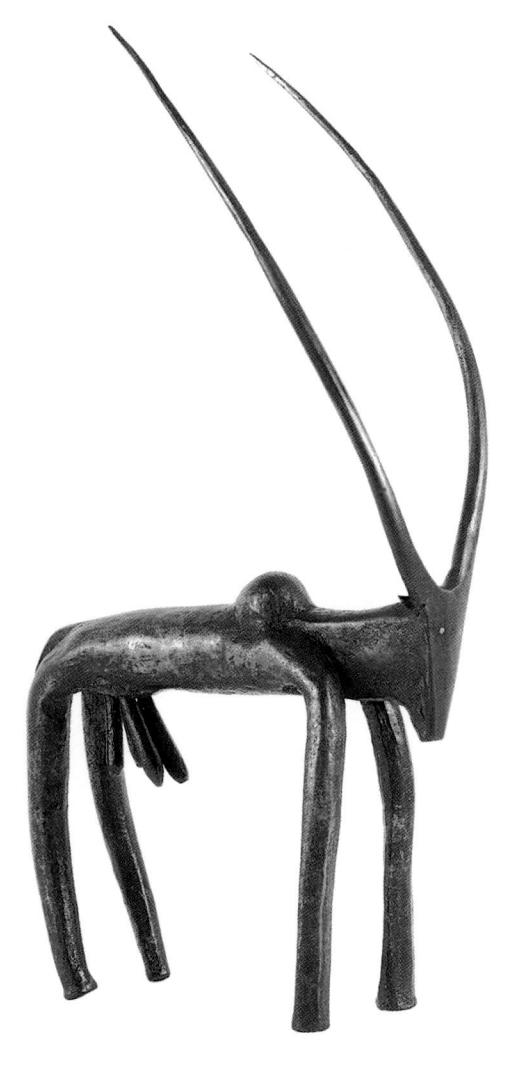

13-25. Bovine figure, attributed to King Ndagara of Karagwe, Tanzania, 19th century. Iron. Height 14½" (37 cm). Linden-Museum, Stuttgart

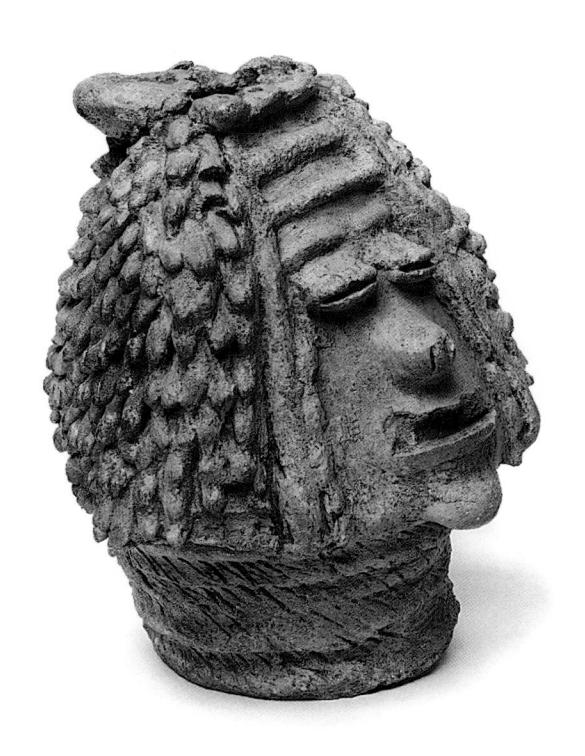

13-26. Head (THE LUZIRA HEAD), BUGANDA, UGANDA, BEFORE C. 1750. TERRACOTTA. HEIGHT 7½" (20 CM). THE BRITISH MUSEUM, LONDON

The selection of cattle and horned forms as subject matter was natural in a kingdom where cattle were a source of wealth and prestige. Rumanika claimed that all of the iron objects in the treasury had been made by his predecessor, Ndagara, who was both king and blacksmith. In Karagwe thought, Ndagara's proclaimed ability to produce this impressive object was a validation of his role as a cultural hero who practiced ancient skills. Even if Ndagara did not actually forge this particular work, the people of Karagwe believed it was created because of his skill and his ties to the ancestors.

Another object from the interlacustrine states may also have been tied to a royal court (fig. 13-26). Known as the Luzira Head, this ceramic fragment was found during the excavation of a lakeshore shrine once kept by priests who served the king, kabaka, of the Buganda. The head was modeled at least two hundred years ago and we do not know who or what it represents. Stylistically the head resembles no other known work from eastern Africa, suggesting that art works in the past may have been quite different from those created during the nineteenth and twentieth centuries.

Ceramics and Basketry

Both ceramic vessels and finely woven baskets were owned by men and women of high status in the interlacustrine states, and some were made exclusively for royal families. Burnished black vases, *ensumbi*, were once proudly displayed by members of the Buganda court (fig. 13-27). The lustrous black surface was created by polishing with graphite. Made by male potters working for the king of Buganda, these shiny, long-necked containers replicate the forms of the calabashes once used by the ruling clans (who were originally pastoral-

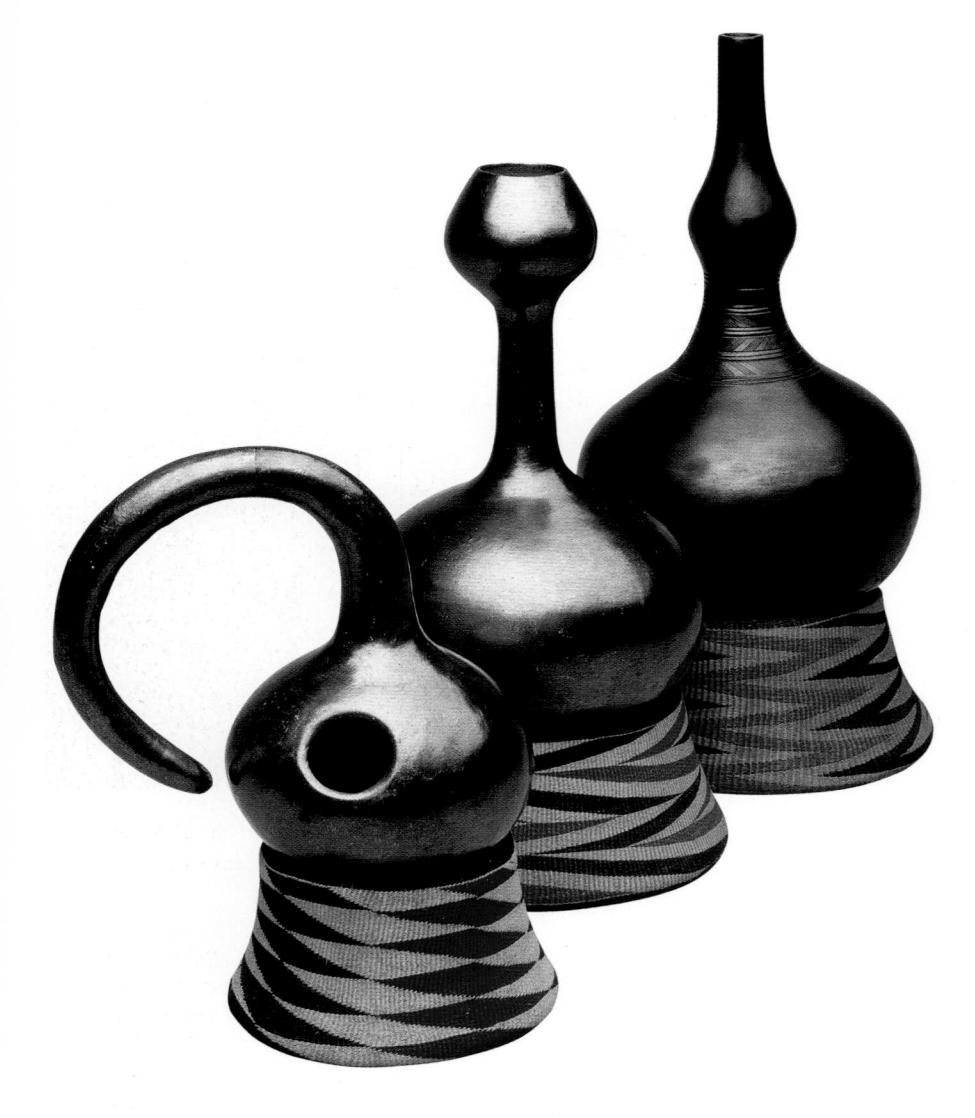

13-27. Gourd-shaped vessels on basketry stands, Ganda, Uganda, late 19th–early 20th century. Terracotta, graphite, glaze, fiber. Height of tallest 13%'' (34 cm). The British Museum, London

ists). The tightly woven fiber stands for these pots were the work of wealthy and leisured Ganda women, whose skill in creating intersecting geometric patterns is displayed in these examples. Other beautiful basketry was once made in Rwanda and Burundi.

Magdalene Odundo, a contemporary ceramic artist born in Nairobi, Kenya in 1950, draws upon this tradition of ceramic connoisseurship (fig. 13-28). Odundo was educated at colleges of art in England, and she was able to travel to Nigeria (where she visited pottery workshops organized by Michael Cardew) and the United States (where she visited Maria Martinez in San Idelfonso, New Mexico). A trip to Kenya in 1974–5 allowed her to research the cultural context of ceramic vessels in the land

of her birth. Although Odundo has lived in England since 1971, her investigation of these African ceramic forms complements her interest in the fired clay objects of many cultures and many periods.

The forms of Odundo's sculpture are even freer and more fluid than those of the vases formerly used by wealthy Ganda. They are not based upon the shapes of gourds, but upon the human body. The full curves of the vase-like sculptures seem to be metaphors for fullness and fecundity. Whereas the Ganda ceramics were items of prestige traded within the interlacustrine region, Odundo's work is produced within an international context; she sculpts and lectures in the United States and Europe as well as Africa.

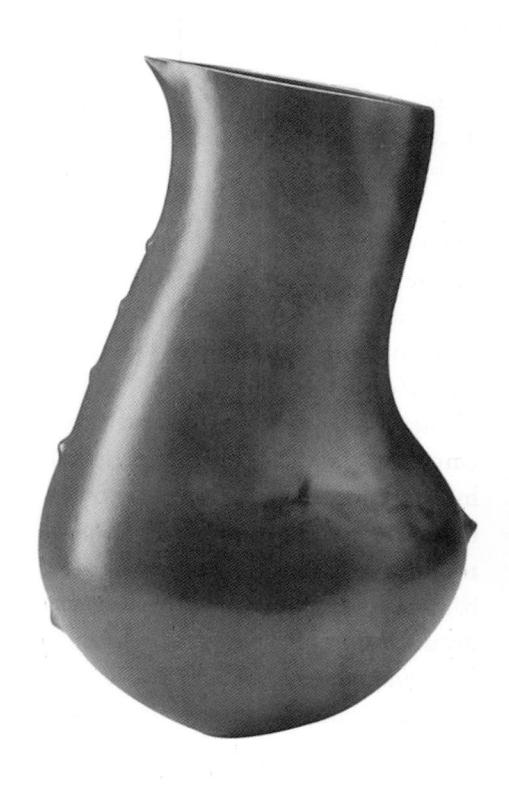

13-28. Vessel, Magdalene Odundo, Kenya/England, 20th century. Burnished earthenware. Height 18" (46 cm)

MASQUERADES AND OTHER ARTS OF THE MARAVI, THE MAKONDE, THE MAKUA, AND THE YAO

Western museums house a fascinating variety of masks purchased or taken as booty during the European exploration and conquest of eastern Africa in the late nineteenth and early twentieth centuries. Yet very little information accompanied these art objects, and the practice of masquerading has since died out in much of East Africa. The only peoples who continue to sponsor elaborate masquerades live in Tanzania, Mozambique, and Malawi. They include the Makonde, the Makua, the Yao, and some of the Maravi peoples.

Nyau

The Maravi once formed several distinct kingdoms that were united under the authority of a sacred emperor, the karonga. The slave trade of the nineteenth century shattered the Maravi empire, yet in at least two Maravi groups, the Chewa and the Mang'anja, a masquerade association called Nyau can still be found. In the Chewa kingdom of Zambia and among the Mang'anja people of southern Malawi, Nyau is responsible for funerary ceremonies held during the dry season after the corn harvest. Nyau masquerades invite animals of the forest to join temporarily with the human community in celebration, thus returning for a time to the harmony of creation. They also initiate children into adulthood. The Mang'anja see Nyau ceremonies as restoring relations between the earth

and the sky so that rain may fall and life may continue (see Aspects of African Cultures: Cycles and Circles, p. 449).

Wooden face masks and facial coverings of fiber, feathers, and rags are worn by Nyau members to give form to the spirits of those who have died during the year. These masks are known generally as nyau, but they also have individual names suggested by their appearance, their behavior, or the songs sung during their performances. Some are easily identifiable as old men, Europeans, or ghosts walking on stilts. A mask of a character known as nkhalamba, or "old man," was collected in a Mang'anja community in the Nsanje district of southern Malawi (fig. 13-29). The projecting brows and nose of the black wooden mask are common in the nyau face masks of the Mang'anja. His eyes and mouth are outlined in red.

The most important nyau are large basketry structures made of bamboo, plant fibers, and cloth. Known as nyau yolemba, they make manifest the souls of forest beasts and other non-human presences. Among the Chewa, a northern Maravi group, the most important of these nyau yolemba manifests the soul of the eland, a type of antelope (fig. 13-30). Called kasiya maliro, it appears at midnight to be led to the home of a deceased member of the community. After communing with the soul of the deceased, the eland brings the soul out of the house, out of the town, and into the forest. There the basketry structure is set alight, and its burning transforms the soul of the deceased into an ancestral spirit that can now be present in the lives of his or her descendants. Boys who are being ini-

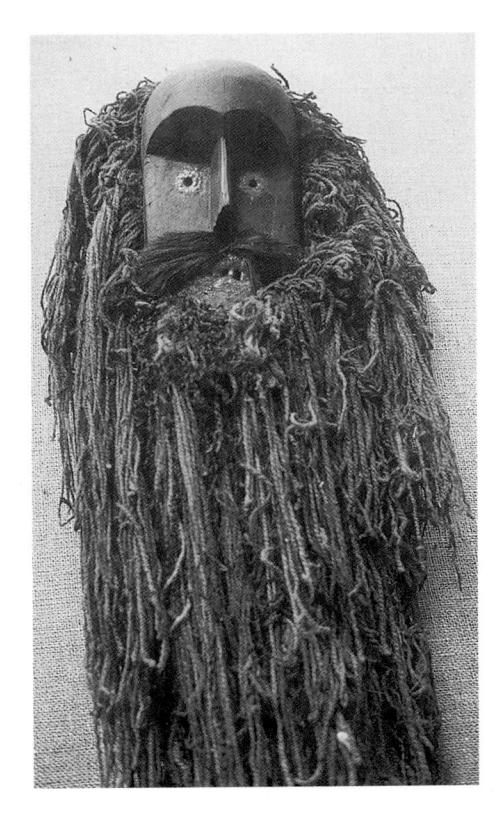

13-29. *Nkhalamba* ("old man" mask), Mang'anja, southern Malawi. Photograph 1960s

Nkhalamba, like all nyau who dance at the edge of Maravi towns, is both a specific, satirical character and the bearer of the spirit of the person who has died. As a dancer and a comic actor, he entertains the men, women, and children who assemble during some stages of the ceremonies. As a spirit medium, he causes women to cry at other times in the ceremonies, for he gives a physical presence to the souls of their deceased relatives.

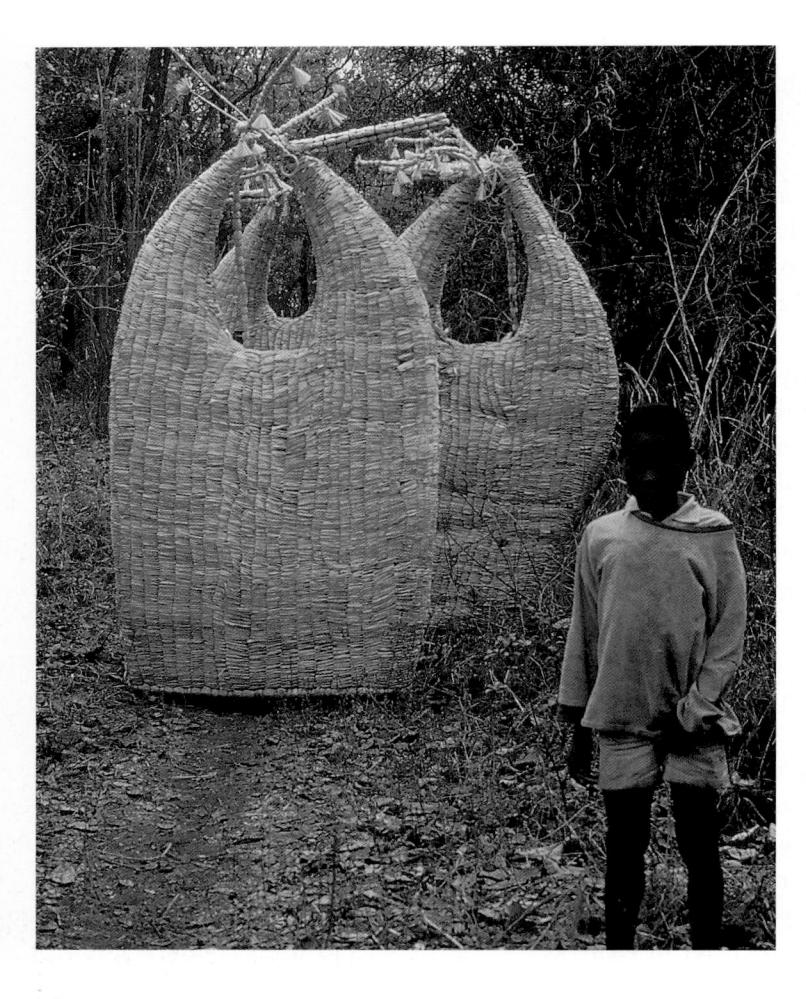

13-30. KASIYA MALIRO (ELAND MASKS) IN PERFORMANCE, CHEWA, ZAMBIA. PHOTOGRAPH 19805

13-31. FEMALE FIGURE, Maravi, Malawi (?), 19TH-EARLY 20TH CENTURY. Wood, glass. Height 22" (56 cm). Museum für Völkerkunde, Staatliche Museen, Berlin

tiated into Nyau eat the ashes of kasiya maliro before returning home to their families.

Nyau masquerades appear when Mang'anja boys and girls are initiated into adulthood, but only boys learn about the nyau of the Chewa. Chewa girls undergo completely separate initiations, which once involved animal forms modeled in the earth. While wooden figures may also have been used for girls' initiations in some Maravi groups, virtually nothing is known of how they functioned in the course of the girls' instruction. A few of these wooden sculptures survive, including the work shown here, purchased almost a century ago (fig. 13-31). The long, tubular torso and

spherical head tie it stylistically to figures from western Tanzania, but the heavy hands and feet and the widely spaced legs are quite distinctive.

Lipiko

Nyau has its equivalent in Lipiko and Isinago, the masquerade institutions of the Makonde and their neighbors (particularly the Yao and the Makua). Lipiko announces and celebrates the initiations of both boys and girls. As in Nyau, the masquerades blend sacred and secular elements. They invoke spirit presences, but the men who are responsible for offering them to the community are named and praised.

Lipiko performances in Tanzania feature face masks. An astounding number of beautiful wooden masks of this type, including the two illustrated here, were taken from Makonde or Makua communities in southern Tanzania by a German visitor at the beginning of the twentieth century. Unfortunately, he recorded virtually nothing about the names of the masks or the characters they represent, and did not note the names of the artists or their places of origin. Both of these masks may in fact have been sculpted specifically in response to his demand for carved objects. As is so often the case in African art, we can only admire the formal inventiveness of works whose mean-

Aspects of African Cultures

Cycles and Circles

Most African arts have as their contexts recurrent and repeated patterns or situations, although some sporadic or arbitrary occasions may arise. Two models—cycles and circles—are especially useful to an understanding of these patterns, which in turn can help us visualize the place and sway of art in everyday and ceremonial life. The most important cycles are the agricultural year and the course of human life from birth to death, and in many places to reincarnation. Certain pulse points or passage rituals in each cycle are magnets for art: planting and harvest ceremonies, transitions to adulthood (puberty rites), and ancestorhood (second burial celebrations). A few cultures acknowledge longer cycles; the Dogon,

for example, mark by an elaborate masquerade the turn of a sixty-year cycle that symbolizes the replacement of one generation with another.

The ownership, orientation, and sway of art also can be modeled conceptually by a series of concentric circles, from the works made for and by individuals, which have the least scope and are represented by the innermost circle, to those for and by an entire community, which have the most scope. This model begins with an individual, extends outward to the family, the lineage group, the village, and the larger community such as a clan or city-state. The boundaries of a people (either as they define themselves or as they are defined by others) define the outermost circle, which would embrace strangers who live on the borderlands and speak different languages. Each

circle tends to foster certain types of art. Scarification and jewelry are personal and individual, domestic compounds are family or lineage based, masquerades tend to be larger group endeavors, while court arts are expressions of a state.

Two relatively new "circles" of importance today are cities and the international world. Groups such as the Yoruba and the Swahili have long built urban centers, but for much of the continent this phenomenon has arisen with colonialism. The international circle that is the intended audience of much contemporary African art is largely a postcolonial, post-independence development, which embraces Africa, Europe, the Americas, and Asia. We can predict that these new circles will become increasingly important. HMC

ing is lost to us, while praising the artistry of creators whose names we do not know.

The first mask is in the form of a lovely oval face (fig. 13-32). The forehead tattoos, the ear spools, and the labret (the cylindrical ornament filling the upper lip) were popular with women in the region, but were occasionally also worn by men, and so we cannot be sure whether the mask depicts a male or a female character. The second mask depicts the face of a rabbit, an animal described as a trickster by East African storytellers (fig. 13-33). The superb abstraction of the detachable ears and the rectangular nose and eyes bear a formal resemblance to the masks of the Western Sudan, while the clear divisions between the oval indentations on either side and the raised chin, nose,

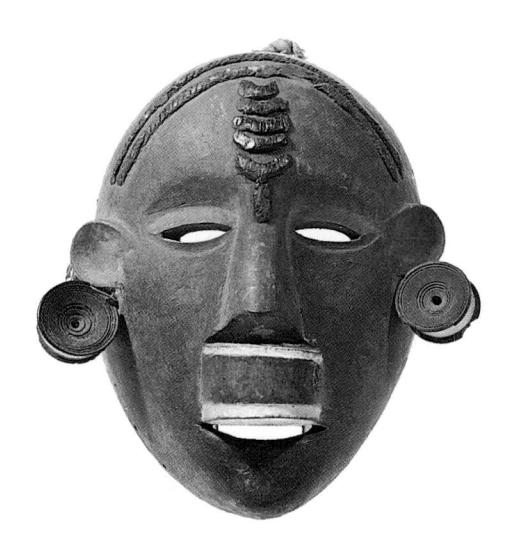

13-32. FACE MASK, MAKONDE OR MAKUA, Tanzania, before 1908. Wood. Museum für Völkerkunde, Leipzig

13-33. FACE MASK, MAKONDE OR MAKUA, Tanzania, before 1908. Wood, white PIGMENT, FIBER. HEIGHT 18½" (47 CM). Museum für Völkerkunde, Leipzig

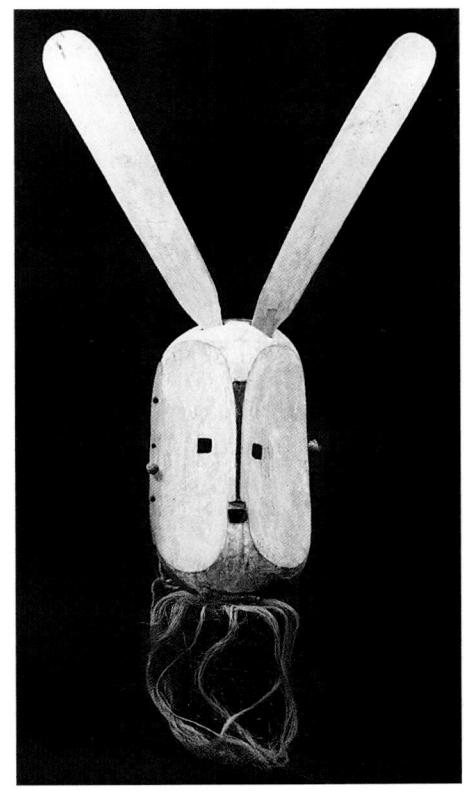

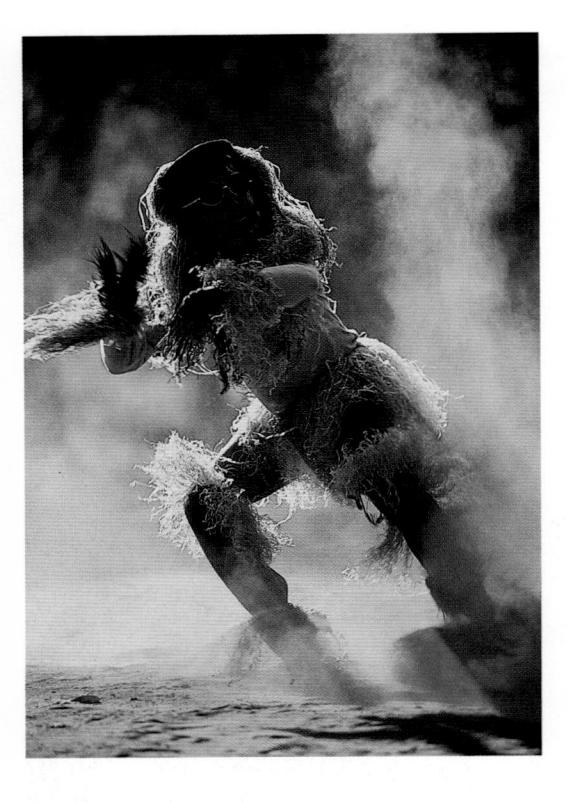

13-34. YAO OR MARAVI HELMET MASK IN PERFORMANCE, MALAWI. PHOTOGRAPH 1990

and brow recall masks from Gabon. The masterful shapes of this mask are probably not the result of outside influences, however, but derive from the artist's skill and experience.

Later in the twentieth century, the masquerades of the Makonde and their neighbors began to be performed primarily with helmet masks covering the entire head. This is particularly true of the Makonde in Mozambique, and their Yao and Maravi neighbors in Mozambique and Malawi. A photograph of a Malawian dancer (who is probably Yao) captures the startling naturalism of contemporary masquerades in the Lipiko tradition (fig. 13-34). This particular masquerader closely resembles the American pop star, Elvis Presley. Throughout the region masked beings are highly respected, but they may also satirize foreigners or other foolish individuals.

13-35. Standing figure, Makonde, Mozambique, Before 1966. Wood, Pig-Ment. Height 15½" (39.5 cm). Museu Nacional de Etnologia Lisbon

Lipiko announces and celebrates
the initiations of both boys and girls.
As in Nyau, the masquerades blend
sacred and secular elements. They
invoke spirit presences, but the
men who are responsible for offering
them to the community are named
and praised.

new mark
torso of o
a Makond
replicate t
that still a
women (f

Sculpture

A large variety of figures have been collected from the Makonde and their neighbors. Some of the earliest examples may have been used in female initiations, but many of the fine sculptures collected during the twentieth century were probably carved for colonial officers, missionaries, and other foreigners by artists exploring

Sculptors in southern Tanzania and northern Mozambique were not restricted to masks and the occasional figure, however. They also carved a variety of staffs and scepters, as well as smaller items used by diviners and their patients. A container filled with mystical matter and tied with strips of beaded cloth was probably used as a protective device, or as a part of a healer's tool kit (fig. 13-36). The side chambers of this delicately patterned object are closed with stoppers in the

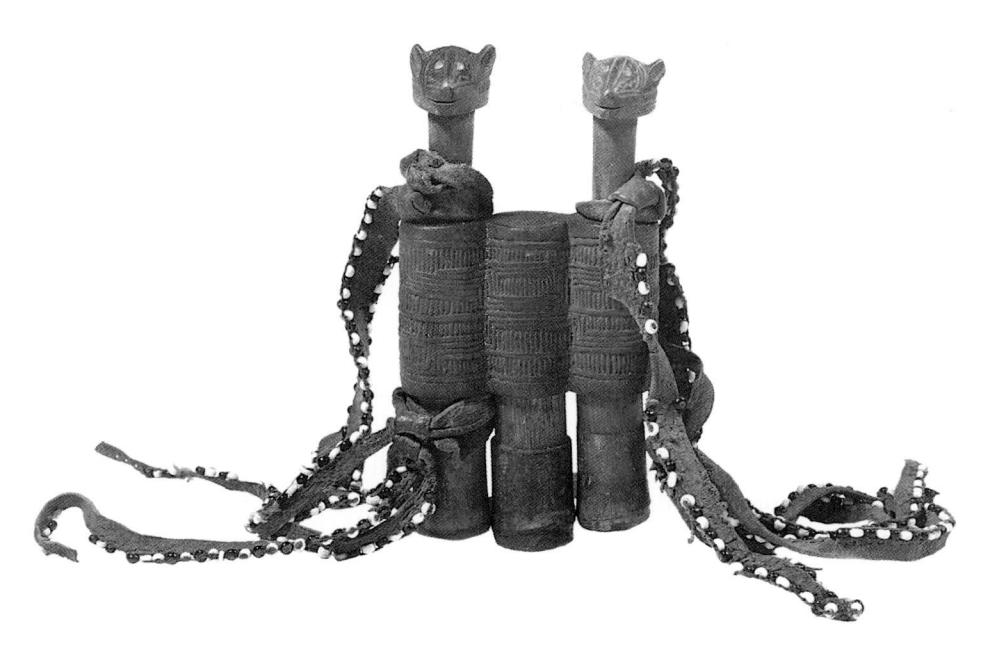

13-36. Multi-Chambered Container with Stoppers, Mwere or Makonde, Tanzania, before 1908. Wood, Beads, Fabric. Museum für Völkerkunde, Leipzig

form of animal heads. They seem closely related to the carved images used to seal the gourds and horns of healers further north (see figs. 13-19, 13-20).

Export Art

In Dar es Salaam, the capital of Tanzania, a businessman commissioned sculpture in ebony (blackwood) from Makonde artists who had settled there in the 1960s. His patrongage encouraged refugees from Mozambique, and Tanzanians of many cultural backgrounds, to create vast numbers of carvings for export and for sale to tourists. Similar centers for export art arose in the coastal cities of Kenva. Some seem to have been modeled on the early workshops established by carvers of the Kamba people who had produced wooden statuary for British colonialists living near Nairobi in the years before independance. Their prodigious output has been called "airport art" (see Aspects of African Cultures: Export Arts, p. 152).

Some sculptures from Makonde workshops are deliberately grotesque, and are called "shetani" ("Satan"), or "devils" by merchants. Others are fluid images of human beings merging with nature and each other. Europeans have been told that these works express Makonde ideas concerning the world of the ancestors and the value of assisting others in the community. Even if these rather romantic ideas may not really be rooted in Makonde religious beliefs, they have encouraged tourists to remember Africans in a positive light. A particularly lyrical example of this type of modern Makonde sculpture can be seen in a work by Nikwitikie Kiasi (born 1929; fig. 13-37). The shapes are polished, smooth, and fanciful, well calculated to accompany art

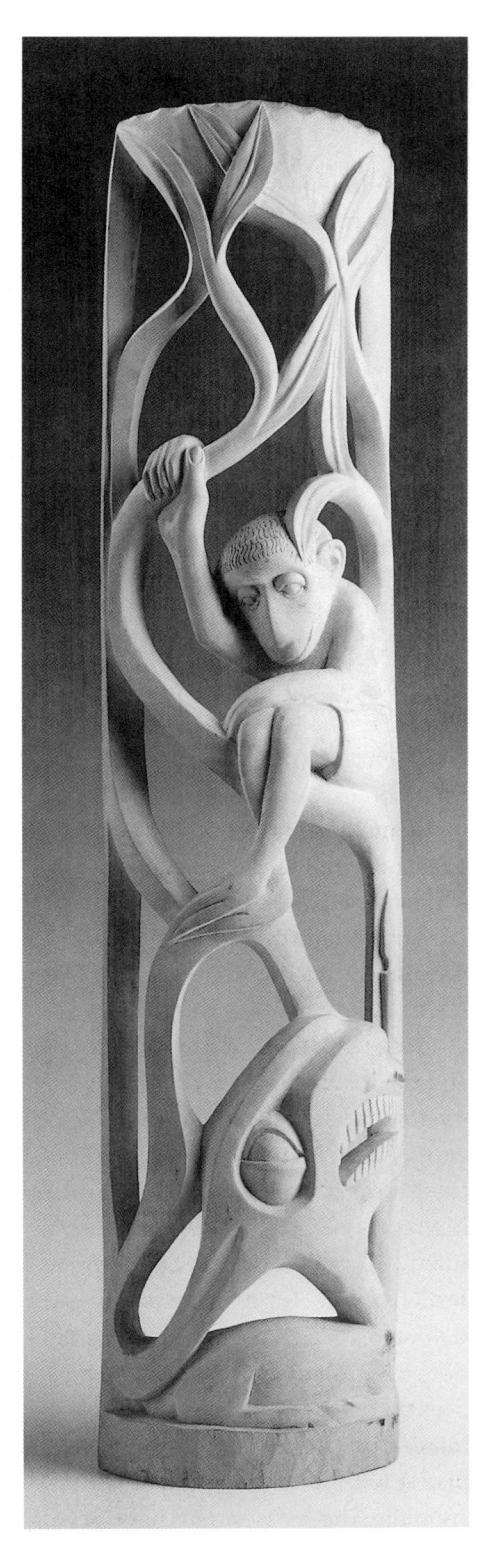

13-37. The Man who became a Monkey, Nikwitikie Kiasi, Tanzania, c. 1974. Jacaranda wood. Height 30%" (77.2 cm). Museum für Völkerkunde, Frankfurt

objects on a foreign bookshelf. Although these Tanzanian works have been subjected to a good deal of critical scorn by art historians, sculptures such as this one should be admired for their inventiveness and their high degree of craftsmanship.

MADAGASCAR

Settled by seafarers from islands of Indonesia, Madagascar has produced an array of art forms based upon both Asian and African traditions. The Malagasy seem to have settled their island around AD 800, just as Swahili culture began to take shape. Numerous similarities between the sculptural traditions of peoples who live along the eastern coasts of the continent and the Malagasy suggest continuous contact between the mainland and its largest off-lying island.

The wooden object from Madagascar shown here (fig. 13-38), meant to be tied around a person's neck or chest, evokes the containers used by healers of southern Kenya and northern Tanzania (compare figs. 13-19, 13-20, and 13-36). This amulet, odi, is from the kingdom of the Merina people, in the central highlands of Madagascar. Odi are filled with powerful substances by a healer, odiase, for his clients. The partial male and female figures here did not serve as stoppers, as similar figures do on the mainland, but were instead part of the sacred materials placed within. Once joined at the shoulder, the figures may have been a reference to male and female ancestors, and an invocation of their spiritual powers. The use of small white beads for eyes and the rounded shape

of the heads link these sculptures stylistically to statuary from certain areas of Tanzania (see figs. 13-21, 13-22).

While the three prongs appear to mimic cattle horns, which are occasionally used as *odi*, they are in fact wooden replicas of the more commonly used crocodile teeth. The only really dangerous predator on the island of Madagascar, the crocodile lends power and authority to protective objects. In fact, the three shapes seem to depict both crocodile teeth and the crocodile itself, with the central protrusion representing a stylized

crocodile head and the other two suggesting front feet.

In addition to their ties to the African mainland, the Malagasy peoples interacted with merchants, pirates, and missionaries before they were colonized by the French at the beginning of the twentieth century. In the middle of the nineteenth century, a Frenchman who had been cast ashore on the island by a shipwreck designed a wooden palace for the powerful Merina queen, Ranavalona I. A Scottish missionary later surrounded it in stone. James Rainimaharosoa (1860–1926), one of

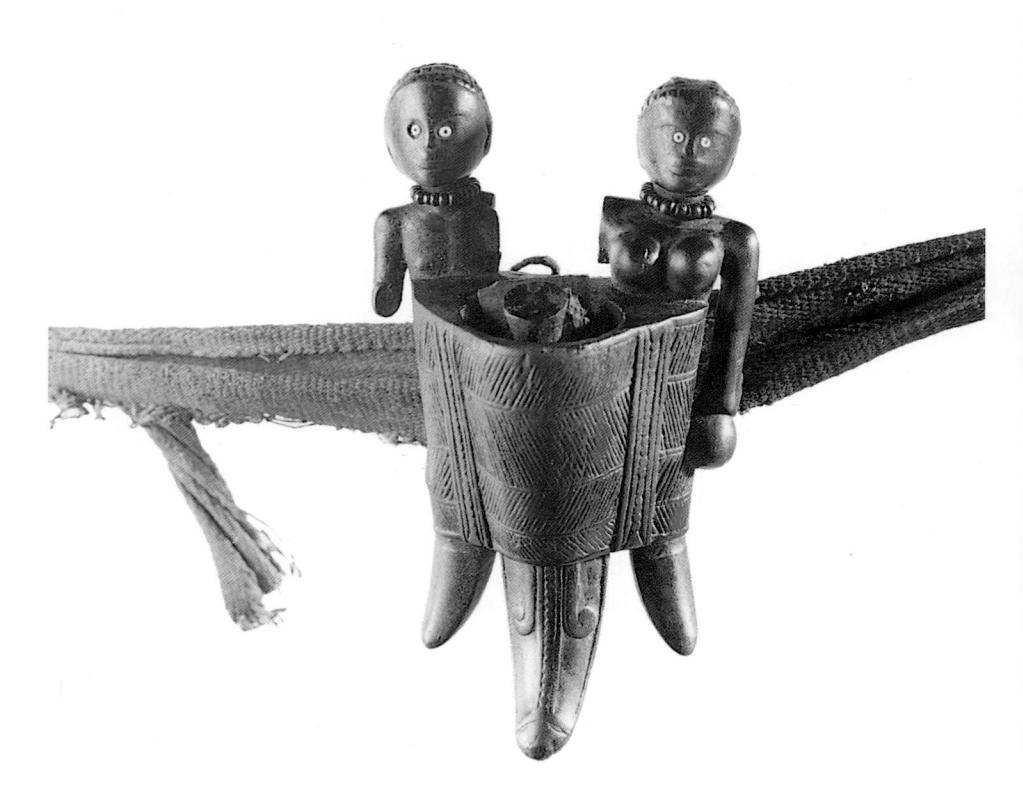

13-38. *Odi* (amulet), Merina, Malagasy Republic, 19th century (?). Wood, horn, fiber. Height 5%" (15 cm). Musée du Quai Branly, Paris

At some point in its history this odi was damaged, and the two connected figures were split apart. Although this damage may be the result of an accident, the amulet may have been deliberately broken by someone determined to destroy its influence or its authority. During the mass conversions of Malagasy to Christianity in the late nineteenth century, many powerful odi belonging to individuals and to royal families were smashed and burned.

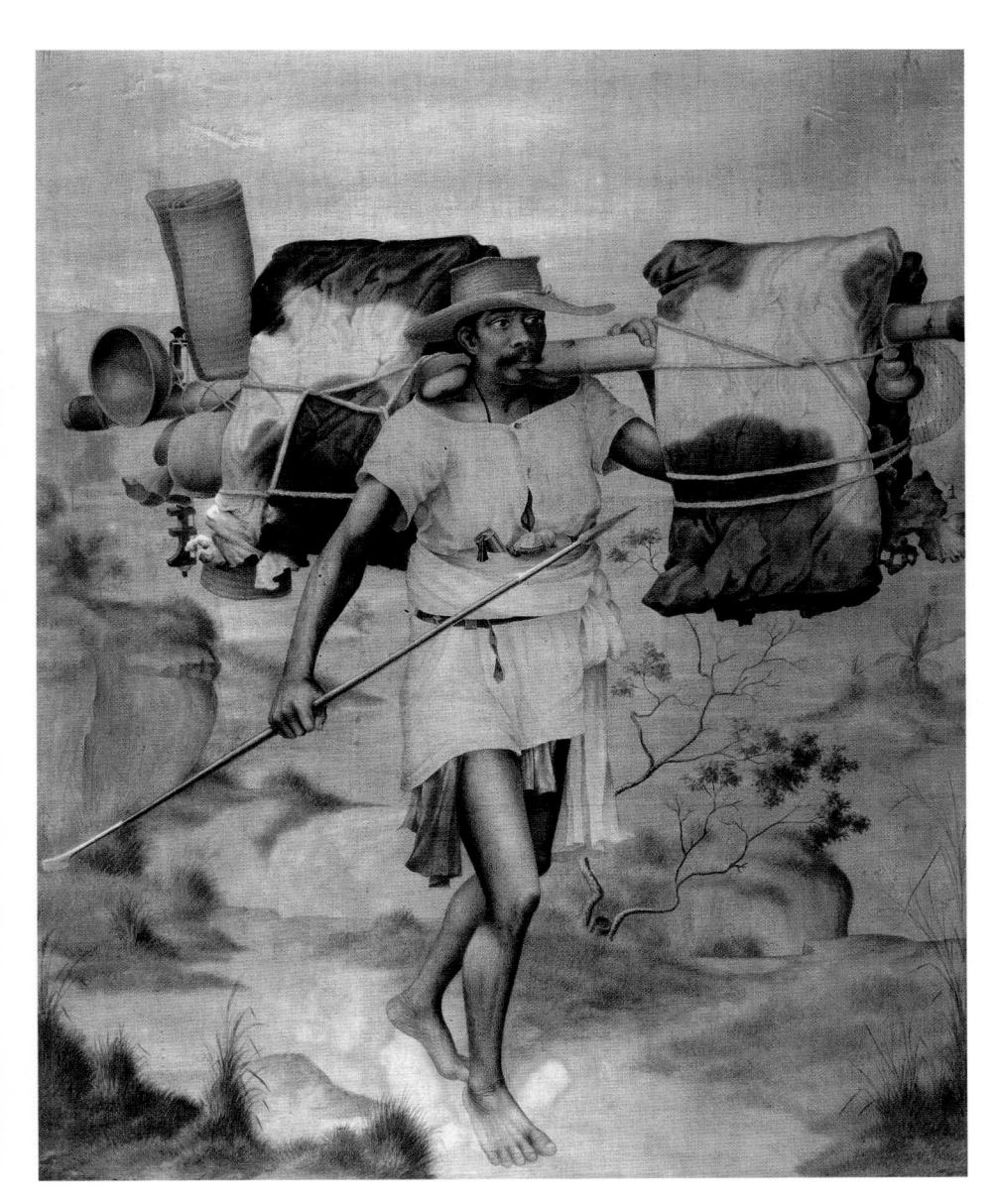

13-39. MALAGASY Porter, Rainimaharosoa, Malagasy Republic, 1901. Watercolor on silk. 35% x 26%" (91 x 68 cm). Musée du Quai Branly, Paris

the earliest Malagasy artists to gain international recognition, studied drawing with an English missionary, and sent his work to a colonial exposition in 1900. His detailed illustrations documented the clothing, the musical instruments, and the architecture of his Merina culture (fig. 13-39). A generation later, Emile Ralambo (1879–1963), followed his example, and has left us numerous naturalistic paintings of Malagasy life and scenery.

Memorial Arts

Perhaps the most interesting Merina architectural structures today are the stone or cement houses of the dead, which are ornamented with painted or incised geometric designs and messages. Within the tombs are textiles, beautiful shrouds used to wrap and re-wrap the remains of the dead at their burial, their exhumation, and their reburial. The shroud illustrated here was woven of locally grown silk on a horizontal loom (fig. 13-40). Though it is indeed a rich red color, all shrouds, even those bleached a gleaming white, are known as lambda mena, or "red cloth." The color red is associated in Merina thought with both royal authority and ancestral power. During the nineteenth century, royal tombs were opened (and the shrouds were thus visible), when the reigning king or queen was bathed and purified during an annual ceremony. Families throughout the kingdom also visited the dead and rewrapped their bones in shrouds in order to liberate the soul of the deceased from the pollution of death and decay. These ceremonies are still performed today.

13-40. LAMBDA
MENA ("RED
CLOTH"), MERINA,
MALAGASY
REPUBLIC, 19TH
CENTURY. SILK.
8' X 5'3" (2.44 X
1.63 M). THE
BRITISH MUSEUM,
LONDON

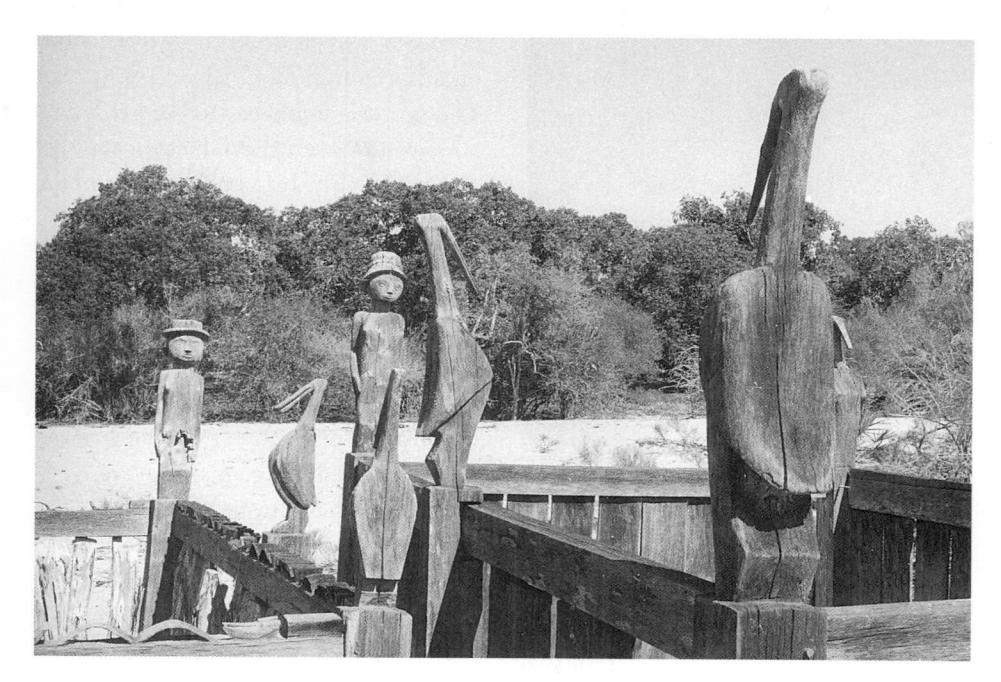

13-41. Cemetery with memorial figures, Sakalava-Vezo area, Madagascar. Photograph before 1970

Other Malagasy groups are best known for their memorial figures, which are interesting to compare to the vigango and other funerary sculpture of the mainland. The Sakalava and their neighbors in eastern and southern Madagascar build fences of wooden planks or posts to form a square enclosure for the coffins of the dead. A photograph shows two of these structures in a southern Sakalava cemetery (fig. 13-41). The corner posts of each enclosure depict either a bird or a human figure. A series of carved images placed along the top of one fence is also visible in the lower left corner of the photograph. Today most Malagasy houses are built of adobe or cement, but these enclosures refer to

the wooden houses of the past. The four sides of the structure are identified with the cardinal directions used in divination, as are the sides of Malagasy houses and shrines. The gender of the human figures is difficult to see in this photograph, but most carved posts of the Sakalava region are female. Male figures are usually found facing female figures, or upon enclosures where women are buried.

Human figures are shown wearing hats, though they are otherwise naked. Since the Malagasy have an ancient weaving tradition, and have always worn long cloth wrappers, unclothed figures are shockingly bare. Scholars suggest that the exposed genitals of Malagasy funerary figures give the site a sexual charge. Indeed, some memorial figures depict humans and birds copulating. Just as sexual activity is necessary to conceive a child, sexual images allow the spirits of the dead to be reborn as ancestors, and Malagasy memorial figures can be understood in the same light as the images of sexuality found in the tombs of New Kingdom Egypt (see chapter 1).

The names of a few of the sculptors active in southern Madagascar during the first half of the twentieth century have survived. Perhaps the most famous sculptor of the region was Fesira (fl. 1920-50), a member of the small Anatanosy group who worked for patrons among the Sakalava as well as the Anatanosy. The Anatanosy, like several other groups in southern Madagascar, do not place figures in the graveyard itself, but erect tall stones, wooden figures, or carved poles in the community as memorials for the dead.

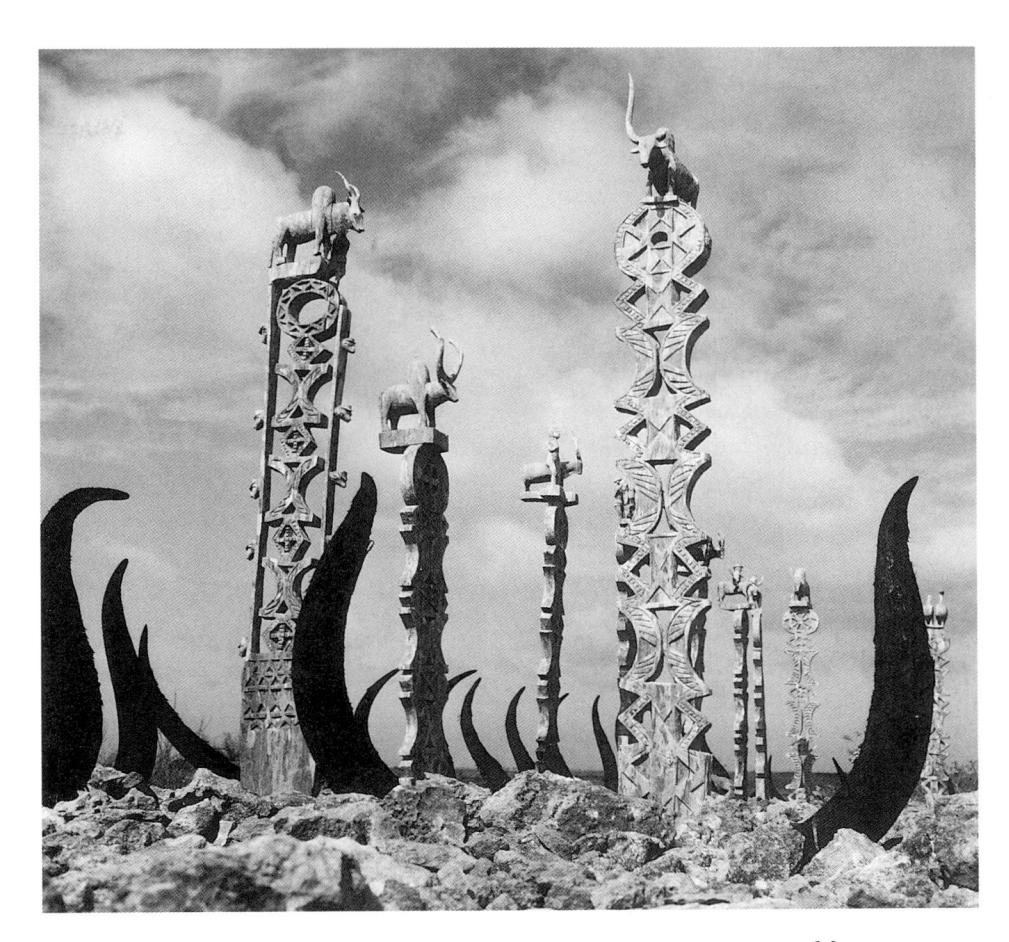

13-42. Alo Alo (memorial posts), Efiambolo, Mahafaly region, southern Madagascar. PHOTOGRAPH BEFORE 1970

Fesira's images were thus not meant to give a sacred aura to a grave site, but to remind the living of the accomplishments of the dead.

Although Fesira's fundamentally naturalistic style differed little from that of other Malagasy artists, his emphasis upon the individuality of the deceased was unique. Elders remember that Fesira would interview family members at length to determine which aspects of the life of the deceased should be commemorated in the sculpture.

Fesira's influence can be seen in contemporary funerary arts of the Mahafaly of southern Madagascar. Like the Sakalava, the Mahafaly place their dead in square enclosures. The walls are made of wood or stone, and the enclosed area is filled with rocks and boulders. Set into the rocks are the horns of the cattle killed during the course of funeral ceremonies. Like some pastoralists on the African continent, the Malagasy train the horns of their favorite cattle so that they grow into striking shapes, and these offerings may thus be seen as a form of sculpture. Also decorating the tombs are carved wooden posts known as alo alo.

The Mahafaly artist Efiambolo carved the alo alo shown here sometime before 1970 (fig. 13-42). The stacked geometric forms of the tall

planks and the chip-carving technique used to produce them are typical of these funerary monuments. The cattle and mounted figures on top of each alo alo are Efiambolo's contribution to the genre, and typical in their simplicity of works produced early in his career. Later, he elaborated such figures into fully orchestrated scenes similar to the commemorative images of Fesira. Today Efiambolo's son produces brightly painted alo alo for foreigners as well as for Malagasy patrons.

CUSHITIC AND NILO-SAHARAN SPEAKERS OF THE INTERIOR

Just as some Malagasy art forms are related to those of Bantu speakers, the art of mainland peoples who speak Cushitic languages of the Afro-Asiatic family and the art of Nilo-Saharan speakers share common features. For many centuries members of these two different language families have lived in close proximity to each other, and they share similar lifestyles and similar beliefs.

Memorial Figures and Stone Tombs

The varied funerary art forms of the Malagasy and of coastal Bantu-speaking peoples in eastern Africa have their counterparts in the tombs and memorial figures of peoples who speak Afro-Asiatic, Nilo-Saharan, and even (in southeastern Sudan) Niger-Congo languages. The most important of these art forms related to the dead are found over a broad area stretching from the Bahr el Ghazal region in southern Sudan east to the foothills

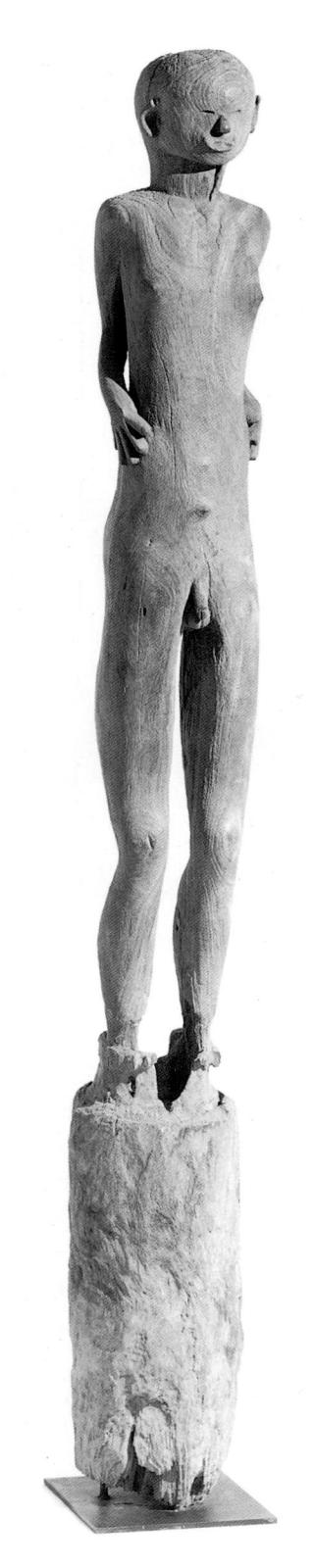

13-43. Grave figure, Bongo, late 19th–20th Century. Wood. Height 7′10½″ (2.42 m). The Menil Collection, Houston

of southern Ethiopia.

Tombs of the Bongo and the Bellanda peoples of southern Sudan were described by explorers during the nineteenth century. A leader was buried under a mass of rocks, which was frequently enclosed in a wooden fence similar to a Sakalava tomb. A sinuous carved figure of the deceased, together with smaller images representing his family, was placed in front of the tomb structure. These elongated figures were evidently not portraits of the deceased, but rather generic evocations of men (fig. 13-43). Other photographs of Bongo graves show ridged columns next to unfenced mounds of stone. They resemble stacks of calabashes or bowls and are probably wooden replicas of the rows of dishes customarily left at Bongo graves even today. Each rounded form is said to symbolize a large game animal or enemy killed by the deceased, or by a man acting in his stead.

Some settled agriculturalists in southern Sudan and southern Ethiopia also build stone tombs. The Arussi, the Derassa, the Sidamo, and other Cushitic peoples who live in the rugged hills far to the south and southeast of Addis Ababa place incised stones next to their tombs, which take the form of stone mounds or cylindrical structures. An Arussi grave photographed by a German expedition in 1958 is surrounded by several large slabs of stone engraved with geometric shapes (fig. 13-44). At the summit of these graves were stone half-figures.

Other peoples in this region carve memorial figures of wood. The best documented are those of the Konso, whose tradition of creating wooden

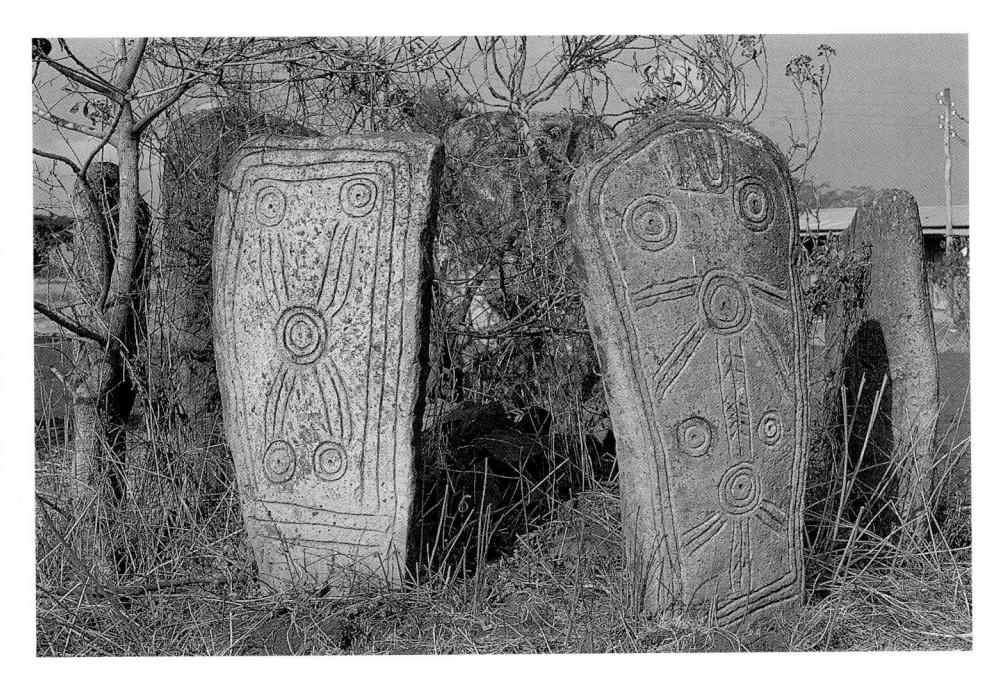

13-44. Grave mound, Arussi, southern Ethiopia. Photograph before 1958

13-45. Grouping of Konso *WAGA* (memorial figures), southern Ethiopia

The central figure of this grouping depicts a man wearing the forehead ornament known throughout the Ethiopian highlands as kallasha. Made of iron or aluminum, these ornaments are worn only by men who had killed an enemy or a large game animal. The central figure is flanked by figures depicting female relatives wearing a distinctive "cockscomb" hairstyle, and by lesser male figures, which probably represent family members, but which may also depict enemies. All of the male figures are equipped with spears.

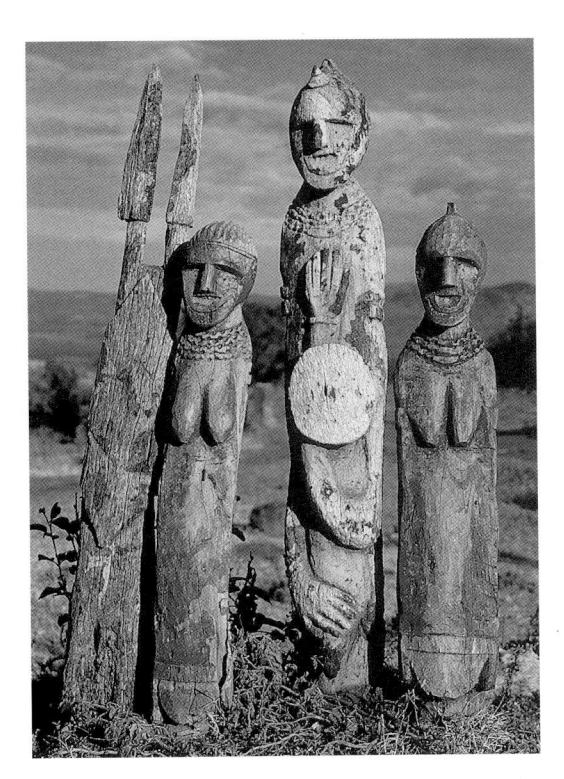

memorial figures, waga, continues to the present day. In the photograph shown here (fig. 13-45), attention is focused on the features of the heads with their rather wedge-shaped jaws. The staring eyes beneath the deep brows, and the teeth affixed in the open mouths, give the figures an aggressive air. Like the vigango of the Mijikenda, Konso memorial figures may not necessarily be placed near the tomb itself. A preferred location for a waga is the town square set aside for men's religious activity, but a cluster of waga may be found in a variety of other locations.

Personal Arts

Although speakers of Nilo-Saharan and Cushitic languages have displayed sculpture such as these memorial figures, they are best known for their arts of personal adornment. The Somali and the closely related Oromo once obtained ornate silver jewelry from a segregated class of smiths. They also purchased amber and silver ornaments in cities such as Mogadishu (in Somalia) and Harar (in Ethiopia). A recent photograph shows a woman from the region near Harar (fig. 13-1). She wears a yarn headband and simple beads rather than the heavy silver pendants of older generations. On her head is a tightly woven basket similar to those of the distant and unrelated Nubian peoples (see fig. 2-36).

The Somali and the Oromo interact with Arab pastoralists who have lived in the deserts of Sudan for centuries. During the late twentieth century, tensions between the Muslim and non-Muslim populations of southern Sudan led to warfare

throughout the region. Muslim forces allied to the Sudanese government were pitted against various rebel factions made up of ancient Nilo-Saharan speaking groups such as the Nuer and the Dinka. In the early twenty-first century, after a tentative peace was made in the southern Sudan, Arabic-speaking Muslim nomads attacked Muslim Nilo-Saharan speaking populations in the eastern Sudan region known as Darfur (see chapter 3).

Two photographers who visited the southern Sudan prior to the civil war recorded the beauty of the beaded ornaments worn by Dinka herders (fig. 13-46), which can easily be seen as abstract art objects. Apart from scarification patterns, beadwork, and a dusting of protective powders, the Dinka wore few clothes. Twenty years later, the pastoralists in these photographs may have been killed or dispersed. A generation of their children made its way on foot to refugee camps in northern Kenya. Some of these survivors, known as the "Lost Boys" of the Sudan, have been re-settled in the United States.

Populations who suffered even more in this phase of the civil warfare in Sudan were the settled agriculturalists of the Nuba Mountains, the highlands west of the White Nile River and north of the Bahr el Ghazal region. These peoples also speak Nilo-Saharan languages. Before they were killed, enslaved, and displaced by this conflict, they distinguished themselves from animals and from their bearded and veiled Muslim neighbors by shaving their bodies and carefully trimming the hair on their heads. Although they wore belts, pendants, and a few other ornaments.

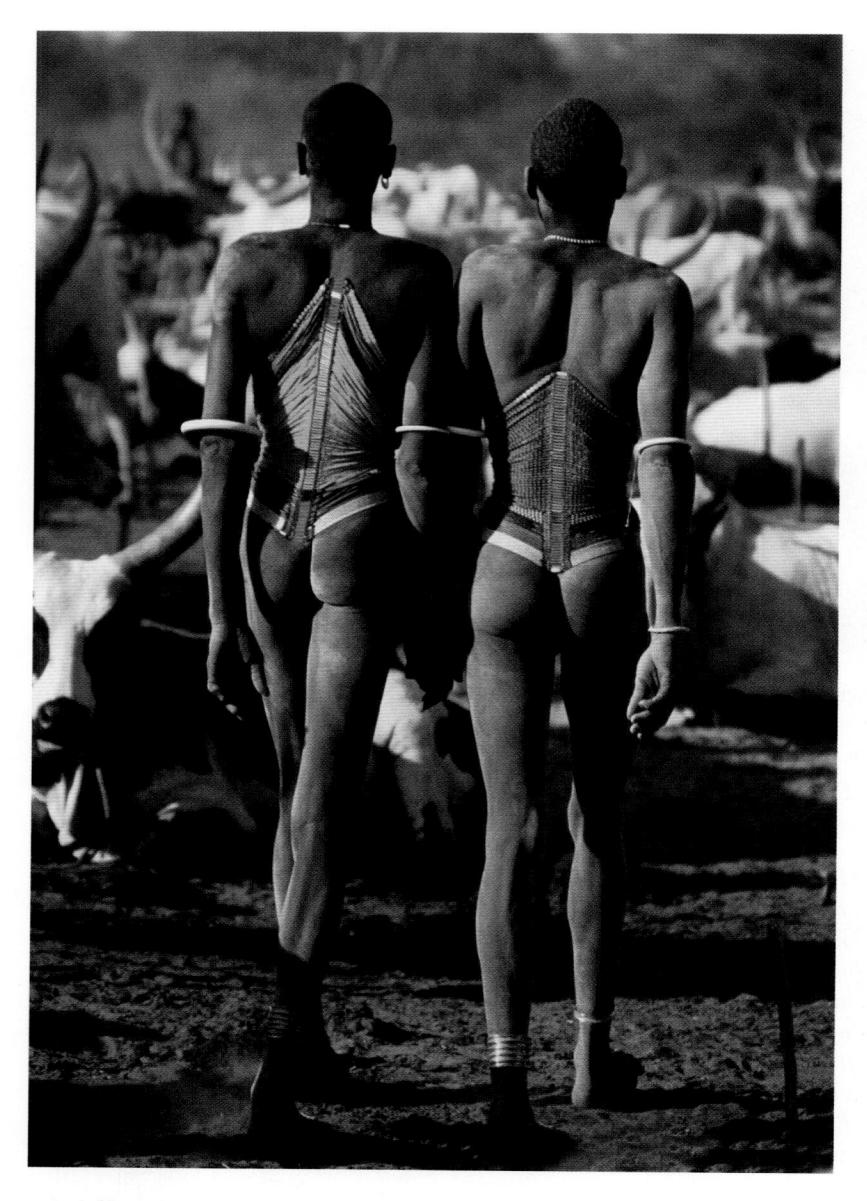

13-46. Herders with cattle in traditional beaded corsets. Dinka, Sudan. Photograph 1980s

only the sick, the aged, or pregnant women wrapped themselves with cloth. Otherwise the body was covered with oil, the sweet-smelling product of human labor and community life. Boys and men painted designs on their bodies, while girls wore a solid layer of red or yellow ochre. Women's bodies were further

ornamented with rows of raised keloids. As among the Ga'anda of Nigeria (see chapter 3), a girl acquired a new set of scars at each important passage of her progress to full adulthood. A married woman who had weaned a child displayed delicate patterns of raised skin over her shoulders, back, and abdomen.

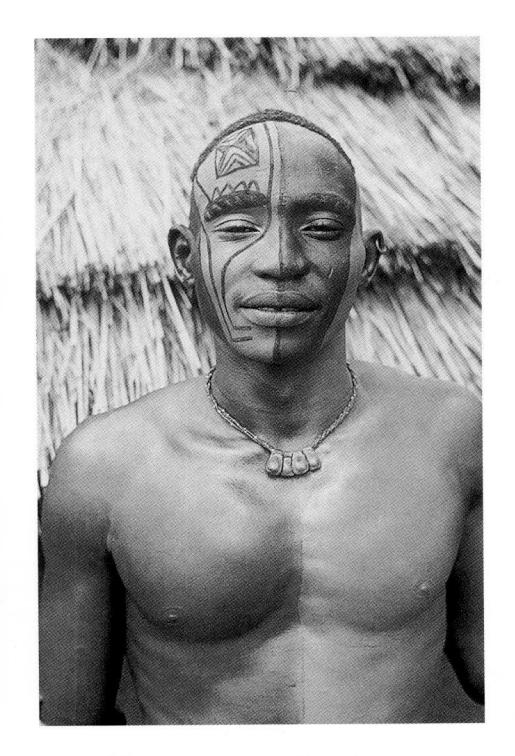

13-47. Nuba *Loer* Youth, Kao, Sudan. Photograph late 1960s

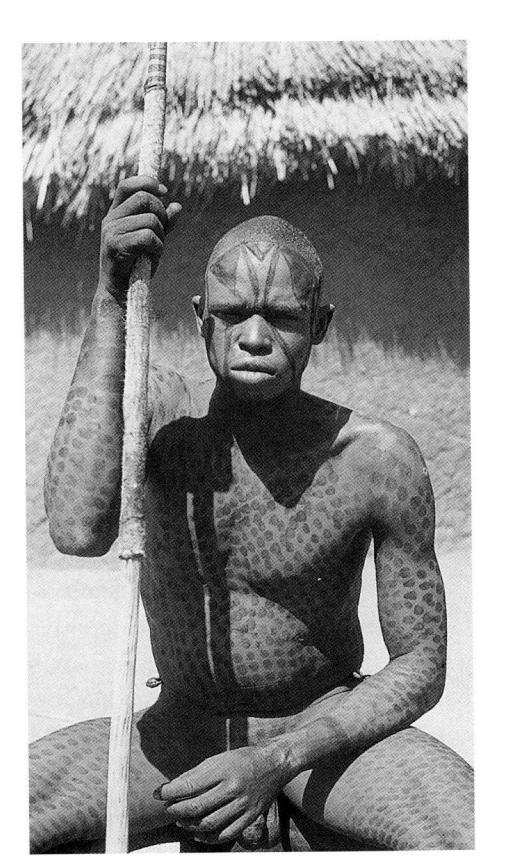

Young men in the community of Kao in the Nuba Mountains learned to apply painted patterns when they joined the age-grade known as loer. For several years they were allowed to experiment with colors, designs, and shapes that complemented their features and expressed their aesthetic tastes. A loer youth photographed in the late 1960s created a wonderful asymmetrical composition (fig. 13-47). Black pigment in one area of his face complements the black paint on the opposite side of his body. The white or yellow background of the other side of the face is similarly matched by the pigment of the other half of the body. The lines drawn on the face may at first suggest an ostrich whose body surrounds the eye and whose legs extend down the side of the cheek. However, the design was

13-48. Nuba *Kadundor* man, Kao, Sudan. Photograph 1970s

These two photographs were taken by an anthropologist who lived in their community during the 1970s. After he left the Sudan, a German photographer named Leni Riefenstahl travelled to the region and photographed hundreds of young Nuba men and women. Riefenstahl, already famous (or infamous) for her early films glorifying Hitler's Third Reich, was criticized for her decision to shoot photographs of the Nuba without their permission, and for hiding in the bushes with a telephoto lens when they had explicitly asked her to leave. We have thus not included her photographs in this book. Ironically, though, those vivid and dramatic photos are now the fullest documentation of the beauty lost to the world when these communities were destroyed.

interpreted by the artist as a non-representational image, one subtly different from a similar pattern identified as "ostrich." Two generations earlier, a friend would have created this art work for the young man, but imported mirrors have given each youth the opportunity to use his own face as a canvas.

The artistic skills of a *loer* were well established by the time he became a *kadundor*, a mature young man who had the right to use a broad spectrum of pigments, to affix a plumed crest to his hair, to become an accomplished wrestler, and to develop an active sexual life. One kadundor was photographed wearing a bold design (fig. 13-48). The strict geometry of the broad lines and triangles he has painted on his face contrasts with the organic surfaces beneath. His body is covered in a spotted pattern identified with the leopards that hunted in the Nuba hills. Such patterns only lasted a day or two, and had to be scraped off when they were smeared so that new designs could be drawn. This art work was not only seen during festivals; it was required daily attire.

Although other Nilo-Saharan peoples living in southern Ethiopia may still adorn their bodies with chalk or ocher, the men of the Nuba Mountains were once unsurpassed as body painters. In other regions, men and women create spectacular personal arts, but they use paint only sparingly, relying instead upon cloth, coiffures, and ornaments to proclaim their beauty, strength, and maturity. Perhaps the most striking of these multicolored body arts is still being created by the Maasai and related peoples of Tanzania and Kenya.

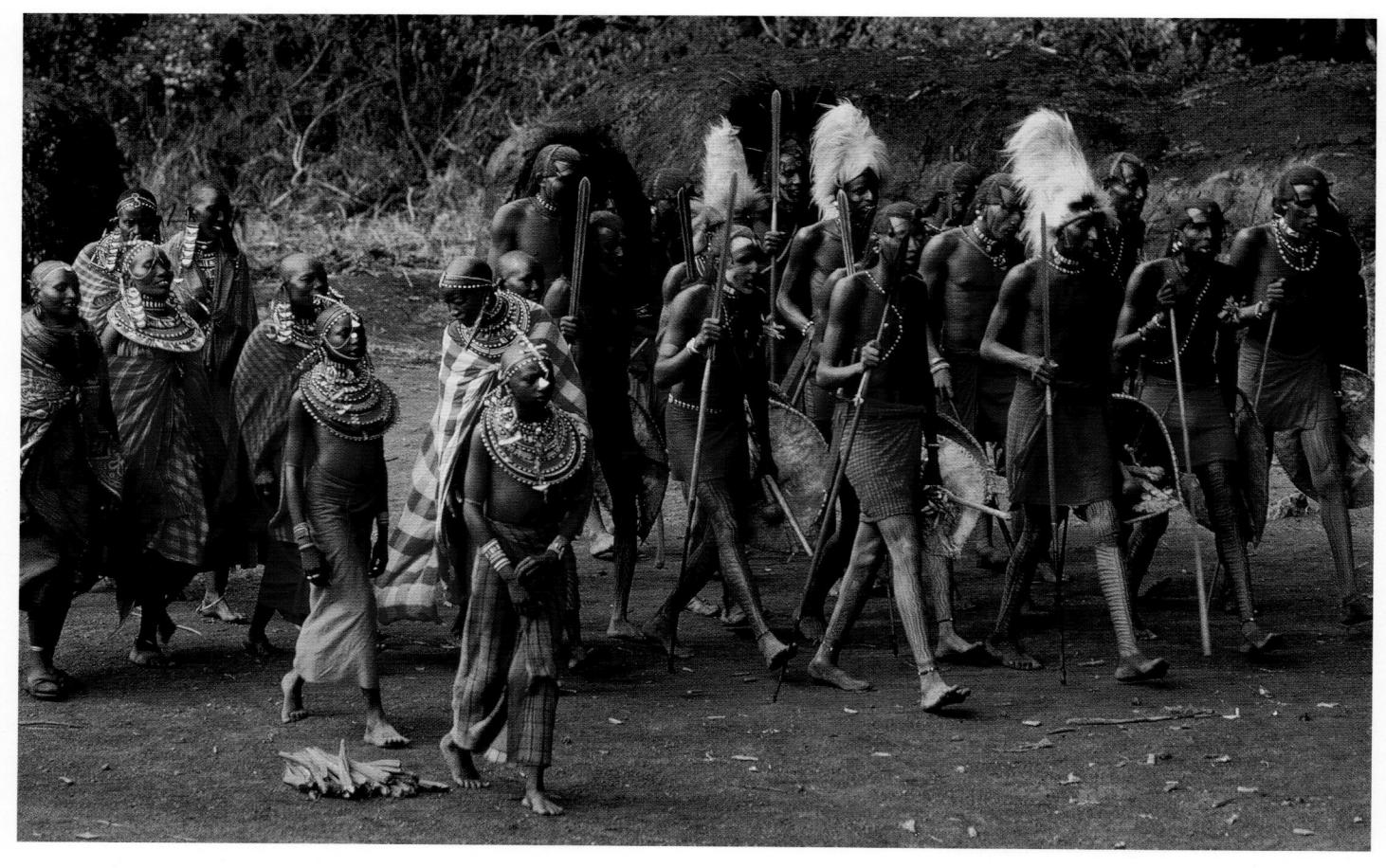

13-49. Maasai procession in honor of Moran (Warriors), southern Kenya. Photograph 1980s

A Maasai procession to celebrate a stage in the training of moran, or warriors, is a spectacular and unforgettable display (fig. 13-49). The warriors themselves wear cloths tied around their waists and lengths of beads around their necks and chests. Their legs are painted with designs in white chalk for the ceremony. Three of the men also wear distinctive fur headdresses. Each moran carries his shield and spear, and wears his hair in the manner of a warrior, with myriad tiny braids colored with ocher and gathered into triangular segments. Before their age-grade gained warrior status, they were not allowed to have any of these forms of adornment, and

they will shave off their meticulously braided hair when they become elders and are able to marry.

The mothers and companions of the warriors walk with them. Long oval ear ornaments proclaim the women's status as mothers of *moran*, just as their cloaks show that they are married women. The two girls, whose ornaments move rhythmically as they walk, are bedecked with beaded collars given to them by admirers. Although they are too young to marry, the community is already honoring their beauty and grace.

Many Cushitic- and Bantu-speaking peoples in this region have also developed their own dramatic forms

of dress, possibly in response to the Maasai and other Nilo-Saharan peoples. Just as the Maasai define the status of both men and women through clothing, beadwork, and hairstyles, the daily dress of the Turkana, Cushitic-speaking pastoralists of northern Kenya, serves as an emblem of their identity and rank. A photograph of three Turkana women shows how dress articulates each stage of life (fig. 13-50). The little girl wears only a few beads around her neck and at her hips. Her older sister, who has entered puberty and who will soon marry, wears a special leather cloak embroidered with a circle of white shell beads. Girls of this age often

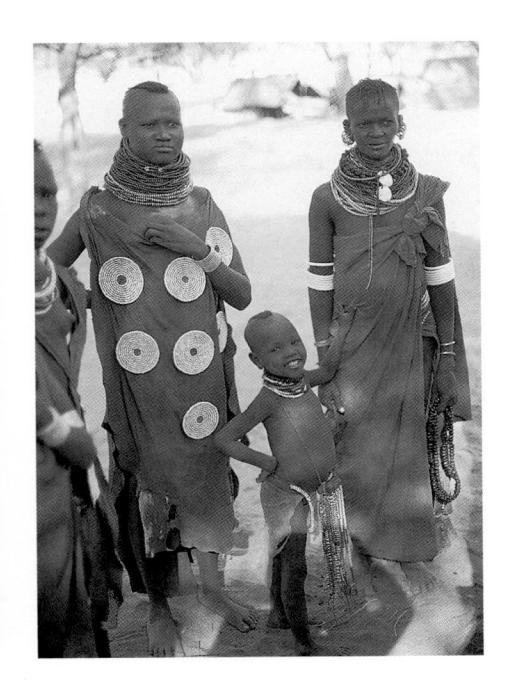

13-50. Turkana women and girl, northern Kenya. Photograph 1970s

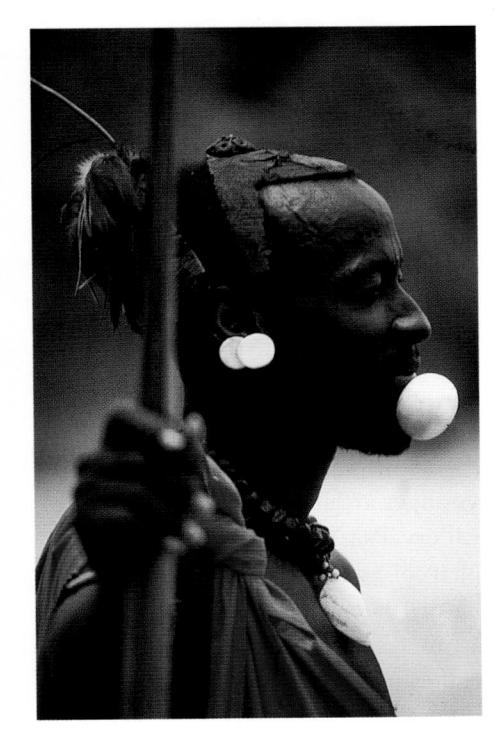

13-51. Turkana man, northern Kenya. Photograph 1970s

carry a gourd or piece of wood encircled with beads to represent a miniature child. This small talisman, the equivalent of a *mwana hiti* (see fig. 13-15), is intended to ensure that she will conceive and bear a healthy child. The older woman has a much simpler wrapper, but the disks on her neck beads indicate that she is a matron.

The Turkana are camel herders, and they encounter many other peoples in their travels through northern Kenya and parts of southern Ethiopia. The colors of the beads the women wear identify them as Turkana, as does their distinctive hairstyle, shaved on the sides and braided on top. The coiffure of Turkana men is much less specific, for mature men of many different groups in Kenya and southern Ethiopia wear a hairstyle that has been called a "mudpack" (fig. 13-51). The hair on the forehead is shaved to create a smooth hairline, and the rest of the hair is pulled back into a rounded bun. The hair is then coated with mud, which holds feathered ornaments in place. Such ornaments mark this man as an elder, for warriors are only allowed simple mudpacks, and boys have none at all. Of course, this elder is also proclaiming his personal sense of style, for the shell ornaments, ivory lip plug, plumed cap, and knotted robe combine to give him a commanding presence.

ARTISTS OF UGANDA, TANZANIA, AND KENYA

The British colonial authorities established colleges and universities in Nairobi, Kenya (where students could study architecture or art education), Dar es Salaam, Tanzania (where they

could study theatre), and Kampala, Uganda. However, only Makerere University, in Kampala, has had a department of art. The establishment of this program in the 1950s was due to the work of a resourceful Englishwoman named Margaret Trowell, and it served as the vibrant artistic center of East Africa for the next two decades before the horrifying genocidal warfare unleashed by the dictator Idi Amin. By the very end of the twentieth century, the country of Uganda and the university itself were on the path to recovery, and Makerere is once more a vibrant cultural center.

An influential artist who studied at Makerere was Francis Nnaggenda (born 1936), who still teaches there. Nnaggenda was teaching in Nairobi in 1978 when he heard rumors of bloodshed in his homeland in Uganda. He returned home with his family and spent the next decade living through a period of horror and chaos. His sculpture, War Victim, was a response to the violence of those times (fig. 13-52). In the words of the artist:

"There is a large *mukebu* tree on the path to the school [of art at Makerere University]. Traditionally the *mukebu* is highly respected. One day, while walking home, I saw that somebody had burned grass against this magnificent tree, resulting in part of the trunk collapsing and blocking the path. I was very upset by this wanton destruction. Somehow it seemed so connected to the war and symbolic of the thoughtless killing of human beings. I rescued the burned and broken piece of wood; it became

13-52. THE WAR VICTIM, FRANCIS NNAGGENDA, 1982–6. WOOD. MAKERERE UNIVERSITY, UGANDA. COURTESY THE ARTIST

According to Nnaggenda, "Destruction exists but the spirit must survive. Amputated but still full of resistance." As he states so clearly through his words and through this sculpture, war and spiritual resistance are part of the human experience in the twentieth century.

War Victim. By the way, this piece is not just about Uganda."

Theresa Musoke (born 1941) has also taught at Makerere University, where she returned after years of exile in Nairobi. Her painting *Birds* is a response to the pain of her native land (fig. 13-53). Here, shadowy gray, brown, and black shapes emerging from a bluish background coalesce into images of twisted, long-legged

13-53. BIRDS, THERESA MUSOKE. ACRYLIC ON CANVAS. COURTESY THE ARTIST

birds. These creatures do not seem to be simply metaphors for "death" or "hope," but rather a direct evocation of fear and despair.

Another painter of Nnaggenda's generation who continues to play an important role in the development of Kenyan art is Elimo Njau. Born in Tanzania in 1932, and educated at Makerere, Njau is best known for his painterly, abstracted scenes (fig. 13-54). Both a teacher and patron of

younger artists, Njau founded an art gallery, Paa Ya Paa, in a suburb of Nairobi, to market contemporary art. Until 1998, when it was destroyed in a fire, Paa Ya Paa was one of the few galleries in Kenya (and possibly on the African continent) to be owned by an African artist.

Although there are limited opportunities for academic studies in art in Kenya, talented painters and sculptors have been able to obtain some

13-54. Milking, Elimo Njau, c. 1972. Oil on cloth. 20" x 15 $\frac{1}{4}$ " (51 x 40 cm). Museum für Völkerkunde, Frankfurt-am-Main

13-55. Market scene with "Tingatinga" paintings for sale, Dar es Salaam, Tanzania. Photograph 1994

instruction and a great deal of encouragement from informal networks patronized by entrepreneurs and expatriates. At the end of the twentieth century, non-governmental organizations and non-profit groups such as Kuona Trust (once sheltered by the National Museums of Kenya) and the Go-Down Art Center (in downtown Nairobi) have enabled artists to work together and exhibit their drawings, paintings, prints, sculpture, photography, and video art.

Elsewhere in East Africa, formal art training is by no means universally accessible. While Madagascar has had a School of Fine Art for over a century, Malawi's central university began to teach art only in the late 1960s. Those with little or no formal schooling in art have managed to sell their paintings in tourist markets, or on the streets. Some of the most popular of these artists paint in a style developed by Edward Saidi, known as Tingatinga, who died in 1972. Tingatinga's followers produce inexpensive, bright, playful images of birds and animals. Like Makonde workshops in Dar es Salaam, "Tingatinga studios" produce an amazing volume of very similar works (fig. 13-55).

In eastern Africa today, most sculpture and painting is purchased by foreign clients. Despite attempts by artists, cultural centers, and workshops to display art where it can be seen by the general population, patronage of eastern Africa's diverse contemporary art is still mostly limited to outsiders and to an educated elite.

Southern Africa

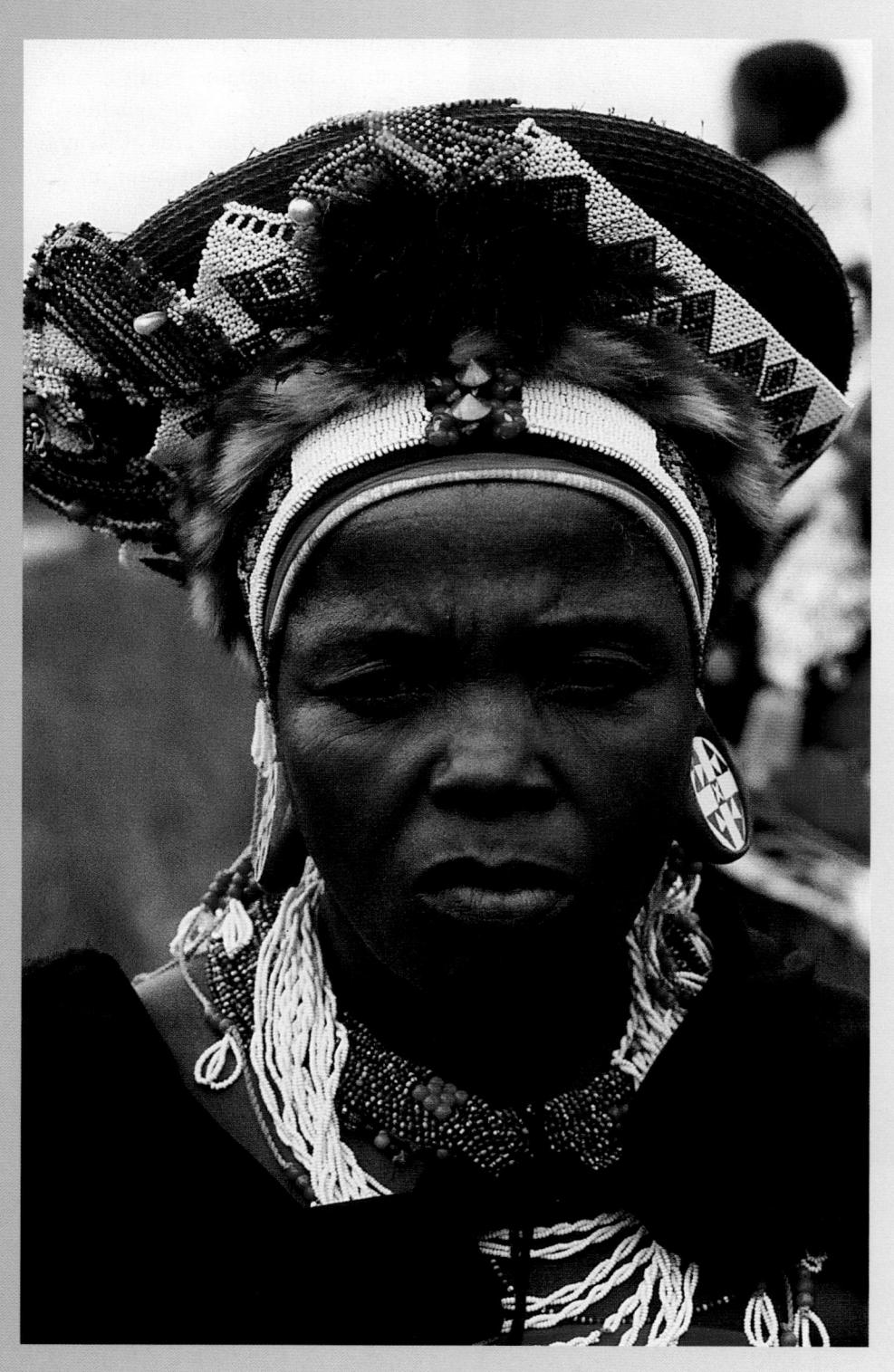

14-1. Woman in Beads and Earrings, Zulu, South Africa. Photograph 1975

South of the Zambezi River, the African landscape is a mosaic of sandy deserts, cool forested highlands, and broad savannahs. Hunting and gathering populations have lived in these diverse environments since the dawn of the human race. The images they incised and painted on rock surfaces are the oldest known art works on the continent, and are among the earliest art made by human beings.

Hunting and gathering peoples were joined in southern Africa by Bantu-speaking agriculturalists and pastoralists about two thousand years ago. These immigrants, who brought with them the technologies of iron and pottery, were part of the great migrations that brought other Bantuspeaking peoples to central and eastern Africa. In southern Africa, their arrival stimulated the growth of new cultures. Bantu-speaking communities with stone terraces arose in the Limpopo River valley in the eleventh century AD; two centuries later the stone-walled site now known as Great Zimbabwe became an important regional capital for the territory between the Limpopo and Zambezi rivers. Today Bantu-speaking groups are numerous. Those whose arts are discussed here include the Shona. Venda, Tsonga, Tswana, and Sotho peoples, and some of the Nguni peoples: the Ndebele, Zulu, and Ngoni.

Non-African immigrants first settled in southern Africa in the seventeenth century, when Dutch farms were established near the Cape of Good Hope. The history of these Dutch-speaking Afrikaaners parallels that of European immigrants to North America; Afrikaaners founded Cape Town about the time the Dutch were settling New Amsterdam (later called Manhattan), and they moved into the interior of the country in covered wagons just before the Oregon Trail and Santa Fe Trail were drawing settlers to the American West. Battles between Bantu-speaking groups and the white settlers mirror those of Native American groups and white settlers.

During the nineteenth century, the British laid claim to South Africa and to the territory they named Rhodesia (after the adventurer Cecil Rhodes). British victories over the Afrikaaners in the Boer War (1899-1902) resulted in new influxes of both European settlers and Asian workers to South Africa. Some Bantu-speaking peoples were assigned to territories that eventually became the semi-autonomous nations of Lesotho, Swaziland, and Botswana. Other African populations were removed from the lands where they had hunted or grazed their cattle for thousands of years, and either forced to work for white farmers or moved into reservations known as "homelands." After World War II, South Africa became independent from Britain, and a new Afrikaanerled government established a system called apartheid. The laws of apartheid classified South Africans as "white," "black," or "colored": non-whites were not allowed to live, work, eat, travel, or be educated in areas reserved for whites without special permission. After decades of struggle, a new constitution brought majority rule to South Africa in 1994, and with it the end of apartheid.

For the other nations of southern Africa, the late twentieth century was also a time of conflict. When Mozambique was finally able to win its freedom from Portugal in 1975, it became the last African nation to gain independence from a colonial power. The white minority government of Rhodesia was defeated after decades of armed resistance in 1979, and took the name Zimbabwe. Namibia, a former German colony administered by South Africa, was granted autonomy in 1990. After decades of civil war and widespread bloodshed, peace had begun to be established throughout the region by the beginning of the twenty-first century.

ROCK ART OF SOUTHERN AND EASTERN AFRICA

A vast array of images painted and engraved on rock surfaces have been documented across the southern and eastern portions of the African continent. Like the rock art forms of northern Africa (see chapter 1), they elicit a host of questions: Who created them, and were their artists the ancestors of the people living in the

region today? How old are they, and how can they be interpreted? If they mark sacred sites, what events or states of being did they evoke?

Earliest Images

The earliest known works of art from the African continent were found in a rock shelter named Apollo 11, in the mountains of the southern Namibian desert. Here eight fragments of painted stone were excavated by archaeologists in a layer of organic debris dated to about 25,000 BC. The stone fragments had not been chipped from the cave walls but rather had been brought into the shelter from elsewhere.

Painted in red or black on the flat surface of each stone is the image of a single animal. The most mysterious of these faded beasts covers a fragment split into two halves (fig. 14-2). The large and bulky head has been described as leonine, but the body and legs resemble those of a herbivore such as an antelope. Although the animals on some of the other stones were drawn in outline, this animal was painted in solid black.

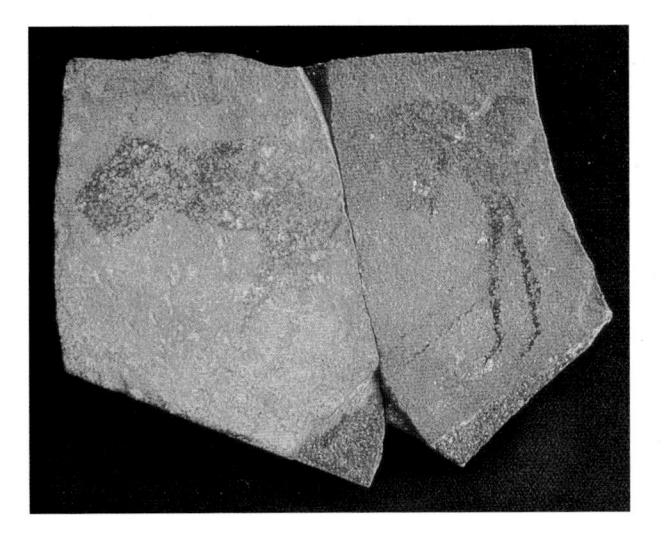

14-2. PAINTED FORMS,
APOLLO 11 CAVE, SOUTHERN
NAMIBIA, BEFORE 21,000 BC.
PIGMENT ON ROCK

14-3. Three figures, Coldstream Cave, Cape Province, South Africa. c. 2,000 BC. Pigment on Stone. South African Museum, Cape Town

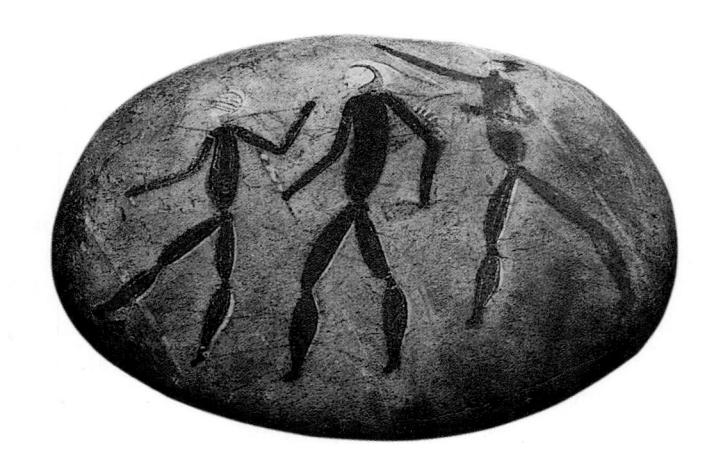

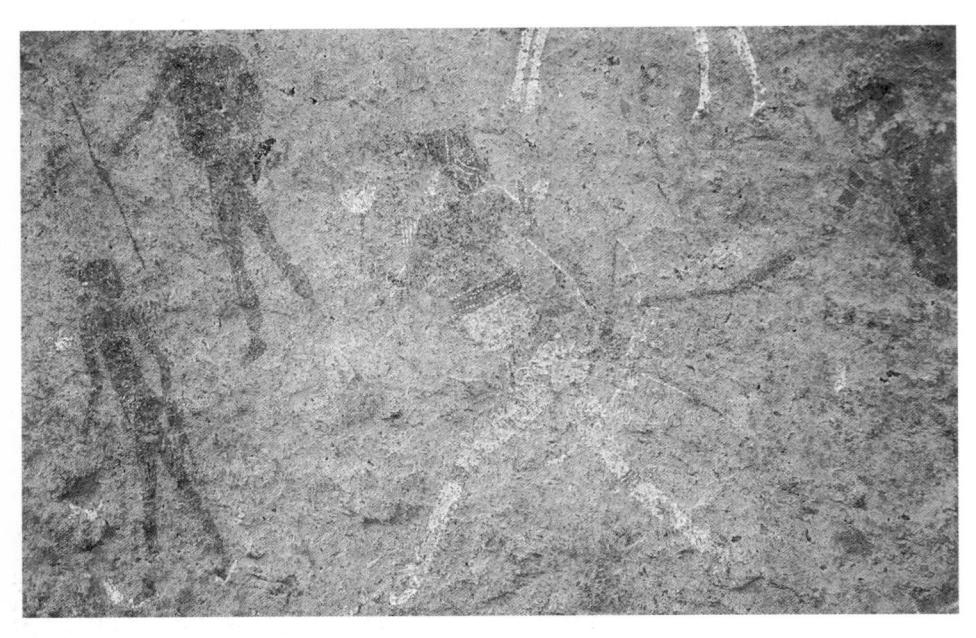

14-4. Ornamented figure from Tsisab Gorge, Brandberg Mountains, western Namibia, c. 2000–1000 bc (?). Pigment on rock face

All of the figures in this frieze stride (or dance) with legs apart. While the legs, hips, and head are shown in profile, chests twist to face the viewer. This is probably not a reference to a contorted pose, but a stylistic convention. As in Kemet, it allowed the artist to show each portion of the body as clearly as possible (see chapter 2). Of course, the stylistic similarities of two-dimensional figures from ancient Egypt and from ancient Namibia should not suggest that the two areas of the continent were in direct contact; they are simply a reminder that talented painters may devise similar solutions to formal and conceptual problems.

Stones and pebbles painted more recently have been found in coastal caves east of Cape Town in South Africa. The most famous of these, the so-called Coldstream stone, was unearthed in Coldstream Cave, where it rested upon the shoulder of a skeleton (fig. 14-3). Although this stone was not scientifically excavated, similar stones have been found by archaeologists in levels dating from 2000 BC to the beginning of the Christian era.

The Coldstream stone shows three human figures moving from right to left. Each is formed of a series of long, sinuous ovals surrounded by an outline. The tallest figure, with a red cockscomb-like projection on his head, raises an arm over the head of the central figure, who has a pouch over one shoulder and holds two objects in his tiny hands. Red lines streak the face of the smallest figure. Although the gestures of all three seem free and spontaneous to us, these clearly defined poses may have had a precise meaning.

A rhythmic painted scene from the wall of a cave in the Tsisab Gorge, in the Brandberg Mountains of central Namibia, may also have been painted as early as 2000 BC. It depicts a dozen elaborately ornamented figures marching or dancing in a long procession (fig. 14-4). Designs painted on or near the figures may either depict physical adornment and material objects, or refer to a spiritual state. For example, rows of white dots at the knees, ankles, and hair of the largest figure shown here could depict ostrich eggshell beads, which have a long history in the region, or they could be references to supernatural power.

Incised images are also found on exposed rock surfaces throughout

14-5. ELAND
ENGRAVED IN ROCK
FROM THE SWEITZER
RENEKE DISTRICT.
WIDTH 15" (38.1 CM).
NATIONAL CULTURAL
HISTORY MUSEUM,
PRETORIA

southern and eastern Africa. Because such images are rarely associated with a covering of organic debris, they cannot be dated. A notable exception is a fragment found at a site called Wonderwerk Cave, in the central mountainous region of South Africa, which was deposited in a layer of datable debris dating back over 10,000 years. Many of these carved boulders are covered with roughly cut parallel grooves, swirling in geometric or organic patterns. Some scholars believe that these concentric lines form entopic images, replicas of hallucinations experienced in trances or other altered mental states.

Although most incised or carved rock art from southern Africa consists of such abstract patterns, highly naturalistic engravings depicting animals have been found. Some, defined by continuous outlines, resemble Large Wild Fauna images from the Sahara (see fig. 1-2). Others consist of solid shapes scraped into the rock surface. One of the most beautiful of these is a depiction of an eland, a large antelope (fig. 14-5).

The artist has carved away the surface in subtle negative relief, leaving low ridges to define the animal's haunches and nostrils, and the markings around its eye. The pose has been sensitively observed and carefully replicated, especially in the legs and the position of the head.

Zimbahwe

North of South Africa, in the highland regions of Zimbabwe and central Mozambique, painted images adorn the overhanging stone surfaces that sheltered early hunters and gatherers. Since they rarely depict domesticated animals they are assumed to have been created prior to the arrival of herders and farmers about two thousand years ago. Future archaeological work may be able to date some paintings more scientifically; a recent excavation of a rock shelter in Zimbabwe uncovered flakes of painted surfaces that had fallen into layers of debris dating between 13,000 and 8000 BC.

A group of images on a concave rock surface from the Matobo (Matopos) Hills of southwestern Zimbabwe is typical of the style and the content of rock art from this region (fig. 14-6). The prominent giraffe at the top of the composition

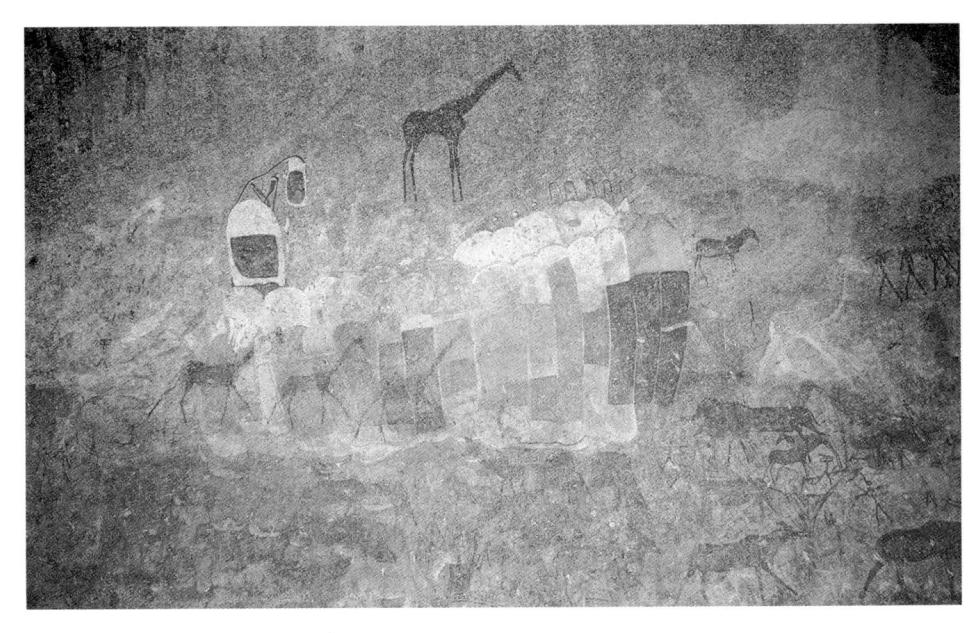

14-6. Giraffes, Zebra, and Abstract Shapes, Nanke, Matob Hills, Zimbabwe, Before ad 1000. Pigment on Rock Face

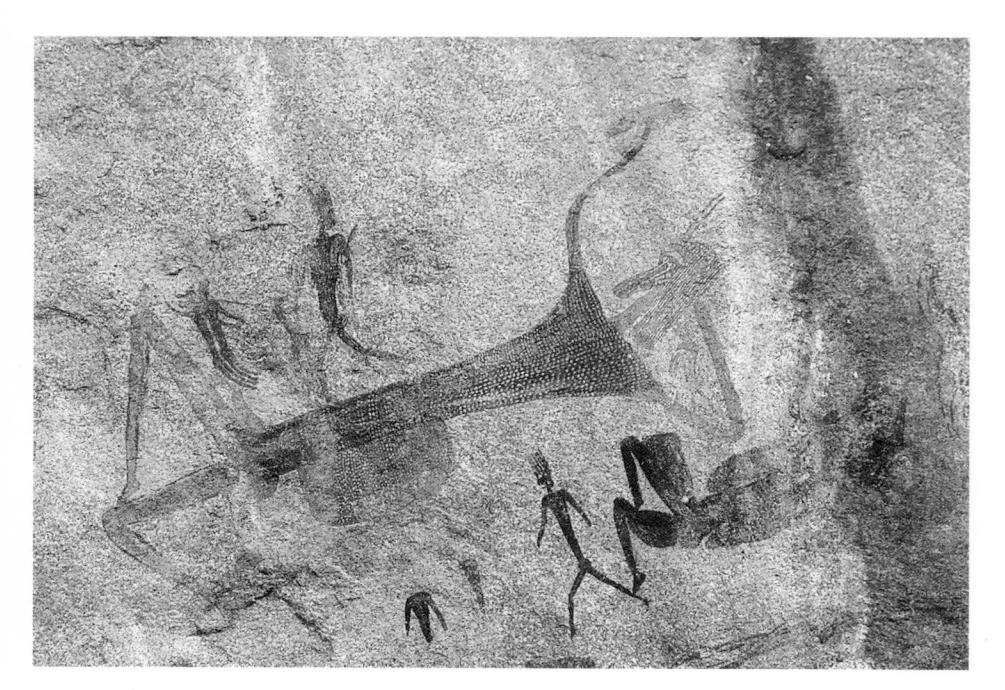

14-7. Figures from rock shelter, near Rusape, Makoni district, eastern Zimbabwe, before ad 1000. Pigment on rock

The first Europeans to study southern African rock art interpreted the images in idiosyncratic ways. A French expert claimed that the art of Tsisab Gorge was too sophisticated for Africa, and identified the figure in figure 14-4 as a "white lady." A German scholar described this scene as a royal funeral orchestrated by a lost, heroic culture. Perhaps in reaction to such imaginative responses, many researchers in the mid-twentieth century regarded rock art simply as a record of the daily life of the hunters who created it. By the 1970s the work of David Lewis-Williams encouraged scholars to study rock art as manifestations of the artists' religious beliefs.

and the smaller giraffes below are joined by a zebra on the right and a spindly anthropomorphic being on the left. The smaller giraffes move through a series of large joined oval shapes, seen frequently in the paintings of the Matobo Hills. Some of the ovals are bright, hard-edged, and distinct, while others merge with surrounding forms. Perhaps these shapes refer to a type of aura, a spiritual force radiating from the wild animals—or from the land itself.

Images in a painted shelter near Rusape in northeastern Zimbabwe show several fascinating variations upon the human form (fig. 14-7). The focus of the scene is a recumbent figure with a wedge-shaped chest, elongated torso, serpentine arms, and an extraordinary head shaped and marked like the muzzle of the sable, a swift antelope. A long curved line extends from the figure's penis, ending in a tassel-like shape below him. Although the figure is lying down, his head is lifted and the arms and

legs are raised in active gestures. Its dark surface is covered with white dots, and some of this dappled area sags downward under the edges of the body. Some of the smaller surrounding figures also appear to have antelope-like markings on their faces. This mysterious scene embodies the beliefs of populations who disappeared over a thousand years ago; interpreting its meaning today is thus almost impossible.

Eastern Africa

North and northeast of the Zambezi River, rock art is even more varied than it is in southern Africa. It is included here (rather than in the previous chapter) because the makers of the oldest examples of rock art appear to have shared the hunting and gathering lives of southern African peoples. However, some eastern African rock art is quite recent, and farmers may still gather in painted caves and rock shelters for initiations, rain-

making, and the ceremonial distribution of meat. Other farmers and pastoralists scrape bits of paint from ancient rock art for use in rainmaking ceremonies.

On the walls of rock shelters at the site of Kolo, in the hills of central Tanzania, elongated figures were painted in what has been called the Kolo style (fig. 14-8). Stone arrowheads in debris layers on the shelter floors date from 8000 BC to the beginning of the Christian era, and the Kolo style paintings were evidently also produced during this long interval. The striking linear figures are composed of long streaks of paint, their strange heads resembling the striped wings of a moth or butterfly. While the figures shown were painted vertically on the rock face, others are stacked horizontally.

The Kolo paintings are located near the homelands of the Sandawe and Hadza non-Bantu populations, who were semi-nomadic hunters until the twentieth century. Sandawe and
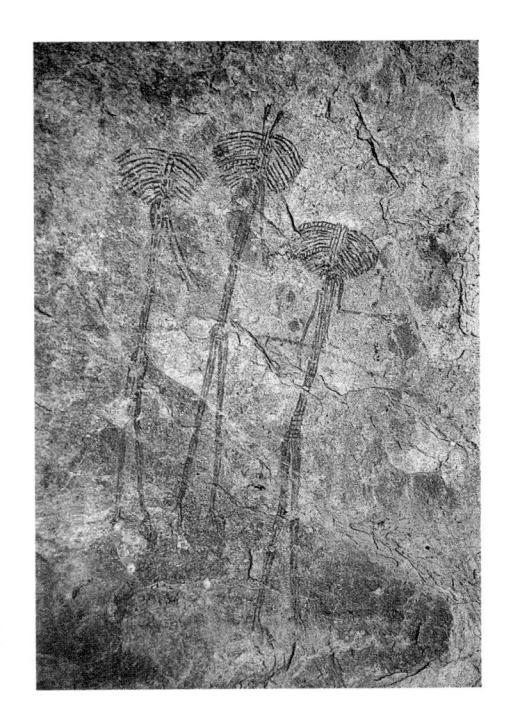

14-8. Abstracted figures from Kolo 1 Site, Near Kondoa, Tanzania, undated. Pigment on rock

Hadza men may still paint images of animals as they prepare for a hunt or celebrate a kill, though their work is much more rudimentary than the Kolo paintings. While these modern peoples cannot be easily linked to painters who lived over two thousand years ago, they do seem to be keeping alive an ancient tradition.

The Drakensberg Mountains

Establishing relationships between living peoples and the ancient rock art of southern Africa is also problematic, especially when we consider the painted images of the Drakensberg Mountains, which separate the southeastern coast of South Africa from the high plains of the interior. Even though evidence suggests that at least some of the evocative scenes must be thousands of years of old, scholars

now generally link them with the San peoples.

San is a generic term used to describe a variety of hunting and gathering populations that were living throughout southern Africa when Europeans first arrived. San groups could be found in the Drakensberg until they suffered genocide at the hands of Afrikaaner pioneers in the late nineteenth century, and nineteenth-century accounts of these Drakensberg San yield some information about their rock art. Men and women from another extinct San group, living south of the Drakensberg, also shared important information with two early ethnographers in the late nineteenth century. Most of our knowledge of the San, however, comes from groups such as the !Kung, who lived until recently in the inhospitable Kalahari Desert. Even though the !Kung and other Kalahari San do not paint or engrave rocks (and may never have done so),

their religious beliefs appear to be similar to those of the extinct San who once painted the rock shelters of the Drakensberg.

A painting from Fetcani Glen, one of the sites in the southernmost mountains of the Drakensberg (fig. 14-9), shows how this rock art may be linked to accounts of San spirituality. The figures appear to be circling the walls in a healing dance, just as !Kung men and women dance today to cure an ailing person, or to cleanse and rejuvenate a community. During these dances, spiritually gifted !Kung feel a supernatural power called n/um boiling up within them. They may tremble, sweat, salivate, and collapse, and they need to be supported by the other dancers. In other San groups, the same type of altered state would trigger nosebleeds. N/um is in the sweat of the affected !Kung, and can anoint a sick patient or the families who have gathered for the dance. The dancer at the left of the scene from

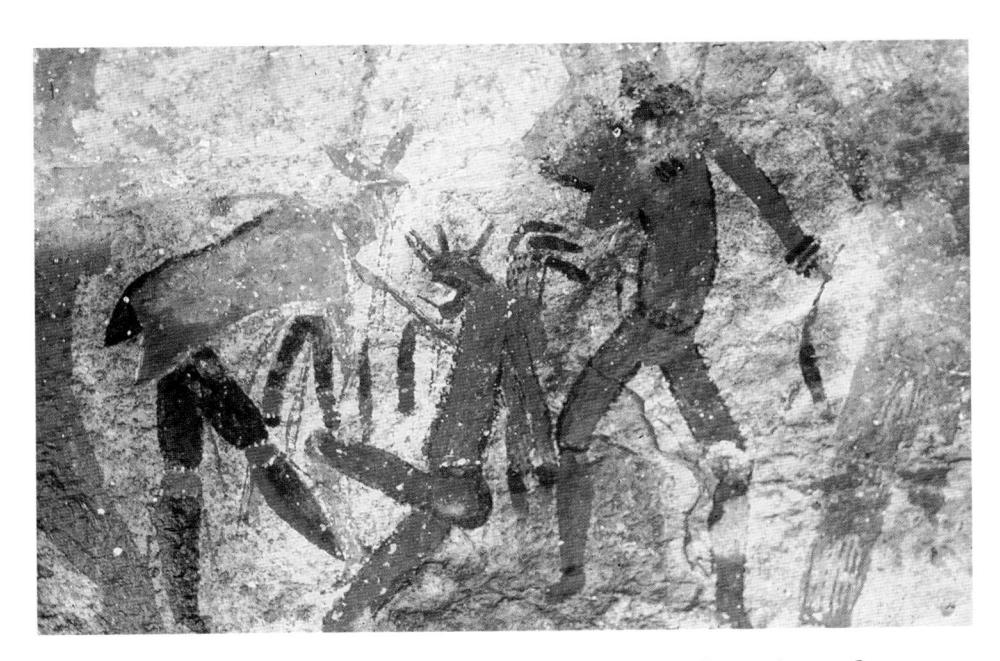

14-9. Dancing figures, Fetcani Glen, Drakensberg Mountains, South Africa, San, undated. Pigment on rock

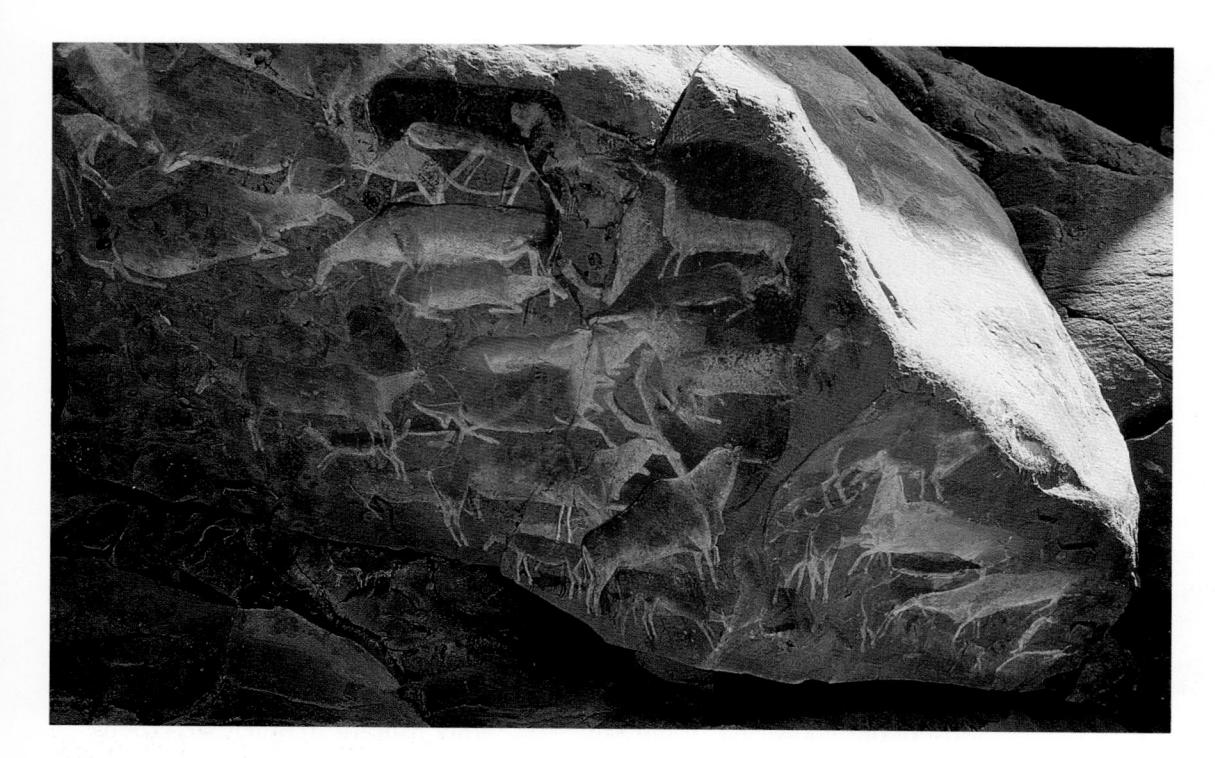

14-10. SCENE WITH ELAND, DRAKENSBERG MOUNTAINS, SOUTH AFRICA, SAN. PIGMENT AND ELAND BLOOD ON ROCK

Fetcani Glen may be either a patient or a man in a trance, while the figure bending over him could be shedding n/um in his nasal blood in order to heal or soothe the fallen figure.

The heads of the figures are enigmatic, and seem to combine human and animal features. Spiritual assistance from a species of animal gives a gifted !Kung person the possibility to enter a trance state, and the animallike heads depicted here could acknowledge the link between the human dancer and the source of his or her abilities to enter a trance. They may also more literally depict humans wearing headdresses with feathers, horns, or animal ears attached. In some San groups, dancers once wore such caps to strengthen ties with their animal helpers, heightening their ability to harness n/um.

Perhaps the most beautiful paintings from the Drakensberg are the magnificent polychrome depictions of eland (fig. 14-10). We can respond to the soft, full volumes and delicately shaded color. We can appreciate the attention the artist has lavished on the animals' varied poses and individual characteristics. However, our aesthetic enjoyment cannot match the wealth of ideas and emotions the San originally brought to this painting. For these highland hunters, the eland was associated with a sacred past, with sexuality and fertility, with spiritual transformation and power, and with joy and beauty.

The painting shown here may have honored the god-like trickster and creator, /Kaggen. Qing, one of the last of the Drakensberg San, told an interviewer that the eland was the animal beloved by /Kaggen. When asked where /Kaggen is, he replied, "We don't know, but the elands do. Have you not hunted and heard his cry, when the elands suddenly start and run to his call? Where he is, elands

are in droves like cattle."

In the past, a San hunter presented an eland to his father-in-law when he married, and the !Kung still say the proper killing of an eland makes a boy into a man. !Kung girls who are announcing their first menstruation anoint their families with fragrant fat from an eland. The girls are then the central figures in an eland dance performed by women, which celebrates the sexual receptivity of female eland, and of the girl herself. Eland thus remind San men and women of important stages in their social and sexual lives.

The lines flowing from the nostrils of the eland, and the tiny, flying human figures scampering above and around them, can be linked to San experiences of trance states. When an eland is mortally wounded by a poisoned arrow, the hair on its neck will rise, and it will stumble, as may be seen clearly in the painting. Some of

the dying eland in this scene are bleeding from the nose, trembling, and gasping for breath. Similar physical symptoms are experienced by dancers filled with n/um. !Kung dancers say that this trance state is like floating or swimming underwater, or like the death of the eland itself. The painting may thus refer to a type of spiritual ecstasy joining dancers to sacrificial elands.

No one asked San painters why they placed these images in rock shelters. We do know that the process of making these art forms was complex and that it apparently involved the manipulation of supernatural power. For example, one account states that women heated the red ocher used as a pigment over a fire by moonlight, and that the artist mixed it with eland blood. Perhaps the images were intended to strengthen the visions and the curative abilities of the "owners of power" or the rain masters who painted them. Perhaps they allowed an artist or a group of dancers to pour out or contain supernatural power in a particular place so that it could be drawn upon in the future. At the very least, these masterpieces of rock art must have allowed ancient peoples to celebrate and relive events of intense spiritual experience.

Yet some paintings from the Drakensberg may be narrative references to past events, rather than images connected to trance states. A few show large figures with spears, probably Bantu-speaking neighbors of the San. In others, Afrikaaner pioneers appear, including men in floppy hats, and women in sunbonnets and long skirts. In paintings of the nineteenth century, British soldiers fire their guns and kill eland,

while Afrikaaners fire their guns and kill the San. The last artist to paint in the rock shelters of the Drakensberg Mountains was shot in the late nineteenth century by British soldiers; on his corpse they found containers of paint.

EARLY ART OF BANTU SPEAKERS

The arrival of Bantu-speaking peoples in the region around the beginning of the Christian era led to the formation of new cultures that forged metals and fired clay. The earliest works of art now known from these new cultures are the seven Lydenburg heads, named for the South African site where they were found. The heads had been buried together in a pit around the sixth century AD. The largest of these hollow terracotta sculptures could have covered a human head and neck (fig. 14-11). The white pigment that appears to have once covered it has now disappeared, while a small animal-like form on the top of the head is damaged and difficult to identify.

A few centuries after the Lydenburg heads were sculpted, a series of towns arose along the stretch of the Limpopo valley dividing the present-day nations of South Africa and Zimbabwe. Cattle were important in the economy of this region, and archaeologists have found hundreds of small clay models of vaguely bovine and anthropomorphic creatures at these sites.

The richest of the Limpopo valley sites was a hilltop site called Mapungubwe, which flourished during the eleventh and twelfth centuries AD. A small rhinoceros made of sheets

14-11. Lydenburg head, c. ad 500. Terracotta. Height 15" (38 cm). South African Museum, Cape Town

of gold comes from one of the burials excavated at Mapungubwe (fig. 14-12). Originally attached to a wooden core, the metal plates evoke the armored look of a rhinoceros, and the head seems to be lowered in that animal's dangerous charge. Although the function of this art work is unknown, a charging rhinoceros would have been an appropriate emblem or metaphor for a powerful leader.

The Shona and Great Zimbabwe

The gold for the Mapungubwe rhinoceros undoubtedly originated in

the granite hills of the highlands north of the Limpopo, in southern Zimbabwe, the homeland of a people now known as the Shona. From the thirteenth to the fifteenth centuries AD, one early Shona group living along the southeastern edge of the highlands constructed a capital that has become the most famous of all southern African ruins. Today we know this site as Great Zimbabwe.

The Shona word *zimbahwe* or *zimbabwe* originally seems to have referred to either a judicial center or a royal palace; it was the equivalent of the English word "court." Shona now use the word to describe any of the 150 to 200 stone ruins found in their homeland, of which Great Zimbabwe is the largest (see fig. 14-15).

Great Zimbabwe can be divided into three distinct sections (fig. 14-13). The oldest, called the Hill Ruin, is built on a rocky hilltop overlooking the other sites laid out in the rocky plain below. The Hill Ruin incorporates an extraordinary natural feature, a cave whose walls act as a huge megaphone projecting any sound out toward the valley. The second section, the imposing monument known as the Great Enclosure, is less than a mile away. Its

14-12. RHINOCEROS,
MAPUNGUBWE, SOUTH AFRICA,
11TH–12TH CENTURY. GOLD
PLATE. ARCHAEOLOGY
DEPARTMENT, UNIVERSITY OF
PRETORIA

14-13. Plan of Ruins, Great Zimbabwe, Southern Zimbabwe. Drawing after Peter Garlake

ruined structures are encircled by a single stone wall 292 feet in diameter. The third section, the Valley Ruins, includes the remnants of low stone walls scattered across the valley floor between the Great Enclosure and the paths leading up to the Hill Ruin. All the stone walls at Great Zimbabwe were constructed of pieces of granite that had been hewn and split from local outcrops. Although no mortar was used in these walls, they often adjoined clay structures, or encircled buildings made of clay and thatch.

The Hill Ruin was constructed around AD 1250. Smooth stone blocks were laid in irregular courses to form walls between (and sometimes over) the huge boulders of the hilltop. The walls create irregular compartments and narrow winding passages, some leading to a lookout area above or to the cave below (which is still a sacred site). Two walled enclosures in the

Hill Ruin once had floors of polished clay. The largest of these is surrounded by 30-foot-high walls surmounted by small cylindrical towers, or turrets, and monoliths. In both enclosures stone platforms once supported monoliths carved with geometric patterns. Seven of these stone pillars culminated in the image of a large bird.

Probably begun over a century after the Hill Ruin, the Great Enclosure was completed prior to AD 1450 (figs. 14-14, 14-15). Its tapered surrounding wall, about 20 feet high along the northern and western sides, rises to some 32 feet along the south and east. Turrets and monoliths rise above it in places, mirroring those crowning the Hill Ruin. Along the top of the wall, a layer of granite blocks laid against one another in opposing diagonals forms a double row of chevrons, barely visible at the far left of figure 14-15.

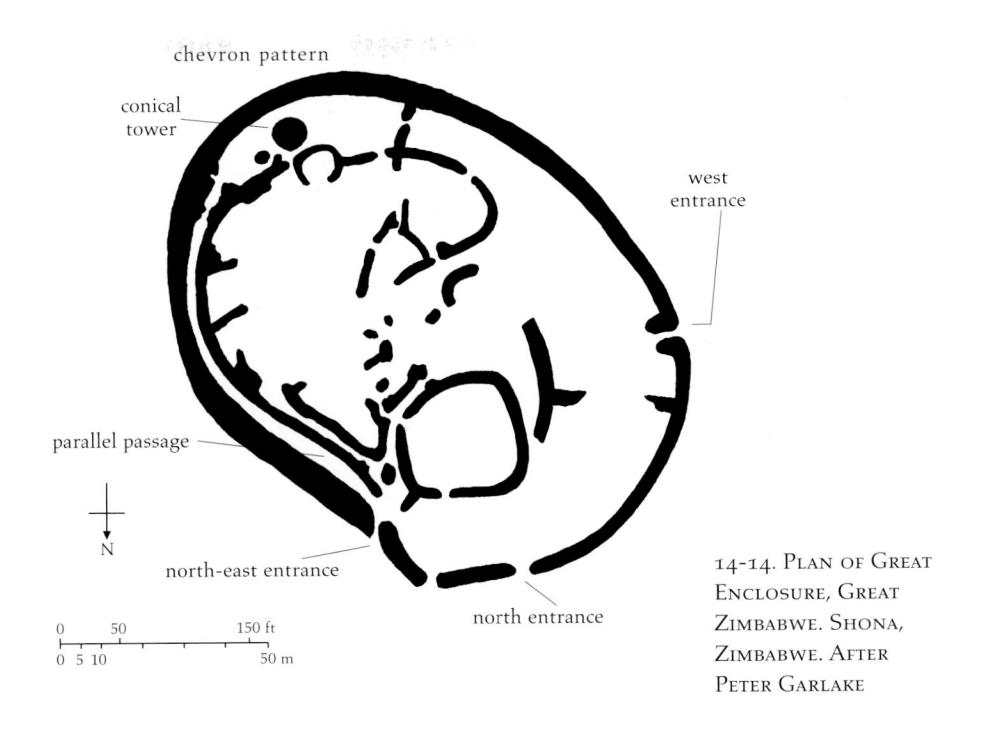

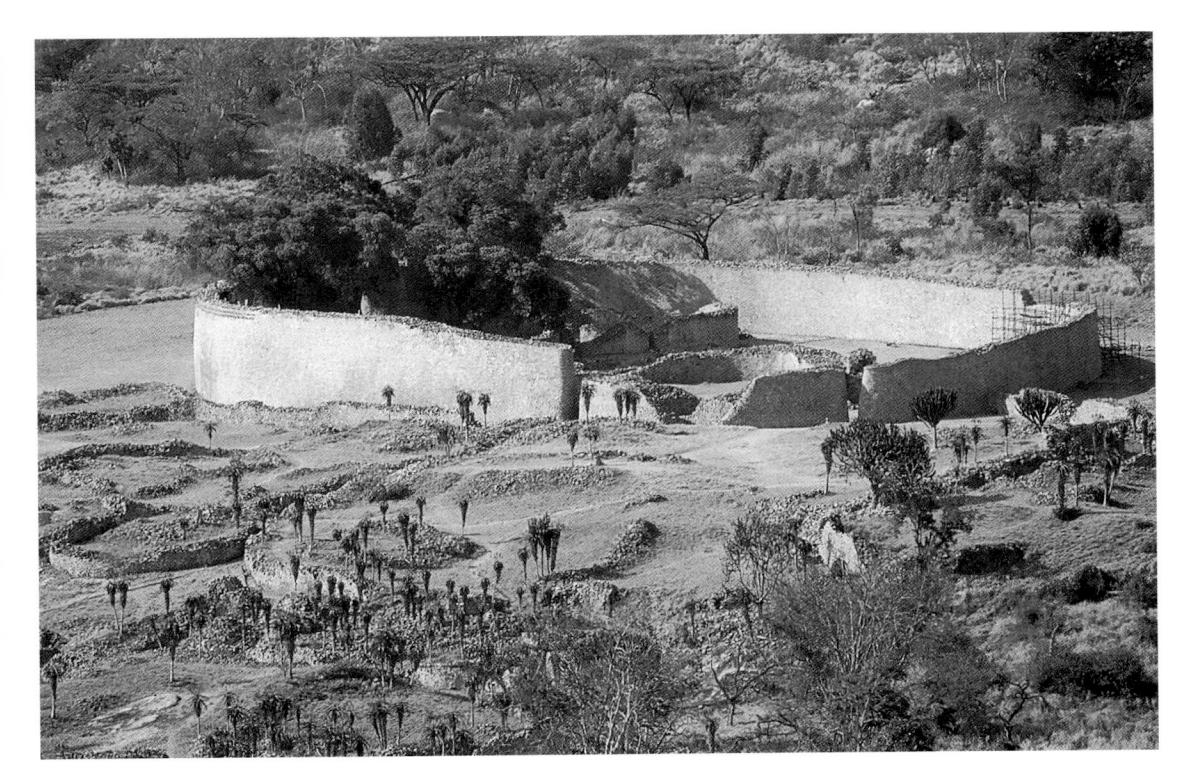

14-15. Exterior of Great Enclosure, Great Zimbabwe, Shona, Zimbabwe, 1350–1450. Stone

Stonemasons fitted and shaped the granite blocks on site to form the regular courses of the smooth wall encircling the Great Enclosure. No mortar was used to bind the stone together. The wall has been amazingly stable; generally it has collapsed only where the wooden lintels above the gateways have disintegrated.

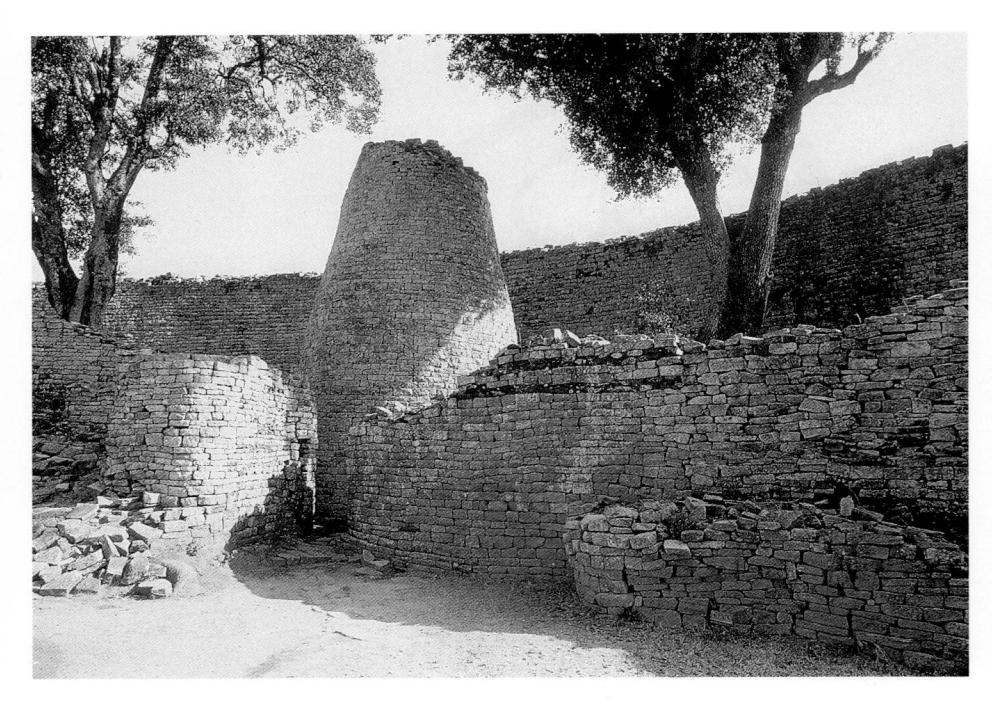

14-16. Conical Tower, Platform, and Inner Wall, Great Enclosure, Great Zimbabwe, Shona, Zimbabwe, C. ad 1350–1450. Stone

Within the Great Enclosure are smaller walled areas and a narrow, canyon-like passageway formed by the gap between the outer enclosing wall and a curved inner wall. At the end of the passage are two solid stone towers built of regularly coursed granite blocks and resembling Shona granaries in form. The large tower is now about 30 feet tall (fig. 14-16).

Near the large tower was a doorway in the inner wall, leading to a space dominated by a stepped, clay-covered stone platform 25 feet in width. This platform seems to have once displayed small soapstone phalliform carvings or simple carved cones with female breasts. The wall near the platform is marked by several bands of dark stone, perhaps meant to evoke zebra stripes, for zebras appear on soapstone bowls taken from Great Zimbabwe and seem to have had symbolic importance there.

The Valley Ruins, the third section of Great Zimbabwe, contain a variety of different structures. In one building a cache of porcelain from China and thousands of beads from southeastern Asia were found, indicating that Great Zimbabwe was trading with Swahili merchants on the East African coast (see chapter 13). Copper ingots and double gongs of iron tie the city to important centers on the Zambezi River as well as to Central African kingdoms located a thousand miles to the north (see chapter 12). In one walled ruin, a stepped platform was found next to a small conical structure of solid stone. Into this base was fixed a soapstone monolith about five feet tall. On the top of the monolith was carved the most forceful and striking of all the soapstone birds found at Great Zimbabwe (fig. 14-17).

This is obviously a bird of prey, whose rounded volumes suggest

14-17. Monolith with bird, Shona, Zimbabwe, C. ad 1200–1450. Soapstone. Height $5'4\frac{1}{2}''$ (1.64 m). Great Zimbabwe National Monuments

On the bird's breast is a vertical line of raised dots, as if the artist were depicting a row of pins joining a layer of metal to a wooden core. Shona royal art works probably included gold-plated wooden objects similar to the rhinoceros from Mapungubwe (see fig. 14-12), for fragments of gold foil have been found in the ruins of Great Zimbabwe. This stone bird may thus be referring to art in gold that has not survived.

tense muscles. The sculptor has shortened the raptor's wings and extended its legs to create a tightly interlocking triangular composition. The image combines human and avian features; the legs are muscled from thigh to toe, and the feet end in fingers or toes rather than talons. The top of the monolith was damaged, and we do not know whether the bird's curved beak once had the human lips found on some of the other soapstone birds from Great Zimbabwe.

The anthropomorphic aspects of the soapstone birds suggest that they are symbolic images of the Shona kings who ruled at Great Zimbabwe. For the past few centuries, eagles and other raptors have been associated with Shona rulers. Fish eagles live on the rocks above sacred pools and holy caves, just as Shona kings once lived on hilltops and made sacrifices to their royal ancestors in the depths of the earth and in deep pools. High-flying eagles touch both heaven and earth, just as royal ancestors intercede with God in the sky above for the living on the earth below. Like lightning, the flight of an eagle is believed to stitch together heaven and earth in a zigzag pattern and to announce the arrival of rain. Rain-bringing birds recall the priestly roles of Shona kings, who like many other southern African and eastern African rulers, are expected to intercede with their ancestors to bring rain to their people.

Up the front of the monolith climbs a slim crocodile with notched teeth. Crocodiles are associated with kings in several southern African cultures, for they are deadly and mysterious, and they live in the deep pools sacred to royal ancestors. Below the bird are several incised circles, with

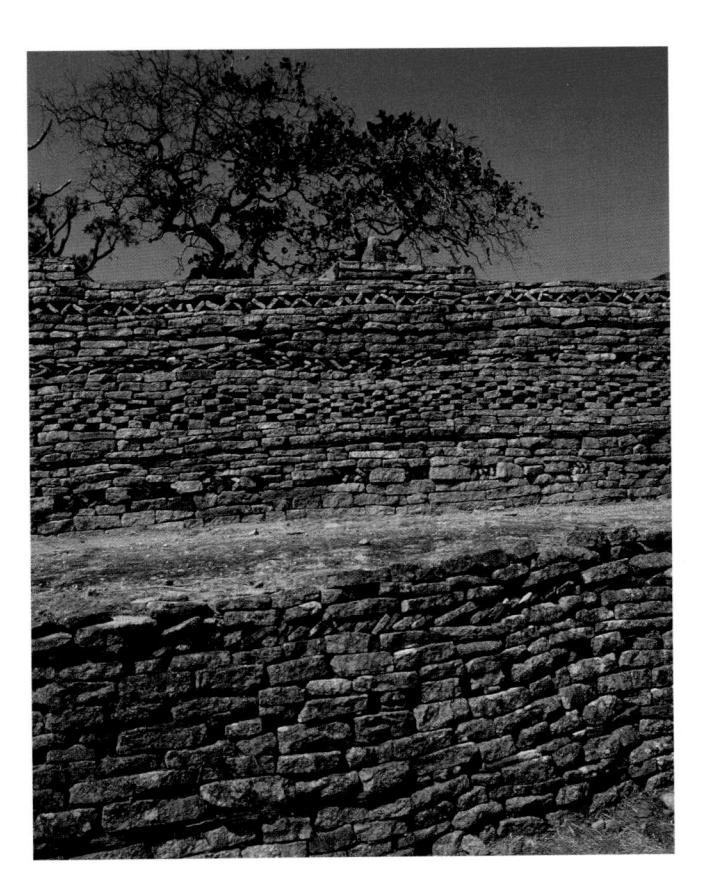

14-18. STONE WALLS OF RUINS, NALETALE, SHONA, ZIMBABWE. C. 1500-1700

two circular "eyes" on each side; these may be references to the eyes of the crocodile. The round shapes are placed above a band of chevrons. This pattern, which also appears on the walls of Great Zimbabwe (see fig. 14-15) and other Shona stone enclosures (see fig. 14-18), seems to symbolize the eagle's flight, the linking of sky and earth, the power of lightning, and the gift of rain.

While interpretations of the function of the Valley Ruins are somewhat speculative, studies of the Great Enclosure are particularly controversial. Archaeologists note that the Great Enclosure and the Hill Ruin share so many physical features that the large site on the valley floor may be a later version of the hilltop site, possibly built to accommodate an expanded population during important civic and religious activities. An alternative (and controversial) interpretation suggests that the Great Enclosure may have been an initiation camp. Among the Venda and other neighbors of the Shona, modern rulers sponsor puberty ceremonies, initiations preparing young women and some young men for marriage. Ordeals and celebrations connected with these periods of seclusion and instruction take place in circular courtyards that are similar in form to the Great Enclosure, but made of wooden posts rather than stone. The small soapstone images from the Great Enclosure are similar to clay and wooden objects used today as part of the instruction that young women receive. The conical towers and other features of the Great Enclosure may have been

sexual symbols connected with initiation.

The last walls erected at Great Zimbabwe were low and roughly built. By 1500, the city was no longer a political and economic center, and successor states had arisen to the northeast and southwest. One important Shona kingdom, Torwa, was based in Khami, almost two hundred miles west of Great Zimbabwe. Objects found at Khami include a seated male figure carved at the tip of an elephant's tusk, and a pair of small ivory leopards on a base marked with a chevron.

Another site, Naletale, was occupied during the seventeenth century by Shona rulers of the Changamire dynasty. The stone-faced earthen terraces of this hill site were ornamented with a variety of patterns (fig. 14-18). These include rows of chevrons, dark stripes, zipper-like herringbone motifs, and checkerboards. Chevrons may refer again to lightning, the flight of eagles, and the ties between the king and his ancestors. Checkerboard patterns perhaps evoke

the scales of the king-like crocodile, while the zebra stripes recall those near the conical tower of the Great Enclosure at Zimbabwe.

Although stone and metal objects have been found at sites such as Mapungubwe, Great Zimbabwe, and Khami, most three-dimensional works made in southern Africa today are sculpted from clay or wood. Thus two stone heads unearthed near the South African town of Kimberly, some two hundred miles south of the Limpopo River, appear to be linked to older stone-carving traditions. The head shown here was uncovered when the Afrikaaner defenders of the town were digging fortifications dur-

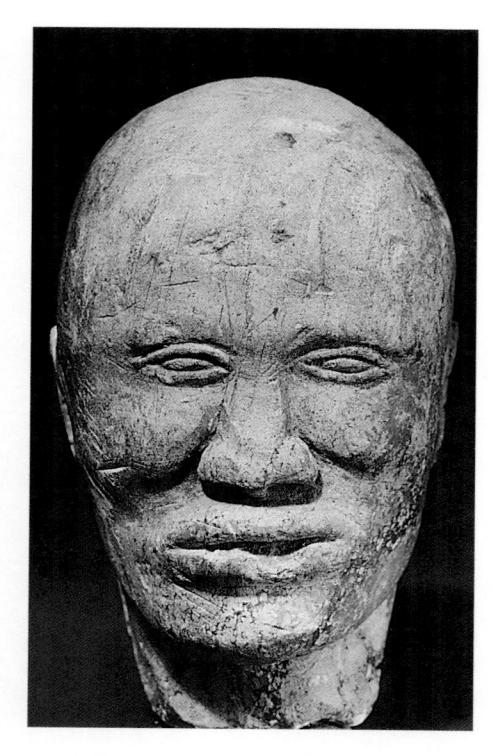

14-19. Kenilworth Head, c. 17th century. Stone. $6\frac{1}{4}$ x $3\frac{1}{4}$ x $4\frac{1}{4}$ " (15.8 x 9.6 x 10.8 cm). McGregor Museum, Kimberley

ing the Boer War (fig. 14-19). The other was found recently by archaeologists in a burial dated to the midseventeenth century. Since it had not been placed upon the grave as a marker, but rather was buried with the deceased, it was probably the deceased's personal possession. Both heads are almost life-size and hauntingly naturalistic. Like the ceramic heads from Lydenburg, they are complete works in themselves, and not fragments of a larger figure.

RECENT ART OF THE SHONA AND THEIR NEIGHBORS

The stone heads and eagles described above undoubtedly had important religious associations for southern African peoples and had no functions other than to be displayed. During the twentieth century, however, most sacred art forms from southern Africa combined both practical and religious uses. While invoking spiritual forces, they may be used as containers, clothing, furniture, or weapons.

Art and Ancestors

The shallow wooden bowl shown here, from the royal court of the Venda people of South Africa, was used by the king's advisors to determine the guilt or innocence of someone accused of a particularly serious offence. The images carved on the bowl's rim and inner surface (fig. 14-20) refer variously to clan, gender, and social rank. A diviner filled the bowl with water and floated grains of corn on the surface until they either touched symbols on the rim or sank to rest upon the images below. The combination of references touched by the corn identified the person responsible for the crime.

A central mound in the middle of the bowl is said to represent the sacred hilltop where the king lives, and the crocodile barely visible on the bottom of the bowl is, as in Shona thought, a metaphor for the king himself. The abstract designs on the reverse side of the bowl are linked to the crocodile and to the python, an animal identified with female fertility. The entire bowl can be seen as a reconstruction of a sacred lake inhabited by the soul of a legendary royal ancestor. As a royal heirloom, this object allowed the Venda ruler to draw upon the vision and wisdom of the ancestors in dispensing justice to his living subjects.

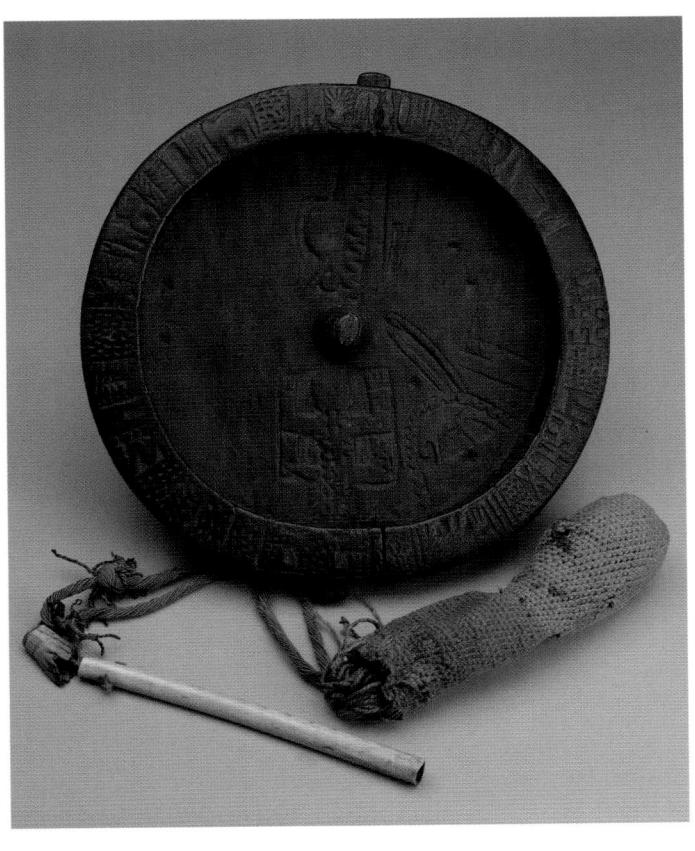

14-20. Inner surface of divination bowl, Venda, 19TH–20TH CENTURY. WOOD. HEIGHT 4" (10 CM), DIAMETER 13" (33 CM). THE BRITISH MUSEUM, LONDON

The ceremonial axes of the Shona, the Venda, and the Thonga, although rarely used in combat, are further examples of functional objects with great religious content. Made both north and south of the Limpopo River, the two examples shown here display imagery seen on many daggers and ritual weapons from the region (fig. 14-21). The example on the right is adorned with a carved stack of calabashes or bowls, containers used for sacrifices made to the ancestors. To reinforce these references to the importance of women in ancestral ceremonies (for women prepare and store sacred libations), two conical breasts appear on the handle. The example on the left acknowledges both the past and the present by setting the ancient form of the axe blade on a handle in the shape of a rifle.

During the Chimurenga, the uprising against minority rule that led to the new nation of Zimbabwe, Shona diviners and leaders commissioned sacred axes whose handles took the form of the weapons used in the conflict.

Although both the divination bowl and the battle-axes were primarily ceremonial, other objects with sacred powers were used in daily life. An example of this duality is seen in headrests, the small wooden platforms that until recently served as pillows, supporting the head of a person lying on his or her side. Headrests were believed to absorb some part of their owners, since they were rubbed with oils from the sleepers' heads, and to bring men dreams that communicated messages from the ancestors. At a man's death, his headrests were often buried with him.

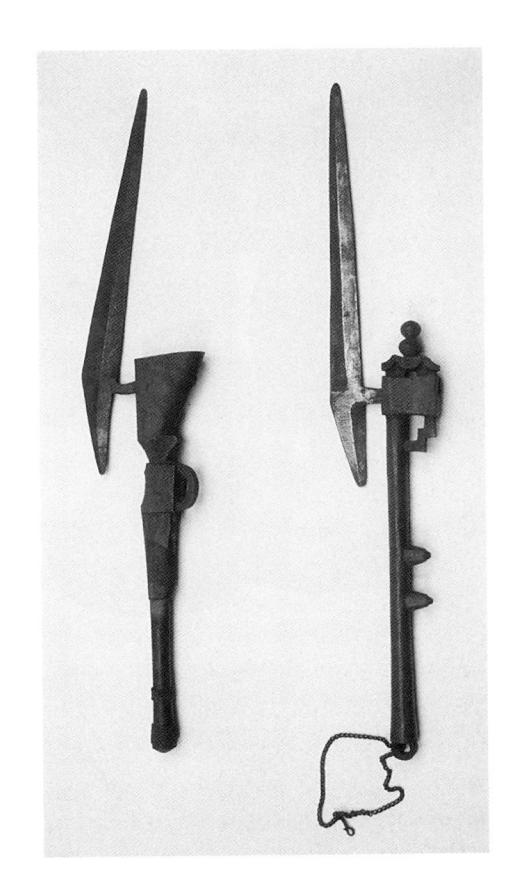

However, they were sometimes kept by his heirs as a sacred link to the ancestral world.

A headrest sculpted in Zimbabwe displays features typical of Shona work (fig. 14-22). It features a sloping base, a curved support for the head, and a flat central portion covered with grooved patterns known as *nyora* (the word also used to describe the raised ridges of scarification once worn by women). The triangular or chevron patterns, recalling the architectural ornaments of Great Zimbabwe, are common on Shona headrests.

The explicit female imagery of this work is extraordinary. Central conical forms replace the flat concentric circles of other Shona headrests. Circular motifs are usually described as ripples in pools, or shell ornaments, or as the eyes of a crocodile, but the

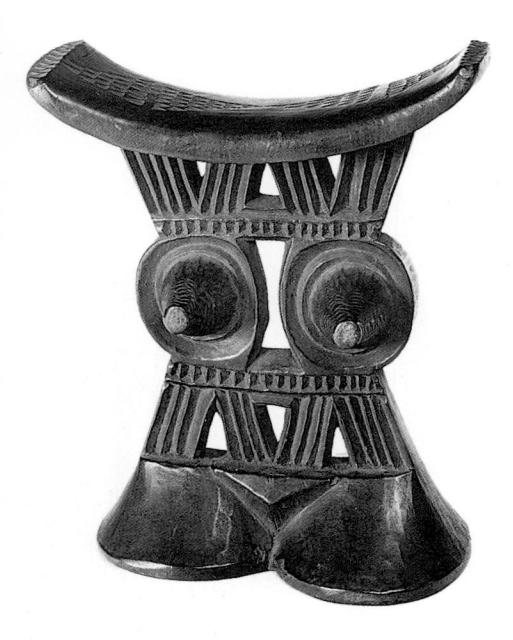

14-22. Headrest, Shona, late 19th–Early 20th Century. Wood. Height 5½" (14 cm). The British Museum, London

Headrests were used in ancient Kemet, and in the twentieth century they could be found throughout eastern, central, and southern Africa. Their historical depth, geographical distribution, and varied religious associations make them a particularly important African art form. In this Shona headrest, the head of the sleeper is joined to the body represented by the object itself. It thus recalls the ways that the head of Tutankhamun conceptually completed the symbol of the horizon referred to in his ivory headrest (see fig. 2-14).

shapes here are obviously female breasts. The shapes at the base of the headrest are clear depictions of the pubic triangle and the upper thighs.

The Tsonga and Chopi, neighbors of the Shona and Venda who live in Mozambique and South Africa, are renowned for the stylistic variety of their headrests. Although some headrests sculpted by their artists are given ears, breasts, or feet, most Tsonga and Chopi works seem to be

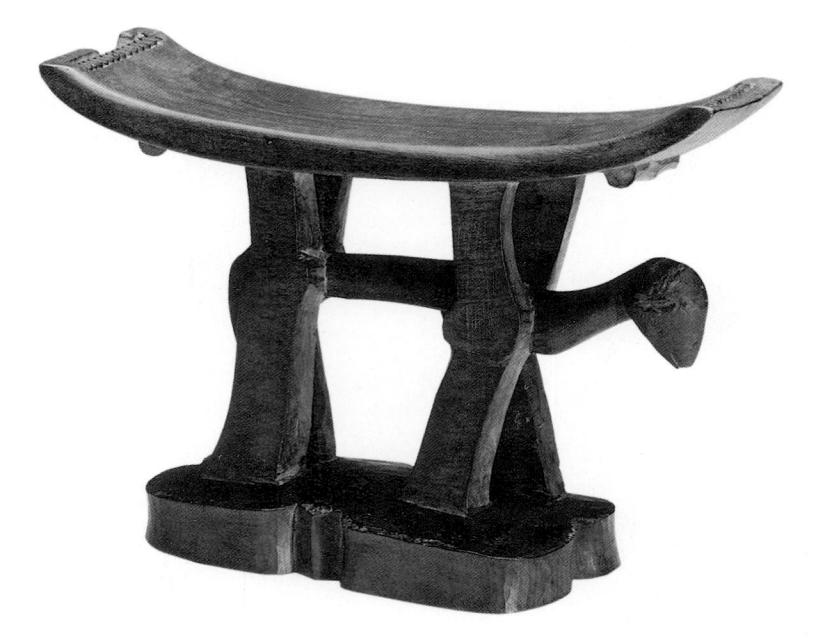

14-23. Headrest, Tsonga. Wood. Fowler Museum of Cultural History, University of California, Los Angeles

simply celebrations of formal beauty. The example shown here, with its multiple supports and contrasts of organic and geometric shapes, includes an abstracted image of an animal (fig. 14-23).

Initiations and Related Art

References to ancestral powers, royal authority, and gender also occur in the initiations held by the Venda, the Tsonga, the Chopi, and the northern Sotho. Training periods for boys and girls and ceremonies inducting members into select groups of citizens have incorporated many visual displays. Old photographs show how spectacular some of these transformations could be. The example shown here is said to record a pair of Venda initiates (fig. 14-24), while other photographs document similar masquerades among northern Sotho peoples such as the Lobedu and the Pedi.

Evidently these constructions of reeds and feathers disguised men who had joined an elite association sponsored by their queen or king, and in some areas they evidently appeared during girl's initiations. The reeds hiding the masqueraders' heads resemble the reed masks worn by Sotho girls today in their initiation ceremonies, masks that evoke myths of creation and possibly allude to human dwellings. This photograph suggests that mysterious substances were placed in the headdresses of the Venda initiates, and it shows one of these dancers carrying a ceremonial iron axe similar to those illustrated in fig. 14-21.

Among the groups mentioned above, just as among eastern African peoples such as the Maravi (see fig. 13-31), initiations preparing young women or men for marriage use figures and objects modeled of clay or carved of wood to illustrate the lessons and symbolize the concepts

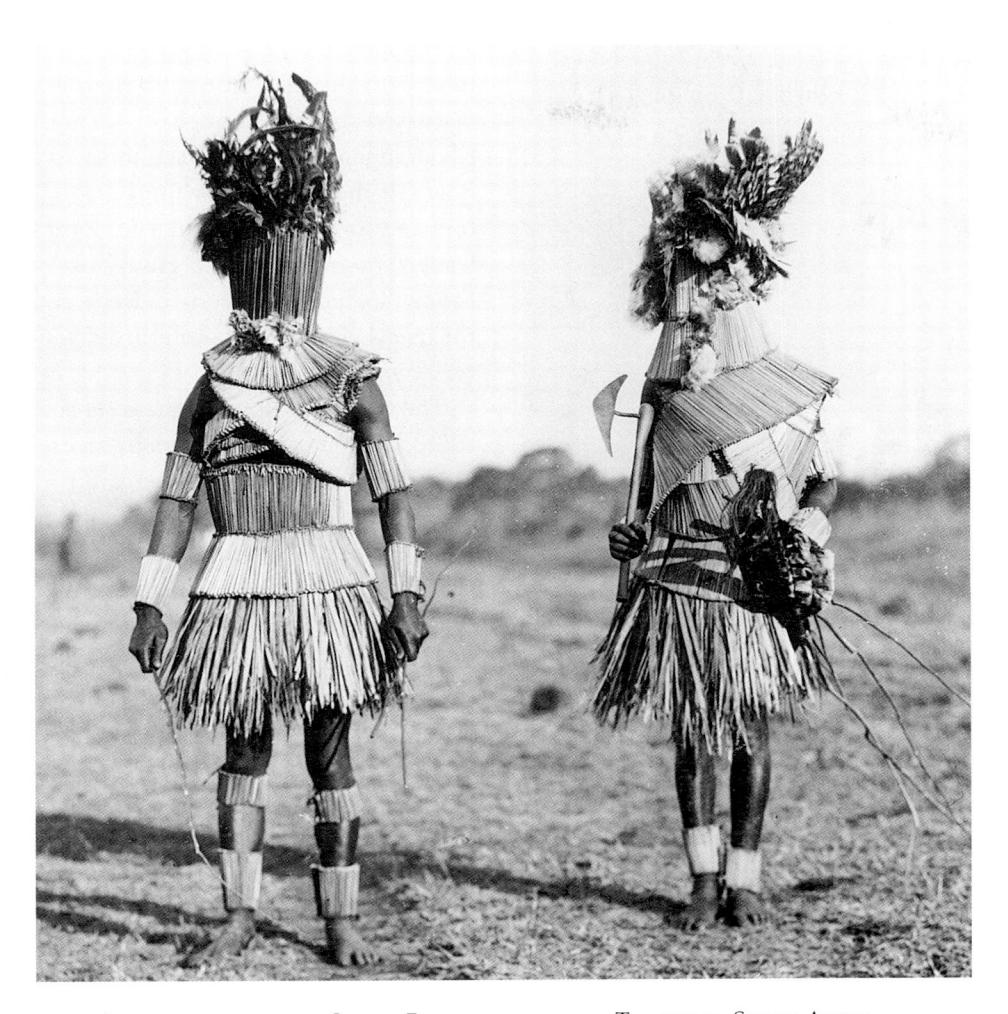

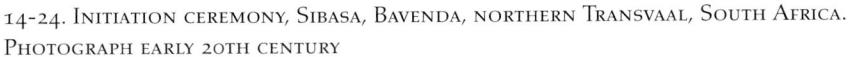

taught by the preceptors. Clay objects are often made by women and are normally destroyed after the initiation is completed. Wooden pieces, however, are purchased or rented from a male sculptor, and may be used repeatedly.

A bearded male figure wearing a beaded necklace may originally have been carved for one of these initiations (fig. 14-25). The beard and the ring encircling the head imply that he is a trained warrior and a married man. This figure would have played the role of a specific character during the numerous theatrical presentations of an initiatory school,

plays that taught young men and women moral precepts.

Figures such as this were clothed for performances. Today initiation figures are often carved fully dressed. The carved and painted *matano* (a name taken from the verb "to show") shown here were created in 1973 for a *domba*, a training session primarily for girls, in a Venda community in South Africa (fig. 14-26). They include a goat-like animal, a round dwelling, a female figure dressed in beads and wrapper, and a female figure wearing a modern dress with her old-fashioned brass anklets. It is instructive to compare the bearded

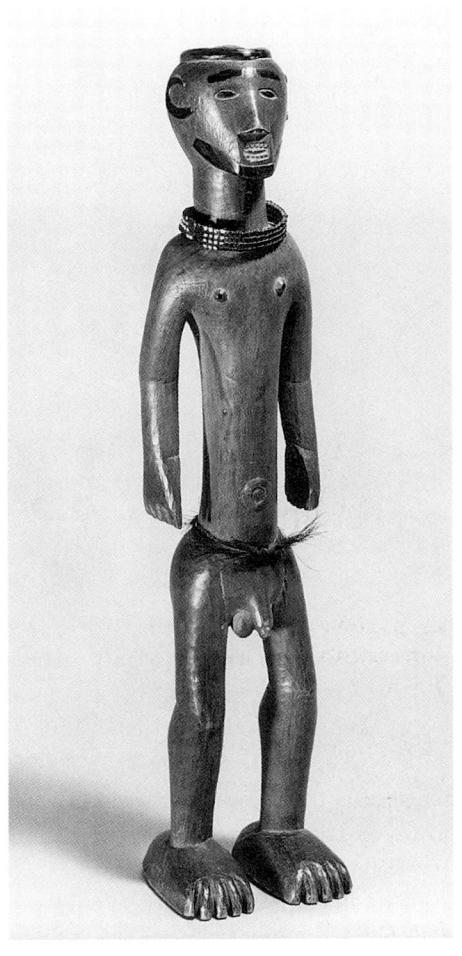

14-25. Male figure, Tsonga (?). Wood, BEADS, PIGMENT, FIBER. HEIGHT 17¾" (44.2 CM). INDIANA UNIVERSITY MUSEUM, BLOOMINGTON

Even though the figure has been attributed to a Tsonga artist, it shares many formal features with works from eastern African cultures much farther north (compare fig. 13-31). Many artistic styles, both figurative and non-figurative, cross ethnic boundaries in southern Africa.

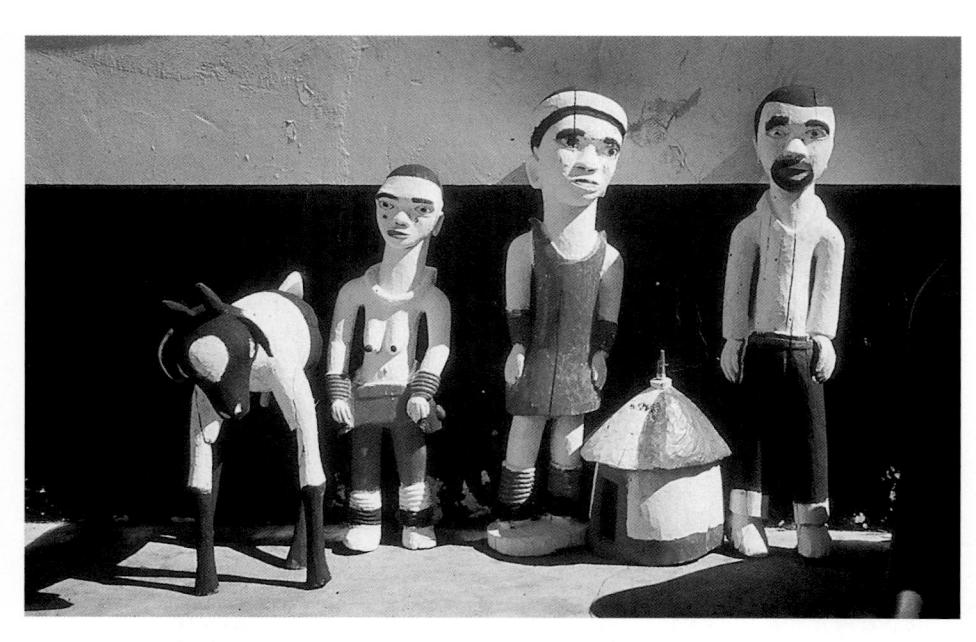

14-26. Matano figures, Venda, before 1976. Wood, paint. Height of tallest figure $26\frac{2}{5}$ " (67 cm). Collection of Chief Khakhu

Venda gentleman in blue jeans and a long-sleeved shirt to his Tsonga predecessor. The stance, the proportions, and the use of shiny surfaces have changed little, even if the type of clothing and the colors are quite different.

Several sculptors living in communities of the Venda, Tsonga, and related peoples seem to have drawn upon these images while creating works for new patrons and new settings. For example, the first figures sculpted by Tsonga artist Johannes Maswanganyi (born 1948) were of unpainted wood and resembled the characters featured in initiations. He then turned to carving portraits of South African celebrities and politicians, which he paints with high gloss enamel paints. His portrait of Professor Hudson Ntswaniwisi is more pensive than his other works, presenting a thoughtful man in jacket and tie (fig. 14-27). Despite the specificity of Professor Ntswaniwisi's portrait, its techniques

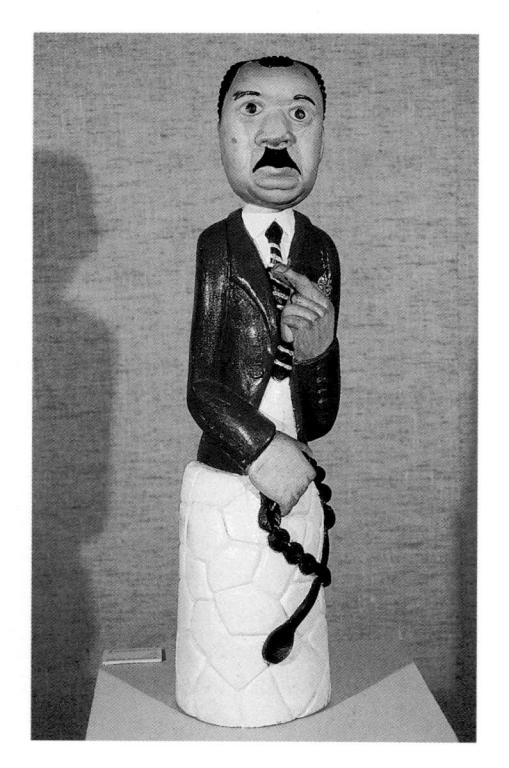

14-27. Professor Hudson Ntswaniwisi, Johannes Maswanganyi, 1987. Wood, Enamel Paint. Height 34¼" (87 cm). University of the Witwatersrand Art Galleries, Jonannesburg. Standard Bank Collection

and proportions have much in common with the male initiation figures discussed above. Although Maswanganyi and other sculptors now sell their work to white collectors and foreigners as well as to local leaders, their figures and groups of figures include the strong didactic and theatrical elements of sculpture made for *domba*.

The career of Noria Mabasa (born 1938), a Venda artist, differs in several ways from that of Maswanganyi and other male sculptors from rural areas of South Africa. She once modeled statues to stand against the walls of the forecourt of her home, a practice shared by other women in the region. In response to a dream or vision she began to make freestanding figures of policemen and Afrikaaner pioneers for sale to white South Africans and foreigners. These small painted images of clay did not resemble the rough clay objects occasionally made by Venda and northern Sotho women for female initiations, but were much closer in style to the wooden figures carved by men.

After she had achieved critical and some financial success with these appealing clay figures, Mabasa had another spiritual crisis leading her to take up the tools usually reserved for male carvers. Her large, haunting sculpture Carnage II (fig. 14-28) was inspired by television coverage of a flood whose victims were attacked by crocodiles. Mabasa's work of the last two decades shares some features with the wooden sculpture of preacher and mystic Jackson Hlungwani (born c. 1923). The intense spirituality expressed in the work of both artists has attracted viewers in South African and abroad.

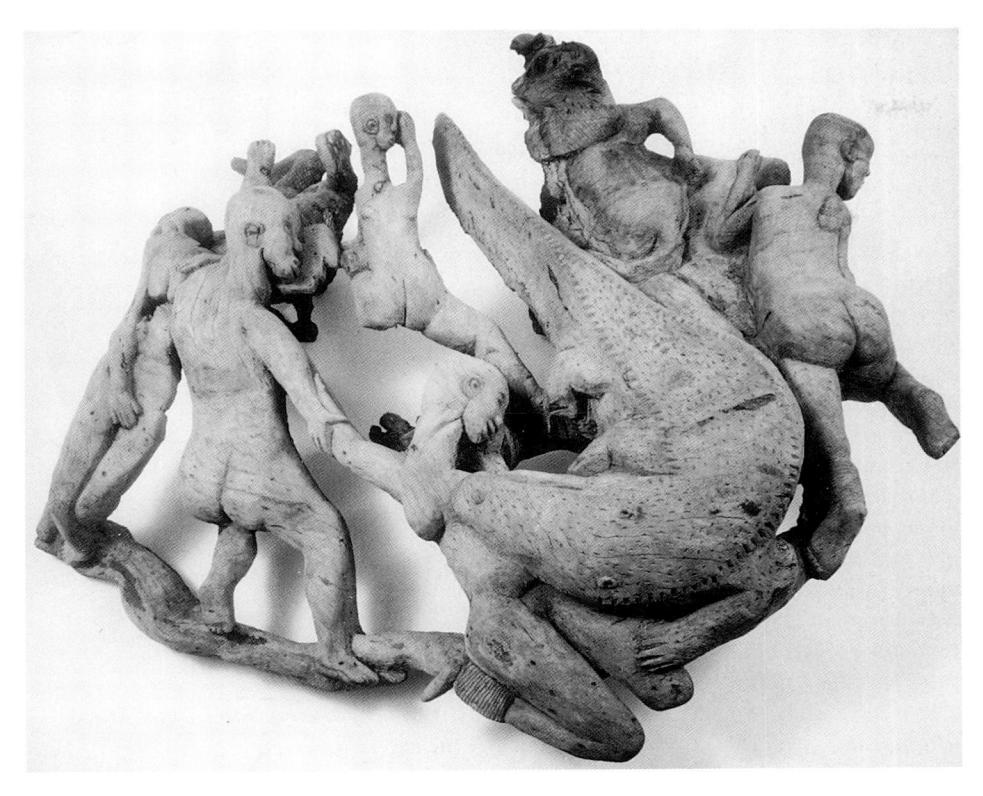

14-28. Carnage II, Noria Mabasa. Wood. Height $6'5\frac{1}{2}''$ (1.97 m). Johannesburg Art Gallery. Courtesy the artist

ARTS OF THE SOTHO AND THE NGUNI

In southern Africa the practice of carving freestanding wooden figures is confined largely to the Tsonga, the Chopi, and the northern Sotho. Sculptors in other Bantu-speaking areas of the region have created masterful objects that might refer to or incorporate anthropomorphic or zoomorphic forms, yet these works are overshadowed by the ceramic arts, beadwork, and architecture of the Sotho, Tswana, and Nguni peoples.

Art and Leadership among the Sotho and the Tswana

Ornamental clubs or staffs once owned by warriors, royalty, and other

leaders of Nguni, Sotho, and Tswana groups were usually carved and polished into elegant abstract shapes. The extraordinary staff shown in figure 14-29, however, is embellished by an attached figure representing its owner, an important northern Sotho leader. The surfaces of the staff are particularly fluid and elongated, and the tactile pleasure the owner must have felt when grasping the staff is evident even in the photograph.

Other items associated with leadership are ornamented with references to cattle. The smooth upward curves of a southern Sotho snuff container carved from a cattle horn are repeated in its stopper, which takes the form of a bull's head (fig. 14-30). Although the form is quite unusual, many snuff containers are made of horn rather

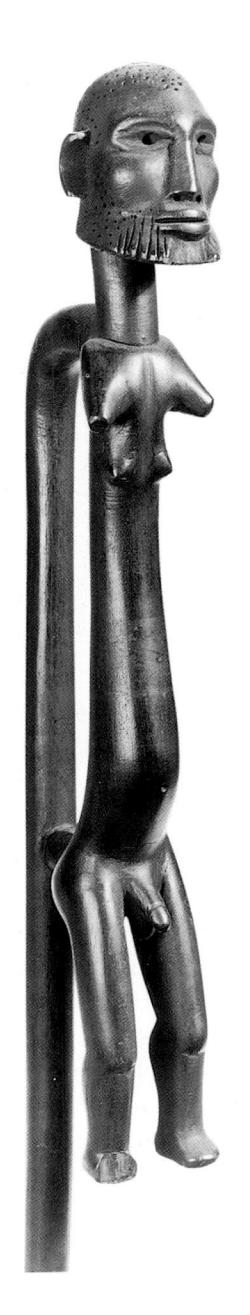

14-29. Top of staff, Sotho, early 20th Century. Wood. Height 45" (1.14 m). The British Museum, London

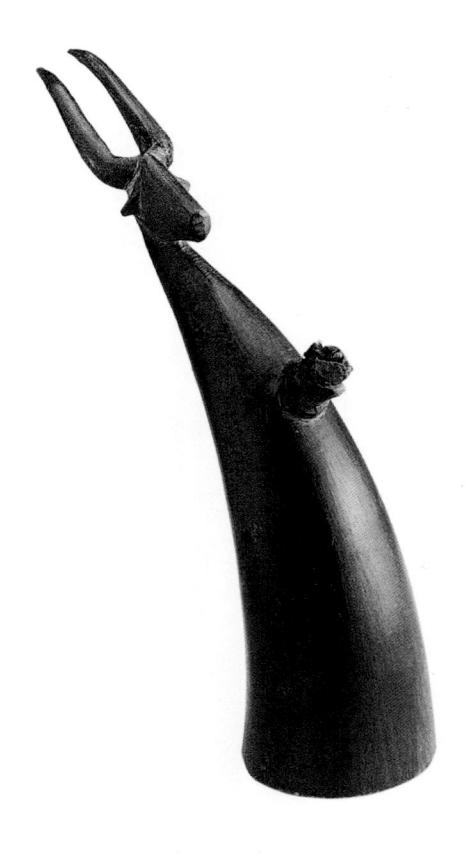

14-30. SNUFF CONTAINER, SOTHO. CATTLE HORN. HEIGHT 7½" (19.2 CM). SOUTH AFRICAN MUSEUM, CAPE TOWN

In some regions of South Africa, cattle and snuff are associated with male sexuality. Appreciative wives liken their husband's virility to the sexual appetite of a bull. Tobacco itself is grown and processed by men and shared by them during social events. Men once wore small ornaments containing tobacco, and snuff boxes and snuff spoons were items of male adornment.

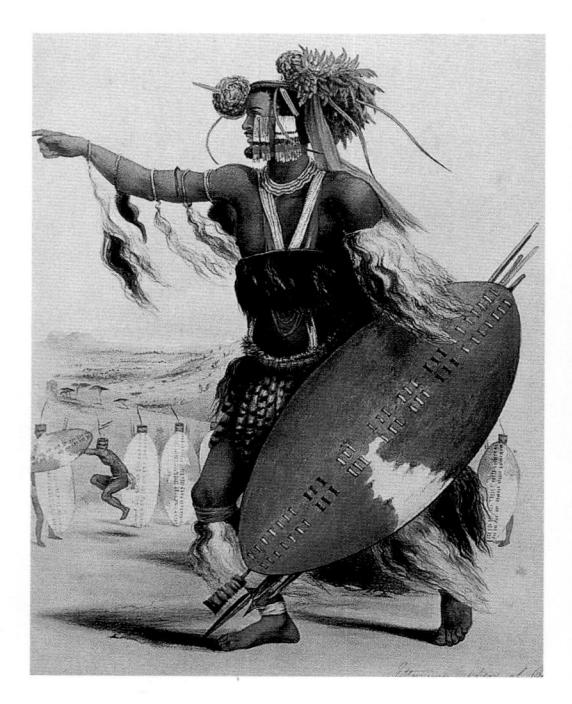

14-31. Utimuni, Nephew of Shaka, G.F. Angas, 1849. Colored lithograph

than wood. Others are modeled of a paste made from bits of hide and flesh from a cow sacrificed to an ancestor.

Among the Sotho, Tswana, and Nguni peoples, references to cattle in such an object evoke ideas concerning kingship. On a mystical level, a king may be incarnated in a black bull for memorial ceremonies. On a practical level, he distributes cattle from his personal herds to faithful subjects. Without gifts of cattle, offered to them by a king or other elder, young men cannot marry. Thus when kings and other leaders distribute snuff from such a container, they remind onlookers of their generosity.

Cattle are also linked to ancestors, for a man inherits the herds of his forefathers. He himself was conceived in a marriage marked by a gift of cattle to the bride's family, and his birth was a sign of ancestral approval of his parents' union. Snuff is offered by men as a sacrifice to ancestors and may allow diviners to become possessed by the spirits of the dead. Thus both the form and the contents of this object have a spiritual dimension.

Nguni Beadwork

References to ancestral blessings and social rank also appear in the spectacular body arts of the Nguni peoples. Although in most areas of southern Africa ceremonial dress has changed dramatically over the course of the twentieth century, many Ngunispeaking peoples have tenaciously retained the forms and the meanings of earlier practice.

An early nineteenth-century lithograph records the appearance of a

warrior named Utimuni (fig. 14-31), a nephew of the famous Zulu king Shaka (ruled c. 1818–28). Utimuni wore a short beard and an elaborate feather headdress. His circular headring proclaimed his right to marry, a privilege bestowed by Shaka himself. An ivory snuff spoon was tucked next to a clump of blue feathers on his head, and a veil of beads was suspended at the side of his face. He wore a beaded necklace, and bands of beads crossed over his chest. A kilt made of animal skins hung from his hips. Many of these items are still worn by Nguni men as a sign of ethnic pride and allegiance to the moral values of the past when they attend ceremonies at the courts of kings or participate in church festivals.

Young Zulu women photographed in front of their home during the late

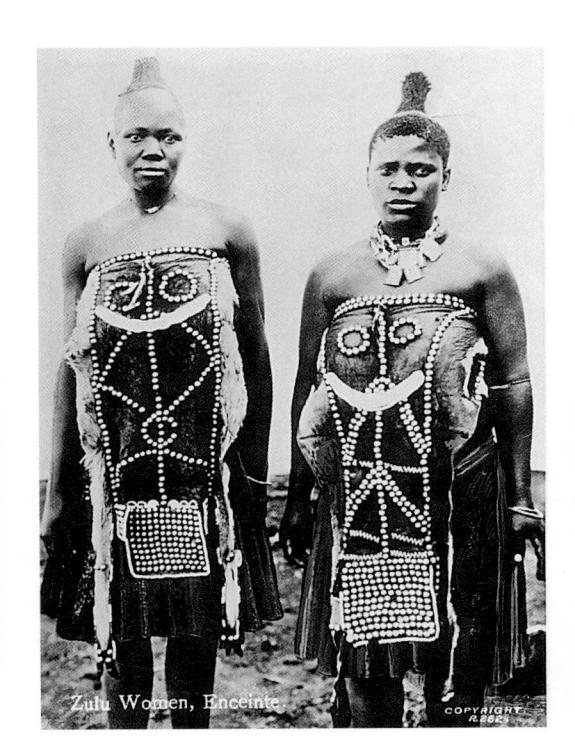

14-32. Married Nguni women wearing leather aprons, Zulu. Photograph c. 1900

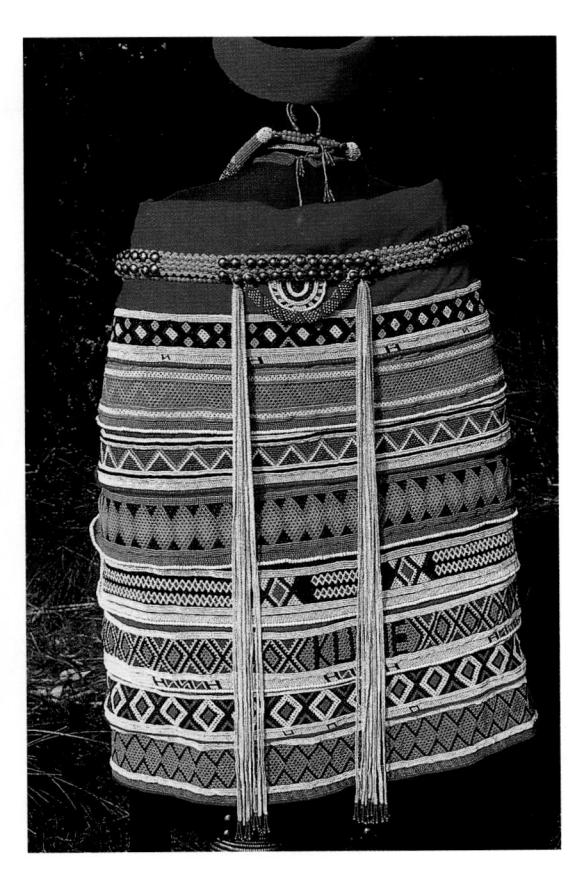

14-33. Married woman with shawl, Zulu

nineteenth century wore several beaded squares or bands of beads around their necks (see fig. 14-38). They had probably given similar items of beadwork to young male friends and relatives, and some of the colors and patterns of the beads may have conveyed messages. Young people still wear these beadwork panels on special occasions, now usually attached to dresses or shirts. For weddings, initiations, royal festivals, and other conservative gatherings, however, modest Zulu maidens remove imported garments. As was the case with the unmarried girls in the photograph, their aprons and beadwork leave their breasts and thighs exposed, for the beauty of their young bodies is believed to reflect the beauty of their character.

Another nineteenth-century photograph shows two Nguni women wearing the hairstyles of married women (fig. 14-32). Their leather aprons were made to protect them during pregnancy and lactation. The crescent shape in the center of the apron may refer to horns, while the many metal studs filling the square panels at the bottom of the aprons probably represented the motif inelegantly called amasumpa, warts; it symbolizes herds of cattle. Rural Zulu women still wear beaded versions of these garments. The leather for the apron is taken from a cow slaughtered by the expectant mother's husband as a sacrifice to his ancestors, and it serves to underscore the role of cattle in marriage and procreation.

Today married women in rural communities in South Africa cover their shoulders with a blanket or shawl. Shawls of Zulu women are adorned with beads. A dazzling shawl rich in reds and greens was photographed on a young Zulu woman living near the Lesotho border (fig. 14-33). The letters appearing in the design seem to have been used purely as visual elements.

The ornaments worn by the Zulu woman in figure 14-1 mingle red, green, white, black, and dark blue, a color scheme called *umzansi*. What strikes us in this photograph, however, is not so much the beauty of the beaded neckrings, vinyl earplugs, and woven cap as objects, but rather the masterful arrangement of colors and shapes around the woman's face.

IMAGES IN CLOTH—WOMEN'S WORKSHOPS

In the impoverished area of the former Zulu homeland known as the Valley of a Thousand Hills, women have turned their skills as beadworkers and seamstresses to commercial advantage. In the late 1970s, women from several Zulu families began to stitch small soft sculptures of fabric and beads for sale in a craft cooperative begun as an outreach program by a white South African cultural organization. While many pieces created by the women were quite decorative. their beaded helicopters were grim commentaries on the South African police state, and tiny beaded coffins holding babies told of their hard lives.

Craft cooperatives have been launched in other areas of southern Africa as well. Most, like those of the Zulu beadworkers, employ members of a single ethnic group. For example, the Kuru Trust in Botswana has provided painting materials for displaced San men and women now living in refugee camps, while the Weya cooperative was organized for Shona women in rural Zimbabwe. However. the work illustrated here (fig. 14-34) was produced by Rose Kgoete for the Mapula Embroidery Project, serving a multi-ethnic community in the Winterveld region (the former Bophathatswana "homeland") in South Africa.

Almost all of these workshops are administered by white South Africans or by foreign aid workers as sustainable development programs, and the products of the workshops are marketed to outsiders rather than to locals. The Mapula Project, while allowing women to support them-

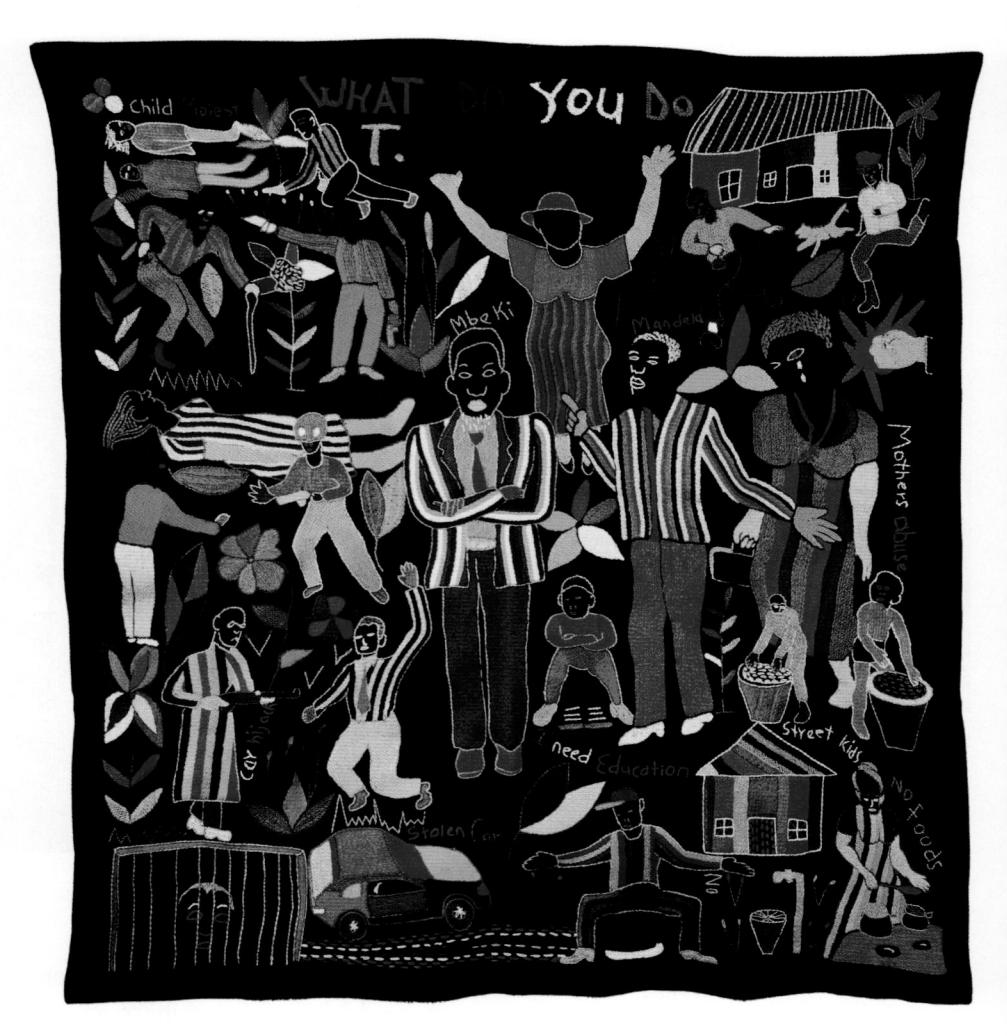

14-34. What Do You Do T. Mbeki?, Rose Kgoete. Cloth and embroidery thread. Mapulu Embroidery Project

selves and their families, also allows the artists to share their lives with a much wider world. As in other workshops, women are encouraged to produce works whose subject matter, such as AIDS, domestic violence, and alcoholism, would normally not be discussed in public. Here Kgoete asks the President of South Africa, Thabo Mbeki, to pay attention to the overwhelming social and economic problems of her community, as if she were able to address him in person.

Kgoete had received no training in Western art traditions prior to coming to the Mapula Project. In fact, in her rural community she had not been exposed to the photographs, paintings, figurative sculpture, film, and video so prevalent in urban centers. Her finished work is quite remarkable considering both her lack of experience with a variety of visual imagery and the difficulties she faced in composing a narrative scene with a needle, thread, and imported embroidery techniques.

Nguni Arts of Daily Life

Just as sewn and beaded garments may reflect complex ideas as well as aesthetic tastes, Nguni household objects carved of wood or molded from clay often carry rich conceptual associations. As is true for other southern African peoples, art works used in daily life by Nguni peoples may also be imbued with ancestral power or linked to sacred forces.

Sensuous sexual references are evident in a wooden spoon once used by a Nguni elder to distribute food (fig. 14-35). Its elegance leads us to believe that it was a prestige object, possibly given to a man by the family of the bride-to-be at a stage in the wedding transactions. With a series of subtle curves the handle of the spoon evokes an elongated female torso, and the bowl of the spoon, a head.

Rectangular panels of tiny raised dots on the figural portion of the spoon have been interpreted as the *amasumpa* "herd of cattle" motif seen previously on the pregnancy apron (see fig. 14-32). This motif was first used by sculptors working at the Zulu royal courts in the nineteenth century and was associated with kingship. Cattle imagery also appears in the headrests sculpted for important men in Nguni cultures. A typical example of a headrest in the abstract-

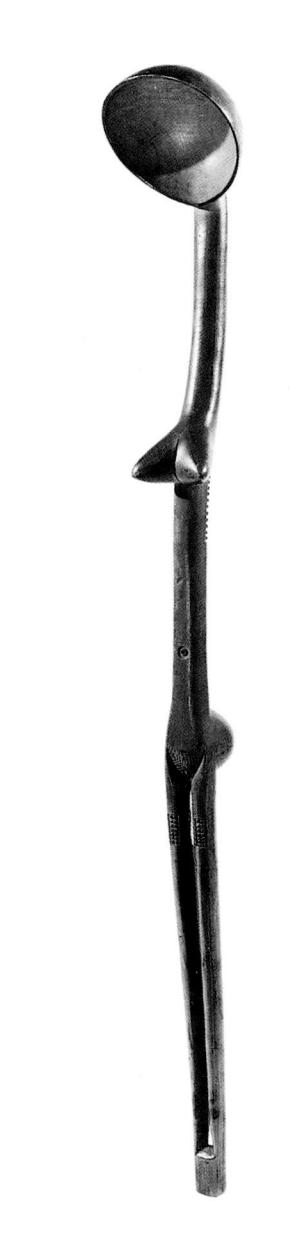

14-35. Spoon, Zulu, before 1977. Wood. Height 22″ (56 cm). Musée du Quai Branly, Paris

ed shape of a bull could have been created by any Nguni group in southern Africa, but comes instead from the Ngoni people of northern Malawi or southern Tanzania (fig. 14-36). The Ngoni are an Nguni group who fled from the wrath of Shaka, finally settling in eastern Africa. This headrest was given by a woman to her husband upon her marriage and incorporates many of the references to virility and fertility mentioned in the discussions above.

Similar references to cattle appear on a thin-walled black vessel for beer with *amasumpa* panels (fig. 14-37). References to cattle on beer vessels invoke ancestors, who are believed to guide and bless the living. In most southern African families, the senior woman in a household stacks beer vessels on a special platform at the rear of her home, and her husband or son comes to this area to pour libations of beer to his forefathers.

The ceramic pot is clearly associated with the female body. In some regions, brewing beer is said to be similar to the process of pregnancy. The *amasumpa* patterns on this vessel may have been similar to the scarification worn by the woman who once owned it. The lid for this vessel seems to have replaced an earlier cover made of woven grass. It is woven of plastic-covered wire, a

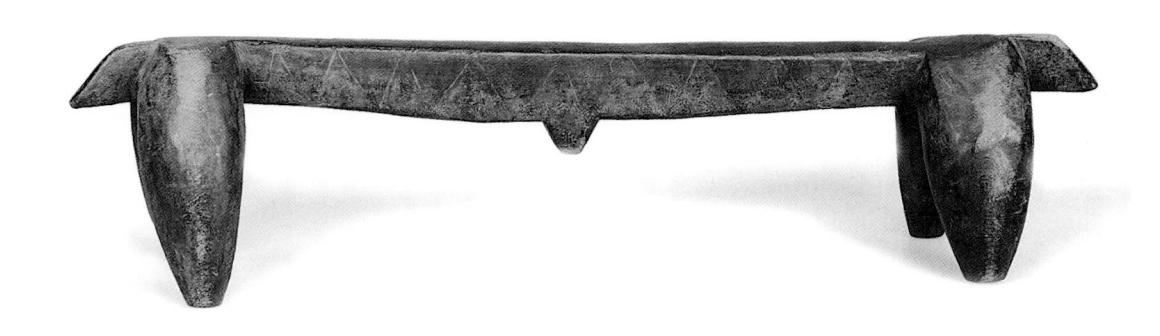

14-36. Headrest, Ngoni. Wood. Length 24½" (63 cm). Linden-Museum, Stuttgart

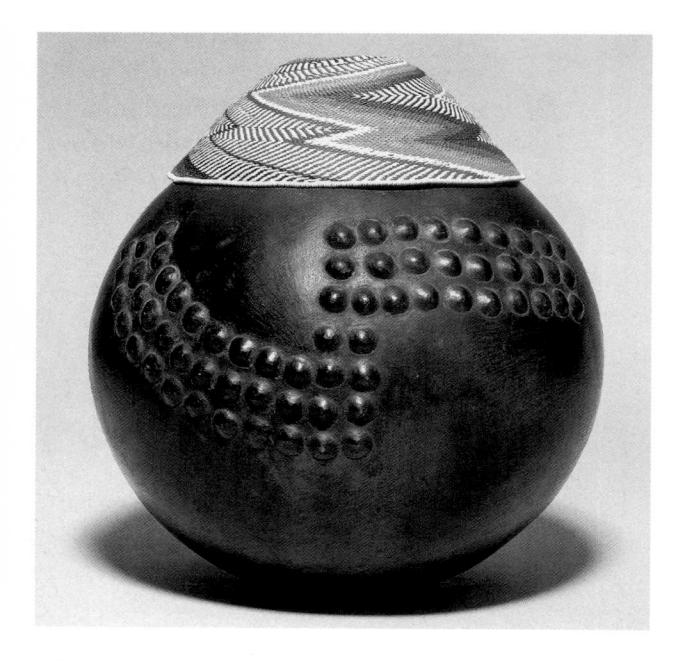

14-37. Beer vessel with LID, Zulu, 20TH CENTURY. TERRACOTTA, TELEPHONE WIRE. HEIGHT 8½" (21 CM). THE BRITISH MUSEUM, LONDON

Ceramic beer containers in southern Africa are involved in the social, economic, and religious life of a community. They appear at the most important ceremonies as well as at work parties, and the quality and quantity of the beer served to each participant establishes social hierarchies and reaffirms social relationships.

medium well suited to these intricate diagonal designs in bright, shiny colors.

Architecture

Most Nguni peoples once lived in hemispherical dwellings made of grass or reeds layered over a curved framework of cross-tied saplings or sticks and tied down by a radiating net of rope (fig. 14-38). At the summit of the house the ropes were drawn into a tightly coiled cylinder, which formed a base for a crescent-shaped wooden attachment known as the thundersticks, abafana, said to protect the house from thunderstorms.

For perhaps a thousand years, southern African cattle-raising peoples created communities by grouping such dwellings around a circular central enclosure for their herds. Nguni groups used the cattle enclosure as a ceremonial ground, holding assemblies within it and burying deceased men beneath its fence. Other south-

ern African peoples put their cattle in smaller pens within or beside a central ceremonial enclosure, or constructed a sacred enclosure near the central corral.

The male head of the family or clan owned the "great house" farthest from the entrance to the cattle enclosure. The houses of his mother and senior wife were close by, while the homes of junior wives, brothers, and other relatives formed a circle around the corral. Older children shared houses near the entrance to the corral, although daughters of marriageable age might be housed behind the home of a senior wife. The city of a king followed the same plan on a grander scale to house his family, soldiers, courtiers, and subjects. One of the capitals of the Zulu king Shaka was a vast circular city of 1400 dwellings.

While non-Nguni Bantu groups also constructed houses of grass and reeds, some had walls of stone or clay. Despite their variety of forms and materials, many divided exterior spaces into public and private realms,

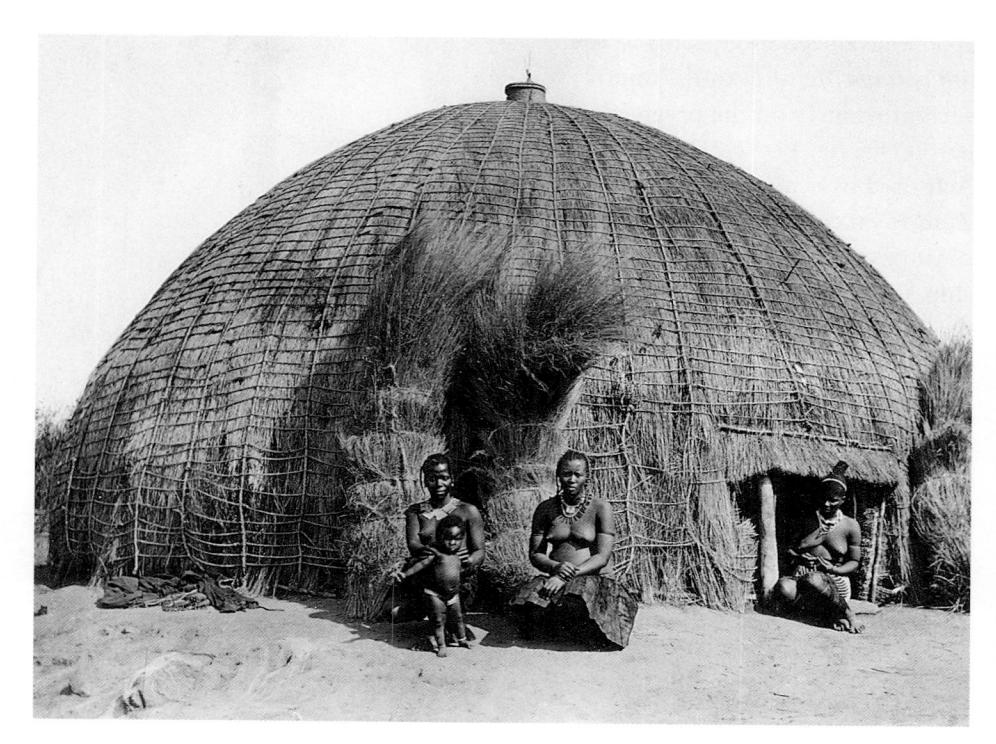

14-38. NGUNI DWELLING, NATAL, SOUTH AFRICA

and most provided an area at the rear of the dwelling for platforms holding the ancestral pots described above (see fig. 14-37). Even after populations were forced to work on white-owned farms as laborers, they were able to maintain some of these spatial divisions in the rectangular cement structures they were given as dwellings. Throughout South Africa, the blank walls of these bleak buildings were transformed by women who applied designs from other media in wonderful murals. Paintings incorporating motifs known as *litema* have been made by Sotho women since the middle of the twentieth century (fig. 14-39). The varied colors and shapes of litema all form repeated organic patterns referring to the fertility of the fields and of women. Inside their homes, Sotho women paint shelves on the back wall to display enamel and china plates, a modern reinterpretation of the platforms for ancestral veneration placed inside nineteenth century homes of reeds and grasses (fig. 14-40).

While Sotho homes have attracted the attention of scholars, the murals of Ndebele women are even better known. Defeated by the British at the end of the nineteenth century, Ndebele families were removed from their land and scattered through the central part of South Africa. Although their ancestral homes of fiber were similar to those of the Zulu, Ndebele women during this period had to adapt to the rectangular housing of the farms where they now worked. Inspired by the murals of their Sotho neighbors, Ndebele painters developed a bold new wall painting style using bright pigments and strong contrasts of light and dark. While these distinc-

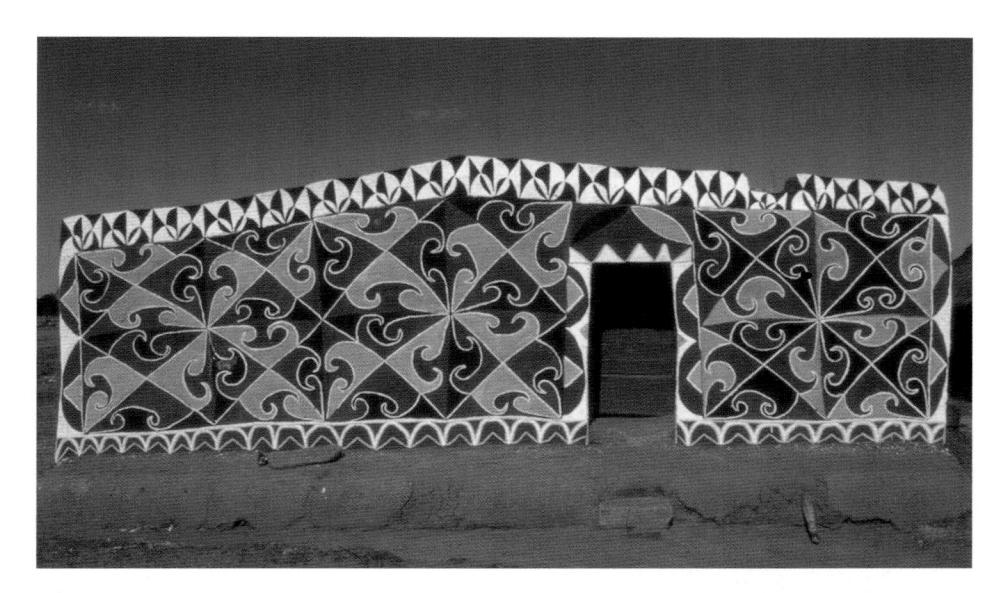

14-39. House facade, Weie Minah Motaung. Commercial paint on hard surface. Photograph 1992

14-40. Display of Ceramics, Maria Mokhethi. Paint, Porcelain, wedding ornament. Photograph 1992

tive patterns helped Ndebele refugees establish a striking presence in a foreign environment, they also inspired the South African government to set up Nbebele model villages in the 1960s. At these centers, tourists could buy Ndebele beadwork, and the attractive, thatched houses with painted walls could present a falsely

idyllic image of rural life, thus serving as propaganda for apartheid's policies of cultural segregation.

Franzina Ndimande is one of the Ndebele artists who have painted homes in the face of great adversity. Her house, once showcased in the former Ndebele "homeland," is shielded by low adobe walls, which form a

14-41. Franzina Ndimande, her daughter Angelina, and granddaughter Maryann inside their home, Kwandebele, South Africa. Photograph 1980s

14-42. Untitled, Tito Zungu. Pen and colored ink on paper. African Art Center, Durban. 19705–1980s

series of forecourts with platforms for seats and working surfaces. These open courtyards are the setting for most domestic activities, and access to them is controlled by the women of the household. Visitors and male family members need their permission to enter the inner courtyards or the house itself.

Ndimande covered the exterior and interior walls of her home with whitewash, and ornamented them

with rectangular panels of brightly colored geometric designs outlined in black (fig. 14-41). Some of the images are based upon old-fashioned razor blades, while others are architectural images, elaborate two-story buildings. Along the interior walls hang beaded ornaments for festive occasions, including the large square apron, ijogolo, worn by married women who are mothers. The artist herself sits with her daughter and granddaughter in a corner of the room, wearing the distinctive brass rings and thick, beaded neckrings of Ndebele women. Under their blankets she and her daughter wear the beaded fringed aprons of Ndebele married women, but the granddaughter wears only the short beaded panel given to young girls and small children. Mats for seating and for bedding are stored in the rafters, while small figures of clay are placed on top of the wall. In addition to creating art for her family, Franzina Ndimande and other Ndebele artists have also painted designs on canvas for museums and collectors.

The imagery in the art of Tito Zungu (1946–2000) seems closely related to the inventive architectural forms Ndimande has painted upon the walls of her home. Born to a dispossessed and landless family, he spent most of his life working in the city of Durban. As a young man, he began to draw meticulous, rather fanciful images of airplanes, ships, and enormous buildings (fig. 14-42). Zungu first drew his idealized visions on envelopes, so that other urban laborers could buy them and mail them to families they had been forced to leave behind in order to find work. His work was eventually brought

to the attention of a gallery director and subsequently became known outside Africa.

Zungu worked with a ruler and colored ball-point pens, filling the surfaces with tiny lines. Sometimes he drew lines on top of or next to each other to create a greater variety of color. As in Ndebele murals, no people seem to be present. The ambiguity of these technological fantasies is revealed in Zungu's statement, "I have liked to look for fifteen or fourteen years at the white man's houses and things like aeroplanes and ships; I don't want them, but I do get jealous about these things, I don't know what to do about them."

ART AND CONTEMPORARY ISSUES

The Beginnings of Modern Art in South Africa

Afrikaaner and other immigrant populations in South Africa produced painters and architects with solid artistic skills during the eighteenth and nineteenth centuries, and many foreign visitors left impressive visual records of South African peoples and landscapes (see the portrait by G.F. Angas, fig. 14-31). During the first half of the twentieth century, South African artists such as Irma Stern (1894-1966) still looked to Europe for training in both premodern and modern styles of painting. The first white South African artist to look at African art directly was Walter Battis (1906-82), who did a serious study of San rock art.

During the twentieth century, primary, secondary, and post-secondary schools for white South Africans were

14-43. Street Scene, Gerard Sekoto, 1939. Oil on hardboard. South African National Gallery, Cape Town

organized around British models, and included classes in fine arts. With very few exceptions, schools for the rest of the country's population taught only vocational skills and useful crafts. Talented and resolute black artists (such as Samuel Makoanyane, 1909–44, Gerhard Bhenga, 1910–90, and George Pemba, 1912–2001) were therefore either self-taught, or were able to arrange for sporadic instruction by white mentors.

Gerard Sekoto (1913–93) and Ernest Mancoba (1904–2002) were both examples of "township artists," painters who used watercolors on paper or oil on canvas to create scenes of life in the townships, the urban areas settled by non-white South Africans. The paintings were collected by white South Africans who were intrigued both by the subject matter (for whites rarely ventured into these parts of their cities) and by the ethnicity of the artists themselves (for the style of their works was decidedly unaffected by art from other regions of Africa). Both Mancoba and Sekoto left their native country for Paris in the last years of World War II, and neither returned to South Africa. Mancoba joined a group of European painters working in pure abstraction. However, even in exile, Sekoto continued to paint representations of South African urban life. Some of the bold, simplified forms in his paintings (fig. 14-43) recall the work of African American artists of the Harlem Renaissance, who had lived and worked in Paris before the war (see fig. 16-1, pp. 522-26).

Modern Art in Mozambique and Zimbabwe

Several of the late twentieth century and twenty-first century South African artists mentioned above (Maswangangi, Ndimande, and Zungu) created works for local clients before foreign collectors and other outsiders began buying their art. Evidently this has not been the case in Zimbabwe (the former Rhodesia), where almost no local patronage has existed for a remarkable body of work produced since the early 1960s.

The roots of this art can be traced in part to two rural missions that encouraged young people to create sacred and secular painting and sculpture in the years after World War II. It also is derived from the work of a talented individual, Joram Mariga (born 1927), who experimented with soapstone carving (fig. 14-44) and

14-44. Intertwined Figures (Man Carrying Another Man), Joram Mariga, early 1960s. Green serpentine. Joseph Raeber Collection

14-45. DESPERATE MAN,
NICHOLAS MUKOMBERANWA,
1988. BLACK SERPENTINE.
11½ X 9½ X 11½" (30 X 25 X
30 CM). COLLECTION OF
BERND KLEINE-GUNK

established a workshop near his home in the Inyanga region in the late 1950s. Finally, the art was nourished by the patronage of a British artist, Frank McEwen, who worked at the National Museum in Salisbury (now Harare) and who dreamed of revitalizing the stale, repetitious modern art of Europe with what he saw as the elemental, uncorrupted originality of Africa.

The first artist McEwen recruited was Thomas Mukarobgwa (1924-99), who created vivid landscapes with the painting materials McEwen gave him. Like Romain-Desfossés (see chapter 12), Georgina Beier (see chapter 8), and European teachers elsewhere on the continent, McEwen refused to subject Mukarobgwa and his other protégés to direct instruction in order to safeguard what he saw as their "innate African aesthetic." However, he did encourage them to study the work of European modernists, and his gallery hosted exhibitions of work by Pablo Picasso and Henry Moore.

McEwen encountered the sculpture of Joram Moraga and his associates around 1961, and decided that their

abstracted figures were directly descended from the soapstone birds of Great Zimbabwe. McEwen began to exhort members of his workshop to create a new "Shona Sculpture." Nicholas Mukomberanwa (born 1940), who had received his first artistic training under Father John Groeber at Serima Mission, was one of the talented sculptors patronized by McEwen during this period. The geometric rigor of Mukomberanwa's sculpture may reflect his exposure to West African art, which McEwen showed to his workshop. Mukomberanwa's works are not carved in soapstone, but in a particularly hard, smooth rock that gives the images precision and power (fig. 14-45).

After McEwen left his post and returned to England in 1973, stone carvers continued to work with white patrons (but in more egalitarian settings) at a farm named Tengenenge, and in a Harare workshop that would become Chapungu Sculpture Park. Although the stone sculpture was still referred to as Shona, most was actually being carved by workers of other

14-46. Mural, Valente Malangatana, 1985. Marracuene, Mozambique

ethnic groups who had migrated to Zimbabwe, and who had prior experience with sculpting traditions in their homelands. Today younger sculptors in Zimbabwe have begun to explore a wide range of ideas and forms, partly as the result of their contacts with contemporary artists in other countries. However, Mukomberanwa's sculpture exemplifies the conservative, modernist approach to forms and materials that still characterizes sculpture from stone carving centers in Zimbabwe.

In Mozambique in the 1960s, the sponsorship of a Portuguese architect enabled a young artist named Valente Malangatana (born 1936) to launch his career as an artist. Other expatriate members of Mozambique's small artistic community sponsored sculptor Alfred Chissano (born 1935). In Malangatana's paintings, twisted, emotionally charged figures appear in acid hues of yellow, orange, blue, and blood red. Imprisoned by Portuguese colonial authorities, Malangatana has

since lived through the turmoils of independence and civil war. In the 1980s, he joined with younger artists to paint public murals (fig. 14-46), and began to advise a new generation of painters, sculptors, and ceramists in Mozambique.

One of these younger artists who grew up during the devastation of the civil wars is Gonçalo Mabundo (born 1975). Although little information is available on Mabundo's background, his art (unlike the modern art of Zimbabwe stone sculptors) does not exhibit formal beauty, or communicate an African spirituality or philosophy. Instead, it appears to be postmodern in its startling juxtaposition of images. Mabundo has used the materials so readily available in his native land—discarded automatic weapons—to form comfortable and comforting easy chairs (fig. 14-47), or even small whimsical replicas of the Eiffel Tower. His art is a testimony to an artist's ability to transform a brutal past into a hopeful present.

14-47. REST (CHAIR MADE OF RECYCLED AUTOMATIC WEAPONS), GONÇALO MABUNDA, 2003. COLLECTION OF CENTRO CULTURAL FRANCO-MOCAMBICAO, MAPUTO, MOZAMBIQUE. COURTESY OF THE ARTIST

Art under Apartheid

In 1949, white South Africans elected an Afrikaaner-led government, which codified divisions between populations based upon assigned racial categories. One artist who reacted immediately to the injustices of the new system of apartheid was photographer David Goldblatt (born 1930). Goldblatt's grandfathers were both Eastern European Jews who had immigrated to South Africa at the end of the nineteenth century, and he believed that the new laws were akin to the Nazi policies that the Allies had just defeated. Goldblatt's work has thus revealed the effects of apartheid upon the people and the very landscape of South Africa. In the early 1980s he photographed the structures (monuments, government offices, and churches) built by Afrikaaner communities to communicate and enforce their values (fig. 14-48). Through dramatic contrasts of light and dark, and effective cropping, this photograph captures both the form and the spirit of a building erected in honor of an Afrikaaner leader (the man whose enormous portrait dominates the composition). It both shaped and was shaped by the desire of South Africa's white minority to dominate all other populations. Goldblatt notes that this monument, fittingly, has collapsed.

Goldblatt, like most other photographers and photojournalists in South Africa, had very little formal training as an artist. Remarkable work has also been produced by other minimally trained or self-taught artists who live in South Africa's cities. One artist who clearly depicted the despair and anger of black South Africans in the

14-48. MONUMENTS TO THE REPUBLIC OF SOUTH AFRICA AND TO J.G. STRIJDOM, WITH THE HEADQUARTERS OF VOLKSKAS BANK ON STRIJDOM SQUARE, PRETORIA, TRANSVAAL, 25 APRIL 1982, DAVID GOLDBLATT, SOUTH AFRICA. PHOTOGRAPH. COURTESY GOODMAN GALLERY, JOHANNESBURG

14-49. Agony, Dumile Mslaba Feni, South Africa. Ink on paper. $9\frac{1}{4}$ x 7'' (25 x 18 cm)

urban slums was Dumile Mslaba Feni, known simply as Dumile (1942-91). Although Dumile followed in the footsteps of Gerard Sekoto and other "township artists," his drawings in charcoal or in ink differ greatly from the earlier artists' work in both their style and content. His figures, while highly disciplined, are intense and distorted (fig. 14-49). Their contortions seem to capture not the physical environment, but the human response to it. Dumile died in exile in the United States, but responses and references to his style can still be seen in the work of artists who began to paint in the 1980s and 1990s.

Willie Bester (born 1956), classified as colored under apartheid, received no formal training in art in his youth even though (like many African chil-

14-50. SEMEKAZI (MIGRANT MISERIES), WILLIE BESTER, 1993. OIL, ENAMEL PAINT, MIXED MEDIA. COURTESY THE ARTIST AND CAAC, PARIS

There is a limited market for contemporary art such as this in non-white South African communities. According to one anecdote, the internationally known artist Sam Nhlengethwa offered one of his collages to his mother. She refused the gift—none of her walls was large enough to display it.

dren) he made toys from discarded scrap. While working as a dental assistant he enrolled in the Community Arts Project in Cape Town, and began to make art documenting the hardships of township life he had experienced while growing up. His assemblages and sculpture combine found objects and oil paint, and are dense re-tellings of oppression, injustice, and deprivation. Semekasi (fig. 14-50), from his Migrant Miseries series, reveals the

story of a gentle, devout man who has spent most of his life working in the spiritual and physical squalor of Crossroads township outside Cape Town. Mr. Semekasi rented a bed, his only personal space in a house full of other people, and in Bester's collage a face peers out from beneath the bedsprings in the center of the composition as if imprisoned by them. Next to it Bester has placed Semekasi's passbook, the apartheid identity document he was forced to carry with him

at all times. Other faces are portraits of Semekasi's wife and children, who lived in the distant Transkei region, and whom he was allowed to visit only three weeks a year. The wire, bicycle wheel, and bits of trash refer to Semekasi's job recuperating material from the trash dumps. In the upper right corner is the text of the Semekasi's desperate handwritten note; after years of hard work, he has found that his employer will not give him a pension. The intensity of the packed, trash-littered surface communicates Bester's outrage at the way Semekasi has been treated by his employer and by his society.

The Community Arts Project where Bester learned from instructors and from fellow participants is similar to earlier workshops set up to reach populations with little access to art education. One of these non-profit centers was established as a mission by the Evangelical Lutheran Church in a rural Zulu area known as Rorke's Drift in the early 1960s. Some of the programs at the center were prototypes for later craft cooperatives (such as the Mapula Embroidery Project described above), as it was intended to provide employment for weavers and potters. It seems that the Swedish missionaries who founded the center also hoped to provide suitable art forms for Christian congregations. Yet in addition to those goals, Rorke's Drift simply gave black African artists the art education they were denied elsewhere.

Until it closed in 1982, Rorke's Drift offered students instruction in printmaking under Azaria Mbatha (born 1941), a former student. Linoleum block prints, which are inexpensive to produce, became par-

ticularly popular with the impoverished artists. This was the relief printmaking technique favored by John Muafangejo (1943-87), the best known of all these artists. Originally from Namibia, this devout and sensitive man created many prints illustrating Christian themes. The print illustrated here is an example of Muafangejo's commentary on the leadership role filled by Archbishop Desmond Tutu during the bleakest years of apartheid (fig. 14-51). It is a bold, fervent expression of hope. Although Muafangejo's popularity with white patrons was partly due to their perception that he was naïve and untutored, his time at Rorke's Drift may have helped him to create works that communicated his messages in a direct and effective way.

Many other accomplished painters and sculptors came from the Polly Street Center, established at the beginning of the apartheid era by the South African government as a recreation and sports center for the black population of Johannesburg. Ignoring the official mandate, artist Cecil Skotnes (born 1926) organized "Polly Street" as a workshop where students could draw, paint, sculpt, and print, and he helped find support for the artists who worked and taught there. Before the center was forced to close in the early 1960s, it had hosted an impressive group of urban artists who worked in both two and three dimensions. They included Sydney Kumalo (1935-88), Durant Sihlali (1935–2004), Ezrom Legae (1937–99), Lucas Sithole (1931–94), and David Koloane (born 1938). All of these artists shared an impassioned, emotional abstracted style, exemplified by Sydney Kumalo's Killed Horse (fig.

14-51. NEW ARCHBISHOP DESMOND TUTU, ENTHRONED AT, JOHN N. MUAFANGEJO, 1986. LINOCUT. 23½ x 16½" (59.8 x 42.2 cm). COURTESY JOHN MUAFANGEJO FOUNDATION, OXFORD

14-52. KILLED HORSE,
SYDNEY KUMALO, 1962.
BRONZE ON WOODEN
BASE. HEIGHT 13"
(33 CM). UNIVERSITY OF
THE WITWATERSRAND
ART GALLERIES,
JOHANNESBURG. COURTESY
MRS. ESTHER KUMALO

14-52). Financial considerations usually forced the artists to work in inexpensive media, but this work is cast in bronze, an indication of how Kumalo was able to apply his skills to metalwork when he was adequately funded.

There are striking formal similarities between the works of these artists and those of German artists working a generation earlier (during a period

of similar political repression) in a style known as Expressionism. However, the South African artists were not specifically encouraged to study European art, and their strong, jagged forms seem to have sprung from their shared emotional reactions to a capricious, unjust society.

After Polly Street closed, Cecil Skotnes began another Johannesburg

14-54. MADE in South Africa No. 18, David Koloane, 1992. Graphite and charcoal on paper. 25 x 36" (64 x 91.5 cm). Courtesy of the artist and CAAC/The Pigozzi Collection, Geneva

14-53. Tyilo-Tyilo, Louis Maqubela, 1997. Gouache on paper. $29\frac{5}{6}$ x $22\frac{1}{6}$ " (74.5 x 56 cm). National Museum of African Art, Smithsonian Institution, Washington, D.C. Museum purchase

arts center known as Jubilee. In a city segregated by gender as well as by race, it provided training for one of the few female artists of this generation, Helen Sebidi (born 1943). In 1985, Polly Street artist David Koloane worked with Bill Ainslie to organize the Thupelo Workshop, the first of several events whose purpose was to allow southern African artists of all races to work together for a limited period. Critics claimed that the abstraction explored by Thupelo artists was part of an "American cultural imperialist agenda," based upon the trends of the New York art scene rather than upon African values and African traditions. Yet Louis Maqhubela (born 1939), who worked at Thupelo, still produces luminous abstract watercolors (fig. 14-53) and bold, abstracted images in oil. Another Thupelo artist, Sam

Nhlengethwa (born 1955), is known for his complex collages, and represented South Africa at one of the first Venice Biennales held after the fall of apartheid.

Koloane has continued to serve as a teacher, mentor, and facilitator in a number of arts organizations. Yet he also continues to create challenging art. In a series of drawings and paintings, Koloane returned to scenes of the townships once recorded by artists such as Sekoto. But by the late twentieth century, these townships were slums racked by the violence and crime spawned by fifty years of apartheid's legalized oppression. In Koloane's Made in South Africa No. 18, a rabid dog roams the urban ruins, a symbol of self-destructive lawlessness (fig. 14-54).

By the end of the apartheid era, artists began to consider themselves

"cultural workers" whose efforts could have political and social repercussions. They protested against specific injustices in performances, sculpture, ceramics, embroidery, etchings, posters, and paintings. Personal responses to the torture and death of student activist Steve Biko by artists such as Paul Stopforth (born 1945) are perhaps some of the contemporary world's most powerful political art. Yet for many observers the most riveting work of this entire era was created by white South African Jane Alexander (born 1959), then a graduate student completing her university studies in art. Her lifesize, horrific Butcher Boys (fig. 14-55) allows us to visualize the dehumanizing effect of racism upon those who perpetrate its injustices. When human beings must shoot unarmed schoolchildren and sleeping families, when they allow

14-55. Butcher Boys, Jane Alexander, South Africa, 1985–6. Mixed Media. 50½ x 84″ (128 x 213.5cm). South African National Gallery, Cape Town

14-56. STILL (DETAIL), Berni Searle, South Africa, 2001. Digital Prints on Backlit Paper. Eight Prints, $47\frac{1}{5}$ x $47\frac{1}{5}$ " (120 x 120 cm) each. Courtesy of the Artist And Michael Stevenson Gallery, Cape Town

themselves to torture suspected terrorists and bulldoze whole communities into oblivion, they are transformed into monsters.

Bernie Searle (born 1964), who also studied art in a university setting, approached the regulations of apartheid from her personal experiences as a woman whose African, European, and Asian ancestry labelled her as "colored." She has created photographs and videotapes of performances and installations in which she uses colored materials (especially aromatic spices) to cover her naked body, to challenge apartheid's nonsensical concepts of race and social value, and to connect her to the lives of her ancestors (fig. 14-56).

Art in the New South Africa

With the arrival of democracy and majority rule, South African artists still address important social issues, as the hardships and poverty of the apartheid era persist for many South Africans. Today South African art historians, art patrons, and art critics find that distinctions between "art" and "craft," "political art" and "personal art" are no longer tenable. However, serious gaps between artists still need to be bridged. Students who would once have been categorized as "black" or "colored" are now welcome to study art in universities as well as in secondary schools, but poor primary education keeps them from meeting high academic entrance standards. They are often still unable to afford tuition, or to travel abroad. South Africans trained in university art programs are, increasingly, sophisticated members of an international art world, while South Africans who have not been exposed to that world have become "outsiders." Such cultural divides mirror the uneven economic development of the new nation.

Economic and social issues are addressed by Zwelethu Mthethwa (born 1960), a photographer who, like Goldblatt, spent years documenting

the effects of apartheid and fighting censorship. His portraits of South Africans in their homes (fig. 14-57) remind the viewers of the dignity and pride of men and women living in conditions of abject poverty. The intimacy of the compositions (despite the large size of the photographs) allows us to see the subjects of these photographs as individuals. We can appreciate the care they have taken to create an orderly domestic environment in a chaotic urban world.

The AIDS epidemic has engaged many artists, including Sue Williamson (born 1941), who was born in England but who has lived in South Africa for most of her life. She has photographed men and women who suffer from AIDS, has asked them to give her a statement for use as a quotation, and has reproduced both their photographs and their words on posters (and in graffiti) that she applies to walls in public spaces. Williamson has also created mixed media pieces using photographs and phrases recorded during trials of the Truth and Reconciliation Commission, encounters that brought the perpetrators of crimes under apartheid face to face with their victims or their victims' families.

Private investigations of complicity, guilt, and redemption fill the drawings, performances, installations, and videos of another white South African artist, William Kentridge (born 1955). Born and raised in Johannesburg, Kentridge localizes some of his wordless and fragmented stories in the famous mines of its region (fig. 14-58). While the relationships between white overseers and black goldminers may be specific to South Africa, the empty lives and troubled marriages of the aging white

14-57. *Untitled*, Zwelethu Mthethwa, South Africa. C-print. Copyright the artist. Courtesy Jack Shainman Gallery, New York

14-58. Soho's Desk WITH IFE HEAD, WILLIAM KENTRIDGE, SOUTH AFRICA, 1991. CHARCOAL ON PAPER. 47¹/₅ x 59" (120 x 150 cm). DRAWING FOR THE FILM MINE. PRIVATE COLLECTION. COURTESY THE ARTIST

protagonists of Kentridge's narratives resonate with American and European viewers, critics, and collectors. His work is now owned by major institutions such as the Museum of Modern Art in New York City. The reception of his deeply moving narra-

tives thus raises questions about how contemporary African art is represented in foreign art markets, and how African identities and African communities are perceived outside the continent, all questions to be addressed in the next two chapters.

PART V

The Diaspora

African Artists Abroad

15-1. Juan de Pareja agressé par les chiens ("Juan de Pareja Menaced by Dogs"), Iba N'Diaye, 1986. Oil on canvas. 51 $\frac{1}{5}$ x 64 $\frac{1}{5}$ " (130 x 163 cm). Collection of Raoul Lehuard, Arnouville lès Gonesse. Courtesy the artist

CCORDING TO A DOCUMENT IN A Spanish archive, a painter named Juan de Pareja left the Spanish city of Seville in 1630 to join his brother in Madrid. There he became the indentured servant of one of Europe's greatest artists, Diego Velazquez. Eventually Velazquez freed him and de Pareja became a respected master himself. We know that Iuan de Pareja accompanied his employer on a trip to Italy, for a painting Juan de Pareja encountered in Rome (a work by the extraordinary Caravaggio) served as a model for his own version of the Calling of Saint Matthew. And during the same voyage Velazquez painted a portrait of his assistant that was an immediate sensation in seventeenth-century Europe, and is now one of the treasures of New York's Metropolitan Museum of Art. It shows Juan de Pareja standing soberly, warily, against a dark background.

We have little documentation of the life of Juan de Pareja, and we do not know whether he was descended from the Africans who entered the Iberian peninsula from the eighth to the twelfth centuries with Muslim armies of conquest. His status as an indentured servant was due to his economic and social standing, and was based upon class rather than race or ethnicity. Yet some of his ancestors might have been slaves brought to North Africa and Europe along ancient trade routes crossing the Sahara and the Mediterranean Sea. It is even possible (though much less

likely) that members of Juan de Pareja's family had been captured in Western or Central Africa during the first century of the transatlantic slave trade, transported to the Americas and thence to Spain. Whatever his family history, Juan de Pareja was a man of African descent living outside the continent of Africa, and thus part of the African diaspora. The term diaspora often refers to the Jews who were defeated, enslaved, driven from their homeland, and scattered throughout the empire by the Romans some two thousand years ago. Yet it also denotes the spread of Africans throughout the world as a result of the intercontinental traffic in slaves, and as the result of the voluntary and involuntary migration of invidividuals and groups. This section of the book discusses artists of the African diaspora.

Diego Velazquez's portrait of Juan de Pareja was the inspiration for Juan de Pareja Menaced by Dogs (Juan de Pareja agressé par les chiens) (fig. 15.1), painted by Senegalese artist Iba N'diaye over three hundred years later. N'diaye captures the hostile attitudes encountered by African artists, and by artists of African descent, who work in cultures where they are seen as exotic, as outsiders, or even as inferior. When N'diaye comes home to Dakar, he is a respected member of his country's educated elite, a revered teacher whose work has a place of honor in the intellectual and cultural history of Senegal (see chapter 4). When he works in his home in Paris, he is an immigrant and (like Juan de Pareja) a member of a minority group set apart from the rest of his community by religion and ethnicity. This first chapter on the diaspora is

focused upon artists (such as N'Diaye) who left their African homelands and established residence elsewhere during the twentieth century. The next chapter discusses artists whose ancestors (such as Juan de Pareja) have lived in Europe or the Americas for centuries, and who are thus the heirs of a much earlier diaspora. Chapter 16 is particularly concerned with artists whose families have survived centuries of slavery and racism in the Americas.

Artists who were born in Africa, or born abroad to African parents, may be equally at home in the country of their adoption and in their country of origin. Traveling frequently to and from Africa, they are members of an urban, cosmopolitan, and intercontinental culture. Iba N'diave himself is one of these international travelers, living in both Paris and Dakar. Other artists have chosen to identify themselves primarily as residents of the community and nation where they now live and work. Sokari Douglas Camp, for example (see fig. 9-59), considers herself to be a British artist despite her close ties to her homeland in Nigeria. Family ties may forge cross-cultural bonds; N'diaye and Douglas Camp have European spouses, and other prominent artists born in Africa have a parent who is not of African origin. In some cases naturalized citizenship in a country may allow an artist to shed an old national heritage in order to stress a preferred cultural identity. Italian artist Fathi Hassan (born 1957), who studied in Italy and is now a naturalized citizen of that country, no longer identifies himself as Egyptian but as Nubian. Yet, as all immigrants know, although both new and old homes

may become more familiar over time, both new and old homes may also become more foreign—an artist born and raised in Madagascar may feel as if he is Malagasy when he lives in France, and as if he is French while he lives in Madagascar.

Many artists featured in this book have chosen to leave Africa in order to take advantage of the rich opportunities available to artists in Europe and the United States. In European and American workshops, universities, and art institutes, they may be mentored by internationally known artists, read the work of influential critics, and gain the support of funding agencies and private patrons. They are much more likely to be able to establish themselves as professional artists, for they can more easily locate teaching positions, be represented by art galleries, create websites, sell their work, and win competitions.

However, many other artists have left Africa involuntarily, as refugees. As described in previous chapters, Abu Bakarr Mansaray (see fig. 6-40) fled civil war in his Liberian homeland, while Gerard Sekoto, Azaria Mbatha, and Dumile Feni (see chapter 14) left South Africa for France, Sweden, and the United States in order to escape the economic and social injustices of apartheid. Ibrahim el Salahi and Gebre Kristos Desta (see chapter 2) went into exile when threatened with imprisonment in Sudan and Ethiopia. Each artist who has lived outside the continent thus brings a distinct, if not unique, perspective to the African expatriate experience.

Yet although the individual histories of these artists are immensely

varied, their careers have all been shaped by the shifting political relationships linking Africa to the rest of the world, and by developments in the art markets of New York, Paris, and London. During the early twentieth century, as Europeans were consolidating their colonial control over Africa, African artists found ways to travel to Europe to study and work. As we have seen, these artists included Mahmoud Mukhtar of Egypt (in chapter 2), Aina Onabolu and Ben Enwonwu of Nigeria (in chapter 8), Christian Lattier of Côte d'Ivoire (in chapter 6), and Ahmed Cherkaoui of Morocco (chapter 1). These early modernists tended to return to their home countries, where they joined compatriots in nurturing new, national forms of African twentiethcentury art.

By the middle of the twentieth century, cultural exchanges and training programs were bringing many more African artists to Europe and North America, and artists from newly independent African nations accompanied popular exhibitions of their art on tours of universities and museums. Competition between capitalist and communist powers during the Cold War encouraged sponsorship for the visual arts of Africa by both camps. Artists from Sudan and Ethiopia were invited to study in the United States, while artists from Mali and Mozambique were given scholarships to study in Cuba. Yet increasing political turmoil in Africa, and the final end to the Cold War, led to a decrease in funding for foreign aid in general, and for arts programs in particular, during the 1970s and 1980s.

Those decades also saw some important shifts in the European and

American art world, which was abandoning some of the central tenets of modern art. The movement known as Pop Art had convinced critics that the aesthetic qualities of an art work were no longer paramount, and materials no longer needed to be manipulated in an accomplished, highly trained manner. Performances, Happenings, and Conceptual Art presented ideas. words, or actions as if they were superior to the mere objects documenting those concepts. More and more artists began to work in experimental new media requiring expensive and complex equipment such as video cameras and computers. Painting, it was (periodically) announced, was dead. Artists who had studied in African institutes and universities had thus learned to create art works (oil paintings, drawings, prints, and sculpture in abstracted styles) that were increasingly considered irrelevant and out-of-date by American critics. During these years very few galleries in the United States would feature the work of artists living in Africa or the work of African artists living abroad.

Ironically, art historians and anthropologists who conducted fieldwork in Africa during those decades often contributed to the marginalization of academically trained painters and sculptors by choosing to study ephemeral arts, conceptual arts, performances, installations, and arts of process based upon regional and cultural traditions. As can be seen in every chapter of this book, the sophistication of these African community-based arts clearly rivaled the new forms of art being explored during the 1970s and 1980s by the American avant-garde. Not only were they multi-media, they were multivalent, communicating with both participant and observer on a variety of levels. In comparison to the arts created in rural African communities, the modernist paintings and sculpture created in African academies by African intellectuals seemed somewhat dull.

This rather grim situation finally began to change in the 1990s. In the United States, an entire generation of academics, critics, and artists had entered into debates stimulated by the ideas of European writers who are often called "poststructuralists" or "postmodernists." Discussions based upon loose interpretations of the ideas of Jacques Derrida were particularly widespread, and artists began to describe their work in terms coined by Derrida and other theorists. This led artists to create works intended to identify, confront, and thus "deconstruct" the underlying assumptions of their viewers.

Curators and critics in the United States who supported these approaches to art became interested in artists of African descent who could provide alternative views to dominant paradigms, who could speak from the "margins" of the art world and could challenge viewers' assumptions about "the other." Understandably, diaspora artists with established careers were somewhat irked when informed that their ethnicity automatically "marginalized" them. Artists living in Africa are accustomed to seeing themselves as normal human beings who look more or less like everyone else in their part of the world, and they are surprised to find that Europeans and Americans assume that their appearance places them in a

state of "difference." Once they enter a culture where artists are categorized by the color of their skin, they become "black." Yinka Shonibare, who spent an extended period of his childhood in Nigeria, describes this best: "I did not have a notion or a concept of blackness until I stepped off the plane."

Furthermore, in their search for art that would "counter" established ideas, some critics wrote as if all African expatriates were expert witnesses who could speak on behalf of their ancestral cultures. Obviously, in many cases artists with two or more nationalities have little contact with the African country where they were born. Immigrants who left the African metropolis of their childhood without ever visiting their family's home town may be unaware of their parents' and grandparents' cultural heritage. Finally, while this critical interest opened doors for many African artists living abroad, the conceptual approaches they were expected to take, and the esoteric postmodern jargon they were required to employ, guaranteed that only African artists who were extraordinarily articulate in English—and who had mastered the specific terms of this "discourse" during their academic training in elite American and British institutions—could participate. For example, a young American critic interviewing Wangechi Mutu asked her "Are you worried about the possibility of sustaining rather than resignifying models of black subjectivity?" Fortunately, Mutu was able to interpret the question and respond to it appropriately.

Meanwhile, critics, curators, and collectors in Europe had begun to

travel to Africa in search of fresh new talent, looking for the creative expressions of unschooled outsiders. Several of the artists these explorers encountered in the streets of African cities have produced works illustrated in previous chapters of this book; they include Samuel Fosso (in chapter 3), Abu Bakarr Mansaray (chapter 6), Cyprien Tokoudagba and Georges Adéagbo (chapter 8), and Chéri Samba (chapter 11). These artists, and other artists whose work had been previously published by art historians (such as Kane Kwei in chapter 7, and Sunday lack Akpan in chapter 9) were featured in a series of sensational exhibitions. The earliest was Magiciens de la Terre (Magicians of the Earth), the 1989 show curated by French critic André Magnin; more recent exhibits display the collection of Jean Pigozzi. While some of these exhibitions have rigorously excluded artists who have received any formal training in art (especially if the training was in institutions outside of Africa), the publicity the shows generated helped revitalize contacts between Western collectors and African artists of all backgrounds.

Both academically trained artists and artists with no formal training were publicized during the 1980s and 1990s by a lavishly illustrated Parisian journal called *Revue Noire*. An even broader vision of the arts of contemporary Africa informed the 1991 exhibition, *Africa Explores*, which was curated by art historian Susan Vogel. For the first time in several decades, a large selection of African artists could be viewed and discussed by a European and American public. A London exhibition, *Seven Stories about African Art*,

built upon this foundation in 1995 by providing in-depth information on modern and contemporary art forms from seven regions of the continent.

Several young African critics responded passionately to the romantically exotic views of André Magnin, and some vociferously objected to the categories set forth by Susan Vogel in her exhibition catalogue. As a result, their writing came to the attention of their European and American counterparts, and the ensuing international recognition has allowed them to become effective advocates for contemporary African artists. In 1995, Olu Oguibe, Salah Hassan, and Okwui Enwezor began to write in a journal named Nka, the first American periodical dedicated to contemporary African artists. By the beginning of the twenty-first century, these critics and others had helped curate their own spectacular exhibitions, and they were involved with a number of international expositions in Venice, Kassel, Dakar, and Johannesburg. An increasing number of galleries in Europe and the United States now represent young artists born in Africa.

Although the artists in this chapter are generally grouped here by their country of origin (or by their parents' nationality), they could just as easily (or just as problematically) be categorized by their current place of residence, or by their generation, or by the media in which they work, or by their educational background. The structure of the discussion is further complicated by the placement of prominent expatriates in previous chapters of this book, usually because their work addresses issues and contains imagery closely linked to the

artistic heritage and cultural history of the region. These inconsistencies remind us that African artists have always crossed ethnic and cultural boundaries, and that African arts have always defied easy categorization.

ARTISTS FROM THE MAGHREB

Emigrants often look back with deep nostalgia to the land of their childhood. This can be seen in the photographs of Jellel Gasteli, which evoke the character of specific places in specific towns (see fig. 1-35). Yet the experience of emigration has oriented another Maghrebi artist away from the experience of a particular time and place and toward a more general engagement with the Islamic and Arabic-speaking world. Rachid Koraïchi (born 1947), who left his native Algeria during a period of violence and chaos, has found in Tunisia and in France a community of artists

engaged with the power of the written word. He has chosen to explore the meaning and impact of Arabic, the language of Islam, by altering its shapes into illegibility and asking the viewer to see the contexts in which it operates. Thus Koraïchi has employed men from Syria and women from North Africa to dye and embroider his designs onto cloth for recent installations. In Steel Talismans, a series of metal tablets (fig. 15-2), Koraïchi evokes the writing boards used in Islamic schools throughout Africa. Wooden writing boards, which are usually inscribed, erased, and reused by students learning to write passages from the Qur'an, may be permanently painted and displayed as a type of diploma when a student completes a period of study (see fig. 3-30). The beauty, power, and mystery of Muslim writing is expressed here, and each tablet has become a point of departure, an object of individual empowerment and inspiration.

Koraïchi's work introduces European viewers to concepts central to African and non-African Islamic practice. Other artists living in exile in France and the United States challenge Westerners' stereotypes of Muslim cultures, the types of ethnocentrism known as "orientalism." For example, both Algerian/French artist Houria Niati and Moroccan/Saudi/American artist Lalla Essaydi directly "quote" nineteenth-century French paintings of North Africans in order to "deconstruct" imagery and assumptions that have shaped two centuries of European colonial and postcolonial activity.

Yet while these artists have responded to their experiences "speaking for" Muslim women by addressing "orientalism" in general rather than referring to specific regional traditions, Zineb Sedira has chosen to understand the nature of cultural identity, migration, and dislocation by exploring her personal histories. She has produced photographs

15-2. Steel Talismans, Rachid Koraïchi, Algerian/French/Tunisian, 1994. Steel. Courtesy of the artist
and videos juxtaposing the Arabic speech of her parents (who were born in Algeria), her own halting Arabic and fluent French (for she was born in France), and her monolingual daughter's English (for her daughter lives with her in England). In two other installations, she designed ceramic tiles akin to those covering the floors and walls of mosques, palaces, and private homes in Algeria (fig. 15.3). But these tiles, while displaying the geometric patterns of Islamic arts, have also been painted with tiny silkscreened images of the faces of Sedira's family members. Sedira may be rebelliously inserting representational images into a tradition that rarely allowed depiction of the human form, but she is also tying her family's specific identity and history to the generalized atmosphere of a Muslim/Maghrebi interior. Memory is now physically imbedded in place.

Even more evocative responses to the loss of an ancestral home and the dissolution of family and community can be found in a performance by Denis Martinez. Martinez was a respected painter who was forced, like so many of his compatriots, to flee Algeria during the bloody fundamentalist insurrection and savage government reprisals of the 1990s. He now teaches in Marseille, in southern France, and there he began to create a series of installations incorporating Berber symbolism and references to Muslim life in Europe. For one series of performances, called Fenêtre du Vent ("Window of the Wind") (fig. 15.4), Martinez created a large window frame. In southern France he placed it on a promontory facing the Mediterranean Sea. Men and women who had emigrated from the Maghreb walked up to this frame

15-3. OUATRE GÉNÉRA-TIONS DES FEMMES ("FOUR GENERATIONS OF Women"), Zineb Sedira, 1997. Two computer-GENERATED PATTERNS SILK-SCREENED ONTO CERAMIC TILES MOUNTED ON WOOD. DIMENSIONS VARIABLE. COMMISSIONED BY GALLERY OF MODERN ART, GLASGOW MUSEUM. COURTESY THE ARTIST

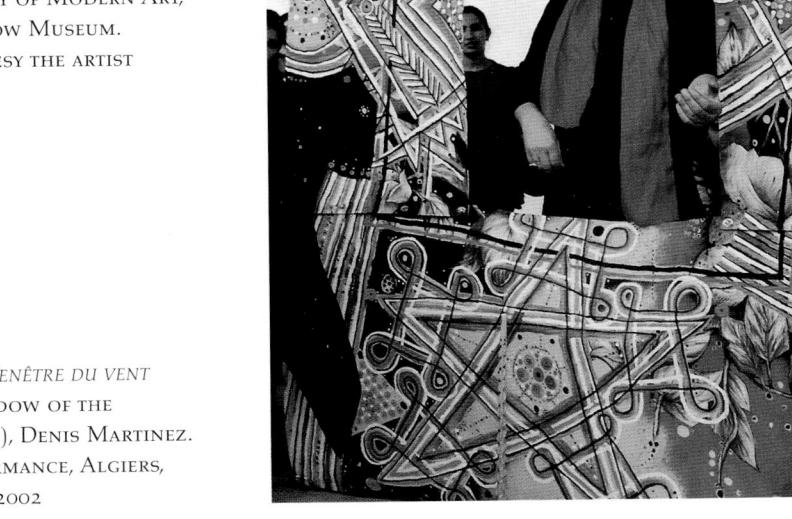

15-4. FENÊTRE DU VENT ("Window of the WIND"), DENIS MARTINEZ. Performance, Algiers, APRIL 2002

and spoke their thoughts, prayers, and desires for their loved ones through the window as though the wind might carry their words southward across the ocean to Algeria. In Algeria, the families they left behind spoke to their distant children and spouses.

ARTISTS FROM EGYPT, SUDAN, AND ETHIOPIA

Before the early twenty-first century, contemporary art from the Maghreb was rarely seen in the United States. However, artists from Sudan and Ethiopia had been featured in American and European exhibitions by the 1960s. One of the most renowned artists of this generation was Ibrahim el Salahi (see chapter 2), who studied in London, worked in Nigeria, exhibited in America, but returned to Khartoum to teach before being forced into exile. Unlike el Salahi, Sudanese artist Mohammed Ahmed Abdalla (born 1935), remained in England after he had received his advanced training in ceramics. But like Magdalene Odundo (see chapter 13), a Kenyan-born ceramicist who also lives in England, Abdalla draws upon many influences in his work. He has experimented with porcelain and earthenware and with high fire glazes to obtain a variety of unusual surfaces. Perhaps his most striking works are a series of vessels based upon the red and black eggshell-thin wares of ancient Nubia (fig. 15-5; see fig. 2-3). Both the fabric (the delicate clay walls) and the dramatic separation of the glazes into two fields of color are fitting tributes to this art form of the distant past.

Sudanese sculptor Amir Nour (born 1939) is currently based in

15-5. Deep-rimmed bowl, Mohammed Ahmed Abdalla, Sudanese/British. Burnished high-fired porcelain stoneware. 6½ x 6¾6″ (15.5 x 16 cm). Collection of the artist

Chicago. Trained in Khartoum and London, Nour completed his studies at Yale University, and his work reflects the last great expressions of modern art, the late twentieth-centurv American art movements known as minimalism (which distilled forms to their geometric essence) and earthworks (whose large-scale projects dominated the landscape). A sculptural group called Grazing at Shendi (fig. 5-6) comprises over two hundred stainless steel cylinders of various sizes, all curved into semi-circles. In this work, Nour invites the museum or gallery to participate in the artistic process by choosing how to place the forms in the display space. The arrangement photographed here was created by the staff of the National Museum of African Art in Washington, D.C. in 1995.

Despite the smooth finish of the industrial material used, this work makes references to the land near

Shendi, the town on the Nile where Nour was born. In Nour's own words:

"As kids, we used to play outside and a man would come around collecting the goats and sheep, and he would take them out of town ... When you see them from the distance, you don't see details ... You just see dots on the space ... I tried to put that type of visual experience into metal to see how it worked."

But the shapes are not just grazing animals. Nour also describes crowds of worshipers praying outside at the end of Ramadan, the Islamic month of fasting and reflection: "They stand in straight lines. And then they prayed. And then they bent down . . . It's the same visual idea. It used to overwhelm me." Just as Abdallah creates startling new forms based upon ancient Sudanese ceramics,

15-6. Grazing at Shendi, Amir Nour, Sudanese/ American, 1969. Installation at the National Museum of African Art, Washington, D.C. Steel (202 pieces). C. 9'11\" X 13'5\" (3.03 X 4.09 M). Photograph 1995. Courtesy of the artist

Nour creates thoroughly American art forms expressing twentieth-century Sudanese experience.

Skunder Boghossian (1937–2003), a contemporary of el Salahi, has already been mentioned as an important figure in the development of twentieth-century art in Ethiopia (see chapter 2), and his impact upon generations of African American artists as a professor at Howard University will be discussed in the last chapter (see chapter 16). Boghossian studied painting in Paris, and his early work was carefully crafted, detailed, mesmerizing, and reminiscent of the European art movement known as surrealism. The images in the painting illustrated here (fig. 15.7) are personal, or universal, and the iconography does not specifically relate to Ethiopian artistic traditions.

Boghossian's art received critical and popular acclaim abroad, where the artist was seen as an inspired African modernist.

After moving to the United States and accepting a teaching position in 1971, Boghossian produced paintings that had looser brushstrokes, and were more abstract. Some of his later work was based upon the long strips of parchment used in Ethiopian healing ceremonies, and thus shared some of the mystical imagery seen in works by Gera (see fig. 2-34). A sustained use of these prayer strips as a source of imagery characterizes the work of Wosene Kosrof (born 1950), one of the younger Ethiopian painters who had also fled to the United States. The faces, script, and geometric symbols on Ethiopian fans, murals, and prayer strips are translated by Kosrof into

abstract patterns in bold, beautiful colors. Yet not all of the forms are based upon ancient Ethiopian talismans and icons—some refer to objects and ideas Kosrof has encountered during his years in the United States. The luminous *Night of the Red Sky* (fig. 15-8) recalls the terror launched by the military government of Ethiopia, the bloodshed that forced Kosrof and so many other Ethiopians to flee the country.

The Sudanese artists mentioned in this book (el Salahi, Abdalla, Nour, Waquialla, and Ishaq) and the Ethiopian artists discussed above (Boghossian and Kosrof) are all examples of artists who have the skills known as "craft"; they are able to paint or sculpt using the materials and the techniques of past generations. To some degree Achamyeleh

15-7. THE NIGHT
FLIGHT OF DREAD AND
DELIGHT, SKUNDER
BOGHOSSIAN,
ETHIOPIAN/AMERICAN,
1964. OIL ON CANVAS
WITH COLLAGE. 56% X
62%" (143.8 X 159.1
CM). NORTH CAROLINA
MUSEUM OF ART,
RALEIGH, N.C.
PURCHASED WITH
FUNDS FROM THE N.C.
ART SOCIETY (ROBERT
F. PHIFER BEQUEST)

15-8. NIGHT OF THE RED SKY, WOSENE WORKE KOSROF, ETHIOPIAN/AMERICAN, 2003. ACRYLIC ON LINEN. 36 X 30¾" (91.4 X 78.1 CM). COLLECTION OF JOLENE TRITT AND PAUL HERZOG, NEW JERSEY

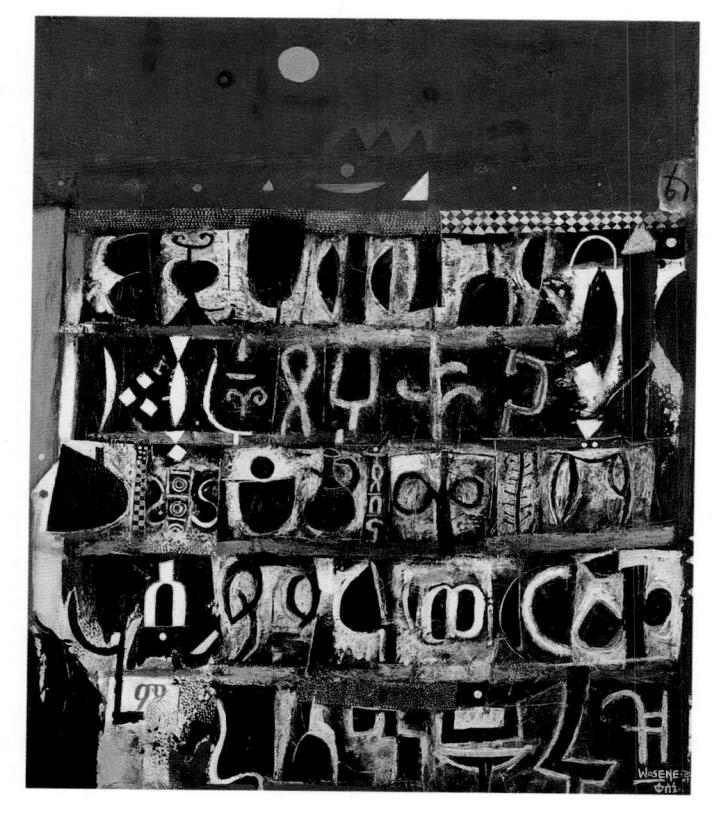

Debela's computer-generated images and Elizabeth Atnafu's fabric constructions also demonstrate a mastery of media that is tied to these Ethiopian artists' awareness of art history as well (see chapter 2). Yet several younger artists from Egypt and Sudan have chosen to emphasize concept rather than craft, and their art attempts to provoke and confront the viewer.

Art that startles (or shocks) the viewer with its explicit sexual imagery is called "transgressive" by contemporary critics, "transgressive" being (invariably) a term of praise in the American art world. Often the art is not merely meant to elicit a strong reaction or protest from the conservative middle-class viewer (an approach the modernists called "épater la bourgeoisie"). Instead, it is meant to free the viewer from the constrictions of outdated views of sexual experience. Excellent examples of transgressive imagery may be found in the work of Ghada Amer (born 1963), who was born in Egypt and who moved to France in her childhood. She studied in several prestigious art institutes in France and the United States, and now works in New York, the epicenter of the Western art world. Her best-known works are of canvas or a more delicate fabric covered with embroidery. Originally the lines of the embroidered images ended in long threads left hanging to form a veillike screen obscuring the imagery (fig. 15.9). Later works superimposed painted floral shapes upon the embroidery.

At first glance, the works appear to be abstract compositions of fine curving lines. Upon closer inspection, however, viewers can see that the

15-9. Black and White French Kisses, Ghada Amer, Egyptian/French/American, 2003. Acrylic, gel, and embroidery on canvas. 78½ x 83½" (200 x 213 cm). Ovitx Family Collection, Los Angeles, CA © Reza Farkhondeh/Ghada Amer. Courtesy Gagosian Gallery, New York

stitches form female faces kissing each other, or nude female figures who are masturbating, or women joined in a sexual embrace. Stray images of breasts or mouths appear as well. Amer found the source of her images in pornographic magazines, and her work engages viewers who question the ways that societies have regulated women's sexuality and women's sexual pleasure. Her work also intrigues viewers who are aware of Amer's Egyptian background and are curious about the restrictions placed upon women under Islam.

Ghada Amer has gained an international reputation, and has received awards and critical acclaim. However, an exhibition of her work in her native country was greeted with a less than enthusiastic reception by Egyptian critics. A comprehensive survey of modern and contemporary art in Egypt mentions her only in passing as "not educated in Egypt" and as addressing her works "to a non-Arab public."

WESTERN AFRICA

Artists from virtually every African nation have established themselves overseas. But it is artists from the smaller African nations who may particularly need to find support for themselves and for their art by immigrating. One such artist is El Loko (born 1950 in Togo). He studied textile design in Accra from 1965–69, studied art in Duesseldorf from 1971–76, and now lives in Cologne, Germany. He is also associated with an international contemporary art center in his hometown in Togo.

El Loko's early work was thoroughly modern in style. His woodcuts are filled with strong, ambiguous shapes resembling masks and bodies. In Tree 2, a print from 1983, simple but evocative black shapes seem to shift from human to vegetal to human (fig. 15.10). Visually intriguing, harmoniously balanced, they are fine examples of two-dimensional art by a modern master. Yet twenty years after he established himself as an artist in Germany, El Loko has revisited the approach of one of his instructors, the renowned installation and performance artist Josef Beuys. He is thus constructing multi-media installations (such as an assemblage called Cosmic Alphabet) featuring carved and stained flat pieces of wood, which may be signs and may be figures. One 2001 installation, however,

15-10. BAUM 2 ("TREE 2"), EL LOKO.
TOGOLESE/GERMAN,
1983. WOODCUT. 12½ X
21½" (32 X 55 CM).
COURTESY THE ARTIST
AND ARTCO,
HERZOGENRATH,
GERMANY

15-11. Star Black, Star Bright, Kwesi Owusu-Ankomah, 2006. Acrylic on canvas. 55% x 70%" (140 x 180 cm). Courtesy the artist and ARTCO, Herzogenrath, Germany

displays only photographs of women's faces and bottles of skin products. Titled *Metamorphosis*, it is a highly unusual critique of the use of the dangerous chemicals now used by African women to soften and bleach their skin. The work of El Loko is an excellent reminder of an expatriate artist's ability to evolve during the course of a career—he was an accomplished modernist and he is now an

accomplished postmodernist.

Owusu-Ankomah (born 1956) also works in Germany. Born in Sekondi, Ghana, Owusu-Ankomah received a degree from Ghanatta, the College of Art in Accra (as did Kofi Setordji, whose work is discussed in chapter 7). Unlike many expatriate artists, Owusu-Ankomah explicitly draws upon images of his own cultural heritage. Having lived and studied in an

Akan region proud of its ancestral arts, Owusu-Ankomah is comfortable incorporating the iconography of Akan art (see chapter 7) into his own work. His drawings, paintings, and prints are populated by idealized, athletic nude men who leap, run, roll, and stretch. By the late 1990s, these male figures were barely discernible white outlines distorting an overlay of black symbols (fig. 15-11). Some of the shapes are identifiable as *adinkra* motifs, while others are the artist's personal adaptations and refiguring of those designs.

Owusu-Ankomah sees his symbols as both rooted in history and as universally accessible. Given the adoption of adinkra by so many members of the African diaspora, and given the similarity of these images to the signage of contemporary urban life, the artist's views seem reasonable. The juxtaposition of white and black, corresponding in older Akan art to purity and power, or life and death, lends additional meaning to the works. Fittingly, given his celebration of the active body and his interest in bridging cultural boundaries, Owusu-Ankomah was one of the artists commissioned to create a poster for the 2006 World Cup hosted by Germany.

Other Ghanaian artists have settled in England (including photographer Gotfried Donkor) and in the United States (including sculptor Bright Bimpong). Insertion into a new country is less difficult for immigrants who have already mastered the language of their new home. For that reason most expatriate artists from the francophone nations of Western and Central Africa live in France or Belgium. However, one artist born in Côte d'Ivoire has chosen to settle in

New York City. Born, raised, and educated in the city of Abidjan as Bakari Ouattara, the artist found that the French spelling of his Mande surname was impossible for Americans to read. He has thus renamed himself Watts. This accommodation of American attitudes may be seen in all of the paintings Watts (born 1957) has produced since arriving in the United States.

Watts studied in Abidian and Paris with members of the Vohou-Vohou group (see chapter 6), and produced abstract painting highly influenced by the work of his fellow students. But a chance meeting with diaspora artist Iean-Michel Basquiat introduced him to an entirely new approach to the production and marketing of art. With Basquiat's encouragement, Ouattara/Watts left Paris for New York. In the words of Watts, "There is a lot of energy in New York, it gives me something (like being in Africa), a kind of energy to do great work ... For me New York is like what Timbuktu must have been like, where everybody came together to exchange things in the market. To make deals and so on."

During the 1990s, Watts created a series of mixed media works that refer to forms of architecture such as Senufo doors and Jenne facades. In the title of one assemblage, Nok Culture (fig. 15-12), Watts invokes the African past (see the Nok terracottas, chapter 3). At the same time, he devises cryptic symbols, such as the "figure" comprised of concentric ovals and, perhaps, raised arms. An inset tablet, replete with Arabic writing and symbolic devices, seems to be an interpretation of a Muslim writing board (see fig. 3-30). Watts's work is

15-12. Nok Culture, Watts/Ouattara, 1993. Acrylic and mixed media on wood. $9'8\frac{1}{2}$ " x $6'7\frac{1}{4}$ " (2.96 x 2.03 m). Courtesy of the artist

multi-layered, vibrant, and bold.

In a 1995 interview, the artist emphasized his interest in African forms of spirituality: "It's about concept. And it's about energy, something like being a shaman or a sorcerer in a positive way. It is about communicating with the invisible ... These constructions are like altars where I can pray and make offerings and perform magic." Such an unabashedly romantic view of the artist's priestly role runs counter to the dominant postmodern trends in the New York art world, where artists

must be detached, clinical, and cynical when they allude to spirituality (if they refer to it at all). An impartial observer might be tempted to think that New Yorkers are expecting an African artist to express beliefs and attitudes they would never countenance in an interview with a European American artist. Sceptics might also note that although Watts's family comes from the Senufo region, his original name (Bakari Ouattara) reflects his membership in a Mande (Dyula) clan that is predominantly Muslim. They might consider it

unlikely that his family encouraged him to conduct shamanic ceremonies during his youth in the urban metropolis of Abidjan, Côte d'Ivoire.

This section on artists from Western Africa ends with a special segment on Nigeria. Nigeria is both the most populous of all African nations and (as can be seen in chapters 3, 8, 9, and 10) the source of many particularly rich artistic traditions. Most West African artists practicing in Africa today are Nigerian, and expatriate Nigerian artists have had a correspondingly important impact upon African art abroad.

Nigeria

Nigerian artists have a long involvement with British art, beginning with Aina Onabolu's short stay in London at the beginning of the twentieth century. One of the first Nigerian artists to settle permanently in England was Uzo Egonu (1932–94), known for his playful paintings and collages, whose style was quite similar to that of modernists working in Nigeria during the same period.

Nigerian-born artists of more recent generations have undergone more radical changes after being introduced to the social and intellectual ferment of contemporary British art. In London they have participated in sophisticated discussions with artists whose families come from all of the colonies of the former British Empire, and have raised many issues concerning the nature of identity and individuality in art. One of the most articulate products of this art scene is Olu Oguibe (born 1964) who was once a member of the Uli group at the University of Nsukka (see chapter 9) and has now

15-13.

OKLAHOMA,

OLU OGUIBE,

NIGERIAN/

AMERICAN,

1995.

INSTALLATION.

COURTESY THE

ARTIST

moved to the United States. Although he has continued to make art, Oguibe is now known for critical writing, his curatorial projects, and his installations. One powerful piece, assembled for an exhibition in Florida, honors the children who were victims of the bombing of the Federal Building in Oklahoma City in 1995 (fig. 15.13).

Oguibe's moving commentary on the deaths of the children killed in the Federal Building's day care center reminds us of other sculptural work responding to tragedies—specifically Isaac Essoua's work on the September 11 attack on the World Trade Center (see fig. 10.45), Kofi Setordji's memorial to the genocide in Rwanda (see fig. 7-44), and even Princess Olowo's memorial to the Biafra War (see fig. 9-18). Yet university art departments in Nigeria are often so steeped in the modernist tradition that politically charged commentaries are rare. Thus for Oguibe, advanced study in England taught him a new language, exposed him to new media, and broadened the scope of his art.

Rotimi Fani-Kayode (1955–89) was the son of a prominent Yoruba leader

forced into political exile when Fani-Kayode was only ten years old. Fani-Kayode was born in Lagos, but his father had close ties to the religious leadership of Ife. Raised in England, the artist received degrees in art in the United States before returning to England. There he produced a visually stunning series of color photographs, and more subdued photographs in black and white. The photographs were taken in collaboration with his partner and lover, Alex Hirst; both artists died of AIDS at a young age. These photographs, together with Rotimi's book White Male/Black Male, are seen in the United States in the context of a hefty body of critical commentary on transgressive images of homosexuality. They particularly relate to the controversies surrounding the famous erotic photographs of black male models by European American Robert Mapplethorpe.

Yet the photograph illustrated here (*Bronze Head*, 1987) (fig. 15-14) clearly relates to Fani-Kayode's Yoruba heritage rather than to analyses of race, power, and gender in the United States. Rotimi's lower back,

15-14. Bronze Head, Rotimi Fani-Kayode, 1987. Photograph. © Rotimi Fani-Kayode/ Autograph ABP, London

buttocks, and thighs fill the frame, and between his spread legs appears a head whose striations identify it as a reproduction of the famous portraits from Ife (see fig. 8-10). The head rests upon a round tray similar to the platters used in Ifa divination (see fig. 8-24) by Yoruba specialists.

Fani-Koyade himself never directly addressed the imagery in this photograph, but other critics have picked apart his interviews and essays to find insights into this work. One statement in particular has been applied to this image:

"On three counts I am an outsider: in matters of sexuality; in terms of geographical and cultural dislocation; and in the sense of not having become the sort of respectably married professional my parents might have hoped for. Such a position gives me a feeling of having very little to lose."

Yet an even more appropriate quotation might be: "In exploring Yoruba

history and civilization, I have rediscovered and revalidated areas of my experience and understanding of the world."

Is the artist's stance thus a form of domination or suppression, a rejection of this venerated royal image? Was the photograph an angry response to his family and to a culture where sexual activity between males was at one time simply unheard of? Or is the artist empowered by the object, absorbing the vital force, the ashe, of the head through his loins, channeling mystic strength into his sexual organs? Or, finally, is the artist shifting genders by giving birth to the head as a creative act, as a re-enactment of the creation of mankind by the orisha at the sacred site of Ife? Given the artist's untimely death, we will never know.

The transgressive art of Yinka Shonibare MBE (born 1962) is much more playful. Born in England to Nigerian parents, Shonibare lived in Lagos for many years. In addition to creating detailed scenes presented as an unfolding narrative in series of photographs, he has also constructed sculptural groups consisting of mannequins wearing elaborate costumes—the mannequins are headless partly because Shonibare found them to be more amusing that way. As we can see in Mr. and Mrs. Andrews without their Heads (fig. 15-15), the costumes are made of brightly colored cotton cloth. The cloth is recognizable to West Africans as batik, or wax resist (or a printed imitation), originally made by hand in Indonesia, then industrially produced in Holland, and then made in factories

15-15. Mr. and Mrs. Andrews Without Their Heads, Yinka Shonibare MBE, 1998. Wax-print cotton costumes on armatures, dog mannequin, bench, gun. 65 x $224\frac{2}{3}$ x 100'' (165 x 570 x 254 cm). Collection of the National Gallery of Canada. Courtesy Stephen Friedman Gallery, London

in England or West Africa itself. Immensely popular in Western African nations today, the cloth is worn as an emblem of identity and pride by British youths of African descent.

The mannequins are posed so that they copy the sitters in a famous portrait of a man and woman by eighteenth-century British painter Thomas Gainsborough, In Gainsborough's painting, the couple are obviously members of England's "landed gentry," for the broad lawns of their estate appear behind them. Yet Shonibare has transformed this most respectable, most English couple into lower-class immigrants from Africa or the Caribbean by switching their silks and satins for African fabrics. Readers who have seen illustrations of displays of cloth from the Niger Delta (see fig. 9-57) may assume that these arrangements of cloth and clothing influenced Shonibare's art, but the British artist has never actually witnessed such displays during his trips to Nigeria. Instead, his references are unique to the experiences of the African diaspora in England. (The letters "MBE" at the end of Shonibare's name tell us that the artist has been made a Member of the British Empire by the Queen of England—this title underscores the themes of Shonibare's work and delights the artist.)

Shonibare's whimsical work has been enormously popular with both critics and the public. This sets him apart from controversial British artist Chris Ofili (born 1968), whose parents were also Nigerian immigrants. Ofili's most famous work (not reproduced here) has been titled *Holy Mother of God*, and was in a British

collection exhibited at the Brooklyn Museum in New York. The mixed media collage features a broadly distorted figure representing the Virgin Mary, illustrations of female genitalia cut out of pornographic magazines, and clumps of elephant dung. Yes, elephant dung. As the exhibitors had hoped, Ofili's painting was considered to be an offensive work of gratuitous blasphemy, and the mayor of New York City drew an extraordinary amount of media attention to the piece when he tried to retaliate against the Brooklyn Museum by cutting its funding.

After a critic suggested that elephant dung might be an integral part of African religious practice, art historians specializing in Africa enjoyed a brief but intense debate, finally concluding (of course) that the suggestion was unfounded. While some scholars attempted to explain that Ofili's Nigerian parentage and a visit to Zimbabwe did not necessarily confer "African" status upon his art, their opinion was largely ignored in the press.

CENTRAL, EASTERN AND SOUTHERN AFRICA

A very different approach to art can be found in the photographs of Angèle Etoundi Essamba (born 1962) who studied philosophy and has been a dancer, a choreographer, and a poet. Born in Cameroon, educated in France, and choosing to study commercial photography rather than conceptual art, her work celebrates the physical beauty of men and women of dark skin and healthy bodies. The

15-16. Le Fil Conducteur 1, Angèle Etoundi Essamba, Cameroonian/French/Dutch. Black and white photograph. Courtesy the artist

photograph shown here is part of a series known as "White Line" or "Le fil conducteur," where a flowing, calligraphic ribbon of white reverberates against the satiny black of an African face or an African body (fig. 15-16). As Essamba has written "the erotic, mystic and esthetic themes continually recur in my work."

Whereas many other photographers of the diaspora produce images meant to be ironic, skeptical, and distant, Essamba's photographs are straightforward, joyful, and as unabashedly sensual as the painting of Pascal Kenfack or the sculpture of Leandro Mbomio Nsue (see chapter 10). Like Pascale Martine Tayou, another expatriate Cameroonian who is much more clearly oriented toward postmodernism, Essamba has participated in exhibitions in Douala. Her photographs are in the collection of the National Museum in Yaounde.

A radical contrast to Essamba's work may be seen in the work of a young artist born in Kenya and educated in the United Kingdom. Wangechi Mutu (born 1972) received her MFA from Yale University (as did Amir Nour, and Ethiopian American artist Julie Mehretu), and her collages are startlingly anti-aesthetic. The example shown here is an assemblage of hair, adhesive, and printed images of a face superimposed upon an engraving of a womb from a nineteenth-century medical manual (fig. 15-17). The image is clearly layered conceptually as well as physically, combining concerns of beauty with a woman's reproductive role, and placing both into the context of sickness and health. Obviously this image, made available by the gallery representing Chris Ofili, is not meant to be

15-17. CANCER OF THE UTERUS, WANGECHI MUTU, 2005. GLITTER, FUR, COLLAGE ON FOUND MEDICAL ILLUSTRATION PAPER. 18½ X 12¾" (46 X 31 CM). THE SAATCHI GALLERY, LONDON

aesthetically pleasing.

Southern African artists who left the continent in the past were often political exiles. Uneven social structures and unequal access to education and cultural activities still encourage black South Africans such as Mosheka Langa to leave their native country for more opportunities in Europe. Today white South African artists such as Kendell Geers may also be in flight from a nation that they see as provincial, a country where restrictions are placed upon sexual, personal, and artistic freedoms. Gordon Bleach, born in the country now called Zimbabwe, emigrated to the United States and taught at the University of Florida. His photographs and installations were re-mappings of spaces and places in both Africa and the Americas. His experiences as a European African living on lands appropriated (stolen) from the original inhabitants informed his experiences living on lands stolen from Native Americans.

Artists of this most recent diaspora thus link their experiences of their native land to their knowledge of other cultures and other art worlds. They may act as bridges, linguists, and conduits for intercultural and intercontinental communication. The resources placed at their disposal, their access to the language and the culture of the West, give them a visibility (and authority) unavailable to artists now living in Africa. Ironically, these talented men and women are often seen as representing contemporary Africa, even when their experiences are very different from those of artists who live on the continent. As art historian Sidney Kasfir has stated repeatedly, today most African artists do not own passports.

And even though expatriate Africans are expected to be familiar with the cultures of their ancestors, artists who are closely tied to communities of the African diaspora in the Caribbean, in Central and South America, or even in the southern United States, may have a deeper understanding of African religious beliefs and cultural practices. Deeply rooted in the New World, sometimes sharing family ties with both European Americans and Native Americans, these artists bring an extraordinary perspective to their explorations of ancient traditions from Africa. It is the art of these men and women that is discussed in the next chapter.

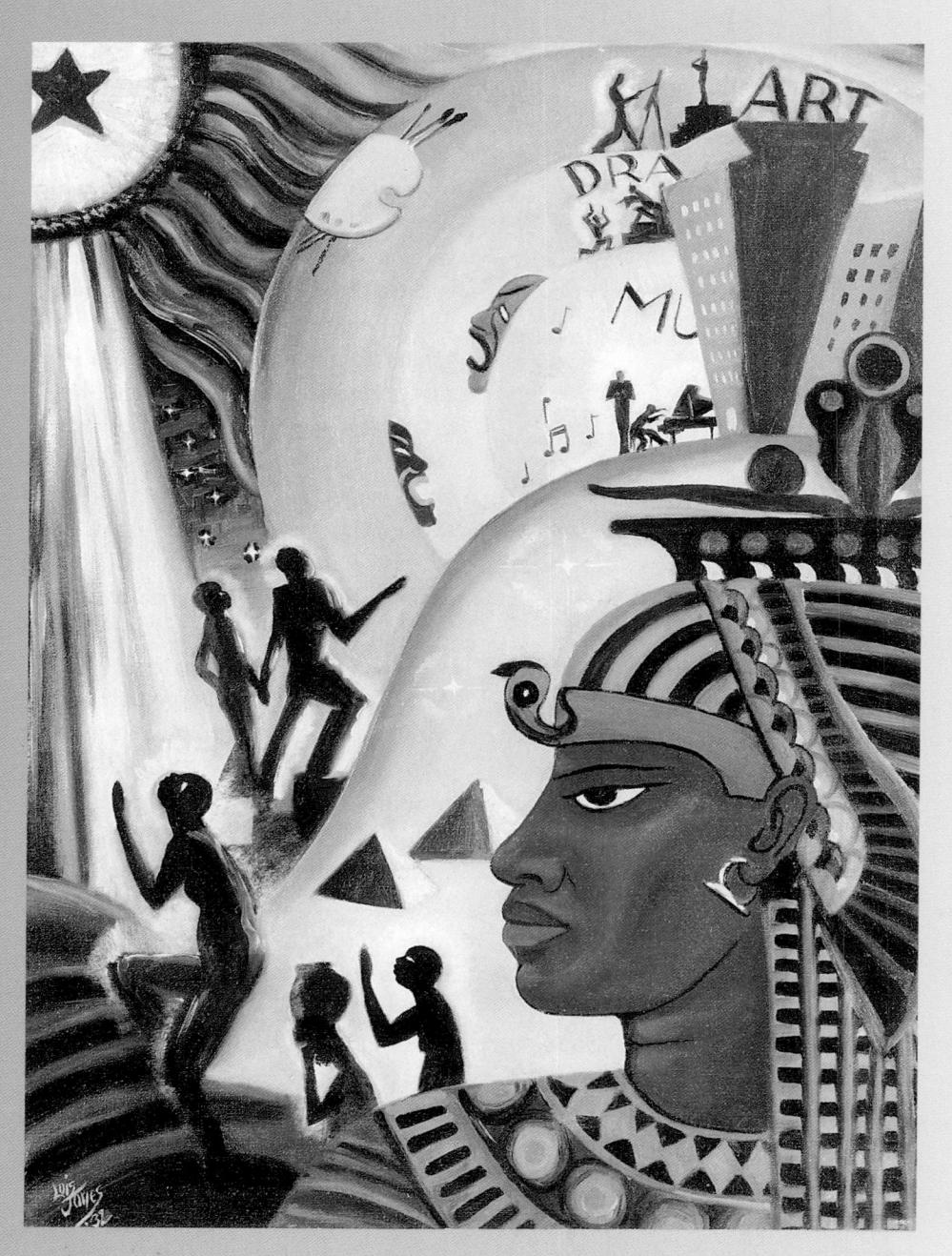

16-1. The Ascent of Ethiopia, Lois Mailou Jones, American, 1932. Oil on canvas. 23½ x 17¼" (59.7 x 43.8 cm). Milwaukee Art Museum, Wi. Purchase African American Art Acquisition Fund, matching funds from Suzanne and Richard Pieper with additional SUPPORT FROM ARTHUR AND DOROTHY NELLE SANDERS

FRICANS WERE TAKEN INTO slavery and shipped across the Atlantic from early in the sixteenth century until the first half of the nineteenth century, with nearly half being transported during the eighteenth century. Approximately fourteen million Africans survived the Atlantic crossing and, though they left their material culture behind, they were cultural beings who carried inside them various ways of approaching and interpreting life. Congregated in the New World, they formed communities and developed new means of meeting the same expressive and artistic needs they had felt in Africa. In some cases, Africans speaking the same language from the same cultural group were gathered together on plantations, especially in the Caribbean and in Brazil, and recognizable cultural practices from their homelands were revived and continued. Often cultural influences from several areas of Africa melded together. The Haitian religious practices known as Vodou, for example, combine Yoruba, Kongo, and Fon elements. In the United States, slaveowners, fearing rebellions, made an effort to group together Africans of varying cultural and linguistic backgrounds in order to suppress communication and collaboration, Still. Africans found what was most common among them and expressed themselves in ways reminiscent of their home cultural practices, though perhaps in more general ways.

One reason Africans became the primary slave labor in the New World was that they were visibly different and, unlike white indentured servants, could not melt into the free white population. Whites entered into contracts for specific periods of indenture after which they were free, but blacks became a profitable long-term solution to the labor shortage. Nineteenth-century efforts to categorize human groups became the foundation for racism as an ideology to justify the slavery and subjugation of Africans, and to separate them from Europeans socially. The result was that most whites thought that a person of African descent was fundamentally different, inferior, and destined for physical or menial labor.

After slavery was abolished, the continued existence of racism affected the aspirations, status, and consciousness of black people. The social restrictions and obstacles they faced affected the production of art, and it is useful to consider these social and historical factors when looking at the work of African American artists. The making and appreciating of paintings and other objects considered to be "fine art" in nineteenth-century Europe and the United States were upper-class activities. The social and economic oppression faced by blacks made it difficult to pursue this kind of art as a career prior to the second half of the twentieth century. Forms of expression considered to be "folk art" or "popular art," however, were less encumbered by racism, and seem (ironically) to have flourished when segregation kept black communities more homogeneous than they are today.

As we have seen throughout this book, culture is dynamic, and new circumstances and outside forces and elements have an effect upon artistic expression. Africans brought to the Americas in the diaspora often used new materials to express themselves. English, French, and Spanish cultural forms and practices also affected them, as did those of Native Americans. In the islands of the Caribbean, Asian immigrants (especially those from India) also had an important influence upon their arts. Throughout the Americas, succeeding generations of the diaspora sought to become full members of the New World societies in which they were born.

ART IN SLAVE AND FOLK SETTINGS

One of the earliest art objects made by Africans in the New World still available to us is a drum acquired in Virginia in the late seventeenth century (fig. 16-2). The drum displays the shape typical of apentemma drums made by the Akan peoples of Ghana (see chapter 9). Like those African drums, this one is carved with bands of saw-edged designs, alternating patches of vertical grooves, and plain squares. The drumhead is secured by tightening pegs, just as Akan drum heads are secured. The materials of its manufacture, however, set it apart: the wood is American cedar, the skin that of a deer. It is very possible that the maker of this drum was born in Afrca, but as time passed specific African designs, such as those found on the drum, gave way to more general African-influenced design in the creation of artifacts in New World slave settings, particularly in the United States.

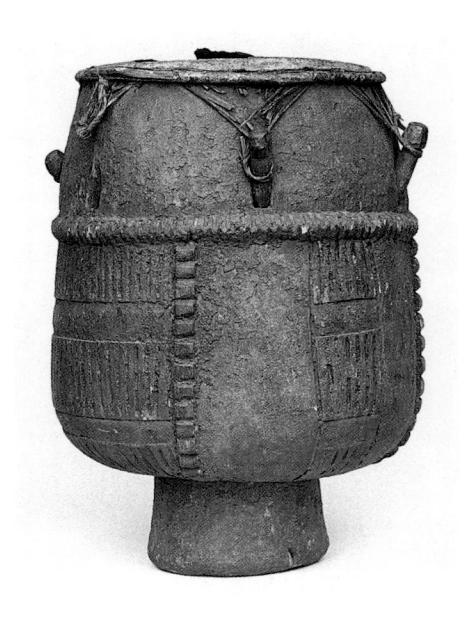

16-2. Slave drum, African American, late 17th century. Cedar wood, deerskin. Height 15¾" (40 cm). The British Museum, London

African architectural influences can be seen in the Americas, where they blended with indigenous (Native American) forms and European traditions. One such influence is the front porch found in several Western and Central African cultures. Like the covered verandahs of interior courtvards in Africa, porches provide a sheltered sitting area in hot, humid climates. Built in the eighteenth century, the slave quarters and the big house of Mulberry Plantation in South Carolina are examples of another African architectural element transplanted to the New World (fig. 16-3). The steeply pitched hip-roofs on these structures resemble some West African thatched roofs. The advantage of this design, where the roof comprises over half the height of the structure, is that the heat in the interior can rise, keeping the house

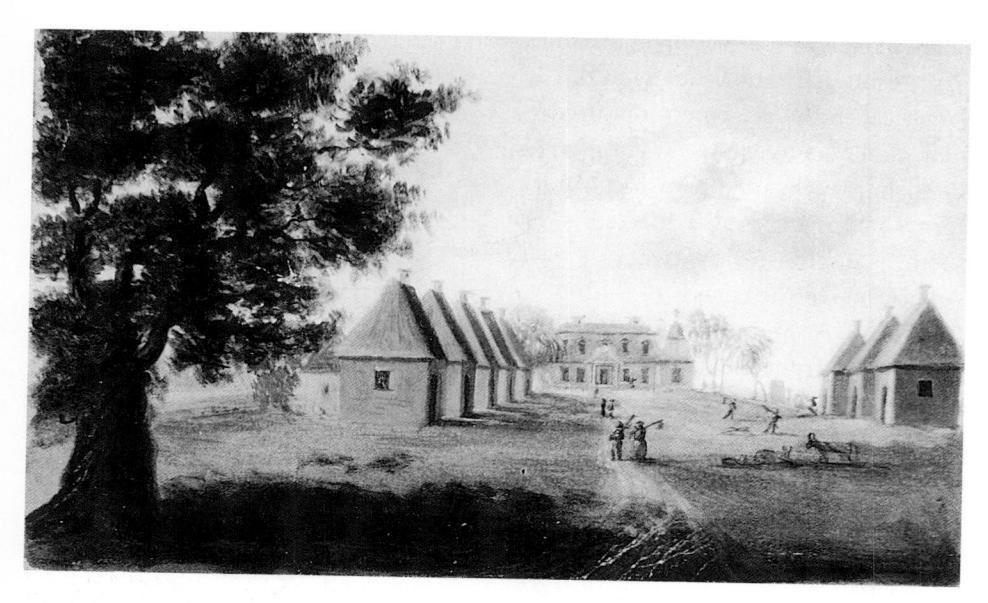

16-3. View of Mulberry (House and Street), Thomas Coram, c. 1805. Oil on paper. $4\frac{1}{16}$ x $6\frac{1}{16}$ (10. 3 x 40.8 cm). Gibbes Museum of Art, Charleston, S.C.

cooler. Also, heavy rain runs quickly off the roof rather than sitting and seeping through the thatching.

Another New World form with African roots is the Haitian *caille*, with its wattle-and-daub construction technique and thatched roofs which are found in Africa as well as in early European housing (fig. 16-4). The example shown here has a front porch and a hip-roof without gables similar

to the roof of African House at Mulberry Plantation.

These houses, with their long narrow formats and in-line rooms, eventually translated into the form known as a "shotgun" house (see fig. 16-27). Shotgun houses can be found all over the southeastern United States, mainly in black neighborhoods, although they occur elsewhere. Built with wood or bricks, shotgun houses have

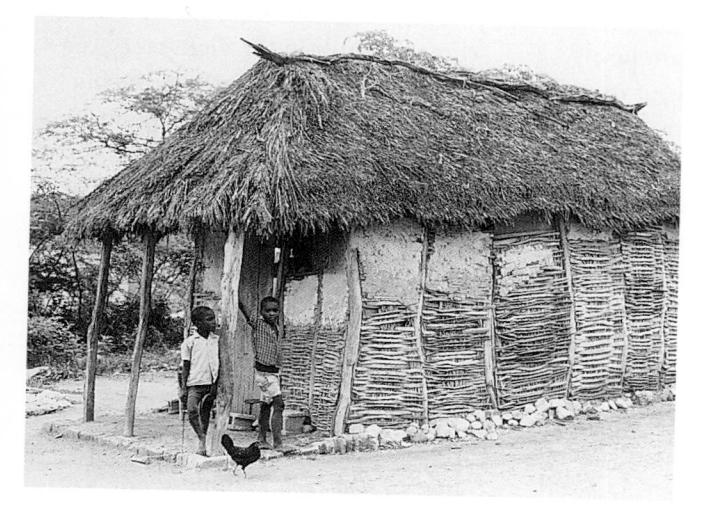

16-4. Rural *Caille,* Chancerelles, Haiti. Photograph 1973

a roof that is less steeply pitched than the African House. Most roofs are gabled, as in the example shown here. The narrow, gable side usually faces the road. John Michael Vlach, an expert on these structures, calls it an "architecture of intimacy among black people." Inside, three or more rooms are aligned consecutively, an arrangement that forces inhabitants to interact with one another Particularly fine examples of shotguns were destroyed when Hurricane Katrina flooded the neighborhoods of New Orleans where this architectural form had flourished.

Many of these art and architectural forms adapted new materials and hybrid forms, but they expressed an African cultural logic. In some cases one can find direct formal links to African expression. In other cases the continuing influence of African expressive forms reveals itself in more subtle ways. Quilts, for example, are European in origin, but African Americans adopted the craft and many have applied a different aesthetic to their design. Asymmetry and strip or string designs often mark African American quilts. Georgia native Harriet Powers (1837–1911) created an appliqué quilt evocative of the narrative appliqué banners of the Fon kings of Dahomey (fig. 16-5; see fig. 8-49). Powers drew her subjects from her own experiences, local folklore, and her deep Christian faith. The second panel from the left in the upper register refers to May 19, 1780, when stars could be seen in the daytime sky, an event so notable that it survived in local lore. The central panel in the second register depicts a meteor shower of November 13, 1833, that frightened people into

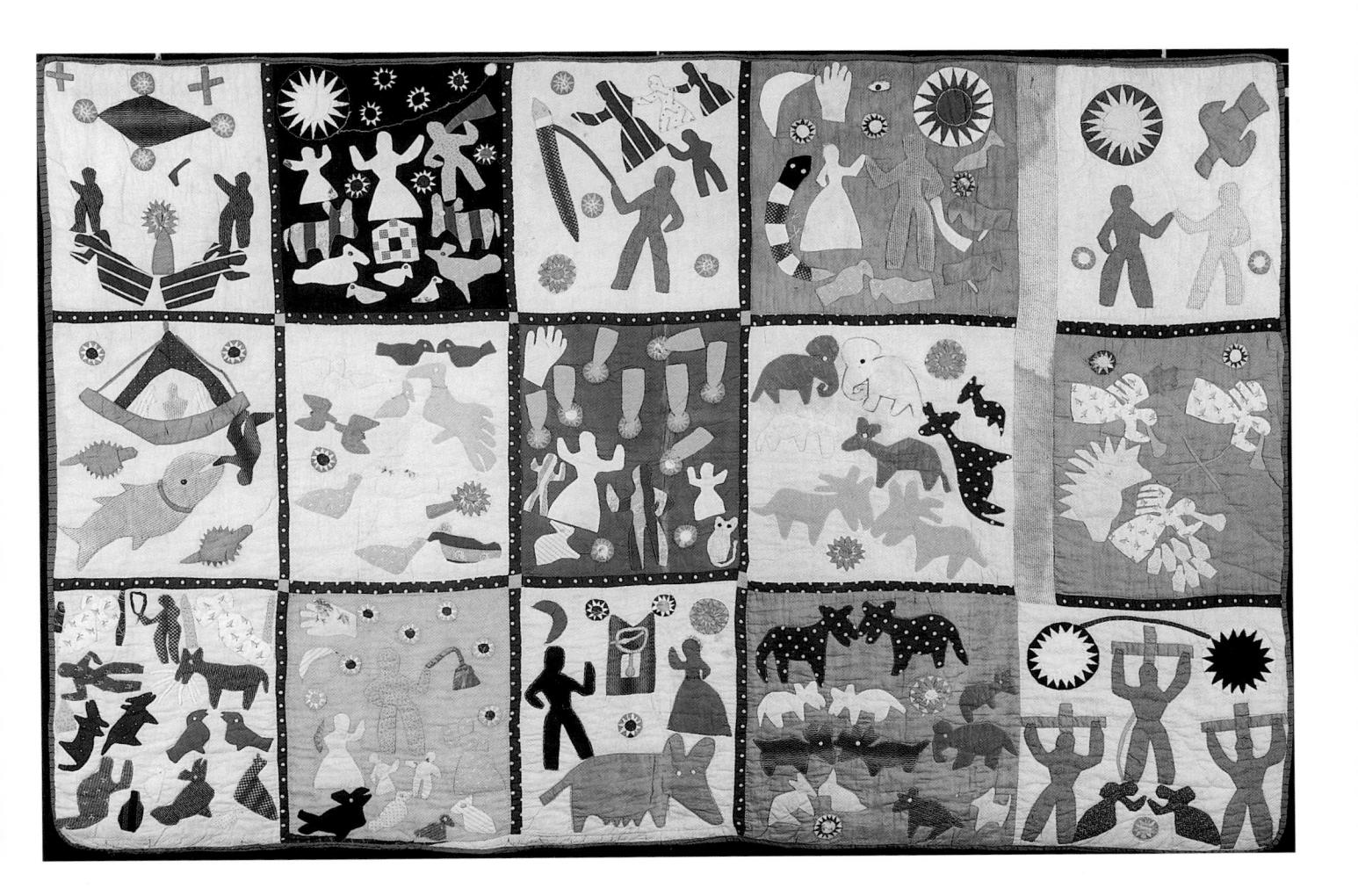

16-5. Pictorial Quilt, Harriet Powers, 1895–8. Pieced, appliquéd, printed cotton embroidered with Plain and Metallic Yarns. 5′8″″ x 8′9″ (1.75 x 2.67 m). Museum of Fine Arts, Boston. Bequest of Maxim Karolik

Several stories from the Bible are illustrated on the quilt. The central panel in the upper register depicts Moses and a serpent. The panel next to it on the right depicts Adam and Eve in the Garden of Eden. Other panels illustrate the story of Jonah and the whale, the crucifixion of Christ, and passages from the book of Revelation.

believing the end of time had come. Financial hardship eventually forced Powers and her family to sell the work, beginning the journey leading to its residence in a museum.

SPEAKING THROUGH NEW FORMS

In the late eighteenth century, a work by Scipio Morehead (whose dates are uncertain) illustrated a volume of poetry by Phyllis Wheatly, and Joshua Johnston (c. 1765–1830) began painting portraits in the Baltimore area. These African Americans were among the first on record to engage in these activities. However, during

the nineteenth century several talented African American artists developed notable art careers, creating memorable work using the forms, materials, and aesthetic traditions of European Americans.

One of the first accomplished African American painters was Robert Duncanson (1823–72), a man of mixed ancestry who resided for most of his adult life in the Cincinnati area. Duncanson exhibited the broad range of atmospheric and emotional elements in his work typical of the style of American landscape painting known as the Hudson River school. Few of his works included African American subjects. At the end

Aspects of African Cultures

Artists Working Outside the Frame

Among the slaves brought to the New World were accomplished sculptors, brasscasters, blacksmiths, architects, leatherworkers, weavers, and potters. Their skills were highly valued by their owners, and allowed some fortunate artists to earn or bargain their way to freedom. Yet the works they made were usually not signed, and we often cannot tell whether an unsigned object made in the Americas during the seventeenth and eighteenth centuries was made by a slave, a freedman, or by someone of European ancestry.

While most objects created by men and women of African birth or descent conformed to the tastes and desires of their employers, some personalized art works have survived that were evidently made for the artist's family and friends. For example, an early American figure cast of iron recalls a Bamana staff, and nineteenthcentury jugs from Georgia have faces tied in concept (if not in style) to Akan terracottas. Countless baskets, walking sticks, textiles, and household implements document skills passed from generation to generation in African American communities. Like the drum based upon Akan models (see fig. 16.2), these objects are examples of African American "folk art"—art once considered to be too inexpensive, too popular, and too useful to be regarded as "fine art."

As art academies and art institutes began to flourish in the United States, their graduates insisted that only properly educated artists could create "high art." Yet even in the late nineteenth century, collectors prized the creative vision of artists without formal academic training. Harriet Powers, for example, was admired by white patrons as well as by members of her own community. The work of sculptor

William Edmondson (c. 1870–1951), whose simple stone statues are somehow full of both insight and emotion, won unprecedented critical acclaim for a "selftaught" artist; the Museum of Modern Art in New York held an exhibition of his work in 1937. Horace Pippin (1888–1946) put brush to canvas after he returned to the United States following his military service in World War II. His paintings were purchased by Albert Barnes, who placed them in his private museum with his collection of Matisses, Picassos, Renoirs, and African sculpture.

Sometimes these independent spirits have been inspired to create because of their religious faith. This was the case for James Hampton (1909-64), a janitor in Washington, D.C., who filled his rented garage with fabulous constructions made of found objects covered with metallic foil. The twenty-seven-foot-long installation that Hampton created in response to the Biblical Book of Revelation is called The Throne of the Third Heaven of the Nations Millennium General Assembly, and is now in the National Museum of American Art of the Smithsonian Institution. Another wellknown artist inspired by Christian visions was Sister Gertrude (1900-80), whose bold paintings are covered with roughly applied brushstrokes and fragmentary texts. Religious fervour also drove the creativity of Bessie Harvey (1929-94), whose sculptural work was made using diverse materials. It has a mysterious intensity.

Perhaps the most famous of all of the diaspora's "outsider artists" was Jean-Michel Basquiat (1960–88). The son of middle-class émigrés to New York from the Caribbean, Basquiat learned to paint by covering surfaces with illegal graffiti. He roamed the streets during the 1980s, when the city was besieged by crime and graffiti was the visible face of the breakdown of civil society. Basquiat was "discovered" by

dealers and artists such as Andy Warhol, who saw the young man as exotic, sexy, dangerous—and talented. They encouraged him to paint magnificent, raw images on canvas before he succumbed to the pressures of his celebrity with a cocaine overdose. Today he is idolized by art students throughout the world, and his influence can be seen in the work of dozens of young painters from the African continent.

Gradually higher education has become more accessible to black Americans, and more art institutions are enrolling African American students. The graduates of such formal programs are able to make art that conforms to the expectations of an artistic mainstream, and (as can be seen in the works illustrated in this chapter) they often have done that very well indeed. However, talented men and women of African descent continue to make art without having been given an official certificate allowing them to do so. They may still work alone, without joining a group or cooperative. As in Africa, academically trained artists see themselves as more accomplished and sophisticated than either community-based artists ("traditional carvers" in Africa, "folk artists" in the United States), or self-taught artists ("visionary," "naïf," or "outsider" artists on both continents). After working hard to achieve their professional status, mainstream artists may resent the critical attention given to men and women who have followed their personal creative vision rather than an approved curriculum. In both Africa and the United States, formally educated artists ask an important question: do critics champion "outsider" artists because the artists produce work that is fresh, original, and compelling; or because of racist stereotypes that see African artistic creativity as spontaneous, uninhibited, and anti-intellectual? MBV

16-6. HAGAR, EDMONIA LEWIS, 1875.

MARBLE. HEIGHT 52¾" (1.33 M). NATIONAL MUSEUM OF AMERICAN ART, SMITHSONIAN INSTITUTION, WASHINGTON, D.C. GIFT OF DELTA SIGMA THETA SORORITY, INC.

of the 1820s, blackface minstrelsy emerged as a favorite form of entertainment in the United States, and it spread stereotypical ideas about plantations and blacks throughout American popular culture. These negative stereotypes combined with the dearth of black patronage and the reluctance of white patrons to pur-

chase art with central black subjects explain why African American painters tended to avoid black Americans or references to African American vernacular culture.

Edmonia Lewis (c. 1843–1909) was the first woman artist of African descent to gain prominence in the United States. Details about her life are sketchy, but she was born to African American and Native American (Ojibwa) parents. Lewis attended Oberlin College for a while before being forced to leave after a highly publicized trial in which she was accused of poisoning two of her roommates.

After leaving Oberlin, Lewis began to produce portraits of well-known abolitionists of the time, and through her art and the support of patrons she was able to travel to England, France, and Italy. She settled in Rome in 1866 and developed her academic neoclassical style there. One of her most notable works in this mode, and one of the few that survive, is Hagar (fig. 16-6). Lewis dealt with racial themes and subjects in her work more directly than most nineteenth-century artists of African descent, and Hagar illustrates how she pursued these themes with subtlety and allusion.

In the Old Testament of the Bible, Hagar is an Egyptian woman and servant (slave) to Sarah, wife of Abraham. Abraham and Sarah, unable to have a child of their own, decide the Abraham will impregnate Hagar, and she gives birth to a son, Ishmael. But when Sarah herself is able to produce an heir, she convinces Abraham to drive both Hagar and Ishmael into the wilderness to die. Here Hagar is shown in prayer as God tells her that she and her son will survive their

ordeal and prosper in a new land. As a slave forced to have sexual relations with her master and forced to watch her son being repudiated by his father, Hagar's plight was shared by many black women in the New World. Even though the Neoclassical figure of Hagar is not clearly identifiable as an African woman, the statue would have been seen in the nineteenth century as a protest again the slavery of African Americans.

In 1893, at the same time as the World's Columbian Exposition in Chicago, blacks from Africa, the Caribbean, and the United States convened the Congress on Africa, possibly the first pan-African meeting. In attendance was Henry O. Tanner (1858-1937), the most accomplished and prominent African American artist of his time. That same year, Tanner completed The Banjo Lesson (fig. 16-7), one of the few paintings of his career that depicted a scene from the life of poor African Americans. The painting joined a long list of nineteenth-century images depicting blacks as entertainers playing banjos or fiddles, including one by Tanner's former teacher at the Philadelphia Academy of Art, Thomas Eakins. However, Tanner's work differs from most of these in its humanism and in its subtle expression of African American cultural practices.

African and African American cultural patterns often were preserved and contained in musical performance and within religious rituals. The theft and distortion of African American musical performance through blackface minstrelsy caused many to associate black musicians, and the instrument most closely associated with them, the banjo, with stereotypical

16-7. The Banjo Lesson, Henry O. Tanner, American, 1893. Oil on canvas. 49 x 35½" (1.24 x 0.90 m). Hampton University Museum, Virginia

ideas and images about black people. The name "banjo" came from an African designation variously named in the Caribbean as banza (Martinique), bangil (Barbados), banshaw (St. Kitts), bonja (Jamaica), and found as bangio in South Carolina and banjou in Philadelphia as early as 1749. The name most likely was derived from the word mbanza, denoting a plucked string instrument in the language of the Mbundu people of the Kongo region. It was constructed from gourds, wood, tanned skins, and had hemp or gut strings.

The Banjo Lesson presents a tender exchange between an elder and a youth, alluding to an educational tradition of inter-generational exchange in which lore and lessons were handed down. It also suggested that the

musical skills attributed to many people of African descent as "natural" and "instinctive" were, in fact, the result of work and developed intelligence. Tanner's use of the banjo in this work was a significant act, reclaiming the banjo from stereotypical definitions.

The African legacies that contributed to African American vernacular practice had been given dignity as suitable subjects of a work of "fine art." In this highly accomplished painting, executed in a long-established European tradition of naturalism, Tanner is sensitive to nuances of light and color. Tanner developed this image from observations and photographs he made during an excursion to rural Georgia and North Carolina in 1889, a trip that sensitized him to

the lives and concerns of southern rural blacks and to their cultural expressions. Soon after completing *The Banjo Lesson* and another painting of African American life, *The Thankful Poor*, Tanner turned almost exclusively to religious subject matter for the next thirty years or so. He spent the last years of his life in Paris, where younger generations of artists were encountering African art.

The sculpture Ethiopia Awakening (fig. 16-8) by Meta Warrick Fuller (1877-1968) can be seen as an extension of Tanner's painting and Edmonia Lewis's sculpture. Fuller's work allegorically depicts a woman emerging from a deep, mummified sleep into lively animation. The lower portion of her body is still wrapped as if entombed, but the upper torso has begun turning and waking from a metaphorical sleep. The work also suggests a butterfly forcing its way out of a cocoon into a new life. Ethiopia—from an ancient Greek word meaning the land of the "sunburnt people"—was a term that embraced a variety of African peoples found in Egypt, Libya, Nubia, or Kush, down into the region of the present-day nation-state of Ethiopia. The term had long been applied to signify things African or black in American parlance—minstrel performances often were called Ethiopian operas—and Fuller uses it in this way here.

Fuller, who like many prominent African American artists of the era studied in Europe, worked in a narrative style. Her work, like that of Edmonia Lewis, suggested African themes and used Egypt as a synonym for Africa. With *Ethiopia Awakening*, however, the focus of Fuller's work

16-8. ETHIOPIA AWAKENING, META WARRICK FULLER, AMERICAN, C. 1907–14. BRONZE. HEIGHT 5'7" (1.7 M). NEW YORK PUBLIC LIBRARY, SCHOMBURG CENTER FOR RESEARCH IN BLACK CULTURE. ASTOR, LENOX, AND TILDEN FOUNDATIONS

moved toward a pan-African imagination. She linked the growing self-consciousness and self-confidence of African Americans with global trends, and her implication that racial identity was the equivalent of national identity as a means for unity in a common cause reflected the ideas of W.E.B. Du Bois (1868–1963), an eminent African American intellectual and one of the co-founders of the National Association for the Advancement of Colored People (NAACP).

RECLAIMING AFRICA

The last decade of the nineteenth century and the first several of the twentieth century witnessed a number of significant events and trends that radically affected African and African American consciousness. The 1893 Chicago Congress on Africa was followed by the formation of the African Association by Trinidadian Henry Sylvester Williams in England in 1897, and a Pan-African Congress in 1900 in England. The sacking of Benin by the British Punitive Expedition in 1897 led to thousands of finely cast and carved African art objects appearing on the market. German ethnographer Leo Frobenius stumbled upon some of the Ife heads during the first decade of the twentieth century (see chapter 8), and their naturalism challenged erroneous assumptions that African art was unintentionally abstract because of an inherent African inability to produce naturalistic work. The growing hommage to African art paid by European avant-garde artists contributed to an increased scrutiny in the West of things African and a growing appreciation of African aesthetics. In the 1920s dancer and performer Josephine Baker, a black woman from St. Louis who moved to Paris, highlighted the fascination among the French with black cultural expression. W.E.B. Du Bois helped organize several pan-African conferences beginning in

1919, and the Marcus Garvey movement energized masses of blacks in the Americas and Europe with increased interest in Africa and their links to the continent.

Image and Idea

Africa became a part of the cultural imagination of many artists in the late 1920s and 1930s. People of African descent in the United States had reached the second and third generations of the post-slavery period, and various migrations had moved many people from harsh, impoverished conditions in rural settings to the crowded urban settings of Chicago, New York, and smaller Midwestern and West Coast cities. People of the diaspora also emigrated to the United States from Caribbean communities in search of economic opportunity. In the minds of most whites the African heritage of Caribbean immigrants linked them with African Americans, and their shared experience of being black encouraged some pan-African ideas and sentiment. However, few of the artists of New World diasporan communities had actually been to Africa, and so the image and idea of Africa that inspired them, though important, was of necessity an imaginary one.

In 1925 Alain Locke published his important essay "Legacy of the Ancestral Arts" in the March issue of *Survey Graphic* magazine that he edited about Harlem, the neighborhood where most African Americans in New York lived. In this essay, reprinted later that same year in his significant book *The New Negro*, Locke implored African American artists to look to Africa for inspiration

and aesthetic ideas just as European modernists such as Picasso, Braque, and Modigliani had done during the previous two decades. He also addressed the need to overcome the visual stereotypes of the nineteenth century, which had codified a distorted view of the physical features of people of African descent. Locke's challenge to African American artists was made during a period when artists and intellectuals were approaching their African cultural heritage from a perspective of self-discovery.

Many artists and poets of the astonishing flowering of literary, musical, and artistic talent known as the Harlem Renaissance created imaginary African settings or people in their work. Like the poets of the slightly later Négritude movement of francophone West Africa and the Caribbean (see chapter 4), they explored the notion of essential African personality traits. In the United States, this translated into an idea of the Negro "soul." The poet Langston Hughes connected African Americans with the Congo, Nile, and Mississippi rivers in his famous poem "The Negro Speaks of Rivers," and Countee Cullen asked, "What is Africa to me?" in his 1925 poem "Heritage."

Congolais, by Nancy Elizabeth Prophet (1890–1960), is emblematic of this trend (fig. 16-9). Prophet studied in France and taught for a while at the all-black, all-female Spelman College in Atlanta. Perhaps Congo, like the terms Egyptian and Ethiopian, here signifies things African in general, because the hairstyle of the figure is more like that of a young Maasai from East Africa than

16-9. Congolais, Nancy Elizabeth Prophet, American, 1931. Wood. Height 17½" (43.5 cm). Whitney Museum of American Art, New York

anything worn by Central African peoples. Yet the work attempts to penetrate the facade of stereotypes that limited Western understandings of African peoples at that time: although it presents an African subject, it does not emphasize her African-ness, nor does it exoticize her. Instead, it presents her as a human being with whom one might have things in common. Her downward gaze does not confront the viewer but suggests a moment of introspection and repose. One can gain some sense of the personality of this unnamed subject, and the overall effect is of a portrait.

Lois Mailou Jones (1906–98) revisited the sense of Egypt/Ethiopia as a metaphor for an exalted African past in the black imagination with her

1932 painting The Ascent of Ethiopia (fig. 16-1). In this work she visually links contemporary African American creativity with the culture of ancient Egypt, represented by pyramids and the large profile of a pharaoh that dominates the foreground, suggesting a continuum of African achievement. Drama, music, and visual art are highlighted within concentric circles that organize and energize the composition. References to the arts emerge from behind skyscrapers just above the pharaoh's head, and each discipline is performed symbolically by black silhouettes. Art and civilization are linked graphically, mirroring the philosophical ideas of Locke, Du Bois, and other intellectuals of the period who felt that artistic and cultural achievement would help facilitate black acceptance into Western societies. The black star centered within the moon at the upper left of the image could represent Marcus Garvey's Black Star Line of ocean vessels. As a big, black-owned business, it gave hope to many blacks for economic freedom, much as the north star, almost a century earlier, served as a guiding light for slaves fleeing north from bondage via the Underground Railroad, a network of contacts that ensured safe passage.

On the West Coast, Sargent Johnson (1887–1967) explored an interest in the physiognomy of African Americans in his sculpture. "It is the pure American Negro I am concerned with," he said in a statement published in 1935, "aiming to show the natural beauty and dignity in that characteristic lip and characteristic hair, bearing and manner; and I wish to show that beauty not so

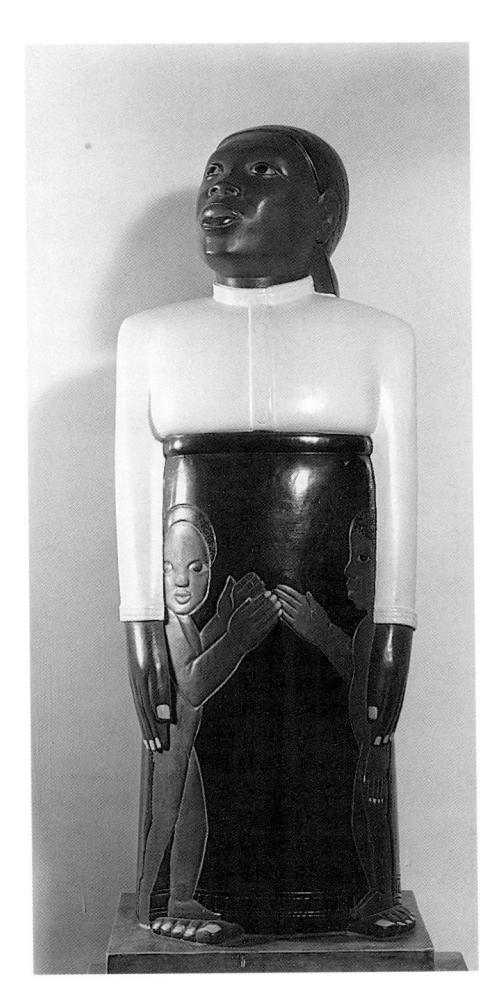

16-10. Forever Free, Sargent Claude Johnson, American, 1933. Lacquered cloth over wood. Height 36" (91.5 cm). San Francisco Museum of Modern Art. Gift of Mrs. E. D. Lederman

much to the White man as to the Negro himself." The 1933 sculpture Forever Free reveals Johnson's interest in color, form, and understated social statement (fig. 16-10). The sculpture depicts a dignified mother protecting her two children at her side. The frontality of the work, its closed form, and the stylization of and emphasis upon the head link it stylistically with some freestanding African sculpture, yet its simplified form gives it abstract qualities that

also invoke modernism and the work of Johnson's European contemporaries such as Brancusi or Henry Moore. The surface was created through techniques similar to those used by ancient Egyptian artists. It was covered with several coats of gesso on fine linen. Each coat was sanded before the next was applied, and finally the smooth surface of the statue was polished to a high luster.

Thematically, Johnson's work improvises upon an 1867 work with the same title carved in marble by Edmonia Lewis. Like Lewis's work, the subject becomes an allegorical representative of black people rather than an individual portrait. The work aggressively portrays a mother's dignity, her protective instincts, and her acceptance of the social responsibilities of motherhood. The dark skin that was so discredited by white American society, and in some ways by black Americans themselves in an intra-group conflict of light versus dark skin, here is celebrated and associated with an array of positive characteristics.

Cuban artist Wilfredo Lam (1902–82), a contemporary of Lois Maillou Jones, brought a Caribbean perspective to the leading modern artists of the century. He grew up in Cuba, the son of a Chinese father and a mother of Congo descent, and his godmother was a priestess of Lucumí, also known as Santería, a religion that developed in Cuba from Yoruba belief. He moved to Europe at age twenty, living first in Spain, then in Paris, where he came under the artistic influence of Picasso and cubism, and also of André Breton and the surrealists. In 1941, at the beginning of World War II. Lam returned to

Cuba. There he combined the diverse cultural and artistic influences of his life in works such as *The Jungle* (fig. 16-11).

Painted in 1943, The Jungle reveals Lam's use of the geometry and multiple simultaneous views of cubism, the juxtaposition of images in sometimes surprising configurations found in surrealism, and the iconography and meaning found in Afro-Cuban religious practices. Figures that combine human, animal, and vegetative elements suggest humankind's oneness with nature. Horse-headed females recur in Lam's work beginning in 1941, and while these often allude to Picasso's work, especially the horse of Picasso's anti-war mural Guernica, the figure at the far left in The Jungle refers to the important Lucumí practice of possession. In possession the devotee is said to be "mounted" by the spirit, orisha, in an exchange of divine energy and potentiality, ashé. Lam's surrealistic grafting of figures onto each other created a metaphoric intersection suggestive of the joining of the orisha with the devotee through possession. Several of the figures in this painting lift their palms upward in a gesture of offering, heightening the sense of ritual activity in the work.

The full buttocks of the figures on either side of the work suggest an awareness of a physiognomic trait often associated with women of African descent. Such concern would link Lam coincidentally to Sargent Johnson's concern with black physiognomy a decade earlier. Another artist whose work evinces a concern with positive portrayals of black physiognomy was African American Aaron Douglas, renowned for his

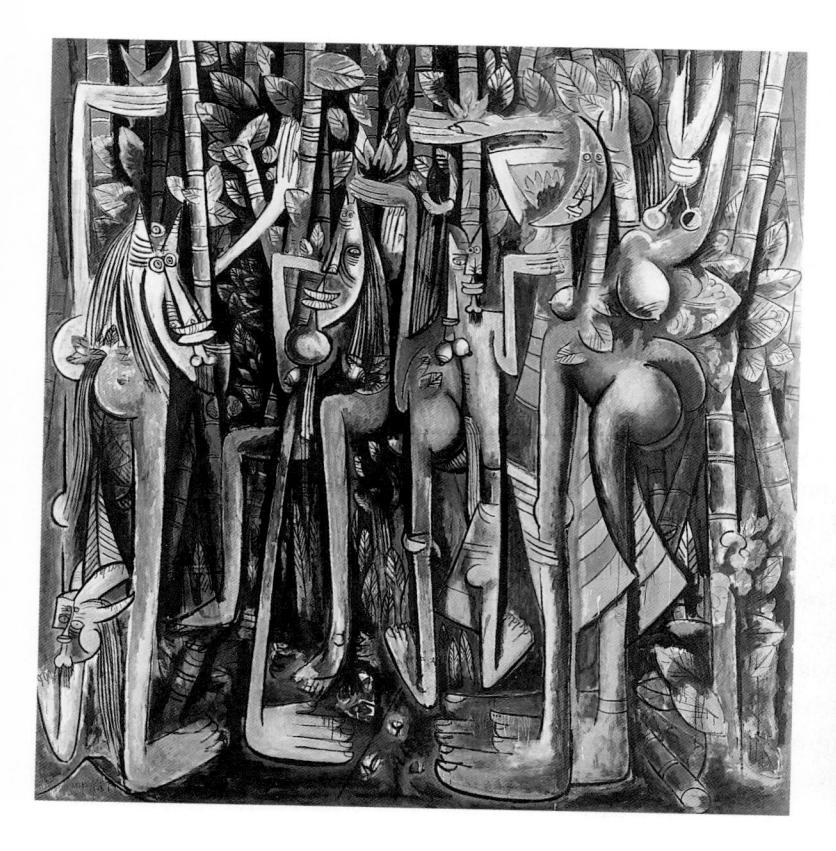

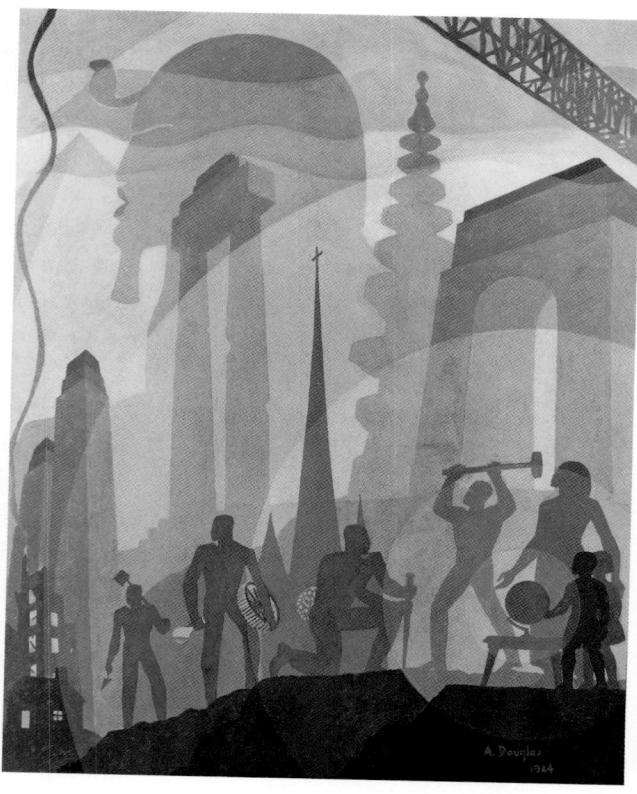

16-11. The Jungle, Wilfredo Lam, Cuban, 1943. Gouache and paper on canvas. 7'10¼" x 7'6½" (2.39 x 2.30 m). Museum of Modern Art, New York. Inter-American Fund

One figure to the left of center has a mask face, which refers at once to African art and Picasso's early work, and another to the right has a face in the shape of a crescent moon. In Santería, the moon is believed to be the wife of the sun, and a crescent-shaped new moon signals a period ripe for ritual activity.

16-12. BUILDING MORE STATELY MANSIONS, AARON DOUGLAS, AMERICAN, 1944. CARL VAN VECHTEN GALLERY OF FINE ARTS, FISK UNIVERSITY, NASHVILLE graphic images and murals. His 1944 work *Building More Stately Mansions* reiterates the idea of linking contemporary African Americans to ancient Egypt (fig. 16-12). One of many commissions executed by Douglas narrating African American achievement and history, this work articulates black contributions to the construction of modern and ancient civilizations as designers, engineers, and workers.

Douglas developed a visual shorthand in his silhouettes for the representation of a black body that was recognizable, but not stereotypical or derogatory. It seems most evident in this work with the image of the young boy touching the globe in the lower right of the frame. The globe is the center of a series of concentric circles expanding beyond the picture frame, and this geometry, along with the slight changes of value in each circle, organizes the composition in a manner superseding and complementing the verticals and diagonals of the work. A pyramid in the upper left near the silhouette of a pharaoh is echoed variously by the church steeple in the center, the ancient tower to its right, and by the perspective angle of the skyscraper below the pyramid. The work prescribes education for the recruitment of today's children as future contributors to the long history of Africans building civilizations and societies.

David Miller, Jr. (1903–77) lived and worked in Kingston, Jamaica, with his father, also an artist. Between 1940 and 1974 he carved a number of heads that explored the physiognomy of blacks. His *Head* from 1958 combines the rich, dark color of the wood with stylized African features to cre-

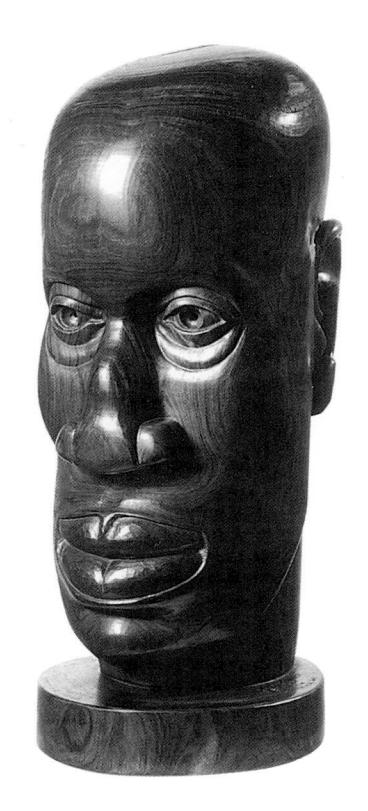

16-13. HEAD, DAVID MILLER, JR., JAMAICAN, 1958. WOOD. HEIGHT 22" (55.9 CM). NATIONAL GALLERY OF JAMAICA, KINGSTON. COURTESY OF ALLON B. MILLER

ate a powerful and sensitive work (fig. 16-13). The head has been elongated and narrowed, its protruding jaw emphasized, but the bags under the eyes and the wistful expression suggest a world weariness. The slight smile on the full lips both Africanizes the work and personalizes it, emphasizing the fullness of the lips while presenting an expression of restrained emotion that often is culturally prescribed in African art. Its naturalism and smoothness recall the bronze heads of Benin (see figs. 9-12, 9-13).

New York artist Romare Bearden (1911–88) explored a variety of techniques and themes during his career, but he is most known for his collages portraying African American life in the South and in Harlem. Bearden

became prominent as an artist during the Civil Rights era in the United States and was part of a group called Spiral. Inspired by the Civil Rights movement of Martin Luther King, Jr. and the 1963 March on Washington, Spiral organized an exhibition in 1964 called Black and White, for which each artist created a work in black and white. Despite their intention not to be overtly political, they could not help but draw attention to issues of racial relations, seen as an opposition between those of dark ("black") and light ("white") skin tones.

From Bearden's discussions with Spiral grew an interest in devising photomontage collages, including a series drawn from his experiences growing up in North Carolina. The art historian Sharon Patton writes that the series focused upon the "daily and seasonal rituals, such as planting and sowing, picking cotton, baptisms in the river, night ceremonies when one hears 'down-home' blues or jazz." A 1964 collage, The Prevalence of Ritual: Baptism, combines Bearden's interest in and study of modern art stylistic movements such as cubism, surrealism, and abstract expressionism with African and African American cultural references (fig. 16-14). The title of the work links baptism rituals in the black church with older African religious and social rituals, which is emphasized by the figure to the lower left with the face of a Kalabari Ijaw mask (see fig. 9-38), partially painted and partially collaged from photographs. Other quotations include a Baga D'Mba (see fig. 16-16), in pro-

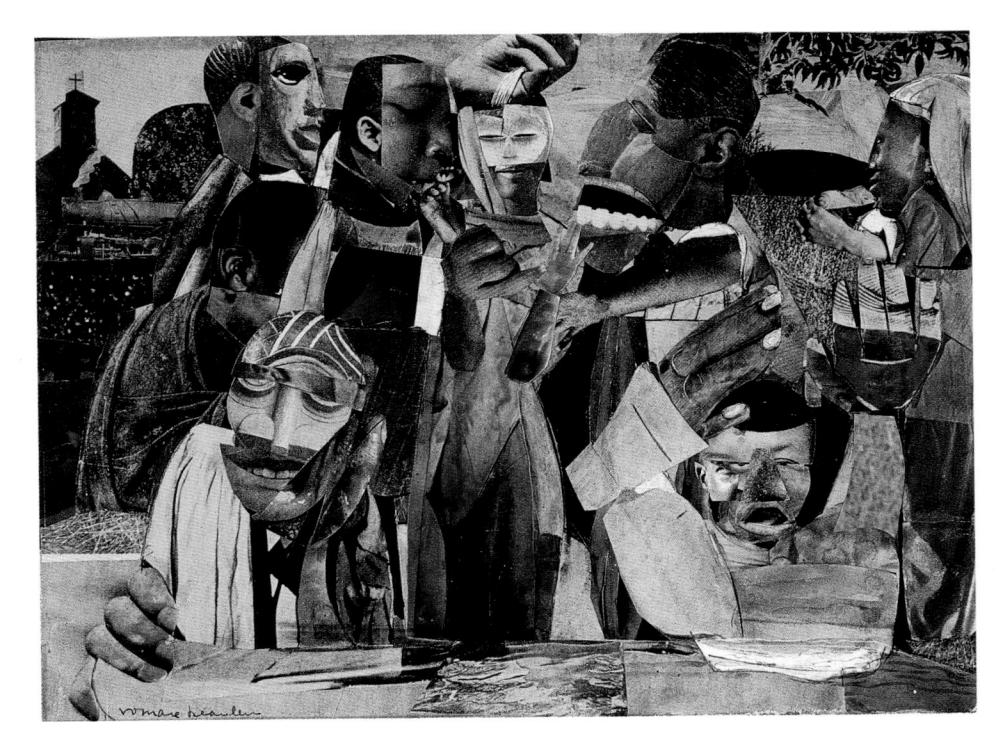

16-14. The Prevalence of Ritual: Baptism, Romare Bearden, 1964. Photomechanical reproduction, synthetic polymer, and pencil on board. 9½ x 12″ (22.9 x 30.4 cm). Hirshorn Museum and Sculpture Garden, Smithsonian Institution, Washington, D.C.

file in the upper right, and a white face in a Gabonese style (see figs. 10-38, 10.40). This juxtaposition of the old with the new speaks of the effort made by many artists in the African diaspora to reconcile their heritage with their current circumstances.

A small church appears at the upper left corner of the image behind railroad tracks and a train engine. Elements in the work suggest that this baptism is taking place down by the riverside, and the total effect is to establish a sense of place, both socially and geographically, for the participants in the ritual. The church must be in a small town or rural area to be so near a river for outdoor baptism. As in blues music, where they often serve as a symbol of longing and of the potential of renewal through relocation, trains allude to black migrations from the South. For Bearden, the train also was "a symbol for the other civilization - the white civilization and its encroachment upon the lives of blacks. The train was always something that could take you away and could also bring you to where you were." The train tracks often stood as an actual color line in southern communities dividing whites and blacks physically and socially from each other. Bearden seems to have created an image drawn from a small southern black community enacting age-old ritual to transcend time, place, and difficult conditions.

Ritual, baptism, and the train all suggest liminal points, places of transition or crossing over. The figures in the foreground dominate the picture plane in the work, suggesting human importance. Created during the height of the Civil Rights movement when racial barriers were being chal-

lenged in the United States, this work may suggest that American society appeared to be on the threshold of a significant transition in race relations. This transformation of the social order was driven by the simple, persistent religious faith of the people following the leadership of their clergy.

Hale Woodruff (1900-80) commemorated the centennial of the 1839 Amistad mutiny—a celebrated incident when Mende captives took over a slave ship off the coast of Cuba to free themselves—with a series of murals at Talladega College in Alabama. In their form and inspirational character the works show the influence of the Mexican muralists David Rivera, José Orozco, and David Siguierios, whom Woodruff had met during a Mexican sojourn. The subiect of the murals served to connect African Americans with Africans in the historical struggle for freedom. Woodruff was living in Atlanta at the time, and the year before completing the murals he also produced several works protesting the lynchings of blacks in the South. Living in the segregated South made Woodruff terribly aware of social issues concerning African Americans, but his move to New York in 1943 for a Rosenwald Fellowship gave him the freedom and resources to focus upon new aesthetic concerns.

Woodruff completed several important mural projects after moving to New York, but by the mid-1950s he had abandoned social realism in favor of abstraction. His 1969 painting *Celestial Gate* shows how he eventually turned to African design for subject matter in his later abstract work (fig. 16-15). Painted in the expressive, painterly style of abstract

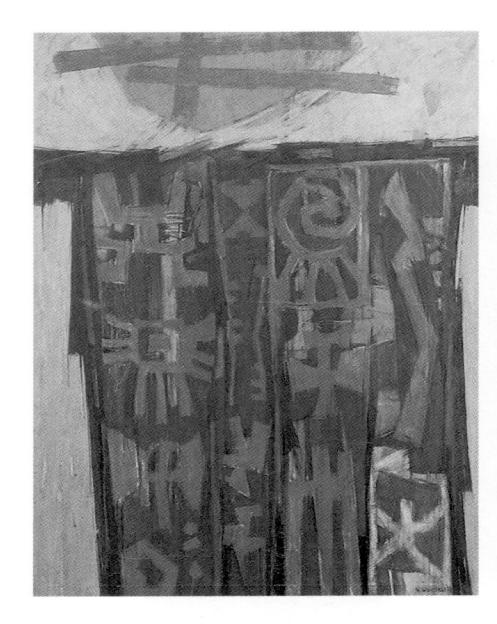

16-15. CELESTIAL GATE, HALE WOODRUFF, AMERICAN, 1969. OIL ON CANVAS. 59% X 45%" (1.51 X 1.42 M). COLLECTION OF SPELMAN COLLEGE, ATLANTA

expressionism, the work's underlying motif is a Dogon granary door decorated with images based upon Asante gold weights (see fig. 5-15; fig. 7-13). Woodruff said, "I have tried to study African art in order to assimilate it into my being, not to copy but to seek the essence of it, its spirit and quality as art." He combined elements from two different African societies to make what can be interpreted as a pan-Africanist statement calling for unity among various peoples of African descent.

Getting Behind the Mask: Transatlantic Dialogues

In the 1960s and thereafter, African artists such as Lamidi Fakeye (born 1928) travelled to the United States and taught workshops. Fakeye is a Nigerian sculptor who trained in the Yoruba tradition, and he allowed

Americans to have direct contact with an heir to the great masters of the Yoruba past. By 1971, Skunder Boghassian (1937-2003) of Ethiopia was a professor of art at Howard University, where he was a colleague of several of the prominent artists discussed here, including Lois Maillou Jones (see fig. 16-1) and Jeff Donaldson (see fig. 16-16). Dialogues joining artists of African descent in Europe, the United States, and the Caribbean helped artists all around the Atlantic basin to develop unique voices in the contemporary international art world that reflected sensibilities rooted in their cultural foundations, but often either transcended ethnic identities or rearticulated their perspectives in the formal and conceptual languages of modern and postmodern art.

Iacob Lawrence visited Nigeria in 1964, where he worked for months at Ulli and Georgina Beier's Mbari Mbayo workshop in Ibadan (see chapter 8). Though he produced an interesting series of works based upon his Nigerian experience, Lawrence was too far advanced in his career for the experience to have a radical impact on his imagery. However, during the 1960s, black nationalism, the Black Arts movement, the revitalization of pan-Africanism, and the optimism spawned by the increasing number of African nations throwing off the yoke of colonialism contributed to more aggressive explorations of African art and culture by younger African American artists, writers, and intellectuals. Many travelled to Africa for varying lengths of time, and the pan-African ideas of Kwame Nkrumah, Ghana's first leader after colonial independence, were inspirational to many in the diaspora. This kind of

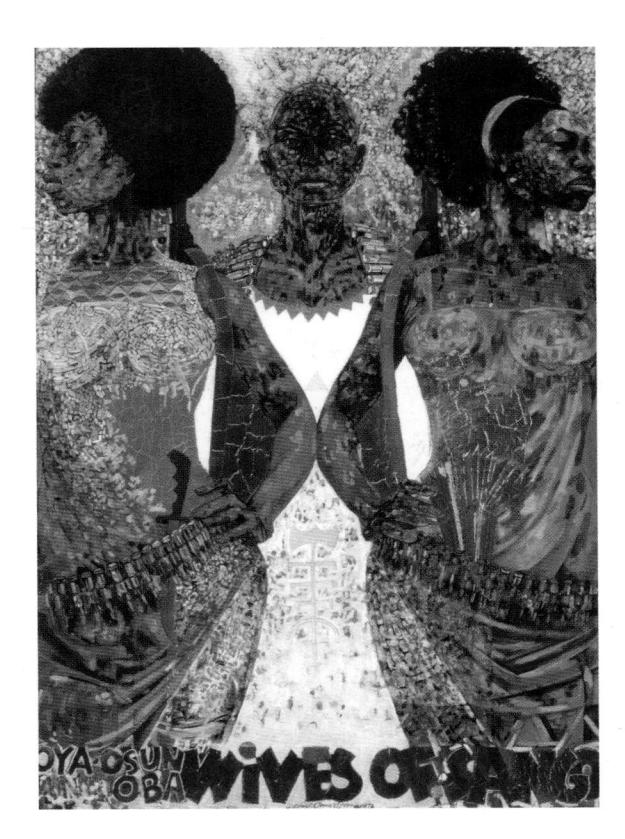

16-16. Wives of Shango, Jeff Donaldson, American, 1968. Courtesy the estate of Jeff R. Donaldson

direct experience allowed many in the African diaspora to gain a fuller understanding of African cultures, to develop relationships with people and artists living in Africa, and to confront their similarities to and differences from Africans. The romantic projections of Africa under the generic terms of Ethiopia, Egypt, or Congo gave way to more specific images. Artists began to penetrate the facade of form in African art. They began to get behind the mask.

One of the early artists to explore the ideas behind African forms was Jeff Donaldson (1932–2004), an artist who spent his formative years in Chicago, and studied the history of African art with archaeologist Frank Willett at Northwestern University. Donaldson was a founding member of the artist collective AfriCOBRA (African Commune of Bad Relevant

Artists) in 1968. Art historian and curator Tuliza Fleming has written that Donaldson's 1968 work, Wives of Shango (fig. 16-16), is one of the first to incorporate African concepts and ideas in an African American setting rather than employing narrative scenes of Africans or using masks or cloth patterns.

Wives of Shango has three African American women standing defiantly in the dress and Afro hair styles of the 1960s, and carrying belts of ammunition and rifles. They represent the Yoruba deities, Oya, Oba, and Oshun who are the consorts of Shango, the powerful *orisha* of adjudication, thunder, and justice. As Fleming writes, the three figures are "the symbolic representations of Yoruba power and strength." She indicates that this is Donaldson's first AfriCOBRA work.

In a statement formulated at the conference he organized in 1970 in Chicago, CONFABA (Conference on the Functional Aspects of Black Art), and revised in a philosophical concept he called TransAfrican art, Donaldson championed art with African cultural and aesthetic properties mediated by the specific circumstances within which the artists operated. He felt that there were shared qualities in visual expression found in Nigeria, the United States, the Caribbean, and wherever artists of African descent who celebrated and articulated their root cultures might be found. However, the particularities of their local experiences generated unique specificities. Perhaps an examples might be seen in the musical forms of reggae, blues, early jazz, highlife, samba, rhythm and blues, salsa, hip hop, calypso, and zouk; expression found all around the Atlantic basin.

Born in the Virgin Islands, Ademola Olugebefola (born 1941) was a member of a group of artists in New York called Weusi, a Swahili word meaning "blackness," which promoted the study of African culture. Olugebefola's painting Shango evokes the Yoruba deity associated with thunder (fig. 16-17). Among the Yoruba the god is represented iconographically by a double-headed axe. Olugebefola took this symbol as the primary design of his painting. but rather than reinterpreting the form of the Shango dance wand commonly seen in art collections (see fig. 8-36), he opened it up to depict the energy inside, the ashé that animates the deity.

Shango is a deified ancestor, a Yoruba king who was known for his fire and passion. He is represented by

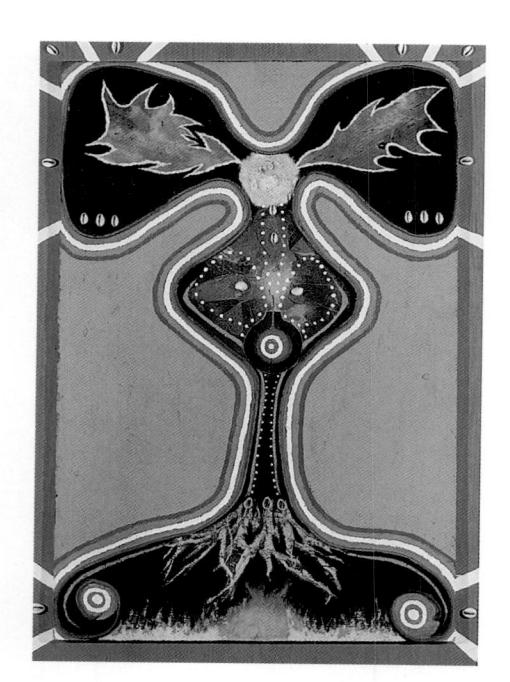

16-17. Shango, Ademola Olugebefola, American, 1969. Acrylic and mixed media on panel. $33 \times 24''$ (83.8 x 61.0 cm). Banks Enterprise. Courtesy of the artist

the exciting colors red and white, and his devotees wear beads in those colors. Olugebefola has included cowrie shells, once used as currency in West Africa, in various sections of the painting, alluding to sacrificial offerings made to deities. Cowrie shells, because of their shape, can suggest either a woman's vulva or, seen in profile, a pregnant woman. The axe form is surrounded by a rich blue field, a reminder that Shango is a deity associated with sky forces, but the lower portion of the figure shows roots reaching toward some deep subterranean fire. As with most African art, the deity is not imagined naturalistically. Instead, a series of visual signs and signifiers elucidate the concept of Shango.

After returning from Africa in the early 1970s, Charles Searles (born 1937) painted a series of works called

Nigerian Impressions, translating the experience of being in Nigeria into rhythmic, patterned compositions. One of the most notable paintings in this series is Fìlàs for Sale (fig. 16-18). Fìlàs are caps sold by Hausa traders all over Nigeria, and a pyramidal pile of them can be seen at the bottom of the image. Abstracted human figures fill the picture field, creating a sense of rhythmic movement and activity, much as they do in a Yoruba carved door. Patterns and mask-like images pack the space with vibrant colors and curvilinear shapes.

Filàs for Sale captures the sometimes overwhelming experience of an African marketplace, with vendors piling their wares in open view, people in bright clothing moving about, and the air filled with the sound of voices. The many patterns suggest the visual impact of a marketplace, but they also operate as a sort of visual equivalent for the layered polyrhythms characteristic of much African music, where drums may weave varied timbres and rhythms together in a complex tapestry of sounds. The painting's interlocking and overlapping patterns and rhythms fill the image area, leaving no sense of negative space, an idea that may be related conceptually to the approach of the adventurous jazz saxophonist John Coltrane in the early 1960s.

Yvonne Edwards Tucker (born 1941) found a sense of her spiritual self through the earth. She says that clay talks to her about "the spiritual nature of earth and our journey on it." Along with her artist husband, Curtis Tucker (1939–92), she developed a love for ceramics while she studied at the Otis Art Institute in

16-18. Fìlàs for Sale, Charles Searles, 1972. Acrylic on Canvas. 72 x 52" (1.83 x 1.32 m). Museum of The National Center of Afro-American Artists, Boston, MA

the mid-1960s. There she began to include philosophical and narrative elements in her works and to emphasize sculptural concerns over the kind of utilitarian concerns normally associated with ceramics.

In the early 1970s the Tuckers saw a demonstration by English ceramicist Michael Cardew and Nigerian potter Ladi Kwali that inspired them to change their focus from ideas and techniques derived from Chinese and Japanese ceramics to those of Africa. Yvonne Edwards Tucker traveled to West Africa in 1975, hoping to gain a fuller understanding of her African heritage and to learn more about African ceramic techniques.

Tucker's vessel *Amadlozi for Jean, Raku Spirit Vessel* (fig. 16-19) capitalizes upon certain technical innova-

16-19. Amadlozi for Jean, Raku Spirit Vessel, Yvonne Edwards Tucker, 1986. Courtesy of the artist

tions in raku firing techniques devised by her husband in conjunction with Nigerian potter Abbas Abahuwan at a summer workshop in Maine in 1974. Japanese in origin, raku is a spontaneous technique where hot pots are pulled from an open kiln with tongs and plunged into a container filled with combustible materials. Putting a lid on the container creates a reduction atmosphere, resulting in a black surface on unglazed sections of the pots and unpredictable changes and variations on glazed surfaces. The Tuckers' variation, which they call Afro-raku, first bisque-fires the pieces in an electric kiln and then raku-fires them in a gas kiln.

Tucker says that she has long had an interest in African sculpture and prefers handbuilt clay sculptural forms to functional pots thrown on a wheel. In this work, which Tucker calls a "raku spirit vessel," she improvises upon ideas of spiritual containment found in Kongo minkisi (see chapter 11) and in the African American practice of placing pieces of broken vessels and plates on the graves of loved ones. The wing-like forms of the lid suggest flight, yet they also have an abstract quality. It is a metaphorical work suggesting spiritual and ancestral ideas.

Autobiography: Water/Ancestros/
Middle Passage/Family Ghosts by
Howardena Pindell (born 1943) presents another approach (fig. 16-20).
Rooted in the ideas and techniques of contemporary American painting, it nevertheless actively acknowledges the artist's African ancestry. In this work, and in the whole Autobiography series, Pindell uses her personal multicultural heritage as a means of making larger statements. She addresses

16-20. Autobiography: Water/Ancestros/Middle Passage/Family Ghosts, Howardena Pindell, 1988. Mixed media on canvas. 9′10″ x 5′11″ (3.00 x 1.8 m). Wadsworth Atheneum, Hartford, Ct. The Ella Gallup Sumner and Mary Catlin Summer Collection Fund

Numerous images and symbols can be found throughout the painting, such as the diagram of a slave ship packed with human cargo at the lower left. Pindell says that the head of the woman in the upper center represents the African woman that genetic theory points to as the ancestor of all modern humans. Violent abuse, both physical and sexual, at the hands of slavemasters, and the social and familial upheaval and fragmentation that occurred during the slave trade is suggested by the body fragments floating throughout the painting.

the horrific Middle Passage of the Atlantic slave trade and suggests that she is a product of that experience. The work is dominated by varied tones and textures of blue that imply the ocean and perhaps suggest blues music and the process of transforming pain and pathos into art. Pindell's work expresses a political consciousness rooted in very personal interpretations and a communal identification with her African American identity. Her work does not use formal or easily recognizable African references or modes of expression. However, Pindell has described how her studies of African art led her to see parallels between the rich textures of her surfaces and the raised patterns that once covered women's bodies and were carved upon art work in central Africa (see the Luba works illustrated in chapter 12).

AFRICAN HERITAGE IN POPULAR AND RITUAL ARTS

One of the more important preservatives of culture is ritual, because its insistence on fidelity to what was done before makes it resistant to change. It is possible to hear songs in African-derived religions like Lucumí or Candomblé still performed in African languages using their original African drum rhythms in much of the Americas. Celebrations of Carnival draw upon African masquerades and performance arts. Also, as we have seen, North American practices such as placing broken pottery on gravesites exhibit African customs adapted to new settings.

While African art forms that have been retained and revived throughout the Americas are too numerous and too complex to be discussed here, several examples can demonstrate their importance to the African diaspora. Yoruba and Fon deities found in renovated form in the New World in religious and ritual settings include the ancestral spirits known as egun in Brazil (fig. 16-21). The art historian Robert Farris Thompson writes that the name "also refers to an orixa, Egun, the ancestor inquisitor, personification of the probing moral demands of the gods." Like some Yoruba egungun (see fig. 8-38), Brazilian egun costumes are made of lavered cloth. Egun are further adorned with mirrors and beads whose colors link each one with a particular deity. The red and white beads of the masquerade shown here link it to Shango.

Among the Yoruba, the cloth of the egungun costume contains and conceals the spirit within. In the same sense, the cloth of the egun mask contains the spiritual force it represents. The concept is similar to the BaKongo practice of tying to contain spiritual powers, as seen, for example, in the nkisi nkondi nail figures from Kongo (see fig. 11-1). In Brazil, strips of colored cloth are tied around items on altars, while in Salvador, Catholic worshipers tie strips around a cross to request a blessing. Since West and Central African cultural practices overlapped in Brazil, it is very likely that the qualities and meanings of cloth from different cultural practices collaged in ritual circumstances.

In Haiti, sequined flags called drapo have been employed in the service of Vodou religious worship to announce religious affiliation and spiritual militancy in devotion to

16-21. EGUN MASQUERADER, LAURO DE FREITAS, BRAZIL, 1982

The beads and mirrors of this egun costume suggest parallels with Cuban bandeles, richly beaded garments used to embellish bata drums. Cuban master drummer García Villamil claims that the mirror "reflects what will be attracted by the drum, the coming of the orisha in spirit possession, and what [the drum] has within, the powers of [the deities] Anyàn and Changó." Mirrors, in Kongo belief, represent the intersection between the physical and the spiritual worlds, a sort of spiritual incandescence. The costume is meant to be seen in performance, and when one considers that many shrines and altars are adorned with draped cloth in symbolic colors, egun also calls to mind a shrine or a ritual object in motion.

deities, lwa. Drapo may have been influenced by the appliqué banners of the Fon kings of Dahomey (see fig. 8-49). They also borrowed from the ways in which European colonial masters used flags and banners. Few examples prior to 1900 exist but a church historian recorded that during the benediction of the Cap Haitian parish church in 1840, members of Vodou societies came with drums and banners to join the celebration. The significance of *drapo* to the societies was illustrated between 1865 and 1867 when a witness to a government campaign against Vodou noted that

flags belonging to the societies were prominent among the ritual objects destroyed.

Many contemporary flags are made of satin, velvet, or rayon and are often adorned with sequins, beads, or appliqué. As embodiments of spirit they incorporate the colors and symbols of the deity. The flag shown in figure 16-22 is organized around a graphic emblem called a v eve, a ritual drawing created on the ground to evoke the lwa. The central point of the crossing lines of the veve here indicates a crossroads where the spiritual and physical worlds intersect, and

16-22. Flag for multiple LWA, Haitian. Sequins on cloth. 43½" x 35" (110 x 89 cm). Fowler Museum of Cultural History, University of California at Los Angeles

16-23. Throne-Altar for St. Lazarus/Babalú Ayé (Obaluaiye), Ramón Esquivél, American, Union City, New Jersey, 16–17 December, 1986

where the spirit arrives when invoked through ritual. Patricia Polk has written that the "scrolls, curls, and lacework patterns of the *vèvè* constitute a fundamental means of consecrating ritual space and a basic geometry for much of Voudou's sacred art." The linear star-like forms throughout the work are derived from *nsibidi* signs from Nigeria (see fig. 10-4).

The snakes depicted on this *drapo* refer to Danbala, a deity associated with water, coolness, and wisdom who is related to the Fon deity Dambalah Hwedo (see fig. 8-55). The heart forms refer to Ezili Freda, a female deity associated with love and affairs of the heart. The circular form refers to another lwa, Simbi, a water deity associated with healing. During the eighteenth and nineteenth centuries, campaigns to suppress the practice of Vodou led to strategies to maintain it behind the facade of Catholicism, so while drapo imagery can be related directly to creolized African deities, these deities may also be masked by or syncretized with a Catholic saint. Christian saints incorporated into Vodou were selected because their histories and qualities closely approximated those of a particular African deity.

When looking at a ritual conglomeration as art, one must read its components and colors—its symbolic elements—as visual statements before examining its formal aesthetic qualities. Often such complexes are constructed by specialists or experts. The *Throne-Altar for St. Lazarus/Babalú Ayé (Obaluaiye)* by Ramón Esquivél (died c. 1993) is an excellent example (fig. 16-23).

A *trono* is an altar of enthronement and initiation, and this one with

its purple satin background and central mirror has a royal formality and symmetry. Here we find evidence of African-derived religious practice that has moved from the Caribbean to the northeastern United States. Christian and African religious beliefs have been blended together through a number of symbolic elements. The sense of visual and textural splendor is created by the use of rich textiles, including the white lace forming a canopy above the altar and the gold cloth accenting the white satin covering the altar table.

The Yoruba and Fon deities who inflict and heal epidemic diseases include Obaluaiye (Babalú Ayé in Cuba); in the New World he became associated with the Catholic St. Lazarus (San Lázaro). Robert Farris Thompson writes that Obaluaive's moralizing purpose is to instill a sense of social conscience. "Obaluaiye, lame, was driven mad by persons making fun of his infirmity, whereupon he took out a broom and some sesame seeds (iyamoti) and swept the seeds into the air, charging the atmosphere with fever and epidemic. Thus he warns you not to make fun of the afflicted or of the poor, for 'little people' can exact vengeance." Obaluaiye is more than just a deity of fever and disease. He also is a god who punishes evil-doers and the insolent. According to Thompson, he is an incarnation of "moral retribution." The bowls of popcorn in the shrine refer to the seed imagery of the Obaluaive story.

Lazarus was raised from the dead by Christ, and Catholic chromolithographs show him on crutches, his body marked with signs of leprosy, the disease that killed him. He eventually became the Bishop of Marseilles and therefore has been associated with a bishop's purple robes. However, the scars on his body allowed him to be linked with smallpox and Obaluaiye's connection to epidemics.

In recent years the line between art and religious ritual has become less distinct. Artists have begun making works that approximate and improvise upon altars and ritual spaces, and functional altars and ritual settings have been incorporated into art publications and exhibitions.

Brazilian artist Eneida Assunçao Sanches (born c. 1963) believes in the orixa (African deities; pronounced "orisha") that are the focus of Candomblé, the African-derived religion of her native state of Bahia. Yet the racial distinctions that have become so rigid in the United States are not maintained overtly in Brazil, so Sanches, while experiencing African cultural practices most of her life, only as an adult came to identify herself as being black. Her art work increasingly began to explore themes and imagery derived from the black culture that pervades most of Brazil and which she took for granted.

The sculpture Jornada impressa no metal (altar de Oxossi) expresses Sanches's deep interest in earth materials such as metal and stone, as well as her experience in Candomblé (fig. 16-24). The work is a tribute to the orixa Oxossi who is a hunter deity associated with the forest. A rhythmic pattern of leaf forms dominates the upper portion of the work, evoking the practice of placing fresh leaves on the ground during the performance of Candomblé ceremonies where the orixa are honored and asked to visit believers through possession.

16-24. Jornada impressa no metal (altar de Oxossi), Eneida Assunçao Sanches, Brazilian. 1997. Courtesy of the artist

Many African art works were designed to be used in rituals, but Sanches, like many of her contemporaries elsewhere in the western hemisphere, has created a work that looks at rituals through art. The work suggests that the viewer is a participant in a ceremony. Historical and autobiographical narrative of the kind found in Howardena Pindell's work is passed over in favor of a memory and evocation of cultural practices.

Houston Conwill (born 1947) was one of the earliest artists to produce work based upon African ritual. While doing graduate study at the University of Southern California, Conwill became interested in tracing ideographic marks on the ground—joining a larger artistic trend of studying sites and nature—and preserving them in latex castings. To his fascination with the earth he added an interest in linking African histories and practices with contemporary

America. His 1978 Juju Installation, which included a ritual performance by the artist, shows the blending of these interests (fig. 16-25). The "juju" of the title is the popular term used generically for spiritual or magical practices in much of English-speaking West Africa.

Conwill spent time in the Air Force, and Juju Installation, as it has been photographed here, shows the sense of mapped or aerially photographed territory that he developed through flying. From above one can see the large circle that defines the space and encloses several smaller circles and one large rectangular form. Sand and stones form the ground (or background) of the work, which is organized visually by the rectangular piece of cloth laid across the sand. Lacking tall structures and not dependent upon walls, the work has a sense of existing in an open space that easily could be seen from above.

The two major elements in Juju Installation are the stool structure pictured to the left and the circular container opposite on the cloth to the right. The stool is a reference to the stools of authority and kingship of the Akan peoples of Ghana (see chapter 7). Metaphorically these stools embody the interests and sanctioned authority given by a community to their ruler, and they are adorned with designs and patterns full of meaning that is not readily decipherable by outsiders. Conwill has adorned his stool with ideographic marks of the kind he had been inscribing in the earth.

The item across from the stool is a gut bucket. In the African American South gut buckets were used to contain the entrails of slaughtered ani-

16-25. Juju
Installation, Houston
Conwill, 1978.
Mixed-media
Performance/
Installation. Courtesy
of the artist

mals. The term became a vernacular reference to something very basic or fundamental in black life and even came to describe a certain mode of blues music. To this one Conwill has added Kongo nkisi bags, textures, and ideographic marks both inside and outside. By including this particular item in the installation he has linked an African royal icon with the most basic and vernacular African American symbol; the new and old worlds have been connected. The bloody, gut-wrenching experience of slavery's Middle Passage has been incorporated into the lore of African peoples and made iconic in a sacred ritual space.

Some artists in the diaspora have focused their creative expression to create objects that are both utilitarian and artistic. Sonya Clark is one such artist. In several Nigerian cultures, the head is regarded as the most important part of the human body because it is the seat of thought, moral strength, spiritual presence, and personality. This outlook is the foundation for emphasis on the head in Yoruba sculpture and for the important role played by beaded crowns.

Clark has made headwear that improvises upon African crowns and

caps, and African and African American hairstyles. Many of her creations have sculptural qualities that draw attention to the head of the wearer. *Bristle Sprout* (fig. 16-26) suggests that the head is a germinating seed, and it makes references to the Yoruba *orisha* Eshu, a deity who also appears in New World religions such as Vodou, Santería, and

16-26. Bristle Sprout, Sonya Clark, 1996. Cotton, linen, copper nails, glass beads. Private Collection of Ralph Miller and Kwung Ae Bae-Miller. Courtesy of the artist

Candomblé. Eshu is a trickster deity, and a messenger who travels between earthly and spiritual realms. The conical form emerging from the cap's center is based on iconography associated with representations of Eshu, and the spikes bristling from the surface, true to Clark's Trinidadian heritage, are a bawdy reference to phallic imagery (compare fig. 8-30). For those unfamiliar with the Yoruba/Caribbean significance of Eshu, Clark has provided a playful title that is a pun on the brussels sprout, a vegetable with a cabbagelike head. Her use of inventive forms and bright colors makes this work, like all her creations, a strong statement of cultural identity.

SIX CONTEMPORARY ARTISTS

John Biggers (born 1924) was one of the first African American artists to visit West Africa, traveling to Ghana in 1957. He combined African patterns and a symbolic approach to imagery with rounded figures and spatial depth. He came to terms with his own African heritage and discovered that his experiences growing up in America had certain resonances with African life. In the later stages of his career, Biggers was able to blend his sense of both worlds in his paintings and murals.

Biggers grew up in Gastonia, North Carolina, and many of his art works draw upon his early years there. *Shotguns* is one of a series of works that pay tribute to these iconic architectural structures that are so familiar to him (fig. 16-27). He uses this architectural reference as a foundation for a further tribute to the mothers and grandmothers who sustained him and so many families of the community during harsh times.

The houses have been clustered to form a pattern that seems to be derived from Kuba cloth (see fig. 11-61), but might also suggest the geometry of a quilt. Five stylized women stand on the front porches of the work in frontal formal poses that seem similar to the stalwart mother in Johnson's Forever Free. Their poses and masklike faces link the women to African sculpture, which often is meant to be seen from the front and in which the face is often stylized or abstracted.

Railroad tracks run in front of the houses and, like Bearden's collage *The Prevalence of Ritual*, speak to racial segregation and the rail line that often divided black and white communities. Tracks also suggest the mobility offered by railroads as blacks

in the United States left the South, migrating northward and westward in several waves during the twentieth century.

Renée Stout (born 1958) grew up in Pittsburgh, and two elements from

16-27. Shotguns, John Biggers, 1987. Oil and acrylic on canvas. 48 x 72'' (1.57 x 1.82 m). Private collection. Courtesy of the artist

The flock of birds soaring upward in the upper right of the painting, according to Alvia Wardlaw, "suggests a spirituality in the community which sustains the necessary resolve for a people's continuity." Perhaps in an interesting coincidence, among the Yoruba, birds often appear in art to refer to the spiritual imperatives of women. Their appearance atop the beaded crowns of Yoruba kings, for example, shows that spiritually empowered women must sanction male authority for it to be legitimate (see figs. 8-18, 8-19).

her childhood there have rippled forward into her mature art. One was the presence in her neighborhood of a spiritualist and seer who called herself Madam Ching. Stout developed a curiosity about the woman, and subsequently about spiritualists, mystic powers, and transformative objects. The other element was a Kongo nkisi nkondi nail figure she saw in her local museum when taking Saturday art classes there (see fig. 11-11). After art studies at Carnegie Mellon University, where she became a photo-realist painter, these memories resurfaced insistently, leading her to create sculptures such as Fetish No. 2 (fig. 16-28).

Fetish No. 2 was created as a protective charm for the artist. Its title, rich in exoticism and psychological mystery, uses the term coined by Portuguese observers to describe images they believed were idols. She drew upon her knowledge of African nkisi complexes, some folk mysticism that occasionally surfaced in her family experience, and her interest in spiritual realms outside the Christian church. The work is a self-portrait, a ritual object, and a fascinating sculpture. An nkisi is created by a ritual expert, nganga, for a client and activated through rituals to become a vessel for the spirit that is called to do the client's bidding. Stout has cast herself as an artist and ritual expert creating the object, the client who has commissioned it, and the object itself. Not only has she engaged what is African in her deeper sensibilities, but she has placed herself within a concept that is African.

James Phillips (born 1945) was born in Brooklyn, grew up in Philadelphia and Virginia, but has

16-28. Fetish No. 2, Renée Stout, American, 1988. Mixed media. Height 5′3″ (1.60 m). Dallas Museum of Art. Metropolitan Life Foundation Purchase Grant. Courtesy of the artist

lived and worked in New York,
Washington, the Bay Area of
California, and Japan. His art blends
African elements with New World
expressions such as jazz and occasional Asian visual elements, an approach
that reflects an awareness of his
African heritage even as it insists
on his status as a citizen of the
modern world aware of many
cultural traditions.

Phillips's works use patterns, often improvised from Kuba cloth, symbols and imagery from various parts of Africa, and high-affect colors. His 1987 painting *Mojo* shows the complexity Phillips has developed in his

work (fig. 16-29). The central figure is a double-faced image suggesting the ability to see into two worlds. A Ghanaian *adinkra* symbol known as *gye nyame* ("fear only God") is at the summit of the central row of images and reappears several times below (for *adinkra*, see fig. 7-13). The four gun images, symbols of protection, are also of Ghanaian origin.

Egyptian symbols are sprinkled throughout the painting, including Nut, the sky goddess, who appears inside the large double-faced figure at the center. Egyptian birds, symbols of renewal or resurrection, appear on either side of the central panel at the bottom. Their presence creates a sense of transparency in the vertical zigzag lines running through them, and thereby a sense of spatial depth.

Though this work has a geometric logic in its design, a close look shows that the small rectangular areas on either side are not symmetrical. Many are slightly offset, creating an asymmetrical rhythm. These structural variations along with color and tonal changes are part of the artist's effort to make the work musical in the same sense that jazz artists John Coltrane and Charlie Parker created horn solos whose organization was fundamentally rhythmical despite the play and innovation with modes or chords.

Cuban-born artist José Bedia (born 1959) has no known African ancestry, but he grew up with an Afro-Cuban cultural and religious background. In 1976, when Bedia was a teenager, his mother took him with her during her visits to a priest of the Afro-Cuban religion known as Palo Monte. The name of the faith refers to "trees of the sacred forest," and it has Kongo

16-29. MOJO, James Phillips, American, 1987. Acrylic on Canvas. c. 9'6'' x 5'6'' (2.90 x 1.68 m). Collection of the Artist

A mojo is an art of casting spells or "working roots," or a charm or other object used for that purpose. This work addresses transformative potentials and histories rooted in African spiritual belief. Most of the symbols in the work have spiritual and cosmological meaning, or are evidence of a belief in material forms that can influence immaterial forces. The visual effect of the colors and complex patterns in the work is one of high-energy music. Perhaps Phillips was not trying to approximate the drumming used in ritual but was creating a jazz riff on the blues lyric "I got my mojo workin'."

16-30. Lembo Brazo fuerte, José Bedia, Cuban/American, 1993. Acrylic and oil stick on canvas. 6'11" x 14'2" (2.1 x 4.32 m). George Adams Gallery, New York. Courtesy of the artist began to make drawings, lots of drawings, with a deliberately down-to-earth line."

Another influence was a series of conversations and visits he had with Wilfredo Lam in 1980, while Lam was in a Cuban hospital recovering from a serious illness. Lam told Bedia to ponder the lean, spare forms of Bamana headdresses (see fig. 4-20) and this seems to have contributed to the elongated stylized figures that developed in Bedia's subsequent drawings and paintings.

A great deal of Bedia's work is built around linear graphic images. Often his canvases are shaped, as can be seen in the 1993 work *Lembo brazo fuerte* (fig. 16-30). The canvas is shaped like the lower portion of a circle or the silhouette of a pot or calabash. The background of the work is a reddish brown and the linear forms are either light yellow or white. It reads like a banner with symbols and printed text.

The art historian Judith Bettleheim indicates that in Cuban culture most things are cross-referenced and may have layered or fluid meanings, so Bedia's title and imagery for this work must be read cryptically. *Lembo*,

roots. In Haitian Vodou the two primary African sources are Dahomean Rada (which includes Yoruba ideas) and Kongo Petwo. In Cuba these two sources form two separate religions, the Dahomey/Yoruba-based Santería and Kongo-based Palo Monte.

In 1983 Bedia applied for initiation in Palo Monte. During the night of initiation Kongo cosmograms were drawn on his back in white for protection. Seven signs including crosses and parallel lines were finely cut into his chest. Bedia says, "Before my initiation, my art was essentially photographic anthropology. But after entrance into Palo I

as understood in Cuba, is a KiKongo word for "arm." Brazo fuerte means "strong arm" in Spanish, but also refers to a Palo spirit. The plant associated with this spirit is the marabú. represented in the center of the painting. The dominant image in the work is a bent arm, which doubles as a switchblade knife that is cutting a piece of the *marabú* for placement in a ritual pot. The head depicted in profile within the knife is the artist's, a signature device that appears in all his work. The metal of the knife also suggests the Rada deity of Ogou, a spirit associated with justice, or any spirit associated with metal.

The linear imagery on a flat background alludes to a system of cosmograms used in Palo Monte known as firmas, which are similar to the $v \grave{e} v \grave{e}$ of Haitian Vodou. Like a Dogon dama masquerade performance (see chapter 5), the meanings within Bedia's work become increasingly apparent the deeper one is initiated into the system behind it.

Though Bedia is not of African ancestry, the African qualities of his work point up the significance of culture in making distinctions between people and the ways they see the world. Racial definitions function very differently in the United States than in places like Cuba or Brazil where whites have practiced African religions since the nineteenth century. The creolization of various European, African, and Native American cultures have led to complex expressive forms in the Caribbean and South America and a general acceptance of fluid, layered definitions and practices. Bedia's work, like that of Wilfredo Lam and Eneida Sanches, reflects these complex mixtures. His racial heritage does not prevent him from making art of the African diaspora.

Cuban-born artist María Magdalena Campos-Pons (born 1959) moved to Boston in 1990. She was born in an old slave barracks in La Vega in Matanzas, Cuba. Matanzas province was the center of the Cuban sugar industry in the nineteenth century. Its population is mainly of African descent, and it has a rich history of resistance and communal effort. There were slave revolts there in 1825, 1835, and 1843. Some escaped and helped form maroon communities (palengues) on the northern coast, interior mountains, and southern swamplands of the province. She says that her great great grandfather was Yoruba and arrived in slavery.

In Cuba, unlike Haiti or Brazil, Yoruba and Kongo religious practices did not combine in one hybrid form. Therefore Palo Monte and Lucumí operate independently with differing rituals and practices. Campos-Pons, whose grandmother was a practitioner, grew up in the Lucumí tradition and her work provides different references than might be found in Bedia's work.

Campos-Pons does work in photography, video, installations, and mixed media, much of it connecting with her Cuban background and family, particularly the plight or experience or familial relationships of women. She does not overtly claim African connections or beliefs, but says that Africa was all around her when she grew up. African references present themselves naturally in her work with titles like Seven Powers That Came From the Sea, an installa-

16-31. THE RIGHT PROTECTION, PART OF WHEN I AM NOT HERE/ESTOY ALLA, MARIA MAGDALENA CAMPOS-PONS, CUBAN/AMERICAN, 1999. POLAROID. 34 X 22" (82 X 56 CM). COURTESY GALLERIA PACK, MILAN

tion with projected images suggesting Yoruba spirits arriving on slave ships, the colored beads associated with the Yoruba orisha found in Lucumí in Cuba, and When I Am Not Here/Estoy Alla, a series of photos dealing with the protection of the ancestors (fig. 16-31). The eyes covering the woman's back in this photograph, likely the artist's unique selfportrait, suggest a spiritual watchfulness in all directions. Interestingly, they are wide open, in contrast to the half-closed eyes one finds in many African masks and sculptures, which imply spiritual presence within the believer and an introspection looking into the spirit world rather than outward into the physical one. In this case, the implication is reversed; instead of looking inward at the spir-
it, the spirits are looking outward for temporal danger.

Willie Birch (born 1942) grew up in that most African and Caribbean city, New Orleans, surrounded by and immersed within musical and cultural traditions including jazz, rhythm and blues, jazz funerals, voodoo (or hoodoo), with its origins among the Fon peoples of Benin, Zulu parades during Mardi Gras, and the Mardi Gras Indians. Though he is welleducated, Birch creates art that is rooted in the folk traditions and music of New Orleans, a city local author Dalt Wonk says can only be understood if we recognize that the "main ingredient in the New Orleans cultural gumbo comes from Africa by way of the Caribbean."

With his sculpture, The Trickster (To Look a Fool is the Secret of a Wise Man) (fig. 16-32), Birch improvises upon the African trickster lore founded upon characters like Ghanian Ananse the spider, and the Yoruba and Fon trickster deity Eshu or Legba. In the New World these characters become Aunt Nancy, Elegba (or Elegua), Papa Legba, Dr. Buzzard, Br'er Rabbit, and the Signifyin' Monkey. Through guile and wit, tricksters overcome forces, creatures, or people more powerful than they, or they test the integrity and character of folk they encounter and challenge. The sculpture, with the boxed image at the navel, plays with the form of Kongo nkisi nkondi figures. Immediately above is an Egyptian ankh hanging from a chain as though it is a gold necklace of the kind worn by showy figures in the black community, such as preachers, pimps, musicians, and street dandies. The ankh as a form of cross has an

16-32. THE TRICKSTER: TO LOOK A FOOL IS THE SECRET OF A WISE MAN, WILLIE BIRCH, AMERICAN, 1990–2003. PAPIER-MÂCHÉ, MIXED MEDIA. 34½ X 21 X 18" (87.6 X 53 X 45.7 CM). ARTHUR ROGER GALLERY, NEW ORLEANS

oblique suggestion of the Kongo cosmogram, tendwa nza (or yowa), what Robert Farris Thompson has called a graphic articulation of the "four moments of the sun." The cosmogram centers upon a cross with circles on the end of each arm, and a circular line connecting all four arms. In the ankh, and the Kongo cosmogram, the cross implies an intersection of the spirit world and the world of men; a place of power and powerful exchanges. It is at these crossroads, liminal intersections, where one encounters Papa Legba or Eshu.

Birch has combined a sense of a charismatic figure from New Orleans, the mystical and mythical undercurrents of that city's culture, African aesthetic icons and references, and his own unique artistry. The figure has adopted a fool's visage with a paper bag hat filled with roots, red sunglasses resembling the 3-D glasses given out at quirky movie showings, and a bright colored tie as a mask to hide awareness and savvy. The man could be a fool, or a Mardi Gras character; a street performer, or a seer. The rough form of the work with its stiff posture and title lettered on the base seem to echo this theme, implicating the artist in a similar ruse of disguising his own competence and learning beneath a veneer of an untrained artist.

Many of the art practices used by the artists discussed in this chapter differ significantly from the types of art created in the African societies of their historical origins. Yet many artists in the Americas have drawn upon the residue of various African cultural practices still active in whole or in part in the communities in which they grew up. Objects from early in the period of slavery, such as the drum from the seventeenth century that opened this chapter, were not much different from their counterparts in Africa. However, as time went on in the New World, the collision of European and African cultural practices in a completely new setting led to the development of new artistic forms that suited the new context. The art of the African diaspora is a rich, diverse range of expression. The work discussed here is a sampling, not a survey, of what has been done.

Glossary

See the essays on "Aspects of African Cultures" for definitions of more terms used in cross-cultural contexts.

- abstraction A style of art in which shapes, forms, and colors do not resemble objects or living beings visible in the world around us. Purely abstract works are also called "non-representational art."
- academic Term applied to artists who have received formal training in art institutes or other schools based upon European models.
- adobe (derived from Arabic) The technique of building with sundried bricks, usually made of earth and other materials.
- Afro-Asiatic languages A family of languages found in Africa and western Asia, including Arabic, Hebrew, Berber languages, and Cushitic languages such as Hausa and Somali.
- age-grade associations Groups of men (and sometimes women) with the same social (assigned) age, who share experiences such as initiations or military service.
- **amulet** Portable object believed to convey protection upon its wearer.
- ancestor In much of Africa the term is reserved for particularly powerful individuals whose memory is kept alive through several generations. Ancestors reside in a spirit world and are thought to influence the world of the living: they can ensure the well-being and fertility of the living and punish them for breaching different ritual prohibitions.
- androgyny Either the condition of being without gender, or combining male and female features (bisexuality). Androgynous beings often appear in African creation myths.
- anthropomorphic Of human form or personality; used here to describe masquerades and other art forms depicting human-like characters.
- **appliqué** Stitching shapes cut from textile onto another fabric.
- Bantu A group of languages in the Niger-Congo family, spoken from Cameroon to Kenya and South Africa.
- baraka (Arabic) Spiritual power or blessing that may be gained from people, art objects, substances, colors, or motifs. Many Islamic practices are based upon the desire for baraka.

- bards Known as griots in French, these musicians and poets who act as praise singers and storytellers.
- barkcloth Textile made from the inner bark of certain trees. Lengths of bark are beaten to the desired thickness, and may then be bleached, dyed, embroidered, or sewn.
- batik Textiles and art forms made with the wax resist technique; wax covers the areas to be left uncolored during the dying process.
- blacksmiths Iron workers (usually male) whose female relatives are often potters. They are often members of an endogamous group, and may be the sculptors and ritual specialists of their communities.
- calabash Gourd which can be specially prepared for use as a durable, lightweight container, and may be beautifully decorated.
- camwood Red wood known also as barwood. In powdered form, camwood is used as both a dye and a cosmetic. Camwood is rubbed on sculptural forms in many areas, providing a reddish coloration.
- Chadic languages Large and varied language groups within the Afro-Asiatic family: Somali is an Eastern Chadic language and Hausa a Western Chadic language.
- chip carving A technique that involves chipping small pieces out of the surface of a piece of wood to form patterns in shallow relief.
- circumcision An operation whereby the foreskin is cut away from the penis. The operation is mandatory for Muslim and Jewish boys. It is practiced in many other contexts at puberty.
- cliterodectomy See excision.
- **cosmology** System of belief concerning the creation and nature of the universe.
- cowry (cowrie) A glossy white oval seashell with a slit-like opening, once used as both a currency and an adornment in much of Africa.
- cut-pile embroidery Cut loops of fiber which have been tightly sewn into a textile in order to create a type of velvet.
- excision/cliterodectomy An operation removing part of a girl's genitals. Some African cultures regard it as the female equivalent of circumcision.

- figurative Representational, depicting a recognizable animate or inanimate subject. Non-figurative or non-representational images are completely abstract.
- **finial** Ornamental attachment placed on top of a staff, umbrella, etc.
- headrest A supprt for the neck and head of a sleeper; once used by many African peoples instead of a pillow.
- helmet mask Headdress covering the entire head of the masquerader; a horizontal helmet mask has jaws extending forward in space, and (usually) horns projecting behind the mask.
- **iconography** The study of the meaning of images.
- initiation The ceremonial process allowing men and women to assume a new status, such as adulthood, membership in an association, or assumption of a high political office. (See Aspects of African Cultures: Rites of Passage, pages 413.)
- **kaolin** A fine-grained, white clay used in many religious contexts.
- liminal/ity The state of being "in between" in ritual contexts. (See Aspects of African Cultures: Rites of Passage, p. 413.)
- **linoleum block print** Relief print made by carving an image out of a linoleum surface, inking the linoleum and pressing it onto paper. The finished print resembles a woodcut.
- **low relief** (bas-relief) A surface with images that project only slightly into three-dimensional space; much more common in Africa than high relief (where projecting images are almost three dimensional).
- magic square A geometric shape, usually divided into equal sections, based upon the correspondence between letters and numbers in Islamic philosophies. Images containing these squares are seen as offering mystical protection to Islamic and non-Islamic owners.
- Mande languages A closely related group of Niger-Congo languages; Mande is often used to refer to the peoples (such as the Bamana and Jula) who speak them.
- Modernism Set of ideas shaping European art

during much of the twentieth century. Modernists believed in artistic progress, arguing that each new generation of inspired individuals created more challenging works. While modernists were entranced by the formal qualities of African sculpture, they had little interest in its context or meaning.

modernity Sharing the values of the modern, industrialized world. Some forms of African modernity have been national or regional, while others have been linked to popular culture in the United States. Today modernity is often associated with "globalism."

mosque A place where Muslim worshipers may pray together. The most important feature of a mosque is the qibla (the wall orienting worshipers toward Mecca). In some mosques, the qibla contains a niche, or mihrab. In the prayerhall may be a pulpit, or minbar, where a teacher or imam may preach. From a tower called a minaret, a muezzin calls the faithful to prayer.

naturalism A style of art in which shapes, forms and colors closely resemble objects or living beings visible in the world around us.

negative relief An image cut into a flat surface so that it is lower than the surrounding background.

Niger-Congo languages An important family of languages which includes the Bantu languages and most language groups spoken in West Africa.

Nilo-Saharan languages A diverse language family which includes languages spoken by the Kanuri, the Maasai, and the people of ancient Nubia.

nkisi (pl. minkisi, Congo Basin) Often glossed as "sacred medicine," the term designates any number of objects thought to contain spiritual power. This power is tapped for purposes of divination, healing, and protection from evil and is used to ensure success in hunting, trade, sex, warfare, etc.

nsibidi An ideographic form of writing developed along the Cross River region of modern Nigeria.

open-work A sculpture that achieves its effect by obstructing the passage of light. The term is

generally applied to such ornamental items as window frames, railings, and balustrades.

painting Both the process and the product of mixing pigment (such as a colored mineral or a vegetable dye) with a binder (such as oil, glue, egg yolk, milk, or blood) and applying this paint to a support, or surface (such as paper, cloth, stone, adobe, or human skin).

pastoralist Person who herds cattle or sheep and thus leads a semi-nomadic existence. In Africa, pastoralists are often known for their spectacular adornment.

patina The surface texture an object acquired from years of use.

polychrome Multi-colored; an object of a single color is monochrome.

positive form The shapes and images perceived as primary by the eye; the background or surrounding space is negative form.

post-colonial When former European colonies in Africa became self-governing nations, they entered a "post-independence" period. Today, however, African regions are discussed in terms of "pre-colonial," "colonial," or "post-colonial" histories.

post-modernism A series of European and American cultural ideas questioning the values of "modernism." Most were influenced by European writers known as "post-structuralists." Artists working in a "post-modernist" context tend to create multimedia performances, installations, and computer-generated works rather than painting, and they engage in a "discourse" rather than creating works of formal beauty.

raffia cloth Fabric made from the fronds of the raffia palm.

rock art Generic term for images painted or engraved on rock faces.

sacred kingship The practice of associating a ruler with a deity, or regarding him or her as a spiritually potent being. In many cases, the welfare of the state is linked to the health and prosperity of the ruler.

second burial A celebration held months, sometimes years, after a prominent person's internment. The ceremony is an occasion for vast expenditure and affirms the status of the deceased in both this and the other world.

soapstone An opaque rock which is soft when first exposed to air and therefore relatively easy to carve.

sorcery The manipulation of invisible powers. In many regions of Africa, the term "sorcery" is a rough translation for the good or evil forces said to be employed by rulers and other leaders for the protection of the community. Soldiers, hunters, masqueraders, and diviners may also be seen as sorcerers. Certain technical skills are also linked to sorcery, including those needed to forge iron, to cast silver and gold ornaments, or to fire ceramics.

terracotta (Italian for "baked earth") Object, often a figure, made of fired clay.

tourist art Art objects made for sale to outsiders rather than for local use.

vodun (Fon) Supernatural powers that can be honored and petitioned as specific deities. Similar words refer to religious practices in the Americas which are based in part upon the worship of vodun in Africa.

wilderness In much of Africa, people operate a clear distinction between the civilized world of the village, town, or camp, and the wilderness, which is associated with a variety of powerful and dangerous spirits.

witchcraft While some African terms may be translated as either "witchcraft" or "sorcery," English-speakers may use the word "witchcraft" to describe either protective spiritual forces of the anti-social misuse of supernatural powers. In some regions, men and women accused of witchcraft are charged with harming their own relatives by mystically (and sometimes unwillingly) "eating" their bodies. Many African shrines, sculptural groups, and masquerades have been created in order to combat witchcraft and rehabilitate witches.

zoomorphic Of animal form or character; used here to describe masquerades and other art forms depicting animal-like characteristics.

Annotated Bibliography

Abbreviations of Periodicals
AA African Arts
Art J Art Journal

GENERAL

Very few texts survey the art history of the entire African continent from the ancient past through the modern era. One exception is a short but useful book by J. Perani and F. Smith, The Visual Arts of Africa: Gender, Power and Life-Cycle Rituals (1997), which omits only the Maghreb. F. Willett's African Art (London, 1971), still a fine introduction to the study of African art south of the Sahara, features archaeological artifacts and a full range of art produced in the mid-twentieth century. P. Garlake's The Early Art and Architecture of Africa (Oxford, 2002), omits Egypt but provides a valuable supplement to the information on other past civilizations discussed in this text. Africa: The Art of a Continent (Munich, 1996), which includes works from North Africa and the Nile Valley, is an impressive resource but includes no modern and no contemporary art. Another lavishly illustrated survey of art objects created before the modern era, Art of Africa, by J. Kerchache, J.-L. Paudrat, and L. Stephan (Paris, 1988, New York, 1993), emphasizes sculpture. Several other surveys of Western and Central African art, such as J.-B. Bacquart's The Tribal Arts of Africa (London, 1998), closely follow a tradition established by early twentieth-century connoisseurs. They present African objects as isolated objects, and categorize them by their cultural ("tribal") style. Although such an approach is orderly and accessible, it ignores the complexity of ethnicity and art production in Africa. In contrast, many excellent exhibition catalogs feature scholarly essays on the meaning and the cultural context of specific West African and Central African art objects in museum collections. Some of the best include F. Lamp's See the Music, Hear the Dance: Rethinking African Art at the Baltimore Museum of Art (Munich, 2004), P. McClusky's Art from Africa; Long Steps Never Broke a Back (Seattle 2002), J. Mack's Africa: Arts and Cultures (Oxford, 2000), and S. Vogel's For Spirits and Kings (New York, 1981). A particularly important resource is provided by the CD-ROM Art and Life in Africa (1996–1998), edited by C. Roy, which includes field photographs, video segments, and text related to African objects in the collection of the University

Many more museum catalogues are thematic studies of African art. References to recent exhibitions and their catalogues may be found on the websites of the museums themselves, especially those of the Musée du Quai Branly in Paris; the Metropolitan Museum of Art and the Museum for African Art (previously the Center for African Art) in New York City; the Fowler Museum of the University of California in Los Angeles; and the National Museum of African Art in Washington, D.C.

Much of the material on contemporary African artists for the first edition of this book was provided by S. Vogel's groundbreaking exhibition catalogue Africa Explores (New York, 1991), and its discussions have continued to inform this edition as well. S. L. Kasfir's, Contemporary African Art (London, 2000) has also been a useful source of ideas. Although Whitechapel Art Gallery's Seven Stories about Modern Art in Africa (Paris, 1995) is focused upon only seven African nations, it contains valuable information on art institutions and art histories throughout Africa. Both O. Enwezor's The Short Century. Independence and Liberation Movements in Africa, 1945-1994 (New York, 2001) and J. Kennedy's New Currents, Ancient Rivers: Contemporary African Art in a Generation of Change (Washington, D.C., 1992) were useful in reconstructing histories of twentieth century artists. N. Fall and J.-L. Pivin's An Anthology of African Art: The Twentieth Century (New York, 2001) contains a broad range of essays and is now the most complete single source of information about modern art in twentieth-century Africa.

PREFACE

R. Sieber's comment on understanding African art is from his "The Aesthetics of Traditional African Art," in Art and Aesthetics in Primitive Societies, ed. C. F. Jopling (New York, 1971): 127. For the translation of Yoruba names see N. Akinnaso, "Yoruba Traditional Names and the Transmission of Cultural Knowledge," Names: Journal of American Name Society 31:3 (1983): 148. The collector's comment on the anonymity of African art is quoted from S. Price, Primitive Art in Civilized Places (Chicago, 1989): 103. For Olowe's oriki see R. Walker, "Anonymous has a Name: Olowe of Ise," in The Yoruba Artist: New Theoretical Perspectives on African Art, ed. R. Abiodun, H. J. Drewal, and I. Pemberton III (Washington, 1994): 100–102; copyright © 1994 by the Smithsonian Institution. Used by permission of the publisher. The Yoruba saying is from O. Owomoyela, The Wit and Humor of the Ages: A Treasury of Yoruba Proverbs (forthcoming). G. Blocker's quotation is taken from his "The Role of Creativity in Traditional African Art," Second Order: An African Journal of Philosophy 2:1-2 (1982): 12. See also R. Abiodun, "A Reconstruction of the Function of Ako. Second Burial Effigy in Owo,' Africa: Journal of the International African Institute 46:1 (1976): 4-20; "Verbal and Visual Metaphors: Mythical Allusions in the Yoruba Ritualistic Art of Ori," Word and Image: A Journal of Verbal/Visual Enquiry 3:3 (1987): 252-70; and "What follows Six is more than Seven": Understanding African Art (London, 1995).

INTRODUCTION

For further discussion of the European reception of African art, see S. P. Blier, "Enduring Myths of African Art," in Africa: The Art of a Continent: 100 Works of Beauty and Power: 26-32; "Imaging Otherness in Ivory: African Images of the Portuguese circa 1492," The Art Bulletin 75:3 (1993): 383-6; and "Art Systems and Semiotics: The Question of Art, Craft, and Colonial Taxonomies in Africa," American Journal of Semiotics 6:1 (1988-9): 7–18. Anthropomorphism in architecture is explored in Blier, "The Anatomy of Architecture: Ontology and Metaphor," in Batammaliba Architectural Expression (New York, 1987). Innovation in royal art forms is discussed in S. Blier, The Royal Arts of Africa: The Majesty of Form (UK title: Royal Arts of Africa) (New York/London, 1998). The art of the Fon is the subject of Blier, African Vodun: Art, Psychology, and Power (Chicago, 1995).

CHAPTER 1

Archaeological evidence for dating art of the central Sahara may be found in F. Mori, Tadrart Acacus, Arte rupestre e culture del Sahara preistorico (Turin, 1965), and in B. Barich, Archaeology and Environment in the Libyan Sahara: The Excavations in the Tadrart Acacus 1978-1983, Cambridge Monographs in African Archaeology 23/BAR International Series 388 (1987). For a different chronology, see A. Muzzolini's entry in UNESCO General History of Africa, ed. G. Mokhtar, vol. 1 (Berkeley, 1990). Information on the ancient Berbers was taken from G. Camps, Berberes. Aux marges de l'histoire (Paris, 1980), and Die Numider. Reiter und Koenige noerdlich der Sahara, ed. H. G. Horn and C. B. Rueger (Bonn, 1979). Photographs of Berber communities (including the Kabylie interior) may be found in M. Courtney-Clark and G. Brooks, Imazighen. The Vanishing Traditions of Berber Women (New York, 1996). The photograph of the woman from Sous was taken by J. Besancenot, whose Costumes of Morocco (London, 1990) was a useful source. Quotations from Ibn Battuta were taken from the translation by S. Hamdun and N. King, Ibn Battuta in Black Africa (London, 1975). Diagrams of Moroccan tigermatin were taken from J. A. Adam, Wohn- und Siedlungsformen im Sueden Marokkos (Munich, 1981). For interpretations of the murals at Walata see J. Gabus, Au Sahara. Vol II: Arts et symboles (Neuchatel, 1958). J. Schacht, "Sur la diffusion des formes d'architecture religieuse musulmane à travers le Sahara," in Travaux de l'Institut de recherches sahariennes XI (Algiers, 1954): 11-27, discusses links between the Saharan oases and the inland Niger delta. Information on twentieth-century artists of the Maghreb was provided by exhibition catalogues published by the ADEIAO, and the

Institut du Monde Arabe, in Paris. Chaibia Tallal is featured in B. LaDuke, Africa through the Eyes of Women Artists (Trenton, 1991), and J. Gastelli's photographs appeared in In/sight: African Photographers, 1940 to the Present (New York,

There appear to be no reliable and up-to-date surveys of Saharan rock art in English as of this writing. The best general source of images and information is in German: K. H. Streidter, Felsbilder der Sahara (Munich, 1984). Beautiful photographs of art from Tassili are available in J.-D. Lajoux, The Rock Paintings of Tassili (London, 1963). D. Coulson and A. Campbell, African Rock Art: Paintings and Engravings on Stone (New York, 2001) also provides fine photographs of Saharan images. P. MacKendrick, The North African Stones Speak (Chapel Hill, 1980), surveys the history of the region from the ninth century BC to the sixth century AD, and includes some illustrations. M. Brett and E. Fentress, The Berbers (London, 1996), illustrate and describe Berber art from this period while providing information on the cultural background of more recent arts; this source updates E. Westermarck, Ritual and Belief in Morocco (London, 1926). From Hannibal to Augustine (Richmond, 1995) features the art of ancient Carthage. There are many excellent surveys of Islamic architecture which cover a wide variety of African and non-African religious and domestic buildings. One of the most inclusive is Architecture of the Islamic World. Its History and Social Meaning, ed. G. Michell (London, 1978), while Maghreb Medieval, L'Apopée de la civilization islamique dans l'occident arabe, ed. F. Gabrieli (Aixen-Provence, 1991), illustrates buildings from the Maghreb and the northern Sahara. Fine photographs of Berber sites may also be found in J.-L. Bourgeois and C. Pelos, Spectacular Vernacular. The Adobe Tradition (New York, 1989), and in N. Carver Jr., North African Villages. Morocco, Algeria, Tunisia (Kalamazoo, n.d.). J. d'Ucel, Berber Art: An Introduction (Norman OK, 1932), is still useful for its illustrations, and M. Courtney-Clark and G. Brooks, Imazighen. The Vanishing Traditions of Berber Women (New York, 1996) is a beautiful introduction to modern Berber arts . A good recent analysis of the art forms of a specific Berber region can be found in C. Becker's Amazigh Arts in Morocco. Women Shaping Berber Identity (Austin, 2006). African Nomadic Architecture, ed. L. Prussin (Washington, 1995), is an excellent source on Saharan tents, while C. Spring, North African Textiles (Washington, 1995), surveys weaving from Morocco to Ethiopia. Art of Being Tuareg: Sahara Nomads in a Modern World, ed.T. K.Seligman and K. Longhran (Los Angeles, 2006) is the most recent survey of the arts of the Inaden. Dozens of artists from the Maghreb are covered in "Afrique mediterranéenne. Afrique noire," Revue noire 12 (March-April-May, 1994. Le Maroc en Mouvement: créations contemporaines (Paris and Casablanca, 2000) is a good source of information on artists in Morocco, but published surveys of contemporary art in Algeria, Tunisia, and Libya remain scarce. The author is grateful to Labelle Prussin for her comments, and to Jean Polet for advice on archaeological material presented throughout this chapter. Barbara Blackmun patiently read several drafts of many chapters, including this one.

ASPECTS OF AFRICAN CULTURES: PERSONAL ADORNMENT Although some of the images in A. Fisher, Africa Adorned (New York 1984) have been criticized because they have been carefully staged for the camera, its photographs (and others published by A.

Fisher and C. Beckwith) celebrate the sumptuous and varied forms of African body arts and performance.

CHAPTER 2

The line from "The Negro Speaks of Rivers" is from Collected Poems by Langston Hughes. © 1994 by the Estate of Langston Hughes. Reprinted by permission of Alfred A. Knopf, a Division of Random House Inc. For information on pre-Islamic Nubian art see Africa in Antiquity, vol. 2, ed. S. Wenig (New York, 1978). The first effort to discuss the art of Kemet as African art is in Egypt in Africa, ed. T. Celenko (Indianapolis, 1996). Many recent sources on the art of Kemet approach this rich material in new ways. A challenging set of questions concerning the Narmer Palette is raised by W. Davis, Masking the Blow (Berkeley, 1992). Contemporary scholarship informs E. Hornung, Idea into Image. Essays on Ancient Egyptian Thought (trans. E. Bredeck; New Jersey, 1992), while a summary of current art historical research is given by R. S. Bianchi, "Ancient Egyptian Reliefs, Statuary and Monumental Paintings," in Civilizations of the Ancient Near East, IV, ed. J. Sasson (New York): 1533-54. The possibility that Akhenaten and other kings wished to be depicted as bisexual is raised by A. Kozloff and B. Bryan, Egypt's Dazzling Sun: Amenhotep III and his World (Cleveland, 1992), but the sexual implications of funerary paintings from Waset are more fully explained in G. Robins, Women in Ancient Egypt (London, 1993). For the cosmology of temple architecture see S. Quirke, Ancient Egyptian Religion (London, 1992). Ancient names for the cities of Kemet and dates of dynasties were taken from J. Baines and J. Malek, Atlas of Ancient Egypt (Oxford, 1980). Plans of the palaces at Aksum are from Axum, ed. Y. M. Kobishchanov and J. W. Michels (trans. L. T. Kapitanoff; University Park, 1979). Most information on the art history of the Ethiopian highlands comes from M. Heldman, African Zion. The Sacred Art of Ethiopia (New Haven, 1993). The art and life of the Egyptian Nubians displaced by the Aswan Dam are discussed in Georg Gerster, Nubians in Egypt. Peaceful People (Austin, 1973), and the former homes of the Sudanese Nubians are also illustrated in M. Wenzel, House Decoration in Nubia (London, 1972). Healing scrolls which inspired the work of Gera are described in J. Mercier and H. Marchaudi, Le roi Salomon et les maîtres du regard: Art et medecine en Ethiopie (Paris, 1992). The career of Hassan Fathy is the subject of many publications, including J. Steele, Hassan Fathy (London, 1988).

An excellent introduction to the art of Kemet is G. Robins, The Art of Ancient Egypt (London, 1997). Also highly recommended are R. H. Wilkinson, Reading Egyptian Art. A Hieroglyphic Guide to Ancient Egyptian Painting and Sculpture (New York/London, 1992), and his Symbol and Magic in Egyptian Art (New York/London, 1994). A. Badawy, The Art of the Christian Egyptians from the Late Antique to the Middle Ages (Boston, 1978), is a basic reference for Coptic art. The important role played by Egypt in the development of Islamic art in North Africa and Asia is discussed in R. Ettinghausen and O. Grabar, The Art and Architecture of Islam 650-1250 (London, 1989), and in J. Bloom and S. S. Blair, The Art and Architecture of Islam 1250-1850 (London, 1994). D. O'Connor, Art of Nubia (Philadelphia, 1993) is an excellent concise survey of ancient art from this region. J. Kennedy, New Currents, Ancient Rivers (Washington, D.C., 1992), and Seven Stories about Modern Art in Africa (London/Paris, 1996) discuss several generations of artists from Sudan and Ethiopia. An excellent survey of twentieth-century art in Egypt is provided in L. Karnouk, Modern Egyptian Art 1910-2003 (Cairo, 2005).

The author wishes to thank Gay Robins for her generous and detailed critique of the sections on ancient Egypt. Achameyeleh Debela and Marilyn Heldman have patiently assisted the author with portions of this chapter that introduce Ethiopia.

ASPECTS OF AFRICAN CULTURES: TECHNIQUES FOR DATING AFRICAN ART Marc Rasmussen generously provided information on several types of analysis for portions of this essay.

Y. I. Bityong, "Culture Nok, Nigeria," in Vallées du Niger (Paris, 1993): 393-415, provided recent data on Nok terracottas. Bernard de Grunne claims an ancient origin for many recently collected Nok works in The Birth of Art in Black Africa: Nok Statuary in Nigeria (Paris, 1998), but the processes used by Europeans to create these "pastiches" are revealed in G. Chesi and G. Merzder, eds, Nok culture: Art in Nigeria 2,500 Years Ago (Munich, 2006). B. Gado reports on his excavation of the Asinda-Sikka site and the Bura terracottas in "'Un village des morts' à Bura en Republique du Niger. Un site methodiquement fouillé fournit d'irremplacables informations," Vallées du Niger (Paris, 1993): 365–74. Information on terracottas from the region south of Lake Chad was taken from G. Connah, Three Thousand Years in Africa: Man and his Environment in the Lake Chad Region of Nigeria (Cambridge, 1981), from J.-P. and A. Lebeuf, La civilization du Tchad (Paris, 1950), which is quite explicit about the excavators' initial unfamiliarity with archaeological methods, and from J.-P. and A. Lebeuf, Les arts des Sao. Cameroun, Tchad, Nigeria (Paris, 1977), which summarizes the authors' discoveries. Drawings of Ga'anda scarification are found in M. Berns, "Ga'anda Scarification: A Model for Art and Identity," in Marks of Civilization (Los Angeles, 1988): 57-76. Drawings and descriptions of Musgum houses come from O. MacLeod, Chiefs and Cities of Central Africa (Edinburgh, 1912), and information on the Jukun is based upon the dissertation of A. Rubin, The Arts of the Jukun-Speaking Peoples of Northern Nigeria (Bloomington, 1969). The description of Mumuye memorial ceremonies is based upon A. Rubin, "A Mumuye Mask," in I am not myself: The Art of African Masquerade (Los Angeles, 1985): 98-9. Photographs of Mambila art are reproduced in P. Gebauer, Art of Cameroon (Portland, 1979). Suaga is described by D. Zeitlyn, "Mambila Figurines and Masquerades: Problems of Interpretation," AA 3 (autumn 1994): 38-47, 94. Little information exists for the art of the Kanuri; the source consulted here was G. Nachtigal, Sahara und Sudan, 3 vols. (1879-89; trans. A. and H. Fisher, 1971). Malam Salif Nohu was quoted by S. Hassan in Art and Islamic Literacy among the Hausa of Northern Nigeria (Lewiston, 1992), the source of information on Hausa writing boards. Drawings of Fulani calabashes are from T. J. H. Chappel, Decorated Gourds in North-Eastern Nigeria (London, 1977), and analysis of a Fulani khasa is taken from P. S. Gilfoy, Patterns of Life. West African Strip-Weaving Traditions (Washington, D.C, 1967); the cultural background of the arkilla was described in an unpublished seminar paper by Rachel Hoffmann. Kodjo Fosso's work has been presented in several different catalogues, but this photograph appeared in S. Njami, Africa Remix (London, 2004).

Some information on the sculpture and masquerades of the central Sudan can be found in two brief catalogues: R. Sieber, Sculpture of Northern Nigeria

(New York, 1961); R. Sieber and T. Vevers, Interaction: The Art Styles of the Benue River Valley and East Nigeria (Lafayette, 1974). R. Fardon, Between God, the Dead and the Wild. Chamba Interpretations of Religion and Ritual (Washington, 1990), is an insightful study of one cultural area. Other excellent studies that focused upon a single region or specific art forms are M. Berns and B. R. Hudson, The Essential Gourd. Art and History in Northern Nigeria (Los Angeles, 1986), and M. Berns, "Ceramic Clues: Art History in the Gongola Valley," AA 22:2 (1989): 48-59, 102-103. A. Bassing, "Grave Monuments of the Dakakari," AA 6:4 (1977): 36-9, is the best source of information on Dakakari memorial figures. D. Heathcote, The Arts of the Hausa. An Aspect of Islamic Culture in Northern Nigeria (Chicago, 1977), and J. C. Moughtin, Hausa Architecture (London, 1985), are good introductions to the art of the Hausa. P. Imperato, "Blankets and Covers from the Niger Bend," AA 12:4 (1979): 38-43, surveys the work of Fulani weavers. Fulani and Hausa arts are also featured in L. Prussin, Hatumere (Berkeley, 1986). Beautiful photographs of the arts of the Wodaabe in Niger can be found in C. Beckwith and M. Van Offelen, Nomads of Niger (2nd ed., New York, 1983), even though some portions of the text are problematic.

Marla Berns' thorough review of this chapter improved it greatly, and the author thanks her for her many contributions.

ASPECTS OF AFRICAN CULTURES: THE ILLICIT TRADE IN ARCHAEOLOGICAL ARTIFACTS Plundering Africa's Past, edited by Roderick I. McIntosh and Peter Schmidt (Bloomington, 1996) is an overview of the illicit trade in archaeological objects. Although many works taken clandestinely from archaeological sites have been illustrated in books and catalogues, none of these publications directly address the ethical issues involved when private collectors and museums purchase such objects. The author thanks Marc Rasmussen for an explanation of how CT scans have revealed that fragments of ancient terracottas (or even traces of ancient charcoal) may be incorporated into newly made objects. His short tutorial in the ways "authentically old" TL and C-14 dates may be produced for these works was particularly helpful. Archaeological sites at risk may be found on the "Red List" on the official website of ICOM, the International Commission on Museums.

CHAPTER 4

Photographs and data on archaeological work at the sites of Kumbi Saleh, Tondidaru, and Inland Niger Delta sites were taken from Vallées du Niger (Paris, 1993), especially from contributions by J. Devisse and B. Diallo, "Le Seuil du Wagadu," 103-115, and by M. Dembele and A. Person, "Tondidarou, un foyer original du megalithisme africain dans la vallée du fleuve Niger au Mali," 441-5. Terms for the houses of Jenne are based upon those of P. Maas and G. Mommersteeg, "L'architecture dite soudainaise: 'le modele de Djenne," Vallées du Niger, 478-92, and upon L. Prussin, Hatumere: Islamic Design in West Africa (Berkeley, 1986). Rao and Payoma are described in L'Age d'or du Senegal (Solutre, 1993). Information on the sacred uses for bogolanfini was provided by S. Brett-Smith, "Symbolic Blood: Cloths for Excised Women," RES 3 (spring 1982): 15-31. Paintings on glass from Dakar were surveyed in Souweres: Peintures populaires du Senegal (Paris, 1987). I am grateful to Victoria Rovine for her assistance in locating a painting by Ismail Diabate, and for information on Bogolan Kasobane. The work of Abdoulaye Konate has appeared in a number of

recent exhibitions. Set Setal was described by Iba Mbeng in Africa Explores. 20th Century African Art, ed. S. Vogel (Munich, 1991), and an issue of Revue noire 7 (1992-3) was devoted to Senegal. A more detailed study of recent Senegalese art is E. Harney, In Senghor's Shadow: Art, Politics and the Avant-Garde in Senegal 1960-1995 (Durham, 2004). The author is grateful to Johanna Grabski-Ochsner for the images and feedback she provided. A brief survey in English of early sites in this region is provided by G. Connah, African Civilizations. Precolonial Cities and States in Tropical Africa: An Archaeological Perspective (Cambridge, 1987). More detailed descriptions may be found in R. McIntosh, The Peoples of the Middle Niger. The Island of Gold (London, 1988). AA 28:4 (autumn 1995) is devoted to archeological artifacts from Mali and includes both important articles and illustrations of major styles. There are excellent art historical studies of the Mande peoples available, including P. McNaughton, The Mande Blacksmiths. Knowledge, Power and Art in West Africa (Bloomington, 1988); B. Frank, More than Objects: An Art History of Mande Potters and Leatherworkers (Washington D.C., 1998); K. Ezra, A Human Ideal in African Art. Bamana Figurative Sculpture (Washington, 1986); and M. J. Arnoldi, Playing with Time (Bloomington, 1995). The most recent and comprehensive is I.-P. Colleyn, ed. Bamana: the Art of Existence in Mali (New York: 2001). Beautiful photographs of homes and mosques from Senegal and Mali are found in M. Courtney-Clark, African Canvas. The Art of West African Women (New York, 1990), and J.-L. Bourgeois and C. Pelos, Spectacular Vernacular. The Adobe Tradition (New York, 1989). The work of Senegalese and Malian photographers is included in In/sight: African Photographers, 1940 to the Present (New York, 1996).

The author is immensely grateful to Barbara Frank for providing excellent feedback on this entire chapter within a very short period of time. She also wishes to thank Kate Ezra for her helpful comments and corrections

ASPECTS OF AFRICAN CULTURES: SHRINES AND ALTARS Some of the aesthetic and philosophical ideas informing sacred assemblages are discussed in G.N. Preston, Sets, Series and Ensembles in African Art (New York, 1985), and in an essay by A. Rubin "Accumulation, Power and Display in African Sculpture", reproduced in J.Berlo and L.A. Wilson, Arts of Africa, Oceania and the Americas: Selected Readings (Englewood Cliffs, 1993), 4-21.

CHAPTER 5

The pioneer scholars of the Dogon are M. Griaule and G. Dieterlin and their students. Griaule's Masques Dogon (Paris, 1938) is still one of the finest, most detailed books on an African masquerade. B. DeMott Dogon Masks (Ann Arbor, 1982) reinterprets this classic monograph. Griaule's Conversations with Ogotemmeli (Oxford 1948, reprint 1965) is a fascinating exposition of Dogon creation mythology that has been linked to complex interpretations of Dogon art and architecture in many publications. All of these have been called into question by many more recent scholars of the Dogon. Foremost among them is W. van Beek; see his "Dogon Restudied: A Field Evaluation of the Work of Marcel Griaule," Current Anthopology 32:2 (1991): 139-67 and "Functions of Sculpture in Dogon Religion," AA 21:4 (1988): 58-65, 91. K. Ezra's catalogue, Art of the Dogon: Selections from the Lester Wunderman Collection (New York, 1988), is a cautious, sensible reading of Dogon art based on verified information.

Other useful Dogon studies include R. M. A. Bedaux, "Tellem and Dogon Material Culture," AA 21:4 (1988): 38–45, 91; J.-C. Huet, "The Togu Na of Tenyu Ireli," AA 21:4 (1988): 34–7; and T. Spini and S. Spini, Togu Na: The African Dogon "House of Men, House of Words" (New York, 1976).

R. Goldwater, Senufo Sculpture from West Africa (New York, 1964) still provides a useful overview of Senufo works in Western collections. The Senufo have been studied most extensively by G. Bochet, T. Forster, and A. Glaze. Glaze's works are the most accessible: Art and Death in a Senufo Village (Bloomington, 1981) is supplemented by several articles in AA on: gender 19:3 (1986): 30-39, 82; women's power 8:3 (1975): 25-9, 64; metalwork and decorative arts 12:1 (1978): 63-71, 107. Glaze and Bochet contributed to the Senufo sections in Art of Côte d'Ivoire, ed. J. P. Barbier (Geneva, 1993). Thanks also to Professor Glaze for personal communications and help with illustrations in this chapter. D. Richter's book, Art, Economics and Change: the Kulebele of Northern Ivory Coast (LaJolla, 1980) is the source of my data on the Kulebele and recent tourist art production.

The Lobi have been studied recently in depth by P. Meyer, whose exhibition catalogue Kunst und Religion der Lobi (Zurich, 1981) was very useful in writing this chapter. Thanks to Lorenz Homberger of the Rietberg Museum, Zurich, for supplying Lobi and Mossi photographs. The Burkinabe peoples (Bwa, Mossi, and others) have been studied extensively by C. Roy, whose book, Art of the Upper Volta Rivers (Paris, 1987), as well as his personal help with both data and illustrations, was critical to the sections on Bwa and Mossi arts. Nankani architecture, which I have also studied in the field, is explicated in an important book by J.-P. Bourdier and T. T. Minh-ha, African Spaces: Designs for Living in Upper Volta (New York, 1985). The work of Amaghiere Dolo is illustrated in N-Gone Fall and Jean-Loup Pivin, An Anthology of African Art: The Twentieth Century (New York, 2001) and was illustrated by the official website of a festival of the arts held at Segou, Mali. Photographs, descriptions, and video copies of films from Mali, Burkina Faso, and Senegal were provided by California Newsreel, San Francisco, and information on FESPACO was taken from its official website.

ASPECTS OF AFRICAN CULTURES: EXPORT ARTS, COPIES, FAKES, AUTHENTICITY, AND CONNOISSEURSHIP African arts produced for tourists were first seriously discussed in N. Graburn, Ethnic and Tourist Arts: Cultural Expressions from the Fourth World (Berkeley, 1976), and in the works of B. Jules-Rosette. C. Steiner, African Art in Transit (Cambridge, 1994) presents the trade in fakes from the viewpoint of African exporters, while R. Corbey, Tribal Art Traffic: a Chronicle of Taste, Trade and Desire in Colonial and Post-Colonial Times (Amsterdam, 2000) explores the European attitudes fueling the trade. Related questions of authenticity and connoisseurship are explored in S. Vogel, The Art of Collecting African Art (New York, 1988), and by S. Kasfir in her influential essay, "African Art and Authenticity: a Text with a Shadow," AA 25(2), April 1992, 40-53, 96-97.

CHAPTER 6

Information on stone sculpture from Guinea, Sierra Leone, and Liberia was taken primarily from F. Lamp, La Guinée et ses heritages culturels: Articles sur l'histoire de l'art de la region (Conakry, 1992), and from conversations with Dr. Lamp. The analyses of Sapi-Portuguese ivories and the quotations from Fernandes are from Africa and the Renaissance: Art

in Ivory (Munich, 1988). Photographs of masquerades in Senegal, Guinea-Bissau, and Guinea (including the Balanta, Papel, and Bidjogo) were found in H. A. Bernatzik, Der Dunkel Erdteil. Information on the Bassari was taken from M. de Lestrange, Les Coniaugui et les Bassari (Guinée française) (Paris, 1955), which contained no illustrations. Photographs of masquerades in Guinea and Côte d'Ivoire appear in M. Huet, J. Laude, and J.-L. Paudrat, The Dance, Art and Ritual of Africa (New York, 1978). The best source on the art of the Bidjogo is D. G. Duquette; see her "Woman Power and Initiation in the Bissagos Islands," AA 12:3 (May 1979). Photographs of masquerades for carnival in Guinea-Bissau were published by D. Ross, AA 25:3 (July 1993). The history of the Mano judgement mask was recounted by G. Harley, "Masks as Agents of Social Control in Northeast Liberia," Papers of the Peabody Museum of American Archaeology and Ethnology 32:2 (1950). The je (dye) masks of the Guro are described by A. Deluz, "The Guro," Art of Côte d'Ivoire, vol. 1 (Geneva, 1993). A. Gnonsoa's quotation of the importance of masquerades for the Weon comes from her book, Masques de l'ouest Ivoirien (Abidjan, 1983). The career of Bruly Bouabre is summarized in A. Magnin and J. Soulillou, Contemporary Art of Africa (New York, 1996). The author's interview with Christine Ozoua Avivi provided information on Vohu-Vohu. T. McEvilly's interviews with Gerard Santoni were published in T. McEvilly, Fusion: West African Artists at the Venice Biennale (New York, 1993), and the best account of Christian Lattier is by Yacouba Konaté, Christian Lattier: le Sculpteur aux Mains Nues (Paris, 1993).

The most comprehensive survey of the arts of this region is W. Siegmann and C. Schmidt, Rock of the Ancestors: Ngamoa Koni (Suakoko, 1977), and it only covers peoples living in Liberia. Good studies of the arts of specific peoples or of related art complexes include: P. Mark, The Wild Bull in the Sacred Forest: Form, Meaning, and Change in Senegambian Initiation Masks (Cambridge), on the Jola and their neighbors; J. Nunley, Moving with the Face of the Devil: Art and Politics in Urban West Africa (Urbana, 1987), on masquerades in Freetown; F. Lamp, Art of the Baga. A Drama of Cultural Reinvention (Munich, 1996); E. Fischer and H. Hinmmelheber, The Arts of the Dan in West Africa (trans. A. Biddle; Zurich, 1984); E. Fisher and L. Homberger, Masks in Guro Culture, Ivory Coast (New York, 1986). A recent book, D. Reed's Dan Ge Performance, Masks and Music in Contemporary Côte d'Ivoire (Bloomington, 2003), explores the contemporary roles of Dan masquerades in national as well as regional contexts. Among several useful articles by M. Adams on the We is "Women and Masks Among the Western We of Ivory Coast," AA, 19:2 (1986): 46-55, 90. The most thoroughly researched art complexes of the region are the masquerades of Sande and Bondo. Books on this subject include a comprehensive study of Sande by R. B. Phillips, Representing Women: Sande Masquerades of the Mende of Sierra Leone (Los Angeles, 1995), and an evocative personal response to Mende culture by S. A. Boone, Radiance from the Water. Ideals of Feminine Beauty in Mende Art (New Haven, 1986).

Frederick Lamp generously assisted the author during several stages in the preparation of this chapter, and provided a detailed final review. William C. Siegman's advice was also very helpful.

CHAPTER 7

Many books deal with the arts of Akan peoples in Ghana: R. Rattray, Religion and Art in Ashanti

(London, 1927); A. A. Y. Kyerematen, Panoply of Ghana (London/New York, 1964); H. M. Cole and D. H. Ross, The Arts of Ghana (Los Angeles, 1977); M. D. McLeod, The Asante (London); Akan Transformations, ed. D. H. Ross and T. F. Garrard (Los Angeles, 1983); D. H. Ross, Wrapped in Pride: Ghanaian Kente and African American Identity (Los Angeles, 1998). The recent funerary arts of southern Ghana are discussed in T. Secretan, Going into Darkness: Fantastic Coffins from Africa (London, 1995). An exhibition catalogue, C. Falgayrettes-Leveau and C. Owusu-Saprong, eds, Ghana Today and Yesterday/Ghana Hier et Aujourd'hui (Paris, 2003) contains an essay on Koma terracottas by J. Danguah in addition to several chapters on Akan arts. The portrait of the Queen Mother of Asante by Almighty God was illustrated in one of its chapters on contemporary arts, and Atta Kwami's chapter on "Ghanaian Art in a Time of Change" provides an excellent overview of artists working in Ghana today. Asante architecture and the Akan interface with Islam are dealt with in L. Prussin, Hatumere: Islamic Design in West Africa (Berkeley, 1986). Fante asafo military arts are well covered by D. H. Ross, Fighting with Art: Flags of the Fante Asafo (Los Angeles, 1979), and "Cement Lions and Cloth Elephants: Popular Arts of the Fante Asafo," in Five Thousand Years of Popular Culture: Popular Culture Before Painting, ed. F. E. H. Schroeder (Bowling Green, 1979). See also: P. Adler and N. Barnard, Asafo! African Flags of the Fante (London, 1992) and the same authors' African Majesty: The Textile Art of the Ashanti and Ewe (London, 1992). Ross deals with varied aspects of Asante royal and popular arts in: "The Verbal Art of Akan Linguist Staffs," AA 26:1 (1982): 56–67; "The Art of Osei Bonsu," AA 17:2 (1984): 28-40, 90; "Queen Victoria for Twenty-five Pounds: The Iconography of a Breasted Drum from Southern Ghana," Art. 47:2 (1988): 114-20; "More than Meets the Eye: Elephant Memories among the Akan," in Elephant: the Animal and its Ivory, ed. D. H. Ross (Los Angeles, 1992): 137-59.

Goldweights, gold, and other art forms for the entire Akan region are explored in two books: T. F. Garrard, Gold of Africa: Jewelry and Ornaments from Ghana, Côte d'Ivoire, Mali and Senegal in the Collection of the Barbier-Mueller Museum (Munich, 1989) and D. Ross, Gold of the Akan from the Glassell Collection (Houston, 2002). Doran Ross has also been extremely helpful in supplying illustrations for this volume, both from his extensive personal files and from UCLA's Fowler Museum of Cultural History.

The most complete and authoritative publication on Baule arts is S. M. Vogel, Baule: African Art, Western Eyes (New Haven/London, 1998). The same author's "People of Wood: Baule Figure Sculpture," ArtJ 33 (1973): 23-6, is useful, as is her Beauty in the Eyes of the Baule: Aesthetics and Cultural Values (Philadelphia, 1980). P. Ravenhill wrote on Baule Statuary Art: Meaning and Modernization and on Wan masquerades that were adopted by the Baule: "An African Triptich: On the Interpretation of Three Parts and the Whole," ArtJ, 47:2: 88–94, while his book Dreams and Reveries: Images of Otherworld Mates among the Baule, Côte d'Ivoire (Washington, 1996) is a reinterpretation of Baule spirit figures. The author's thanks are hereby extended to both Dr. Vogel and the late Dr. Ravenhill for help with information and photographs over the years.

Very little information is available on the arts of the Anyi, although their terracottas are discussed by P. C. Coronel, "Aowin Terracotta Sculpture," AA 13:1 (1979): 28-35, 97-98 and by R. Soppelsa in his 1982

dissertation, Terracotta traditions of the Akan of Southeastern Ivory Coast.

Lagoon arts are explicated by M. Blackmun Visonà in Art of Côte d'Ivoire, ed. J.-P. Barbier (Geneva, 1993) vol. 1: 368–83; "Divinely Inspired Artists from the Lagoon Cultures of the Ivory Coast," in The Artist and the Workshop in Traditional Africa, ed. Christopher Roy, Iowa Studies in African Art, vol. 3 (Iowa City, 1987); "Portraiture among the Lagoon Peoples of Côte d'Ivoire," AA 23:4 (1990): 54–61.

In addition to the chapters on modern Ghana in C. Falgayrettes-Leveau and C. Owusu-Saprong, eds, Ghana Today and Yesterday/Ghana Hier et Aujourd'hui (Paris, 2003), several useful essays of academic artists of the Akan region may be found in N. Fall and J.-L. Pivin, An Anthology of African Art. The Twentieth Century (New York, 2002); artists of the colonial period in the Gold Coast (Ghana) are discussed by Joseph Gazari Seini. J. Picton, ed. El Anatsui: a Sculpted History of Africa (London, 1998) presents that artist's work.

ASPECTS OF AFRICAN CULTURES: ART AND LEADERSHIP African Art & Leadership, ed. D. F. Fraser and H. M. Cole (Madison, 1971), and S. Blier, The Royal Arts of Africa: The Majesty of Form (UK title: Royal Arts of Africa) (New York/London, 1998) examine African art and authority cross-culturally. Both books contain essays or chapters on Akan states in Ghana; the former has an article by H. Himmelheber on the gold-covered objects of Baule notables.

CHAPTER 8

For further reading on the Yoruba, see H. J. Drewal and J. Pemberton III, et al., Yoruba: Nine Centuries of African Art and Thought (New York, 1989); W. B. Fagg and J. Pemberton III, Yoruba Sculpture of West Africa (New York, 1982); and R. F. Black, Gods and Kings (Los Angeles, 1971). Information on the art of ancient Ife may be found in F. Willett, Ife in the History of West African Sculpture (New York/London, 1967), and in E. Eyo and F. Willett, Treasures of Ancient Nigeria (New York, 1980). D. Fraser investigated the Tsoede bronzes and drew connections with the arts of Owo in "The Tsoede Bronzes and Owo Yoruba Art," AA 8:3 (spring 1975): 30-5. For the art of Owo see several articles by R. Povnor, among them "Edo Influence on the Arts of Owo," AA 9:4 (July 1976): 40-5, 90. The udamolore sword is discussed by Poynor in Vogel, For Spirits and Kings; for other ivories from Owo see E. Bassani and W. Fagg, Africa and the Renaissance: Art Ivory (New York/Munich, 1988). P. Stevens, who was helpful in locating images for Esie, wrote the definitive book on Esie images, The Stone Images of Esie, Nigeria (Ibadan, 1978). A landmark study of the arts of leadership is African Art and Leadership. Among numerous works addressing the royal arts of the Yoruba are: Blier, The Royal Arts of Africa; R. F. Thompson, "The Sign of the Divine King," AA 3:3 (1970), 8-17, 74-80; W. Fagg and John Pemberton III, Yoruba Beadwork (New York, 1980); H. J. Drewal and J. Mason, Beads, Body, and Soul: Art and Light in the Yoruba Universe (Los Angeles, 1998). R. S. Walker investigates the work of Olowe of Ise in Olowe of Ise: A Yoruba Sculptor to Kings (Washington, D.C., 1998) and in "Anonymous has a Name: Olowe of Ise," in The Yoruba Artist. Yoruba places are examined by G. J. Afolabi Ojo in Afins of Yorubaland (London, 1966). The ogboni society is the focus of a study by P. Morton-Williams, "The Yoruba Ogboni Cult on Oyo," Africa 30:4 (1960): 362-74. H. Witte looks at ogboni art in his catalog Earth and the Ancestors: Ogboni Inconography (Amsterdam,

1988). J. R. O. Ojo deals with ogboni agba in "Ogboni Drums," AA 6:3: 50-2. An early source on Yoruba religion is E. B. Idowu, Oludumare, God in Yoruba Belief (New York, 1963). W. Bascom investigates Yoruba divination process in Ifa Divination: Communication Between the Gods and Men in West Africa (Bloomington, 1969). A comparison between the gods Eshu and Orunmila is drawn by R. Poynor in African Art at the Harn Museum: Spirit Eyes, Human Hands (Gainesville, 1995). H. Witte surveys ifa trays in "Ifa Trays from the Oshogbo and Ijebu Regions," in The Yoruba Artist. The nature of the god Eshu is addressed by J. Wescotts, "The Sculpture and Myths of Eshu-Elegba," Africa 32:4 (1962): 336-53, and J. Pemberton III, "Eshu-Elegba: The Yoruba Trickster God," AA 9:4 (1975): 20-7, 66-70. For Yoruba stone sculpture see P. Allison in African Stone Sculpture (New York, 1968). The nature of the god Ogun is studied by several scholars in Africa's Ogun: Old World and New, ed. S. T. Barnes (Bloomington, 1989). R. Thompson explores the distribution of Osanyin paraphernalia and its meaning in "Icons of the Mind: Yoruba Herbalism Arts in Atlantic Perspective," AA 8:3 (1975): 52-9. Thompson focuses on Eyinle ceramic arts in "Abatan: A Master Potter of the Egbado Yoruba," in Tradition and Creativity in Tribal Art, ed. D. Biebuyck (Berkeley, 1969): 120-82. Numerous scholars have looked at the thunder god Shango, among them R. Plant Armstrong in "Oshe Shango and the Dynamic of Doubling," AA 16:2 (February 1983): 28-32, and B. Lawal, Yoruba Sango Sculpture in Historical Retrospect (Ann Arbor, 1970). The relationship between the Shango and twins is explored by Thompson, "Sons of Thunder: Twin Images among the Oyo and Other Yoruba Groups," AA 4:3 (spring 1971): 813, 77–80, and by M. Houlberg, "Ibeji Images of the Yoruba," AA 7:1 (1973): 20-7, 91-2. The entire issue of AA 11:3 (April 1978), ed. H. Drewal, is devoted to the arts of egungun among the Yoruba peoples with contributions from I. Adedeii, H. Drewal, M. Thompson Drewal, M. Houlberg, J. Pemberton III, R. Poynor, and M. Schiltz. Two important books have been written on the spectacle of gelede: H. J. Drewal and M. T. Drewal, Gelede, a Study of Art and Feminine Power among the Yoruba (Bloomington, 1983), and B. Lawal, The Gelede Spectacle: Art, Gender, and Social Harmony in an African Culture (Seattle, 1996). Father Kevin Carroll surveyed Epa masks in northeastern Yoruba country in Yoruba Religious Carving (London, 1956) William Rea shared images and information from his dissertation fieldwork with the author. See Blier, The Royal Arts of Africa, chapter 2, for the royal arts of the Fon, and African Vodun, for royal bocio and those of commoners. See also: F. Picqué and Leslie H. Rainer, Wall Sculptures of Abomey (London, 1999). M. Adams focuses on Fon textile arts in "Fon Appliquéd Cloths," AA 13:2 (February 1980): 28-41, 87. E. Bay surveys Fon iron altars in Asen: Iron Altars of the Fon People of Benin (Atlanta, 1985), while D. Crowley addresses brass casting in "Fon Brass Tableaux as Historical Documents," AA 20:1 (November 1986): 54-9, 98. For the Allada divination board discussed in the Fon section see E Bassani, "The Ulm Opon Ifa (ca. 1650): A Model for Later Iconography," and O. Yai, "In Praise of Metonymy: the Concepts of 'Tradition' and 'Creativity' in the Transmission of Yoruba Artistry over Time and Space," in The Yoruba Artist. For a discussion of Brazilian architecture along the Guinea Coast see B. Hallen and C. de Benedetti. "Afro-Brazilian mosques in West Africa," Mimar; architecture in development 29, Sept. 1988, 16-23 and A. B. Laotan, "Brazilian Influence on Lagos," Nigeria Magazine 69 (1960): 156-65. Laotan investigated colonial architecture in Rives Coloniales: Architecture, de Saint-Louis à Douala (Marseille, 1993). Luc Gnacadja, who contributed to Rives Coloniales, also provided photographs for this chapter. Several sources explore art in the town of Oshogbo. U. Beier scrutinizes S. Wenger's revival of the shrines at Oshogbo in The Return of the Gods: The Sacred Art of Suzanne Wenger (Cambridge, 1975), and covers other aspects of Oshogbo phenomena in Thirty Years of Oshogbo Art (Bayreuth, 1991). The author of this chapter thanks Uli Bauer of Bayreuth University for help with ideas on Oshogbo art and Nike Davies-Okundaye for discussing and providing photographs of her work. M. D. Harris explores the work of the Ona group in "Beyond Aesthetics: Visual Activism in Ile-Ife," in The Yoruba Artist. Moyosore Okediji was kind enough to discuss his painting with the author and provide a photograph. An essay by Chike Okeke in Enwezor, Okwui, ed. The Short Century. Independence and Liberation Movements in Africa, 1945-1994 (New York, 2001) provides useful information on Nigerian art in the twentieth century, as does a chapter on Nigeria in J. Kennedy's New Currents, Ancient Rivers: Contemporary African Art in a Generation of Change (Washington, D.C., 1992). A short essay by S. Ogbechie "Onabolu, Lasekan and the Murray School," in N. Fall and J.-L. Pivin's An Anthology of 20th Century Art: The Twentieth Century (New York, 2001) is a good introduction to the early twentieth century Nigerian artists.

ASPECTS OF AFRICAN CULTURES: LOST-WAX CASTING For a full discussion of African brasscasting, see E. Herbert, *Red Gold of Africa: Copper in Pre-colonial History and Culture* (Madison, 1984).

CHAPTER 9

Among the extensive bibliography on Benin is a survev of its arts by K. Ezra, The Royal Art of Benin: The Perls Collection in the Metropolitan Museum of Art (New York, 1992). Scholars who have published the results of their fieldwork in Benin include R. E. Bradbury, P. G. Ben Amos, B. Blackmun, and J. Nevadomsky. Paula Girshick, Ben Amos, and Joseph Nevadomsky were helpful in supplying photographs and expertise on earlier versions of this chapter. Thanks are due to Cathy Curnow for her critiques of the first edition, and the author is grateful to Barbara Blackmun for her generous and patient assistance with the second edition. A fine treatment of most aspects of this art, with an emphasis on history, is by Ben Amos, The Art of Benin (London, 1980; rev. 1995). See too the articles by the same author: "Symbolism in Olokun Mud Art," AA, 6:4 (1973): 28-31, 95; "Men and Animals in Benin Art," Man N.S.II:2 (1976): 243-52. Varied aspects of Benin art are also explored in The Art of Power/the Power of Art: Essays in Benin Iconography, ed. P. G. Ben Amos and A. Rubin (Los Angeles, 1983). Benin ivory is covered in many essays by B. Blackmun; see especially "Obas' Portraits in Benin," AA 23:3 (1990): 61-9, 102-4, and "The Elephant and its Ivory in Benin," in The Elephant and its Ivory in African Culture, ed. D. H. Ross (Los Angeles, 1992): 163-83. J. Nevadomsky has written many informative essays on Benin, three of which were especially useful in writing this chapter: "Religious Symbolism in the Benin Kingdom," in Divine Inspiration: From Benin to Bahia, ed. P. Galembo (Santa Fe, 1993); "Kemwin-Kemwin: The Apothecary Shop in Benin," AA 22:1 (1988): 72-83, 100; J. Nevadomsky, "Signifying Animals: The Leopard and Elephant in Benin Art and Culture," in Kulte, Kunstler, Konige in Africa-Tradition und Moderne in Sud Nigeria, ed. S. Eisenhofer (Linz, 1997): 97-107. Afro-Bini ivories

are covered in E. Bassani and W. Fagg, Africa and the Renaissance: Art in Ivory.

Ancient cultures of the lower Niger basin are well summarized in T. Shaw, Nigeria: Its Archaeology and Early History (London, 1978), while Igbo Ukwu is discussed in great detail in the same author's Igbo-Ukwu: An Account of Archaeological Discoveries in Eastern Nigeria, 2 vols. (London/Evanston, 1970). M. A. Onwuejeogwu, An Igbo Civilization: Nri Kingdom and Hegemony (Londona, 1981) bridges ancient Igbo Ukwu with the modern Igbo. An earlier work on the high points of the Lower Niger region is W. Fagg, Nigerian Images (London, 1963). The arts of the Igbo and their neighbors (excluding Benin) are surveyed in G. I. Jones, The Art of Eastern Nigeria (Cambridge, 1984). Jones also wrote articles about two institutions explored further here: "Okorosia" [masking], Nigerian Field 3:4 (1934): 175-7, and "Mbari Houses," Nigerian Field 6:2 (1937): 77-9. The fullest, most recent survey of Igbo arts is H. M. Cole and C. C. Aniakor, Igbo Arts: Community and Cosmos (Los Angeles, 1984). Mbari houses are analyzed in some depth in H. M. Cole, Mbari: Art and Life among the Owerri Igbo (Bloomington, 1982), while the same author looks at mbari history in two articles: "The History of Ibo Mbari Houses: Facts and Theories," in African Images: Essays in African Iconology, ed. D. F. McCall and E. Bay (New York, 1975): 104-32, and "The Survival and Impact of Igbo Mbari," AA 21:2 (1988): 54-65, 96. For Igbo masking see J. S. Boston, "Some Northern Igbo Masquerades," Journal of the Royal Anthropological Institute 90 (1960): 54-65; C. C. Aniakor in "The Omabe Festival," Nigeria Magazine 126-127 (1978): 3-12, and "The Igbo Ijele Mask," AA 11:4 (1978): 42-7, 95; S. Ottenberg, Masked Rituals of the Afikpo (Seattle, 1975); R. N. Henderson, The King in Every Man (New Haven, 1972); R. N. Henderson and I. Umunna, "Leadership Symbolism in Onitsha Igbo Crowns and Ijele," AA 21:2 (1988): 28-37, 94-6; J. Picton, "Ekpeye Masks and Masking," AA 21:2 (1988): 46-53, 94.

For cross-cultural treatments of personal shrines in this region see J. S. Boston, Ikenga Figures among the North-West Igbo and the Igala (London, 1977) and S. M. Vogel, Gods of Fortune: the Cult of the Hand in Nigeria (New York, 1974). For Urhobo person shrines see W. P. Foss, "Images of Aggression: Ivwri Sculpture of the Urhobo," in African Images: Essays in African Iconology, ed. D. F. McCall and E. Bay (New York, 1975); C. A. Lorenz, "The Ishan Cult of the Hand," AA 20:4 (1987): 70-5, 90; P. M. Peek, "The Isoko Ethos of Ivri," AA 20:1 (1986): 42-7, 98. A good recent catalogue is W. P. Foss, Where Gods and Mortals Meet: Continuity and Renewal in Urhobo Art (New York, 2004). The most comprehensive survey of this area of Nigeria may be found in M. Anderson and P. Peek, eds., Ways of the Rivers: Art and Environments of the Niger Delta (Los Angeles, 2002).

Cross-cultural treatments of contrasting light and dark masks are more difficult to find. See J. Borgatti, From the Hands of Lawrence Ajanaku (Los Angeles, 1979) and "Dead Mothers of Okpella," AA 12:4 (1979): 48–57, 91: P. Ben Amos, "Keeping the Town Healthy: Ekpo Ritual in Avbiana Village," AA 2:4 (1969): 8–13, 79; Cole and Aniakor, Igbo Arts; J. C. Messenger, "Annang Art, Drama, and Social Control," African Studies Bulletin 5:2 (1962): 29–35 lbibio memorial arts are covered in J. Salmons, "Funerary Shrine Cloths of the Annang Ibibio, Southeast Nigeria," in Textiles of Africa, ed. D. Idiens and K. G. Ponting (Bath, 1980): 119–41.

Kalabari Ijaw arts, including festivals, are dealt with in many fine publications of R. Horton, especially Kalabari Sculpture (Lagos, 1965), and The Gods as Guests: An Aspect of Kalabari Religious Life (Lagos, 1965). For funerals and ancestral memorials, respectively, see J. B. Eicher and T. V. Erekosima, "Kalabari Funerals: Celebration and Display," AA 21:1 (1987): 38-45, 87-8, and N. Barley, Foreheads of the Dead: An Anthropological View of Kalabari Ancestral Screens (Washington, 1988). For iria bo dress see M. C. Daly, J. B. Eicher, and T. V. Erekosima, "Male and Female Artistry in Kalabari Dress," AA 19:3 (1986): 48-53, 83. Thanks to Joanne Eicher for supplying photographs. The artists of the Uli School of the University of Nsukka are most fully discussed in S. Ottenberg, New Traditions from Nigeria: Seven Artists of the Nsukka Group (Washington, D.C.,

ASPECTS OF AFRICAN CULTURES: MAMY WATA The Mamy Wata phenomenon is analyzed in several papers by H. J. Drewal, who also kindly supplied the photograph for chapter 9. See especially his "Mermaids, Mirrors, and Snake Charmers: Igbo Mamy Wata Shrines," AA 21:2 (1988): 38–45, 98; "Performing the Other: Mami Wata Worship in Africa," TDR: A Journal of Performance Studies 32:2 (1988): 160–85. See also C. Gore and J. Nevadomsky, "Practice and Agency in Mammy Wata Worship in Southern Nigeria," AA 30:2 (1997): 60–9, 95.

CHAPTER 10

For further information on the Cross River, see S. P. Blier, Africa's Cross River: Art of the Nigerian-Cameroon Border Redefined (New York, 1980); on the Cameroon Grasslands, see P. Gebauer, Art of Cameroon (Portland, 1979); on Gabon, see L. Perrois, Ancestral Art of Gabon: From the Collections of the Barbier-Mueller Museum (Geneva, 1985). For Cross River carved stones see P. Allison, African Stone Sculpture (New York, 1968), and Cross River Monoliths (Lagos, 1968). Keith Nicklin provided the in situ photograph of carved monoliths for this chapter. For Cross River terracottas see V. I. Eyo, "Qua Terracotta Sculptures," AA 18:1 (November 1984): 58-60, 96. For information on Ngbe society emblems see Nicklin "An Ejagham Emblem of the Ekpe Society," Art Tribal (1991): 3-18. Numerous sources delve into the masking societies of the Cross River, among them two articles by Nicklin: "Nigerian Skin-Covered Masks," AA 7:3 (spring 1974): 8-15, 67-68; "Skin-Covered Masks of Cameroon," AA 12:2 (February 1979): 54-9, 91. K. Nicklin and J. Salmons discuss regional style in "Cross River Art Style: Towards a New Definition," AA 18:1 (1984): 28-43.

C. Geary, Images from Bamum: German Colonial Photography at the Court of King Njoya, Cameroon, West Africa, 1902-1905 (Washington D.C., 1988) examines the court of Njoya. Bamum is also investigated by C. Tardits, "The Kingdom of Bamum," in Kings of Africa, ed. E. Beumers and H.-J. Koloss (Maasstricht, 1992). Geary discusses royal stools in "Bamum Thrones and Stools," AA 14:4 (1981): 32-43. Geary also addresses figural sculpture, a topic explored by P. Harter, "Royal Commemorative Figures in the Cameroon Grasslands," AA 23:4 (October 1990): 70-7, 96, and by S. Rudy, "Royal Sculpture in the Cameroon Grasslands," in African Art and Leadership: 123-35. For Kom stool figures see T. Northern, Royal Art of Cameroon (Dartmouth, 1973). The Afo-a-Kom spurred great interest and numerous articles with its disappearance and return to Kom in 1973. Northern discusses several regulatory societies in The Art of Cameroon. H.-J. Koloss focuses on Kwifon in "Kwifon and Fon in

Oku: On Kingship in the Cameroon Grasslands," in Kings of Africa. For the Msop association see J.-P. Notué, Batcham, sculptures du Cameroun: nouvelles perspectives anthropologiques (Marseille, 1993). The author of this chapter thanks Rosalinde Wilcox for sharing information on the arts of Duala and portions of her dissertation, "The Maritime Arts of the Duala of Cameroon: Images of Power and Identity," University of California, Los Angeles, 1994.

Among L. Perrois' extensive writings on Gabonese art is Ancestral Art of Gabon: From the Collections of the Barbier-Mueller Museum (Geneva, 1985). J. W. Fernandez discusses the Fang culture and the tradition of reliquaries in "Principles of Opposition and Vitality in Fang Aesthetic," in Art and Aesthetic in Primitive Societies, ed. C. Jopling (New York, 1971): 356-73. For Hongwe variations on Kota reliquary figures see L. Siroto, "The Face of the Bwiiti," AA 1:2 (winter 1968): 22-7, 86-9, 96; Perrois offers a response in AA 2:4 (summer 1969): 67ff. I. Child and Siroto address Kwele in "BaKwele and American Aesthetic Evaluations Compared," in Art and Aesthetics: 271-89. Siroto focuses on the Kwele gon mask in "Gon, a Mask Used in Competition for Leadership among the Bakwele," in African Art and Leadership: 55-7. A. LaGamma shared information from her dissertation, "The Art of the Punu Mukudj Masquerade: Portrait of an Equatorial Society, Columbia University, 1995, and provided the field photograph.

An essay on Ibrahim Njoya by Alexandra Loumpet-Galitzine may be found in N. Fall and J.-L. Pivin, An Anthology of African Art: The Twentieth Century (New York, 2002). Leandro Mbomio kindly provided photographs of his sculpture, and discussed his work. The painting by Pascal Kenfack was illustrated in Art pour L'Afrique (Paris, 1988), and the work of Malam was illustrated on the official website of the art festival called Doual'art.

ASPECTS OF AFRICAN CULTURES: MASQUERADES Cross-cultural comparisons of masking in Africa may be found in H.M. Cole, *I am not myself: The Art of African Masquerade* (Los Angeles, 1985).

CHAPTER 11

For further reading see: A. P. Bourgeois, Arts of the Yaka and Suku (Meudon, 1984); M. Felix, 100 Peoples of Zaire and their Sculpture (Brussels, 1987); H.-J. Koloss, Art of Central Africa: Masterpieces from the Berlin Museum fur Volkerkunde (New York, 1990); R. F. Thompson and J. Cornet, The Four Moments of the Sun: Kongo Art in Two Worlds (Washington, 1981); G. Verswijver, et al., Treasures from the Africa Museum Tervuren (Tervuren, 1995); Z. Strother. Inventing Masks. Agency and History the Art of the Central Pende (Chicago, 1998); M. Jordan, Chokwel: Art and Initiation among Chokwe and Related Peoples (Munich/New York, 1998).

M. Felix, C. Meur, and N. Batulukisi explored issues of Kongo region style and history in *Art and Kongos* (Brussels, 1995). For leadership art of the Kongo kingdom see Blier, *The Royal Arts of Africa*, chapter 5, and J. Thornton, "The Regalia of the Kingdom of Kongo, 1491-1895," in *Kings of Africa*. For the maternity figures of the Yombe see R. Lehuard, *Les Phemba du Mayombe* (Anouville, 1976). For funerary arts and associated practices see R. F. Thompson and J. Cornet, *The Four Moments of the Sun: Kongo Art in Two Worlds* (Washington, 1981). *Minkisi* are thoroughly investigated by W. MacGaffey, *Astonishment and Power* (Washington, 1993).

An early article on Teke variations of power figures was consulted for "Teke Fetishes," *Journal of the Royal Anthropological Institute* 86:1 (Jan.–June 1956): 25–36.

M.-L. Bastin has published numerous works on the Chokwe and related peoples: La sculpture Tchokwe (Meudon, 1982); "The Mwanangana Chokwe Chief and Art," in Kings of Africa; "Arts of the Angolan Peoples: Chokwe," AA 2:1 (Autumn 1968): 40-7, were especially helpful in sorting through issues of both figures and masks. For leadership arts of the Chokwe see D. Crowley, "Chokwe, Political Art in a Plebian Society," in African Art and Leadership: 21-40. The most recent research among the Chokwe has been published by M. Jordan. Among A. P. Bourgeois' extensive writings on the art of the Yaka and Suku are: Arts of the Yaka and Suku (Meudon, 1984); "Mbwoolo Sculpture of the Yaka," AA 12:3 (May 1979): 58-61, 96; "Kakungu Among the Yaka and Suku," AA 14:1 (November 1980): 42-8, 88; "Yaka Masks and Sexual Imagery," AA 15:2 (February 1982): 47-50. Bourgeois provided field photographs of an adze in context, a luumbu and its mmbwoolo figures, and an mweelu mask. Information on Pende society and art came from L. De Sousberghe, L'Art Pende (Brussels, 1959) and Z. Strother, "Eastern Pende Constructions of Secrecy," in Secrecy: African Art that Conceals and Reveals, ed. M. Nooter (New York, 1993).

Information on the Salampasu came from E. L. Cameron , "Sala Mpasu Masks," AA 22:1 (November 1988): 34–42, 98, and R. Ceyssens in Treasures from the Africa Museum Tervuren.

For leadership arts of the Kuba see J. Cornet, Art Royal Kuba (Milan, 1982); and D. Coates Rogers, Royal Art of the Kuba (Austin, 1979). For Ndop portraits see J. Vansina, "Ndop: Royal Sculptures among the Kuba," in African Art and Leadership: 41-55; J. B. Rosenwald, "Kuba King Figures," AA 7:3 (1974): 26–31; M. Adams, "Eighteenth-century Kuba Figures," AA 21:3 (May 1988): 32–8, 88. Kuba royal dress and textiles are discussed by Cornet in Art Royal Kuba. For leadership headdresses see P. Darish and D. Binkley, "Headdresses and Titleholding Among the Kuba," in Crowning Achievements: African Arts of Dressing the Head (Los Angeles, 1995). For cloth and dress in leadership context see M. Adams "Kuba Embroidered Cloth," AA 12:1 (November 1978): 24-39. Darish investigates textile production in light of funerary ritual in "Dressing for the Next Life: Raffia Textile Fabrication and Display among the Kuba of south central Zaire," in Cloth and Human Experience, ed. A. B. Weiner and J. Schneider (Washington, 1989). For masquerading in the context of the court see Cornet, "Avatar of Power: Kuba Masquerades in Funerary Context, Africa 1: 75-97. Binkley explores the non-royal use of masks in initiation and funeral contexts in "Masks, Space and Gender in Southern Kuba Initiation Ritual," Iowa Studies in Art, 3: Art and Initiation in Zaire (Iowa City, 1990).

For Lulua figures see C. Petridis' entry in *Treasures* from the Africa Museum Tervuren. Ndengese king figures are examined by C. M. Faik-Nzuji in the same source.

Information on painters of the colonial period, including Thango, may be found in several articles in N. Fall and J. –L. Pivin's *An Anthology of African Art: The Twentieth Century* (New York, 2001). Some of the earliest discussions of the paintings of Chéri Samba and Trigo Piula by art historians appeared in

S. Vogel, Africa Explores (New York, 1991). Recent work by Chéri Samba is illustrated in several catalogues, including A. Magnin, African Art Now: Masterpieces from the Jean Pigozzi Collection (Houston, 2005).

ASPECTS OF AFRICAN CULTURES: DIVINATION, DIAGNOSIS, AND HEALING Paired publications: A. LaGamma, Art and Oracle: African Art and Rituals of Divination (New York, 2000), and J. Pemberton, Insight and Artistry in African Divination (Washington D.C., 2000) form the most useful introductions to the subject. F. Herreman, To Cure and Protect: Sickness and Health

in African Art (New York, 1999) is also a useful

CHAPTER 12

overview of art and healing.

For further reading see: D. Biebuyck, Lega Culture: Art, Initiation, and Moral Philosophy among a Central African People (Berkeley, 1973); M. Felix, 100 Peoples of Zaire and their Sculpture (Brussels, 1987); D. Hersak, Songye Masks and Figure Sculpture (London, 1986); H.-J. Koloss, Art of Central Africa: Masterpieces from the Berlin Museum fur Volkerkunde (New York, 1990); E. Schildkrout and K. Kein, African Reflections: Art from Northeastern Zaire (New York/Seattle, 1990); Treasures from the Africa Museum Tervuren.

F. L. van Noten discusses the archaeology of the Upemba Depression in *The Archaeology of Central Africa* (Graz, 1982). Many aspects of Luba culture are addressed in M. Nooter Roberts and A. F. Roberts, *Memory: Luba Art and the Making of History* (New York/Munich, 1996) and in entries they wrote for *Treasures from the Africa Museum Tervuren*. J. Flam examines symbolic leadership stools in "The Symbolic Structure of the Baluba Caryatid Stool," *AA 4:2* (winter 1971): 54–9. The *lukasa* was first examined in T. Reefe, "Lukasa: A Luba Memory Device," *AA* 20:4 (1977): 49–50, 88. For the striped masks of the Luba see M. Felix, *Luba Zoo: Kifuebe and Other Striped Masks of Southeast Zaire* (Brussels, 1992).

F. Neyt focuses on Hemba figures in *La grande statuaire Hemba du Zaire* (Louvain-la-Neuve, 1995). T. Blakely and P. Blakely have researched *so'o* masks and reported their findings in "So'o Masks and Hemba Funerary Festival," *AA* 21:1 (November 1987): 30–7, 84.

For Tabwa culture and art see A. F. Roberts and E. Mauer, *Tabwa: The Rising of a New Moon: A Century of Tabwa Art* (Ann Arbor, 1985). Marc Felix provided photographs of Tabwa buffalo masks in context.

The most thorough coverage of Songye art is by Hersak, *Songye Masks and Figure Sculpture*, who also supplied the field photograph of the Songye *kifwebe* mask.

Daniel Biebuyck has provided numerous resources for studying the Lega and other groups in the eastern regions of the Democratic Republic of Congo. His *The Arts of Zaire*, 2 vols. (Berkeley, 1986) includes essential details of many groups. A landmark work on the Lega is his *Lega Culture*. His "The Kindi Aristocrats and their Art among the Lega," in *African Art and Leadership: 7–20*, and "Function of a Lega Mask," *International Archives of Ethnography* 47:1 (1954): 108–20, address specific types of objects used in the Bwami society. S. Klopper uses Biebuyck's resources as a basis for her "Speculations

on Lega Figurines," AA 19:1 (November 1985): 64–9, 88. Biebuyck addresses the art of Bembe associations in "Bembe Art." AA 5:3 (spring 1972): 12–9, 75–84, and that of the Mbole Lilwa in "Sculpture from the Eastern Zaire Forest Regions: Mbole, Yela, and Pere," AA 10:1 (October 1976): 54–61, 99.

Early reports on the court of the Azande and Mangbetu are in G. Schweinfurth, *The Heart of Africa: Three Years' Travels and Adventures in the Unexplored Regions of Central Africa from 1868 to 1871*, 2 vols. (trans. E. Frewer; New York, 1874). E. Schildkrout and C. Keim investigate the Mangbetu and their neighbors in *African Reflections: Art from Northeastern Zaire* (New York/Seattle, 1990). For changes in Mangbetu pottery traditions see G. Schildkrout, et al., "Mangbetu Pottery: Tradition and Innovation in Northeast Zaire," *AA* 22:2 (Feb 1989): 38–47, 102. Schildkrout also provided personal communication and advice on photographs in the American Museum of Natural History.

The barkcloth paintings of the Ituri Forest are discussed in R. F. Thompson, Painting from a Single Heart: Preliminary Remarks on Bark-cloth Designs of the Mbute Women of Haut-Zaire (Munich,1983), and G. Meurant and R. Farris, Mbuti Design: Paintings by Pygmy Women of the Ituri Forest (New York, 1996). Marc Felix provided the field photograph of Mbuti women.

Information on Djilatendo, Pili-Pili, and other artists of Leopoldville/Lumbumbashi may be found in contributions by several authors to N. Fall and J.-L. Pivin's An Anthology of African Art: The Twentieth Century (New York, 2001). The concept of the urban artist is introduced in J. Fabian and I. Szombati-Fabian, "Art, History and Society: Popular Painting in Shaba, Zaire," Studies in the Anthropology of Visual Communication 3 (1976): 1–21. The author thanks Ilona Szombati for providing information and sharing her photographs.

ASPECTS OF AFRICAN CULTURES: RITES OF PASSAGE Although many of the sources cited in this bibliography elucidate the arts of specific initiations in specific regions (such as the references listed for the Bamana, Dogon, Senufo, Bidjogo, Dyula, Mende, Dan, Guro, Igbo, Kuba, Chokwe, Lega, Maravi, Makonde, Sotho, and Venda), theoretical approaches often engage the work of A. van Gennep, The Rites of Passage (Chicago, 1960, originally published as Les rites de passage, Paris, 1909) and V. W. Turner, The Ritual Process: Structure and Anti-structure (Chicago, 1969).

CHAPTER 13

The plan of the Swahili house is from L. D. Reed, "Life in the Swahili Town House," African Archaeological Review 5 (1987). P. Garlake, The Early Islamic Architecture of the East African Coast (Nairobi, 1966), provided plans for the Great Mosque at Kilwa. Information on doors comes from J. Aldrich, "The Nineteenth-century Carved Wooden Doors of the East African Coast," Azania 25 (1990): 1-18, while S. Battle, "The Old Dispensary. An Apogee of Zanzibari Architecture," in The History and Conservation of Zanzibar Stone Town (Athens, 1995), described this important building in Zanzibar. The work of contemporary Swahili woodworkers was described by Said Abdullraham El-Mafazy during an interview. The sculpture of eastern Africa is most fully illustrated by K. Krieger, Ostafrikanische Plastik (Berlin, 1990) and M. Felix, et al., Tanzania: Meisterwerke Afrikanischer Skulptur (Munich, 1994). For the art of the Zaramo and their neighbors see M. Felix, Mwana Hiti: Life and Art of the

Matrilineal Bantu of Tanzania (Munich, 1990). An entry by M. Poznansky for the Luzira head may be found in Africa: The Art of a Continent: 140. For Nyau among the Mang'anja see B. Blackmun and M. Schoffeleers, "Masks of Malawi," AA 5:4 (summer 1972): 36-41, 69, 88, while Chewa masquerades are documented in L. B. Faulkner, "Basketry Masks of the Chewa," AA 21:3 (May 1988): 28-31, 86, and K. Yoshida, "Masks and Secrecy among the Chewa," AA 26:2 (April 1993): 34-45, 92. K. Weule's methods of collecting Makonde and Makua art are described in his Native Life in East Africa (New York, 1909). Contemporary Makonde workshops are the subject of S. Kasfir, "Patronage and Maconde Carvers," AA 13:3: 67-70, 91-2. M. Urbain-Faublée, L'Art Malagache (Paris, 1963) illustrates a rich variety of Malagasy art. Grave mounds and memorial figures from southern Sudan and southern Ethiopia are illustrated in: G. Schweinfurth, The Heart of Africa (New York, 1874); C. G. Seligman and B. Seligman, Pagan Tribes of the Nilotic Sudan (London, 1932); W. Kronenberg, "Wood Carvings in the South Western Sudan," Kush 8 (1960): 274-8; C. R. Hallpike, The Konso of Ethiopia: A Study of the Values of a Cushitic People (Oxford, 1972); E. von Haberland, Voelker Sud-Athiopiens (Stuttgart, 1959). Leni Riefenstahl's photographs of the Nuba appeared in People of Kau (New York, 1976) and The Last of the Nuba (New York, 1979). For twentieth-century East African art, essays in S. Vogel's Africa Explores (New York, 1991), Seven Stories about Modern Art in Africa (Paris: 1995), and N. Fall and J.-L. Pivin's An Anthology of African Art: The Twentieth Century (New York, 2001) were all useful. S. Kasfir provides important discussions of East African artists and patronage in several chapters of Contemporary African Art (London, 2000). A recent source is Z. Kingdon and H. Avero, East African Contours: Reviewing Creativity and Visual Culture (London, 2005).

An excellent introduction to the arts of eastern Africa is J. Coote and J. Mack, "Africa, VII: Regions: 7. East Africa," in The Dictionary of Art (London, 1996). For a fine introductory survey of early art from eastern Africa see J. Sutton, A Thousand Years of East Africa (Nairobi, 1990). U. Ghaidan, Lamu (Nairobi, 1992) provides a useful study of the art and architecture of one Swahili city. E. Wolfe, Vigango (Williamstown, 1986) is a readable introduction to the memorial arts of the Mijikenda. Photographs and paintings of both carved art forms and elaborate body arts are reproduced in J. Adamson, The Peoples of Kenya (New York, 1967). An overview of Makonde masking is given by J. Wembah-Rashid, "Isinyago and Midimu: Masked Dancers of Tanzania and Mozambique," AA 4:2 (1971): 38-44, but the most complete source is Z. Kingdon, A Host of Devils: The History and Contex of the Making of Makonde Spirit Sculpture (London, 2002). The best overview of the Malagasy arts is in J. Mack, Madagascar. Island of the Ancestors (London, 1986). Body arts and adornment of eastern Africans were first discussed by H. M. Cole, "Vital Arts of Northern Kenya," AA 7:2 (winter 1974). J. C. Faris, Nuba Personal Art (London, 1972) and C. Beckwith and T. Ole Saitoti, Maasai (London, 1980) are also excellent sources. Somalia in Word and Image, ed. K. S. Loughran (Bloomington, 1986), surveys Somali art and literature.

Elsbeth Court provided valuable suggestions for resources on the art of East Africa, and the US Department of Education Fulbright Group Projects Abroad funded a study tour which allowed the author to refine this chapter. She wishes to thank her

fellow participants for their friendship and support. Several scholars attending the University of Iowa conference on "Cross Currents: Art and Power in East Africa" read and commented upon portions of the manuscript. Peri Klemm offered useful advice and photographs for the 2nd edition.

ASPECTS OF AFRICAN CULTURES: CYCLES AND CIRCLES For life cycles, see R. Sieber and R. Walker, *African Art in the Cycle of Life* (Washington, 1987), and cross-cultural themes by various authors in *Art and Life in Africa* (1996–1998), the CD-ROM edited by C. Roy. For the multiple identities and expanding social circles of African artists, see the variety of artists featured in S. Njami, *Africa Remix* (London, 2004).

CHAPTER 14

Illustrations of ancient rock art from eastern Africa can be found in M. Leakey, Africa's Vanishing Art. The Rock Paintings of Tanzania (London, 1983). Some specific dates and references to sites of southern African rock art were taken from A. R. Willcox, The Rock Art of Africa (New York, 1984). For images carved in relief see T. Dowson, Rock Engravings of Southern Africa (Johannesburg, 1992). The gold rhinoceros from Mapungubwe is illustrated in M. L. Hall, Farmers, Kings, and Traders: The Peoples of Southern Africa, 200-1860 (Chicago, 1987). Iconographical analysis of the birds from Zimbabwe comes from T. N. Huffman, "The Soapstone Birds from Great Zimbabwe," AA 18:3 (1985): 68-73; Huffman's controversial interpretation of the site itself is set forth in "Snakes and Birds: Expressive Space at Great Zimbabwe," African Studies 40 (1981): 131-50. Architectural symbolism is the subject of "Indlu: The Domed Dwelling of the Zulu," in Shelter in Africa, ed. Paul Oliver (London, 1971): 96-105, and A. Kuper, "Symbolic Dimensions of the Southern Bantu Homestead," Africa 50 (1980): 8-23. Other aspects of southern African arts were taken from AA 21:3 (summer 1988). The history of stone sculpture in Zimbabwe is informed by Sidney Kasfir's Contemporary African Art (London, 2000). Information on twentieth-century artists of South Africa comes from J. Kennedy, New Currents, Ancient Rivers. Contemporary African Artists in a Generation of Change (Washington D.C., 1992), from Seven Stories about Modern Art in Africa (London/Paris, 1996), and from several essays in N. Fall and J.-L. Pivin's An Anthology of African Art: The Twentieth Century (New York, 2001). We are grateful to Elizabeth Morton for her assistance in locating photographs of sculpture by Joram Moriga. The work of W. Bester is described in A. Magnin and J. Soulillou, Contemporary Art of Africa (New York, 1996), and a more detailed analysis was provided by H.M. Cole.

For an excellent brief introduction to the arts of southern Africa see P. Davison, "Southern Africa," in Africa. Art of a Continent, chapter 3. African Art in Southern Africa. From Tradition to Township, ed. A. Nettleton and D. Hammond-Tooke (Johannesburg, 1984), is another good summary. Ancient rock art is the subject of J. D. Lewis-Williams, Believing and Seeing. Symbolic Meanings in Southern San Rock Paintings (London, 1981), and P. Garlake, The Hunter's Vision. The Prehistoric Art of Zimbabwe (Seattle, 1995). Art and Ambiguity. Perspectives on the Brenthurst Collection of Southern African Art (Johannesburg, 1991) surveys art works of the last two centuries. An excellent source for the art of the Shona and their neighbors is Zimbabwe, ed. W. Dewey (London, 1997); earlier research is summarized in P. Garlake, Great Zimbabwe (London, 1973) Good regional studies include Ndebele. A People and

their Art, ed. I. Powell (New York, 1995), G. van Wyck, African Painted Houses: Basotho Dwellings of Southern Africa (New York, 1998), and J. Morris and E. Preston-Whyte, Speaking with Beads. Zulu Arts from Southern Africa (London, 1994). Among the excellent books and catalogs on apartheid-era artists of the region are: S. Williamson, Resistance Art in South Africa (London, 1989); G. Younge, Art from the South African Townships (London, 1988); O. Levinson, The African Dream (on John Muafangejo) (London, 1992); Art from South Africa, Museum of Modern Art, Oxford (London, 1990). A good source for South African art at the end of the twentieth century is Liberated Voices (New York, 1999. Recent South African art has appeared in many exhibition catalogues. One that focuses upon a broad range of arts in contemporary South Africa is P. Allara et. al., Coexistence: Contemporary Cultural Production in South Africa (Waltham, MA, 2003). D. Brodie, ed. Personal Affects. Power and Politics in Contemporary South African Art (New York, 2004) is also a useful catalogue.

William Dewey provided the author with valuable assistance on many different occasions, and the author is particularly grateful for his generous, prompt, and thorough review of the final version of this chapter.

CHAPTER 15

Information on Juan de Pareja and artists of African descent who lived in Europe prior to the modern period is surprisingly difficult to find. However, the work of twentieth-century African expatriate artists has appeared in dozens of catalogues, beginning with S. Vogel's Africa Explores (New York, 1991) where Iba N'Diaye's "Juan de Pareja Agressé par les Chiens" was illustrated. Two catalogues have specifically discussed relationships between art produced in Africa and art produced by Africans living elsewhere: Laurie Farell's Looking Forward/Looking Back (New York), which is informed by the curator's knowledge of a broad range of African art, and O. Britto Jinorio, et. al., A Fiction of Authenticity: Contemporary African Art Abroad (St. Louis, 2003), which yielded the interviews of Wangetcha Muti and Yinka Shonibare. The latter contains passages that summarily dismiss the contributions of artists working in African communities. Coverage of African artists working and living abroad is particularly strong in S. Niani, Africa Remix (London, 2004); in S. Hasan and O. Oguibe, Authentic, Ex-centric: Conceptualism in Contemporary African Art (Ithaca, 2001); in S. Hasan and I. Dadi, Unpacking Europe: Towards a Critical Reading (Rotterdam, 2001); and in E. Okwui and O. Oguibe, Reading the Contemporary. African Art: From Theory to the Marketplace (Cambridge, 1999). Valuable discussions of some of the issues raised in this chapter may be found in R. Araeen, "A New Beginning: Beyond Postcolonial Cultural Theory and Identity Politics," Third Text (2000) vol. 50, 3-29 and in K. A. Appiah, "The Case for Contamination," The New York Times Magazine, Jan. 1, 2005, 30-37, 52. Appiah's influential essay, "Is the Post in Postmodern the Post in Postcolonial?" in My Father's House (Cambridge, 1991) also speaks to the experience of artists who work in international worlds.

CHAPTER 16

Art made in African American communities is discussed in J. M. Vlach, *The Afro-American Tradition in Decorative Arts* (Cleveland, 1978).

For art of the Caribbean islands see V. Poupeye, Caribbean Art (London, 1998), and The Sacred Arts of Haitian Vodou, ed. D. Cosentino (Los Angeles, 1995). Recent scholarship on the legacy of the Kongo is found in W. McGaffey and M. D. Harris, Astonishment and Power (Washington D.C., 1993), and in R. F. Thompson, Face of the Gods (New York, 1993). Information on African Cuban art was taken from Wilfredo Lam and His Contemporaries (New York, 1992). Several of the artists discussed in this chapter appear in C. Bernard, Afro-American Artists in Paris, 1919-1930 (New York, 1989). Issues of identity and representation are explored in M. D. Harris, Colored Pictures: Race and Visual Representation (Chapel Hill, 2003). Although there was no space for a discussion of photography in this chapter, D. Willis' Reflections in Black: a History of Black Photographers 1840 to the Present (New York, 2000) invites further discussion of the ideas discussed here. Several fine exhibition catalogs provided information on specific artists: some examples are Howardina Pindell: Paintings and Drawings (Potsdam College of the State University of New York, 1992) and D.S. Rubin, ed. Celebrating Freedom; the Art of Willie Birch (Manchester VT, 2005). Some good catalogues showcasing various artists are P. Perry, Free Within Ourselves: African-American Artists in the Collection of the National Museum of American Art (Washington D.C., 1992); Black Art, Ancestral Legacy: The African Impulse in African-American Art (Dallas, 1990). A younger generation of artists is featured in T. Golden et al., Freestyle (New York,

Excellent surveys are available on the art of African American artists. R. J. Powell, Black Art and Culture in the 20th Century (London, 1997), and S. Patton, African-American Art (New York, 1998), follow in the footsteps of R. Bearden and H. Henderson, A History of African American Artists, From 1792 to the Present (New York, 1993) and S. Lewis, African American Art and Artists (Berkeley 1999). The author of this chapter is particularly grateful to Richard Powell for his careful reading and useful comments.

ASPECTS OF AFRICAN CULTURES: ARTISTS WORKING OUTSIDE THE FRAME

R. F. Thompson celebrates art works based upon specific African traditions yet created in African American communities in Flash of the Spirit (Yale, 19). Trans-Atlantic religious arts are beautifully photographed by Phyllis Galembo in Divine Inspiration: From Benin to Bahia (Santa Fe, 1993). Although most surveys of "outsider art" are problematic for the reasons indicated in this essay, some interesting issues are raised by J. Helfenstein and R. Stanulis, Bill Traylor, William Edmonson and the Modernist Impulse (Urbana, 2004).

Picture Credits

Laurence King Publishing, the authors and the picture researcher wish to thank the institutions and individuals who have kindly provided photographic material. Collections are given in the captions alongside the illustrations. Sources for illustrations not supplied by museums or collections, additional information, and copyright credits are given below. Numbers are figure numbers unless otherwise indicated.

While every effort has been made to trace the present copyright holders we apologize in advance for any unintentional omission or error and will be pleased to insert the appropriate acknowledgement in any subsequent edition.

The following abbreviations have been used:

> t top b bottom

A.B.M. © abm- Archives Barbier-Mueller

A.M.N.H. American Museum of Natural History, New York B.M. © Trustees of the British

Museum, London

B.P.K. Bildarchiv Preußischer Kulturbesitz, Staatliche Museen zu Berlin

C.A.A.C. The Contemporary African Art Collection, Paris

D.A.C.S. Design and Artists Copyright Society, London Dapper Archives Musée Dapper,

Paris. Photo Hughes Dubois

Elisofon/N.M.A.A. Eliot Elisofon Photographic Archives, National Museum of African Art, Smithsonian Institution

Estall Robert Estall Photo Library, Sudbury, Suffolk

Fowler Fowler Museum of Cultural History, University of California at Los Angeles Held Photothèque André and Ursula

Held, Lausanne Hutchison Hutchison Library/Eye

Ubiquitous Indiana Indiana University Art

Museum, Bloomington, I.N. Photo Michael Cavanagh &

Kevin Montague

Metropolitan Image © The

Metropolitan Museum of Art, New York

Network Network Photographers, London

N.M.A.A. National Museum of African Art, Smithsonian Institution, Washington, D.C.

R.A.I. Royal Anthropological Institute of Great Britain, London

R.A.R.C. Rock Art Research Centre University of the Witwatersrand, Johannesburg Rietberg Museum Rietberg, Zürich

R.M.C.A. Royal Museum for Central Africa, Tervuren R.M.N. Réunion des Musées Nationaux, Paris

W.F.A. Werner Forman Archive, London

page 5 See fig 4-33. Photo Jerry L. Thompson, Amenia, N.Y.

page 6 See fig 6-43. Photo Jerry L. Thompson, Amenia, N.Y. page 8t See fig 10-33. Völkerkunde

Museum der Universität, Zürich-

page 8b See fig 13-27. B.M. page 9 See fig 16-19. Museum of the National Center of Afro-American Artists, Boston

page 10 Unknown photographer, courtesy of Rowland Abiodun page 11 Photo Henry J. Drewal.

Henry J. & Margaret Thompson Drewal Collection. Elisofon/ N.M.A.A. # A1992-028-05613

page 12 Photo Heini Schneebeli

PART ONE

20 See fig 4-33. Photo Jerry L. page Thompson, Amenia, N.Y.

Jean Besancenot. Courtesy of Mme M-D. Girard Besancenot and l'Institut du Monde Arabe,

Frobenius-Institut, Frankfurtam-Main. # S: III-74 ∂ X/181; # S: III-65 a X/168

1-4, 1-5, 1-7, 1-9 Jean-Dominique Lajoux/Rapho, Paris/Network

Jean-Dominique Lajoux/Artephot, Paris/Estall M. d'Heilly/Artephot, Paris

1-12, 1-29 W.F.A.

Fototeca Unione of the American Academy in Rome

1-15 Roger Wood/Corbis images after K. A. C. Cresswell. From

Early Muslim Architecture Vol II Erich Lessing/AKG-images

Margaret Courtney-Clark 1-20, 1-30 B.M. # 1994 AF12.2; #

Ethno +5773 John Hatt/Hutchison

Henry Guttmann/Hulton Getty Picture Collection,

Tim Beddow/Hutchison

Lars Oddvar Løvdahl/Keystone Collection/Hulton Getty. London

T. Monod/Musée du Quai 1-26 Branly, Paris

John Wright/Hutchison

G. Gasquet/Hoa Qui, Paris Institut du Monde Arabe, Paris. 1-32 Photo Philippe Maillard, Paris

1-33 Photo Cynthia Becker Photo Betty LaDuke

© Jellel Gasteli, Paris 1997

2-1, 2-3, 2-10, 2-15 B.M. # EA 1770; # EA 55424; # EA 37977; #EA 9901 sheet 5

2-2, 2-11, 2-21 Brooklyn Museum, New York. # 07.447.505; # 37.635E: # 49.48

2-4 a&b, 2-9 Jürgen Liepe, Berlin 2-5, 2-12 Hirmer Verlag GmbH,

Munich © Paul M. R. Maeyaert

© Museum of Fine Arts, Boston # 11 1738

2-13, 2-14 Photography by Egyptian Expedition, Metropolitan. # TAA 512B: # TAA 475

(after Michalowski). From Kazimierz Michalowski, Art of Ancient Egypt (New York: H. N. Abrams, 1969. Drawing by Pierre Hamon. Reproduced with the permission of Editions Citadelles et Mazenod, Paris

W. Vivian Davies

Staatliche Sammlung Ägyptischer Kunst, Munich. # ANT 24466

2-19, 2-25 Derek Welsby

Photo R.M.N. - © Hervé Lewandowski

Drawing after E Littman et al & Peter Garlake

Iulia Bayne/Robert Harding 2-24 Picture Library, London

Photo Elzbieta Gawryszewaka

2-27, 2-28, 2-36 Georg Gerster/Network

2-29 @ Malcolm Varon, New York. Courtesy of the Hill Monastic Manuscript Library, St John's Abbey & University, Collegeville Minnesota. # EMML 7602 ff 109v-110r;

@ Malcolm Varon, New York. # IES 3980

Victoria & Albert Museum, London. # M.36-1915

David Beatty/Robert Harding Picture Library, London 2-33

Michel Setboun/Corbis images Photo Guy Vivien

Georg Gerster/Panos Pictures, 2-35 London

Photo Liliane Karnouk

Photo Gary Otte. Collection of the Aga Khan Award for Architecture

2-39 Photo the Gazbia Sirry

2-40, 2-41 Photo Salah Hassar 2-42 Courtesy of Achameyeleh

National Commission for Museums and Monuments,

© Photo Dirk Bakker, Michigan

Heini Schneebeli/Bridgeman 3-3

Art Library 3-8, 3-15 Fowler. # X88-300

3-9, 3-11 Marla Berns 3-10 Reproduced with the permis-

sion of Marla Berns Fowler. Photo Richard Todd. B.M. # 1911.12-14.72, 1932.10-

21.117, 1954+23.962, 1954-23 966

3-16, 3-19, 3-20 Photo Arnold Rubin.

Robert H. Nooter

3-18 Photo Jerry L. Thompson, Amenia, N.Y.

Gilbert Schneider

Metropolitan #1972.4.19 3-22

Werner Forman Archive Photo Eliot Elisofon. Elisofon/

N.M.A.A. # EEPA EECL 6338 From J. C. Moughtin, Hausa Architecture (London: Ethnographica, 1985). Reproduced with the permission of the author

Abbas/Magnum Photos,

London James Morris/Axiom, London

Frank Willett

Textile Museum of Canada, Toronto. Photo Rachel Ashe. # Г94.3008

Salah Hassan

Carollee Pelos courtesy of Jean-Louis Bourgeois

Photo Ristorcelli/Musée du Quai Branly, Paris

M. Renaudea/Hoa Qui, Paris Bernhard Gardi, Basel

Department of Anthropology, Smithsonian Institution, Washington, D.C. # 341658-Fulani

3-36, 3-37, 3-38 Carol Beckwith/Estall From T. J. H. Chappel, Decorated Gourds in Northeastern Nigeria (London: Ethnographica, 1977). Reproduced with the permis-

sion of the author N.M.A.A. Photograph by Franko Khoury. # 86-12-2

Serge Robert

Courtesy Musée National, Nouakchott & Robert Vernet/Centre Regional Inter-Africain d'Archaeologie. Photo R.M.N. - © Dennis Rouvre

A.B.M. Studio Ferrazzini-

Bouchet, Geneva. # 1004-125

Art Institute of Chicago. Photo Alan Newman. # 1987.314.1-5

Jonathan Hope/Hutchison From Pierre Maas and Geert Mommersteeg, Djenné: chef-d'oeuvre architectural (Amsterdam: K.I.T. Press/ Royal Tropical Institute, 1992). Reproduced with the permission of the authors

John Hatt/Hutchison 4-10, 4-16, 4-17, Carollee Pelos, courtesy of Jean-Louis

Bourgeois

4-11 Georg Gerster/Network 4-12, 4-13 Metropolitan. # 1979.206.153; # 1979.206.121 & 1983 600a b

New Orleans Museum of Art.

77.254 Photo R M N Paris

Photograph by Edmond Fortier. General Fortier Postcard Collection Flisofon/N M A A # Series 4B, vol. II, 1906-1910

Rietberg. # RAF 204

Staatliches Museum für Völkerkunde, Munich. Photo:

S. Autrum-Mulzer B.M. # 1956 AF27.10 4-21

Kate Ezra

Indiana. # 72.111 Photo M. Griaule. Musée du

Quai Branly, Paris Photograph by Philip L. Ravenhill. Elisofon/N.M.A.A. #

1989-060934

Margaret Courtney-Clarke/Corbis images

Corbis images

4-30 M. Renaudeau/Hoa Oui, Paris Photo courtesy of Clementine 4-31

Deliss Courtesy of Bara Diokhane and Spike Lee. Photo Jerry L.

Thompson, Amenia, N.Y Jerry L. Thompson, Amenia, N.Y. for "Africa Explores" at the Museum for African Art,

New York Photo Joanna Grabski,

Washington, D.C. National Museum of Natural History, Smithsonian Institution. Photo Diane Nordeck. # E428417

Photo Abdoulaye Konate

University of Iowa Museum of Art. # x1986.553

5-2, 5-11, 5-22, 5-30, 5-31, 5-43, 5-45, 5-46 Herbert M. Cole

Koninklijk Instituut voor de Tropen, Amsterdam. # 4133-2 5-4, 5-18 Metropolitan. #

1978.412.322 Michael C. Rockefeller Memorial Collection. Bequest of Nelson

A. Rockefeller 1969; # 1978.412.421

5-5, 5-7, 5-9 Dapper 5-6, 5-8 Metropolitan. # 1977.394.15; # 1979.206.173 a-c

5-10, 5-15 Walter van Beek 5-12, 5-14, 5-16 Philip Ravenhill

5-13, 5-29 A.B.M. Photo Roger Asselberghs. # 1004-48; # 1006-37

Photograph by Eliot Elisofon. 5-17 Elisofon/N.M.A.A. # EEPA FECI. 3508 5-19, 5-32 A.B.M. Photo Pierre-Alain

Ferrazzini. # 1006-27; # 1006-31B Photo © Malcolm Varon, New

York N.M.A.A.. Photograph by

Franko Khoury. # 2005-6-51 5-23, 5-24, 5-26, 5-27, 5-28 Anita J. Glaze

5-25 Piet Meyer

5-33, 5-34 Photo Piet Meyer. Museum Rietburg, Zürich

Museum Rietburg, Zürich. Photo Wettstein & Kauf 5-36, 5-37, 5-38 Christopher D. Roy

Photograph by Jerry L 5-40 Thompson, Amenia, N.Y.

Rietberg. Photo Rainer 5-41

Wolfsberger Department of Archaeology, University of Ghana, Legon. # YKP/85/C/BAK. Photo Dapper

After Jean-Paul Bourdier and Trinh T. Minh-ha, African Spaces: Designs for Living in Upper Volta (New York: Holmes & Meier, 1985) Copyright © by John-Paul Bourdier. Reproduced and adapted with the permission of the publisher 5-47 Photo Clovis Prévost

page 166 See 6-43. Photo Jerry L. Thompson, Amenia, N.Y.

Fred Lamp B.M. # VI/40

6-3, 6-30 Metropolitan # 1978. 412.375; # 1979.206.264 Michael C. Rockefeller Memorial Collection. Bequest of Nelson A. Rockefeller

6-4, 6-7 A.B.M. Photo Pierre-Alain Ferrazzini.# 1002-3; # 1000-2

W.F.A

N.M.A.A. Photograph by 6-6 Franko Khoury. # 2005-6-9 M. Renaudeau/Hoa Qui, Paris

6-9 Danielle Gallois Duquette

6-10 Doran Ross

University of Iowa Museum of Art. # x1986,541

Musée du Quai Branly, Paris 6-13 6-14, 6-20, 6-26, 6-29 Michel Huet/ Hoa Qui, Paris

6-15 Fred Lamp

Musée du Quai Branly, Paris. 6-16 Photo I. Oster 6-17 Brooklyn Museum, New York.

6-18, 6-19, 6-37 William C. Siegmann

Peabody Museum, Harvard 6-21 University, Cambridge, M.A. Photo Hillel Burger. # 48-36-50/7315

Fine Arts Museums of San Francisco. # 73.9 6-23, 6-32, 6-34, 6-36 Eberhard

Fischer Fowler. Photo Denis J. Nervig

Heini Schneebeli/Bridgeman 6-25 Art Library, London

Photo Hans Himmelheber.

Courtesy of Eberhard Fischer Monni Adams

Photo R.M.N. Paris

6-33, 6-35 Lorenz Homberger Eye Ubiquitous/Hutchison

6-38 David Gamble, Brisbane C.A. 6-41 Courtesy Rose Lattier

Monica Blackmun Visonà 6-42 Photo Jerry L. Thompson, Amenia, N.Y. 6-43

6-44 C.A.A.C. Photo Claude Postel

7-1, 7-2, 7-15, 7-32, 7-34, 7-40 Doran Ross

7-3, 7-5, 7-12, 7-19, 7-27, 7-37, 7-38 Herbert M. Cole

Rene David/Galerie Walu, Zurich

A.B.M.

A.B.M. Photo Monique Barbier-Mueller, # 382

7-8, 7-24, 7-31 A.B.M. Photo Pierre-Alain Ferrazzini. # 1008-2, 1008-3 & 1008-1; # 1007-12; # 1007-51

7-9, 7-10, 7-11, 7-14, 7-16, 7-25, 7-35 Fowler Photo Don Cole

7-17, 7-18 Adapted from Michael Swithenbank, Ashanti Fetish Houses (Accra: Ghana Universities Press, 1969)

Metropolitan

Fowler. Photo Denis J. Nervig

Lap Nguyen Tien

7-29 Susan Vogel, Prince Street 7-28. Pictures, N.Y.

Philip Ravenhill

7-33 Monica Blackmun Visonà From Herbert M. Cole and 7-36

Doran H. Ross, Arts of Ghana (Los Angeles: Museum of Cultural History, University of California, 1977). Reproduced with the permission of the museum.

Dapper

7-41 Carol Beckwith & Angela Fisher/Estall

Samuel P. Harn Museum of Art, University of Florida. # 2005.37. Photo Oriel Mostyn Gallery / Noel Brown

8-1, 8-9, 8-10, 8-12, 8-13 Held 8-2, 8-19, 8-23 Photo by William

Fagg. R.A.I. # WBFP 58/75/6RAI; # HT260; # WBFP 49-50/23/10

8-3, 8-14 Frank Willett From Peter Garlake,

"Excavation at the Woyeasiri Family Land" in West African Journal of Archaeology, vol 7. Reproduced and adapted with the permission of the author

Ekpo Eyo

Jerry L .Thompson, Amenia, 8-7 N.Y.

Photo Frank Willett. Courtesy Hunterian Museum. University of Glasgow

8-20, 8-22, 8-63 B.M. # 18.31; # 1949 AF46.146; # 1971 AF35.17

© National Museums Liverpool

© 1980 Dirk Bakker John Pemberton III, Amherst, 8-18 MA

8-21 8-24 8-35 N.M.A.A. Photograph by Franko Khoury # 2005-6-73; # 2005-6-69; # 95-10-1a, b

Margaret Thompson Drewal

Field Museum of Natural History, Chicago. # A109448c

B.P.K. Museum of Fine Arts, Boston. 8-28 # 1991.1066

Philip Allison, courtesy of Mrs 8-29 Lesley Allison

Indiana. # 87.24.2

Samuel P. Harn Museum of 8-31 Art, University of Florida, Gainesville. Randy Batista Media Image Photography. #

Seattle Art Museum. Photo Paul Macapia. # 81.17.601

8-33 Robert Farris Thompson

Leo Frobenius. Frobenius 8-34 Institut, Frankfurt-am-Main. # a IV /5010

8-37, 8-38, 8-39 Marilyn Houlberg 8-40, 8-41 Photograph by Henry John Drewal. Henry John Drewal and Margaret Thompson Drewal Collection Elisofon/N.M.A.A. # EEOA D00411: # EEPA D00639

William Rea 8-42

Toledo Museum of Art. # 1977.22

J Paul Getty Trust # 8-44

ABO.94.3.17.sd Photo Jean Gabus. Musée 8-45 d'Ethnographie, Neuchâtel, Switzerland. #1B8E467

Brooklyn Museum, New York 8-46

Musée du Quai Branly, Paris. Photo D. Ponsard

Dapper

Photo Suzanne Preston Blier 8-51

Edna Bay 8-52

Ulmer Museum, Ulm. Photo Helga Schmidt-Glassner

Musée du Quai Branly, Paris 8-54

Photo Dana Rush Juliet Highet/Hutchison 8-57

Afolabi Ojo

United Nations DPI Photo/M Tzovaras

From Jean Kennedy. New Currents, Ancient Rivers: Contemporary African Artists in a Generation of Change. Washington and London Smithsonian Institution Press

Indianapolis Museum of Art. # 1993.82. © Twins Seven-Seven

Photograph by Victoria Scott. Elisofon/N.M.A.A. # EEPA 1984-0003

John Picton

Photo: Stephan Köhler, 8-68 Courtesy: Philadelphia Museum of Art and jointadventures.org

9-1, 9-5, 9-7, 9-16, 9-44, 9-60 B.M. # 1897.10.11.2; # 98,1-15.46; 1910,5-13.1; # 1954.Af23.428; # 1950 Af45 334

9-4, 9-17 R. E. Bradbury, courtesy of Mrs Ros Bradbury

9-6, 9-50 Paula Ben-Amos Girshick 9-9, 9-23, 9-25, 9-27, 9-29, 9-31, 9-34, 9-35, 9-37, 9-56 Herbert M. Cole

From Kate Ezra, Royal Art of Benin: The Perls Collection in the Metropolitan Museum of Art (New York: Metropolitan Museum of Art; distr. by H. N. Abrams, 1992).

From Jan Vansina, Art History in Africa: An Introduction to Method (London; New York: Longman, 1984). Redrawn and adapted with the permission of the author

University of Pennsylvania 9-12 Museum, Philadelphia. # AF 2064B

9-13, 9-42 Metropolitan. # 1991.17.2; # 1978.412.628

Photo Frank Willett. Courtesy the Hunterian Museum, University of Glasgow.

W.F.A.

Photo courtesy Barbara 9-18 Blackmun

By permission of Thurstan Shaw 9-20, 9-22 © Photo Dirk Bakker,

Michigan, 1979 9-24 Eli Bentor

Photo courtesy Bumerang verlag/Norbert Aas, Bayreuth

Henry J. Drewal Photo A. W. Banfield. Royal 9-32 Ontario Museum. # 950.257.56

Seattle Art Museum. Photo Paul Macapia. # 81.17.625

9-38, 9-39 G. I. Jones

9-40 Simon Ottenberg 9-41 Elizabeth Evanoff

9-45 N.M.A.A. Photograph by Franko Khoury. # 87-6-1; # 2005-6-122

Field Museum of Natural History, Chicago. # A109312

Fowler. Photo Don Cole

9-48, 9-49 Jean M. Borgatti 9-52, 9-53, 9-54 Keith Nicklin & Jill Salmons

9-55, 9-57 Joanne Eicher

Indiana. # 96.49 9-58

Photo Sokari Douglas Camp. © D.A.C.S., London 2007

© Bruce Onobrakpeya. Photo courtesy Fowler

PART THREE

page 316 see 10-33. Völkerkunde Museum der Universität, Zürich

Keith Nicklin

New Orleans Museum of Art. 10-5 #86.83

Elliott Leib

Cambridge University 10-7 Museum of Archaeology and

Anthropology. # 1917-51 Fowler. Photo Denis J. Nervig 10-8

R.M.C.A. # EPH 4556 10-10, 10-14 Photo Frank Christol, Fontaine-Lavganne. Musée du

Quai Branly, Paris 10-11 Gilbert Schneider

10-12 B.P.K. Photo Dietrich Graf 10-13 Photo Marie Pauline Thorbecke, Historisches Fotoarchiv, Rautenstrauch-Joest Museum für Völkerkunde, Cologne. # 19336

10-15 Metropolitan. The Photograph Study Collection, Department of the Arts of Africa, Oceania and the Americas, Bequest of Paul Gebauer, 1977. PSC #

1977.1.401.683 10-16, 10-22 Photo Ankermann. B.P.K.

10-17 B.P.K.

10-18 N.M.A.A. Photograph by Franko Khoury. # 2005-6-31

10-19 Dapper # 3343

10-20 © Hans-Joachim Koloss, Berlin 10-21 Musée d'Ethnographie, Geneva. Photo Johnathan Watts. # 033559

10-23 Field Museum of Natural History, Chicago. #A95753 10-24 Photo Paul Gebauer. Robert

Goldwater Library, Metropolitan. # 198-frame 5 10-25 C Pavard/Hoa Qui, Paris

10-26 Rietberg. Photo Wettstein & Kauf National Museum of Natural History, Department of Anthropology, Smithsonian

Institution. # 166178 10-28 National Museum of Ethnology, Stockholm. Photo

Bo Gabrielsson 10-29 © National Museums Liverpool

10-30, 10-31 Metropolitan. # 1979. 206.229; # 1978.412.441 10-32, 10-34 A.B.M. Photo Pierre Alain Ferrazzini. # 1019-5; #

1019-4 10-36 Denver Art Museum. # 1942.443

10-37 University of Iowa Museum of Art. # x1986.338

10-39 Photo R.M.N. Paris 10-40 W.F.A./Entwistle Gallery, London

10-41 Alisa LaGamma

10-43 © Pascal Kenfack 10-44, 10-45 Photo Didier Schaub, Doual'art, Douala, Cameroon

11-1, 11-2, 11-16, 11-21, 11-28; 11-32 11-41, 11-66 R.M.C.A. Photo Roger Asselberghs. # RG 43800; # 14796; # RG 7943; # RG 33107; # RG 43161; # RG 43146; # RG 26520; # RG 3693 11-3 Pitt Rivers Museum, Oxford. #

1886.1.254.1

11-5, 11-60 Virginia Museum of Fine Arts, Richmond, VA. Photo Katherine Wetzel, © 1994. # 85 591. # 85 592

11-6, 11-8 B.P.K. Photo W. Scheider-Schütz

11-7, 11-25, 11-27, 11-37, 11-70 B.P.K. 11-9, 11-64 Peabody Essex Museum, Salem, M.A. # E 67754 Photo

by Mark Sexton; # 17-41-50/B1908

11-11 Photo H. Deleval. R.M.C.A. # EPH 13535

11-13 Rietberg. Photo by Wettstein & Kauf. # RGW 7361 11-14, 11-69 Brooklyn Museum,

New York. # 22.1203; # 50.124 11-15, 11-33, 11-48, 11-63 R.M.C.A. # EPH 5833; # RG 32510; # RG 36522; # RG 24968 11-17 F. L. Michel. Emil Torday and

M. W. Hilton-Simpson Collection, R.A.I.# RAI 8013

11-18 Staatliches Museum für Völkerkunde, Munich. # 93.630

11-19 © National Museums, Liverpool. # 8.12.97.13 11-20 Samuel P. Harn Museum of Art, University of Florida, Gainesville. Randy Batista, Media Image Photography. #

1998.19 11-22 Manuela Palmeirim Universidade do Minho, Braga,

Portugal 11-23, 11-39, 11-44 N.M.A.A Photograph by Franko Khoury. # 83-3-5a,b; # 99-2-1; # 2005-6-476

11-24 W.F.A./Christies 11-26, 11-65 The Baltimore Museum of Art. # 1997.231; # 1989.150 11-29 Metropolitan # 1978.412.619 11-30 Museo do Dundo, Luanda.

Photo courtesy of R.M.C.A. # I 11-31 Photo E. Steppé. R.M.C.A. #

EPH 9420 11-34, 11-36, 11-53, 11-61, 11-68 B.M. # 1907, 5-28.138; # 1907, 5-28.141; # 1909, 12-10.1; #

1979 AF1.2674; # 1910 4-20.21 11-35 Photo Hughes Dubois, Brussels Paris. Courtesy Musée Dapper, Paris

11-38 Photo F. L. Michel. R.M.C.A. # EPH 11402

11-40 Photo Arthur P. Bourgeois 11-42 Rietberg. Photo Ernst Hahn 11-43 Photograph by Père Léon de Sousberghe. Elisofon/N.M.A.A.

EEPA 1999-100086 11-45 Photo C. Souris. R.M.C.A. # EPH 12247 11-46, 11-47 Photo A. Scohy.

R.M.C.A. # EPH 11531; # EPH 7030 11-49, 11-51 Photo C. Lamote. R.M.C.A. # EPH 3039; # EPH

3044 11-52, 11-56 Photograph by Eliot Elisofon. Elisofon/N.M.A.A. # EEPA EECL 2142; # EEPA, neg. no. 22923, P4, 11 11-55 Photo C. Zagourski. R.M.C.A.

FPH 820

11-57, 11-59 Indiana. # 63.327 11-58 Samuel P. Harn Museum of Art, University of

- Florida, Gainesville, Photo David Blankenship. 2004.37.8
- 11-62 Photo J.M. Vandyck. R.M.C.A. # 11/106
- 11-67 B.P.K. Photo Bast
- 11-71 C.A.A.C. Photo Claude Postel 11-72 C.A.A.C. Photo Patrick Gries
- 11-74 Photo courtesy Sotheby's, London
- 11-75 Jerry L. Thompson, Amenia, N.Y. for "Africa Explores" at the Museum for African Art, New York
- 12-1 University of Pennsylvania Museum, Philadelphia. # AF 5121
- After a drawing by Mrs. Y. Bale in Francis van Noten, The Archaeology of Central Africa (Graz, Austria: Akademische Druck- u. Verlagsanstalt, 1982)
- Pierre de Maret 12-4, 12-13 Etnografisch Museum,
- Antwerp. # AE. 772 Photo Paul de Backer.; # AE. 864 Rietberg. Photo Ernst Hahn
- 12-6, 12-15, 12-21, 12-26 Metropolitan # 1979.290: # 1978.412.591 & 592; # 1979.206.277; # 1978.412.571
- National Museum of Denmark. Copenhagen. Photo Lennart Larsen. # G 8376
- A.M.N.H. # 2423b
- 12-9 Brooklyn Museum, New York # 76.20.4
- 12-10 Photo W. F. P. Burton.
- R.M.C.A. # EPH 3463 12-11, 12-19; 12-27 Photo R.M.C.A. # EPH 8808; # RG 51.10.1; # RG 61.18.1
- 12-12, 12-18, 12-23, 12-29 R.M.C.A. Photo Roger Asselberghs. # RG 23470; # RG 30621; # RG 55.3.40; # RG 7602
- 12-14 Linden-Museum, Stuttgart. # F 52.595L
- 12-17, 12-36 Marc Felix
- 12-20 Photograph by Eliot Elisofon. Elisofon/N.M.A.A. # EEPA EECL 541
- 12-22 University of Iowa Museum of Art. # x1986.571
- 12-28, 12-34 Photo C. Zagourski R.M.C.A. # EPH 8905; # EPH 8903
- 12-30 A.B.M. Photo Roger

- Asselberghs. # 1026-115 12-31 Drawing by E Bayard, 1874
- from Georg Schweinfurth "The Heart of Africa" 1874 vol 2 frontispiece
- 12-32 Photo Herbert Lang. A.M.N.H. # 224507
- 12-33 Illustration by Georg Schweinfurth "The Heart of Africa" 1874 vol 2
- 12-35 A.M.N.H. Photo Lynton Gardiner
- 12-37 N.M.A.A. Photograph by Franko Khoury. # 92-15-1
- PART FOUR
- page 428 See 13-27. B.M.
- Peri Klemm, Northridge From Peter S. Garlake, The Early Islamic Architecture of the East African Coast (Nairobi: Oxford University Press, 1966). Redrawn and adapted with the permission of
- the author
- 13-3 M. Csaky/Hutchison 13-4, 13-7 Fowler. Photo Denis J. Nervig; # X89.367
- 13-5, 13-10 Cambridge University Museum of Archaeology & Anthropology. # P6928.ACH.1; # P 6922.ACH.1
- 13-6, 13-9, 13-45, 13-46, 13-49 Carol Beckwith and Angela Fisher/ Estall
- From Linda Donnaly, "Life in the Swahili Town House" in The African Archaeological Review, issue 5, 1987
- 13-11 David Coulson/Estall
- 13-12 Ernie Wolfe III
- 13-13 B.P.K. Photo Dietrich Graf 13-14, 13-20, 13-31 B.P.K. Photo W.
- Scheider-Schütz 13-15, 13-21, 13-22 B.P.K
- 13-16 Staatliche Museum für Völkerkunde, Munich. Photo S. Antrum-Mulzer. # 17-14-98
- 13-17 Reiss-Museum, Mannheim Photo Jean Christen. # IV Af.9095
- 13-18 N.M.A.A. Photograph by Franko Khoury. # 89-10-1
- 13-19, 13-23, 13-25 Linden-Museum, Stuttgart. Photo V. Didoni. # 59316; # 45993; # 40486
- 13-26, 13-40 B.M. # 1931.1-5.14: # 1901,11-13.50 & 51, 1971 AF38.2; # 1990 AF15-1

- 13-28 Courtesy Magdalene Odundo
- 13-29 Barbara Blackmun -30 Laurel Birch Aguilar
- 13-32, 13-36 Museum für Völkerkunde, Leipzig. Photo Karin Wieckhorst. # MAF 15663
- 13-33 Museum für Völkerkunde Leipzig. Photo Ingrid Hänse. # MAF 16593
- 13-34 Chris Johns/N.G.S. Image Collection, Washington, D.C.
- 13-35 Photo Instituto Português de Museus, Lisbon/Carlos Monteiro. # AH 961-M
- 13-37 Museum für Völkerkunde, Frankfurt. Photo Gisela Simrock. # N.S. 51074
- 13-39 Art Archive/Dagli Orti 13-41, 13-42 Photo N. Boulfroy. Musée du Quai Branly,
- Paris 13-43 Menil Collection, Houston. Photo Hickey-Robertson. #83-
- 029 DI 13-44 Sybil Sassoon/Robert Harding Picture Library
- 13-47, 13-48 James Faris
- 13-50, 13-51 Herbert M. Cole
- 13-52, 13-53, 13-54 Photo Clementine Deliss
- 13-55 Christraud M. Geary
- Mischa Scorer/Hutchison
- R.A.R.C. Photo W. E. Wendt
- 14-3 South African Museum, Cape Town. Photo Herschel Mair. # AA 6008
- R.A.R.C. Photo T. A. Dowson 14-4
- © National Cultural History Museum, Pretoria (incorporated with the Northern Flagship Institution) # ARG 6993
- 14-6, 14-8, 14-10, 14-15, 14-16 David Coulson/Estall
- R.A.R.C.
- 14-9 R.A.R.C. Photo David Lewis-Williams
- 14-11 South African Museum, Cape Town. Photo Herschel Mair. # UCT 701/1
- 14-13, 14-14 From Peter S. Garlake, Great Zimbabwe (London) Thames and Hudson, 1974). Redrawn and adapted with the permission of the author
- 14-17 D. Allen, courtesy of the National Museums and Monuments of Zimbabwe

- 14-18 Chris Howes/Wild Places
- Photography/Alamy 14-20, 14-21, 14-22, 14-29, 14-37 B.M. # 1946 AF4.1; # 1954 AF23.2813 & 2815; # 1949 AF46.810: # 1937. 12-1.1: # 1934,12-1.5 & 1991 AF9.8
- 14-23 Fowler. # X93.37.2
- 14-24 Photo A M Cronin. Cambridge University Museum of Archaeology and Anthropology. # P7434.ACH.1 14-25 Indiana. # 77.36
- 14-26 Anitra Nettleton
- 14-30 South African Museum, Cape Town. Photo Hershel Mair. # AE 449
- 14-32 Photographer unknown. Publisher unknown. Postcard Collection. Elisofon/N.M.A.A.
- 14-33 Jean Morris. Courtesy of her
- 14-35 Musée du Quai Branly, Paris. Photo C. Lemzaoude.
- 14-36 Linden-Museum, Stuttgart. Photo V. Didoni. # 49050
- 14-38 Photo V. C. Scott O'Connor. Royal Geographical Society, London
- 14-39, 14-40 Photo Gary van Wyk 14-41 Margaret Courtney
- Clarke/Tom Keller Associates New York
- 14-43 Iziko Museums of Cape Town/Cecil Kortije
- 14-44 Photo Elizabeth Morton
- 14-45 Courtesy of Bernd Kleine-Gunk, Galerie Zak, Zürich
- 14-46 Elizabeth Schneider
- 14-47 Photo Rui Assubuji 14-49 Courtesy of Marriam Morris
- and the National Heritage & Cultural Studies Centre, University of Fort Hare, Alice
- 14-53 N.M.A.A. Photograph by Franko Khoury. 98-19-2 Courtesy Louis Maghubela
- 14-55 Iziko Museums of Cape Town/Cecil Kortije
- PART FIVE
- page 498 See 16-19. Museum of the National Center of Afro-American Artists, Boston, M.A page 499 See 15-15. National Gallery
- of Canada, Ottawa. Courtesy Stephen Friedman Gallery, London. Courtesy of Stephen Friedman Gallery (London)

- and James Cohan Gallery (New York). © Yinka Shonibare MBE
- 15-1 Photo Béatrice Hatala, Paris
- Photo Philippe Maillard, Paris 15-4 Photo Mohamed Redjah
- 15-5Photo Mohammed Ahmed
- 15-7 North Carolina Museum of Art, Raleigh, N.C. #98.6
- 15-8 Fine art photography by Black Cat Studio, San Rafael, CA. Courtesy Color of Words Fine Arts Management
- © A.D.A.G.P., Paris and D.A.C.S, London 2007
- 15-11 Photo Rüdiger Lubricht
- 15-12 Photo Jerry L. Thompson, Amenia, N.Y.
- 15-15 Courtesy of Stephen Friedman Gallery (London) and James Cohan Gallery (New York). © Yinka Shonibare MBE.
- Milwaukee Art Museum, W.I # M1993.191
- 16-2 B.M. # SL.1368
- Gibbes Museum of Art, 16-3 Charleston, SC. # 68.18.01
- John Michael Vlach
- Museum of Fine Arts, Boston. # 64 619
- Art Resource, New York
- Whitney Museum of American Art, New York. Photo by Geoffrey Clements. # 32.83
- San Francisco Museum of
- Modern Art. # 52-4695 16-11 Scala. © D.A.C.S., London
- 2007 16-13 Photo Denis Valentine, Kingston, Jamaica
- 16-14 Hirshhorn Museum and Sculpture Garden, Smithsonian Institution. Gift of Joseph H. Hirshhorn, 1966. Photo Lee Stalsworth. # 66.410 © Romare Bearden Foundation/D.A.C.S., London/V.A.G.A., New York
- 2007 16-20 Wadsworth Atheneum Museum of Art, Hartford, CT. # 1989.17
- 16-21 Robert Farris Thompson
- 16-22 Fowler. # X94.151 16-23 Photo David Brown
- 16-26 Photo Jim Nedresky
- 16-29 Courtesy Dallas Museum of Art

Index

aale (Yoruba power construct) 10, II

Abakwariga, the: adze 86, 3-15

Abahuwan, Abbas 531

Abdalla, Mohammed Ahmed 506 bowl 506, 15-5 Abomey (Benin) 257; palaces 257 260, 263, 8-44; shrine 262, 8-54 Accra (Ghana) 225; Achimoto College 226 Adama, Mobodo 102 Adamawa Plateau 102 Addis Ababa (Ethiopia): Fine Arts School 75 Adéagbo, Georges 271, 503; Abraham 271, 8-68 adinkra (Akan cloth) 207, 208-9, 510, 7-13 adire cloth, Yoruba 268, 8-63 Adjukru, the 203, 7-7 Ado Ekiti (Nigeria): palace 265, 8-58 adzes see axes and adzes Afflatoun, Effie 73 Afikpo Igbo, the 300, 9-40 afin (Yoruba palace) 239-40 Afolabi, Iacob 267 Afonso Mvemba a Nzinga 351 African Americans 501, 502–3, 515, 516–17, 523–4, 528–9; architecture 190-91, 517-18, 6-37, 16-3, 16-4; ceramics 530-31, 16-19; Harlem Renaissance 489, 524; installations 535-6, 16-25 murals 528, 16-15; music 521-2, 530, 532; painting, collage and mixed media 519, 520, 521, 522, 525-6, 527-8, 529-30, 531-2, 537, 16-1, 16-7, 16-11, 16-12, 16-14, 16-16-16-18, 16-20; popular and ritual arts 532–7, 16-22–16-26; quilts 518–19, 16-5; sculpture 522–3, 524–5, 526–7, 538, 541, 16-6, 16-8-16-10, 16-13, 16-28, 16-32; slave drum 517, AfriCOBRA 529 Afrikaaners 464–5, 469, 471, 476, 489, Agadez (Niger): Great Mosque 36, Agaja, king of Dahomey 256 Agasu, the 256 agba (Ogboni drum) 243, 8-22 Agbandana Nri (Nigeria): shrine 288-9, 9-27 Agbedeyi Asabi Ija: vessel 249, 8-33 agere ifa (Yoruba divination cup) 246, Agoli Abo, king of Dahomey 257, 8-45 Agwa (Nigeria): okoroshi maskers 297–9, 9-37; mbari 293, 295, 9-33, 9-34 AIDS 497, 512 Ainslie, Bill 495 Aja, the 228, 256, 261 Akan, the 130, 162, 196-7; contem-

porary arts 224–6; drums 216–17, 7-25, 7-26; goldwork and goldweights 197, 201,

(containers) 205, 7-9; regalia 199–200, 205; stools and chairs 200-1, 213, 7-20; terracottas 200–1, 213, 7-20; terracottas 209–11, 7-14–7-16; textiles 207–9, 7-11; thrones 201, 7-4; wooden sculpture 211-12, 213, 7-16; see also Asante; Fante; Ghana; Lagoons Akanji, Adebisi 267–8; shrine wall 267, 8-62 Akenzua II, Benin king 274-5, 284, 9-4 Akhenaten (Amenhotep IV) 53-4, Akhetaton 53 ako (Yoruba burial effigy) 10, I Akpan, Sunday Jack 309, 503; memorial figure 309–10, 9-53 Aksum (Ethiopia) 61, 62, 64; monoliths 63, 2-24; palaces 62-3, akua ma (Akan figures) 211-12, 213, 7-16 akunitan (Akan cloth) 207, 209 Akwa (Nigeria): masquerades 299, 9-38, 9-39 akwambo (Fante festival) 223-4, 7-37, 7-38 Akwamu, kingdom of 196 akwanshi (monoliths) 319-20, 10-2 Akye, the: drums 221, 7-33 Akyem, kingdom of 196 Ala (deity) 293, 295, 9-33, 9-34 al Bakri (Muslim scholar) 105 al-B'rak masquerades, Baga 178, 179, Alexander the Great 61 Alexander, Jane 495; Butcher Boys 495-6, 14-55 Algeria 22, 40-41, 504-5; Berbers/Tuaregs 32–4, 40, 1-19, 1-31; rock art 25, 26, 1-5–1-7, 1-9; see also Mzab; Timgad Alhadeff, Maurice 398 Allada, kingdom of 256 allo/allo zayyana (Islamic writing board) 97, 3-30 alo alo (Mahafaly memorial posts) 455-6, 13-42 altars 120; Bamana 119, 4-23; Benin (royal) 279, 280, 9-9; Fon 260-61, 8-51; Lower Niger 302-4, 9-42-9-45; see also personal altars; shrines 'Alunga society, Bembe 414, 416; mask 416–17, 12-25 Alwa, kingdom of 64 Amanishakhito, Queen; tomb ornament 59, 2-18 Amanitare, Queen 59, 60 Amarna Period (Egypt) 53, 54, 55; statue of Akhenaten 54, 2-12 Amenhotep III 53 Amer, Ghada 508, 509; Black and White French Kisses 508-9, 15-9 Amin, Idi 461 Amistad mutiny 528

205-6, 7-2, 7-10; kuduo

temple 57, 2-16 Anatanosy, the (Malagasy sculptors) 455 Anatsui, El 227; Old Man's Cloth 227, 7-43 ancestor figures: Beembe 361-2, 11-20; Hemba 408, 12-13; Oron 310, 9-54 ancestral screens, Kalabari 313, 9-60 Ancient Mother (Senufo) 144-6, 5-21 Angas, G. F.: Utimuni 482, 489, 14-31 Angola 351, 364, 395; animal headdress or mask 351, 11-2; see also Chokwe; Pende; Salampasu Anokye 201 anthills see termite mounds Anthony, St, of Padua ("Toni Malau") 354-5, 11-8 anthropomorphism 15 Antuban, Kofi 226 Anubis (deity) 56 Anyi, the 196, 221; ceramics 209, 211, 7-14; sculpture 215 Aowin, the: ceramics 209, 211 apartheid 465; and art 492-6 Arabs 23, 35, 36, 38, 431, 434, 437; slavers 402, 409 archaeological artifacts, illicit trade in architecture/buildings/dwellings: African-American 190-91 517–18, 6-37, 16-3, 16-4; Afro-Brazilian 264–5, 8-57, 8-58; Berber 32–5, 1-19–1-23; Cameroon 325–6, 10-9–10-11; Dogon 137–40, 5-10–5-14; Egyptian 48–9, 2-5, 2-6; Hausa 94, 95, 3-27, 3-28; Kuba 384–5, 11-54, 11-55; Mali 116, 4-17; Mangbetu 422–3, 12-34; Musgum 85, 3-13; Nankani 162–4, 5-43, 5-44; Nguni 486, 14-38; Swahili 435-8, 13-8-13-11; see also mosques; murals; shrines; temples Ardra, kingdom of 228 Areogun of Osi Ilorin: bowl 246-7, 8-28; mask 256, 8-43 Ariwajoye I, Yoruba ruler 239, 8-18 arkilla (Fulani wedding blanket) 99,

3-34

Arussi, the: tombs 456, 13-44

goldweight 16; swords 201 Asante Confederacy 196, 201

asen (Fon altar) 260-61, 8-51 ashenad (calabash supports) 36-7

asipim (Akan chairs) 201, 213 Aswan High Dam (Egypt) 44, 64, 70

asasia (Akan cloth) 208

asie usu (earth spirits) 214

atano shrines 212, 7-19

Asafo (Fante military associations) 221, 222; akwambo 223–4, 7-37,

7-38; flags 223, 224, 7-35, 7-36, 7-38; posuban 222–3, 7-34
Asante, the 17, 196, 197, 205; carvings

and shrines 212-14, 7-17-7-19

Amun/Amon (deity) 53, 54, 57, 59;

Atnafu, Elizabeth 75, 508 Aton/Aten (deity) 53, 54 a-tshol see tshol 'authentic" art objects 152 Awa (Dogon society) 140, 141 axes and adzes: Abakwariga (Jukun) 86, 3-15; Kisalian period 401, 12-2; Luba 403, 12-5; Shona, Thonga and Venda 477, 14-21; Yaka 371, 11-35; Yoruba 248, 8-31 Ayivi, Christine Ozoua 194; Untitled 194, 6-42 Azande, the 17, 400, 414, 418-19, 423; sanza 419, 12-29; see also Mani society babalawo (Yoruba diviners) 245, 246 Babungo, king of (Cameroon) 329, 10-15 Baga, the 171, 176; masquerades 176–9, 6-13, 6-15, 6-16; tshol ("medicine") 176, 6-12 bago bundo (Dogon masquerade) 140-41 Baham (Cameroons grasslands): palace 326, 10-10 Bak (sculptor) 54 Baker, Josephine 523 Baki, Salu 178 Bakor-Ejagham, the 321; monoliths 319-20, 10-2 Ballana culture (Nubia) 63, 64; chest 63, 70, 2-25 Ballom, the: olifant 172, 6-6 Bamako (Mali): artists 128–9, 164–5 Bamana, the (Mali) 18, 104, 209; bogolanfini cloths 118-19, 123, 4-21; boli altars 119, 4-23; gwandusu and gwantigi figures 113, 4-13; jonyeleni figures 115, 4-14; jow (associations) 112–13; kala nege (staff) 113, 4-12; puppets 122-3, 4-26; see also Ci Wara; Komo; Kono; Kore; Ntomo Bamgbose (Areogun) 256; epa mask 256, 8-43 Bamileke (Cameroon): Kuosi masks 334-5, 10-25 Bamum (Cameroon) 324; nja festival 333; palace 325-6, 10-9; see also Njoya, Prince banda masquerades, Nalu 177-9, Bandiagara escarpment (Mali) 131, 132, 5-2, 5-11 Bandjoun, kingdom of: Msop masks 335-6, 10-26 banganga (Kongo healers) 359, 360, Bangui (Central African Republic) 102, 103 Bankoni (Mali) 108; terracottas 108, barkcloth, Mbuti 423-4, 12-36

basketry: Buganda 446; Chewa masks 447–8, 13-30; Cross River masks

323, 10-8; Ga'anda 84, 3-12

Basquiat, Michel 520

Bassa, the 179

Bassari (Balian), the: masks/ masquerades 173-4, 6-8 batakari (Akan tunics) 207, 209, 7-12 bateba figures, Lobi 154, 155, 5-33, 5-34 batik, Nigerian 268, 8-64 Battis, Walter 489 Baule, the 196, 203; masks/masquerades 218-21, 7-28-7-31; regalia 203, 204; sculpture 214-16, Bay Akiy, king of Isu 330, 10-18 Baya (Berber painter) 42 beadwork: Akan 199, 205; Dinka 458, 13-46; Zulu 482–3, 14-1, 14-33 Bearden, Romare 527; The Prevalence of Ritual: Baptism 527-8, 537, 16-14 Bedia, José 538-9; Lembo brazo fuerte 539-40, 16-30 Beembe, the 351; ancestor figures 361–2, 11-20; muzidi (man-nequins) 357, 11-12 beer vessel, Zulu 485–6, 14-37 Beier, Georgina 268, 398, 529 Beier, Uli 398, 529 bekhenet (gateway) 57, 58, 59-60, 2-19 Belkahia, Farid 42, 289; Hand 42, 1-33 Bellanda, the: tombs 456 Bembe, the 416; see also 'Alunga; Elanda Benin 17, 102, 228, 229, 236, 272, 273-4, 308; British punitive expedition 273, 523, 9-2; contemporary art 271; heads 279-82, 9-11-9-13; ivories 280, 282-3, 9-10, 9-16; masks/masquerades 283-4, 9-16, 9-17; oba 39, 274-6, 277, 279, 280, 9-4, 9-13; oni 198; palace 273, 275, 276; personal altars (ikengobo) 275, 279, 303, 308, 9-1, 9-9; plaques 275, 277-8, 9-5, 9-7, 9-8; Portuguese 282-3, 9-15; royal altars 279, 280, 9-9; shrines 276-7, 9-6; see also Abomey Benin City 274, 284, 9-3 Benue River 82, 86, 88, 102 Berbers 23, 28, 30, 32, 36; architecture and household arts 32-5, 1-19-1-23; clothing 39-40, 1-30; contemporary art 42; jewelry 38-9, 1-1; pottery 33, 1-19; rock art 26, 28, 1-8-1-9; sculpture 27, 1-10; see also Tuareg, the Bester, Willie 492-3; Semekazi (Migrant Miseries) 493, 14-50 Bete, the 195 Bhenga, Gerhard 489 Bidan, the 36 Bidjogo, the 174, 176; masks/masquerades 174-5, 6-9 bieri (reliquary) figures, Fang 340–41, 10-30–10-32 bifwebe (Luba and Songye masks) 406-7, 411-12, 12-11, 12-18 Biggers, John 537; Shotguns 537,

Biko, Steve 495 bilongo (Kongo empowering substances) 359-60, 361 Bimpong, Bright 510 Bini, the: masks 307, 308, 9-51 Binji, the 392; masks 392-3, 11-67 binu (Dogon ancestors) 137 Biokou, Simonet 263 Birch, Willie 541; The Trickster 541, 16-32 Bissau (Guinea Bissau): Carnival 175-6, 6-10 biteki (Yaka power figures) 372-3, 11-37 bitumba (Kongo funerary figures) 357, 358 11-13, 11-15 blacksmiths 112, 113, 120, 133, 148, 159 blankets, Fulani 99-100, 3-34, 3-35 Bleach, Gordon 515 bo (Dahomey sculpture) 258 Boakye, Yaw 227 Bobo, the 130, 154, 160–61; masks 161 bocio (Fon sculpture) 258–60, 8-46-8-50 body painting 15, 39; Nuba 14, 458-9; see also scarification Boer War 465, 476 Boghossian, Skunder 75, 507, 529: The Night Flight of Dread and Delight 507, 15-7 Bogolan Kasobane (art group) 165, 289 bogolanfini (Bamana textiles) 118-19, 123, 128, 4-21 boli (Bamana altars) 119, 4-23 Boma, the 351; memorial houses 358, 11-15 Bondo see Sande Bongo, the: funerary arts 456, 13-43 Bono, kingdom of 196 Bonsu, Osei 216, 226, 7-1; drum 216, 7-25 bonu amwin (Baule mask) 220-21, 7-31 Book of the Dead 55-6, 70, 2-15 Bornu, kingdom of 91, 97 Botswana 465; Kuru Trust 484 Bouabré, Frédéric Bruly 195; Knowledge of the World series 195, 6-44 Bougouni (Mali) 108 bowls: Areogun 246–7, 8-28; Foumban (Bamum) 329–30, 10-16, 10-17; Luba 405-6, 12-8; Mamluk 67–8, 2-31; Olowe of Ise 249–50, 8-35; Sudan 506, 15-5; Venda 476, 14-20 Bozo, the 121 brasswork: Benin 275, 279, 281, 282, 9-1, 9-11-9-13; Ife 233-4, 8-10, 8-11; Lobi 155-6, 5-35; Mamluk 67-8, 2-31; Senufo 147, 5-24; Yoruba 512-13, 15-14 Brazil: architecture 264-5; masquerade 533, 16-21; sculpture 535, 16-24 British, the 273, 461, 465, 471, 523 bronzes/copper alloy: Benin 275, 277–8, 9-5, 9-7, 9-8; Cross River 320, 10–3; Ife 234–5, 8-12; Igbo 285-7, 9-20-9-22; Jenne 107-8, 4-5; Yoruba 234-5, 8-12 Bubalous Style rock art 23 buffalo masks, Tabwa 410-11, 12-17 Buganda, the: basketry 446; Luzira Head 445, 13-26; terracotta vessels 445-6, 13-27 Buli Master: stool 404, 405, 12-5 Bullom, the 191 Bura terracottas 80-81, 3-5, 3-6 Buraimo, Jimoh 267 burial practices see funerary arts: pyramids; tombs Burkinabe, the 130, 131, 154 Burkino Faso 37, 143, 153-4, 164: see also Bobo; Bwa; Lobi; Mossi; Nankani Burundi 431; basketry 446 Bushoong, the 17, 381, 382 Bwa masquerades 156-8, 5-36-

bwaantshy (Kuba state dress) 383, 11-52 masks/masquerades 117-18, 4-18-4-20 Bwami society, Lega 414-16, 12-20; circumcision 118, 134, 181 figure 415, 12-23; masks 415, 12-21, 12-22 Clark, Sonya 536; Bristle Sprout 536-7, 16-26 Bwende, the 351; niombo (mummies) Cleopatra VII 61 355-6, 11-10 clitoridectomies 118, 134, 181, 186, bwoom masks, Kuba 390, 11-63 190 Byzantine empire 23, 30, 31, 61, 64, Congo, Democratic Republic of 296, 106 297, 351, 364, 375, 400, 415, 424; 20th-century art 424–7; see also Beembe; Bembe; Kinshasa; Luba; Cairo (Egypt) 67; 20th-century art and architecture 72-3 Mangbetu; Pende calabashes (gourds) 36-7; Cameroon Congo River/basin 350-51, 400 329, 10-15; Fulani 100, 102, 3-36, Coniagui, the 3-39; Ga'anda 84–5, 102, 3-12; containers: Kuba 387, 11-58; Pare 441–2, 13-19; Shambaa 441–2, Nankani 163, 5-45, 5-46; Tanzanian 441-2, 13-19 13-20; Sotho 481-2, 14-30; see Camara, Fode 127; Le Vieux Nègre... also bowls; calabashes; cups 127, 4-33 contemporary arts: African-American Camara, Habou: painted interior 123, 528-32, 535-6, 537-8; Akan 4-27 224-6: Brazil 535: Central Africa Camara, Seydou 115 348–9; Côte d'Ivoire 193–5; Cuba Cameroon 81, 86, 318–29; expatriates 514–15; see also Cameroon 538-40; Egypt 508-9; Ethiopia 507-8: Ghana 68, 224-6, 510 grasslands; Duala; Mambila; Guinea 193, 342; Haiti (flags) Musgum 533–4; Kenya 446, 462–3; Kinshasa 395–9; Liberia 193: Cameroon grasslands 318-19, 323-5; bowls 329-30, 10-16, 10-17; fon Madagascar 455–6; Maghreb 198; masks/masquerades 333-6. 504-6; Makonde 451-2; Malawi 10-22-10-26; palace architecture 463; Senegal 125-8; South Africa 325–6, 10-9–10-11; portrait figures 331–3, 10-18–10-20; royal 487-9, 495-7, 515; Sudan 506-7; Tanzania 462; Tsonga 480; art and artifacts 326-7, 329, Tunisia 43, 504; Uganda 461-2; 10-15; stool-thrones 327-8, 329, Venda 480 10-12, 10-13; textiles 327, 328, Conwill, Houston 535-6; Juju 10-14 Installation 536, 16-25 Camp, Sokari Douglas 501; Otobo Masquerade 312–13, 314, 9-59 Copts/Coptic art 62, 64, 67; textile 62, 2-22 Campos-Pons, Maria Magdalena 540 Cosentino, David: flag for lwa 533-4, When I Am Not Here/Estoy Alla 16-22 540-41, 16-31 Côte d'Ivoire 105, 143, 153, 154, 168; Candomblé religion 532, 535, 537 canoe art, Duala 337–9, 10-28 contemporary art 193-5; Flali masquerades 189–90, 6-35, 6-36; see also Dan; Guro; Lagoons canoe houses, Kalabari 310 Cardew, Michael 446 peoples; We Carter, Howard 54 Cotonou (Benin): contemporary art Carthage 27, 28, 35; stele 27-8, 1-11 271 Casamance region (Senegal): masquerades 173, 174, 6-8 Creole communities 190 Cross River region (Nigeria) 318, 319; festivals and masquerades ceramics/pottery/terracottas: African-American 530–31, 16-19; Akan 209–11, 7-14; Berber 33, 1-19; 321-3, 334-6, 10-6-10-8 10-22-10-26; metalwork and Bura 80-81, 3-5, 3-6; Cameroon sculpture 319, 320, 10-3; mono-329–30, 10-16, 10-17; Dakakari liths 319–20, 10-2; societies and nsibidi signs 320–21, 10-4, 10-5 82, 3-8; Egyptian 45-6, 2-2; Ganda 445-6, 13-27; Ife 231-3, 234, 8-6-8-9; Jenne 107, 4-1; crucifixes, Kongo 354, 11-7 Cuba 502; art 525, 538-41, 16-11, Kenyan 446, 506, 13-28, 15-5; Koma 161–2, 5-42; Kumbi Saleh 16-30, 16-31 Cullen, Countee: "Heritage" 524 cups: Kuba 386–7, 11-57; Wongo 393, 11-68; Yoruba (divination) 246, 106, 4-3; Lydenburg heads 471, 14-11; Mangbetu 423, 12-35; Nok 77, 79, 80, 3-1-3-3: Nubian 46. 2-3; Owo 236, 8-13, 8-14; cycles and circles 449 Sakadiba 363, 11-23; Sao 81, 3-7; Sotho 487, 14-40; Zulu 385-6. Da Costa, Joao Baptist: mosques 264, 8-57 Chad/Lake Chad 76, 77, 81, 102; Dagomba, the 209 see also Kanem; Kanuri Dahomey 17, 228, 264; see also chairs see stools, stool-thrones and Fon, the chairs Dakakari, the 82, 85; terracottas 82, 3-8 Chamba, the 86, 87-8; masks 87, 90, Dakar, School of 125, 126, 127 3-16; wooden figure 88, 3-17 Dakpogan, Théodore and Calixte 263: Cherkaoui, Ahmed 41, 502; Homage Cakatu 263-4, 8-56 to Fatimah 41, 1-32 dama (Dogon masquerade) 141, 143 Chewa, the 447: female figure 448, Dan, the 183, 186; masks/masquer-13-31; Nyau masks 447-8, 13-30 ades 183-5, 6-23, 6-24; spoon Chibunda Ilunga, king of Lunda 363, 364; figure 363, 11-24 187, 6-30; women's arts 186-7 Danbala (deity) 534 Chinguetti (Mauritania) 106; mosque dance wands, Yoruba 247-8, 251, 36, 111, 1-26 8-30, 8-36 Chokwe, the 351, 363, 364, 365; chair Dar es Salaam (Tanzania): British colleges 461; "Tingatinga" 367-8, 11-29; divination 365-6, 11-26; masks/masquerades 368–71, 11-30–11-33; sculptures studios 463 13-55 dating techniques 58, 107 363, 364, 365, 11-24, 11-25; staff David, King 65, 69 366–7, 11-27; stool 367, 11-28; water pots 363, 11-23 Davies-Okundaye, Nike 268; Oshun

Goddess 268-9, 8-64

Debela, Achamyeleh 75, 507-8

Denkyira, kingdom of 196

Derassa, the: tombs 456

Chopi, the 478, 481; headrests 478

Christianity 16, 19, 35, 62, 91, 295, 309, 351, 359, 452, 535

Ci Wara/Tyi Wara 113, 116-17;

Desta, Gebre Kristos 75, 501; Crucifix 75. 2-42 Diabate, Ismail 128; Si Kolona 128, Dike, Ndidi 289 Dinka, the 458; beadwork 458, 13-46 Diola, the see Jola, the divination 366; Chokwe 365-6. 11-26; Fon 257, 261-2, 8-53; Luba 402, 406, 12-10; Venda 476, 14-20; Yoruba (ifa) 245-7 8-25-8-28 diwani (Nubian marriage hall) 70, 2-36 Djerma/Zerma, the 92, 99; armor 92, 3-24 Djilatendo (Tshyela Ntendu) 425; L'Église 425, 12-37 Djoser's funerary complex (Saqqara) 48-9, 2-5, 2-6 d'mba masquerades, Baga 179, 6-16 Do (Bwa organization) 156–7, 158 Do masks/masquerades, Fante 221, 7-32 Dogon, the 130, 131, 132-3; architecture/architectural sculpture 137-40, 5-10-51-14; masks/ masquerades 15-16, 140-43, 158 449, 5-15-5-18; sculpture 133-7, 5-4-5-9 Dolo, Aminghere 165; sculpture 165, Donaldson, Jeff 529, 530; Wives of Shango 529–30, 16-16 Donkor, Gottfried 510 Douala (Cameroon) 348–9, 515 Douglas, Aaron 525–6; Building More Stately Mansions 526, 16-12 Drakensberg Mountains (South Africa): San rock art 469-71, 14-9.14-10 drapo (Haitian flags) 533-4, 16-22 drums: African-American slave 517, 16-2; Akan 216-17, 7-25, 7-26; Fante 216; Kongo 355, 361, 11-9, 11-19; Lagoons 221, 7-33; Ogboni society 243, 8-22 Duala, the 336; canoe art 337-8, 10-28; masks 339, 10-29; stools 336-7, 10-27 Du Bois, W.E.B. 523, 524 Dumile (Dumile Mslaba Feni) 492, 501; Agony 492, 14-49 Duncanson, Robert 519 Dungur (Ethiopia): palace 62-3, 2-23 Eakins, Thomas 521 Ebrie, the 204, 215 edan (Ogboni sculpture) 243, 8-23 Edmondson, William 520 Edo, the 272, 276, 282, 302; Ekpo masks 306-8, 9-50, 9-51; ikengobo (personal altars) 302; see also Okpella, the Efiambolo: alo alo (memorial posts) 455-6, 13-42 Egonu, Uzo 512 egun masquerades (Brazil) 533, 16-21 egungun (Yoruba masquerades) 191, 252-4, 8-38, 8-39 Egypt, ancient (Kemet) 16, 17, 19, 44–5, 52, 56, 57–8, 60–61; Amarna Period 53, 54; animal sacrifice 61; Book of the Dead 55-6, 70, 2-15; ceramics 45-6, 2-2; Djoser's funerary complex 48-9, 2-5, 2-6; dynasties 48; female figures 51–2, 2-9; Great Sphinx 50, 2-7; ibis coffin 61–2. 2-21; mastaba 49, 50; Mamluk art 67-8, 2-31; Menkaure and Khamerernebty (statue) 51, 2-8; mirror 53, 2-11; Palette of Narmer 46-7, 59, 2-4; Ptolemaic period 61; pyramids (Giza) 49-50, -7; Sphinx 50, 58, 2-7; temples 57, 59-60, 2-16, 2-19; tombs and debtera (Ethiopian lay priests) 69, 70 tomb paintings 45, 52-3, 2-10; Tutankhamun's tomb/treasure 54-5, 2-13, 2-14; writing 45, 46,

Derrida, Jacques 502

47; see also Copts; Kawa; Kush; Nubia Ejagham, the: masks/masquerades 321-3, 10-7, 10-8; monoliths 319-20, 10-2; Ngbe society 321-2, 10-5, 10-6; ejumba (Jola horned mask) 173 Ekiti Yoruba 255 ekpe (Igbo leopard societies) 288, 9-24 ekpo masks, Ibibio 304-5, 9-46, 9-47 Ekpo masks (Edo) 306-8, 9-50, 9-51 Elanda society, Bembe 414, 416; mask 416, 12-23 El Loko 509, 510; Metamorphosis 509–10; *Tree* 2 509, *15-10* El-Mafazy, Said Abdullrahan 434 el Salahi, Ibrahim 73-4, 501, 506; Funeral and Crescent 74, 2-40 Emokpae, Erhabor 266; Olokun 266, Enwezor, Okwui 503 Enwonwu, Ben 265-6, 502; Anyanwu 266, 8-59 epa masquerades, Yoruba 255-6, 8-42, 8-43 ere ibeji (Yoruba twin figures) 251-2, 8-37 Eresonyen, Oba 283 Eritrea 62 Eshu (deity) 244, 245, 247-8, 536-7, 8-29 Esie (Nigeria): soapstone figures 237-8, 8-17 Esquivél, Ramón: Throne-Altar for St. Lazarus/Babalú Ayé 534–5, 16-23 Essamba, Angèle Etoundi 514-15; Le fil conducteur 514, 15-16 Essaydi, Lalla 504 Essoua, Isaac (Malam) 349; installation 349, 512, 10-45 Ethio-Sabaen kingdoms 62 Ethiopia 45, 62, 64, 68, 69, 461, 502, 509; Arussi tombs 456, 13-44; Christian art and sculpture 16, 17, 64-5, 68-9, 2-27, 2-28, 2-32; contemporary art 75, 507-8, 529; see also Aksum; Konso; Lalibala; Oromo; Solomonic periods Ewe, the (Togo) 18, 207, 228, 261 Eweka II, Benin king 279, 9-9 Exana, Aksumite king 63, 64 export arts 152, 451 Eyinle (deity) 249 fa (Fon divination) 257, 261 Fa (deity) 257, 262 Fabunmi, Adebisi 267 face painting 15, 459, 13-47 fake art objects 152 Fakeye, Lamidi 528–9 Fang, the 339-40; bieri (reliquary) figures 340-41, 10-30-10-32 masks 344-5, 10-36, 10-37 Fani-Kayode, Rotimi 512; Bronze Head 512–13, 15-14 Fante, the 196, 197, 213; ceramics 210, 211; drums 216; linguist staffs 202, 7-5; masquerades 221, 7-32; see also Asafo Faras (Egypt) 64; cathedral mural 64, 67, 2-26 Fathy, Hassan 72-3; New Gournia 73, 2-38 Faye, Mor 126; Untitled 126, 4-32 Fernandes, Valentin 171, 172 Fesira (sculptor) 455 FESPACO 165 Fezzan region 23; rock art 23-4, 1-2, film festival (Ouagadougou) 165 flags: Asafo 223, 224, 7-35, 7-36, 7-38; Haitian drapo 533-4, 16-22 Flali masquerades 189, 6-35 Fleming, Tuliza 529–30 Folarin, Agbo 270; frieze 270, 8-66 Fon, the 18, 228, 229, 238, 256; asen (memorial altars) 260-61, 8-51. bocio 258-60, 8-46-8-50; deities 533, 534, 535; divination 257, 261-2, 8-53; royal arts 257-60,

5-38

Frobenius, Leo 400, 523 Fulani, the 77, 91, 93, 97–102, 3-32, 3-33; clothing and blankets 39, 77. 99-100, 201, 3-34, 3-35; gerewol (festival) 100-2, 3-37, 3-38; mosques 97-8, 3-31; see also Wodaabe Fuller, Meta Warrick 522; Ethiopia Awakening 522-3, 16-8 funerary and memorial arts and practices: Akan 209-11, 7-14, 7-15; Arussi 456, 13-44; Bongo 456, 13-43; Egypt 48–9, 55–6, 70; Fon 260–61, 8-51; Ghana 210, 224–6, 7-15, 7-39-7-41; Giriama 438, 13-12; Ibibio 308-10, 9-52, 9-53; Kalabari 310, 312, 913, 9-57, 9-60; Kongo 357, 358, 11-13, 11-15; Konso 456–7, 13-45; Kuba 389, 391-2, 11-65; Mahafaly 455-6, 13-42; Malagasy 453-6, 13-40-13-42; Nyau society 447; Senufo 148, 150–51, 5-26, 5-27; Yombe 356–7, 358, 11-11, 11-15; Yoruba 234; Zaramo 439, 13-13, 13-14; see also reliquary figures; tombs Fungom (Cameroons grasslands): palace 326, 10-11 Fustat (Egypt) 67 Futa Diallon (Guinea): Fulani 97-8, 3-32; mosques 97-8, 3-31 Ga'anda, the 82-5, 86; hleeta (scarification) 83-4, 3-10; terracotta figures 83, 3-9; wedding basket of calabashes 84–5, 102, 3-12 Gabon 339; masks/masquerades 344-7, 10-36-10-41; reliquary figures 339-44, 10-1, 10-30-10-35 gadl (lives of the saints) 66, 2-29 Galla, the: jewelry 457 Gambia 102, 168, 192; monoliths 112, 4-11 Gardaia (Algeria): mosque 35, 1-24 Garvey, Marcus 523, 525 Gasteli, Jellel 43, 504; White Series 43, Gbana 182-3; regalia 199-200, 7-3 Gbandi, the: Poro masquerades 181 gbini masquerades, Mende 181, 6-18 gbon (Senufo mask) 150, 5-27 Gebel Barkal (Egypt): temple of Amun 57, 2-16 Geers, Kendell 515 Gelede Society masquerades 191, 254, Gensin, Jean 194 Gera (Ethiopian lay priest) 69, 507; scrolls 69–70, 2-34 Gere, the 185 gerewol (Fulani festival) 100-2, 3-37, Gertrude, Sister 520 Ghana 36, 102, 105, 154; contemporary artists and academies 226-7 7-42-7-44; contemporary funerary arts 68, 224-6, 7-39-7-41; expatriates 510; royal festivals 217–18, 7-27; see also Akan; Asante: Fante; Nankani; Soninke; Wagadu Gharbaoui, Jilali 41 ginna 138, 5-11 Giriama, the: vigango (memorial planks) 438, 13-12 Giza (Egypt): pyramids 49–50, 2-7 glass painters, Senegalese 125, 4-30

Glele, king of Dahomey 257, 258,

259-60

8-44, 8-45, 8-47, 8-49-8-51;

vodun 258, 261, 263

190-91, 6-37

103.3-40

shrines 261, 262-3, 8-52, 8-54;

Fortsville (Liberia): Macon Hall House

Fosso, Samuel 103, 503; The Chief

Foumban (Bamum): bowls 329-30,

10-16, 10-17; palace 325-6, 10-9

Freetown (Sierra Leone) 191; festivals and masquerades 191–2, 6-38,

Glover, Ablade 226: Market Lanes 226-7, 7-42 masquerades 182, 6-21 Goba, Ajani and John 191 Gola, the 179 Goldblatt, David 492; Monuments to the Republic of South Africa 492, goldwork: Akan 197-8, 201, 205-7 7-2, 7-10; Baule 204; Egypt 54-5, 2-13; Ghana 199, 7-3; Lagoons 203, 204, 7-6; Nubia (Meroitic) 59, 2-18; South Africa 471, 14-12; Wolof 111-12, 125 goli (Baule masquerade) 218–20, 7-30 gon masks, Kwele 345–6, 10-39 Gondar/Gondarene style (Ethiopia) 68; church of Debre Berhan Selassie 68-9, 2-32 Gongola River region 82-5, 86 gourds see calabashes graves see tombs Great Rift Valley 430, 443 Grebo, the 185 Griaule, Marcel 133 Grillo, Yusuf 313 Gu (deity) 188, 259, 6-34 Guezo, Dahomey king 256, 257 Guinea 168, 177, 179; contemporary art 193, 348; ivories 171, 172; stone figures 169, 170; see also Baga; Futa Djallon; Kono; Malinke Guinea Bissau 168, 173, 174, 175; masquerades 175-6, 6-9, 6-10 gunye ge masks, Dan 184, 6-23 Gur speakers 153, 154, 157 Guro, the 187, 194; masquerades 188-90, 6-32-6-36 Gwan (assocation) 113, 115 gwandusu and gwantigi (Bamana figures) 113, 4-13 Gyaman, the 208 Gye (deity) 189, 190 Hadza, the 468-9

Haile Selassie, Emperor 69 hairstyles 15; Fulani 98, 3-32; Luba 405; Maasai 39; Mangbetu 421, 12-32; Nguni 483, 14-32; Turkana 461, 13-51; Yoruba 39 Haiti: caille 518, 16-4; drapo (flags) 533-4, 16-22; Vodou 516, 533-4, 537 Hampton, James 520 "Hangar, Le" (Lumbumbashi artists) 425-6 hanif (Berber cape) 39, 1-30 Harlem Renaissance 489, 524 Harratin, the 36, 106, 123, 1-27 Harvey, Bessie 520 Hassan, Fathi 501 Hassan, Salah 503 Hathor (deity) 46, 51, 53 Hausa, the 77, 86, 91, 530; allo zayyana (writing board) 97, 3-30; armor 92; mosques and civic architecture 93–5, 3-25–3-28; robes 96, 3-29 headrests: Chopi 478; Luba 405, 12-7; Ngoni 485, 14-36; Shona 477-8, 14-22; Tsonga 478, 14-23; from Tutankhamun's tomb 55, 2-14 Heinan, Adam 73 Hemba, the 408; ancestor figures 408, 12-13; so'o mask 408-9, 12-14 Herodotus 32

Hevioso (deity) 260

hleeta (Ga'anda scarification) 83-4,

Hongwe reliquary figures 343-4,

houses/house decoration see architec-

Hughes, Langston 524; "The Negro Speaks of Rivers" 44

Huntondji, Allode: bocio 260, 8-50

Hirst, Alex 512

85, 3-10

10-35

Horus (deity) 52, 53

ture; murals

hogon (Dogon priest) 136

Ibibio, the 272, 302; *ekpo* masks 304–5, 9-46, 9-47; memorial arts 308–10, 9-52, 9-53 ivri (Isoko/Urhobo personal altars) Ibn Battuta 37, 431 Ibrahim, Ahmad ibn 68 303-4, 9-44, 9-45 Iyanla (deity) 254 iyepko mask, Bini 307-8, 9-51 Ibrahim, Uthman 266 ibulu lya alunga mask, Bembe 416–17, 12-25 Jamaican art 511-12, 16-13 Idena (Ife "gatekeeper") 229-30, 8-3 je (dye) masquerades, Guro 189–90, 6-36 Idoma, the 272, 308 idu masks 305–6, 9-49 Jenne/Jenne-Jeno (Mali) 107; copper figure 107–8, 4-5; Great Mosque 111, 4-9, 4-10; houses 108, ifa see divination, Yoruba Ife/Ile-Ife (Nigeria) 16, 79, 228, 229, 8-4, 8-5; Archaic period 229–30; 110-11, 4-7, 4-8; terracottas 107, brass and copper sculpture 4-7 jewelry 15, 39; Berber/Tuareg 38-9, 233-4, 235, 8-1, 8-10-8-12; Idena 229-30, 8-3; Ona Group 269-70; 40, 1-1, 1-31; Ethiopia 457, 13-1; Fulani 98-9, 3-33; Jenne 107: oni 232, 281-2, 9-14; Opa Lobi 155; Nubia 59, 2-18; Oromo Oranmiyan monolith 229, 457; Rao 111–12, 125; Senufo 147, 5-24; Somali 457; Wolof 8-2; Pavement period 229, 230-35; terracotta heads 232-3, 234, 8-8, 8-9; vessels 231-2, 111-12, 125; Zulu 483, 14-1; see also goldwork; silverwork Jews/Judaism 35, 38, 62, 64, 70, 492; Igala, the 272, 302, 308; *okega* altars (*okega*) 302–3, 9-43 silvérwork 39 Jinaboh II, king of Kom 10-20 Joao I, of Kongo (Nzinga aNkuwa) 351 Igbo/Igbo Ukwu 191, 272, 284, 287; altar stand 286, 9-21; burial chamber 284-5, 286, 9-19; Johannesburg art centers 494–5 Johnson, Sargent 524–5; Forever Free 525, 537, 16-10 double egg with bells 286-7 9-22; finial or flywhisk handle 285, 9-20; masks/masquerades Johnston, Joshua 519 Jo/jo/jow (associations) 112–13, 115, 297-302, 304, 9-37-9-41; mbari 119 houses 293-6, 9-33-9-35; murals Jola masks 173, 6-7 288-9, 290, 9-27, 9-29; personal altars (ikenga) 302, 303, 9-42; Iolof 112 shrines/shrine figures 288-9, Jones, Lois Mailou 524, 529; The Ascent of Ethiopia 524, 16-1 jonyeleni)Bamana figures) 115, 4-14 291-3, 9-27, 9-31, 9-32; title arts and dress 287-8, 290, 9-23-9-25; ugonachonma 296-7, 9-36; uli jow see Jo Jubilee arts center (Johannesburg) patterns 288-9, 9-26 494–5 Igbomina Yoruba 239, 255 Jukun, the 86, 328; adz 86, 3-15 Jula, the 104–5, 143, 204, 206, 208 Ijaw, the 302; see also Kalabari Ijaw ijele masquerades, Igbo 301–2, 9-41 jumba (Swahili stone houses) 435-7, ikenga (Igbo personal altars) 302, 303, 13-8, 13-9 Kabylie art and pottery 32, 33, 39, ikengobo (Benin personal altars) 275, 279, 303, 308, 9-1, 9-9 42.1-19 Ikere (Nigeria): palace 240-42, 8-19, Kafigelejo (deity) 153, 5-32 kagle masks, Dan/We 184, 6-24 Kaka society 191, 6-38 8-20 ikhoko (Pende mask-pendants) 379, Kalabari Ijaw 310; ancestral screens 11-48 313, 9-60; canoe houses 310; festive and funerary dress 310, ikul (Kube swords) 385-6 Ile-Ife see Ife Iloki (artist) 398 Imhotep: Djoser's funerary complex 312, 9-55-9-57; masks 312, 9-58; sculpture 312–13, 9-59 Kalala Ilunga, king of Luba 363, 402 (Saggara) 48-9, 2-5, 2-6 Kamal, Prince Youssef 72 Inaden, the 38, 40 Iniai, Brahaima 192–3 Kamba schulpture 451 Kamelon Ton (associations) 121-3, 'inland style" stone figures 171 iran (Bidjogo shrine figure) 176, 6-11 4-26 Kamilambian period 401 iroke (Yoruba divination tapper) Kampala (Uganda): Makere 245-6, 8-2 University 461, 462 ironware: Dogon 136–7, 5-9; Konso waga 457, 13-45; Lobi 155–6, kanaga (Dogon mask) 15-16, 142, 5-35; Sara knives 85-6, 3-14; 5-17 Kanem, kingdom of 91, 97 from Upemba depression 401, 12-2; Yoruba 248-9, 8-31, 8-32 Kano (Nigeria) 93, 100; palace of the sarki 94, 3-27 Ishyeen Imaalu masks, Kuba 392, Kanuri, the 91-2, 97, 431; textiles 91, 11-65 isikimanji figures, Ndengese 392, 96, 3-23 Kao. the 459, 13-47 11-66 Isinago masquerades, Makonde 448 Isis (deity) 52, 53, 62 Kaolo (Tanzania): tomb pillars 433 Kappata, Stephen 427 Karagwe (Tanzania) 444–5; bovine Islam/Islamic art/Muslims 16, 19, figure 444, 13-25 29–30, 35, 45, 91, 105, 130, 169, 179, 457–8; and the Akan 197; Kasa-Vubu, Joseph 426 kashekesheke divination, Luba 406, Akan metalwork 104-5; Egyptian 12-10 metalwork 67-8, 2-31; malam 94, kasiya maliro masks, Chewa 447-8, 95-6; Sierra Leone festivals 192, 6-39; Sudanese 77; see also 13-30 Kassa, the 173 Fulani; Hausa; mosques; Qur'an Isoko, the 272, 303; ivri (personal

Kassena, the 164

Huntondji, Tahozangbe: asen 260,

Ibadan (Nigeria): Agbeni Shango shrine 249, 8-34; Mbari Mbayo

hwedom (Akan chairs) 201

workshop 267

Ibadites 35 Ibeto, Christopher 266

shrines) 303, 304, 9-45

13-6; Yoruba 245–6, 8-26

Issakhem 41

Itsekiri, the 272

Katsina 93 Kawa (Egypt) 57-8; Sphinx of Taharqo 58, 2-1 kebul (Jola horned mask) 173, 5-7 ivories: Ballana 63, 2-25; Benin 280, 282–3, 9-10, 9-16; Kongo Keita, Seydou 124; untitled portrait 352-3, 11-5; Lagoons 204, 7-8; 124. 4-28 Lega (Bwami mask) 415, 12-21; Owo 236–7, 8-15, 8-16; Pende Kemet see Egypt, ancient Kendo, Akati Akpele: bocio 259, 8-48; 379, 11-48; Sapi-Portuguese 171-3, 6-5, 6-6; Swahili 434, swords 259-60 Kenfack, Pascal 348, 515; L'Enfant et l'Ancêtre 348, 10-43 Kenilworth Head 476, 14-19 kente (Akan cloth) 203, 207, 208, 209, 212 Kentridge, William 497; Soho's Desk with Ife Head 497, 14-58 Kenya 430, 431, 433, 460, 461; export art 451; healers 442; language 45; stone tombs 433, 13-5; see also Lamu; Nairobi; Pate Island Kenyatta, Jomo 198 Kerma (Egypt) 56; ceramics 46, 2-3 Kgoete, Rose 484; What Do You Do T. Mbeki? 484, 14-34 Khafre, pyramid of (Giza) 50, 2-7 Khalil. Mohammad Omer 75–6 Khartoum (Sudan)44; School of Art 73-5 khasa (Fulani blanket) 99-100, 3-35 Khufu, pyramid of (Giza) 49-50 Kiasi, Nikwitikie: The Man who Became a Monkey 451–2, 13-37 kibulu (Pende ritual houses) 376-7, 11-43 kifwebe see bifwebe Kijango see vigango Kilwa (Tanzania) 16, 431, 434; Great Mosque 431–3, 13-2, 13-3; tombs 433 Kingelez, Bodys Isek 397; Kimbembele Ihunga 397, 11-73 Kinshasa (Congo): contemporary art 395-9 kipoko masks, Pende 377–8, 11-45 Kisalian period 401; axes 401, 12-2 Kissi, the 169, 170, 181 kiti cha ensi (Swahili "chair of power") 434, 13-7 KNUST artists 226-7 Kofi, Vincent 226 Kolo style rock art (Tanzania) 468–9, Koloane, David 494, 495; Made in South Africa No. 18 495, 14-54 Kom, kingdom of 328; portrait figures 331-3, 10-20 Koma 161; terracottas 161-2, 5-42 Kombo-Kiboto, Chief 11-43 Komo (association) 113, 120; komo kun 121, 4-24 Konate, Abdoulaye 128; The Drama of the Sahel 128-9, 4-36 Kongo, kingdom of 351-2; drum 355, 11-9; funerary and memorial arts 355–9, 11-10–11-16; ivories 352–3, 11-10-11-10, Wolfes 352–3, 11-5; minkisi and minkon-di 359–63; and Portuguese 351–2, 355; religious arts 353-5, 11 6-11-8; textiles 352, 11-3, 11-4 Kongwe, the 341 Kono, the 169; masquerades 182, 6-20 Kono (association) 113, 119–20; shrine 119, 4-22 Konso, the: waga (memorial figures) 456-7, 13-45 Koraïchi, Rachid 504; Steel Talismans 504, 15-2 Kore (association) 113, 121; masquerades 121, 4-25 Korhogo (Côte d'Ivoire): tourist arts 151, 153, 5-31 Kosrof, Wosene 507; Night of the Red Sky 507, 15-8 Kot a Mbweeky III, Kuba king 11-52 Kota, the 341–2; mbulu-ngulu (reliquary figures) 342, 10-33, 10-34 Kotoko, the 81 kpaala (Senufo public shelter) 148, 151, 5-30 Kpelle, the 179, 181 kponungo masks, Senufo 150, 5-1 Kran, the 185

Kru masks/masquerades 185, 6-25 ksar/ksour (Berber towns, Morocco) 34, 36, 1-21, 1-22 Kuba, the 198, 351, 381-2; architecture 384-5, 11-54, 11-55; cups 386–7, 11-57; funerary arts 389, 391–2, 11-65; ikul (swords) 385-6; leadership arts 382-3; masks/masquerades 389–92, 11-62–11-65; ndop (royal portrait figure) 383–4, 11-53; state dress 383, 11-52: textiles 387-9, 11-59-11-61; tukula (container) 387, 11-58 kuduo (Akan vessel) 205, 212-13. kuk masks, Kwele 345, 10-38 Kulebele carvers 143, 151-2: Ancient Mother figures 144-6, 5-21; champion cultivator's staff 143, 5-19; Kafigelejo 153, 5-32; "rhythm pounders" 144, 5-20 Kumalo, Sydney 494; Killed Horse 494, 14-52 Kumasi (Nigeria) 97; College of Technology 226–7 Kumbi Saleh (Mauritania) 36; mosque 105-6, 4-2; terracotta figure 106, 4-3 !Kung, the 469-71 Kuosi society masks (Cameroon) 334–5, 10-25 Kure, Marcia 289 Kusasi, the 164 Kush/Kushites 56-60, 198; Sphinx of Taharqo 58, 2-1; see also Meroe/Meroitic period Kwali, Ladi 531 Kvam, Bvu: Bay Akiy 330, 10-18 Kwame Fori II, King 7-27 Kwami, Grace 226 Kwei, Kan 503 Kwele, the 345: masks 345-6, 10-38 10-39 Kwere, the: musical instrument 441, 13-17 Kwifo society masks (Cameroon Grasslands) 334, 10-23, 10-24 Kyaman, the 204, 215

Lagoons people 194, 195, 196, 197 age-grade arts 221; drums 221, 7-33; goldwork 203, 204, 7-6; ivories 204, 7-8; regalia 203–4, 7-7; staffs 202, 203, 7-6, 7-8; terracottas 209–10, 7-14; wood sculptures 215–16, 7-24

Lagos (Nigeria): art colleges 265 266, 269; contemporary artists 270-71

Lalibala/Lalibela (Ethiopia) 64; churches 64-5, 2-27, 2-28; festival of Timkat 69, 2-33 Lam, Wilfredo 525, 539, 540; The Jungle 525, 16-11

Lamu (Kenya) 435; jumba (stone house) 435–7, 13-8, 13-9

landai masquerades, Toma 181-2, 6-19 Landuman, the 176

Langa, Mosheka 515

languages: Adamawa 77; Akan 196, Bantu 86, 431, 438, 464; Berber 23, 36, 41; Chadic 77, 431; Cushite 431, 456; Dogon 130; Gur 153, 154, 157: Kemet 45: Kru 185; Malagasy 431; Mande 104–5; Niger-Congo 77, 86, 168; Nilo-Saharan 45, 76, 77, 91, 430-31, 456; semi-Bantu 319; Senufo 130; Swahili 431

lanterns 192, 6-39 Large Wild Fauna style rock art 23-4, 1-2, 1-3 Lasekan, Akinola 265 Lattier, Christian 193-4, 502; Mask

194, 6-41 Lawrence, Jacob 529 Lega, the see Bwami society Legae, Ezrom 494 Legba (deity) 257, 262, 8-54 Legu (Ghana): akwambo festival 224,

leopard societies, Igbo 288, 9-24 Lesotho 465

Lewis, Edmonia 521; Hagar 521, 16-6 Liberia 168, 172, 179, 184; architecture 190-91, 6-37; contemporary art 193; Poro societies 180-82; soapstone figures 169

Libya 32; see also Fezzan region Lilwa society, Mbole 414, 417-18, ofika figures 417, 418, 12-26 Limpopo valley 464, 471 linguist staffs. Akan 202-3, 7-5 linocuts, South African 493-4,

14-51 Lipiko masquerades (Tanzania) 448-50

Loango, king of 352, 11-4 Lobedu, the 478 Lobi sculpture and metalwork 154-6, 5-33-5-35

Locke, Alain 523-4 Lods, Pierre 398, 425 Logone River region 85 Loma, the see Toma, the lost-wax casting 204, 233, 234 Luba, the 367, 400, 401, 402; axes 402.

12-5; bowstand 402, 12-4; divination 402, 406, 12-10; headrests 405, 12-7; lukasa (initiation emblem) 406, 12-9; masks 406-8, 12-11, 12-12; mboko (figure-with-bowl) 405-6, 12-8; Mbudye association 402, 403; stools 402, 403-4, 12-1, 12-5

Lubaki, Andre 425 Lubumbashi (Congo) 424; 20th century art 424-7

Lucumi religion 525, 532, 540 Luguru, the 441; throne 441, 13-18 lukasa (initiation emblem), Luba 406,

lukwakongo mask, Bwami society 415, 12-22

Lulua, the 393; mother-and-child figure 393–4, 11-69; warrior figures 394–5, 11-70

Lumbo, the 344; masks 346; reliquary figures 344

Lumumba, Patrice 426, 427, 12-39 Lunda empire 351, 363, 364, 371, 375, 379-80; Mwaat Yaav 363, 11-22; vessels 363, 11-23 Lusaka (Zambia) artists 427 Luzira Head, the 445, 13-26 Lydenburg heads 471, 14-11

Maabuube (Fulani weavers) 99 Maasai, the 39, 460, 13-49 Mabasa, Noria: Carnage II 480.

Mabea, the 341; bieri figure 341, 10-32

Mabundo, Gonçalo 491; Rest 491, 14-47

McEwen, Frank 490 Madagascar 430, 431, 452; memorial arts 453–6, 13-40-13-42; painting 452–3, 13-39; see also Merina culture

Maghreb, the 22-3, 27, 30, 43; contemporary artists 504-6: see also Berbers

Magnin, André 503 Mahafaly, the: funerary arts 455–6,

Makoanyane, Samuel 489 Makonde, the 447, 451; containers 450-51, 13-36; masks/masquerades 448-50, 13-32, 13-33, sculpture 450, 451-2, 13-35

13-37 Makua, the 447; masks/masquerades 448–50, 13-32, 13-33 Makuria, kingdom of 64

Malagasy arts see Madagascar malam 94, 95-6 Malangatana, Valente 491; mural 14-46

Malawi 431, 447, 463; see also Mang'anja

Mali 16, 35, 104, 107, 108, 143, 502-Bandiagara escarpment 131, 132, 5-2, 5-11; saho (association house) 116, 4-17; Tondidaru monoliths 106, 4-4; see also Bamana; Jenne; Manden

Malinke, the 104; masquerades 116,

Mambila, the 86, 90; Suaga masquerades 90-91, 3-21; tadep figure 91,

Mamluk period 67, 68; metalwork 67-8, 2-31

Mamprussi, the 209 Mamy Wata (deity) 291; shrine 291,

Mancoba, Ernest 489 Mandara Mountains 86 Mande, the: expatriates 511-12; see also Jula, the

Mandela, Nelson 198 Manden/Mande-speakers 104-5, 111, 112, 130, 131, 143, 161, 168 Manding, the 36

Mandingo/Maninka, the 104 Mang'anja, the (Malawi): nkhalamba masks 447, 13-29; Nyau ceremonies 447, 448

Mangbetu, the 17, 400, 418, 420; ceramics 423, 12-35; court art 418, 420-21; hairstyles 421, 12-32; houses 423, 12-34; musical instruments 419-20, 12-28, 12-30

Mani society, Azande 414, 418; yanda figures 418, 12-27 mankishi sculptures, Songye 412-13, 12-19

Mano masks/masquerades 182-3, 6-21.6-22

Mansaray, Abu Bakarr 193, 501, 503: Alien Resurrection 193, 6-40 manuscripts, Ethiopian 66, 2-29, 2-30 Mapula Embroidery Project (South

Africa) 484, 14-34 Mapungubwe (South Africa): gold rhinoceros 471, 14-12 Maqhubela, Louis 495; Tyilo-Tyilo

495, 14-53 Maravi, the 447, 478; masks 450, 13-34; sculpture 448, 13-31

Marc-Stanislaus, Frère 397-8 Mariga, Joram 490; Intertwined Figures 490, 14-44

Martinez, Denis 505; Window of the

Wind 505-6, 15-4 masks/masquerades 15, 18, 169, 173, 324; Baga 176–9, 6-13, 6-15, 6-16; Bamana 104; Bassari 173-4 6-8; Baule 218-21, 7-28-7-31; Bembe 416-17, 12-24, 12-25; Benin 283–4, 9-16, 9-17; Bidjogo 174–5, 6-9; Binji 392–3, 11-67; Bobo 161; Bwa 156-8, 5-36-5-38; Brazilian (egun) 533, 16-21; Bwami society (Lega) 415, 12-21, 12-22; Cameroon grasslands 333-6, 10-22-10-26; Chamba 87–8, 90, 3-16; Chewa 447–8, 13-30; Ci Wara 117-18, 4-18-4-20; Cross River 321-3 10-6-10-8-Dan 183–5, 6-23, 6-24; Dogon 15-16, 140-43, 158, 449, 5-15-5-18; Duala 339, 10-29; Edo 306-8. 9-50, 9-51; egun 533, 16-21; Gabon 344-7, 10-36-10-41; Guinea Bissau 175-6, 6-9, 6-10:

304–5, 9-46, 9-47; Igbo 297–302, 304, 9-37–9-41; Jola 173, 6-7; Komo 120, 121, 4-24; Kono 182, 6-20; Kono society 120; Kore 121, 4-25; Kru 185, 6-25; Kuba 389-92, 11-62-11-65; Luba 406-8, 12-11, 12-12; Makonde or Makua

Hemba 408–9, 12-14; Ibibio

448-50, 13-32, 13-33; Malinke? 116, 4-16; Mano 182-3, 6-21, 6-22; Maravi 450, 13-34; Mende 180, 181, 6-17, 6-18; Mossi 158, 160, 5-41; Mumuye 88–90, 3-19, 3-20; Nalu 176-8, 6-14; Ntomo 115-16, 4-15; Nyau 447, 448;

Okpella 305-6, 9-48, 9-49; Pende 377-9, 11-44-11-48; Salampasu 380, 11-49-11-51; Sande/Bondo 180, 6-18; Senufo 148, 150-51, 5-1, 5-26-5-29; Songye 411-12, 12-18; Suaga (Mambila) 90-91, 3-21; Suku 373–5, 11-41; Tabwa 410–11, 12-17; Tempe 180, 6-1; Toma/Loma 181–2, 6-19; We 185, 186, 6-24, 6-26, 6-27; Yaka 373-5, 11-40, 11-42; Yoruba 252–6, 533, 8-38-8-43 nastaha 49, 50

Master of the Cascade Hairdo: headrest 405, 12-7 Master of Mulong: mboko (figure-

with-bowl) 405-6, 12-8 Maswanganyi, Johannes 480, 490; Professor Hudson Ntswaniwisi

480, 14-27 matano figures, Venda 479–80, 14-26 Matulu, Tshibumba Kanda 426: La Mort historique de Lumumba...

427, 12-39 Mauritania 28, 36; mosque 36, 1-26; see also Chinguetti; Kumbi Saleh;

Walata mbari houses, Igbo 293-6, 308, 9-33-9-35

Mbatha, Azaria 493, 501 Mbayo Mbari workshop (Ibadan) 267, 529

M'bengue, Gora: Les Amoreaux 125,

Mbidi Kiluwe 402 Mbirhlengnda 83, 3-9 mboko (Luba figure-with-bowl) 405-6, 12-8

Mbole, the 417; see Lilwa society Mbop Mabiine maKyen, Kuba king 385, 11-56

mbulu-ngulu (Kota reliquary figures) 342-3, 10-33, 10-34

Mbunza, king of the Mangbetu 420, 421, 12-31; court 421–3, 12-32 Mbuti, the 423-4; barkcloth 423-4, 12-36

mbuya masks, Pende 378-9, 11-47 Mehretu, Julie 515 memorial arts see funerary and

memorial arts Mende, the 169, 179, 191, 528; masks/masquerades 180, 181,

6-17, 6-18; Menkaure and Khamerernebty 50-51, 2-8

Merina culture: odi (amulets) 452,

13-38; textiles 453, 13-40 Meroe/Meroitic period (Nubia) 58, 63; bekhenet (gateway) 59-60, 2-19 gold ornament 59, 2-18; pyramids 58–9, 2-17; "reserve head" 60, 2-20

metalwork see brasswork: bronzes/copper alloy; goldwork; ironware; silverware

mgbedike masquerades, Igbo 299–300, 9-39 Mijikenda, the 438, 439, 441

Mika'ilu: Friday Mosque (Zaria, Nigeria) 93–4, 3-15, 3-26 Miller, David, Jr. 526; Head 526-7, 16-13

Mindumum the 341 minganji maskers, Pende 378, 11-46 minkisi (nkisi) 353, 357, 359-61, 362,

11-17, 11-18, 11-21 minkondi (nkondi) 359, 361, 11-1, 11-17

mintadi (Kongo funerary figure) 358,

11-14 Mitterrand, François 395-6, 11-71 Mobutu Seke Seko 198, 395-6, 427,

11-71 Mogadishu (Somalia) 431

Mohammed Bello 93 Moke (Monsengwo Kejwamfi) 395, 397; Mitterand and Mobutu 395–6, 11-71

Mokhethi, Maria: ceramics 487, 14-40 Mombasa (Kenya) stone tombs 433,

monoliths: Aksum 63, 2-24; Bakor-Ejagham 319-20, 10-2; Opa Oranmiyan (Ife) 229, 8-2; Shona 474–5, 14-17; Tondidaru (Mali) 106, 4-4; Wassu (Gambia) 112, 4-11

Moonens, Laurent 398

Morehead, Scipio 519 Morocco 22, 108, 192; art 41–3, 1-32– 1-34; ksar (Berber town) 34, 36, 1-21, 1-22; tighremt (farmhouse) 34–5, 1-22, 1-23; see also Berbers mosques 16; Afro-Brazilian 264, 8-57;

Agadez 36, 1-25; Chinguetti (Mauritania) 36, 111, 1-26; Egypt 67; Futa Jallon 97-8, 3-31; Gardaia (35–6, 1-24; Jenne 111, 4-9, 4-10; Kilwa 431–3, 13-2, 13-3; Kumbi Saleh 105-6, 4-2; Oairouan 30-32, 94-5, 106. 1-15-1-18; Swahili 431-3, 435, 13-2, 13-3; Zaria 93-4, 3-25, 3-26

Mossi, the 131, 154; masks 158, 160, 5-41; sculpture 159-60, 5-39,

5-40 Motaung, Weie Minah: house façade

487, 14-39 mother-and-child figures: Lulua 393-4, 11-59; Yombe (pfemba)

353-4, 399, 11-6 Mozambique 431, 447, 465, 478, 502modern art 491

mpundu (Tabwa figure) 410, 12-16 Msop association masks 335-6, 10-26 Mthethwa, Zwelethu 496-7; Untitled 497. 14-57

Muafangejo, John 494; New Archbishop Desmond Tutu 494, 14-51

Mugongo society 380 Muhammad, Prophet 29-30, 96, 126 mukanda masquerades and rituals 368-9, 373, 391, 11-31

Mukarobgwa, Thomas 490 Mukhtar, Mahmoud 72. 502; Fellahin

Mukomberanwa, Nicholas 490, 491; Desperate Man 490, 14-45

mukudj masks, Punu 346-7, 10-40, 10-41

Mulongoye, Pilipili 425; Birds Eating Fishes 425-6, 12-38 Mumuye, the 86; masks/masquerades

88–90, 3-19, 3-20; wooden images 88, 3-18 Muraina 267

murals: Igbo 288-9, 290, 9-27, 9-29; Mozambique 491, 14-46; Ndebele 487-8, 14-41; Soninke 36, 105, 106, 123, 4-27; Sotho 487, 14-39

Murray, Kenneth 265, 266 Musa, king of Mali 107 Musgum, the 85; dwellings 85, 3-13 music/musical instruments 532: African-American 521-2; Azande

419, 420, 12-29; Berber 1-1; Kwere 441, 13-17; Mangbetu 419–20, 12-28, 12-30; Senufo 143; see also drums Muslims see Islam

Musoke, Theresa 462: Birds 462, 13-53

Mutu, Wangechi 503, 515; Cancer of the Uterus 515, 15-17 muzidi (Beembe mannequins) 357, 11-12

mwana hiti ("daughter of the chair"). Zaramo 439-40, 441, 13-15 mwashamboy masks, Kuba 389, 391, 11-62

Mwere, the: container 450-51, 13-36 Mzab (Algeria): Gardaia minaret 35-6, 1-24

Naga/Naqa (Egypt): temple of Apedemak 59-60, 2-19 Nairobi (Kenya) 461; Go-Down Art Center 463; Kuona Trust 463; Paa Ya Paa gallery 462 Naletale (Zimbabe) 476, 14-18 Nalu, the 176; tshol 176, 6-12

Namibia 465; rock art 465, 466, 14-2, Nankani, the 154; architecture 162-4 5-43-5-45; calabash net 163, 5-48 Napata, Egypt 57, 58 Naqada sculpture (Egypt) 45–6, 2-2 Narmer, Palette of 46–7, 59, 2-4 Nassar, Lake (Egypt) 70 Natakamani, King 59 Ndagara, King of Karagwe: bovine figure 444, 445, 13-25 Ndebele, the 464, 487; murals 487–8, Ndengese, the 392; isikimanji figures 392, 11-66 N'diaye, Iba 126, 501; Juan de Pareja... 501, 15-1 Ndimande, Franzina 490; murals 487-8, 14-41 Ndjamena (Chad) 102 ndop (Kuba royal portrait figures) 383-4, 11-53 nduda figures, Kongo 361, 11-18 nduen fobara (Kalabari ancestral screens) 313, 9-60 Nebamun, tomb of (Waset) 52-3, 2-10 ngady a mwash masks, Kuba 390–91, 11-64 nganga see banganga Ngbe society 321–3, 10-5, 10-6 Ngil society masks, Fang 344, 10-36 Ngoni, the 464, 485; headrest 485, 14-36 ngontang masks, Fang 344-5, 10-37 Nguni, the 464, 481, 482, 483, 485; beadwork 482–3, 14-33; dwellings 486, 14-38; pregnancy aprons 483, 14-32; staffs 481 Nhlengethwa, Sam 495 Niani (Mali) 107 Niati, Houria 504 Niger 93; Bura terracottas 80-81, 3-5, 3-6; mosque 36, 1-25; rock art 26, 1-8 Niger, River 104, 105, 108, 130, 272 Nigeria: Civil War 284, 295; modern and contemporary art 265-71, 512-14, 528-9; see also Agadez; Benin; Chamba; Cross River: Dakakari; Esie; Fulani; Ga'anda; Hausa; Ibadan; Ibibio; Ife; Igbo; Ikere; Kano; Kanuri; Lagos; Mambila; Mumuye; Nnokwa; Nok; Oshogbo; Owerri; Owo; Sao; Sokoto; Yoruba: Zaria Nile, River 44, 45, 56, 70; early cultures 45-8, 51-2 Nimi a Lukemi 351 niombo (Bwende mummies) 355-6, 11-10 nia festival, Cameroon 333-4, 10-22 Njau, Elimo 462; Milking 462, 13-54 Njoya, king of Bamun 325, 327-8, 329, 10-9, 10-13 Njoya, Prince Ibrahim 333-4, 10-22; Chronology of Bamun Kings 333, 10-21 Nka (journal) 503 Nkanu, the: initiation structures 373, 11-38 11-39 nkhlalmba mask, Mang'anja 447, 13-29 nkishi see mankishi nkisi see minkisi nkondi see minkondi Nkrumah, Kwame 198, 529 Nnachi, D. L. K. 266 Nnaggenda, Francis 461; War Victim 461–2, 13-52 Nnam, the 319, 320 Nnokwa (Nigeria): mural 290, 9-29 Nobatia/Nobotia, kingdom of 64 Nok style (Nigeria): terracottas 77, 79, 80, 3-1-3-3 nommo, Dogon 134, 136 nomoli figures, coastal-style 169-70,

Nour, Amir 75, 506; Grazing at

Shendi 506-7, 15-6

Nri, the 285, 286, 287

Nsangu, king of Bamum: throne 327, 328, 10-12 nsibidi signs, Cross River 320-21, 10-4 Nsue, Leandro Mbomio 348, 515; Mascara bifronte 348, 10-42 Nsukka artists 289-90, 313 ntapo marks, Luba 403 Ntendu, Tshyela see Djilatendo N'tomo (association) 113, 115; masks 115–16, 4-15 Nuba, the 458, 459; body painting 14, 459, 13-48; face painting 459, 13-47 Nubia/Nubians 17, 44, 45, 56, 58, 68, 431; ceramics 46, 2-3; Christian art 64, 67, 2-26; painted houses 70, 2-35, 2-36; Sphinx of Taharqo 58, 2-1; see also Meroe Nuer, the 60, 458 Numidia (Tunisia) 28; tomb 28, 1-12 Nuna, the 156, 158, 159, 164 Nunuma, the 156, 158, 159 Nupe, the 82, 85, 96, 191, 235 Nwoko, Demas 314 nwomo (Ibibio funerary cloths) 308-9, 9-52 nyama (power) 112, 118, 119, 120, 121, 123 Nyamwezi, the 442-3, 444; figure 444, 13-24; throne 443, 13-22 Nyankpe (masquerader) 322-3, 10-6 Nyau society masquerades 447-8, 13-29 Nzambi Kalunga (deity) 353 oba see Benin Obaluaiye (deity) 535; altar 534-5, 16-23 Obalufon II, Ife ruler 235 Obamba, the 341 Obatala (deity) 229, 234 Obemne, king of Baham 326, 10-10 Ode-Lay (society) 191 odi (Merina amulet) 452, 13-38 odudua masks, Benin 283, 9-17 Oduduwa (deity) 229, 232, 236, 239 Odundo, Magdalene 446; vessel 446, 13-28 ofika figures, Mbole 417, 418, 12-26 Ofili, Chris 514, 515; Holy Mother of God 514

Ogboni Society 238, 242-4; agba (drum) 243, 8-22; edan 243, 8-23; onile 242–3, 8-21; title cloths 243–4, 8-23 ogoni, the 308 Oguibe, Olu 503, 512; Oklahoma 512, 15-13 Ogun (deity) 244, 248-9 Ogundele, Rufus 267 Oguta (Nigeria) 287, 9-23 Ohelami 267 Ojeikere, J. D. 'Okhai 270; Hairstyles 270-71, 8-67 Okak, the: bieri figure 341, 10-31 Okediji, Moyosore 269; Ero 269-70, 8-65 okega (personal altars) 302-3, 9-43 Okeke, Uche 289, 314 okoroshi masquerades 297–9, 9-37 Okpella, the 272, 302; masks 305–6, 9-48, 9-49 olifants 172, 6-6 Olokun (deity) 275, 276, 277, 278,

282, 308; shrine 276–7, 9-6 Olorun (deity) 244, 246

240-41, 8-19

olubaru 140, 141

530, 16-17

Ona art group 269-70, 289

Onitsha (Nigeria) 287, 302

Onabolu, Aina 265, 502

8-35

Olowe of Ise 11, 240; bowl 249–50, 8-

Olowo, Princess Elizabeth 284; Biafra

Olugebefola, Ademola 530; Shango

olumeye (Yoruba altar bowl) 249-50

onile figures, Ogboni 242-3, 8-21

11-53

Portuguese, the 171, 172, 351-2, 355,

War Monument 284, 512, 9-18

35; ibeji iii; oriki 11-12; palace door 241-2, 8-20; verandah posts

Onobrakpeya, Bruce 313-14; Shrine Piece (Akporode) 314-15, 9-61 Opa Oranmiyan (Ife monolith) 229, 8-2 Opening of the Mouth ceremony (Egyptian) 55–6, 2-15 opon igedeu (Yoruba divination bowl) 246-7, 8-28 Orebok-Okoto 176, 6-11 oriki (Yoruba citation poetry) 11-13 orisha (Yoruba deities) 244, 249, 261, 268 oro efe masquerades, Yoruba 254, 8-40 Oromo, the 457; jewelry 457, 13-1 Oron commemorative figures 310, Orunmila (deity) 244, 245, 247, 248 Osanobua (deity) 244, 249 Osanyin (deity) 248, 249 pylons 57 Osei Tutu, Asante ruler 196, 201 oshe shango (dance wand) 251, 8-36 Oshogbo (Nigeria): artists 266–9, Oshun (deity) 268, 8-64; shrine 267, Osiris (deity) 52, 53, 56 otobo masks, Kalabari 312–13, 9-58, 9-59 Ottoman empire 68 Ouagadougou (Burkino Faso) 164, 165 Our Mothers (Yoruba) 239, 249, 254 Owerri (Nigeria): *mbari* houses 293–6; shrine figures 293, 9-32 Owo (Nigeria) 235–6; ivory bracelets 236–7, 8-16; ivory sword 236, 8-15; terracottas 236, 8-13, 8-14 Owusu-Ankomah, Kwesi 510; Star Black, Star Bright 510, 15-11 Oxossi (deity) 535 Oyo kingdom 228, 229, 235, 250, 252, 125 256 Ozo Society 287, 288, 291, 9-25 Palette of Narmer 46-7, 59, 2-4 Palo Monte religion 538–9, 540 panya ngombe masks, Pende 378 Pare, the: calabash container 442, 13-19; figure 442, 443, 13-21 Pareia, Juan de 500-1, 15-1 Pate Island (Kenya): Qur'an 433, 13-4; siwa (horn) blower 434, 13-6 Pavement Period see Ife/Ile-Ife pedi, the 478 Pemba, George 489 Pende, the 375–6; kibulu (ritual houses) 376–7, 11-43; ikhoko mask-pendants 379, 11-48; masks/masquerades 377-9, 11-44-11-47 personal altars: Benin 275, 279, 303, 308, 9-1; Edo 302; Igala 302-3, 9-43; Igbo 302–3, 9-42; Isoko 303, 304, 9-45; Urhobo 303, 9-44 Peul, the 97; see Fulani, the pfemba (Yombe mother-and-child figure) 353–4, 399, 11-6 Phillips, James 538; Mojo 538, 16-29 Phoenicians 23, 27 photographs/photography 123-4; Cameroon 514-15, 15-16; Mali 124, 4-28, 4-29; Nigeria 512–13; South Africa 492, 496–7, 14-28, 14-57; Tunisia 43, 504, 1-35 Picasso, Pablo 10, 17, 524, 525 Pigozzi, Jean 503 Pindell, Howardena: Autobiography... 531-2, 535, 16-20 Pippin, Horace 520 Piula, Trigo 398–9; Materna 399, Poham, king of Baham 326 Polly Street Center (Johannesburg) 494 pomdo/pomtan (Kissi stone figures) 170–71, 6-4 Popo, the 228 Poro societies 144-6, 148, 180-82; masks 148, 150-51 portrait figures: Cameroon 331-3, Sapi-Portuguese 171; ivories 171-3, 10-18-10-20; Kuba 383-4,

395, 434, 465; see also Sapi-Portuguese posuban (Asafo structure) 222–3, 7-34 potige (façade) 110–11 Poto-Poto artists 398 pottery see ceramics power images 120 Powers, Harriet: quilt 518–19, 16-5 Prophet, Nancy Elizabeth 524; Congolais 524, 16-9 Ptolemaic period (Egypt) 61 pumbu masks, Pende 377, 11–44 Punic Wars 28 Punu, the 344; masks 346-7, 10-40, 10-41; reliquary figure 344, 10-1 puppets, Bamana 122–3, 4-26 pwo masks, Chokwe 371, 11-33 pyramids: Egyptian 49–50, 2-7; Mero 58–9, 2-17 Qairouan (Tunisia): Great Mosque 30–32, 94–5, 106, 1-15–1-18; madrasa 32 Quaye, Kane 225-6 quilts, African-American 518–19, Ounbi see Kumbi Saleh Qur'an, the 30, 96-7, 125, 209, 433, 437, 457, 13-4 Racim, Mohammed 40-41 radiocarbon dating 58 raffia cloth, Kuba 387–9, 11-59– Rainimaharosoa, James 452-3; Malagasy Porter 453, 13-39 Ralambo, Emile 453 Rao (Senegal); cemetery finds 111-12, reliquary figures, Gabon 339-44, 10-1, 10-30–10-35 Rhodesia 465, see Zimbabwe Riefenstahl, Leni 459 rites of passage 413 rock art: Algeria 25, 26, 1-5-1-7, 1-9;466, 14-2, 14-4; Libya (Fezzan) 23-4, 1-2, 1-3; Niger 26, 1-8; South Africa 466, 467, 469-71, 14-3, 14-5, 14-9, 14-10; Tanzania 468–9, 14-8; Zimbabwe 467–8, 14-6, 14-7 Romain-Desfossés, Pierre 425 Romans, the 23, 28, 29, 31, 35, 39, 61, 62, 106 Rorke's Drift (South Africa) art center 493-4 rugs, Zemmour Berber 33-4, 1-20 Rumanika I, king of Karagwe 444, 445 Rwanda 424, 431; basketry 446 Sahara, the 22-3, 27, 45; oasis cities 35-7; rock art 23-7; see also Berbers; Tuareg saho (Mali association house) 116, Sakadiba water pot 363, 11-23 Sakalava cemeteries 454-5, 13-41 Salampasu, the 379-80; dance enclosures 380, 11-51; masks 380, 11-49, 11-50 Samba, Chéri 310, 396, 503; Enfin!...après tant d'années 397, San, the 469; rock art 469-71, 14-9, 14-10 Sanches, Eneida Assunção 535, 540; Jornada impressa no metal (altar de Oxossi) 535, 16-24 Sandawe, the 468-9 Sande/Bondo (women's society) 179-80; mask 180, 6-18 Sandogo societies, Senufo 146–8 Santería (religion) 537, 525 Santoni, Gerald 195; Untitled 195, 6-43 Sanwi, the 209 Sao terracottas 81, 3-7 Saou bi Boti 189

6-5, 6-6; stone head 170, 6-3

Saqqara (Egypt): Djoser's funerary

complex 48-9, 2-5, 2-6 Sara throwing knives 85–6, 3-14 satimbe masks (Dogon) 142–3, 5-18 scarification 15, 39; Akan 210, 211; Dakakari 82; Ga'anda (hleeta) 83-4, 3-10; Gongola River 83; Luba 403, 405; Nri (ichi) 285, 286; Nuba 458, 459; Nuer 60; Ogboni 242; Senufo 147; Tera 84, 3-11; Yoruba 233 Schweinfurth, George: drawings 420, 421, 12-31, 12-33 Searle, Bernie 496; Still 496, 14-56 Searles, Charles 530; Filàs for Sale 530, 16-18 Sebidi, Helen 495 Sedira, Zineb 504-5; Quatre générations des femmes 505, 15-3 Sekoto, Gerard 489, 495, 501; Street Scene 489, 14-43 Selam, Ale Felege 75 Senegal 112, 168, 192, 501; burial mounds (Rao) 111–12, 125; glass paintings 125, 4-30; Soninke mural 123, 4-27; 20th- and 21stcentury art 125-8; tapestry 125-6, 4-31; see also Casamance region Senghor, Léopold Sédar 125, 126, 398 Senufo, the 130, 131, 143, 209; brass amulets and charms 147, 5-24; celebrations 151; diviners' shrines 146–7, 5-22, 5-23; door motifs 147-8, 5-25; kpaala (public shelter) 148, 151, 5-30; masks/ masquerades 148, 150-51, 5-1, 5-26-5-29; Poro societies 144-6, 148, 150-51; Sandogo societies 146-8; see also Kulebele carvers Serer people 111 Set Setal ("clean-up" campaign) 127 Setordji, Kofi 510; Genocide 227, 512, 7-44 Shaka, Zulu king 482, 485, 486 Shake, the 341 Shamaye, the 341 Shambaa, the: horn container 442, 13-20 Shango (deity) 244, 250–51; shrine 249–50, 251, 8-34 Sherbro, the 171; mask 180, 6-17 Shitta Bey, Muhammad 264 Shleuh Berbers 39, 1-1 Shona, the 464, 472; axes 477; Great Zimbabwe 472–4, 475–6, 14-13-14-16; headrests 477-8, 14-22; soapstone bird monolith 474-5, 14-17; walls (Naletale) 476, 14-18; Weya cooperative 484 Shonibare, Yinka 503, 513; Mr. and Mrs. Andrews without their Heads 513-14, 15-15 shotgun houses, US 518, 537, 16-27 shrines and shrine figures 120; Asante 212-14, 7-17-7-19; Benin 276-7 9-6; Fon 261, 262–3, 8-52, 8-54; Igbo 288-9, 291-3, 9-27, 9-31, 9-32; Isoko 303, 304, 9-45; Kono 119, 4-22; Senufo 146–7, 5-22, 5-23; Yoruba 249–50, 251, 269, 8-34; see also altars; personal altars Shyaam aMbul a-Ngoong 381, 382, 383, 384, 386, 11-53 Sidamo, the: tombs 456 Sidibe, Malik 124; Untitled 124, 4-29 Sierra Leone 168, 171, 179; export ivories 171-3; lantern processions 192, 6-39; masks/masquerades 179-80, 191-2, 6-1, 6-38; Poro societies 180-82; stone figures 169-70, 6-3 Sihlali, Durant 494 silverware: Jewish 39; Ethiopian 457, 13-1; Somali 457; Tuareg 40, 1-31 sirige masks (Dogon) 141, 142, 160, 5-16 Sirry, Gazbia 73; Martyr 73, 2-39 Sissoko, Oumar: Guimba 165, 5-48 Sithole, Lucas 494 siwa (Swahili horn) 434, 13-6 Siyon, Fre 67; diptych 67, 69, 2-30

Skotnes, Cecil 494 slaves/slave trade 16, 238, 256, 264, 321, 352, 402, 409, 447, 500–1, 516-17, 520

slit gongs, Kongo 361, 11-10, 11-19 snuff container, Sotho 481-2, 14-30 soapstone figures: contemporary 490, 14-44; Esie 237–8, 8-17; Shona birds 474-5, 14-17; West Atlantic (nomoli) 169-70, 6-2

Sokoto-style terracottas 79. 3-4 Solomonic periods (Ethiopia) 65-7, 68; diptych 67, 2-26; manuscripts 66-7, 2-30

Somali, the 457; jewelry 457 Somalia 62, 433; see also Kilwa Somono, the 121; saho 116, 4-17 Songhai 93, 104, 108; builders 110, 4-7 Songye, the 411; mankishi 412-13, 12-19; masks 407, 411-12, 12-18

Soninke, the 36, 105, 106; painted interiors 123, 4-27 so'o masks, Hemba 408-9, 12-14 Sosa Adede: bocio 258, 8-47 Sotho, the 464, 478, 481, 482; ceramics

487, 14-40; murals 487, 14-39; snuff container 481-2, 14-30; staff 481, 14-29

South Africa 464–5; apartheid 465, 492; Boer War 465, 476; expatriates 515; rock art 466, 467, 469–71, 14-3, 14-5, 14-9, 14-10; Lydenburg heads 471, 14-11; 20th- and 21st-century art 489, 492-7, 14-43; see also Afrikaaners; Sotho; Tswana; Venda; Zulu

Sow, Ousmane 127–8; Battle of Big Horn 128, 4-34

Sphinx, Great (Giza) 50, 2-7 Sphinx of Taharqo 58, 2-1 staffs: Bamana 112, 113, 4-12; Benin 279; Chokwe 366-7, 11-17; Ghanaian linguist 202-3, 7-5, 7-6; Igbo Ukwu 285, 9-20; Lagoons 204, 7-7, 7-8; Senufo

143, 5-19; Sotho 481, 14-29; Yoruba 249, 8-32; Zaramo 440, 13-16 Stanley, William 444

Stern, Irma 489 stools, stool-thrones and chairs: Akan 200–1, 7-4; Cameroon 327, 336–7, 10-12, 10-27; Chokwe 367–8, 11-29, 11-29; Luba 403-5, 12-1, 12-5; see also

thrones Stopforth, Paul 495 Stout, Renée 538; Fetish No. 2 538, 16-28

Suaga (Mambila) masquerades 90-91, 3-21

Sudan 76-7, 82, 130-31, 450, 502; contemporary art 506–7, 508; Khartoum School 73–5

Suku, the 371; biteki figures 372; initiation 373; kopa (vessel) 372, 11-36; masks/masquerades 373-5, 11-41

Sukuma, the: standing figures 444, 13-23

Sumégné, Joseph Fraccis 348; Les 9 Notables 348-9, 10-44

Sundjata 107, 120, 128 Swahili, the 431, 434; architecture 435-8, 13-8-13-11; kiti cha enzi ("chair of power") 434, 13-7; siwa (horn) 434, 13-5; tombs 433, 434, 13-5; see also Kilwa Swazi, the 198

Swaziland 465 swords and sword ornamanet: Abomey 259-60; Akan 197-8, 7-2; Ghanaian state 201; Kuba

Tabwa, the 409; masks 410-11, 12-17; sculpture 409-10, 12-15, 12-16 Tada (Nigeria): copper figure 234-5, 8-12

Tado, kingdom of 228 Takrur empire 104, 111 Tall, Papa Ibra 125, 126; Royal Couple 125–6, 4-31 Tallal, Chaibia 42–3; Women of

Chtouka 43, 1-34 tange (Duala prow ornaments) 337-8, 10-28

Tanit (deity) 27, 28 Tanner, Henry O. 521; The Banjo Lesson 521, 522, 16-7

Tanzania 430, 431, 441, 460; contemporary art 462; export art 451-2; language 45; rock art 468-9. 14-8; stoppers 441-2, 13-19, 13-20; see also Dar es Salaam Kilwa; Nyamwezi; Pare; Zanzibar; Zaramo

tapestries: Coptic 62, 2-22; Senegalese 125-6, 4-31

Tassili n'Ajjer highlands (Algeria): rock art 25, 26, 1-5-1-7, 1-9 tattoos 15, 102 Tayou, Pascale Martine 515 Tebu, the 431 Teke, the: nkisi figures 362, 11-21 Tellem, the 131-2; wood figure 132,

Temaden, the 38 Temne, the 170, 171, 179; masks/ masquerades 180, 6-1; olifant 172.6-6

Temne, the 191 temples, Egyptian 57, 59-60, 2-16, 2-19

tengabisi (farmers) 159 tents, Tuareg 37-8, 1-28, 1-29 termite mounds 275–6, 294, 302 terracottas see ceramics

textiles: Akan 203, 207-9, 7-11, 7-12; Bamana 118-19, 4-21; Baule 203; Berber 33-4, 39, 1-20, 1-30; Cameroon grasslands 327, 328, 10-14; Coptic 62, 2-22; Djerma 92, 3-24; Fulani 39, 77, 99-100, 3-34, 3-35; Hausa 96, 3-29; Jukun 86; Kalabari Ijaw 310, 312, 9-55-9-57; Kanuri 91, 96, 3-23; kente 203; Kongo 352, 11-3, 11-4; Kuba 387-9, 11-59-11-61; Lagoons 203; Mbuti 423-4, 12-36; Merina 453, 13-40; Senegal 125-6, 4-31; Wukari 328, 333, 334; Yoruba 253, 255, 268-9,

8-63, 8-64 Thamugadis see Timgad Thango, François 398; Untitled 398,

Thebes, Egypt see Waset thermoluminescence testing 58, 107 Thies (Senegal): Manufactures Nationales des Tapisseries 125 thil/thila (deities) 154-6

Thonga, the: axes 477, 14-21; head-rests 478, 14-23 Thoth (deity) 61, 62

thrones: Akan 200-1, 7-4; Luguru 441, 13-18; Nyamwezi 443 13-22; Swahili 434, 13-7; see also stools, stool-thrones and chairs

Thupelo Workshop (Johannesburg) 495

tighremt/tigermatin (Moroccar farmhouse) 34-5, 1-22, 1-23 Timbuktu (Mali) 16, 107 Timgad (Algeria) 29, 1-13, 1-14 Tingatinga (Edward Saidi) 463, 13-55 Tiv, the: adz 86, 3-15 togere/toge (Fulani mounds) 105, 106

Togo 228; see also Ewe, the togu na (Dogon meeting house) 138-9, 5-12, 5-14

Tokoudagba, Cyprien 263, 503; "Rainbow SErpent" 263, 8-55 Toma/Loma masquerades 181-2,

tombs/burial grounds/graves: Arussi 456, 13-44; Bongo 456, 13-43; Egyptian 45, 52-3, 54, 56, 2-10; Kisalian 401; Numidian 28, 1-12; Rao (Senegal) 111–12, 125; Sakalava 454-5, 13-41; Swahili 433, 434, 13-5

Tondidaru (Mali): monoliths 106, 4-4 Toni Malau 354-5, 11-8 Traore, Sedu 121 Trowell, Margaret 461

tshol (Baga sacred objects) 176, 6-12 Tsonga, the 464, 481; headrests 478, 14-23; sculpture 479, 480, 14-25, 14-27

Tswana, the 464, 481, 482; staffs 481 Tuareg, the 37, 100; silverwork 40, 1-31; tents and leatherwork 37-8, 1-28, 1-29 Tucker, Curtis 530-31

Tucker, Yvonne Edwards 530-31: Amadlozi for Jean, Raku Spirit Vessel 531, 16-19 tukula (Kuba containers) 387, 11-58

tumba see bitumba Tunisia 16, 22, 23, 32, 40; photo graphy 43, 504; see also

Carthage; Numidia; Qairouan Turkana, the 460–61, 13-50, 13-51 Tutankhamun, tomb of 54; funerary mask 54-5, 2-13; headrest 55, 2-14

Twifo, the: ceramics 211, 7-14 Twins Seven-Seven, Prince 267; Healing of the Abiku Children 267, 8-61 Tyi Wara see Ci Wara

Udechukwu, Ada 289 Udechukwu, Obiora 289–90; Our Journey 290, 9-28 Uganda 431, 461 Ugoji, I. 266

ugonachonma (Igbo display figures) 296-7, 9-36

uli motifs, Igbo 288-9, 290, 9-26 Uli School (Nigeria) 227 Umana, A. P. 266

Umofeke Agwa (Nigeria): mbari 293, 9-33 United States 502-3; slave trade

516-17, 520; see also African Americans

Upemba depression 402; metalwork 400–1, 12-2, 12-3 Urhobo, the 272, 302, 314, 315: personal altars 303, 9-44

Usman dan Fodio 93 Utimuni (Zulu warrior) 482, 14-31 vabo masks, Mumuye 88-90, 3-19, 3-20

Vai, the 179 Vandals, the 23, 29, 39 Velázquez, Diego 500, 501 Venda, the 464; axes 477, 14-21; contemporary sculpture 480, 14-28; divination bowl 476, 14-20; initiation ceremony 478, 14-24; matano figures 479-80, 14-26 vigango (memorial planks), Giriama

438, 13-12 Vodou, Haitian 516, 533-4, 537 vodun (Fon deities) 258, 261, 263, 264 Vogel, Susan 503

Vohou-Vohou (art group) 194–5

waga (Konso memorial figures) 456-7, 13-45 Wagadu (Ghana) 104, 105; mosque 105-6, 4-2; terracotta figure 106,

Walata (Mauritania) 36, 107, 123, 1-27 Wan, the 218, 219 Waqialla, Osman 73, 74; Opening of

the Surat Ya Sin 74, 2-41 Warua Master: stool 404, 405, 12-1 Waset (Thebes, Egypt): female figure

51, 2-9; tomb painting 52-3, 2-10 Wassu (Gambia): monoliths 112,

Watts (Bakari Ouattara) 511-12; Nok Culture 511, 15-12 We, the 185, 186, 6-29; masks/mas-

querades 185, 186, 6-24, 6-26, 6-27; women's arts 186-7 Wenger, Suzanne 267 Wheatly, Phyllis 519 Williams, Henry Sylvester 523

Williamson, Sue 497 Winiama, the 156, 158, 159 Wobe, the 185

Wodaabe (Fulani cattle herders) 97; calabash displays 100, 3-36; gerewol (festival) 100–2, 3-37, 3-38

Wolof, the 111; jewelery 111-12, 125 Wongo, the 392, 393; cup 393, 11-68 Woodruff, Hale 528; Celestial Gate 528, 16-15

writing boards, Islamic 97, 504, 3-30 Wukari (Nigeria) 86; textiles 328, 333,

Yaka, the 371; adz 371, 11-35; biteki (power figures) 372-3, 11-37;

headdresses 371, 11-34; initiation structures 373, 11-38, 11-39; masks/masquerades 373-5, 11-40, 11-42

yalimidyo (Senufo mask) 150–51, 5-28

yanda figures, Mani 418, 12-27 Yao, the 447; masks 448, 450, 13-34 Yatenga masks 160 Yaure, the: masks 218

Yemoo (deity) 234 Yombe, the 351; bitumba (funerary figures) 358, 11-15; funerary cart 356-7, 11-11; minkisi figures 359 11-17; pfemba (mother-and-child

figures) 353–4, 11-6 Yoruba, the 191, 228–9, 238; architecture 239-40; dance wands 247-8, 8-30; deities 244-9, 250-51, 533 535; divination 245–7, 8-25–8-28; funeral rites 234; hairstyles 39, 270-71; masquerades 252-6, 8-38-8-42; naming ceremonies 11; oba 198; oriki (citation poetry) 11–13; Oshogbo artists 266–9, 8-62; royal arts 238–42; sculpture 10, 512-13, I—III, 15-14; shrines/shrine paintings 248, 249-50, 269 8-34; staffs 249, 8-32; textiles 253, 255, 268-9, 8-63, 8-64; see also Esie; Ife; Ogboni Society; Owo Yu, king of Kom 332-3

Zagwe Dynasty 64-5, 67 Zaire see Congo, Democratic Republic of

Zake, king of Babungo 329, 10-15 Zambia 364, 431; see also Chewa, the Zamble 188, 6-32

Zanzibar (Tanzania): doorway 437, 13-10; The Old Dispensary 437-8, 13-11

Zaramo, the 438-9; funerary figure 439, 13-13; memorial posts 439, 13-14; mwana hiti figures 439-40, 13-15; staff finial 440, 13-16

Zaria 93; Friday Mosque 93-4, 3-25, 3-26; zaure 95, 3-28 "Zaria Rebels" 289, 313–14 Zauli 188-9, 6-33

zaure 95, 3-28 Zemmour Berber rug 33-4, 1-20 Zerma, the see Djerma, the zidaka (Swahili storage niches) 437)

Zimbabwe 16, 465; expatriate artists 515; Great Zimbabwe 464. 472-4, 475-6, 14-13-14-16; modern art 490-91; rock art 467-8, 14-6, 14-7; see also Shona, the

Zlan of Belewale 187; figure 187, 6-31

Zulu, the 198, 464, 482–3; beer vessel 485-6, 14-37; shawls 483, 14-33; spoon 485, 14-35; women 483, 484, 14-1

Zungu, Tito 488-9, 490; Untitled 14-42

709 .6 Vis 2008

Visonà, M. A history of art in Africa. Aurora P.L. APR08 33164002970643